Readings on Color
Volume 1: The Philosophy of Color

Readings on Color
Volume 1: The Philosophy of Color

edited by Alex Byrne and David R. Hilbert

A Bradford Book
The MIT Press
Cambridge, Massachusetts
London, England

This book was set in Times Roman on the Monotype "Prism Plus" PostScript Imagesetter by Asco Trade Typesetting Ltd., Hong Kong and was printed and bound in the United States of America.

Library of Congress Cataloging-in-Publication Data

Readings on color / edited by Alex Byrne and David R. Hilbert.
 p. cm.
Includes bibliographical references and index.
Contents: v. 1. The philosophy of color — v. 2. The science of color.
ISBN 0-262-02424-1 (v. 1 : hardcover : alk. paper). — ISBN 0-262-52230-6 (v. 1 : pbk. : alk. paper). — ISBN 0-262-02425-X (v. 2 : hardcover : alk. paper) — ISBN 0-262-52231-4 (v. 2 : pbk. : alk. paper)
 1. Color. 2. Color—Philosophy. I. Byrne, Alexander. II. Hilbert, David R., 1959– .
QC495.R32 1997
152.14′5—dc21 96-44539
 CIP

Contents

 Alex Byrne and David R. Hilbert

15 **Reinverting the Spectrum** 289
 C. L. Hardin

 Bibliography 303
 Contributors 313
 Index 315

Acknowledgments

Larry Hardin gave us good advice on selecting papers for this volume. We are also grateful to Larry and to Ned Block, Andrew Botterell, Fiona Cowie, Ned Hall, Katie Hilbert, Steven Palmer, Jim Pryor, Daniel Stoljar, and Judith Thomson for comments on the Introduction, although we are quite sure the final result will not satisfy all of them. Austen Clark and Joe Levine helped with the early stages of the project. Peter Ross made some last-minute corrections to the Bibliography. Betty Stanton, Jerry Weinstein, and Katherine Arnoldi at The MIT Press were, as usual, indispensable. Finally, Ned Block needs to be thanked again, this time for his enthusiastic support for this project.

Sources

1 J. J. C. Smart, On Some Criticisms of a Physicalist Theory of Colors. Reprinted with permission from *Philosophical Aspects of the Mind–Body Problem*, ed. C. Cheng, Honolulu: University Press of Hawaii. © 1975 University Press of Hawaii.

2 Edward Wilson Averill, Color and the Anthropocentric Problem. Reprinted from *Journal of Philosophy* 82 (1985), pp. 281–304, by permission of the author and *The Journal of Philosophy*.

3 D. M. Armstrong, Smart and the Secondary Qualities. Reprinted from *Metaphysics and Morality: Essays in Honour of J. J. C. Smart*, ed. P. Pettit, R. Sylvan, and J. Norman (1987), by permission of Blackwell Publishers.

4 J. J. C. Smart, Reply to Armstrong. Reprinted from *Metaphysics and Morality: Essays in Honour of J. J. C. Smart*, ed. P. Pettit, R. Sylvan, and J. Norman (1987), by permission of Blackwell Publishers.

5 Christopher Peacocke, Colour Concepts and Colour Experience. Reprinted from *Synthese* 58 (1984), pp. 365–82, with kind permission from Kluwer Academic Publishers.

6 Frank Jackson and Robert Pargetter, An Objectivist's Guide to Subjectivism about Colour. Reprinted with permission from *Revue Internationale de Philosophie* 41 (1987), pp. 127–41.

7 Paul A. Boghossian and J. David Velleman, Colour as a Secondary Quality. Reprinted from *Mind* 98 (1989), pp. 81–103, by permission of Oxford University Press.

8 Paul A. Boghossian and J. David Velleman, Physicalist Theories of Color. From *Philosophical Review* 100 (1991), pp. 67–106. © 1991 Cornell University. Reprinted by permission of the publisher and the authors.

9 Mark Johnston, How to Speak of the Colors. Reprinted from *Philosophical Studies* 68 (1992), pp. 221–63, with kind permission from Kluwer Academic Publishers. Postscript: Visual Experience. Written specially for this volume.

10 John Campbell, A Simple View of Colour. Reprinted from *Reality, Representation, and Projection*, ed. J. Haldane and C. Wright (1993), by permission of Oxford University Press.

11 Justin Broackes, The Autonomy of Colour. © Justin Broackes 1992. Reprinted from *Reduction, Explanation, and Realism*, ed. D. Charles and K. Lennon (1992), by permission of the author and Oxford University Press.

12 Sydney Shoemaker, Phenomenal Character. Reprinted from *Noûs* 28 (1994), pp. 21–38, by permission of Blackwell Publishers.

13 Gilbert Harman, Explaining Objective Color in Terms of Subjective Reactions. Reprinted with permission from *Philosophical Issues* 7 (1996), ed. E. Villanueva (Atascadero, CA: Ridgeview Publishing Co.).

14 Alex Byrne and David Hilbert, Colors and Reflectances. Written specially for this volume.

15 C. L. Hardin, Reinverting the Spectrum. Written specially for this volume.

Introduction

Color is a peculiarly striking aspect of the world as it appears to us. It is therefore a natural starting point for any investigation into appearance and reality. No surprise, then, that philosophy has always taken an interest in color. And even when colors have not been the topic, they have often been used to stain a specimen under the philosophical microscope: Hume's missing shade of blue; G. E. Moore's comparison of good with yellow, Nelson Goodman's "grue" and "bleen"; Frank Jackson's super-scientist Mary who doesn't know what it's like to see red.[1]

As C. L. Hardin remarks in the expanded edition of *Color for Philosophers*, a "small chromatic zeitgeist has been loose in the philosophical world" (1993, p. xix), its presence being significantly due to the influence of Hardin's book. But *Color for Philosophers* has done more than stimulate philosophers to work on color: it has also made them (or, anyway, some of them) familiar with the main findings of color science. And greater sensitivity to the empirical facts has certainly raised the level of debate.

This volume contains a selection of recent philosophical papers on color and a comprehensive bibliography. Its companion volume, *Readings on Color, vol. 2: The Science of Color*, is a broad collection of current scientific work on color and color vision.

Philosophers have become increasingly aware of the relevance of science to philosophy. This is a welcome trend, and we hope these two volumes will do something to reinforce it. But how relevant is philosophy to science? Here we can only point to the papers in this book.

1 Summary of This Volume

There is a central concern shared by nearly all the papers collected here (and most contemporary philosophical discussions of color), namely, to answer the following questions: Are physical objects colored?[2] And if so, what is the nature of the color properties? These questions form the problem of *color realism*.

Eliminativists answer no to the first question. They think that although physical objects seem to be colored, this is no more than a peculiarly stable illusion. Thus C. L. Hardin: "We are to be eliminativists with respect to color as a property of objects, but reductivists with respect to color experiences" (1993, p. 112). Eliminativism is of course controversial, but so is the second of Hardin's claims, namely that there is a physicalist reduction of color experiences. In his contribution to this volume (chapter 15) Hardin attempts to overturn objections to the latter. An extended case for eliminativism is given by Paul Boghossian and David Velleman (chapters 7, 8). For arguments against it, see Mark Johnston's chapter 9.

If, *contra* the eliminativists, the answer to the first question is yes, then what is the answer to the second? *Dispositionalists* say that the property green (for example) is a disposition to produce certain perceptual states: roughly, the disposition to *look green*. Johnston (chapter 9 and its postscript), E. W. Averill (chapter 2), and Christopher Peacocke (chapter 5) argue for versions of dispositionalism.[3] It receives a wide variety of criticism from Boghossian and Velleman (chapter 7), Justin Broackes (chapter 11), and Gilbert Harman (chapter 13).

Physicalists claim that colors are physical properties (for instance, that green is a certain property of selectively reflecting incident light). J. J. C. Smart (chapter 1, 4) is the father of this view[4]; Smart's position is criticized by Averill (chapter 2) and defended by D. M. Armstrong (chapter 3). Physicalism (in various versions) is also held by Frank Jackson and Robert Pargetter (chapter 6), Sydney Shoemaker (chapter 12), Harman (chapter 13), and Byrne and Hilbert (chapter 14). Johnston argues against physicalism by taking Jackson and Pargetter's version as representative, and Boghossian and Velleman (chapter 8) attack a wide range of physicalist theories.

Primitivists agree with the physicalists that objects have colors, and that these properties are not dispositions to produce perceptual states. But they also hold that colors are sui generis, and so they deny, in particular, that colors are identical to physical properties. John Campbell (chapter 10) defends this position, and Broackes (chapter 11) is officially agnostic as between primitivism and physicalism. An argument against primitivism can be found in Johnston's chapter 9.

For those wanting a more leisurely tour of the territory, the following section explains various views in the philosophy of perception. In subsequent sections this material is drawn on to elaborate the main philosophical accounts of color.

2 Visual Experience: Some Distinctions

2.1 *Red-Representing Experiences and Red-Feeling Experiences*

If you have normal vision, then when you see a ripe tomato in good light, it looks red and round. If the world is as it appears to be—that is, if your visual experience is *veridical*—then the tomato is red and round. Now certainly sometimes objects do not have the colors or shapes they appear to have. Let us suppose this is so in the case of the tomato; in particular, suppose that although the tomato *looks* red, it *isn't* red. Then the world is not, or not exactly, as it appears to be—your visual experience is at least partly illusory.

Because a visual experience may be veridical or illusory, we may speak of visual experiences *representing* the world to be a certain way. For example, when you look

at a tomato, your visual experience represents the world as containing, inter alia, a round red object in front of you. That is, the *representational content* (content, for short) of your experience includes the proposition that there is something red and round before you.

It will be useful to classify visual experiences by their contents.[5] Let us say that a visual experience is *red-representing* just in case it represents that something is red.[6] (Henceforth, "experience" will mean *visual* experience.)

Provided you take conditions to be normal, and are uncontaminated by philosophy, you will also believe that the tomato is red. This belief, like the experience, represents the world as being a certain way, and so has representational content (the proposition that the tomato is red). The belief and the experience, then, have content in common. Might the connection between experience and belief be even more intimate? Could we *identify* the experience with a cluster of (occurrent[7]) beliefs? (The cluster would presumably be something like: the belief that the tomato is red, that it is a certain shape, that it is a certain distance from the perceiver, etc.) The answer is no. One reason why is that the experience may occur unaccompanied by the cluster of beliefs: you may not take conditions to be normal, and hence not believe the testimony of your senses. It is possible, for example, to have an experience that represents that something is red without believing that something is red. Another reason for not identifying experiences with clusters of beliefs is that, intuitively, one's perceptual beliefs are *based on* the deliverances of experience: experience provides us with reasons for perceptual beliefs. That suggests that experience and belief are quite distinct.[8]

There is a third reason why, prima facie, experience is a different animal from belief. There need be nothing "it is like" to believe—or even consciously to believe—that something is red. (At any rate, if there is something it's like to have such a belief, the accompanying phenomenology does not necessarily distinguish this belief from the belief that something is green, or square.) And—admittedly a further step—no distinctive phenomenology need accompany a large cluster of conscious beliefs. But, notoriously, there is something quite distinctive it's like to look at a ripe tomato.

So, in addition to classifying experiences by their contents, we may classify them by their phenomenology. Experiences as of red objects resemble one another in a salient phenomenological respect. In that respect, they resemble experiences as of orange objects more than they resemble experiences as of green objects. Let us say that a *red-feeling experience* is an experience of the phenomenological kind picked out by the following examples: the typical visual experiences of ripe tomatoes, rubies, blood, and so forth.[9,10]

Are any important questions being begged by our claim that experiences may be classified by their phenomenology? No. Admittedly, some philosophers will profess

only to understand "red-feeling experience" as another name for an experience that represents that something is red.[11] For these philosophers, this apparently new distinction between red- and green-feeling experiences is just the previous distinction between red- and green-representing experiences, relabeled. But their position is accommodated, because we are not insisting that these are *different* distinctions (although, as we shall see, many hold that they are).

We can all agree that, at least typically, a red-feeling experience is red-representing, and conversely.[12] (And similarly for the other colors.) Could these two ways of classifying visual experiences come apart? That is, could someone either have a red-feeling experience that was not red-representing, or else have a red-representing experience that was not a red-feeling experience? Different answers to this question mark important divisions among philosophical views of perception.

If the two ways of classifying experiences are inseparable, then, of necessity, any red-feeling experience represents that something is red, and conversely. First, let us take the left-to-right direction: the thesis that, necessarily, all red-feeling experiences are red-representing:

COLOR-FEEL → COLOR-REP
For all possible subjects S, and possible worlds w, if S is having a red-feeling experience in w, S is having a red-representing experience in w. (Similarly for the other colors.)

Now for the right-to-left direction: the thesis that, necessarily, all red-representing experiences are red-feeling experiences:

COLOR-REP → COLOR-FEEL
For all possible subjects S, and possible worlds w, if S is having a red-representing experience in w, S is having a red-feeling experience in w. (Similarly for the other colors.)[13]

Let CONTINGENCY be the thesis that both COLOR-FEEL → COLOR-REP and COLOR-REP → COLOR-FEEL are *false*. CONTINGENCY says that there is only a contingent connection between red-feeling experiences and red-representing experiences: red-feeling experiences can occur without being red-representing, and red-representing experiences can occur without being red-feeling experiences.

Famously, a case that forms the basis for an argument for CONTINGENCY was described by Locke, in his *Essay Concerning Human Understanding*. Suppose, Locke said, that "by the different Structure of our Organs, it were so ordered, That *the same Object should produce in several Men's Minds different* Ideas at the same time; *v.g.* if the *Idea*, that a *Violet* produced in one Man's Mind by his Eyes, were the same that

a *Marigold* produced in another Man's, and *vice versa*" (Locke 1689/1975, II, xxxii, 15).[14] In our terminology, Locke is supposing that a person might have yellow-feeling experiences when he looks at violets, and blue-feeling experiences when he looks at marigolds. (On Locke's view, this case is merely possible, not actual, because he thinks that, as things have turned out, "sensible *Ideas*, produced by any Object in different Men's Minds, are most commonly very near and undiscernably alike" (ibid.).)

Let us suppose that Invert is "spectrally inverted" in the way that Locke describes, and has been since birth.[15] Let Nonvert be a normal human: he has blue-feeling experiences when he looks at violets, and yellow-feeling experiences when he looks at marigolds. Nonvert and Invert both speak English: at any rate, they both call marigolds "yellow" and violets "blue." Now if we also stipulate that Nonvert and Invert are exactly alike physically, or exactly alike in internal functional organization, or even exactly alike behaviourally, then we shall run into controversy, for some will deny that the resulting case is possible (see Hardin, chapter 15). But for present purposes we do not need to make any of these stipulations.[16]

In normal humans blue-feeling experiences and blue-representing experiences go together. So Nonvert's experience, when he looks at a violet, is a blue-representing experience. What about Invert's experience, when he looks at a violet? It is a yellow-feeling experience, but is it also yellow-representing? Many philosophers have thought not, often on the basis of the two following arguments.

First argument. It seems plausible that Invert means by "blue" just what Nonvert and the rest of us mean. When Invert describes how violets look to him, then, he will say and believe that they do look blue and don't look yellow. But if his experience when he looks at a violet is yellow-representing, Invert is mistaken about how things look (how things are visually represented) to him. Violets in fact look yellow to him, although he believes that they look blue. This is a counterintuitive result. Hence Invert's experience when he looks at a violet, although yellow-feeling, is blue-representing.

Second argument. Consider Nonvert and Invert, each looking at a violet. Since nothing can be yellow and blue all over, if Invert's experience is yellow-representing, then at most one of Nonvert and Invert's experiences is veridical. Now since we may fairly suppose that violets *are* blue, it follows that if Invert's experience is yellow-representing, it is not veridical. But, again, this is a counterintuitive result. After all, presumably Invert can use his color vision to navigate the world successfully. Given this fact, there is at least a presumption against the view that he systematically misperceives the color of things. So Invert's experience is blue-representing as well as Nonvert's.

Of course, if either of the above arguments is persuasive, we can also show by similar reasoning that Invert's experience when he looks at a marigold is yellow-representing.

Suppose we accept these conclusions about the content of Invert's experiences. We can now argue for CONTINGENCY as follows. Take blue as an example, and consider Invert, looking at a marigold. Invert is having a blue-feeling experience. But his experience is representing the marigold to be yellow and so, given that yellow and blue are contraries, is not representing it to be blue. So Invert is having a blue-feeling experience, but is not having a blue-representing experience.[17] That falsifies COLOR-FEEL → COLOR-REP.

Now take Invert again, this time looking at a violet. His experience is representing the violet to be blue, and so is blue-representing. But his experience is a yellow-feeling experience. So Invert is having a blue-representing experience, but is not having a blue-feeling experience. That falsifies COLOR-REP → COLOR-FEEL. Hence, since COLOR-FEEL → COLOR-REP is also false, CONTINGENCY is true.

So runs the argument. For those who endorse it, an obvious candidate for the property blue is Locke's "the Texture of a *Violet*" (op. cit.): the physical property that typically causes blue-feeling experiences (in Nonvert) and yellow-feeling experiences (in Invert). (For this line of thought, see especially Jackson and Pargetter [chapter 6], and Shoemaker [chapter 12].)[18]

If CONTINGENCY is true, the texture of a marigold, which typically causes yellow-feeling experiences in human beings, typically causes, in some possible world, normal perceivers of some species (Martians, say) to have blue-feeling experiences. Hence, if CONTINGENCY is true, there is some motivation to say—and Jackson and Pargetter do say—that there is no *single* property blue, but rather a family of properties: blue-for-humans, blue-for-Martians, etc.[19]

2.2 *Phenomenal Properties*

We can unpack COLOR-FEEL → COLOR-REP thus:

COLOR-FEEL → COLOR-REP

There is a property P such that, for all possible subjects S, and all possible worlds w, if S is having a red-feeling experience in w, then:

(i) S's experience represents an object as having P

and:

(ii) P is the property red.

(Similarly for the other colors.)

Let us call the thesis obtained by deleting (ii) from COLOR-FEEL → COLOR-REP, COLOR-FEEL → PROPERTY-REP. Now return to the argument against COLOR-FEEL → COLOR-REP. That only attempted to show that there is no one *color C*, such that, necessarily, all yellow-feeling experiences represent something as having *C*. So if this argument is correct, it only provides a reason for rejecting COLOR-FEEL → COLOR-REP, and not COLOR FEEL → PROPERTY-REP. For all that has been argued is that if there *is* a property that is represented by all (actual and possible) yellow-feeling experiences, this property is *not* yellow. And that is consistent with there being such a property. So, even granting the argument against COLOR-FEEL → COLOR-REP, COLOR-FEEL → PROPERTY-REP might yet be true.

And, one might think, COLOR-FEEL → PROPERTY-REP *is* true. Surely, what all yellow-feeling experiences have in common, in whatever possible world in which they occur, is that something *looks to be a certain way*, which we can gloss as: looks to have a certain property. What else can the common element be, if not part of the content of all yellow-feeling experiences? As Shoemaker puts it, "If one is asked to focus on [an] experience without focusing on its intentional aspect, or its representational content, one simply has no idea of what to do" (chapter 12, p. 237). So, Shoemaker thinks, yellow-feeling experiences, although not all yellow-representing, nonetheless represent *some* common property.

Call the property that, by COLOR-FEEL → PROPERTY-REP, is represented by all yellow-feeling experiences, *phenomenal-yellow* (similarly for the other colors). The phenomenal-colors are examples of—in Shoemaker's terminology—*phenomenal properties*. Now suppose that Nonvert and Invert are looking at a violet. Since they are enjoying, respectively, yellow- and blue-feeling experiences, their experiences are, respectively, phenomenal-yellow- and phenomenal-blue-representing. Hence, unless the violet has *both* properties, at least one of their experiences is not veridical. But, it might be thought, it is not plausible to suppose that either Nonvert or Invert is the victim of an illusion. (Compare the second inverted spectrum argument for CON-TINGENCY in the previous section.) If this is right, we can conclude that the violet, at least when Nonvert and Invert are looking at it, is both phenomenal-yellow and phenomenal-blue.

After considering a number of candidates for being phenomenal-yellow, Shoemaker argues that this property is, in our terminology, the relational property of "producing in a viewer" yellow-feeling experiences (chapter 12, p. 241). The violet is producing in a viewer (Nonvert) yellow-feeling experiences, and is also producing in a viewer (Invert) blue-feeling experiences. It is therefore both phenomenal-yellow and phenomenal-blue, as desired. (For an objection to Shoemaker, see Harman, chapter 13; see also Shoemaker 1996 and Harman 1996.)

2.3 Sensational Properties

According to the arguments of section 2.1, when Invert looks at the leaves and flowers of a marigold, he is having a red-feeling experience (and a blue-feeling experience) that represents the leaves to be green (and the flowers to be yellow). So he is having a red-feeling experience that is not red-representing. But there are alleged to be other kinds of examples, where a red-feeling experience is not red-representing because the experience does not represent an object to have a property at all. Boghossian and Velleman (chapter 7, pp. 91–2) describe a case of this kind, that of having a red afterimage. According to them, having a red afterimage, although a red-feeling experience, is not red-representing. When you have a red afterimage, and so a red-feeling experience, they say your experience does not—or at any rate need not[20]—represent anything as having any property: a fortiori, it does not represent anything as being red.[21]

This second kind of case presents an obvious difficulty for COLOR-FEEL → PROPERTY-REP. There cannot be a property things are represented as having by all (possible) red-feeling experiences if some red-feeling experiences are not representational at all. Some philosophers have argued that these sorts of examples show that the content of an experience does not determine the phenomenology of the experience. Take the experience of having a red afterimage and the experience of having a green afterimage. The experiences are phenomenologically different. But if Boghossian and Velleman are correct, there need be no difference in content between the two experiences, and so the content of an experience does not determine its phenomenology.

Nonetheless, even if we grant that in the case of a red afterimage, the experience does not represent that something is red, or phenomenal-red, it seems that, when one is having a red afterimage, one can be "aware," in some sense, of the presence of a distinctive property, a property of which one is not aware when one is having a green afterimage. Following Christopher Peacocke (1983), let us call these properties *sensational properties*, and label the sensational property one may be aware of when having a red afterimage, "red′" ("red-prime"). Sensational properties are not supposed to be properties that experiences may *represent* objects as having. According to Peacocke, they are properties of "regions of the visual field" (chapter 5, p. 60). (Such regions bear a close resemblance to the *sense-data* of twentieth-century empiricism.) With Peacocke's conception of sensational properties thus explained, it is not surprising that he takes red′ to be a property of a region of one's visual field not just in the case of afterimages, but whenever "a normal human sees a red object in daylight" (chapter 5, p. 58).[22]

2.4 Three Kinds of Experiential Property

The distinctions made so far can be further clarified by employing this threefold classification: properties *of* experiences; properties *represented by* experiences; and properties *presented in* experiences. Suppose you have normal vision and are looking at a ripe tomato in good light. Let *e* be the visual experience you are currently enjoying. *e* is an event, and it has certain properties, for example the property of occurring at a certain time. More relevantly, *e* also has the property of *being a red-representing experience*, and of *being a red-feeling experience*. So we may say that these are properties *of* your experience. On one usage of the term, *qualia* are certain properties of experiences; e.g., one *quale* your experience currently instantiates is the property of being a red-feeling experience. Qualia, on this conception, are properties in which almost everyone can believe. For, as noted above in section 2.1, someone may take red-feeling experiences to be, simply, those experiences of something's looking (i.e., being visually represented as) red.

Now, because your experience *e* is a red-representing experience, red is a property *e* represents something to have. So we may say that red is a property *represented by* your experience. Of course, from the fact that a property is represented by an experience, one cannot conclude that anything *has* this property: the experience may not be veridical.

If, like Shoemaker, you believe in phenomenal properties, then you will say that there is *another* property that is represented by *e*, namely the property phenomenal-red. What is that property? There are a variety of possible views here, but as we saw, Shoemaker takes it to be the property of "producing in a viewer" red-feeling experiences. The phenomenal property that Shoemaker thinks is *represented by e*, then, is defined partly in terms of a *property of e*: such properties of experience being qualia in the sense explained above.

If, like Peacocke, you believe in sensational properties, then you will say that there is a property (red′), which is neither a property *of e*, nor a property *represented by e*, but instead a property of a region of your visual field, of which you can be aware when you are having *e*.[23] Such properties, we may say, are *presented in* experiences. (On another usage of "qualia," qualia are properties like red′; to avoid confusion, the term is really best avoided.) Like properties *of* an experience, but unlike properties *represented by* an experience, if a property is *presented in* an experience then, necessarily, something (namely, a region of one's visual field) really does have this property.

With these distinctions in hand, we can use them to elaborate and sharpen the four main responses to the problem of color realism.

3 Eliminativism

Eliminativism about color is the thesis that no physical objects are colored. Since physical objects certainly look to be colored, eliminativism charges experience with widespread misrepresentation. Eliminativism is, perhaps surprisingly, a perennial favorite, and goes back at least to the early Greek atomist Democritus. The connection between atomistic metaphysics and eliminativism has seemed to many fairly immediate: if the physical world ultimately consists of colorless atoms in the void, how can colors find a place in it? Although Democritean atomism has not survived, the apparent conflict between the world as described by physics and the world as we perceive it has remained. Galileo and, following him, an impressive parade of philosophers including Descartes and Locke seem to have thought that modern science straightforwardly shows that physical objects are not colored. Many contemporary color scientists are of the same opinion. This fact gives color science a dubious honour not shared by many other fields of scientific enquiry.

Eliminativists will convict experience of different sorts of error, depending on their other views about the nature of visual experience. For an eliminativist who takes the visual field to be populated by sensational properties like red', the natural view to take is that we mistakenly take red'—a property of regions of the visual field—to be a property of material objects.[24] (Such an eliminativist may, like Frank Jackson [1977], take red' to *be* red,[25] and so hold that *some* things are red, but not physical objects like tomatoes. But this is an optional extra.) Boghossian and Velleman (chapter 7, 8) hold this sort of "projective" eliminativism, which is, on some interpretations, a close cousin of the traditional Galilean view.

A more straightforward sort of eliminativism, which does not depend on a commitment to sensational properties, is simply that experience falsely represents objects as being colored. We do enjoy red-representing experiences, but they are never veridical. The most prominent recent defender of this view has been C. L. Hardin (1984, 1993), who reinforces it further in chapter 15. (See also Mackie 1976; Landesman 1989; Averill 1992; Maund 1995.)

4 Dispositionalism

According to Locke, "a Violet, by the impulse of such insensible particles of matter of peculiar figures, and bulks, and in different degrees and modifications of their Motions, causes the *Ideas* of the blue Colour ... to be produced in our minds" (op. cit., II, viii, 13). Moreover, he thinks, such an idea of blue does not "resemble" anything in the violet; and by this he arguably means that violets, although they are

represented to be blue, are not in fact blue. That is the eliminativist strand in Locke. But he is somewhat equivocal on the point. One property a violet certainly has is "a Power to produce those Sensations in us" (ibid., II, viii, 15): an example of a *secondary quality*. And Locke often speaks as if the power or disposition to produce ideas of blue may, without undue violence to ordinary talk, be fairly called "blue."

Although Locke was not the first to formulate the thesis that colors are dispositions to cause certain kinds of visual experiences,[26] his discussion is the point of departure for contemporary versions of dispositionalism. Taking blue as an example, the basic claim of the dispositionalist is something of the following form:

(*D*) The property blue = the disposition to cause in perceivers *P* in circumstances *C*, visual experiences of kind *K*.[27]

What is the status of (*D*), once the schematic letters are filled in appropriately? According to Johnston (chapter 9), it does not express our naive conception of blue (which, strictly speaking, does not apply to anything), but rather a conception that, for pragmatic reasons, we should adopt. According to other philosophers, no such revision is required: our naive conception of blue is correctly analyzed as such a disposition (see, for example, Evans 1980, McGinn 1983, McDowell 1985).

There remains the question of how to fill in the schematic letters. As far as the first two are concerned, dispositionalists have been usually content with "normal" perceivers in "standard" conditions, without properly explaining what these terms mean (for some of the problems, see chapter II of Hardin 1993; for a response see Johnston's chapter 9). What about the "visual experiences of kind *K*"? If these are specified in terms that explicitly or implicitly employ the concept of the color in question (blue, in our example) then let us say that the resulting dispositionalism is *nonreductive*, and *reductive* otherwise.

It is here that issues about visual experience intrude. Suppose the "visual experiences of kind *K*" are specified in terms of what *colors* they represent things as having; in the case of blue, this will amount to specifying the experiences as *blue-representing*. Then evidently this will be a version of *non*reductive dispositionalism: the property blue has not been analysed in terms that do not employ the concept of blue, because blue-representing experiences are introduced by saying that they represent that something is *blue*. Of course, the nonreductive dispositionalist's thesis is circular (that is just another way of saying that it is nonreductive). Circularity as such is no vice, but Boghossian and Velleman argue in chapter 7 that here it is fatal.

In any case, if *reductive* dispositionalism is to be an option, there must be some way of picking out the visual experiences in question without recourse to their color contents. In section 2.1 above, we said that experiences may be classified by their

distinctive phenomenology, as well as by their contents. So could a reductive dispositionalist simply identify the desired visual experiences, not as *blue-representing*, but as *blue-feeling*?

That depends. Blue-feeling experiences are those that saliently resemble, in respect of what it is like to undergo them, standard visual experiences of clear sky, Levi 501s, and lapis lazuli. As we noted in section 2.1, the introduction of this terminology is innocuous: it is quite compatible with the tightest of conceptual connections between blue-feeling and blue-representing experiences. In particular, it is compatible with the claim that "blue-feeling experience" can only be understood by presupposing that such experiences are also blue-representing. And if this claim is right, then characterizing dispositionalism in terms of blue-feeling experiences leaves it firmly nonreductive.

Therefore, if nonreductive dispositionalism is to get off the ground, it must be argued that "blue-feeling experience" can be understood without presupposing that such experiences are blue-representing. The most straightforward way to do this is to argue that blue-feeling experiences can occur without being blue-representing. And the most straightforward way to do *that* is to argue for the CONTINGENCY thesis of section 2.1.

5 Physicalism

Physicalism about color is, to a first approximation, the view that colors are physical properties that we sometimes veridically perceive objects to possess. The "physical" is a notoriously slippery notion, but fortunately those problems are not relevant here. The leading idea behind physicalism is not so much that colors are *physical* properties, but rather that colors are to be identified with properties whose natures (a) are specifiable in ways that do not employ our color concepts, and (b) are not constituted by relations to the psychological states of perceivers. That being so, the obvious candidates for such properties are either certain kinds of dispositions to affect incident light, or the diverse kinds of microphysical properties that realise such light-affecting dispositions. (On the former, see Land, *Readings on Color, vol. 2*, chapter 5, Wandell, *vol. 2*, chapter 6; on the latter, see Nassau, *vol. 2*, chapter 1.) As it happens, such properties are paradigmatic examples of physical properties, at any rate as philosophers have come to use this term; but that is incidental.

Because of (a), physicalism is *reductive*. Sometimes, because of (b), it is classified as "objective," the intended contrast here being with dispositionalism, said to be "subjective." But this can be misleading. Consider, for example, the physicalism of

Jackson and Pargetter (chapter 6; see also Jackson 1996). According to them, something like the following is a priori: green is that property that would standardly cause an object which has the property to look green.[28] So, on their view, it's a priori that something is green just in case it has a disposition to look green. But they also think that "dispositions do not cause their manifestations" (p. 69) (the "manifestation" in this case being the visual experience of the object's looking green). Hence, as the property green plausibly does cause such experiences, they decline to *identify* green with the disposition to look green. Rather, they say, green is the categorical base of the disposition, which science tells us is a physical property of some kind. As Johnston points out, the difference between physicalism in the style of Jackson and Pargetter and the corresponding version of dispositionalism "must really be quite subtle" (chapter 9, p. 148). It is not obviously helpful to characterize this difference by locating Jackson and Pargetter's account at the objective end of the spectrum.

Rather than employing the subjective/objective distinction to distinguish physicalism from rival views, it is more useful to classify accounts of color as subjective to the extent that they claim a substantive a priori connection between being a certain color and causing certain visual experiences. On this latter usage, dispositionalism, and Jackson and Pargetter's physicalism, both count as subjective. Armstrong, on the other hand, advocates a physicalism that cuts "all logical links between colours and what happens in the perceivers of colours" (chapter 3, n. 13),[29] a view that he says is also held by Smart. Armstrong, then, holds an objective version of physicalism; and so do Harman, and Byrne and Hilbert.

While Jackson and Pargetter identify colors with (disjunctions of) microphysical properties, Byrne and Hilbert identify them with dispositions to affect light (see also Hilbert 1987, Matthen 1988). Harman, on the other hand, suggests that colors are dispositions "to produce a certain reaction in normal perceivers, where the relevant reaction is identified in part with reference to the mechanisms of color perception" (chapter 13, p. 259). As Harman makes clear, this is not strictly a version of dispositionalism, because the "relevant reactions" are supposed to be specified "in terms of *biological* mechanisms of color perception" (p. 255), not as (say) red-feeling experiences or red-representing experiences.[30] All these three views are in part driven by their proponents' conceptions of visual experience. As noted at the end of section 2.1, Jackson and Pargetter hold CONTINGENCY. They also agree with Peacocke that there are sensational properties.[31] Harman, and Byrne and Hilbert, disagree on both counts. Harman, unlike Byrne and Hilbert, finds some insight in reductive dispositionalism, but his denial of CONTINGENCY prevents him from fully endorsing it.

6 Primitivism

An obvious, although in practice quite uncommon, view of the colors is to align them closely with paradigmatic "primary qualities," shapes. The property of being square, for example, is not reducible (to properties specified in nonspatial terms, at any rate); is not identical to the disposition to look square; and often our visual perceptions as of square things are veridical. According to the primitivist, colors are just like shapes in these respects. And especially in view of the problems that are widely held to afflict other views of color, primitivism can seem an attractive option.

A primitivist may hold that colors do not even supervene on physical properties of objects, a view to which Hardin (1993, pp. 60–1) rightly objected.[32] If there could be two physically alike objects that differ in their colors, then since both objects will affect light in the same way, it seems that the color of an object is causally irrelevant to the way it affects light. And if so, then vision does not *detect* the colors; but without visual detection, we have no reason to think that objects have the colors they look to have.

The primitivist, then, would be well-advised to claim that colors, although not identical to any physical properties, at least supervene on them. This is precisely what John Campbell does (chapter 10).

One of the most compelling, yet elusive, ideas in philosophical thinking about color is that the nature of the colors is fully revealed, or is transparent, to us in visual experience (Johnston, in chapter 9, calls this *Revelation*). Since it is not evident in visual experience that colors are physical properties, physicalism is not consistent with Revelation, and arguably any form of dispositionalism has the same failing. Hence one obvious motivation—apparently Campbell's—for primitivism comes from taking the metaphors about transparency seriously.[33]

Whatever Revelation amounts to exactly, it is not compatible with CONTINGENCY, as Campbell implicitly recognises. Return to Invert and Nonvert (section 2.1). They are both looking at a marigold and are enjoying, respectively, yellow- and blue-feeling experiences. If their experiences are *both* representing the marigold to be yellow, then intuitively it does not seem that the nature of yellow is transparent to either of them: their experiences are merely a sign or indication of yellow, rather than exposing its underlying nature.[34]

It is too much to expect that the foreseeable future will produce a philosophical consensus on the question of color realism. For one thing, the content and phenomenology of perceptual experience are topics that have only recently been treated with anything like the sophistication they demand. But this itself is genuine progress, suggesting new positions, and exposing new flaws in old ones. For those of us who

prefer solutions as opposed to problems, contemporary philosophical work on color provides some grounds for hope.

Notes

1. Hume 1740/1978, p. 6; Moore 1903/1993, §§7, 10; Goodman 1983, chapter 3; Jackson 1982. It is no accident that the colors used in these examples are all unique hues (the four unique hues are red, green, blue, and yellow). It is interesting to speculate whether Moore would have thought a binary hue such as orange also an example of a "simple and indefinable quality." On the perceptual and linguistic salience of the unique hues, see Kay and McDaniel 1978 (chapter 17 of *Readings on Color, vol. 2*). On their connections with psychophysics and physiology, see Hurvich 1981, and De Valois and De Valois 1975 (chapters 3 and 4, respectively, of *vol. 2*).

2. For simplicity, we shall concentrate on surface color, and ignore the fact that colors also appear to be properties of light sources, transparent volumes, and expanses such as the sky. On these modes of color appearance, see Katz 1935.

3. Averill also argues that, although "green" should be analyzed in terms of perceptual effects on ourselves, "color" should not. The color of an object, according to Averill, is (simplifying a bit) the (maximally determinate) way the object affects visible light. (See also Hilbert 1987, pp. 98–9.) On Averill's view then, green is *not* a color and so, by his own lights, he is not a dispositionalist about *color*.

4. As Smart says, the midwives were David Lewis and D. M. Armstrong.

5. Some caveats. First, it is not clear in general just what the content of a given experience is. Does visual experience represent objects as being *tomatoes*, as opposed to being red and bulgy? Second, it is not clear whether there is such a thing as *the* content of an experience. Without more said about the individuation of experiences, perhaps talk about their contents is somewhat ill-posed. However, "observational" properties like the colors provide relatively uncontroversial examples of properties that visual experiences—however they might be individuated—represent objects as having, and that will do for present purposes.

6. Here we just assume for simplicity that the content of experience is existentially quantified: when you look at a tomato, your experience represents, inter alia, that there is a red object. An opposing view is that the content takes the form: that *o* is red.

7. The occurrent/nonoccurrent distinction is hard to make precise. But the rough idea is that a belief is occurrent to the extent that it is playing an active role in one's mental economy. Some writers reserve "thought" for this kind of belief.

8. See Evans 1982, pp. 122–4, p. 227. Evans also holds that experiences, unlike beliefs, have "non-conceptual content." But this further view is certainly not required in order sharply to distinguish belief and experience (see, e.g., McDowell 1994).

9. A visual experience, then, may be both a red-feeling experience and a green-feeling experience: for example, the visual experience one typically has when looking at ripe tomatoes on the vine.

10. It should be pointed out that if the phenomenological character of the visual experience of ripe tomatoes and the rest varies widely from person to person, this attempt to fix the reference of "red-feeling experience" will not do the trick! (See Block 1990, p. 57.) But for ease of exposition we shall assume that this is not the case.

11. Philosophers who think that that there are two distinctions here may well say that "looks red" has a use on which it means *is visually represented to be red*, and another on which it picks out the "phenomenological quality" characteristic of actual experiences of ripe tomatoes and the like. (Cf. p. 106 of Boghossian and Velleman's chapter 8.) Connectedly, they may say that "red" is ambiguous as between a property of physical objects and a property of mental objects or experiences. See, for instance, Block 1983 and Rosenthal 1990.

12. Tolliver (1994) excepted: he argues that visual experiences do not represent objects as having colors.

13. Here the restriction to *visual* experience is important. Many philosophers would claim that there could be another (non-visual) sense modality that represents things as having the property red (under a different "mode of presentation"). If so, and if the restriction to visual experience were dropped, COLOR-REP → COLOR-FEEL would be false.

14. The classic contemporary discussion is Shoemaker 1982.

15. More exactly, let us suppose, whether or not this was what Locke had in mind, that the inversion is not only with respect to blue- and yellow-feeling experiences. Let's stipulate that Invert's color-feeling experiences in a given circumstance *C* may be obtained from what a normal person's color-feeling experiences would be in *C* by the mapping that takes a point on the color circle to the point opposite it. (We are not supposing that such an inversion would be undetectable—see the text below.)

16. For the kind of evidence that color scientists have taken to be relevant to the discovery of such cases, see Alpern et al. 1983 (chapter 9 of *Readings on Color, vol. 2*) and Boynton 1979, pp. 380–2.

17. Strictly speaking, we need the further assumption that Jones's experience is not blue-representing for other reasons (as it would be if there were a violet next to the marigold, for instance).

18. See also Shoemaker 1986. For a more elaborate thought experiment, designed to support, inter alia, the same conclusion while avoiding some objections to the spectrum inversion case described above, see Block 1990.

19. See also Averill 1992.

20. Having a red afterimage with one's eyes closed would presumably be a case, according to Boghossian and Velleman, of having a red-feeling experience that was not representational at all. An experience of having a red afterimage with one's eyes open will typically have *some* content, however.

21. Or so we interpret Boghossian and Velleman. Bigelow et al. (1990) claim that afterimage experiences are not representational, but deny that this is Boghossian and Velleman's view.

22. For critical discussion of chapter 5 see Smith 1986 and Peacocke's reply (1986).

23. In his book *Sense and Content* (1983) Peacocke often writes, although not exclusively, as if sensational properties were properties *of* experiences, rather than properties *presented in* experiences. However, in chapter 5 of this volume (an elaboration of part of chapter 2 of *Sense and Content*), he largely dispenses with this potentially confusing mode of expression.

24. Cf. Hume's famous metaphor: "The mind has a great propensity to spread itself on external objects" (1740/1978), p. 167.

25. Jackson later changed his mind: see this volume, chapter 6, n. 5.

26. See Boyle 1666/1979 and Descartes 1644/1970. A precursor is Galileo 1623/1957.

27. This is a slight oversimplification, for the dispositionalist may wish to distinguish between various kinds of disposition (on this point, see Johnston, chapter 9).

28. Although Jackson and Pargetter employ expressions such as "the experience of looking red," and "looking-red experience," they do not mean, in our terminology, *red-representing* experience. Rather, they mean *red-feeling* experience.

29. By the quoted remark Armstrong clearly means to be simply denying that any kind of dispositionalist claim is a priori. Of course, he would agree that there are *some* "logical links"; for example, it is a priori that an experience as of something's looking red is veridical only if the thing is red.

30. See also Smith 1987. Evan Thompson (1995) may perhaps be interpreted as holding a view similar to Harman's.

31. CONTINGENCY does not force acceptance of sensational properties. Shoemaker, for instance, holds CONTINGENCY but explains the similarity between red-feeling experiences in terms of properties *represented by* experiences—phenomenal properties. But Jackson and Pargetter agree with Peacocke rather than Shoemaker (see Bigelow et al. 1990, pp. 281–4, esp. n. 7).

32. Hardin attributes this position to James Cornman (1974, 1975). But although Cornman is certainly a primitivist, it is not clear to us that he also intends to deny supervenience.

33. Jonathan Westphal (1991) is a primitivist who appeals to the findings of color science to uncover the "real essence" of the colors. Hence his version of primitivism, unlike Campbell's, does not pretend to be consistent with Revelation. P. M. S. Hacker (1987) is a primitivist who would probably reject Revelation as conceptually confused.

34. Cf. Descartes: "Clearly, then, when we say we perceive colours in objects, it is really just the same as though we said that we perceive in objects something as to whose nature we are ignorant, but which produces in us a very manifest and obvious sensation, called the sensation of colour" (1644/1970, I, lxx).

References

Alpern, M., K. Kitahara, and D. H. Krantz. 1983. Perception of colour in unilateral tritanopia. *Journal of Physiology* 335, 683–97. Reprinted in *Readings on Color, vol. 2: The Science of Color.*

Averill, E. W. 1992. The relational nature of color. *Philosophical Review* 101, 551–88.

Bigelow, J., J. Collins, and R. Pargetter. 1990. Colouring in the world. *Mind* 99, 279–88.

Block, N. 1983. Mental pictures and cognitive science. *Philosophical Review* 92, 499–541.

Block N. 1990. Inverted Earth. In *Philosophical Perspectives 4*, ed. J. Tomberlin. Atascadero, CA: Ridgeview.

Boyle, R. 1666/1979. The origin of forms and qualities according to the corpuscular philosophy. In *Selected Philosophical Papers of Robert Boyle*, ed. M. A. Stewart. Manchester, England: Manchester University Press.

Boynton, R. M. 1979. *Human Color Vision*. New York: Holt, Rinehart & Winston.

Cornman, J. 1974. Can Eddington's 'two' tables be identical? *Australasian Journal of Philosophy* 52, 22–38.

Cornman, J. 1975. *Perception, Common Sense, and Science*. New Haven: Yale University Press.

Descartes, R. 1644/1970. *Principles of Philosophy*. Extracts in *Descartes: Philosophical Writings*, ed. and trans. E. Anscombe and P. T. Geach. Middlesex, England: Nelson.

De Valois, R. L., and K. K. De Valois. 1975. Neural coding of color. In *Handbook of Perception, vol. 5: Seeing*, ed. E. C. Carterette and M. P. Friedman. New York: Academic Press. Reprinted in *Readings on Color, vol. 2: The Science of Color.*

Evans, G. 1980. Things without the mind. In *Philosophical Subjects: Essays Presented to P. F. Strawson*, ed. Z. Van Straaten. Oxford: Oxford University Press.

Evans, G. 1982. *The Varieties of Reference*. Oxford: Clarendon Press.

Galileo, G. 1623/1957. *The Assayer*. In *Discoveries and Opinions of Galileo*, ed. and trans. S. Drake. Garden City, N.Y.: Doubleday.

Goodman, N. 1983. *Fact, Fiction, and Forecast* (fourth edition). Cambridge, MA: Harvard University Press.

Hacker, P. M. S. 1987. *Appearance and Reality*. Oxford: Basil Blackwell.

Hardin, C. L. 1984. Are 'scientific' objects coloured? *Mind* 93, 491–500.

Hardin, C. L. 1993. *Color for Philosophers* (expanded edition). Indianapolis: Hackett.

Harman, G. 1996. Qualia and color concepts. In *Philosophical Issues* 7, ed. E. Villanueva. Atascadero, CA: Ridgeview.

Hilbert, D. R. 1987. *Color and Color Perception*. Stanford: CSLI.

Hume, D. 1740/1978. *A Treatise of Human Nature*. Oxford: Clarendon Press.

Hurvich, L. M. 1981. Chromatic and achromatic response functions. Chapters 5, 6 of his *Color Vision*. Sunderland, MA: Sinauer Associates. Reprinted in *Readings on Color, vol. 2: The Science of Color.*

Jackson, F. 1977. *Perception: A Representative Theory*. Cambridge: Cambridge University Press.

Jackson, F. 1982. Epiphenomenal qualia. *Philosophical Quarterly* 32, 127–36.

Jackson, F. 1996. The primary quality view of color. In *Philosophical Perspectives* 10, ed. J. Tomberlin. Cambridge, MA: Blackwell.

Katz, D. 1935. *The World of Colour*. London: Kegan Paul, Trench, Trubner & Co. Ltd.

Kay, P., and C. K. McDaniel. 1978. The linguistic significance of the meanings of basic color terms. *Language* 54, 610–46.

Landesman, C. 1989. *Color and Consciousness*. Philadelphia: Temple University Press.

Locke, J. 1689/1975. *An Essay Concerning Human Understanding*. Oxford: Oxford University Press.

Mackie, J. 1976. *Problems from Locke*. Oxford: Clarendon Press.

Matthen, M. 1988. Biological functions and perceptual content. *Journal of Philosophy* 85, 5–27.

Maund, J. B. 1995. *Colours: Their Nature and Representation*. Cambridge: Cambridge University Press.

McDowell, J. 1985. Values and secondary qualities. In *Morality and Objectivity*, ed. T. Honderich. London: Routledge and Kegan Paul.

McDowell, J. 1994. *Mind and World*. Cambridge, MA: Harvard University Press.

McGinn, C. 1983. *The Subjective View: Secondary Qualities and Indexical Thoughts*. Oxford: Clarendon Press.

Moore, G. E. 1903/1993. *Principia Ethica* (revised edition). Cambridge: Cambridge University Press.

Peacocke, C. 1983. *Sense and Content: Experience, Thought, and their Relations*. Oxford: Clarendon Press.

Peacocke, C. 1986. Reply to Michael Smith. *Synthese* 68, 577–80.

Rosenthal, D. 1990. The colors and shapes of visual experiences. Report 28, Research Group on Mind and Brain, Perspectives in Theoretical Psychology and the Philosophy of Mind (ZiF), University of Bielefeld, Germany.

Shoemaker, S. 1982. The inverted spectrum. *Journal of Philosophy* 79, 357–81.

Shoemaker, S. 1986. Review of C. McGinn's *The Subjective View*. *Journal of Philosophy* 83, 407–13.

Shoemaker, S. 1996. Colors, subjective reactions, and qualia. In *Philosophical Issues* 7, ed. E. Villanueva. Atascadero, CA: Ridgeview.

Smith, M. A. 1986. Peacocke on red and red'. *Synthese* 68, 559–76.

Smith, P. 1987. Subjectivity and colour vision. *Proceedings of the Aristotelian Society Suppl.* 61, 245–64.

Thompson, E. 1995. *Colour Vision*. London: Routledge.

Tolliver, J. T. 1994. Interior colors. *Philosophical Topics* 22, 411–41.

Westphal, J. 1991. *Colour: A Philosophical Introduction*. Oxford: Basil Blackwell.

1 On Some Criticisms of a Physicalist Theory of Colors

J. J. C. Smart

I want to discuss some criticisms made by M. C. Bradley[1] of the account of colors in my book *Philosophy and Scientific Realism*. I shall put forward a modified account of colors, which was first suggested to me by David K. Lewis, though a rather similar view has been put forward by D. M. Armstrong.[2] In fact there turn out to be certain differences between Lewis' present view of colors and that which he first suggested to me, and also between Armstrong's and Lewis', as also between Armstrong's and mine (or Lewis' original one). However, these differences seem to me to be of no ontological significance, but are rather differences as to which account of colors best fits our ordinary ways of talking. I suspect that our ordinary color discourse contains enough obscurity to make the choice between various philosophical analyses to some extent an arbitrary one.

In *Philosophy and Scientific Realism* I elucidate colors as dispositions of physical objects to evoke characteristic patterns of discriminatory color behavior by normal human percipients in normal circumstances. (Color discrimination, it will be remembered, can be elucidated antecedently to the notion of color, and so there is no circularity here.) Bradley brings up two imaginary cases to show the inadequacy of this view. One was originally C. B. Martin's, and is as follows. All colors can be represented on a color circle, where the various radii represent the various hues, and hues which are nearly indistinguishable from one another correspond to radii which are near to one another. The various amounts of saturation of a color are represented by distances along the radii. Thus, points near the center of the circle represent a high degree of additive mixing of white. (For simplicity of exposition I am here neglecting differences of brightness, and hence that between white, gray and black, but the full story can easily be adapted to the full color cone, which takes these differences into account. For "color circle" read "any cross section of the color cone.") Now let us envisage a miraculous transformation of things in the world so that the colors of things change into the diametrically opposite colors on the color circle. Thus if O is the center of the color circle and P and P' are points on opposite radii such that O P = O P', a thing whose color is represented by P will change to the color which is represented by P', and vice versa. The only things that will not change will be those things (white ones) whose color is represented by the center O of the color circle.

In the envisaged case the physical constitutions of things will change and so will the wavelengths of the light radiated from them. That is, the change is a perfectly objective and scientifically detectable one. It might correctly be remarked that such a miraculous change would be physically inexplicable, and it would almost certainly

lead to difficulties for even the existence of human life. Both food and human flesh would have to undergo changes in order for them to have the chemical constitutions required for the new colors. Moreover, we would have to make all sorts of assumptions about boundary conditions in order to keep our story compatible with the laws of physics. For example, we would have to suppose the nonexistence of rainbows. (For how could color interchange occur on a rainbow without there being a change in the laws of physics?) Such objections can probably be set aside as quibbles, because for the purposes of the objection we can even suppose the laws of physics to be different from what they are, so long as they remain the same throughout the story. After all, we are concerned with elucidating commonsense color concepts, which have mostly grown up before the rise of modern science.[3]

Now in the envisaged case, everybody will want to say (on the basis both of physics and of immediate experience) that there has been a systematic change of the colors of things in the world. Yet the patterns of discriminatory responses will *not* have changed. Normal human percipients will still find it hard to pick geranium petals from a pile of ripe tomatoes, but easy to pick them from a heap of unripe ones, and hard to pick out lettuce leaves from a distant part of the lawn, but easy to pick out delphinium petals which have fallen onto the lawn. Thus the systematic interchange in the constitutions of things will not lead to any change in discriminatory responses of normal human percipients. (This supposes, of course, that the nervous systems of normal human percipients will continue to function as before, even though the constitution of blood, nerve tissue, etc., may have changed. We have already agreed to neglect any objection of this sort as being something of a quibble.) On the basis of immediate experience, and also on the basis of physics, people will say that a systematic interchange of colors will have occurred. And yet there will be no change in the patterns of discriminatory responses which are evoked by things in the world. Consequently there must be something wrong with an account of colors in terms of powers to cause certain patterns of discriminatory behavior.

In my book I tried unavailingly to get out of this difficulty by bringing in color experiences; in the envisaged case we should notice that our color experiences had changed. I elucidated the experience of something looking red in terms of "something going on in me which is like what goes on in me when I am in normal health and in normal light and there is something in front of my eyes which *really is* red." That is, the experience of red is elucidated in terms of the redness of objects. (Not the other way round, as by John Locke, although my account is like the Lockean one, insofar as it elucidates colors as powers. But to elucidate redness as the power to cause red ideas or sense data, as in Locke, leads to obvious difficulties for a thoroughgoing physicalism.) Bradley shows convincingly that if I modify my account so that redness becomes not just the power to cause a certain pattern of discriminatory

responses but the power to cause the experience of "seeing something red" as well, I am caught in a vicious circularity. Colors are elucidated in part in terms of color experiences, and these are elucidated in terms of colors, which are elucidated in part in terms of experiences, which are. . . .

I admit that this objection from color reversal is damaging to my original account of colors. I am therefore disposed to give up my original account in favor of a different one which is, however, equally compatible with physicalism. In correspondence, David Lewis asked me why I did not say that a color is a physical state of the surface of an object, that state which normally explains certain patterns of discriminatory reactions of normal human percipients. (Fairly obvious modifications would have to be made to deal with the colors of public yet illusory objects, such as the sky or a rainbow.) I replied at the time that I did not like this because the state would be a very disjunctive and idiosyncratic one. In effect, Lewis replied, "Very disjunctive and idiosyncratic—so what?" And I then thought to myself, "So what?" Let me explain this.

Consider the following absurd piece of fiction. A man (Smith, say) has a peculiar neurosis. If he sees a tomato, a rainbow, a bulldozer, or an archbishop, he goes red in the face and stands on his head. No other objects produce this odd behavior. Then doubtless the property corresponding to the open sentence "tomato x or rainbow x or bulldozer x or archbishop x" would be of some interest to this man and to his psychiatrist. It is a perfectly objective property, but because of its peculiar disjunctiveness (the oddity of the different components of the disjunction occurring within the same disjunction) it is both a disjunctive and an idiosyncratic property. Let us call this disjunctive and idiosyncratic property "snarkhood." Now, although snarkhood is a perfectly objective property, it is only Smith's neurosis which makes it of any interest to anyone. Were it not for Smith's neurosis, neither he nor his psychiatrist would have any reason to single it out from the infinity of other highly disjunctive and idiosyncratic properties. Similarly, the disjunction of physical properties which is the physical property of greenness seems to be a very disjunctive and idiosyncratic physical property. We single it out only because of certain highly complex facts about the human eye and nervous system. This is because infinitely many different mixtures of light of various wavelengths and intensities can produce the same discriminatory response. Just as the property of snarkhood is of no interest except to Smith or his psychiatrist, so we need not expect the physical property of greenness to be of any interest to extraterrestrial beings, who would have differently constituted eyes and nervous systems.

A simple formula F might be suggested which would describe all the mixtures of wavelengths which would give rise to the same color behavior (and color experience) in a normal percipient. For this reason Armstrong is tempted to say that if there is

no such simple formula there are not really any colors, because it is an aspect of our color perception that all red things look to have some simple and nondisjunctive property in common. Compare the case in which a disease is described by some complex syndrome, and medical scientists come to divide it into two diseases characterized by different (although possibly overlapping) parts of the syndrome and ascertainably different etiologies. We would be inclined to say in such a case that the scientists had discovered the existence of two new diseases, and also the nonexistence of the original disease. There seems to be a choice here: we could redescribe the old disease as a disjunction of the two new diseases, or else say that the old disease is nonexistent. My own inclination in the case of colors would be to take the analogue of the former choice. That is, if no suitable F exists Armstrong would say that there are not really any colors. I do not think that any ontological issue depends on the difference, even if the simple formula F exists.

It may be worth recalling my reason for thinking that no simple formula exists. Consider an arrangement of three photoelectric cells in a circuit which approximately simulates the human visual system (as elucidated by the three-color theory of vision).[4] We should have to choose three cells with appropriately related characteristic curves (current plotted against wavelength of light) such that the shapes of the curves were such-and-such, and their maxima were such-and-such. These specifications would have a quite arbitrary look about them and would be dictated by the nature of the human visual system. In this way the properties of physical objects which explain human visual discriminations are idiosyncratic properties. Presumably they are disjunctive properties because quite different mixtures of light can lead to the same visual response. Moreover, a mixture of light for which the intensity-wavelength curve is single-peaked, say at wavelength λ, can produce the same reactions as light with a many-peaked intensity-wavelength curve, and this last curve may even have a trough around λ. Nevertheless, there *may* be a nondisjunctive specification of the physical properties which are colors of objects although it is at least not obvious what this might be. I shall, however, mention an ingenious suggestion which David Lewis has communicated to me in correspondence. Consider a hyperspace of infinitely many dimensions, indeed as many dimensions as there are points in the real number continuum. A particular spectrum could be represented by a point in this hyperspace. Suppose that we give the space a metric, perhaps by taking the interval between two points in the hyperspace to be the mean square difference of intensities (for the two spectra) averaged over all wavelengths. Then, according to Lewis, it is possible that a color might correspond to (be the power to reflect light corresponding to) a simple shaped volume in this hyperspace. But at any rate is seems clear that if there is a simple formula of the sort for which Armstrong hankers, it cannot be any-

thing very obvious, such as the capacity to reflect light of such-and-such a single wavelength. And if color should be such a simple property, so much the better. My defense of physicalism, however, will allow that it can be as idiosyncratic and disjunctive as you wish; like snarkhood it will nevertheless be a perfectly *objective* property.

Let me now revert to the earlier "So what?" A highly complex, disjunctive or idiosyncratic property would be objectionable at one end of a correlation law (nomological dangler). The assertion, however, that the color *is* the property, however disjunctive and idiosyncratic it may be, does not lead to this trouble. (If it should turn out to be less disjunctive or idiosyncratic than I fear, so much the better.) If the color *is* the physical property, then we have no nomological dangler depending from the property.

The property of snarkhood is disjunctive in that it might be defined by means of the disjunction:

Snarks $x =_{df}$ tomato x or rainbow x or bulldozer x or archbishop x.

Nevertheless snarkhood could also be described nondisjunctively as the property which things have if and only if they cause the neurotic behavior in question. Snarkhood is the property which *causes* or which *explains* the peculiar behavior; it is the property such that it is a *lawlike* proposition that, if and only if Smith is presented with something possessing the property, then he stands on his head. Such a description of the property makes use of words like "causes," "explains," "is lawlike." (Another possibility, related to the last one, is that we teach "snarks x" ostensively; snarkhood would then in a sense be indefinable, but we would be teaching someone to come out with the word "snarks" on any of a disjunctively describable set of occasions, whether or not he was aware of the disjunctiveness of the property of snarkhood.)

Notice that the identification of snarkhood with the property which causes the behavior in question is a contingent one. There is no difficulty about the contingent identification of properties, although it has for some reason been hard for many philosophers (including myself) to come to see this.[5] To use an example which I got from Lewis in correspondence, consider the statement that the property of conductivity is identical with the property measured by the piece of apparatus with such-and-such serial number. This statement is quite clearly a contingent and factual one. We must resist the temptation to suppose that all true statements of identity of properties would have to be necessary. It is clear, then, that although colors may be disjunctive and idiosyncratic physical properties, it need not be the case that those who use color words need know that this is so. For them, colors are described in a

purely topic-neutral way (neutral between physicalist and nonphysicalist metaphysical theories). They are the properties, whatever they are, which could explain the characteristic patterns of discriminatory responses of normal human percipients. It would be perfectly possible for an Aristotelian type of person to agree with the analysis, but to suppose that the property which explains the pattern of responses is a nonphysicalist, emergent, and perhaps nondisjunctive one. We, with our scientific knowledge, will suspect that it is an idiosyncratic and possibly very disjunctive, purely physical property of the surfaces of objects. Not at first knowing or suspecting that the property is an idiosyncratic and possibly very disjunctive one, people might wrongly claim that they know that it is not an idiosyncratic and disjunctive one.

Armstrong suggests that mistakes of this sort can arise from a tendency of mind which gives rise to the headless woman illusion.[6] To cause this illusion, a dark cloth is put between the woman's head and the audience, and the background is similarly dark. Armstrong points out that the illusion arises from the tendency to suppose that because we do not perceive the woman to have a head we think that we perceive that she does not have a head, and he holds plausibly that a similar error causes people to think that they have an intuition that experiences are not brain processes. Such an error could occur in thinking about the possible identity of colors and physical states.

(I do not mean to say that Armstrong approves of this particular application of his idea about the headless woman illusion. He has told me that because all red things look to have something in common he does not think that the apparent simplicity of colors can be explained by a failure to perceive a real disjunctiveness.)

Notice now that though greenness is the very property which (in normal circumstances) explains a certain pattern of discriminatory reactions, a different color could explain the same pattern in the case of the miraculous color reversal. Two different things can explain the same thing. There is no reason why we should not therefore say that the colors had changed over. No doubt our inner experiences and memories would incline us to take this course because there will be a systematic change in our color experiences. (I go along with Martin and Bradley in supposing this; it seems to be probable. But since there would also have to be a complete change in our semantic habits we might simply feel dizzy or go mad.) Percipients will notice the change and will say (for example) that tomatoes are blue and that delphiniums are red. They will want to rewrite the *Concise Oxford English Dictionary* and interchange the entries "shades . . . seen in blood" (see the definition of "red") and "colored like the sky" (see the definition of "blue"), though they might allow "red" and "blue" to be defined as "the shade *formerly* seen in blood" and "the color *formerly* of the sky." In

short, then, the revised account of colors, which defines colors as the physical states of objects which (in our normal world) explain a pattern of discriminatory reactions, allows us consistently to describe the color reversal case: A and B can be different and yet each can explain the same phenomenon C. The trouble which arose for the account of colors as simply powers to cause patterns of discriminatory reactions does not arise. The colors are the physical states which explain these powers, but other states could explain the very same powers after the miraculous interchange.

I think that the revised account of colors also saves the physicalist from Bradley's objection that it is conceivable that everyone might have the appropriate discriminatory responses so that they would satisfy the behavioral tests for color vision, and yet everything would look gray to them. I am not completely sure that Bradley's case really is conceivable, because if someone has not at least a tendency not to discriminate (with respect to color) red things from gray things, can he really see red things as gray? Just as in Martin's example, however, the inability to think through the example in a scientific manner probably does not suffice to discredit the *philosophical* potency of the example, and so I shall waive this point. Now I think that we can accommodate this case to the revised account of colors as follows: Colors are the (perhaps highly disjunctive and idiosyncratic) properties of the surfaces of objects that explain the discriminations with respect to color of normal human percipients, and also the experiences of these percipients, the looking red, or looking blue, etc., of objects. They would also, however, help to explain the abnormal experiences of the people in Bradley's proposed case.

We might consider that there would be some abnormality in the brains of people who always had inner experiences of seeing gray even though their behavior showed a complete range of color discriminations. Then colors (properties of surfaces of objects) would help to explain the normal discriminatory behavior of these people and would also help to explain the abnormal color experiences of the people with the abnormal brains. It is interesting to speculate whether and in what sense these people would have a color language. They might learn color words purely by reference to discriminatory behavior and would have no words for color experiences. They would doubtless be able to describe illusory color perceptions, in the sense that someone might in slightly abnormal circumstances want to match A with B even though a normal human percipient (behavioristically speaking) would not want to do so. They would need at least a behavioristic analogue of "B looks the color of A."

Let us revert to Bradley's case. He strengthens it (so as to avoid the considerations of the last paragraph) by supposing that both the discriminatory color behavior and the looking gray of everything were *ex hypothesi* inexplicable. Then could I say, as I

have done, that the colors of things are those objective physical properties (perhaps highly disjunctive and idiosyncratic) which explain the patterns of discriminatory behavior of human beings? If the answer is negative, I do not see how Bradley can suppose that there could be a color vocabulary at all. Surely a certain degree of explicability is presupposed by any color vocabulary? How would we teach or learn a purely private language of color discrimination or of color experiences? Both colors (which I am arguing to be objective properties of the surfaces of objects) and color experiences (which in my view are physical processes in human brains) are identified by their typical causes and effects (in the case of the colors themselves, mainly by effects, and in the case of color experiences, mainly by causes). This does not mean that for the purpose of giving sense to our color language we need strict causal laws, which would give strict necessary or sufficient conditions for color behavior or color experiences. The difficulties into which philosophical behaviorism has run provide sufficient evidence of the fruitlessness of a search for such strict conditions. Typical causes and effects in typical conditions are all that we need.[7]

I think that the revised account of colors will even enable us to follow Bradley in saying that color discriminations must be on "the different observed appearances of things."[8] For (a) we hypothesize colors as the (perhaps highly disjunctive and idiosyncratic) physical states of the surfaces of objects which in fact explain (from the side of the objects) typical color discriminations, and also (b) we hypothesize color experiences as those processes which (from the side of the person—in fact, the brain) explain this same discriminatory behavior. That the causal chain goes not direct from the surface of the object to behavior but goes via the person (his brain and hence his inner experiences) is perfectly consistent with the physicalist thesis.

A color sensation, in this view, is what is hypothesized as a typical cause of the typical response of normal color percipients in typical circumstances. ("Normal" can be defined without circularity.) Such a sensation will also partially serve to explain the nontypical false reports of percipients who suffer from illusion or from intention to deceive. (Illusion leads to false reports about external things, while intention to deceive can also lead to false sensation reports.) I therefore see no difficulty for the amended view in Bradley's remarks about false sensation reports which arise from intention to deceive.[9] Nor shall I touch on Bradley's argument[10] from the alleged incorrigibility of sensation reports, since he no longer subscribes to this argument.[11]

I have no doubt that I have been unable to do justice to all of Bradley's criticisms or even to the full subtlety of any of them, but I hope that I have been able to explain why I think that, although my earlier account of colors must be given up, there is nevertheless another physicalist account of colors which avoids these objections.

Ideally, for Quinean reasons, I should like to supplant my talk of colors as properties by a more extensional set theoretic account.[12] Ideally, too, the notion of "explains" or "causes" which comes into the account should rest on an extensional account in terms of the syntax (or possibly semantics) of the language of science.[13] It should be noticed, in any case, that this property talk, as well as the use of the concept of explanation ("colors are the physical states of objects which explain certain discriminatory behavior") is needed only to identify the colors of our ordinary commonsense talk with physicalist properties, that is, as a defense against someone who thinks that a physicalist world view leaves something out. Once this is conceded, we can drop the words "property" and "explain" within our statement of world view. But it would be good to do the job set-theoretically, rather than in terms of properties.

Acknowledgments

I wish to thank Professor D. K. Lewis and Professor D. M. Armstrong for commenting on an earlier version of this paper.

Notes

1. In his "Critical Notice of *Philosophy and Scientific Realism*," *Australasian Journal of Philosophy* 42 (1964): 262–283, and also in his "Sensations, Brain Processes and Colours," ibid. 41 (1963): 385–393.

2. D. M. Armstrong, *A Materialist Theory of Mind* (London: Routledge & Kegan Paul, 1968), pp. 256–260, 272–290.

3. It may be questioned whether the concept of the sort of color change which we are envisaging can be made structurally consistent. See Paul E. Meehl, "The Compleat Autocerebroscopist: A Thought-Experiment on Professor Feigl's Mind-Body Identity Thesis," in Paul K. Feyerabend and Grover Maxwell, eds., *Mind, Matter and Method: Essays in Philosophy and Science in Honor of Herbert Feigl* (Minneapolis: University of Minnesota Press, 1966), pp. 103–180, especially pp. 147–148. Also Bernard Harrison, "On Describing Colours," *Inquiry* 10 (1967): 38–52. I welcome such considerations if they can be made out, but even so I do not want my defense of physicalism to have to depend on them.

4. P. J. Bouma, *Physical Aspects of Colour* (Eindhoven, Netherlands: Philips Industries, 1949), pp. 154–156.

5. I myself learned this point from Lewis. N. L. Wilson argued, however, for the possibility of contingently identifying properties in his interesting paper, "The Trouble with Meanings," *Dialogue* 3 (1964): 52–64.

6. D. M. Armstrong, "The Headless Woman Illusion and the Defence of Materialism," *Analysis* 29 (1968): 48–49.

7. David K. Lewis, "An Argument for the Identity Theory," *Journal of Philosophy* 63 (1966): 17–25, especially 22.

8. Bradley, "Sensations, Brain Processes and Colours," p. 393.

9. Bradley, Critical Notice, p. 269.

10. Bradley, Critical Notice, pp. 272–278.

11. Bradley, "Two Arguments against the Identity Theory," in R. Brown and C. D. Rollins, eds., *Contemporary Philosophy in Australia* (London: Allen & Unwin, 1969).

12. See my paper, "Further Thoughts on the Identity Theory," *The Monist* 56 (1972).

13. To elucidate "explanation" we need to elucidate "law." A law is a universally quantified sentence which occurs either as an axiom or a theorem of an important and well-tested theory (or, in an informal theory, somehow "follows from" it) or is such that we guess that it will one day be incorporated in such a theory. Thus to elucidate "explanation" we seem to need value words (e.g., "important"). Value expressions enable us to avow preferences; there is nothing contrary to physicalist metaphysics about them.

2 Color and the Anthropocentric Problem

Edward Wilson Averill

By the phrase 'anthropocentric account of color' I mean an account of color that makes an assumption of the following form: two objects are the same color if and only if they would appear to be exactly similar in color to normal human observers under such-and-such viewing conditions. Anthropocentric accounts are distinguished from one another by the way in which they fill in the viewing condition. The purpose of this paper is to compare anthropocentric and nonanthropocentric accounts of color and to argue for a certain nonanthropocentric account.

An anthropocentric account of color that fills in the viewing condition with 'normal viewing conditions' will be called an *a-nor account*. Every nonphysicalist account of color that I am aware of is an a-nor account. Since I want to compare anthropocentric and nonanthropocentric accounts of color without getting into too many other questions, I will consider only physicalist accounts of color in this paper. However, I believe that the criticisms that will be made of J. J. C. Smart's physicalist a-nor account of color can be extended to all nonphysicalist accounts of color.

In part I a trilemma is set up which displays the consequences of giving up an a-nor account of color. More specifically, the working out of this trilemma in parts II and III shows that any account of color must have at least one of the following consequences: many things that appear to be the same shade of yellow to normal human observers under normal viewing conditions are not the same shade of yellow; or yellow is not a color and the various shades of yellow are not colors; or some a-nor account of color is correct.

The purpose of part II is to show that accounts of color that grasp the third horn of the trilemma have more problems than a certain account of color that grasps the second horn. In part II J. J. C. Smart's a-nor account of color is compared with an anthropocentric account which assumes that the viewing conditions should be filled in with 'all lighting conditions (but otherwise normal viewing conditions, e.g., no viewing of objects through light filters)'. Call any anthropocentric account of color which fills in the viewing condition this way an *a-all account*. No simple argument is given to show that Smart's a-nor account of color is false. Instead it is shown that Smart's account of color is vastly more complex and cumbersome than his presentation of that account suggests and that this complexity stems from Smart's a-nor assumption. By contrast the a-all account to be developed in part II is much simpler, even though this a-all account holds that neither yellowness nor its shades are colors, i.e., even though this a-all account grasps the second horn of the trilemma. On this a-all account every shade of yellow is a set of colors.

Part III is concerned with accounts of color that grasp the first horn of the tri-
lemma. Such accounts of color are not anthropocentric. In part III an account of
color is considered which treats yellowness as a natural kind. This account of color
has the consequence that many things that appear to be the same shade of yellow to
normal observers under normal conditions are not yellow. Of course, all accounts
that grasp the first horn of the trilemma have this consequence. It is argued that this
consequence makes all such accounts unacceptable.

By the end of part III I hope to have established that the best accounts of color
grasp the second horn of the trilemma, as the a-all account of part II does. In part
IV the problems raised in connection with Smart's a-nor account are generalized,
and it is shown that the a-all account of part II cannot solve all these problems. To
deal with these further problems an account of color is developed in part V which
generalizes from the a-all account of part II in much the same way that the a-all
account generalizes from Smart's a-nor account. But with this generalization the
importance of humans drops out; i.e., the new account is not anthropocentric. On
this new account the concept of color depends on the concepts of light and visibility
(like the anthropocentric accounts of color and unlike the natural-kind account of
color), but the distinctions between colors are no longer restricted to distinctions that
are visible to normal human beings (unlike anthropocentric accounts of color).

I The Trilemma

Objects that reflect very different combinations of wavelengths of light can appear to
be the same color to normal human beings looking at these objects in sunlight. For
example, the different combinations of wavelengths of light reflected by objects that
appear to be any specific shade of white or yellow (except for the brightest, most
saturated shades of yellow) are almost endless. Furthermore these combinations can
be made up of light from many different parts of the spectrum. Given these facts,
suppose that the paints in two pots, A and B, appear to normal humans to be the
same shade of yellow in sunlight; and suppose that the paint in pot A reflects only
light from the red and green parts of the spectrum and the paint in pot B reflects
only light from the yellow and blue parts of the spectrum (the large majority of
which will be light from the yellow part of the spectrum). A figure is painted on a
canvas with paint from pot A, and the background is filled in with paint from pot B.
The canvas now appears to be a uniform shade of yellow to normal human beings
looking at it in sunlight. What is the color of this canvas? Clearly the following three
statements are inconsistent:

(a) The canvas is a uniform shade of yellow.

(b) This uniform shade of yellow is one distinct color.

(c) The figure on the canvas is different in color from its background.

Before getting into the problems involved in resolving this inconsistency, consider some of the ways in which the reasoning leading to the inconsistency can be generalized. To begin with, the inconsistency does not need to be developed in terms of sunlight. It can be developed in terms of candlelight, firelight, or the light from the large majority of incandescent lamps, since under each of these sources pots A and B will reflect different kinds of light, but the canvas will appear to normal humans to be a uniform shade of yellow. So the conditions under which the above inconsistency was derived can be generalized from sunlight to normal lighting conditions. Note for later use that these conditions cannot be generalized to all lighting conditions, because if the canvas were placed under a light source that emitted light from the yellow band of the spectrum only it would appear to normal observers to have a black figure on a yellow background. Secondly, the pots might contain paint that appeared to be another color under normal viewing conditions, e.g., another shade of yellow or a shade of green. Finally, there is no need to limit the above reasoning to canvases or to reflected light. Any object will do which appears to normal human beings to be a uniform color under normal viewing conditions and which reflects or radiates light from one part of its surface different in composition from the light reflected or radiated from another part of its surface.

Given these generalizations, there are a great many actual and possible objects about which sets of three inconsistent statements could be generated that are like the above example. Each of these sets involves a-like, b-like, and c-like statements. All a-like statements, including (a) itself, will be called *shade-identity statements*. Similarly, b-like statements and c-like statements will be called *color-identity statements* and *color-different statements*, respectively.

How should the trilemma be resolved? It is tempting to begin by assuming that we can be sure that (a) is true. This seems reasonable, because it seems that the canvas passes the most basic test imaginable for being a uniform shade of yellow; i.e., it appears to be a uniform shade of yellow to normal observers who can inspect it as much as they want under normal viewing conditions. However, Saul Kripke[1] has taught us that there is a deeper test for being gold than appearing to be gold to normal observers under normal conditions; and similarly for other natural kinds. Furthermore, Kripke claims that yellow objects form a natural kind (354). This suggests that there might be a deeper test for being yellow than appearing to be yellow

to normal observers, and that such a test might show that (a) is false. This solution to the trilemma will be taken up in part III.

J. J. C. Smart holds an a-nor physicalist account of color. So he accepts shade- and color-identity statements and rejects color-different statements. As I will explain in part II, there are good reasons for rejecting this view.

I think (b) is false. I think there are good reasons for holding that the specific shades of red, yellow, blue, etc., should be anthropocentrically defined, but that colors should not be anthropocentrically defined. It is one thing to argue that accounts of color which accept color-identity statements have problems and another thing to present a full-fledged account of color which keeps shade-identity and color-different statements and rejects color-identity statements. So I will start this latter task in part II and finish it in part V.

II Smart's Account of Color

Smart, in his essay "On Some Criticisms of a Physicalist Theory of Color,"[2] sums up his account of color this way:

Colors are the (perhaps highly disjunctive and idiosyncratic) properties of the surfaces of objects that explain the discriminations with respect to color of normal human percipients, and also the experiences of these percipients, the looking red, or looking blue, etc. of objects (60).

For example:

... greenness is the very property which (in normal circumstances) explains a certain pattern of discriminatory reactions (59).

Here the concept of colored (physical) object is being explained in terms of the concepts of color discrimination (those color discriminations made by normal human beings under normal viewing conditions) and color experience (those color experiences that normal human beings have under normal viewing conditions). Smart sends us to a previous work of his, *Philosophy and Scientific Realism*,[3] which explains how the concepts of color experience and color discrimination can be understood independently of the concept of colored (physical) object (75–84, and "Some Criticisms...," 54). The thesis that the concept of color experience or color discrimination is logically independent of the concept of colored (physical) object is controversial. Some authors who hold this thesis define color experiences or color discriminations in terms of color sensations, whereas others appeal to "color behavior." I will not consider this thesis here because I think it can be successfully

defended, and I want to get on to other considerations.[4] (Every account of color considered in this paper holds some version of this controversial thesis.)

There is a problem about exactly what Smart means by "same color" in the above passages. If color is a matter of explaining the sorts of discriminations Smart has in mind, then it would seem that, strictly speaking, greenness is not a color, but shades of green are colors. In his earlier work on color Smart addressed this problem.

What about the differences between Oxford blue and Cambridge blue? (Dark blue and light blue.) We call things of both these colours 'blue', but they are nevertheless from the present point of view different colours. A normal percipient will easily distinguish otherwise similar objects, one of which is Oxford blue and the other of which is Cambridge blue (78).

Since Smart refers us to the passages in *Philosophy and Scientific Realism* to explain the notion of discrimination that he uses in "On Some Criticisms of a Physicalist Theory of Colors," I feel safe in assuming that Smart holds an account of color that assumes that color-identity statements are true.

In summary, Smart explicitly adopts the following three assumptions. (1) The A-Nor Assumption: two objects have the same color if and only if they would appear to have the same color to normal human percipients under normal lighting conditions. This assumption makes (c), and other color-different statements, false. Furthermore, this assumption divides objects up into equivalence classes, such that there is one specific color associated with each class, and all and only the members of that class are the specific color associated with the class. To explain how shades are related to colors Smart holds the following shade assumption: (2) colors and shades have the same identity conditions. So color-identity statements are true, and the equivalence classes defined above are shades. For example, any specific shade of blue would be such a class. Notice that, strictly speaking, blue is not a color. From these first two assumptions it follows that shade-identity statements are true. (3) The Physicalist Assumption: the color of an object is that physical property of the object which causally explains which equivalence class the object belongs to.

Smart's a-nor account of color is to be compared to the following a-all account of color, which makes the following three assumptions. (1) The A-All Assumption: two objects have the same color if and only if the two objects would appear to have the same color to normal human percipients under all lighting conditions (other viewing conditions being normal). (Both on this view and on Smart's view it is assumed that, when a color comparison is being made between two objects under a light source, they are oriented in the same way toward that light source.) Like Smart's a-nor assumption, this a-all assumption also sorts objects into equivalence classes. We have already noticed that under certain light sources the figure on the canvas appears to

be black against a yellow background. Given the a-all assumption, (c) is contingently true. To make (a) true we need the following assumption about the identity conditions for shades: (2) the shade of yellow on the canvas is a set of colors such that all and only those objects which appear to be this shade of yellow to normal human observers under normal viewing conditions have a color that is a member of this set. So (a) and other shade-identity statements are true, whereas (b) and other color-identity statements are false. Strictly speaking, the yellow shade of the canvas is not a color but a set of colors. Similar remarks hold for other shades. (3) The Physicalist Assumption: the color of an object is that physical property of the object which causally explains which equivalence class the object belongs to.

Before getting into the differences between these two accounts, it is interesting to note the following similarities between them. Strictly speaking, yellow is not a color on either account. On both accounts a shade of yellow is an "a-nor concept," because on each account two objects are the same shade of yellow if and only if the two objects would appear to be the same shade of yellow to normal observers under normal viewing conditions.

Smart says in "Some Criticisms ..." that his account of color may make colors highly disjunctive and idiosyncratic properties of objects, and for this reason he was at one time reluctant to accept it (56). (Note Smart's parenthetical remarks in the first quote cited above.) Smart explains why colors may be highly disjunctive properties in the following passage:

Presumably they (i.e., colors) are disjunctive properties because quite different mixtures of light can lead to the same visual response. Moreover, a mixture of light for which the intensity-wavelength curve is single-peaked, say at wavelength λ, can produce the same reactions as light with a many-peaked intensity-wavelength curve, and this last curve may even have a trough around λ (57). (my "i.e.")

For example, the intensity-wavelength curve of the paint in pot B is very nearly single-peaked in the yellow part of the spectrum, but the paint in pot A is double-peaked and has a trough in the yellow part of the spectrum.

So the shade of yellow on the canvas mentioned above is a disjunctive physical structure of either the same physical type as the paint in pot A, or the same physical type as the paint in pot B, or the same physical type as ... —and so on through all the many types of physical structures that look to normal humans this shade of yellow in sunlight. In this way the figure and the background of the canvas turn out to have the same physical property. Given the above a-all account, this shade of yellow is also a disjunctive physical property.

Consider how this disjunctiveness works out in the description of specific perceptual situations. Normal observers could see the figure on the canvas under normal

lighting conditions by holding a filter in front of their eyes that screens out all and only light from the red part of the spectrum. To such observers the canvas appears to have a green figure on a yellow background. Since the figure is really yellow (both accounts take shade-identity statements to be true), this situation involves a hue illusion; i.e., the figure looks green when it is really yellow. This sort of an illusion is quite common, since the hue of many objects will appear to be different when seen under abnormal lighting conditions or when seen through filters.

Given Smart's account of color, this situation also involves a color-distinction illusion. Since the figure and its background are the same color (because Smart accepts the truth of shade- and color-identity statements), the apparent distinction in color between them is an illusion. Furthermore, the color-distinction illusion is different from the hue illusion because there are hue illusions that are not color-distinction illusions. For example, suppose that a figure on a canvas is painted with paint that reflects only light from the red and green parts of the spectrum (similar to the above case) but the background is filled in with paint that reflects only light from the blue part of the spectrum. If normal observers look at this canvas under normal light through a filter that screens out all and only light from the red part of the spectrum, then the figure on the canvas will look green against a blue background. Here there is a hue illusion, because the figure looks green when it is really blue. However, there is no color-distinction illusion because the figure and its background appear to be different in color and really are different in color.

Given Smart's account of color, the observers do not see a color distinction in the above situation. But they do see a real distinction. How should Smart describe the distinction that normal observers see in the above situation as a color distinction? When one sees the shade of yellow on the canvas described in part I, the object of perception is a disjunctive physical property. Since this disjunctive physical property can be an object of perception, the nondisjunctive components of this disjunction must also be objects of perception; otherwise the perception of the disjunctive property would be unintelligible. Hence it is a consequence of Smart's account of color that when normal observers see the color-distinction illusion described above they are really seeing the distinction between two nondisjunctive components of a certain shade of yellow, which in this case appear to be different in color even though they are not different in color. In order to describe this perceptual situation Smart will have to introduce types of this shade of yellow; one type for each nondisjunctive component of this disjunctive property.

Is there a nonillusionary way for normal observers to see the distinction between the components of this shade of yellowness, on Smart's account of color? Perhaps they could see the differences between the microstructures if they looked at the

canvas through an electron microscope. However, there is no simple nonillusionary way to see this distinction. This makes the color-distinction illusion unusual because most visual illusions are contrasted with nonillusionary ways of seeing that do not require a lot of special equipment.

By contrast, the a-all account described above handles this situation quite easily. There is, of course, a hue illusion; i.e., the figure does not appear to be the shade that it really is. But there is no color-distinction illusion, because the observers looking at the canvas through the filter see the color distinction between the color of the figure and the color of the canvas. Clearly the a-all account describes this situation more simply than Smart's a-nor account.

So far we have considered the perceptions of normal humans. Since normal human observers can see the figure on its background under normal lighting conditions, when they have the appropriate filters in front of their eyes, it is easy to imagine that some unusual human observers should have eyes that can distinguish the figure from its background; i.e., it is easy to imagine that some humans should have the appropriate filter "built in." Perhaps genetic engineers or microsurgeons could create such people. In any case, there are two reasons for thinking that normal observers are color-blind to a color distinction that the unusual human perceivers could perceive. In the first place normal observers pass the basic test for color blindness (i.e., failure to see the figure on the canvas under normal lighting conditions) relative to the unusual perceivers. Secondly, under normal lighting conditions these unusual human perceivers see the figure as a figure that is different in color from its background. Thus, if (c) is true, as it would be if the a-all account described above were true, there is an easy and natural way to characterize the difference between normal observers and the unusual observers; i.e., normal observers are, and the unusual observers are not, color-blind to the difference in color between the figure and its background. (The unusual observers are also color-blind to distinctions that normal observers can perceive, e.g., they are color-blind to the difference between the color of an object that reflects light from the green part of the spectrum only and one that reflects light from the red and green parts of the spectrum.)

But suppose, as Smart does, that (c) is false. In this case there are not two colors on the canvas for the unusual perceivers to see. So, of course, normal observers are not color-blind with respect to these two colors. How then should we understand the difference between the unusual human observers and normal human observers? The unusual human observers perceive the figure on the canvas by perceiving a color-distinction illusion. On the a-all account described above there are two colors on the canvas for the unusual observers to see. On Smart's a-nor account there are two types of yellowness on the canvas for them to see. So Smart has to introduce as

many objects of perception as the a-all account does. He also has to introduce color-distinction illusions that the a-all account does not need. But there is more to this example.

Smart points out that, given his account of color, color is idiosyncratic in this sense: if a machine were to be constructed that detected color distinctions, the specifications of this system "would have a quite arbitrary look about them and would be dictated by the nature of the human visual system" ("Some Criticisms . . .," 57; also see the parenthetical remarks in the first quote from Smart at the beginning of this part). Since the unusual human observers have a perceptual mechanism that responds to light unlike the perceptual mechanism that normal human observers have, they do not see colors insofar as their mechanism is different from ours. For example, when the unusual observers see a blue figure on a green background, they do see a color distinction, although they do not see a color distinction when they look at the canvas described above. In this way Smart's account of color implies that there is a radical discontinuity in the sorts of things that the unusual observers see. In some cases they see color distinctions, and in other cases they see color-distinction illusions. But surely we think of the unusual observers as seeing much the same sort of thing in these two cases, because the perceptual situations are so similar. For this reason the a-all account spelled out above describes what the unusual observers see in a better way than Smart's account does.

Consider a generalization of this "unusual human observers" case. Scientists have established that color perception in humans has a lot to do with cone cells in the eye, different groups of which are sensitive to different combinations of wavelengths of light, and to the way in which these cells are hooked together by the nervous system. Once one starts thinking about how such mechanisms might be different, and comparing our neural setup with those of other animals (including animals that we are very close to, such as those we evolved from and may evolve into), it is natural to think that a virtually endless variety of color perceivers is physically possible, despite what Smart says about the idiosyncratic nature of color. Such speculations assume that any animal that has groups of cells in a light-sensitive organ, i.e., an eye, which are differentially sensitive to combinations of wavelengths of light, perceives colors, even if those cells are not differentially sensitive to the same combinations of wavelengths of light to which humans' eyes are sensitive. But this assumption makes sense only if there are color distinctions associated with the different combinations of wavelengths of light; i.e., if color-different statements are true. In other words speculations about the color distinctions that other beings may see are not speculations about a large variety of color-distinction illusions, as they would have to be if color-different statements were false. But if color-different statements are not false, Smart's

a-nor assumption is false. (Notice that this generalization of the argument given in the paragraph preceding this one does not assume that animals, who are sensitive to combinations of wavelengths of light to which humans are not sensitive, see colors by having color sensations that are similar to the color sensations that humans have. This was assumed for the unusual human observers above, in order to emphasize the point that Smart must hold that observers that are very close to normal human observers see the figure on the canvas by means of a color-distinction illusion, i.e., there is a discontinuity between what normal humans see and what those who are much like them see.)

One final point before leaving Smart. Smart says that colors *may be* highly disjunctive and idiosyncratic properties of objects, given his account of color and modern scientific accounts of the way humans perceive color distinctions. He does not say that they *are* disjunctive and idiosyncratic. Smart says that it could turn out that color properties have a simple nondisjunctive characterization in terms of modern physical theory, besides their present disjunctive characterization, which we are not aware of at this time. I do not see how this could be true. Suppose that the figure and its background have some common nondisjunctive property. The figure and its background react differentially to normal light. It could not be that this common property causally explains how both the figure and its background react to normal light, since the same cause cannot have different effects. Thus, it could not be that this common property causally explains the differential reaction of our retinas to the light reflected from the figure and to the light reflected from its background.

III A Natural-Kind Account of Color

So far I have argued that color-different statements are true. If this is correct, then either shade- or color-identity statements are false. Consider shade-identity statements. Are there any good reasons for thinking that such statements are false? Although I do not know of any philosopher who ever argued that such statements are false (D. M. Armstrong may have[5]), it is easy to see how someone holding Kripke's position on color might construct such an argument.

Kripke holds that a description, or paradigm examples, can be used to fix the reference of a natural-kind term in a nonanalytic way, where the natural-kind term refers to some, perhaps unknown, deep structural property that all and only things of this kind have in common. About yellowness he writes:

... the reference of 'yellowness' is fixed by the description 'that (manifest) property of objects which causes them, under normal circumstances, to be seen as yellow (i.e., to be sensed by certain visual impressions)' (354).

Given what has been said above, there is no known nondisjunctive physical property that all and only things have in common which appear to be yellow to normal observers looking at them under normal conditions, nor does it seem that scientists are looking for such a property. There are several ways that Kripke might deal with these facts. For example, these facts may only show that the deep structural property in question might be disjunctive. However, what is interesting in this context is that Kripke could conceivably deal with them in a way that makes (a) false.

Kripke might hold that the scientific study of yellowness shows that many things that appear to be yellow are not really yellow (just as things may appear to be gold but are not really gold). In fact, all and only things that appear to be the most saturated and brightest yellow emit light from the yellow part of the spectrum only.[6] This is why the paint in pot B had to reflect a little light from the blue part of the spectrum in order to match the color in pot A. This phenomenon is even more pronounced for other hues; e.g., no mixture of light, from other than the green part of the spectrum, comes close to matching the bright rich green appearance of the light emitted from the green part of the spectrum. Thus Kripke might hold that the only things that are really yellow are those which emit light from the yellow part of the spectrum. More generally, the color of an object is the color of the spectral light that it emits. On this view the background of the canvas is yellow, or almost pure yellow, and the figure on the canvas only appears to be yellow but is not really yellow. The figure is really red and green. So, (a) is false. Since (b) presupposes (a), (b) is either false or incorrect in some way. Similar remarks are to hold for all shade- and color-identity statements.

The consequences of this position are interesting. To begin with, purple is not a color because there is no such thing as purple spectral light. Purple things are really red and blue. Of course white and black are not spectral colors either. If a white surface is one that reflects all light and a black surface is one that absorbs all light, then a white surface is really a combination of all colors and a black surface is colorless. More importantly for us, if shade-identity statements are false, then normal observers cannot tell in the large majority of cases that an object is yellow by simply looking at the object under normal viewing conditions; e.g., one cannot tell that the figure is not yellow but its background is yellow. Only in the relatively few cases where an object appears to be an example of the brightest, most saturated form of yellow can normal observers be reasonably certain that the object is indeed yellow.

Could normal observers tell what the color of an object is if they could see the object under different conditions, such as through a microscope? It might turn out that through a really powerful microscope the figure on the canvas, or the paint in

pot A, would appear to be made up of little particles that looked red and green. It is also possible that the paint in pot A might be a compound whose total electron structure reflects light from the red and green parts of the spectrum in such a way that there are no particle parts of the compound, such as atoms, some of which reflect red light and some of which reflect green light.[7] So it seems that there are red and green things whose surfaces are not made up of spatially distinct red and green parts; i.e., they are red and green all over at the same time! The point is that in many cases there is no way that the color of an object can be determined by looking at it under normal lighting conditions, even if one is using a microscope.

This account has not completely abandoned the human eye. If a normal observer placed an object under light from a narrow band of the spectrum it would either appear to be black, because it did not reflect light from this part of the spectrum, or it would appear to be the color of the light shining on it, because it did reflect light from this part of the spectrum. By working through the spectrum, one narrow band at a time, a normal observer could determine the color of an object.

This account of color seems to be consistent, and is one that I believe is really used in some scientific work. But it is not an account of yellowness that captures our ordinary concept of yellow, because we could not use this concept of yellow and still quickly and easily identify yellow objects as yellow. Surely there is a sense of the term 'yellow' such that we quickly and easily identify the canvas mentioned above as a yellow canvas. Indeed the canvas is to be distinguished from other canvases that are two or more shades of yellow. We know what canvases that are two or more shades of yellow look like, and this is not one of them. For this reason I think that (a), and other shade-identity statements, are true.

Hilary Putman, who has supported a view about natural-kind terms that is much like Kripke's, has explained that there is a linguistic division of labor, such that some members of our society are the experts upon whom we call when we need to be sure about whether or not a particular object belongs to a particular natural kind.[8] For example, chemists use special equipment to determine whether an object is made of gold. But the yellowness of the canvas should not be thought of in this way. Although we need experts sometimes, we also need simple and easy methods of identification that do not require experts or special equipment. The concept of yellowness that I am concerned with in this paper forms part of the everyday methods we use in the identification of objects.

We have reached the following conclusions. Given the assumption that many different sorts of animals are like humans, in that they see objects by seeing color distinctions, color-different statements must be true. Given the assumption that shades of red, yellow, white, etc. are commonly recognized by normal observers under nor-

mal conditions in the everyday identification of things, shade-identity statements are true. To avoid inconsistency it must be that color-identity statements are false. In the next section it will be argued that the a-all account of part II does not satisfy the condition that many different sorts of animals who have eyes unlike ours see colors, for a broad enough range of animals.

IV Problems with the A-All Account of Part II

Consider the following perceptual object. A figure and its background each reflect light of the same wavelength (from the yellow part of the spectrum, say) and of the same intensity under normal lighting conditions. The light reflected from the background is diffuse. For each incident ray of light some of the light reflected from the figure is polarized in a plane perpendicular to the plane containing the incident ray and a line perpendicular to the plane of the figure. (Reflected light from beams that strike the figure perpendicularly are unpolarized.) Are the figure and its background the same color?

Given the a-all account developed in part II, the figure and its background are the same color, because humans are insensitive to the difference between polarized and unpolarized light. (Here I ignore the effect of polarized light on the human eye known as Haidinger's brush, because it is so slight.) However, the same sort of considerations that were raised against Smart's position in part II can now be raised against the a-all account of part II. Imagine normal observers who hold a filter in front of their eyes which screens out light that vibrates in some plane perpendicular to their line of sight. If light strikes the figure and its background at an oblique angle, then there will be some position from which the figure appears darker in color to the observers than its background. If the figure and its background are not distinct colors, then these observers see a color-distinction illusion. To deal with this the a-all account will have to introduce color types, much as Smart has to have types of yellowness. As on Smart's account, the description of color becomes very cumbersome in many perceptual situations, because partial polarization is a very widespread phenomenon. And, as on Smart's account, the physical property common to all objects that are one distinct color is a disjunctive physical property.

Consider another example. Imagine a being who is much like us, but who has only two types of retinal cells. Both types of cells will react to light of any wavelength. Covering each of the many type-one cells is a tiny filter that transmits only light waves or components of light waves that are in the plane determined by the two eyes and the direction in which the eyes are looking. A tiny filter in front of each of the many type-two cells transmits only light waves or components of light waves that are

perpendicular to those that reach type-one cells. Stimulation of type-one cells give this imaginary being a sensation that is like our sensation of red, and stimulation of type-two cells produces a sensation that is like our sensation of green. Stimulation of type-one and -two cells simultaneously produces a yellow-like sensation. Under some normal lighting conditions there are perspectives from which the figure described above looks red and its background looks yellow to the imaginary being. Again it seems that normal observers are color-blind with respect to such an observer. (It is interesting to note that bees, and several other insects, can detect the vibration direction of linearly polarized light, and that the human perception of polarized light, i.e., Haidinger's brush and light seen through special filters, is seen as a color distinction.[9]).

If the criticisms given in part II worked against Smart's a-nor account, then the above arguments work against the a-all account of part II. To deal with this situation, another anthropocentric account of color could be introduced that made the viewing conditions more general than the a-all account allows: two objects have the same color if and only if they would appear to be the same color to normal human beings under all viewing conditions. Here the viewing conditions can include the use of any kind of filter, as well as any kind of light source. Should they include viewing equipment more exotic than filters?

Suppose there are two large cans of white paint that are physically identical. A drop of red paint is stirred into one of these cans. These two cans will appear to be the same in color to normal human observers under any kind of light when viewed through any kind of filter. So, given this last notion of same color, they will be the same color. But this result seems unsatisfactory. Since it has been argued that many different sorts of reactions to light count as color differences, it seems that the two cans of paint should be considered to be slightly different in color because they react to light in appropriately different ways. If there was a being that could see the difference between these two cans of paint as a color difference, then that being would be seeing a color distinction, not a color-distinction illusion. Thus, if we are going to have an anthropocentric account of color, the viewing conditions will be so broad that they will include special viewing equipment sensitive to minute differences between light waves. But now there seems to be no point to making colors conceptually dependent on the distinctions that humans can draw, because color seems to have little to do with human sensitivity. In other words an anthropocentric account must make the viewing conditions very broad, but these very broad conditions make the concept of same color depend upon a general notion of visibility rather than upon a more specific notion of what is visible to humans. (On Smart's a-nor account of color the two cans of paint are the same color, and the problems

he will have in dealing with this consequence of his theory are not unlike those developed in part II.)

At this point one is inclined to hold that two objects are the same color if and only if they react to light in the same way. But this will not do. A perfect vacuum transmits all the light that strikes it without doing anything to the light. A perfect mirror reflects all the light that hits it without doing anything to it, other than changing its direction. Since no animal could see a perfect vacuum or a perfect mirror, these two objects are colorless. Yet they do react differently to light; so, by the above conception of same color, they are different in color. Hence this conception of same color is false. The problem with this conception of same color is that it has no notion of visibility. But this problem can be remedied.

V Another Nonanthropocentric Account of Color

If there is some real or imaginary animal that could see object O under light source L, then the reaction that O would have to L will be called a *visible light reaction of O* or a *vlr* of O. Assume the following: two (nonradiant) objects have the same color if and only if the two objects have the same visible light reactions to every light source.[10] (Again it is assumed when using this definition that the objects are oriented the same way toward the light sources.)

The colors that objects have are the equivalence classes implied by this conception of same color. To bring this idea out, note again that an object may react in one way to light of one sort and another way to light of another sort. For example, the figure on the canvas discussed in part I reacts differently to normal light than it does to light from only the yellow part of the spectrum. Each such vlr of an object is specified by describing the reaction of the object (which makes it visible) to a specific type of light. An object has as many vlrs as there are types of light under which it is visible. The task of giving a description of what goes on when an object reacts to light is left to the scientists. The color of an object is identical with its set of vlrs. Or: the color of an object is the set of dispositional reactions that it has to light of all kinds that make it visible. [For an object to be visible under a light source it is necessary, but not sufficient, that it have a vlr to the light source. If an object is visible to some animal, the object must also be different in color from the background against which it is seen. For this to happen the vlr of the object must be different from the vlr(s) of its background. Here I assume that animals see objects by seeing color distinctions. (Smart does not assume this, since he must hold that animals can see objects by seeing color-distinction illusions.)]

Scientific investigations of the way things react to light make it possible to explain and deepen this conception of color. Scientists begin with the commonsense assumption that an object reacts to light by reflecting, or absorbing, or transmitting the light shining on it. They have discovered that the reflected or transmitted light can be diffused (or scattered) in varying degrees or polarized in different ways (plane polarization being by far the most common). The reactions of an object that make it visible are absorbing some of the light that strikes it, or diffusing the light it reflects or transmits, or polarizing the light it reflects or transmits. Thus an object that did not absorb any light and that reflected or transmitted all the light shining on it without diffusing or polarizing it would not have a color. Intuitively, such transmissions and reflections do not mark the light with which they come in contact. In other words, some objects do not change the light that strikes them so that the light carries the information that it has been in contact with these objects.

Consider some examples. Clean air does scatter some of the light that strikes it (making the sky blue and also polarizing some sunlight in the process), but small volumes of air are close to colorless. A clear transparent piece of glass nondiffusely reflects and transmits light, but if the light striking the glass is not perpendicular to its surface it polarizes some of the light it reflects and transmits. Mirrors that we use around the house reflect nondiffuse light, but they also polarize some of this light. Since our eyes are not sensitive to the difference between polarized and unpolarized light or between light polarized in different ways, panes of glass and ordinary mirrors seem colorless to us; i.e., we can see objects through a pane of glass or in a mirror, but we do not see either the surface of the glass or the surface of the mirror. Most opaque objects are visible to us and to other animals because they reflect some light diffusely and absorb the rest. Black objects absorb all the light falling on them, and some white objects diffusely reflect almost all the light that strikes them. A red piece of glass absorbs all the light that strikes it which is not from the red part of the spectrum and may either diffuse the light it transmits (making it translucent) or not diffuse it (making it transparent).[11]

The rest of this paper is concerned with the assumptions that will have to be added to the vlr assumption given above to deal with the relationship between color and human observation. I begin with the often-made point that 'look' and 'appear' have an implication in some contexts which they do not have in others. Sentences of the form 'O appears A to S' imply in some contexts that it is S's best judgment, based on all that S believes and on his present perceptual experiences, that O is A. Call this sense of appears *appears*(j). At other times sentences of the form 'O appears A to S' do not carry this implication. Most objects appear, but do not appear(j), to change color when the illumination we see them under changes. For example, our clothes do

not appear(j) to change color as we step from direct sunlight into shadows or into the illumination of fluorescent lamps. Undoubtedly our clothes sometimes appear to change color, when we are aware of or paying attention to the fact that the light reactions of our clothes change as lighting conditions change. But the color we attribute to our clothes, i.e., the color we normally *see* our clothes as having under changing lighting conditions, remains constant. Given the vlr assumption, it is the dispositional property of our clothes to react to light of all kinds that remains constant under different lighting conditions.

There is a fundamental thesis that follows from the vlr assumption and some commonsense points, which connects the vlr conception of same color to the perception of color: two objects have the same color if and only if, for every light source, the two objects would appear to have the same color to all beings who could see the objects under this light source (assuming that there is no disturbing factor that affects the way the color perceivers perceive one of the objects but not the other,[12] and assuming that the objects are oriented in the same way toward the light sources.[13]) To establish this thesis, suppose, to begin with, that two objects are different in color. In this case the two objects would react differently to some light source (given the vlr assumption), and so under it they would reflect or transmit light differently. Hence, a light-sensitive organ with the appropriate receptor cells could be sensitive to this difference. Thus, the two objects would appear to be different in color to a perceiver with the appropriate sort of eyes. To prove the other side of the equivalence, suppose that two objects appear to be different in color to some perceiver under a given light source. In this case the eyes of the color perceiver are reacting differently to the reflected or transmitted light of the two objects. This could happen only if in fact the reflected or transmitted light of the two objects was different, which would make the two objects different in color. (Notice that this equivalence is established from the vlr conception of color and the commonsense point that objects react to light by reflecting it or transmitting it or absorbing it. So no scientific discoveries are needed to link the vlr conception of color to the appearance of objects.)

One consequence of the above thesis is this: if two objects appear to be different in color to us or to any other color perceiver, instruments included, under some light source (provided that the objects are oriented toward the light source in the same way), then the objects are different in color. The converse of this conditional is not true, as the yellow canvas mentioned earlier illustrates. This point can be developed further into a definition of 'shade', but first I need to say something about hues.

I assume that yellow is an anthropocentric causal concept: an object is yellow if and only if under normal lighting conditions the object's visible light reactions cause

it to appear yellow to normal human perceivers who have the best possible view of it. (Sometimes a color spot will appear to be one color when viewed from a distance but appear to be made up of multicolored particles when viewed up close. One view of a color spot will be said to be *better* than another view if and only if more color distinctions can be made out from the former than from the latter view. For most people the best views of a color spot are between one and two feet from the spot.) Yellow is not a color. It is the set of all those colors which contain in their vlr sets vlrs to normal lighting conditions that cause objects to appear yellow to normal human beings. What has been said here about yellow holds for red, dark blue, black, white, etc. These sets will be called *color-sets*; so, although yellow is not a color, it is a color-set. There will be more on yellowness when we finish with shades.

Two objects are the same shade of yellow if and only if they are yellow and they appear to be the same color to normal human beings under normal viewing conditions. Clearly, A and B can be the same shade of yellow, B and C can be the same shade of yellow, and yet A and C not be the same shade of yellow. (This complication was ignored in part II because Smart ignores it.) To obtain well-defined sets, let 'O' be the name of any object and let O-set be the name of the set of colors that include the color of O and the color of any object that normal humans cannot distinguish from O under normal lighting conditions. Shades are O-sets. O-sets are defined in terms of some object O (or group of objects, Os, that are assumed to have the same color). For example, 'sky blue' and 'lemon yellow' are the names of O-sets. Given these definitions, dark blue is better thought of as a color-set than as a shade. [Note that 'x is the same length as y', like 'x is the same color as y', refers to a transitive relation. But 'x appears to be the same length as y', like 'x is the same shade as y', refers to an intransitive relation (i.e., A and B, like B and C, may appear to be the same length to normal observers under some set of conditions, although A and C do not appear to be the same length under these conditions). A phrase like '$3.26 \pm .02$ meters' functions something like a shade term in that it is often used to refer to a set of lengths that appear to be the same under some set of conditions. In general 'x appears to be the same as y to so-and-so with respect to _____ under such-and-such conditions' does not pick out a transitive relation; so no wonder that 'x is the same shade as y' is intransitive.]

The above conception of yellow needs to be applied with care when the phenomena of color constancy and color contrast are involved. If an observer is looking at snow under a clear blue sky, it may appear to be a bluish white to him even though it appears(j) white to him. The problem is that the observer may think that the snow appears white to him because he believes that he is discounting a perceptual judgment that he is not in fact discounting. We can determine that the observer is not

discounting his perceptual judgments by arranging for him to see the snow and describe its color-set, when he does not know that it is snow he is perceiving. There is another problem with brightness-contrast and color-contrast phenomena. A small green patch on a large yellow surface appears blue. This does not mean that the patch really is blue, because in this case it is not the vlr of the patch alone that is causing the patch to appear blue but the combined vlrs of the patch and its background. These problems do not arise frequently, but when they do arise they can be solved by having normal observers, who are ignorant of what they are looking at, observe the object through a reduction screen, i.e., a screen with a hole in it that lets the observer see only a small part of the object's surface (small enough so that the observer can neither identify the object nor see its background).

A great deal of scientific work has been done on how the apparent color-set of an object is affected by lighting conditions. This work can be combined with the causal concept of color-sets given above to obtain a deeper analysis of color-set terms. To see how this can be done, note that two dependent variables, called *dominant wavelength* and *purity*, can be defined in terms of the physical features of a beam of light (i.e., the intensity of each wavelength in the beam). A third variable, called *brightness*, is determined by the physical features of a beam of light, although it is not defined in terms of those features.[14] Two beams of light may have entirely different physical features, even though their dominant wavelength, purity, and brightness are the same. This is the case with the light reflected from the paint in pots *A* and *B* discussed in part I. The important point is that dominant wavelength, brightness, and purity characterize (or are one way of characterizing) the features of light which affect the color-set to which an object appears to belong. Applying these discoveries to the causal concept of yellow given above, one gets the following: an object is yellow if, and only if, if the object is under normal lighting conditions and the reflected or transmitted light from the object reaches any normal observer unchanged in its journey to the observer's eye, then the dominant wavelength, purity, and brightness of the smallest beams of light that the eye can resolve into distinct points (when the observer is in the best possible position to see the object's color) cause the object to appear yellow.

Let us apply this analysis of yellowness to specific examples that we can compare with our intuitions. Suppose a surface that appears to be yellow (to normal observers under normal lighting conditions) is made up of tiny dots that cannot be distinguished without a magnifying glass. Seen through a magnifying glass these dots appear to be red and green. Even so, it would be very natural to say that this surface really is yellow, as it should be if the above theory is right. [But see note 5.] Are the dots really red and green? Given the vlr account, objects that are too small to

be perceived with the naked eye could belong to a color-set only in a derivative sense. Suppose that this example is changed so that the dots can be perceived with the unaided eye if one is close enough to the surface, but the surface still appears yellow from a distance. Examples like this include parts of Seurat paintings, and a football field that looks yellow from an airplane but is divided up into a checker board of large red and green blocks. Given this vlr account, both the painting and the football field are really red and green although they appear to be yellow under some conditions.

One half of a circular disk is red and the other half is green. When the disk spins slowly it appears to be red and green, but as it speeds up it appears to be yellow. In this case the dominant wavelength of the light reaching the eye is changing faster than the reaction time of the eye. More exactly, the light reaching the eye from any fixed point above the disk during the reaction time of the eye is from both the red and green parts of the disk. In this sense the light reflected from, say, a red part of the disk does not reach the eye unchanged, but is mixed with light from other parts of the disk. Since it is not the vlr of such a red part of the disk alone that causes that part to appear yellow, its apparent yellowness is an illusion.

If the preceding analysis is right, the distinctions we make between color-sets and between shades go only as deep as the unaided human eye can go. This is unlike the distinctions we draw between colors, which go as deep as many of the distinctions between lightwaves. Although the distinctions between color-sets are not so deep as the distinctions between colors, they are for that very reason easier to apply and more suitable in the everyday identification of objects.[15]

Acknowledgments

I would like to thank Robert Audi, John Heil, and Evan Jobe, all of whom made helpful criticisms of earlier drafts of this paper. Special thanks are also due to the National Endowment for the Humanities for a fellowship which helped make this essay possible.

Notes

1. "Naming and Necessity," in Donald Davidson and Gilbert Harman, eds., *Semantics of Natural Language* (Boston: D. Reidel, 1972).

2. Chung-ying Cheng, ed., *Philosophical Aspects of the Mind-Body Problem* (Honolulu: UP of Hawaii, 1975). [chapter 1, this volume]

3. New York: Humanities, 1963.

4. Frank Jackson has argued that Smart's account of red cannot account for red afterimages, because afterimages do not have the appropriate physical structure to reflect any light, let alone light that causes humans to have the sensation of red. [See his *Perception: A Representative Theory* (New York: Cambridge, 1977), pp. 127/8.] Jackson is missing the point just made in the text. Smart's account of red takes the concept of an experience of red to be essentially different from the concept of a red physical object. Clearly, red afterimages are certain sorts of experiences and so do not, on Smart's account of red, need to reflect light in order to be red.

5. D. M. Armstrong may hold that shade-identity statements are false. He points out that under a microscope blood appears to be mostly colorless. Only a small area of the blood seen through a microscope appears to be red. He says ["Colour-Realism and the Argument from Microscopes" in Richard Brown and C. D. Rollins, eds., *Contemporary Philosophy in Australia* (New York: Humanities, 1969), p. 127]:

> A drop of freshly drawn blood looks red all over to normal perceivers in standard conditions, and is a very suitable object to teach a child 'what red is'. We can admit these facts, and still say it makes sense to deny the drop is really red all over.

Armstrong denies that the blood drop is red all over because it does not appear to be red all over through a microscope. And this shows, he claims, that the light actually reflected from the blood is not characteristic of red surfaces (124/5). Suppose that a drop of blood and a surface that really was red were indistinguishable to the unaided eye. Armstrong might claim that these two surfaces were not the same shade of red, since one of them was not red. But maybe Armstrong would not say this, because if the drop of blood is a suitable object to teach a child what red is, it may be red in some sense.

6. Yves Le Grand, *Light, Colour and Vision*, R. W. G. Hunt, J. W. T. Walsh, and F. R. W. Hunt, trans., 2d English ed. (London: Chapman & Hall, 1968), pp. 147 and 155.

7. For more on the physics of the color of objects, see Kurt Nassau, "The Causes of Color," *Scientific American*, CCXLIII, 4 (October 1980): 124–154. [chapter 1, *Readings on Color, vol. 2*]

8. "The Meaning of 'Meaning' " in *Mind, Language and Reality* (New York: Cambridge, 1979), pp. 227–229.

9. William A. Shurcliff and Stanley S. Ballard, *Polarized Light* (Princeton, N. J.: Van Nostrand, 1964), pp. 95–98.

10. For radiant objects we have the following principle: two radiant objects are the same color if and only if, for every nonradiant object, the vlr that the nonradiant object would have to each of these radiant objects would be the same.

11. Scientific discoveries have simplified the description of the color of some objects. For example, there is a law that makes a substantial part of the description of the color of an object particularly easy. When the intensity of the light of a given wavelength striking a surface is varied, the intensity of the reflected light of that wavelength is always a constant fraction of the intensity of the incident light. Hence, the description of how an object reflects light of a particular wavelength but varying in intensity involves just one fraction, for with this fraction one can deduce how the object will react to each of the infinite variations in the intensity of that wavelength. A complete description of how an object reflects light of all wavelengths is given by its reflection curve: the reflection curve of a surface is a graph that plots for each wavelength of light the fraction of the intensity of the incident light that the surface will reflect. Similarly, an object will have a transmission curve. Of course the reflection and transmission curves of an object form a large part of the description of that object's color. (Smart calls the reflection curve the "intensity-wavelength curve" in one of the above quotes from his work.)

12. For the sort of disturbing factors involved and how to deal with them, see Le Grand, *op. cit.*, pp. 134/5.

13. The notion of being "oriented in the same way to a light source" can now be spelled out. The vlr conception of same color and scientific discoveries about the reaction of objects to light imply the following: two objects have the same color (or no color) if and only if, for every light source, if the objects were to be oriented in the same way toward the light source then the objects would reflect, absorb, or transmit the same wavelengths of light with the same intensity for each wavelength and they would diffuse and

polarize the same amount of the light they reflected or transmitted, wavelength by wavelength. In practice, identically shaped slabs of a handy size which are made from different substances are tested for their reaction to light, wavelength by wavelength. Although these slabs are easily oriented in the same way toward a light source, the geometric notion of same orientation does not mean just that the surfaces to be tested be at the same angle and distance from the light source. The surfaces may also have to be lined up in the same way relative to each other, in order to deal with polarization. (If two slabs polarize sunlight that strikes them in the same way when they are at the same oblique angle to the sun *and* when they are appropriately rotated about an axis perpendicular to their surface, then to be oriented in the same way toward any light source they must always have this same relative position to each other. Without this or something like this condition, two identically made filters could be turned so that they polarized the light shining on them into different planes and hence were different in color. Also a slab that polarized light would change its color when rotated.) By making the important assumption that objects made of the same substance react in the same way to light, the color of any object whose chemistry is known can be found by knowing the color and chemistry of the slabs. Thus, given this important assumption, the problem of explaining in a general way what 'oriented in the same way toward a light source' means can be avoided. All of which is just as well, because there may be no general way of defining this phrase so that, for any light source, a highly curved surface and a flat surface can be oriented in the same way toward this light source.

14. For details see Le Grand, *op. cit.*.

15. A related structural account of color goes like this: the color of an object is that part of its structure which causes it to react to light in a way that makes the object visible. Thus, two objects have the same color if and only if they have exactly similar vlr structures. Two objects that are different in color according to the vlr account in the text are different in color according to this structural account, because different effects must have different causes. Two objects that are different in color according to the structural account might be the same in color according to the vlr account, because different causes can have the same effect. But this seems implausible; i.e., it seems implausible that two objects could be different in color although no conceivable animal or instrument could tell they were different in color by looking at them under any lighting condition. The reader may want to compare this argument with the last argument in part IV.

3 Smart and the Secondary Qualities

D. M. Armstrong

Jack Smart is a world figure in contemporary philosophy, in particular for the part he has played in developing scientific realism. But in Australia it is natural to turn to what he has done for philosophy in this country. There was a sort of pre-established harmony between the man and what he found when he came here.

His completely open and direct way of doing philosophy, springing from his completely open and direct personality, made an instantaneous appeal to students and colleagues. The appeal was all the stronger because it joined hands with Australian values. His philistinism—early in our acquaintance he told me that there was little need to bother about Shakespeare especially if you could look out of your study window at Mt Lofty instead—and his indifference to the history of his subject—why bother about those chaps who are dead?—did him no harm! His writing was straightforward and colloquial, although it did have a great deal of style thus covertly contradicting his declared indifference to aesthetic matters.

To this he has joined disinterested generosity of intellectual spirit, a readiness to praise the good as he saw it as soon as he saw it, and a habit of answering philosophical and other correspondence by return of post. The philosophers of Australia owe him a lot.

One of the topics about which he and I have exchanged letters and papers over many years is that of the secondary qualities. It is to this topic that I now turn. In the first part of this chapter I discuss the development of Smart's views on the secondary qualities, relating this to larger themes in his thought: the development of his scientific realism, his physicalism and his view of the mind. The account of the secondary qualities which he now rests in he had arrived at by 1968, although the paper which contained this account was not published until 1975.[1]

I think that this view is the true one, or close to the truth. So in the second part of this chapter I defend it against objections, in particular against the nagging feeling that it must be rejected because it does not do phenomenological justice to our perception of the secondary qualities.

The Development of Smart's View

If one had to sum up Smart's philosophical development in a phrase, one could say that he went from science to scientific realism. He was early inclined to believe that it is pre-eminently scientific investigation that gives us knowledge and rational belief about the nature of the world. But given the Oxford of his graduate studies, and his

admiration for the work of Gilbert Ryle, this did not immediately translate into a realistic view of the entities that science speaks of, or appears to speak of.

I begin with the development of Smart's view of the mind. We each believe that it is rational to postulate other minds besides our own. The scientific realist will naturally see this as an inference to unobserved processes and states which are causes of much of the observable behaviour of bodies besides our own. It is a case of inference to the best explanation. The inference is perhaps suggested, and in any case is further supported, by the fact that we are able to observe such processes and states in our own case (introspection), and are even able, apparently, to observe the causal efficacy of some of these processes and states in producing our own outward behaviour.

At Oxford, Smart held no such view. Instead, he leaned to a reductive account which, putting it roughly, identified the mind with behaviour. No doubt, at the time this seemed to him to be the right line for a scientifically minded philosopher to take. For the philosophical orthodoxy of the time took it as obvious that if there were minds which lay behind, and which caused, behaviour, then these minds were immaterial things. At the same time, it seemed that no respectable science of the immaterial could be developed. It might appear that in our own case we have direct awareness of the distinction between our behaviour and our mental states. But this introspective faculty was thought to be a suspicious affair. Orthodoxy, stretching back to Descartes, held that its deliverances were indubitable or incorrigible. It was not easy to see how these characteristics of introspection were to be reconciled with a scientific view of human beings.

But after Oxford Smart made a most important break. In Adelaide, under the influence of U. T. Place, for the case of sensations and the phenomenon of consciousness he reversed what Russell in phenomenalist mood had called the supreme maxim of scientific philosophizing. Unlike Russell, he moved *from* logical constructions *to* inferred entities. But Place and he sought to preserve scientific plausibility by identifying the having of sensations and other conscious experiences with physical processes in the brain.

The Place-Smart view was a half-way house, of course, even if one which Place has continued to find satisfactory. Smart was later to move on to a fully scientific realist, and physicalist, view of the mental, where all mental processes, events and states are identified with physical processes, events and states in, or of, the brain.

A similar development appears to have taken place in Smart's view of the theoretical entities of physics. In his Oxford days he did not take a fully realistic attitude to such entities as molecules. I suppose that the old historical link between empiricism, on the one hand, and positivism and instrumentalism, on the other, was an influence here. That link was certainly present in Ryle's realism about the physical

world—a realism about the entities of common sense, but not a realism about the entities that physicists, for the most part, think of as constituting the entities of common sense.

Here is Smart, in an article published in 1951, apparently poised between denying and asserting the literal reality of molecules:

unless we recognize the difference of language level between the various uses of 'particle' it might be misleading to say that a gas consists of particles. On the other hand it would not do to retain the use of the word 'particle' for things like billiard balls and refuse to say that a gas consists of particles. How else can we bring out the analogy on which the explanatory power of the theory consists?[2]

This soon changed. Concluding his article 'The reality of theoretical entities', published in 1956, he wrote:

The modern tendency in philosophy is to be opposed to phenomenalism about tables and chairs but to be phenomenalist about electrons and protons.[3]

However, just before saying this, he had made it clear that he had now repudiated this half-phenomenalism:

The naive physicist thinks that his science forces us to see the world differently and more truly. I have tried to defend him in this view.[4]

To adopt the physicist's view leads to certain difficulties, of course. For instance, one will be led to say that ordinary physical objects, as opposed to the collapsed, and hugely dense, state of matter found in neutron stars, are mostly empty space. But is not a desk, say, a paradigm of something in which, to use Parmenides's phrase about his One, what is stands close to what is?

This argument from paradigm cases is not very difficult to surmount, as most philosophers would now judge. It is perhaps sufficient to note that something which consistently appears in perception to have a certain character will serve as a perfectly good paradigm of that character for ordinary thought and language (and for teaching a child), even if it in fact lacks that character.

But a much more serious problem is posed by the secondary qualities. In the manifest image of the world, to adopt Wilfrid Sellars's expression, colour, heat and cold, sound, taste and smell, play a conspicuous part. Yet as far back as Galileo (with intellectual precedents stretching back to the Greek atomists) physicists could find no place for these qualities as intrinsic properties of physical things. The trouble is that these properties do not *explain* anything physical. Does the high-pitched sound shatter the glass? To superficial observation it might appear to do so. But investigation reveals that it is vibrations in the air which really break the glass. The

secondary qualities do not even help to explain how they themselves are perceived. Contrary to earlier speculations, it is not the sensible species of colours, but rather patterns of light waves, that cause us to see the colours of the surfaces of objects.

What is the scientific realist to do? A traditional solution is to use the mind as an ontological dustbin, or sink, for the secondary qualities. Locke gave us a classical formulation. For him, the surface of a ripe Jonathan apple can properly be said to be red. But what constitutes its redness is only this. The surface has nothing but the primary qualities. In virtue of certain of these properties, however, properties of the micro-structure of the surface, it has the power to produce in the minds of normal perceivers in standard conditions (this last fills out Locke a little) ideas, or sense-impressions or sense-data, mental objects which have a certain simple quality, a quality unfamiliar to persons blind from birth. (Some philosophers, although not Locke himself, might then go on to *identify*, at least token by token, the redness of the surface with the primary qualities of the surface responsible for it having that power.)

This solution does have a phenomenological disadvantage, neatly captured by Berkeley in a little remarked passage: 'Besides, if you will trust your senses, is it not plain all sensible qualities co-exist, or to them appear as being in the same place? Do they ever represent a motion, or a figure, as being divested of all other visible and tangible qualities?'[5] By the 'sensible qualities' Berkeley means, of course, the phenomenological qualities. He is surely right that, for example, the sensible quality of redness looks to be an intrinsic (non-relational) property of certain surfaces. Phenomenally, the secondary and the primary qualities cannot be separated. The difficulty can of course be met by embracing a Representative theory of perception of *all* the sensible qualities, primary as well as secondary. But a Representative theory has its own disadvantages.

Here, however, I want to focus upon a much more serious difficulty, much more serious at any rate for one who, like Smart, has accepted a physicalist account of the mind. If we have not merely accepted a scientific realism about the physical world, as Locke did, but have also made the mind part of that world, then there is no hiding place down in the mind for the sensible secondary qualities. The same reasons that made one want to exclude them from the physical world will make one want to exclude them from the mind. So what is the *physicalist* to do with the secondary qualities?

It will help us to appreciate the physicalist's problem if we consider further the phenomenology of these qualities, that is, their characteristics as revealed, or apparently revealed, to observation.[6] In the first place, as we have already noted, they appear to be intrinsic, that is, non-relational, properties of the physical things, sur-

faces, etc. to which they are attributed. This seems clear enough for the cases of colour and heat and cold. Perhaps it is not so clear for sound, taste and smell. After all, we do have the view of Hume and others that qualities of these three sorts are not spatial. It seems to me on the contrary, as a matter of phenomenology, that sounds have sources and can fill areas, that smells hang around places, and that tastes are intrinsic properties of tasty objects. However, if Hume's view is phenomenologically correct (I do not know how we decide the issue) that will make the existence of the secondary qualities even harder to reconcile with physicalism. (The physicalist will have to say that sounds, tastes and smells *are* spatial but that their spatiality is not revealed to perception.)

Second, the secondary qualities appear as lacking in 'grain', to use Wilfrid Sellars's excellent term. Perhaps Locke was wrong in claiming that they appear to be simple. But they do have a uniformity, a lack of extensive structure, even if they have an intensive structure.

Third, despite the point just made, the different secondary qualities are not merely blankly different from each other. Each determinate quality is set in a logical space, a quality-space it has been called, which psychologists and others are trying (with difficulty) to map for us. Consider, in the case of the colours, the dimensions of hue, saturation and intensity and the resemblance-orderings which these dimensions are associated with.

Fourth, however closely primary and secondary qualities may be correlated, the two sorts of quality appear to be wholly distinct from each other.

So much for the way it seems. Why, now, do these secondary qualities *so conceived* constitute an embarrassment for the scientifically minded philosopher? We have already encountered one reason. The qualities seem to play no part in physical explanations of phenomena. In G. F. Stout's fine phrase, they are not part of 'the executive order of the material world'.[7] And if one takes a physicalist view of the mental, then no relief will be gained by transferring the location of the qualities to the mind.

However, the difficulty that Smart himself emphasized, although not unconnected with the point just made, was a bit different. It was this. If one treats the secondary qualities as qualities *additional* to the primary qualities, and as having the general nature that they appear to have, then one will require *laws* to connect them with the primary qualities. But these laws will have to have a very strange structure.

The laws will be emergent laws. When exceedingly complex assemblages of physical conditions occur (outside or inside the brain will make no difference), then in association with these conditions, relatively simple qualities emerge. Smart says that, as a scientifically minded person, he cannot believe in such laws. He used Herbert

Feigl's phrase: the qualities so conceived are 'nomological danglers', excrescences on the organized and beautiful structure of physical law that is beginning to appear. He also said that such laws had a bad smell!

So what solution to the problem does Smart offer? It is very interesting to notice that once again his first reaction was to look for an operationalist/behaviourist answer. The answer is adumbrated in 'Sensations and brain processes' (1959), expanded in 'Colours' (1961) and repeated in his major work *Philosophy and Scientific Realism* (1963).[8]

Smart's solution has a Lockean element to it, as he points out. Secondary qualities are identified with powers in the objects to which the qualities are attributed, powers which one might then identify with categorial characteristics of the objects. But these powers are powers to cause normal perceivers ('normal' is given a special definition which need not concern us) to be endowed with further powers: *discriminatory* powers. Thus to say something is red is to say, very roughly, that it would not easily be discriminated from, picked out from, a background of ripe tomatoes, but would easily be discriminated from, picked out from, a background of lettuce leaves.

Smart was immediately hit with two objections, objections of a sort very familiar to us today from contemporary discussions of Functionalism. The first was raised by Michael Bradley, and would now be called the 'absent qualia' objection. Is it not possible, asks Bradley, that we should see the world in a uniform shade of grey, and yet be able to make all the discriminations that normally sighted persons make on the basis of the perceived colours of things?[9] The second objection was raised by C. B. Martin, that of the 'inverted spectrum'. Could not the colours of things be systematically inverted (an objectivist form of the inverted spectrum), and yet our ability to discriminate between tomatoes and lettuce leaves remain exactly as before?[10]

Smart originally tried to meet these difficulties by admitting colour-*experiences* into his analyses. To say that something is red *both* says that the thing has the power to furnish a normal perceiver with appropriate discriminatory powers *and* (less important) that it has the power to furnish such a perceiver with the right visual experiences.

But this did not last long at Bradley's hands. Once again, the trouble is caused by Smart's physicalism about the mind. What are these experiences? For Smart they can only be brain processes, as indeed he emphasizes. Furthermore, he maintains, the only introspective notion that we have of these experiences is a topic-neutral one, a notion definable only by reference to the nature of the stimulus that brings the experiences to be. (The idea of a topic-neutral analysis of our mental concepts was, of course, one of Smart's major contributions to developing a central-state physicalism about the mind.) As a result, for something to look red to me (the right sort of

experience) is for me to have something characteristically brought about by red things. Red things, however, in Smart's theory, are constituted red by the discriminations they cause, so for him experiences of red must be defined in terms of these discriminations, and cannot vary independently of the right discriminations. As a result, Smart's appeal to experiences adds nothing that will allow him to make sense of Bradley's (and Martin's) case.[11]

In a paper given to a conference at Hawaii in 1968, but not published until 1975, Smart accepts Bradley's criticism.[12] (This paper has not become widely known. I have discovered that many philosophers think that Smart is still committed to the quasi-Lockean quasi-behaviourist view that he held at the time he wrote 'Sensations and brain processes'.) As a result, he finally comes to a realistic account of the secondary qualities. They are objective qualities of objective things. What of the demands of physics, then? He meets these by accepting a suggestion that had been put to him by David Lewis: he identifies a colour, and by implication the other secondary qualities, with a *physical* property of the coloured object. It is a fact that this property is causally responsible for certain discriminatory responses of normal human percipients. It is also a fact that certain colours are associated with certain sorts of physical objects, in particular with their surfaces. When all this is filled out, it will provide identifying descriptions for the colours. Using Kripke's terminology (not that that would please Smart very much) we can say that the descriptions can, if we wish, be used as rigid designators. But the descriptions do not pertain to the essence of the colours.[13]

The only difference in all this from a naive view of colour is that the colour-properties are identified with primary qualities of the micro-structure of the surfaces of the coloured objects. Though realist, the view is reductionist. Smart shows how this account can deal with Bradley's and Martin's cases.

He goes on to explain why he originally rejected Lewis's suggestion. The reason had to do with the particular case of colour, and not the secondary qualities generally. According to Smart, the scientific evidence about the physical correlates of colour is such that a particular shade of colour would have to be a highly *disjunctive* and very *idiosyncratic* property. This, he thought, was a reason to reject the identification. Lewis simply responded by asking him what was wrong with a disjunctive and idiosyncratic property. And by the time Smart came to give his Hawaii paper, he had accepted Lewis's 'So what?'.

Defence of an Objectivist Physicalism About the Secondary Qualities

I proceed to defend a physicalist realism about colour and the secondary qualities. The first point I want to make is that there is no difficulty at all in the fact, if it is a

fact, that a particular secondary quality is very *idiosyncratic*. In this respect, a certain shade of colour might be like a certain complex, idiosyncratically complex, shape. Such a shape might well be a repeatable, and so a clear case of a property, even though its idiosyncratic nature made it an unimportant property in physical theory. (It might still be important in biological theory. Consider the way that the young of many species of birds automatically cower when a hawk-like shape appears in the sky above.) The physicalist could well admit that, unlike, say, sensible degrees of heat, the colour-properties are not very important physical properties. Perhaps the point of colour-recognition is just to break up the perceptual environment to make it more manageable, or, as Ruth Millikan has suggested, to render more easy the re-identification of individual objects.[14]

That colour-qualities might have to be adjudged ineluctably disjunctive is perhaps a bit more worrying.[15] Certainly, it worried me for a long time. Suppose it turns out that surfaces which we judge by objective tests to be of the very same shade of colour cannot be brought under a genuinely unifying *physical* formula. At one stage, this led me to flirt with the idea that, if the so-called colour-properties really are irreducibly disjunctive in this way, then the proper moral for a physicalist to draw is that, despite their phenomenological prominence, colours do not really *exist*. In Berkeley's splendid phrase, which he of course used pejoratively, they are 'a false, imaginary, glare'.[16]

My problem was compounded in the following way. In the past, I had asserted that all genuine properties are universals. Now there are excellent reasons in the theory of universals to deny that there are *disjunctive* universals. One problem about disjunctive universals is that there would be no identity, no sameness, in the different instances. Let a instantiate universal P but not universal Q. Let b instantiate Q but not P. Both instantiate P *or* Q. But this would appear to yield what Peter Geach calls a 'mere Cambridge' sameness. For this and other reasons I was led to reject disjunctive properties.

But I would now reject the first premiss of this argument. While continuing to reject disjunctive *universals*, I think that we should be prepared to accept disjunctive *properties*. I am influenced by two points here. First, it seems clear that what are *ordinarily* called properties can for the most part only be explicated in terms of more or less tightly knit *ranges* of universals, ranges which must be understood disjunctively. (Wittgenstein on games is relevant here.) Second, I am fortified by the reflection that such properties—which Peter Forrest suggests should be called multiversals—are logically supervenient upon the instantiation of genuine universals, that is, properties and relations which are genuinely identical in their different instances. Given all the non-disjunctive properties of things, then their disjunc-

tive properties are determined. The reflection is fortifying because, I think, what is supervenient is ontologically nothing over and above what it supervenes upon. If that is correct, then we can take disjunctive properties on board without making any addition to our ontology. They are a free lunch.

But what then of the phenomenological point? Suppose that we have two instances of what, despite close examination, appear to be surfaces of exactly the same shade of colour. Could we, if the science of the matter demanded it, accept that the two surfaces instantiate two quite different micro-structural characteristics, where the latter characteristics *constitute* the colour of the surfaces?

I think that we can, as the following simplified neurophysiological thought-experiment is meant to show. Let there be an *or* neuron which is fed by two or more incoming channels. Each channel is activated by a different sort of retinal stimulation, and ultimately by a different sort of distal stimulation: a different sort of surface. Let the neuron be situated at an early stage in the neural processing leading up to the perception of coloured surfaces. Since the neuron is an *or* neuron it will fire, and so pass on its message, even where only *one* incoming channel is activated. Furthermore, that message will be identical whichever channel is activated. Different causes, same effect. So for the higher-ups in the brain it will not be possible to sort out which incoming channel has fired. Hence different sorts of stimuli must be *represented* as the same at the higher level, even though they are not in fact the same.

This result will be enhanced by what I call the 'Headless Woman' effect. Here the failure to perceive something (say the head of a woman, where the head has been obscured by a black cloth against a black background) is translated into the illusory perception of seeming to perceive the absence of that thing. It seems to be illustrated by the case of introspective awareness. When we introspect, we are certainly not aware that what we introspect are brain processes. This, by an operator shift, gives rise to the impression that what we introspect are not brain processes. This impression is inevitable *even if what we introspect are actually brain processes*, as we physicalists hold.

In the present case, a failure to perceive the presence of disjunctivity in a certain property would translate into an impression of the absence of disjunctivity, that is, an impression of identity. I regret to say that Smart suggested this application of the Headless Woman principle in the 1975 paper but, as he records there, in correspondence with him I rejected this particular application. I cannot now see any good reason for my rejection. I think it was just hostility to disjunctive properties.

There is one other problem about taking colours or other secondary qualities to be disjunctive properties. The problem has been put to me by David Lewis, now a little worried about his own suggestion for dealing with Smart's problem. When we

perceive the sensible qualities of physical things the quality must presumably play a causal role in bringing the perception to be. But now consider a disjunctive property. It cannot be thought that the disjunctive property itself plays any causal role. Only the disjuncts do that. So if sensible qualities are disjunctive, how can they be perceived?

It seems to me that this problem can be met by a legitimate relaxation of the causal condition for perception. Provided that each disjunct, operating by itself, would have produced exactly the same sensory effect, is it not reasonable to say that the perceiver is perceiving the disjunctive property? Consider, after all, that although the actual qualities that things have are determinate, yet they are not perceived as having some determinate quality. Even if a non-disjunctive account of colour is correct, it remains true that surfaces are perceived as having a certain shade of red but are not perceived as having an absolutely precise shade of red. As a result there will be a disjunctivity in the nature of what is actually registered perceptually. At the same time, it is the precise shades which act causally. And whatever account is given of this situation can presumably be applied to disjunctions of a more 'jumpy' sort.

Returning to the Headless Woman, she seems valuable in explaining two further phenomenological facts: (1) that the secondary qualities appear, if not simple, at least as lacking in grain; (2) that the secondary qualities appear to be quite distinct from the primary qualities.

The particular primary qualities with which Smart, Lewis and myself propose to identify the secondary qualities will fairly clearly be *structural* properties at the microscopic level. But the secondary qualities appear to lack structure ('grain'). How can the structured appear structureless?

What perhaps we need is an *and* neuron. If a cell has a number of incoming channels, each susceptible to different sorts of stimuli, but *each* channel has to fire before the cell emits a *single* impulse, then one could see how a complex structure might register perceptually as something lacking in structure. (It will be a bit more complicated if an irreducible *disjunction* of structures has to register both as a non-structural and non-disjunctive property, but no difficulties of principle seem involved.) Then the Headless Woman effect will explain why the lack of perception of structure gives rise to an impression of lack of structure.

But what of the point that the secondary qualities appear to be other than the primary qualities? The vital point to grasp here, I think, is that, with an exception or two to be noticed, our *concepts* of the individual secondary qualities are quite empty. Consider the colour red. The concept of red does not yield any necessary connection between redness and the surface of ripe Jonathan apples or any other sort of object. It does not yield any necessary connection between redness and any sort of discrim-

inatory behaviour, or capacity for discriminatory behaviour, in us or in other creatures. It does not yield any necessary connection between redness and the way that the presence of redness is detected (eyes, etc.) in us or in other creatures. Finally, and most importantly, it does not yield any necessary connection between red objects and any sort of perceptual experience, such as looking red to normal perceivers in normal viewing conditions.

There may be a conceptual connection between redness and extendedness. But a physicalist, in particular, will think that this gives us little line on its form. There is certainly a conceptual connection between redness and the other colours: the complex resemblances and differences that the colours have to each other. But these conceptual connections do not enable us to break out of the circle of the colours.

With these exceptions, all we have are various identifying descriptions of redness. They identify it all right, but the identification is not conceptually certified. In my opinion, this conceptual blankness is all to the good if we seek to make intelligible a physicalist identification. For it means that there is no conceptual *bar*, at least, to such an identification. There is topic-neutrality. *Neither* the identity of redness with some primary quality structure *nor* its non-identity with such a property is given us. So if we can find a physical property which qualifies red things (what a good theory will tell us are red things) and bestows the same powers as the powers of red things, including their powers to act on us, then it will be a good bet that this property *is* redness. And I hope it is not overworking the Headless Woman to say that failure to perceive identity with primary qualities gives rise to the impression that that identity definitely does not obtain.

But still one may not be satisfied. Many will think that when we perceive a red surface under normal conditions, perceiving that it is red, we are directly acquainted with a quality, apparently an intrinsic, that is, non-relational, property of the surface, which is visibly different from any physical micro-structure of the surface, or physical micro-goings on at the surface. (And, it may be added, visibly different from any physical goings on in the brain.) I confess that I myself am still not fully satisfied with the physicalist reduction. I accept the reduction; I advocate it. But the phenomenology of the affair continues to worry me.

Here is something that may help to explain further this profound impression of concretely given intrinsic quality. Consider again the relations of resemblance that we perceive to hold between the members of the particular ranges of the secondary qualities. We are not merely aware of the difference in colour of different colour-shades, but also of their resemblances and the degrees of their resemblance. The different hues of red, for instance, do fall naturally together. Any red is more like purple in hue than it is like any blue. As we have already said, the colours exist in a

colour-space exhibiting degrees of resemblance along different dimensions. The same holds for the other secondary qualities.

These resemblance relations are, like any resemblance relations, *internal* relations. They hold in every possible world. But if some physicalist account of colour is correct, then despite the rather clear way in which we grasp the resemblances we lack any concrete grasp of the nature of the qualities on which the resemblances depend.

Now I do not think that this creates any epistemological difficulty. It is commonplace for this sort of thing to happen in perception and elsewhere. Smart pointed this out when discussing that famous having of a yellowish-orange after-image which is *like* what goes on in me when an actual orange acts upon my sense-organs. He spoke there of 'The possibility of being able to report that one thing is like another, without being able to state the respect in which it is like'. He went on to say:

> If we think cybernetically about the nervous system we can envisage it as being able to respond to certain likenesses of its internal processes without being able to do more. It would be easier to build a machine which would tell us, say on a punched tape, whether or not the objects were similar, than it would be to build a machine which would report wherein the similarities consisted.[17]

No epistemological problem, then. But I suggest that it is the fact that we grasp these resemblances among the secondary qualities so clearly and comprehensively that generates, or helps to generate, the illusion that we have grasped in a concrete way the natures of the resembling things. In an unselfconscious way, we are all perfectly aware that resemblances are completely determined by the natures of the resembling things. So given resemblances, we automatically infer natures. We know further that in perception what is automatically inferred is regularly felt as directly given, as contrasted with being inferred. (Consider for example the way we pass from hearing words to the semantic intentions of speakers.) So in perception of the secondary qualities, we have a vivid impression of intrinsic nature.

Smart, Lewis and myself share a reductive (physicalistic) and realistic view of the secondary qualities. In the first section of this chapter I traced the path by which Smart reached this conclusion. In the second section I have tried to strengthen the defence of this position.

Notes

1. J. J. C. Smart, 'On some criticisms of a physicalist theory of colors', in Chung-ying Cheng (ed.), *Philosophical Aspects of the Mind-Body Problem*, Honolulu, University Press of Hawaii, 1975, pp. 54–63. [chapter 1, this volume]

2. J. J. C. Smart, 'Theory construction', *Philosophy and Phenomenologial Research* 11 (1951), reprinted in A. G. N. Flew (ed.), *Logic and Language*, Second Series, Oxford, Basil Blackwell, p. 235.

3. J. J. C. Smart, 'The reality of theoretical entities', *Australasian Journal of Philosophy* 34 (1951), p. 12.

4. Ibid., p. 12.

5. G. Berkeley, 'First dialogue', in D. M. Armstrong, ed., *Berkeley's Philosophical Writings*, New York, Collier-Macmillan, 1965, pp. 157–8.

6. When considering the phenomenology of colours in particular, it is useful to draw a distinction between *standing* and *transient* colours. This is intended as a distinction in the coloured object, and is not perceiver-relative. The distinction may be illustrated by considering two senses of 'spherical' as applied to squash balls. There is a sense is which squash balls, to be any use for squash, must be and remain spherical. They may be said to be spherical in the standing sense. In the transient sense, however, squash balls are frequently not spherical, for instance when in more or less violent contact with a racquet or wall. To be spherical in the standing sense can be analysed in terms of being transiently spherical. If a ball is transiently spherical when the forces acting upon the ball are those found in 'normal', that is, unstruck conditions, then it is standing spherical.

Now consider a coloured surface such as a piece of cloth with fast dye which is subjected to different sorts of illumination. We often say that it presents a different *appearance* under the different illuminations. This seems misleading. In a standing sense the colour does not change. But *in a transient sense* it really does change colour. The mix of light-waves that leaves the surface is different. A standing colour is thus a disposition to have that transient colour in normal lighting conditions. (See my paper 'Colour realism and the argument from microscopes' in R. B. Brown and C. D. Rollins, eds, *Contemporary Philosophy in Australia*, London, Allen and Unwin, 1969. The terminology of 'standing' and 'transient' was suggested by Keith Campbell.)

We may think of transient colour as the painter's sense of (objective) colour. And if we are considering the phenomenology of colour, it is transient colour upon which we should concentrate.

7. G. F. Stout, 'Primary and secondary qualities', *Proceedings of the Aristotelian Society* 4 (1904), p. 153.

8. J. J. C. Smart, 'Sensations and brain processes', *Philosophical Review* 68 (1959), pp. 141–56; 'Colours', *Philosophy* 36 (1961), pp. 128–42; *Philosophy and Scientific Realism*, London, Routledge and Kegan Paul, 1963.

9. M. Bradley, 'Sensations, brain-processes and colours', *Australasian Journal of Philosophy* 41 (1963), p. 392.

10. J. J. C. Smart, *Philosophy and Scientific Realism*, London, Routledge and Kegan Paul, 1963, p. 81 (acknowledging Martin).

11. M. Bradley, Critical notice of *Philosophy and Scientific Realism*, *Australasian Journal of Philosophy* 42 (1964).

12. J. J. C. Smart, 'On some criticisms of a physicalist theory of colors.'

13. Or so I interpret Smart. In a very interesting recent paper ('Color and the anthropocentric problem', *Journal of Philosophy* 82 (1985) [chapter 2, this volume], Edward Wilson Averill appears to interpret Smart differently. He quotes from Smart's 1975 paper ('On some criticisms of a physicalist theory of colors'): 'Colours are the (perhaps highly disjunctive and idiosyncratic) properties of the surfaces of objects that explain the discrimination with respect to colour of normal human percipients, and also the experiences of these percipients, the looking red, or looking blue, etc. of objects'. Averill then seems to take 'explains' here as involving a logical tie. If that is correct, there is still a Lockean or subjectivist element in Smart's account. I, however, take Smart to be cutting all logical links between colours and what happens in the perceivers of colours. (It may be that I do this because I think that a complete objectivity, a complete realism, about the secondary qualities is the true view!)

But there is much of interest in Averill's paper. He points out that Smart assumes that two objects are the (very) same colour if and only if they would appear to be exactly similar in colour to normal human observers under normal viewing conditions. (He fails to note Smart's special definition of a 'normal' observer.) There is no doubt that this is Smart's assumption, even although, I take it, he does not assume that this is conceptual or definitional. But Averill's arguments seem to show that if the assumption is not taken to be a conceptual or definitional truth, then there is no reason to take it to be true *at all*. The moral for the complete anti-Lockean, the complete realist, about colour is that the link between objective colours and the colour-appearances presented to normal perceivers has to be very indirect indeed.

Averill, however, thinks that this is bad news for the full-blooded realist about colours. He thinks that Smart's normality assumption—which is, of course, the assumption generally made—is true, cannot be contingent, and must therefore be conceptual. However, he does concede that the full-blooded realist position might be maintained if the assumption is dropped. (A proposal I had already tentatively made in my 'Colour realism and the argument from microscopes'.) He even points to one advantage that dropping the normality assumption would have. It would become possible to evade saying that the objective colours are disjunctive properties. That would be a considerable gain. It may be noted that Averill's holding to the normality assumption is not without costs. He finds himself forced to say that e.g. yellowness is not (strictly) a colour.

14. Ruth Garrett Millikan, *Language, Thought and Other Biological Categories*, Cambridge, Mass., Bradford Books, MIT Press, 1984, p. 316.

15. Averill's work, cited in note 13, may show that the qualities involved are not after all ineluctably disjunctive. That will be all to the good. But it seems well worth a physicalist contemplating, and trying to deal with, a 'worst case' from the physicalist point of view.

16. G. Berkeley, 'Second dialogue', in Armstrong, ed. *Berkeley's Philosophical Writings*, p. 74.

17. J. J. C. Smart, 'Sensations and brain processes', *Philosophical Review* 68 (1959).

4 Reply to Armstrong

J. J. C. Smart

I must thank David for his very kind remarks about me. I do not deny the philistin-
ism, about which I have just now said something. David may have given the im-
pression that philistinism goes down well in Australia, and perhaps it does, though
my first impression of Australia was very different. Never in Britain had I seen so
many boys and girls walking about carrying violin cases as I did in the vicinity of the
Adelaide University conservatorium! The question of whether Shakespeare or Mt
Lofty (which at the time to which David refers had not been disfigured by its three
television masts) does or ought to give the greater aesthetic pleasure raises an inter-
esting quasi-philosophical problem. Shakespeare had the wonderful ability always to
choose the right word, with a rarely equalled insight into human character. Con-
templating him we feel great awe. Consider, however, the extraordinary interlocking
complexities of the structure and biochemical processes of even one cell of one leaf
of one gum tree on Mt Lofty. Consider again an outstanding sculpture of a human
head. When I contemplate such a sculpture I am naturally impressed, but the
impression is mixed up with the reflection that the sculpture has nothing between its
ears, whereas my wife's beautiful head (for example) contains 10^{10} neurons (each
neuron being of amazing complexity), not to mention blood vessels, glands and
other extraordinary organs. It seems to me, therefore, that nature always far out-
strips art. I leave it to aestheticians to tell me where I am wrong.

In his paper Armstrong begins by tracing the development of my own thinking
about the secondary qualities: criticisms on the part of M. C. Bradley and C. B.
Martin and a suggestion by David Lewis have helped me to move from the behav-
iourist account in my paper 'Colours' (1961)[1] to a position very close to the one to
which Armstrong had already moved.[2] According to this later view of mine, colours
are physical properties of the surfaces of objects. (I leave out qualifications about
rainbows and the like.) My worry was that these properties must be highly dis-
junctive and idiosyncratic ones. Lewis said 'Disjunctive and idiosyncratic, so what?'
Though disjunctive and idiosyncratic (that is, of interest to humans but not, say, to
Alpha Centaurians) they could still be perfectly physical properties. To adapt an
analogy used by Robert Boyle,[3] the shape of a lock might be of interest only because
of a certain shaped key, but the shape of the lock is something perfectly physical—
indeed geometrical—which can be described without reference to the key.

By and large I agree with Armstrong's positive theory of the secondary qualities,
though I am not sure how far I can accept his theory of universals, and so I shall not
comment on this. I do, however, want to comment on Armstrong's long note

(note 13), in which he remarks on E. W. Averill's important paper 'Color and the anthropocentric problem'.[4]

In this note Armstrong quotes a passage, also quoted by Averill, in which I say: 'Colours are the (perhaps highly disjunctive and idiosyncratic) properties of the surfaces of objects that explain the discrimination with respect to colour of normal human percipients, and also the experiences of these percipients.'[5] There is an important syntactical ambiguity here which may have misled Averill in his interpretation of me. (Armstrong has it right.) The words 'and also' are not meant to be governed by 'colours are' but by 'that explain'. However, I do not think that Averill's main arguments are affected by this matter.

In my article 'Colours' I introduce the notion of a normal human percipient, which is that of someone who can make at least as many discriminations as any other. Thus if Jones makes the best discriminations at the red end of the spectrum and McTavish the best at the blue end, the notion of a normal human percipient might be realized by Jones and McTavish acting in concert, or perhaps 'normal human percipient' might express an idealized notion, as does 'the mean sun' in astronomical chronology. I also assume that the discriminations are made in sunlight. I think this accords well with the ordinary use of colour words. However, there are pressures in another direction, to which Averill responds by relaxing the condition that canonical discriminations be made in sunlight, and also by relaxing the notion of a normal percipient by allowing super-discriminating humans who might be produced by genetic engineering, or who might even possess the power of responding to polarized light as bees do. Well, if all sorts of bug-eyed monsters are allowed, we do get away from anthropocentricity. Which is the right analysis of our concept of colours? I began on the slippery slope by allowing that a normal human percipient might be an idealization, or perhaps a syndicate. I am inclined to think that we capture ordinary usage best by sticking to illumination in daylight and not allowing, as Averill does, various special conditions of illumination which might allow discriminations to be made that cannot accord with what I take as ordinary usage. But whether it is he or I that is right about the ordinary use of colour words, or which of two contrary pressures to respond to, he does of course end up with a perfectly acceptable physicalist account of colour. I like it because of its rejection of anthropocentricity. With my account of colours the anthropocentricity exists but is as harmless as the key-centeredness of the shape of a lock. (Harmless, that is, so long as it is recognized for what it is. We must not get confused and project this anthropocentricity on to the perceived world.) Thus ontologically I see no need to disagree with Averill. I might say that when he talks of how coloured surfaces appear to percipients, I would rather talk about how these percipients discriminate (with respect

to colour) various shapes on surfaces. I think that Averill could consistently be interpreted in this way. I should also like to remind the reader that, for me, 'discriminate with respect to colour' is a simpler notion than that of 'colour', just as in set theory 'equinumerous' is a simpler (or more fundamental) notion than that of number.

Notes

1. J. J. C. Smart, 'Colours', *Philosophy*, 36 (1961), 128–42.

2. On p. 6 Armstrong follows my use (in 'Sensations and brain processes', *Philosophical Review* 68 (1959), 141–56) of Feigl's expression 'nomological danglers' to refer to dangling entities, not, as Feigl did, to the dangling laws themselves. Subsequently I followed Feigl's usage.

3. Robert Boyle, *Origin of Forms and Qualities*, 1666.

4. E. W. Averill, 'Color and the anthropocentric problem', *Journal of Philosophy* 72 (1985), 281–304. [chapter 2, this volume]

5. Ibid.

5 Colour Concepts and Colour Experience

Christopher Peacocke

What is the relation between the concept of an object's being red on the one hand and experiences as of red objects on the other? That is the recalcitrant question to which this paper is addressed.[1]

The question contains the term of art "concept". This term will be used here correlatively at the level of properties as the phrase "mode of presentation" is used at the level of objects by Frege. Thus if the thought that an object presented in a given way is ϕ has potentially a different cognitive significance from the thought that it is ψ, then ϕ and ψ are different concepts. Our recalcitrant question concerns the realm of thought, informativeness and cognitive significance, rather than the realm of reference.

Why has the question, and similarly its analogue for any other secondary quality, proved so recalcitrant? The reason is that there exists an apparently straightforward dilemma about the relation between being red and experiences as of red things, i.e., experiences in which something looks red. There are arguments for saying that each must be more fundamental than the other. Someone does not have the concept of being red unless he knows what it is like to have a visual experience as of a red object; and the occurrence of such an experience is just an experience in which something looks red. The connection here is specifically with visual experience. Consider these two biconditionals:

A perceptible object is red iff it looks red in standard circumstances

and

A perceptible object is square iff it looks square in standard circumstances.

Both seem to be true, but they are not of the same status. For

A perceptible object is square iff it feels square in standard circumstances

is as acceptable as the visual version in the case of squareness; whereas "feels red" makes no sense. Again, the congenitally blind can understand "is square". For these familiar reasons, visual experience seems to occupy a special position in an explanation of what it is for something to be red that no particular sense modality occupies in an explanation of what it is for something to be square. The point is not just that squareness is accessible to more than one sense: rather, what it is for something to have the property of being square cannot be explained in sensory terms at all. (Other differences are consequential on this.) These points are precisely what we should

expect if looking red is conceptually more fundamental than being red. Yet on the other hand the expression "looks red" is not semantically unstructured. Its sense is determined by that of its constituents. If one does not understand those constituents, one does not fully understand the compound; and conversely, with a general understanding of the "looks" construction and of some predicate ϕ for which "looks ϕ" makes sense, one can understand the compound without the need for additional information. Equally on the side of thought rather than language, being red is precisely how an experience as of something red presents that thing as being: the remark is platitudinous. So from this angle it appears that looking red could not be more fundamental than being red. How is this dilemma to be resolved?[2]

If colour is a coherent notion at all, it seems there are three possible types of response to this problem. These types are defined by the relations that they take to hold between the concept of being red on the one hand and concepts of experience on the other:

(i) The concept of being red is philosophically prior to that of looking red and to other experiential concepts. This is true not just in the uncontroversial sense that the phrase "looks red" contains "red" as a semantic constituent.[3] On this first type of view it is true also in the more substantial sense that an account of what makes an experience an experience as of something red must ultimately make use of the concept applicable to physical objects of being red where this concept is not to be explained in terms of properties of experiences. This we will label "the anti-experientialist option".

(ii) Neither being red nor any relevant family of concepts true of experiences ("experiential concepts") is prior to the other: both have to be characterized simultaneously by means of their relations to one another and to other notions. This is the no-priority view.

(iii) The concept of being red has to be explained in terms of experiential concepts: this can be done in a way not undermined by the fact that "looks red" semantically contains "red" and without any circular use of the concept of being red. This might be called "the pure experientialist view"—"pure" because the no-priority view is a partially experiential view. But for brevity we will call a view of this third type simply "the experientialist view".

These three positions exhaust the possibilities only for a given notion of priority. I have written, very loosely, of the relation "more fundamental than", "conceptually prior to", and "philosophically prior to". To be more precise, my topic here is a priority of definability. We can say that concept A is definitionally prior to concept B iff B can be defined illuminatingly in a given respect in terms of A: the fixed relation of priority with which we are concerned is definitional priority, and the respect in

which we want to be illuminated is what it is to have the concept of being red. There are other notions of priority in the offing: I will return to one of them later.

I take first the anti-experientialist view. One form such a view might take has been developed by Shoemaker: he holds, by implication, that the fact that an experience is as of something red consists in the fact that it would, in the absence of countervailing beliefs, give rise to the belief that the presented object *is* red.[4] Alternatively, such an anti-experientialist might try to characterize such experiences as those playing a certain role in an experientially-based ability to discriminate red from non-red things. In either case, the property of being red is employed in the account of what it is for an experience to be as of something red.

What, then, can the anti-experientialist say about the property of being red? His view collapses into the third option, that taken by the experientialist, if he attempts to explain redness in turn by appeal to the properties of experiences. One cannot assess the anti-experientialist's view, and neither can he establish the special connection with visual experience, until he gives some positive account of colour properties of objects.

One response that is not immediately circular is to say that the predicate "red" in fact picks out either a dispositional property of objects to reflect light of a certain sort, or picks out the categorical ground of this disposition. This is Armstrong's view, later adopted by Smart.[5] Such a view may have a relatively sophisticated structure. It may be said that after being introduced to certain sample objects as being within the extension of "red" one goes on to act in accordance with the definition that "red" picks out that state S of these objects which causes human observers to be in some experiential state which tends to give rise to the belief that some object has S, or tends to give rise to an ability to discriminate things with the property S. Such methods of introducing "red" are not formally illegitimate and avoid circularity, provided that the states quantified over can be characterized in terms other than "states which produce experiences of such-and-such kind". For instance, in verifying that some physical state T conforms to this more sophisticated definition, one has to check that T is possessed by the initial sample objects and that it produces in humans the belief that some object has T, or produces an ability to discriminate objects with the property T. The objections at this point are not those of circularity.

Told only that a word refers only to a certain object, we are not in a position to know what way of thinking of the object that word is used to express. Similarly, we can draw a distinction between physical properties themselves and ways of thinking of them; and the move we are envisaging the anti-experientialist as making gives an

account of which physical property the word "red" picks out, but gives no account of a way of thinking of that property the word expresses. We just said cautiously on behalf of the anti-experientialist that "red" picks out that state S of some initial sample of objects which causes human beings to be in some experiential state which tends to give rise to the belief that some object has S, or tends to give rise to the ability to discriminate things with the property S. But someone would equally be "acting in accordance with" such a specification if he employed some instrument which is sensitive to the reflectance properties of surfaces, and which gives this information in auditory form through a small loudspeaker. He may come to use this device unreflectively, and have beliefs about the properties of surfaces, beliefs which are caused by the auditory experience produced by the instrument, and which are not based on inference. Yet this person, if blind, need not have the concept of being red; and he does not fully understand "red" if he knows only that the word picks out the property he knows to be instantiated when he uses the instrument. This way of developing the anti-experientialist view lacks any component which would explain why possession of the concept and full understanding of the word is so closely tied to visual experience.

Since the anti-experientialist has an account only of the property "red" picks out but does not have any account of the way an understander is required to think of that property, the only propositional attitude and more generally psychological contexts containing "red" that he can explain are those in which it occurs transparently: contexts that say that someone believes of the property that such-and-such object has it, or of the property that it falls under so-and-so higher order condition. This leads to a difficulty in carrying out the anti-experientialist's programme of explaining the property of looking red in terms of being red, even when we confine our attention to visual experience.

Suppose that initially surfaces with a given physical reflectance property R look red, and those with a given physical reflectance property G look green. Then at a certain time, perhaps because of some effect on people's brains, things with R look green, and things with G look red. This is a case of universal intrasubjective change; it is detectable, and, we suppose, actually detected. The most difficult problem for our anti-experientialist is not whether in these circumstances things with R are no longer red—a question on which intuitions vary—but what account of "looks red" he can give which squares with the possibility of the case: for as the case is described, it is not in dispute that objects which have R no longer *look* red after the change (whether or not they really are red). How can the anti-experientialist secure this consequence?

The anti-experientialist may reply that immediately after the change experiences of a kind that before the change were produced by objects with R still tend to produce after the change the belief of the property R that the presented object has it. Such a belief, after the change, is false: but the anti-experientialist can argue that the case is analogous to those considered in discussions of proper names. If someone just like Quine kidnaps Quine early on in Quine's life and starts to act Quine's role, we will falsely believe this man to be Quine; in acquiring beliefs about him we also acquire beliefs that Quine is thus-and-so. The problem is rather that if the impostor continues long enough, the beliefs expressed in utterances of "Quine is thus-and-so" come to concern the impostor, so similarly in the anti-experientialist's account of the colour example: after a time it is correct to say that experiences in which something looks red tend to produce the belief that the presented object has physical property G, the one which before the change produced experiences as of green objects. In whatever sense Armstrong, for instance, would say that before the change experiences as of something red tend to produce beliefs (in a transparent sense) about physical property R, a long time after that change in that same sense such experiences will tend to produce beliefs about the different physical property G. For exactly the same relations hold between experiences in which things look red and the physical property G at a much later time as held before the change between such experiences and physical property R. This remains true if the change in the effects of R and G went unnoticed. (The same general point can also be made if the account of looking red in terms of red speaks of abilities to discriminate objects with property R.) But then the anti-experientialist account delivers the wrong answer on the question of the qualitative similarity of two experiences, one e before the change and another e' a sufficiently long time afterwards. e and e' may both be as of something red, but e tends to produce the belief of the presented object that it has physical property R (by Armstrongian standards), while e' tends to produce the belief that it has physical property G. It does not help to try to appeal to what would be the case if experience of the kind of e and e' occurred simultaneously to someone: for the *kinds* here will have to include determinate specifications of the experienced colour, and that is what we were asking the anti-experientialist to explain, and not just take for granted.

At this point the anti-experientialist may be tempted to argue that he can admit the possibility of intrasubjective inversion of the colour experiences produced by a given type of physical surface in fixed lighting conditions. He may argue that this possibility is allowed for in the fact that different central brain states may be produced by looking at such a physical surface at different times. But of course brain states may alter while experience remains the same: a change of brain state produced

by the surface is not sufficient for a change in colour experience. To make this account work, our anti-experientialist needs to distinguish just those changes in brain state which produce or are correlated with change in the colour the object looks: and he cannot legitimately do so in explaining "looks red". The problem here is one of meaning or significance. We have a conception of colour experience on which such a change of brain state is not constitutively sufficient for change in colour experience (which is not to say that it may not in some circumstances be good evidence for it). A general principle is applicable here. Suppose one can conceive of evidence which counts in favour of a hypothesis: that does not suffice to show the hypothesis to be significant if it is also true that our conception of what it is for that hypothesis to be true allows that either the evidence could obtain and the hypothesis be false, or *vice versa*. The rationale for this principle is obvious: if either the hypothesis or the evidence can obtain independently of the other obtaining, then to cite possible evidence does not exhaust the content of the hypothesis. We could call this general principle the Principle of Significance. It is not itself intrinsically a verificationist principle: rather, it functions as a constraint, a condition of adequacy, on any substantive general theories of meaning together with views about the content of particular sentences.[6] The Principle gets a grip here because the anti-experientialist was citing as possible evidence for intrasubjective inversion altered brain states, which are not, as we ordinarily conceive it, sufficient for such inversion.[7]

The anti-experientialist may complain that too much is being asked of him. "Why", he may ask, "cannot the concept of being red have the priority I claim for it whilst that concept is not further explicable? To someone who does not possess it, one can convey it only by suitable training (or brain surgery)." The problem with such a position is that it still does not account for the special features of the ability such training or brain surgery induces. No one has the concept of redness unless his exercises of that concept stand in quite special relations to his visual experience: it is hard to see how the anti-experientialist can explain why this is so without moving, by bringing in experience, from the first position to the second or third of the possibilities we described. The difficulty seems endemic to the anti-experientialist view.

The second option was a no-priority view. A no-priority view must offer more than the observation that 'Red things in standard circumstances look red' and 'Being red cannot be eliminated from an account of what it is for an experience to be as of something red' are both constitutively true. For corresponding claims are true of being square, and yet being square does not have the special relationship with visual experience that being red does. It is a virtue of the pure experientialist view, the third option, that it is not left as a mysterious, inexplicable necessary truth that one cannot experience objects as red in modalities other than the visual: the impossibility is

rather a simple consequence of an account of what it is for an object to be red which mentions specifically a feature special to visual experience. A no-priority theorist must explain the special relationship with visual experience.

A different no-priority theorist, one aware of this requirement, might try to explain both "red" and "looks red" in terms of the type of experience that is present when a certain experientially-based ability is exercised: something looks red to someone when this ability would be exercised with a particular result, and it is really red when it would be exercised with that result in standard circumstances. Now what would the ability be? One cannot say it is the ability on the basis of visual experience to discriminate red from non-red things. The occurrence of "red" in his description of the ability would prevent the resulting claim from being described as a no-priority view. But we ought to consider a bold modification of this idea, one on which we try to characterize the ability extensionally. We say that someone has a *reactive recognitional ability* (RRA) for a class *A* of objects in a given period (with respect to given physical circumstances) if and only if when trained to act in a particular way when he has a visual experience caused by objects in some sample subset of *A*, he goes on to act in the same way on the basis of the visual experience caused in him in the given physical circumstances by the remaining members of *A*, all in that period. An RRA is something one has in relation to a class, and so long as there is a class of red objects, one can speak of the existence of an RRA for a given class, and in terms of it explain "looks red" and "red" without initially using "red" and "looks red". Presumably the idea would be that there is a class with respect to which we have an RRA, a class such that when an object causes us (after training) to give on the basis of the visual experience it causes in us a positive response to it, we say it looks red: and it is red if it meets a similar condition in some standard specified circumstances. So the idea of this particular no-priority theory would be that both "red" and "looks red" are explained by reference to an RRA, and in such a way that certain connections—as that a red object looks red in standard conditions, etc.—are preserved between them.

This is a tempting theory, but the problems seem insuperable. If the properties of being purple and being shiny were coextensive, the corresponding RRA's would be identical, since they are identified by classes. The account needs to be thickened to distinguish between looking purple and looking shiny. This could not be done by appealing to counterfactual circumstances in which the responses for "purple" and "shiny" would come apart. This is not because they would not come apart— they would—but because the antecedents of the counterfactuals specifying the circumstances in which they come apart would either contain colour predicates or mention of the physical grounds of looking a particular colour. If they contained

colour predicates, the account would be circular, while the physical grounds of looking red may alter.[8]

There is also a second problem. The definition of a RRA requires the ability to learn to produce a new response to red objects when conditioned anew. But the ability to learn new responses seems distinct from the enjoyment of colour experience, and may be absent in a creature though it does enjoy such experiences. It would be too weak to require only that in some circumstances the creature gives the same experientially based response to precisely the things in a certain class; for in some circumstances the response may not be to the colour of the object.

This does not exhaust the plausible no-priority theories. In particular, there is a form of no-priority view which tries to take on board the considerations in favour of the third option, that of the experientialist, and then goes on to claim that these considerations can all be accommodated within the no-priority view. We will be able to formulate this properly only after developing that third option, taken by the experientialist.

The experientialist can say that when a normal human sees a red object in daylight, there is a certain property possessed by the region of his visual field in which that object is presented to him. This property we can label "red'": the canonical form is that region r of the visual field is red' in token experience e. Being purely a property of the visual field, rather than a property the experience has in virtue of representing the world as being a certain way, red' does not require the possession of any particular concepts by the subject in whose experiences it is instantiated. It is true, of course, that we have picked out the property red' of experiences by using the ordinary notion of redness; but it does not follow that someone could not manifest a sensitivity to the red'-ness of his experiences without already possessing the concept of redness. The experientialist may now say this: in mastering the predicate "red" of objects, one comes to be disposed to apply it to an object when the region of one's visual field in which it is presented is red' and circumstances are apparently normal (and when one has indirect evidence that it would meet this condition were it so presented). The experientialist will say that this explains the inclination we feel initially to explain "red" in terms of "looks red". He will say that what is correct is to explain red in terms of red': since normally when something looks red, the region of the visual field in which it is presented is red', he will say that the inclination is not surprising. Since for him the property red' of experiences and a sensitivity of one's judgements to its presence are the fundamental notions, rather than that of looking red, this experientialist does not need to deny the obvious fact that "red" is a semantically significant constituent of "looks red".

The experientialist is not committed to the consequence that anyone who can exercise the concept of redness also has to have the sophisticated concept of experience. All this experientialist requires for the possession of the concept of redness is a certain pattern of sensitivity in the subject's judgements to the occurrence of red' experiences: this sensitivity can exist in a subject who does not himself possess the concept of experience. This experientialist can then agree with the letter of Wittgenstein's claims in these passages:

315. Why doesn't one teach a child the language-game "It looks red to me" from the first? Because it is not yet able to understand the rather fine distinction between seeming and being?

316. The red visual impression is a new *concept*.

317. The language-game that we teach him then is "It looks to me ..., it looks to you ..." In the first language-game a person does not occur as perceiving subject.

318. You give the language-game a new joint. Which does not mean, however, that now it is always used.[9]

It is important to note that the experientialist is operating with three, and not two, notions: that of being red', that of looking red, and that of being red. The second of these is not in any simple way definable in terms of the first. However plausible it may seem at first blush, it is not true that anything which looks ϕ must be presented in a region of the visual field which is ϕ'. If one looks through a sheet of red glass at an array which includes a sheet of white paper, the sheet will be represented in the experience itself as being really white: anyone who has such an experience will, taking his experience at face value, be disposed to judge that the sheet really *is* white, and "white" here refers to the property of physical objects. It should be emphasized that this is not a matter of conscious inference: the surface of the paper is *seen* as white.[10] In such a case, it would be wrong to insist that the region of the visual field in which the paper is presented is white' and wrong to insist that it is red'. We have here a new kind of experience, and any extension of these primed properties from the cases where the conditions of viewing are more normal seems partly stipulative. Certainly to insist that in this case the region of the visual field is obviously white' seems to rely tacitly on the representational content of the experience in determining the application of the primed predicates: and since this representational content contains the concept of being white, the experientialist cannot on pain of circularity use such applications of primed properties in explaining colour predicates. The experientialist should, rather, agree that something can look ϕ without being presented in a ϕ' region of the visual field, and explain how this can be so as follows. Insofar as he is prepared to offer a definition of "x is red", it would be along these

lines: "x is disposed in normal circumstances to cause the region of the visual field in which it is presented to be red$'$ in normal humans". Now this concept of being red may enter the representational content of a subject's experiences. That it may so enter is an instance of a general phenomenon of concepts entering the representational content of experience. In possessing for instance the concept of complacency, one has the concept of a person who is unconcerned about something when there are available to him good reasons for concern: this is a trait that manifests itself in the man's thoughts. But one can also *see* a face or a gesture as complacent, and one can hear an utterance as complacent. The experientialist should say that the property red$'$ stands to being red as the components of an account of being complacent stand to being complacent; while the property of an experience of representing something as red stands to being red in certain respects as the property of representing a gesture as complacent stands to being complacent. One must, then, beware of pinning an overly simple account of the property of representing something as red on the experientialist. In normal circumstances (and—unlike complacency—constitutively so) a thing presented in a red$'$ region of the visual field is indeed seen as being red; but this is not the only way something can be seen as red, and the experientialist can acknowledge the fact.

We noted earlier that not all views of the no-priority type had yet been discussed. What we considered earlier were no-priority views which claimed that being red and looking red have to be simultaneously explained. It now appears that a much stronger type of no-priority view would be one on which the concepts which have to be introduced simultaneously are not those of being red and looking red, but rather those of being red and of being red$'$. Red objects are ones that in normal viewing conditions are presented in red$'$ regions of the visual field: and red$'$ is that property of regions of the visual field instantiated in regions in which red objects are presented in normal circumstances. Such a no-priority view can take over much of what we have already attributed to the experientialist, including the threefold distinction between red, looking red and red$'$.

But can these relations between red and red$'$ really sustain the claim that we have here a no-priority view? We said that the sense in which the definition of being red in terms of red$'$ was relevant to possession of the concept of redness is not that anyone who possesses it must be able to supply that definition, but rather that it captures a sensitivity to red$'$ experiences which must be present in judgements that a presented object is red. Is it equally true that if someone possesses the concept red$'$, there must be some appropriate sensitivity of his judgements involving *it* to the presence of redness, as opposed to other properties? One way to see that this is implausible is to consider a community the members of which not only often see things in normal

daylight, but also often see them under ultraviolet light (perhaps at night). They might use "red$_{UV}$" as a predicate true of objects which are presented in a red$'$ region of the visual field when seen under ultraviolet light. Now we can ask: is it true that anyone who possesses the concept red$'$ must have a special sensitivity of his judgements involving it to the presence of redness as opposed to red$_{UV}$-ness? This seems to have no plausibility: if someone learns that red$'$ is that property of the visual field instantiated by regions in which red$_{UV}$ objects are presented in ultraviolet light, he can fully understand "red$'$". Indeed anything that tells him what that experiential property is, whether or not it mentions redness, will suffice to give him understanding. This seems to undermine the status of the view under consideration as a no-priority view: though one can indeed give definitions of each of "red" and "red$'$" in terms of the other, a sensitivity to red$'$-ness is essential in grasping the concept of redness, whereas a sensitivity to redness is not essential to grasping the concept of red$'$-ness in the same way. The result seems to be a priority of red$'$-ness, an experientialist rather than a no-priority conclusion.[11]

An objector might agree that it is false that red rather than red$_{UV}$ has to be used to explain red$'$; but he may nevertheless say that what is definitionally prior to both red and red$_{UV}$ is a certain *character*, in a suitable generalization of Kaplan's notion.[12] Different utterances of "I" may refer to different persons, but there is a single uniform rule for determining which person is referred to at any given context of utterance. The objector's point may be that we should adapt Kaplan's notion by replacing "context of utterance" with "condition of perception taken as standard". We could then say this: words differing as "red" and "red$_{UV}$" differ may refer to different properties, but there is a single uniform rule for determining which property such a word refers to if any given condition of perception is taken as standard. Thus in a certain sense the characters of our "red" and their "red$_{UV}$" are one and the same, and it is this character which is prior to red$'$.

This view would indeed circumvent the objection. But the difficulty for it lies in stating what the common character of "red" and "red$_{UV}$" is. What is the common rule which, applied to different conditions of perception taken as standard, gives the different properties of being red and of being red$_{UV}$? The objector can hardly say that for given conditions of perception the rule picks out the property of looking *red* under those conditions: for that brings back all the old problems. But if the objector were to say that the rule should advert to the property of being presented in a red$'$ region of the visual field, he has not shown red to be definitionally prior to red$'$.

There are other types of priority than the definitional. We can say that a concept *A* is *cognitively prior* to *B* if no one could possess the concept *B* without possessing the concept *A*. In the simplest case, this will be because a property thought of by way

of the concept B has to be thought of as the property bearing certain relations to concept A. One should not assume that definitional priority and cognitive priority must coincide. It may be that in some cases one concept is definitionally prior to a second, while that second concept is cognitively prior to the first. This may be the case where the first concept is red$'$ and the second is that of being red.

If concept A is definitionally prior to concept B because a thinker has to use that definition in thought when he employs the concept A, and if one concept can be cognitively prior to another only because the latter has to be defined in terms of the former, then it might be that definitional and cognitive priority have to coincide. But in the case of red$'$ and red, the first antecedent of this conditional is false. A definition of an object's being red as its disposition to present itself in a red$'$ region of the visual field under certain conditions is good not because it captures the way everyone must think of being red; rather, as we said, the judgements of one who has the concept of being red are responsive to experience and evidence in exactly the same ways as would be the judgements of one who explicitly used this definition. If one wishes to maintain that red$'$ is definitionally prior to red, but cognitively posterior to it, then the fact that one can have an experience in which a region of one's visual field is red$'$ without having the concept red$'$ is crucial in avoiding circularity in the account of mastery of the concept of being red.

The reasons which might be given for saying that red is cognitively prior to red$'$ are subjects for other work.[13] It might, for example, be held that a necessary condition of possessing a conception of other minds according to which others can have red$'$ experiences in exactly the same sense as one can oneself is that red$'$ experiences, one's own and others, are alike thought of as experiences which bear certain relations to the property of objects, perceivable by oneself and others, of *being* red. (Such a reason would, if correct, have an a priori status, as required by the characterization of cognitive priority.) What matters for the present is just the possibility of such a position. For if it is possible, one must be careful before drawing any anti-experientialist conclusions from considerations of priority, and correspondingly careful in ascribing the anti-experientialist view to others. For someone's insistence that red is prior to red$'$ may be an expression of cognitive priority. Such a theorist may not be rejecting definitional priority in the reverse direction. If he is not, then it would be wrong to ascribe to him anti-experientialist views. Indeed, it may well be that Wittgenstein should be regarded as holding just such a combination of views. In a passage already displayed, he insists that "red" has to be learned before certain concepts of experience; while elsewhere he seems to hold at least that seeming to be a certain colour cannot be left out of an account of what it is to have that colour:

97. Don't we just *call* brown the table which under certain circumstances appears brown to the normal-sighted? We could certainly conceive of someone to whom things seemed sometimes this colour and sometimes that, independently of the colour they are.

98. That it seems so to men is their criterion for its *being* so.

99. Being and seeming may, of course, be independent of one another in exceptional cases, but that doesn't make them logically independent; the language-game does not reside in the exception.[14]

If Wittgenstein did or would have believed in the cognitive priority of red over red', but was nevertheless not an anti-experientialist, then according to the arguments I have been endorsing, his position was consistent.

The experientialist view also has consequences for the explanation of experience. In the case of primary qualities, it is legitimate, and arguably mandatory in normal cases, to explain someone's experience of an object as square by the fact that it really is square (or by something entailed by its being square). But on the experientialist view one could not explain in a central case an object's looking red to someone by citing the fact that is really is red—at least, not if this explanation were intended to leave open the question of whether there is any primary quality ground of redness. Genuine explanations cannot have a *virtus dormitiva* character. On the particular experientialist theory I suggested, for something to be red is for it to produce experiences of a certain kind, red' experiences, in standard circumstances. In central cases—those by reference to which possession of the concept of redness was analysed—for a thing to look red to someone is for it to produce red' experiences. So on the experientialist option, the conditional "If circumstances are standard, in a central case if an object is red, then it looks red" is *a priori*: it reduces to a logical truth of the form $\forall x((Sx \ \& \ (Sx \supset Rx)) \supset Rx)$. An expression might of course be introduced as an abbreviating ("descriptive") name for whatever physical state (if any) is the ground of objects' producing red' experiences. It is not clear, and perhaps not determinate, whether "red" is used in this way in English, but if it were what would make it legitimate to say "It's red" in explanation of something's producing red experiences in standard conditions would be the existence of some other, physical, characterization of the object that produces red' experiences.[15]

Acknowledgements

I have been helped by the comments of Rogers Albritton, Philippa Foot, John McDowell, and Colin McGinn on an ancestor of this paper written in 1980, and by Crispin Wright on a more recent version. This paper was written before, and the proofs corrected after, the final version of my *Sense and Content*, Oxford University

Press, Oxford, 1983. Where it differs from, or is more elaborate than, the treatment of colour concepts in *Sense and Content*, the paper supercedes the book. The book does, however, contain more elaboration of the idea of a sensational property, of which red' is but one instance.

Notes

1. This question is intimately related to another, also touched on by Wittgenstein, viz., 'What is the nature of the relation of qualitative sameness of two experiences of different subjects, or of one subject at different times?' An answer to that question is partly constrained by the correct answer to the question of this paper.
 The present paper is the first half of another, too long for inclusion in this special issue. The second half of the longer paper is concerned with sameness of experience between subjects and over time: I aim to publish that second part as soon as other pressures permit.
 The reader whose primary interest is the interpretation of Wittgenstein should be warned that, wanting to take into account the views of more recent writers on our question, I have adopted a more eclectic framework for the discussion than Wittgensteinian exegesis alone would dictate.

2. There is a passage in *The Concept of Mind*, Penguin, London, 1963 in which Ryle brings out the dilemma, but curiously leaves it untreated: "... when I describe a common object as green or bitter ... I am saying that it would look or taste so-and-so to anyone who was in a condition and position to see or taste properly ... It must be noticed that the formula "it would look so-and-so to anyone" cannot be paraphrased by "it would look *green* to anyone", for to say that something looks green is to say that it looks as if it would if it were green and conditions were normal." Having denied that this paraphrase is correct, Ryle is left explaining "green" by a definition which takes the phrase "looks so-and-so" as an unexplained primitive: this unacceptable price is what he pays to avoid the threatened circularity.

3. For emphasis on the importance of this relatively uncontroversial point, see Anscombe, 'The Intensionality of Sensation' in R. Butler (ed.), *Analytical Philosophy* (Second Series), Blackwell, Oxford, 1965, p. 172 and W. Sellars, 'Empiricism and the Philosophy of Mind' in his *Science, Perception and Reality*, Routledge, London, 1963, p. 141ff. Sellar's later explanation (p. 147) of why, as he puts it, it is a necessary truth that something is red iff it looks red to standard observers in standard circumstances is that standard conditions are just conditions in which things look as they are. This may be true, but it applies to any predicate F for which "looks F" has some application: it does not explain why the concept of being red has a closer connection with visual experience than does the concept of being square.

4. Shoemaker, 'Functionalism and Qualia', *Philosophical Studies* **27**, 1975, 291–315.

5. D. M. Armstrong, *A Materialist Theory of the Mind*, Routledge, London, 1968; J. J. C. Smart, 'On Some Criticisms of a Physicalist Theory of Colors', in Chung-ying Cheng (ed.), *Philosophical Aspects of the Mind-Body Problem*, University of Hawaii, Honolulu, 1975. [chapter 1, this volume]

6. The principle should also be accepted by criterial theorists of meaning, in the sense in which "criterion" is understood by, for instance, P. M. S. Hacker in *Insight and Illusion*, Oxford University Press, Oxford, 1972. Such a theorist would (or should) not admit the possibility that someone be in pain yet none of the criteria, however far one investigates possible defeating conditions, indicate that he is.

7. These remarks apply to Shoemaker, 'Phenomenal Similarity', *Critica* **20**, 1975, p. 267. They could also be applied *mutatis mutandis* to his remark in 'Functionalism and Qualia' that if two persons could fuse into a single subject of consciousness, "the behaviour of the resulting person could presumably settle [the question of whether their colour spectra were inverted relative to each other]"—N. Block (ed.), *Readings in the Philosophy of Psychology* (Reprint), Vol. 1, Harvard University Press, Cambridge, 1980, p. 264.

8. Extensionality also produces other problems: it is difficult to give a satisfactory account of how an object that is in fact red might not have been.

9. Ludwig Wittgenstein, *Remarks on the Philosophy of Psychology*, Vol. 2 (ed. G. H. von Wright and H. Nyman), University of Chicago Press, Chicago, 1980, p. 60e.

10. The red of a pane of red glass is a transparent film colour (Flächenfarbe) rather than a surface colour in the sense of psychologists of colour perception. The *locus classicus* is D. Katz, *The World of Colour*, Kegan Paul, London, 1935, p. 17ff. In seeing a snowman through a pane of red glass, one sees the pane as having a transparent film colour red and the snowman as having the *surface* colour white behind it. A red snowman by contrast would have the surface colour red. If the pane of glass is thick, the colour red may appear as a volume colour—one that is presented as occupying a volume of space. (See Katz, or again J. Beck, *Surface Colour Perception*, Cornell University Press, Ithaca, 1972, p. 20.) Anyone who doubts these points should look at a white surface through a coloured transparent bottle, or consult Plate 1 of Beck's book.

11. This point does not depend upon taking "red" and "red′" as natural kind terms. The view for which I am arguing is that for an object to be red is for it to be presented in a red′ region of the visual field in certain conditions (external and internal to a perceiver). In the case of red and red$_{UV}$ these conditions are different, and so the properties of being red and of being red$_{UV}$ are different in at least one sense. There is no commitment in saying that an object is red$_{UV}$ to how it would look in normal daylight.

12. David Kaplan, 'On the Logic of Demonstratives', *Journal of Philosophical Logic* **8**, 1978, 81–98.

13. I have discussed some of them in 'Consciousness and Other Minds', *Proceedings of the Aristotelian Society*, Supp. Vol. 1984.

14. Ludwig Wittgenstein, *Remarks on Colour* (trans. L. McAlister and M. Schättle), Blackwell, London, 1977, p. 29e.

15. In *Form and Content*, Blackwell, Oxford, 1973, Bernard Harrison argues that colours are not "natural nameables". These last are objects which are "defined as distinct objects of reference ... independently of linguistic convention". The experientialist does treat colours as natural nameables under this definition: the fact that something is a natural nameable in Harrison's sense does not exclude the possibility that an account of the nature of the object may have to make reference to human experience.

Harrison's own model of colour-naming is as follows: we fix a set of shades as name-bases, and apply the colour word associated with that name-base to any shade which more closely resembles that name-base than any other. He takes this to justify his view that colours are not natural nameables: yet it seems clear that the experientially caused actions of a nonlinguistic creature could manifest sensitivity to exactly the colour distinctions which are determined by Harrison's model of colour-naming as applied to, say, English.

6 An Objectivist's Guide To Subjectivism About Colour

Frank Jackson and Robert Pargetter

Locke saw that science teaches us something important about colour, but he wavered between saying that it taught that colour was a property of experiences (ideas), not objects, and saying that it taught that colour was the disposition in objects to produce those experiences. We suspect that he wavered because he did not care about the difference between the two positions. What he most wanted to say was that colour was *not* a non-dispositional, objective property of objects. It differs, thus, from shape and the other primary qualities in general, which are objective properties of objects, and even if some are dispositions, none is merely a disposition to cause certain kinds of experiences.

This paper is a defence of exactly what Locke most wanted to deny. It is a defence of the view that colours are non-dispositional properties of objects as 'primary' in their nature as shape and motion. Indeed, in the case of opaque objects, they are probably complexes of such properties of the object's surface and immediate surroundings, though we will not be going into the contentious scientific details.

This view is far from new. We first heard it expounded many years ago by David Armstrong.[1] What is, we trust, new is partly the argument path to the view, but mainly the way the particular version of the view that we will defend explains the special features many have perceived are characteristic of colours by contrast with shapes. (i) Colours are much more closely tied to the experience of colour than are shapes to the experience of shape. (ii) Something like 'To be red is to look red in normal circumstances' is a truism for standing colours; and something like 'To be red in C is to look red in C' is a truism for transitory colours. (iii) The argument from microscopes and similar subjectivist arguments really do show something important about colours which they do not show about shapes. (iv) The ascription of a certain shape to an object is related to the object's causal interactions with other objects in a way that the ascription of a certain colour is not.

Points like these have been independently noted by many writers on the distinction between primary and secondary qualities. They individually and collectively suggest an important difference between colours and shapes which justifies labelling the first 'secondary' and the second 'primary', and which in any case rules out identifying colours with physical properties of objects. Indeed, these points are why we did not accept Armstrong's view for many years. But we will see that this suggestion is a *suggestio falsi*.

We will start in Section 1 by suggesting a simple and plausible account of the meaning of colour terms. We will see how it leads, along with the empirical facts disclosed by science, to the thesis that colours are physical properties of objects. In

Section 2, we will see how to preserve the dispositional truism. In Section 3, we will show how to develop our theory so as to accommodate the basic insight that has wrongly led to subjectivism about colour; and the remaining sections will be concerned with causal interaction patterns, and with colours in the dark and in possible worlds where objects look a quite different colour from their actual colour.

1 Colour Terms

It is surely good methodology to start with what seems most obvious. What is most obvious about the colour terms, 'red', 'yellow', 'blue', and so on is that we use them to denote properties that we take to be presented to us in visual experience. Redness is visually presented in a way that having inertial mass and being fragile, for instance, are not. Our access to colour is through our visual experience of colour. If you do not know what looking red is like, you do not have our concept of redness. But if you do, what else do you need, in what way can your *concept* of redness then be defective? By contrast, it is clearly not enough in order to possess the concept of squareness to know what it is like for something to look square. Grasping squareness requires tactual experience and geometrical understanding as well as visual experiences of things looking square.

Accordingly, it would be quite wrong to say, as an account of their meaning, that the terms for shapes—'round', 'square', and so on—are simply terms for properties that present themselves in certain visual experiences. A much more complicated story than this is called for in the case of shapes. But not in the case of colours. Both shapes and colours present themselves in visual experience—things look green and look round—but only in the case of terms for colours is this fact plausibly the only essential ingredient in giving an account of their meaning. But we do not use 'red' as the name of the experience itself, but of the property putatively experienced. We examine *objects* to determine their colour, we do not introspect. We thus get the following clause for 'red': 'red' denotes the property presented in the experience of looking red, or, in more natural English, redness is the property objects look to have when they look red. If the last sounds like a truism, that is all to the good; it is evidence that we are on the right track. There will, of course, be similar clauses for 'yellow', 'blue', and so on.

We now face a difficult question. What is it for an experience to be the presentation of a property? How must experience E be related to property P, or an instance of P, for E to be the presentation of P, or, equivalently, for E to represent that P? One thing, though, is immediately clear. A necessary condition is that there be a causal connection. Sensations of heat are the way heat, that is, molecular kinetic

energy, presents itself to us. And this is, in part, a matter of kinetic energy *causing* sensations of heat. We say 'in part', because, for instance, the causation must be in the 'right way'.[2] If a hot iron causes a burn mark on my shirt and seeing this burn mark startles someone holding a hot potato so that they drop it on my arm, thus causing a sensation of heat, I am not perceiving the heat in the iron although it causcd my sensation of heat. The sensation of heat in my arm is not a presentation of the heat of the iron (although it is a presentation of the heat of the potato), or, in more natural English, the sensation of heat, though caused by the iron's heat, is not an apprehension of the iron's heat.

For present purposes, however, the causal part of the story is enough. We can work with the rough schema: redness is the property of objects which causes objects to look red, without worrying here about the needed 'add ons', that is, without worrying about what needs to be added to causation to bring it up to presentation.

For instance, despite its roughness, our schema makes it clear why the familiar dispositional treatment of colour is mistaken. Redness is not the disposition, power or capacity of an object to look red. For if it were, an object's looking red would not be the apprehension of that object's redness, because dispositions do not cause their manifestations. Their categorical bases do that. Fragility is not what causes a glass to break on being dropped. It is the very fact that it would break when dropped; and the fact that it would break when dropped is not what breaks the glass when it is dropped. Its internal molecular nature or whatever does that.[3] Holding that redness is the disposition to look red would commit us to denying the evident fact that a thing's looking red in the right circumstances is the *apprehension* of that thing's redness.

We are now ready to make use of what science tells us about colour. Colours are what cause (in the right way etc.) objects to look coloured. That is a piece of philosophy. What causes (in the right way etc.) objects to look coloured are physical properties—notably, certain highly complex primary properties involving shape, extension, motion and electromagnetic energy, though much is still unclear. That is a piece of science. Therefore, colours are physical properties.

The basic theory is now before you. We turn to the task of explaining the widely shared philosophical insights about colours in terms of it, or in terms of refinements of it that we will introduce as the need arises.

2 The Dispositional Truism

The popularity of the dispositional account of colours derives, of course, from the fact that something along the lines of: '*x* is red iff *x* looks, or would look, red in

normal circumstances' sounds like a truism (as an account of standing colour). What more natural, then, than to identify redness with the disposition? But we can admit the truism while resisting the identification.

Consider the range of height which disposes towards victory in basketball, and tag it 'alcindor'. Alcindor is *not* a dispositional property; it is, say, being over seven feet tall, which is not a dispositional property (or, at least, not one towards victory in basketball). But '*x* has alcindor iff *x* is disposed to win at basketball' is a truism, being in fact analytically true. The property is not itself a disposition, but earns the label 'alcindor' by virtue of conferring a disposition on what possesses it. We should say the same about redness. Redness is the categorical basis of the disposition, not the disposition itself, and it earns the name 'redness' by virtue of being the categorical basis of the disposition. (We consider shortly what to say if there are many bases of the disposition.) Thus, we can explain the dispositional truism without making colours dispositions to look coloured.

We could, of course, say something similar for fragility. (As David Lewis convinced us.) We *could* use 'fragility' to denote whatever (non-dispositional) property is responsible for an object being such that if it were dropped, it would break (the latter property would then need a new name). This would preserve the special status of something like '*x* is fragile iff *x* would break on being dropped' without making fragility a disposition to breaking. There is, however, no reason to do this in the case of fragility. The trouble for identifying colours with dispositions to look coloured is that this is inconsistent with the prime intuition that colours are properties presented in the visual experience of having something look coloured. But it is not a prime intuition that fragility is a property presented in experience, and so we do not need to give it itself a causal role with respect to experience. We perceive colour, but infer fragility.

3 Subjectivism About Colour

If colours are physical properties of objects, then they are as objective and primary as shapes. The redness of a tomato is just as much an objective property of it as is its roundness. Thus we are flying in the face of the host of persuasive arguments for a broadly subjectivist account of colour. We think that the significance of these arguments has been completely misunderstood. They show something important about colour, but that important truth is not subjectivism.

The arguments turn on three truths about colours. (i) The fundamental ground for ascribing a certain colour to something is the colour it looks to have. (ii) The colour something looks to have may be highly variable, depending both on viewing

conditions and on who is doing the viewing. (iii) There are clear cases—actual and also possible-but-not-fantastical ones—where the apparent colour of a given object is quite different in one set of circumstances from the apparent colour in another set of circumstances, and yet it is impossible in any non-arbitrary way to settle on which apparent colour, in which set of circumstances, should be the guide in ascribing a colour to the object.

As everyone knows, Berkeley said that the same goes for shape. But neither (i) nor (iii) applies to shape. The shape something looks to have is not *the* fundamental ground, but one among a number of grounds, for ascribing shape to an object. And, relatedly, as we will see, *non-arbitrary* choice between conflicting apparent shapes can always be made, at least in principle. How, then, do we avoid subjectivism, while granting so much to the arguments for it. We will introduce the leading idea by reference to taste instead of colour, because, as Jonathan Bennett observes, phenol affords a particularly striking example of the kind we are interested in.[4]

Phenol tastes bitter to about seventy percent of the population, and is tasteless to about thirty percent of the population. Is phenol bitter, or is it tasteless? There seems to be absolutely no reason to prefer one group's answer to the other's. The statistics could easily be changed in either direction by selective breeding; those to whom phenol tastes bitter are not generally better at perceptual discriminations than those to whom phenol is tasteless; the conditions under which the tastings are done are equally good in both cases; and so on and so forth. How then can we avoid giving a broadly subjectivist, or at least dispositional, account of being bitter? We avoid subjectivism by saying that bitterness for those to whom phenol tastes bitter is a *different* property from bitterness for those to whom phenol is tasteless. Bitterness for phenol tasters is not the same property as bitterness for phenol non-tasters. We are not saying that tasting bitter, the experience, is a different kind of experience for the two groups, but we are saying that the property presented to the first group when something tastes bitter is different from that presented to the second group when something tastes bitter. The idea is far less revolutionary than it may at first sound. We are familiar with the idea that pain for humans may be different from pain for dolphins, that what fills the pain-role may differ from one group of organisms to another (which is compatible with the experience being the same in both).[5]

We noted a moment ago that a *non-arbitrary* choice between conflicting apparent shapes can, in principle, always be made. Suppose an object looks spherical to Jim but looks slightly flattened at the ends to Fred. We settle the dispute by investigating the causal origins of Jim's and Fred's experiences and shape judgements. If the property of the object which causally explains the experiences and judgements is its

being spherical, Jim is right; while if it is its being oblate, Fred is right. The difference with taste is that this kind of investigation can easily fail to settle disagreements. The majority declare phenol bitter, the minority declare phenol tasteless. We investigate which properties of the object causally explain the declarations, and find that it is property, P, in each case—the difference in the declarations being due to the different effects of P on the two groups. This result in itself gives us no reason to favour one declaration over the other. It shows merely that P is bitterness for the first group but not for the second. The crucial point with shape is that there is no question of one and the same property being one shape for one group and a distinct shape for another group. Oblateness, for instance, is the same property for everyone in all circumstances and at all times. Not so with taste.

And not so for colour. We said, in our rough schema, that redness is the property of objects that causes them to look red. But which property it is that causes an object, 0, to look red to a person, S, may depend both on the nature of S's internal physiology at the time, t, and on the circumstances, C. Accordingly, a refinement of our schema is:

Redness for S in C at t is the property which causes (or would cause) objects to look red to S in C at t.

The point is that redness—though not the experience of having something look red—may very from person to person, and, for a given person, from circumstance to circumstance or from time to time. We say 'may', not 'will'. It is a question for science if and when redness for one person is different from redness for another, and redness in one lighting condition is different from redness in another lighting condition. For, in terms of our rough schema, it is the empirical question as to whether the property which causes things to look red to S_1 in C_1 at t_1 is the same as the property which causes them to look red to S_2 in C_2 at t_2; or, in terms of the presentation of properties in experiences, the question is whether the property presented in the looking-red experience of S_1 in C_1 at t_1 is the same property as that presented in the looking-red experience of S_2 in C_2 at t_2.

Subjectivists and dispositional theorists about colour taunt objectivists with the notorious variability of apparent colour. They point out that an object 0 may look one colour to typical percipient Fred in good viewing circumstances C_1, and another colour to Fred in different, but still good, viewing circumstances C_2, and that there may be no principled reason for discriminating between C_1 and C_2 in respect to which are the best conditions for apprehending the properties of the world around us. Accordingly, they ask how Fred could possibly make a *non-arbitrary* decision as to the real colour of 0.

Our reply is to grant that it is wrong to insist that either Fred's robust declaration in C_1 that 0 is, say, red or Fred's equally robust declaration in C_2 that 0 is, say, yellow must be false. The subjectivist is right that it would be unacceptably arbitrary to do so. What we say instead is that *both* declarations may be true. The correct position is that 0 may be red in C_1 and yellow in C_2. How can we reconcile this with taking colours to be physical properties?

We need to distinguish two cases. One is where the change from C_1 to C_2 actually changes which physical properties cause the relevant experiences. This case is patently no problem for us. The difference in colours is matched by a relevant difference in physical properties. A white wall looking blue under blue light may be an example of this kind. The blue light may actually change the relevant physical properties of the wall's surface, in which case the right thing to say is that the wall under blue light *is* blue. The light actually *turns* the wall from white to blue. Acknowledging this does not, of course, prevent us from saying, as speakers of English typically do, that the wall is really white. The 'really' though has no metaphysical significance. It merely marks the existence of the convention in English that the colour an object has in white light is given, for reasons of convenience, a special label.

The hard case for us is where it is plausible that no change in the relevant physical properties occurs. Mountains seen from afar need be no different from mountains seen close up; putting blood under a microscope need not change its physical nature, yet its apparent colour changes from red to yellow. Our treatment of these cases turns on the point that despite initial appearances, the following triad is consistent: (i) 0 is red in C_1, and yellow in C_2, (ii) the relevant physical properties of 0 are the same in C_1 and C_2, and (iii) redness and yellowness are both physical properties.

The triad is consistent because the physical property which is redness in C_1 may be the physical property which is yellowness in C_2. The physical property which is redness for blood in normal viewing conditions is yellowness for blood under a microscope. The right thing to say in these cases is that which physical property is which colour changes, just as which property is bitterness is different for the two groups in the phenol case.

Three objections are likely to spring to mind at this point. The first is that if, as we grant is possible, redness in C_1 for me now is the same property as greenness in C_2 for me now, then when I say, in C_1, that 0 is red, and, in C_2, that 0 is green, I must be saying the same thing about 0. But clearly I am not. But if I say that Fred has the same height as the tallest man in France, and also that he has the same height as the tallest man in Britain, I am not saying the same thing about Fred even if the height of the tallest man in France is exactly the same as the height of the tallest man in Britain. Conversely, even if redness in C_3 for me now is a different property from red-

ness in C_4 for me now, when I say that an object in C_3 is red and another in C_4 is red also, I am saying that they (and not just the experiences they may cause in me) have something in common. Both have what is redness for me now in their circumstances.

The second objection is that we go around saying that objects are red or green or blue or ..., we do not go around saying that they are red to S in C or green to T in D or But equally we go around saying that squash balls are round, yet much of the time—during rallies anyway—they are anything but round. Metaphysically speaking, the round shape a squash ball has at rest is no more its real shape than the flattened shape it has on impact against the back wall. Nevertheless, in normal circumstances it is 'Squash balls are round' that counts as true. It is clear, even without inquiring into how to analyse 'normal', that we interpret 'Squash balls are round' said without further ado, as 'Squash balls are round in normal circumstances'. Similarly, 'Tomatoes are red', said without further ado, is interpreted as 'Tomatoes are red to normal people in normal circumstances', and so is true iff 'Tomatoes have redness for normal people in normal circumstances' is true. But this in no way shows that redness for normal people in normal circumstances is, or is not, redness for you now, or whatever. Our position here is a natural extension of a common attitude towards the distinction between standing and transitory colour. Everyone grants this distinction, and many hold that it is the transitory colours which are basic, standing colours simply being transitory colours in normal circumstances.[6] Our view is that it is the 'transitory' colour to S in C at t, which is basic.

The third objection claims that we are taking unfair advantage of the earlier slide from presentation to causation. We claimed that the points we wished to make in what was to come were independent of what needed to be added to causation to get presentation, and so, that we could work with the rough schema. The fourth objection is that this claim is false. The difference between presentation and causation blocks the possibility of redness for S_1 in C_1 (at t_1) being different from redness for S_2 in C_2 (at t_2). But how could the 'add ons' make trouble for this possibility?

It might be argued that in order for an experience to be a presentation of a property of the objects around us, the experience and the objects need to share the relevant property. We must have resemblance, to put it in the Lockean terminology. Thus, as looking red is the same experience for different people in different circumstances, redness is the same presented property throughout. It is now widely believed that Berkeley won at least this part of the argument with Locke and that resemblance in any literal sense between ideas and mind-independent objects is a mystery. Moreover, however you stand on this question, you cannot hold that resemblance is a necessary condition for presentation. We do perceive the heat in objects, yet in no sense, literal or metaphorical, does molecular kinetic energy resemble sensations of

heat. And, of course, very different experiences can be presentations of the same property. Seeing and feeling the roundness of something are very different experiences. We are merely insisting on the converse possibility that the same experiences may be presentations of different properties. Indeed, to insist that the same experiences must be the presentation of the same property may be plausible if we are talking about properties of experiences but not if we are talking about properties of objects presented in experience.

Therefore, the difference between causation and presentation does not block our view that redness for S_1 in C_1 at t_1 may be distinct from redness for S_2 in C_2 at t_2. But the difference does enable us to avoid an unwelcome consequence. Illusions concerning colour are surely possible. It is not always the case that an object that looks red is in fact red, even if it is a physical property of the object and its surroundings (and not of a brain probe) that is responsible for its looking red. Now if causation and presentation were the same, that physical property would automatically have to be redness in the circumstances for the person at the time; and so the object would *be red* in the circumstances for the person at the time, as well as looking red in the circumstances to the person.

4 An Empirical Complication

We now need to note a possible complication. The physics and physiology of colour vision is far from settled, and it may well turn out that the diversity of physical properties which cause (in the right way) objects to look red outruns the diversity of viewers, times, and circumstances. It may well be that even if we restrict ourselves to a given viewer, S, in a given circumstance, C, at a given time, t, there are a number of different physical properties, P_1, \ldots, P_n, that would cause an object, 0, to look red to S in C at t; that is, each P_i is such that were 0 to possess it, 0 would, in virtue of possessing it, look red to S in C at t.

There are two ways we might respond to this point. We might identify redness for S in C at t with the disjunctive property of being P_1 or ... or P_n. If we respond this way, we may not be able any longer to say that redness for S in C at t is the property which does or would cause an object to look red to S in C at t. For it is at least arguable that disjunctive properties of the kind in question do not cause anything. Being P_1 or ... or P_n may not be potentially causally efficacious, though *each* of P_1, \ldots, P_n may be. Accordingly, we would need to modify our account of redness to count a property as redness for S in C at t if it is a disjunctive property each disjunct of which is such that it does or would cause an object to look red to S in C at t. Of course, some have worried that being P_1 or ... or P_n is not enough for all red (or, on

our approach, all red-for-S-in-C-at-t) objects to have in common in the possible case where the disjuncts are themselves unrelated. But they *are* related in the way that matters here. They have in common that they each cause things to look red in the right way for presentation.

The second response is to rest content with an account of the redness *of 0* for S in C at t, the redness of 0 for S in C at t being the property of 0 which does or would cause 0 to look red to S in C at t. In this case, the redness of 0 for S in C at t must actually be a property of 0; a property which may or may not actually be causing 0 to look red to S in C at t, for S may not actually be looking at 0. We cannot see any decisive reason to favour one response over the other.[7] Each enables us to say of any object in any possible world, whether or not it is red. In any case, we will suppress this complication in what follows.

5 Colours, Shapes, and Causal Interaction Patterns

"Square objects have characteristic interaction patterns. They do not, for instance, roll smoothly down flat planes. Red objects do not have characteristic interaction patterns. The red and white billiard balls behave in exactly the same way on the billiard table". Something like this is sometimes urged to be an essential difference between shape and colour. This is obviously incompatible with our view that colour is a physical property not different in kind from shape, so it is important for us to see that it is false.

Red and white billiard balls do not behave the same way on billiard tables. The red balls go down the pockets much more often. It may be objected that it is not their redness *per se* which is responsible. Rather certain physical properties of the red balls cause them to look red to the players, and that, along with the players' beliefs and desires causes the red balls to go into the pockets more often than the white balls. But this is a blatant *Petitio* as part of an argument against us. It is being *assumed* that redness is not a physical property in order to show that redness is causally inactive.

Perhaps the thought is rather that, by contrast with colour, the characteristic interaction patterns for, say, squareness are *partially definitive* of squareness; but the usual examples are unconvincing. It seems entirely contingent that square objects do not roll smoothly down flat planes. There are possible worlds without gravity, and ones where objects move through each other effortlessly. Rather, what does seem to be true is this. An object's interactions with other *non-sentient* objects constitutes evidence concerning its shape, and evidence which has roughly equal weight with those of its interactions with *sentient* creatures that are responsible for it looking or

feeling to be a certain shape. By contrast, those of an object's interactions with sentient creatures responsible for it looking a certain colour have a very special status where colour is concerned. This, though, is very obviously no threat to our version of the view that colours are physical properties. For, on it, which physical properties are which colours (for which sentient creatures in which circumstances at which times) depends precisely on the kind of experiences they cause, that is, on their effects on sentient creatures.

6 Colours in the Dark and in Other Worlds

Locke asked whether porphyry was red in the dark. We will ask whether ripe tomatoes are red in the dark and in other possible worlds where they do not look red.

Are tomatoes literally red in the dark? We wish to enter a plea for tolerance on this question. Some writers answer it with 'Obviously, yes', others with 'Obviously, no'. But the very fact that opposite answers are found obvious shows that *neither* answer is *obvious*. How might we explain the disagreement? There is no disagreement about the underlying metaphysical facts of the matter. It is agreed that tomatoes do not look red in the dark, while having in the dark whatever physical basis it is that is responsible for it being the case that they would look red were they being viewed in daylight. Consequently, the obvious place to locate the disagreement is in an ambiguity in the question. Our treatment suggests a simple way of doing this.

We have lately spoken, not of redness, but of redness for S in C. Now, how should we relate redness for S in C, the *property*, to the truth or falsity of *sentences* about objects being red? Two things are immediately clear. First, we should count 'X is red in C for S' as true iff X has redness for S in C. Secondly, this observation is completely silent about what to say about 'X is red'. But the literature, particularly the parts concerned with the distinction between transitory and standing colours, suggest an obvious strategy. Count 'X is red' as true iff X has redness for normal perceivers in normal circumstances (however 'normal' is to be elucidated).

The ambiguity in the question, Are tomatoes red in the dark?, is now clear. On one disambiguation, it is the question, Do tomatoes have redness-in-the-dark? To which the answer is no, only fluorescent objects have that property, for only they red-present or look red in the dark. On the other disambiguation, it is the question, Do tomatoes have redness-in-normal-circumstances in the dark? To which the answer is, we take it, yes. The (physical) property which red-presents in daylight is a property that tomatoes have in the dark as well as in daylight. Turning the lights out does not remove the property, although it does stop it making tomatoes look red to us. We said 'we take it' because there is much about colour vision that is still a puzzle

to scientists, and it just might turn out that the relevant property is only present in the daylight. In this case, the answer to the question, Are tomatoes red in the dark?, is no, on either interpretation. (And is not this just what we would say in this eventuality?)

A similar ambiguity infects corresponding questions about tomatoes in other possible worlds. Consider a world in which tomatoes look orange in daylight, not because they are different but because daylight is different. Are tomatoes red or are they orange in this world? Equivalently, had daylight been like sodium light, would tomatoes have been orange; or would they still have been red, despite looking orange to normal observers in normal circumstances.

One approach is to view the question as being as to whether certain descriptions should be read rigidly or non-rigidly. If 'redness' (or, as we would put it, 'redness in normal circumstances to normal perceivers') is short for the non-rigid, definite description 'the property responsible (in the right way) for things looking red', and likewise for 'orangeness', then *the* clear answer is that tomatoes are not red, and are orange, in our imagined world; while if 'redness' is short for the rigid, descriptive name 'the property *actually* responsible for things looking red', then *the* clear answer is that tomatoes are red in our imagined world. For, while not looking red in it, they do have in it the property responsible in the actual world for their looking red.

The trouble with this approach to the question is that, in either case, the answer is clear; though which answer it is that is clear is different. But the answer is manifestly not clear. People's *pre-theoretic* responses to, 'Had daylight been much more like sodium light so that tomatoes looked orange in it, would tomatoes have been red or orange (in normal circumstances)?' are notoriously all over the place. But not because of an underlying disagreement over the basic facts of the matter. The best explanation, therefore, is ambiguity of question and it is the non-rigid reading which allows an ambiguity. If we read 'redness' non-rigidly, our question, Are tomatoes red in our imagined world? is ambiguous as between, Do tomatoes have redness-in-our-world in our imagined world?' to which yes is the answer, and, Do tomatoes have redness-in-our-imagined world? to which no is the answer.

7 Conclusion

Science does not show that colours are properties of experiences or that they are mere dispositions to produce certain kinds of experiences. Rather, it shows that colours are physical properties of objects—highly complex and possibly largely extrinsic, though we have said almost nothing about the scientific details—which may vary according to person, circumstance, and time. Our case for this kind of view has been how it can explain what it ought to explain. In particular, we have seen how treating

colours as physical properties, but possibly different ones for different persons, circumstances, or times can explain the features which have led philosophers to propound subjectivist or dispositional accounts of colour. Indeed, on our view, subjectivists have *mis-located* the subjective element in the story about colour. Colours are objective properties of the world around us, but it *is* a subjective matter *which* objective properties are which colours to which persons in which circumstances at which times.

Acknowledgments

Special thanks are due to Michael Smith and I. L. Humberstone for many fruitful discussions arising from earlier versions of this material, and to Keith Campbell for saving us from a blunder in Section 5.

Notes

1. In a paper which became chapter 12, of D. M. Armstrong, *A Materialist Theory of the Mind* (Routledge Kegan Paul, London, 1968). Similar views have been put to us in discussion by J. J. C. Smart and, particularly, David Lewis (to whom we also owe the idea for the title).

2. The corresponding point for intentional actions' connection with beliefs and desires, is discussed in Donald Davidson, 'Freedom to Act', reprinted in his *Actions and Events* (Clarendon Press, Oxford, 1980), pp. 63–81. For discussions of the point as it arises in the perceptual context, see, e.g. David Lewis, 'Veridical Hallucination and Prosthetic Vision', *Australasian Journal of Philosophy*, 58 (1980), pp. 239–249, and references therein.

3. For a detailed argument to this conclusion see Elizabeth W. Prior, Robert Pargetter, and Frank Jackson, 'Three Theses about Dispositions', *American Philosophical Quarterly*, 19 (1982), pp. 251–257.

4. Jonathan Bennett, 'Substance, Reality, and Primary Qualities', *American Philosophical Quarterly*, 2 (1965), pp. 1–17.

5. See, e.g., David Lewis, 'Review of Putnam', in *Readings in Philosophy of Psychology*, vol. I, ed. N. Block (Harvard University Press, Mass., 1980), and Frank Jackson, Robert Pargetter, and Elizabeth W. Prior, 'Functionalism and Type-Type Identity Theories', *Philosophical Studies*, 42 (1982), pp. 209–225. Note though that here and throughout we say nothing one way or the other about whether colour experiences can be understood physicalistically. For all we say, you can be a qualia freak and believe in sense-data—though you cannot think that sense-data are the real bearers of the colour properties. One author thus retracts this latter claim made in Frank Jackson, *Perception* (Cambridge University Press, Cambridge, 1977), chapter 5.

6. We are indebted here to Keith Campbell, 'Colours', and D. M. Armstrong, 'Colour-Realism and the Argument from Microscopes', both in *Contemporary Philosophy in Australia*, ed. R. Brown and C. Rollins (Allen and Unwin, London, 1969).

7. But note that the second style of response is not available for the corresponding problem for functionalist theories of mind, see the final section of Jackson, Pargetter, and Prior, *op. cit.*

7 Colour as a Secondary Quality

Paul A. Boghossian and J. David Velleman

The Galilean Intuition

Does modern science imply, contrary to the testimony of our eyes, that grass is not grccn? Galilco thought it did:

Hence I think that these tastes, odors, colors, etc., on the side of the object in which they seem to exist, are nothing else than mere names, but hold their residence solely in the sensitive body; so that if the animal were removed, every such quality would be abolished and annihilated. Nevertheless, as soon as we have imposed names on them, particular and different from those of the other primary and real accidents, we induce ourselves to believe that they also exist just as truly and really as the latter.[1]

The question whether Galileo was right on this score is not really a question about the content of modern scientific theory: aside from some difficulties concerning the interpretation of quantum mechanics, we know what properties are attributed to objects by physics. The question is rather about the correct understanding of colour concepts as they figure in visual experience: how do objects appear to be, when they appear to be green? Galileo seems to have found it very natural to say that the property an object appears to have, when it appears to have a certain colour, is an intrinsic qualitative property which, as science teaches us, it does not in fact possess.

Subsequent philosophical theorizing about colour has tended to recoil from Galileo's semantic intuition and from its attendant ascription of massive error to ordinary experience and thought. Thus, in a recent paper Sydney Shoemaker has written:

[S]ince in fact we apply color predicates to physical objects and never to sensations, ideas, experiences, etc., the account of their semantics recommended by the Principle of Charity is one that makes them truly applicable to tomatoes and lemons rather than to sense experiences thereof.[2]

Should a principle of charity be applied in this way to the interpretation of the colour concepts exercised in visual experience? We think not. We shall argue, for one thing, that the grounds for applying a principle of charity are lacking in the case of colour concepts. More importantly, we shall argue that attempts at giving the experience of colour a charitable interpretation either fail to respect obvious features of that experience or fail to interpret it charitably, after all. Charity to visual experience is therefore no motive for resisting the natural, Galilean response to a scientific understanding of light and vision. The best interpretation of colour experience ends up convicting it of widespread and systematic error.[3]

Charitable Accounts of Colour Experience

According to the principle of charity, the properties that objects are seen as having, when they are seen as coloured, must be properties that they generally have when so perceived. Two familiar interpretations of visual experience satisfy this principle.

The Physicalist Account

The first of these interpretations begins with the assumption that what objects appear to have, when they look red, is the physical property that is normally detected or tracked by that experience. Since the physical property that normally causes an object to be seen as red is the property of having one out of a class of spectral-reflectance profiles—or one out of a class of molecular bases for such profiles—the upshot of the present interpretation is that seeing something as red is seeing it as reflecting incident light in one of such-and-such ways, or as having surface molecules with one of such-and-such electron configurations.[4]

Now, we have no doubt that experiences of an object as having a particular colour are normally correlated with that object's possessing one of a class of spectral-reflectance profiles. But to concede the existence of such a correlation is not yet to concede that membership in a spectral-reflectance class is the property that objects are seen as having when they are seen as having a particular colour. Indeed, the claim that visual experience has this content yields unacceptable consequences.

In particular, this claim implies that one cannot tell just by looking at two objects whether they appear to have the same or different colours. For according to the physicalist interpretation, which colour one sees an object as having depends on which spectral-reflectance class one's visual experience represents the object as belonging to; and which spectral-reflectance class one's experience represents an object as belonging to depends on which spectral-reflectance profiles normally cause experiences of that sort. Hence in order to know whether two objects appear to have the same colour, under the physicalist interpretation, one must know whether one's experiences of them are such as result from similar spectral-reflectance profiles. And the latter question cannot be settled on the basis of the visual experiences alone: it calls for considerable empirical enquiry. The physicalist interpretation therefore implies that knowing whether two objects appear to have the same colour requires knowing the results of empirical enquiry into the physical causes of visual experiences.

But surely, one can tell whether two objects appear similarly coloured on the basis of visual experience alone. To be sure, one's experience of the objects will not necessarily provide knowledge of the relation between their actual colours. But the physicalist account implies that visual experience of objects fails to provide epistemic

access, not just to their actual colour similarities, but to their apparent colour similarities as well. And here the account must be mistaken. The apparent colours of objects can be compared without empirical enquiry into the physical causes of the objects' visual appearances; and so the properties that objects appear to have, when they appear coloured, cannot be identified with the physical properties that are detected or tracked by those appearances.

Dispositionalist Accounts

We turn, then, to another class of theories that respect the principle of charity in application to colour experience. These theories are united under the name of dispositionalism. All of them are based, in one way or another, on the claim that the concept of colour is such as to yield a priori truths of the following form:

(i) x is red if and only if x appears red under standard conditions.[5]

Different versions of dispositionalism interpret such biconditionals differently and apply them to the vindication of colour experience in different ways.

Applying the Biconditionals: The Direct Approach Perhaps the most direct way to argue from the dispositionalist biconditionals to the veridicality of colour experience is to point out that the biconditionals assert, as a priori truths, that there are conditions under which things appear to have a colour if and only if they actually have it, and hence that there are conditions under which colour experience is veridical. The possibility of global error in colour experience is thus claimed to be excluded a priori by the very concept of colour.

We think that this version of dispositionalism misappropriates whatever a priori truth there may be in the relevant biconditionals. We are prepared to admit that the concept of colour guarantees the existence of privileged conditions for viewing colours, conditions under which an observer's colour experiences or colour judgements are in some sense authoritative. But colour experiences and colour judgements may enjoy many different kinds of authority, some of which would not entail that objects have the properties that colour experience represents them as having.

Even philosophers who regard colour experience as globally false, for example, will nevertheless want to say that some colour experiences are correct in the sense that they yield the colour attributions that are generally accepted for the purposes of describing objects in public discourse. Of course, such a claim will yield slightly different biconditionals, of the following form:

(ii) x is to be described as red if and only if x appears red under standard conditions.

Our point, however, is that (ii) may be the only biconditional that is strictly true, and that (i) may seem true only because it is mistaken for (ii). If biconditional (ii) expresses the only genuine a priori truth in the vicinity, then the authority of experiences produced under standard conditions may consist in no more than there being a convention of describing objects in terms of the colours attributed to them in such experiences. As we shall argue at the end of this paper, such a convention may be perfectly justifiable even if all colour experience is, strictly speaking, false. Hence the intuitive support for biconditionals like (i) may not be such as to ground a vindication of colour experience.

In order for the dispositionalist biconditionals to vindicate colour experience, they must mean, not just that convention dictates describing objects in terms of the colours that they appear to have under standard conditions, but also that objects actually have the properties that they thereby appear to have. And we see no reason for regarding this stronger claim as an a priori truth.

Applying the Biconditionals as Content-Specifications Another way of arguing from dispositionalist biconditionals to the veridicality of colour experience is to interpret the biconditionals as specifying the content of that experience. This argument proceeds as follows.

The first premiss of the argument says that the property that objects are represented as having when they look red is just this: a disposition to look red under standard conditions. The second premiss says that many objects are in fact disposed to look red under standard conditions, and that these are the objects that are generally seen as red. These premisses yield the conclusion that the experience of red is generally veridical, since it represents an object as having a disposition that it probably has—namely, a disposition to look red under standard conditions.

The first premiss of this argument corresponds to a biconditional of the following form:

(iii) *Red* [i.e., the property that a disposition to appear
 objects are seen as having = def red under standard
 when they look red] conditions

The right side of biconditional (iii) can be interpreted in two different ways, however; and so there are two different versions of the associated argument.

Two Versions of Content-Dispositionalism The first version of the argument interprets the phrase 'a disposition to look red' on the assumption that the embedded phrase 'to look red' has its usual semantic structure. The entire phrase is therefore taken to mean 'a disposition to give the visual appearance of being red'.[6] The second

version interprets the phrase on the assumption that 'to look red' has a somewhat unusual structure. The predicate following 'look' is interpreted as expressing, not a property that a thing is disposed to give the appearance of having, but rather an intrinsic property of the visual appearance that it is disposed to give. The phrase 'a disposition to look red' is therefore taken to mean something like 'a disposition to cause reddish visual appearances'.[7]

Under these two interpretations, (iii) assigns two different contents to colour experience. Under one interpretation, the property that things are seen as having when they look red is defined as a disposition to give the visual appearance of being red; under the other, the property that things are seen as having is defined as a disposition to cause reddish visual appearances. In either case, the content of colour experience is claimed to be true, on the grounds that objects seen as red do have the appropriate disposition.

We regard both versions of the argument as faulty. In the next section, we shall raise an objection that militates against both versions equally. In subsequent sections, we shall consider each version in its own right.

A General Problem in Content-Dispositionalism Both versions of the present argument are to be faulted, in our opinion, for misdescribing the experience of colour. In assigning colour experience a dispositionalist content, they get the content of that experience wrong.

When one enters a dark room and switches on a light, the colours of surrounding objects look as if they have been revealed, not as if they have been activated. That is, the dispelling of darkness looks like the drawing of a curtain from the colours of objects no less than from the objects themselves. If colours looked like dispositions, however, then they would seem to *come on* when illuminated, just as a lamp comes on when its switch is flipped. Turning on the light would seem, simultaneously, like turning on the colours; or perhaps it would seem like waking up the colours, just as it is seen to startle the cat. Conversely, when the light was extinguished, the colours would not look as if they were being concealed or shrouded in the ensuing darkness: rather, they would look as if they were becoming dormant, like the cat returning to sleep. But colours do not look like that; or not, at least, to us.

More seriously, both versions of (iii) also have trouble describing the way in which colours figure in particular experiences, such as after-images. The colours that one sees when experiencing an after-image are precisely the qualities that one sees as belonging to external objects. When red spots float before one's eyes, one sees the same colour quality that fire-hydrants and maraschino cherries normally appear to have.[8] The problem is that dispositionalist accounts of colour experience must analyse the appearance of colour in after-images as the appearance of a disposition to

look red under standard conditions; and after-images simply cannot appear to have such a dispositional property.

This problem would not arise if after-images were full-blown illusions. That is, if seeing an after-image consisted in seeming to see a material object suspended in physical space, then that object, though in fact illusory, could still appear to have the same colour quality as any other material object. But after-images are not seen as material objects, any more than, say, a ringing in one's ears is heard as a real noise. The items involved in these experiences are not perceived as existing independently of being perceived. On the one hand, the after-image is seen as located before one's eyes, rather than in one's mind, where visual memories are seen; and the ringing is likewise heard as located in one's outer ear, rather than in the inner auditorium of verbal thought and musical memory. But on the other hand, one does not perceive these items as actually existing in the locations to which they are subjectively referred. The ringing is heard as overlaying a silence in one's ears, where there is audibly nothing to hear; and similarly, the after-image is seen as overlaying the thin air before one's eyes, where there is visibly nothing to see. The ringing is thus perceived as a figment or projection of one's ears, the image as a figment or projection of one's eyes: both, in short, are perceived as existing only in so far as one is perceiving them.

Thus, the possibility of a red after-image requires that one see something as simultaneously a figment of one's eyes and red. But how could something that looked like a figment of one's eyes also appear disposed to look a particular way under standard conditions? Because an after-image is seen as the sort of thing that exists only in so far as one is seeing it, it cannot be seen as the sort of thing that others could see nor, indeed, as the sort of thing that one could see again oneself, in the requisite sense. In seeing an after-image as a figment of one's eyes, one sees it as the sort of thing that will cease to exist when no longer seen and that will not be numerically identical to any future after-images, however similar they may be. One does not see it, in other words, as a persisting item that could be reintroduced into anyone's visual experience; and so one cannot see it as having a disposition to present this or any appearance either to others or to oneself on other occasions.

The foregoing, phenomenological problems are common to both versions of the dispositionalist argument currently under consideration. Each version of the argument also has peculiar problems of its own, which we shall now consider in turn. We begin with the first version, which understands a disposition to look red as a disposition to give the visual appearance of having the property red.

Problems in the First Version of Content-Dispositionalism The problem with this version has to do with the property expressed by the word 'red' in the phrase 'a dis-

position to appear red under standard conditions'—the phrase constituting the right side of biconditional (iii). Keep in mind that the entire phrase has itself been offered as expressing the property that objects are seen as having when they look red. When things are seen as red, according to the present argument, what they are seen as having is a disposition to appear red under standard conditions. But does the word 'red' here express the same property that the entire phrase purports to express?

Suppose that the answer to our question is no. In that case, what biconditional (iii) says is that the property that things are seen as having when they look red is a disposition to give the appearance of having some *other* property called red. This other property must naturally be a colour, since the property red could hardly be seen as a disposition to appear as having some property that was not a colour. For the sake of clarity, let us call this other property red*.

Now, in order for objects to have the property red that they appear to have, under the present assumption, they must actually be disposed to give the appearance, under standard conditions, of having the property red*; and in order to have that disposition, they must actually give the appearance of having the property red* under standard conditions. Thus, if the property that things are seen as having when they look red is a disposition to appear red*, then the experience of seeing them as red is veridical, as the dispositionalist wishes to prove, only if they also appear red*. And the question then arises whether red* is a property that things ever do or can actually have. The dispositionalist's argument does not show that the appearance of having red* is ever veridical, since that property is admitted to be different from the disposition whose existence the dispositionalist cites in vindicating the appearance of red. The consequence is that there must be colour experiences that the dispositionalist has failed to vindicate.

Suppose, then, that the dispositionalist answers yes to our question. That is, suppose he says that 'red' expresses the same property on the right side of (iii) as it does on the left. In that case, the dispositionalist's account of colour experience is circular, since in attempting to say what property things appear to have when they look red, he invokes the very property that is at issue.

The dispositionalist may refuse to be troubled by this circularity, however.[9] He may point out that a circular account of a property can still be true, and indeed informative, despite its circularity. For instance, to define courage as a disposition to act courageously is to give a circular definition, a definition that cannot convey the concept of courage to anyone who does not already have it. Even so, courage *is* a disposition to act courageously, and this definition may reveal something important about the property—namely that it is a behavioural disposition. The dispositionalist about colour claims that the circularity in his explication of red is similar.

We grant that circularity alone does not necessarily undermine a definitional equivalence. Yet the circularity in biconditional (iii) is significantly different from that in our circular definition of courage. Our definition of courage invokes courage in an ordinary extensional context, whereas the right side of (iii) invokes red in an intentional context expressing the content of a visual experience, an experience that happens to be the very one whose content (iii) purports to explicate. The result is that the visual experience of seeing something as red can satisfy (iii) only if it, too, is circular, and hence only if it is just as uninformative as (iii). Not only does (iii) fail to tell us which colour red is, then; it also precludes visual experience from telling us which colour an object has. The former failure may be harmless, but the latter is not.

Let us illustrate the difference between an unproblematic circular definition and a problematic one by means of an analogy. Suppose that you ask someone who Sam is and are told, 'Sam is the father of Sam's children'. This answer does not tell you who Sam is if you do not already know. But it does tell you something about Sam—namely, that he has children—and, more importantly, it places Sam in a relation to himself that a person can indeed occupy. In order for Sam to satisfy this assertion, he need only be the father of his own children. Now suppose, alternatively, that your question receives the answer 'Sam is the father of Sam's father'. This response also identifies Sam by reference to Sam; but it has a more serious defect. Its defect is that it asserts of Sam that he stands to himself in a relation that it is impossible for a person to occupy.

These two circular identifications of Sam are analogous to the two circular definitions that we are considering. The definition of courage as a disposition to act courageously is uninformative, but it places courage in a relation to itself that a disposition can occupy. In order to satisfy this definition, courage must simply be the disposition to perform actions that tend to be performed by someone with that very disposition. By contrast, the dispositionalist about colour not only invokes the content of colour experience in explicating that content; he places that content in a relation to itself that is impossible for it to occupy. For his explication says that the content of the visual experience of red must contain, as a proper part, the content of the visual experience of red. To see something as red, according to (iii), is to have an experience whose content is that the thing is disposed to produce visual experiences *with the content that it is red*. The experiential content that something is red is thus embedded within itself, and this is a reflexive relation that no determinate content can occupy. Consequently, (iii) requires that the visual experience of red have an indeterminate content that fails to represent its object as having any particular colour.

Under the terms of (iii), an experience can represent its object as red only by representing it as disposed to produce visual experiences that represent it as red. The

problem here is that the experiences that the object is thus represented as disposed to produce must themselves be represented as experiences that represent the object as red, rather than some other colour—lest the object be represented as disposed to appear something other than red. Yet these experiences can be represented as representing the object as red only if they are represented as representing it as disposed to produce experiences that represent it as red. And here the circle gets vicious. In order for an object to appear red rather than blue, it must appear disposed to appear red, rather than disposed to appear blue; and in order to appear disposed to appear red, rather than disposed to appear blue, it must appear disposed to appear disposed to appear red, rather than disposed to appear disposed to appear blue; and so on. Until this regress reaches an end, the object's appearance will not amount to the appearance of one colour rather than another. Unfortunately, the regress never reaches an end.

One might attempt to staunch the regress simply by invoking the relevant colour by name. 'To appear red', one might say, 'is to appear disposed to appear red—and that's the end of the matter.' 'Of course,' one might continue, 'if you don't already know what red is, then you haven't understood what I've said. But that doesn't impugn the truth of my assertion, nor its informativeness, since you have learned at least that the property things appear to have in appearing red is a disposition to produce appearances.'

This reply cannot succeed. Staunching the regress with the word 'red' can work, but only if the word is not understood in the sense defined in biconditional (iii). We readily agree that red things do appear disposed to look red, and that they appear so without requiring the viewer to run an endless gamut of visual appearances. But what they appear disposed to do is to give the appearance of being red in a non-dispositional sense—the appearance of having a non-dispositional redness. And the way they appear disposed to give that appearance is usually just by giving it—that is, by looking non-dispositionally red.[10] Similarly, objects can appear disposed to look square just by looking square, but only because they look square intrinsically and categorically.

As we have seen, however, the dispositionalist cannot admit an intrinsic and categorical sense of the word 'red' into his formulation. For then he would have to acknowledge that objects appear disposed to look red, and do look red, in a non-dispositional sense. And he would then have acknowledged that an object's being disposed to look red does not guarantee that it is as it looks, in respect to colour, since the redness that it is thereby disposed to give the appearance of having is a different property from the disposition that it admittedly has. The dispositionalist must therefore say that although an object looks disposed to look red just by looking

red, this looking red does not involve looking anything except disposed to look red. *In short, the object must look disposed to look a particular way without there being any particular way that it looks, or looks disposed to look, other than so disposed.* And that is why the vicious regress gets started.

Note, once again, that the problem created by the regress is not that we are unable to learn what red is from the statement that red is a disposition to look red. The problem is that, under the terms of that statement, the subject of visual experience cannot see what colour an object has. For he cannot see that particular colour of an object except by seeing the particular way the object tends to appear; and he cannot see the way it tends to appear except by seeing the way it tends to appear as tending to appear; and so on, *ad infinitum*. To be sure, a person can see all of these things if he can just see the object as having a colour, to begin with; but under the terms of dispositionalism, he cannot begin to see the object as having a colour except by seeing these dispositions; and so he can never begin to see it as having a colour at all.[11]

The Second Version of Content-Dispositionalism The only way to save dispositionalism from its fatal circularity is to ensure that the disposition with which a colour property is identified is not a disposition to give the appearance of having that very property. Christopher Peacocke has attempted to modify dispositionalism in just this way.

According to Peacocke, the property that an object is seen as having when it looks red should be identified as a disposition, not to appear red, but rather to appear in a portion of the visual field having an intrinsic property that Peacocke calls red'. Let us call these portions of the visual field *red' patches*. We can then say that looking red, according to Peacocke, is looking disposed to be represented in red' patches under standard conditions—an appearance that can be accomplished by being represented in a red' patch under recognizably standard conditions, of course, but also in other ways as well, such as by being represented in an orange' patch when illuminated by a yellow-looking light. The upshot, in any case, is that objects often are as they look when they look red, because they both look and are just this: disposed to be represented in red' patches under standard conditions.

Peacocke's qualified dispositionalism eliminates circular experiential contents because it says that appearing to have a colour property is appearing disposed to present appearances characterized, not in terms of that very property, but rather in terms of a different quality, a 'primed' colour. Peacocke can also account for the role of red in the experience of seeing a red after-image, because he can say that the experience consists in a red' patch represented, in the content of one's experience, as a figment of one's eyes.

Peacocke's qualified dispositionalism differs from pure dispositionalism in that it introduces a visual field modified by qualities that—to judge by their names, at least—constitute a species of colour. Peacocke thus abandons a significant feature of the theories that we have examined thus far. Those theories assume that visual experience involves colour only to the extent of representing it. They analyse an experience of red as an experience with the content that something is red—an experience that refers to redness. Because the role of colour in experience is restricted by these theories to that of an element in the intentional content of experience, we shall call the theories intentionalist.

Peacocke's theory is not intentionalist, because it says that visual experience involves colour (that is, primed colour) as a property inhering in the visual field, and not just as a property represented in the content of that experience. We have two points to make about Peacocke's anti-intentionalism. We shall first argue that Peacocke is right to abandon intentionalism and to introduce colours as intrinsic properties of the visual field. But we shall then argue that, having introduced such properties, Peacocke is wrong to remain a dispositionalist about the colours that visual experience attributes to external objects. Peacocke's modification of dispositionalism is unstable, we believe, in that it ultimately undermines dispositionalism altogether.

The Case Against Intentionalism Peacocke has argued elsewhere, and on independent grounds, for the need to speak about a sensory field modified by intrinsic sensational qualities.[12] We should like to add some arguments our own.

Our first argument rests on the possibility, noted above, of seeing an after-image without illusion. Consider such an experience, in which an after-image appears to you *as* an after-image—say, as a red spot obscuring the face of a person who has just taken your photograph. Since you suffer no illusion about the nature of this spot, you do not see it as something actually existing in front of the photographer's face. In what sense, then, do you see it as occupying that location at all? The answer is that you see it as merely appearing in that location: you see it as a spot that appears in front of the photographer's face without actually being there. Now, in order for you to see the spot as appearing somewhere, it must certainly appear there. Yet it must appear there without appearing actually to be there, since you are not under the illusion that the spot actually occupies the space in question. The after-image must therefore be described as *appearing in* a location without *appearing to be in* that location; and this description is not within the capacity of any intentionalist theory. An intentionalist theory will analyse the visual appearance of location as the attribution of location to something, in the intentional content of your visual experience.

But the intentional content of your visual experience is that there is nothing at all between you and the photographer.

The only way to describe the after-image as appearing in front of the photographer without appearing to be in front of the photographer is to talk about the location that it occupies in your visual field. In your visual field, we say, the after-image overlays the image of the photographer's face, but nothing is thereby represented as actually being over the photographer's face. The after-image is thus like a coffee-stain on a picture, a feature that occupies a location on the picture without representing anything as occupying any location. Similarly, an adequate description of the after-image requires reference to two kinds of location—location as an intrinsic property of features in the visual field, and location as represented by the resulting visual experience.

One might think that this argument cannot be applied to the after-image's colour, since you may see the after-image not only as appearing red but also as actually *being* red. But then intentionalism will have trouble explaining what exactly your experience represents as being red, given that the experience is veridical. Your experience cannot represent some external object as being red, on pain of being illusory. And if it represents an image as being red, then its truth will entail that colour can enter into visual experience as an intrinsic property of images, which is precisely what intentionalism denies. Hence there would seem to be nothing that the experience can veridically represent as being red, according to intentionalism. And if the experience represented something as merely appearing red, then our foregoing argument would once again apply. For how could you have a veridical experience that something appeared red unless something so appeared? And if something did so appear, it would have to appear *to be* red, according to intentionalism, which would be an illusion in the present case, unless images can be red.[13]

There are other, more familiar cases that refute intentionalism in a similar way. These, too, are cases in which something is seen without being represented in the content of experience as intentionalism would require. If you press the side of one eyeball, you can see this line of type twice without seeing the page as bearing two identical lines of type. Indeed, you cannot even force the resulting experience into representing the existence of two lines, even if you try. Similarly, you can see nearby objects double by focusing on distant objects behind them, and yet you cannot get yourself to see the number of nearby objects as doubling. And by unfocusing your eyes, you can see objects blurrily without being able to see them as being blurry. None of these experiences can be adequately described solely in terms of their intentional content. Their description requires reference to areas of colour in a visual field,

areas that split in two or become blurry without anything's being represented to you as doing so.

The Case Against Peacocke's Dispositionalism We therefore endorse Peacocke's decision to posit a visual field with intrinsic sensational qualities. What we question, however, is his insistence that the colours of external objects are still seen as dispositions. We believe that once one posits a visual field bearing properties such as red', one is eventually forced to conclude that objects presented in red' areas of that field are seen as red' rather than as possessing some other, dispositional quality.

The reason is that visual experience does not ordinarily distinguish between qualities of a 'field' representing objects and qualities of the objects represented. Visual experience is ordinarily naïvely realistic, in the sense that the qualities presented in it are represented as qualities of the external world. According to Peacocke, however, the aspects of visual experience in which external objects are represented have qualities—and, indeed, colour qualities—that are never attributed by that experience to the objects themselves. Peacocke thus gets the phenomenology of visual experience wrong.

Try to imagine what visual experience would be like if it conformed to Peacocke's model. The visual field would have the sensational qualities red', blue', green', and so on, and would represent various external objects; but it would not represent those qualities as belonging to those objects. Where, then, would the qualities appear to reside? What would they appear to be qualities of? They would have to float free, as if detached from the objects being represented, so as not to appear as qualities of those objects. Or perhaps they would seem to lie on top of the objects, overlaying the objects' own colours—which would be seen, remember, as different dispositional qualities. The result, in any case, would be that visual experience was not naïvely realistic, but quite the reverse. A veil of colours—like Locke's veil of ideas—would seem to stand before or lie upon the scene being viewed. But one does not continually see this veil of colours; and so visual experience must not conform to Peacocke's model.

The failure of Peacocke's model to fit the experience of colour can be seen most clearly, perhaps, in the fact that the model is a perfect fit for the experience of pain. When one pricks one's finger on a pin, pain appears in one's tactual 'field', but it is not perceived as a quality of the pin. Rather, the pin is perceived as having a disposition—namely, the disposition to cause pain, and hence to be presented in areas of the tactual field bearing the quality currently being felt. The ordinary way of describing the experience would be to say that by having an experience of pain one perceives the pin as disposed to cause pain. But this description can easily be

transposed into Peacocke's notation, in which it would say that one perceives the pin as painful by perceiving it in a painful' patch.

Peacocke's theory is thus ideally suited to describing the experience of pain. Yet the experience of pain is notoriously different from the experience of colour. Indeed, the difference between pain experience and colour experience has always been accepted as an uncontroversial datum for the discussion of secondary qualities. The difference is precisely that pain is never felt as a quality of its apparent cause, whereas colour usually is: the pain caused by the pin is felt as being in the finger, whereas the pin's silvery colour is seen as being in the pin. Hence Peacocke's model, which fits pain experience so well, cannot simultaneously fit colour experience. When applied to colour, that model would suggest that the experience of seeing a rose contains both the flower's redness and the visual field's red'ness, just as the experience of being pricked by a pin contains both the pin's painfulness and the finger's pain.

One might respond that our objection to Peacocke is undermined by an example that we previously deployed against intentionalism. For we have already argued that seeing something blurrily involves a blurriness that is not attributed to what is seen. Have we not already admitted, then, that visual experience contains qualities that it does not attribute to objects, and hence that it is not always naïve?

We have indeed admitted that visual experience is not always naïve, but that admission is consistent with the claim that visual experience is naïve most of the time, or in most respects. Seeing blurrily is, after all, unusual, in that it involves seeing, as it were, 'through' a blurry image to a visibly sharp-edged object. It is an experience in which the visual field becomes more salient than usual, precisely because its blurriness is not referred to the objects seen. Peacocke's theory does manage to improve on intentionalism by explaining how one can blurrily see an object as being sharp-edged. But Peacocke goes too far, by analysing all visual experience on the model of this unusual case. He says that every perception of colour has this dual structure, in which the colours that are attributed to objects are seen through colour qualities that are not attributed to them. According to Peacocke, then, the redness of external objects is always seen through a haze of red'ness, just as the sharp edges of an object are sometimes seen through a blur.

The Projectivist Account

We have argued, first, that visual experience cannot be adequately described without reference to intrinsic sensational qualities of a visual field; and second, that intrin-

sic colour properties of the visual field are the properties that objects are seen as having when they look coloured. We have thus arrived at the traditional projectivist account of colour experience. The projection posited by this account has the result that the intentional content of visual experience represents external objects as possessing colour qualities that belong, in fact, only to regions of the visual field. By 'gilding or staining all natural objects with the colours borrowed from internal sentiment', as Hume puts it, the mind 'raises in a manner a new creation'.[14]

Talk of a visual field and its intrinsic qualities may seem to involve a commitment to the existence of mental particulars. But we regard the projectivist view of colour experience as potentially neutral on the metaphysics of mind. The visual field may or may not supervene on neural structures; it may or may not be describable by means of adverbs modifying mental verbs rather than by substantives denoting mental items. All we claim is that, no matter how the metaphysical underpinnings of sense experience are ultimately arranged, they must support reference to colours as qualities of a visual field that are represented as inhering in external objects.

Pros and Cons

The projectivist account of colour experience is, in our opinion, the one that occurs naturally to anyone who learns the rudimentary facts about light and vision. It seemed obvious to Galileo, as it did to Newton and Locke as well.[15]

The Principle of Charity as Applied to Visual Experience Given the intuitive appeal that the projectivist account holds for anyone who knows about the nature of light and vision, the question arises why some philosophers go to such lengths in defence of alternative accounts. The reason, as we have suggested, is that these philosophers are moved by a perceived requirement of charity in the interpretation of representational content. External objects do not actually have the colour qualities that projectivism interprets visual experience as attributing to them. The projectivist account thus interprets visual experience as having a content that would be systematically erroneous. And it therefore strikes some as violating a basic principle of interpretation.

In our opinion, however, applying a principle of charity in this way would be questionable, for two reasons. First, a principle of charity applies primarily to a language, or other representational system, *taken as a whole*; and so, when rightly understood, such a principle is perfectly consistent with the possibility that large regions of the language should rest on widespread and systematic error. Second, what a principle of charity recommends is, not that we should avoid attributing widespread error at all costs, but that we should avoid attributing inexplicable error. And the error that a Galilean view of colour entails is not inexplicable; it can be explained precisely

as an error committed through projection—that is, through the misrepresentation of qualities that inhere in the visual field as inhering in the objects that are therein represented.

We therefore think that the usual motives for resisting projectivism are misguided, on quite general grounds. Nevertheless, some philosophers have criticized projectivism for being uncharitable to visual experience in rather specific ways; and we think that these more specific charges deserve to be answered. We devote the remainder of this section to three of these criticisms.

Colours as *Visibilia* One argument in this vein comes from the dispositionalists. They contend that failing to see colours as dispositions to look coloured would entail failing to see them as essentially connected with vision, as *visibilia*.[16] But nothing can be seen as a colour without being seen as essentially connected with vision, the dispositionalists continue, and so colours cannot possibly be misrepresented in visual experience.

This version of the argument from charity relies on the assumption that the only way to see colours as essentially connected with vision is to see them as dispositions to cause visual perceptions. We reply that colours can be seen as essentially connected with vision without being seen as dispositions at all. In particular, they can be seen as essentially connected with vision if they are seen as the qualities directly presented in visual experience, arrayed on the visual field. The experience of seeing red is unmistakably an experience of a quality that could not be experienced other than visually. Consequently, red is seen as essentially visual without being seen as a disposition to cause visual perceptions.

A Berkeleyan Objection Another version of the argument from charity begins with the premiss that qualities of the visual field cannot be imagined except as being seen, and hence that they cannot be imagined as intrinsic and categorical qualities of material objects—qualities belonging to the objects in themselves, whether they are seen or not. This premiss is taken to imply that visual experience cannot possibly commit the error of representing colour *qualia* to be intrinsic and categorical qualities of objects, as projectivism charges, simply because it cannot represent the unimaginable.[17]

Our reply to this argument is that its premiss is false. The colour qualities that modify the visual field can indeed be imagined as unseen. Of course, one cannot imagine a colour as unseen while instantiated in the visual field itself, since to imagine a quality as in the visual field is to imagine that it is seen. But one can imagine a colour as instantiated elsewhere without being seen—by imagining, for example, an

ordinary red-rubber ball, whose surface is red not only on the visible, near side but also on the unseen, far side.

What exponents of the present objection are pointing out, of course, is that one cannot imagine the unseen side of the ball as red by means of a mental image whose features include a red area corresponding to that side of the ball. Here they may be correct.[18] To form an image containing a coloured area corresponding to the unseen side of the ball would be to imagine seeing it, and hence not to imagine it as unseen, after all. But one's imagination is not confined to representing things by means of corresponding features in one's mental image. If it were, then one would be unable to imagine any object as being both opaque and three-dimensional; one would be reduced to imagining the world as a maze of backless façades, all artfully turned in one's direction. In actuality, one imagines the world as comprising objects in the round, whose unseen sides are represented in one's image indirectly and, so to speak, by implication. One can therefore imagine unseen colours, despite limitations on how one's imagination can represent them.

Visual experience has the same representational capacity, despite similar limitations. That is, although one cannot visually catch colours in the act of being unseen, one nevertheless sees the world as containing unseen colours—on the far sides of objects, in areas obscured by shadow, and so on. Just as one sees one's fellow human beings as having hair at the back, skin up their sleeves, and eyeballs even when they blink, so one sees them as possessing these unseen features in their usual colours. Thus, one has no trouble seeing colours as intrinsic and categorical properties that exist even when unseen.

Can Experience Commit Category Errors? A third version of the argument from charity alleges that according to projectivism visual experience commits not just a mistake but a *category* mistake, by representing external, material objects as having properties that can occur only within the mental realm.[19] Such a mistake is thought too gross for visual experience to commit.

It is not clear whether it is a necessary or merely contingent fact that external objects do not possess the sorts of property we understand colours to be; hence, it is not clear whether the mistake projectivism attributes to visual experience is categorial or merely systematic. But even if it were a category mistake, why should this necessarily be considered a difficulty for projectivism?

The assumption underlying the objection is that it is somehow extremely difficult to see how experience could commit a category mistake. But as the following remark of Wittgenstein suggests, just the opposite seems true.

Let us imagine the following: The surfaces of the things around us (stones, plants, etc.) have patches and regions with produce pain in our skin when we touch them. (Perhaps through the chemical composition of these surfaces. But we need not know that.) In this case we should speak of pain-patches just as at present we speak of red patches.[20]

In the normal experience of pain, pain is not perceived as a quality of its cause. As Wittgenstein remarks, however, this seems to be thanks only to the fact that the normal causes of pain constitute such a heterogeneous class. Were pain to be caused solely, say, by certain specific patches on the surfaces of plants, we might well experience pain as being in the plant, much as we now experience its colour. Far from being unimaginable, then, it would seem that nothing but a purely contingent fact about our experience of pain stands between us and a category mistake just like the one that projectivism portrays us as committing about colour.

Interpreting Colour Discourse

Thus far we have discussed colour concepts as they are exercised in the representational content of colour experience. Let us turn, somewhat more briefly, to the content of ordinary discourse about colour.

We assume that ordinary discourse about colour reports the contents of visual experience. The most plausible hypothesis about what someone means when he calls something red, in an everyday context, is that he is reporting what his eyes tell him. And according to our account, what his eyes tell him is that the thing has a particular visual quality, a quality that does not actually inhere in external objects but is a quality of his visual field. We therefore conclude that when someone calls something red, in an everyday context, he is asserting a falsehood. Indeed, our account of colour experience, when joined with the plausible hypothesis that colour discourse reports the contents of colours experience, yields the consequence that all statements attributing colours to external objects are false.

One would be justified in wondering how we can accept this consequence, for two related reasons. First, we will clearly want to retain a distinction between 'correct' and 'incorrect' colour judgements, distinguishing between the judgement that a fire-hydrant is blue and the judgement that it is red. And it seems a serious question what point we error theorists could see in such a distinction. Second, it seems perfectly obvious that colour discourse will continue to play an indispensable role in our everyday cognitive transactions. Yet how are we error theorists to explain this indispensability, consistently with our claim that the discourse in question is systematically false? We shall begin with the second question.

The Point of Colour-Talk Consider one of the many harmless falsehoods that we tolerate in everyday discourse: the statement that the sun rises. When someone says that the sun rises, his remark has the same content as the visual experience that one has when watching the horizon at an appropriately early hour. That is, the sun actually looks like it is moving, and that the sun moves in this manner is what most people mean when talking about sunrise. So interpreted, of course, talk about sunrise is systematically false. When someone says that the sun rises, he is wrong; and he usually knows that he is wrong, but he says it anyway. Why?

When one understands why talk about sunrise is false, one also understands that its falsity makes no difference in everyday life. We do not mean that nothing in everyday life would, in fact, be different if the sun revolved around the earth, as it seems to. No doubt, the tides and the phases of the moon and various other phenomena would be other than they actually are. But those differences are not missed by the ordinary person, who does not know and has no reason to consider precisely how the tides and phases of the moon are generated. Consequently, someone who has a normal background of beliefs will find no evidence in everyday life to controvert his belief that the sun revolves around the earth. That belief will not mislead him about any of the phenomena he normally encounters; and it will in fact give him correct guidance about many such phenomena. His judgements about the time of day, the weather, the best placement of crops, the location of glare and of shadows at noon, will all be correct despite being derived from premises about a stationary earth and a revolving sun. Indeed, he is likely to derive more true conclusions from his belief in a revolving sun than he would from a belief in a rotating earth, for the simple reason that the consequences for earthlings of the former state of affairs are easier to visualize than those of the latter, even though those consequences would be the same, for everyday purposes. Talking about horizon-fall rather than sunrise would thus be downright misleading, even though it would be more truthful. Only an undue fascination with the truth could lead someone to reform ordinary discourse about the sun.

Talk about colours is just like talk about sunrise in these respects. That is, life goes on as if objects are coloured in the way that they appear to be. Experience refutes few if any of the conclusions derived from beliefs about objects' colours; and many true conclusions are derived from such beliefs. Most of those true conclusions, of course, are about how objects will look to various people under various circumstances. And these conclusions are extremely useful in everyday life, since one's ability to communicate with others and with one's future selves about the external world depends on the ability to describe how various parts of that world appear. The point

is that such conclusions are more easily and more reliably drawn from the familiar false picture of colours than they would be—by the ordinary person, at least—from the true picture of wavelengths and spectral-reflectance curves. Why, then, should one replace such a useful false picture with a true but misleading one?

Correct vs. Incorrect Colour-Talk The case of colour differs from that of sunrise in one important respect. The sun never seems to do anything but move in a regular arc across the heavens, whereas objects often seem to have different colours in different circumstances. The ordinary speaker therefore finds himself drawing a distinction between the colours that objects really have and the colours that they only seem to have on some occasions. How can we countenance this distinction between real and illusory colours, given that our theory brands all colours as illusory?[21]

The answer is that classifying an object by the colour that it appears to have under so-called standard conditions is the most reliable and most informative way of classifying it, for the purposes of drawing useful conclusions about how the object will appear under conditions of any kind. Obviously, classifying an object by how it appears in the dark is not at all informative, since all objects appear equally black in the dark, even though they appear to have different colours in the light. Hence one can extrapolate an objects' appearance in the dark from its appearance in the light, but not vice versa. The same is true—though to a lesser degree, of course—for other non-standard conditions. For instance, distance tends to lend a similar appearance to objects that look different at close range; coloured light tends to lend a similar appearance to objects that look different in daylight; and so on. The common-sense calculus of colour addition and subtraction therefore enables one to infer an objects' appearance under non-standard conditions from its appearance under standard conditions, but not its appearance under standard conditions from that under non-standard conditions. That is why one set of conditions, and the accompanying colour-illusion, are privileged in everyday life.

There are notable exceptions to our claim about the varying informativeness of various colour appearances. But these exceptions actually support our explanation of why particular colour-illusions are privileged in ordinary discourse, because consideration of them leads the ordinary speaker to reconsider the distinction between true and illusory colour.

Some pairs of objects that appear to have the same colour in daylight—say, green—can appear to have different colours under incandescent lighting, where one may appear green and the other brown.[22] In these cases, how an object appears in daylight is not an indication of how it will appear under other less standard conditions.

Yet in these cases, one begins to wonder whether the object has a 'true' or standard colour at all. If an object's apparent colour does not vary, from one set of conditions to the next, in the same way as the apparent colour of objects that share its apparent colour in daylight, then one is tempted to say that the object does not have any one colour at all. Consider the object that looks green in daylight but brown in incandescent light, where most other objects that look green in daylight still look green. Is the object really green? really brown? Does it have any single 'real' colour at all?[23] Here intuitions diverge and ultimately give out. The reason, we think, is precisely that the common-sense notion of an object's real colour presupposes that it is the one apparent colour from which all its other apparent colours can be extrapolated, by fairly familiar rules of colour mixing. When that assumption is threatened, so is the notion of real colour.

Acknowledgments

We have benefited from discussing the material in this paper with: Sydney Shoemaker, David Hills, Larry Sklar, Mark Johnston, and participants in a seminar that we taught at the University of Michigan in the fall of 1987. Our research has been supported by Rackham Faculty Fellowships from the University of Michigan.

Notes

1. *Opere Complete di G. G.*, 15 vols, Florence, 1842, IV, p. 333 (as translated by E. A. Burtt in *The Metaphysical Foundations of Modern Science*, Doubleday, Garden City, NY, 1954, p. 85).

2. Sydney Shoemaker, 'Qualities and Qualia: What's In The Mind?' *Philosophy and Phenomenological Research* 50, 109–31.

3. One might be tempted to dissolve the conflict between the Galilean view and the charitable view of colour experience by rejecting a presupposition that they share. Both sides of the conflict assume that the properties mentioned in our descriptions of visual experience are properties that such experience represents objects as having. The only disagreement is over the question whether the colour properties that are thus attributed to objects by visual experience are properties that the objects tend to have. One might claim, however, that visual experience does not attribute properties to objects at all; and one might bolster one's claim by appeal to a theory known as adverbialism. According to adverbialism, the experience of seeing a thing as red is an event modified by some adverbial property—say, a seeing event that proceeds red-thing-ly. Not all adherents of adverbialism are committed to denying that such an experience represents an object as having a property; but adverbialism would indeed by useful to one who wished to deny it. For adverbialism would enable one to say that the phrase 'seeing a thing as red' describes a seeing event as having some adverbial property rather than as having the content that something is red. One could therefore contend that the question whether things really have the colour properties that they are seen as having is simply ill-formed, since colour properties figure in a visual experience as adverbial modifications of the experience rather than as properties attributed by the experience to an object.

Our view is that this extreme version of adverbialism does unacceptable violence to the concept of visual experience. Seeing something as red is the sort of thing that can be illusory or veridical, hence the sort of

thing that has truth-conditions, and hence the sort of thing that has content. The content of this experience is that the object in question is red; and so the experience represents an object as having a property, about which we can legitimately ask whether it is a property that objects so represented really tend to have. ·

4. D. M. Armstrong, *A Materialist Theory of Mind*, Routledge & Kegan Paul, London, 1968; J. J. C. Smart, 'On Some Criticisms of a Physicalist Theory of Colors', in *Philosophical Aspects of the Mind-Body Problem*, ed. Chung-ying Cheng, University of Hawaii, Honolulu, 1975 [chapter 1, this volume] (as cited by Christopher Peacocke, 'Colour Concepts and Colour Experience', *Synthèse*, 1984, pp. 365–81, n. 5) [chapter 5, this volume].

5. The final clause of this biconditional is often formulated so as to specify not only standard conditions but a standard observer as well. But the observer's being standard can itself be treated as a condition of observation; and so the distinction between observer and conditions is unnecessary.

6. See John McDowell, 'Values and Secondary Qualities', in *Morality and Objectivity; a Tribute to J. L. Mackie*, ed. Ted Honderich, Routledge & Kegan Paul, London, 1985, pp. 110–29; David Wiggins, 'A Sensible Subjectivism?', in *Needs, Values, Truth*, Basil Blackwell, Oxford, 1987, pp. 185–214, p. 189; Gareth Evans, 'Things Without the Mind—A Commentary Upon Chapter Two of Strawson's *Individuals*', in *Philosophical Subjects; Essays Presented to P. F. Strawson*, ed. Zak van Straaten, Clarendon Press, Oxford, 1980, pp. 76–116, see pp. 94–100, esp. n. 30.
 Wiggins and McDowell favour a similar strategy for vindicating our perceptions of other qualities such as the comic and perhaps even the good. See McDowell's Lindley Lecture, 'Projection and Truth in Ethics'.

7. Peacocke, 'Colour Concepts and Colour Experience'.

8. Perhaps the best argument for this claim is that no one who can identify the colours of external objects needs to be taught how to identify the colours of after-images. Once a person can recognize fire hydrants and maraschino cherries as red, he can identify the colour of the spots that float before his eyes after the flash-bulb has fired. He does not need to be taught a second sense of 'red' for the purpose of describing the latter experience.

9. See McGinn, *The Subjective View*, Clarendon Press, Oxford, 1983, pp. 6–8; McDowell, 'Values and Secondary Qualities', n. 6; Wiggins, 'A Sensible Subjectivism?', p. 189; Michael Smith, 'Peacocke on Red and Red'', *Synthèse*, 1986, pp. 559–76.

10. See McDowell, 'Values and Secondary Qualities', p. 112: 'What would one expect it to be like to experience something's being such as to look red, if not to experience the thing in question (in the right circumstances) as looking, precisely, red?'

11. When McDowell discusses dispositionalism about the comic, in 'Projection and Truth in Ethics', he tries to make the circularity of the theory into a virtue, by arguing that it blocks a projectivist account of humour. He says, 'The suggestion is that there is no self-contained prior fact of our subjective lives that could enter into a projective account of the relevant way of thinking'—that is, no independently specifi-able subjective response that we can be described as projecting onto the world (p. 6). We would argue that the same problem afflicts, not just a projectivist account of the comical, but our very perceptions of things as comical, as McDowell interprets those perceptions.

12. *Sense and Content; Experience, Thought, and Their Relations*, Clarendon Press, Oxford, 1983, ch. 1. Other arguments are provided by Sydney Shoemaker in 'Qualities and Qualia: What's in the Mind?'.

13. Intentionalism cannot characterize the experience in question as being similar to, or representing itself as being similar to, the experience you have when you see redness as attaching to a material object. Such an experience would have a different content from the one you are now having, and so it would not be like your present experience in any respect that the intentionalist can identify. Of course, once we abandon intentionalism, we can say that your present experience and the experience of seeing a red material object are alike in their intrinsic qualities. But such qualities are denied by intentionalism.

14. David Hume, *Enquiry Concerning the Principles of Morals*, ed. L. A. Selby-Bigge, Oxford University Press, Oxford, 1975, Appendix 1. Of course, this passage is literally about the projection of value, not colour. But surely, Hume chose colour as his metaphor for value, in this context, because he regarded projectivism about colour as an intuitively natural view.

15. Isaac Newton, *Opticks*, Dover Publications, New York, 1979, Book I, part i, definition; John Locke, *An Essay Concerning Human Understanding*, ed. Peter H. Nidditch, Clarendon Press, Oxford, 1975, Book II, ch. viii. Jonathan Bennett has interpreted Locke as a dispositionalist about colour (*Locke, Berkeley, Hume; Central Themes*, Clarendon Press, Oxford, 1971, ch. IV). But the textual evidence is overwhelming that Locke believed colour experience to be guilty of an error, and a projectivist error, at that. Locke was a dispositionalist, in our opinion, only about the properties of objects that actually cause colour experience, not about the properties that such experience represents objects as having.

16. See McDowell, 'Values and Secondary Qualities', pp 113–15.

17. See Evans, 'Things Without the Mind', pp. 99–100. Berkeley carried this argument farther, by claiming that unperceived qualities, being unimaginable, were also inconceivable and hence impossible. Berkeley's willingness to equate imagination with conception was due to his theory of ideas, which equated concepts with mental pictures.

18. We grant this point for the sake of argument; but we think that it, too, underestimates the representational powers of the imagination. For surely one can form a mental image that contains a 'cut-away' view, showing how the far side of the ball looks while implying that it is, in reality, unseen.

19. See Shoemaker, 'Qualities and Qualia: What's In The Mind?', p. 114.

20. *Philosophical Investigations*, Blackwell, Oxford, 1974, section 312. We do not necessarily claim that the use to which we should like to put this passage coincides with Wittgenstein's.

21. We should point out that a similar question will confront those who adopt a dispositionalist interpretation of colour discourse. For according to dispositionalism, the colours of objects are their dispositions to present the appearance of colour; and objects are disposed to present the appearance of different colours under different circumstances. Corresponding to every colour that an object ever appears or would appear to have, there is a disposition of the object to give that appearance under the circumstances then prevailing. Now, dispositionalism denominates only one of these innumerable dispositions as the object's real colour, and it does so by defining the object's colour to be that disposition which is manifested under conditions specified as standard. But surely, dispositionalism should have to justify its selection of dispositions—or, what amounts to the same thing, its selection of standard conditions. For if colour is nothing but a disposition to produce colour appearances, one wants to know why a particular disposition to produce colour appearances should be privileged over other such dispositions. And this is, in effect, the same question as why one colour-illusion should be privileged over other colour-illusions, given the assumption that all colours are illusory.

22. This phenomenon is called metamerism. See C. L. Hardin, *Color for Philosophers; Unweaving the Rainbow*, Hackett, Indianapolis, 1988, pp. 28, 45 ff.

23. People who spend much time considering these cases have been known to give up the notion of true colour entirely. We once asked a scientist who performs research on colour vision why people think that most opaque objects have a real colour. His answer was, 'They do? How odd.'

8 Physicalist Theories of Color

Paul A. Boghossian and J. David Velleman

The Problem of Color Realism

The dispute between realists about color and anti-realists is actually a dispute about the nature of color properties. The disputants do not disagree over what material objects are like. Rather, they disagree over whether any of the uncontroversial facts about material objects—their powers to cause visual experiences, their dispositions to reflect incident light, their atomic makeup, and so on—amount to their having colors. The disagreement is thus about which properties colors are and, in particular, whether colors are any of the properties in a particular set that is acknowledged on both sides to exhaust the properties of material objects.

In a previous paper [chapter 7] we discussed at length one attempt to identify colors with particular properties of material objects—namely, with their dispositions to cause visual experiences. Here we shall discuss a different and perhaps more influential version of realism, which says that the colors of material objects are microphysical properties of their surfaces.[1] We shall call this theory physicalism about color (physicalism, for short). In order to evaluate this theory, however, we shall first have to clarify some methodological issues. Our hope is that we can bring some further clarity to the question of color realism, whether or not we succeed in our critique of the physicalists' answer.

Metaphysics and Semantics

To say that the question of color realism is really about the nature of color properties is not yet to define the question sufficiently. One is tempted to ask, Which are the properties whose nature is at issue?

Of course, the latter question may seem like an invitation to beg the former. For in order to say which properties are at issue in the debate about the nature of colors, one would have to say which properties colors are—which would seem to require settling the debate before defining it. How, indeed, can one ever debate the nature of a property? Until one knows which property is at issue, the debate cannot get started; but as soon as one knows which property is at issue, it would seem, the debate is over.

Well, not quite. One can pick out a property by means of a contingent fact about it. And one can thereby specify the property whose nature is to be debated without preempting the debate. Such indirect specifications are what motivate questions about the nature of properties. One knows or suspects that there is a property

playing a particular role, say, or occupying a particular relation, and one wants to know which property it is, given that playing the role or occupying the relation isn't the property in question.

The role in which colors command attention, of course, is their role as the properties attributed to objects by a particular aspect of visual experience. They are the properties that objects appear to have when they look colored. What philosophers want to know is whether the properties that objects thus appear to have are among the ones that they are generally agreed to have in reality.

Yet if the question is whether some agreed-upon set of properties includes the ones that objects appear to have in looking colored, then it is partly a question about the content of visual appearances. When philosophers ask whether colors are real, they are asking whether any of the properties acknowledged to be real are the ones attributed to an object by the experience of its looking colored; and so they are asking, in part, which properties are represented in that experience—which is a question of its content.

What is Looking Colored?

The foregoing attempt to define which properties are at issue in the question of color realism may seem viciously circular. For we identified colors as the properties that things appear to have when they look colored; and how can this description help to pick out the relevant properties? It specifies the properties in terms of their being represented in a particular kind of experience, but then it seems to specify the relevant kind of experience in terms of its representing those properties. Which properties objects appear to have in looking colored depends on what counts as looking colored, which would seem to depend, in turn, on which properties colors are— which is precisely what was to be defined.

This problem is not insuperable, however. The phrase "looks colored" and its determinate cousins—"looks red," "looks blue," and so forth—have a referential as well as an attributive use. That is, one learns to associate these phrases directly with visual experiences that are introspectively recognizable as similar in kind to paradigm instances. Paradigm cases of looking red fix a reference for the phrase "looks red," which then refers to all introspectively similar experiences. We can therefore speak of something's looking red and rely on the reader to know which kind of visual experience we mean, without our having to specify which property red is.[2] There is no circularity, then, in identifying red as the property attributed to objects by their looking red and, more generally, in identifying colors as the properties attributed to objects by their looking colored.[3]

Color Experience vs. Color Discourse

One might think that the references we have stipulated here are simply the references that color terms have anyway, in ordinary discourse. Surely, words like "red" and "blue" are sensory terms, designed to report what is seen. One may therefore feel entitled to presuppose that the term "red," as used in ordinary discourse, already denotes the property that things appear to have when they look red.

Yet the validity of this presupposition may depend on the answer to the question of color realism. For whether the ordinary term "red" always expresses the property that things appear to have in looking red may depend on whether that appearance is veridical or illusory. Suppose that an error theory of color experience is correct, in that the property that things appear to have when they look red is a property that they do not (and perhaps could not) have. In that case, the meaning of "red" in ordinary discourse will be subject to conflicting pressures. The term may still be used to express the property that objects are seen as having when they look red. Yet statements calling objects red in that sense will be systematically false, even if such statements tend to be made, and to garner assent, in reference to objects that have some physical property in common. In the interest of saying what's true, rather than what merely appears true, speakers may then be inclined to shade the meaning of "red" toward denoting whatever property is distinctive of red-looking objects.[4] The pressure towards speaking the truth will thus conflict with the pressure towards reporting the testimony of vision. How the meaning of "red" will fare under these conflicting pressures is hard to predict; it may even break apart, yielding two senses of the term, one to express the content of color experience and another to denote the property tracked by color attributions.

We are not here proposing or defending such an account of color language. We are merely pointing it out as a possibility and suggesting that this possibility shouldn't be excluded at the outset of inquiry about color. To assume that color terms denote the properties represented in color experience is to assume that terms used to attribute those properties to objects wouldn't come under pressure from the systematic falsity of such attributions—something that may or may not turn out to be the case but shouldn't be assumed at the outset. One should begin as an agnostic about whether color terms ordinarily denote the properties that are represented in color experience. If they are to be used in a debate about those properties, their reference to them must be explicitly stipulated.

Versions of Physicalism

If physicalism is to settle the debate over color realism, it must be formulated as a thesis about the properties at issue in that debate. When the physicalist says that colors are microphysical properties, he must mean that microphysical properties are the ones attributed to objects by their looking colored. Otherwise, his claim will not succeed in attaching the uncontroversial reality of microphysical properties to the properties whose reality is in question—that is, the properties represented in color experience. Physicalism must therefore be, in part, a thesis about which properties color experience represents.

The Naive Objection

When the physicalist thesis is so interpreted, however, it tends to elicit the following, naive objection. The microphysical properties of an object are invisible and hence cannot be what is represented when the object looks colored. One can tell an object's color just by looking at it, but one cannot tell anything about its molecular structure—nor, indeed, that it has such a structure—without the aid of instruments or experimentation. How can colors, which are visible, be microphysical properties, which are not?

Physicalists regard this objection as obviously mistaken, although different physicalists regard it as committing different mistakes. A particular physicalist's response to the objection will be conditioned by his brand of physicalism, on the one hand, and his conception of visual representation, on the other. We therefore turn our attention, in the next two sections, to these potential differences among proponents of physicalism.

Colors vs. Ways of Being Colored

The claim that red is a microphysical property can express either of two very different theses. On the one hand, the claim may state a strict identity between properties. In that case, it means that having a particular microphysical configuration is one and the same property as being red. On the other hand, the claim may mean that having this microphysical configuration is a way of being red and, in particular, the way in which things are red in actuality. In that case, the relation drawn between these properties is not identity. Rather, red is envisioned as a higher-order property—the property of having some (lower-order) property satisfying particular conditions—and the microphysical configuration is envisioned as a lower-order property satisfying those conditions, and hence as a realization or embodiment of red.

The difference between these two views is analogous to that between type-physicalism and functionalist materialism in the philosophy of mind. Physicalism says that pain is one and the same state as a configuration of excited neurons. Functionalist materialism says that pain is the higher-order state of occupying some state that plays a particular role, that this role is played in humans by a configuration of excited neurons, and hence that having excited neurons is the way in which humans have pain. Both views can be expressed by the claim that pain is a neural state, but this claim asserts a strict identity only when expressing the former view.

We shall distinguish between the corresponding views of color by referring to them as the *physical identity* view and the *physical realization* view, or *identity-physicalism* and *realization-physicalism*.[5] To repeat, only identity-physicalism says that red is one and the same property as a microphysical configuration; realization-physicalism says that the microphysical configuration is merely a way of being red.

Adherents of both identity-physicalism and realization-physicalism will dismiss the naive objection mooted above, but they will dismiss it on different grounds. A realization-physicalist can say that the naive objection confuses color properties with the properties that embody them. The ability to see which color an object instantiates is perfectly compatible, in his view, with an inability to see the particular way in which it instantiates that color. For in his view, seeing that an object is red consists in seeing that it has some property satisfying particular conditions; and seeing that an object has *some* such property need not entail seeing *which* such property it has. The invisibility of microphysical properties therefore doesn't preclude them from realizing or embodying colors.

This refutation of the naive objection is not available to the identity-physicalist, of course, since he doesn't draw any distinction between colors and their realizations. The identity-physicalist can still fend off the objection, however, by claiming that it misconstrues the use to which he puts the phrase "microphysical properties." The objection construes this phrase, he says, as articulating a mode of presentation under which colors are represented in visual experience—as expressing what colors are *seen as*—whereas the phrase is actually intended only to identify the nature of color properties. The physicalist points out that although one never sees anything as a layer of molecules—never sees anything under the characterization "layer of molecules"—one nevertheless sees things that are, in fact, layers of molecules, since that's precisely what the visible surfaces of objects are. Similarly, the physicalist argues, seeing nothing under the mode of presentation "microphysical property" doesn't prevent one from seeing things that *are* microphysical properties. And that colors *are* such properties is all that any physicalist means to say.

The Propositional Content of Visual Experience

Thus, the suggestion that physicalism requires colors to be seen under microphysical modes of presentation will be rejected by physicalists of all stripes. Some physicalists will go further, however, by denying that colors are seen under any modes of presentation at all. Whether a physicalist makes this further denial depends on his views about the propositional content of color experience.

On the one hand, a physicalist may take a fregean view of the visual representation of color. According to that view, the experience of seeing something as red has that content by virtue of the subject's relation to a proposition containing a concept, characterization, or (as we have put it) mode of presentation that is uniquely satisfied by instances of red. The property itself is not an element of the propositional content, as the fregean conceives it; rather, it is represented by an element of the content, namely, a characterization.

On the other hand, a physicalist might take a completely different view of how color is visually represented, a view that we shall call russellian. According to that view, the experience of seeing something as red has that content by virtue of the subject's relation to a proposition containing the property red—the property itself, not a conception, characterization, or presentation of it. A russellian believes that the property is introduced into the content of experience by something that directly refers to it. This item may be an introspectible, qualitative feature of visual experience, for example, or a word of mentalese tokened in some visual-experience "box." Whatever it is, it must be capable of referring to the property red directly—say, by virtue of a correlation or causal relation with it[6]—rather than by specifying it descriptively, in the sense of having a meaning uniquely satisfied by red objects.[7]

A strict russellian may believe that the mental symbol for red has no descriptive meaning at all—just a reference. A more liberal russellian may believe that it has a meaning, but that its meaning is not sufficient to specify the property red or to determine a complete proposition about redness, and hence that the content of seeing something as red must still be completed by the property itself, introduced via direct reference. The difference between these two variants of russellianism is analogous to that between two variants of the familiar causal theory about natural-kind terms. On the one hand, the word "gold" can be viewed as a name that has no descriptive meaning over and above its reference to gold (although this reference may have been fixed, of course, with the help of a description). On the other hand, "gold" can be viewed as having a descriptive meaning such as "a kind of matter," which is not sufficient to specify a particular kind of matter and must therefore be supplemented by a causally mediated relation of reference to gold. According to the latter

view, "gold" and "silver" share the meaning "a kind of matter" but refer to different kinds of matter; and their contributions to the content of sentences must include not only their shared meaning but also their distinct referents. According to the corresponding view about the visual representation of color, there are mental symbols for red and orange that may contribute a shared meaning to the content of visual experiences—say, "a surface property"—while introducing different properties as their referents.

A proponent of this liberal russellianism will acknowledge that visual experience contains some characterization of colors, but his stricter colleague will not, since the strict russellian believes that red is introduced into visual content by an item possessing no descriptive meaning at all. The strict russellian will therefore deny that colors are seen under any modes of presentation. And he will consequently think of the naive objection to physicalism as doubly mistaken—not only in suggesting that he uses the phrase "microphysical property" to articulate such modes of presentation but also in suggesting that he acknowledges their existence.

Further Distinctions

The foregoing responses to the naive objection are cogent, as far as they go; but in our opinion, they don't go far enough. The physicalists have described a way in which microphysically constituted colors *aren't* represented in visual experience—namely, under microphysical characterizations—but they haven't yet told us how else such colors *are* represented. Similarly, the realization-physicalist has described what color properties are not—namely, microphysical properties—but he hasn't yet told us what colors are instead. The realization-physicalist therefore owes us an account of the higher-order properties that are identical with colors, in his view; and all of the physicalists owe us an account of how the properties with which they identify colors can be the ones represented in visual experience.

Once again, different physicalists are likely to respond differently. The distinction between fregeanism and russellianism and the distinction between the physical identity view and the physical realization view define a four-fold partition of physicalist theories. And within each cell of the partition, further variation is possible. For example, some physicalists believe that the experience of seeing something red normally has a distinctive, introspectible quality in addition to its representational content—a visual "feel," if you will—and that what the experience represents cannot be understood independently of how it feels. Others believe that a visual experience doesn't have intrinsic qualities, or that such qualities are in any case incidental to its content. Different physicalists are also motivated by different intuitions about how physically constituted colors are best identified and hence about how they are

likely to be picked out in visual experience. Some identify colors as those physical properties which are common to various classes of objects; they consequently treat the perception of colors as the recognition of physical similarities and differences.[8] Others identify colors as those physical properties which cause particular visual effects, and consequently treat color perception as the recognition, via those effects, of their physical causes.[9]

These disagreements might be thought to require further subdivision of physicalist territory, into eight or even sixteen regions instead of four. But we begin to wonder, at this point, whether all of the resulting regions would be occupied by theories that were even remotely plausible. We shall therefore proceed less abstractly, by developing the latter intuitions about how to identify physically constituted colors. Each of these intuitions could in principle lead to eight different theories, as it is combined with fregeanism or russellianism, with identity theory or realization theory, and with credence or skepticism about qualia. As we have suggested, however, not all of the resulting permutations are viable. What's more, the lines of thought departing from these intuitions ultimately tend to converge. We shall therefore attempt to formulate only those accounts of color experience which are both plausible and distinct.

The First Intuition: Similarity Classes

One way of picking out an object as red is by saying that its surface shares a property with the surfaces of ripe tomatoes, British phone booths, McIntosh apples, and so on. Perhaps, then, an object can be visually represented as colored by being represented as sharing a property with certain other objects.

But do references to phone booths and tomatoes crop up in the visual representation of objects as red? Surely, people can see things as red without even having the concept of a tomato or a phone booth. Of course, this particular problem could be circumvented if each person's visual experience were conceived as characterizing red objects in terms of paradigms familiar to that person. But the resulting conception of visual experience would still be wrong, for two reasons.

First, the experience of seeing one thing as red makes no explicit allusion to other instances of the color, familiar or not. No matter how conversant one is with tomatoes, and no matter how centrally tomatoes may have figured in one's acquisition of color concepts, seeing a red fire engine doesn't appear to be an experience about tomatoes. Second, visual experience never represents objects as having their colors necessarily or trivially, whereas it would represent tomatoes (or some other objects) as necessarily and trivially red if it represented things as red by characterizing them as sharing a property with tomatoes (or with those other objects).[10]

The moral of these observations is not that an object's color isn't visually represented as a property shared with other objects; the moral is simply that if it is so represented, the other objects aren't specified individually. The possibility remains that the experience of an object as red represents it as sharing a property with objects in a set that includes tomatoes but which is specified without reference to them or to any other individual members.

Yet how can the appropriate set of objects be specified in the content of visual experience, if not in terms of its members? To suggest that it be specified in terms of a property characteristic of those members would defeat the point of the current intuition. The point of the intuition is that a color can be represented in terms of a set of objects precisely because it's the only property common to all members of the set. Specifying the set in terms of the property characteristic of its members would therefore require an antecedent capacity to represent the color—which would render specification of the set superfluous.

A Humean Proposal

Nevertheless, the intuition that an object's color is seen as a property shared with other objects can be preserved, with the help of a proposal dating back to Hume's *Treatise*.[11] Imagine that the experience of seeing an object as red has the indexical character "It's one of *that* kind," wherein the reference of "that kind" is determined by the subject's disposition, at the prompting of the experience, to group the object together with other objects. If the latter objects do constitute a kind, by virtue of possessing some common property, then the experience will have as its content that the former object belongs to that kind and hence that it possesses the characteristic property—a property that could easily be microphysical or realized microphysically.

This account of color experience is of the liberal russellian variety, since it suggests that visual content characterizes its object as belonging to a kind, but that the kind in question must be specified by direct reference rather than by a more specific characterization. Direct reference is mediated in this case by a correlation between potential classificatory behavior of a subject, on the one hand, and a microphysically constituted kind of object, on the other. As we have seen, the proposal has no fregean version, because it requires specification of a kind, and no such specification can be found in the introspectible content of color experience.

An Information-Theoretic Proposal

Here is an alternative way of preserving the first intuition. Imagine that a particular mental symbol is regularly tokened in response to visual encounters with objects of a

particular kind, whose members belong to it by virtue of possessing some character-istic property. The symbol may then qualify as indicating—and thus, in a sense, as referring to—the kind with which it is correlated.[12] And tokenings of the symbol may consequently introduce its referent into the content of visual experiences, in such a way that objects are represented as members of the kind to which the symbol refers. Such an experience will naturally be described, on the one hand, as registering the similarity of its object to other members of the kind and, on the other, as attrib-uting to its object the property characteristic of the kind. In a sense, then, the object will be seen as having a property by being visually associated with other objects that have it. A microphysical or microphysically realized property may thus be attributed to an object by way of the object's visually detected similarity to other objects.[13]

Introducing Qualia

Now suppose that the mental correlate of a color category were not some item of a subliminal mentalese but, rather, an introspectible sensation or quale. To begin with, this supposition could simply be appended to the foregoing russellian account. The visual sensation associated with the appearance of a particular object could then be treated like a numeral in a paint-by-numbers scene, assigning the object to a kind, and hence attributing to it an associated property, without characterizing the kind or property in any way. Which kind or property a particular sensation denoted would be fixed, as before, by causation or correlation.[14]

Once the mental correlate of a color category is imagined as accessible to intro-spection, however, the resources for a fregean theory become available. The content of a visual experience can then be imagined to invoke the accompanying sensation and hence to characterize its object under the description "having the property that is this sensation's normal or predominant cause."

Such an account of how colors are represented can be adopted by proponents of both identity- and realization-physicalism. An identity-physicalist can say that red is the property referred to within the proposed characterization—the property that tends to cause the accompanying sensation. A realization-physicalist can say that red is the higher-order property expressed by the entire characterization—the property of having a property that tends to cause the sensation. On the first reading, colors may turn out to be identical with microphysical properties; on the second, they may turn out to have microphysical realizations.

The Second Intuition: Causes of Visual Effects

At this point our development of the first intuition, that colors can be identified in terms of similarity classes, has brought us around to the second intuition, that colors

can be identified in terms of their visual effects. Indeed, we have already canvassed the only plausible theories derivable from the latter intuition—namely, theories according to which colors are visually represented by, or by reference to, visual sensations that they cause.

These theories can be paraphrased as saying that colors are visually represented as the properties that normally cause objects to look colored. But such a paraphrase will make sense only if looking colored is understood to consist in giving a visual appearance that's accompanied by particular visual sensations, rather than in being visually represented as having colors. For if colors were represented as the properties that normally cause objects to be represented as having colors, the content of color experience would be viciously circular.

Now, some philosophers have denied that this circularity would be vicious. One philosopher has even claimed that it would be a virtue, in that it would account for the notorious undefinability of colors. Colors are indefinable, he says, precisely because their definitions are unavoidably circular.[15]

We think, however, that the proposed circular definition would imply that the content of color experience is vacuous. When one describes an object as having properties that would cause it to be visually represented as red, one is describing it in terms of the experiences that it is equipped to cause, and one is describing those experiences in terms of their content—namely, as experiences of seeing the thing as red. The content of one's description therefore includes, as a proper part, the content of the experiences that the thing is described as equipped to cause; and the content of one's whole description depends on that component. For this reason, the description cannot express the content of the experiences in question. If the content of seeing something as red were that the thing was equipped to cause experiences of seeing it as red, then the content of seeing something as red would include and depend upon the content of experiences of seeing it as red. The content of seeing something as red would thus include and depend upon itself; it would characterize the thing, in effect, as having a property that would cause experiences containing this very characterization; and hence it would fail to attribute any particular property to the object. Circularity in the content of color experience would render that content vacuous.[16]

Thus, the content of visually representing something as colored cannot be that the thing has whatever normally causes objects to be visually represented as colored. As we have seen, however, the content in question can still be that the thing has whatever normally causes objects to look colored, in the sense that it causes their visual appearances to be accompanied by a color sensation.

Outline of the Argument

We have now developed various proposals for ways in which visual experience might represent microphysically constituted color properties. We began with the Humean proposal that colors are directly denoted by the subject's classificatory dispositions. We then introduced an information-theoretic proposal, which says that colors are directly denoted by mental correlates, whether they be items of mentalese or introspectible qualia. We concluded with a fregean variant of the latter possibility, to the effect that colors are characterized descriptively as the properties that normally cause color sensations.

Despite the diversity of these proposals, we think that they are uniformly unsuccessful in showing that visual experience might represent microphysical or microphysically realized colors. Each of them fails to satisfy one of two fundamental requirements for an adequate theory of color vision.

First, we shall argue, a theory of color must respect the epistemology of color experience: it must be compatible with one's knowing what one knows about color properties on the basis of seeing them. The epistemological problem for physicalism is not that the microphysical nature of colors cannot be known on sight; it is rather that other things about colors are known on sight but could not be known in this way if physicalism were true.

Second, we shall argue that a theory of color must respect the phenomenology of color experience: it must be compatible with what it's like to see the world as colored. Mere reflection on what it's like to see colors does not reveal whether the properties being seen are microphysical, but it does yield various constraints on any theory of what those properties are. In particular, such reflection reveals that color experience is naive, in that it purports to acquaint us directly with properties of external objects. In our opinion, no physicalist theory can meet this phenomenological constraint while meeting those imposed by the epistemology of color as well. We consider these constraints in turn, beginning with the epistemological.

Epistemological Constraints

What do you know about colors, not as a student of physics or physiology, but simply in your capacity as a subject of visual experience? We think that you know, for example, that red and orange are properties; that they are different properties, though of the same kind—different determinants of the same determinable; that they are not as different from one another as they are from blue; and that they cannot simultaneously be instantiated in exactly the same place. Finally, you know that red

and orange are properties that things visually appear to have, and you know when things appear to have them.

All but the last two items of knowledge are necessary propositions. Red and orange—that is, the properties that things appear to have in looking red and in looking orange—not only are distinct, similar determinants of the same determinable but are essentially so. A property that wasn't a determinate of the same determinable as red, or wasn't distinct from red, or wasn't similar to red—such a property simply wouldn't be orange. And vice versa.

What's more, mere reflection on color experience provides all the support that might ever be needed for all of the knowledge cited above. That is, you need only reflect on the experiences of seeing things as red and as orange in order to know that they are two distinct, incompatible, but rather similar determinates of a single determinable property; you need only reflect on particular experiences in order to tell which of these properties they represent; and there are no possible circumstances under which more evidence would be needed. We wish to remain neutral on the explanation for this phenomenon. The knowledge in question may be delivered in its entirety by introspection on the contents of the relevant experiences. Alternatively, it may require the recognition of relations among the contents of these experiences, so long as the relations are such as can be recognized *a priori*. It may even require empirical support, so long as the support required is no more than what's provided by the experiences themselves. All we claim is that the experiences of seeing red and orange provide whatever is necessary for this rudimentary knowledge about those properties.

Consider the consequences of denying that your knowledge about colors has this status. If the experiences of seeing red and orange didn't provide all of the support required for the knowledge that they're distinct but similar determinates of the same determinable, then your knowledge of these matters would be hostage to future empirical discoveries. You would have to consider the possibility of obtaining evidence that red and orange are in fact the same property or, conversely, that they aren't similar at all. And given how the references of "red" and "orange" are fixed, evidence that red and orange are the same property, for example, would amount to evidence that the property that objects appear to have in looking red is the same as the property that they appear to have in looking orange.

Does visual experience leave room for the hypothesis that things appear to have the same property in looking red as they do in looking orange? We think not. Nor does it leave room for the hypothesis that red and orange are less alike than red and blue, or that something seemingly seen as red on a particular occasion is being represented as having a property other than red. Your knowledge on these matters is such that nothing would count as evidence against it.

Meeting the Epistemological Constraints

Yet would such knowledge be possible if physicalism were true? We believe that the answer may be yes in the case of fregean realization-physicalism, but that in the case of all other versions of physicalism—that is, russellian theories and identity theories—the answer is no.

What sets the latter theories apart from fregean realization-physicalism is their implication that visual experiences like yours represent colors only as a matter of contingent fact. Under the terms of these theories, an experience internally indistinguishable from your experience of seeking something as red might fail to represent its object as having that color. The reason is that red is represented by your experience, according to these theories, only by virtue of facts incidental to the internal features of the experience.

Which facts these are depends on the physicalist's conception of visual representation. Under the terms of russellianism, they are the causal or correlational facts by virtue of which some mental item, or some behavioral disposition, introduces the microphysically constituted property red into the contents of experiences. Twin-earth examples, in the style of Putnam,[17] will readily demonstrate that the same mental item or the same classificatory behavior might have been correlated with objects of a different kind, sharing a different property—in which case, internally similar experiences would not have represented the property that, according to physicalism, is red.

Under the terms of fregeanism, the facts in virtue of which visual experience represents a microphysical property are the facts in virtue of which instances of that property uniquely satisfy the characterization by which things are visually represented as red. And these facts, too, are bound to be contingent if red is identical with a microphysical property, for reasons illuminated by the naive objection discussed above. Although the naive objection cannot defeat physicalism, it does force the fregean identity-physicalist to concede that the characterization by which things are visually represented as red does not represent what it is to be red. For as an identity-physicalist, he believes that to be red is to have a particular microphysical property, and yet the objection forces him to concede that things aren't seen under microphysical characterizations. The fregean identity-physicalist must therefore believe that things are seen as red by means of a contingent characterization—a characterization that is, in fact, uniquely satisfied by instances of the property red, but not because it represents what redness is. And twin-earth examples will once again demonstrate that such a characterization might not have been uniquely satisfied by instances of red or might have been uniquely satisfied by instances of another property. Just as a mental symbol might have tracked a different property, so the visual char-

acterization "whatever causes this feeling" might have been satisfied by a different property; and in either case, your visual experiences wouldn't have represented red, under the terms of the corresponding theory.

Thus, fregean identity-physicalism is like russellian physicalism in implying that your experience of something's looking red might have been exactly as it is, in all respects internal to you, while failing to represent anything as red. And this consequence has the corollary that there are circumstances under which you couldn't tell, by mere reflection on the experience of something's looking red, whether it is being represented as having the property red.

The physicalist may object, at this point, that something's being contingent doesn't entail its being *a posteriori*. He will argue, more specifically, that the reference of "red" has been fixed for you by a description alluding to your visual experiences: red is, by stipulation, whatever property is attributed to objects by their looking red. That red is the property that something appears to have in looking red is therefore knowable *a priori*, even though it is contingent, just like the length of the standard meter-bar in Paris.[18]

This response misses the epistemological point. The term "red" has been stipulated as denoting the property attributed to objects by their looking red; but the phrase "looks red" has been stipulated as denoting experiences introspectively similar to some paradigm experience. The problem is that under the terms of the theories now in question, there is no introspectively recognizable kind of experience for which you can always tell by introspection whether the same property is represented in all or most experiences of that kind. These theories therefore imply, to begin with, that, for all you know by reflection on visual experience, the attempt to fix the referent of "red" as the property attributed to objects by their looking red may have failed, since there may be no property that predominantly satisfies that description. They imply furthermore that, even if there is a property represented by most instances of things' looking red, you cannot necessarily tell by reflection when a particular experience is representing that property.

This problem can best be illustrated by imaginary cases of context-switching.[19] Suppose that your environment were to change in such a way that your mental designator for red was correlated with, or your visual characterization of red was satisfied by, a new and different property that replaced the current property red wherever it occurred. At first the content of your visual experiences might remain the same, with the result that you saw objects as having a property that they no longer had. But gradually your visual designators or characterizations would come to denote the new property rather than the old. Tomatoes would therefore appear to have a new and different color property—appear to have it, that is, in the only sense in which a

russellian or an identity-theorist can conceive of them as appearing to have any color at all. Yet in all respects internal to you, your experiences would remain unchanged, and so you would be unable to tell by reflection that you were no longer seeing tomatoes as having the color property that you had previously seen them as having.

Russellianism and identity-physicalism therefore entail that without investigation into the physical causes and correlates of your visual experiences, you cannot necessarily know whether tomatoes appear today to have a different color property from the one that they once appeared to have. You might know that whatever property they appear to have is likely to be the current holder of the title "red," if any property is. But you may not be able to tell when things have appeared to have that property in the past; and you may not be able to tell in the future when things appear to have it. Hence there remains a significant sense in which you don't necessarily know when things appear to be red.[20]

Indeed, these theories entail that you cannot always tell without investigation whether objects appear to have any color properties at all. For just as experiences internally indistinguishable from yours might represent different properties, so too they might simply fail to represent properties. Such a failure would occur if the characterizations applied to objects in visual experience were not satisfied, or if the corresponding mental designators were not systematically correlated with visual stimulation from objects of any particular kind.

Consider the russellian theories, which say that visual experience represents objects as colored by means of symbols or behavioral dispositions that designate microphysically constituted kinds. Reflection on such an experience wouldn't necessarily reveal whether the symbols being tokened, or the behavior being prompted, were correlated with objects sharing a common property and constituting a genuine kind. For all one could tell from having the experience, the objects associated with the symbol or behavior might be utterly miscellaneous, and so these purported designators might not indicate membership in a kind or possession of a property. Hence one would be unable to tell, when things looked red, whether there was a property that they thereby appeared to have. And if one didn't know whether things appeared to have a property in looking red, one wouldn't know whether there was such a property as red at all.

The same problem attends the fregean theory, in all but its realization-theoretic form. According to fregean identity-physicalism, as we have developed it, visual experience represents red by characterizing it as the property that normally causes a particular sensation. Yet reflection on a visual representation of this form would not necessarily reveal whether there was a property that normally caused the sensation,

and so it wouldn't reveal whether the associated characterization succeeded in denoting a property.

Of course, the possibility of there being no colors represented in visual experience is only the most bizarre of many possibilities that introspection could not rule out if the present theories were true. A less bizarre possibility is that visual experience might represent only two color properties—one when things look either red, orange, or yellow, and another when they look either green, blue, or violet. The correlational or causal facts could certainly be arranged in such a way as to give these experiences one of only two contents, under the terms of russellian or identity-theoretic physicalism. These theories therefore imply that one cannot always tell without investigation whether red and orange are different colors, the same color, or no color at all.

Some Defenses and Replies

Now, physicalists sometimes admit that visual experience, as they conceive it, is compatible with the possibility that there are no colors.[21] We wonder, however, whether the full import of this concession is generally appreciated. The statement that there may be no colors sounds as if it should gladden the heart of an anti-realist, but it is in fact different from, and perhaps even incompatible with, the views that many anti-realists hold. What these anti-realists believe is that colors are properties that visual experience attributes to objects even though no objects instantiate them. What proponents of the present theories must concede, however, is that there may be no properties attributed to objects by their looking colored, and hence that there may be no such properties as colors, not even uninstantiated ones. They must allow that color experience not only may attribute properties to objects that don't have them, as the anti-realists claim, but may actually fail to attribute properties to objects at all, by failing to express any properties. If this possibility were realized, color experience would lack the representational competence required to be false, strictly speaking, whereas the falsity of color experience is what anti-realism is usually about. And in our opinion, the fact that color experience can at least be false is evident on the face of it.

A physicalist might respond that the designators and characterizations involved in color experience can be assumed to indicate some properties, since something or other is bound to be responsible for one's visual sensations, as specified in the characterizations, and something or other is bound to be correlated with the designators. But the liberal criteria of visual representation that would enable one to assume that some properties or other were being represented would simultaneously undermine one's claim to other items of knowledge about those properties.[22] For if one's

experiences of things as red and as orange represented whatever properties in heaven or earth were correlated with two different designators, or responsible for two different sensations, then one would be even less able to tell by reflection whether those properties belonged to the same determinable, or required extension for their instantiation, or bore greater similarity to one another than to some third property. For all one could tell from seeing colors in the way imagined here, red might be an electrical charge, orange a degree of acidity, and blue a texture.

A physicalist might respond that if the similarities and differences among colors were conceived as relative to an observer, then they would indeed be revealed by reflection on visual experience.[23] Let the imperfect similarity between red and orange consist in the fact that they have distinct but similar effects on normal human observers, and any normal human observer will be able to detect their relation on sight.

The problem with this suggestion is that it can account only for our knowledge of contingent similarities and differences. Red and orange, as conceived by the physicalist, are properties that happen to have distinct but similar effects on human observers, but they might have had effects that were not distinct or were even less similar. Hence the similarity relation that would be accessible by reflection on visual experience, according to physicalism, is a relation that red and orange might not have had. In reality, however, reflection on the experiences of seeing red and orange tells us that if two properties didn't stand in precisely this relation, they wouldn't be the properties we're seeing.[24]

Smart's Analogy

Now, the epistemology of color similarities and differences has received considerable attention from some physicalists who are aware that their theories appear unable to account for it. Because these physicalists subscribe to russellian or identity-theoretic versions of physicalism, they are committed to the proposition that visual experience doesn't characterize objects in terms that would reveal wherein their color properties consist. The problem is that if visual experience doesn't reveal wherein colors consist, it cannot reveal wherein they are essentially alike or different. In order for visual experience to represent how being red is essentially similar or dissimilar to being orange, it would have to represent what it is to be red or to be orange—which it doesn't do, under the terms of the theories in question. These theories therefore seem unable to explain why the similarities and differences among colors can be known on sight.

Physicalists have attempted to meet this challenge by disputing its premise—namely, that visual experience would have to represent the nature of color properties

in order to reveal their similarities and differences. They insist upon "the possibility of being able to report that one thing is like another, without being able to state the respect in which it is like."[25]

J. J. C. Smart once offered an analogy to illustrate this possibility. He wrote:

If we think cybernetically about the nervous system we can envisage it as being able to respond to certain likenesses ... without being able to do more. It would be easier to build a machine which would tell us, say on a punched tape, whether or not ... objects were similar, than it would be to build a machine which would report wherein the similarities consisted.

David Armstrong quotes this passage in application to color similarities and concludes, "No epistemological problem, then."[26]

What Armstrong seems to be suggesting is that one detects the bare fact that red and orange are similar by means of a sensory mechanism that responds to their similarity and produces an awareness of it in one's mind. This similarity-detecting component of the visual sensorium is what corresponds, in Armstrong's view, to the similarity-detecting machine described by Smart.[27] Unfortunately, such a detector, though perfectly conceivable, would not yield the right sort of knowledge about color similarities. For if the similarities among colors were detected by sight, then one's knowledge of them would be defeasible, by evidence of an optical illusion or malfunction. The experience of seeing things as red and as orange would reveal that these colors looked similar, and hence that they were similar if one's eyes could be trusted; but one would have to acknowledge the possibility that their apparent similarity might be an illusion, and that they might not be similar, after all.

In reality, of course, the similarity between red and orange is known beyond question and could not turn out to be an illusion. One needs to have seen red and orange in order to know that they're similar, of course, but only because one needs to have seen them in order to know which properties they are. Once acquainted with them, one doesn't depend on visual evidence for one's knowledge of their similarity, since nothing would count as countervailing evidence.

Armstrong's Analogy

Armstrong has suggested that one's ability to perceive color similarities without perceiving their bases is analogous to the ability to perceive family resemblances:

How can we be aware of the resemblance and the incompatibility of the colour-shades, yet be unaware of, and have to infer, the nature of the colour-properties from which these features flow? The answer, I take it, is in principle the same ... as for the cases where resemblance of particulars such as faces is observed but the respect of resemblance cannot be made out. Despite the fact that the respect in which the faces resemble one another is not identified, it can still act upon our mind, producing in us an awareness of resemblance.[28]

Now, if we follow Armstrong's instructions to interpret this analogy as comparing the perceived similarity of color properties to the perceived similarity of particular faces, then it does nothing to overcome our stated objection. Although one can often see that two faces are alike, one remains aware that the appearance of likeness may be illusory, and hence that the faces may turn out not to be alike, after all, whereas the appearance of similarity between red and orange is not subject to empirical refutation.

Yet Armstrong's analogy is open to a slightly different interpretation, which might seem to suggest a case in which knowledge of bare resemblance need not be defeasible, either. Let the similarity between colors be compared not to that between particular faces but, rather, to that between the contours that the faces appear to have, which are properties rather than particulars.[29] When the perception of family resemblance is thus interpreted as the perception of similarity between complex shapes, it no longer seems exposed to the risk of illusion. The faces may not have the shapes that they appear to have, of course, but the similarity between those shapes remains unmistakable, even though one may not be able to articulate the respects in which they're alike. Why, then, can't the similarity between perceived colors be equally unmistakable and yet equally unanalyzable?

The problem with this version of Armstrong's analogy is that one's ignorance of the respects in which perceived shapes are alike is not analogous to the ignorance that one would have of color similarities if russellian or identity-theoretic physicalism were true. Although one cannot say what's common to the contours that two faces appear to have, one sees those contours under modes of presentation that represent their nature, since shapes are spatial properties and are visually characterized in spatial terms.[30] Information about the aspects in which shapes are similar is therefore included in the introspectible content of their visual appearance. One may just be unable to isolate that information or extract it or put it into words. Under the terms of russellianism or identity-physicalism, however, one's inability to tell what colors have in common isn't due to the difficulty of processing information contained in their visual characterization; it's due to the absence of that information, since colors aren't characterized in terms that represent their nature.

The difference between these cases is like that between purely referential concepts, which have no sense, and concepts whose sense is difficult to explicate. If one has the concept of gold without being able to say what gold is, the reason may be that having the concept consists in nothing more than standing in the right causal relation to the appropriate objects. But if one has the concept of compassion without being able to say what compassion is, the reason is probably that one's concept has a *de dicto* content that one cannot immediately explicate. Thus, reflection on one's concepts of

compassion and pity may not reveal how compassion and pity are alike, any more than reflection on concepts will reveal the relation between gold and silver—but not for the same reason. In the case of gold and silver, the reason will be that one's concepts simply don't reflect the basis of similarity; in the case of compassion and pity, it will be that a relation reflected in one's concepts isn't easy to articulate.

This difference is manifested by differences in one's authority about proposed accounts of the relevant objects or similarities. If someone proposes an account of what gold is, or how it is like silver, one cannot confirm his account simply by consulting one's concepts. But if someone proposes an account of what compassion is, or how it is like pity, reflection on one's concepts may indeed suffice to reveal whether he's right, even if it wouldn't have enabled one to formulate the account on one's own.

To judge by this test, the visual representation of shape is like a concept that's difficult to explicate, since one can indeed confirm an account of the resemblance between two faces by reflecting on how they look. There is thus good reason to believe that one's knowledge of family resemblance depends on visual information of a sort that is not contained in the appearance of colors, as understood by russellian or identity-theoretic physicalism. One does see the respects in which two faces are alike, although one may be unable to isolate or describe them, whereas the versions of physicalism under discussion imply that the respects of similarity between colors are utterly invisible. Hence one's ability to be certain about family resemblances is no indication that one could be equally certain about color resemblances if these versions of physicalism were true.

Explaining the Epistemological Intuitions Away

We believe that the foregoing epistemological objections rule out any theory that portrays visual experience as representing colors contingently—that is, without characterization that denote them necessarily. They thereby rule out russellian versions of physicalism and fregean identity-physicalism as well.

Although such theories cannot respect ordinary intuitions about the epistemology of color, some of them can attempt to explain those intuitions away. In particular, any physicalist who acknowledges the existence of distinctive color sensations, or qualia, can argue that we have mistaken introspective knowledge about those sensations for knowledge about the color properties that they help to represent. What the ordinary observer knows by reflection, this physicalist may claim, is not that there are distinct but similar properties that red-looking and orange-looking objects appear to have but, rather, that there are distinct but similar sensations that accompany these appearances. According to this response, we have displaced—indeed,

projected—these items of knowledge from their true objects, which are color qualia, onto color properties.

But can the physicalist extend this explanation to our most fundamental knowledge claim, that color experience can be known on reflection to represent properties? He can try. For he can say that we have mistaken the introspectible presence of color qualia in visual experience for an introspectible *re*presentation of color properties. Because reflection on visual experience does reveal that things look colored in the sense that their visual appearances are accompanied by color sensations, the physicalist may argue, we have mistaken it as revealing that they look colored in the sense of being represented as having color properties.

But why would we commit this mistake in the case of color, when we have no tendency to commit it in the cases of other, equally vivid sensations? One isn't tempted to think that sensations of pain, for example, attribute any properties to the objects that cause them. Reflection on the experience of being pricked by a pin doesn't yield the conviction that the pin is being represented as having a pain-property. Why, then, should reflection on an experience accompanied by a color sensation yield the conviction that its object is being represented as colored?

Here again the physicalist may think that he has an explanation. For as Wittgenstein pointed out, sensations of pain, unlike sensations of red, are not regularly received from particular objects or surfaces; if they were, "we should speak of pain-patches just as at present we speak of red patches."[31] Perhaps, then, we believe that visual experience attributes color properties to objects because we've observed the regularity with which color sensations are associated with the perception of particular surfaces. According to this explanation, the knowledge that we have claimed to possess on the basis of mere reflection is in fact derived from observed patterns and correlations within visual experience.[32]

Unfortunately, the patterns and correlations cited here would provide no grounds whatsoever for believing that visual experience attributed color properties to objects in the ways required by russellian or identity-theoretic physicalism. From the fact that particular objects are individually associated in visual experience with a particular sensation, no conclusion can be drawn about whether the sensation has any normal or predominant cause, and hence about whether there is an external property that it can help to represent. Various objects regularly occasion sensations of red, but those objects are so various that they may not have any surface properties in common, for all one can tell from visual experience. Hence their observed association with one and the same quale provides no grounds for thinking that the quale has any informational potential.

What's more, the association of color sensations with particular objects is no more regular or reliable than that of pain with particular kinds of events. After all, pain serves its monitory function only because young children can learn that it regularly accompanies bumps, scrapes, punctures, encounters with extreme heat or cold, and so forth. Having obvious external correlates is essential to the evolutionary purpose of pain. If what led us to view a sensation as the representation of something external were its observed correlation with various external stimuli, we would have no more occasion to take this view of color than of pain.

Thus, the point of Wittgenstein's remark about pain patches cannot be that pain appears to have no representational content because it has no apparent external correlates. What, then, is the point? Surely, it's that sensations like pain (and color) involve qualities that we can easily think of as located in the external world, but that this thought is blocked, in the case of pain, by there being no particular places where it seems to be located. The external correlates of pain aren't places, and so pain isn't subject to the sort of displacement that the mind practices on other sensations.

Thus, what the association of sensations with particular surfaces produces, and what Wittgenstein was suggesting that it would produce even in the case of pain, is a tendency to perceive the sensations as located on those surfaces—an inducement, in short, to the projective error. But the result of this error is precisely that the qualia themselves, rather than microphysical properties, are attributed to objects in visual experience. Thus, if the patterns cited by the physicalist have their most likely result, they result in the falsity of physicalism as an account of the properties that visual experience represents.

The physicalist explanation of our basic epistemological intuition is therefore unstable. The physicalist wishes to claim that visual experience does not project sensations onto external objects, as their perceived properties, but that reflection on visual experience does project our knowledge about sensations onto objects, as knowledge about their perceived properties. What is cited as accounting for the latter projection doesn't really account for it, however, and would in fact account for the former projection instead.

Fregean, Realization-Theoretic Theories

Russellian and identity-theoretic versions of physicalism fail to cope with the epistemology of color because they must portray visual experience as representing color without a characterization that denotes it necessarily. Such visual representations

would denote properties only contingently, and would therefore fail to provide the appropriate introspective knowledge of the properties denoted.

This problem does not affect fregean, realization-theoretic theories. A realization-physicalist can concede, in response to the naive objection, that red objects aren't visually characterized in microphysical terms, and yet hold a version of fregeanism according to which they are characterized in terms that express what it is to be red; for he doesn't believe that to be red is to have a microphysical property. His theory of visual representation may then enable him to account for the epistemology of color experience. For if visual experience represented red by means of a characterization that represented what it is to be red, then introspection on the content of such an experience would leave no doubt whether there was such a property, introspection on experiences containing the same characterization would leave no doubt whether they represented the same property, and introspection on experiences containing characterizations of various colors would reveal the relations of similarity among them—all because the introspectible content of each experience would reveal what it is to have the property therein represented.

We therefore turn to a consideration of fregean, realization-theoretic versions of physicalism. One such theory was already introduced, in our initial survey of physicalist theories. Before returning to that theory, however, we shall briefly introduce a new proposal, which is motivated by epistemological arguments of the sort considered above. This proposal has little intuitive appeal of its own; indeed, it would hardly have been intelligible before our epistemological arguments against the other proposals had been aired. As a response to those arguments, however, it has some apparent plausibility.

A New Proposal

The new proposal is an attempt to kill two birds with one stone.[33] It purports to explain at a stroke how colors are visually represented and how their similarities and differences are known. The explanation is that colors are visually characterized precisely as those properties which bear the appropriate similarities and differences to one another.

How could all of the similarities and differences among colors be included in their visual characterization? Here is how.

Let a *pigmentation* be any property of extended things that stands with its co-determinates in relations of similarity and difference representable by a spheroid space in which distance around the circumference, distance from the ends, and distance from the interior correspond to differences in three different respects (to be called, for our purposes, hue, lightness, and saturation). Then let coordinates be

defined so that any determinate pigmentation can be labelled by three numbers specifying its longitude, latitude, and depth in the property space. The description "pigmentation xyz" will then have as its condition of satisfaction the presence of a determinate whose relation to its co-determinates corresponds to position xyz in a property space of this structure.

Now suppose that visual experience characterized surfaces as having pigmentations, specified by their coordinates in pigmentation-space.[34] Under the terms of fregeanism, such experiences would represent the surfaces as having some appropriately related determinates of some appropriately structured determinable. Under the terms of realization-physicalism, colors would be the second-order properties expressed by such characterizations—that is, the properties of having appropriately related determinates of an appropriately structured determinable.

We believe that this version of the proposal can account for all of the knowledge claimed in our epistemological intuitions. Reflection on the visual characterization of objects as having pigmentations xyz and qrs would yield the appropriate knowledge about the higher-order properties that the objects were thereby seen as having. That is, it would reveal that the experience represented its objects as having genuine, co-determinate properties, properties identical to those represented by internally similar experiences and differing from one another in degrees proportionate to $x–q$, $y–r$, and $z–s$. One would therefore know when one was seeing things as red or orange, and one would be able to tell their similarities and differences.

Unfortunately, this remedy for earlier epistemological problems only creates new ones. Once all of the requisite information has been encoded into the proposed visual characterization of colors, the resulting proposal—in any version—credits the subject of that experience with too much knowledge rather than too little. For it implies that the characterization of any one color encompasses that color's relations to all of the others, by locating it in a fully conceived color space. If color experience conformed to this proposal, the difference between red and orange would not only be evident from the experiences of seeing red and orange; it would be evident from the experience of seeing red alone, since that experience, by representing red as located in a property space of a particular shape, would already intimate the locations of co-determinate properties. The characterization of something as having a property located at longitude x, latitude y, and depth z in a space of co-determinate properties would already suggest the location of properties to the north or south, properties to the east or west, and properties above or below. Yet the experience of seeing something as red does not by itself reveal that the property now in view has a yellower neighbor (orange) and a bluer neighbor (violet), nor that it has more or less bright and more or less saturated neighbors, either. The current proposal has the

unfortunate consequence that to see one color is, in a sense, to see them all.[35] The current proposal thus continues to get the epistemology of color wrong.

The Initial Fregean, Realization-Theoretic Proposal

We therefore return to the initial candidate for a fregean, realization-theoretic version of physicalism. This was the theory that objects are visually characterized as having properties that normally cause color sensations, and that colors are the higher-order properties expressed by these characterizations.[36]

The content that this theory assigns to visual experience, say, of red would be introspectively recognizable as representing a genuine property; for even if there is no property that's predominantly responsible for sensations of red, the property of having such a property is undoubtedly genuine. Furthermore, any internally similar experience would be introspectively recognizable as representing the same (higher-order) property, by virtue of containing the same characterization. And color properties, so defined, would stand in relations of similarity and difference generated by similarities and differences among the associated sensations. If one visual sensation differed from another in various respects, then the properties of being equipped to cause those sensations would differ isomorphically, by differing as to the sensations caused. Reflection on how it feels to see things as red and as orange would therefore be sufficient to reveal similarities and differences among those colors.

This fregean, realization-theoretic version of physicalism can therefore account for our knowledge of colors. Unfortunately, it does so at the expense of misrepresenting the *phenomenology* of color experience.

The present theory implies that the content of visual experience alludes to color qualia as properties distinct from the perceived colors of objects.[37] In order for one to see an object as having the property that causes visual experiences with a particular feel, one's experience would have to represent that feel as well as the property causing it. And one's experience would then lack the naiveté characteristic of vision.

Visual experience is naive in the sense that it doesn't distinguish between the perceived properties of objects and the properties of perceptions. Whereas the experience of pain, for example, distinguishes between an external cause (a pin's sharpness) and its sensory effect (a finger's pain), visual experience does not distinguish between color as it is in the object and as it feels to the eye: one feels sharp points as causing pains but one doesn't see colored surfaces as causing visual feels. The normal experience of seeing an object as red no more alludes to a sensation as distinct from the object's redness than it does to tomatoes or fire engines.

Thus, the only version of physicalism that gets the epistemology of color experience right gets the phenomenology wrong. In our opinion, any version of physicalism

that acknowledges color *qualia* will commit the same phenomenological error, since it will imply that visual experience always has introspectible color qualities over and above the color properties that it attributes to objects. But this general thesis need not be defended here, since the only version of the second proposal that has survived our epistemological arguments is the fregean, realization-theoretic version, which portrays visual experience not only as having introspectible qualities but also as alluding to them in its representational content. This version of the proposal implies that visual experience not only involves color sensations but is also about those sensations, in addition to color properties—which is clearly mistaken.

Conclusion

We do not pretend to have proved that any physicalist theory of color must be inadequate, since we have not canvassed every possible theory. We think of our arguments as posing a challenge to any aspiring physicalist. We challenge the physicalist to explain how the physical properties that constitute colors, in his view, are represented in visual experience, and to explain it in a way that meets reasonable epistemological and phenomenological constraints.

One might think that the constraints that we have applied cannot be met by any theory of color, and hence that they must be unreasonable. The solution to the problems we have raised, one might conclude, is not to reject physicalism but rather to relax our epistemological and phenomenological constraints. In our view, however, there is a theory that satisfies these constraints, and it is one of the oldest and most familiar. It is the theory that colors are qualitative properties of visual experiences that are mistakenly projected onto material objects. A defense of that theory must be deferred, however, to another occasion.

Acknowledgements

For comments on earlier drafts of this paper, we are grateful to David Armstrong, C. L. Hardin, David Hills, Sydney Shoemaker, and Steve Yablo.

Notes

1. Our earlier paper contained a brief discussion of this theory [chapter 7, pp. 82–3]. The present paper can be regarded as expanding on that passage.

2. These remarks are intended to apply exclusively to expressions of the form "looks colored." Expressions of the form "seeing something as colored," "appearing to be colored," and so forth, will be interpreted compositionally.

Note that the problem discussed in this passage doesn't preclude "looks red" from *meaning* "visually appears to be red," in the sense of contributing that content to the statements in which it is used. If the kind of experience denoted by "looks red" is the kind that represents its object as red, then the phrase may indeed be used to introduce the content "visually appears to be red." The problem discussed here merely restricts the way in which the phrase may acquire its reference to that kind of experience. (See note 16, below.)

3. Here a further complication arises. We assume in the text that there is a single property represented by all or most instances of looking red. There will certainly be such a property if the way in which experiences qualify as instances of something's looking red is by representing the same property as the paradigm instance. In that case, the paradigm of something's looking red will define a kind of experience whose instances attribute the same property to their objects, and so all instances of looking red will represent the same property. The name "red" can then be fixed by the phrase "the property attributed to an object by its looking red."

But what if kinds of visual appearance are individuated differently? In that case, the kind of appearance defined by a paradigm case of something's looking red may include appearances representing different properties; and so there may be no property represented in most instances of looking red. Our attempt to attach the name "red" to the property attributed to an object by its looking red will consequently fail, since there will be no single property predominantly satisfying that description.

Physicalists who regard this outcome as a live possibility sometimes think that the reference of "red" cannot be fixed to a single property; and so they make a definition out of the description that we have treated as a reference-fixer. That is, they treat "red" as synonymous with the phrase "the property attributed to an object by its looking red," and they expect the term, so defined, to denote different properties in different circumstances. (See Frank Jackson and Robert Pargetter, "An Objectivist's Guide to Subjectivism About Colour," *Revue Internationale de Philosophie* 160 (1987), pp. 127–141, [chapter 6, this volume].)

These philosophers may find our usage strange, as we do theirs. But our linguistic differences with them will not prevent us from engaging them in argument. For they believe that red is a microphysical property in some circumstances, in the sense that a microphysical property is the one attributed to an object, in those circumstances, by its looking red. And we shall argue that an object's looking red never represents it as having a microphysical property, under any circumstances at all. Our arguments will therefore address their view, though not necessarily in their terms.

For a related problem, see the following note.

4. Some may contend that if there is a physical property that's distinctive of red-looking objects, then it will inevitably be the property that's attributed to objects by their looking red. But this contention simply assumes that the content of color experience is determined in a way that's conducive to the truth of physicalism about color—which should not be assumed from the outset. We shall consider at length whether the content of color experience is determined in this way. At the moment we are merely pointing out that until one has ascertained how colors are visually represented, one must allow for the possibility that their visual representation may have a content that is less useful for people to put into words that other facts correlated with color perception. One must therefore allow for the possibility that the content of color talk may diverge from that of color experience.

Some may argue that even if color experiences somehow represented properties other than external properties correlated with them, they would *also* represent those external properties, by virtue of the correlation. In that case, color experiences would attribute two different properties to their objects, and our identification of colors as the properties attributed to objects by color experiences would be ambiguous. (We owe this suggestion to Sydney Shoemaker.)

What is being imagined here—if it is indeed imaginable—is that visual experiences representing one property would be correlated with another property and would thereby come to indicate it, much as a Cretan's saying "It's raining" may come to indicate sunshine. If visual experiences representing one property could thus come to indicate another, the former property would still be identifiable as the one that they represented *in the first instance* (just as rain would be identifiable as what the Cretan was reporting in the first instance). Our identification of colors as the properties attributed to objects by their looking colored could therefore be easily disambiguated.

5. Note that in our terminology, identity-physicalism entails that colors have their microphysical natures necessarily. For in our terminology, the thesis "red = microphysical property *x*" is an identity statement whose arguments are rigid designators of properties.

As we explained in note 3, some physicalists treat "red" as synonymous with a non-rigid property description. These physicalists can therefore treat the thesis "red = microphysical property *x*" as a contingent truth.

6. For correlational theories of reference, see F. Dretske, *Knowledge and the Flow of Information* (Cambridge, Mass.: The MIT Press, 1981); D. Stampe, "Towards a Causal Theory of Linguistic Representation," *Midwest Studies in Philosophy* 2 (1977). We have reservations of a general nature about the prospects for correlational semantics, but we shall suspend these reservations for present purposes.

7. For a russellian view of how colors are visually represented, see Armstrong, in D. M. Armstrong and Norman Malcolm, *Consciousness and Causality: A Debate on the Nature of Mind* (Oxford, England: Basil Blackwell, 1984), p. 172: "A perception of something green will involve a green-sensitive element, that is to say, something which, in a normal environment, is characteristically brought into existence by green things, and which in turn permits the perceiver, if he should so desire, to discriminate by his behaviour the objects from things which are not green."

See also Jackson and Pargetter, "An Objectivist's Guide to Subjectivism About Colour," [pp. 68–9, this volume]:

> What is it for an experience to be the presentation of a property? How must experience E be related to property P, or an instance of P, for E to be the presentation of P, or, equivalently, for E to represent that P? One thing ... is immediately clear. A necessary condition is that there be a causal connection. Sensations of heat are the way heat, that is, molecular kinetic energy, presents itself to us. And this is, in part, a matter of kinetic energy *causing* sensations of heat. We say 'in part', because, for instance, the causation must be in the 'right way'.... For present purposes, however, the causal part of the story is enough. We can work with the rough schema: redness is the property of objects which causes objects to look red....

8. See J. J. C. Smart, "On Some Criticisms of a Physicalist Theory of Colors," in *Philosophical Aspects of the Mind-Body Problem*, ed. Chung-ying Cheng (Honolulu, Hawaii, University Press of Hawaii, 1975), pp. 54–63 [chapter 1, this volume]; D. M. Armstrong, "Smart and the Secondary Qualities," in *Metaphysics and Morality: Essays in Honour of J. J. C. Smart*, ed. Philip Pettit, Richard Sylvan, and Jean Norman (Oxford, England: Basil Blackwell, 1987), pp. 1–15 [chapter 3, this volume].

9. See Jackson and Pargetter, "An Objectivist's Guide to Subjectivism About Colour" [chapter 6, this volume]. This view also appears in Shoemaker, "Qualities and Qualia: What's In the Mind?" *Philosophy and Phenomenological Research* (1990), 50, suppl., pp. 109–131.

10. The only way to circumvent this problem would be to suppose that the redness of everything but tomatoes is seen as a surface similarity to tomatoes, whereas the redness of tomatoes is seen as a similarity to fire engines. Yet this supposition would imply that the redness of tomatoes looks different from that of other objects—which is false.

11. *A Treatise of Human Nature*, I.i.vii. This proposal may also be what Armstrong has in mind in some parts of *A Materialist Theory of the Mind* (London, England: Routledge and Kegan Paul, 1968), Chapter Twelve.

12. A full correlational theory would identify the referent of a mental item not with its actual causes or correlates but, rather, with the causes or correlates that it would have under counterfactual ideal circumstances. Different theories propose different sets of ideal circumstances, but these differences needn't concern us here. We shall gloss over these issues by saying simply that under such a theory, a mental item refers to its normal or predominant cause.

13. This account of how colors are visually represented follows the strict russellian line, in that it credits the mental symbol for a color with no meaning beyond a correlationally determined reference. There is some room here for liberalization. The mental symbol for red may have a very general sense, such as "a kind of object," and the visual representation of something as red may therefore characterize it, literally,

as of a kind. Which kind is being represented, however, will still be determined by the symbol's reference, since this account, like the preceding one, offers no resources for a descriptive characterization of the kind.

14. An identity-theoretic version of this account would say that color sensations denote microphysical properties. A realization-theoretic version would say that they denote higher-order properties that have microphysical realizations.

We do not wish to rule out either of these possibilities entirely. However, one realization-theoretic version of the current proposal can be excluded in advance. This version would be the russellian counterpart of a fregean theory that we shall introduce below. The fregean theory says that visual experience characterizes each color as the higher-order property of having some property that tends to cause a particular color sensation. The russellian counterpart of this theory would say that each color sensation is appropriately correlated with, and hence refers to, the higher-order property of having a property that tends to cause it.

The problem with the latter theory is that it would utterly trivialize the correlational semantics on which russellianism depends. Almost every property is correlated with the higher-order property of there being a property that tends to cause it. A semantics that allowed such a correlation to ground a relation of reference would be unable to draw a distinction between what has a reference and what doesn't.

15. John McDowell, "Values and Secondary Qualities," in *Morality and Objectivity: A Tribute to J. L. Mackie*, ed. Ted Honderich (London, England: Routledge and Kegan Paul, 1985), pp. 110–129.

16. We develop this argument at length in "Colour as a Secondary Quality," [pp. 86–90, this volume].

Note that the circularity at issue here is significantly different from the circularity at issue in our earlier discussion of the expression "looks red." There we were concerned with a circularity that could result from the structure of this expression. Identifying red in terms of things' looking red will be circular, we argued, if "looks red" gets its reference by logical composition, in a way that depends on the reference of "red." Here we are concerned with a circularity in the content of a visual representation, irrespective of which symbols bear that content or how they are structured. We argue that if the content of representing something as red is that the thing has the property that causes objects to be represented as red, then that content will be embedded in itself. The former circularity can easily be resolved, since "looks red" can be restructured as a unitary expression referring directly to a kind of experience. The latter circularity cannot be resolved by any restructuring of symbols. (See note 2.)

17. Hilary Putnam, "The Meaning of 'Meaning'," in *Mind, Language, and Reality* (Cambridge, England: Cambridge University Press, 1975); see also Tyler Burge, "Individualism and the Mental," in *Studies in Metaphysics*, ed. P. French, T. Uehling, and H. Wettstein (Minneapolis, Minn.: University of Minnesota Press, 1979).

18. See Saul Kripke, *Naming and Necessity* (Cambridge, Mass.: Harvard University Press, 1980), pp. 54ff.

Of course, those who define "red" as synonymous with "the property attributed to an object by its looking red" will think that it is not only necessary but analytic that red is the property something appears to have when it looks red. They will therefore claim that their view is compatible with your ability to tell that something appears to be red, since things necessarily appear to be red whenever they look red, and a thing's looking red is (by stipulation) an introspectively recognizable kind of experience.

True enough. But what these philosophers describe as the ability to tell that something appears to be red is less than meets the ear. It's the ability to tell that whatever property the thing appears to have is to be called red on this occasion. It's not the ability to tell which property something appears to have that property.

Our claim that you can tell when something appears to be red means that there is a property, red, such that you can tell when something appears to have it. And this claim cannot be accommodated by these linguistic maneuvers.

19. Context-switching and its relevance to self-knowledge is discussed at greater length in Paul A. Boghossian, "Content and Self-Knowledge," *Philosophical Topics* (1989), pp. 5–26.

20. This problem is especially acute for the Humean proposal, according to which objects are represented as colored by being characterized as "one of *those*," where the reference of "those" is determined by the subject's classificatory dispositions. Not only would one be unable to tell by introspection whether the property characteristic of a particular set of objects was the same as it was previously; one would also be unable to tell whether an object was being assigned to the same set of objects as it was previously. In order

to tell whether the set to which tomatoes were visually assigned today was the same as the one to which they were assigned yesterday, one would have to investigate precisely which other objects one was disposed to include in that set on each occasion. Mere introspection would therefore fall even further short of revealing whether tomatoes appear to have the same color that they once appeared to have.

21. See, for example, Armstrong, *A Materialist Theory of the Mind*, p. 289.

22. Such liberal criteria are also unlikely to yield a plausible theory of representation. But as we said in note 6, we are ignoring such general problems in correlational semantics.

23. We owe this suggestion to Sydney Shoemaker.

24. Here, as elsewhere, a physicalist may reply that our sense of having introspective knowledge can be explained away. We shall consider this objection below.

25. These words are from J. J. C. Smart's "Sensations and Brain Processes." They are quoted in application to color by D. M. Armstrong in "Smart and the Secondary Qualities," [p. 44, this volume].

26. "Smart and the Secondary Qualities," [p. 44, this volume].

27. See Armstrong's *A Theory of Universals*, vol. 2 (Cambridge, England: Cambridge University Press, 1978), p. 127: "[W]hy should not the colour-properties act on our mind (or, rather, why should not states of affairs involving these properties act on our mind), producing awareness of resemblance and incompatibility, but not producing awareness of those features of the properties from which the resemblance and incompatibility flow?"

28. *A Theory of Universals*, vol. 2, p. 127, See also *A Materialist Theory of the Mind*, pp. 275–276.

29. Armstrong himself sometimes suggests that shapes rather than individuals are the relevant analogue. See *Consciousness and Causality*, pp. 178–179.

30. One might well have reservations about whether the spatial terms in which shapes are visually characterized fully capture their spatial nature. But such reservations tend to undermine Armstrong's claim that similarities of shape are evident on sight. In assuming that shapes are visually represented in terms that reveal their nature, we are simply taking Armstrong's view of the matter.

31. *Philosophical Investigations* (Oxford, England: Basil Blackwell, 1974), p. 312.

32. This suggestion, too, is due to Sydney Shoemaker.

33. The following remarks of Armstrong's sound like the theory developed in this section:

> The vital point to grasp here, I think, is that, with an exception or two to be noticed, our *concepts* of the individual secondary qualities are quite empty. Consider the colour red. The concept of red does not yield any necessary connection between redness and the surface of ripe Jonathan apples or any other sort of object. It does not yield any necessary connection between redness and any sort of discriminatory behaviour, or capacity for discriminatory behaviour, in us or in other creatures. It does not yield any necessary connection between redness and the way that the presence of redness is detected (eyes, etc.) in us or in other creatures. Finally, and most importantly, it does not yield any necessary connection between red objects and any sort of perceptual experience, such as looking red to normal perceivers in normal viewing conditions.
>
> There may be a conceptual connection between redness and extendedness.... There is certainly a conceptual connection between redness and the other colours: the complex resemblances and differences that the colours have to each other. But these conceptual connections do not enable us to break out of the circle of the colours ("Smart and the Secondary Qualities," [pp. 42–3, this volume]).

However, the rest of Armstrong's work makes clear that he does not subscribe to the theory developed here. In *A Theory of Universals*, vol. 2, he attributes such a theory to R. W. Church (pp. 108–111).

34. The use of numerical coordinates is not essential to this conception of color experience. Visual experience can be conceived as locating colors in the property space directly, without the use of coordinates; or it can be conceived as locating them in a network of similarity relations, without the use of any spatial analogy at all.

35. A proponent of this theory may reply that the complete conception of color space may be acquired gradually, as the subject of visual experience encounters new colors. But this reply isn't to the point, because our objection is not especially about the acquisition of color concepts. What refutes the present theory of color representation is not just that someone who has never seen orange cannot derive the concept of it from seeing red. It's also that someone who has seen both red and orange still does not have experiences of either color that, by themselves, would ground knowledge about the other.

What's more, the most plausible account of how a naive subject might discover color space is not compatible with the proposal under consideration. For according to the proposal, either one already sees colors in terms of their locations in a space of co-determinates—in which case the appearance of one color already alludes to the others—or one doesn't yet see colors in terms of their locations in color space—in which case, their appearances furnish no grounds for drawing the similarities and differences constitutive of such a space. One colored surface will appear to differ from another along three dimensions, according to the proposal, only if each surface is already seen under characterizations specifying three coordinates for its pigmentation. Hence the proposal doesn't allow for the possibility of *discovering* the dimensions of color space *on the basis of* what is seen in color experience. If one doesn't already see colors under characterizations locating them in such a space, then one sees nothing on the basis of which locations could be assigned to them.

36. Whether one regards realization-physicalism as equivalent to dispositionalism will depend on one's views on the relation between dispositions and their bases. For a dispositionalist theory of color that may be equivalent to realization-physicalism, see Christopher Peacocke, "Colour Concepts and Colour Experience," *Synthèse* 58 (1984), pp. 365–381 [chapter 5, this volume].

37. The following argument is developed more fully in "Colour as a Secondary Quality," [pp. 93–4, this volume].

9 How to Speak of the Colors

Mark Johnston

It seems to me that the philosophy of color is one of those genial areas of inquiry in which the main competing positions are each in their own way perfectly true.

For example, as between those who say that the external world is colored and those who say that the external world is not colored, the judicious choice is to agree with both. *Ever so inclusively speaking* the external world is not colored. *More or less inclusively speaking* the external world is colored.

What is it to speak *ever so inclusively* about the colors? There are many beliefs about color to which we are susceptible, beliefs resulting from our visual experience and our tendency to take that visual experience in certain ways. Some of these beliefs are "core" beliefs in this sense: were such beliefs to turn out not to be true we would then have trouble saying what they were false of, i.e., we would be deprived of a subject matter rather than having our views changed about a given subject matter. Contrast the more "peripheral" beliefs; as they change, we are simply changing our mind about a stable subject matter. However, what some call the lack of any sharp analytic/synthetic distinction means that there typically are many legitimate ways of drawing the core/periphery distinction. Let's say that we speak *more inclusively* about color as we underwrite more beliefs with some legitimate title to be included in the core. Then, speaking of color *ever so inclusively* is employing a conception of color which underwrites any belief included in the core on some one or other legitimate way of drawing the core/periphery distinction.

When the most inclusive way of talking about some phenomenon is either internally inconsistent or at odds with discovered facts, the question of elimination or revision of the talk arises. But when the question arises, the real issue is how inclusively we have to speak. In the case of color the interesting question is not "Is the external world colored?" but rather "How far short of speaking ever so inclusively do we have to fall in order to say truly that the external world is colored?"[1]

These remarks about the concept of color are quite general. Corresponding remarks apply to many if not all concepts. Color can in many ways function as an illustrative case of the systematic reasons which favor conceptual revision over elimination, reasons made more prominent and probative by the vagueness of the analytic/synthetic distinction.

Color Concepts as Cluster Concepts

Why does the external world fail to be colored ever so inclusively speaking?

Taking canary yellow as an example, beliefs with a legitimate title to be included in a core of beliefs about canary yellow include:

(1) *Paradigms*. Some of what we take to be paradigms of canary yellow things (e.g. some canaries) are canary yellow.

(2) *Explanation*. The fact of a surface or volume or radiant source being canary yellow sometimes causally explains our visual experience as of canary yellow things.

(3) *Unity*. Thanks to its nature and the nature of the other determinate shades, canary yellow, like the other shades, has its own unique place in the network of similarity, difference and exclusion relations exhibited by the whole family of shades. (Think of the relations exemplified along the axes of hue, saturation and brightness in the so-called color solid. The color solid captures central facts about the colors, e.g. that canary yellow is not as similar to the shades of blue as they are similar among themselves, i.e. that canary yellow is not a shade of blue.)

(4) *Perceptual Availability*. Justified belief about the canary yellowness of external things is available simply on the basis of visual perception. That is, if external things are canary yellow we are justified in believing this just on the basis of visual perception and the beliefs which typically inform it. (Further philosophical explication of this belief would come to something like this: if you are looking at a material object under what you take to be adequate conditions for perceiving its color and you take yourself to be an adequate perceiver of color then your visually acquired belief that the material object is canary yellow is justified simply on the strength of (i) the information available in the relevant visual experience and (ii) those general background beliefs about the external causes of visual experience which inform ordinary perception.)

(5) *Revelation*. The intrinsic nature of canary yellow is fully revealed by a standard visual experience as of a canary yellow thing.

Canary yellow is of course only an example. For each color property F, beliefs legitimately included in the core of beliefs concerning F will include the relevant instances of Paradigms, Explanation, Unity, Availability and Revelation.

The hardest of these beliefs to explicate is Revelation. Partly because of this, it is a quite controversial occupant of any core of beliefs about color. The content of Revelation was captured by Bertrand Russell in *The Problems of Philosophy* in these terms: "the particular shade of colour that I am seeing ... may have many things to be said about it.... But such statements, though they make me know truths about the colour, do not make me know the colour itself better than I did before: so far as concerns knowledge of the colour itself, as opposed to knowledge of truths about it, I know the colour perfectly and completely when I see it and no further knowledge of it itself is even theoretically possible."[2] Russell's view here is that one naturally does take and should take one's visual experience as of, e.g. a canary yellow surface,

as completely revealing the intrinsic nature of canary yellow, so that canary yellow is counted as having just those intrinsic and essential features which are evident in an experience as of canary yellow. Hence, canary yellow is a simple non-relational property pervading surfaces, volumes and light sources. It is just this idea that visual experience is transparently revelatory which Descartes denied when he wrote of our visual sensations as arbitrary signs of the properties that cause them, employing the analogy of the sensations which a blind man receives of texture as a result of using a cane "to see".[3] Most recently, David Hilbert has stigmatized something very like Revelation as "'the fallacy of total information," suggesting that it is a philosopher's imposition on common sense.[4]

Other contemporaries take a different, more Russellian, view. There are those who think that no family of properties whose natures are not wholly revealed in visual experience could deserve the name of the colors. Thus, for example, Galen Strawson, in a vivid and tantalizing paper, writes "color words are words for properties which are of such a kind that their whole and essential nature as properties can be and is fully revealed in sensory-quality experience given only the qualitative character that that experience has."[5] Strawson's claim is not only a lucid statement of Revelation, but also in effect a denial that there is any negotiating with Revelation when it comes to speaking of the colors. You must either completely endorse Revelation or cease to speak of the colors.[6]

What follows is for those who find the positions of both Hilbert and Strawson unsatisfying. Our visual experience is the occasion of our making a cognitive error, the error of taking features of our experience to transparently reveal the nature of certain external features, so that, as against Hilbert, we are ordinarily inclined to feel the pull of Revelation. Nonetheless, as against Strawson, properties which satisfy Paradigms, Explanation, Unity and Availability could still deserve the names of the colors even if their natures were not fully revealed by sight.[7]

Before we consider such a compromise, why should we admit that the external world is not colored ever so inclusively speaking? Well, given what we know from the psychophysics of perception it follows that Revelation and Explanation cannot be true together. For when it comes to the external explanatory causes of our color experiences, psychophysics has narrowed down the options. Those causes are either non-dispositional microphysical properties, light-dispositions (reflectance or Edwin Land's designator dispositions[8] or something of that sort) or psychological dispositions (dispositions to appear colored) with microphysical or light-dispositional bases. Explanation therefore tells us that we must look among these properties if we are to find the colors. Revelation tells us that the natures of the colors are, in Gregory Harding's useful idiom, *laid bare* in visual experience.[9] The nature of canary yellow

is supposed to be fully revealed by visual experience so that once one has seen canary yellow there is no more to know about the way canary yellow is. Further investigation and experience simply tells us what further things have the property and how that property might be contingently related to other properties.

However, the natures of the non-dispositional microphysical properties and the surface reflectance properties in play in visual perception are not revealed or laid bare by our visual experience. It is not even evident in visual experience that such properties are implicated in its production. In any case, visual experience certainly leaves us with a lot more to know about the nature of both the categorical microphysical properties of surfaces and the reflectance properties of surfaces. So those properties do not satisfy Revelation. Hence, ever so inclusively speaking, no such property can be the property canary yellow. Mutatis mutandis for the other colors.

The remaining surface property which is a standard explanatory cause of visual experience as of canary yellow things, and hence the remaining candidate to be canary yellow, is the disposition to look canary yellow. Now the nature of a disposition to look a certain way *may* be revealed by a visual experience if that experience is appropriately construed. For when it comes to the disposition of objects to produce a certain experience, it is plausible to hold that if one has an experience of the kind in question, *and takes that experience to be a manifestation of the disposition in question*, one thereby knows the complete intrinsic nature of the property which is the disposition. Consider this example: twenty five years ago I felt nausea when I tasted a juicy apricot during a rough sea-crossing. I had the experience of nausea and I took it to be a manifestation of the power or disposition of juicy apricots to produce nausea in me during rough sea-crossings. What more was there to know about this dispositional property? Only certain extrinsic matters, matters concerning not the nature of the dispositional property of being nauseating for me on rough seas but rather its relations to other things. I did not know which things in general had the property, nor did I know the property's relations to other properties such as the chemical and biological properties responsible for the nauseating effect of juicy apricots on a susceptible subject. But so far as knowing the *intrinsic* nature of the dispositional property, i.e. knowing that property in the sense relevant to Revelation, experiencing nausea and taking it to be a manifestation of the disposition sufficed. When a disposition is a disposition to produce a certain subjective response then a subjective response of the kind in question may indeed reveal the nature of the disposition so long as the subject takes his response to be the manifestation of that disposition. So the disposition to look canary yellow can be revealed by sensory experience if that sensory experience is appropriately construed.

That is, although we can immediately show that the colors-as-Revelation-represents-them-as-being are neither categorical microphysical properties nor light-dispositional properties on the grounds that we had more (in fact almost everything) to understand about what these properties were like even after having encountered the colors, the same point cannot be decisive against identifying the colors-as-Revelation-represents-them-as-being with dispositions to look colored.

The decisive consideration is rather that *steady* colors, as opposed say to highlights, do not appear to be relational properties and hence do not appear to be dispositions to look colored.

A basic phenomenological fact is that we see most of the colors of external things as "steady" features of those things, in the sense of features which do not alter as the light alters and as the observer changes position. (This is sometimes called "color constancy".) A course of experience as of the steady colors is a course of experience as of light-independent and observer-independent properties, properties simply made evident to appropriately placed perceivers by adequate lighting. Contrast the highlights: a course of experience as of the highlights reveals their relational nature. They change as the observer changes position relative to the light source. They darken markedly as the light source darkens. With sufficiently dim light they disappear while the ordinary colors remain. They wear their light- and observer-dependent natures on their face. Thus there is some truth in the oft-made suggestion that (steady) colors don't look like dispositions; to which the natural reply is "Just how would they have to look if they were to look like dispositions?"; to which the correct response is that they would have to look like colored highlights or better, like shifting, unsteady colors, e.g. the swirling evanescent colors that one sees on the back of compact discs.

But if this is a good way of making the point that colors don't look like dispositions then it cannot be right to follow Paul Boghossian and David Velleman, and conclude that the external world is not colored because colors do not look like relations and so do not look like dispositions.[10] For some colors do look like relations. Within our visual experience there is a phenomenal distinction between steady and shimmering color appearances, and the latter appear as relational qualities in just this sense: a course of experience of such qualities reveals their dependence on the perceiver's position and the light source.[11] Given that the relational nature of the "unsteady" colors is apparent in visual experience, it is hard to motivate the claim that *they* look non-dispositional.

Nor is a version of the Bohossian-Velleman thesis restricted to the steady colors very appealing. The restricted thesis would be that nothing in the external world is colored except the backs of compact discs, highlighted spots, holographically colored

patches on credit cards, and a few other odd exceptions. These very qualifications weaken the phenomenologically based denial that the external world is colored, for they count some overt dispositions as colors of external things. We should then want to know why the covert dispositions, dispositions to look steadily colored, do not also count as colors.

Even so, Boghossian and Velleman seem to me completely right to emphasize the disparity between *steady* colors-as-they-naively-seem-to-be and colors conceived of as dispositions. A property cannot appear as a disposition unless it appears as being a relation of the bearer of the disposition to the manifestation of the disposition and the circumstances of manifestation. Given that, Revelation is at odds with taking the steady colors to be dispositions. We have already concluded that Revelation is at odds with taking the colors to be either non-dispositional microphysical surface properties or light-dispositional surface properties: such properties can't have their natures laid fully bare to us in visual experience.

Barring a bizarre pre-established harmony of redundant causes of our visual experience, a harmony in which the colors-as-Revelation-represents-them are extra causes of our visual experience on top of the causes that psychophysics recognizes, it follows that the colors-as-Revelation-represents-them-as-being are not among the external causes of our visual experience. That is, assuming both Revelation and what we know from psychophysics, it follows that Explanation is violated. So, ever so inclusively speaking, the external world is not colored (or at least not steadily colored.)

It would however be an instance of the characteristic fallacy of many Eliminativists in many areas of philosophy to draw the conclusion that the external world is not really (steadily) colored.

For we are not bound to speak ever so inclusively. Speaking ever so inclusively can seem like speaking strictly and so can seem demanded by philosophical seriousness. But it turns out to be just speaking under the aegis of one among several conceptions of color; indeed, the most belief-laden and incautious of these conceptions. Such is the shadow cast across Eliminativist projects by the vagueness of the analytic/synthetic distinction.

Any serious philosopher tempted by Eliminativism or Irrealism about color (more generally, about Xs) must consider this question: how far short of speaking ever so inclusively must we fall in order to say truly that the world is colored (or includes Xs)? The prospects of various accounts of color *more or less* inclusively speaking, accounts which abandon or weaken Revelation, need investigating.[12] The investigation begins at a familiar conceptual juncture.

Are Color Concepts Primary or Secondary?

As between those who say that the world is colored because colors are primary qualities and those who say that the world is colored because colors are secondary qualities the judicious choice is first to agree with neither, then to agree with both and finally to agree with the friends of the secondary qualities.

Agreeing with neither might be a way of registering the fact that there is a salient, "intuitively based" conception of color which they both fail to underwrite, namely the conception of the colors-as-Revelation-represents-them-as-being. But it might also be a way of highlighting the fact that the very distinction between primary and secondary qualities has itself the dubious distinction of being better understood in extension rather than intension. Most of us can generate two lists under the two headings, but the principles by which the lists are generated are controversial, even obscure. Of course, on one well-known criterion, secondary qualities are supposed to be dispositions to produce a sensory response. Yet, even if we adhere to the dispositional criterion we still lack an adequate understanding of what dispositions are and what their exact relations to their bases might be. As we shall presently see, this means that we lack precisely the understanding which would allow us to appreciate what would *count* as an argument for taking canary yellow either to be a disposition to look canary yellow or to be the microphysical or light-dispositional basis of such a disposition.

One way to show that would be to show that a full-dress account of dispositions invalidates most of the standard arguments against the dispositional or secondary quality theory of color. Fortunately, even the first steps in an account of dispositions—all that can be given here—suffice to show that *many* of the popular arguments against dispositional theories of color are better taken as arguments against an over simplified conception of dispositions.

Let us say that the concept of the property F is a concept of a dispositional property just in case there is an a priori property identity of the form

(6) The property F = the T disposition to produce R in S under C.

A T disposition is some specified type of disposition, e.g. an invariable disposition, a probabilistic disposition, or a standardly mediated disposition (more on these later). R is the manifestation of the disposition; S is the locus of the manifestation and C is the condition of manifestation.

Let us then say that the concept of the property F is a response-dispositional concept when something of the form of (6) is a priori and (a) the manifestation R is

some response of subjects which essentially and intrinsically involves some mental process (responses like sweating and digesting are therefore excluded), (b) the locus S of manifestation is some subject or group of subjects, (c) the conditions of manifestation are some specified conditions under which the specified subjects can respond in the specified manner. Moreover, we shall require (d) that the relevant a priori identity does not hold simply on a trivializing "whatever it takes" specification of either R or S or C, e.g. "the F-detecting response, whatever that is" or "the F-detecting subjects, whoever they are" or "the F-detecting conditions, whatever they are". In a manner of speaking these would not be specifications at all since in offering them one would not be evidencing any real knowledge of *who* the subjects or *what* the responses or conditions of response are.

According to one well-known criterion secondary quality concepts are response-dispositional concepts of *sensible* qualities.[13] Primary quality concepts are categorical concepts of sensible qualities. We may follow Locke and further distinguish concepts of Tertiary qualities, i.e., concepts of dispositions to produce effects other than subjective responses, e.g. dispositions to reflect light.

Hence, someone who alleges that it is a priori that

(7) the property red = the standardly realized disposition to look red to standard perceivers under standard conditions

is claiming that the concept of red is a response-dispositional concept of a sensible quality, i.e., a secondary quality concept. But the following are also secondary quality accounts, if the identities are understood as true a priori:

(8) The property of being red = the disposition to look red to standard perceivers as they actually are under standard conditions as they actually are.

(9) The property red for subjects S_i under conditions C_i = the disposition to look red to the S_is under conditions C_i.

Talk of response-dispositions immediately provides useful consequences. As (8) indicates, it is not an objection to all secondary quality accounts of color concepts to observe that in a possible world in which the standard perceivers saw things differently in the standard conditions of the world, the colors of things need not be different from what they actually are. (8) allows just that. As (9) indicates, it is not an objection to all secondary quality accounts of color concepts to observe that for many or all of the things we take to be colored there are no standard perceivers or standard viewing conditions, so that the best we can do is talk about the color relative to this kind of perceiver or that kind of viewing condition. (9) allows just that.

Furthermore, the explicit focus on dispositions as opposed to mere counterfactual conditionals serves to show that many of the other sorts of arguments which have led philosophers to abandon the secondary quality account of color concepts do not in fact succeed. We can now see why they are better taken as arguments against an all too simple account of dispositions.

Case 1. There might have been a ray emitted from the center of green objects, a ray which acted directly on our visual cortices so that green objects always would look red to us in any viewing situations. But this would not be enough to make them green.

Case 2. There might have been a shy but powerfully intuitive chameleon which in the dark was green but also would intuit when it was about to be put in a viewing condition and would instantaneously blush bright red as a result. So although in the dark the chameleon is green it is not true of it in the dark that were it to be viewed it would look green. It would look bright red. (Although this seems like a bizarre case from the philosopher's wax museum, it turns out that we have something rather like shy chameleons in our eyes! For consider rhodopsin, the photoreactive chemical in the rods on the surface of our retinas. Before it is hit by enough photons to trigger electrical impulses in the rods, rhodopsin is crimson. Photons bleach rhodopsin so that it first becomes yellow and then transparent. But since the rods function as a backup system to the retinal cones to enable us to see under very poor lighting conditions, any good viewing condition is probably a condition in which the rods are firing as a result of their constituent rhodopsin having undergone a photochemical change with its resultant color change. How do we know that rhodopsin is crimson in the near dark? Well, we can in fact view it under very poor light, i.e. insufficient light to produce the photochemical change. So rhodopsin is not utterly "shy" in the manner of the chameleon.)

Case 3. Consider a transparent object whose surface is green but never looks and almost never would look surface green because the object's interior *radiates* orange light at such an intensity that the greenness is masked or obscured. It is nonetheless surface green even though it would never look so, as is shown by the fact that it *reflects* just the same kind of light that some other surface green things reflect.

These sorts of cases would constitute good objections if a secondary quality account had to assert things like

(10) It is a priori that x is red for S_i in C_i iff x would look red to S_i's under C_i.

However, to assume that is to assume that something having a disposition to produce R in S under C is equivalent to the holding of the corresponding dispositional conditional: if the thing were to be in C it would produce R in S. That this is not so,

that the relation between the holding of a disposition and the holding of its corresponding dispositional conditional is more complex, is shown by cases which precisely parallel those just discussed.

Case 1 Mimicking.* A gold chalice is not fragile but an angel has taken a dislike to it because its garishness borders on sacrilege and so has decided to shatter it when it is dropped. Even though the gold chalice would shatter when dropped, this does not make it fragile because while this dispositional conditional is not bare, i.e. the breaking when struck has a causal explanation, something *extrinsic* to the chalice is the cause of the breaking. Mutatis mutandis for the ray-bedeviled green surface. Even though the surface would look red if viewed, this does not make the surface itself disposed to look red.[14] For while this conditional is not bare, i.e. the surface's looking red when viewed has a causal explanation, something extrinsic to the surface is the cause of its looking red.

Case 2 Altering.* The glass cup is fragile but an angel has decided to make the cup shatterproof if it begins to fall to the ground or if it is about to be hit by a hammer, or enter any other condition of being struck. Even though the conditional corresponding to fragility does not hold, i.e. the cup would not break if struck, the cup was fragile before the angel did its work. Were it not for the extrinsic activities of the angel prior to the cup being struck then the cup would have broken when struck. Mutatis mutandis for the shy but intuitive chameleon. In the dark, there is an extrinsic property of the chameleon's skin, i.e. the property of being the skin of a chameleon with a shy and intuitive psychology, which leads the chameleon's skin to change color before it goes into a viewing condition. Were it not for these extrinsic features, if the chameleon's skin were to be viewed then it would look green.

Case 3 Masking.* Consider a fragile glass cup with internal packing to stabilize it against hard knocks. Packing companies know that the breaking of fragile glass cups involves three stages: first a few bonds break, then the cup deforms and then many bonds break, thereby shattering the cup. They find a support which when placed inside the glass cup prevents deformation so that the glass would not break when struck. Even though the cup would not break if struck the cup is still fragile. The cup's fragility is masked by the packing which is a) something extrinsic to the glass cup and b) causes the glass cup when struck to withstand deformation without breaking. Were it not for such an extrinsic masker the cup would break when struck. Mutatis mutandis for the green thing which intensely radiates orange from its interior. Were it not for the masking properties extrinsic to the surface, if the surface were to be viewed then it would look surface green.

In order to say when something has the disposition to R in S under C let us first provide a general characterization of mimicking, altering and masking.

In the mimicking of x's disposition to R in S under C, something extrinsic to x and the circumstances C is the cause of the manifestation R. This includes the case of veridical mimicking, where e.g., x has the disposition to break when struck but a deranged guardian angel has decided to break x when struck in a way that is independent of its fragility.

In the case of altering with respect to the disposition to R in S under C, there are intrinsic changes in x before[15] x goes into the circumstances of manifestation C such that these changes are or include a cause of x's R-ing, and if x had not changed intrinsically in such ways then x would not have R-ed.

In the masking of x's disposition to R in S under C, something extrinsic to x and the circumstances C is a cause of a manifestation inconsistent with the manifestation R.

We are now able to present one (inevitably somewhat stipulative) notion of a disposition. A thing x has the disposition to R in S under C iff one or other of the following cases hold—

The (Possibly Vacuous) Case of the Bare Disposition

x would R in S under C and no intrinsic feature of x or of anything else is the cause of x's R-ing in S. (Because bare dispositions by definition lack a constituting basis there seems little to be made of the idea of a bare disposition being masked, altered or mimicked.)

The Case of the Constituted Disposition

There are intrinsic features of x which masking, altering and mimicking aside, would cause R in S under C. These intrinsic features of x are the "constituting basis" of x's disposition to R in S. *We may therefore think of a constituted disposition as a higher-order property of having some intrinsic properties which, oddities aside, would cause the manifestation of the disposition in the circumstances of manifestation.*[16]

The dispositional thesis which many find in Locke,[17] may now be understood as the thesis that color concepts, like the concepts of the various sounds, tastes and smells, are concepts of *constituted* response-dispositions. In so far as Locke believed that redness was a power or disposition he did not believe that redness was a bare power or disposition but rather, in our terms, a constituted disposition.

Explanation

Clarifying the Secondary/Primary distinction as a restriction of the dispositional/categorical distinction and recognizing some complexity in our concept of a disposition

implies that the difference between Secondary and Primary accounts of color concepts must really be quite subtle. The Secondary account treats canary yellow as a constituted disposition to appear canary yellow, i.e. as the higher-order property of having some (lower-order) intrinsic properties which, oddities aside, would cause the appearance as of a canary yellow thing. The Primary account treats canary yellow as a disjunction of such lower-order intrinsic properties, or at least ends up doing this once it assimilates the fact that the standard causes of the appearances of canary yellow are surprisingly disparate.[18]

Frank Jackson and Robert Pargetter suggest that when it comes to Explanation, i.e., counting a thing's having the property canary yellow as an explanatory cause of its appearing canary yellow, Primary Quality accounts do better because the Primary Qualities are more basic explainers of the canary yellow appearances than the dispositions are.[19] On their view, if dispositions are explainers at all, then they are explainers at one remove and by courtesy; as it were on the back of the explanatory role of the underlying, categorical Primary Qualities.

Given the present account of dispositions and the point that any Primary Quality account will have to make do with identifying canary yellow with a disjunction of those disparate properties responsible for (standard, veridical) appearances as of canary yellow things, there is no room for an invidious distinction when it comes to Explanation. Primary and Secondary Quality accounts of color are on all fours with respect to Explanation.

For consider Zinka the canary and a lifelike color photograph of her. The canary yellow appearance produced when one looks at Zinka is due to a physical property very different from the physical property responsible for the canary yellow appearance of the relevant part of the photograph. Call the relevant physical properties P1 and P2 respectively. The fact that Zinka's feathers have P1 explains the canary yellow appearance that occurs when one looks at Zinka. But P1 is not canary yellowness according to the Primary Quality Account. On that account, canary yellowness is what canary yellow things have in common and so is a disjunctive property which includes as disjuncts P1, P2 and so on. That disjunctive property is a property which standardly explains the occurrences of appearances as of canary yellow things. So we may also explain the appearance one has when one looks at Zinka in terms of Zinka's having the disjunctive property. However this appeal to the disjunctive property is as much an explanation at one remove from P1, an explanation by courtesy, as the explanation that the canary yellow appearance of Zinka is due to the property of having some property, in Zinka's case P1, which, oddities aside, causes the manifestation of the disposition to appear canary yellow. We get from P1 to the Primary Quality of canary yellow by moving, as it were, sideways to the disjunction. We get

from P1 to the Secondary Quality of canary yellow by moving, as it were, upwards to the disposition, i.e., to the higher-order property of having some property which, oddities aside, would cause the appropriate visual experience in the appropriate viewing condition.

Hence the theoretical mood which prompts the remark that as between those who say that the external world is colored because colors are Primary Qualities and those who say that the external world is colored because colors are Secondary Qualities the judicious choice is to agree with both. Having understood better what constituted dispositions are, considerable subtlety is required to discern any advantage had by one theory and not the other. Is canary yellow a disposition constituted by different properties in different cases or simply a disjunction of these different properties? As a result of so clarifying the issue one might well have the feeling that here, as elsewhere, a vigorous dispute is simply fed by indeterminacy, i.e., that there is no fact of the matter between the disputants, so that the disputed positions simply represent roughly equally good styles of argumentative bookkeeping.

Contrary to such metaphilosophical ennui, there is really nothing intrinsically wrong with considerable subtlety. And indeed, with just a little subtlety, we can discern a significant weakness in the Primary Quality account of the colors, a weakness that ultimately turns on the fact that the account implies that vision does not acquaint us with the colors but only gives us knowledge of the colors by description.

Unity and Availability

Recall the requirement of Unity. The family of similarity and difference principles holding among the colors includes the principle that canary yellow is not a shade of blue, i.e. that canary yellow is not as similar to the blues as they are among themselves.[20] The Primary Quality account of color has it that the shade canary yellow is the non-dispositional (and probably disjunctive) property which standardly explains the canary yellow appearances. Mutatis mutandis for the various shades of blue. Suppose that color science ends up discovering this: the non-dispositional property which standardly explains the canary yellow appearances and the various non-dispositional properties which standardly explain the various appearances of the shades of blue are not, when taken together, as similar among themselves as are the various non-dispositional properties which standardly explain the various appearances of the shades of blue. On the simplest version of the Primary Quality account, this would be the discovery that canary yellow is not a shade of blue, i.e., not to be counted among the blues.[21]

But is it really a matter of scientific discovery that canary yellow is not a shade of blue? No: such similarity and difference principles surely have a different status. We take ourselves to know these principles just on the basis of visual experience and ordinary grasp of color language. No one had to wait until the end of the second millennium A.D. to find out whether or not canary yellow is a shade of blue.

That, of course, is just a first move against the Primary Quality account. The friend of the account should be allowed to answer that indeed it is not a matter of scientific discovery that canary yellow is not a shade of blue. Rather, he might say, such a principle, along with other unity principles, must be held true as a condition on any family of properties deserving the color names. So the principle that canary yellow is not a shade of blue turns out to be relatively a priori after all. More exactly what is a priori is a biconditional: P deserves the name "canary yellow" just in case (i) P is the categorical surface property standardly responsible for the appearances as of canary yellow things and (ii) this property stands in the right similarity relations to other standardly explanatory categorical properties.

On the envisaged account, a given property turns out to count as canary yellow only if a complex similarity condition on that property and a host of others is discovered to hold. For example, the candidate properties to be the blues have to show a natural or genuine similarity among themselves, a similarity which they do not share with the candidate to be canary yellow.

Suppose color science discovers this condition holds along with the other unity conditions which the Primary Quality theorist regards as central. Then some (complex, disjunctive) physical properties turn out to be canary yellowness, teal, turquoise, sky blue and so on. And particular things turn out to have these properties. But what then gives one the right to say that there are canary yellow things is not simply visual perception and the very general background beliefs which inform visual perception, but also and crucially, recherche facts from color science. That is, on this version of the Primary Quality account one is not justified in believing that some things are canary yellow unless one knows that color science finds that among the causes of our experiences of color are physical properties which stand in certain complex similarity and difference relations. For this is a central precondition which this version of the account lays down on any property characterized in color science turning out to be canary yellowness, and hence on particular things turning out to be canary yellow. The unwelcome consequence is that the colors are not perceptually available.

The conclusion for which we are aiming is this: when the Primary Quality account is adjusted to accommodate Unity, it violates Availability, i.e., it will follow that the colors of things are not perceptually available. Given the adjusted account, we are not justified simply on the basis of visual perception and the background beliefs

which characteristically inform perception in believing that Zinka is canary yellow. For we are evidently not justified simply on this basis in supposing that the non-dispositional surface causes of our visual experiences exhibit the relevant similarities and differences.

However, to successfully argue that on the present version of the Primary Quality account the colors of things are not perceptually available we must engage with a complication familiar to epistemologists. This is the idea that by a convenient "failure of deductive closure" we could still be perceptually justified in believing that there is a property, canary yellow, had by Zinka even though we are not perceptually justified in believing that any property satisfies the similarity condition for being the property canary yellow. Whatever the general merits of the idea that one need not be justified in believing all the deductive consequences of what one is justified in believing, the idea of failure of deductive closure has its limits, and it can be shown that the conclusion for which we are aiming cannot be plausibly evaded by an appeal to a convenient failure of deductive closure. For on the present version of the Primary Quality account, the requirement that a host of microphysical similarity and difference relations hold is not just a collateral consequence of there being colors in general and canary yellow in particular. Instead, the present account has it that the claim that there are colors is conceptually equivalent to the claim that the categorical surface properties standardly causally responsible for our experiences as of colored things exhibit the required similarities and differences.

The relevance of this last point may be brought out in the following way. Imagine a sophisticate who took the alleged conceptual equivalence to heart and found himself therefore hesitating in concluding just on the basis of the way Zinka the canary looks that Zinka is canary yellow. "Zinka certainly looks the way something would have to look to count as canary yellow" he thinks "but we must wait and see if color science discovers the similarities and differences required for there to be such a property as canary yellow." Given his lucid understanding of the Primary Quality concept of canary yellow the sophisticate would not be justified in concluding just on the strength of perception that there is such a property as canary yellow. Hence he is not justified just on the strength of perception in taking Zinka or anything else to be canary yellow. Yet on the present account the sophisticate has the correct understanding of the concept canary yellow. So we in our turn can hardly be justified in concluding just by looking that Zinka (or anything else) is canary yellow. For we gain no global advantage with respect to justification by failing to be conceptually lucid. Thus the Primary Quality account is at odds with Availability.

To be sure, there are well-known cases in which more *empirical* knowledge would put one at a comparative disadvantage with respect to empirical justification—cases

in which one "knows more by knowing less"—and we can invent conceptual analogues of such cases.[22] However such cases never show the kind of *global* disadvantage with respect to justification from which our sophisticate suffers. If conceptual lucidity is not enough in itself to produce a global epistemic disadvantage and the Primary Quality account is true, then we can be no more perceptually justified in believing that things are canary yellow than is the conceptual sophisticate apprised of the Primary Quality account. Conclusion: on the Primary Quality account the colors of things are not perceptually available. The upshot is that in trying to secure the right status for the unity principles, and so avoid allowing that canary yellow might turn out to be a shade of blue, the Primary Quality account ends up violating Availability.[23]

Does the Secondary Quality account fare any better? First, does it secure the right status for the unity principles, allowing for example that we can know just on the basis of perception and ordinary understanding of the color terms that canary yellow is not a shade of blue?

The problem may be reduced to its simplest form: take teal and turquoise. They are similar color properties. Indeed they are essentially and intrinsically similar. That is to say teal and turquoise exhibit a kind of similarity that is not a similarity in the other properties to which they are related, nor a mere similarity in their causes and effects, nor a similarity in the properties upon which they supervene. Rather, the similarity between teal and turquoise with which we are concerned is to be found in any possible situation no matter how their instances, effects or contingent relations with other properties (including lawlike relations) vary. This is what I mean to focus upon by saying that teal and turquoise are essentially and intrinsically similar. Suppose one could spell out the nature of teal and the nature of turquoise, i.e., the higher-order features these properties have in any possible situation. Then that specification of features would list some common features of teal and turquoise. That is the way in which teal and turquoise are similar. They are not similar simply in virtue of being (even nomically) related to similar consequences or similar bases. They are similar in virtue of what they essentially and intrinsically are.

If teal and turquoise were categorical microphysical properties then any essential and intrinsic similarity between them would have to be a similarity in some higher-order microphysical respect. What we know simply on the basis of perception is not sufficient to know that there is such a similarity.

However, if teal is essentially the disposition to manifest a certain appearance Te and turquoise is essentially the disposition to manifest the appearance Tq then teal and turquoise will be essentially and intrinsically similar if these two manifestations are similar. *That these dispositions have similar manifestations is a fact available to us*

in visual perception. For it is evident in visual perception that the appearance Te is similar to the appearance Tq. That these manifestations are more similar to each other than either is to the manifestation of the disposition canary yellow is also a fact available to us in visual perception. By a simple extension of these considerations, the fact that canary yellow is not a shade of blue, i.e., the fact that canary yellow is not as similar to the blues as the blues are among themselves, is guaranteed by the claim that these properties are dispositions and by the evident fact that the appearance of canary yellow is not as similar to the appearances of the blues as those appearances are among themselves.

Notice that the different status of color similarities on the Primary and Secondary Quality accounts derives exactly from the central difference between the two accounts. It is precisely because the Primary Quality account treats the color appearances as merely the standard effects of the microphysical properties it identifies as the colors that the account cannot allow for perceptual knowledge of intrinsic and essential similarities among the colors. On the Secondary Quality account the color appearances are not merely the standard effects of the dispositions whose manifestations they are. Since they are also the manifestations cited when attributing the relevant dispositions, we know something intrinsic and essential to these dispositions when we know their manifestations.

The Secondary Quality account provides no threat to Unity. But does it secure Availability? Are the dispositions to appear colored perceptually available?

Someone who has no reason to suppose that he is an inadequate color perceiver or is in bad viewing conditions is such that his spontaneous visually acquired belief about the color of a thing he is seeing is typically justified. He acquires the belief by perception and typically nothing he believes warrants his suspending this belief. Suppose then that Sam's belief that Zinka is canary yellow is a belief of this kind. We considered the epistemic situation of a sophisticate who lucidly accepted that version of the Primary Quality account, an account which has it that conditions involving similarities among the categorical causes of color experience are a priori constraints on anything turning out to be canary yellow. Such a person would not be justified in concluding just by looking that Zinka or anything else is canary yellow. But then, *given that one cannot be in a (globally) worse epistemic condition just as a result of conceptual lucidity, if the Primary Quality account in question is true then Sam cannot be perceptually justified in believing that Zinka is canary yellow.*[24]

Can a similar argument be run against a Secondary Quality account? Such an account treats colors as constituted dispositions to present color appearances. So if the fact that Zinka is canary yellow is to be perceptually available then perception must be able to justify the belief that Zinka has a constituted disposition to appear

canary yellow. Otherwise a sophisticate who accepts the Secondary Quality account would not be perceptually justified in concluding that Zinka (or anything else) is canary yellow. That is to say that perception must provide the materials to justify the claim that Zinka has the property of having some intrinsic property which, oddities aside, would cause the relevant appearance in the relevant circumstances. These materials do seem to be provided by having the relevant appearance in the relevant circumstances and employing the background beliefs on which perception feeds. These are beliefs about our perceptual experience being by and large the effects of our perceptual capacities, the circumstances of perception and the intrinsic properties of the things perceived. On the strength of having the appearance and enjoying these background beliefs we are justified in believing that the object perceived has some intrinsic properties which would typically cause the appearance in the circumstances. But that means that on the strength of perception one can be justified in believing that the object has the constituted disposition to appear so in the circumstances.

Indeed one can perhaps be justified in believing slightly more on this basis. It is a perceptually available fact that certain colored things standardly block out the colors of things behind them in the line of sight; while others, color volumes or filters, standardly transform those colors; while still others, transparent volumes such as unpolluted air, clear water or colorless glass, in no way obscure or transform those colors. Therefore, visual perception supports the hypothesis that transparent but not opaque bodies allow to pass through them some standard conveyor or class of standard conveyors of information about the colors of external things. That is, a course of experience as of opaque and transparent bodies encourages the belief that there is some standard conveyor or class of standard conveyors of information about color.[25] Since it is perceptually evident that there are some standard conveyors of information about color, it is therefore perceptually evident that there is some standard process or processes mediating between the dispositions to appear colored and their effects, viz. the various color appearances. But then, if a Secondary Quality theorist were to identify colors with such standardly mediated dispositions, he would not threaten the ordinary perceptually based justification which we have for taking things to be the color they seem to be. Let us now turn to the motives for just such an identification.

Which Response-Dispositional Concepts are the Color Concepts?

Just what form should the Secondary Quality account take? The reasonable choice emerges from a critical version of the method of cases. We look to our intuitive judgments in both real and imaginary cases, we examine to what extent these intui-

tions are influenced by a bogus conception of colors driven by Revelation and then try to save the undebunked intuitions.[26]

Rigidification

Is it really so that in a possible world in which ripe tomatoes are chemically as they actually are but standardly look violet, they are nonetheless red because they standardly look red in the actual world? For a dispositionalist this is the question of whether to rigidify, i.e., fix on actual responders and actual conditions. Whichever way one is drawn, the main point is that the rigidified and the unrigidified response-dispositions are equally response-dispositions. If a case can be made for the colors being rigidified response-dispositions then so be it. However, we may run into indeterminacy here even if our intuitions initially favor the idea that in a possible world in which ripe tomatoes are chemically as they actually are but standardly look violet they are nonetheless still red. For this intuition may be influenced by a conception of color driven by Revelation. In imaginatively picturing the relevant possible world to ourselves we slap onto the tomato surfaces redness-as-Revelation-represents-it-as-being, thereby providing an independent standard of correctness by which to criticize the counterfactually standard appearances. As a result, a simple reliance on intuition might here make things seem more determinate than they could in fact be.

Standard Mediation

As well as the consistent fancy of the strange ray from the *center* of a red-surfaced ball masking the redness of the surface by acting directly on the visual cortex to produce an impression of a green surface, we have the equally consistent fancy of such a strange ray emanating from the *surface* to likewise obscure the redness of the surface by directly producing the appearance of a green surface. In this second case it is utterly implausible to deny that the surface itself has the constituted disposition to look green. Yet it is not green but red.

Fatal for the dispositional theory? No; a dispositionalist who identifies the colors with standardly mediated dispositions need not count the surface as green. For the strange ray bypasses the eye. This is sufficient to make the processes involving it nonstandard causes of visual experiences. But then the disposition of the red ball to look green, based as it is in such a process, will not be a standardly mediated disposition to look green. So although the red surface is disposed to look green, the right sort of dispositionalist need not count it green.[27]

No doubt this use of the modifier "standardly" to qualify the way in which the target dispositions are to be mediated or realized will prompt the question as to just what might or might not count as the processes involved in the standardly mediated

dispositions to appear colored. The processes of refraction-influenced reflection frequently involved in producing the appearances of the shimmering colors may be counted standard enough, even if the processes of reflection without refraction involved in producing the appearances of the steady colors are more commonly in play. There will of course be a region of indeterminacy, in which there is no fact of the matter as to whether or not a given process is common enough to be a standard mediator. But there will also be clear cases on the other side, where the disposition to appear colored is not standardly mediated, as with the case of the rotating Benham disc.

The top of one typical kind of Benham disc is divided along a diameter into black and white regions. If the disc is rotated at a rate of about seven cycles per second and viewed under bright tungsten light various colored bands will appear on the top of the disc. But it feels very strained to say that while rotating the top of the disc changes color. Contrast a disc whose surface is chemically prepared so that the air rushing by as the disc rotates sets off a color-affecting chemical change on the surface.

Psychologists call the colors which appear during the rotation of Benham discs "subjective" colors, thereby registering a conviction that these discs only seem to change color while rotating. The intuition to be captured is thus that these achromatic discs remain achromatic throughout rotation. How is the dispositionalist to capture that intuition? In his informative discussion of Benham discs, C. L. Hardin supposes that the best move for the dispositionalist bent on excluding such subjective colors is to insist that the real colors are those that appear to standard perceivers under standard *viewing* conditions and then to claim that movement with respect to the eye is not a standard viewing condition. Hardin rightly rejects this last claim and consequently rejects dispositionalism. He writes

There are at least three difficulties with this initially plausible restriction 'on movement'. First we need not move the black-and-white stimulus at all. It is the pulsed sequence of presentations which matters. One stillborn proposal for color television derived a chromatic effect from a suitably pulsed set of black-and-white signals. The "Butterfield encoder" gave a fairly good color rendition including skin tone.... One can in fact see faint, desaturated subjective colors by looking closely at the noise pattern of an unoccupied channel on a black-and-white television set.... The second difficulty with the restriction is that the eye moves involuntarily and incessantly in a random series of drifts and jerks, and these are sufficient to generate "subjective" colors on a stationary black-and-white pattern.... The third difficulty is the mate of the second: if all relative motion between target and eyeball is prevented, both the outline and the colors of the object soon disappear.[28]

Surely these are effective considerations against the idea that the standard viewing condition for color rules out movement. Many things constantly move relative to us,

indeed rotate relative to us, without this in any way undermining our confidence that we have seen them in their true colors. We cannot capture the intuition that the colors of rotating Benham discs are "subjective" by stipulating that only color appearances which arise under standard viewing conditions are veridical. The thing to do is not to require that the viewing condition be standard but that the processes which mediate the relevant dispositions to produce color appearances be among the processes which are standard or typical when it comes to seeing color.

Hardin's example of the Butterfield encoder and his emphasis on pulses suggests just this idea. In the case of an encoder beginning to work at some time t, if d is the time taken for light from a given region of the encoder's screen to reach the observer's eye and e is a period just shorter than the resolution time of the human eye, i.e., the time required for the eye to process light, then the light arriving from that region at $t + d + e$ will be light that is very different in its subjective effects from light that arrived at $t + d$. When these conditions are satisfied let us say that the light is temporally *inhomogeneous*. In such cases very different kinds of light "bunch up" in the eye forcing the receptors to integrate across such inhomogeneities. Now the finite resolution time of the receptors in the eye means that there is always "bunching up." That is to say that where d is the time light takes to reach the eye from the viewed region, the light from the region that the eye is responding to at $t + d$ is never just the light that left the region at t. Rather it includes the light that left the region during the period between t and $t - e$. But standardly this does not matter, for the bundle of light that left the region at t is light with the same subjective effects as the bundle of light that left the region at $t - e$. What bunches up is more or less the same sort of light. In the case of temporal inhomogeneity this last condition is not met. This makes for a non-standard process mediating the appearances and hence realizing the dispositions to appear. The eye is forced to integrate across temporally inhomogeneous packets of light coming in swift sequence from the same region of the scene before the eyes.

Hence a dispositionalist has the resources to say that despite the fact that the screen of the Butterfield encoder is disposed to look yellow, green and blue, it is really achromatic. And he will say the same about the process mediating the subjective colors of the Benham disc. They too are produced by the eye integrating in a case of temporal inhomogeneity. The light coming from a given region of the scene before the eyes is temporally inhomogeneous thanks to the rotation of black and white portions of the disc through that region. The eye is forced to integrate across inhomogeneous packets of light coming in swift sequence from the same region of the scene. This is a non-standard process mediating the visual appearances. So although various hues are disposed to appear across the Benham disc during rotation

they are not standardly so disposed. The Benham disc remains achromatic through-
out rotation.

Let us now turn to a spatial analog of temporal inhomogeneity; the case of poin-
tillism. Pointillism or the optical fusion of small adjacent regions of different color
arises because the eye also integrates over spatial inhomogeneities. One need not
think that there is a deep ontological divide between space and time to think that
while integrating over temporal inhomogeneity is non-standard, integrating over
spatial inhomogeneity is on the way to becoming standard. The standard technology
of four-color printing means that most of the printed colors other than cyan,
magenta, yellow and black which we now see are the products of the optical fusion
of a mixed selection of dots of these four colors. It is a bit too severe to say that the
only veridical colors that we now see on the pages of magazines are white, black,
cyan, magenta and yellow, the rest being illusory color appearances. But it is not
obvious that a dispositionalist is required to say this. "Standardly mediated" is not
equivalent to "naturally mediated" but rather to "typically mediated," and the
pointillistic realization of printed color has arguably now become typical or stan-
dard. Again the dispositionalist may happily admit that indeterminacies may well
arise when we consider cases in which a mode of realizing color appearances is
becoming standard. The dispositionalist should not be disturbed by the fact that this
admission is at odds with a naive conception of color, i.e., a conception which con-
forms to Revelation and as a result thinks of surfaces as wrapped in phenomenally
revealed features which will always make it a determinate fact what the real color of
the surface is. (For we have shown that such a conception is not coherent, not con-
sistent with the idea that we *see* colors.)

Relativized Colors

It is one thing to say that there are indeed red patches of color on the pages of many
magazines. But it would be strange to deny what the closest viewing of some of these
patches reveals: that these patches are made up of small magenta and yellow dots,
that therefore these patches are motley in color. How can the same patch be red and
motley yellow and magenta? Relativism to the rescue: the patches are standardly
disposed to look red to the naked eye from a normal reading distance and standardly
disposed to look motley yellow and magenta to the closest view. They are, according
to the best kind of dispositionalist, red for perceivers employing the naked eye at
reading distance, and motley yellow and magenta for perceivers at the closest view-
ing range. The best kind of dispositionalist is a color relativist.

It is not widely recognized that a color relativist can consistently find some truth
in many remarks about "real" colors. Chromatic lights are said to obscure the real

colors of patches viewed under them. The color relativist avoids one kind of invid-
ious distinction between the standard disposition of a cloth to look pinkish-blue in
daylight and the standard disposition of the same cloth to look simply pink under
pink light. For the relativist, both are equally *veridical* colors. But the second color
is, as things ordinarily go, the color associated with the more transient and inter-
rupted appearance of the cloth. If we mean by "real color" the least transient verid-
ical color then daylight and ordinary indoor light *do* typically reveal the real colors
of things. When the colored thing is something whose color appearance changes as
the quality of the daylight changes, e.g. the sea, there may be no simple answer to
questions which seek to pinpoint the real color. Is the sea *really* green or grey or
blue? Or greenish-blue or bluish-grey or grayish-bluish-green? Again we should not
be too perturbed by indeterminacy.

 Hence we arrive at the following account of when a surface has a relative color

X is hue H for perceivers P under conditions C iff X is [?actually?] *standardly*
disposed to look H to perceivers P [?as they actually are?] under conditions C
[?as they actually are?].

What is standard in the way of the processes mediating a visual response-disposition
will vary from possible world to possible world. Once again some may feel the temp-
tation to rigidify or fix on what is actually standard in the way of causally mediating
between visual response-dispositions and visual responses. And once again there is
the question of how much of the alleged intuitive privilege of the actual world's
mechanisms is due to picturing the imagined alternatives as exemplifying the colors-
as-Revelation-represents-them-as-being. Were there such colors then they could be
systematically misrepresented in any alternative world by that world's standardly
mediated appearances. But there cannot be such colors. Perhaps that saps much of
the temptation to rigidify or fix on the processes that are actually standard. In any
case it would be odd to do this once it is allowed, as in the case of four-color print-
ing, that what is standard may vary over time. For we can imagine our world evolv-
ing in the direction of what is standard in some other world. What was always
standard there becomes standard here.

 If one wants to avoid the consequences of not rigidifying on the actually standard
processes mediating the color appearances one had probably better understand
"standard mediating processes" as "natural mediating processes" and so disparage
pointillism and therefore accept the slightly odd view that the pages of magazines are
filled with occasions for color illusions. Neither choice is wholly comfortable, but
either way the resultant and, I think, relatively mild discomfort *is not peculiar to the
Secondary Quality account*. Recall that the Primary Quality account picks out its

favored properties as the non-dispositional properties standardly or normally responsible for the relevant color appearances. Similar discomfort arises when this account gets explicit about what it means by "standard" or "normal". The discomfort is mostly an aftershock of the inevitable denial of Revelation.

Kripke's Reference-Fixing Account

In order to justify the claim that such a Secondary Quality account of the colors allows us to speak more inclusively of the colors than any Primary Quality account allows, it must be shown that the kind of problem illustrated by the fact that we know in advance that canary yellow could not turn out to be a shade of blue arises because of the central idea behind the Primary Quality account, and not just because the argument concentrated on a determinate shade like canary yellow rather than on the determinable hue that is yellow.

Someone might think that if we began with a Primary Quality account of the hues—red, blue, green, yellow, etc.—then we could just stipulate that canary yellow is a yellow and not a blue, thereby getting round the problem of canary yellow threatening to turn out to be a shade of blue.

Indeed, when one of the most inventive advocates of the view that colors are Primary Qualities gives his account of the color properties he naturally treats the hues and not the shades. Thus in *Naming and Necessity* Saul Kripke writes of yellow, not canary yellow, claiming that the hue term "yellow" is akin to a natural kind term.[29] On that account, the term "yellow" has its reference fixed in terms of the description "the manifest (i.e., non-dispositional) surface property which is normally responsible for things appearing yellow". Of course, something will then count as yellow only if this description denotes, so that the reference fixing account for "yellow" will treat the following conditional as having a priori status.

(10) If there is a unique manifest surface property normally responsible for things appearing yellow, say Y, then yellowness is Y, otherwise "yellow" does not denote.

This account yields its own paradoxical consequences. To see why, recall that hue is just one color determinable, along with saturation and brightness. Let us focus on brightness and its determinates—being (quite) bright, being dark and being intermediate in brightness. These stand to the determinable brightness as yellow stands to hue. If "yellow" gets a reference-fixing treatment then so should the names for these brightness qualities.[30] So we have

(11) If there is a unique surface property normally responsible for things looking bright, say B1, then brightness is B1, otherwise 'brightness' does not denote.

(12) If there is a unique surface property normally responsible for things looking dark, say B2, then darkness is B2, otherwise 'darkness' does not denote.

(13) If there is a unique surface property normally responsible for things looking intermediate in brightness, say B3, then the property of being intermediate in brightness is B3, otherwise "the property of being intermediate in brightness" does not denote.

One of the things we know about yellow just on the basis of sight and without relying upon information about scientific discoveries is that there cannot be a yellow with no brightness quality whatsoever, a yellow which is neither bright nor dark (i.e., brownish) nor intermediate in brightness. However, on the reference-fixing account so far adumbrated this is at most a matter of scientific discovery—a discovery to the effect that everything that has Y also has at least one of B1 or B2 or B3. For all we know now it might actually turn out that there are things with Y but none of B1 or B2 or B3. On the present account such things would be a shade of yellow that was neither bright nor dark nor anywhere in between on the scale of brightness. Were there such shades, they could not be the object of fully veridical perception, since any visual perception would present some brightness quality. So in that sense they would be not be fully visible shades of yellow.

Furthermore, on the reference-fixing account it is at most a matter of scientific discovery that everything that has Y has at most one of B1 or B2 or B3. For all we know now it might actually turn out that there are things with Y and both B1 and B3. On the account under discussion, such things would be a shade of yellow that was at once bright and dark, e.g., as bright as the yellow on the disc of the moon and as dark as a dark brown. (Dark yellow get called brown.)[31]

As against all this we know in advance that there cannot be such strange yellows just as we know in advance that canary yellow is not a shade of blue. Or rather, to put the point in a way that takes proper note of the vagueness of the analytic/synthetic distinction: any account which has it coming out true that we know these things in advance thereby better deserves the name of an account of the *colors*.

What about the strategy of conditionalizing on what we know in advance? What about articulating in an antecedent of a conditional just the requisite relations between hue and brightness. An example of the required "frontloading" (Peter Railton's nice term) would be—

(14) IF Y is the property normally responsible for the yellow appearances and B1 is the property normally responsible for the bright shade appearances and B2 is the property normally responsible for the dark shade appearances and B3 is the property normally responsible for the appearances of intermediate shades AND it is

a consequence of the laws of color science that anything that has Y has one and at most one of B1 and B2 and B3 THEN yellowness is Y, otherwise the term "yellowness' does not denote.

Once again a problem about the perceptual availability of the colors arises. Suppose that in the year 2000 as a result of discoveries in color science we come to know that the antecedent of (14) is satisfied. Then the account employing (14) implies that some parts of the external world were colored yellow all along. But we were not justified in believing this all along. For until 2000 we were ignorant of a central precondition on things being yellow. Indeed, even after the year 2000 we can only know that surfaces are yellow by relying upon knowledge of what holds up as a lawlike statement of color science. As against this, we have Availability: if there are yellow surfaces, good perceivers can be justified in believing this just by looking at them and without relying upon exotic scientific discoveries. Once again, the properties alleged to be the colors are not perceptually available, and this is because the account which identifies or conditionally identifies the colors with the non-dispositional, microphysical properties talked about in color science thereby concerns itself with properties one step too remote from the appearances—the microphysical bases of dispositions to appear colored rather than the dispositions themselves.

The dispositional account fares better with the internal relations among hue, saturation and brightness. Beginning again with the fully determinate shades, notice first that every color experience is an experience of some shade of color. That is to say that every color experience is simultaneously an experience of a certain hue quality, a certain saturation quality and a certain brightness quality. Each appearance of a shade is an appearance of something with a specific value along these three dimensions. So to be disposed to produce an appearance with some single hue quality is ipso facto to be disposed to produce an appearance with some single saturation quality and is ipso facto to be disposed to produce an appearance with some single brightness quality. Hues with no brightness quality, saturationless hues and so on are no more possible than *experiences* of shades devoid of hue, saturation or brightness are possible. This is just because of the intimate connection between the experiences and the colors according to the dispositional view.[32]

The perceptual availability of the colors; our being able to tell there are colors, and what colors things are, just on the basis of perception, has played an important role in the argument so far. It has not been assumed that an account which violates Availability could not deserve the name of an account of the colors, but only that ceteris paribus, an account which does *not* violate this principle better deserves the name of an account of the colors. Mutatis mutandis with Unity. Our conclusion

should therefore not be that the Primary Quality account is hopeless as an account of the colors. Rather we should conclude that while we can speak of the colors as response-dispositions and still speak more or less inclusively, we must speak less inclusively if we speak of the colors as the categorical bases of such dispositions. For we must then give up either Unity or Availability.

There is a reply in the offing. As against this attempt to produce a contradiction among Unity, Availability and the Primary Quality account, the friend of the account may urge that we treat "similar" wherever it occurs in the formulation of a unity principle as simply short for "looks similar" so that the unity relations are indeed knowable just on the basis of visual perception. Then canary yellow would be a shade of blue only if it looked as similar to the blues as they look among themselves. We know just on the basis of visual perception that this last condition is not satisfied. The Primary Quality theorist may thus hope to escape our arguments so far by replying that Unity is much less demanding than we thought.

I think it can be shown that the reply falsifies the contents of the unity principles which are central to our beliefs about the colors. For the reply entails that in knowing on the basis of vision that canary yellow is not a shade of blue we simply know that canary yellow does not look as similar to the blues as the blues do among themselves. That implies that what we know on the basis of vision leaves it open that canary yellow may nonetheless be as similar to the blues as they are among themselves. But that means that vision tells us almost nothing about what canary yellow, teal, turquoise, sky blue are like. And that is to say that on the Primary Quality account, vision merely gives us knowledge of the colors by description, i.e., allows us to know the colors just as the properties, *whatever they might be like*, which are standardly causally responsible for the color appearances. However, if vision gives us only knowledge by description of the colors, if vision does not acquaint us at all with the way the colors are intrinsically, then the colors can hardly be said to be visible properties.

On the other hand, vision can acquaint us with the natures of the color properties if these properties are dispositions to produce visual responses. The similarities that color vision reveals will then be visually apparent similarities among the colors, not mere similarities among the visual appearances which the colors, whatever they might be like, cause. There will be, after all, a grain of truth in Revelation—visual experience taken, not naively, but as a series of manifestations of visual response-dispositions, can acquaint us with the natures of the colors. (Despite this grain of truth, Revelation as it stands is still false on the Secondary Quality account, for Revelation implies that if colors are dispositions then all colors, even the steady colors, look like dispositions.)

Revelation Revisited

The Secondary Quality account can recognize a grain of truth in Revelation. This grain of truth is important when it comes to accounting for the value of vision. The faculty of vision either represents itself as (or is spontaneously taken by its possessors as) a mode of revelation of the natures of certain properties of visible things, viz. their colors and Euclidean shapes. A particular counts as visible only if it has visible properties and it has visible properties only if it has properties with whose natures vision acquaints us. That is to say that although it is a necessary condition of a property F being visible that something's having F at some time explains a visual experience, this is not sufficient. For many fundamental physical properties satisfy this necessary condition while nonetheless not being visible properties. They fail to count as visible properties because vision does not acquaint us with the nature of these properties but only with their effects.[33]

The notion of acquaintance with a property, equivalently of knowing the nature of a property, is somewhat obscure. We do not want to follow Russell's line in *The Problems of Philosophy* and say that when one is acquainted with a property one has nothing more to know about it except which particulars in fact have it. For then, as we have seen, it would follow that *no* causes of our experience are visible.

In lieu of Russell's all too demanding account, we might offer the following operational consequence of being acquainted with a number of properties. If you know or are acquainted with the nature of properties F1, F2, ... FN then you can know a family of similarity and difference relations (unity principles) holding among F1 through FN and know these without relying upon knowledge of the laws in which the properties are implicated or upon knowledge of which particulars have the properties. Obviously acquaintance can be a matter of degree on this view. So we do not need a complete revelation of the nature of a property to be acquainted with the property. Vision can thus acquaint us with the response-dispositions that are the colors of the Secondary Quality account, even though vision fails to represent them as dispositions. Contrast Kripke's Primary Quality account of the colors as properties picked out by reference-fixing descriptions which mention mere effects of the properties: on this view since vision gives us only knowledge by description of the microphysical causes of our experience of colors, and those causes are the colors, vision gives us only knowledge by description of the colors.

Return now to the defensive suggestion of the Primary Quality theorist to the effect that the only unity conditions worth underwriting are similarity and difference conditions among appearances. Notice that this maneuver and our operational account of acquaintance together imply that we are not at all acquainted with the

colors but only with their visual effects. Given that visible properties are the properties with which vision can acquaint us, it follows that the colors are invisible.

The Primary Quality theorist can of course allow that the colors are visible in a less demanding sense, namely that they are properties which in a standard and systematic way explain our visual experience. So the whole issue ultimately turns on this question: "Why is it so bad if we are not acquainted with the colors and with other visible qualities by vision but know them only by description?"

This is a question about the comparative interest and point of concepts of the colors and of other visibilia. And I think that the question has an interesting answer which favors the Secondary Quality account. For I believe that our implicit cognitive values favor acquaintance with objects, people, places, and hence with their properties. If that is so than we have reason to want vision to be a mode of access to the natures of visible properties. But then we have reason to refigure our concepts of the colors along the lines suggested by the Secondary Quality theorist.

That our implicit cognitive values favor acquaintance with things emerges if we consider what would be so bad about the situation which the skeptic claims we are actually in. Consider two familiar philosophical cartoons by which the traditional skeptical problem of the external world is typically presented—the case of the eternal movie buff and the case of the brain in the vat. The eternal movie buff has spent all his life in a dark room watching images on a screen before his eyes. Never having left his room he has no idea whether the images correspond to anything outside his chamber. The brain in the vat is fed a full sensorium by fiendishly clever neural stimulation. A computer coordinates the pattern of stimulation so that the brain has a complete and consistent sensory illusion, say as of living an ordinary life in Boise, Iowa. These bizarre predicaments are employed to highlight a skeptical worry about our own predicament. The eternal movie buff cannot be justified in holding any visually generated beliefs about the external world, restricted as he is to mere images which he cannot check against external reality. He can only check experience against experience. But this is also our predicament. We also can only check our experiences against other experiences. It is no more possible for us to attempt to match our experience against external reality as it is in itself, as it is independently of how it is experienced by us. The case of the brain in the vat deflates the natural thought that we have an epistemic advantage over the eternal movie buff by possessing a number of potential windows on the world which we can use to triangulate to an external reality as it is in itself. The triangulations of the envatted brain lead it to beliefs about a life lived in Boise, Iowa. But all these beliefs are false.

Whatever the force of these cartoons in presenting the traditional problem of the justifiability of our beliefs about the external world, and even if their force is

undermined by noting that a spontaneous and utterly natural belief is justified in the absence of a good case against it, the cartoons also serve to illustrate a deeper epistemic anxiety about our own condition.

This deeper problem of the external world is the problem of acquaintance, the problem of how we could be acquainted with anything given the nature of information transmission. The nature of any signal received is partly a product of the thing sending the signal and partly a product of the signal receiver. We cannot, it seems, separate out the contribution of our own sensibility to our experience from the contribution of the objects sensed. The case of the brain in the vat shows that our experience does not discriminate between many different kinds of external objects so long as their effects on our sensibility are isomorphic in certain ways. But that suggests that relative to the problem of acquaintance, even if we are not brains in vats things are as bad as they would be if we were brains in vats.[34] We cannot take our experiences to reveal the natures of external things. No sensory experience could at the same time reveal two things so intrinsically unalike as the nature of life in Boise and the nature of the inner working of the vat computer. But for all that could be revealed in a fully coherent experience either could be the cause of that course of experience. Conclusion: sensory experience does not reveal the nature of its causes.

In both cartoons sensory experience is clearly depicted as simply an effect of external causes whose natures are in no way revealed by the experiences they cause. Sensory experience in no way acquaints the brain or the buff with the nature of the external causes of that experience. In this respect, sensory experience is unsatisfyingly like Morse code transmission: both involve interpretable effects at the end of an information-bearing process or signal. But the intrinsic natures of the originators of the signal are not manifest in the signal. This is a very depressing comparison. Perception represents itself as (or is at least spontaneously taken by its possessors as) a mode of access to the natures of things. When I see the sun setting against the magenta expanse of the sky, I seem to have something about the nature of the sky and the sun revealed to me. I seem not just to be partly under their causal influence in a way that leaves completely open what their natures might be like. The acquaintance with external features which vision seems to provide is something we very much value, or so it seems to me.

The general problem of acquaintance is a difficult one, but we have already accumulated the materials for a solution to that problem as it arises for vision and color. Part of my pleasure in seeing color is not simply the pleasure of undergoing certain experiences but the pleasure of having access to the natures of those features of external things that are the colors. This need not be a pleasure founded in a false belief, a pleasure which philosophical reflection would have me see through. For

suppose the colors are response-dispositions. These are genuine, albeit relational, features of external objects. Their manifestations are the various experiences in various subjects as of the various colors. These sensory manifestations are not simply the effects of the dispositions they manifest. They are or can be manifestations in a more interesting sense. About any disposition of objects to produce a given experience, it is plausible to hold that if one has an experience of the kind in question and takes that experience to be a manifestation of the disposition in question, one thereby knows the complete intrinsic nature of the disposition. Of course one does not thereby know the facts concerning how in general the disposition is specifically secured or realized. But these are facts concerning the disposition's contingent relations to other properties. They do not concern the intrinsic and essential nature of the disposition. So, as claimed earlier, I take myself as having come to understand the complete nature of the property of being nauseated one afternoon twenty five years ago when I tasted a juicy apricot on a ferry crossing from Melbourne to Hobart. Similarly, if I conceive of the magenta of the sunset as a (constituted) disposition to produce a certain visual response in subjects like me, and I now discover myself to be responding just so, I can be in possession of all there is to know about the essential nature of the dispositional property that is magenta. I do not thereby know the contingent details of how magenta might be physically realized here before my eyes or anywhere else. But that is ignorance of the relation between the disposition and the other properties which happen to realize the disposition. I do seem to know everything intrinsic and essential to the response-disposition that is magenta. Mutatis mutandis for the other colors. Vision can be a mode of revelation of the nature of visual response-dispositions. It cannot be a mode of revelation of the properties which the Primary Quality Theorist identifies with the colors. Since we are inevitably in the business of refiguring our inconsistent color concepts, we should make the revision which allows us to secure an important cognitive value—the value of acquaintance with those salient, striking and ubiquitous features that are the colors.[35]

The point here is not simply that the Primary Quality Account does not satisfy even a qualified form of Revelation. What is more crucial is that as a result, the account does not provide for something we very much value: acquaintance with the colors. The ultimate defect of the Primary Quality View is therefore a practical one. From the point of view of what we might call the ethics of perception, the Secondary Quality Account is to be preferred. It provides for acquaintance with the colors.

I began by indicating that the possibility of speaking more or less inclusively about the colors is a typical consequence of the vagueness of the analytic/synthetic distinction. But that means that the vagueness of the analytic/synthetic distinction will

typically have this consequence: without clearly changing the topic we will always face a choice of precisely which concepts to use. Such a choice is not dictated by the natures of the things under discussion. For those natures, admit of many types of true descriptions. (For example, there is no doubt that colored objects have both the features favored by the Secondary Quality theorist and the features favored by the Primary Quality theorist.) What should guide such conceptual choices? Surely here, Pragmatism is entirely vindicated: it is human interests, broadly construed, which make it reasonable to confront the world armed with these concepts rather than those.

So although the philosophy of color may be one of those genial areas of inquiry in which the main competing positions are each *in their own way* perfectly true, *it may also be that given what we value only one account is the right one for us to employ.*[36]

Acknowledgments

Thanks to Paul Boghossian, C. L. Hardin, David Lewis, Peter Railton, David Velleman and Stephen Yablo. An earlier draft of this paper was delivered as an invited paper at The Eastern Division of the American Philosophical Association, December 1989. An outline of many of these ideas was presented at the 1989 Spring Colloquim of the University of Michigan Philosophy Department, although then I was more favorable towards the Primary Quality account than I am now. I am told that Charlie Martin discussed mimicked and masked dispositions thirty years ago in his classes at Sydney University.

Notes

1. If one wants a reason for being interested in the answer, the quick reason is that unless the external world is colored it is invisible. For if the external world is not colored then we do not see the colors of external things. They are not visible. Now the surfaces of material objects are visible only if they are either visibly translucent, visibly transparent, visibly opaque or visibly reflective. Determinables like transparency, opacity, etc. are visible only if their determinates are visible. The various volume colors are the determinate ways of being transparent and translucent, the various barrier colors are the determinate ways of being opaque, and the various colors of virtual images in mirrors are the determinate ways of being reflective. So if colors are not visible then no surface of a material object is visible. But if no surface of a material object is visible, then no material object is visible. Such is the consequence of denying that nothing corresponds to external color, the proper sensible of sight. Unless the external world is colored we do not see it and that means we do not see, period. If the world is not colored, we may get some kind of schematic propositional knowledge about our environment by sight but sight does not acquaint us with the natures of any external things. Our question might as well be "How far short of speaking ever so inclusively do we have to fall in order to say truly that we see?" or "In what sense do we see external things?" The last section of this paper addresses, in a preliminary way, the question as to why we should care about seeing external things in one or another sense of "seeing".

2. See *The Problems of Philosophy* (London, OUP, 1912) p. 47.

3. For this analogy, see the first few pages of part one of Descartes' *Optics*.

4. See David R. Hilbert *Color and Color Perception* (CSLI, Stanford, 1987) pp. 29–42.

5. "'Red' and Red" *Synthèse* 78, 1989; p. 224.

6. I cannot help thinking that it is this conviction which is driving some of the provocative arguments of Paul Boghossian and David Velleman to the conclusion that the external world is not colored. When for example they discuss Christopher Peacocke's version of the dispositional theory their main point is that if colors were that kind of disposition then visual experience could be convicted of misrepresenting the nature of the colors. To which a friend of the Peacocke account should reply "Just so! Revelation is a bit of an overstatement. We can't completely save the phenomenology of color experience." Nor do Boghossian and Velleman themselves completely save the phenomenology of color experience, for that experience represents the external world as colored. See Paul A. Boghossian and J. David Vellman "Color As A Secondary Quality" *Mind* 1989 [chapter 7, this volume].

7. The same point about the relevant error can be made in the terms allowed by those, like Gilbert Harman, who take what others regard as sensational features of perceptual experience to be none other than further representational features of perceptual experience. The error in question involves taking these further representations as indicating the complete nature of sensory qualities. See Gilbert Harman "The Intrinsic Quality of Experience" *Philosophical Perspectives* 4, pp. 31–52.

8. The reflectance of a surface is given by a set of proportions of reflected light to incident light for each wavelength of visible light. For the original version of Land's theory see *Scientific American*, 237, Dec 1977. In the latest version of the theory Land shows how the color appearance of an illuminated patch is associated with a triple of "designators." A designator is a weighted proportion of the light of a given wavelength coming from the colored patch to the light of that wavelength coming from a given surround. When we have a designator for each of the long, medium and short wavelengths coming from and around an illuminated patch, we have enough physical information to determine the color appearance of the patch to normal perceivers. So we could identify colors with dispositions to give off light conforming to an appropriate set of triples of designators. This would be a complex and scientifically realistic light-dispositional theory.

9. See Harding, G. 1991. Color and the mind-body problem. *Review of Metaphysics* 45, 289–307. As I understand him Harding completely endorses Revelation and builds his ontology around the result.

10. See "Color as a Secondary Quality" op. cit.

11. For the distinction between steady and unsteady or "shimmering" colors see Hazel Rossotti *Color: Why the World Isn't Grey* (Princeton University Press, 1983) chapters 3 and 4. Rossotti uses "stable colors" for what I am calling "steady colors". "Stable" sounds to me to be the opposite of "transient" and there can be transient colors that are nonetheless steady, e.g. the greyness of the sky when it is overcast.

12. Why abandon or weaken Revelation rather than Explanation? The answer turns on the fact that Explanation is also a very plausible condition on colors being visible. It would be perverse to allow that the colors are indeed properties satisfying Revelation but that they are invisible.

13. Sensible qualities are qualities that are visible, audible, testable, etc.

14. Some tell me that their intuition is that something extrinsic to the ray-bedeviled surface disposes it to look red, so the surface is indeed disposed to look red. I do not so much want to deny the intuition as to separate out a conception of dispositions which requires an intrinsic basis for the disposition. Maybe the ordinary notion of a thing's power or capacity tends to carry this implication of there being in the thing an intrinsic basis for the disposition that is the power. At least it seems more strained to say that the ray-bedeviled surface *itself* has the power to look red. That seems to suggest that it would continue to have that power were the surface hived off from the ray-emanating core.

The related case of the strange ray emanating from the surface is discussed below in the main body of the text.

15. Why not also allow the case where x changes intrinsically as x goes into the circumstances C? Because this would rule out an absolutely straightforward case of the manifestation of a disposition, a case in which putting x in C changes x in precisely the way that is causally responsible for the manifestation.

16. This is not, of course, an analysis of the notion of a disposition, since it does not tell us the conditions for attributing dispositions when the oddities are in play. I attempt a full-blown analysis in "Dispositions: Predication with a Grain of Salt" unpublished manuscript.

17. For reasons to hesitate in attributing the dispositional thesis to Locke see A. D. Smith "Of Primary and Secondary Qualities" *The Philosophical Review* XCLX, 1990.

18. On the disparate nature of the standard causes, even of appearances of the same shade, see C. L. Hardin *Color For Philosophers* (Hackett, 1988) pp. 1–52.

19. "An Objectivist's Guide to Subjectivism About Color" *Revue Internationale de Philosophie* 1987 [chapter 6, this volume].

20. Since similarity is always similarity in some respect it is a fair question as to what respect I have in mind here. The answer is similarity in respect of hue, the most salient of the similarities among the shades.

21. Or at least it would be that discovery if the similarity in question was plausibly identified with a similarity in respect of hue. For more on what this involves see the discussion of Saul Kripke's view below.

22. Suppose that I am a waif brought up in a monastery. As a matter of strict monastic rule no married male is allowed to enter the gates of the monastery. I have a highly predictive stereotype associated with the concept of a bachelor inhabiting the monastery, viz. that of a male inhabiting the monastery. Now as a result of monkish gossip it is widely but wrongly suspected that Brother Bernard, who we all know to have been a man of the world, has a wife or two in Tuscany. I know of the gossip and accept it, but because of my stereotype of a bachelor as a male inhabiting the monastery, I adhere to my true and well-grounded belief that Brother Bernard is a bachelor. In rhetoric class I am finally taught the definition of "bachelor" and I conclude that Brother Bernard is not a bachelor. As a result of conceptual lucidity I know less by knowing more.

Nonetheless the crucial point is that even in such cases being conceptually lucid does not confer a **global** disadvantage when it comes to justified applications of the concept in question. When it comes to applying the concept bachelor outside the monastery, where there are indeed married males, I am not disadvantaged as a result of what I learned in the rhetoric class. Nor is this so within the monastery when it comes to the bachelorhood of the other monks beside Bernard. And there are many *possible* cases in which thanks to my newly acquired conceptual lucidity I would be better placed when it comes to having justified belief about who the bachelors are. The thing that it is hard to believe about our color sophisticate is that in every actual and possible case he is worse off than we as a result of his conceptual sophistication, so that he never could be justified simply on the basis of perception in judging the colors of things, while we are almost always so justified. This is not made any easier to believe by examining cases in which one ignores a misleading defeater thanks to a conceptual mistake.

23. By the way, it is tempting to see here the form of a general worry about any natural kind account of concepts for which analogues of Unity and Availability hold. Most observational concepts seem to me to have such analogues.

24. The strategy of considering the epistemic position of the relevant philosophical sophisticate has wide application. It also has at least three attractive features. It does not assume what is anyway crazy, i.e., that *ordinary* subjects' possession of justified belief depends upon their employing implicitly or explicitly the right philosophical account of those beliefs. Secondly, the strategy provides a way around all too convenient appeals to the failure of deductive closure—to one's not having to know all of the consequences of what one knows. Thirdly, the strategy does not entail the paradox of analysis because it does not depend upon supposing that we can always substitute into belief contexts on the basis of the conceptual equivalences that make up philosophical accounts. It is enough to warrant suspension of the perceptually based belief that canary yellow is not a shade of blue if this belief is conceptually equivalent to a belief for which one could possess no perceptual justification, *viz.*, that the microphysical causes of the appearances of canary yellow are not as similar microphysically to the microphysical causes of the appearances of the blues as this latter class of causes are similar among themselves.

25. However, as against Goethe, who suggested that we can see that the colors are the deeds and vicissitudes of light, it is *not* perceptually evident whether light is such a standard conveyor or simply a medium of ambient brightness which allows such standard conveyors to propagate. Hence Newton's Tertiary Quality account of being red as being such as to give off light which is "Rubrifick", light which is such as

to cause in perceivers the appearance of a red thing, goes beyond what is perceptually evident about the relation between color and light. Thus the persistence among astute phenomenologists of vision of the classical doctrine of "visual rays"—the doctrine that seeing is achieved by exploratory rays which in illuminated conditions go out from the eye to the object perceived. Avicenna in his *Treatise on Meteorology* written in the first half of the 11th century still finds the need to argue against this classical theory of vision by pointing to the implausibility of supposing that the eye has something that extends into the celestial spheres. See David C. Lindberg *Theories of Vision From Alkindi to Kepler* (University of Chicago, 1976) pp. 44–49.

26. Compare the method employed in the paper "Human Beings" *Journal of Philosophy* 1987; where the strict analogue of the Revelation-driven conception of color is the Bare Locus view of personal identity, according to which we are subjects of reflective consciousness capable of surviving any amount of psychological and physical change, however abrupt. This view comes about as a result of taking the simple way in which we are presented to ourselves in conscious experience as the presentation of a simple subject of that experience. To adequately theorize about personal identity in the wake of this error we must examine the extent to which our judgments about cases are driven by this error.

27. Notice that we have in this case, as with the first sort of ray-bedeviled red surface, an example of a persistent color illusion: fool's green, if you like. On the dispositionalist view we are here developing, fool's green can arise in at least two ways: either by the mimicking of the disposition to look green or as a result of the non-standard nature of the processes involved in the disposition to look green.

28. See *Color For Philosophers* op. cit. p. 72.

29. *Naming and Necessity* (Harvard University Press 1980) fn71, p. 140. This footnote offers a very clear formulation of a straightforward reference-fixing account of the hue concepts. In a Spring Colloquium held at the University of Michigan in 1989, Kripke presented a much more detailed treatment of these issues in which color concepts did seem to be turning out to be more like cluster concepts.

30. This assumption simply makes things neater. I leave it to the reader to verify that the problem that follows would apply even to a mixed account which treated the hues as Primary and the brightness qualities as Secondary.

31. Once again, since visual experience cannot present a shade with incompatible brightness properties such shades would not be fully visible. Notice that the Primary Quality theorist is badly placed to rule out such not-fully-visible shades. First his account implies that there are such shades. But secondly, on his account it is a natural assumption that not all the properties importantly associated with the causing of a visual experience are manifested in that visual experience.

32. The astute reader may be thinking of the possibilities opened up by allowing the masking of dispositions. Even with a perpetually masked disposition to look, say, surface green, the masked manifestation will be an appearance of a green surface. Such an appearance will ipso facto be the appearance of a surface with some saturation and some brightness quality.

33. The physical properties associated with sound could also have been the dominant cause of our visual experiences. But we would not then have seen sound in the relevant sense. The trouble with the idea that we could have seen the sound properties is that vision could tell us nothing about the natures of such properties, it could not acquaint us with the way these properties intrinsically are, it could only acquaint us with their effects. So in the bizarre possible world in which similar physical processes are causally responsible for both the appearances of canary yellow and the sound of B-flat it would be wrong to say that we see B-flat as we see canary yellow. It would have been equally wrong to say this if the actual world had turned out to be bizarre in just this way.

The composer Alexander Scriabin (1872–1915) had synesthesia and so "saw" B-flat in the sense that he had, thanks to neural cross-wiring, certain visual experiences when he heard B-flat. It is an interesting question what it was like to be Scriabin, in particular whether the visual experiences he had when he heard B-flat presented themselves as revelations of the nature of B-flat, a nature missed by all great musicians except Scriabin, or whether these experiences simply seemed to Scriabin to be the "visual signatures" of B-flat. Even if the former, it is hard not to imagine Scriabin then going on to think of B-flat as a sensible complex with two sides to its nature, the one which all people with perfect pitch knew, and the other reserved for him and a few other select souls. What he couldn't have coherently thought is that B-flat was

a simple quality whose nature was as much revealed by vision as by hearing. That would be the absurd thought that he saw the sound B-flat, the thought ruled out by our intuitive condition on visibilia.

34. In *Reason, Truth and History* (Cambridge, 1983) Ch 2, Hilary Putnam claims that if we were brains in vats then we couldn't mean the standard thing by "WE ARE BRAINS IN VATS" so that we could not formulate to ourselves the traditional problem of the external world. Notice that even if this were so it would not in anyway deal with the deeper epistemic anxiety.

35. It may be worth noting how the distinction between Primary and Secondary Qualities looks for someone who appreciates that response-dispositions can have their natures revealed by their manifestations. As well as the dispositional criterion, Locke had another way of demarcating Secondary from Primary Qualities. Our experiences of Primary Qualities "resemble" their causes in external things. This resemblance thesis is notoriously difficult to coherently fill out. But if the resemblance thesis implies that we can come to know the nature of certain sensible properties on the basis of our experience of them then there is an interesting consequence to be drawn. Since response-dispositions but not their bases have their natures revealed by their manifestations, the qualities that are Secondary by the dispositional criterion are Primary by the resemblance criterion and the qualities that are Primary by the dispositional criterion are Secondary by the resemblance criterion

36. For more on this Pragmatic approach to concept employment see "Objectivity Refigured: Pragmatism minus Verificationism", in *Reality, Representation, and Projection*, eds. J. Haldane and C. Wright. New York: Oxford University Press, 1993.

POSTSCRIPT: VISUAL EXPERIENCE

So the colors are best construed as dispositions to produce certain visual experiences in us. What are visual experiences? Is it true, as some have suggested, that one can make sense of Revelation

the intrinsic nature of a shade is fully revealed by a standard visual experience as of a thing having that shade

only if one construes visual experience as awareness of sense data; so that the appeal of Revelation depends upon either mistaking some of the properties of sense data for the color properties of external things or at least supposing that there is a nature-revealing match between some of the properties of sense data and the color properties of external things? If so, wouldn't visual experience here be tempting us into a particularly crude form of projective error, i.e., either the sheer mistaking of a mental feature for a physical feature or at least the odd belief that a mental feature could "match" a physical one? And, as Sydney Shoemaker and Michael Tye have urged, wouldn't such a crude projective account itself be an implausible story about visual experience?

Yes it would. But fortunately, Revelation is not tied to this account of visual experience. The first thing to see is that Revelation can be perfectly well explicated on the Intentionalist View which denies that visual experience involves the direct awareness of a mind-dependent item or sense datum. On the Intentionalist View, visual experience is a sui generis propositional attitude—visually entertaining a con-

tent concerning the scene before the eyes. Visually entertaining a content to the effect that p is to be distinguished from believing that p and indeed even from having the suppressed inclination to believe that p. When I have a visual experience of a stick half submerged in water the stick looks separated, but I do not believe that the stick is separated. David Armstrong's suggestion is that such cases show that experiencing is the acquisition of a possibly suppressed inclination to believe things about the scene before the eyes. As against this, the acquisition of a disposition seems to be only a regular effect of the event of experiencing. It is conceptually possible that the cause occurs without the effect, so that the acquisition of a disposition to believe is not a necessary condition of experience. Nor is it sufficient. One could acquire a suppressed disposition to believe, say, that the scene before the eyes is poorly lit—in ways that bypassed experience—latent depression, hypnotism, etc. One would not thereby be experiencing a poorly lit scene. We have no accurate statement of what the right way of acquiring the suppressed disposition to believe is unless we require that it is by way of visual experience. That is to say that seeing or visually experiencing is not believing. Still, visually experiencing might be the acquisition of a sui generis propositional attitude, which I have chosen to dub "visually entertaining a content."

How would Revelation work given this view of visual experience? If we think of visual experience as the entertaining of contents concerning the scene before the eyes, then it is natural to take the contents that are visually entertained to be layered. First there are contents to the effect that such and such objects have such and so colors and shapes. Then there is a level of content concerning what these colors and shapes are like, what their natures are. This could be understood as the attribution of higher-order properties to the color and shape properties themselves. Visual experience seems to tell us not just that things are canary yellow but just what canary yellow is like.[1] That is why vision seems to give us a particularly intimate contact with the visible aspects of visible things, why it seems to lay the natures of these aspects bare.[2] Unfortunately, we lack the vocabulary to well articulate the content of these higher-order attributions. Some talk of the dissectiveness of the colors, their particular "grain," the way red and yellow come toward you while blue and green discreetly "hang back," the way we can see red and blue in purple, and so on and so forth.

In any case, it is clear how Revelation could be explained within this framework. Given that visual experience involves entertaining contents layered in this way, Revelation is the claim that the higher-order content which attributes properties to the colors itself fixes what it is to be this or that color.

But as I have argued, none of the candidate properties which are causally relevant in the production of our visual experience fit anything like the profiles which are

plausibly taken to be part of the higher-order content of visual experience. So the external world is not colored or at least is not colored in the way visual experience represents it as being.

There is a obvious worry at this point. Surely, when it comes to the concept of canary yellow—the profile a property would have to fit in order to count as canary yellow—the *visual* concept of canary yellow, or equivalently the profile associated with canary yellow by visual experience, has a special privilege. If there is such a thing as the visual concept of canary yellow and nothing in the external world fits that concept, then nothing in the external world is canary yellow. We might, as in "How to Speak of the Colors," find some surrogate property or properties which fit most of our central beliefs about canary yellow, but this is not much of an achievement if there is a visual concept of canary yellow, a concept deployed in visual experience itself, and that concept fits no property of external things. Visual experience's own concept of canary yellow dominates and minimizes the relevance of these other beliefs. The worry is then that if we explain Revelation in terms of the Intentionalist View augmented with the account of layered content, then the only thing to say will be that the external world is not colored. Whereas on the Sense Data Theory we have a veil of mental items between subjects and external objects, on the Intentionalist View visual experience is the entertaining of systematically false content.

However there is still a third account of visual experience, which seems to me to be compatible with the doctrine of "How to Speak of the Colors." This is the so-called Multiple Relation Theory of visual experience.[3]

Visual experience is a type of awareness. Awareness is a relation between a subject and an object. What is characteristic of visual experience is that it is the type of awareness in which an object phenomenally looks a certain way to a subject. As on the Intentionalist View, an object *phenomenally* looking a certain way to a subject is distinct from and prior to the object producing in the subject the belief or the inclination to believe that it is that way. (Hence the familiar contrast between phenomenal and epistemic uses of "looks," where an epistemic use is one in which the subject is expressing his belief or possibly suppressed inclination to believe that something is some way.) As against the Intentionalist View, an object's phenomenally looking a certain way to a subject is not to be analyzed as the object's causing the subject to visually entertain the content that it is that way. As against the Sense Data Theory, an object's phenomenally looking a certain way to a subject is not to be analyzed as the object's causing in the subject a sense datum which is that way. According to the Multiple Relation Theory both the Sense Data Theory and the Intentionalist View go wrong in trying to analyze the primitive notion of visual awareness, equivalently, the notion of an object phenomenally looking a certain way to a subject.

So what then goes on when Zinka the canary looks canary yellow to me? I have a certain visual experience which involves Zinka's phenomenally looking canary yellow to me. At this level of experience there is no room for error because there is as yet no judgment, no belief, and indeed no content entertained. A particular relation holds between Zinka and me. Then in immediate reflection upon my visual experience, I mistakenly abstract out from Zinka's phenomenally looking a certain way to me a certain way which I take Zinka to be. It is this kind of immediate belief, e.g. that Zinka is, as it were monadically, the way she phenomenally looks that is the locus of error in visual perception. (This is not the mistaking of a mental feature for a physical feature but the mistaking of a relational feature for a non-relational feature. Is this the mistake one unlearns in art school?)

Visual experience itself is not poisoned by concepts of colors which could never find application to external objects. Visual experience is not a conceptual matter. But visual experience does prompt immediate beliefs which take things to be colored in ways they could never be. Nonetheless these beliefs are not our only central and important beliefs concerning the colors. Hence, even if these immediate beliefs are false it could still turn out in an interesting sense that the external world is colored.

A bonus of adopting the Multiple Relation Theory is that we can then reply to the familiar objection that the dispositional account of the colors is inevitably circular, and circular in a way that is either self-defeating or at least unhelpful.

The dispositional account had it that

x is canary yellow for O in C iff x is (standardly) disposed to look canary yellow to O in C.

The term "canary yellow" appears on the left- and right-hand sides of the biconditional. This raises questions about circularity.[4] However this dispositional account analyzes a relational property—being canary yellow to O in C—as the power or disposition to produce the holding of another relation between x and O in C. That relation is x's phenomenally looking canary yellow to O in C. This latter relation is not x's looking canary yellow for O in C to O in C. Hence it is not x's looking standardly disposed to look canary yellow to O in C, whatever that could be.

The dispositional account is unmysterious. It treats the colors as dispositions of objects to produce certain types of visual awareness (equivalently, certain phenomenal looks). Perhaps it is just asking for trouble to partially characterize those types of visual awareness with terms which are the same as the names for the colors themselves. So, to be less misleading,

x is canary yellow for O in C iff X is (standardly) disposed to produce a certain kind of visual awareness of x by O in C.

Which kind of visual awareness? We can introduce the kind of awareness in question to an appropriate subject by experiential paradigms and foils. A visual experience of Zinka would be among the paradigms, a red afterimage would be among the foils. In learning to attend to such a kind of visual experience, the subject learns to neglect differences among experiences which do not make for a difference in respect of the experiential kind in question. We can thus make our concepts of the dispositional colors as coarse-grained or as fine-grained as we like.

Notes

1. Mike Thau, who is writing a dissertation on perception and from whom I have learnt much on these issues, believes that I should instead think of perception as attributing to surfaces both colors, which surfaces do have, and another set of colorlike properties which surfaces could not have. I find no evidence for this double attribution on the part of perception. In coming to master color terms we never find ourselves confused as between which of the two kinds of colorlike properties which visual perception represents a surface as having is supposed to be denoted by the term we are mastering. The best explanation of this is that there is only one kind of colorlike property, the kind we know as the colors.

2. This way of putting the point is due to Greg Harding from whose deep work on color perception I have learnt much.

3. For detailed treatments of this theory see chapter 4 of Frank Jackson's *Perception* (Cambridge University Press, 1977) and Harold Langsam's "The Theory of Appearing Defended" forthcoming in *Philosophical Studies*.

4. See Paul Boghossian and David Velleman, chapter 7, pp. 86–90.

10 A Simple View of Colour

John Campbell

I

Physics tells us what is objectively there. It has no place for the colours of things. So colours are not objectively there. Hence, if there is such a thing at all, colour is mind-dependent. This argument forms the background to disputes over whether common sense makes a mistake about colours. It is assumed that the view of colour as mind-independent has been refuted by science. The issue, then, is whether the view of colour as mind-independent is somehow implicit in the phenomenology of colour vision. I want to look at the background argument which controls this dispute.

We can see this argument at work in the dispute between Mackie, who presses the charge of error in the phenomenology, and McDowell, who resists the charge. They take the issue to be the characterization of colour experience. For Mackie's Locke, 'colours as we see them are totally different ... from the powers to produce such sensations'.[1] Further, if we take the appearances at face value, we will not take colours to be microphysical properties of things: they do not appear as microphysical properties. Still, if we take the appearances at face value, we will take it that we are seeing the properties of objects in virtue of which they have the potential to produce experiences of colour. The perception reveals the whole character of the property to us. Since it is not just a power to produce experiences in us, there is a sense in which this property is mind-independent; and according to Mackie, the mistake of common sense is to suppose that there are any such non-physical mind-independent properties. McDowell, on the other hand, insists that vision presents colours as dispositions to produce experiences of colour. After all, he asks, '[w]hat would one expect it to be like to experience something's being such as to look red'—that is, as having the dispositional property—'if not to experience the thing in question (in the right circumstances) as looking, precisely, red?'[2] For Mackie and McDowell, the legitimacy of our ordinary talk about colours turns on this issue about phenomenology. They agree that we do have colour experiences, and that objects have the powers to produce these experiences in virtue of their microphysical structures. They agree there is no more going on than that. The only issue between them is whether this is enough to vindicate the phenomenology. The question is whether it seems that there is more to colour than dispositions to produce experiences of colour, whether it seems that colour is mind-independent.

I shall take the view of colours as mind-dependent to find clearest expression in the thesis that they are powers of objects to produce experiences in us. I shall not be

concerned with more rarefied theses of mind-dependence, which might be applied to properties quite generally.

The view of colours as mind-independent must acknowledge some role for colours in colour-perception. I shall equate this view with the thesis that they are to be thought of as the grounds of the dispositions of objects to produce experiences of colour. This is not a kind of physicalism about colours. To suppose that it must be is to assume an identification of the physical and the objective which the thesis may question. It may instead be that the characters of the colours are simply transparent to us. Of course, we often have to consider cases in which the character of a property is not transparent to us; but there may also be cases in which transparency holds.

The background argument with which we began needs elaboration. It does not as it stands provide a convincing argument for the assumption that colours are mind-dependent. A simpler view of colours thus remains in play. On this view, redness, for example, is not a disposition to produce experiences in us. It is, rather, the ground of such a disposition. But that is not because redness is a microphysical property—the real nature of the property is, rather, transparent to us. This view of colours would be available even to someone who rejected the atomic theory of matter: someone who held that matter is continuous and that there are no microphysical properties. The view of colours as mind-independent does not depend upon the atomic theory. Nevertheless, without there being a commitment to any thesis of property identity, someone who holds this simple view may acknowledge that colours are supervenient upon physical properties, if only in the minimal sense that two possible worlds which share all their physical characteristics cannot be differently coloured. It is usually supposed that if common sense accepts this position, it is mistaken: to defend common sense is to clear it of the charge of accepting the view. But we shall see that we do not have any reason to abandon this Simple View.

II

The central line of objection to the Simple View depends upon a particular conception of what is required for a property to be mind-independent. This attack depends on supposing that a mind-independent property must be one that figures in an 'absolute', or 'objective' description of the world. The defining feature of such a description of reality is that understanding it does not require one to exploit anything idiosyncratic about one's own position in the world.

Colours, conceived as the Simple View conceives them, cannot figure in any such description. The Simple View acknowledges that to understand ascriptions of colour, one must have, or have had, experiences of colour. There is no other way of grasping

what a particular colour-property *is*. The character of the property is, though, transparent to this way of grasping it.

This is a forceful line of argument for the mind-dependence of colours. But it proves too much. If it were correct, it could be extended to show more than that colours are mind-dependent. We could also use it to show that *particularity*—a physical thing's being the *particular* thing that it is—is mind-dependent. It is much easier to see what is going wrong when we apply the above line of thought to the case of physical things. So I shall spend most of this section on this case, returning at the end of it to draw the comparison with colour.

The possibility of massive duplication shows that the subject can never fade out of the picture in singular reference. There is no 'absolute' or 'objective' conception which refers to particulars. The point needs some glossing, though. The possibility of massive duplication makes it vivid that we use spatiotemporal locations to differentiate things—that is what makes the difference between identifying particulars, and identifying types. But we can identify spatiotemporal locations only by appeal to their relations to things. How then does the apparatus of singular reference get off the ground? The possibility of massive duplication rules out its being by purely qualitative singling-out. One answer is that one uses one's own location, as what ultimately anchors one's singular reference to *this* sector of the world rather than to a duplicate. Yet this cannot be right. One cannot locate all other objects by reference to oneself, for one's own location is itself identified by appeal to the objects one perceives. One is not oneself somehow a uniquely firmly anchored spatial thing. In fact, the conclusion is correct, that the subject can never fade entirely out of the picture in singular reference, but not because one has always to identify things by appeal to one's own location. The point is rather that the demonstratives we need to get reference to physical things off the ground invariably *introduce* the subject: his identifications of objects always provide a frame of reference by which the subject can triangulate his own location, or else they depend upon a range of identifications of objects by references to which the subject can triangulate his own location.

One might conclude from this that particularity is mind-dependent. One might conclude that what makes a physical thing the *particular* thing that it is, is, ultimately, its relation to a mind. If we want to resist this conclusion, we have to explain how particularity can be mind-independent even though there is no 'absolute' or 'objective' way of identifying particulars.

The mind-independence of particularity is what explains a modal datum. Intuitively, it would seem that I can make sense of the idea that all the things around me might have existed, and might continue to exist, even if I simply had not been around to think about any of them. But in thinking this thought, I am, of course,

using the fact that I am demonstratively linked to those things: for the thought I have is a thought about *those very* objects. This also, however, provides room for the thought of my own location with respect to them: so what makes it possible for me to abstract away from that? At this point one might appeal to the existence of other thinkers than oneself, who can identify those very objects whether or not I am around. But we surely want to underwrite the possibility that many of the particular things around us might have existed even if there had been no sentient beings. It is here that it can seem so appealing to invoke ways of identifying those particulars from *no* point of view. Yet there is no such way of identifying a particular thing.

We have to abandon the notion of an 'absolute' or 'objective' description of reality, which identifies particular things. We need another tack. We have to appreciate how fundamental in our thinking is our grasp of a simple theory of perception. This theory provides us with the idea that our perceptions are caused by a pair of factors: by the way things are in the environment, and by one's meeting the enabling conditions of perception—being in the right place at the right time, suitably receptive, and so on. The problem about the mind-independence of particularity is the result of operating as if we had a range of thoughts relating to what is there anyway, which we can as it happens employ in a simple theory of perception. Operating in this way, we naturally have some difficulty in explaining how it is that we find it intelligible that things are thus and so anyway. The correct response is to acknowledge that *what makes it the case* that our thoughts concern what is there anyway, is that they are embedded in a simple theory of perception. This embedment is internal to those thoughts: it is what constitutes them as being the thoughts they are.

Simple predicates of physical things are themselves explained in terms internal to this theory. The *stability* of predications of enduring objects, and the framework of expectations into which they fit, make sense only in the context of this simple theory.

This simple theory, being so fundamental, has an autonomous role to play in controlling our grasp of modal truth. It is this simple theory that makes it intelligible to us that our perceptions concern a world of objects which are there independently of us. The independence of the particulars is grasped once the subject understands that perception of them requires not just their existence, but the meeting of these further, enabling conditions of perception. The existence and character of the particulars is quite independent of whether these further conditions are met.

Of course the theory is *corrigible*, and it is always open to us to make new discoveries about the essential character of the world. The fact remains that our grasp of modal truth, including our conception of what sorts of things there are, is controlled by our developing grasp of this theory.

This point about spatial thinking marks a contrast between it and thought of abstract objects. For abstract objects in general, it is plausible that there is a canonical level of singular thought which controls our grasp of modal truth. Thus for numbers we have the numerals: modal truths about numbers are ultimately responsible to what is transparently conceptually possible at the level of thought expressible using numerals. The reason why it is not essential to any number that it be the number of the planets is that it is transparently conceptually possible that 9, for example, should not be the number of the planets. The reason why 9 is essentially greater than 7 is that it is transparently conceptually necessary that 9 is greater than 7. As Quine once put it, making sense of modality here means 'adopting a frankly inequalitarian attitude towards the various ways of specifying the number'.[3] In the spatial case, however, there is no level of singular thought which can play this role. The position of a number in the number series individuates it, and is essential to it, if anything is, and that is precisely what the numerals capture. In contrast, what individuates a physical thing is its location at a time: and that is the very paradigm of a contingent property. How is it that individuation and essence can come apart like this? The reason for the asymmetry is the role which is played by a simple theory of perception in the spatial case, in controlling our grasp of modal truth. This simple theory has no parallel in the case of abstract objects.

What holds for spatial things here, holds for their properties. The mind-independence of a property of physical things is just a different issue to whether it can figure in an 'absolute' or 'objective' conception of reality: it has to do rather with the embedment of the property in a simple theory of perception.

We can put the point by asking how we are to explain the modal datum for colours, that objects might have been coloured exactly as they are even had there been no sentient life. The proponent of the dispositional analysis takes it that in explaining this datum we have to appeal to an 'absolute' or 'objective' conception of the world, which can only be a physical characterization of it. And there is also an appeal to the global supervenience of colour on the physical, so that the datum is explained as amounting to the fact that the world might have had just the physical structure it actually does even had there been no sentient life: and that structure is one which has the power to produce particular colour-experiences in us, as we actually are. On this approach, the modal datum would simply not be intelligible to someone who rejected the atomic theory, taking matter to be continuous. But there is an alternative way of explaining the modal datum. The alternative is to point out that the experience of a colour is characteristically the joint upshot of the operation of a pair of factors: the object's having that colour, on the one hand, and on the other, the satisfaction of a whole range of enabling conditions of perception: for

example, that the lighting is standard, the percipient is appropriately situated and oriented, and so on. All the modal datum comes to is that this pair of factors is genuinely distinct. Whether the object has the colour is one thing, and whether anybody is in a position to see it—indeed, whether anybody is there at all—is another. Grasping this point does not require an acquaintance with the atomic theory of matter. At this point, though, it may be said that colours, conceived as the Simple View conceives them, can play no role in the causation of perception.

III

One line of argument against the Simple View is that on it, colours become epiphenomena. We can put the point in terms of the intuitive notion of an 'explanatory space'. The suggestion is that common sense and science are jostling for the same 'explanatory space'. They are attempting to give causal explanations of the same phenomenon: perception of colour. One explanation we might give of colour perception is in terms of wavelengths and physiology. But on this view, to suppose both explanations are correct would be to suppose that the colour-experience is causally overdetermined. The only reasonable alternative is to take the colours to be epiphenomena.

The dispositional analysis is an attempt to resist this conclusion while hanging on to the idea that the two ways of explaining colour perception can be driven, in an easily understood way, into a single 'explanatory space'. On the dispositional theory, the relation between the two accounts is analogous to that between an explanation of the dissolution of salt in terms of its solubility, and an account of the underlying chemistry of salt and water. These two accounts do not compete; rather, the explanation of dissolution by solubility merely holds open the place for the scientific account. So too, on the dispositional analysis, the explanation of colour perception in terms of colour does not compete with the scientific account, but more modestly, just holds open the place for it.

The obvious response to this whole line of thought is to question whether talk of colours and talk of wavelengths really do occupy the same 'explanatory space'. We have, on the one hand, the causal explanation of colour perception by colour, and on the other, the explanation of visual processes by wavelength. The obvious model for the relation between the two accounts is the relation between the following two types of causal explanation: the explanation of one psychological state by appeal to others—the explanation of a desire by appeal to a further belief and desire, for instance—and the explanation of one neural state by appeal to others. There is surely some connection between these two types of explanation, but it is not easy to

characterize, and it is not evident that we should think of them as occupying a single 'explanatory space'.

Another line of attack on the role of colour in causal explanation comes from Locke. In some moods, he held that causal explanation must be mechanistic. The transmission of motion by impulse is inherently intelligible, and all other phenomena are rendered intelligible by being shown to be merely complex cases of the operation of impulse. An attempt at causal explanation which did not reduce the phenomena to contact phenomena would, on this view, have failed to render them intelligible. So it would not explain. If we think of colours on the Simple View, as the grounds of dispositions to produce experiences of them, we must acknowledge that they have no role to play in this type of explanation. They have no role in mechanistic science. This criticism, though, is not devastating. There is a wide range of causal explanations which are not themselves given at the level of basic physics—in zoology, in economics, in meteorology, and by common sense, for instance. And we have abandoned the view that basic physics must be mechanistic.

The obvious model is, again, causation in the mental. Many philosophers would want to view psychological explanations as causal, while acknowledging that they are not given at the level of basic physics. There is, of course, a problem about how psychological explanation is related to description of the world in terms of physical law. The very same problem arises for the simple view of colour properties as non-dispositional causes of our perceptions. The problem is how causation at this level is related to descriptions of the phenomena in terms of basic physics. But the problem here is no worse than in the case of causation in the mental, and it can surely receive a parallel solution.

Just to illustrate, a simple, familiar solution in the case of the mental would be to hold that mental events are physical events, and that the nomological character of causation shows up at the level of description of these events as physical. Just so, one might hold that a thing's being red is a physical event, an experience of redness is a physical event, and that the nomological character of the causation between them shows up at the level of physical description.

It is sometimes charged that this view allows for a systematic relation between explanations at the level of the supervening properties—psychological properties of colours—and genuinely causal explanations, but that it does not show how explanations at the level of the supervening properties can themselves be causal explanations. Another way to put the point is to ask how there can be more than one 'explanatory space', if all causation is physical causation.

This is a problem for all causal explanations given by the special sciences and common sense. We are certainly not in the habit of proceeding as if the only causal

explanations are those given in terms of basic physics. Nor does it seem that any causal explanation not given in terms of basic physics must be one which appeals to properties which are dispositions, or properties which are functionally defined. Suppose, for example, that a round peg fails to enter a round hole. We explain this by saying the peg and board are made of a rigid material, and that the diameter of the peg is greater than that of the hole. This is not explanation in terms of basic physics, but it is causal explanation. And there is no reason to suppose that the roundness and size of the peg are anything other than categorical properties of it. Equally, when we explain an experience of redness by appeal to the redness of the object seen, this may be causal explanation though it is not at the level of basic physics, and even if the redness is not a disposition or a functionally defined property of the object.

There are many models which might be given for the relation between the two 'explanatory spaces'. Here is one. A thing's possession of a higher-level property can be related to a range of physical properties like this: in each nearby possible world in which the thing has the higher-level property, it also has some one or another of that range of physical properties. Suppose now that we causally explain someone's having an experience of redness, by appeal to the redness of the object seen. In each nearby world in which the object seen is still red, it has one or another of a range of microphysical properties. In each such nearby world, the particular structure the object has in that world initiates a causal sequence ending, so far as we are concerned, in a physical event which is also an experience of redness. So the explanation in terms of redness adds modal data to a description of the physical sequence. It says that in nearby worlds in which the physical character of the thing was varied but its redness maintained, an experience of redness was still the upshot. This is, of course, only a sketch. But there seems to be no difficulty of principle about providing such a picture of the relation between the 'explanatory spaces'.[4]

IV

One source of resistance to the Simple View is suspicion of the idea that colours can have any substantive role in causal explanation, suspicion grounded on their lack of what we might call 'wide cosmological role'. The argument is that even if the causal relevance of colours stretches somewhat beyond the explanation of perception, it certainly is not possible to state laws concerning colour which have the sweeping generality of laws concerning mass. As it stands, this line of argument is quite unconvincing. The special sciences make copious reference to properties which do not have a wide cosmological role, but they are none the less engaged in causal explanation.

We might in particular remark that we appeal to the colours of things not just in explaining particular perceptions of them, but also in explaining the evolution of the mechanisms of colour vision. The reason why our visual system was selected for just was, in part, its utility in identifying the colours of things. That is the point of the system. Of course, it is rarely helpful to know the colour of a thing simply for its own sake: an interest in colour is typically serving some further end of the organism. But it is precisely the identification of *colour* that has this instrumental value. There is, then, a rich role for the appeal to colours, conceived as the Simple View conceives them, in explaining the development of the mechanisms of colour vision.

It might be noted further that, even in explaining the perceptions of a single individual, there is a certain richness in the structure of our appeal to colours. It is not just that we explain an individual perception of redness by the redness of the thing perceived. We also explain the relations between our experiences by the relations between the colours of the things seen. For example, the similarity between two experiences of redness may be causally explained by the similarity in colour of the objects seen. The similarity and difference between an experience of light red and an experience of dark red are explained by the similarity and difference of the colours seen: by the fact that the objects seen have the same hue combined with varying quantities of white and black. And so on.

There is, though, a further question lying behind this suspicion about the Simple View. The challenge is the more extreme one, not merely that colours simply lack wide cosmological role, but that the attempt to use colours in framing causal hypotheses yields only pseudo-hypotheses.

We can begin by putting the point as a sceptical problem. On the dispositional analysis, there is no question but that objects have the colours we ordinarily take them to have. Looking red in ordinary circumstances just is being red, so there is no room for doubt about whether something that ordinarily seems to be red is red. It might be charged against the Simple View, though, that precisely because it rejects the identification of redness with the power to produce experiences of redness, it has to regard the sceptical question as posing a real problem. The problem is exacerbated by the fact that colours lack 'wide cosmological role'. We can bring this out by contrasting the case of shapes. Suppose someone asks whether objects really have the shapes we ordinarily take them to have, on the strength of their appearances. For example, suppose he asks whether bicycle wheels, though they look circular, might not in fact be triangular. The question can be dealt with by attempting to ride the bicycle: for ordinary motion, only circular wheels will do. Triangular wheels would give a very different effect. In contrast, consider the case in which someone asks whether this bicycle, though it looks white, really is white. Here there is no such

auxiliary test we can use. Colour has no effect on the motion of the bicycle. The dispositionalist may hold that rejecting the dispositional analysis gives one a quite unreal sceptical problem, which one is forced to take seriously: do things have the colours they ordinarily seem to?

The proponent of the Simple View cannot evade the problem by saying that he takes whiteness to be whatever is the ground of the disposition to produce experiences of whiteness. That would indeed finesse the sceptical question—but it would also yield a view on which ordinary colour vision leaves us in the dark as to *which* property whiteness is. On this view, colours are hypothesized causes of our perceptions, rather than properties with which ordinary observation directly acquaints us.

As I have explained the Simple View, though, it holds that the characters of ordinary colour properties are transparent to us, and that ordinary colour vision is enough for us to know *which* property blueness is, for example. The charge is that on the Simple View, the ordinary percipient is left in the position of knowing which property blueness is, without having any guarantee that that property is the usual cause of his, or anyone's, perceptions of blueness.

The sceptical problem might be pursued by constructing an alternative explanation of ordinary colour perceptions, and asking whether the Simple View has the resources to rule it out. For example, it might be proposed that we live in an environment in which blueness is the ordinary cause of our perceptions of redness, greenness the ordinary cause of our perceptions of yellowness, and so on. To complete the construction of the alternative explanation, we should have to include stipulations about how the relations between the colours affect the relations between experiences of them. For instance, it might be said that one object's being bluer than another is the usual reason why an experience of it is an experience as of a redder object than is the experience of the second thing. And so forth. The dispositional analysis can rule out the proposal as absurd. We have yet to see whether the Simple View can do so.

The line of objection certainly ought to be pressed by someone who holds an error theory about ordinary colour vision. Someone like that takes the Simple View to be implicit in the phenomenology, but insists that the Simple View is entirely mistaken: nothing like colour figures in the causal explanation of perception, only the microphysical properties of things. If it is not only intelligible, but true, that our ordinary explanations of colour experience are altogether wrong, then it is legitimate to invite the proponent of the Simple View to consider various alternatives to his own preferred line of explanation, including deviant coloration.

At this stage, though, the objection to the Simple View need no longer be put in terms of scepticism. The problem can be reformulated as an attempt to construct

what is sometimes called a 'switching objection' to the causal hypotheses offered by the Simple View, with the intention of showing them to be pseudo-hypotheses.[5]

It may help to make the strategy clearer if I first give an example of a 'switching objection' from a quite different area, and then show how a problem of that form is here facing the Simple View. The example I have in mind is the objection raised by Strawson's Kant to Cartesian dualism. The Cartesian assumes that one is immediately acquainted with one's own enduring soul. The objection is that whatever constitutes this 'immediate acquaintance', it is equally consistent with a whole series of hypotheses, for example: (i) that there is a sequence of momentary souls, each of which transmits its psychological states to the next in the sequence, as motion might be transmitted along a series of elastic balls, and (ii) that at any one time, one's body is connected up to a thousand qualitatively indistinguishable souls, all of which speak simultaneously through the same mouth.[6] This is not at all a sceptical problem. The strategy is rather to discredit the Cartesian by showing that the conceptual materials he introduces enable us to generate a variety of incompatible hypotheses, all of which must be acknowledged, by his own standards, to be equally legitimate.

The suspicion is that a parallel strategy can be used to discredit the causal hypotheses offered by the Simple View. Given the conceptual materials it introduces, the argument runs, it is possible to introduce a whole variety of causal hypotheses, all of which must be acknowledged, by the standards of the Simple View, to be equally legitimate. And, this line of thought concludes, that shows that these causal hypotheses are merely pseudo-hypotheses. We have already seen the kinds of alternative hypotheses that might be introduced, in which perceptions are said to be caused by quite unexpected colours, and the relations among the perceptions explained by quite unexpected relations among the colours of the objects seen.

This whole line of objection rests on the supposition that perceptions have their contents, as experience of this or that property, quite independently of which properties of things in the environment they are responses to. That assumption is questionable.

Again, the analogy with particulars is instructive. Recall the thesis that what makes a thing the particular thing that it is, is its relation to a mind. Consider how a proponent of this view might go about constructing a 'switching' objection to the assumption that particularity is mind-independent. The argument would be that, on that assumption, the course of one's experiences is consistent with a wide range of hypotheses as to *which* things are causing one's perceptions. The point could be stated as being, in the first instance, a sceptical problem: how can I be sure the very things I take to be causing my perceptions are causing them, rather than it being some range of qualitatively indistinguishable duplicates? There is obviously a variety

of individual rival hypotheses that could be stated here. The 'switching' objection then is that by the standards of the view of particularity as mind-independent, all of these hypotheses have to be viewed as on a par with each other, and with the ordinary supposition that the things which seem to be causing my experiences are causing them. The only way out, the objection runs, is to suppose that particulars are individuated precisely by their relations to minds: that what *makes* a thing the *particular* thing it is, is the way it is related to the minds which apprehend it, so that there is no possibility of those minds being wrong about which particular thing it is.

This line of argument is not persuasive, and it seems evident that what has gone wrong is the supposition that one's experiences of things have their contents, as experiences of those *particular* things, independently of the question of which things they are responses to. That is what makes it possible for the question to arise, whether the experiences really are brought about by the things they are experiences of. But this is a mistake: the experience's being an experience of *that* thing is made so by its being brought about by that thing. So even though particularity is mind-independent, there is no possibility of the experiences being in general brought about by things other than the things they are experiences of. The answer to the 'switching' point is not that particularity is mind-dependent, but that experience is particular-dependent.

A parallel response can be made to the use of a 'switching' argument to show that colour is mind-dependent: namely, that what constitutes experiences being experiences of the particular colours they are is their being responses to just those features of the environment. Of course, it is not that illusion is impossible. It is rather that an experience's being an experience of a particular depends upon the subject's being able to use his colour vision to track that particular colour. So there is no possibility of setting up alternative causal hypotheses to explain colour vision: they simply bring with them changes in the characterization of the experiences to be explained.

V

Colour predicates seem to be in some sense 'observational'. I want to end by sketching a way of bringing this out. The point I want to make is that in the case of 'observational' predicates, there seems to be an epistemic dimension in the way the phrase 'looks φ' operates. In some cases, part of the effect of saying that a thing looks, for instance, round to someone is to say that if that person took the appearances at face value, without engaging in any reasoning, he would think that the thing is round. The phrase is connected to what one would judge without reflection. This certainly seems to hold for a whole range of 'looks φ' predications, such as 'looks

old', 'looks expensive', 'looks efficient', and so on. But in the case of 'observational' predicates, there seems to be an epistemic aspect to the phrase 'looks φ'. It is possible for something to look old to a person who is in fact very bad at judging how old things are—someone whose unreflective judgements of age never constitute knowledge. In contrast, consider the phrase 'looks round'. Someone to whom a thing looks round must be someone who has the ability to tell whether things are round, unreflectively, on the strength of perception alone. It is not that such a person must be immune to illusion. Rather, the point is that without the capacity to tell, on occasion, unreflectively, that a perceived object is round, there is no basis for supporting that things ever look round to the subject. A parallel point seems to hold for colour predicates. Someone to whom things sometimes look green is someone who has a capacity to track greenness.

This line of thought can be pressed further, to resolve a dilemma over the characterization of colour experience. On the one hand, one may feel reluctantly compelled to acknowledge the possibility of inverted spectra—systematic differences between the qualitative characters of different people's colour experiences which do not show up in verbal or other behaviour. On the other hand, recoiling from this possibility, one may, in effect, deny the qualia and insist that if two percipients agree extensionally when they discriminate and group objects by colour, then their experiences just are the same, and there is no further question about qualitative similarity or difference. The Simple View allows a different approach. On it, we can say that the qualitative character of a colour-experience is inherited from the qualitative character of the colour. It depends upon which colour-tracking capacity is being exercised in having the experience. So if you and I are tracking the same colours, our colour-experiences are qualitatively identical. This view does not allow for the hypothesis of spectrum inversion; nor does it deny the qualitative character of colour vision.

Acknowledgments

I am indebted to Bill Brewer, Justin Broackes, Quassim Cassam, David Charles, Bill Child, Adrian Cussins, Philippa Foot, Elizabeth Fricker, Michael Smith, and Timothy Williamson. My focus on these issues was changed by Barry Stroud's John Locke lectures in 1987.

Notes

1. J. L. Mackie, *Problems from Locke*, p. 14.
2. J. McDowell, 'Values and Secondary Qualities', in T. Honderich (ed.), *Morality and Objectivity*, p. 112.

3. W. V. Quine, 'Reply to Professor Marcus', in *The Ways of Paradox*, p. 184.

4. This adapts the account of 'programme explanation' given in F. Jackson and P. Pettit, 'Functionalism and Broad Content', *Mind* 97, pp. 381–400, and 'Structural Explanation in Social Theory', in D. Charles and K. Lennon (eds.), *Reduction, Explanation and Realism*.

5. For a helpful taxonomy of such arguments, see C. Peacocke, 'The Limits of Intelligibility', *Philosophical Review* 97.

6. P. F. Strawson, *The Bounds of Sense*, p. 168.

11 The Autonomy of Colour

Justin Broackes

This essay takes two notions of autonomy and two notions of explanation and argues that colours occur in explanations that fall under all of them. The claim that colours can be used to explain anything at all may seem to some people an outrage. But their pessimism is unjustified and the orthodox dispositional view which may seem to support it, I shall argue, itself has difficulties. In broad terms, section 2 shows that there exist good straight scientific laws of colour, constituting what one might call a phenomenal science. Section 3 offers a larger view of what we are doing when we attribute colours to things, a view which makes it a case of holistic explanation, similar in many ways to psychological explanation. Section 2 emphasizes the model of scientific explanation, and section 3 the holistic model found in rational explanation; but it will emerge that colour explanation in different ways fits both models, as it also does the two principal notions of autonomy that the first section identifies.

1 Are Colours Explanatorily Idle?

Philosophers often say that colours are explanatorily idle. As McGinn has put it:

First, these qualities are not ascribed to things as part of the enterprise of explaining the causal interactions of objects with each other: colour and taste do not contribute to the causal powers of things. Primary qualities are precisely the qualities that figure in such explanations ... Secondly, secondary qualities do not explain our perception of them; primary qualities are what do that.[1]

On the other hand, some philosophers have thought the contrary,[2] and they have painters[3] and much of everyday speech on their side. We regularly hear claims like these:

(1) The red paint turned pink because he added white to it.

(2) The house gets hot in summer because it is painted black.

(3) The orange light of the evening sun made the façades of the buildings seem to glow.

(4) The yellow of a life-jacket caught his eye as he looked across the water into the distance.

(5) He stopped at the traffic lights because they were red.

Colours are invited to explain the appearance of things (3), human perception (4), action (5), and even the characteristics of non-sentient items, like the colour of a paint (1) and the temperature of a house (2).

Why then deny that colours explain what they seem to? Of course they are not fundamental physical properties, like mass and charge. But we should not need reminding that good explanation is not always explanation in the terms of basic physics. As Putnam has said, we can explain why a square peg will not fit into a round hole, by saying the board and the peg are rigid, and the round hole is smaller than the peg. An 'explanation' in quantum mechanics, or whatever other basic terms, would miss the relevant features. For 'the same [higher-level] explanation will go in any world (whatever the microstructure) in which those *higher level* structural features [rigidity and size] are present. In that sense *this explanation is autonomous.*'[4]

Why shouldn't colours occur in explanations that are autonomous in a similar way? Autonomy means different things to different people, and it may be helpful to clarify the two main senses I shall be giving it. The first involves no more than is introduced in the last quotation from Putnam: the same explanation would go through in any world where the same higher-level properties were present. It is no part of an autonomy claim in this sense, therefore, that properties invoked in an autonomous explanation are in every way independent of properties at other levels. The squareness of the peg is, for example, supervenient on the basic physical properties and arrangement of the peg's constituent parts. Colours similarly will be supervenient upon physical properties. In this usage, therefore, interdependence is not, as it is for Patricia Churchland, 'autonomy's opposite'.[5] Colour explanations will be autonomous in this sense if they are indifferent to the underlying realization of the property—if the same explanation would go through if the object's redness, for example, were realized in some microstructurally different way. But that does not imply that the explanation is independent of other properties in every way. It means that it is independent of microstructural variations that would result in the same macroproperty.

In what is probably a different sense, explanations are autonomous if they rule themselves, in that they are responsible to, and to be judged by, criteria internal to that style of explanation—and not by criteria from another domain. On this understanding, an autonomous explanation will typically (though not necessarily) be 'epistemically independent' of other explanations, in that knowledge that it meets the appropriate internal standards of success will be independent of knowledge concerning any other form of explanation. But it may still (and typically will) be the case that the explanation fails to be 'ontologically independent', in the sense that the higher-level causal relations would hold even if the underlying lower-level causal relations did not. In between these two senses of independence there is a third issue, of whether for any higher-level *classification* there has to be at a lower level a classification that corresponds (a type-identity, or restricted type-identity); and a fourth

issue, of whether every higher-level *causal generalization* must correspond to (or be reducible to) one or more lower-level causal generalizations. But to claim that a property figures in autonomous explanations in the sense explained at the start of this paragraph is not to claim independence in any sense stronger than the first of these four.

I shall be exploring the prospects that colours figure in explanations that are autonomous in these two senses. Why should one resist the idea? Localized error, so to speak, is of course unavoidable: individual explanatory claims are bound sometimes to turn out false—as I shall later suggest is actually the case with (4). But some people may still suspect a global error—a mistake in the very idea that colours can occur in 'autonomous explanations'. The resistance must have a theoretical source, and I shall briefly consider four.

One might suspect that colour explanation, if there were such a thing, would compete for space with physics, and each would crowd the other out. The obvious reply is that explanatory schemes at different levels may peacefully coexist if they stand in appropriate relations. It is widely believed that mental and physical schemes of explanation can peacefully coexist if mental phenomena are supervenient upon physical phenomena. Could not colour explanation in a similar way coexist with the physical sciences, if a corresponding supervenience relation held there too?[6] The suggestion is plausible. My present perception of blue, for example, would be explained by the blueness of the mug in front of me, while the underlying visual processes were explained by whatever physical features are relevant. There will be no competition between the explanations, if the colour, as seems plausible, supervenes on the physical features.

One might worry about the fact that the putative effects of colour are primarily on humans, or, if on other things, on their colour, rather than on, say, their size and shape.[7] But that is hardly a reason to deny them causal efficacy: the primary effects of economic factors like an increase in the money supply are also on humans and other economic factors (rather than directly on the size and shape of physical objects); but we do not treat that as a reason to say they are causally idle.

A third worry might be that colours are parochial: there are totally colour-blind humans, and if they had been the only ones around, then they would hardly have felt they were missing something. But we can admit the parochiality of something without denying it causal efficacy. Economic factors, again, are parochial (there are societies without money, and a view of our own existence that makes money an irrelevance); but that does not make us deny the reality of economic causes.

Perhaps the most serious concern is that colours are dispositions, and dispositions neither cause nor explain. The issues are too complex to discuss properly here,[8] but

there are problems at each stage of the argument. First, one may doubt whether colours are in fact dispositions. I shall later be giving reasons to deny the orthodox view of them as dispositions to produce experiences in us, while suggesting that they are dispositions of a different kind. But we can certainly not simply presume that colours are dispositions of any kind, in the face of the substantial body of philosophers who have recently argued that they are not.[9] Secondly, it is doubtful whether dispositions are explanatorily idle. There is a tradition of scoffing at explanations in terms of *virtus dormitiva*. But dispositions are not all like dormitive virtue (what about the engineer's properties of capacitance, inductance, resistance, and elasticity?), and even dormitive virtue has its explanatory uses. (The man fell asleep at the controls of the machine because he had drunk too much of a cough mixture with a dormitive virtue.) The issues can hardly even be aired here, but even if colours are dispositions, we cannot assume that they are explanatorily idle for that reason, any more than for the other reasons I have considered.

2 Colour Laws and Colour Science

What are the prospects of finding good straight scientific explanations that employ colours? What can colours be used scientifically to explain? We might distinguish three possible uses of colours: to explain (1) the effects of bodies (and light) on humans and other animals (notably in perception), (2) the effects of bodies (and light) on the colour properties of other bodies, and (3) the effects of bodies (and light) on the non-colour properties of other bodies (like their temperature, motion, or size).

The last category is the least promising. The most conspicuous cases where colour affects the non-colour properties of non-sentient things are cases where they do so only by affecting sentient beings, who in turn produce the effects in the non-sentient things. (The colour of the traffic-lights affects the motion of the cars, but only as it is seen by the drivers.) These cases therefore reduce to the first category. There may seem to be cases where colour is directly responsible for the non-colour properties of something: the warehouse walls, we may say, are heating up in the sun because they are painted black. But on closer inspection, the explanation seems to be invalidated by lower-level facts. The walls, we find out, are really heating up because they fail to reflect the infra-red light from the sun, rather than because they fail to reflect the visible light in the way that makes us call them black. It is not the blackness proper than explains the effect. Black things commonly absorb infra-red as well as visible light, so we naturally say 'if it hadn't been black, it wouldn't have heated up like that'. But the counterfactual is strictly false: the house could well have been some

other colour and still heated up like that (if, say, it was painted in a green paint that also absorbed in the infra-red); and it could well have been black and not heated up like that (if the paint absorbed light in the visible range but not in the infra-red). The threat of invalidation by lower-level explanation may well be endemic to purported explanations of this kind. We have reason to believe that non-colour physical phenomena can in principle be explained in physical terms; we know (particularly from the existence of metamerism, described below) that colours are (often quite strikingly) variably realizable in physical terms; so it seems likely that for any physical effect produced by an object of one colour, there could be another object of the same colour that did not have that effect. The prospects, therefore, of finding laws by which colours could be treated as causes of the instantiation of other physical properties (other than via perception) seem remote—though the argument does not rule out the possibility in principle.

The initial prospects look better of giving scientific explanations on the basis of colour for the other two ranges of phenomena: human perceptions and the colours of things. Here a similar challenge arises, but in this case I think it can, at least often, be met. Quite aside from any general prejudice that the only decent explanation is explanation in the terms of physics, there is a worry that these phenomena are simply (as a matter of fact) better explained in terms of physical properties more basic than colour. The main reason for saying this is the existence of metamerism. Because of the limited sensitivity of the eye, two lights may have the same colour though their spectral composition is different. Two objects may look the same colour though the light coming from them is spectrally different, and their spectral reflectance profiles are different. This in itself is no reason to say that colours are unexplanatory: so far it seems a standard case of variable realizability. But many of the effects that we commonly ascribe to the colours turn out too to be determined not by the colours but rather by their realizations. We may say that the tomato looked brown because it was in green light. But it turns out that the *colour* of the object and the *colour* of the light are not sufficient to determine the object's appearance: it is the *spectral reflectance* of the object and the *spectral composition* of the light that determine the character of light reflected from the object, and hence its appearance. As is well known, a shirt and a pair of trousers may match in the midday sun, but differ in fluorescent lighting. Clearly, therefore, the appearance of the objects in the fluorescent light cannot be determined by the *colour* of the light and the *colour* of the objects.[10] The threat is not that there is lower-level explanation which goes deeper than the higher-level account (that in itself would not invalidate the account), but rather that the lower-level explanations show us that the purported higher-level account rests on claims that are just not true. It is simply *not true*, the challenge runs,

that the reason the tomato looked that shade is that it was in green light of just that colour: for that shade of green illumination is neither necessary in the circumstances nor sufficient for the thing with that shade of red to look that shade of brown. A proper explanation will have to refer to the lower-level spectral characteristics of the object and the light. This threat, that the variable realizability of colours will invalidate purported colour explanations, I shall call 'the challenge of metamerism'.

If the threat seems to be realized in the case just described, that does not mean that it is in all colour explanations. Maybe some colour explanations can defeat the challenge of metamerism, and some cannot. This will be so if some but not all colour explanation is 'autonomous' in Putnam's sense: 'the same explanation will go in any world (whatever the microstructure) in which those *higher level* ... features are present'[11] Some explanations do seem to meet this condition. The mug looks blue to John because it is blue and John is looking at it in decent lighting, and he has good colour vision. The claim cannot be undermined by considering objects whose blueness is realized in a different spectral reflectance profile: whatever its spectral profile, as long as the mug is blue, then it will look blue to John in the circumstances described. It is the blueness that nomologically correlates with the effect, not just some lower-lying property that happens to be coinstantiated with the blueness. Other candidates for autonomy status come to mind: the object is opaque because it is white;[12] the paint is this particular green because it was mixed from paints of this blue and this yellow, in these particular proportions; the yellow book looks brown because it is in violet light. But are all these explanations in fact autonomous? Are they in fact immune to the challenge of metamerism? To see which are and which aren't, it will help to review some of the attempts of colour theorists to come up with serious laws.

I shall put aside the theory of the aesthetic qualities of colours in various combinations. Working often to develop a discipline parallel to those of harmony and counterpoint in music, Alberti, Goethe, Munsell, and Itten, to name only some of the more prominent, have tried to set out principles of the harmony of colours.[13] Some of the attempts have bordered on the fanatical: Munsell, trained as a painter, conceived his system of colour notation, with its numerical measures of hue, chroma, and value, as a prerequisite for the proper statement of the principles of colour harmony. 'COLOR ANARCHY IS REPLACED BY SYSTEMATIC COLOR DESCRIPTION,' he exclaimed in capital letters.[14] The status of such principles of harmony is a matter of such complexity that I shall set it aside for another time.[15]

In the field of straight experimental science, there is a fine body of explanation of colour phenomena. The work straddles areas which are otherwise often separated, like optics, quantum electrodynamics, chemistry, psychology, and psychophysics. The best-known work—like that of Newton in optics, and of Helmholtz and Max-

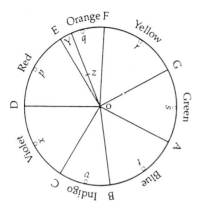

Figure 11.1
Newton's colour wheel: to predict the colour of mixtures of light. The circumference *DEFGABCD* represents "the whole Series of Colours from one end of the Sun's colour'd Image to the other." Let *p, q, r, s, t, v, x* be the "Centers of Gravity of the Arches" *DE, EF, FG, GA, AB, BC,* and *CD,* respectively; "and about those Centers of Gravity let Circles proportional to the Number of Rays of each Colour in the given Mixture be describ'd." "Find the common Center of Gravity of all those Circles, *p, q, r, s, t, v, x.* Let that Center be *Z*; and from the Center of the Circle *ADF,* through *Z* to the Circumference, drawing the Right Line *OY,* the Place of the Point *Y* in the Circumference shall shew the Colour arising from the Composition of all the Colours in the given Mixture." The ratio of *OZ* to the radius of the circle gives the relative saturation of the colour. (From Newton, *Opticks,* 154–5.)

well in psychophysics—is on the explanation of colour phenomena in terms of physics. The kinds of explanation and law that are our present concern, on the other hand, are those that explain colour phenomena in terms of other colour phenomena. From a wide possible range, I shall consider five types of law, as developed in the work of the nineteenth-century colour theorists Grassmann, Chevreul, and Rood.

One might take Newton's 'centre of gravity' law of additive colour mixing to be the first straight scientific law where colours are among the explanantia.[16] Newton claims that if the colours of the spectrum are arranged in a circle, with white in the centre, then if you know the colours of the component spectral lights out of which a compound light is composed, then you can predict the colour of the mixture. If you consider the points on the colour circle representing the spectral lights in the mixture, and assign to each of them a weight proportional to the intensity of light of that kind, then the centre of gravity of the resultant figure will represent the colour of the mixture of lights, as illustrated in figure 11.1. But though Newton talks of predicting the colour of the mixture from 'each Colour in the given Mixture'; he is using 'colour', I think, really for refrangibility or, as we would now say, wavelength. He is giving a rule to allow us, from the relative amounts of light at each *wavelength*, to predict the colour of the result. It was only with Grassmann's Third Law 150 years

later that it became clear that the explanantia in this kind of colour mixture law could be colours rather than wavelengths.[17] For, as a matter of empirical fact, the results of mixing a green light and a blue light of a particular hue and saturation will be perceptually indistinguishable, whatever the spectral composition of the two lights—however the green and blue are 'realized'. In the laws on the results of mixing coloured lights, the 'challenge of metamerism' can be met: in so far as Grassmann's Third Law is true (and that is within wide limits) variation in the spectral composition of the lights which does not change their colour will not change the colour of the mixture. Explanation of the colour of the mixture in terms of the *colour* of the lights combined is, in Putnam's terms, autonomous.

In the mid-nineteenth century, Chevreul, a chemist working at the Gobelins tapestry factory, tried to formulate other scientific laws of colour. Out of the many which he offered in his *Principles of Harmony and Contrast of Colours*,[18] I shall consider three important types: laws on the mixing of coloured pigments; laws for what appearance is produced when light of one colour falls on objects of a second colour; and laws of colour contrast, either simultaneous or successive. Two of these turn out, I think, not to meet the initial challenge of metamerism.

The mixture of coloured pigments is today called subtractive mixing, because each pigment may be thought of as subtracting a certain amount from the incident light in the process of (only partially) reflecting it. Crudely considering only red, green, and blue components of light, we may say that a yellow object reflects only the red and the green (and filters out the blue), a blue object reflects only the green and the blue (and filters out the yellow). If we paint, therefore, a layer of blue paint on top of a layer of yellow on some white paper, then the only light that is reflected is the light that can pass so to speak through both filters, namely, the green light. The effect of mixing two pigments subtractively is the same as that of superimposing two filters, so we seem to have an explanation here of why, when we mix yellow and blue paint, we get green.[19]

The trouble is, however, that this kind of explanation is not well equipped to resist the challenge of metamerism. It turns out that the colour of a pigment mixture is not determined solely by the *colours* and quantities of the components, but also by their spectral reflectance characteristics. It was a simplification to think of the filtering action of a blue pigment as simply removing the yellow. Two pigments of different spectral characteristics may look the same colour in a certain form of daylight. But now imagine we also have a coloured celluloid filter, and look at the metameric samples through it. It may well happen that, through the filter, the samples now look different from each other.[20] And the situation is essentially the same if, instead of having a celluloid filter in front of the eyes, we paint a layer of colour on top of the

sample, as in subtractive mixing of pigments. The result is, then, that we cannot pretend that it is colour alone that determines the outcome of subtractive mixing: there may be differences between the result of mixing one yellow paint with blue and the result of mixing another yellow paint with it, even if the two paints look the same colour in daylight. In this area, it seems, rough-and-ready generalizations are all we can hope for.[21]

Chevreul extensively studied the effects of seeing an object of one colour in light of another colour. Pages of his *Principles of Harmony and Contrast* are filled with experimental generalizations like these:

Yellow rays falling upon a Black stuff, make it appear of a Yellow-Olive.

Yellow rays falling upon a White stuff, make it appear of a light Yellow....

Yellow rays falling upon a Blue stuff, make it appear Yellow-Green, if it is light, and of a Green-Slate if it is deep.

(Chevreul, *Principles*, 92)

Violet rays falling upon a Yellow stuff, make it appear Brown with an excessively pale tint of Red.

(Ibid. 94)

Unfortunately, these laboriously-collected generalizations are simply not reliable. Recognizing some of their shortcomings, theorists later in the nineteenth century (like Ogden Rood) tried to amend them. But there is a problem of principle: the existence of metamers makes it impossible to predict accurately the apparent colour of an object of one colour seen in light of another. There will be metameric yellow objects, for example, that in daylight are indistinguishable in colour, but in the same violet light no longer match each other. It therefore cannot be simply the *colour* of the object and the *colour* of the light that determine the appearance. I shall return to the question whether this conclusively scotches claims of lawlike autonomous status for all colour generalizations of this sort, but the initial challenge of metamerism has not been met.

The third category of colour law in Chevreul which I shall consider is laws of colour contrast. The appearance of a region of colour is affected both by the colours of objects that were in the field of view a short time before, and by the colours of other objects which are in the field of view at the same time. After-images are dramatic examples of the first phenomenon. Leonardo noted cases of the second: 'white garments make the flesh tints dark, and yellow garments make them seem coloured, while red garments show them pale.'[22] The phenomena were studied widely in the eighteenth century,[23] but it was Goethe and Chevreul who made them famous. Goethe explained that in both cases, it is 'the colours *diametrically opposed* to each

other which reciprocally evoke each other in the eye' (*Farbenlehre*, §50, my emphasis). Each colour evokes its complementary—hence the names *successive contrast* and *simultaneous contrast*.[24] An object seen as red will leave a green after-image, one seen as turquoise will leave a yellow one.[25] 'A grey building seen through green pallisades appears ... reddish.' (Goethe, *Farbenlehre*, §57.)

The laws here are precisely ones of colour: the colour of the after-image is the complementary of the colour of the original appearance, and is not affected by the spectral realization of that colour.[26] The robustness of these laws is easy to understand given a knowledge of the causal processes involved; given that the cones in the retina respond in indistinguishable ways to two metameric red objects, and that our after-images and simultaneous contrast effects causally depend on our retinal responses, we would expect metameric red objects to be indistinguishable in their contrast effects. The challenge of metamerism in this case is therefore fully met.

Now for the final type of law. Ogden Rood worked on all forms of colour science at Columbia in the 1870s, and his *Modern Chromatics*[27] is still well worth reading. He offers one type of causal colour generalization that we have not considered before: describing how hue changes with saturation. One of several tables details 'the effects of mixing white with coloured light':

Name of colour	Effect of adding white
Vermilion	More purplish
Orange	More red
Chrome-yellow	More orange-yellow
Pure yellow	More orange-yellow
Greenish-yellow	Paler (unchanged)
Green	More blue-green
Emerald-green	More blue-green
Cyan-blue	More bluish
Cobalt-blue	A little more violet
Ultramarine (artificial)	More violet
Violet	Unchanged
Purple	Less red, more violet

(p.197)

The general formula covering these effects is this: 'when we mix white with coloured light, the effect produced is the same as though we at the same time mixed with our white light a small quantity of violet light.' (p. 197.) And this generalization again seems able to meet the challenge of metamerism. The process of mixing white with a

coloured light is one of additive mixing, which we have seen already is unaffected by change of spectral composition. So if one orange of one spectral type turns redder on the addition of white, then a metameric orange of another spectral type will do so too.

Of the five types of law considered, three immediately meet the challenge of metamerism: the laws of additive mixing, of colour contrast, and of change of hue as a colour is desaturated. Only the first is readily expressed in mathematical terms (when developed for example in connection with a CIE x, y diagram). But they are all of them robust in the sense that substitution of metamers will not invalidate them. We can accept without worry, therefore, the autonomy in Putnam's sense of a wide variety of explanations that invoke colour.

Two of the types of law considered fail the test for robustness. Laws of subtractive mixing and of the appearance of objects seen in light of another colour are at risk of being invalidated by substitution of metamers. But the challenge may be being exaggerated. The existence of metamers certainly means that we will not be able to find absolutely precise and indefinitely refinable generalizations on these issues that are also true. But that does not mean that there cannot in this area be broad generalizations which are quite literally *true* and *lawlike* in the sense that they are supported by their instances and support counterfactuals. (There is a difference between a narrow claim that is only partly true, and a broad claim that is precisely true.) Though the appearance of a yellow object in violet light may not be determined exactly by the colours of the object and the light, it may still be determined roughly by them, for example, to lie somewhere in the brown region. Similarly, even if we cannot predict the exact appearance of a mix of yellow and blue paint, we may none the less be able to predict that it will be some form of green. And if this is so, then explanations that use precisely these deliberately broad terms will still be autonomous in Putnam's sense.[28]

How far exactly this objection is valid is an empirical matter. If we employ sufficiently broad colour classifications, then it will be fairly easy to find true generalizations about them. If we employ colour classifications that are too narrow, then it will be easy to find metameric counter-examples. How broad the classifications must be in order to be 'sufficiently broad' is an empirical question to which I do not know the answer. But the apparent availability of broad generalizations suggests that the challenge of metamerism is not an objection in principle to the idea of lawlike colour generalizations, even in those cases where colour does not determine *all* the colour properties at issue in the outcome. Even if the generalizations are broad and intrinsically incapable of indefinite refinement, they may still be lawlike, unobvious, and non-trivial.

In this section we have considered the prospects of good scientific laws about colours. The challenge to be met was not that lower-level explanation would be available as well (for that is innocuous), but that the proposed colour laws would actually be invalidated by metamerism: colour effects could only be explained in terms of information at the level of wavelengths, rather than colours. We considered five types of law as examples. Three of them conclusively meet the challenge: laws of additive mixture, of colour contrast, and of change of hue with saturation. Two of them on the other hand do not: laws of subtractive mixture, and of how objects of one colour appear in light of another. But even in these cases, there are still prospects at least of broad generalizations that are lawlike, and of correspondingly broad causal explanations. The case for the autonomy of at least some scientific colour explanations seems complete.

3 Colour Interpretation

We raised earlier the possibility that colours might have their home in a holistic interpretative scheme like that of rational explanation. The scheme might even be an extension of the scheme of rational explanation. This would certainly seem right if the traditional dispositional thesis were correct. If colours were dispositions to produce experiences in us, and if experiences were ascribed to people in the course of interpreting them as (more or less) rational creatures, then colours would figure in an extension of rational explanation. One striking consequence would be that a second form of *autonomy*, mentioned in section 1, would then seem to attach to ascriptions of colour. On one familiar picture, the ascription of psychological states is autonomous in the sense that it is responsible only to assessment by standards internal to that form of explanation. In one form of this view, set out by Davidson and developed by McDowell, psychological explanation is explanation of a special sort, namely 'rational explanation', which has different aims from those of broadly 'physical' explanation.[29] The ascription of psychological states has 'its proper source of evidence' only 'in terms of the vocabulary of the propositional attitudes'.[30] If colours were simply dispositions to produce psychological occurrences, then we might expect the former to inherit the same sort of autonomy as attaches to the latter—though the line of inheritance might not be direct. Though of course colours would not themselves be psychological states, they would in a sense be 'offshoots of the psychological'.

This is a powerful picture, but things are not that simple. Though the main figures are already recognizable, much will need to be repainted. The traditional dispositional thesis fails to make sense of some of our colour attributions, and this shows,

so I shall argue, that we have a deeper conception of the nature of colours—namely, as (in the case of surfaces) ways in which objects change the light. This might threaten to remove any essential connection of colour with the psychological, but that depends on how exactly we characterize the 'ways' in which objects change the light. The ascription of colours does indeed prove to be part of the implementation of a scheme of explanation of everyday experience. That, by itself, might be said equally of other characteristics of external objects, like their size and shape, and does not guarantee that the qualities ascribed are themselves interestingly 'psychological'. None the less, it will turn out to be not just a prejudice that there is something both 'relative' and 'subjective' about colours which puts them in a different position: they really are connected with the psychological in a way that size and shape are not. The view of psychological ascription as the employment of a scheme of *rational* interpretation will turn out to need qualification; but the claim to autonomy in the special sense of this section will survive.

3.1 Away from the Dispositional Thesis

I shall set aside criticisms of the dispositional thesis on grounds of circularity or triviality, since these are not, I think, conclusive against versions that make no pretence at a reduction of colour. There is a more telling criticism that touches even the truth of the coextensiveness claim that something is red, yellow, or whatever iff it would look red, yellow, or whatever to normal observers under normal circumstances.[31] The problem is this. There are, we may imagine, killer yellow objects that kill anyone who looks at them.[32] Far from having a disposition to produce experiences of yellow in normal observers, they have a disposition to end all experience in them whatever. A defender of the dispositional thesis might insist: 'Such an object would still look yellow *if only it could be seen* by normal observers under normal circumstances.' But this does not need to be true: there is a difference between the nearby possible worlds in which an object is visible, and the nearby possible worlds in which it is visible and also has its actual present colour. Imagine a situation where there are a lot of killer yellow objects around, but we have learnt to deal with them: they tend to be small, they emit a distinctive bleeping sound, and (taking care not to look at them) we can easily cover them with thick black paint which the death-rays cannot penetrate. In such a situation the sentence 'If only the object could be seen . . . then it would look yellow' will be false, simply because, if only the object could be seen, it would be covered in black paint.

The natural response is to plug the gap: instead of saying 'If only it could be seen . . . ', the dispositionalist will say 'If only it could be seen *without changing its colour* . . .'. This is progress, but not enough. There will be situations where an object can be

seen and its colour is unchanged, but the colour itself cannot be seen. It may be a very short and faint flash of light; it may put our cones out of order but not the rods; it may be visible but only through a dark filter (and otherwise the death-rays get us). It looks as though we have to ensure not only that the object is visible and its colour unchanged, but that *the colour itself is visible*. We seem to have arrived at this:

(D1) *x* is yellow iff if only *x*'s colour could be seen by a normal observer *y*, then *x* would look yellow to *y*.

This is true but trivial. It is tantamount to:

(D2) *x* is yellow iff if only a normal observer *y* could see what colour *x* is, then *y* would see *x* to be yellow.

And the same of course could be said of other properties too:

(D3) *x* is a dog iff if only a normal observer *y* could see what kind of animal *x* is, then *y* would see *x* to be a dog.

and even:

(D4) *x* is a piece of platinum iff if only a normal observer *y* could see what kind of substance *x* is, then *y* would see *x* to be a piece of platinum.

Of course there is a difference between these claims. The 'if only' clauses become progressively harder for humans to satisfy: we can often tell at sight whether something is yellow, perhaps less often whether it is a dog, and very seldom whether it is platinum. But by the time the dispositional thesis has been reduced to (D1), the interest lies not in what it says, but in any surrounding commentary that can be given to explain what part it plays in our thought about colours, and what else plays a part in addition.

A deeper problem should also be evident. The puzzle cases are ones in which a normal observer *cannot* in fact see the colour (or chemical composition) of the object, but (struggling to maintain a version of the dispositional thesis) we insist on talking about how he *would* see the object if only he *could* see its colour (or chemical composition). But obviously if we take a view on this issue in any particular case, this can only be because we have already—quite independently of these dispositional theses—taken a view on what is necessary for an object to count as yellow or whatever. (In the parallel case, if we say 'if only he were able to see what substance it is, he would see it as platinum', then this can only be because we know already, for reasons other than its appearance, that the sample really is platinum.) If, therefore, we make sense of these cases of killer yellow, it can only be because we have—

independently of the dispositional thesis (D1)—a view on what it takes for something to be yellow. We must have, therefore, a conception of the nature of colours, just as we have a conception of the nature of platinum and of other chemical substances.[33]

What is this conception? What is the common factor between a visibly yellow object and one that is yellow but not visibly so? We cannot say simply: the primary qualities of the objects and their parts. Something that had exactly the same primary qualities (of all constituent parts) as a killer yellow object would kill people just as surely as the killer yellow object does. (Interestingly, even an ordinary yellow object in the dark cannot be said to have exactly the same primary qualities as a similar object in the light: a yellow book cover, for example, will in the light be absorbing photons and emitting photons, which it will not be doing in pitch darkness. If in the dark it were literally in the same primary quality state as it is normally in when illuminated, then it would be glowing!) If it has to be some physical property, then the common factor to all yellow objects will at best be some subset of primary qualities, or some relatively complex high-level primary quality. This of course is the physicalist proposal of Armstrong,[34] much criticized in the recent writings of Hardin and Westphal. It turns out that it is much harder to find a physical property common and peculiar to yellow things than one might imagine. There plainly is no one structural property responsible for the yellowness of all yellow objects. Neither is there any simple physical characteristic common to the light they give off, even when normally illuminated. (They will not, for example, merely give off light from the 'yellow' part of the spectrum: something that only reflected light of wavelengths from 565 to 575 nanometres would look so dark it would be black.) But on the other hand the suggestion that there might well be no physical property at all common and peculiar to yellow things is an odd one: for more than a century, psychophysics has investigated the physical characteristics of things that look yellow without obviously wasting its time. The idea of building a machine to tell the colour of any object from a 'purely physical' specification of it is hardly in the same class as the idea of building one to identify sentimental poems or baroque façades.

There are both phenomenal and non-phenomenal elements in our conception of colours; the difficulty is to see their interconnection. At one extreme there is the temptation to recognize only the phenomenal element: to say for example, as the dispositional thesis does, that being yellow is solely a matter of how a thing looks to people. But we know from killer yellow that this is not true. At the other extreme there is the temptation to recognize only the non-phenomenal element: to say for example that being yellow is solely a physical property.[35] But apart from the difficulty of saying how ordinary observers could (on this conception) have any

confidence in their own ability to tell the colour of something at sight (why should unaided perception be a reliable guide to a 'physical property' of yellowness any more than it is to alkalinity, or to being made of platinum?), there is the difficulty of identifying the 'physical property' in question, and in offering an account of why we should wish to dignify with the title 'yellow' the items that have that physical property. A promising compromise is to make colour a non-phenomenal property identified phenomenally: 'yellowness is picked out and rigidly designated as that external physical property of the object which we sense by means of the *visual impression of yellowness.*'[36] This instantly accommodates killer yellow: killer yellow objects have the same underlying non-phenomenal property as those which produce impressions of yellow, though they do not themselves produce that impression because of the death rays they give off as well.

But we should not let our minds be narrowed by the thought that the only range of properties available for our fundamental conception of colour is the range of physical properties. There are, at least at first sight, many properties that are not physical properties: mental, economic, functional, aesthetic, and moral properties, to cite only a few of the more striking (and perhaps overlapping) categories. Of course philosophers will take different attitudes to the apparent diversity: some will accept it whole-heartedly; others will deny it outright, insisting that there are no genuine classifications other than those of physics. In the middle will be people who accept certain ranges and try to reduce the others. To assure one's title to any of these views is not the task of a paragraph or two. The pressure towards a pluralism of types of property will be great for anyone impressed with Strawson and Grice's observation[37] that where there is agreement on the use of expressions with respect to an open class, there must necessarily be some kind of distinction present—unless one also believes that every distinction made with any predicate can be identified with a physical distinction, quite unrestrictedly[38] and without massaging the extensions of the terms. The arguments that this kind of physicalist property-identity is unlikely to be available are known well enough from the works of Davidson and Fodor not to need repeating here. Accepting a pluralism of properties, the principal challenge is then, I think, to show how this pluralism is compatible with a belief in the fundamentality of physics. Again, I think the essential moves have been made by Davidson and Fodor, showing that the irreducibility of, for example, mental to physical classifications is no obstacle to a broader physicalism that treats the former as supervenient upon the latter.

None of these views is uncontroversial. But given the prima facie availability of a view of mental properties of this general type, the possibility is open of regarding colours in a similar way: as properties that figure in an autonomous explanatory

space (or subspace), irreducible to physical science, but supervenient upon it. Colours would figure in a distinctive form of colour explanation. The concerns of colour attribution would be different from those that govern the attribution of other ranges of property, though there would no doubt be points of contact.

3.2 Colour Interpretation

To say this is not to be relieved of the burden of doing something more to characterize the nature of the properties that colours, thus conceived, are, or to characterize the scheme of explanation which equips us thus to conceive them. I shall take the latter question first, and the former in the section that follows.

On the present suggestion, colours are in some ways parallel to mental properties, figuring in their own explanatory discourse. It may help, therefore, to employ some of the same techniques to elucidate colour discourse as have been used elsewhere to characterize mental discourse. In Davidson, and in a different way, in functionalists like Lewis and Shoemaker, one can find the suggestion that psychological discourse is the employment of an explanatory theory governed by certain constitutive principles. To characterize that discourse, we need to articulate some of the constitutive principles, and make clear how the overall explanatory scheme is applied to empirical cases.[39]

In Davidson's procedure of holistically interpreting either aliens or fellows, we make use of a priori principles which, for example, link belief, desire, and action, or (in another famous example) belief, meaning, and holding true. In Lewis and Shoemaker, there is a parallel idea that each psychological state can be characterized by the role it plays in a functional organization implicit in the platitudes and other a priori claims of common-sense psychology. What will be the parallel principles for colour explanation? Some of them will indicate relations between the various colour concepts; others will indicate their relations to the phenomena which they are used to explain.

Perhaps the fullest articulation of such principles is provided in Wittgenstein. In the *Remarks on Colour*, he considered a variety of propositions which seem to characterize a kind of 'logic' of colour. 'Pure yellow is lighter than pure, saturated red, or blue.' (III. 4.) 'A *shine*, a "high-light" cannot be black.' (III. 22.) 'Yellow is more akin to red than to blue.' (III. 50.) '[We don't] speak of a "pure" brown.' (II. 60.) 'Grey is between two extremes (black and white), and can take on the hue of any other colour.' (III. 83.) 'Black seems to make a colour cloudy, but darkness doesn't' (III. 156.) The source of many of the most interesting remarks is the letter from the painter Runge, which Goethe reproduced in his *Farbenlehre*—which in turn Wittgenstein had before him as he wrote some of the *Remarks*.[40] 'If we were to think of a

bluish orange, a reddish green or a yellowish violet, we would have the same feeling as in the case of a southwesterly north wind.' 'Both white and black are opaque or solid.' 'White water which is pure is as inconceivable as clear milk.' (Runge's letter, §§2 and 11; cp. Wittgenstein, *Remarks* III. 94.) 'Black makes all colours dirty, and if it also makes them darker, then they equally lose their purity and clarity.' (Runge's letter, §5.) 'The opaque colours lie between white and black; they cannot be either as light as white or as dark as black.' (Runge's letter, §12, my translation.) A particularly important claim in Wittgenstein links the notions of surface colour and film colour: 'Something white behind a coloured transparent medium appears in the colour of the medium, something black appears black.'[41]

Wittgenstein's *Remarks* contain a fascinating discussion of the ways in which our mastery of such principles depends upon our natural capacities and our innate endowment—as also, we might add, does our mastery of parallel principles connecting psychological states. A fuller account of colour classification than my own would have to investigate this issue. But for present purposes, it will be sufficient to draw out other types of parallel between colour explanation and psychological explanation.

The ascription of psychological states to people is part of the holistic explanation of behaviour; similarly, the ascription of colours to things is part of the holistic explanation of our perception. To describe just one small element in the picture: rather as beliefs and desires (in a certain context) produce action, the colours of objects, the lighting conditions, and the presence of observers together (in a certain context) produce perceptions of colour. The explanation is holistic: one and the same perception may have been produced by say, a blue object in white light, or by a white object in blue light, just as one piece of behaviour may be caused by alternative combinations of beliefs and desires; and only the accumulation of evidence can allow us to choose between such alternatives. Most importantly, the mastery of the holistic scheme depends on mastery of a range of a priori principles which together constitute a kind of theory. It is of course a posteriori that any particular system can be interpreted as having beliefs and desires, but it is a priori that if a system has beliefs and desires, then they relate in various particular ways to each other, and to inputs and outputs. (In the hackneyed example, if someone desires that p and believes that her ϕing will bring it about that p, then other things being equal, she will tend to ϕ.) In similar fashion, though it is a posteriori that any particular region of the universe is coloured, it is a priori that colours relate in various ways to each other, and to things that they cause and are caused by. (For example: 'Nothing can be red and green all over.' 'If there is something blue at place p, and a person is present with p in front of her, conscious and with a normally functioning perceptual system, then

(subject to various provisos) she will have an impression as of a blue object in front of her.'[42])

Most interesting is the way the parallel lends support to both the subjectivity and (in a different sense) the objectivity of colour. We are used to the idea that the states we ascribe to people when we employ the psychological scheme are 'subjective' in the sense not just that they are states *of* subjects, but also that the states are themselves perspective-dependent: only a theorist who has a particular point of view (embodied in his grasp of the a priori theory) will so much as comprehend the states thus ascribed. (Martians might make nothing of our talk of jealousy, through lacking the constitution necessary to grasp the theory, or to feel jealous.)[43] And yet the ascription of such states is perfectly objective in the sense that those ascriptions can perfectly well be really (and not merely 'apparently' or 'for practical purposes') true. (It may be a perfectly objective fact that person *a* is jealous.) In a similar way, the employment of colour terms is subjective in the sense that it embodies a particular point of view, inaccessible to certain perfectly rational people. At the same time, the colour ascriptions of people who have that 'point of view' are objective, in the sense of being assessable as genuinely true or not.[44]

Of course there is more than merely a parallel between the psychological scheme and the colour scheme. There are direct connections between them, because of the fact that colours give rise to experiences of colour, and (to put the matter carefully) variations in physiology determine simultaneously variations in the colours of which we are capable of being aware, and variations in the perceptual experiences in which we are aware of them.

How exactly does this picture of colour explanation relate to the issue of autonomy? In the second usage which I have distinguished, the term 'autonomy' is used for the status of a discipline or explanatory scheme which is self-governing, in the sense that it sets its own standards of correctness and is open to critical assessment only from within the discipline or explanatory scheme. In this sense, everyday classification of metals recognizes its own non-autonomy: we recognize that, on whether something is gold, common-sense judgements make claims that can only be fully justified (and may in fact be overturned) by going outside everyday methods of judging and turning to the metallurgists. Whether an explanatory scheme is autonomous or not is highly sensitive to the delimitation of the explanatory scheme: taken together, everyday classification of metals and metallurgy might count as autonomous, though the first alone did not. The notion is not easy to apply: psychological explanation might be presented as autonomous, in the sense that it sets its own standards; but yet it may turn out that those standards themselves make essential reference to physical and externalist considerations. So autonomy in this sense does

not mean 'independence of the physical'. A claim of autonomy in itself carries no anti-scientific bias either: the physical sciences themselves could be described as autonomous. But what autonomy does mean is that if the *internal standards* of a field leave no place for criticism on scientific grounds of judgements in that field, then there is no place *simpliciter* for criticism of such judgements on those grounds. The claim of autonomy in itself is usually a trivial one, a demand to recognize an explanatory scheme for what it is: to recognize the relevance of certain kinds of consideration to judgements made in it, and the intrinsic irrelevance of other kinds of consideration. Whether the claim is news to anyone will depend on what kinds of consideration exactly are mentioned when the claim is developed in detail.

The role of colours as properties used in interpretation suggests that they occur in explanations that are autonomous in this second sense. How exactly? The most important point is that nothing outside the methods of colour discourse can force us to abandon a colour judgement: if on looking at an object in a variety of circumstances and checking with other people, we conclude that it is red, then there is no place provided for correction of this judgement on other grounds. So far, this is a pretty high-grade form of self-government. What we have also provided for, however, is the possibility that on occasion it may be impossible to tell by looking what colour something is (for example, because it would kill you first), and then it will often only be information about the physical (for example, the object's spectral reflectance curve) that can conclusively underwrite a colour attribution. Is this a departure from 'autonomy'? It is a little hard to know how to answer. Not if the internal rules on colour ascription themselves provide for this. It is only possible to apply colours to objects that cannot be seen if you already have a view on what colours *are*. I would suggest that it is now an integral part of colour ascription that anything which has the property that underlies our ordinary perceptions of red will itself be red. It is of the nature of a discovery, though a fairly obvious one, that the property in question, in the case of surfaces, is a way of changing the light (as I shall argue in the next subsection); but which spectral reflectance curves correspond to this way of changing the light will be a piece of *recherché* information. On this view, it is integral to colour explanation that there will be cases where the colour of something can only be determined by means other than simple perception: so colour explanation is autonomous precisely by itself making provision for reference to the areas outside superficial perception. By now this is a fairly modest claim of autonomy; but less turns on the employment of the label than on the understanding of the reasons for which it is employed.

Two further issues are worth a few quick comments. To describe colour explanation and psychological explanation as forms of 'interpretation' should not be taken

as suggesting (as it does sometimes in Davidson) an instrumentalist or anti-realist view of the items ascribed in such explanation. Unless the occurrence of a term in a theory used to explain or interpret phenomena automatically forces an anti-realist understanding of that term, then the use of the word 'interpretation' here will not do so. Secondly, I have sometimes used the term 'rational explanation' where 'psychological explanation' would in some respects have been less misleading. I used the former term to allude to a view of the nature of psychological explanation found in Davidson and McDowell, which I wished to use as a model for colour explanation. But the term may have shortcomings even in its original context. The domain of psychological explanation seems to be wider than that of rational explanation, if the latter is defined by the 'constitutive ideal of rationality'. We may on occasion explain what people are doing by saying they are playing football, doodling, or dancing. The explanations are perspective-dependent (and may be impenetrable to the Martians), but it is not clear that the concept of *rationality* is central either to the activities or to our recognition of them. One might well say that we can describe people as engaging in such activities only if we treat them *also* as subjects of belief and desire, that is, as subjects of explanation that really is governed by the constitutive ideal of rationality. But even if this is true, it concedes that rationality is only one dimension of assessment of the distinctive lives of sentient beings. Even if the 'constitutive ideal of rationality' is the clearest source of the combination of subjectivity, autonomy, and realism that we find in psychological explanation, it is not to be assumed that it is the only one.

If this section has described some of the nature of colour discourse, it leaves us with the unfinished business of describing the nature of the items that this discourse actually equips us to talk about—that is, the nature of colours themselves. A recent suggestion is that of Jonathan Westphal: the colours of surfaces are ways in which they change the light.[45] The suggestion is immensely valuable, but it needs care to develop it in a satisfactory way.

3.3 *The Colour of a Surface as a Way in Which it Changes the Light*

There is a difference between the light reflected from a surface and the light incident on it. At or around any one wavelength the surface will reflect a certain proportion of the light, transmit a certain proportion, and absorb the remainder. And it is a high-level empirical fact about objects in our environment that these proportions, for any one surface, usually stay roughly constant from one time to another, regardless of how much light is falling on the object.[46] It is therefore usually possible to describe how a surface changes the light by giving a 'spectral reflectance curve' for it, showing the proportion of light it reflects at each wavelength (see figure 11.2). The

Reflectance

Figure 11.2
Spectral reflectance curves of some typical natural objects. (From Wyszecki, G., and W. S. Stiles, 1967/ 1982. *Color science—Concepts and methods, quantitative data and formulae*, 2nd ed. New York: Wiley, p. 63.)

spectral reflectance curve for a surface determines its colour, on at least one natural understanding of that term, according to which the colour of, for example, a British post-box is red—even if it is being mistaken for brown because the light is bad, or for green by a person who is colour-blind or a recent victim of spectrum-inversion, or it is invisible because there is no light on it at all.

Though spectral reflectance curves determine colours, they are not identical with them. There are two problems. First, the space of spectral reflectance curves differs from colour space: spectral reflectances vary in an infinite number of dimensions (corresponding to the proportion of light reflected at each of an infinite number of wavelengths of visible light), whereas on a natural interpretation, colours vary in just three dimensions of hue, saturation, and brightness or lightness. The loss of dimensions corresponds to the fact that there are only three kinds of cone in the retina, and objects with physically different spectral reflectances may be indistinguishable in colour. Secondly, the phrase 'the colour of the object' is indeterminate: the object may be at one and the same time red, vermilion, a highly saturated vermilion, and also R10Y 3080 (to pick a figure out of the air for the object's coordinates in the Natural Colour System). The colour of an object is like its position, which may be at one and

the same time: in the house, in the bedroom, in the top drawer of the bedside table, and at such-and-such a coordinate position. Plainly at best there is going to be a many-to-one relation between spectral reflectance and even a colour coordinate position like R10Y 3080; and it will be even more many-to-one between spectral reflectance and a colour classification like *red*.

This does not mean that the colours of surfaces are not ways in which they change the light; it means only that ways of changing the light can be individuated in ways other than those of physics. Westphal's suggestion in his book *Colour* has two distinctive features; my own will emerge in discussion of them. First, Westphal seems to think we can characterize the colour of an object by taking its spectral reflectance curve and 'phenomenalizing' it—that is, reading it so that 'the *x*-axis is illuminant colour, not wavelength' (p. 32). (A surface colour itself might then be characterized by a certain *type* of thus phenomenalized spectral reflectance curve.) Secondly, following a suggestion of Wilson and Brocklebank, Westphal says that the significant property of objects 'is not the colour . . . of the light they reflect, but rather the colour of the light they *don't* reflect' (p. 80). So a green object will be one which 'refuses to reflect a significant proportion of red light' (p. 81); a yellow object will be one that refuses to reflect much blue light (p. 80). When defining the colour of lights, Westphal mentions how lights of different colours will 'darken' objects—that is, I think, make them appear dark (compared with other objects illuminated with the same light). Thus a red light is one that is 'disposed to darken green objects' (p. 85), and a blue one that will darken yellow objects. Putting the two types of definition together, we have a medium-sized if not small circle: objects are green if they refuse to reflect red light, and light is red if it darkens green objects.

Neither of the two distinctive features of Westphal's suggestion will quite do. First, if we simply read the *x*-axis of a spectral reflectance graph as illuminant colour, then it is most unlikely that for any one *x*-value a single *y*-value can be recorded as the proportion of light of that colour which the object is disposed to reflect. For, given the facts of metamerism, it is quite possible for an object to reflect, say, 85 per cent of incident light of 570 nm, but only 75 per cent of a mixture of light of 550 and 600 nm which looks (and is) exactly the same colour. Secondly, specifying kinds of light which an object fails to reflect is not enough to determine its colour, unless we add that those are the *only* kinds of light which it fails to reflect[47]—and that of course would then be equivalent to telling us that it does reflect significant amounts of other kinds. So I cannot see any advantage in talking of the kinds of light that objects *fail* to reflect rather than the kinds that they succeed in reflecting.[48]

But this should not discourage us from working for a conception of colours as ways in which objects change the light, which is phenomenal but not quite in the way

that Westphal suggests. Abandoning the two-step procedure that defines surface colour in terms of the (complementary) colour of light which such surfaces refuse to reflect, we might talk instead of the light that the surfaces succeed in reflecting. Holding to the aim of characterizing colour phenomenally, we might say: the red surfaces are those that when illuminated with normal white light tend to reflect light that is, phenomenally, red (whatever the spectral composition of that light)—where for accuracy that must be interpreted: the surfaces tend in normal white light to reflect light that results in normal people when normally affected by it having a perception as of a red material object.[49] But by then it seems no less illuminating to say, quite non-reductively, that red things are ones that change the light in a certain way, and that way is the way in which red things change the light. Does this make a pointless detour? No: for the route brings to light the fact that surface colours are ways of changing the light. What red surfaces have in common is *what they do* to the light: a factor that remains constant, however the character of the incident and reflected light vary individually. It is like the elasticity of a spring, a constant factor characterizing the way the length varies with the force to which the spring is subjected.[50]

Are there other ways to characterize this way of changing the light? We can say a lot within the everyday language of colour, employing either a priori or a posteriori connections: red things look darker than yellow ones; red is a deep colour; the most saturated reds seem more saturated than the most saturated yellows; red shades into orange in one direction and into purple in the other; a lightened red becomes a pink; red is a 'unique' hue: there are reds that seem to contain no hint of any other colour; nothing can be red and green all over. We can produce samples: *these* things are red, we may explain, and *those* are not, and there are borderline cases like *these*—though the samples will only be of use to people who can perceive pretty much as non-colour-blind humans do.

Can red be characterized in non-colour terms? We can clearly go a long way. We can characterize it as the colour corresponding to spectral light of approximately wavelengths 650 to 750 nanometres. But that of course uses the predicate 'colour'. We can do better: psychophysics and colorimetry have, I think, put us in a position where we can tell of any newly presented object what colour it is, simply from its spectral reflectance curve (together with standard data culled from human subjects).[51] It should therefore be possible to find a 'physical' property coextensive with 'red'. The questions remain whether this physical property will be *necessarily* coextensive with the colour, and whether it will be identical with it—and I cannot pretend to answer these here. But it must be obvious that the view of colours as introduced by a distinctively subjective scheme of explanation, and as phenomenally

characterized ways of changing the light (as the present section has suggested), does nothing to rule out the idea that they might be characterizable a posteriori in other ways as well.

The attractions of taking colours as ways of changing the light are tremendous. I shall mention several.

First, consider a red car on a bright day. It clearly looks red. But you will also be able to see in it the reflections of other things around, from the road and the other cars to the sky above. The surface in one sense looks a perfectly uniform colour, but almost every point on it is, in another sense, presenting a different appearance. What is it that it constantly looks to be, when in this sense it constantly looks red? Why does it 'look the same'? Because there are in the visual array cues[52] that enable us to recognize it as a presentation of an object across whose surface there is a constant *relation* between incident and reflected light: there is a constant *way in which the surface changes the incident light.*

Secondly, this conception explains how it is that in order to tell what colour an object is, we may try it in a number of different lighting environments. It is not that we are trying to get it into one single 'standard' lighting condition, at which point it will, so to speak, shine in its true colours. Rather, we are looking, in the way it handles a variety of different illuminations (all of which are more or less 'normal'), for its constant capacity to modify the light.

Thirdly, this makes sense also of what might otherwise be thought a strange phenomenon: aspect-shift in colour perception. I have had the experience of looking at a book cover from just one angle, uncertain whether it is dark blue or black. At that point I can see it alternately as dark blue, and then as black, shifting at will between appearances. The effect goes as soon as I turn the book at a new angle to the light: it is suddenly clear that the object is dark blue. To count a transient perception as a perception of a dark blue object is to be prepared to count some different perceptions as perceptions of the same enduring object with the same colour; if such different perceptions do not in fact materialize as expected, then the object after all is not dark blue.[53] To be dark blue is not crudely to have a disposition to present a single appearance in a single kind of lighting; it is to present a variety of appearances in a variety of kinds of lighting, according to a constant pattern. And if it is puzzling how a *dynamic* property can make itself manifest in a *static* perception ('how can a disposition to present a variety of appearances be visible in a single appearance?'), then we already have, in familiar discussions of aspect-shift, the theoretical apparatus for a solution. It is because there is 'the echo of a thought in sight':[54] our perception of an object as having a certain colour is 'soaked with or animated by, or infused with'—the metaphors are Strawson's—'the thought of other past or possible

perceptions of the same object'.[55] If it is a shock to find even colour appearances treated as soaked with thought—rather than being the brutely given *qualia* of today's descendants of sense-data—then that is a shock worth undergoing.[56]

A remarkable related phenomenon occurs with various forms of partial colour-blindness. The impression is often given that people classed as 'red-green colour-blind' (namely, the roughly 8 per cent of men and 0.5 per cent of women who have impaired colour discrimination of reds and greens, usually in the form of deuter-anomaly) have one and the same type of perception when looking at red, green, and grey objects.[57] Nothing could be farther from the truth. I myself have red-green deficiencies of vision, according to the Ishihara colour tests.[58] I confuse certain reds and greens in certain circumstances. But I do not have a single kind of perception from red, green, and grey things in general. I have no difficulty in seeing the red of a post-box, or the green of the grass, and my identification of their colour is not due to knowing already what kind of thing I am looking at. (I am equally good on large blobs of paint.) So I plainly do not have just one *concept*, applicable equally to red, green, and grey things. My problem is that occasionally I take something to be red (or brown) which turns out later to be green. What is interesting is that, when told of my mistake (or recognizing it myself, for example after trying the object in slightly different lighting), I can usually come to see the object *as* having its true colour. This involves what I earlier called an aspect-shift: the object actually comes to *look different*, even when the physical sensory stimulation is the same. Even in the lighting situation where I originally took the object to be brown, I do not 'get one and the same impression' as before if I later take the object to be dark green.

This makes perfectly good sense if colours are ways of changing the light. The person with red-green deficiencies is simply less good at telling from one viewing what is the object's *way of changing the light*; but by getting a variety of views of it, he may none the less recognize that property. There is no reason to say he lacks proper colour concepts; he is simply less good in applying them. His experience is, so to speak, ambiguous where other people's is not—in rather the same way as the experience of a person who sees with only one eye will be ambiguous, where that of a person who sees with two eyes is not. Most of the time those with monocular vision have no difficulty in recognizing the three-dimensional shape of objects around them—resolving cases of ambiguity by seeing the object from different angles. We certainly have no temptation to say that they lack a concept of shape in three dimensions.[59] And something parallel can be said of people with anomalies of colour vision.

This conception of colour also makes good sense of how colour perception could have evolutionary significance: the ways in which a surface changes the light will be a constant factor the tracking of which can easily be of benefit to an organism that is tracking that surface.[60]

The attractions of regarding colour as a way of changing the light are clear, though (particularly in the case of evolution, ecology, and colour-blindness) they raise questions that demand attention at much greater length. None the less, this cannot be a full conception of colour, simply because colours apply not only to objects that change the light, but also to objects that emit light. 'Yellow' is not simply ambiguous, as applied to surfaces, lights, illumination, films, after-images, and so on. But in at least some of these cases, the colour plainly cannot be a 'way of changing the light', so if yellow is a single feature, it cannot strictly ever be literally a way of changing the light.

The beginnings of a solution of the problem are not hard to find. There are a number of links between the yellowness of light and the yellowness of a surface. Yellow light falling on a white object will make it look yellow or yellowish, depending on the degree of adaptation possible to the light. Yellow light shining through a white translucent glass (like the globe of an old station waiting-room) will look similar to white light shining through a yellow globe. The exact connection of the two categories (surface colour and light colour), however, is complex, as Wittgenstein has taught us. Why is there no brown light? Why are there no grey lights?[61] What exactly are the parallels between the two areas of colour application? My own answer, which I think is also Wittgenstein's, involves both language and innate endowment, including physiology. To put the answer schematically: it is part of our language that some terms and not others apply to both lights and surfaces; someone who failed to grasp this would count as using different concepts from us. Other species might act differently from us in this, but then they would be using colour-concepts that were at best analogues of our own. But what we are here characterizing as similarities embedded in the language cannot be separated from our innate predispositions: it may, for example, be necessary to have a certain kind of neurophysiology in order to be capable of learning a language of this type. As always with rule-following, the ability to 'go on' in a certain way, given a certain training, is something that depends upon a certain natural endowment (and incidentally also upon environmental conditions, like certain kinds of constancy in the objects around us). Human beings to a large extent share with other humans these natural endowments, but there are conspicuous cases where, for example in the case of colour-blindness, a person is unable to learn a concept that others try to teach him.

The suggestion is that colours of surfaces are ways in which they change the light. The colours of lights are intimately connected with them: at one level, we may say, the same colours apply in parallel cases 'because such cases look similar'; but if pushed to say *in what respect* the cases look similar, we could only say 'in colour', and that was the very similarity we were (perhaps misguidedly) trying to explain. If on the other hand we say only 'the cases strike us similarly' then that is clearly cor-

rect: the very fact that we react by applying the same term shows that. But it is not a deep explanation of why the colour applies as widely as it does. Changing levels, we may indeed look at neurophysiological characteristics that are similar between human perception of the two cases. But in the most general terms, we may say that the similarity resides as much in our reactions to the things as in the things.

Section 2 defended autonomy in Putnam's sense: independence from mode of realization. The present section has defended autonomy in a second sense. A third sense might come to mind: explanatory independence from the objects of other explanatory schemes. I should make clear that I am not claiming autonomy in this third sense, either for colours or for psychological states. Psychological states do not form an explanatorily closed system, and the defence of psychological explanation as a form of holistic explanation autonomous in the other two senses does not need to pretend otherwise. There are a mass of psychological phenomena that are not explicable by the methods of rational explanation. 'Why do human beings forget as much as they do?' 'Why is a person who has just lost his job more susceptible to illness than one who hasn't?' 'Why do people become schizophrenic?' 'Why do people with Alzheimer's disease lose their mental faculties?' Maybe part of the answer to these questions will involve rational explanation invoking psychological states like imagining and desiring. But in most cases, what explanation is available will cross into other areas, like (at different levels, more than one of which may be relevant to a single puzzle) physiology, evolutionary biology, scientific psychology, and others.

In similar fashion, colour phenomena, though sometimes explained by other colour phenomena, will not always be. A mass of questions come to mind the answers to which force us to turn to other disciplines. 'Why do colours fade?' 'Why does red seem to advance in front of green?' 'Why is the sky blue?' 'Why is grass green?' 'Why do colour contrast effects occur?' 'Why do blue objects come to seem relatively brighter *vis-à-vis* red objects as the light goes in the evening?' (The Purkinje phenomenon.) 'Why does hue change with brightness?' (The Bezold-Brücke effect.) Only physics, physiology, chemistry, and various forms of scientific psychology can tell us. But the admission that colour phenomena form anything but an explanatorily closed set is perfectly compatible with claims of autonomy in the other two senses.

Acknowledgments

For discussion and comments on earlier versions of this paper, I am grateful to David Bell, Quassim Cassam, William Child, Larry Hardin, Kathleen Lennon, Michael Martin, Peter Smith, Paul Snowdon, Helen Steward, and Tim Williamson,

as well as to other members of audiences where I have presented it. I owe a special debt to John Campbell: without his own writings on colour this would have been very different work, and without our many discussions, it would have been a good deal less enjoyable. To David Charles I am grateful for criticism and encouragement that go way beyond those of a generous editor.

Notes

1. C. McGinn, *The Subjective View: Secondary Qualities and Indexical Thoughts* (Oxford: Oxford University Press, 1983), 14–15. Cf. J. Bennett, *Locke, Berkeley, Hume: Central Themes* (Oxford: Oxford University Press, 1971), 102f.; J. McDowell, 'Values and Secondary Qualities', in T. Honderich (ed.), *Morality and Objectivity: A Tribute to J. L. Mackie* (London: Routledge & Kegan Paul, 1985), 118.

2. 'Colours have characteristic causes and effects—that we do know' (Wittgenstein, *Remarks on Colour*, ed. G. E. M. Anscombe, trans. L. L. McAlister and M. Schättle (Oxford: Blackwell, 1977), III. 82).

3. The painter Philipp Otto Runge said in a letter to Goethe: 'This has driven me on at least to study the characteristics of the colours, and whether it would be possible to penetrate so deeply into their powers, that it would be clearer to me what they achieve, or what can be produced by means of them, or what affects them'. (Runge, as quoted in Goethe's *Farbenlehre*, in the *Zugabe* that follows §920, my translation; J. W. Goethe, *Sämtliche Werke*, ed. K. Richter, H. G. Göpfert, N. Miller, and G. Sauder (Munich: Carl Hanser, 1989), x. 266). There is a translation of virtually all of the *Didaktischer Teil* (Didactic Part) of the *Farbenlehre*, by Charles Eastlake (Goethe, *Theory of Colours* (London: John Murray, 1840), repr. with intro. by D. B. Judd (Cambridge, Mass.: MIT Press, 1970)). Unfortunately Runge's letter is not translated by Eastlake.

4. H. Putnam, 'Philosophy and our Mental Life', in H. Putnam, *Philosophical Papers*, ii: *Mind, Language and Reality* (Cambridge: Cambridge University Press, 1975), 296.

5. P. S. Churchland, *Neurophilosophy* (Cambridge, Mass.: MIT Press, 1986), 380.

6. Though no definition of supervenience is uncontroversial, a first approximation would be: *f*-properties supervene on *g*-properties iff it is metaphysically necessary that situations indiscernible in *g*-terms are also indiscernible in *f*-terms, but not vice versa. The case for peaceful coexistence of mental and physical discourses has been made in different ways by Davidson, Fodor, and Dennett. Therre are people who have argued for the elimination of the mental. But the most notable proposals (like that of Churchland, *Neurophilosophy*, esp. chs. 7–9) attack the mental scheme of discourse not on the a priori ground that different levels of discourse can never coexist peacefully (Churchland is herself a defender of a plurality of levels of scientific discourse—see p. 358), but rather on the a posteriori ground that 'folk psychology' is not the best candidate for the job it is intended for, and looks set to be replaced by an ideally developed neuroscience (see e.g. p. 396). So the belief in a plurality of legitimate levels of discourse is I think not a contentious one. The second issue—raised by the claim that folk psychology should be replaced by neuroscience—is not one which I can pretend to discuss properly here. But since the issue lurks in the background of discussions later in this paper, it may help to say now that my own response would be to call into question Churchland's view of what the aim of mental discourse *is*. If its aim is not to 'explain and predict' in the manner of the physical sciences, then failure *at that job* is not a reason to abandon it. (For alternative views of the domain and methods of rational explanation, see e.g. Davidson, 'Mental Events' and 'Psychology as Philosophy', repr. in D. Davidson, *Essays on Actions and Events* (Oxford: Clarendon Press, 1980); J. McDowell, 'Functionalism and Anomalous Monism', in E. LePore and B. McLaughlin (eds.), *Actions and Events: Perspectives on the Philosophy of Donald Davidson* (Oxford: Blackwell, 1985); K. Lennon, *Explaining Human Action* (London: Duckworth, 1990).) A third and different matter is Churchland's claim that 'cognitive psychology' looks unlikely to succeed in isolation from neural science (or if it persuades itself that it is 'autonomous with respect to neuroscience' (p.362)). On this issue, Churchland's view seems completely persuasive, if the domain of cogitive psychology includes such questions as why we

sleep, and why we forget as much as we do. But that does not immediately lend support to the second claim, unless the aims of ordinary mental discourse and 'folk psychology' are the same as those of cognitive psychology. For the comparison between the relation of mental and physical explanations and that of colour explanation and physical explanation, see J. Campbell, 'A Simple View of Colour', in J. Haldane and C. Wright (eds.), *Realism and Reason* (Oxford: Oxford University Press, forthcoming), §3 [chapter 10, this volume]. I urged the same point in J. Broackes, 'The Identity of Properties' (D. Phil. thesis, Oxford University, 1986), 228. Not being able to argue all points at once, the succeeding discussion presumes the peaceful coexistence of the first pair, and considers the suitability of using that as a model for the relation of the second pair.

7. The effect of the black paint on the temperature of the house seems an exception to this. But we will shortly have reasons to doubt whether the claim is strictly true.

8. I discuss them more fully in my book *The Nature of Colour* (Routledge, forthcoming).

9. e.g. P. M. S. Hacker, *Appearance and Reality* (Oxford: Blackwell, 1987), chs. 3 and 4; Campbell, 'A Simple View of Colour'; and Barry Stroud in his John Locke lectures in Oxford.

10. Cf. R. M. Evans, *An Introduction to Color* (first pub. 1948; New York: Wiley, 1965), 59: 'The whole key to the solution of any color problem lies in a knowledge of what has happened to the relative *energy* distribution of the light ... Two light sources having completely different energy distributions may look exactly alike to an observer and yet may produce entirely different colors if the light from them falls on the same object. It is apparent that no description of these lights in terms of *colors* can ever explain the situation, but knowledge of the energy distributions may make it entirely obvious' (my emphasis in the first sentence).

11. 'Philosophy and our Mental Life', quoted above.

12. Cf. J. Westphal, *Colour* (Oxford: Blackwell, 1987), 37–8.

13. Alberti, for example writes: 'Grace will be found, when one colour is greatly different from the others near it ... This contrast will be beautiful where the colours are clear and bright. There is a certain friendship of colours so that one joined with another gives dignity and grace. Rose near green and sky blue gives both honour and life. White not only near ash and crocus yellow but placed near almost any other gives gladness. Dark colours stand among light with dignity and the light colours turn about among the darks. Thus, as I have said, the painter will dispose his colours' (Leon Battista Alberti, *Della Pittura*, book II, near end; in J. R. Spencer's translation, *On Painting*, rev. edn. (New Haven, Conn. and London: Yale University Press, 1966), 84–5). (John Spencer's reference in his notes to 'the colour chords' of 'the Albertian colour system' (p. 130 n. 83, cf. p. 105 n. 23), however, finds more systematicity in Alberti's comments than I can find there.) Goethe's *Farbenlehre*, pt. 6, esp. §§803 ff., sets out principles of colour harmony, and traces them to the eye's 'tendency to universality' (§805). The same tendency as he uses to explain contrast effects (when the eye 'spontaneously and of necessity ... produce[s]' the complementary colour) is responsible also, he thinks, for our finding combinations of complementary colours harmonious (§§805–7, cf. §61). Munsell carefully distinguishes the aesthetic characteristics of three typical paths one may take from a given colour: the 'vertical' path (taking lighter and darker values of the same hue), the 'lateral' path (changing the hue without changing either value or chroma) and the 'inward' path (towards the centre of the colour solid and beyond to the opposite hue). Describing their uses, he adds that the third is 'full of pitfalls for the inexpert' (A. H. Munsell, *A Color Notation*, 8th edn. (The Munsell Color Company, 1905, 1936), 38).

14. Munsell, *A Color Notation*, 24.

15. One point, however, may be worth raising. There is a tendency to think that aesthetic responses to colour are direct and unaffected by reasoning, training, and cultural influence. But this (like the 'tingle-immersion' view of aesthetic response in general) will not survive scrutiny. Aesthetic judgement, with respect to colour as anything else, is always open to revision, at least in its details, as a result of aesthetic experience of other situations, reflection, and *thought*. None the less, it is remarkable that there is such a discipline as harmony and counterpoint at all—and it seems therefore that, at least with respect to what might be called a strictly delimited aesthetic language, it is possible to make rough-and-ready aesthetic judgements on the basis of rules: 'this is not (for the language of Haydn and Mozart) discordant', 'the chord progressions of this chorale harmonization are more or less in the style of Bach'. Something similar

in the case of colour seems promising: you cannot tell in advance that this particular colour combination will never, in any context, look good. (Maybe the four colours look terrible together on the walls of a room, and awful used in a particular textile design for a dress. But when employed in a particular way on a book jacket, they suddenly look right.) It is a matter of continual artistic discovery that things that people once assumed would never look right or sound right can suddenly begin to do so, employed in a new way—a way which may itself change the artistic or musical language. But we can none the less come up with limited rules of thumb: for example, that any employment of this combination of colours, if seen pretty much with present eyes, will look a bit unpleasant

16. Isaac Newton, *Opticks* (first pub. 1704, 4th edn. 1730; New York: Dover, 1979), book I, pt. 2, prop. vi, prob. ii (pp. 154–8).

17. 'Two colours, both of which have the same hue and the same proportion of intermixed white, also give identical mixed colours, no matter of what homogeneous colours they may be composed.' (H. G. Grassmann, 'Theory of Compound Colours', *Philosophical Magazine*, 4 (1854); repr. in D. L. MacAdam (ed.), *Sources of Color Science* (Cambridge, Mass.: MIT Press, 1970), 60.) Some qualifications should be noted. Maxwell's triangle and the subsequent empirical research leading to the 1931 CIE x, y chromaticity diagram showed that in place of Newton's circle, the locus of spectral points in this kind of mixing diagram needs rather to be in the shape of a plectrum or tongue. Secondly, each point on a modern chromaticity diagram represents a certain hue and saturation, but brightness is not taken into account, as it needs to be in a full explanation of additive mixing. (For further details, see e.g. R. W. G. Hunt, *Measuring Colour* (Chichester: Ellis Horwood, 1987), 58–60.)

18. M.-E. Chevreul, *The Principles of Harmony and Contrast of Colours, and their Applications to the Arts*, 2nd edn. (1st French edn. 1838; trans. Charles Martel (London: Longmans, 1855)).

19. Some forms of colour mixing are neither precisely subtractive nor precisely additive. In colour printing, if dots of different colours are printed *on top of* one another, the mixing can be considered subtractive; if dots too small to be individually seen are printed *next to* one another, then the mixing can be considered additive.

20. Mathematically, to get the character of light reaching the eye we would (at each wavelength λ) multiply the power of the illuminant at λ by the reflectance of the sample at λ and then by transmittance of the filter at λ. Now (as far as the character of light reaching the eye is concerned) it does not make any difference whether the filter comes between the illuminant and the object, or between the object and the eye. (The two cases may be perceptually different, if the context results in different adaptation.) Since we already know that two metameric samples may become distinguishable in colour when the illumination is varied, it is not surprising then that the same happens when the samples are seen through a filter.

21. F. W. Billmeyer and M. Saltzman, *Principles of Color Technology*, 2nd edn. (New York: Wiley, 1981), 130, gives a remarkable CIE diagram (after Johnston, 1973) showing the results of mixing various paints with increasing amounts of titanium dioxide white. The colour changes often show up as lines that are anything but straight, and in some cases the result of adding a small quantity of white is to move the colour not in the direction of white but at 90° to it. In certain circumstances, there will also be chemical reactions in colorant mixing, and then clearly no mixing rule that attended only to the colours of the colorants and not to their chemistry could hope to account for the results.

22. *The Notebooks of Leonardo da Vinci*, ed. I. A. Richter (Oxford: Oxford University Press, 1952), 136.

23. Chevreul (*Principles*, pt. 1, sect. 2, ch. 2) acknowledges that Buffon (1743) noticed examples of both types, and also mentions Scherffer (1754), Œrpinus (1785), Darwin (1785), and Count Rumford (1802).

24. Chevreul gives the impression that he invented the terms. (In *Principles*, p. 374, he talks of earlier writers who lacked 'the fundamental distinction which I had made between two sorts of contrast under the names of *simultaneous contrast* and *successive contrast* of colours'.) But Goethe had grasped the distinction quite clearly (e.g. in the *Farbenlehre*, §56). I have not seen any reference in Chevreul to Goethe's work, and I do not know what the relation between them was. But there is a fundamental agreement between them, notably on the universality of these contrast effects (Chevreul: '*every* colour seen simultaneously with another, appears with the modification of an accidental colour' (*Principles*, p. 376, my emphasis); Goethe, *Farbenlehre*, §51) and in the view that an understanding of contrast is the foundation for understanding the laws of colour harmony (Chevreul, *Principles*, 376–7; Goethe, *Farbenlehre*, §§60–1, §§805–7). This is why

both of them attack earlier writers' descriptions of contrast effects as 'accidental colours' or 'adventitious colours' (Goethe, *Farbenlehre*, §§1–2, Chevreul, *Principles*, p. 376), whereas in fact 'they are the foundation of the whole doctrine' (Goethe, *Farbenlehre*, §1).

25. One description of the phenomenon in the *Farbenlehre* is almost as remarkable as the event it describes: 'I had entered an inn towards evening, and, as a well-favoured girl, with a brilliantly fair complexion, black hair, and a scarlet bodice, came into the room, I looked attentively at her as she stood before me at some distance in half shadow. As she presently afterwards turned away, I saw on the white wall, which was now before me, a black face surrounded with a bright light, while the dress of the perfectly distinct figure appeared of a beautiful sea-green' (Goethe, *Farbenlehre*, §52, p. 22).

26. It is worth noting however, as Goethe and Chevreul did not, that after-image complementaries are not always the same as mixture complementaries: the colour of the after-image produced by a coloured light may not be the same as the colour of a second light that when mixed with the first yields white. Perhaps unfortunately for Goethe, the eye's 'tendency to universality' (*Farbenlehre*, §805) is not entirely precise. See M. H. Wilson and R. W. Brocklebank. 'Complementary Hues of After-Images', *Journal of the Optical Society of America*, 45 (1955), 293–9.

27. (London: C. Kegan Paul, 1879.)

28. Davidson makes a telling admission when discussing psychophysical generalizations. He admits that, notwithstanding his denial of psychophysical laws, it would be embarrassing to deny that there are any 'inductively established correlations between physical and psychological events' ('The Material Mind', in his *Essays on Actions and Events*, 250). 'The burned child avoids the flame' is his example; one even less susceptible of counter-example might be: 'A conscious person with no otherwise detectable abnormality, holding a hand in a flame, will begin to feel pain'. Davidson's comment is that such generalizations 'are lawlike in that instances make it reasonable to expect other instances to follow suit without being lawlike *in the sense of being indefinitely refinable*' ('Mental Events', 224, my emphasis). If what Davidson says here is right, then the broad generalizations about colour contemplated at this point in the main text will be 'lawlike' only in the weaker of two senses of the term. But Davidson's stronger sense of 'lawlike' may itself be anomalous. Why should being lawlike in any sense be a matter of being 'indefinitely refinable' or 'sharpen[able] without limit'? Davidson's original explanation of the notion was that 'Lawlike statements are general statements that support counterfactual and subjunctive claims, and are supported by their instances' ('Mental Events', 217). But it is not clear that this notion of law has any internal connection with that of indefinite refinability. If this is right, then Davidson's denial of psychophysical laws is rather weaker than at first appears (strictly all it denies is *indefinitely refinable* psychophysical laws, *sharpenable without limit*); and his argument for the identity theory would require not just the Nomological Character of Causality as naturally interpreted, but the stronger principle that 'events related as cause and effect fall under strict deterministic laws, *indefinitely refinable and sharpenable without limit*' ('Mental Events', 208, amended by the addition of the words in italics). A further difficulty with Davidson's view comes to the surface here: if on his view there are two senses of 'lawlike', and it is in only one of these that he wishes to deny the existence of lawlike psychophysical connections, then it is odd that the argument for that denial actually seems to make no play with the difference between those two senses. To rephrase the point: if the criterial and evidential differences between the nature of mental and physical discourse do not rule out the existence of lawlike psychophysical connections in the weaker sense, it is not clear that they can rule out the existence of lawlike psychophysical connections in the stronger sense—given that Davidson's argument for the latter claim shows no obvious sensitivity to the difference between these two senses.

29. 'To recognize the ideal status of the constitutive concept [of rationality] is to appreciate that the concepts of the propositional attitudes have their proper home in explanations *of a special sort*: explanations in which things are made intelligible by being revealed to be, or to approximate to being, as they rationally ought to be.' By contrast, what might roughly be called 'physical' explanation is characterized as 'a style of explanation in which one makes things intelligible by representing their coming into being as a particular instance of how things generally tend to happen' (McDowell, 'Functionalism and Anomalous Monism', 389, my emphasis).

30. Davidson, 'Mental Events', 222, 216.

31. There are good reasons for adding 'actually' and perhaps also 'now' operators to this. But I shall not go into these here, and they are independent of my present concerns.

32. I have heard the killer yellow example ascribed to Saul Kripke and Michael Smith. I do not know how either of them has used the example, however, and I can only apologize if I have distorted it or omitted the best bits.

33. I bracket here questions of what Putnam has called the 'division of linguistic labor'. It may be that individual users do not need such a conception, if others in the community, to whom they are prepared to defer, have one. So I talk here of what 'we' need. Our conception may itself be 'obscure and relative'—like a definite description of which we only later identify the satisfier.

34. See D. M. Armstrong, *A Materialist Theory of the Mind* (London: Routledge & Kegan Paul, 1968), ch. 12.

35. Abstracting from a number of contentious issues, I shall offer as a first elucidation of the notion of a physical property: 'a property that can be introduced in the language of physics'.

36. S. Kripke, *Naming and Necessity*, rev. edn. (Oxford: Blackwell, 1980), 128 n. 66. I take it here that Kripke means by 'physical property' a property introduced by the predicates of physics. He also says, however, that yellowness is 'a manifest physical property of an object' (128 n. 66; cf. 140 n. 71), and it would be possible to take 'manifest physical properties' to be something other than properties of physics: perhaps physical in a broad sense (part of the natural world) but also 'manifest' in the sense *fully open to view, fully grasped by anyone who understands the term*, so that colour would be a phenomenal property rather than one of physical science. This would make the view closer to the 'simple view' of John Campbell, the non-reductive realisms of Hacker, Stroud, and Putnam, and the view which I defend myself.

37. See P. F. Strawson and H. P. Grice, 'In Defence of a Dogma', *Philosophical Review*, 65 (1956), 141–58.

38. Note that even those who (like Lewis) advocate restricted type-identity must (if Grice and Strawson are right) allow that there is some property common, say, to Martians in pain and humans in pain, even if it is not what these theorists call 'pain'. This may be the property of being in a physical state which plays the role of pain for that kind of organism, and we can call it a second-order physical property if we like. But it should be noted that it is not definable in the language of physics alone, unless the specification of the higher-level *functional role* is itself definable in the language of physics—which there is reason to doubt. Some would take refuge at this point in a metaphysically charged use of the word 'property', designed not to apply to just any classification that people are capable of coherently effecting. But that still leaves the problem of making sense of a plurality of classifications, to replace that of making sense of a plurality of properties.

39. There are of course notable differences in these philosophers' attitudes to the constitutive principles. Lewis and Shoemaker, for example, believe that the significant interrelations between psychological states can be captured in *topic-neutral* causal terms (which yet are sufficient to form an individuating description of each such state), whereas Wittgenstein would not: the constitutive principles might themselves embody a particular 'point of view', the grasp of which was not available to just anyone. The idea of treating colour discourse in parallel to mental discourse can be found in Wittgenstein: 'The colour concepts are to be treated like the concepts of sensations.' (*Remarks on Colour*, III. 72.)

40. It is a great pity that the letter is omitted from Eastlake's translation, and even from some German collected editions of Goethe's works. The letter follows §920 of the *Didaktischer Teil* of Goethe's text (Munich edn., 264–71).

41. *Remarks on Colour*, III. 173; cf. Goethe, *Farbenlehre*, §582. Wittgenstein may have unconsciously remembered Goethe's comment, or he may have independently rediscovered it. In general Wittgenstein seems to have paid more careful attention to Runge's letter than to the rest of Goethe's text.

42. For parallels between the explanation of action and the explanation of perception (though he is not talking of colour in particular) see C. Peacocke, *Holistic Explanation* (Oxford: Clarendon Press, 1979), esp. ch. 1.

43. A further form of subjectivity lies in the fact that, in the case of ordinary psychological descriptions, the scheme employed by the theorist is also a scheme employed by the object of the theory: persons are in a special sense self-interpreting systems. This form of subjectivity clearly does not have a direct parallel in the case of colour.

44. Of course there are other senses of 'subjectivity' and 'objectivity' of which I am not here speaking. The particular combination of forms of subjectivity and objectivity which I propose receives a fuller defence in McDowell, 'Values and Secondary Qualities', and D. Wiggins, 'A Sensible Subjectivism?', in D. Wiggins, *Needs, Values, Truth* (Oxford: Blackwell, 1987).

45. A physical colour is defined by Westphal as 'the alteration of a complete spectrum'. A green object, for example, is 'an object which will absorb or darken almost all of any incident red light and reflect or not darken higher proportions of light of the other colours' (*Colour*, 84).

46. Exceptions include objects that change colour with temperature, those that fade in the light, and things like light-sensitive sunglasses. Fluorescent, iridescent, and glossy surfaces also need special treatment.

47. This is significant, for example, for Westphal's project of explaining why nothing can be red and green all over. The incompatibility is only a straight logical incompatibility, as Westphal wishes, if it is the incompatibility of an object's reflecting a low proportion of green light *but not of red light*, and also reflecting a low proportion of red light *but not of green light*. Without the italicized clauses, it would be open to someone to think an object could be both red and green, by being black.

48. Westphal's motive, I think, is that the results of subtractive colour mixing are more directly predicted from the former kind of information than from the latter (though, as we have seen in section 2, they will not be exactly predictable from colour information at all without recourse to spectral data). This of course does not show how ordinary people (as opposed perhaps to dyers) *think* of colours; and if Westphal is not making a claim at the level of thought (or Fregean sense), then there seems no reason for preferring his kind of characterization to an equivalent one in terms of colours reflected. As a matter of fact, grass actually reflects what one might well think a significant proportion of red light: approaching 80% at the extreme red end of the spectrum, as figure 11.2 illustrates. It none the less looks green partly because of the relatively low sensitivity of the eye at that point, and also because the effect of increasing by just a small amount the reflectance of the complementary colour red will only be to *lighten* or desaturate the green.

49. I talk of 'normal' white light, to count out, for example, light that is composed of two very narrow complementary bands around, say, 480 and 580 nm. Such light is phenomenally detectable for the reason that coloured objects illuminated by it look quite different from normal. A defence of the employment of the notion of normality must wait for another occasion.

50. I should perhaps make clear that the claim is that (all) surface colours are ways of changing the light, not that (all) ways of changing the light are surface colours. There will be some objects that change the light in ways that preclude our ascribing any simple colour to them—e.g. mirrors, highly metameric objects, oil films—except perhaps relative to a particular angle or position of view, or of illumination.

51. I describe the method to be employed in *The Nature of Colour*.

52. Here and elsewhere I employ some of the language and the doctrine of Gibson's ecological optics. See e.g. J. J. Gibson, *The Ecological Approach to Visual Perception* (first pub. 1979; Hillsdale, NJ: Lawrence Erlbaum, 1986), ch. 5 and pp. 97–9.

53. Cf. Strawson: 'there would be no question of counting any transient perception as a perception of an enduring and distinct object unless we were prepared or ready to count some different perceptions as perceptions of one and the same enduring and distinct object ... To see [a newly presented object] as a dog, silent and stationary, is to see it as a possible mover and barker, even though you give yourself no actual images of it as moving and barking' ('Imagination and Perception', in P. F. Strawson, *Freedom and Resentment and Other Essays* (London: Methuen, 1974), 52–3).

54. The phrase is Wittgenstein's (*Philosophical Investigations*, II. xi., p. 212). Strawson makes much of it in 'Imagination and Perception'.

55. 'Imagination and Perception', 53.

56. There are some interesting consequences of applying this outlook to the inverted-spectrum puzzles, but I cannot go into these here.

57. 'To about 5 per cent of all men, green and red are both indistinguishable from grey' (Hazel Rossotti, *Colour* (Harmondsworth: Penguin, 1983), 123). Such people have 'an inability to discriminate red, green and grey' (Hacker, *Appearance and Reality*, 151).

58. These are the cards devised by Shinobu Ishihara, Professor of Ophthalmology at the University of Tokyo, in 1917. Each card carries a circle made up, like a *pointilliste* painting, of small blobs of different colour. Normal trichromats will see one numeral in the pattern of blobs; the colour-blind, according to their pattern of non-discrimination, will see a different numeral, or sometimes none at all. More sophisticated tests are available now, though I have not seen them myself, and the Ishihara test is still rated as efficient in detecting red-green defects. My own deficiency is, I think, deuteranomaly.

59. There is another source of difficulty for the view that those with red-green anomalies lack normal colour concepts. They are said to be capable of recognizing variation in saturation and in brightness (obviously enough in, for example, the case of yellow and blue objects); they also (if they are not deuteranopes) see a full variation of spectral hues. But in that case, putting together the concepts of saturation, brightness, and hue, they ought to have a full conceptual grasp of the variation of colour within the red and green regions too—whatever their difficulties may be in recognizing it. There are more serious deficiencies of colour perception which result in certain spectral lights being seen as achromatic—which one would naturally suppose was bound to result in misapprehension of the hue circle. But there is still, even with such people, a real question (and I mean just that) whether they may none the less have learned our own colour concepts properly, by appreciating the abstract structure of colour space (which other people in the community can tell them about) and recognizing as much of their colour perception as is sound as the (more than usually fallible) presentation of *certain* colours in restricted regions of that space—which can serve as points of reference allowing them to 'place' other colours which they actually cannot see.

60. By contrast it is hard on the orthodox dispositional view to see any reason why colour-vision should have had adaptive value. Why on earth should our ancestors have evolved so as to be good at tracking the disposition of objects to cause a sensation of red in normal humans under normal circumstances? Human beings didn't even exist then!

61. And remember: 'If we taught a child the colour concepts by pointing to coloured flames, or coloured transparent bodies, the peculiarity of white, grey and black would show up more clearly.' (Wittgenstein, *Remarks on Colour*, III. 240.)

12 Phenomenal Character

Sydney Shoemaker

I

I have opposed, in various places, what I call the object-perceptual model of introspection (see Shoemaker, 1986). This is the view that introspective knowledge should be thought of as analogous to the sort of perceptual knowledge, in particular visually based knowledge, in which we know whatever facts we know by perceiving one or more objects and observing the intrinsic properties of these objects and their relations to one another. On this view of introspective awareness, awareness of mental particulars is primary and awareness of mental facts derives from this. I would like to hold, in opposition to this, that introspective awareness is awareness of facts unmediated by awareness of objects; awareness *that* unmediated by knowledge *of*.[1] In part, although by no means entirely, my opposition to the object-perception model is my opposition to the act-object conception of sensations and sensory experiences.

This issue is not, directly, the subject of the present paper. I mention it because it provides part of the background for the issues I shall be discussing. As will soon be apparent, there is a prima facie strain between my opposition to the object-perception model of introspection and my being what Frank Jackson calls a "qualia freak."

If we had only such intentional states as beliefs and desires to deal with, the view that introspective awareness is awareness of facts unmediated by awareness of objects would seem phenomenologically apt. My awareness of a belief just comes down to my awareness that I believe such and such. This goes with the fact that the properties of beliefs that enter into the content of such awareness seem to be primarily intentional or representational properties—the property of being a belief that such and such is the case—and include few if any of the "intrinsic" properties which, on the object-perception model, objects of perception ought to be perceived as having. But in the case of sensations, feelings, and perceptual experiences things seem to be different. While a few philosophers have recently maintained that the only introspectively accessible properties of these are intentional ones, I think that the majority view is still that these have a "phenomenal" or "qualitative" character that is not captured simply by saying what their representational content, if any, is.[2] There is, in the phrase Thomas Nagel has made current, "something it is like" to have them. It is commonly held, and has been held by me, that the introspectible features of these mental states or events include non-intentional properties, sometimes called "qualia," which constitute their phenomenal character and determine what it is like to have them. While these qualia are taken to be themselves non-intentional, or

non-representational, they are held to play a role in determining the representational content of experiences; *within* the experiences of a single person, sameness or difference of qualitative character will go with sameness or difference of representational contents. But it is held to be conceivable that in different persons, or the same person at different times, the same qualitative character might go with different representational contents. Then we would have a case of "inverted qualia." The classic case of this is John Locke's example of spectrum inversion, in which one person's experiences of red are phenomenally like another person's experiences of green, and vice versa, and likewise for other pairs of colors.

Qualia are often taken as paradigms of *intrinsic* properties. And insofar as our introspective awareness of sensations and sense experiences involves awareness of qualia, it may seem to satisfy one of the requirements of the object-perception model of introspection that is not satisfied by introspective awareness of beliefs and other intentional states, namely that it is in the first instance awareness of intrinsic properties of objects of the awareness. And there is in fact one conception of qualia which presupposes the object-perception model. Philosophers sometimes give as examples of qualia properties they call by such names as "phenomenal redness." This suggests a view according to which for each "sensible quality" S which we can perceive an external thing to have there is a property, phenomenal S-ness, such that perceiving an external thing to be S involves "immediately" perceiving, or in some way being directly aware of, an internal "phenonomenal object" which is phenomenally S. This is the much reviled sense-datum theory of perception. If we reject this, we are left with the question of what conception of qualia, and of introspective awareness of them, we can accept if we do not accept the version that goes with the sense-datum theory.

But this question is inextricably bound up with others. There are questions about the relationship between the phenomenal or qualitative character of experiences and their representational content. And, closely related to these, there are questions about the status of, and the nature of our awareness of, the so-called "secondary qualities" of external objects—for the identity of the latter seems in some way bound up with the phenomenal character of our perceptual experiences of them. These collectively make up what I shall call the problem of phenomenal character.

II

Wittgenstein said that "It shews a fundamental misunderstanding, if I am inclined to study the headache I have now in order to get clear about the philosophical problem of sensation" (Wittgenstein, 1953, I, 314). This is, I am afraid, an inclination I fre-

quently have when I think about philosophy of mind. But I am not entirely repentent about this. Wittgenstein was certainly right if he meant that studying one's headache is not likely to provide one with the solution to any philosophical problem about sensation. But while providing oneself with examples of the phenomenal content of experience won't provide the solution to the problems, it can help to make vivid what the problems are.

Another passage in Wittgenstein is pertinent here. He talks about the "feeling of an unbridgeable gulf between consciousness and brain process," which occurs when I "turn my attention in a particular way on to my own consciousness, and, astonished, say to myself: THIS is supposed to be produced by a process in the brain!—as it were clutching my forehead" (Wittgenstein, 1953, I, 412). The sense of mystery is all the greater, I think, if we replace "be produced by" in Wittgenstein's expostulation with "consist in," getting "THIS is supposed to consist in a process in the brain." Wittgenstein goes on to comment on how queer this alleged business of "turning my attention on to my own consciousness" is. But we can get much the same puzzle without any attempt to turn our attention inwards. I look at a shiny red apple and say to myself "THIS is supposed to be a cloud of electrons, protons, etc., scattered through mostly empty space." And, focussing on its color, I say "THIS is supposed to be a reflectance property of the surface of such a cloud of fundamental particles." Here we have, of course, the seeming disparity between what Wilfrid Sellars called the "manifest image," the world as we experience it, and what he called the "scientific image," the world as science tells us it is (see Sellars, 1963). How, one wonders, can the color one experiences be any part or aspect of what the best scientific theory tells us is out there?

And it is not only in the case of such properties as color that we can generate perplexity about this disparity without any problematic turning of attention onto one's own consciousness. For return to the case of pain. The headache, after all, is experienced as being in one's head, a part of one's body. To counteract any tendency to confuse the head and the mind, let's change our example—instead of attending to a headache, attend to the pain in a stubbed toe. One may well be inclined to say to oneself, incredulously, "THIS is supposed to be a neural process in the brain!" For many of us the perplexity this generates is not dissipated by Wittgenstein's attempt to show that such remarks are, in a philosophical context, a case of language gone on a holiday.

In the first instance, then, the problem of phenomenal character isn't really a problem about the objects of *introspective* awareness. At least in the case of color, taste, smell, etc. it is about the objects of *perceptual* awareness. The case of pains, itches, tickles, etc., is tricky. There is a well established tradition of regarding these

as mental entities, and that may make it seem that the awareness of them must be introspective. Yet, as I observed, we experience these items as being in one place or another in our bodies. Since the seventeenth century, at least, a prominent subtheme in discussions of these matters has been that despite differences in the way they are treated in ordinary language, pain and the secondary qualities are metaphysically on a par. In a few philosophers this has led to attempts to objectify pains—to construe them as states of the body which we perceive in having pain experience (See Graham and Stephens, 1985, and Newton, 1989). More commonly it has led to attempts to subjectify the secondary qualities—to construe them as features of sensations.

I will assume here that colors are where the contents of our visual experiences and our ordinary ways of talking place them—on the surfaces of physical objects, or in expanses of sky or water. Grass is green, the sky is blue, ripe tomatoes are red. But reflection on the disparity between the manifest and the scientific image makes inescapable the conclusion that, to put it vaguely at first, the phenomenal character we are confronted with in color experience is due not simply to what there is in our environment but also, in part, to *our* nature, namely the nature of our sensory apparatus and constitution. The intuition that this is so finds expression in the inverted spectrum hypothesis—it seems intelligible to suppose that there are creatures who make all the color discriminations we make, and are capable of using color language just as we do, but who, in any given objective situation, are confronted with a very different phenomenal character than we would be in that same situation, and it is not credible that such creatures would be misperceiving the world. But I think that the intuition is plausible independently of that. How *could* the phenomenal character we are confronted with be solely determined by what is in the environment, if what there is in the environment is anything like what science tells us is there? At the very least, the way things appear to us is determined in part by limitations on the powers of resolution of our sensory organs. And it seems obvious that it depends on the nature of our sensory constitution in other ways as well. There is good reason to think, for example, that the phenomenological distinction between "unique" and "binary" hues (e.g., ones like "pure" red, on the one hand, and ones like orange, on the other) is grounded in a feature of our visual system, and has no basis in the intrinsic physical properties of the objects we see as colored (see Hardin, 1988).

I have deliberatedly used the vague phrase "the phenomenal character we are confronted with," which leaves it unspecified what is supposed to *have* this phenomenal character—the external objects perceived, or our subjective experiences of them. And the problem is, in part, about how to eliminate this vagueness. Looking at the matter one way, the obvious solution is to put the phenomenal character in the experiences. This gets us off the hook with respect to the problem of reconciling

the manifest image with the scientific image, as the latter applies to the external objects—although it still leaves us, if we are materialists, with the problem of reconciling the manifest image, i.e., the phenomenal character, with what we think about the real nature of the mind itself. But, putting this latter problem on the side for now, locating the phenomenal character in the experiences seems to fly in the face of the phenomenology. For what seemed to pose the problem was the experienced character of redness, sweetness, the sound of a flute, and the smell of a skunk. And *these* are not experienced as features of sensations or sense-experiences; they are experienced as features of things in our environment.

If we insist on saying that the phenomenal character really belongs to experiences or sensations, it is hard to avoid the conclusion that our sense-experience systematically misrepresents its objects in the environment—that it represents them as having features that in fact belong to the experiences themselves. This is the view I have called "literal projectivism"—that we somehow project onto external objects features that in fact belong to our experiences of them.[3] But this seems, on reflection, to be unintelligible. I am looking at a book with a shiny red cover. The property I experience its surface as having, when I see it to be red, is one that I can only conceive of as belonging to things that are spatially extended. How could *that* property belong to an experience or sensation? Remember that an experience is an experiencing, an entity that is "adjectival on" a subject of experience. It seems no more intelligible to suppose that a property of such an entity is experienced as a property of extended material objects than it is to suppose that a property of a number, such as being prime or being even, is experienced as a property of material things. The literal projectivist view may seem more palatable if the projected properties are said to be properties of portions of the visual field (see Boghossian and Velleman, 1989). But that, if taken literally, amounts to a resurrection of the sense-datum theory, with all of its difficulties.

A different view is what I have called "figurative projectivism." This concedes that qualia, understood as properties of experiences, are not properties that could even seem to us to be instantiated in the world in the way in which colors, for example, are perceived as being. But it says that associated with each quale is a property that can seem to us to be instantiated in the world in this way—and that when an experience instantiates a quale, the subject perceives something in the world as instantiating, not that quale itself, but the associated property. The property is in fact not instantiated in the external object perceived, or in any other object—its seeming to be instantiated there is a result of how the perceiver is constituted. That is what makes the view projectivist. But the property also is not instantiated in the experiences of the perceiver—that is what makes the projectivism figurative. In fact, on

this view, the "secondary qualities" that enter into the intentional content of our experiences are never instantiated anywhere. They live only in intentional contents; in Descartes' terminology, they have only "objective" reality, never "formal" reality.[4]

This view has its own set of unattractive consequences. Like literal projectivism, it implies that our perceptual experience is incurably infected with illusion—that we cannot help but perceive things as having properties that they do not and could not have. In addition, while we can make sense of the idea of there being properties that are in some way represented in our experience but never instantiated in anything— e.g., the property of being a ghost—it is difficult, to say the least, to make sense of the idea that experienced color could be such a property. Granted that there are in fact no ghosts, we at least have some idea of what would *count* as someone veridically perceiving an instantiation of the property of being a ghost. But if we ourselves do not count as veridically perceiving the instantiation of redness-as-we-experience-it, I think we have no notion of what would count as veridically perceiving this.

Although it seems to me clearly unacceptable, figurative projectivism has some of the features which I think an acceptable account ought to have. It holds that the phenomenal character we are presented with in perceptual experience is constituted by some aspect of the representational content of our experience, thereby acknowledging the fact that we focus on the phenomenal character by focusing on what the experience is *of*. It holds that the properties that enter into this representational content, and in that way (i.e., by being represented) fix this phenomenal character, are not themselves features of our experiences—are not themselves qualia. But it holds that the qualia instantiated in an experience do determine the representational content that fixes the phenomenal character. Indeed, it holds that it is of the essence of any given quale that its instantiation by an experience makes a certain determinate contribution to that experience's representational content. But this is not to say that all aspects of the representational content of an experience are among the features that determine its qualitative character. For suppose Jack and Jill are spectrum inverted relative to each other. When both are looking at a ripe tomato, their experiences will be markedly different in phenomenal character, and so in one sense different in representational content—given that phenomenal character is determined by representational content. Yet I would want to say, and a figurative projectivist could agree, that the experiences of both represent the tomato, and represent it correctly, as being red. So the figurative projectivist need not say, and I think should not say, that redness is among those properties represented in our experience but not instantiated anywhere in the world, although he may want to say this of "redness-as-we-experience-it," on some understanding of that phrase. Further, the figurative projectivist would say, and I would agree, that despite the differences in phenomenal

character, and representational content, between the experiences of Jack and Jill, there is no sense in which the experience of one of them is more or less true to the objective nature of what is experienced, namely the tomato, than the experience of the other. They experience the tomato differently, but not in a way that makes the experience of one of them more or less veridical that the experience of the other. All of this I agree with. The question is how one can hold all this without going all the way with figurative projectivism and holding that the experiences of *both* Jack and Jill, each in a different way, misrepresent the tomato by representing it as having a property it does not have, and that, more generally, every visual experience represents its object as having properties that *nothing* in this world has?

Once these desiderata for a solution to the problem have been made clear, it begins to be clear what sort of solution it must have. How can the experiences of Jack and Jill represent the tomato differently and yet neither of them misrepresent it, given that the same information about its intrinsic nature is getting to both? This can only be because the different properties their experiences attribute to the tomato are *relational* properties. So the bare bones of the solution is this. Let Q1 be the quale associated with redness in Jack, and let Q2 be the quale associated with redness in Jill. There is a relational property consisting in producing or being disposed to produce experiences with Q1. And there is one that consists in producing or being disposed to produce experiences with Q2. Jack's experience represents the tomato as having the first of these relational properties, and Jill's experience represents it as having the second of them. And in fact it has both. Neither property is the property of being red, which is also attributed to the tomato by the experiences of Jack and Jill. So while the contents of their experiences have something in common (both represent the tomato as being red), they also differ in a way that does not involve either of them misrepresenting the tomato.

What, more specifically, are these relational properties? There are in fact a number of candidates. One pair that might seem to qualify consists of the property something has just in case it is producing in Jack an experience with Q1 and the property something has just in case it is producing in Jill an experience with Q2. Another consists of the property something has just in case it is apt to produce in Jack, under certain conditions, an experience with Q1, and the property something has just in case it is apt to produce in Jill, under these conditions, an experience with Q2. Other pairs are defined not with respect to the experiences of Jack and Jill specifically, but with respect to creatures having the sorts of sensory apparatus, or sensory constitutions, Jack and Jill have. Finally, there is a pair which consists in the property something has just in case it is currently producing an experience with Q1 in a subject appropriately related to it, and the property something has just in case it is

currently producing an experience with Q2 in a subject appropriately related to it. Our tomato has properties of all of these kinds, and each of these pairs of properties is such that Jack's experience could represent the tomato as having one member of the pair and Jill's experience could represent it as having the other member of the pair, without either experience misrepresenting it. If we give the name "phenomenal properties" to those properties of external things the representation of which constitutes the "phenomenal character" of experiences, then these different kinds of relational properties are candidates for being phenomenal properties; I shall return later to the question of which of them is the best candidate for this.

But it is bound to be objected that it cannot possibly be the representing of such *relational* properties as these that constitutes the phenomenal character of perceptual experiences. We do not, at least ordinarily, experience things *as* affecting our experience in certain ways, or *as* being apt to affect our experience in certain ways. The content of our experience is not relational in this way. Insofar as the difference between the experiences of Jack and Jill lies in what properties they ascribe to the tomato, it surely consists in what *monadic* properties they ascribe to the tomato.

But the way properties are represented in our experience is no reliable guide to what the status—as monadic, dyadic, etc.—of these properties is. Reflection shows that the relation *to the right of* is, at least, triadic, but do we experience it as such? And consider being heavy. What feels heavy to a child does not feel heavy to me. Reflection shows that instead of there being a single property of being heavy there are a number of relational properties, and that one and the same thing may be heavy for a person of such and such build and strength, and not heavy for a person with a different build and strength. But when something feels heavy to me, no explicit reference to myself, or to my build and strength, enters into the content of my experience. Indeed, just because one is not oneself among the objects of one's perception, it is not surprising that where one is perceiving what is in fact the instantiation of a relational property involving a relation to oneself, one does not, pre-reflectively, represent the property as involving such a relation. Thus it is that one naturally thinks of *to the right of* as dyadic.

Just as one's self is not among the objects one perceives, so the qualia of one's experiences are not among the objects, or properties, one perceives. And so these too are not explicitly represented in the content of one's experience. Does this mean that we are not introspectively aware of the qualia? Well, if I am right in my rejection of the perceptual model of introspection, we don't in any sense *perceive* them. But neither do we in any sense *perceive* the representational content, and the phenomenal character, of the experience. Introspective awareness is awareness *that*. One is introspectively aware that one has an experience with a certain representational content,

and with the phenomenal character this involves. And if one reflects on the matter, and has the concept of a quale, this brings with it the awareness that one's experience has the qualia necessary to bestow that content and that character. But it would be wrong to say either that one is aware of what the qualia are like or that one is not aware of what the qualia are like. In the sense in which there is something seeing red is like, there is nothing qualia are like (just as, in that sense, there is nothing electricity is like, and nothing apples are like). What is "like" something in this sense is an experience, sensation, or whatever, or perhaps the having of an experience or sensory state, and being like something in this sense is a matter of having phenomenal character, which in turn is a matter of having a certain sort of representational content. The relation of qualia to this phenomenal character is not that of *being* it, and not that of *having* it, but rather that of being constitutive determiners of it. The qualia are determiners of it in two ways. It is partly in virtue of having the qualia it does that the experience represents what it does; the qualia serve as "modes of presentation." And part of what it represents is the instantiation of a property, a "phenomenal property," which is in fact, although it is not explicitly represented as, the relational property of producing, or being apt to produce, experiences having these qualia.

This account needs qualia because it needs a way of typing experiences which not does consist in typing them by their representational contents. It needs this because only so can there be properties whose identity conditions are given by saying that things share a certain property of this type just in case they produce, or are apt to produce under certain conditions, experiences of a certain type. Such types can be called phenomenal types. Sameness of phenomenal type, and likewise phenomenal similarity, is a functionally definable relation (see Shoemaker, 1975a, 1975b, 1982 and 1991). Roughly speaking, the similarity ordering amongst the experiences in the repertoire of a creature corresponds to the similarity ordering amongst the associated stimuli that constitutes what Quine calls the creature's "quality space"; it is shown behaviorally by what discriminations the creature can make, by what sorts of conditioning it is subject to, what sorts of inductions it makes, and so on. Qualia will be the features of experiences in virtue of which they stand in relations of phenomenal similarity and difference, and belong to phenomenal types. It is usual to characterize qualia as being, among other things, nonintentional features of experiences. But if, as I have suggested, the properties represented by our experiences include ones that are constituted by their relations to the qualitative character of the experiences, qualia will be very intimately related to a kind of intentional property. If, for example, an experience having quale R represents its object as having a phenomenal property, call it R*, which something has just in case it is producing or apt to

produce R-experiences, then R will be necessarily coextensive with the intentional property an experience has just in case it represents something as having R* in a way that involves having R.[5]

To at least one reader there has seemed to be a "whiff of circularity" here. It is true that a particular phenomenal property is defined in terms of a particular quale—in my example, R* is defined in terms of R. And since it belongs to the functional role of the quale that it serves as a mode of presentation for the phenomenal property, there is a sense in which R is defined in terms of R*. But this seems to me an innocent circularity of the sort we can get around by what David Armstrong calls a "package definition," or, more technically, by the use of the Ramsey-Lewis method for defining theoretical terms. Certainly there is no circularity involved in saying that there is a pair of properties x and y such that the possession of x by an experience represents the possession by something of y, and the possession by something of y consists in its producing, or being apt to produce, an experience with x. By itself this will not provide a basis for defining any particular pair of properties, since there will be indefinitely many different pairs satisfying this description. But we can pin down one of these pairs by building more into the description. E.g., given the notion of phenomenal similarity, we might pin it down by saying that the experiences having x are phenomenally like those I have when I see a ripe tomato. There is no vicious circularity here. And while it is true that in virtue of having R an experience represents a property, R*, which is in fact a relational property that is defined in terms of R, this property is not represented *as* a relational property, and no reference to R enters into the content of the experience. Compare literal projectivism. According to it, an experience having R thereby represents an external object as having R; but although R is in fact a property of experiences, and is the very property whose possession by the experience gives it its representational content, it is not represented as being such. If, as I think, there is no circularity here (just implausibility), there is none in my account.

It is an important part of this view that what in the first instance we are introspectively aware of, in the case of experience, is its representational content. In this respect my view is similar to that of Gilbert Harman, who claims that the only introspectible features of experiences are their intentional or representational ones (see Harman, 1990). Harman does not recognize the special class of intentional features which according to me determine the phenomenal character of experiences, namely those that represent relational properties that an object has in virtue of producing or being apt to produce experiences with certain qualia. But let me focus for a moment on the point of agreement between him and me, namely that in the first

instance introspective awareness is of representational content, or what comes to the same thing, of intentional features. What are the reasons for saying this?

One reason is phenomenological. As I have said already, if asked to focus on "what it is like" to have this or that sort of experience, there seems to be nothing for one's attention to focus on except the content of the experience. Indeed, it may seem at first that there is nothing to focus on except the external object of perception e.g., the tomato one sees. Initially it may seem as though the question of what seeing the tomato is like can be none other than the question of what the visually detectable aspects of the tomato are. But then reflection makes one realize that one could be having the experience one does even if there were no tomato, and that there could be creatures whose experience of the tomato is different but who don't misperceive it. Even after this realization, however, one's attention remains fixed on the tomato— although now with the awareness that it doesn't matter, to the "what is it like" question, whether the tomato one sees is really there or is merely an intentional object. If one is asked to focus on the experience without focusing on its intentional object, or its representational content, one simply has no idea of what to do.

But this phenomenological fact goes with a fact about what our representational faculties are *for*, and what they presumably evolved to enable us to do. The most central fact about minded creatures is that they are able to represent aspects of their environment, both as they take it to be and as they want it to be, and to be guided by these representations of their environment in their interactions with it. In intellectually more sophisticated creatures the control over the world that is bestowed by this representational capacity is enhanced by a second order representational capacity—a capacity to represent their own first order representational states. But what this is in aid of is still effective representation of the environment (including the subject's own body). So it is not surprising that introspective awareness is keyed to representational states, and to the contents of these states.

III

Although I have focused on the example of visual experience, and in particular our experience of color, I think that what I have said can be applied to other sorts of perceptual experience—smell, touch, taste, and hearing. In all of these cases the phenomenal character of the experiences consists in a certain aspect of its representational character, i.e., in its representing a certain sort of property of objects, namely "phenomenal properties" that are constitutively defined by relations to our experience.

I think that the same account can also be extended to the case of pains, itches, and the like. When, for example, I have the experience I describe as a pain in my foot, my experience represents my foot as having a certain property. What property? The best available name for it is "hurting." This really is a property of my foot. But what it is for my foot to have this property is for it to cause me to have an experience having certain qualia. It is therefore a relational property. But I am not aware of it *as* a relational property, just as in my visual experience I am not aware of a red object *as* having a relational property defined in terms of a color quale. And my awareness of the quale of the pain experience, insofar as I am aware of it at all, is of the same sort as my awareness of the color quale; if you like, it is knowledge by description. What is primary here is a case of *perceptual* awareness—awareness of my foot as having a certain phenomenal property, namely hurting. Normally this goes with perceptual awareness of the foot that goes beyond awareness of it as having this property—e.g., feeling that it is bruised or cut. Going with this perceptual awareness of the foot hurting is introspective awareness *that* one is having an experience of one's foot hurting. And this should not be thought of as an inspection by inner sense of the quale which gives the experience this introspective character. There is no such inspection. The kinds of awareness there are here are, first, perceptual awareness of the foot, second, introspective awareness (which is awareness *that*) to the effect that one is having an experience which if veridical constitutes such a perceptual awareness, and, third, the theoretically informed awareness that the experience has qualia which enable it to have the representational content it has.

I maintain that there is a sense in which our color experiences, our tactual, gustatory, etc. experiences, and our bodily sensation experiences have the same structure. This should not be interpreted to mean that color words, words for odors and tastes, and words like "pain" and "itch," all have the same sort of semantics, or express the same kinds of concepts. I doubt, for example, that "red" and "bitter" have the same sort of semantics. Consider Jonathan Bennett's example of phenol-thio-urea, which tastes bitter to three-quarters of the population and is tasteless to the rest (see Bennett, 1968). If as the result of selective breeding, or surgical tampering, it becomes tasteless to everyone, I say it has become tasteless. And if more drastic surgical tampering makes it taste sweet to everyone, I say it has become sweet. But I don't think that if overnight massive surgery produces intrasubjective spectrum inversion in everyone, grass will have become red and daffodils will have become blue; instead, it will have become the case that green things look the way red things used to, yellow things look the way blue things used to, and so on. I think that our color concepts are, for good reasons, more "objective" than our concepts of flavors. Here the semantics of our terms reflects our interests. Our dominant interest in clas-

sifying things by flavor is our interest in having certain taste experiences and avoiding others, and not our interest in what such experiences tell us about other matters.[6] With color it is the other way around; the evidential role of color dominates such interest as we have in the having or avoiding of certain color experiences.

Despite the differences between "red" and "bitter," both name properties of objects of perception, properties things can have when no relevant experiencing is going on. "Pain" does not name such a property. And probably "hurts" does not. If someone reports that there is a pain in his foot, we do not say that he is mistaken if there is nothing wrong with his foot and his feeling of pain is induced by direct intervention in his brain. And probably we do not say he is wrong in this case if he says that his foot hurts—although someone who said this would not seem wildly out of line. We could have had a usage in which the truth-value of a pain ascription depends on what is going on in the part of the subject's body in which she reports feeling pain; and there are recessive tendencies in that direction in our actual usage, as is shown by our uncertainty about how to describe cases of "phantom limb pain." But here again, the actual semantics reflects our interests. We have a strong interest in pain experiences, namely in avoiding them and getting rid of them, which is independent of our interest (which of course is not negligible) in what they reveal about the condition of our bodies. And this interest provides a reason for having an economical way of reporting and expressing these experiences—a way more economical than saying "I *seem* to feel a pain in my foot." But the phenomenology of pain experience, and the aspects of our usage of "pain" that reflect it (i.e., our speaking of pains as located in parts of our bodies), does not go comfortably with our truth conditions for pain ascriptions. The experience we report by saying that we feel a pain in the foot or the tooth does represent something about the foot or tooth; but we make the condition of the foot or tooth logically irrelevant to the truth of the pain ascription. In any case, what is important for my present purposes is that the differences in the semantics of "red," "bitter" and "pain" should not hide the similarities there are between the structure of our experiences of color, taste, and pain. The seventeenth century writers who were fond of comparing the status of the "secondary qualities" to that of pain were on to something right.

IV

I now want to return to the case of color, and to the question of what relational property it is the representation of which bestows on a visual experience its phenomenal character. In other words, the question of which relational properties count as phenomenal properties. Earlier I was casual about this; I mentioned several

possibilities, and did not decide between them. The reason for my indecision is that none of the candidates is ideal. When I list my desiderata for a property the visual representation of which constitutes the phenomenal character common to my experiences of red thing, I find that some of the relational properties I mentioned satisfy some of these, and some satisfy others, but that none satisfies all.

What are these desiderata? First, the property should be one that can belong to the external objects we perceive as having colors. All of the candidates satisfy this. If we let R be the quale associated in my experience with redness, then the property of producing an R-experience in me, the property of being apt to produce an R-experience in me under such and such conditions, the property of being apt to produce an R-experience in someone with my sensory constitution under such and such conditions, and the property something has just in case it is currently producing an R-experience in a subject related to it in a certain way, are all properties that can belong to an external object and which normally *will* belong to an object I perceive as being red.

A second desideratum is that the properties should be of a kind such that where, intuitively, the color experiences of two subjects are phenomenally the same, the subjects are perceiving (or seeming to perceive) the same property of that kind, and that where the color experiences of two subjects are phenomenally different, they are perceiving (or seeming to perceive) different properties of that kind. Assuming the possibility of spectrum inversion, this would mean that the properties should be of a kind such that different perceivers can, under the same objective conditions, perceive the same objective thing, or things of exactly the same color, to have different properties of that kind, and perceive things having different colors to have the same property of this kind, this because of differences in their subjective constitutions. On the view of phenomenal character we are working with, these two differences are what the possibility of "spectrum inversion" comes to. Here a number of our candidates fail. Properties defined with respect to a particular subject, such as being disposed to produce R-experiences in me, cannot be perceived by other subjects in the way they can be perceived by that one; and so the perceiving of the same ones of these cannot go with having experiences the same in phenomenal character. Likewise, properties defined with respect to creatures with a particular sensory constitution cannot be perceived by creatures with other sensory constitutions in the way they can be by creatures with that constitution. Yet subjects who are spectrum inverted relative to each other will differ in their sensory constitutions—and such inversion requires that, for example, the experiences the one subject has in viewing red things be phenomenally like those the other has when viewing green things. Of our candidates, the only properties that satisfy this desideratum are the relational

properties things have in virtue of actually causing experiences of certain sorts, e.g., the property something has just in case it is currently producing an R-experience in someone related to it in a certain way. Subjects who are perceiving the same properties of this kind will be having color experiences that are phenomenally alike.

Another desideratum is that the properties should be ones that one can perceive something *not* to have by perceiving it to have an incompatible property of the same sort, in the way one can perceive something not to be red by perceiving it to be green. The properties that failed the last test pass this one nicely—e.g., I can perceive that something is not apt to produce R-experiences in me in these conditions by perceiving that it is apt to produce G-experiences in me in these conditions (where G is the quale associated in me with the color green). But the properties that passed the last test fail this one. If I am not perceiving something to have the property *is producing an R-experience in a viewer*, and am instead perceiving it to have the property *is producing a G-experience in a viewer*, I am not thereby perceiving it to lack the first of these properties—for it may be producing G-experiences in someone else while it is producing R-experiences in me.

To make matters worse, there is another desideratum that is not satisfied by several of our candidates. This is that the properties should be ones that things can have when they are not being perceived. This is failed by the candidate that, all things considered, I prefer, namely *is producing an R-experience in a viewer*, i.e., the property something has just in case it is producing a R-experience in someone appropriately related to it.

So, unless I have overlooked something, there is no ideal candidate. What is to be done? Unless we decide that the whole approach I have been pursuing is off on the wrong foot, our best course would seem to be to see if we can maintain that some of the desiderata do not have to be honored. The first two desiderata seem to me not negotiable. But it is arguable that the last two seem compelling because we conflate two different elements in the representational content of our experiences, which we do because the experience itself does not distinguish these. If I am right, a color experience represents an object as having a "phenomenal" property that is constituted by a relation to sense-experience—and it is the representation of this property that gives the experience its phenomenal character. The experience *also* represents the object as having a certain color. The second of the represented properties, the color, does of course satisfy the last two desiderata—it is a property one can observe something to lack by observing it to have an incompatible property of the same kind, and it is a property something can have when unobserved. Conflating the first property with this one leads to the mistaken view that it ought to satisfy these desiderata; failing to distinguish the phenomenal property from the color, we think that the phenomenal

property, like the color, should be such that we can perceive something to lack it, and such that something can have it when it is not being perceived. Once we see the need to distinguish these properties, we are free to take the phenomenal property to be what I say it is, namely the property of producing an experience with a certain quale in something related in such and such a way to the possessor of the property.[7]

I have just said that one's experience of, e.g., a ripe tomato represents it both as having a certain color and as having a certain phenomenal property, and that these two properties are conflated in the content of the experience. But these are not independent and separable aspects of the experience's content; rather, the experience represents the color *by* representing the phenomenal property. To put it otherwise, we see the color of a thing *by* seeing a phenomenal property it presents.[8] Since we are not in fact subject to intrasubjective spectrum inversion, in the experience of any particular person the seeing (or seeming to see) of a particular color invariably goes with the seeing (or seeming to see) of a particular phenomenal property. And since colors and their associated phenomenal properties go together in this way, it takes philosophical reflection, of the sort I have been engaged in here, to distinguish them.

Admittedly, the view that there is this two-fold character to the representational content of experiences is prima facie counterintuitive. But the alternatives are much worse. One alternative is to accept one of the versions of "projectivism" distinguished earlier: literal projectivism, which says that our color experiences ascribe to external things properties that in fact belong only to our experiences, and figurative projectivism, which says that our color experiences ascribe to external things properties that in fact belong to nothing. I have already said what I have against those views. Another alternative is to hold that the phenomenal character of experiences consists in their representational content, but that none of the properties they represent are in any way constituted by their relations to our experience. This view has no explanation to give of the seeming discrepancy between the world as we experience it and the world as science says it is. It makes no provision for cases in which experiences having the same "objective" representational content differ in phenomenal character. And it has the unpalatable consequence that the closest we can come to a case of spectrum inversion is a case in which someone systematically misperceives all of the colors. Another alternative is to hold that there are qualia which give experiences their phenomenal character, and that we have a direct, quasi-perceptual, introspective awareness of them. This, if divorced from literal projectivism, seems false to the phenomenological facts. As noted earlier, there seems to be no way to attend to the phenomenal character of one's experience other than by attending to putative objects of one's experiences—to the things one sees, hears, feels, etc., or

at least seems to see, hear or feel, and to the properties one perceives, or seems to perceive, those things as having.[9]

As David Lewis likes to emphasize, every philosophical position has its costs. The costs of the views just surveyed seem to me far too much to accept. I have just been talking about one of the costs of my own view; in order to explain away its failure to satisfy one of the desiderata, we are required to say that our experiences represent different properties that they do not distinguish. This is similar in a way to another cost mentioned earlier: the account requires us to say that our experiences represent the instantiation of what are in fact relational properties, without representing these properties *as* relational properties. What are the benefits that outweigh these costs? First, the view is tailor made to fit the phenomenological facts. It puts the phenomenal character of experiences in their representational content. But it does this in a way that does justice to the intuition that how we experience the world is partly due to our sensory constitution, and the intuitions that have led philosophers to insist that there are qualia. And it does it without implying that our experience is systematically illusory.

Acknowledgments

Some of the material in this paper formed part of my Royce lectures, delivered at Brown University in October, 1993. Earlier versions of this paper were read at King's College, London, and Cornell University. I am grateful to the audiences on those occasions for helpful comments and suggestions. I am also grateful to David Robb, Michael Tye, and referees for *Noûs* for very helpful written comments.

Notes

1. A similar view is expressed in Dretske, 1993.

2. For the view that all introspectively accessible features of experience are intentional, see Gilbert Harman, 1990. There are similar views in William Lycan, 1987, and Michael Tye, 1991. The view advanced in the present paper can be seen as an attempt to reconcile the intuitions behind this view with belief in "qualia."

3. See Shoemaker, 1990. The view I call literal projectivism has recently been advocated in Perkins, 1983, and Boghossian and Velleman, 1989.

4. Such a view is suggested by Barry Stroud's formulation of the "theory of secondary qualities" in Stroud, 1977, pp. 86–87. It also seems to be the view of John Mackie in Mackie, 1976. Although in some passages the view Mackie attributes to Locke, with approval, seems to be literal projectivism, in the end it seems closer to figurative projectivism. For, on Mackie's reading, the resemblance thesis Locke affirms for primary qualities and denies for secondary qualities says, not that our ideas resemble things in the world with respect to their intrinsic natures (this is held to be false for the ideas of *both* sorts of qualities), but that the way external things are represented in our ideas resembles the way they actually are. Given that

the rejection of this thesis as applied to secondary qualities and their ideas does not reduce to the rejection of the first resemblance thesis (that which is rejected for secondary and primary qualities alike), it amounts to figurative projectivism. There is a more recent expression of figurative projectivism in Averill, 1992—the "sensuous colors" that he says our experiences attribute to objects are not, he says (p. 569), instantiated "in any physically possible world."

5. Suppose that someone has a remarkable perceptual sensitivity such that just by looking at someone viewing a red object she can see whether that object is producing in that person an R-experience, or just by looking at an object she can see whether it is apt to produce R-experiences in persons with a certain sort of perceptual system, even though she herself does not have that sort of perceptual system and is incapable of having R-experiences. It would seem that that person could have an experience with the intentional property *represents something as having R**, but lacking the quale R. If this case is possible, it will hardly do to say that it is the possession of this intentional property that confers on the experience its phenomenal character. (I owe this objection to Michael Tye.) What this example shows is the need to distinguish between intentional properties that are "reference-individuated" and ones that are "sense-individuated." (I make this distinction is Shoemaker, 1990). If Jack is someone whose experience represents something as being R* in virtue of having quale R, and Jill is someone with the remarkable perceptual sensitivity just imagined, then when both perceive something to be R* their experiences will share the reference-individuated property *represents something as having R**. But the senses, or modes of presentation, by means of which R* is represented will be different, and Jill's experience will not have the sense-individuated intentional property that Jack's experience has. It is those sense-individuated intentional properties whose possession essentially involves having certain qualia that confer phenomenal character.

6. Presumably our senses of taste and smell evolved, not to enhance the aesthetic quality of our lives, but to provide us with information about external objects that is pertinent to our survival. So if, as I suggest in the text, the semantics of our taste concepts and experiences is now tied more closely to the qualitative character of the experiences than to the objective information they provide, it would appear that the semantics has changed (here I am indebted to Bill Lycan). This does not seem to me an objection to my suggestion, but it does show that my suggestion is incompatible with the view that evolutionary function is the sole determiner of the representational content of experiences.

7. In virtue of what does an experience having a quale represent an object as having a particular phenomenal property, if phenomenal properties are what I say they are? It cannot do so in virtue of a causal relation between the experience and the property it represents—one cannot say that the causing of A by B is the (or a) cause of A (here I am indebted to David Robb). And of course I have ruled out the view that the content of the experience picks out the property by encoding a description, involving reference to the quale, which the property uniquely satisfies. I have no fully satisfactory answer to this question (which is hardly surprising, given that no one has a fully satisfactory account of how any experience has the representational content it has). But I think that my account fares well, in this respect, with its main competitors—literal projectivism and figurative projectivism. All three accounts hold that our color experiences represent properties that satisfy my "second desideratum": the properties are held to be of such a kind that where the color experiences of two creatures are phenomenally the same, the experiences represent the same property of that kind, and where they are phenomenally different they represent different properties of that kind. Neither sort of projectivism has any explanation to give of how it is that an experience represents the property which the projectivist theory says it represents. Literal projectivism says that the property represented is a quale belonging to the experience itself; but the fact that an experience *has* a property is certainly no explanation, by itself, of how it is that it is *that* property that it represents some other thing as having. Figurative projectivism says that the represented property is one that is instantiated nowhere; and so far as I can see, it offers no account of what makes an experience represent the particular uninstantiated property it does. Where my account has an edge over these theories is that the properties it says are represented satisfy the first desideratum as well as the second; they are properties the things represented actually have (in normal circumstances), even though the contents of the experiences do not tell the whole truth about them (in particular, do not say that they are relational). And if phenomenal properties as I construe them are the only properties that satisfy both of the first two desiderata, it seems to me that that should count as at least a partial explanation of how it is that our experiences represent these properties.

8. Here again I am indebted to David Robb.

9. As a referee pointed out, one can attend to a color without attending to what it is the color of, and can imagine a color without imagining any colored object. But even in these cases the property that is the object of the attending or imagining is external in the sense that to perceive or imagine it as being instantiated is necessarily to perceive or imagine it being instantiated in something external. I do not believe that after-images are a counterexample to this. If one "sees a red after-image" the property of redness enters into the intentional content of one's experience; but the experience is not veridical, and one is not perceiving the actual instantiation of redness in something, either external or internal.

References

Averill, Edward. (1992) "The Relational Nature of Color." *Philosophical Review*, 101, 3, 551–588.

Bennett, Jonathan. (1968) "Substance, Reality and Primary Qualities." In C. B. Martin and D. M. Armstrong (eds), *Locke and Berkeley, A Collection of Critical Essays*. New York: Anchor Books.

Boghossian, Paul, and Velleman, David. (1989) "Color as a Secondary Quality." *Mind*, 98, 81–103. [chapter 7, this volume]

Dretske, Fred. (1993) "Conscious Experience," *Mind*, 102, 263–281.

Graham, George, and Stephens, Lynn. (1985) "Are Qualia a Pain in the Neck for Functionalists?". *American Philosophical Quarterly*, 22, 2, 72–80.

Hardin, C. L. (1988) *Color for Philosophers: Unweaving the Rainbow*. Indianapolis, Indiana: Hackett Publishing Company.

Harman, Gilbert. (1990) "The Intrinsic Quality of Experience." In James Tomberlin (ed.), *Philosophical Perspectives, 4, Action Theory and Philosophy of Mind*, 31–52.

Lycan, William G. (1987) *Consciousness*. Cambridge, Mass.: Bradford-MIT.

Mackie, J. L. (1976) *Problems From Locke*. Oxford: Oxford U.P.

Newton, Natika. (1989) "On Viewing Pain as a Secondary Quality." *Noûs*, 23, 5, 569–598.

Perkins, Morland. (1983) *Sensing the World*. Indianapolis, Indiana: Hackett Publishing Company.

Sellars, Wilfrid. (1963) "Philosophy and the Scientific Image of Man." In *Science, Perception and Reality*, London: Routledge & Kegan Paul.

Shoemaker, Sydney. (1975a) "Functionalism and Qualia." *Philosophical Studies*, 27, 291–315.

——(1975b) "Phenomenal Similarity." *Critica*, 7, 20, 3–34.

——(1982) "The Inverted Spectrum." *Journal of Philosophy*, 79, 7, 357–381.

——(1986) "Introspection and the Self." *Midwest Studies in Philosophy*, X, 101–120.

——(1990) "Qualities and Qualia: What's in the Mind?" *Philosophy and Phenomenological Research*, 50, Supplement, 109–131.

——(1991) "Qualia and Consciousness." *Mind*, 100, 4, 507–524.

Stroud, Barry. (1977) *Hume*. London: Routledge & Kegan Paul.

Tye, Michael. (1991) *The Imagery Debate*. Cambridge, Mass.: Bradford-MIT.

Wittgenstein, Ludwig. (1953) *Philosophical Investigations*. Translated by Elizabeth Anscombe. Oxford: Blackwell.

13 Explaining Objective Color in Terms of Subjective Reactions

Gilbert Harman

I am concerned with attempts to explain objective color in terms of subjective reactions so I had better begin by saying what I mean by "objective color" and what I mean by "subjective reactions."

By "objective color" I mean the color *of an object*, in a very broad sense of "object" that includes not only apples and tables but also the sky, a flame, a shadow, and anything else that has color. So, objective color in this sense includes the red of an apple, the blue of the sky, the yellow of a flame, the purple cast of a shadow, and so forth.

By "subjective reactions" I mean a normally sighted perceiver's subjective impressions of color: how color looks. A person blind from birth might learn that objects have colors and might in some sense have subjective reactions to color, but not the sort of subjective reactions I mean.

I will be concerned both with the sort of explanation of color and the relevant subjective reactions to color that are available to normally sighted perceivers and with the sort of explanation that is available to others, including those who cannot have the relevant subjective reactions themselves.

1 Why Objective Color Should Be Explained in Terms of Subjective Reactions

Many salient facts about color cannot be explained purely in terms of properties of the surfaces of colored objects. We need also to appeal to the biology and psychology of color perception. These facts include red's being closer in color to blue than to green, even though the frequency of pure red light is farther from that of pure blue than from pure green. Related to that fact is the circular structure of hues, as opposed to the linear structure of relevant light frequencies. There is also the way in which colors can be organized in terms of three polar contrasts, white-black, red-green, and blue-yellow. These aspects of color are due to facts about the biology and psychology of color perception rather than to facts about the structures of surfaces.

Shepard (1992, 1993) offers an evolutionary explanation of the biological and psychological facts by noting that natural illumination from the sun varies in three independent respects: (1) in amount of total overall illumination, (2) in relative amount of longer red wavelengths (depending on the sun's angle), and (3) in relative amount of shorter blue wavelengths (depending on whether illumination is directly from the sun or indirectly from light scattered by the atmosphere). (If the red wavelengths are removed from sunlight, the remaining wavelengths center on green. If the blue wavelengths are removed instead, the remaining wavelengths center on yellow.)

Given these sorts of variation in natural illumination, a visual system structured like ours, in which light is analyzed in terms of white versus black, red versus green, and yellow versus blue, will be able to achieve a kind of constancy in colors attributed to objects, a color constancy that Shepard sees as having evolutionary benefits.

Shepard's evolutionary account contrasts with the suggestion in Dennett (1991) that human color perception and the colors of natural objects have evolved together. But Shepard's proposal explains facts of color perception not accounted for by Dennett's suggestion. In what follows, I will assume Shepard is basically right.

In any event, it would seem that we have to explain facts about objective color in terms of facts about perceivers (Gold 1993).

One simple way to do so identifies an object's being a particular color C with its tendency to be perceived as C by normal observers viewing it under standard lighting conditions. Various complications arise here, for example, concerning chameleons that change color when looked at (Johnston 1992). I want to disregard those (significant) issues in order to try to say more about the relevant subjective reaction, "perceiving something as C."

2 Color Sensations

Some authors call the relevant subjective reactions "color sensations." A normal viewer's perception of a red object in adequate lighting provides the viewer with "red color sensations." Some authors (Shoemaker 1981; Peacocke 1983) use the term "color qualia" in much the same way that other writers use the term "color sensations." I will argue below (section 4) that talk of color sensations is misleading in important respects, but let me use that terminology for the time being.

In these terms, a blind person does not in the normal way obtain color sensations from the perception of objects. Someone blind from birth may never have experienced color sensations. Such a person would normally not know what it is like to have such sensations.

Red color sensations are not red in the same sense in which red apples are red. We might say that red apples are red in the sense that they tend to produce certain reactions when viewed by perceivers. But red color sensations are not red in that sense. Red sensations cannot be viewed and they are (supposed to be) the relevant reactions, not the causes of the reactions.

To avoid possible confusion, some authors use a symbolism that distinguishes these senses of the word *red*, for example, distinguishing the word *red* from the

word *red'* and saying we have *red'* color sensations rather than red color sensations (Peacocke 1983).

One problem is to say how these senses are related.

2.1 Objective Color Explained in Terms of Color Sensations

It may seem that the most obvious way to relate the two senses of color terms along the lines of the suggested reduction of objective color to subjective reactions is to try to define the colors of objects in terms of the color sensations they produce in observers: An object is red if and only if perception of it would give normal perceivers *red'* sensations under standard viewing conditions.

A number of issues arise here. What makes a perceiver a normal perceiver? What determines standard viewing conditions?

Circularity must be avoided. A normal perceiver cannot be defined as one who gets the right sensations from colored objects, nor can standard viewing conditions be defined as those in which normal perceivers get the right sensations.

One possible approach simply asserts that there are objective criteria of normalcy N and objective criteria of standardness S such that an object has color C if and only if perception of it by perceivers who are N in conditions that are S would produce C color sensations. Let us suppose for the sake of argument that such criteria exist. (A full account would have to investigate the criteria S and N.)

2.2 Color Sensations as Basic

A further issue concerns the nature of color sensations. What are they and what makes a sensation that sort of color sensation that it is?

Many authors (e.g., Nagel 1974) believe that no purely scientific account of color sensations is possible. In their view, the essence of such sensations is precisely their subjective "qualitative" character. They believe that there is no way to describe this qualitative character in purely scientific terms so that it would be fully understood by someone who had never experienced the sensation firsthand; someone who has never experienced a *red'* sensation cannot know what it is to have such a sensation.

In their view, the notion of a *red'* sensation is the notion of a sensation "like this," where "this" refers to a sensation that one is actually experiencing or imagining.

Since in this view the redness of an object is its power to produce *red'* sensations in perceivers, it follows that someone who has never experienced a *red'* sensation cannot fully understand what it is for an object to be red. A red object is an object with the power to produce sensations "like this" in perceivers. Someone who never

experiences a red' sensation is never in a position to be able to identify red objects as objects with the power to produce sensations "like this."

I postpone discussion of what conception of color and color sensations might be available to someone who has never had such experiences.

2.3 Variations in Color Sensations

It is interesting to consider the possibility that different people might have relevantly different sorts of sensations when perceiving objects that they call "red."

This possibility may seem quite likely, (1) if the relevant aspect of a sensation is its intrinsic qualitative character, (2) if the intrinsic qualitative character of a sensation depends on the exact nature of the underlying physical events in the brain giving rise to the sensation, and (3) if there are differences in these underlying physical events from one brain to the next (Block 1990, pp. 56–57).

The suggested analysis of objective color in terms of sensations implies that if there are relevant differences in people's color sensations, then different people have different concepts of the colors of objects and do not mean the same thing by their color terms. They do not mean the same thing by "red," "green," etc. even though they use the terms in exactly the same way of exactly the same objects, at least as far as their outer usage is concerned.

For George, an object is red if and only if it has the relevant power to produce sensations "like this" in normal perceivers, where George refers to the kind of sensation that he gets from viewing red objects. For Mary, an object is red if and only if it has the relevant power to produce sensations "like this" in normal perceivers, where Mary refers to the kind of sensation that she gets from viewing red objects. If George and Mary get different sorts of sensations from viewing red objects, they mean different things when they say that an apple is "red," in this view.

This is actually a pretty strange consequence: that people might mean different things by their words even though they use them in the same way with respect to objects in the world. But a further consequence is even stranger. Given the hypothesis that people do get different kinds of color sensations from objects they call "red," the suggested analysis implies that no objects have any colors (Block 1990, p. 56)!

According to the analysis, an object is red if and only if it has the power to produce sensations "like this" in normal perceivers viewing the object in standard viewing conditions. But, by hypothesis, no object has that power. A ripe tomato may have the power to produce sensations "like this" in me under those conditions, but it does not have the power to produce sensations of that sort in all other normal perceivers viewing the object in standard conditions. By hypothesis, viewing a ripe tomato produces different kinds of sensations in different, otherwise normal, per-

ceivers. So, the analysis we are considering implies that a ripe tomato has no color, given that hypothesis.

So we have two absurd results. First, different people mean different things by their color terminology even when they use the terminology in the same way of external objects. Second, when people use color terminology to say that external objects are "red," "blue," or whatever, what they say is always false.

To avoid such absurd results, we must either abandon the suggested analysis of objective color or rule out the possibility that different perceivers get different sorts of color sensations from viewing objects called "red."

3 Functional Definitions of Color Sensations

The discussion so far has assumed that it is possible to fix on a kind of sensation by attending to it and intending to include in that kind of sensation anything "like this." But a sensation that occurs on a particular occasion can be classified in infinitely many ways and is therefore an instance of many different kinds of sensation. The sensation itself does not determine a single kind or type of sensation. Saying that red objects are objects with the power to produce sensations "like this" is not yet to say what type of sensations red objects have the power to produce, since there are infinitely many different ways in which sensations can be "like this." It is necessary also to say in what respect sensations have to be "like this" in order to count as "red' sensations."

It would be wrong to say that a sensation has to share every aspect of "this sensation" if it is to be "like this," for then no other occurrences would count. There are always some differences among sensations: they occur at different times, have different causes, different effects, occur to different people, and so forth. Not all these differences are important. For example, the fact that "this sensation" is a sensation of mine distinguishes it from all sensations of other people, but that had better be irrelevant to its being a red' sensation if anyone else is to be able to have a red' sensation.

What is needed is a way of classifying sensations so that the sensations normal observers have on viewing a given color normally fall under the same classification, even if, according to some other way of classifying sensations, people have different sorts of sensations from viewing a given color.

One approach to solving the problem of type specification appeals to a "functional definition" of the relevant type of sensation in terms of typical causes and effects (Armstrong 1968; Lewis 1966). For example, the sensations classified as pains are those that are typically caused by tissue damage or extremes of pressure or heat applied to some location in one's body and that typically have as effects the belief

that something undesirable is occurring at the relevant bodily location and the desire to be free of the occurrence.

A first stab at a functional definition of color sensations might suppose that they are typically caused by the perception of appropriately colored objects and that their typical effects are beliefs that perceived objects have the appropriate colors. So, a red' sensation would be a sensation that is typically caused by the perception of red things and that typically leads to the belief that one is perceiving something red.

Various worries can be raised about this account and more needs to be said. If it could be made to work, the suggested account would avoid some of the problems raised about the previous account. The account would not have to suppose that differences in the brain events that underlie color sensations mean that different, otherwise normal, perceivers have relevantly different sensations from the perception of the same objects. If you and I are both normal color perceivers, we will both receive red' sensations from the perception of ripe red tomatoes. What we mean by "red object" (namely, "object with the power to produce red' sensations ...") will be the same if we use the word in the same way of external objects, even if our red' color sensations differ in their detailed neurophysiological realizations.

However, when a functional account of color sensations is combined with an explanation of objective color in terms of color sensations, the resulting account of objective color is circular. It reduces to the claim that red objects are those that produce the sort of sensation that red objects produce. This is not only to explain the notion of objective color in terms of itself but to do so in a way that is almost completely empty.

4 Complication: There Are No Color Sensations

Before addressing the problem of circularity, it is necessary to clear up a point we have been so far ignoring, namely, that it is wrong to describe color impressions as color "sensations."

Normally, we use the term "sensation" for bodily feelings. Usually sensations have a more or less definite location in one's body—a headache, a pain in one's foot, butterflies in the stomach, etc. There are also other cases, such as a sensation of dizziness.

But the perception of color does not normally involve sensations in any ordinary sense of the term "sensation." When someone literally has visual sensations, they are pains or other feelings in the eye, resulting from overly bright scenes, perhaps, or itching from allergies or minor eye injuries. Color perception does not normally involve such sensations. On seeing what appears to be a ripe tomato, one does not

feel a sensation of red in one's eye, nor is there literally a sensation or feeling at the location at which the tomato looks red.

How then should we think of perceptual experience, if not as involving visual sensations?

4.1 Representational Character of Perceptual Experience

One important point is that perceptual experience has a certain presentational or representational character, presenting or representing the environment in a certain way. When it looks to you as if you are seeing a ripe tomato, your perceptual experience presents or represents the environment as containing a red and roughly spherical object located at a certain distance and orientation "from here."

When you think about visual representation, it is very important to distinguish (a) qualities that experience represents the environment as having from (b) qualities of experience by virtue of which it serves as a representation of the environment. When you see a ripe tomato your visual experience represents something as red. The redness is represented as a feature of the tomato, not a feature of your experience.

Does your experience represent this redness by being itself red at a relevant place, in the way that a painting of a ripe tomato might represent the redness of the tomato with some red paint on the appropriate place on the canvas? No. That is not how visual representation works.

Does your experience represent this redness by having at some place some quality other than redness, a quality of red'ness, which serves to represent the redness of the tomato in some other way, different from the way in which a painting might use red paint to represent a tomato? Well, who knows? You have no conscious access to the qualities of your experience by which it represents the redness of the tomato. You are aware of the redness of the represented tomato. You are not and cannot become consciously aware of the mental "paint" by virtue of which your experience represents the red tomato.

It follows that your concept of a red object cannot be analyzed into your concept of a red' experience, meaning the specific quality that your perceptual experience has in order to represent objective redness, because you have no such concept of a red' experience. You have no idea what specific quality of your perceptual experience is used to represent objective redness. You only have the concept of objective redness!

4.2 The Concept of Color

In fact, your color *concepts* are almost certainly basic and not analyzable in causal terms. You perceive colors as simple primitive features of the world, not as dispositions or complexes of other causal features.

(Maybe some color concepts like *orange* can be analyzed in terms of concepts of primary colors, like *red* and *yellow*. And maybe some color concepts like *brown* can be analyzed in terms of hue, brightness, and saturation. I am not concerned with such internal analyses. I am concerned only with analyses of color in external terms, especially causal terms.)

Now, a scientific explanation may involve an analysis of something without claiming to be analyzing an ordinary concept. For example, when a scientific explanation of facts about the circle of hues treats color as a tendency to produce certain responses in perceivers, it is not offering that analysis of color as an account of the perceptual concept of color. The perceptual concept of color can be quite simple even if color itself is a complex phenomenon.

Of course, it would be useful to give an account of what it is *to have* a basic perceptual concept like the concept of redness, an account that might even be understood by someone lacking that basic perceptual concept. A congenitally blind person can understand that a normal color perceiver might have a basic perceptual concept of redness, for example. And normal color perceivers can understand that there may be animals or other alien creatures with basic perceptual concepts that humans do not have. To this end, we might try to provide a functionalist account of what it is for perceptual experience to have a given perceptual concept.

Now, in general, perceptual experience represents the environment in ways that enable a perceiver to negotiate paths among objects, to locate desired things and to avoid undesired things. Normally and for the most part, a perceiver accepts his or her (or its) perceptual representation, believing that things are as they appear, although the strong disposition to acceptance can be inhibited on special occasions.

The perceptual concept of red figures as part of the perceptual experience of red objects, enabling a perceiver to identify and reidentify objects as red. In other words, if a perceptual concept is a concept Q such that one has perceptual experiences of something being Q, then (roughly speaking) we can say that the concept Q is the concept of redness if perception of red things tends to produce experiences of something being Q.

But we must be careful to avoid circularity. Recall that we have been supposing that red is a tendency to produce perceptual reactions of a certain sort. We have seen that it is incorrect to describe the relevant reactions as sensations. Suppose then that we take the relevant reactions to be experiences with a certain representational or presentational content. If the relevant representational or presentational content is then identified functionally, we seem to be identifying redness as a property R, where R is a tendency to produce experiences that represent something as Q, where Q is the concept produced by perception of R things. That characterization is circular and does not distinguish red from green, for example.

Sosa (1990) points out that we can avoid circularity if we *use* the normally sighted person's primitive perceptual concept of red objects in our account. Then we can say that something is red if and only if it has a property R, where R is a tendency to produce experiences that represent something as *Q*, where *Q* is the concept produced by perception of *red* things, where here we are using the primitive perceptual concept *red*.

Of course, a person lacking that perceptual concept of *red* could not avoid circularity in the way Sosa suggests. Nor could normal human perceivers use that approach to provide noncircular accounts of animal or alien perceptual concepts that do not correspond to human perceptual concepts.

One noncircular account that might be useful to those lacking the relevant perceptual concepts would identify color in terms of *biological* mechanisms of color perception, perhaps via the evolutionary reasons for those mechanisms. In this view, for something to be red is for it to have a tendency to have a certain specific complex effect on a normal perceiver's sensory apparatus, in ways described by the scientific theory of color.

5 The Inverted Spectrum

Supposing this last account can be made to work up to a point, one might still worry that it seems to leave out an important aspect of color perception. As Block (1990) puts the objection, the functional account of what it is to have a concept of red captures the "intentional content" of the concept, but not its "qualitative content."

Qualitative content is what we imagine to be different when we imagine that one person perceives colors in a way that differs from the way in which another person perceives them. We seem even to be able to imagine the possibility of an inverted spectrum in the sense that the way things look to one of two otherwise normal color perceivers, George, might be qualitatively hue-inverted with respect to the way things look to the other, Mary (Shoemaker 1981).

It is not that (we imagine that) what looks red to George looks green to Mary. A given object looks green to both or red to both. That is, the colors their experiences represent the environment as having are the same. The imagined difficulty is that "what it is like" for George to see something as red is different from "what it is like" for Mary to see something as red.

The "what is it like" terminology comes from Nagel (1974). I am not convinced that this particular appeal to "what is it like" for a particular person to see something as green is in the end really intelligible. (I discuss what this might

mean in section 7, below.) But let us assume that it is intelligible in order to explore the idea.

As I have argued, the difference in "what it is like" for George and Mary to see something as red cannot be a difference in visual sensations, so it has to be a difference in how George and Mary perceive objects to be. And it cannot be a difference in what colors they perceive objects to have, because they both count as correctly perceiving the colors of objects. The difference between them cannot be at that level.

So, the difference must be a difference in other qualities that objects are presented or represented as having. What we are imagining, then, seems to be something like this (Shoemaker 1994).

When George sees a red apple, his perceptual experience represents it as being Q. His experience also represents the apple as being red. Furthermore, the fact that his experience represents the apple as being Q makes it true in present circumstances that his experience represents the apple as being red. It seems we can imagine other circumstances in which neuronal connections leading from George's retina to his visual cortex were switched before birth in such a way that later, when his experience represents something as being Q, that constitutes representing it as being green, because, in these imagined circumstances, the perception of green things normally leads George to have perceptual experiences of those things as Q.

When we imagine normal perceivers like George and Mary with inverted spectra, we are then imagining something like this: A red object looks Q to George and T to Mary. A green object looks T to George and Q to Mary. An object's looking Q to George counts as its looking red to George. An object's looking Q to Mary counts as its looking green to Mary.

This may seem odd, so let me briefly review what led to this seemingly strange idea. We want to describe a case in which two people have inverted spectra with respect to each other. The difference between them has to be a difference in what they experience, but it cannot be a difference in properties they perceive their experience to have, because the relevant properties are perceived as properties of objects in the environment. The difference cannot be a difference in the colors they perceive these objects to be, because we are assuming that, as normal color perceivers, they attribute the same colors to external objects. So, it has to be a difference in other properties objects are experienced as having, properties we can identify as Q and T.

6 Worries About Inverted Spectra

I am not sure that the imagined possibility of inverted spectra is really coherent. (Please note: I am not sure.)

A red object supposedly looks Q to George and T to Mary. It would seem that an object cannot be both Q and T in the same place at the same time in the same way. That would be like an object's being both red and green at the same place and time in the same way. But then, either George's experience or Mary's experience or both of their experiences must be in some respect nonveridical, incorrectly representing the object seen.

Shoemaker (1994) observes that the best way to avoid this result is to suppose that the properties Q and T are radically relational, so that something can be Q to one person without being Q to another. Q and T would be incompatible only in the sense that an object cannot be both Q and T to the same person at the same place at the same time in the same way. On the other hand, an object could be Q to George and T to Mary at the same place at the same time in the same way.

What is it for an object to be Q to a given person? Shoemaker (1994) mentions two possibilities. First, it might be that an object is Q to a given person S if and only if S's perceptual experience currently represents the object as Q. Second, it might be that an object is Q to a given person S if and only if the object has a tendency to provide S with perceptual experiences representing that object as Q. In the first case, objects are Q to S if and only if S is experiencing them as Q. In the second case, objects can be Q to S even if S is not currently experiencing them if they are such as to produce relevant experiences under the right conditions.[1]

But either of these possibilities involves a serious circularity. In order to understand what the concept Q is, we need to understand what objects are Q to someone, but in order to understand what objects are Q to someone, we need to understand what the concept Q is.[2]

Recall Sosa's point, noted in section 4.2 above, that we might use the perceptual concept of color possessed by normal color perceivers to give a key part of a functional account of what it is to have such a concept: the perceptual concept of red is activated in perceptual experiences produced by the perception of *red* objects. Could we use the same idea here—experiences involving the concept Q are produced by perception of Q objects? That explanation would be satisfactory only if one had a firm grasp of the concept Q. But I do not find that I have a firm grasp of that concept.

If it is suggested that we try to break out of this circle as I suggested we might break out of our earlier circle with respect to actual color terms, like "red" and "green," by appeal to some tendency objects have to affect S's perceptual mechanisms, I find myself at a loss to know what aspects of perceptual mechanisms would be relevant.

Settling on something, for example, certain events in the visual cortex would seem simply to let the same problem arise all over again. For surely we can *imagine* even

molecule-for-molecule identical people with the same events occurring in their visual cortex having inverted spectra with respect to one another. That seems to be just as imaginable as the previous case.

But this suggests the "problem" is really a pseudoproblem.

This makes me doubt that there is a concept Q of the claimed sort and so doubt that I have the relevant grasp of "what it is like for so and so to see red" that would allow me to suppose that red things might look different to different, otherwise normal, color perceivers.

But let me try to say more about "what it is like" to have an experience of a certain sort.

7 What Is It Like to See Red?

Terminology can become confusing here because different people seem to use similar terminology in different ways and people often use a variety of terminology. For example, philosophers talk about "what it is like" to have a given experience, about an experience's "phenomenological character," and about "qualia," as if these are different ways of getting at the same thing.

In fact, at least two different issues are involved. Let me explain by citing two different ways in which the term "qualia" has been used. First, qualia are sometimes taken to be experienced qualities of a mental experience, those qualities by virtue of which one's experiences represent what they represent (when they represent things), the mental paint of one's picture of the environment, one's mental sense-data. Philosophers who use the term "qualia" in this sense tend to hold that not all mental experiences involve qualia. They take qualia to be involved in perception and sensation but not always in relatively abstract beliefs and thoughts. In this sense of "qualia," it is at least a matter of controversy whether all experiences involve qualia.

On the other hand, qualia are sometimes identified with what it is like to have a given experience and it is supposed to be relatively obvious that all mental experiences involve qualia. Even with respect to a relatively abstract judgment, there is something that it is like to have that judgment—some qualitative character in this second sense.

Now, as I have indicated already, I am strongly inclined to deny that there are qualia in the first sense, the mental paint or sense-datum sense. In perception, all qualities of which we are aware seem to be presented to us as qualities of perceived things, external objects for the most part. Introspection does not support the claim that we are aware of mental paint. And, although arguments can be given for sup-

posing that despite appearances we are aware of mental paint, these arguments seem to be uniformly fallacious through confusions over intentionality (Harman 1990a). So I see no reason to suppose that we are aware of mental paint.

With respect to qualia in the second sense, what it is like to have a given experience, I agree with Nagel (1974) that there is a distinctive kind of understanding that consists in finding an equivalent in one's own case. That is "knowing what it is like to have that experience." I have compared that sort of understanding with knowing what an expression used by someone else means. One understands it to the extent that one finds an equivalent expression in one's own language or by learning how to use the expression oneself. Even if use determines meaning, an external objective description of use need not provide the sort of understanding that comes from knowing the translation into one's own terms (Harman 1990b, 1993a).

Translation is a holistic enterprise. I map as much as I can of your language into mine in a way that tries to preserve certain constraints as much as possible (Harman 1993b). Similarly, in trying to understand what it is like for you to have certain experiences, I map as much as I can of your total experiential system into mine in a way that tries to preserve certain constraints as much as possible.

In either case, there is the possibility of "indeterminacy of translation" (Quine 1960). We can imagine that there are two different ways to map your color vocabulary into mine, or your color experiences into mine, preserving relevant constraints as much as possible. That is to imagine a genuine indeterminacy as to what it is like for you (or me) to see red, just as there is a genuine indeterminacy as to the best interpretation of numbers in set theory.

With respect to the color experiences of normal perceivers who are normal speakers of English, there is no such indeterminacy, because the relevant constraints on mapping one person's experiences into another's include taking into account what objects in the world give rise to those experiences.

So, what it is like for one normal color perceiver to see red is quite similar to what it is like for any other normal color perceiver to see red.

8 Conclusion

My tentative conclusion is that objective color is plausibly identified with a tendency to produce a certain reaction in normal perceivers, where the relevant reaction is identified in part with reference to the mechanisms of color perception.

The subjective response to color is constituted by perceptual experience presenting or representing the environment as relevantly colored. The concept of color as it

figures in this representation is simple and unanalyzable in causal terms, because color is experienced as a simple basic quality, rather than a disposition or complex of causal properties. Possession of a perceptual concept of color is to be understood functionally: objective color leads to experiences in which the perceptual concept of color is manifested.

These causal accounts do not capture everything we seem to be able to imagine about color. In particular, they do not allow for possible inverted spectra in otherwise normal color observers. But it is far from clear that what we seem to be able to imagine is actually a coherent possibility.

Notes

1. I have oversimplied. Shoemaker's actual account supposes that an experience has a certain intrinsic phenomenal feature x that is responsible for its representing something as Q. For something to be Q is for it to be such as to produce experiences with feature x.

2. Shoemaker's attempted way out of this circle is to say, for example, that experiences of something as Q (i.e., experiences with feature x) are those experiences that "are phenomenally like those I have when I see a ripe tomato." That would help only if we already had the sort of account of interpersonal phenomenal similarity that would enable us to make sense of interpersonal inverted spectra. But we are in the process of trying to develop such an account. So that account would be circular if we adopted Shoemaker's suggestion.

References

Armstrong, D. 1968. *A Materialist Theory of the Mind*. London: Routledge & Kegan Paul.

Block, N. 1990. Inverted earth. *Philosophical Perspectives*, **4**, 53–79.

Dennett, D. 1991. *Explaining Consciousness*. Boston: Little, Brown.

Gold, I. 1993. *Color and Other Illusions: A Philosophical Theory of Vision*. Ph.D. dissertation, Princeton University.

Harman, G. 1990a. The intrinsic quality of experience. *Philosophical Perspectives*, **4**, 31–52.

Harman, G. 1990b. Immanent and transcendent approaches to the theory of meaning. In *Perspectives on Quine*, ed. R. Gibson and R. B. Barrett. Oxford: Blackwell, pp. 144–57.

Harman, G. 1993a. Can science understand the mind? In *Conceptions of the Human Mind: Essays in Honor of George A. Miller*, ed. G. Harman. Hillside, NJ: Erlbaum, pp. 111–21.

Harman, G. 1993b. Meaning holism defended. *Grazer Philosophische Studien* **46**, 163–71.

Johnston, M. 1992. How to speak of the colors. *Philosophical Studies*, **68**, 221–63 [chapter 9, this volume].

Lewis, D. 1966. An argument for the identity theory. *Journal of Philosophy*, **63**, 17–25.

Nagel, T. 1974. What is it like to be a bat? *Philosophical Review*, **83**, 435–50.

Peacocke, C. 1983. *Sense and Content*. Oxford: Oxford University Press.

Quine, W. V. 1960. *Word and Object*. Cambridge, MA: MIT Press.

Shepard, R. N. 1992. The perceptual organization of colors: An adaptation to regularities of the terrestrial world? In *The adapted mind: Evolutionary psychology and the generation of culture*, ed. J. H. Barkow,

L. Cosmides, and J. Tooby. New York: Oxford University Press [chapter 14, *Readings on Color, vol. 2*].

Shepard, R. N. 1993. On the physical basis, linguistic representation, and conscious experience of colors. In *Conceptions of the human mind: Essays in honor of George A. Miller*, ed. G. Harman. Hillsdale, NJ: Erlbaum.

Shoemaker, S. 1981. The inverted spectrum. *Journal of Philosophy*, **74**, 357–81.

Shoemaker, S. 1994. Phenomenal character. *Noûs*, **28**, 21–38 [chapter 12, this volume].

Sosa, E. 1990. Perception and reality. In *Information, Semantics and Epistemology*, ed. E. Villanueva. Oxford: Blackwell.

14 Colors and Reflectances

Alex Byrne and David R. Hilbert

1 Introduction

When we open our eyes, the world seems full of colored opaque objects, light sources, and transparent volumes. One historically popular view, *eliminativism*, is that the world is not in this respect as it appears to be: nothing has any color. Color *realism*, the denial of eliminativism, comes in three mutually exclusive varieties, which may be taken to exhaust the space of plausible realist theories. Acccording to *dispositionalism*, colors are *psychological* dispositions: dispositions to produce certain kinds of visual experiences. According to both *primitivism* and *physicalism*, colors are not psychological dispositions; they differ in that primitivism says that no reductive analysis of the colors is possible, whereas physicalism says that they are physical properties. This paper is a defense of physicalism about color.

We shall proceed as follows. After first making a useful distinction and some preliminary clarifications immediately below, we outline and motivate our own theory in section 2. Then, in section 3, we reply to three objections. The case for physicalism is summarized in section 4.

1.1 Green-Representing and Green-Feeling Experiences

If it looks to you as if something is green and square at location L, then your experience is veridical only if something is green and square at L. If in fact there is nothing green and square at L (perhaps there is only a green circle or a pink square at L, or perhaps there is only a pink circle, or even nothing at all) then your experience is (at least partly) illusory. Thus your experience is veridical only if the proposition *that there is something green and square at L* is true, and illusory otherwise. It may also look to you as if something is orange and round at location L'. Thus your experience is veridical only if the proposition *that there is something orange and round at L'* is true, and illusory otherwise.

Your experience, then, may be said to *represent* that there is something green and square at L, and that there is something orange and round at L'. If we take propositions to be sentence-like entities, we may define a conjunctive proposition C—the *content* of your experience—as follows. A proposition p is a conjunct of C iff p is represented by your experience (taking C to be a conjunct of itself, and "represents" to distribute over conjunction). Intuitively, the content of a visual experience is the complete way the experience represents the world as being.

Typically, you will accept "the testimony of your senses," and believe that there is something green and square at L. If you come to believe that the lighting conditions

are abnormal (for example), you may change your mind, and not believe that the world is this way. But even so, it will continue to look as if there is something green and square at L—the proposition that there is something green and square at L will continue to be represented by your experience. There is no straightforward relationship, then, between the content of an experience and the content of beliefs formed on the basis of that experience.

Let a *green-representing experience* be a visual experience that represents the world as containing something green. Thus the content of such an experience will have as a conjunct a proposition that predicates the property green.[1]

Now, when people with normal vision look at grass, shamrocks, and jade, in daylight, they have green-representing experiences. These experiences are thus similar in respect of content. Assuming, as we shall, that "spectrum inversion" does not actually occur, such experiences are also phenomenologically alike: there is something obviously similar in respect of what it is like to undergo them. Let a *green-feeling experience* be a visual experience with this phenomenological character.

Whether green is a physical property or even whether anything *is* green, at least this much is true: typically, whenever someone has a green-feeling experience, she has a green-representing experience.[2] That is, the property green is a property that green-feeling experiences typically represent objects as having.[3] However, what is very much in dispute is whether this connection between green-feeling experiences and green-representing experiences is *necessary*. Many think, for example, that in some possible worlds green-feeling experiences represent, not that objects are green, but that they are red. We shall be taking up this question later.

So, let it be clear at the outset that our main interest is in properties that certain types of (human) visual experiences represent objects as having. We are not significantly concerned with the question of whether other animals see colors and, if so, what sort of properties these might be (on this latter topic, see Hilbert 1992). Neither are we significantly concerned with the semantics of color words. And we are not at all concerned with an "objective physical definition" (MacAdam 1985, p. 34) of color that can be employed in good conscience by color scientists irrespective of how matters stand with visual experience.

2 A Physicalist Theory of Color

Our physicalist theory of color has two main components. First, colors are types of surface spectral reflectances. Second, color content and color phenomenology necessarily go together. We shall discuss these in turn.

2.1 Colors Are Reflectances

The surface spectral reflectance (SSR) of an object is given by specifying, at each wavelength in the visible spectrum, the percentage of light the object reflects at that wavelength. As one of us has argued at length before, the most plausible version of physicalism about *surface* (or object) colors takes these properties to be types of SSRs.[4] For simplicity we will concentrate here on surface color[5]; the extension of our account to light sources and transparent volumes is a matter for another time.[6]

If two objects have the same SSR, in all visible illuminations they will reflect the same amount of light. If one object is substituted for another with the same SSR (assuming they are the same size) in the scene before the eyes, no visible color difference will result. The SSR of an object is (typically) an illumination-independent property: the SSR of an object does not change if the object is taken from a room to a sunny street, or if the lights are turned out. And this, arguably, is also a feature of color.

Let us assume that our visual experiences are, in normal viewing conditions, mostly veridical in respect of color. Certain frogs, iceberg lettuce, and dollar bills (say) are green. Is there an SSR that all and only green objects share? Given that our color perceptions are mostly veridical, the answer is no. Green objects differ widely in their SSRs. This is even true for particular shades of green, as is shown by the phenomenon of *metamerism*: the fact that some objects with different SSRs have perceptually indistinguishable colors in normal conditions of illumination. Two objects that differ in reflectance but have perceptually identical colors in a certain illumination are a *metameric pair* (with respect to that illumination).[7] Moreover, the difference in reflectance between the members of a metameric pair need not be small in the way that the difference in length between two lines of perceptually indistinguishable length is small. An object that reflects almost no light in the neighborhood of 540 nanometers (nm) could be indiscriminable in normal conditions of illumination from an object that reflects nearly all the incident light at this wavelength.

But is there a *physical property* that all and only (actual and possible) green objects share? Given our assumption about the general correctness of our color perceptions, the answer is (plausibly) yes. The property that all green objects share is a *type* of SSR.[8] Very roughly, this property—call it "SSR_{GREEN}"—is the type of SSR that allows an object in normal illumination to reflect significantly more light in the middle-wavelength part of the spectrum than in the long-wavelength part, and approximately the same amount of light in the short-wavelength part as in the rest.[9]

Obviously, particular reflectances meeting these specifications—for instance those of frogs, lettuce, and dollar bills[10]—may be otherwise very different.

The property green, if it is this type of SSR, is not a particularly interesting property from a physical point of view. Since we only find it salient because our perceptual apparatus is built to detect it, it might be called an *anthropocentric* property (cf. Hilbert 1987). Alien physicists lacking our visual apparatus would not need to single it out for special attention, unlike the property of having charge *e*, or spin 1/2. (These aliens might likewise find the visible spectrum no more than an arbitrary segment of the entire electromagnetic spectrum.) But that does not at all impugn the status of an idiosyncratic type of SSR as a physical property that is "objective," in almost every sense of that protean word. Particular SSRs are not in any philosophically interesting sense dependent on human beings; neither is the type, "either SSR_α or SSR_β or SSR_γ, ...," where these particular SSRs seem from a physical standpoint to be a motley collection.

As for the hues, so for the other color categories. The determinable green has various determinate shades—olive green, lime green, and so on. And it is itself a determinate of the determinables chromatic color, and color. These are all types of reflectances.

Let SSR_{GREEN} be a set of SSRs, such that an SSR is a member of this set just in case it is of the type we sketched a few paragraphs back—SSR_{GREEN}.[11] And in general: for any color X (a type of SSR), a particular SSR will be of this type just in case the SSR is a member of SSR_X. If we like, we can call the individual SSRs the "maximally specific colors," although it must be stressed that this is simply a natural way of extending our everyday color talk. The reflectance-types that the human visual system represents objects as having are considerably coarser than the maximally specific colors. Hence, although of course *objects* having maximally specific colors are visible, the maximally specific colors themselves are not, because they are not properties that one can tell an object possesses simply by looking at it. That is why the terminology is an extension of ordinary usage.[12]

This set-theoretic apparatus gives us a nice way to explain the determinate-determinable relation. But first we need a distinction. A *color property* is simply a reflectance-type. Thus, assuming our version of physicalism, examples of color properties are red, bluish green, sky blue, purple-or-green, sky blue-or-bluish-green-or-pink, and the maximally specific colors.

Now some color properties are those that objects can look to have, and others are not. An object can look lemon yellow, yellow, chromatically colored, or simply colored, but to humans nothing can look purple-or-green, or to have a maximally specific color. (Admittedly, one can tell simply by looking that an object is purple-or-

green, but that is not to say that the object *looks* purple-or-green; rather, it will look green, or look purple, and thus one may infer that the object is purple-or-green.)

Those color properties that objects can look to humans to have will be precisely those that human visual experience can represent objects as having. Say that such properties are *representable color properties*.

With this distinction between color properties (like green) that are representable and those (like purple-or-green) that are not, we can say that two color properties, X and Y, stand to one another in the relation of determinate to determinable just in case X and Y are representable color properties and SSR_X is a proper subset of SSR_Y. So lime green is a determinate of green, because this property (and green itself) is a representable color property, and $SSR_{LIME-GREEN}$ is a subset of SSR_{GREEN}. But, although SSR_{PURPLE} is a proper subset of $SSR_{PURPLE-OR-GREEN}$, purple-or-green is not a representable color property and hence, as desired, not a determinable of purple.

2.2 Content and Phenomenology

The relationship between the content and phenomenology of experience has recently been much debated.[13] Any adequate theory of color must take a stand on this question, at least as it concerns color experience.

Let us say that two experiences are *the same in color content* just in case they represent the same color properties instantiated at the same (viewer-centered) locations. And let us say that two experiences are *the same in color phenomenology* just in case (to put it loosely and intuitively) any phenomenological difference between them would not be described using color vocabulary. (So the phenomenological difference between seeming to see movement at the periphery of one's field of view and not seeming to see such movement is not a difference in color phenomenology.)

We may now put the thesis we wish to defend as follows:

NECESSITY

For all possible subjects S_1, S_2 and all possible worlds w_1, w_2, if S_1 is having a visual experience in w_1 and S_2 is having a visual experience in w_2, then these experiences are the same in color content iff they are the same in color phenomenology.

That is, we claim that the color content and color phenomenology of visual experience cannot come apart. (It is worth noting that Boghossian and Velleman's attack on physicalism in chapter 8 of this volume is largely directed against versions that hold color content and color phenomenology to be only *contingently* connected.[14])

NECESSITY is intuitively plausible, at least in straightforward cases of vision. The experience of seeing a ripe tomato does not seem to contain content and phenomenology

as separable elements. Asked, first, to imagine having a visual experience that represents the world as containing a red tomato immediately before one and, second, to imagine having a visual experience whose color phenomenology is like *that*, the naive subject has only one way of responding to both questions.

Why think NECESSITY is false? There are a number of apparent counterexamples. Of these, only one—the case of "spectrum inversion"—requires extended discussion. The rest we shall relegate to a footnote.[15]

Imagine, then, that Invert and Nonvert are "spectrally inverted" with respect to each other, and have been since birth. Nonvert has normal vision, but Invert has red-feeling experiences when he looks at gooseberries, and green-feeling experiences when he looks at raspberries. First premise: this case is possible. Second (relatively uncontroversial) premise: Nonvert's experiences represent, by and large, the true colors of objects. Third premise: the same is true of Invert (cf. Shoemaker 1982; Block 1990). If these three premises are true (and we shall examine how the first and third might be supported shortly), then we have counterexamples to both the left-to-right and right-to-left parts of NECESSITY, as follows.

The left-to-right part. When Invert and Nonvert both look at a gooseberry, their experiences are both green-representing. Thus this is a case of same color content (the gooseberry is represented as having the property green), but different phenomenology (Invert and Nonvert have, respectively, red- and green-feeling experiences).

The right-to-left part. When Invert looks at a gooseberry and Nonvert looks at a raspberry, they both have red-feeling experiences that are, respectively, green- and red-representing: same phenomenology, different color content.[16]

Our response is this. First, we shall describe a hypothetical case of a subject—Fred—who is spectrally inverted in only one eye, using only assumptions that the inverted spectrum argument itself requires. Then we shall imagine that Fred is presented with a red raspberry, and looks at it first through one eye, and then through the other. His visual experience will change. If the inverted spectrum argument against NECESSITY is sound, then (it turns out) this change in Fred's experience is not a change in the color properties the raspberry is represented as having. We shall argue that this is not acceptable. Hence the inverted spectrum argument is unsound.[17] We shall finally discuss the question of which premise of the inverted spectrum argument should be denied.

To begin. Suppose that Fred is spectrally inverted in only one eye, his left. So, he has red-feeling experiences when he looks at green objects with his left eye, and green-feeling experiences when he looks at green objects with his right eye. Further imagine that Fred only uses one eye at a time (say the left on Monday, Wednesdays, and Fridays, and the right the other days of the week). He has been raised in an en-

vironment that changes color early on Monday, Wednesday, and Friday mornings, and changes back on Tuesday, Thursday, and Saturday. These changes amount to successive color inversions and reinversions: before dawn on Monday, gooseberries change from green to red, and raspberries change from red to green; before dawn on Tuesday gooseberries change back to green, and raspberries change back to red.

Gooseberries, then, produce green-feeling experiences in Fred any day of the week; likewise, mutatis mutandis, for other objects. So we may fairly suppose that Fred believes he is cyclopean, and has no inkling that his environment changes color in this systematic way.[18] It seems reasonable to presume that, if Invert's phenomenological inversion with respect to Nonvert is possible, Fred's case, as we have described it so far, is likewise possible.

Now, on the assumption that Invert's visual experience, when he is looking at a gooseberry, represents the gooseberry as having the property green, and so forth, what are we to say about the content of Fred's visual experiences?

Well, why is it supposed that Invert sees the true colors of objects? Here we should distinguish two reasons. First, it might be claimed that this is simply an intuitive judgment about the case—after all, Invert can use his color vision to navigate the world successfully, so why suppose he is systematically misperceiving it? If this is the reason, then it seems we may draw the same conclusion in Fred's case (perhaps, because of the additional complexity, a little more tentatively): so, for example, when Fred looks at a (green) raspberry on Monday with his left eye, his red-feeling experience is green-representing.

Second, it might be argued that Invert sees the true colors of objects from the theoretically motivated premise that color content is an *extrinsic* matter: it varies between subjects who are duplicates, and so can be affected by purely environmental changes.[19] Putnam's familiar Twin Earth story shows that this is so in the case of contents involving natural kind concepts, like the concept of water (Putnam 1975). On Earth Oscar believes that water is wet. On Twin Earth, where the clear potable fluid XYZ flows in the rivers and falls from the sky, and where H_2O is nowhere to be found, his perfect twin Twoscar does not have this belief. He believes that *twater* (the stuff XYZ) is wet.

For simplicity, let us suppose that the diagnosis of this difference in content is that an inner state-type of Oscar is reliably caused by the presence of water, not twater, and vice versa for Twoscar. If the moral of Twin Earth extends to Invert's case, then because his red-feeling experiences are reliably caused by the presence of green objects before his eyes, he has a green-representing experience when he looks at a gooseberry.

If all this is right, then it would seem that red-feeling experiences produced by Fred's left eye are green-representing. For they are reliably caused by the presence of green objects—Monday's raspberries, for instance. And we may suppose that the visual pathways leading from each of Fred's eyes do not causally interact. He thus has, in effect, two visual systems used on different days, and that is presumably enough to apply the simple externalist theory of content mentioned above to each individually.

(Of course, externalist theories of content may take other forms [see, for example, Millikan 1984; Dretske 1981, 1988; Fodor 1990]. But whatever the details, it seems very likely that we can have our desired result—that green-feeling experiences produced by Fred's left eye, and red-feeling experiences produced by his right, are red-representing—at the cost of complicating our example.)

The upshot, then, is that if Invert is not the victim of a systematic color illusion, by parity of reasoning Fred isn't either.[20]

So, if the standard inverted spectrum case is a genuine counterexample to NECESSITY, Fred's plight may be described as follows. He has his left eye phenomenologically inverted with respect to his right: red objects viewed with his left eye cause green-feeling experiences, and red-feeling experiences when viewed with his right. But Fred's green-feeling experiences produced by his left eye are red-representing, just like the red-feeling experiences produced by his right eye.

Now for the advertised change in Fred's experience that we say a proponent of the inverted spectrum argument must misdescribe. Suppose that we take a red raspberry and allow Fred to look at it first with his right eye, and then with his left (contrary to his usual practice). What will Fred's visual experience be like? Well, simply imagine a raspberry that changes color from red to green, and imagine looking at the raspberry through one eye, blinking just as the raspberry changes color. Assuming you have normal vision, that is what it will be like for Fred.

To Fred it will be as if the raspberry—part of the scene before his eyes—has undergone a change. If Fred thinks conditions are normal, and that his visual apparatus is functioning properly, he will believe, on the basis of his experience, that the raspberry has changed in respect of a salient surface property. That is, the raspberry first looks one way to Fred, and then *another* way.

But of course this is precisely what a defender of the inverted spectrum argument *cannot* say. The difference between Fred's first and second look is *not* a difference in the properties his experience represents objects as having. If the inverted spectrum argument is sound, the "testimony" of Fred's experience is that the world is exactly the same way both times, *that the raspberry has not changed at all.* Surely this cannot be correct. The fact is that the scene before Fred's eyes *looks to him to change* (it is

irrelevant that the appearances are deceptive). But this just *is* a change in the content of his experience, at least if we are to retain any intuitive grip on that notion.[21,22]

The inverted spectrum argument is therefore unsound. According to the first premise, the phenomenology of Invert's color experiences is inverted with respect to Nonvert's. According to the second premise, Nonvert sees the true colors of objects. According to the third premise, Invert's visual experiences are likewise veridical. As we have indicated, in the present context the second premise may be taken for granted. We now need to examine what either denying premise one, or denying premise three, would involve.

As we mentioned, two reasons might be given for holding the third premise: that Invert's experiences represent raspberries as having the property red, gooseberries as having the property green, and so on. First, that this is more or less obvious just from the description of the case. Second, that color content is an extrinsic matter.

We may similarly distinguish two reasons for holding the first premise: that Invert's alleged long term phenomenological inversion is possible. First, that this is more or less obvious just from the description of the case. Second, that phenomenology is an *intrinsic* matter: it does not vary between subjects who are duplicates, and so is unaffected by purely environmental changes. According to this second reason, there is a certain intrinsic state that is sufficient for having a green-feeling experience, and Invert is hooked up to the world in such a way that a raspberry before his eyes causes him to be in it.

So there are two reasons—intuitive and theoretical—for each of the first and third premises. And therefore we need to deny both the intuitive and theoretical reasons for one of them. If it's the third premise, then we must say that (a) any intuition that Invert sees the true colors of objects is not probative, and (b) the content of color experience is intrinsic[23]—it does *not* vary between duplicate subjects. If it's the first premise, then we must say that (c) any intuition that Invert's phenomenological inversion is possible is not probative, and (d) the phenomenology of color experience is extrinsic—it *does* vary between (some) duplicate subjects.

And here, it might be thought, we face a dilemma, because (a), (b), (c), and (d) are widely taken to be very implausible. But each of thinks he can comfortably sit on one of these horns.[24] Although we concede that both premises have some measure of intuitive support, it is surely far from conclusive, and thus a case can be made for (a) and (c). (Admittedly, it would be nice to have an explanation of why intuition has led us astray.) What about (b) and (d)? First, however matters may stand with water-beliefs, it is quite disputable that color content is extrinsic. Not all theories of intentionality worth taking seriously exclude intrinsic content across the board.[25] To take a crude example, consider the theory that the mental symbol "red" refers to the

property red because in ideal conditions instantiations of red *would* cause tokenings of the symbol "red," and similarly for the other colors. Provided that the specification of "ideal conditions" is wholly determined by the intrinsic properties of the subject, as it conceivably might be, twins will share color contents, and so color content will be intrinsic. We do not think that anyone is in a position to rule out all possible versions of such theories. Second, it is also quite disputable that phenomenology is intrinsic (for recent dissent, see Dretske 1995, 1996; Tye 1995; Lycan 1996).

3 Replies to Objections

So far we have set out, with some accompanying defence, the main lines of our own theory. In this section we reply to three objections. The first is (in effect) an objection to NECESSITY. The second two are common objections that are widely taken to be fatal to any sort of physicalism about color.

3.1 First Objection: Actual Variations in Phenomenology

When subjects with normal vision are asked to locate "unique" green on the spectrum—a green that is neither yellowish nor bluish—the variation in their responses is significant, at least covering the interval from 490 to 520 nm. And disputes about whether, say, a bluish green fabric is predominantly green or predominantly blue are common in everyday life.

Take two normal subjects, Ted and Alice, who disagree on the spectral location of unique green. Ted says it's 490 nm, Alice says it's 520 nm. It is natural to suppose that Ted and Alice have phenomenologically identical experiences when looking at, respectively, 490 and 520 nm lights. And it is equally natural to suppose that they have phenomenologically different experiences when they look at 490 nm lights. To avoid complications with the colors of light sources, let's switch attention to object color. There will be a patch that produces in Ted a unique-green-feeling experience, but produces in Alice a bluish-green-feeling experience.

By NECESSITY, since our subjects enjoy phenomenologically different experiences, the color contents of their experiences must differ. Ted's experience is representing the patch to be unique green, and Alice's experience is representing the patch to be bluish green. These are different properties, and (so the argument goes) they are contraries: if something is unique green, it is not also bluish green. So either Ted or Alice is misperceiving the color of the patch. This, it might be thought, is implausible.

According to us, unique green is a type of SSR—SSR$_{\text{U-GREEN}}$. And an SSR is of this type just in case it is a member of SSR$_{\text{U-GREEN}}$. Likewise, bluish green—let's pick

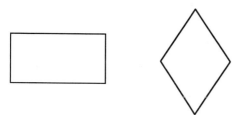

Figure 14.1

a particular shade—is a reflectance-type whose corresponding set is SSR$_{\text{B-GREEN}}$. So far, none of this helps. But suppose that SSR$_{\text{U-GREEN}}$ and SSR$_{\text{B-GREEN}}$ intersect—they have some members in common. Then although Ted and Alice's visual experiences represent the patch to have different properties, those properties are not contraries. Therefore, if this supposition is reasonable, there is no barrier to supposing that both Ted's and Alice's experiences are veridical. We cannot prove, of course, that this supposition is correct, but we do claim that it is a possibility to be taken seriously.

But is it reasonable? Surely nothing can be both unique green and bluish green! But why not? Of course, we are not denying that unique green and bluish green are *distinct* properties. Nor are we denying that nothing can *appear* simultaneously to one perceiver to be both unique green and bluish green. We are suggesting, though, that some ways of being unique green are also ways of being bluish green.

One way to show that this is an option is to find other perceptible properties that are partners in crime. Take the experiences of, on the one hand, something's looking rectangular and, on the other, something's looking diamond-shaped. When one enjoys the former type of experience, the symmetries about the bisectors of the figure's sides are salient. And when one enjoys the latter type of experience, the symmetries about the bisectors of the figure's angles are salient.[26] For an example of the types of experiences we mean, look at figure 14.1.

Now, although the property of being a diamond and the property of being a rectangle are *not* contraries, arguably nothing can *look* simultaneously to be a rectangle and a diamond. Squares, of course, are both diamonds and rectangles. But no square both looks to be a rectangle and a diamond simultanously. Not, at any rate, in the particularly obvious way illustrated by figure 14.2.

Here the left-hand figure looks rectangular, and the right-hand figure looks diamond-shaped. It is not perceptually obvious that the left-hand figure is diamond-shaped, or that the right-hand figure is rectangular. It would not be altogether surprising to find a perceiver on a restricted diet of shape perceptions who mistakenly thought that no diamond could ever be rectangular.

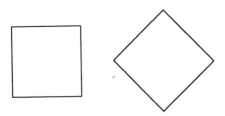

Figure 14.2

But isn't there this disanalogy with the color case? By physically rotating figure 14.2, or by rotating the corresponding mental image, one can readily see that the right hand figure is rectangular. That is why the idea that the properties of being a square and of being a diamond are contraries does not survive informed reflection. But if a patch looks unique green, that's the end of the matter.

Not quite. If a patch looks unique green, it can typically be made to look bluish green by changing the viewing conditions slightly. Admittedly, there is nothing that is exactly parallel to the rotation of a mental image, but the analogy does not have to be perfect. The point is simply to show that two shape properties could *mistakenly* seem to be contraries, and hence that the corresponding claim in the color case is at least a possibility.

But even if bluish green and unique green are in fact contraries, this is not a disaster. That many of us misperceive unique green objects is certainly an unwelcome result; but at least (for all the objection says) we veridically perceive them as green, and perhaps that is enough.

3.2 *Second Objection: Red Is Really* More Similar to Orange than It Is to Green

Before stating this objection, we need to introduce two senses of similarity.

First, *relative* similarity. Let x, y, and z be distinct things ($x \neq y \neq z \neq x$). x and y are perfectly similar (or just plain similar) relative to a family of properties $\{P_1, \ldots, P_n\}$ just in case both x and y have each P_i. x is more similar to y than to z, relative to a family of properties $\{P_1, \ldots, P_n\}$ just in case x and y share more P_is than x and z do.[27]

So, for example, a square and a triangle are both similar relative to the family {having at least three angles}, and are also both similar relative to the family {being either a square or a triangle}. (This last relative similarity claim shows that *any* two things are similar relative to *some* property or other.[28]) Properties themselves have properties, and so, like particulars, stand in various relative similarity relations. For example, the property squareness and the property triangularity are similar relative to the family {being a geometrical property}.

Here are two examples of comparative relative similarity. A square is more similar to a circle than to a triangle, relative to the family {having at least fourfold symmetry, being a nontriangle, having exactly three angles}. A square is more similar to a triangle than to a circle, relative to the family {being angled, being a closed figure, having no straight edges}.

One might think that relative similarity is all the similarity there is, but this is arguably not the case. Think of perfect duplicates—this cube of sugar and a molecule-for-molecule copy of it. They share all their intrinsic properties. Isn't this a *natural* respect in which they are similar? Suppose we have cube, a tetrahedron, and a sphere. Isn't the first more similar, in a natural respect, to the second than it is to the third? Again, isn't squareness more similar, in a natural respect, to triangularity than it is to circularity? Assuming these questions are at least intelligible, let us call similarity in a natural respect, *natural* similarity.[29]

Let SIMILARITY be the claim that—in the natural sense—red is more similar to orange than to green. Now we can set out the objection in the form of an argument[30]:

(1) We know SIMILARITY solely on the basis of ordinary visual experience.

If the colors are physical properties—the argument continues—then we would need to find out which physical properties red, orange, and green are, in order to determine whether or not SIMILARITY is true. That is, we would need color science—ordinary visual experience wouldn't suffice. So:

(2) If physicalism is true, (1) is false.

Hence:

(3) Physicalism is false.

It must be admitted that the first premise appears to be in good shape. The first premise (and so SIMILARITY) seems true, perhaps even obviously so. Indeed, theses like SIMILARITY are often given as paradigmatic examples of natural similarity relations holding among properties.[31]

What about the second premise? We may well regard the above reasoning in its support with some suspicion. Admittedly, if colors are physical properties, then SIMILARITY is hostage to empirical fortune. Color science, we may fairly presume, reveals the nature of properties like reflectances, and thus reveals the natural similarity relations in which reflectances stand to each other. And there can surely be no guarantee that these similarity relations will be the ones we believe to hold on the basis of ordinary perception. However, the mere possibility of defeat does not

generally overturn claims to knowledge—why should it do so in this case? To this there are two replies. First, it might be argued that there is no reason to suppose that ordinary perception is a reliable guide to natural similarity relations between *physical* properties. If so, physicalism implies, not just the possibility of defeat, but that we have no business believing SIMILARITY simply because red, orange and green look that way. According to this first reply, if physicalism is true, then we are not *justified* in taking SIMILARITY to be true solely on the basis of ordinary perception, and thus we do not *know* it by these means. Second, it might be argued that our claim to know SIMILARITY has a special status: it is simply not defeasible. According to this second reply, the first premise should be reformulated along these stronger lines. Then, since physicalism implies that our claim to know SIMILARITY *is* defeasible, the argument for the second premise is straightforward.

We need not pursue this any further, because if physicalism (our brand of it, at least) is true, some intuitively correct natural similarity claims in the style of SIMILARITY will be *false*. Perhaps SSR_{RED} *is* more similar, in the natural sense, to SSR_{ORANGE} than to SSR_{GREEN}; but it seems extremely doubtful that this relation holds between, for example, SSR_{BLUE}, SSR_{PURPLE}, and SSR_{GREEN}.[32] Hence the truth of (a variant of) the second premise is immediate. Physicalism implies that we couldn't know that blue is more similar to purple than to green without color science, for the simple reason that blue is *not* more similar to purple than to green, if physicalism is true. So it appears that we are in big trouble.

We deny the first premise. Visual experience, we think, does *not* tell us that the colors are naturally similar. Rather, visual experience tells us that colored *objects* in the scene before the eyes are *relatively* similar—relative to the color properties that one's experience represents the objects as having. This needs some explaining.

A certain colored chip looks to be a maximally determinate shade of red—call it "red_{21}." It also looks scarlet (say), red, chromatically colored, and colored. So the visual experience of the chip not only represents it as having red_{21}, but also as having, *inter alia*, the color properties scarlet, red, chromatic color, and color. Thus, assuming physicalism, the chip is visually represented as having various types of reflectances, ranging from the comparatively determinate $SSR_{RED_{21}}$ to the maximally indeterminate $SSR_{COLORED}$, where any object that falls under the more determinate reflectance-types also falls under the less determinate ones. (Recall the end of section 2.2. above.)

Now suppose that you see three chips—x, y, and z—together, and that x looks scarlet, y crimson, and z lemon yellow. You would judge that x is more similar (in respect of color) to y than to z. Why? An explanation is to hand if we make a natural assumption about the sorts of color properties that your experience represents the

chips as having. Namely, there are more color properties that x and y are both represented as having than there are color properties that x and z are both represented as having. If that were so, then x would be seen as sharing more color properties with y than with z. And this would make your comparative similarity judgment intelligible.

That assumption seems right in this case. Indulging in some oversimplification, the color properties that x and y are both represented as having are: red, chromatic color, and color. The color properties that x and z are both represented as having are: chromatic color, and color. And there are more of the former than the latter.

So we propose that our judgments of color comparative similarity relations between objects are simply reflections of *relative* similarity relations holding between those objects. Let C_1, C_2, ... be all the color properties. Suppose x is judged more similar (in respect of color) to y than to z, on the basis of experience E. Then this judgment is explained by the fact that x is more similar to y than to z, relative to the family {being visually represented by E as having C_1, being visually represented by E as having C_2, ... }. But what is the *content* of the judgment that x is more similar (in respect of color) to y than to z? Let an E-*color property* be a color property that E actually represents either x or y or z as having. Then we may analyze—or, perhaps better, explicate—the judgment that x is more similar (in respect of color) to y than to z thus: x and y share more E-color properties than x and z do.

It is a good deal less clear what people are up to when they make similarity claims about color *properties*, for instance, that scarlet is more similar to crimson than to lemon yellow. Some of them, at least, will mean to be making a natural similarity claim. (In which case, according to us, sometimes they will speak falsely.) We have already explained why, when confronted with any three objects, looking scarlet, crimson, and yellow, respectively, a subject will judge the first more similar to the second than the third. Any reflective subject knows that any three such objects will elicit such a similarity judgment. And, without getting into the question of whether subjects speak truly when they say that scarlet is more similar to crimson than to lemon yellow, this is enough to explain why they say it.

To make this explanation of our similarity judgments between color properties quite general, it will be useful to define a relation between three color properties X, Y, and Z as follows:

X looks more similar to Y than to Z iff for all possible visual experiences E^{33}, and for all possible objects x, y, and z, if E represents x as having X, y as having Y, z as having Z, then:

There are more color properties that E represents x and y as having than there are color properties that E represents x and z as having.

Then we can say that our explanation of judgments of similarity between the colors is this: any *intuitively true* similarity claim of the form "X is more similar to Y than to Z" (setting aside whether it *is* true) corresponds to a truth of the form "X looks more similar to Y than to Z," and vice versa.

Now someone might object that this is not always so. For consider red, orange, and green. Suppose x, y and z are seen as having these colors, respectively. x is represented to be various more or less determinate shades of red, red, chromatically colored, and colored. y is represented to be shades of orange, orange, chromatically colored, and colored. z is represented to be various shades of green, green, chromatically colored, and colored. If this is the full story, then the color properties x and y are both represented as having *are* the color properties that x and z are both represented as having, viz. chromatic color and color. Thus, if we look back at how "red looks more similar to orange than it does to green" is defined, we see that it's false. But of course "red is more similar to orange than it is to green" is an intuitively true similarity claim. This looks like a difficulty for our account.

But it can be overcome. It is reasonable to suppose that there *is* a color property that x and y, but not z, are represented as having, and if so the above account of the color properties x, y, and z are represented as having is incomplete. The common property is *red-or-orange-or-purple*—"reddishness," for short (we are taking pink to be a kind of red and brown a kind of orange). Anything that's either red or orange or purple does look (as we say) reddish. Therefore the natural supposition is that there is a property that visual experience represents all red, orange, and purple objects (and no others) as having.

According to the proponent of the argument we have just been considering, visual experience tells us that red is more similar to orange than to green, in the natural sense. We say it tells us nothing of the sort. Visual experience simply tells us that red objects have certain color properties in common with orange objects, and certain color properties in common with green objects; and there are more of the former than the latter.

It must be emphasised that we are not explaining *why* or *how* the visual system represents objects as having this multitude of properties. That might be thought a disadvantage, but in any case we are not denying anything that is known at the neurophysiological level, or taking a stand on the details of opponent-process theory.

One advantage of our account is that it makes no appeal to the notion of natural similarity relations among properties. It is not so clear that the idea is intelligible,

and in any case has proved very hard to analyze.[34] A fortiori, we do not need to suppose that visual experience can represent such relations.

3.3 Third Objection: Physicalism Cannot Account for Binary Structure

Hardin has claimed that even if physicalism is successful in accounting for the relations of similarity and difference among the colors, there still remains one crucial sort of chromatic fact that resists a physicalist treatment. As we have already noted, some colors, for example, orange, always look to be mixtures, whereas others, for example, red and yellow, do not. Any shade of orange appears, or at least will appear to a reflective perceiver, to be a mixture of red and yellow in varying proportions. In the case of yellow, however, there is a shade of yellow that does not appear to be a mixture of any other hues—unique yellow. There are exactly four unique hues (red, green, yellow, blue) and all the others are binary.[35] This distinction is deeply embedded in contemporary color science and is thought by many to reflect fundamental facts about the physiology of color vision.[36] Here, Hardin argues, we have a serious problem for physicalism:

> If we reflect on what it is to be red, we readily see that it is *possible* for there to be a red that is unique, i.e., neither yellowish nor bluish. It is equally apparent that it is *impossible* for there to be a unique orange, one that is neither reddish nor yellowish.... If yellow is identical with **G**, and orange is identical with **H**, it must be possible for there to be a unique **G** but impossible for there to be a unique **H**. If hues are physical complexes, those physical complexes must admit of a division into unique and binary complexes. No matter how gerrymandered the physical complex that is to be identical with the hues, it must have this fourfold structure, and, if objectivism [i.e. physicalism] is to be sustained, once the complex is identified, it must be possible to characterize that structure on the basis of physical predicates alone (1993, p. 66).[37]

Let BINARY be the claim that yellow is unique and orange is binary. The passage from Hardin suggests an argument paralleling the one in the previous section:

(1) We know BINARY solely on the basis of ordinary visual experience.

If—the argument continues—yellow and orange are "physical complexes," and if BINARY is true, "those physical complexes must admit of a division into unique and binary complexes." Hence, if the colors are physical properties, then we would need to find out which physical properties are yellow and orange, in order to determine whether or not BINARY is true. That is, we would need color science—ordinary visual experience wouldn't suffice. So:

(2) If physicalism is true, (1) is false.

Hence:

(3) Physicalism is false.

Unlike the previous argument, where SIMILARITY had a tolerably clear interpretation, the usual explanation of BINARY is more than a little opaque. Take orange. We say it is a binary color because it is, or appears to be, a mixture of red and yellow. But what does that mean? Is orange a combination of the two properties red and yellow? No: a "combination" of two properties A and B is presumably the property $A\&B$ (if it's not that, what is it?). Everything that has the property *red&yellow* is red, but (many) orange objects are not red. Is orange a mixture of red and yellow as a field of poppies and buttercups is a mixture of red and yellow? No, because an orange patch does not appear composed of separate red and yellow blobs. Is orange binary because any orange pigment looks as if it was formed by mixing red and yellow pigment? Well, given common experience with pigments, and a mildly theory laden account of perception, perhaps it does appear that way. But this can hardly be in what the binary/unique distinction consists.[38] If there is a sense in which orange pigment looks to be a mixture of red and yellow pigment, then presumably green pigment looks in this sense to be a mixture of yellow and blue pigment. If this explanation of the binary/unique distinction were right, green would be a binary color. But it isn't.

So it is really not at all obvious that there is a natural interpretation of BINARY such that its truth requires some physically motivated "division into unique and binary complexes."[39] In any case, we have an analysis of BINARY that shows that, even if physicalism is true, it may be known on the basis of ordinary visual experience. Thus we deny (2).

In the previous section we claimed that there is a color property—reddishness—that visual experience represents all and only red, orange, and purple objects as having. Therein lies the similarity between these colors. There is equal reason to believe that visual experience represents objects as having greenishness, blueishness, and yellowishness.

Setting aside color properties that are always represented in (chromatic) color experience—chromatic color and color—the four properties just mentioned are plausibly the *superdeterminables*: every other representable color property is a determinate of one of these properties.

Now any object that is visually represented as orange is also represented as having precisely two of these superdeterminables, reddishness and yellowishness (in fact, we may identify orange with *reddishness&yellowishness*). And any object that is visually represented as yellow is either represented as having greenishness and yellowishness,

reddishness and yellowishness, or, in the case of unique yellow, only yellowishness. Thus, there is a shade of yellow such that any object represented as having that shade is represented as having just one superdeterminable, and no such shade of orange. This is our analysis of BINARY. And so there is no evident difficulty in knowing that yellow is unique and that orange is binary on the basis of ordinary visual experience. The objection from binary structure therefore fails.[40]

4 Conclusion: The Case for Physicalism

Physicalism about color has considerable attractions. Unlike eliminativism, it does not convict experience of widespread error. Unlike primitivism, it provides a reduction of the colors and, moreover, a reduction to properties that we are already committed to on independent grounds. The physicalist theory presented here has some additional advantages. Unlike the most popular version of dispositionalism, it gets by without suspect visual-field properties like Peacocke's red' (see, for example, Peacocke, this volume, chapter 5). Further, it can accommodate our intuitive judgments of similarity relations among the colors, and the binary/unique distinction. But serious problems—although not peculiar to physicalism—remain. Two stand out. First, what makes it the case that visual experience has the representational content that it does? Second, what is the right account of the difference between the various sensory modalities? We are as yet far from satisfactorily answering these questions.

Acknowledgments

We are particularly indebted for comments on early drafts and much discussion to Ned Hall, Katie Hilbert, Jim Pryor, Judith Thomson, Robert Stalnaker, and Ralph Wedgwood. For comments on later versions, thanks to Justin Broackes, Fiona Cowie, Mark Crimmins, Daniel Stoljar, Sarah Stroud, and Mark Johnston.

Notes

1. The preceding remarks about the content of experience will pass for the purposes of this paper. But they are sketchy, and do not begin to do justice to the many complexities here (for some of these, see Peacocke 1992, chapter 3).

2. Why "typically?" Because, perhaps, some green-feeling experiences—for example, the experience of having a green afterimage—are not green-representing (see Boghossian and Velleman, this volume, chapter 7, section 2.3 of the Introduction, and note 15 below).

3. Athough relatively uncontroversial this claim is not universally accepted. Tolliver (1994) denies that visual experiences represent objects as having colors. Of course, the claim is also problematic if spectrum

inversion is supposed to be a live possibility (but here our assumption that it is not is largely for convenience).

4. See Hilbert 1987. Defenders of a similar account include Matthen 1988; Grandy 1989; and Tye 1995.

5. Also for simplicity, we shall ignore the fact that colors vary along dimensions other than hue.

6. For some remarks about light sources, see Hilbert 1987, pp. 132–4.

7. Metamerism is not just illumination-relative, but also observer-relative. The phenomenon is treated at greater length in Hilbert 1987; it is argued there that metamerism creates difficulties for some forms of dispositionalism.

8. It might be claimed that there are colored objects in a possible world where the laws are such that objects reflect and absorb certain ectoplasmic rays, and could not interact with light (and hence do not have reflectances). If so, then colors are not reflectance-types. Perhaps this alleged possibility is even clearly conceivable—at least in the sense in which philosophers' "zombies" are clearly conceivable. But it would be hasty to remove "alleged." Maybe all we can reasonably conclude is that objects could *look* colored in a world where objects do not have reflectances—and we can live with that. For some relevant discussion see Yablo 1993 and Tye 1995, chapter 7.

9. This will ensure that the hypothesized red-green opponent channel is negative (i.e., biased toward green) and the yellow-blue channel is more or less balanced. See Hardin 1993, chapter 1, and Hurvich 1981. For the graphical representation of an SSR of a typical green paint, see MacAdam 1985, figure 2.1. For present purposes, the details of the psychophysics and physics do not matter.

10. Of course, even the parts of a dollar bill that look green at arm's length are not uniformly green viewed close up. Thus the parts that look green and so are represented as having SSR$_{GREEN}$ themselves have parts whose reflectances are not of this type. Does this mean that when dollar bills appear at arm's length to have large green regions this is an illusion? No. True, when a region looks uniformly green parts of it are represented as having SSR$_{GREEN}$, but not *arbitrarily* small parts. (Cf. Hilbert 1987, chapter 2.)

11. Taking SSR$_{GREEN}$ to be well-defined is certainly an oversimplification, because of the vagueness of color categories. For an attempt, using fuzzy set theory, to accomodate such vagueness, see Kay and McDaniel 1978.

12. In Hilbert 1987 (chapters 5, 6) the maximally specific colors are called "maximally determinate colors," "individual colors," or simply "colors," and the fact that this is an extension of everyday talk is not explicitly discussed. For some criticism, see Watkins 1995, esp. pp. 3–4, 11–12.

13. *Loci classici*: Shoemaker 1982, Peacocke 1983, Harman 1990 and Block 1990. See also Block 1996, forthcoming; DeBellis 1991; Dennett 1991; Harman, this volume, chapter 13; Shoemaker 1990, 1991, 1994a, this volume, chapter 12; Tye 1992, 1994; Lycan 1987, 1996b; and many of the papers in *Philosophical Issues* 7, ed. E. Villanueva (Atascadero, CA: Ridgeview, 1996).

14. See especially pp. 118–21.

15. Here are three apparent counterexamples. The first two are directed against the left-to-right part of NECESSITY, the last against the right-to-left part.

First, a case suggested by some remarks of Peacocke's (this volume, chapter 5, p. 59). If you look through a sheet of green cellophane at a white sheet of paper, rather surprisingly it looks white. Without the cellophane, of course it still looks white. So, it might be argued, the color contents of the two sorts of experiences are the same—both represent the paper as having the property white—but there is a clear phenomenological difference between them. There is, as it were, a "green tinge" present in the first sort of experience but not in the second.

However, with the green cellophane in place, the scene before the eyes looks just as if the paper is white and the ambient illumination is green. It is therefore natural to propose that the first experience, but not the second, represents (falsely) that this is the case. Therefore the color content of the two experiences differs.

For the second case, consider the experiences of having, respectively, a red and a green afterimage. They differ, of course, in phenomenology. But, it might be argued, such experiences do not represent anything as having a color, and so they are trivially alike in color content. (Cf. Boghossian and Velleman, this volume, chapter 7, pp. 91–2.)

However, we think the experience of having a green afterimage represents that there is a green patch some indeterminate distance before the eyes, and hence it is green-representing (and nonveridical). Cf. Harman 1990, p. 40; Tye 1995, pp. 107–8; Lycan 1996a, p. 83. (And in fact, sometimes one mistakes afterimages for colored patches on the surfaces of objects.) So, as in the first case, the color content of the two experiences differs.

For the third case, consider blindsight. Blindsighted patients are, apparently, able to perform above chance when forced to choose the color of an object presented in their blind fields (see Hardin 1993, p. xxx). Two blindsighted patients, one of whom performs above chance (call her "S") and the other at chance, might enjoy visual experiences identical in phenomenology when a tomato is presented in their blind fields. This, it might be argued, is a case of a difference in the color properties represented by visual experience, with no accompanying difference in phenomenology.

However, although this may be a case of different content, it is not a difference in the content of *visual experience*. The tomato may be represented as having the property red by some part of S's visual system. But since there is certainly no ordinary sense in which the tomato *looks red* to S (she herself would deny it), the property red does not enter into the content of her visual experience.

16. Someone who is persuaded to deny NECESSITY on the basis of either the inverted spectrum argument or one of the first two cases given in note 15 above will think that there are (possible) green-feeling experiences that are not green-representing. So she owes us an account of what is common to all and only green-feeling experiences. It cannot be color content, so what is it? It is worth briefly examining Peacocke and Shoemaker's answers to this question.

First, Peacocke's answer: all green-feeling experiences present the "sensational property" *green'* ("green-prime") to the subject. Green' is, of course, *not* the property green, and not a property objects are *represented* as having. Rather, it is supposed to be a property of "regions of the visual field"—a property, that is, of something like sense-data. (See Peacocke 1983, chapter 1, 1992, pp. 7–8, and this volume, chapter 5.)

Although we shall not argue for this here, we think that once sensational properties like green' are admitted, an error theory of color experience is inescapable: the common person mistakenly takes green' to be a property of gooseberries and cucumbers (for precisely this view, see Boghossian and Velleman, this volume, chapters 7, 8).

Shoemaker's ingenious answer (this volume, chapter 12) is that while all green-feeling experiences do not share a *color* content, they all represent objects as having a "phenomenal property," which we may call "phenomenal-green." Phenomenal-green (not to be confused with green) is the property of "producing in a viewer" green-feeling experiences, and is thus a property things do not have when they are not being perceived (p. 241). But Shoemaker's view has, like Peacocke's, the disadvantage that it leads to an error theory, or so it seems to us. According to Shoemaker, when Invert and Nonvert look at a raspberry, their experiences each represent it as having two properties: phenomenal-green and red (Invert) and phenomenal-red and red (Nonvert). If Shoemaker is right that experience represents objects as having phenomenal-colors, then we think that the common person mistakenly takes objects to have these properties when they are not being perceived.

17. In fact, we think that Fred's case is simply an especially vivid way of making points that could be made using the standard inverted spectrum case, and is therefore a ladder that may be kicked away. But it does not seem fruitful to insist on this, because it seems most unlikely that our opponents would agree.

18. Fred's plight might be described as a case of partial intrapersonal spectrum inversion on Alternately Inverting Earth (cf. Block 1990). We should emphasize that we are not supposing that Fred *in principle* could not tell on the basis of his visual experience that something is awry. Given certain assumptions about his environment and the asymmetry of color space, perhaps he could. All we are supposing is that (perhaps due to limitations on his part) he is not able to notice any difference.

19. Of course, the conclusion that Invert sees the true colors of objects is not *entailed* by the premise that color content is extrinsic. What is true, rather, is this. Most, maybe all, *plausible* theories of extrinsic color content entail that Invert (or Invert as he appears in a more intricate example) sees the true colors of objects.

20. It might be objected that this is not right, because Fred and Invert differ in a crucial respect (here we are indebted to Robert Stalnaker). Fred remembers that some objects look the same (in respect of color) to him on Tuesday as other objects did on Monday (in Shoemaker's "qualitative sense" of "looks the

same"—see Shoemaker 1982). In particular, suppose that Fred is looking at a strawberry on Tuesday and recalls that it looks the same as a raspberry he saw on Monday. Now if our description of Fred's case is correct, the raspberry was represented by Fred's experience on Monday as *green*, while the strawberry is represented as *red*—yet he remembers that they look the same! And this, it might be thought, is not plausible. (Compare Invert's case: he remembers that a raspberry looked the same to him yesterday as a strawberry does today, but his experiences represent them as having the *same* color.)

We reply as follows. Cases where someone *undergoes* spectrum inversion and, after a while, sees the true colors of objects as before, are taken, by the proponents of the inverted spectrum argument, to be clearly possible. (Indeed, more so than cases of spectrum inversion from birth.) Thus the subject remembers that some objects (for example, gooseberries) looked the same to him before the inversion as others (for example, raspberries) do after the inversion, but even so gooseberries were represented as green, whereas raspberries are represented as red. If this is not problematic, why suppose Fred's case is?

21. It might be replied that although it appears to Fred that the world has not changed, he mistakenly *believes* that it appears to him that the world has changed. That is, Fred is the victim of an illusion with respect to his *experience*: he believes that his visual experiences differ in content, but in fact there is no difference. But this reply does not work, for at least two reasons. First, we may suppose that Fred, perhaps like many of us in normal circumstances, has no beliefs about his visual experience—he just has beliefs about the scene before his eyes. Second, we may alternatively suppose that Fred is apprised of his role in the Gedankenexperiment, and is a proponent of the inverted spectrum argument. He will then believe that his visual experiences are the *same* in content, but the world will still appear to him to change.

22. Another reply—requiring some stage-setting—is this. Return to Invert and Nonvert, both looking at a gooseberry. A proponent of the inverted spectrum argument will usually say that this is not just a case of same properties represented, but a case of same content *simpliciter*. Call this the "Same Content Claim" (see, for example, Shoemaker 1982, Block 1990). But there is another way of taking the inverted spectrum, equally inhospitable to NECESSITY, which we will call the "Fregean Response."

According to the Fregean Response, two visual experiences may differ in content despite representing objects as having the same properties. Visual experiences, on this account, represent properties under various "modes of presentation," akin to Fregean senses. And these modes of presentation are supposed to enter into the content of the experience.

The Fregean Response and the Same Content Claim both agree that Invert and Nonvert's experiences are the same in respect of what we are calling "color content": they both represent the raspberry as having the *property* red. But the Fregean Response, unlike the Same Content Claim, says that the experiences differ in their visual modes of presentation of this property, and thus in their content.

Now go back to Fred and the red raspberry. According to the Same Content Claim, the change in Fred's experience is not a change in content—it is solely a change in phenomenology. We complained that it *is* a change in content. So far, so good.

However, it might be objected that our complaint is of no force against the Fregean Response. According to it, the content of Fred's experience *does* change. When he takes his first look, the raspberry is represented as having the property red under one mode of presentation, and when he takes his second, the raspberry is represented as having this same property under a *different* mode of presentation.

But the Fregean Response does not do justice to the fact that the *raspberry* appears to Fred to change. The raspberry changes only if it gains or loses a property, and so the raspberry will *appear* to change only if it appears to gain or lose a property. If the difference between Fred's experiences were simply a difference in modes of presentation, then the raspberry would not appear to gain or lose a property, and so would not appear to change. That is, if the Fregean Response were right, then although *the way the raspberry appears* would change, *the raspberry itself* would not appear to change.

To see the difference, consider a case where modes of presentation might do useful work: distinguishing between sensory modalities (cf. Shoemaker 1990). Arguably, the very same property—shape—can be represented by both tactile and visual experiences. If that's right, it would be natural to appeal to modes of presentation to give a representational account of the phenomenological difference between seeing that an object is square and feeling that it is. To switch to a hypothetical example, suppose that Fred can taste colors. Red things have a distinctive taste that green things lack, and so on. The property red (we are pretending) is a property that certain of Fred's visual and gustatory experiences both represent raspberries as

having. The experiences are different, it might be claimed, because they differ in content at the level of sense rather than reference; that is, Fred's visual and gustatory modalities represent the same property—red—under different modes of presentation. Here the appeal to modes of presentation, whatever its other defects, does not suffer from the problem just raised for the Fregean Response. When Fred successively sees and tastes a raspberry, the way the raspberry appears changes, but the raspberry itself does not appear to change.

23. Sometimes philosophers use "narrow content" to refer to what we have here called "intrinsic content." But "narrow content" is used ambiguously in a way that invites confusion. Some say that while Oscar and Twoscar do not share a belief with the content *that water is wet*, they *do* share some *other* mental state: a mental state that determines, together with the environmental facts, whether the subject believes that water is wet, or whether she believes that twater is wet. Such a state—the organismic contribution to believing *that water is wet* (and to believing *that twater is wet*)—is supposed to have "narrow content" (see, for example, Fodor 1987). Narrow content in this sense is at best some etiolated kind of content and at worst unintelligible (for some classic objections see Stalnaker 1989). This sense of "narrow content" is not what we mean by "intrinsic content": the latter is just familiar propositional content that is necessarily shared between duplicates.

24. We should record that one of us (DH) prefers to deny the first premise, while the other (AB) prefers to deny the third.

25. Hilbert 1987 implicitly assumes a correlational theory of content in the style of Dretske 1981, and Hilbert 1992 explicitly assumes a teleological theory in the style of Millikan 1984. These two theories do exclude intrinsic content.

26. See Peacocke 1992, pp. 74–6, from which the example is taken.

27. These definitions are inevitably somewhat stipulative. For instance, we might just as well have said that x and y are perfectly similar relative to a family of properties $\{P_1, \ldots, P_n\}$ just in case x and y either both have or both lack each P_i. And we might just as well have said that x is more similar to y than to z, relative to a family of properties $\{P_1, \ldots, P_n\}$ just in case x and y share some P_i that z lacks, and if x and z have some P_j, then y has P_j. But for the argument to follow, the (second) definition given in the text is the one we want.

28. We are here assuming that properties are "abundant" in Lewis's (1983) sense. To every set of possible things, no matter how diverse, each thing paired with a possible world it inhabits, there corresponds a property had by all and only those things in those worlds. Assuming, as Lewis holds, that possible individuals inhabit only one world, we can put this more cleanly as: to every set of possible things, no matter how diverse, there corresponds a property had by all and only those things.

29. For a defense of natural similarity (although not under this name) see Lewis 1983; and Armstrong 1978, 1989. Natural similarity is not usually left as primitive: Armstrong, for instance, analyzes simple cases of it as the sharing of certain special sorts of properties—universals—which are wholly present wherever they are instantiated.

30. Cf. Johnston, this volume, chapter 9, pp. 149–54; and Boghossian and Velleman, chapter 8, pp. 116–127.

31. See, for example, Armstrong 1989, p. 33.

32. See MacAdam 1985, figures 2.1, 2.2, and 2.6.
 Hilbert 1987 (chapter 6) can be understood as arguing that physicalism can accomodate SIMILARITY (although perhaps not our knowledge of it). There colors are identifed with certain triples of integrated reflectances. It is claimed that a certain space of such triples, with a physically motivated metric, is roughly isomorphic to color similarity space. But this is not right, or not right enough: the space of triples provides only a very loose approximation to similarity relations among the colors. See Thompson 1995, chapter 3, for detailed discussion.

33. Here (although not in the statement of NECESSITY) "possible visual experience" should be understood to be restricted to visual experiences that can be produced by the *human* visual system (as it actually is). On our view, we cannot rule out the possibility that some strange kinds of visual systems can produce an experience that represents three objects x, y, and z to be scarlet, crimson, and lemon yellow, but does not represent (for example) x and y to be red. (Although, of course, every scarlet object *is* red.) Dropping the

restriction to the human visual system would therefore imply that the defined three-place relation does not hold between any color properties.

34. See Armstrong 1978, chapters 21, 22; 1989, pp. 103–7.

35. If we wish to include the achromatic colors the list of unique hues should include black and white. Brown is a puzzling case (see Hardin 1993, p. 141). These complications do not affect our argument and will be ignored in what follows.

36. See *Readings on Color, vol. 2: The Science of Color.*

37. For endorsements of this complaint, see Varela et al. 1991, p. 166; Thompson 1995, pp. 135–9. (Thompson's endorsement is somewhat qualified: he thinks the argument shows that colors are not "nonrelational" properties.)

38. *Pace* Tye 1995, p. 148.

39. Hardin's official demand is that "those physical complexes must admit of a division into unique and binary complexes." On a uncharitable reading, this is easy to meet: just stipulate that the physical properties to be identified with red, green, yellow, and blue are to count as unique, and the rest binary. But we take it that Hardin thinks that (if physicalism is to be saved) the division must be physically motivated.

40. Our response to this objection also provides an account of the opponent structure of the hues. Red is opposed to green, and blue is opposed to yellow, because no object is represented by the human visual system simultaneously as having reddishness and greenishness, or yellowishness and bluishness. But we are not offering any explanation of this fact (see the end of 3.3 above).

References

Armstrong, D. M. 1978. *Universals and Scientific Realism.* Cambridge: Cambridge University Press.

Armstrong, D. M. 1989. *Universals: An Opinionated Introduction.* Boulder, CO: Westview Press.

Block, N. 1990. Inverted Earth. In *Philosophical Perspectives 4*, ed. J. Tomberlin. Atascadero, CA: Ridgeview.

Block, N. 1996. Mental paint and mental latex. In *Philosophical Issues 7*, ed. E. Villanueva. Atascadero, CA: Ridgeview.

Block, N. Mental ink. In *Anti-Individualism and Scepticism*, ed. M. Hahn and B. Ramberg. Cambridge, MA: MIT Press, forthcoming.

Boghossian, P. A., and J. D. Vellemen. 1989. Colour as a secondary quality. *Mind* 98, 81–103. Reprinted as chapter 7 of this volume.

Boghossian, P. A., and J. D. Vellemen. 1991. Physicalist theories of color. *Philosophical Review* 100, 67–106. Reprinted as chapter 8 of this volume.

DeBellis, M. 1991. The representational content of musical experience. *Philosophy and Phenomenological Research* 51, 303–24.

Dennett, D. 1991. *Consciousness Explained.* Boston: Little, Brown.

Dretske, F. 1981. *Knowledge and the Flow of Information.* Cambridge, MA: MIT Press.

Dretske, F. 1988. *Explaining Behavior.* Cambridge, MA: MIT Press.

Dretske, F. 1995. *Naturalizing the Mind.* Cambridge, MA: MIT Press.

Dretske, F. 1996. Phenomenal externalism. In *Philosophical Issues 7*, ed. E. Villanueva. Atascadero, CA: Ridgeview.

Fodor, J. A. 1987. *Psychosemantics.* Cambridge, MA: MIT Press.

Fodor, J. A. 1990. A theory of content, II: the theory. In his *A Theory of Content and Other Essays.* Cambridge, MA: MIT Press.

Grandy, R. E. 1989. A modern inquiry into the physical reality of colors. In *Mind, Value and Culture: Essays in Honour of E. M. Adams*, ed. D. Weissbord. Atascadero, CA: Ridgeview.

Hardin, C. L. 1993. *Color for Philosophers: Unweaving the Rainbow* (expanded edition). Indianapolis: Hackett.

Harman, G. 1990. The intrinsic quality of experience. In *Philosophical Perspectives* 4, ed. J. Tomberlin. Atascadero, CA: Ridgeview.

Harman, G. 1996. Explaining objective color in terms of subjective reactions. In *Philosophical Issues* 7, ed. E. Villanueva. Atascadero, CA: Ridgeview. Reprinted as chapter 13 of this volume.

Hilbert, D. R. 1987. *Color and Color Perception: A Study in Anthropocentric Realism*. Stanford: CSLI.

Hilbert, D. R. 1992. What is color vision? *Philosophical Studies* 68, 351–70.

Hurvich, L. M. 1981. Chromatic and achromatic response functions. In his *Color Vision*. Sunderland, MA: Sinauer Associates. Reprinted as chapter 3 in *Readings on Color, vol. 2: The Science of Color*.

Johnston, M. 1992. How to speak of the colors. *Philosophical Studies* 68, 221–63. Reprinted as chapter 9 of this volume.

Johnston, M. 1997. Postscript: visual experience. An appendix to chapter 9 of this volume.

Kay, P., and C. K. McDaniel. 1978. The linguistic significance of the meanings of basic color terms. *Language* 54, 610–46. Reprinted as chapter 17 in *Readings on Color, vol. 2: The Science of Color*.

Lewis, D. K. 1983. New work for a theory of universals. *Australasian Journal of Philosophy* 61, 343–77.

Lycan, W. G. 1987. *Consciousness*. Cambridge, MA: MIT Press.

Lycan, W. G. 1996a. Layered perceptual representation. In *Philosophical Issues* 7, ed. E. Villanueva. Atascadero, CA: Ridgeview.

Lycan, W. G. 1996b. *Consciousness and Experience*. Cambridge, MA: MIT Press.

MacAdam, D. L. 1985. The physical basis of color specification. In his *Color Measurement: Theme and Variations*. New York: Springer-Verlag. Reprinted as chapter 2 in *Readings on Color, vol. 2: The Science of Color*. References to the latter.

Matthen, M. 1988. Biological functions and perceptual content. *Journal of Philosophy* 85, 5–27.

Millikan, R. G. 1984. *Language, Thought, and Other Biological Categories: New Foundations for Realism*. Cambridge, MA: MIT Press.

Nassau, K. 1980. The causes of color. *Scientific American* (October), 124–54. Reprinted as chapter 1 in *Readings on Color, vol. 2: The Science of Color*.

Peacocke, C. 1983. *Sense and Content: Experience, Thought, and their Relations*. Oxford: Oxford University Press.

Peacocke, C. 1984. Colour concepts and colour experience. *Synthese* 58, 365–82. Reprinted as chapter 5 of this volume.

Peacocke, C. 1992. *A Study of Concepts*. Cambridge, MA: MIT Press.

Putnam, H. 1975. The meaning of 'meaning.' In *Language, Mind and Knowledge: Minnesota Studies in the Philosophy of Science* 7, ed. K. Gunderson. Minneapolis: University of Minnesota Press.

Shoemaker, S. 1982. The inverted spectrum. *Journal of Philosophy* 79, 357–81.

Shoemaker S. 1990. Qualities and qualia: what's in the mind? *Philosophy and Phenomenological Research* 50 (Suppl.), 109–31.

Shoemaker, S. 1991. Qualia and consciousness. *Mind* 100, 507–24.

Shoemaker, S. 1994a. Self-knowledge and 'inner sense.' Lecture III: the phenomenal character of experience. *Philosophy and Phenomenological Research* 54, 291–314.

Shoemaker, S. 1994b. Phenomenal character. *Noûs* 28, 21–38. Reprinted as chapter 12 of this volume.

Stalnaker, R. 1989. On what's in the head. In *Philosophical Perspectives* 3, ed. J. Tomberlin. Atascadero, CA: Ridgeview.

Thompson, E. 1995. *Colour Vision*. New York: Routledge.

Tolliver, J. T. 1994. Interior colors. *Philosophical Topics* 22, 411–41.

Tye, M. 1992. Visual qualia and visual content. In *The Contents of Experience*, ed. T. Crane. Cambridge: Cambridge University Press.

Tye, M. 1994. Qualia, content, and the inverted spectrum. *Noûs* 28, 159–83.

Tye, M. 1995. *Ten Problems of Consciousness: A Representational Theory of the Phenomenal Mind*. Cambridge, MA: MIT Press.

Varela, F. J., E. Thompson, and E. Rosch 1991. *The Embodied Mind: Cognitive Science and Human Experience*. Cambridge, MA: MIT Press.

Watkins, M. 1995. Dispositionalism in disguise: reply to Averill and Hilbert. Paper delivered at APA Central Division meeting.

Yablo, S. 1993. Is conceivability a guide to possibility? *Philosophy and Phenomenological Research* 53, 1–42.

15 Reinverting the Spectrum

C. L. Hardin

Even if Divine Revelation should tomorrow provide us with the definitive solution to the problem of color realism, we would still be faced with an even more difficult question of ontology: the nature and locus of the qualities of color experience. The question is hard to avoid; even those philosophers who would ultimately locate colors outside of organisms typically grant an important role to color experiences. Independently of philosophical proclivity, it is evident that color experience is intimately involved with the brain, and the appearance of at least some colors is inextricably bound up with brain function. The colors experienced in afterimages, colored shadows and simultaneous contrast, are explicable in terms of the operation of nervous systems and cannot plausibly be supposed to exist apart from them.[1]

Most philosophers would agree that the qualities of color experiences *supervene* upon brain function. But to say this is not to shed much light on the precise nature of the relationship. Is the supervenience necessary, or only contingent? Does the supervenience relationship in this instance simply reflect a causal relationship, or is the color experience–brain function connection more intimate than that? Are the qualities of color experience ultimately physical? If so, in what way? Are they perhaps physical, but not reducible to the properties and entities known to present-day physics? Or are they nonphysical denizens of Cartesian minds?

Mind-body materialists of a reductive stripe offer an ontologically parsimonious reply to these questions. According to such reductive materialists, experiencing color qualities is nothing more than having certain neural processes. However, there is a philosophical tradition, based upon some powerful intuitions, according to which even an explanatory relationship between qualitative experiences and brain processes—let alone an identity of one with the other—is unintelligible. Here is a famous passage from Leibniz:

It must be confessed, moreover, that *perception* and that which depends on it *are inexplicable by mechanical causes*, that is, by figures and motions. And, supposing that there were a machine so constructed as to think, feel and have perception, we could conceive of it as enlarged and yet preserving the same proportions, so that we might enter it as into a mill. And this granted, we should only find on visiting it, pieces which push one against another, but never anything by which to explain a perception. (*Monadology*, section 17)

More recently, Joseph Levine (1983) argues that although mental processes and physical processes might in fact be identical, we can never have scientific grounds for supposing them to be so:

Let's call the physical story for seeing red 'R' and the physical story for seeing green 'G'.... When we consider the qualitative character of our visual experiences when looking at ripe

McIntosh apples, as opposed to looking at ripe cucumbers, the difference is not explained by appeal to G and R. For R doesn't really explain why I have the one kind of qualitative experience—the kind I have when looking at McIntosh apples—and not the other. As evidence for this, note that it seems just as easy to imagine G as to imagine R underlying the qualitative experience that is in fact associated with R. The reverse, of course, also seems quite imaginable.

Levine is here suggesting that in the absence of an intelligible connection between seeing red and the R story and seeing green and the G story, we can never be entitled to take seeing red to be identical with having neural processes R. The very possibility that somebody could have had the same physical constitution and display the very same behavior that she does now and yet have seen as red what she now sees as green (and, generally, for the same set of stimuli, experiencing all colors as interchanged with their actual-world complements) is sufficient to show that no physical story can ever capture what it is to experience a color.

In what follows, I will contend that the prospect for a reduction of color experiencing to neural functioning is not so bleak. Reflection upon known facts will suggest that the possibility of an undetectable spectral inversion may be an illusion based upon our ignorance, and that if the facts were to be filled in further, the possibility of an undetectable spectral inversion would come to seem to be as fanciful as the possibility of a human being having Superman's x-ray vision. Specifically I wish to argue that:

• Primate surface-color space is asymmetric.

• The structure of this space reflects intrinsic characteristics of the colors.

• Rather than serving as a stumbling block for a program of neurofunctionalist reduction, color qualities are the natural expression of neurofunctional mechanisms.

• We have good reason to believe that two human beings with similar neurofunctional architectures will not have color qualities undetectably inverted with respect to each other.

• We ought to be disinclined to attach much theoretical weight to the claim that there are possible creatures who have both similar functional architecture and sensory qualities undetectably inverted with respect to each other.

I shall confine my attention to perceived surface colors, that is, the perceived colors of reflective objects with visual surrounds, in order to include both brown and black among the colors. The focus throughout is to be on the qualities of sensory experience, but I have no philosophical theory of "qualia" to offer here, and I shall try to avoid using that term in what follows.

Some features of the opponent scheme of color vision will be important for our discussion. The scheme calls for six phenomenally elementary colors, which I shall refer to as the *Hering primaries*, after the founder of opponent-process theory, Ewald Hering. Two of these, white and black, are achromatic colors, and the remaining four, red, yellow, green, and blue, are chromatic colors. Each of the Hering primaries is *unitary*, that is, contains no perceptible trace of any of the others, and this feature distinguishes them from the rest of the colors, such as the pinks, the maroons, the limes, the browns, and the oranges, which are *binary*, that is, perceptual mixtures of the elementary colors. The pinks, for example, are reds that are both whitish and bluish. Oranges are reddish yellows. Browns are blackish oranges or blackish yellows. To say that orange is a *perceptual* mixture of red and yellow is not to refer to the way that orange pigments or lights are physically generated. This point is important, so let's consider it in more detail.

Suppose we project onto a screen two overlapping beams of light, one red, one green. The region of overlap will look yellow. Now let one of the beams be red, the other yellow. The region of overlap will look orange. In both instances, we have physically combined lights to produce a mixed color. The difference is that whereas the orange spot *looks* like a mixture of red and yellow, the yellow spot does not *look* like a mixture of red and green—we would not, for instance, be inclined to describe it as a reddish green. The orange is both physically and perceptually mixed, whereas the yellow is physically mixed, but not perceptually mixed. In fact, if we choose our green and our red beams properly, the yellow will look pure, without any tinges of other colors. It will, in fact, look exactly the same as a monochromatic yellow, a yellow produced by light of a single wavelength of about 580 nm. The orange light, which we here produced by physically combining red and yellow beams, could also be matched precisely by light of a single wavelength, in this case, 590 nm. We may thus conclude that perceptual mixture is independent of physical mixture.

Orange is, then, a perceptual mixture of red and yellow. Its location midway between red and yellow in perceptual resemblance space is consequent upon its resembling red as much as it resembles yellow, but this is in turn consequent upon its perceptually containing the same amount of red as it contains yellow. The description of orange as perceptually *containing* a certain percentage of red and *containing* a certain percentage of yellow may sound bizarre, but it can be justified by the performance of human subjects. People who are presented with patches of light from a spectral source and then asked to estimate the percentage of a given hue *in* the patch can, with a little practice, do it easily and reliably. It is interesting to see what visual scientists Sternheim and Boynton (1966) discovered when they required their experimental subjects to use only a restricted set of hue terms to describe light samples

drawn from the longwave end of the spectrum. If the subjects were permitted only the names 'red', 'yellow', and 'green', they were able to describe all of the samples in the longwave range, with the percentage totals for each wavelength sample adding to 100. The term 'orange' proved to be replaceable by terms for red and yellow, even at the wavelengths where those same subjects would in other experiments locate their best examples of orange. However, when the term 'yellow' was forbidden, and the terms 'red', 'orange', and 'green' permitted, the region surrounding 580 nm, where most subjects would locate their best yellows, was underdescribed, with total hue estimates falling well below 100 percent through most of the region, and typically going to zero for 580 nm, the spectral region which most subjects see as unitary yellow.

In a nutshell, whereas orange can always be described in terms of red and yellow, yellow cannot be described in terms of red, green, and orange. The same asymmetry holds between all of the Hering primaries on the one hand, and all of the remaining colors on the other. The Hering primaries are necessary and sufficient for naming all of the colors, a fact that justifies singling them out as perceptual primaries. One might wonder whether this is a fact about linguistic primacy rather than a fact about perceptual primacy. The answer to that question seems to be no, as we shall presently see.

But first, let us notice a consequence of the fact that orange is a perceptual mixture of red and yellow. Could it be otherwise? Could someone experience a color that would be orange but be neither reddish nor yellowish? Of course there could quite easily be a creature who readily discriminates patches of 590 nm light from a wide variety of surrounds without experiencing those patches as reddish or yellowish. But that's not the present question, which is whether such a creature would nevertheless experience those patches as *orange*. It seems perfectly plain that the creature's failing to see reddishness and yellowishness would *constitute* its failing to see orange.[2] To use an old-fashioned mode of philosophical speech, orange is *internally related* to red and yellow. Precisely because of that, any "spectral inversion" that would carry a binary color like orange into a unitary color like blue would be readily detectable. To distinguish binary from unitary colors, we would only need to run the Sternheim-Boynton procedure.

Nearly all of the hundreds of nameable colors are, like the orange colors, binaries, and therefore perceptually composite, specifiable by necessary and sufficient conditions, and thus nicely suited for pairing off with structured neural processes. There are but six colors that fail to be composite. We have thus severely constrained the possibilities for undetectable spectral shifts such as those that some philosophers have claimed might be brought about by small rotations of the hue circuit. Assuming

that the circuit is so configured that unitary red, yellow, green, and blue are 90 degrees from each other, any rotation less than 90 degrees will carry some binary hues into unitary hues, and each unitary hue into a binary hue, a definitely detectable result. Although this is a useful consequence, we have not yet solved our problem. What we must next do is to show that the primaries are not interchangeable. This is a more difficult task, for there is nothing about the simple opponent-process scheme that forbids such an interchange of primaries. We must look into other aspects of color phenomenology to see if we might find deep reasons, based in the qualitative features of the colors themselves, for thinking that the colors of human experience are intrinsically not invertible.

To see whether there might be such reasons, it will be helpful to return to the question that was raised a moment ago, about whether the composite nature of orange and the noncomposite nature of yellow is really a matter of linguistic rather than perceptual primacy. Let us approach this question by comparing color categorization in human adults with color categorization in human infants, as well as with color categorization in our close primate relatives, chimpanzees and macaques.

Categories are equivalence classes of items that need not be identical. When we call a particular surface 'blue', we do not mean to say that it is identical in color to every other surface that is blue. Things that you take to be blue—your neighbor's car, your boss's dress, the sky, the sea—typically differ from one another in tint, shade, or hue. There are light blues, navy blues, electric blues, powder blues. Yet all of them resemble each other more than any of them resembles something that you see as yellow, or as red. It is important to understand that the resemblance that connects two instances of the same color category is not necessarily a function of the perceptual distance between them. It is not hard to find three color samples A, B, and C, which are such that B is separated from A on the one side and from C on the other by the same number of just-noticeable differences, and yet A and B are seen to belong to the same color category whereas C is seen to belong to a different color category. The rainbow looks banded, even though each of its constituent regions blends smoothly into its neighbors.

Are some categorizations of color continua more natural than others? We have already seen that adult speakers of English find that four hue names—'red', 'yellow', 'green', and 'blue'—are necessary and sufficient to describe the colors of the spectrum. Four-month infants know precious little English, and they cannot describe what they see. Nevertheless, by watching their eye fixations one can tell whether they see two stimuli as similar or different. Infants will lose interest in a stimulus that looks similar to its predecessor, but continue looking at a stimulus that they regard as different from what went before. This is the basis of a standard technique, used by

Spelke and others, to study categorization of various sorts among the very young. By exposing infants to sequences of colored lights whose dominant wavelengths are 20 nm apart, and recording their eye movements, Bornstein and his collaborators were able to map out their spectral color categories (Bornstein et al. 1976). These proved to line up rather well with the spectral categories of adults that are mapped with color-naming procedures. In a similar fashion, a macaque was trained to respond differentially to spectral lights that human beings would see as good representatives of their categories, and then presented with randomized sequences of lights that did not match the training lights. These lights were categorized by the macaque in pretty much the same way as adult human English speakers would classify them (Sandell et al. 1979).

We can now see that there must be innate mechanisms not only for detecting resemblances among colors but for categorizing them as well. We should not of course suppose that color categories are consciously or explicitly born in mind by monkeys or infants, but rather that their brains are so wired as to incline them to respond to certain classificatory demands in a characteristic fashion. This was strikingly demonstrated in a series of chimpanzee categorization experiments by Matsuzawa (1985).

In order to see what motivated Matsuzawa, we need to take a brief look at Berlin and Kay's famous work on basic color terms (Berlin and Kay 1969). Basic color terms are distinguished from nonbasic terms by their salience and their generality. Applying criteria based on these characteristics, Berlin and Kay were able to show that no language currently has more than 11 basic color terms, that each of the terms has a small set of best, or *focal* examples, that the focal examples from different languages cluster tightly in perceptual color space, and that, in consequence, basic color terms are readily translatable from one language to another. In English, the basic color terms are, as one might expect, the names for the Hering primaries, 'red', 'yellow', 'green', 'blue', 'black', and 'white', as well as 'brown', 'gray', 'orange', 'purple', and 'pink'. The stimuli in the Berlin and Kay work were a selection of Munsell color chips, a collection of color samples carefully scaled and reproduced to exacting standards. The sample consisted of maximally saturated chips taken from the outer shell of the Munsell color space. Using alternative color-order systems, other investigators, notably Boynton and Olson (1987) in the United States and Sivik and Taft (1994) in Sweden, have since carefully studied the ranges of these terms with very good overall agreement, exploring the interior of the color solid as well as its outer skin. Among other findings, they showed that some colors, such as blue and green, are seen over wide regions of the space, whereas other colors, such as red, orange, and yellow, are of much more restricted extent. We will look at the implications of this in a moment.

In the Matsuzawa experiment, to which I alluded above, the chimp, whose name was Ai, was trained on a set of 11 focal samples, learning to press the key that contained a contrived character for the appropriate basic color term. She was then presented with 215 of the Berlin and Kay chips that she had not seen. They were shown to her one at a time and in random order, and she was asked to name them. Following the sessions with the training chips, she did not receive reinforcement for her choices. The experimenter assigned a label to a chip when the chimpanzee gave it that label on at least 75% of the trials. The results were compared with those generated in a human color-naming experiment, again using the 75% consistency criterion. The outcomes were closely similar. The chimp had generalized from focal chips in essentially the same fashion as the human being.

This is a striking result, but what is its application to our problem? Think of it this way. Ai was presumably not doing what she was doing because of cultural bias, the grammar of color concepts, or any other such fancy hoo-hah. She was guided by what she saw, by what looked like what, by, if you will, the *intrinsic quality* of her sensory experience. The array of Munsell chips is scaled so that the samples are a constant number of just-noticeable-hue-differences apart, and a constant number of just-noticeable-lightness-differences apart. At one level of resemblance ordering, everything is smooth and orderly. But at the level of categorization, this is not at all the case, as we have already seen. (I might note parenthetically that other measures of perceptual distance are used in other color-order systems, but the results of categorization are essentially independent of this fact. The principles of scaling in the Swedish Natural Color System yield a solid of entirely regular shape, but the categorized areas are as irregular in shape and strikingly diverse in extent in the Natural Color System as they are in the Munsell solid.) If red occupies a small volume in the solid, and green a large one, what does this betoken but a substantial difference in phenomenal structure between red and green? Moreover, this difference is surely intrinsic to the qualities themselves. What else could serve as the basis for categorization? After all, the whole procedure only involves assessing the qualitative similarities and differences between one color and another.

I would next like to direct your attention to another categorical asymmetry, the strange case of the color brown. People differ in their sense of just how singular brown is. Nearly everybody agrees that brown has a certain affinity for yellow and orange, and if anyone is obliged to find the region of color space where it belongs, I would think that they would shove it down toward black, tucked underneath yellow and orange. But is brown just a blackened orange or yellow? Many people will hesitate to say so, for brown looks to have a very different quality from those two colors. People are surprised, and sometimes incredulous, to be told that, viewed in a bright light through a peephole, a chocolate bar looks to have exactly the same hue as an

orange. They are surprised when they see a demonstration in which a projected orange spot is first dimmed, looking orange to the very edge of invisibility. The same spot is then blackened by surrounding it with an annulus of bright white light. When the blackening occurs, the orange spot is transformed into a rich brown. It is as if the original quality has been lost, and replaced by another. Performing a careful Sternheim-Boynton procedure shows that this brown is, indeed, none other than blackened orange (Quinn et al. 1988), but the sense of major qualitative alteration persists.

It is important to bear in mind that this appearance of strong qualitative differences is not a general characteristic of blackened colors, most of which resemble their parent hues. Blackened blues, such as navy blue, continue to look blue, and blackened greens—olive greens—continue to look green. Only oranges and yellows seem to lose the parental connection when blackened. If this is so, what would happen in the hypothetical case of spectral inversion in which hues are carried into their complements? The inverse of orange is turquoise, the inverse of yellow, blue. Therefore the inverse of the browns would be blackened turquoises and navy blues. If you are like most people, you find brown and yellow to be far more different from each other than light blue is from navy blue. It is worth remarking that in many languages, as in English, the difference between yellow and brown is marked by the use of two distinct basic color terms, but in no language whatever is the light blue–dark blue difference marked with distinct basic color terms and the yellow-brown difference left unmarked. In fact, with the possible exception of Russian, no language even has separate basic terms for light blue and dark blue.

It is thus fair to conclude that something has got lost in the inversion, and that if a human being were to be born with such an inversion, it would not go undetected. More to the point, since the blackness in a blackened yellow is the same as the blackness in a blackened blue, or, for that matter, red or green, there must be some characteristic of yellow that is not present in blue or in any of the other Hering primaries. We have here the mark of something we don't yet understand, probably having to do with the fact that yellow, unlike any other chromatic primary, is most pronounced only at high lightness levels. But couldn't there be a creature for whom the best yellow would exist at low lightness levels? I was once inclined to think so, but this is because I was insufficiently sensitive to the distinctions among yellow as hue, yellow as color category, and yellow as focal color, that is, the "best" example of a yellow. Although the *hue* yellow is to be found at all lightness levels, in brown, for instance, the *focal color* yellow is intrinsically light. The right thing to say about our hypothetical creature is that the very fact that its best example in the yellow hue category is at low lightness levels is the best of reasons for taking that to be a focal brown, rather than a focal yellow.

We of course want to understand why focal yellow is of intrinsically high lightness. This is basically to ask why its chromatic content should be highest at high lightness levels. The most helpful, indeed, I think, the *only* helpful explanation of this would be in terms of a neural mechanism. Recent neurophysiological evidence indicates that color-sensitive color cells in the cerebral cortex statistically "prefer" their yellows light and their reds dark (Yoshioka et al. 1996). This must of course be regarded as only the first step in a long journey that, if we are lucky, will bring us to a suitably rich mechanism to account for the properties of yellow. Finding such a mechanism would be the way to understand other facts about yellow, such as why it is that yellowish greens look as though they ought to be classified as greens, even though we judge the yellow content to be well above 50 percent. The very fact that the internal relations between yellow and its neighbors do not have the same form as the internal relationships between blue and its neighbors suggests that although yellow may be elementary with respect to phenomenal color mixing, it is not elementary simpliciter, any more than a proposition that is commonly used as an axiom for certain purposes is an axiom simpliciter. The only way to understand why the phenomenal structure of primary yellow is what it is, is to devise a good functional model, consistent with what we know about the underlying neurophysiology. Such models have already helped us to understand the unitary-binary and opponent structures of phenomenal color space (Hardin 1988). Irregularities in the structure of phenomenal color space not only render problematic the claim that colors are invertible, thus defusing an objection to a functional analysis of color perception, they positively cry out for explanation couched in terms of functional or neurofunctional mechanisms.

It would of course be nice at this point to produce a reasonable functional model that could account for the special phenomenal characteristic of brown. None is, alas, forthcoming. Indeed, for many of the asymmetries one finds in color spaces there is little in the way of available functional or neural mechanisms to explain them. But one never knows what tomorrow's mail may bring. For example, in an earlier version of this essay, I wrote the following:

There are several intrinsic irregularities in the phenomenal space of the colors. The *warm-cool* distinction is well-known, robustly cross-cultural, and still mysterious. There may be those who think that such mysteries are here to stay, and remain forever beyond the bounds of empirical inquiry. I do not share this pessimism. Furthermore, I think that nothing would be so helpful in making it unmysterious as a nice set of neurophysiological mechanisms that are otherwise confirmed and have built into them the images of the asymmetries that we find in the phenomenology.

Not long thereafter, there came to me a draft of a paper written by Betsy Katra and Billy Wooten of Brown University. Katra and Wooten asked 10 subjects to rate eight color samples as "warm" or "cool" on a 10-point scale, with 10 as "very warm." As one might have expected, the mean results gave the lowest rating (3.5) to the unitary blue sample, and the highest rating (6.75) to the orange sample. There was a high level of agreement among subjects. Katra and Wooten compared the group data with summed averaged opponent-response cancellation data, which can be interpreted as giving the level of activation of opponent channels. To quote Katra and Wooten's conclusion:

The remarkable correspondence between the obtained ratings of warmth and coolness and the activation levels in the opponent channels ... suggests that the attribution of thermal proper-ties to colors may be linked to the low-level physiological processes involved in color percep-tion. Higher ratings of warmth corresponded with levels of activation of the opponent channels in one direction, while cooler ratings corresponded with activation in the opposite direction. This suggests that a link to the activation level of the opponent channels, rather than the psychological quality of hue, drives the association of temperature with color, and that the association is more than simply a cognitive process.

They thus trace the connection between the warm-cool of temperature and the warm-cool of color to the corresponding activation levels of their respective neural systems rather than to stereotypical environmental associations such as red with fire and blue with water. This does not by itself warrant the conclusion that the respec-tive *intrinsic* characters of the warm colors and the cool colors are a function of opponent activation levels, but it is consonant with that stronger claim. Further-more, if one reflects on just how Katra and Wooten's subjects could gain informa-tion about the state of activation of their visual opponent cells, it becomes clear that it could *only* be by experiencing the colors of which these cells are the neural sub-strate. In other words, the color qualities themselves are the natural expression of neural activation, and we implicitly read them as such.

Now let us sum up these considerations. Color space has an irregular structure. The structure of color space is arrived at entirely by comparing the colors with each other, so the irregularity of structure is intrinsic to the domain of colors. Experi-ments with nonhuman primates strongly suggest that this irregular, intrinsic struc-ture is of biological rather than cultural origin. The peculiarities of chromatic structure invite explanation in terms of biological mechanisms, and in some cases it is possible to produce such explanations, at least in outline. The details of the chro-matic structural irregularities prohibit putative undetectable interchanges of color experiences: small rotations of the hue circuit carry unitary into binary hues; inter-

changes of warm and cool colors carry negative opponent-channel activations into positive ones, and vice versa; interchange of yellows with blues exchanges dark blues and cyans with browns; interchange of reds with greens maps a small categorical region into a large one, and a large region into a small one.

Some proponents of the possibility of an inverted spectrum (Shoemaker 1984) who have thought about these empirical data have conceded that human color space may not be invertible. They have, however, urged that this does not show that no creature could possibly have inverted sensory qualities, and some of them (e.g., Levine 1991) go on to argue that the mere possibility of inverted sensory qualities is sufficient to make any functionalist account of the qualities of experience suspect.

In one respect, they are right. Empirical arguments cannot (nontrivially) yield necessary truths. We philosophers rather tenaciously cling to this truism, perhaps because we sense that the independence of our discipline depends upon it. But we must beware of letting it bear too much weight. That we can in some fashion imagine that water is not H_2O, or that heat is a fluid, or that there exists a perfectly rigid body, does not license us to suppose that any of these things is possible in any scientifically interesting sense. At our present state of knowledge, to regard any of them as genuinely possible is to exchange hard-won intelligibility for a murky mess of imagery. Given as background what we now know about fluids and heat, it becomes much harder for us even to *imagine* that heat is a fluid. Granted, there is still no knockdown argument that there is no possible world in which the heat of a gas is a fluid, but we are not thereby tempted to suspect that the heat of a gas might not after all be identical with molecular kinetic energy. When it comes to scientific identities, logical possibility is trumped by overwhelming implausibility.

The case at hand is similar. Much of the appeal of the inverted spectrum as an antifunctionalist weapon has lain in its intuitiveness: what looks to me to be THIS color (inwardly ostending red) could have looked to me to be THAT color (inwardly ostending green) without anyone being the wiser. This simple intuition has doubtless been aided and abetted by the wide currency of oversimplified models of color space, such as the color sphere and hue circle, in which the structure of color qualities is presented as smoothly symmetrical. But once we do the phenomenology of THIS and THAT, becoming aware of their intrinsic structure, and elaborating the functional structure that underlies them, the initial plausibility of interchange begins to fade, just as the plausibility of heat's being a fluid begins to fade once one understands how the ideas of the kinetic theory engage the empirical facts about heat. And when this paradigmatic example of qualitative interchange loses its grip on our imaginations, the idea of there being *abstractly specified* qualitative states being

interchangeable in *abstractly specified* creatures with *abstractly specified* physical workings ought to lose its grip on our intuitions.

Merely schematic specification of the subject matter plagues both sides of the disputes about functionalism. On the one hand a defender of functionalism (Lewis 1980) gives us Martians with plumbing instead of neurons, and on the other, a critic of functionalism (Block 1980) presents us with the spectacle of the whole nation of China acting as a Turing machine. Amusing though these fantasies may be, they are as desperately lacking in the details of what is to be explained as they are lacking in constraints on the putative explanatory mechanisms. It is as if we were asked to judge the possibility of a physical account of living organisms based only on a thorough knowledge of Lucretius' *On the Nature of Things*. To judge rightly the adequacy of functionalism to capture the qualitative character of experience, we must carefully describe both sides of the equation. To do so, we need good ideas, the right distinctions, and lots of careful empirical work. That work must take place on several levels, regimenting the phenomenology, developing functional models that are capable of imaging that phenomenology, and investigating how those models might be realized by the available neural resources (cf. Clark 1993). The patient application of these methods can in principle capture any sayable fact about sensory qualities, and bring that fact within the ambit of scientific explanation.

Will there be a plurality of plausible functional models adequate to the total phenomenology, or will there be but one? Will the preferred future explanations of sensory qualities take the form only of correlations among the behavioral, phenomenal, and neural domains, or will they involve a proper reduction of phenomenology to neural mechanisms? We are simply too ignorant of the relevant facts to answer these questions now, and we ought not to pretend that clever conceptual analysis can offset this epistemic deficiency. We can responsibly judge these questions only on hand of a sufficiently rich broth of data and theory. Such a broth is not yet ready to be tasted, but the pot is already on the burner.

Notes

1. Furthermore, since the perceptions of both black and brown arise only as a consequence of simultaneous contrast, they depend essentially on the visual system. This poses a problem for a realist account of these colors. Cf. Hardin 1988.

2. In this sense, orange necessarily has both red and yellow as constituents. However, this will not be true for any plausible version of color realism that identifies orange with some constellation of extradermal physical properties. More generally, the unitary-binary structure of the colors as we experience them corresponds to no known physical structure lying outside of nervous systems that is causally involved in the perception of color. This makes it very difficult to subscribe to a color realism that is supposed to be about red, yellow, green, blue, black, and white—that is, the colors with which we are perceptually acquainted. Cf. Hardin 1988.

References

Berlin, B., and P. Kay. 1969. *Basic Color Terms*. Berkeley: University of California Press.

Block, N. 1980. Troubles with functionalism. In *Readings in Philosophy of Psychology*, vol. 1, ed. N. Block. Cambridge, MA: Harvard University Press.

Bornstein, M. H., W. Kessen, and S. Weiskopf. 1976. Color vision and hue categorization in Young Human Infants. *Journal of Experimental Psychology*, 2, 115–19.

Boynton, R. M., and C. X. Olson. 1987. Locating basic colors in the OSA space. *Color Research and Application*, 12 (2), 94–105.

Clark, A. 1993. *Sensory Qualities*. Oxford: Clarendon Press.

Hardin, C. L. 1988. *Color for Philosophers: Unweaving the Rainbow*. Indianapolis, MA: Hackett.

Katra, B., and B. H. Wooten. n. d. Perceived lightness/darkness and warmth/coolness in chromatic experience. Unpublished MS, 38 pp.

Levine, J. 1983. Materialism and qualia: The explanatory gap. *Pacific Philosophical Quarterly*, 64, 354–61.

Levine, J. 1991. Cool red: A reply to Hardin. *Philosophical Psychology*, 4 (1), 27–40.

Lewis, D. 1980. Mad pain and Martian pain. In *Readings in Philosophy of Psychology*, vol. 1, ed. N. Block. Cambridge, MA: Harvard University Press.

Matsuzawa, T. 1985. Colour naming and classification in a chimpanzee (*Pan troglodytes*). *Journal of Human Evolution*, 14, 283–91.

Quinn, P. C., J. L. Rosano, and B. R. Wooten. 1988. Evidence that brown is not an elemental color. *Perception and Psychophysics*, 37 (3), 198–202.

Sandell, J. H., C. G. Gross, and M. H. Bornstein. 1979. Color categories in macaques. *Journal of Comparative and Physiological Psychology*, 93, 626–35.

Shoemaker, S. 1984. The inverted spectrum. In *Identity, Cause, and Mind: Philosophical Essays*. Cambridge: Cambridge University Press.

Sivik, L., and C. Taft. 1994. Color naming: A mapping in the NCS of common color terms. *Scandinavian Journal of Psychology*, 35, 144–64.

Sternheim, C. E., and R. M. Boynton. 1966. Uniqueness of perceived hues investigated with a continuous judgmental technique. *Journal of Experimental Psychology*, 72, 770–76.

Yoshioka, T., B. M. Dow, and R. G. Vautin. 1996. Neural mechanisms of color categorization in areas V1, V2, and V4 of macaque monkey cortex. *Behavioural Brain Research*, 76, 51–70.

Bibliography

Books

Philosophy

Recent philosophical books substantially concerned with color:

Broackes, J, *The Nature of Colour*. Routledge, forthcoming.

Clark, A. 1993. *Sensory Qualities*. Oxford: Oxford University Press.

Hacker, P. M. S. 1987. *Appearance and Reality*. Oxford: Blackwell.

Hardin, C. L. 1993. *Color for Philosophers: Unweaving the Rainbow* (expanded edition). Indianapolis: Hackett.

Harrison, B. 1973. *Form and Content*. Oxford: Blackwell.

Hilbert, D. R. 1987. *Color and Color Perception: A Study in Anthropocentric Realism*. Stanford: CSLI.

Jackson, F. 1977. *Perception: A Representative Theory*. Cambridge: Cambridge University Press.

Landesman, C. 1989. *Color and Consciousness: An Essay in Metaphysics*. Philadelphia: Temple University Press.

Maund, J. B. 1995. *Colours: Their Nature and Representation*. Cambridge: Cambridge University Press.

McGinn, C. 1983. *The Subjective View: Secondary Qualities and Indexical Thoughts*. Oxford: Oxford University Press.

Mundle, C. W. K. 1971. *Perception: Facts and Theories*. London: Oxford University Press.

Thompson, E. 1995. *Colour Vision*. New York: Routledge.

Westphal, J. 1991. *Colour: A Philosophical Introduction*. Oxford: Blackwell. (First published as *Colour: Some Philosophical Problems from Wittgenstein*.)

Wittgenstein, L. 1977. *Remarks on Colour*, ed. G. E. M. Anscombe, trans. L. L. McAlister and M. Schättle. Berkeley: University of California Press.

Goethe

Goethe's *Farbenlehre* has influenced a number of philosophers, notably Schelling, Schopenhauer, Hegel, and Wittgenstein:

Goethe, J. W. von. 1840/1970. *Theory of Colours*, trans. C. L. Eastlake. Cambridge, MA: MIT Press.

For a useful historical account see:

Sepper, D. L. 1988. *Goethe contra Newton: Polemics and the Project for a New Science of Color*. Cambridge: Cambridge University Press.

Color in Culture

The best survey of color in Western culture is:

Gage, J. 1993. *Color and Culture: Practice and Meaning from Antiquity to Abstraction*. Boston: Bulfinch Press.

And for fun:

Theroux, A. 1994. *The Primary Colors*. New York: Henry Holt.

Theroux, A. 1996. *The Secondary Colors*. New York: Henry Holt.

Papers

We have attempted to list every philosophical paper since 1950 in English whose main topic includes color. Aesthetics has been omitted, but selected historical material, book chapters, and book reviews have been included. We would be grateful to be told of errors or omissions.

Aldrich, V. C. 1952. Colors as universals. *Philosophical Review* 61, 377–81.

Allaire, E. B. 1959. *Tractatus* 6.3751. *Analysis* 19, 100–5.

Anscombe, G. E. M. 1974. The subjectivity of sensation. *Ajatus* 36, 3–18.

Arbini, R. 1963. Frederick Ferré on colour incompatibility. *Mind* 72, 586–90.

Armstrong, D. M. 1961. Problems about the secondary qualities. *Perception and the Physical World*, London: Routledge & Kegan Paul, chapter 14.

Armstrong, D. M. 1968a. The secondary qualities: an essay in the classification of theories. *Australasian Journal of Philosophy* 46, 225–41.

Armstrong, D. M. 1968b. The secondary qualities. *A Materialist Theory of the Mind*, London: Routledge, chapter 12.

Armstrong, D. M. 1969. Colour realism and the argument from microscopes. In *Contemporary Philosophy in Australia*, ed. R. Brown and C. D. Rollins. London: Allen & Unwin.

Armstrong, D. M. 1987. Smart and the secondary qualities. In *Metaphysics and Morality: Essays in Honour of J. J. C. Smart*, ed P Pettit, R. Sylvan, and J. Norman. Oxford: Blackwell. Reprinted as chapter 3 of this volume.

Armstrong, D. M. 1993. Reply to Campbell. In *Ontology, Causality and Mind: Essays in Honour of D. M. Armstrong*, ed. J. Bacon, K. Campbell, and L. Reinhardt. Cambridge: Cambridge University Press.

Arthadeva. 1961. Naive realism and the problem of color-seeing in dim light. *Philosophy and Phenomenological Research* 21, 467–78.

Austin, J. 1980. Wittgenstein's solutions to the color exclusion problem. *Philosophy and Phenomenological Research* 41, 142–9.

Averill, E. W. 1980. Why are colour terms primarily used as adjectives? *Philosophical Quarterly* 30, 19–33.

Averill, E. W. 1982. The primary-secondary quality distinction. *Philosophical Review* 91, 343–62.

Averill, E. W. 1985. Color and the anthropocentric problem. *Journal of Philosophy* 82, 281–304. Reprinted as chapter 2 of this volume.

Averill, E. W. 1991. Review of C. L. Hardin's *Color for Philosophers* and D. R. Hilbert's *Color and Color Perception*. *Philosophical Review* 100, 459–63.

Averill, E. W. 1992. The relational nature of color. *Philosophical Review* 101, 551–88.

Baldes, R. W. 1978. Democritus on the nature and perception of 'black' and 'white'. *Phronesis* 23, 87–100.

Beard, R. W. 1967. Analyticity, informativeness, and the incompatibility of colors. *Logique et Analyse* 10, 211–7.

Benardete, J. A. 1958. The analytic *a posteriori* and the foundations of metaphysics. *Journal of Philosophy* 55, 503–14.

Bennett, J. 1965. Substance, reality, and primary qualities. *American Philosophical Quarterly* 2, 1–17.

Bennett, J. 1971. Primary and secondary qualities. *Locke, Berkeley, Hume*, Oxford: Oxford University Press, chapter 4.

Berchielli, L. 1995. Representing color: discussions and problems. In *Bilder im Geiste: Zur kognitiven und erkenntnistheoretischen Funktion piktorialer Repräsentationen*, ed. K. Sachs-Hombach. Amsterdam: Rodopi.

Bigelow, J., J. Collins, and R. Pargetter. 1990. Colouring in the world. *Mind* 99, 279–88.

Block N. 1990. Inverted earth. In *Philosophical Perspectives* 4, ed. J. Tomberlin. Atascadero, CA: Ridgeview.

Boghossian, P. A., and J. D. Velleman. 1989. Colour as a secondary quality. *Mind* 98, 81–103. Reprinted as chapter 7 of this volume.

Boghossian, P. A., and J. D. Velleman. 1991. Physicalist theories of color. *Philosophical Review* 100, 67–106. Reprinted as chapter 8 of this volume.

Boyne, C. 1972. Vagueness and colour predicates. *Mind* 81, 576–7.

Bradley, M. C. 1963. Sensations, brain-processes and colours. *Australasian Journal of Philosophy* 41, 385–93.

Bradley, M. C. 1964. Critical notice of J. J. C. Smart's *Philosophy and Scientific Realism. Australasian Journal of Philosophy* 42, 262–83.

Brenner, W. 1982. Wittgenstein's color grammar. *Southern Journal of Philosophy* 20, 289–98.

Brenner, W. 1987. 'Brownish-Yellow' and 'Reddish-Green.' *Philosophical Investigations* 10, 200–11.

Broackes, J. 1992. The autonomy of colour. In *Reduction, Explanation and Realism*, ed. D. Charles and K. Lennon. Oxford: Oxford University Press. Reprinted as chapter 11 of this volume.

Broackes, J. 1993. Critical notice of J. Westphal's *Colour: A Philosophical Introduction. Philosophical Quarterly* 43, 233–8.

Buckner, D. K. 1986. Transparently false: reply to Hardin. *Analysis* 46, 86–7.

Byrne, A., and D. R. Hilbert. 1997. Colors and reflectances. In *Readings on Color, vol. 1: The Philosophy of Color*, ed. A. Byrne and D. R. Hilbert. Cambridge, MA: MIT Press. Chapter 14 of this volume.

Campbell, J. 1993. A simple view of colour. In *Reality, Representation, and Projection*, ed. J. Haldane and C. Wright. New York: Oxford University Press. Reprinted as chapter 10 of this volume.

Campbell, K. 1969. Colours. In *Contemporary Philosophy in Australia*, ed. R. Brown and C. D. Rollins. London: Allen & Unwin.

Campbell, K. 1979. The implications of Land's theory of colour vision. *Logic, Methodology and Philosophy of Science* 6, ed. L. Cohen. Amsterdam: North Holland.

Campbell, K. 1993. David Armstrong and realism about colour. In *Ontology, Causality and Mind: Essays in Honour of D. M. Armstrong*, ed. J. Bacon, K. Campbell, and L. Reinhardt. Cambridge: Cambridge University Press.

Casati, R. 1990. What is wrong in inverting spectra. *Teoria* 10, 183–6.

Clark, A. 1985a. Qualia and the psychophysiological explanation of color perception. *Synthese* 65, 377–405.

Clark, A. 1985b. Spectrum inversion and the color solid. *Southern Journal of Philosophy* 23, 431–43.

Clark, A. 1989. The particulate instantiation of homogeneous pink. *Synthese* 80, 277–304.

Clark, A. 1996. True theories, false colors. *Philosophy of Science* 63 (Proceedings), S143–50.

Clement, W. C. 1956. Quality orders. *Mind* 65, 184–99.

Cornman, J. 1969. Sellars, scientific realism, and sensa. *Review of Metaphysics* 23, 417–51.

Cornman, J. 1974. Can Eddington's 'two tables' be identical? *Australasian Journal of Philosophy* 52, 22–38.

Cornman, J. 1975. Naive realism. *Perception, Common Sense, and Science*, New Haven: Yale University Press, chapter 6.

Cottingham, J. 1989–90. Descartes on colour. *Proceedings of the Aristotelian Society* 90, 231–46.

Cummins, R. 1978. The missing shade of blue. *Philosophical Review* 87, 548–65.

Daniels, C. B. 1967. Colors and sensations, or how to define a pain ostensively. *American Philosophical Quarterly* 4, 231–7.

Dedrick, D. 1995. Objectivism and the evolutionary value of colour vision. *Dialogue* 34, 35–44.

Dedrick, D. 1996. Can color be reduced to anything? *Philosophy of Science* 63 (Proceedings), S134–42.

Dennett, D. C. 1981. Wondering where the yellow went. *Monist* 64, 102–8.

Deshpande, D. Y. 1982. An alleged case of factual a priori. *Indian Philosophical Quarterly* 9, 107–12.

Dolby, R. G. A. 1973. Philosophy and the incompatibility of colours. *Analysis* 34, 8–16.

Dummett, M. A. E. 1979. Common sense and physics. In *Perception and Identity: Essays Presented to A. J. Ayer with his Replies*, ed. G. F. MacDonald. Ithaca, NY: Cornell University Press.

Edwards, J. 1992. Secondary qualities and the a priori. *Mind* 101, 263–72.

Erickson, G. W. 1991. Wittgenstein's *Remarks on Colour*. *Dialogos* 57, 113–36.

Evans, G. 1980. Things without the mind—a commentary upon chapter two of Strawson's *Individuals*. In *Philosophical Subjects: Essays Presented to P. F. Strawson*, ed. Z. Van Straaten. Oxford: Oxford University Press.

Ferré, F. 1961. Colour incompatibility and language-games. *Mind* 70, 90–94.

Fales, E. 1982. Generic universals. *Australasian Journal of Philosophy* 60, 29–39.

Fogelin, R. J. 1984. Hume and the missing shade of blue. *Philosophy and Phenomenological Research* 45, 263–71.

Foti, V. 1990. The dimension of color. *International Studies in Philosophy* 22, 13–28.

Geach, P. T. 1957. Abstractionism and colour-concepts. *Mental Acts*, London: Routledge & Kegan Paul, section 10.

Gibbard, A. 1996. Visible properties of human interest only. In *Philosophical Issues* 7, ed. F. Villanueva. Atascadero, CA: Ridgeview.

Gilbert, P. 1987. Westphal and Wittgenstein on white. *Mind* 76, 399–403.

Gilbert, P. 1989. Reflections on white: a rejoinder to Westphal. *Mind* 98, 423–6.

Goldman, A. H. 1975. Criteriological arguments in perception. *Mind* 84, 102–5.

Goodman, N. 1957. Letter to the editor on W. C. Clement's 'Quality and order.' *Mind* 66, 78.

Grandy, R. E. 1989. A modern inquiry into the physical reality of colors. In *Mind, Value and Culture: Essays in Honour of E. M. Adams*, ed. D. Weissbord. Atascadero, CA: Ridgeview.

Guerlac, H. 1986. Can there be colors in the dark? Physical color theory before Newton. *Journal of the History of Ideas* 47, 3–20.

Hacker, P. M. S. 1976. Locke and the meaning of colour words. *Royal Institute of Philosophy Lectures* 9, ed. G. Vesey. New York: St. Martin's Press.

Hacker, P. M. S. 1986. Are secondary qualities relative? *Mind* 95, 180–97.

Hahm, D. E. 1978. Early Hellenistic theories of vision and the perception of color. In *Studies in Perception*, ed. P. K. Machamer and R. G. Turnbull. Columbus, OH: Ohio State University Press.

Hall, R. J. 1996. The evolution of color vision without colors. *Philosophy of Science* 63 (Proceedings), S125–33.

Hardin, C. L. 1983. Colors, normal observers, and standard conditions. *Journal of Philosophy* 80, 806–13.

Hardin, C. L. 1984a. A new look at color. *American Philosophical Quarterly* 21, 125–34.

Hardin, C. L. 1984b. Are 'scientific' objects coloured? *Mind* 93, 491–500.

Hardin, C. L. 1985a. A transparent case for subjectivism. *Analysis* 45, 117–9.

Hardin, C. L. 1985b. The resemblances of colors. *Philosophical Studies* 48, 35–47.

Hardin, C. L. 1985c. Frank talk about the colours of sense-data. *Australasian Journal of Philosophy* 63, 485–93.

Hardin, C. L. 1988. Phenomenal colors and sorites. *Noûs* 22, 213–34.

Hardin, C. L. 1989a. Idle colours and busy spectra. *Analysis* 49, 47–8.

Hardin, C. L. 1989b. Could white be green? *Mind* 98, 285–8.

Hardin, C. L. 1989c. Review of J. Westphal's *Colour: Some Philosophical Problems from Wittgenstein*. *Mind* 98, 146–9.

Hardin, C. L. 1989d. Review of D. R. Hilbert's *Color and Color Perception*. *Canadian Philosophical Reviews* 9, 47–9.

Hardin, C. L. 1990a. Why color? In *Perceiving, Measuring, and Using Color: 15–6 February 1990, Santa Clara, California*, ed. M. Brill. Bellingham, WA: SPIE.

Hardin, C. L. 1990b. Color and illusion. In *Mind and Cognition*, ed. W. G. Lycan. Oxford: Blackwell.

Hardin, C. L. 1991a. Color for philosophers: a précis. *Philosophical Psychology* 4, 21–6.

Hardin, C. L. 1991b. Reply to Levine. *Philosophical Psychology* 4, 41–50.

Hardin, C. L. 1991c. Reply to Teller. *Philosophical Psychology* 4, 61–4.

Hardin, C. L. 1992a. The virtues of illusion. *Philosophical Studies* 68, 371–82.

Hardin, C. L. 1992b. Physiology, phenomenology, and Spinoza's true colors. In *Emergence or Reduction? Essays on the Prospects of Nonreductive Physicalism*, ed. A. Beckermann, H. Flohr, and J. Kim. New York: Walter de Gruyter.

Hardin, C. L. 1993. Van Brakel and the not-so-naked emperor. *British Journal for the Philosophy of Science* 44, 137–50.

Hardin, C. L. 1997. Reinverting the spectrum. In *Readings on Color, vol. 1: The Philosophy of Color*, ed. A. Byrne and D. R. Hilbert. Cambridge, Massachusetts: MIT Press. Chapter 15 of this volume.

Harding, G. 1991. Color and the mind-body problem. *Review of Metaphysics* 45, 289–307.

Harman, G. 1996a. Explaining objective color in terms of subjective reactions. In *Philosophical Issues* 7, ed. E. Villanueva. Atascadero, CA: Ridgeview. Reprinted as chapter 13 of this volume.

Harman, G. 1996b. Qualia and color concepts. In *Philosophical Issues* 7, ed. E. Villanueva. Atascadero, CA: Ridgeview.

Harrison, B. 1967. On describing colours. *Inquiry* 10, 38–52.

Harrison, B. 1986. Identity, predication and color. *American Philosophical Quarterly* 23, 105–14.

Harvey, J. 1979. Systematic transposition of colours. *Australasian Journal of Philosophy* 57, 211–9.

Harvey, J. 1992. Challenging the obvious: the logic of colour concepts. *Philosophia* 21, 277–94.

Hatfield, G. 1992. Color perception and neural encoding: does metameric matching entail a loss of information? *Proceedings of the Philosophy of Science Association* 1, 492–504.

Hilbert, D. R. 1992. What is color vision? *Philosophical Studies* 68, 351–70.

Hilton, J. 1961. Red and green all over again. *Analysis* 22, 47–8.

Holman, E. L. 1979. Is the physical world colourless? *Australasian Journal of Philosophy* 57, 295–304.

Holman, E. L. 1981. Intension, identity, and the colourless physical world: a revision and further discussion. *Australasian Journal of Philosophy* 59, 203–5.

Illetterati, L. 1993. Hegel's exposition of Goethe's theory of colour. In *Hegel and Newtonianism*, ed. M. J. Petry. Dordrecht: Kluwer.

Jackson, F. 1973. Do material things have non-physical properties? *Personalist* 54, 105–10.

Jackson, F. 1996. The primary quality view of color. In *Philosophical Perspectives* 10, ed. J. Tomberlin. Cambridge, MA: Blackwell.

Jackson, F., and R. Pargetter. 1987. An objectivist's guide to subjectivism about colour. *Revue Internationale de Philosophie* 41, 127–41. Reprinted as chapter 6 of this volume.

Jacquette, D. 1990. Wittgenstein and the color incompatibility problem. *History of Philosophy Quarterly* 7, 353–65.

Jacquette, D. 1995. Color and Armstrong's color realism under the microscope. *Studies in History and Philosophy of Science* 26, 389–406.

Jarvis, J. 1961. Definition by internal relation. *Australasian Journal of Philosophy* 39, 125–42.

Johnson, D. M. 1984. Hume's missing shade of blue, interpreted as involving habitual spectra. *Hume Studies* 10, 109–24.

Johnston, M. 1992. How to speak of the colors. *Philosophical Studies* 68, 221–63. Reprinted as chapter 9 of this volume.

Johnston, M. 1996a. Is the external world invisible? In *Philosophical Issues* 7, ed. E. Villanueva. Atascadero, CA: Ridgeview.

Johnston, M. 1996b. A mind-body problem at the surface of objects. In *Philosophical Issues* 7, ed. E. Villanueva. Atascadero, CA: Ridgeview.

Johnston, M. 1997. Postscript: visual experience. In *Readings on Color, vol. 1: The Philosophy of Color*, ed. A. Byrne and D. R. Hilbert. Cambridge, MA: MIT Press. An appendix to chapter 9 of this volume.

Keating, L. 1993. Un-Locke-ing Boyle: Boyle on primary and secondary qualities. *History of Philosophy Quarterly* 10, 305–23.

Kenner, L. 1965. The triviality of the red-green problem. *Analysis* 25, 147–53.

Kraut, R. 1992. The objectivity of color and the color of objectivity. *Philosophical Studies* 68, 265–87.

Krishna, D. 1961/2. Colour incompatibility and language-games. *Indian Journal of Philosophy* 3, 55–60.

Landesman, C. 1993. Why nothing has color: color skepticism. In *Theory of Knowledge: Classical and Contemporary Readings*, ed. L. Pojman. Belmont, CA: Wadsworth.

Lauxtermann, P, F, H, 1987. Five decisive years: Schopenhauer's epistemology as reflected in his theory of colour. *Studies in History and Philosophy of Science* 18, 271–91.

Lauxtermann, P. F. H. 1990. Hegel and Schopenhauer as partisans of Goethe's theory of color. *Journal of the History of Ideas* 51, 599–624.

Leeds, S. 1975. Two senses of 'appears red.' *Philosophical Studies* 28, 199–205.

Levin, J. 1987. Physicalism and the subjectivity of secondary qualities. *Australasian Journal of Philosophy* 65, 400–11.

Levine, J. 1991. Cool red. *Philosophical Psychology* 4, 27–40.

Lewis, D. K. 1966. Percepts and color mosaics in visual experience. *Philosophical Review* 75, 357–68.

Lewis, D. K. 1987. Naming the colours. *Australasian Journal of Philosophy*, forthcoming.

Lycan, W. G. 1973. Inverted spectrum. *Ratio* 15, 315–9.

Macintyre, A. 1992. Colors, cultures, and practices. *Midwest Studies in Philosophy* 17, 1–23.

Mackie, J. L. 1976. Primary and secondary qualities. *Problems from Locke*, Oxford: Oxford University Press, chapter 1.

Matthen, M. 1988. Biological functions and perceptual content. *Journal of Philosophy* 85, 5–27.

Maund, J. B. 1981. Colour: a case for conceptual fission. *Australasian Journal of Philosophy* 59, 308–22.

Maund, J. B. 1991. The nature of color. *History of Philosophy Quarterly* 8, 253–63.

McCulloch, G. 1987. Subjectivity and colour vision. *Proceedings of the Aristotelian Society Suppl.* 61, 265–81.

McDowell, J. 1985. Values and secondary qualities. In *Morality and Objectivity: A Tribute to J. L. Mackie*, ed. T. Honderich. London: Routledge & Kegan Paul.

McGilvray, J. A. 1983. To color. *Synthese* 54, 37–70.

McGilvray, J. A. 1991. Review of C. L. Hardin's *Color for Philosophers*. *Philosophy of Science* 58, 329–31.

McGilvray, J. A. 1994. Constant colors in the head. *Synthese* 100, 197–239.

McGinn, C. 1996. Another look at color. *Journal of Philosophy* 93, 537–53.

McGinn, M. 1991a. On two recent accounts of colour. *Philosophical Quarterly* 41, 316–24.

McGinn, M. 1991b. Westphal on the physical basis of colour incompatibility. *Analysis* 51, 218–22.

McGinn, M. 1991c. Wittgenstein's *Remarks on Colour*. *Philosophy* 66, 435–53.

Melica, C. 1993. Hegel on shadows and the blue of the sky. In *Hegel and Newtonianism*, ed. M. J. Petry. Dordrecht, Netherlands: Kluwer.

Montgomery, R. 1990. Visual perception and the wages of indeterminacy. *Proceedings of the Philosophy of Science Association* 1, 365–78.

Morreall, J. 1982. Hume's missing shade of blue. *Philosophy and Phenomenological Research* 42, 407–15.

Mulligan, K. 1991. Colours, corners and complexity. In *Existence and Explanation: Essays Presented in Honor of Karel Lambert*, ed. W. Spohn, B. C. Van Fraassen, and B. Skyrms. Dordrecht: Kluwer.

Nathan, N. 1986. Simple colours. *Philosophy* 61, 345–53.

Nelkin, N. 1994. Phenomena and representation. *British Journal for the Philosophy of Science* 45, 527–47.

Nelson, J. O. 1961. y-Propositions. *Philosophical Studies* 12, 65–72.

Nelson, J. O. 1989. Hume's missing shade of blue re-viewed. *Hume Studies* 15, 353–63.

Noren, S. J. 1975a. Cornman on the colour of micro-entities. *Australasian Journal of Philosophy* 53, 65–7.

Noren, S. J. 1975b. The conflict between science and common sense and why it is inevitable. *Southern Journal of Philosophy* 13, 331–46.

O'Hair, S. G. 1969. Putnam on reds and greens. *Philosophical Review* 78, 504–6.

Pap, A. 1957. Once more: colors and the synthetic a priori. *Philosophical Review* 66, 94–9.

Peacocke, C. 1984. Colour concepts and colour experience. *Synthese* 58, 365–82. Reprinted as chapter 5 of this volume.

Peacocke, C. 1986. Reply to Michael Smith. *Synthese* 68, 577–80.

Pears, D. F. 1953. Incompatibilities of colours. In *Logic and Language (second series)*, ed. A Flew. Oxford: Blackwell.

Perkins, M. 1983. Vision. *Sensing the World*, Indianapolis: Hackett, chapter 6.

Pickering, F. R. 1975. Is light the proper object of vision? *Mind* 84, 119–21.

Pitcher, G. 1971. Colors: our perception of them and their ontological status. *A Theory of Perception*, Princeton: Princeton University Press, chapter 4.

Pluhar, E. B. 1986–7. The perceptual and physical worlds. *Philosophical Studies (Ireland)* 31, 228–40.

Putnam, H. 1956. Reds, greens, and logical analysis. *Philosophical Review* 65, 206–17.

Putnam, H. 1957. Red and green all over again: a rejoinder to Arthur Pap. *Philosophical Review* 66, 100–3.

Radford, C. 1963. The insolubility of the red-green problem. *Analysis* 23, 68–71.

Radford, C. 1965a. Reply to Mr. Kenner's 'The triviality of the red-green problem.' *Analysis* 25, 207–8.

Radford, C. 1965b. Incompatibilities of colours. *Philosophical Quarterly* 15, 207–19.

Remnant, P. 1961. Red and green all over again. *Analysis* 21, 93–5.

Rhees, R. 1963. The *Tractatus*: seeds of some misunderstandings. *Philosophical Review* 72, 213–20.

Ribe, N. M. 1985. Goethe's critique of Newton: a reconsideration. *Studies in History and Philosophy of Science* 16, 315–35.

Rosenberg, J. F. 1982. The place of color in the scheme of things: a roadmap to Sellar's Carus lectures. *Monist* 65, 315–35.

Rosenthal, D. 1990. The colors and shapes of visual experiences. Report No. 28, Research Group on Mind and Brain, Perspectives in Theoretical Psychology and the Philosophy of Mind (ZiF), University of Bielefeld, Germany.

Rozeboom, W. W. 1958. The logic of color words. *Philosophical Review* 67, 353–66.

Sahu, N. 1988. On 'this is red and this is blue': *Tractatus* 6.3751. *Journal of Indian Council of Philosophical Research* 6, 1–19.

Sanford, D. 1966. Red, green and absolute determinacy: a reply to C. Radford's 'Incompatibilities of colours.' *Philosophical Quarterly* 16, 356–58.

Saunders, B. A. C., and J. van Brakel. 1989. Review article: On cross cultural colour semantics: *Color for Philosophers* by C. L. Hardin. *International Journal of Moral and Social Studies* 4, 173–80.

Sellars, W. 1971. Science, sense impressions, and sensa. *Review of Metaphysics* 24, 391–447.

Sellars, W. 1981a. The lever of archimedes. *Monist* 64, 3–36.

Sellars, W. 1981b. Is consciousness physical? *Monist* 64, 66–90.

Sepper, D. L. 1989. Review of C. L. Hardin's *Color for Philosophers*. *Review of Metaphysics* 42, 834–37.

Shiner, R. A. 1977. Goldman on the non-contingency thesis. *Mind* 86, 587–90.

Shiner, R. A. 1979. Sense-experience, colours and tastes. *Mind* 88, 161–78.

Shoemaker, S. 1982. The inverted spectrum. *Journal of Philosophy* 79, 357–81.

Shoemaker, S. 1986. Review of C. McGinn's *The Subjective View*. *Journal of Philosophy* 83, 407–13.

Shoemaker, S. 1990. Qualities and qualia: what's in the mind? *Philosophy and Phenomenological Research* 50 (Suppl.), 109–31.

Shoemaker, S. 1991. Qualia and consciousness. *Mind* 100, 507–24.

Shoemaker, S. 1994a. Self-knowledge and 'inner sense.' Lecture III: the phenomenal character of experience. *Philosophy and Phenomenological Research* 54, 291–314.

Shoemaker, S. 1994b. Phenomenal character. *Noûs* 28, 21–38. Reprinted as chapter 12 of this volume.

Shoemaker, S. 1996. Colors, subjective reactions, and qualia. In *Philosophical Issues* 7, ed. E. Villanueva. Atascadero, CA: Ridgeview.

Sibley, F. N. 1968. Colours. *Proceedings of the Aristotelian Society* 68, 145–66.

Sievert, D. 1989. Another look at Wittgenstein on color exclusion. *Synthese* 78, 291–318.

Silverman, A. 1989. Color and color-perception in Aristotle's *De Anima*. *Ancient Philosophy* 9, 271–92.

Sloman, A. 1964. Colour incompatibilities and analyticity. *Analysis* 24, 104–19.

Smart, J. J. C. 1959. Incompatible colors. *Philosophical Studies* 10, 39–41.

Smart, J. J. C. 1961. Colours. *Philosophy* 36, 128–42.

Smart, J. J. C. 1963. The secondary qualities. *Philosophy and Scientific Realism*, London: Routledge, chapter 4.

Smart, J. J. C. 1971. Reports of immediate experiences. *Synthese* 22, 346–59.

Smart, J. J. C. 1975. On some criticisms of a physicalist theory of colors. In *Philosophical Aspects of the Mind–Body Problem*, ed. C. Cheng, Honolulu: University Press of Hawaii. Reprinted as chapter 1 of this volume.

Smart, J. J. C. 1987. Reply to Armstrong. In *Metaphysics and Morality: Essays in Honour of J. J. C. Smart*, ed. P. Pettit, R. Sylvan, and J. Norman. Oxford: Blackwell. Reprinted as chapter 4 of this volume.

Smart, J. J. C. 1995. 'Looks red' and dangerous talk. *Philosophy* 70, 545–54.

Smith, A. D. 1990. Of primary and secondary qualities. *Philosophical Review* 99, 221–54.

Smith, M. A. 1986. Peacocke on red and red'. *Synthese* 68, 559–76.

Smith, M. A. 1993. Colour, transparency, mind-independence. In *Reality, Representation, and Projection*, ed. J. Haldane and C. Wright. New York: Oxford University Press.

Smith, P. 1987. Subjectivity and colour vision. *Proceedings of the Aristotelian Society Suppl.* 61, 245–64.

Sorabji, R. 1972. Aristotle, mathematics, and colour. *Classical Quarterly* 22, 293–308.

Sosa, E. 1990. Perception and reality. In *Information, Semantics & Epistemology*, ed. E. Villanueva. Oxford: Blackwell.

Sosa, E. 1996. Is color psychological or biological? Or both? In *Philosophical Issues* 7, ed. E. Villanueva. Atascadero, CA: Ridgeview.

Srzednicki, D. J. 1962. Incompatibility statements. *Australasian Journal of Philosophy* 40, 178–86.

Steinle, F. 1993a. Newton's rejection of the modification theory of colour. In *Hegel and Newtonianism*, ed. M. J. Petry. Dordrecht, Netherlands: Kluwer.

Steinle, F. 1993b. Newton's colour-theory and perception. In *Hegel and Newtonianism*, ed. M. J. Petry. Dordrecht, Netherlands: Kluwer.

Strawson, G. 1989. Red and 'red.' *Synthese* 78, 193–232.

Stroud-Drinkwater, C. 1994. The naive theory of colour. *Philosophy and Phenomenological Research* 54, 345–54.

Swartz, R. J. 1967. Color concepts and dispositions. *Synthese* 17, 202–22.

Taylor, D. M. 1966. The incommunicability of content. *Mind* 75, 527–41.

Teller, D. Y. 1991. Simpler arguments might work better. *Philosophical Psychology* 4, 51–60.

Terrell, D. B. 1951. On a supposed synthetic entailment. *Philosophical Studies* 2, 57–63.

Thompson, E. 1992. Novel colours. *Philosophical Studies* 68, 321–49.

Thompson, E., A. Palacios, and F. J. Varela. 1992. Ways of coloring: comparative color vision as a case study for cognitive science. *Behavioral and Brain Sciences* 15, 1–74.

Thompson, E. 1995. Colour vision, evolution, and perceptual content. *Synthese* 104, 1–32.

Thornton, M. T. 1972. Ostensive terms and materialism. *Monist* 56, 193–214.

Tolliver, J. T. 1994. Interior colors. *Philosophical Topics* 22, 411–41.

Topper, D. 1990. Newton on the number of colours in the spectrum. *Studies in History and Philosophy of Science* 21, 269–79.

Tye, M. 1994. Qualia, content, and the inverted spectrum. *Noûs* 28, 159–83.

Tully, R. E. 1976. Reduction and secondary qualities. *Mind* 85, 351–70.

Valberg, E. 1980. A theory of secondary qualities. *Philosophy* 55, 437–53.

Van Brakel, J. 1993. The plasticity of categories: the case of colour. *British Journal for the Philosophy of Science* 44, 103–35.

Van Brakel, J. 1994. The *ignis fatuus* of semantic universalia: the case of colour. *British Journal for the Philosophy of Science* 45, 770–83.

Van Steenburgh, E. W. 1974. The problem of simple resemblance. *Philosophical Studies* 25, 337–46.

Vendler, Z. 1995. Goethe, Wittgenstein, and the essence of color. *Monist* 78, 391–410.

Vesey, G. N. A. 1968. Sensations of colour. In *Mill: A Collection of Critical Essays*, ed. J. B. Schneewind. New York: Doubleday.

Vision, G. 1982. Primary and secondary qualities: an essay in epistemology. *Erkenntnis* 17, 135–69.

Watkins, M. 1994. Dispositions, ostension, and austerity. *Philosophical Studies* 73, 55–86.

Wolfgang, W. 1990. Marty and Magnus on colours. In *Mind, Meaning and Metaphysics: The Philosophy and Theory of Language of Anton Marty*, ed. K. Mulligan. Dordrecht, Netherlands: Kluwer.

Westphal, J. 1982. Brown: remarks on colour. *Inquiry* 25, 417–33.

Westphal, J. 1984. The complexity of quality. *Philosophy* 59, 457–72.

Westphal, J. 1986. White. *Mind* 95, 310–28.

Westphal, J. 1989a. Black. *Mind* 98, 585–9.

Westphal, J. 1989b. Review of C. L. Hardin's *Color for Philosophers*. *Mind* 98, 145–6.

Westphal, J. 1990a. Universals and creativity. *Philosophy* 65, 255–60.

Westphal, J. 1990b. Review of C. Landesman's *Color and Consciousness*. *Times Literary Supplement*, 13 July, 758.

White, S. 1994. Color and notional content. *Philosophical Topics* 22, 471–503.

Wilson, M. D. 1987. Berkeley on the mind-dependence of colors. *Pacific Philosophical Quarterly* 68, 249–64.

Wilson, M. D. 1992. History of philosophy in philosophy today; and the case of the sensible qualities. *Philosophical Review* 101, 191–243.

Wilson, N. L. 1972. Color qualities and reference to them. *Canadian Journal of Philosophy* 2, 145–69.

Wolgast, E. H. 1962. A question about colors. *Philosophical Review* 71, 328–39.

Wright, C. 1988. Moral values, projection and secondary qualities. *Proceedings of the Aristotelian Society Suppl.* 62, 1–26.

Contributors

D. M. Armstrong
Department of Traditional and
Modern Philosophy
University of Sydney

Edward Wilson Averill
Department of Philosophy
Texas Tech University

Paul A. Boghossian
Department of Philosophy
New York University

Justin Broackes
Department of Philosophy
Brown University

Alex Byrne
Department of Linguistics and
Philosophy
Massachusetts Institute of Technology

John Campbell
New College
University of Oxford

C. L. Hardin
Department of Philosophy
Syracuse University

Gilbert Harman
Department of Philosophy
Princeton University

David R. Hilbert
Department of Philosophy
University of Illinois at Chicago

Frank Jackson
Philosophy Program
Research School of Social Sciences
Australian National University

Mark Johnston
Department of Philosophy
Princeton University

Robert Pargetter
Department of Philosophy
Monash University

Christopher Peacocke
Magdalen College
University of Oxford

Sydney Shoemaker
Sage School of Philosophy
Cornell University

J. J. C. Smart
Automated Reasoning Project
Centre for Information Science Research
Australian National University

J. David Velleman
Department of Philosophy
University of Michigan

Index

EXHIBIT 7.11: FINANCIAL STATEMENT EFFECTS FOR LAKE COMPANY (EQUITY METHOD OF ACCOUNTING FOR ACTIVE MINORITY INVESTMENTS)

Assets	=	Liabilities	+	Total Shareholders' Equity		
				CC	AOCI	RE
Acquisition of investment						
Investment						
in Pond +500,000						
Cash −500,000						
Dividends received						
Investment						
in Pond −12,000						
Cash +12,000						
Recognition of						
Pond's earnings						
Investment						Equity in Affiliate
in Pond +14,000						Earnings +14,000

Acquisition of investment			
Investment in Pond	500,000		
Cash		500,000	
Dividends received			
Cash	12,000		
Investment in Pond		12,000	
Recognition of share of Pond's earnings			
Investment in Pond	14,000		
Equity in Affiliate Earnings		14,000	

Although Lake's net income includes an increment of $14,000 from investment revenue, it received only $12,000 of cash dividends. Therefore, Lake's statement of cash flows will report a $2,000 deduction in the operating activities section for undistributed earnings of affiliates.

Minority, active investments are *related parties*. Sales to and purchases from related parties, including any receivable and payable relationships, must be disclosed in the notes to the financial statements.[28] Related-party transactions with minority, active investments are not eliminated from the investor's financial statements. However, profit lodged in inventory from intercompany sales or purchases must be eliminated by reducing both equity in net income of the affiliate and the Investment in Affiliate account. Assume that Lake sold inventory costing $75 to Pond for $100. Pond holds $10 of the inventory at year-end. Lake must eliminate $1 profit because, based on the gross margin percentage of 25 percent (= $25 profit/$100 selling price), the $10 inventory contains $2.50 in profit and Lake owns 40 percent of Pond ($2.50 × 40% = $1).

The analyst also should be cautious when examining the financial statements of firms in other countries that do not prepare under IFRS. Firms commonly use the equity method for minority, active investments in Canada, France, and Great Britain and in certain filings with the Ministry of Finance in Japan. Countries that follow a strict legal definition of the entity, such as Germany, tend to report these intercorporate investments at acquisition cost, even when significant influence is present.

[28] Detailed related-party disclosures can be found in Financial Accounting Standards Board, *Statement of Financial Accounting Standards No. 57*, "Related Party Disclosures" (1982); *FASB Codification Topic 850;* International Accounting Standards Board, *International Accounting Standard 24*, "Related Party Disclosures" (revised 2003); and International Accounting Standards Board, *International Accounting Standard 1*, "Presentation of Financial Statements" (revised 2007).

Example 18

PepsiCo owns less than a majority interest in its major affiliated bottling operations, but it still exerts significant influence over its affiliates' operations, for strategic reasons, which we discussed in Chapter 1 and which PepsiCo discusses throughout its 2008 Annual Report (Appendix B). The assets and liabilities of these bottlers do not appear on PepsiCo's balance sheet, but summary financial information for Pepsi Bottling Group (PBG) and PepsiAmericas (PAS) appears in Note 8, "Noncontrolled Bottling Affiliates" (Appendix A). A later section demonstrates the procedure an analyst might follow to incorporate amounts for such investments on the balance sheet. PepsiCo reports "Bottling equity income" of $374 million on its income statement for 2008 (Appendix A). To compute cash flow from operations, PepsiCo's statement of cash flows shows a subtraction from net income of $202 million for "Bottling equity income, net of dividends," suggesting that PepsiCo received dividends of $172 million from these intercorporate investments during 2008. PepsiCo derived less than 10 percent of its pretax earnings from equity method investees during 2006–2008. Companies must disclose partial balance sheet and income statement information for significant intercorporate investments, as well as the fair value of the investments.[29] PepsiCo states in Note 8 that for its two most significant affiliates, PBG and PAS, investment fair values exceed book values by $567 million and $143 million, respectively.

Majority, Active Investments

When one investor firm owns more than 50 percent of the voting stock of another company, the investor firm generally has control. This control may occur at both a broad policy-making level and a day-to-day operational level. The majority investor in this case is the *parent,* and the majority-owned company is the *subsidiary.* Financial reporting requires combining, or *consolidating,* the financial statements of majority-owned companies with those of the parent (unless for legal or other reasons the parent cannot exercise control).[30]

Reasons for Legally Separate Corporations

For several reasons, a parent company may prefer to operate as a group of legally separate corporations rather than as a single legal entity. For example, separate operations reduce financial risk. Separate corporations may mine raw materials, transport them to a manufacturing plant, produce the product, and sell the finished product to the public. If any part of the total process proves to be unprofitable or inefficient, losses from insolvency fall only on the owners and creditors of the one subsidiary corporation. Furthermore, creditors have a claim on the assets of the subsidiary corporation only, not on the assets of the

[29] Companies also may choose the fair value option to report minority active investments, recording all gains and losses from revaluation in operating income.

[30] Accounting for investments that represent control (majority, active investments) is governed by Committee on Accounting Procedure, *Accounting Research Bulletin No. 51,* "Consolidated Financial Statements," as amended by *Statement of Financial Accounting Standards No. 94,* "Consolidation of Majority-Owned Subsidiaries" (1987); Financial Accounting Standards Board, *Interpretation No. 46R,* "Consolidation of Variable Interest Entities" (2003) (referred to as *Interpretation No. 46R);* Financial Accounting Standards Board, *Statement of Financial Accounting Standards No. 167,* "Amendments for FASB Interpretation No. 46(R)" (2009); Financial Accounting Standards Board, *Statement of Financial Accounting Standards No. 166,* "Accounting for Transfers of Financial Assets—an amendment of FASB Statement No. 140" (2009); *FASB Codification Topic 810;* International Accounting Standards Board, *International Accounting Standard 28,* "Investments in Associates" (1989); International Accounting Standards Board, *International Accounting Standard 27,* "Consolidated and Separate Financial Statements" (revised 2003); International Accounting Standards Board, *International Financial Reporting Standard 3,* "Business Combinations" (revised 2008); and International Accounting Standards Board, *Standing Interpretations Committee Interpretation 12,* "Special Purpose Entities" (1998).

parent company. For corporations with potential environmental and product liabilities, legal separation through the use of subsidiaries can be especially advantageous. Also, if a firm does business in many states and countries, often it must contend with overlapping and inconsistent taxation, regulations, and legal requirements. Organizing separate corporations to conduct the operations in the various jurisdictions may reduce administrative costs. Control can be achieved with less than 100 percent ownership of the common shares, which can reduce the amount of capital needed for the investment, and that can make strategic expansion easier. Finally, sometimes there are organizational benefits to operating separate entities, such as incentive alignment between managers and investors when stock in a focused firm can be part of compensation.

Purpose of Consolidated Statements

For a variety of reasons then, a parent and several legally separate subsidiaries may exist as a single economic entity. A consolidation of the financial statements of the parent and each of its subsidiaries presents the results of operations, financial position, and changes in cash flows of an affiliated group of companies under the control of a parent, essentially as if the group of companies were a single entity. The parent and each subsidiary are legally separate entities, but they operate as one centrally controlled economic entity. Consolidated financial statements generally provide more useful information to the shareholders of the parent corporation than do separate financial statements of the parent and each subsidiary.

In general, consolidated financial statements also provide more useful information than does the equity method used to account for minority, active investments. The parent, because of its voting interest, can effectively control the use of the subsidiary's individual assets. Consolidation of the individual assets, liabilities, revenues, and expenses of both the parent and the subsidiary provides a more realistic picture of the operations and financial position of the whole economic entity.

In a legal sense, consolidated statements merely supplement, and do not replace, the separate statements of the individual corporations, although it is common practice in the U.S. to present only the consolidated statements in published annual reports. In some cases, firms do report separate financial statements for consolidated subsidiaries (for example, large conglomerates such as General Electric and Ford reporting separate financial statements for their finance subsidiaries).

Corporate Acquisitions and Consolidated Financial Statements Illustrated

Corporate acquisitions occur when one corporation acquires a majority ownership interest and control in another corporation. Accounting for corporate acquisitions is governed by SFAS 141, 141R, 160 (FASB codification topics 805 and 810) and IFRS 3.[31] Current standards are the result of a joint project between the FASB and IASB on business combinations. This section deals with two types of business combinations: (1) *statutory*

[31] Financial Accounting Standards Board, *Statement No. 141R* (which requires the acquisition method for business combinations) replaces *Statement No. 141*, which required firms to account for all corporate acquisitions using the purchase method. For many years prior to the issuance of *Statement No. 141*, U.S. GAAP required firms to use one of two methods to account for corporate acquisitions: a version of the purchase method or the pooling-of-interests method. The pooling-of-interests method viewed a corporate acquisition as a uniting of the ownership interests of two entities that, while legally combined, continued to operate as they did as separate entities prior to the acquisition. To qualify for the pooling-of-interests method under the rules when it was an allowable reporting technique, the "acquiring" firm had to exchange shares of its common stock for the common stock of the "acquired" company. Most firms preferred to account for corporate acquisitions as pooling of interests rather than as purchases because of the positive effect on earnings subsequent to the acquisition. Pooling, however, has not been an allowable method for some time.

mergers that result when one entity acquires all of the assets and liabilities of another entity and places the acquired assets and liabilities on its books and (2) *acquisitions* of between 51 and 100 percent of the common stock of an acquired entity, where the acquired entity continues to operate as a separate legal entity with separate financial records. Both types of business combinations use the *acquisition method* as laid out in *SFAS 141R* and have the same financial statement effects. However, acquisitions of over 50 percent are active, majority investments as described in the preceding section and thus require the preparation of consolidation worksheets to support consolidated financial statements.

Example 19

On December 31, 2009, Parker issues 100,000 shares of its common stock to acquire 100 percent of the common stock of Smith Company. In addition, Parker agrees to pay former Smith Company shareholders an additional $500,000 in cash if certain earnings projections are achieved over the next two years. Based on probabilities of achieving the earnings projections, Parker estimates the fair value of this promise to be $300,000. Parker pays $20,000 in legal fees and $25,000 in stock issue costs to effect the acquisition. Parker also incurs $10,000 in internal costs related to management's time to complete the transaction. Parker's shares have a fair value of $30 per share at the date of acquisition. Exhibit 7.12 provides the book values of Parker Company and the book and fair values of Smith Company at the date of acquisition.

Assuming a Statutory Merger. To record the acquisition assuming that Smith Company is dissolved (a statutory merger), the acquisition method is applied to this business combination using the following three steps:

1. *Measure the fair value of the consideration transferred to acquire Smith.* A key concept underlying the acquisition method is measurement of the transaction at the fair value transferred by Parker. Parker chose to issue common stock with a fair value of $3,000,000 (10,000 shares × $30 fair value per share) and to incur a liability (the contingent consideration obligation) with a fair value of $300,000. Parker also incurred $55,000 in related legal costs, internal costs, and stock issue costs. Because *SFAS No. 157* defines fair value as the price received to sell an asset or the price paid to transfer a liability in an orderly transaction between market participants at the measurement date, standard setters concluded that the fair value of the transaction is the net proceeds from the stock issue, $2,975,000 (= $3,000,000 − $25,000 costs to issue), plus the fair value of the stock issue costs, $25,000, plus the fair value of the liability assumed, $300,000, which sum to $3,300,000. (Alternatively, just add the fair value of the stock issued to the fair value of the liability assumed because stock issue costs appear as an addition to and subtraction from fair value.) The legal costs of $20,000 and the internal costs of $10,000 are expenses of the period and are not considered part of the acquisition price.

2. *Measure the fair values of the identifiable assets acquired, liabilities assumed, and noncontrolling interests (if any).* In arriving at the $3,300,000 acquisition price, Parker estimated the value of the net assets of Smith Company whether or not they were recorded on Smith's books. The information provided in Exhibit 7.12 indicates that cash, accounts payable, and notes payable had acquisition date fair values equal to their book values. The equality of book and fair values for short-term monetary assets and liabilities (that is, assets and liabilities with fixed cash flows set by contract) is common. Also, with the advent of the fair value option, the likelihood that book values and fair values will be identical increases. Parker estimates

EXHIBIT 7.12

Date of Acquisition Book and Fair Values for Parker Company and Smith Company

	Parker Company Book Values at 12/31/09	Smith Company Book Values at 12/31/09	Smith Company Fair Values at 12/31/09
Cash	$ 900,000	$ 400,000	$ 400,000
Receivables	1,400,000	500,000	450,000
Inventory	1,700,000	1,200,000	1,400,000
PP&E (net)	14,000,000	1,600,000	2,000,000
Customer lists	0	0	100,000
Unpatented technology	0	0	200,000
In-process R&D	0	0	300,000
Total Assets	**$ 18,000,000**	**$ 3,700,000**	**$ 4,850,000**
Accounts payable	$ (600,000)	$ (400,000)	$ (400,000)
Notes payable	(5,100,000)	(2,100,000)	(2,100,000)
Total Liabilities	**$ (5,700,000)**	**$(2,500,000)**	**$(2,500,000)**
Common stock ($1 par)	$ (200,000)	$ (100,000)	
Additional paid-in capital	(4,400,000)	(500,000)	
Retained earnings, 1/1/09	(3,700,000)	(300,000)	
Revenues	(9,000,000)	(2,000,000)	
Expenses	5,000,000	1,700,000	
Total Shareholders' Equity	**$(12,300,000)**	**$(1,200,000)**	

Revenues, gains, and net income are in parentheses to indicate that their signs are opposite those of expenses and losses; that is, they are credits for those interpreting the worksheet from the accountant's traditional debit/credit approach. Liabilities and shareholders' equity accounts are in parentheses to indicate that they are claims against assets; again, they are credits in the traditional debit/credit framework.

the fair value of receivables to be $450,000, which is $50,000 less than book value, an indication that Parker believes that Smith has under-reserved for potential uncollectible accounts. Parker estimates that Smith's nonmonetary assets, inventory and property, plant, and equipment, have fair values that are greater than their book values. Under SFAS 141R, an acquirer must recognize separately from goodwill any intangible assets that arise from legal or contractual rights or that can be sold or otherwise separated from the acquired enterprise. SFAS 141 and 141R identify a nonexhaustive list of possible identifiable intangible assets other than goodwill that meet the criteria for recognition as assets. (See Exhibit 7.13.) Parker identifies three such intangible assets that are not recorded on Smith's books. Smith has customer lists with fair values of $100,000, unpatented technology that has a fair value of $200,000, and in-process R&D that has a fair value of $300,000. These assets have no book value because Smith engaged in internal marketing, advertising, and R&D activities to create them. By rule, these costs must be expensed as incurred by Smith.

EXHIBIT 7.13

Examples of Intangible Assets that Meet the Criteria of Recognition Separately from Goodwill

Marketing-related intangible assets

Trademarks, trade names[CL]
Service marks, collective marks, certification marks[CL]
Trade dress (unique color, shape, or package design)[CL]
Newspaper mastheads[CL]
Internet domain names[CL]
Noncompetition agreements[CL]

Customer-related intangible assets

Customer lists[S]
Order or production backlog[S]
Customer contracts and related customer relationships[S]
Noncontractual customer relationships[S]

Artistic-related intangible assets

Plays, operas, and ballets[CL]
Books, magazines, newspapers, and other literary works[CL]
Musical works such as compositions, song lyrics, advertising jingles[CL]
Pictures and photographs[CL]
Video and audiovisual material, including motion pictures, music videos, television programs[CL]

Contract-based intangible assets

Licensing, royalty, standstill agreements[CL]
Advertising, construction, management, service, or supply contracts[CL]
Lease agreements[CL]
Construction permits[CL]
Franchise agreements[CL]
Operating and broadcast rights[CL]
Use rights such as landing, drilling, water, air, mineral, timber cutting, and route authorities[CL]
Servicing contracts such as mortgage servicing contracts[CL]
Employment contracts[CL]

Technology-based intangible assets

Patented technology[CL]
Computer software and mask works[CL]
Unpatented technology[S]
Databases, including title plants[S]
Trade secrets, including secret formulas, processes, recipes[CL]

(Source: SFAS 141 and SFAS 141R)

[CL]indicates that the assets meet the *Contractual/Legal* criterion. (The asset also might meet the separability criterion, but that is not necessary for recognition.)

[S]indicates that the asset does not meet the contractual/legal criterion, but does meet the *Separability* criterion.

3. *Assign any excess consideration to goodwill or record a gain from a bargain purchase.* The difference between the fair value given by the acquirer and the fair values of the individual identifiable assets is goodwill. In this example, Parker gave $3,300,000 to acquire net assets of Smith that had a fair value of $2,350,000 (= $4,850,000 fair value assets − $2,500,000 fair value liabilities). Therefore, goodwill is the difference, $950,000 (= $3,300,000 − $2,350,000). The parties, in their negotiation, assign an enterprise value to Smith that exceeds the sum of the fair values of identifiable assets. Goodwill represents the superior expected profitability of Smith's operations that exceeds what one would expect from Smith's assets.

 If Parker acquired Smith at a bargain, the fair value given would have been less than the fair values of the individual identifiable assets. Bargain purchases rarely

occur given the rational behavior of owners. However, they do exist, often because of some unusual circumstance that requires a quick liquidation of a company, such as the death of an owner or forced liquidation due to bankruptcy or other financial distress. If a bargain purchase occurs, the acquirer has an economic gain equal to the fair value received less the fair value given. The gain is reported on the acquirer's income statement.

Exhibit 7.14 shows the effects of the acquisition and the journal entry to record the acquisition on Parker's books at December 31, 2009.

Parker records the fair value of assets and liabilities received from Smith and the fair values of consideration given to Smith's shareholders (the contingent performance obligation and the common stock issued). Note that identifiable intangible assets, in-process

EXHIBIT 7.14: FINANCIAL STATEMENT EFFECTS OF A MERGER (ACQUISITION DATE)

Assets	=	Liabilities	+	Total Shareholders' Equity		
				CC	AOCI	RE
Cash +400,000		Accounts Payable +400,000		Common		
Receivables +450,000		Notes Payable +2,100,000		Stock +100,000		
Inventory +1,400,000		Contingent		APIC +2,900,000		
PP&E +2,000,000		Performance				
Customer Lists +100,000		Obligation +300,000				
Unpatented						
Technology +200,000						
In-Process R&D +300,000						
Goodwill +950,000						
Legal and						
management costs:						
Cash −30,000						Operating
						expenses −30,000
Stock issue costs:						
Cash −25,000				APIC −25,000		

Cash	400,000	
Receivables	450,000	
Inventory	1,400,000	
PP&E	2,000,000	
Customer Lists	100,000	
Unpatented Technology	200,000	
In-Process R&D	300,000	
Goodwill	950,000	
Accounts Payable		400,000
Notes Payable		2,100,000
Contingent Performance Obligation		300,000
Common Stock		100,000
APIC		2,900,000
(to record fair values paid and received)		
Operating Expenses	30,000	
Cash		30,000
(to record legal fees and management time)		
APIC	25,000	
Cash		25,000
(to record stock issue costs)		

R&D, and goodwill are recorded at their fair values even though their original book values on Smith's books were zero. Given that many firms expensed in-process R&D in the past, the change in U.S. GAAP and IFRS to the current acquisition accounting standards is a significant change for firms acquiring technology-intensive firms. Legal costs and management time related to the combination are expensed as part of operating expenses. Stock issue costs reduce the proceeds of the issue and thus are treated as a reduction of additional paid-in capital.

Because Smith's assets and liabilities now appear on Parker's books and Smith no longer exists as a separate legal entity, Parker does not have to prepare consolidated financial statements.

Assuming an Acquisition. If the terms of the business combination cause Smith to continue as a separate legal entity (an acquisition), the date of acquisition journal entry differs from the entry used to record a statutory merger. Exhibit 7.15 shows the effects of the acquisition and the journal entry to record the acquisition on Parker's books if Smith continues as a separate legal entity. In an acquisition, Parker records a single account, "Investment in Smith," to represent its interest in the fair values of Smith. The remaining entries are identical to the entries for a merger.

Because Smith's assets and liabilities do not appear on Parker's books and Parker controls Smith, Parker must prepare consolidated financial statements to reflect the substance of the entity over its legal form. The following schedule is a review of why Parker paid $3,300,000 to acquire Smith's shares. The fair value allocation schedule shows three components present in the $3,300,000 acquisition price. The first two are (1) the book value of Smith and (2) the amounts by which individual identifiable assets exceed their book values. The sum of the first two components equals the fair value of the identifiable assets of Smith. The third component is goodwill.

EXHIBIT 7.15: FINANCIAL STATEMENT EFFECTS OF AN ACQUISITION (ACQUISITION DATE)

Assets	=	Liabilities	+	Total Shareholders' Equity		
				CC	AOCI	RE
Investment in Smith +3,300,000		Contingent Performance Obligation +300,000		Common Stock +100,000 APIC +2,900,000		
Legal and management costs: Cash −30,000						Operating Expenses −30,000
Stock issue costs: Cash −25,000				APIC −25,000		

Investment in Smith	3,300,000	
Contingent Performance Obligation		300,000
Common Stock		100,000
APIC		2,900,000
(to record fair values paid and received)		
Operating Expenses	30,000	
Cash		30,000
(to record legal fees and management time)		
APIC	25,000	
Cash		25,000
(to record stock issue costs)		

Fair value allocation schedule (date of acquisition):

Fair value of consideration transferred by Parker		$ 3,300,000
Book value of Smith (total shareholders' equity from Exhibit 7.12)		(1,200,000)
Excess		$ 2,100,000
Allocation to differences between fair value and book value at acquisition:		
Receivables ($450,000 − $500,000)	$(50,000)	
Inventory ($1,400,000 − $1,200,000)	200,000	
PP&E ($2,000,000 − $1,600,000)	400,000	
Customer Lists ($100,000 − $0)	100,000	
Unpatented Technology ($200,000 − $0)	200,000	
In-Process R&D ($300,000 − $0)	300,000	(1,150,000)
Allocated to goodwill		$ 950,000

Preparing Consolidated Statements at the Date of Acquisition

Exhibit 7.16 presents the worksheet necessary to consolidate Parker and Smith at the date of acquisition. The primary objective of the worksheet is to replace the Investment in Smith account with the aforementioned three components in the account.

1. In the Eliminations column, "Investment in Smith" is removed so that, after the row is summed, the account does not appear in the Consolidated column. From a consolidated viewpoint, the combined Parker and Smith entity does not have an investment in Smith separate from the entity's ownership of all of Smith's assets. Because Parker will add the individual assets and liabilities of Smith into the consolidated totals, maintaining the Investment in Smith account would be double-counting.

2. All of the individual assets and liabilities from Smith Company's own financial statements are added to Parker's individual assets and liabilities by summing each row to obtain the consolidated total. Smith's shareholders' equity accounts are eliminated because no outside ownership of Smith's shares exists. These steps accomplish the objective of having the first component of the acquisition price, *book value of Smith*, appear in the consolidated totals.

3. The remainder of the eliminations add the second (*differences between fair and book values of Smith's identifiable net assets*) and third (*goodwill*) components of acquisition price into the consolidated totals.

The consolidated assets and liabilities appearing in Parker's consolidated financial statements are equal to the sum of Parker's book values and Smith's fair values as remeasured at the acquisition date. Smith's income statement amounts are not part of the consolidation process because the consolidated entity has not yet engaged in operations. Of course, prior year's incomes of Smith Company are reflected in its asset and liability levels. The elimination entries are worksheet entries only. They are not entered in the financial records of Parker or Smith. Therefore, the consolidation worksheet must be prepared each reporting period.

A Note on Acquisition "Reserves"

Use of the acquisition method often entails establishing specific "acquisition reserves" at the time one company acquires another company because the acquiring company may not know the potential losses inherent in the acquired assets or the potential liabilities of the acquired

EXHIBIT 7.16

Date of Acquisition Consolidation Worksheet (December 31, 2009)

	Parker (adjusted for the acquisition) effects)	Smith	Eliminations	Consolidated
INCOME STATEMENT				
Revenues	$ (9,000,000)	—	—	$ (9,000,000)
Expenses	5,030,000	—	—	5,030,000
Net Income	$ (3,970,000)	—	—	$ (3,970,000)
BALANCE SHEET				
Cash	$ 845,000	$ 400,000		$ 1,245,000
Receivables	1,400,000	500,000	$ (50,000)	1,850,000
Inventory	1,700,000	1,200,000	200,000	3,100,000
PP&E (net)	14,000,000	1,600,000	400,000	16,000,000
Investment in Smith	3,300,000	—	(3,300,000)	—
Customer lists	—	—	100,000	100,000
Unpatented technology	—	—	200,000	200,000
In-process R&D	—	—	300,000	300,000
Goodwill	—	—	950,000	950,000
Total Assets	$ 21,245,000	$ 3,700,000	$(1,200,000)	$ 23,745,000
Accounts payable	$ (600,000)	$ (400,000)	—	$ (1,000,000)
Notes payable	(5,100,000)	(2,100,000)	—	(7,200,000)
Contingent performance obligation	(300,000)	—	—	(300,000)
Common stock	(300,000)	(100,000)	$ 100,000	(300,000)
Additional paid-in capital	(7,275,000)	(500,000)	500,000	(7,275,000)
Retained earnings, Dec. 31, 2008	(7,670,000)	(600,000)	600,000	(7,670,000)
Total Liabilities and Shareholders' Equity	$(21,245,000)	$(3,700,000)	$ 1,200,000	$(23,745,000)

Revenues, gains, and net income are in parentheses to indicate that their signs are opposite those of expenses and losses; that is, they are credits for those interpreting the worksheet from the accountant's traditional debit/credit approach. Liabilities and shareholders' equity accounts are in parentheses to indicate that they are claims against assets; again, they are credits in the traditional debit/credit framework.

company.[32] Acquisition reserve accounts increase a liability or reduce an asset. The acquiring company will allocate a portion of the purchase price to various types of acquisition reserves (for example, estimated losses on long-term contracts and estimated liabilities for unsettled lawsuits). An acquiring company has up to one year after the date of acquisition to revalue these acquisition reserves as new information becomes available. After that, the acquisition reserve amounts remain in the accounts and absorb losses as they occur. That is, the acquiring firm charges actual losses against the specific acquisition reserves established, instead of against income, to measure the expected loss.

[32] Chapter 6 discusses the various types of reserve accounts that appear in financial statements. In the title of an account in the U.S. the term *reserve* is generally unacceptable unless it includes a descriptor as to its purpose. U.S. firms generally use more precise titles for reserve accounts, such as allowance for uncollectible accounts and estimated warranty liability.

To illustrate, assume that an acquired company has an unsettled lawsuit for which the acquiring company anticipates that a $10 million pretax loss will ultimately result. It allocates $10 million to an acquisition reserve (estimated liability from lawsuit). The acquiring firm would presumably pay less for this company because of the potential liability. Assume that settlement of the lawsuit occurs three years after the date of the acquisition for $8 million (pretax). The accountant charges the $8 million loss against the $10 million reserve instead of against net income for the year. Furthermore, the accountant reverses the $2 million remaining in the acquisition reserve, increasing net income in the year of the settlement.

Acquisition reserves can affect assessments of the quality of accounting information, and regulators carefully monitor their use (and abuse). When used properly, acquisition reserves are an accounting mechanism that helps ensure that the assets and liabilities of an acquired company reflect market values. However, given the estimates required in establishing such reserves, management has some latitude in managing earnings.

Consolidated Financial Statements Subsequent to Date of Acquisition

For an illustration of the consolidation process after the date of acquisition, consider the Parker acquisition of Smith one year later.

Example 20

Referring to the original data in Example 19 that listed differences between Smith's fair values and book values at the date of acquisition, assume that PP&E, customer lists, unpatented technology, and in-process R&D have remaining useful lives of ten years. Exhibit 7.17 presents the consolidated worksheet one year later on December 31, 2010. To

EXHIBIT 7.17

Consolidation Worksheet One Year after Date of Acquisition

	Parker 12/31/10	Smith 12/31/10	Eliminations	Consolidated 12/31/10
INCOME STATEMENT				
Revenues	(P)	(S)		(P) + (S)
Cost of goods sold	P	S	$200,000	P + S + $200,000
Bad debts expense	P	S	($50,000)	P + S − $50,000
Depreciation expense	P	S	$40,000	P + S + $40,000
Amortization expense	P	S	10,000	
			20,000	P + S + $60,000
			30,000	
Equity in Smith's earnings	(P)		P (to eliminate S's net income adjusted for amortizations of the excesses of fair values over book values)	$0
Net Income	(P)	(S)	S	(P)

(Continued)

EXHIBIT 7.17 (Continued)

	Parker 12/31/10	Smith 12/31/10	Eliminations	Consolidated 12/31/10
BALANCE SHEET				
Cash	P	S		P + S
Receivables	P	S		P + S
Inventory	P	S		P + S
PP&E (net)	P	S	$360,000	P + S + $360,000
Investment in Smith	P		(P) (to eliminate equity method balance equal to original investment + S's net income adjusted for amortizations of the excesses of fair values over book values) – S's dividends paid	$0
Customer lists	P		$90,000	P + S + $90,000
Unpatented technology	P		$180,000	P + S + $180,000
In-process R&D	P		$270,000	P + S + $270,000
Goodwill			$950,000	$950,000
Total Assets	P	S	$1,850,000	P + S + $1,850,000
Accounts payable	(P)	(S)		(P) + (S)
Notes payable	(P)	(S)		(P) + (S)
Contingent performance obligation	(P)	(S)		(P) + (S)
Common stock	(P)	(S)	S to eliminate S's shareholders' equity	(P)
Additional paid-in capital	(P)	(S)	S to eliminate S's shareholders' equity	(P)
Retained earnings, 12/31/09	(P)	(S)	S to eliminate S's shareholders' equity	(P)
Total Liabilities and Shareholders' Equity	(P)	(S)	S	(P) + (S's liabilities)

Revenues, gains, and net income are in parentheses to indicate that their signs are opposite those of expenses and losses; that is, they are credits for those interpreting the worksheet from the accountant's traditional debit/credit approach. Liabilities and shareholders' equity accounts are in parentheses to indicate that they are claims against assets; again, they are credits in the traditional debit/credit framework.

focus on eliminations and the meaning of the resulting consolidated numbers, we use P and S for Parker and Smith's own financial statement amounts, respectively. Italicized passages describe the differences between consolidation at acquisition and consolidation subsequent to acquisition.

1. In the Eliminations column, "Investment in Smith" is removed so that, after the row is summed, it does not appear in the Consolidated column. *"Investment in Smith" includes the original investment plus Parker's equity in Smith's earnings for the period (all of Smith's earnings because of 100 percent ownership adjusted for amortizations of the differences between fair and book value) minus Parker's share of Smith's dividends (again, all of Smith's dividends because of 100 percent ownership).*

2. Parker adds all of the individual assets and liabilities from Smith's financial statements to Parker's individual assets and liabilities by summing each row to obtain the consolidated total. Parker eliminates Smith's shareholders' equity accounts because no outside ownership of Smith's shares exists. These steps accomplish the objective of having the first component of the acquisition price, book value of Smith, appear in the consolidated totals. *Smith's assets, liabilities, and owners' equity reflect the book value of Smith at the date of acquisition plus the changes in assets and liabilities from Smith's activities during the year. The changes in assets and liabilities reflected in Smith's income are based on the* book value *of Smith's assets and liabilities. For example, Smith charges cost of goods sold for the book value of inventory when inventory is sold, not the fair value established at the date of acquisition.*

3. A set of adjustments adds the second component (differences between fair and book values of Smith's identifiable net assets) and the third component (goodwill) of acquisition price into the consolidated totals. Exhibit 7.18 supports the entries in the Elimination column. *At the date of acquisition, we deducted $50,000 from receivables in the consolidated worksheet to reflect the lower receivable fair value. Assuming that Parker was correct in believing that the receivables would not be collected (that*

EXHIBIT 7.18

Date of Acquisition Differences	Charged (Credited) to Expense	Balance One Year Later
Receivables: ($50,000)	($50,000) reduction of bad debt expense	$ 0
Inventory: $200,000	$200,000 increase in cost of goods sold	$ 0
PP&E: $400,000	$400,000/10 years = $40,000 increase in depreciation expense	$ 360,000
Customer lists: $100,000	$100,000/10 years = $10,000 increase in amortization expense	$ 90,000
Unpatented technology: $200,000	$200,000/10 years = $20,000 increase in amortization expense	$ 180,000
In-process R&D: $300,000	$300,000/10 years = $30,000 increase in amortization expense	$ 270,000
Allocated to goodwill: $950,000	$0 unless impaired	$ 950,000
Net effects	Decrease income by $250,000	Increase assets by $1,850,000

*is, customers defaulted), Smith has shown a larger bad debt expense on its own finan-
cial statements due to the unexpected (from its viewpoint) customer defaults in the
current year. As Exhibit 7.18 shows, the consolidated worksheet in Exhibit 7.17
reduces bad debts expense by $50,000 and makes no adjustment to accounts receiv-
able. The allocation of all of the fair value/book value acquisition date differences to
expenses and none to the asset will occur when an item (accounts receivable in this
case) is a current asset. Given that inventory also is a current asset (that is, the inven-
tory is sold in less than a year), Exhibit 7.18 allocates all of the acquisition date
$200,000 fair value excess to cost of goods sold and none to inventory. As noted in Item
2 above, Smith based cost of goods sold on book value when it sold the inventory.
Parker uses the worksheet to adjust cost of goods sold to the consolidated point of view.
The remaining items in Exhibit 7.18 are long-term; therefore, if the items are depre-
ciable or amortizable, a portion of the acquisition date excess fair value will be allo-
cated to expense based on the item's estimated remaining useful life, with the
remainder allocated to the asset. Goodwill is not amortized; so the full amount is
reflected in the Elimination column as an adjustment to the asset.*

4. *Equity in Smith's earnings is eliminated. The one-line consolidation of Smith has been con-
 verted to an item-by-item income statement consolidation through addition of revenues
 and expenses of Parker and Smith across columns.*

We use the letters *P* and *S* instead of numbers in the financial statements of Parker and
Smith, respectively, one year later to concentrate on what appears in the Consolidated col-
umn subsequent to the date of acquisitions. "Investment in Smith" and "Equity in Smith's
earnings" do not appear. The consolidated assets and liabilities appearing in Parker's con-
solidated financial statements are equal to the sum of Parker's book values and Smith's fair
values as measured at the acquisition date and are adjusted for Parker's expensing of a por-
tion of the fair value/book value differences to calculate net income on a consolidated basis.
Note that in the case of 100 percent ownership, consolidated net income is simply P's net
income under the equity method. Individual revenues and expenses replace the summary
of S's income in the Equity in Smith's earnings account, which is already in Parker's net
income because of its use of the equity method.

Related-Party Transactions

Several additional transactions must be considered in the preparation of consolidated
financial statements. Transactions between the parent and the subsidiary affect their indi-
vidual financial statements but should not affect the consolidated financial statements.
Additional eliminations should be made for:

- Intercompany loans and receivables and the interest expense and revenues from those
 arrangements. Parents often provide loans to subsidiaries, and the subsidiary's account-
 ing system will show a payable and accrued interest expense on its own books. Similarly,
 the parent will show a receivable and accrued interest revenue.
- Intercompany sales and purchases and the profits lodged in ending inventory. An ear-
 lier section of this chapter discussed investments in affiliates (minority, active invest-
 ments). Recall that intercompany sales and purchases are disclosed as related-party
 transactions but are not eliminated. An example also was provided of how profits
 lodged in inventory on such sales must be eliminated. In the preparation of consoli-
 dated financial statements, the intercompany sales and purchases also must be elimi-
 nated because the purchases and sales were not with a party outside the consolidated
 entity. PepsiCo does not eliminate sales to its noncontrolled bottling affiliates. If the
 affiliates are consolidated, however, PepsiCo eliminates the intercompany sales.

- Intercompany payables and receivables as a result of intercompany sales and purchases. For example, if the parent company purchases inventory from the subsidiary company on credit, the subsidiary will recognize receivables that include payables from the parent.

Other extremely complex transactions that occur between parents and subsidiaries are beyond the scope of this text. However, the guiding principle in the preparation of consolidated financial statements is the need to view the substance of transactions from the consolidated entity's point of view.

What are Noncontrolling Interests?

If an investing firm acquires less than 100 percent of another firm, a *noncontrolling interest* will exist. Many companies use the term *minority interest* to describe the noncontrolling interest in their financial statements. The noncontrolling interest, which may be widely held, has its right to a pro rata portion of net assets, earnings, and dividends. Recent accounting standards have drastically changed accounting for the noncontrolling interest. In the past, an acquisition of less than 100 percent resulted in only a partial remeasurement of the acquired firm's assets and liabilities to fair value. For example, in a 70 percent acquisition, land with a book value of $100 and fair value of $110 would be remeasured and reported at $107 in the consolidated financial statements. The parent's interest in the land would be based on fair value, $77 (= $110 × 70%), and the noncontrolling interest would be based on book value, $30 (= $100 × 30%). Under current standards (the acquisition method), the basis for recording the acquisition transaction is the fair value of the acquired firm. Therefore, land is remeasured to its fair value of $110, with a pro rata share allocated to parent and noncontrolling interests. The measurement of noncontrolling interests also extends to goodwill, which puts both controlling and noncontrolling interests at full fair value. However, under IFRS, firms have an option (on a transaction-by-transaction basis) to assign to noncontrolling interests only their pro rata share of differences between fair value and book value of identifiable assets and liabilities, but not goodwill.

Prior to the issuance of the current accounting standards, noncontrolling interests received disclosure on the balance sheet between liabilities and shareholders' equity ("mezzanine" disclosure). Under current accounting standards, noncontrolling interests are a component of shareholders' equity.

Example 21

Exhibit 7.19 presents the separate financial statements at December 31, 2011, of Power Company and its 80 percent owned subsidiary Small Technologies. Two years earlier, on January 1, 2009, Power acquired 80 percent of the common shares of Small for $3,900 in cash (all amounts in millions). Small's 2010 net income was $350, but Small paid no dividends in that year. Small's 2011 income was $450, and it paid $250 dividends on common stock during 2011.

Shortly after the date of acquisition, Small common stock traded at a share price that was close to the share price Power paid in the acquisition. Because this condition indicated the lack of a control premium, the fair value of Small Technologies was computed as $4,875 (= $3,900 acquisition price ÷ 80%). Recording the acquisition at $4,875 (the acquisition method based on fair value) rather than $3,900 (the purchase method) causes the noncontrolling interest to reflect fair value as well.[33]

[33] If Small common stock trades at a lower amount than the per share price paid by Power, a control premium exists. The fair value of the acquisition (and, hence, the fair value assigned to the noncontrolling interest) would be based on the price paid by Power plus the lower fair value of the remaining noncontrolling shares.

EXHIBIT 7.19

Power Company and Small Technologies Financial Statements at December 31, 2011

	Power Company	Small Technologies
Revenues	$ (4,550)	$(2,150)
Cost of goods sold	1,720	1,000
Depreciation expense	300	100
Amortization expense	500	375
Interest expense	350	225
Equity in subsidiary earnings	(320)	0
Net Income	$ (2,000)	$ (450)
Cash	$ 2,600	$ 2,000
Short-term investments	1,030	225
Land	1,520	1,475
Equipment (net)	1,950	800
Investment in Small Technologies	4,260	0
Patented technologies	4,400	2,700
Total Assets	$ 15,760	$ 7,200
Long-term liabilities	$ (5,410)	$(2,950)
Common stock	(4,350)	(1,150)
Retained earnings	(6,000)	(3,100)
Total Liabilities and Shareholders' Equity	$(15,760)	$(7,200)

Revenues, gains, and net income are in parentheses to indicate that their signs are opposite those of expenses and losses; that is, they are credits for those interpreting the worksheet from the accountant's traditional debit/credit approach. Liabilities and shareholders' equity accounts are in parentheses to indicate that they are claims against assets; again, they are credits in the traditional debit/credit framework.

Exhibit 7.20 presents Power's allocation of Small's fair value at the date of acquisition, updated through the current balance sheet date, December 31, 2011. One year of excess fair value amortization must be reflected in consolidated net income each year, and the balance sheet amounts have accumulated two years of amortization as of December 31, 2011. For example, patented technologies had a fair value that exceeded Small's book value by $600. If the estimated life is 20 years, patent amortization expense on a consolidated basis must be increased by $30 in a given year. After two years have passed, the consolidated balance sheet reports the excess fair value at $540.

Exhibit 7.21 traces Power Company's equity method accounting for Small. Power paid $3,900 at the acquisition date, increased the investment account to recognize its equity in Small's earnings (percent ownership times Small's earnings, adjusted for the excess amortizations from Exhibit 7.20), and decreased the investment when it received its share of Small's dividends. The $320 equity in Small's earnings for 2011 appears in Power's own income statement, and the $4,260 investment in Small Technologies appears on Power's own December 31, 2011 balance sheet. The noncontrolling interest computations follow the same process, yielding

EXHIBIT 7.20

Power Company's Fair Value Allocation at the Date of Acquisition of Small Technologies

	Allocation of Fair Values	Estimated Life	Charged (Credited) to Expense Each Year	Balance on December 31, 2011
Small fair value at acquisition date	$4,875			
Small book value at acquisition date	(3,700)			
Fair value in excess of book value	$1,175			
Land (not depreciated)	300	NA	$ 0	$300
Equipment	(50)	10	(5)	(40)
Patented technologies	600	20	30	540
Long-term liabilities (lower fair value)	200	8	25	150
Goodwill	$ 125	Indefinite	0	125
			$50	

EXHIBIT 7.21

Investor Interests in Small Technologies (in millions)

	Power Company Controlling Interest (80%)	Noncontrolling Interest (20%)
Acquisition date fair value (1/1/10) = $4,875	$3,900	$ 975
2010 net income of Small = $350	$280	$70
Annual excess amortizations = $50 (Exhibit 7.20)	(40)	(10)
Equity in Small's earnings for 2010	240	60
Investment in Small Technologies (12/31/10)	$4,140	$1,035
2011 net income of Small = $450	$360	$90
Annual excess amortizations = $50 (Exhibit 7.20)	(40)	(10)
Equity in Small's earnings for 2011	320	80
Dividends paid by Small in 2011 = $250	(200)	(50)
Investment in Small Technologies (12/31/11)	$4,260	$1,065

a noncontrolling interest in 2011 net income of $80 and a noncontrolling interest in the net assets of Small of $1,065 at December 31, 2011.

Exhibit 7.22 presents the consolidation worksheet at December 31, 2011. The eliminations have been coded to facilitate the explanation. The consolidation process for less than 100 percent ownership follows the same process as illustrated for 100 percent ownership,

EXHIBIT 7.22

Consolidation Worksheet at December 31, 2011 (in millions)

	Power	Small	Eliminations		Consolidated
Revenues	$ (4,550)	$(2,150)			$ (6,700)
Cost of goods sold	1,720	1,000			2,720
Depreciation expense	300	100	C $	(5)	395
Amortization expense	500	375	C	30	905
Interest expense	350	225	C	25	600
Equity in subsidiary earnings	(320)	0	D	320	0
Net Income	$ (2,000)	$ (450)			
Consolidated net income					$ (2,080)
Noncontrolling interest in net income			E	80	80
Net income to controlling interest					$ (2,000)
Cash	$ 2,600	$ 2,000			$ 4,600
Short-term investments	1,030	225			1,255
Land	1,520	1,475	C	300	3,295
Equipment (net)	1,950	800	C	(40)	2,710
Investment in Small Technologies	4,260	0	A	(4,260)	0
Patented technologies	4,400	2,700	C	540	7,640
Goodwill			C	125	125
Total Assets	$ 15,760	$ 7,200			$ 19,625
Long-term liabilities	$ (5,410)	$(2,950)		150	$ (8,210)
Common stock	(4,350)	(1,150)	B	1,150	(4,350)
Noncontrolling interests			E	(1,065)	(1,065)
Retained earnings	(6,000)	(3,100)	B	3,100	(6,000)
Total Liabilities and Shareholders' Equity	$(15,760)	$ 7,200	$	0	$(19,625)

Revenues, gains, and net income are in parentheses to indicate that their signs are opposite those of expenses and losses; that is, they are credits for those interpreting the worksheet from the accountant's traditional debit/credit approach. Liabilities and shareholders' equity accounts are in parentheses to indicate that they are claims against assets; again, they are credits in the traditional debit/credit framework.

with the addition of recognizing the noncontrolling interest in net income and net assets computed in Exhibit 7.21. The eliminations are as follows:

- A = Elimination of the Investment in Small Technologies account
- B = Elimination of Small's shareholders' equity accounts
- C = Allocation of excess fair value amounts at the date of acquisition to expenses and to the balance sheet as computed in Exhibit 7.20
- D = Elimination of the Equity in subsidiary earnings account
- E = Recognition of an $80 noncontrolling claim on consolidated net income and of noncontrolling equity of $1,065

The noncontrolling equity interest of $1,065 should be reported as a component of shareholders' equity. As noted in Chapter 4, if the denominator of the ROA computation

includes all assets (as it typically does), the numerator should be calculated *before* the allocation of consolidated net income to the noncontrolling interest. A tax effect adjustment is not necessary because the noncontrolling interest is in after-tax net income.

Corporate Acquisitions and Income Taxes

Most corporate acquisitions involve a transaction between the acquiring corporation and the *shareholders* of the acquired corporation. Although the board of directors and management of the acquired company are usually deeply involved in discussions and negotiations, the acquisition usually takes place with the acquiring corporation giving some type of consideration to the shareholders of the acquired corporation in exchange for their stock. From a legal viewpoint, the acquired corporation remains a legally separate entity that has simply had a change in the makeup of its shareholder group.

The income tax treatment of corporate acquisitions follows these legal entity notions. In many acquisitions, the acquired company does not restate its assets and liabilities for tax purposes to reflect the amount that it paid for the shares of common stock. Instead, the tax basis of assets and liabilities of the acquired company before the acquisition carries over after the acquisition (termed a *nontaxable reorganization* by the Internal Revenue Code).

The preceding examples ignored the tax effects to focus on the acquisition and consolidation process. However, the following illustrates how deferred taxes would be recognized on a given difference between fair and book values. Assume that inventory had a book value of $70 and a fair value of $80; the tax rate is 35 percent. In the fair value allocation at the date of acquisition (and in the elimination entries during consolidation) inventory is increased by $10 and a deferred tax liability is increased by $3.50 (= $10 × 35 percent). The deferred tax liability is accrued at the date of acquisition to recognize the increase in tax liability when the inventory is sold in the future. If during the next year the subsidiary sells the inventory at its $80 fair value, the subsidiary will have a pretax profit (for book purposes) and a taxable income (for tax purposes) of $10. However, the consolidated financial statements recognize no profit on the sale because of two counterbalancing effects: the subsidiary shows a $10 pretax profit, but the $10 additional cost of goods sold (the $10 extra paid by the parent to acquire the inventory) is recognized through the elimination process. Accordingly, consolidated pretax profit on the transaction is zero; thus, consolidated income tax expense is zero. However, the tax basis of the inventory has not been "stepped up" to $80 at the date of acquisition. Therefore, the subsidiary must pay taxes of $3.50 when the inventory is sold (the reversal of the deferred tax liability).

Consolidation of Unconsolidated Subsidiaries and Affiliates

In some cases, firms have joint ventures or minority-owned affiliates that comprise strategically important components integral to the operations of the firm but that are not consolidated. To get a more complete picture of the economic position and performance of the firm, the analyst may want to assess the firm after consolidating all important minority-owned affiliates. For example, firms frequently work together in joint ventures to carry out their business activities. These companies do not consolidate the financial statements of the joint ventures with their financial statements, but instead use the equity method to account for the joint ventures because they are not majority-owned by the firm.

As discussed in this chapter and Chapter 1, PepsiCo has significant investments in bottlers that are integral to its operations. PepsiCo does not consolidate the bottlers because they are less than majority-owned. However, consolidation of the financial statements of these affiliates with those of PepsiCo provides a glimpse of the firm from a more fully integrated, *operational* perspective.

Example 22

Exhibit 7.23 presents a consolidation worksheet for PepsiCo and its two primary bottlers, PBG and PAS, based on Note 8, "Noncontrolled Bottling Affiliates" to PepsiCo's financial

EXHIBIT 7.23 (in millions)

Consolidation of PepsiCo and Significant Affiliates

December 27, 2008	PepsiCo	PBG	PAS	Eliminations PBG	Eliminations PAS	Consolidated
Current assets	$ 10,806	$ 3,141	$ 906			$ 14,853
Investments in noncontrolled affiliates	3,883			$(1,457)	$ (972)	1,454
Remainder of noncurrent assets	21,305	9,841	4,148	536	318	36,148
Total Assets	$ 35,994	$ 12,982	$ 5,054	$ (921)	$ (654)	$ 52,455
Current liabilities	$ (8,787)	$ (3,083)	$(1,048)			$(12,918)
Noncurrent liabilities	(15,101)	(7,408)	(2,175)			(24,684)
Preferred stock	97					97
External interests		(1,148)	(307)	$ (422)	$ (870)	(2,747)
Common shareholders' equity	(12,203)	(1,343)	(1,524)	1,343	1,524	(12,203)
Total Liabilities and Shareholders' Equity	$(35,994)	$(12,982)	$(5,054)	$ 921	$ 654	$(52,455)
PepsiCo's Investment Balance		$ 1,457	$ 972			

December 29, 2007	PepsiCo	PBG	PAS	Eliminations PBG	Eliminations PAS	Consolidated
Current assets	$ 10,151	$ 3,086	$ 922			$ 14,159
Investments in noncontrolled affiliates	4,354			$(2,022)	$(1,118)	1,214
Remainder of noncurrent assets	20,123	10,029	4,386	507	303	35,348
Total Assets	$ 34,628	$ 13,115	$ 5,308	$(1,515)	$ (815)	$ 50,721
Current liabilities	$ (7,753)	$ (2,215)	$ (903)			$(10,871)
Noncurrent liabilities	(9,641)	(7,312)	(2,274)			(19,227)
Preferred stock	91					91
External interests		(973)	(273)	$(1,100)	$(1,043)	(3,389)
Common shareholders' equity	(17,325)	(2,615)	(1,858)	2,615	1,858	(17,325)
Total Liabilities and Shareholders' Equity	$(34,628)	$(13,115)	$(5,308)	$ 1,515	$ 815	$(50,721)
PepsiCo's Investment Balance		$ 2,022	$ 1,118			

Revenues, gains, and net income are in parentheses to indicate that their signs are opposite those of expenses and losses; that is, they are credits for those interpreting the worksheet from the accountant's traditional debit/credit approach. Liabilities and shareholders' equity accounts are in parentheses to indicate that they are claims against assets; again, they are credits in the traditional debit/credit framework.

statements (Appendix A). The top and bottom halves of the exhibit consolidate the group as of December 27, 2008, and December 29, 2007, respectively. In Note 8, PepsiCo indicates that PBG and PAS are the firm's most significant noncontrolled bottling affiliates but does not disclose additional information about its other affiliates. Therefore, we can prepare a consolidation of PepsiCo with only PBG and PAS.

The first four columns of Exhibit 7.23 present the separate summary balance sheets of PepsiCo, PBG, and PAS. The Eliminations columns show the worksheet adjustments necessary to consolidate the affiliates. The final column presents PepsiCo's balance sheet if the affiliates had been consolidated. The worksheet consolidates two affiliates in each of two years.

According to Note 8, PepsiCo has an investment in PBG of $1,457 million at December 27, 2008. PepsiCo owns 33 percent of PBG common stock, 100 percent of PBG's class B common stock, and 7 percent of the common stock of PBG's primary operating subsidiary. PepsiCo's investment in PBG common stock was 2 percent higher in 2007. PepsiCo also reports that "our investment in PBG, which includes the related goodwill, was $536 million and $507 million higher than our ownership interest in their net assets at year-end 2008 and 2007, respectively." These disclosures imply that PepsiCo's interest in the net assets is as follows (in millions):

	2008	2007
Investment in PBG	$ 1,457	$ 2,022
Excess of investment over book value of PBG net assets	(536)	(507)
Ownership interest in book value of PBG net assets	$ 921	$ 1,515
Combined PBG minority interest and common shareholders' equity	÷2,491	÷3,588
Effective interest in net assets implied by PepsiCo's disclosures	37.0%	42.2%

The combined minority interest and common shareholders' equity equals the book value of PBG's net assets.

Repeating the computations for PAS:

	2008	2007
Investment in PAS	$ 972	$ 1,118
Excess of investment over book value of PAS net assets	(318)	(303)
Ownership interest in book value of PAS net assets	$ 654	$ 815
Combined PAS minority interest and common shareholders' equity	÷1,831	÷2,131
Effective interest in net assets implied by PepsiCo's disclosures	35.7%	38.5%

The 2008 portion of the worksheet for PBG accomplishes the following:

1. We eliminate the $1,457 million of investment in PBG. In Items 2 and 3 below, we replace the single investment line with the individual assets and liabilities in which PepsiCo invested with (a) the individual assets and liabilities of PBG (which are measured at a book value of $921 million shown in the schedule above) and (b) the amount PepsiCo paid for PBG in excess of its book value, $536 million.
2. We add the individual assets and liabilities across columns to yield consolidated numbers. PBG's assets and liabilities are carried at book value.

3. We add $536 million to assets because it represents the portion of PepsiCo's investment that is not reflected in the book values of PBG's net assets.

4. As explained earlier in the chapter, the purpose of preparing a consolidated worksheet is to simulate the balance sheet that would have occurred if PepsiCo had acquired the assets and liabilities of PBG and PBG's shares no longer existed. Therefore, we eliminate the common equity of PBG.

5. The noncontrolling interest in PBG's net assets from a consolidated (PepsiCo's) viewpoint is 100% − 37.0% (PepsiCo's interest) = 63.0% × PBG's net assets of $2,491 million = $1,569 million. Given that PBG has minority interest at $1,148 million, we add $422 million to minority interest. The remainder of Exhibit 7.23 repeats the process for PBG in 2007 and PAS in 2008 and 2007.

Consider now the effect of consolidating PepsiCo's bottlers on its ROA. For 2008, Chapter 4 calculates an ROA (adjusted for the nonrecurring items discussed in that chapter) as follows:

$$\frac{\$5,142 + (1 - 0.35)(\$329) + \$0}{0.5\,(\$35,994 + \$34,628)} = 15.2\%$$

To exclude the effect of financing from the numerator of ROA, the interest expense (net of taxes) recognized by PepsiCo's bottlers must be added back. Note 8 does not provide the amount of interest expense for those entities, so we estimate the amount by assuming that the noncurrent liabilities of the bottlers represent interest-bearing debt. Based on disclosures in PepsiCo's Note 9, "Debt Obligations and Commitments" (Appendix A), we assume an average interest rate of 5.8 percent on long-term debt. The debt of PepsiCo's investees and amounts for noncurrent liabilities from Note 8 yield interest expense of $555 million [= 0.058 × 0.5($7,408 + $7,312 + $2,175 + $2,247)] for 2008. Obviously the calculation of ROA will be slightly in error if some of the current liabilities of these entities bear interest, if some of the noncurrent liabilities do not bear interest, or if 5.8 percent is not a reasonable interest rate for PBG and PAS debt.

The final adjustment to the numerator of ROA to consolidate these bottlers is to add the minority interest in earnings. This adjustment permits the numerator to include 100 percent of the operating income of PepsiCo and its bottlers and the denominator to include 100 percent of the assets of these entities. PepsiCo's Note 8 shows that the total income for PBG and PAS bottlers for 2008 is $162 million and $226 million, respectively. Applying the noncontrolling interest percentages yields the share of income attributable to the external interests in these two subsidiaries of $247 million (= $162 × 63.0% + $226 × 64.3%). Consolidating PepsiCo's bottlers results in the following recomputed ROA for 2008:

$$\frac{\$5,142 + (1 - 0.35)(\$329 + \$555) + \$247}{0.5\,(\$52,455 + \$50,720)} = 11.6\%$$

Thus, PepsiCo's ROA for 2008 drops significantly, from 15.2 percent to 11.6 percent—a 24 percent decline. The capital-intensive nature of bottling reveals itself in this pro forma ratio analysis in that the asset base for PepsiCo increases substantially when the bottling companies are consolidated. The consolidation of majority-owned subsidiaries is a relatively recent phenomenon in some countries (for example, Germany and Japan). These countries tended to follow strict legal definitions of the reporting entity. Non-IFRS financial reporting in these countries now generally requires the preparation of consolidated financial statements, although the requirement in Japan applies only to filings with the Ministry of Finance.

Joint Ventures: Proportionate Consolidation of Unconsolidated Subsidiaries and Affiliates

An alternative to full consolidation of PepsiCo's bottlers is proportionate consolidation. Under proportionate consolidation, the investor's share of the affiliate's assets and liabilities appears in separate sections on the asset and liabilities sides of the balance sheet, with the equity investment account eliminated. (Recall that PepsiCo currently accounts for its investments using the equity method.)

This alternative is particularly appealing for firms that enter into joint ventures in which ownership of the venture is split equally between two firms. Under U.S. GAAP, firms account for investments in joint ventures using the equity method (unless FASB *Interpretation No. 46R* applies) because these investments fall between minority, active investments and majority, active investments. IFRS permits use of proportionate consolidation for joint ventures, arguing that proportionate consolidation better captures the economics of transactions in which joint control is present.

Primary Beneficiary of a Variable-Interest Entity

Control achieved by ownership of more than 50 percent of voting shares justifies the preparation of consolidated financial statements. However, firms can have far less than 50 percent ownership in an entity but still be the primary beneficiary of the entity's operations and achieve control over the entity's decision-making process by contractual relationships. Special-purpose or variable-interest entities (VIEs) were part of the massive fraud infamously perpetrated by Enron, and such arrangements now tend to conjure up images of corporate malfeasance. However, companies may establish VIEs for legitimate business purposes. VIEs can take the form of a corporation, partnership, trust, or any other legal structure used for business purposes. Examples include entities that administer real estate leases, R&D agreements, and energy-related foreign exchange contracts. Often VIEs hold financial assets (such as accounts or loans receivable), real estate, or other property. The VIE may be passive and simply carry out a function on behalf of one or more firms (administering a commercial real estate lease, for example), or it may actively engage in some activity on behalf of one or more firms (such as conducting R&D activities). VIEs can be quite large and significant relative to the sponsoring firms. For example, in 2004, The Walt Disney Company announced that it would consolidate VIEs Euro Disney and Hong Kong Disneyland. The Walt Disney Company owned slightly more than 40 percent of each affiliate.

One of the primary benefits of the VIE is low-cost financing of asset purchases. For example, a sponsoring firm can create a VIE by using minimal amounts of equity investment, some debt investment, and probably some guarantee of VIE debt or other loss protection to outside investors. The VIE could acquire an asset and lease it to the sponsoring firm. Isolation of the asset from the sponsor's operations, the collateral presented by the asset, and sponsor debt guarantees motivate lenders to provide a lower interest rate loan to the VIE to acquire the asset.

Because of the low level of equity investment, the sponsoring firm would not consolidate a VIE under the percentage of ownership criterion. However, the sponsoring firm might possess the rights of a typical equity investor via contractual control of a VIE's operating, investing, and financing activities and may bear losses and reap profits as if it were an equity investor.

When is an Entity Classified as a VIE?

A firm's investment in another entity is classified as a VIE investment, and thus is subject to *Interpretation No. 46R,* if either of the following conditions exist: [34]

- The total equity investment at risk is not sufficient to permit the entity to finance its activities without additional subordinated financial support from other parties, including equity holders. The presumption is that an equity investment of less than 10 percent of the entity's total assets is not sufficient to permit the entity to finance its activities without additional support. However, entities that are holding high-risk assets or are engaging in high-risk activities or that are exposed to risks beyond their reported assets and liabilities may be required to have more than a 10 percent investment.
- The equity investing firms lack any one of the following three characteristics of a controlling financial interest:
 - The direct or indirect ability to make decisions about the entity's activities through voting rights or similar rights. Contractual arrangements with the subordinated providers of funds usually restrict the ability of the equity-investing firms to make decisions about the entity's activities.
 - The obligation to absorb the expected losses of the entity if they occur. The subordinated providers of funds absorb some of the expected losses.
 - The right to receive the expected residual returns of the entity if they occur. The subordinated providers of funds have a claim on some of the expected residual returns.

Which Entity Should Consolidate the VIE?

If a firm has a relationship with an entity deemed to be a VIE, the firm must apply the criteria of FIN 46R to determine whether it is the primary beneficiary of the VIE. If it is, it must consolidate the VIE's assets, liabilities, revenues, expenses, and noncontrolling interests. The firm is the primary beneficiary if it has:

- The direct or indirect ability to make decisions about the entity' activities.
- The obligation to absorb the entity's expected losses if they occur.
- The right to receive the entity's expected residual returns if they occur.

The aforementioned criteria recognize that contractual rights can cause a sponsoring firm to have *variable interests* similar to those possessed by traditional equity owners. FIN 46R provides examples of variable interests, explaining how the variable interests link to potential losses and returns as follows:

- Participation rights (entitling holders to the VIE's residual profits)
- Asset purchase options (entitles holders to benefit from increases in fair values, often versus bargain repurchase rights)
- Guarantees of debt (the maker of the guarantee must stand ready to repay a VIE's liabilities if the VIE cannot)
- Subordinated debt instruments (the subordinated creditor provides the cash flow to pay senior debt when the VIE cannot)
- Lease residual value guarantees (the maker of the guarantee covers losses when a leased assets value falls below its expected residual value)

[34] Financial Accounting Standards Board, *Statement No. 140,* discussed in Chapter 8, addresses the accounting for the sale of receivables. In the past, entities formed by the transferor for the sale of receivables, often referred to as *qualifying special-purpose entities,* were excluded from the scope of *Interpretation No. 46R* and thus were not classified as variable-interest entities. As of the June 2009 issue of Financial Accounting Standards Board, *Statement of Financial Accounting Standards No. 166,* "Accounting for Transfers of Financial Assets, an amendment of FASB Statement No. 140," 2009, effective for reporting periods beginning November 15, 2009, the notion of a qualifying special purpose-entity is terminated. Therefore, entities formed by the transferor for the sale of receivables fall under the provision of *Interpretation No. 46R* (*FASB Codification Topics 810 and 860*).

The presence of these variable interests leads to control in the absence of equity owner-ship. Therefore, consolidation of the VIE is appropriate because the primary beneficiary controls the net assets of the VIE. Consolidation of a VIE follows the same process as that illustrated for majority, active investments.

Disclosure Requirements of Interpretation No. 46R. Both the primary beneficiary firm and the firms holding significant variable interests in a VIE are subject to *Interpretation No. 46R* disclosure rules. If material to the financial statements, the primary beneficiary must dis-close (1) the nature, purpose, size, and activities of the VIE; (2) the carrying amount and classification of the consolidated assets that represent collateral for the VIE's obligations; and (3) the status of VIE creditors' recourse (if any) to the assets of the primary benefici-ary. Firms holding significant variable interest in a VIE must disclose (1) the nature of its involvement with the VIE and the start of that involvement; (2) the nature, purpose, size, and activities of the VIE; and (3) the investing firm's maximum exposure to loss given its involvement with the VIE.

Example 23

Ford Motor Company describes its VIEs in Note 11 to its 2008 Consolidated Financial Statements. Ford provides the following opening statement in the note:

> We consolidate VIEs of which we are the primary beneficiary. The liabilities recog-nized as a result of consolidating these VIEs do not necessarily represent additional claims on our general assets; rather, they represent claims against the specific assets of the consolidated VIEs. Conversely, assets recognized as a result of consolidating these VIEs do not represent additional assets that could be used to satisfy claims against our general assets.

This initial statement illustrates the key business purpose of most VIEs, the isolation of risk. As diagrammed in Exhibit 7.24, Ford Motor Company's finance subsidiary, Ford Credit, sponsors (that is, creates) a VIE with a minimal amount of equity investment. The VIE's balance sheet shows relatively small amounts of cash. The VIE needs to acquire assets of some kind to carry out its operations; therefore, it must attract capital from other parties. When a potential capital provider (for example, bank, insurance company, or equity investor) assesses the risk of the VIE, Ford Motor Company's risk is not an issue. The VIE

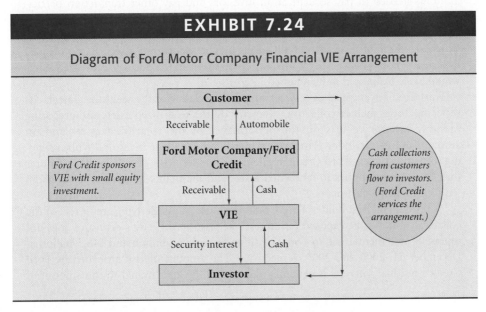

EXHIBIT 7.24

Diagram of Ford Motor Company Financial VIE Arrangement

is a legally separate entity from Ford Motor Company. The term used to describe this status is *bankruptcy remote.* Because of bankruptcy remote status, the VIE should be able to obtain better financing terms. The VIE will determine its capital structure based on the risk of cash flows from the assets it acquires to carry on its stated purpose. In the case of Ford's financial services VIEs, the VIEs acquire customer receivables from Ford Credit and securitize the receivables. That is, the VIEs issue rights to investors to the cash flows from receivable collection. The cash it collects from investors upon selling the secured interests is transferred back to Ford Credit as payment for the receivables acquired. Customers pay cash on their receivables to Ford Credit (Note 11 indicates that Ford Credit services the receivables), and Ford Credit delivers scheduled cash payments to the VIEs' investors.

The benefit to Ford Motor Company of this arrangement is clear: Ford quickly converts its receivables to cash, and Ford Credit can offer more financing to stimulate future sales. This benefit comes at a cost. The VIEs' investors demand a return. The bankruptcy remote status of the VIE will help incent VIE investors to accept a lower return, but the VIEs' investors often require more guarantees that Ford Credit will share in the risk that the securitized receivables will not generate sufficient cash flows. Consider the following passages from the same note that describes Ford Credit's risk sharing:

> Ford Credit provides various forms of credit enhancements to reduce the risk of loss for securitization investors. Credit enhancements include over-collaterization (when the principal amount of the securitized assets exceeds the principal amount of related asset-backed securities), segregated cash reserve funds, subordinated securities, and excess spread (when interest collections on the securitized assets exceed the related fees and expenses, including interest payments on the related asset-backed securities). Ford Credit may also provide payment enhancements that increase the likelihood of the timely payment of interest and the payment of principal at maturity. Payment enhancements include yield supplement arrangements, interest rate swaps, liquidity facilities, and certain cash deposits.
>
> Ford Credit retains interests in its securitization transactions, including senior and subordinated securities issued by the VIE, rights to cash held for the benefit of the securitization investors (for example, a reserve fund) and residual interests. Residual interests represent the right to receive collections on the securitized assets in excess of amounts needed to pay securitization investors and pay other transaction participants and expenses. Ford Credit retains credit risk in securitizations because its retained interests include the most subordinated interests in the securitized assets, which are the first to absorb credit losses on the securitized assets. Based on past experience, Ford Credit expects that any credit losses in the pool of securitized assets would likely be limited to its retained interests.
>
> Ford Credit is engaged as servicer to collect and service the securitized assets. Its servicing duties include collecting payments on the securitized assets and preparing monthly investor reports on the performance of the securitized assets and on amounts of interest andor principal payments to be made to investors. While servicing securitized assets, Ford Credit applies the same servicing policies and procedures that Ford Credit applies to its owned assets and maintains its normal relationship with its financing customers.
>
> As residual interest holder, Ford Credit is exposed to underlying credit risk of the collateral, and may be exposed to interest rate risk. Ford Credit's exposure does not represent incremental risk to Ford Credit and was $18.2 billion and $16.3 billion at December 31, 2008 and 2007, respectively. The amount of risk absorbed by Ford Credit's residual interests is generally represented by and limited to the amount of

overcollaterization of its assets securing the debt and any cash reserves funded. For Ford Credit's wholesale transactions, it also includes cash it has contributed to excess funding accounts and its participation interests in the VIE.

Ford Motor Company has applied *FIN 46R* and has concluded that it is the primary beneficiary of the VIEs. Therefore, it consolidates its financial services VIEs. Ford also discloses automotive sector joint ventures for which it is the primary beneficiary. The passage below (from Note 11) illustrates how a company such as Ford controls operations of the VIE through contractual arrangements and how it has variable interests that cause it to be the primary beneficiary (that is, substantially shares in profits and losses based on the VIE's performance).

> Activities with the joint ventures described below include purchasing substantially all of the joint ventures' output under a cost-plus-margin arrangement and/or volume dependent pricing. These contractual arrangements may require us to absorb joint venture losses when production volume targets are not met or allow us, in some cases, to receive bonuses when production volume targets are exceeded.

Income Tax Consequences of Investments in Securities

For income tax purposes, investments fall into the following two categories:

- Investments in debt securities, in preferred stock, and in less than 80 percent of the common stock of another entity. Firms recognize interest or dividends received or receivable each period as taxable income (subject to a partial dividend exclusion), as well as gains or losses when they sell the securities.
- Investments in 80 percent or more of the common stock of another entity. Firms can prepare consolidated tax returns for these investments.

As is evident, the methods of accounting for investments for financial and tax reporting do not overlap precisely. Thus, temporary differences will likely arise for which firms must recognize deferred taxes. PepsiCo, for example, cannot file consolidated tax returns with PBG, PAS, or other equity investments because its ownership percentage is less than 80 percent. In Note 5, "Income Taxes" (Appendix A), PepsiCo reports deferred tax liabilities of $1,193 million on December 27, 2008 ($1,163 million on December 29, 2007), relating to these equity investments because it includes its share of the investees' earnings each year for financial reporting but recognizes dividends received as income on its tax return.

FOREIGN CURRENCY TRANSLATION

Firms headquartered in a particular country often have substantial operations outside of that country. For example, in Note 1, "Basis of Presentation and Our Divisions" (Appendix A), PepsiCo indicates that it generates approximately 48 percent of its net revenues internationally (defined as outside the U.S.).[35] For some firms (such as Coca-Cola), international sales dominate even though the firm is headquartered in the U.S.

[35] Financial reporting requires firms to disclose segment data by geographic location (foreign versus domestic) as well as by reportable operating segments and major customers [Financial Accounting Standards Board, *Statement of Financial Accounting Standards No. 131*, "Disclosures about Segments of an Enterprise and Related Information" (1997); *FASB Codification Topic 280*]. PepsiCo reports extensive geographic segment information in Note 1 (Appendix A).

U.S. parent companies must translate the financial statements of foreign branches and subsidiaries into U.S. dollars before preparing consolidated financial statements for shareholders and creditors. This section describes and illustrates the translation methodology and discusses the implications of the methodology for managing international operations and for interpreting financial statement disclosures regarding such operations.[36]

The following general issues arise in translating the financial statements of a foreign branch or subsidiary:

- Should the firm translate individual financial statement items using the exchange rate at the time of the transaction (referred to as the *historical exchange rate*) or the exchange rate during or at the end of the current period (referred to as the *current exchange rate*)? Financial statement items that firms translate using the historical exchange rates appear in the financial statements at the same U.S. dollar equivalent amount each period regardless of changes in the exchange rate. For example, land acquired in France for €10,000 when the exchange rate was $1.05 per euro appears on the balance sheet at $10,500 each period. Financial statement items that firms translate using the current exchange rate appear in the financial statements at a different U.S. dollar amount each period when exchange rates change. Thus, a change in the exchange rate to $1.40 per euro results in reporting the land at $14,000 in the balance sheet. Financial statement items for which firms use the current exchange rate give rise to a *foreign exchange adjustment* each period.
- Should the firm recognize the foreign exchange adjustment as a gain or loss in measuring net income each period as it arises, or should the firm defer its recognition until a future period? The foreign exchange adjustment represents an unrealized gain or loss, much the same as changes in the market value of derivatives, marketable securities, inventories, and other assets. Should financial reporting require realization of the gain or loss through sale of the foreign operation before recognizing it, or should the unrealized gain or loss flow directly to the income statement as the exchange rate changes?

The sections that follow address these two questions.

Functional Currency Concept

Central to the translation of foreign currency items under GAAP is the *functional currency concept*.[37] Determination of the functional currency drives the accounting for translating the financial statements of foreign entities of U.S. firms into U.S. dollars.

Foreign entities (whether branches or subsidiaries) are of two general types:

- A foreign entity operates as a relatively self-contained and integrated unit in a particular foreign country. The functional currency for these operations is the currency of that foreign country. The rationale is that management of the foreign unit likely makes operating, investing, and financing decisions based primarily on economic conditions in that foreign country, with secondary concern for economic conditions, exchange rates, and similar factors in other countries.
- The operations of a foreign entity are a direct and integral component or extension of the parent company's operations. The functional currency for these operations is the U.S. dollar. The rationale is that management of the foreign unit likely makes decisions from the perspective of a U.S. manager concerned with the impact of decisions on U.S. dollar amounts even though day-to-day transactions of the entity are usually conducted in the foreign currency.

[36] Other than terminology and other relatively minor implementation differences, IFRS and U.S. GAAP are similar in the foreign currency translation area.

[37] Financial Accounting Standards Board, *Statement of Financial Accounting Standards No. 52* (as amended by *Statement No. 130*, "Reporting Comprehensive Income"), "Foreign Currency Translation" (1981); *FASB Codification Topics 220 and 830.*

The FASB issued *Statement No. 52* prior to the rapid growth in globalization, with firms now sourcing products, services, and capital and selling products and services and investing capital on a global basis. In these settings, no single currency may satisfactorily reflect the global activities of the foreign subsidiary. Nonetheless, U.S. GAAP requires firms to select a single currency—the currency of the foreign unit or the U.S. dollar—as the functional currency.

Statement No. 52 sets out characteristics for determining whether the currency of the foreign unit or the U.S. dollar is the functional currency. Exhibit 7.25 summarizes these characteristics. The operating characteristics of a particular foreign operation may provide mixed signals regarding which currency is the functional currency. Managers must exercise judgment in determining which functional currency best captures the economic effects of a foreign entity's operations and financial position. As a later section discusses, managers may structure certain financing or other transactions to influence the identification of the functional currency. Once a firm determines the functional currency of a foreign entity, it must use that currency consistently over time unless changes in economic circumstances clearly indicate that a change in the functional currency be made.

Statement No. 52 provides for one exception to the guidelines in Exhibit 7.25 for determining the functional currency. If the foreign entity operates in a highly inflationary country, U.S.

EXHIBIT 7.25

Factors for Determining Functional Currency of a Foreign Unit of a U.S.-Based Firm

	Foreign Currency Is Functional Currency	**U.S. Dollar Is Functional Currency**
Cash Flows of Foreign Entity	Receivables and payables denominated in foreign currency and not usually remitted to parent currently	Receivables and payables denominated in U.S. dollars and readily available for remittance to parent
Sales Prices	Influenced primarily by local competitive conditions and not responsive on a short-term basis to exchange rate changes	Influenced by worldwide competitive conditions and responsive on a short-term basis to exchange rate changes
Cost Factors	Foreign unit obtains labor, materials, and other inputs primarily from its own country	Foreign unit obtains labor, materials, and other inputs primarily from the U.S.
Financing	Financing denominated in currency of foreign unit or generated internally by the foreign unit	Financing denominated in U.S. dollars or ongoing fund transfers by the parent
Relations between Parent and Foreign Unit	Low volume of intercompany transactions and little operational interrelations between parent and foreign unit	High volume of intercompany transactions and extensive operational interrelations between parent and foreign unit

GAAP considers its currency too unstable to serve as the functional currency and the firm must use the U.S. dollar instead. A highly inflationary country is one that has experienced cumulative inflation of at least 100 percent over a three-year period. Some developing nations fall within this exception and pose particular problems for U.S. parent companies.

Translation Methodology—Foreign Currency is Functional Currency

When the functional currency is the currency of the foreign unit, U.S. GAAP requires firms to use the *all-current translation method*. The left-hand column of Exhibit 7.26 summarizes the translation procedure under the all-current method.

EXHIBIT 7.26

Summary of Translation Methodology

	Foreign Currency Is the Functional Currency (all-current method)	U.S. Dollar Is the Functional Currency (monetary/ nonmonetary method)
Income Statement	Firms translate revenues and expenses as measured in foreign currency into U.S. dollars using the average exchange rate during the period. Income includes (1) realized and unrealized transaction gains and losses and (2) realized translation gains and losses when the firm sells the foreign unit.	Firms translate revenues and expenses using the exchange rate in effect when the firm made the original measurements underlying the valuations. Firms translate revenues and most operating expenses using the average exchange rate during the period. However, they translate cost of goods sold and depreciation using the historical exchange rate appropriate to the related asset (inventory, fixed assets). Net income includes (1) realized and unrealized transaction gains and losses and (2) unrealized translation gains and losses on the net monetary position of the foreign unit each period.
Balance Sheet	Firms translate assets and liabilities as measured in foreign currency into U.S. dollars using the end-of-the-period exchange rate. Use of the end-of-the-period exchange rate gives rise to unrealized transaction gains and losses on receivables and payables requiring currency conversions in the future. Firms include an unrealized translation adjustment on the net asset position of the foreign unit in accumulated other comprehensive income, until the firm sells the foreign unit.	Firms translate monetary assets and liabilities using the end-of-the-period exchange rate. They translate nonmonetary assets and equities using the historical exchange rate.

Firms translate revenues and expenses at the average exchange rate during the period and balance sheet items at the end-of-the-period exchange rate. Net income includes only *transaction* exchange gains and losses of the foreign unit. That is, a foreign unit that has receivables and payables denominated in a currency other than its own must make a currency conversion on settlement of the account. The gain or loss from changes in the exchange rate between the time the account originated and the time of settlement is a transaction gain or loss. Firms recognize this gain or loss during the period the account is outstanding even though it is not yet realized or settled. As Chapter 8 discusses, firms often acquire derivatives to hedge the risk of foreign currency gains and losses. Firms include the offsetting loss or gain on the derivative to the gain or loss on the item hedged in net income each period. Thus, net income increases or decreases only to the extent that the derivative did not perfectly hedge the change in exchange rates.

When a foreign unit operates more or less independently of the U.S. parent, financial reporting assumes that only the parent's equity investment in the foreign unit is subject to exchange rate risk. The firm measures the effect of exchange rate changes on this investment each period but includes the resulting "translation adjustment" as a component of other comprehensive income rather than net income. The rationale for this treatment is that the firm's investment in the foreign unit is for the long term; therefore, short-term changes in exchange rates should not affect periodic net income. Firms recognize the cumulative amount in the translation adjustment account in net income when measuring any gain or loss in the case of a sale or disposal of a foreign unit.

The "translation adjustment" reported by a firm can include a second component in addition to the effect of exchange rate changes on the parent's equity investment in foreign subsidiaries or branches. Firms can hedge their investment in foreign operations using forward contracts, currency swaps, or other derivative instruments. As part of the translation adjustment, firms report the change in fair value of a derivative that qualifies as a hedge of the net investment in a foreign entity.[38] In this sense, the foreign currency hedge is treated similar to a cash flow hedge (discussed and illustrated in Chapter 8) in that the change in the fair value of the hedge appears in other comprehensive income. The difference is that firms do not separately disclose the change in the fair value of the hedge, but rather embed it in the translation adjustment, which also captures the effect of exchange rate changes on the parent's equity investment in the foreign entity.

Example 24

The functional currency for PepsiCo's foreign subsidiaries is the currency of the foreign unit. As a result, PepsiCo reports the currency translation adjustment in other comprehensive income. PepsiCo's total comprehensive income for 2008 is $1,349 million, which includes a *negative* Currency Translation Adjustment of $2,484 million for the year. This adjustment is a loss, and it substantially explains why net income is $5,142 million, but comprehensive income is only $1,349. The Statement of Changes in Common Shareholders' Equity (Appendix A) for PepsiCo includes the $2,484 million currency translation adjustment in reconciling the change in Accumulated Other Comprehensive Loss for 2008. Also, Note 13, "Accumulated Other Comprehensive Loss" (Appendix A), discloses that the December 27, 2008, accumulated other comprehensive income balance is $(4,694) million (a reduction of shareholders' equity). Of this amount, $(2,271) million represents cumulative translation losses through time.

[38] Financial Accounting Standards Board, *Statement of Financial Accounting Standards No. 133,* "Accounting for Derivative Instruments and Hedging Activities" (1998); *FASB Codification Topic* 815. However, if the foreign currency hedge does not qualify as a hedge of the net investment, the criteria established in this standard for fair value and cash flow hedges are applied to determine the appropriate accounting. See Chapter 8 for a discussion of the accounting for derivatives used in fair value and cash flow hedging activities.

Illustration—Foreign Currency Is Functional Currency

Exhibit 7.27 illustrates the all-current method for a foreign unit *during its first year of operations*. The exchange rate was $1:1FC on January 1, $2:1FC on December 31, and $1.5:1FC on average during the year. Thus, the foreign currency increased in value relative to the U.S. dollar during the year. That is, it takes fewer foreign currency units to acquire $1 at the end of the year than at the beginning of the year. The firm translates all assets and liabilities on the balance sheet at the exchange rate on December 31. It translates common

EXHIBIT 7.27

Illustration of Transition Methodology When the Foreign Currency Is the Functional Currency

	Foreign Currency		U.S. Dollars	
BALANCE SHEET				
ASSETS				
Cash	FC	10	$2.0:1FC	$ 20.0
Receivables		20	$2.0:1FC	40.0
Inventories		30	$2.0:1FC	60.0
Fixed assets (net)		40	$2.0:1FC	80.0
Total Assets	FC	100		$200.0
LIABILITIES AND SHAREHOLDERS' EQUITY				
Accounts payable	FC	40	$2.0:1FC	$ 80.0
Bonds payable		20	$2.0:1FC	40.0
Total Liabilities	FC	60		$120.0
Common stock	FC	30	$1.0:1FC	$ 30.0
Retained earnings		10		12.5[a]
Accumulated other comprehensive income— unrealized translation adjustment		—		37.5[b]
Total Shareholders' Equity	FC	40		$ 30.0
Total Liabilities and Shareholders' Equity	FC	100		$200.0
INCOME STATEMENT				
Sales	FC	200	$1.5:1FC	$300.0
Realized transaction gain		2[c]	$1.5:1FC	3.0[c]
Unrealized transaction gain		1[d]	$1.5:1FC	1.5[d]
Cost of goods sold		(120)	$1.5:1FC	(180.0)
Selling & administrative expense		(40)	$1.5:1FC	(60.0)
Depreciation expense		(10)	$1.5:1FC	(15.0)
Interest expense		(2)	$1.5:1FC	(3.0)
Income tax expense		(16)	$1.5:1FC	(24.0)
Net Income	FC	15		$ 22.5

EXHIBIT 7.27 (Continued)

	Foreign Currency	U.S. Dollars	
[a]Retained earnings, January 1	FC 0.0		$ 0.0
Plus net income	15.0		22.5
Less dividends	(5.0)	$2.0:1FC	$ (10.0)
Retained Earnings, December 31	FC 10.0		$ 12.5
[b]Net Asset Position, January 1	FC 30.0	$1.0:1FC	$ 30.0
Plus net income	15.0		22.5
Less dividends	(5.0)	$2.0:1FC	$ (10.0)
Net Asset Position, December 31	FC 40.0		$ 42.5
		$2.0:1FC	80.0
Unrealized Translation "Gain"			$ 37.5

[c]The foreign unit had receivables and payables denominated in a currency other than its own. When it settled these accounts during the period, the foreign unit made a currency conversion and realized a transaction gain of FC2.

[d]The foreign unit has receivables and payables outstanding that will require a currency conversion in a future period when the foreign unit settles the accounts. Because the exchange rate changed while the receivables/payables were outstanding, the foreign unit reports an unrealized transaction gain for financial reporting.

stock at the exchange rate on the date of issuance; the translation adjustment account includes the effects of changes in exchange rates on this investment. The translated amount of retained earnings results from translating the income statement and dividends. Note that the firm translates all revenues and expenses of the foreign unit at the average exchange rate. The foreign unit realized a transaction gain during the year and recorded it on its books. In addition, the translated amounts for the foreign unit include an unrealized transaction gain arising from exposed accounts that are not yet settled. Note (a) to Exhibit 7.27 shows the computation of translated retained earnings. The foreign unit paid the dividend on December 31.

Note b shows the calculation of the translation adjustment. By investing $30 in the foreign unit on January 1 and allowing the $22.5 of earnings to remain in the foreign unit throughout the year while the foreign currency was increasing in value relative to the U.S. dollar, the parent has a potential exchange gain of $37.5. It reports this amount as a component of other comprehensive income.

Translation Methodology—U.S. Dollar Is Functional Currency

When the functional currency is the U.S. dollar, firms must use the *monetary/nonmonetary translation method*. The right-hand column of Exhibit 7.26 summarizes the translation procedure under the monetary/nonmonetary method.

The underlying premise of the monetary/nonmonetary method is that the translated amounts reflect amounts that the firm would have reported if it had originally made all measurements in U.S. dollars. To implement this underlying premise, it is necessary to distinguish between monetary items and nonmonetary items.

A monetary item is an account whose nominal maturity amount does not change as the exchange rate changes. From a U.S. dollar perspective, these accounts give rise to exchange gains and losses because the number of U.S. dollars required to settle the fixed foreign currency amounts fluctuates over time with exchange rate changes. Monetary items include cash, marketable securities, receivables, accounts payable, other accrued liabilities, and short-term and long-term debt. Firms translate these items using the end-of-the-period exchange rate and recognize translation gains and losses. These translation gains and losses increase or decrease net income each period whether or not the foreign unit must make an actual currency conversion to settle the monetary item. The rationale for the recognition of unrealized translation gains and losses in net income is that the foreign unit will likely make a currency conversion in the near future to settle monetary assets and liabilities or to convert foreign currency into U.S. dollars to remit a dividend to the parent, activities consistent with foreign units that operate as extensions of the U.S. parent.

Nonmonetary items include inventories, fixed assets, common stock, revenues, and expenses. Firms translate these accounts using the historical exchange rate in effect when the foreign unit initially made the measurements underlying these accounts. Inventories and cost of goods sold translate at the exchange rate when the foreign unit acquired the inventory items. Fixed assets and depreciation expense translate at the exchange rate when the foreign unit acquired the fixed assets. Most revenues and operating expenses other than cost of goods sold and depreciation translate at the average exchange rate during the period. The objective is to state these accounts at their U.S. dollar-equivalent historical cost amounts. In this way, the translated amounts reflect the U.S. dollar perspective that is appropriate when the U.S. dollar is the functional currency.

Illustration—U.S. Dollar Is Functional Currency

Exhibit 7.28 shows the application of the monetary/nonmonetary method to the data considered in Exhibit 7.27. Net income again includes both realized and unrealized transaction gains and losses. Net income under the monetary/nonmonetary translation method also includes a $22.5 translation loss.

As Note b to Exhibit 7.28 shows, the firm was in a net monetary liability position during a period when the U.S. dollar decreased in value relative to the foreign currency. The translation loss arises because the U.S. dollars required to settle these foreign-denominated net liabilities at the end of the year exceed the U.S. dollar amount required to settle the net liability position before the exchange rate changed.

The organizational structure and operating policies of a particular foreign unit determine its functional currency. The two acceptable choices and the corresponding translation methods were designed to capture the different economic and operational relationships between a parent and its foreign affiliates. However, firms have some latitude in deciding the functional currency (and therefore the translation method) for each foreign unit. In many cases, signals about the appropriate functional currency will be mixed and firms will have latitude to select among them. Actions that management might consider to swing the

EXHIBIT 7.28

Illustration of Translation Methodology When the U.S. Dollar Is the Functional Currency

	Foreign Currency		U.S. Dollars	
BALANCE SHEET				
ASSETS				
Cash	FC	10	$2.0:1FC	$ 20.0
Receivables		20	$2.0:1FC	40.0
Inventories		30	$1.5:1FC	45.0
Fixed assets (net)		40	$1.0:1FC	40.0
Total Assets	FC	100		$145.0
Liabilities and Shareholders' Equity				
Accounts payable	FC	40	$2.0:1FC	$ 80.0
Bonds payable		20	$2.0:1FC	40.0
Total Liabilities	FC	60		$120.0
Common stock	FC	30	$1.0:1FC	$ 30.0
Retained earnings		10		(5.0)[a]
Total Shareholders' Equity	FC	40		$ 25.0
Total Liabilities and Shareholders' Equity	FC	100		$145.0
Income Statement				
Sales	FC	200	$1.5:1FC	$300.0
Realized transaction gain		2	$1.5:1FC	3.0
Unrealized transaction gain		1	$1.5:1FC	1.5
Unrealized translation loss		—		(22.5)[b]
Cost of goods sold		(120)	$1.5:1FC	(180.0)
Selling & administrative expense		(40)	$1.5:1FC	(60.0)
Depreciation expense		(10)	$1.0:1FC	(10.0)
Interest expense		(2)	$1.5:1FC	(3.0)
Income tax expense		(16)	$1.5:1FC	(24.0)
Net Income	FC	15		$ 5.0
[a]**Retained earnings, January 1**	FC	0		$ 0.0
Plus net income		15		5.0
Less dividends		(5)	$2.0:1FC	(10.0)
Retained Earnings, December 31	FC	10		$ (5.0)

[b]Income for financial reporting includes any unrealized translation gain or loss for the period. The net monetary position of a foreign unit during the period serves as the basis for computing the translation gain or loss. The foreign unit was in a net monetary liability position during a period when the U.S. dollar decreased in value relative to the foreign currency. The translation loss arises because the U.S. dollars required to settle the net monetary liability position at the end of the year exceed the U.S. dollars required to settle the obligation at the

(Continued)

EXHIBIT 7.28 (Continued)

time the firm initially recorded the transactions that gave rise to change in net monetary liabilities during the period. The calculations appear below.

	Foreign Currency		U.S. Dollars	
Net Monetary Position, January 1	FC	0.0	—	$ 0.0
Plus:				
Issue of common stock		30.0	$1.0:1FC	30.0
Sales for cash and on account		200.0	$1.5:1FC	300.0
Settlement of exposed receivable/payable				
at a gain		2.0	$1.5:1FC	3.0
Unrealized gain on exposed receivable/payable		1.0	$1.5:1FC	1.5
Less:				
Acquisition of fixed assets		(50.0)	$1.0:1FC	(50.0)
Acquisition of inventory		(150.0)	$1.5:1FC	(225.0)
Selling & administrative costs incurred		(40.0)	$1.5:1FC	(60.0)
Interest cost incurred		(2.0)	$1.5:1FC	(3.0)
Income taxes paid		(16.0)	$1.5:1FC	(24.0)
Dividend paid		(5.0)	$1.5:1FC	(10.0)
Net Monetary Liability Position, December 31		(30.0)		$ (37.5)
			$2.0.1FC	–(60.0)
Unrealized Translation Loss				$ 22.5

balance of factors toward use of the foreign currency as the functional currency include the following:

- *Decentralize decision making to the foreign unit.* The greater the degree of autonomy of the foreign unit, the more likely its currency will be the functional currency. The U.S. parent company can design effective control systems to monitor the activities of the foreign unit while permitting the foreign unit to operate with considerable freedom.
- *Minimize remittances/dividends.* The greater the degree of earnings retention by the foreign unit, the more likely its currency will be the functional currency. The parent may obtain cash from a foreign unit indirectly rather than directly through remittances or dividends. For example, a foreign unit with mixed signals about its functional currency might, through loans or transfer prices for goods or services, send cash to another foreign unit whose functional currency is clearly its own currency. This second foreign unit can then remit it to the parent. Other possibilities for interunit transactions are acceptable as well to ensure that *some* foreign currency rather than the U.S. dollar is the functional currency.

Research suggests that approximately 80 percent of U.S. firms with foreign operations use the foreign currency as the functional currency and that the remainder use the U.S. dollar.[39] Few firms select the foreign currency for some operations and the U.S. dollar for other operations

[39] Eli Bartov and Gordon M. Bodnar, "Alternative Accounting Methods, Information Asymmetry and Liquidity: Theory and Evidence," *The Accounting Review* (July 1996), pp. 397–418.

(except for operations in highly inflationary countries, where firms must use the U.S. dollar as the functional currency). Thus, it appears that firms prefer the all-current translation method, in large part because they can exclude unrealized foreign currency "gains and losses" from earnings each period and experience fewer earnings surprises due to exchange rate fluctuations.

The question for the analyst assessing earnings quality is whether to include the change in the foreign currency translation account in earnings or leave it as a component of other comprehensive income. The principal argument for excluding it is that the unrealized gains or losses may well reverse in the long term and, in any case, may not be realized for many years. The principal arguments for including it in earnings are that (1) management has purposely chosen the foreign currency as the functional currency to avoid including such gains or losses in earnings, not because the firm allows its foreign units to operate as independent units, and (2) the change in the foreign currency translation adjustment represents the current period's portion of the eventual net gain or loss that *will* be realized. When using earnings to value a firm, Chapter 13 suggests that earnings should include all recognized value changes regardless of whether GAAP includes them in net income or other comprehensive income.

A study examining the valuation relevance of the translation adjustment regressed market-adjusted returns on (1) earnings excluding exchange gains and losses, (2) transaction exchange gains and losses included in earnings, and (3) changes in the translation adjustment reported as a component of comprehensive income.[40] The study found that the coefficient on the translation adjustment was statistically significant but smaller than that on earnings excluding all exchange gains and losses, suggesting that the market considers the translation adjustment relevant for security valuation but less persistent than earnings excluding gains and losses. Given this finding, the FASB's decision to require firms to report the translation adjustment change as a *separate and distinct* component of comprehensive income appears to be helpful for investors.

Foreign Currency Translation and Income Taxes

Income tax laws distinguish between a foreign branch of a U.S. parent and a subsidiary of a U.S. parent. A subsidiary is a legally separate entity from the parent; a branch is not. The translation procedure of foreign branches is essentially the same as for financial reporting (except that taxable income does not include translation gains and losses until realized). That is, a firm selects a functional currency for each foreign branch and uses the all-current or monetary/nonmonetary translation method as appropriate.

For foreign subsidiaries, taxable income includes only dividends received each period (translated at the exchange rate on the date of remittance). Because parent companies typically consolidate foreign subsidiaries for financial reporting but cannot consolidate them for tax reporting, temporary differences that require the provision of deferred taxes likely arise.

Interpreting the Effects of Exchange Rate Changes on Operating Results

In addition to understanding the effects of the foreign currency translation method on a firm's financial statements, the analyst should consider how changes in exchange rates affect changes in sales levels, sales mix, and net income.

[40] Billy S. Soo and Lisa Gilbert Soo, "Accounting for the Multinational Firm: Is the Translation Process Valued by the Stock Market?" *The Accounting Review* (October 1995), pp. 617–637.

Example 25

Assume that a firm generated sales of $10,000 in the U.S. and FC2,000 in a particular foreign country during Year 1. The exchange rate between the U.S. dollar and the foreign currency was $2:FC1 during Year 1. The FC2,000 of sales translates into $4,000 of foreign sales, resulting in a mix of 71.4 percent domestic sales and 28.6 percent foreign sales. For illustration, assume that domestic sales for Year 2 are $10,000 and foreign sales are FC2,000. Also assume first that the U.S. dollar increases in value relative to the foreign currency during Year 2, with an average exchange rate of $1.8:FC1. The FC2,000 of foreign sales translates into $3,600, resulting in a mix of 73.5 percent domestic sales and 26.5 percent foreign sales. Alternatively, assume that the U.S. dollar decreases in value during Year 2, with an average exchange rate of $2.4:FC1. The FC2,000 of foreign sales translates into $4,800, resulting in a mix of 67.6 percent domestic sales and 32.4 percent foreign sales. Without considering the effects of changes in selling price and volume, changes in exchange rates affect the level and mix of domestic versus foreign sales.

	Exchange Rate	Domestic Sales	Foreign Sales	Total Sales	Sales Domestic	Mix Foreign
Year 1	$2.0:FC1	$10,000	$4,000[a]	$14,000	71.4%	28.6%
Year 2	$1.8:FC1	$10,000	$3,600[b]	$13,600	73.5%	26.5%
Year 2	$2.4:FC1	$10,000	$4,800[c]	$14,800	67.6%	32.4%

[a]FC2,000 × $2:FC1 = $4,000
[b]FC2,000 × $1.8:FC1 = $3,600
[c]FC2,000 × $2.4:FC1 = $4,800

Changes in exchange rates also affect profit margins and rates of return. The profit margin for a firm is a weighted average of the profit margins of its domestic and foreign units, for which the weights are the sales mix percentages. Changes in exchange rates affect the sales mix proportions (in addition to any affects on the amount for foreign-source earnings) and thereby the firm's overall profit margin.

In PepsiCo's MD&A section accompanying its 2008 Annual Report (Appendix B), PepsiCo discusses the effects of exchange rates on the sales of its various divisions. For some of the divisions, foreign exchange rate fluctuations (and acquisitions) explain major portions of the compound growth rate for sales. In Chapter 10, we predict PepsiCo's future sales. To perform this analysis, we analyze the effects of exchange rates on sales.

SUMMARY

Investing activities create the capacity for operations. Firms invest in assets for their own operations. Their balance sheets report the balances of property, plant, and equipment; intangible assets (including goodwill); and natural resources. Firms also invest in the operations of other firms. Their balance sheets report passive investments in marketable debt and equity securities; active equity method investments in affiliates; and because they are the consolidated with entities they control, the individual assets, liabilities, revenues, and expenses of majority investments in subsidiaries and VIEs for which they are the primary beneficiary.

Firms undertake investing activities on behalf of the claimants to the firm's assets—debtholders, preferred shareholders, controlling interests in shareholders' equity, and non-controlling interests in shareholders' equity. Management's goal is to generate returns on these investments through operating activities. The next chapter examines the operating process and presents the accounting and reporting for operating activities.

QUESTIONS, EXERCISES, PROBLEMS, AND CASES

Questions and Exercises

7.1 CAPITALIZATION VERSUS EXPENSING DECISION. When a firm incurs costs on an item to be used in operations, management must decide whether to treat the cost as an asset or an expense. Assume that a company used cash to acquire machinery expected to contribute to the generation of revenues over a three-year period and the company erroneously expensed the cost to acquire the machine.

 a. Describe the effects on ROA of the error over the three-year period.
 b. Explain how the error would affect the statement of cash flows.

7.2 SELF-CONSTRUCTED ASSETS. Assume that a company needs to acquire a large special-purpose materials handling facility. Given that no outside vendor exists for this type of facility and that the company has available engineering, management, and productive capacity, the company borrows funds and builds the facility. Identify the costs to construct this facility that should be capitalized as assets.

7.3 NATURAL RESOURCES. The three types of costs incurred in oil production are acquisition costs (costs to acquire the oil fields, minus the cost of the land, plus the present value of future cash flows necessary to restore the site), exploration costs (costs of drilling), and development costs (pipes, roads, and so on, to extract and transport the oil to refineries). Should each of these costs be capitalized or expensed? Explain.

7.4 RESEARCH AND DEVELOPMENT COSTS. U.S. GAAP requires firms to expense immediately all internal expenditures for R&D costs. Alternatively, GAAP could require firms to capitalize and subsequently amortize all internal expenditures on R&D that have future potential. Why have standard setters chosen not to allow the capitalization alternative? How would analysts be better served if GAAP required capitalization of R&D costs?

7.5 CAPITALIZATION OF SOFTWARE DEVELOPMENT COSTS. In practice, very few firms capitalize costs of developing computer software. However, *Statement No. 86* requires that firms capitalize (and subsequently amortize) development costs once the "technological feasibility" stage of a product is reached. Review the Adobe Systems illustration in the chapter (Example 5) and discuss why the firm does not capitalize any software development costs.

7.6 TESTING FOR GOODWILL IMPAIRMENT. Goodwill is an intangible asset that firms report on their balance sheets as a result of acquiring other firms. Goodwill generally has an indefinite life and should not be amortized, but should be tested for impairment at least annually. Describe the procedures prescribed by U.S. GAAP and IFRS to test for goodwill impairment. How do these procedures differ from the procedure followed for testing the impairment of a patent, which is an intangible asset with a definite life?

7.7 EARNINGS MANAGEMENT AND DEPRECIATION MEASURE-MENT. Earnings management entails managers using judgment and reporting estimates in such a way as to alter reported earnings to their favor.

 a. Discuss the three factors that must be estimated in measuring depreciation.
 b. Provide an illustration as to how each of these factors can be employed to manage earnings.

7.8 CORPORATE ACQUISITIONS AND GOODWILL. Not every acquisition results in goodwill reported in the consolidated balance sheet. Describe the valuation procedures followed by the acquiring firms to determine whether any goodwill should be recorded as a result of an acquisition and the circumstances that could lead to no recognition of goodwill in an acquisition.

7.9 CORPORATE ACQUISITIONS AND ACQUISITION RESERVES. Often the application of the acquisitions method entails establishing one or more acquisition reserves. Define an acquisition reserve, provide several examples of such reserves, and discuss how the quality of accounting information can be diminished as a result of misusing acquisition reserves.

7.10 ACCOUNTING FOR AVAILABLE-FOR-SALE AND TRADING MARKETABLE EQUITY SECURITIES. Firms invest in marketable securities for a variety of reasons. One of the most common reasons is to temporarily invest excess cash. Securities that qualify for the available-for-sale reporting classification are accounted for differently from those that qualify for the trading reporting classification. Describe the similarity between the reporting for the two classifications. Also describe the differences in reporting between the two classifications.

7.11 EQUITY METHOD FOR MINORITY, ACTIVE INVESTMENTS. GAAP requires firms to account for equity investments in which ownership is between 20 and 50 percent using the equity method. Ace Corporation owns 35 percent of Spear Corporation during 2010. Spear Corporation reported net income of $100.4 million for 2010 and declared and paid dividends of $25 million during the year.

 a. Calculate the equity income that Ace Corporation reports in 2010 related to its ownership in Spear Corporation.

 b. What does Ace Corporation report in its statement of cash flows for 2010 related to its ownership in Spear Corporation?

 c. Assuming that Ace Corporation's balance sheet account, Investment in Spear Corporation, is $1,100 million at the beginning of 2010, what is the balance in the account at the end of 2010? Support your answers with calculations.

7.12 CONSOLIDATION OF VARIABLE-INTEREST ENTITIES. Some accounting theorists propose that firms should consolidate any entity in which they have a "controlling financial interest." Typically, the percentage of equity ownership that one firm has in another entity determines whether consolidation is appropriate, with greater than 50 percent ownership requiring consolidation. Why is the percentage of ownership criterion often *not* appropriate for judging whether a VIE should be consolidated? What criterion is used to determine whether a VIE should be consolidated?

7.13 CHOICE OF A FUNCTIONAL CURRENCY. Choosing the functional currency is a key decision for translating the financial statements of foreign entities of U.S. firms into U.S. dollars. Qing Corporation, a U.S. firm that sells car batteries, formed a wholly owned subsidiary in Mexico to manufacture components needed in the production of the batteries. Approximately 50 percent of the subsidiary's sales are to Qing Corporation. The subsidiary also sells the components it manufactures to independent third parties, and these sales are denominated in Mexican pesos. Financing for the manufacturing plants in Mexico is denominated in U.S. dollars, but labor contracts are denominated in both dollars and pesos. All material contracts are denominated in Mexican pesos. Senior managers of

the subsidiary are employees of Qing Corporation who have been transferred to the subsidiary for a tour of international service. Is the functional currency of the subsidiary the peso or the U.S. dollar? Explain your reasoning.

7.14 FOREIGN CURRENCY AS FUNCTIONAL CURRENCY. Identify the exchange rates used to translate income statement and balance sheet items when the foreign currency is defined as the functional currency. Discuss the logic for the use of the exchange rates you identified.

Problems and Cases

7.15 ANALYZING DISCLOSURES REGARDING FIXED ASSETS. Exhibit 7.29 presents selected financial statement data for three chemical companies: Monsanto Company, Olin Corporation, and NewMarket Corporation. (NewMarket was formed from a merger of Ethyl Corporation and Afton Chemical Corporation.)

Required

 a. Compute the average total depreciable life of assets in use for each firm.
 b. Compute the average age to date of depreciable assets in use for each firm at the end of the year.

EXHIBIT 7.29

Three Chemical Companies
Selected Financial Statement Data on Depreciable Assets
(amounts in millions)
(Problem 7.15)

	NewMarket Corporation	Monsanto Company	Olin Corporation
Depreciable Assets at Cost:			
Beginning of year	$752	$4,611	$1,796
End of year	777	4,604	1,826
Accumulated Depreciation:			
Beginning of year	584	2,331	1,301
End of year	611	2,517	1,348
Net Income	33	267	55
Depreciation expense	27	328	72
Deferred tax liability relating to depreciable assets:			
Beginning of year	13	267	83
End of year	9	256	96
Income tax rate	35%	35%	35%
Depreciation method for financial reporting	Straight-Line	Straight-Line	Straight-Line
Depreciation method for tax reporting	Accelerated	Accelerated	Accelerated

c. Compute the amount of depreciation expense recognized for tax purposes for each firm for the year using the amount of the deferred taxes liability related to depreciation timing differences.

d. Compute the amount of net income for the year for each firm assuming that depreciation expense for financial reporting equals the amount computed in Part c for tax reporting.

e. Compute the amount each company would report for property, plant, and equipment (net) at the end of the year if it had used accelerated (tax reporting) depreciation instead of straight-line depreciation.

f. What factors might explain the difference in average total life of the assets of NewMarket Corporation and Olin Corporation relative to the assets of Monsanto Company?

g. What factors might explain the older average age for depreciable assets of NewMarket Corporation and Olin Corporation relative to Monsanto Company?

7.16 ASSET IMPAIRMENTS

Hammerhead Paper Company owns a press used in the production of fine paper products. The press originally cost $2,000,000, and it has a current carrying amount of $1,200,000. A decrease in the demand for fine paper products has caused the company to reassess the future cash flows from using the machine. The company now estimates that it will receive cash flows of $160,000 per year for 12 years. The company uses a 10 percent discount rate to compute the present value for this investment. A similar machine recently sold for $1,000,000 in the secondhand market. Hammerhead estimates that it would cost $50,000 to sell the machine.

Required

a. Compute the amount of Hammerhead's press impairment, if any, under U.S. GAAP and IFRS.

Sterling Co. acquires Vineyard Aging, Inc., on January 1, 2010, by paying $2,000,000 in cash. At the date of acquisition, the price is allocated as follows:

Price paid	$ 2,000,000
Fair value of Vineyard's identifiable assets	(1,600,000)
Goodwill	$ 400,000

One year later on December 31, 2010, Sterling estimates the fair value of the unit to be $1,800,000. The carrying value of Vineyard's identifiable assets is $1,500,000 after impairment tests are applied.

Required

b. Compute the amount of Sterling's goodwill impairment, if any.

c. How is the goodwill impairment reflected in the financial statements?

7.17 UPWARD REVALUATIONS UNDER IFRS

Bed and Breakfast (B&B), an Italian company operating in the Tuscany region, follows IFRS and has made the choice to remeasure long-lived assets at fair value. B&B purchased land in 2009 for €150,000. At the end of the next four years, the land is worth €160,000 in 2009, €155,000 in 2010, €140,000 in 2011, and €145,000 in 2012.

Required

a. Describe how B&B will reflect the changes in the land's value in each of its annual financial statements.

b. Assume that the asset was a building with a ten-year remaining useful life as of the end of 2009. After writing the building upward to €160,000, how much should B&B charge to depreciation expense in 2009?

7.18 APPLICATION OF *STATEMENT NO. 115* FOR INVESTMENTS IN MARKETABLE EQUITY SECURITIES. SunTrust Banks owns a large block of Coca-Cola Company (Coke) common stock that it has held for many years. SunTrust indicates in a note to its financial statements that all equity securities held by the bank, including its investment in Coke stock, are classified as available for sale. A recent annual report of SunTrust reports the following information for its Coke investment (amounts in thousands):

Coke common stock investment, market value on December 31, 2006	$2,324,826
Coke common stock investment, market value on December 31, 2005	$1,945,622
Net income for 2006	$2,109,742

Required

a. Calculate the effect of the change in the market value of SunTrust's investment in Coke's common stock on SunTrust's 2006 (1) net income and (2) shareholders' equity. Ignore taxes.

b. How would your answer to Part a differ if SunTrust classified its investment in Coke's common stock as a trading security?

c. Does the value reported on SunTrust's balance sheet for the investment in Coke's stock differ depending on the firm's reason for holding the stock (that is, whether it is classified as available for sale versus trading by management)? Explain.

7.19 EFFECT OF AN ACQUISTION ON THE DATE OF ACQUISITION BALANCE SHEET. Lexington Corporation acquired all of the outstanding common stock of Chalfont, Inc., on January 1, 2009. Lexington gave shares of its no par common stock with a market value of $504 million in exchange for the Chalfont common stock. Chalfont will remain a legally separate entity after the exchange, but Lexington will prepare consolidated financial statements with Chalfont each period. Exhibit 7.30 presents the balance sheets of Lexington and Chalfont on January 1, 2009, just prior to the acquisition. The market value of Chalfont's fixed assets exceeds their book value by $80 million. Chalfont owns a copyright with a market value of $50 million. Chalfont is a defendant in a lawsuit that it expects to settle during 2009 at a cost of $30 million. The firm carries no insurance against such lawsuits. Lexington plans to establish an acquisition reserve for this lawsuit.

Required

a. Prepare a schedule that shows the allocation of the consideration given to individual assets and liabilities under the acquisition method. Ignore deferred tax effects.

b. Prepare a consolidated balance sheet for Lexington and Chalfont on January 1, 2009. Show your supporting calculations for any amount that is not simply the sum of the amounts for Lexington and Chalfont from their separate financial records.

EXHIBIT 7.30

Lexington Corporation and Chalfont, Inc.
Balance Sheets
January 1, 2009
(amounts in millions)
(Problem 7.19)

	Lexington Corporation	Chalfont, Inc.
Cash	$ 100	$ 30
Accounts receivable	240	90
Fixed assets (net)	1,000	360
Copyright	—	—
Deferred tax asset	40	—
Goodwill	—	—
Total Assets	$1,380	$480
Accounts payable and accruals	$ 240	$ 80
Long-term debt	480	100
Deferred tax liability	160	—
Other noncurrent liabilities	120	—
Common stock	320	100
Retained earnings	60	200
Total Liabilities and Shareholders' Equity	$1,380	$480

7.20 EFFECT OF AN ACQUISITION ON THE POSTACQUISITION BALANCE SHEET AND INCOME STATEMENT.

Ormond Co. acquired all of the outstanding common stock of Daytona Co. on January 1, 2010. Ormond Co. gave shares of its common stock with a fair value of $312 million in exchange for 100 percent of the Daytona Co. common stock. Daytona Co. will remain a legally separate entity after the exchange, but Ormond Co. will prepare consolidated financial statements with Daytona Co each period. Exhibit 7.31 presents the balance sheets of Ormond Co. and Daytona Co. on January 1, 2010, just after the acquisition. The following information applies to Daytona Co.:

1. The market value of Daytona Co.'s fixed assets exceeds their book value by $50 million.
2. Daytona Co. owns a patent with a market value of $40 million.
3. Daytona Co. is a defendant in a lawsuit that it expects to settle during 2010 at a cost of $25 million. The firm carries no insurance against such lawsuits. If permitted, Ormond Co. wants to establish an acquisition reserve for this lawsuit.
4. Daytona Co. has an unrecognized and unfunded retirement health care benefits obligation totaling $20 million on January 1, 2010.

Required

a. Prepare a consolidated balance sheet for Ormond Co. and Daytona Co. on January 1, 2010. Ignore deferred tax effects. (A consolidated worksheet is not required, but it will be illustrated in the solution.)

EXHIBIT 7.31

Ormond Co. and Daytona Co.
Balance Sheets on January 1, 2010
(amounts in millions)
(Problem 7.20)

	Ormond Co.	Daytona Co.
Cash	$ 25	$ 15
Accounts receivable	60	40
Investment in Daytona	312	—
Fixed assets (net)	250	170
Patent	—	—
Deferred tax asset	10	—
Goodwill	—	—
Total Assets	$657	$225
Accounts payable & accruals	$ 60	$ 40
Long-term debt	120	60
Deferred tax liability	40	—
Other noncurrent liabilities	30	—
Common stock	392	50
Retained earnings	15	75
Total Liabilities and Shareholders' Equity	$657	$225

b. Exhibit 7.32 presents income statements and balance sheets taken from the separate-company books at the end of 2010. The following information applies to these companies:

- The fixed assets of Daytona Co. had an average remaining life of five years on January 1, 2010. The firms use the straight-line depreciation method.
- The patent of Daytona Co. had a remaining life of ten years on January 1, 2010.
- Daytona Co. settled the lawsuit during 2010 and expects no further liability.
- Daytona Co. will amortize and fund its retirement health care benefits obligation over 20 years. It included $1 million in operating expenses during 2010 related to amounts unrecognized and unfunded as of January 1, 2010.
- The test for goodwill impairment indicates that no impairment charge is necessary for 2010.

Prepare a consolidated income statement for 2010 and a consolidated balance sheet on December 31, 2010. (A consolidated worksheet is not required, but it will be illustrated in the solution.)

7.21 VARIABLE-INTEREST ENTITIES. Molson Coors Brewing Company (Molson Coors) is the fifth-largest brewer in the world. It is one of the leading brewers in the U.S. and Canada; the company's brands include Coors, Molson Canadian, Carling, and Killian's Irish Red. Sales exceeded 32 million barrels (1 U.S. barrel equals 31 gallons) for the year ended December 26, 2004. The firm reported $4.3 billion of net sales for 2004.

Molson Coors invests in various entities to carry out its brewing, bottling, and canning activities. The investments take the legal form of partnerships, joint ventures, and limited

EXHIBIT 7.32

Ormond Co. and Daytona Co.
Income Statement and Balance Sheet for 2010
(in millions)
(Problem 7.20)

	Ormond Co.	Daytona Co.
Income Statement for 2010		
Sales	$ 600	$ 450
Equity in earnings of Daytona Co.	30	—
Operating expenses	(550)	(395)
Interest expense	(10)	(5)
Loss on lawsuit	—	(20)
Income tax expense	(28)	(12)
Net Income	$ 42	$ 18
Balance Sheet on December 31, 2010		
Cash	$ 45	$ 25
Accounts receivable	80	50
Investment in Daytona Co.	339	—
Fixed assets	280	195
Patent	—	—
Deferred tax asset	15	—
Goodwill	—	—
Total Assets	$ 759	$ 270
Accounts payable and accruals	$ 90	$ 55
Long-term debt	140	75
Deferred tax liability	50	—
Other noncurrent liabilities	40	—
Common stock	392	50
Retained earnings	47	90
Total Liabilities and Shareholders' Equity	$ 759	$ 270

liability corporations, among other arrangements. The firm states in its 2004 annual report that each of these arrangements has been tested to determine whether it qualifies as a VIE under *Interpretation No. 46*. (*Interpretation No. 46R* supersedes this interpretation by clarifying certain aspects of its predecessor interpretation. However, most of the content is similar, and either interpretation is sufficient to address this problem.)

The following excerpt is taken from the firm's note on VIEs in its 2004 annual report:

Note 3. Variable-Interest Entities. Once an entity is determined to be a VIE, the party with the controlling financial interest, the primary beneficiary, is required to consolidate it. We have investments in VIEs, of which we are the primary beneficiary. Accordingly, we have consolidated three joint ventures in 2004, effective December 29, 2003, the first day of 2004. These include Rocky Mountain Metal Container (RMMC), Rocky Mountain Bottle Company (RMBC) and Grolsch (UK) Limited (Grolsch). The impacts to our balance sheet include the addition of net fixed assets of RMMC and RMBC totaling approximately $65 million, RMMC debt of approximately $40 million,

and Grolsch net intangibles of approximately $20 million (at current exchange rates). The most significant impact to our cash flow statement for the year ended December 26, 2004, was to increase depreciation expense by approximately $13.2 million and cash recognized on initial consolidation of the entities of $20.8 million. Our partners' share of the operating results of the ventures is eliminated in the minority interests line of the Consolidated Statements of Income.

As required under *Interpretation No. 46,* Molson Coors also provides additional information in its annual report on each of the consolidated joint ventures, as follows:

1. RMBC is a joint venture with Owens-Brockway Glass Container, Inc., in which we hold a 50 percent interest. RMBC produces glass bottles at a glass-manufacturing facility for use at the Golden, Colorado brewery. Under this agreement, RMBC supplies our bottle requirements and Owens-Brockway has a contract to supply the majority of our bottle requirements not met by RMBC. In 2003 and 2002, the firm's share of pretax joint venture profits for the venture, totaling $7.8 million and $13.2 million, respectively, was included in cost of goods sold on the consolidated income statement.

2. RMMC, a Colorado limited liability company, is a joint venture with Ball Corporation in which we hold a 50 percent interest. RMMC supplies the firm with substantially all of the cans for our Golden, Colorado brewery. RMMC manufactures the cans at our manufacturing facilities, which RMMC operates under a use and license agreement. In 2003 and 2002, the firm's share of pretax joint venture profits (losses), totaling $0.1 million and ($0.6) million, respectively, was included in cost of goods sold on the consolidated income statement. As stated previously, on consolidation of RMMC, debt of approximately $40 million was added to the balance sheet. As of December 26, 2004, Coors is the guarantor of this debt.

3. Grolsch is a joint venture between CBL and Royal Grolsch N.V. in which we hold a 49 percent interest. The Grolsch joint venture markets Grolsch branded beer in the United Kingdom and the Republic of Ireland. The majority of the Grolsch branded beer is produced by CBL under a contract brewing arrangement with the joint venture. CBL and Royal Grolsch N.V. sell beer to the joint venture, which sells the beer back to CBL (for onward sale to customers) for a price equal to what it paid plus a marketing and overhead charge and a profit margin. In 2003 and 2002, the firm's share of pretax profits for this venture, totaling $3.6 million and $2.0 million, respectively, was included in cost of goods sold on the consolidated income statement. As stated previously, on consolidation, net fixed assets of approximately $4 million and net intangibles of approximately $20 million were added to our balance sheet.

Required

a. Describe the operational purpose of the three VIEs consolidated by Molson Coors.

b. Molson Coors is the primary beneficiary for three investments that the firm identified as VIEs. What criteria did Molson Coors apply to determine that the firm is the primary beneficiary for these three investments?

c. For each investment, Molson Coors reports the income statement impact as a reduction of cost of goods sold on the consolidated income statement. What is the rationale for reporting the impact this way on the income statement?

d. The firm states, "Our partners" share of the operating results of the ventures is eliminated in the minority interests line of the Consolidated Statements of Income. Define *minority interests* as it appears on the income statement. Discuss why Molson Coors subtracts it to calculate consolidated net income.

e. RMBC, RMMC, and Grolsch are consolidated with the financial statements of Molson Coors because the three investments qualify as VIEs as defined in *Interpretation No. 46*

and the firm determined that it is the primary beneficiary for the investments. Explain what reporting technique Molson Coors would use to account for the investments if, in fact, they did not qualify as VIEs. What would be the impact on the balance sheet? What would be the impact on the income statement? What would be the impact on the statement of cash flows?

f. The firm reports that the depreciation expense on the statement of cash flows for 2004 increased by approximately $13.2 million as a result of consolidating the VIEs. Why did consolidating the VIEs increase depreciation expense?

7.22 ACCOUNTING FOR A MERGER UNDER THE ACQUISITION METHOD. On December 31, 2010, Pace Co. paid $3,000,000 to Sanders Corp. shareholders to acquire 100 percent of the net assets of Sanders Corp. Pace Co. also agreed to pay former Sanders shareholders $200,000 in cash if certain earnings projections were achieved over the next two years. Based on probabilities of achieving the earnings projections, Pace estimated the fair value of this promise to be $150,000. Pace paid $10,000 in legal fees and incurred $10,000 in internal cash costs related to management's time to complete the transaction. Exhibit 7.33 provides the book and fair values of Sanders Corp. at the date of acquisition.

EXHIBIT 7.33

Sanders Corp. Book and Fair Values as of December 31, 2010
(Problem 7.22)

	Sanders Corp. Book Values at 12/31/10	Sanders Corp. Fair Values at 12/31/10
Cash	$ 400,000	$ 400,000
Receivables	500,000	500,000
Inventory	1,200,000	1,600,000
PP&E (net)	1,600,000	2,000,000
Unpatented technology	0	300,000
In-process R&D	0	200,000
Total Assets	$ 3,700,000	$ 5,000,000
Accounts payable	$ (400,000)	$ (400,000)
Notes payable	(2,100,000)	(2,200,000)
Total Liabilities	$(2,500,000)	$(2,600,000)
Common stock ($1 par)	$ (100,000)	
Additional paid-in capital	(500,000)	
Retained earnings, 1/1/09	(300,000)	
Revenues	(2,000,000)	
Expenses	1,700,000	
Total Shareholders' Equity	$(1,200,000)	

Revenues, gains, and net income are in parentheses to indicate that their signs are opposite those of expenses and losses; that is, they are credits for those interpreting the worksheet from the accountant's traditional debit/credit approach. Liabilities and shareholders' equity accounts are in parentheses to indicate that they are claims against assets; again, they are credits in the traditional debit/credit framework.

Required

a. Record the merger using the financial statement effects template or journal entries.

b. How would the financial effects *change* if the cash paid was $2,000,000?

7.23 CONSOLIDATION SUBSEQUENT TO THE DATE OF ACQUISITION METHOD. Exhibit 7.34 presents the separate financial statements at December 31, 2011, of Prestige Resorts and its 80 percent-owned subsidiary Booking, Inc. Two years earlier on January 1, 2010, Prestige acquired 80 percent of the common shares of Booking for $1,170 million in cash. Booking's 2010 net income was $105 million, and Booking paid no dividends in 2010. Booking's 2011 income was $135 million, and it paid $75 million dividends on common stock during 2011. Booking's pre- and post-acquisition stock prices do not support the existence of a control premium. Exhibit 7.35 shows the allocation of fair value at the date of acquisition, January 1, 2010. Exhibit 7.36 traces Prestige Resorts' equity method accounting for Booking, Inc. Ignore deferred tax effects.

EXHIBIT 7.34

**Prestige Resorts and Booking, Inc. Financial Statements
at December 31, 2011 (in millions)
(Problem 7.23)**

	Prestige Resorts	**Booking, Inc.**
Revenues	$(1,365)	$ (645)
Cost of goods sold	516	300
Depreciation expense	90	30
Amortization expense	150	112.5
Interest expense	105	67.5
Equity in subsidiary earnings	(96)	0
Net Income	$ (600)	$ (135)
Cash	$ 780	$ 600
Short-term investments	309	67.5
Land	456	442.5
Equipment (net)	585	240
Investment in Small Technologies	1,278	0
Customer lists	1,320	810
Total Assets	$ 4,728	$ 2,160
Long-term liabilities	$(1,623)	$ (885)
Common stock	(1,305)	(345)
Retained earnings	(1,800)	(930)
Total Liabilities and Shareholders' Equity	$(4,728)	$(2,160)

Revenues, gains, and net income are in parentheses to indicate that their signs are opposite those of expenses and losses; that is, they are credits for those interpreting the worksheet from the accountant's traditional debit/credit approach. Liabilities and shareholders' equity accounts are in parentheses to indicate that they are claims against assets; again, they are credits in the traditional debit/credit framework.

EXHIBIT 7.35

Allocations of Fair Value (in millions)
(Problem 7.23)

	Allocation of Fair Values	Estimated Life	Charged (Credited) to Expense Each Year	Balance on December 31, 2011
Booking fair value at acquisition date	$ 1,462.5			
Booking book value at acquisition date	(1,110.0)			
Fair value in excess of book value	$ 352.5			
Land (not depreciated)	90	NA		
Equipment	(15)	10		
Customer lists	180	20		
Long-term liabilities (lower fair value)	60	8		
Goodwill	$ 37.5	Indefinite		

EXHIBIT 7.36

Investor Interests in Booking, Inc. (in millions)
(Problem 7.23)

	Prestige Properties (80% controlling interest)		Noncontrolling Interest (20%)	
Acquisition date fair value (1/1/10) = $1,462.5			$1,170	
2010 net income of Booking = $105	$ 84			
Annual excess amortizations = $15	(12)			
Equity in Booking's earnings for 2010			72	
Investment in Booking, Inc. (12/31/10)			$1,242	
2011 net income of Booking = $135	$108			
Annual excess amortizations = $15	(12)			
Equity in Booking's earnings for 2011			96	
Dividends paid by Booking in 2011 = $75			(60)	
Investment in Booking, Inc. (12/31/11)			$1,278	

Required

a. Complete Exhibit 7.35 to show income effects and balance sheet adjustments to be reflected in the December 31, 2011 Eliminations column of the consolidated worksheet.

b. Complete Exhibit 7.36 to trace the noncontrolling interests in Booking, Inc.'s earnings and net assets.

c. Prepare a worksheet to consolidate Prestige and Booking at December 31, 2011.

7.24 CALCULATING THE TRANSLATION ADJUSTMENT UNDER THE ALL-CURRENT METHOD AND THE MONETARY/NONMONETARY METHOD.

Foreign Sub is a wholly owned subsidiary of U.S. Domestic Corporation. U.S. Domestic Corporation acquired the subsidiary several years ago. The financial statements for Foreign Sub for 2010 in its own currency appear in Exhibit 7.37.

The exchange rates between the U.S. dollar and the foreign currency of the subsidiary were as follows:

December 31, 2009	$10:1FC
Average, 2009	$ 8:1FC
December 31, 2010	$ 6:1FC

On January 1, 2010, Foreign Sub issued FC100 of long-term debt and FC100 of common stock in the acquisition of land costing FC200. Operating activities occurred evenly over the year.

EXHIBIT 7.37

Foreign Sub
Financial Statement Data
(Problem 7.24)

	December 31			
	2009		**2010**	
Cash	FC	100	FC	150
Accounts receivable		300		350
Inventories		350		400
Land		500		700
Total Assets	FC	1,250	FC	1,600
Accounts payable	FC	150	FC	250
Long-term debt		200		300
Common stock		500		600
Retained earnings		400		450
Total Liabilities and Equities	FC	1,250	FC	1,600

	For 2010	
Sales	FC	4,000
Cost of goods sold		(3,200)
Selling and administrative expenses		(400)
Income taxes		(160)
Net Income	FC	240
Dividend declared and paid on December 31		(190)
Increase in Retained Earnings	FC	50

Required

a. Assume that the currency of Foreign Sub is the functional currency. Compute the change in the cumulative translation adjustment for 2010. Indicate whether the change increases or decreases shareholders' equity.

b. Assume that the U.S. dollar is the functional currency. Compute the amount of the translation gain or loss for 2010. Indicate whether the amount is a gain or loss.

7.25 TRANSLATING THE FINANCIAL STATEMENTS OF A FOREIGN SUBSIDIARY; COMPARISON OF TRANSLATION METHODS. Stebbins Corporation established a wholly owned Canadian subsidiary on January 1, Year 1, by contributing US$500,000 for all of the subsidiary's common stock. The exchange rate on that date was C$1:US$.90 (that is, one Canadian dollar equaled 90 U.S. cents). The Canadian subsidiary invested C$500,000 in a building with an expected life of 20 years and rented it to various tenants for the year. The average exchange rate during Year 1 was C$1:US$.85, and the exchange rate on December 31, Year 1, was C$1:US$.80. Exhibit 7.38 shows the amounts taken from the books of the Canadian subsidiary at the end of Year 1, measured in Canadian dollars.

EXHIBIT 7.38

Canadian Subsidiary
Financial Statements
Year 1
(Problem 7.25)

Balance Sheet as of December 31, Year 1

ASSETS

Cash	C$ 77,555
Rent receivable	25,000
Building (net)	475,000
	C$577,555

LIABILITIES AND EQUITY

Accounts payable	C$ 6,000
Salaries payable	4,000
Common stock	555,555
Retained earnings	12,000
	C$577,555

Income Statement for Year 1

Rent revenue	C$125,000
Operating expenses	(28,000)
Depreciation expense	(25,000)
Translation exchange loss	—
Net Income	C$ 72,000

Retained Earnings Statement for Year 1

Balance, January 1, Year 1	C$ —
Net income	72,000
Dividends	(60,000)
Balance, December 31, Year 1	C$ 12,000

Required

a. Prepare a balance sheet, an income statement, and a retained earnings statement for the Canadian subsidiary for Year 1 in U.S. dollars assuming that the Canadian dollar is the functional currency. Include a separate schedule showing the computation of the translation adjustment account.

b. Repeat Part a assuming that the U.S. dollar is the functional currency. Include a separate schedule showing the computation of the translation gain or loss.

c. Why is the sign of the translation adjustment for Year 1 under the all-current translation method and the translation gain or loss for Year 1 under the monetary/nonmonetary translation method the same? Why do their amounts differ?

d. Assuming that the firm could justify either translation method, which method would management of Stebbins Corporation likely prefer for Year 1? Why?

7.26 TRANSLATING THE FINANCIAL STATEMENTS OF A FOREIGN SUBSIDIARY; SECOND YEAR OF OPERATIONS. Refer to Problem 7.25 for Stebbins Corporation for Year 1, its first year of operations. Exhibit 7.39 shows the amounts

EXHIBIT 7.39

Canadian Subsidiary
Financial Statements
Year 2
(Problem 7.26)

Balance Sheet

ASSETS

Cash	C$116,555
Rent receivable	30,000
Building (net)	450,000
	C$596,555

LIABILITIES AND EQUITY

Accounts payable	C$ 7,500
Salaries payable	5,500
Common stock	555,555
Retained earnings	28,000
	C$596,555

Income Statement

Rent revenue	C$150,000
Operating expenses	(34,000)
Depreciation expense	(25,000)
Translation exchange gain	—
Net Income	C$ 91,000

Retained Earnings Statement

Balance, January 1, Year 2	C$ 12,000
Net income	91,000
Dividends	(75,000)
Balance, December 31, Year 2	C$ 28,000

for the Canadian subsidiary for Year 2. The average exchange rate during Year 2 was C$1:US$.82, and the exchange rate on December 31, Year 2, was C$1:US$.84. The Canadian subsidiary declared and paid dividends on December 31, Year 2.

Required

a. Prepare a balance sheet, an income statement, and a retained earnings statement for the Canadian subsidiary for Year 2 in U.S. dollars, assuming that the Canadian dollar is the functional currency. Include a separate schedule showing the computation of the translation adjustment for Year 2 and the change in the translation adjustment account.

b. Repeat Part a assuming that the U.S. dollar is the functional currency. Include a separate schedule showing the computation of the translation gain or loss.

c. Why is the sign of the translation adjustment for Year 2 under the all-current translation method and the translation gain or loss under the monetary/nonmonetary translation method the same? Why do their amounts differ?

d. Assuming that the firm could justify either translation method, which method would management of Stebbins Corporation likely prefer for Year 2? Why?

7.27 IDENTIFYING THE FUNCTIONAL CURRENCY. Electronic Computer Systems (ECS) designs, manufactures, sells, and services networked computer systems; associated peripheral equipment; and related network, communications, and software products.

Exhibit 7.40 presents geographic segment data. ECS conducts sales and marketing operations outside the U.S. principally through sales subsidiaries in Canada, Europe,

EXHIBIT 7.40

Electronic Computer Systems
Geographic Segment Data
(amounts in thousands)
(Problem 7.27)

	Year 3	Year 4	Year 5
Revenues			
United States Customers	$ 4,472,195	$ 5,016,606	$ 5,810,598
Intercompany	1,354,339	1,921,043	2,017,928
Total	$ 5,826,534	$ 6,937,649	$ 7,828,526
Europe Customers	$ 2,259,743	$ 3,252,482	$ 4,221,631
Intercompany	82,649	114,582	137,669
Total	$ 2,342,392	$ 3,367,064	$ 4,359,300
Canada, Far East, Americas			
Customers	$ 858,419	$ 1,120,356	$ 1,443,217
Intercompany	577,934	659,204	912,786
Total	$ 1,436,353	$ 1,779,560	$ 2,356,003
Eliminations	$(2,014,922)	$(2,694,829)	$(3,068,383)
Net Revenue	$ 7,590,357	$ 9,389,444	$11,475,446

EXHIBIT 7.40 (Continued)

	Year 3	Year 4	Year 5
Income			
United States	$ 342,657	$ 758,795	$ 512,754
Europe	405,636	634,543	770,135
Canada, Far East, Americas	207,187	278,359	390,787
Eliminations	(126,771)	(59,690)	(38,676)
Operating Income	$ 828,709	$ 1,612,007	$ 1,635,000
Interest Income	116,899	122,149	143,665
Interest Expense	(88,079)	(45,203)	(37,820)
Income before Income Taxes	$ 857,529	$ 1,688,953	$ 1,740,845
Assets			
United States	$ 3,911,491	$ 4,627,838	$ 5,245,439
Europe	1,817,584	2,246,333	3,093,818
Canada, Far East, Americas	815,067	843,067	1,293,906
Corporate Assets (temporary cash investments)	2,035,557	1,979,470	2,057,528
Eliminations	(1,406,373)	(1,289,322)	(1,579,135)
Total Assets	$ 7,173,326	$ 8,407,386	$10,111,556

Central and South America, and the Far East; by direct sales from the parent corporation; and through various representative and distributorship arrangements. The company's international manufacturing operations include plants in Canada, the Far East, and Europe. These manufacturing plants sell their output to the company's sales subsidiaries, the parent corporation, or other manufacturing plants for further processing.

ECS accounts for intercompany transfers between geographic areas at prices representative of unaffiliated-party transactions.

Sales to unaffiliated customers outside the United States, including U.S. export sales, were $5,729,879,000 for Year 5, $4,412,527,000 for Year 4, and $3,179,143,000 for Year 3, which represented 50 percent, 47 percent, and 42 percent, respectively, of total operating revenues. The international subsidiaries have reinvested substantially all of their earnings to support operations. These accumulated retained earnings, before elimination of intercompany transactions, aggregated $2,793,239,000 at the end of Year 5, $2,070,337,000 at the end of Year 4, and $1,473,081,000 at the end of Year 3.

The company enters into forward exchange contracts to reduce the impact of foreign currency fluctuations on operations and the asset and liability positions of foreign subsidiaries. The gains and losses on these contracts increase or decrease net income in the same period as the related revenues and expenses; for assets and liabilities, in the period in which the exchange rate changes.

Required

Discuss whether ECS should use the U.S. dollar or the currencies of its foreign subsidiaries as its functional currency.

STARBUCKS

Part I—Accounting Policy

Presented below are excerpts from Note 1 to Starbucks' September 28, 2008, Consolidated Financial Statements in which Starbucks describes accounting policy for long-lived assets.

Excerpts from Note 1: "Summary of Significant Accounting Policies"

Property, Plant and Equipment

Property, plant and equipment are carried at cost less accumulated depreciation. Depreciation of property, plant and equipment, which includes assets under capital leases, is provided on the straight-line method over estimated useful lives, generally ranging from two to seven years for equipment and 30 to 40 years for buildings. Leasehold improvements are amortized over the shorter of their estimated useful lives or the related lease life, generally 10 years. For leases with renewal periods at the Company's option, Starbucks generally uses the original lease term, excluding renewal option periods, to determine estimated useful lives. If failure to exercise a renewal option imposes an economic penalty to Starbucks, management may determine at the inception of the lease that renewal is reasonably assured and include the renewal option period in the determination of appropriate estimated useful lives. The portion of depreciation expense related to production and distribution facilities is included in "Cost of sales including occupancy costs" on the consolidated statements of earnings. The costs of repairs and maintenance are expensed when incurred, while expenditures for refurbishments and improvements that significantly add to the productive capacity or extend the useful life of an asset are capitalized. When assets are retired or sold, the asset cost and related accumulated depreciation are eliminated with any remaining gain or loss reflected in net earnings.

Goodwill and Other Intangible Assets

Goodwill and other intangible assets are tested for impairment annually and more frequently if facts and circumstances indicate goodwill carrying values exceed estimated reporting unit fair values and if indefinite useful lives are no longer appropriate for the Company's trademarks. Based on the impairment tests performed, there was no impairment of goodwill or other intangible assets in fiscal 2008, 2007 and 2006. Definite-lived intangibles, which mainly consist of contract-based patents and copyrights, are amortized over their estimated useful lives. For further information on goodwill and other intangible assets, see Note 9.

Long-lived Assets

When facts and circumstances indicate that the carrying values of long-lived assets may be impaired, an evaluation of recoverability is performed by comparing the carrying values of the assets to projected undiscounted future cash flows in addition to other quantitative and qualitative analyses. Upon indication that the carrying values of such assets may not be recoverable, the Company recognizes an impairment loss by a charge to net earnings. The fair value of the assets is estimated using the discounted future cash flows of the assets. Property, plant and equipment assets are grouped at the lowest level for which there are identifiable cash flows when assessing impairment. Cash flows for retail assets are identified at the individual store level. Long-lived assets to be disposed of are reported at the lower of their carrying amount, or fair value less estimated costs to sell.

The Company recognized net impairment and disposition losses of $325.0 million, $26.0 million and $19.6 million in fiscal 2008, 2007 and 2006, respectively, due to underperforming Company-operated retail stores, as well as renovation and remodeling activity in the normal course of business. The net losses in fiscal 2008 include $201.6 million of asset impairments related to the US and Australia store closures and charges incurred for office facilities no longer occupied by the Company due to the reduction in positions within Starbucks leadership structure and non-store organization. See Note 3 for further details. Depending on the underlying asset that is impaired, these losses may be recorded in any one of the operating expense lines on the consolidated statements of earnings: for retail operations, these losses are recorded in "Restructuring charges" and "Store operating expenses"; for specialty operations, these losses are recorded in "Other operating expenses"; and for all other operations, these losses are recorded in "Cost of sales including occupancy costs," "General and administrative expenses," or "Restructuring charges."

Research and Development

Starbucks expenses research and development costs as they are incurred. The Company spent approximately $7.2 million, $7.0 million and $6.5 million during fiscal 2008, 2007 and 2006, respectively, on technical research and development activities, in addition to customary product testing and product and process improvements in all areas of its business.

Asset Retirement Obligations

Starbucks accounts for asset retirement obligations under FASB Interpretation No. 47 ("FIN 47"), "Accounting for Conditional Asset Retirement Obligations—an interpretation of FASB Statement No. 143," which it adopted at the end of fiscal 2006. FIN 47 requires recognition of a liability for the fair value of a required asset retirement obligation ("ARO") when such obligation is incurred. The Company's AROs are primarily associated with leasehold improvements which, at the end of a lease, the Company is contractually obligated to remove in order to comply with the lease agreement. At the inception of a lease with such conditions, the Company records an ARO liability and a corresponding capital asset in an amount equal to the estimated fair value of the obligation. The liability is estimated based on a number of assumptions requiring management's judgment, including store closing costs, cost inflation rates and discount rates, and is accredited to its projected future value over time. The capitalized asset is depreciated using the convention for depreciation of leasehold improvement assets. Upon satisfaction of the ARO conditions, any difference between the recorded ARO liability and the actual retirement costs incurred is recognized as an operating gain or loss in the consolidated statements of earnings. ARO expense was $6.5 million and $4.2 million, in fiscal 2008 and 2007, respectively, with components included in "Costs of sales including occupancy costs," and "Depreciation and amortization expenses". The initial impact of adopting FIN 47 at the end of fiscal year 2006 was a charge of $27.1 million, with a related tax benefit of $9.9 million, for a net expense of $17.2 million, with the net amount recorded as a cumulative effect of a change in accounting principle on the consolidated statement of earnings for fiscal year 2006. As of September 28, 2008 and September 30, 2007, the Company's net ARO asset included in "Property, plant and equipment, net" was $18.5 million and $20.2 million, respectively, while the Company's net ARO liability included in "Other longterm liabilities" was $44.6 million and $43.7 million, as of the same respective dates.

Required

a. Leasehold improvements are substantial costs incurred by Starbucks to outfit, remodel, and improve leased retail outlets. Why does Starbucks capitalize and amortize leasehold improvements? Does its policy for determining useful lives in the presence of a lease renewal option yield high-quality accounting numbers? How would Starbucks account for the leasehold improvement costs remaining at the end of a lease it had expected to renew but did not?

b. Starbucks has an ARO related to the leasehold improvements. Describe how Starbucks recognizes the ARO initially in the balance sheet. Then describe how Starbucks recognizes changes in the ARO-related asset and ARO liability in the income statement over time. How is income affected when Starbucks actually spends cash to return a leased property to its original condition? If Starbucks spends more cash than reflected in the ARO liability, how will it account for the difference?

c. How would the first sentence of the Long-lived Assets section of Note 1 appear if Starbucks followed IFRS? Which system do you believe provides the best quality accounting for long-lived asset impairment?

d. The second paragraph of the long-lived assets section of the note describes how Starbucks reflects impairment charges in the income statement. Which line item would you prefer that Starbucks use to report the charges? Why?

e. How would the first sentence of Starbucks R&D accounting policy appear if Starbucks followed IFRS? Do you prefer the IFRS or U.S. GAAP approach to R&D accounting? Why?

Part II—Business Combinations (Majority, Active Investments)

Starbucks prepares consolidated financial statements. Presented below are excerpts from Note 1 describing accounting policy, Note 2, and a major portion of Note 9 from Starbucks' fiscal 2008 Consolidated Financial Statements.

Excerpts from Note 1: Recent Accounting Pronouncements

In December 2007, the FASB issued SFAS No. 141 (revised 2007), "Business Combinations" ("SFAS 141R"), which replaces SFAS 141. SFAS 141R establishes principles and requirements for how an acquirer recognizes and measures in its financial statements the identifiable assets acquired, the liabilities assumed, any resulting goodwill, and any noncontrolling interest in the acquiree. SFAS 141R also provides for disclosures to enable users of the financial statements to evaluate the nature and financial effects of the business combination. SFAS 141R will be effective for Starbucks first fiscal quarter of 2010 and must be applied prospectively to business combinations completed on or after that date.

In December 2007, the FASB issued SFAS No. 160, "Noncontrolling Interests in Consolidated Financial Statements—an amendment of Accounting Research Bulletin No. 51" ("SFAS 160"), which establishes accounting and reporting standards for noncontrolling interests ("minority interests") in subsidiaries. SFAS 160 clarifies that a noncontrolling interest in a subsidiary should be accounted for as a component of equity separate from the parent's equity. SFAS 160 will be effective for Starbucks first fiscal quarter of 2010 and must be applied prospectively, except for the presentation and disclosure requirements, which will apply retrospectively. The Company is currently evaluating the potential impact that adoption of SFAS 160 may have on its consolidated financial statements.

Note 2: Business Acquisitions

In the fourth quarter of fiscal 2008, the Company acquired substantially all of the assets, including development and operating rights, of Coffee Vision, Inc. ("CVI") and Coffee Vision Atlantic, Inc. ("CVAI"), its licensee in Quebec and Atlantic Canada. In addition, Starbucks acquired full development and operation rights for the retail stores in these provinces. In the third quarter of fiscal 2008, Starbucks purchased 100% equity ownership in Coffee Equipment Company ("CEC"), a Seattle-based manufacturer and seller of a single cup, commercial grade coffee brewer called the CloverTM. In the second quarter of fiscal 2008, the Company purchased the remaining 10% equity ownership in its operations in Beijing, China. Starbucks has applied the consolidation method of accounting since the first quarter of fiscal 2007, when it acquired 90% of these previously-licensed operations.

Note 9: Other Intangible Assets and Goodwill

Other intangible assets consisted of the following *(in millions)*:

Fiscal Year Ended	Sept. 28, 2008	Sept. 30, 2007
Indefinite-lived intangibles	$58.3	$36.9
Definite-lived intangibles	14.2	9.5
Accumulated amortization	(5.9)	(4.3)
Definite-lived intangibles, net	8.3	5.2
Total other intangible assets	$66.6	$42.1
Definite-lived intangibles approximate remaining weighted average useful life in years	8	8

The increase in indefinite-lived intangibles was primarily due to the purchase of distribution rights for Seattle Best Coffee products in Canada as well as the CEC acquisition (see Note 2). The increase in definite-lived intangibles was primarily due to patents acquired in the CEC acquisition. Amortization expense for definite-lived intangibles was $1.5 million, $1.0 million and $1.2 million during fiscal 2008, 2007 and 2006, respectively.

The changes in the carrying amount of goodwill by reportable operating segment for the fiscal year ended September 28, 2008 were as follows *(in millions)*:

	United States	International	Global CPG	Total
Balance as of September 30, 2007	$127.6	$ 78.3	$9.7	$215.6
Business Acquisitions	11.8	39.3	—	51.1
Other	—	(0.2)	—	(0.2)
Balance as of September 28, 2008	$139.4	$117.4	$9.7	$266.5

United States

The $11.8 million increase in goodwill was due to the acquisition of CEC.

International

The increase in goodwill was due to the acquisition of CVI and CVAI, as well as the remaining equity interest in Beijing during the fiscal year, which increased goodwill by $33.0 million and $6.3 million, respectively (see Note 2). The decrease related to "Other" was due to foreign currency fluctuations.

Required

a. How will the concept of fair value drive the accounting for future acquisitions?

b. Starbucks indicates that it will account for the change in standards relating to non-controlling (minority) interests "prospectively." What does that mean?

c. What caused the change in goodwill during 2008? What, if any, impairments were recorded?

Part III—Minority, Passive Investments

Presented below is a major portion of Starbucks' Note 4 to its fiscal 2008 Consolidated Financial Statements in which it describes its minority passive investments.

Excerpt from Note 4: Short-term and Long-term Investments

The Company's short-term and long-term investments consisted of the following (*in millions*):

	Amortized Cost	Gross Unrealized Holding Losses	Fair Value
September 28, 2008			
Short-term investments—available-for-sale securities:			
Corporate debt securities	$ 3.0	$ —	$ 3.0
Total	3.0	$ —	3.0
Short-term investments—trading securities	58.2		49.5
Total short-term investments	$ 61.2		$ 52.5
Long-term investments—available-for-sale securities:			
State and local government obligations	$ 65.8	$(6.0)	$ 59.8
Corporate debt securities	12.1	(0.5)	11.6
Total long-term investments	$ 77.9	$(6.5)	$ 71.4
September 30, 2007			
Short-term investments—available-for-sale securities:			
State and local government obligations	$ 81.4	$(0.1)	$ 81.3
US government agency obligations	2.5	—	2.5
Total	83.9	$(0.1)	83.8
Short-term investments—trading securities	67.8		73.6
Total short-term investments	$151.7		$157.4
Long-term investments—available-for-sale securities:			
US government agency obligations	$ 21.0	$ —	$ 21.0

For available-for-sale securities, proceeds from sales were $75.9 million, $47.5 million and $431.2 million, in fiscal years 2008, 2007 and 2006, respectively. Gross realized gains from sales were $3.8 million in fiscal year 2006. Gross realized losses from sales were $0.1 million in fiscal year 2006. For fiscal years 2008 and 2007, there were no realized losses and immaterial amounts of realized gains from sales.

As of September 28, 2008, the Company's long-term available-for-sale securities of $71.4 million included $59.8 million invested in auction rate securities ("ARS"). As of September 30, 2007, the Company held $75.6 million of ARS, which were all classified as short-term available-for-sale securities. ARS have long-dated maturities but provide liquidity through a Dutch auction process that resets the applicable interest rate at predetermined calendar intervals. Due to the auction failures that began in mid-February 2008, these securities became illiquid and were classified as long-term investments. The investment principal associated with the failed auctions will not be accessible until:

- successful auctions resume;
- an active secondary market for these securities develops;
- the issuers replace these securities with another form of financing; or
- final payments are made according to the contractual maturities of the debt issues which range from 22 to 37 years.

The Company intends to hold the ARS until it can recover the full principal amount and has the ability to do so based on other sources of liquidity. The Company expects such recoveries to occur prior to the contractual maturities. In July 2008, one of the Company's ARS was called at its par value of $4.7 million. The Company recorded $6.0 million of unrealized losses on ARS in fiscal 2008, determined to be temporary, which is included in accumulated other comprehensive income as a reduction in shareholders' equity. The Company's ARS are collateralized by portfolios of student loans, substantially all of which are guaranteed by the United States Department of Education. As of September 28, 2008, approximately $4.4 million in ARS was rated AA/Aa3 by Standard & Poor's and Moody's, respectively. All of the remaining securities were rated AAA by two or more of the following major rating agencies: Moody's, Standard & Poor's and Fitch Ratings.

Gross unrealized holding losses on the state and local obligations consist of unrealized losses on the Company's twelve ARS. Gross unrealized holding losses on the corporate debt pertain to five fixed income securities and were primarily caused by interest rate increases subsequent to the date of purchase. The contractual terms of the non-ARS fixed income securities do not permit the issuer to settle at a price less than the par value of the investment, which is the equivalent of the amount due at maturity. As Starbucks has the ability and intent to hold its available-for-sale securities until a recovery of fair value, which may be at maturity, the Company does not consider these securities to be other-than-temporarily impaired. Long-term corporate debt securities generally mature in less than five years. There were no realized losses recorded for other than temporary impairments during fiscal years 2008, 2007 or 2006.

Trading securities are comprised mainly of marketable equity mutual funds that approximate a portion of the Company's liability under the Management Deferred Compensation Plan ("MDCP"), a defined contribution plan. The corresponding deferred compensation liability of $68.0 million in fiscal 2008 and $86.4 million in fiscal 2007 is included in "Accrued compensation and related costs" on the consolidated balance sheets. In fiscal years 2008 and 2007, the changes in net unrealized holding gains/losses in the trading portfolio included in earnings were a net loss of $14.5 million and a net gain of $7.5 million, respectively.

Required

a. As of its September 28, 2008 fiscal year-end, Starbucks reports short-term investments in trading securities having an amortized cost of $58.2 million and a fair value of $49.5 million. Calculate (and explain) the amounts Starbucks shows in the following financial statement accounts as of September 28, 2008. Assume a 35 percent tax rate.

 (i) September 28, 2008 Short-term investments—trading securities

 (ii) 2008 net income effect of the trading securities transactions

 (iii) September 28, 2008 retained earnings effect of the trading securities transactions

 (iv) 2008 comprehensive income effect of the trading securities transactions

 (v) September 28, 2008 accumulated other comprehensive income effect of the trading securities transactions

 b. Repeat Requirement 1 assuming that the securities are available for sale instead of trading.

 c. Starbucks' available-for-sale securities are primarily ARS. The ARS have been shifted from short- to long-term investments due to liquidity problems in the auction market. At September 28, 2008, the securities had an amortized cost of $65.8 million and a fair value of $59.8 million; thus, they are reported at $59.8 million in the balance sheet. What caused the fair value change? Could Starbucks justify a reclassification of the securities to keep fair value changes out of comprehensive income?

Part IV—Minority Active Investments

Note 7 to Starbucks' 2008 Consolidated Financial Statements presents information about equity method (minority, active) investments.

Note 7: Equity and Cost Investments

The Company's equity and cost investments consisted of the following (*in millions*):

Fiscal Year Ended	Sept. 28, 2008	Sept. 30, 2007
Equity method investments	$267.9	$234.5
Cost method investments	34.7	24.4
Total	$302.6	$258.9

Equity Method

The Company's equity investees and ownership interests by reportable operating segment are as follows:

Fiscal Year Ended	Sept. 28, 2008	Sept. 30, 2007
United States		
StarCon, LLC	50.0%	50.0%
International		
Starbucks Coffee Korea Co., Ltd	50.0	50.0
Starbucks Coffee Austria GmbH	50.0	50.0
Starbucks Coffee Switzerland AG	50.0	50.0
Starbucks Coffee España, S.L.	50.0	50.0
President Starbucks Coffee Taiwan Ltd.	50.0	50.0
Shanghai President Coffee Co.	50.0	50.0
Starbucks Coffee France SAS	50.0	50.0
Berjaya Starbucks Coffee Company Sdn. Bhd. (Malaysia)	50.0	49.9
Starbucks Brasil Comercio de Cafes Ltda.	49.0	49.0
Starbucks Coffee Japan, Ltd.	40.1	40.1
Starbucks Coffee Portugal Lda.	50.0	—
CPG		
The North American Coffee Partnership	50.0	50.0
Starbucks Ice Cream Partnership	50.0	50.0

StarCon, LLC is a joint venture formed in March 2007 with Concord Music Group, Inc. that is engaged in the recorded music business. The International entities operate licensed Starbucks retail stores. The Company also has licensed the rights to produce and distribute Starbucks branded products to two partnerships in which the Company holds 50% equity interests: The North American Coffee Partnership with the Pepsi-Cola Company develops and distributes bottled Frappuccino® beverages and Starbucks DoubleShot® espresso drinks, and Starbucks Ice Cream Partnership with Dreyer's Grand Ice Cream, Inc. develops and distributes superpremium ice creams. Prior to fiscal 2005, Starbucks acquired equity interest in its licensed operations of Malaysia, Austria, Shanghai, Spain, Switzerland and Taiwan. The carrying amount of these investments was $24.3 million more than the underlying equity in net assets due to acquired goodwill, which is evaluated for impairment annually. No impairment was recorded during fiscal years 2008, 2007 or 2006.

The Company's share of income and losses is included in "Income from equity investees" on the consolidated statements of earnings. Also included is the Company's proportionate share of gross margin resulting from coffee and other product sales to, and royalty and license fee revenues generated from, equity investees. Revenues generated from these related parties, net of eliminations, were $128.1 million, $107.9 million and $94.2 million in fiscal years 2008, 2007 and 2006, respectively. Related costs of sales, net of eliminations, were $66.2 million, $57.1 million and $47.5 million in fiscal years 2008, 2007 and 2006, respectively. As of September 28, 2008 and September 30, 2007, there were $40.6 million and $30.6 million of accounts receivable, respectively, on the consolidated balance sheets from equity investees primarily related to product sales and store license fees.

As of September 28, 2008, the aggregate market value of the Company's investment in Starbucks Japan was approximately $214 million, based on its available quoted market price.

Summarized combined financial information of the Company's equity method investees, that represent 100% of the investees' financial information, was as follows (*in millions*):

Financial Position as of	Sept. 28, 2008	Sept. 30, 2007	
Current assets	$ 247.2	$ 183.1	
Noncurrent assets	604.9	408.6	
Current liabilities	273.5	166.4	
Noncurrent liabilities	59.8	56.8	

Results of Operations for Fiscal Year Ended	Sept. 28, 2008	Sept. 30, 2007	Oct. 1, 2006
Net revenues	$1,961.0	$1452.9	$1,303.5
Operating income	171.3	186.2	152.3
Earnings before cumulative effect of change in accounting principle	136.9	159.5	136.4
Net earnings	136.9	159.5	124.0

Cost Method

The Company has equity interests in entities to develop and operate Starbucks licensed retail stores in several global markets, including Mexico, Hong Kong and Greece. Additionally, Starbucks has investments in privately held equity securities unrelated to Starbucks licensed retail stores of $2.8 million at September 28, 2008 and September 30, 2007. As of September 28, 2008 and September 30, 2007, management determined that the estimated fair values of each cost method investment exceeded the related carrying values.

There were no realized losses recorded for other-than-temporary impairment of the Company's cost method investments during fiscal years 2008, 2007 or 2006.

Starbucks has the ability to acquire additional interests in some of these cost method investees at certain intervals. Depending on the Company's total percentage of ownership interest and its ability to exercise significant influence over financial and operating policies, additional investments may require the retroactive application of the equity method of accounting.

Required

a. Starbucks' 2008 net income is $315.5 million, and its interest expense is $53.4 million. Assuming a tax rate of 35 percent and the information presented in the worksheet below the requirements, compute Starbucks' 2008 ROA.

b. Using the worksheet below and the note information, consolidate the unconsolidated equity method affiliates using a full consolidation approach. Recompute ROA and explain the change in ROA.

c. Using the information from the full consolidation worksheet, describe how you would change your computation of ROA if you followed a proportionate consolidation approach. Recompute ROA under that approach.

Full Consolidation of Equity Method Affiliates

September 28, 2008	Starbucks	Affiliates	Eliminations	Consolidated
Current assets	$ 1,748.0			
Equity and cost investments	302.6			
Remainder of noncurrent assets	3,622.0			
Total Assets	$ 5,672.6			
Current liabilities	$(2,189.7)			
Noncurrent liabilities	(992.0)			
Shareholders' equity (noncontrolling interest)				
Shareholders' equity (controlling interest)	(2,490.9)			
Total Liabilities and Shareholders' Equity	$(5,672.6)			

September 30, 2007	Starbucks	Affiliates	Eliminations	Consolidated
Current assets	$ 1,696.5			
Equity and cost investments	258.9			
Remainder of noncurrent assets	3,388.5			
Total Assets	$ 5,343.9			
Current liabilities	$(2,155.6)			
Noncurrent liabilities	(904.2)			
Shareholders' equity (noncontrolling interest)				
Shareholders' equity (controlling interest)	(2,284.1)			
Total Liabilities and Shareholders' Equity	$(5,343.9)			

Part V—Investments in Long-Lived Assets

Presented below is a portion of Note 8 to Starbucks' 2008 Consolidated Financial Statements.

Note 8: Property, Plant and Equipment
Property, plant and equipment consisted of the following *(in millions)*:

Fiscal Year Ended	Sep 28, 2008	Sep 30, 2007
Land	$ 59.1	$ 56.2
Buildings	217.7	161.7
Leasehold improvements	3,363.1	3,179.6
Store equipment	1,045.3	1,007.0
Roasting equipment	220.7	208.8
Furniture, fixtures and other	517.8	477.9
Work in progress	293.6	215.3
	$ 5,717.3	$ 5,306.5
Less accumulated depreciation and amortization	(2,760.9)	(2,416.1)
Property, plant and equipment, net	$ 2,956.4	$ 2,890.4

Required

a. Estimate the average total estimated useful life of depreciable property, plant, and equipment. Starbucks reports $604.5 million of depreciation and amortization in the statement of cash flows, of which $1.5 million relates to amortization of limited-life intangible assets. Does the estimate reconcile with stated accounting policy on useful lives for property, plant, and equipment? Explain.

b. How should an analyst interpret fluctuations in this estimate for a given company over time? How should an analyst interpret differences in this estimate between a company and its competitors?

c. Estimate the average age of depreciable assets, the percentage of PP&E that has been used up, and the remaining useful life. How might an analyst use this information?

Part VI—Brand Name

In 2008, Interbrand listed Starbucks as having the 85th most valuable brand name in the world and estimated brand value to be $3.9 billion. Examine the disclosures for intangible long-lived assets in Part II and tangible long-lived assets in Part V. Where in the financial statements does Starbucks disclose brand value?

CASE 7.2

DISNEY ACQUISITION OF MARVEL ENTERTAINMENT

In September 2009, The Walt Disney Company announced that it would acquire Marvel Entertainment in a $4 billion cash and common stock deal. On a per-share basis, the consideration given by Disney to Marvel shareholders represents a 29 percent premium over Marvel's share price at the date of acquisition. Disney acquires the more than 5,000 characters in Marvel's library, including Iron Man, Spider-Man, X-Men, Captain America, and the Fantastic Four. Exhibit 7.41 presents the Condensed Consolidated Balance Sheet of Marvel at the end of its June 30, 2009 second quarter.

EXHIBIT 7.41

Marvel Entertainment, Inc.
Condensed Consolidated Balance Sheets
(unaudited)

	June 30, 2009	December 31, 2008
	(in thousands, except per share amounts)	
ASSETS		
Current assets:		
Cash and cash equivalents	$ 81,039	$105,335
Restricted cash	38,220	12,272
Short-term investments	—	32,975
Accounts receivable, net	29,471	144,487
Inventories, net	13,473	11,362
Income tax receivable	206	2,029
Deferred income taxes, net	25,497	34,072
Prepaid expenses and other current assets	9,164	5,135
Total current assets	$197,070	$347,667
Fixed assets, net	4,194	3,432
Film inventory, net	192,068	181,564
Goodwill	346,152	346,152
Accounts receivable, non-current portion	7,010	1,321
Income tax receivable, non-current portion	5,906	5,906
Deferred income taxes, net—non-current portion	17,046	13,032
Deferred financing costs	3,320	5,810
Restricted cash, non-current portion	42,274	31,375
Other assets	5,489	455
Total assets	$820,529	$936,714
LIABILITIES AND EQUITY		
Current liabilities:		
Accounts payable	$ 2,860	$ 2,025
Accrued royalties	89,912	76,580
Accrued expenses and other current liabilities	33,826	40,635
Deferred revenue	67,468	81,335
Film facility	—	204,800
Total current liabilities	$194,066	$405,375
Accrued royalties, non-current portion	806	10,499
Deferred revenue, non-current portion	93,696	48,939
Film facility, non-current portion	—	8,201
Income tax payable	66,522	59,267
Other liabilities	10,680	8,612
Total liabilities	$365,770	$540,893

EXHIBIT 7.41 (Continued)

	June 30, 2009	December 31, 2008
	(in thousands, except per share amounts)	
Commitments and contingencies	—
Marvel Entertainment, Inc. stockholders' equity:		
Preferred stock, $.01 par value, 100,000,000 shares authorized, none issued	—	—
Common stock, $.01 par value, 250,000,000 shares authorized, 134,681,030 issued and 77,997,619 outstanding in 2009 and 134,397,258 issued and 78,408,082 outstanding in 2008	$ 1,347	$ 1,344
Additional paid-in capital	752,438	750,132
Retained earnings	628,628	555,125
Accumulated other comprehensive loss	(4,574)	(4,617)
Total Marvel Entertainment, Inc. stockholders' equity before treasury stock	$1,377,839	$1,301,984
Treasury stock, at cost, 56,683,411 shares in 2009 and 55,989,176 shares in 2008	(921,700)	(905,293)
Total Marvel Entertainment, Inc. stockholders' equity	$ 456,139	$ 396,691
Noncontrolling interest in consolidated Joint Venture	(1,380)	(870)
Total equity	$ 454,759	$ 395,821
Total liabilities and equity	$ 820,529	$ 936,714

Required

a. From a strategic perspective, discuss why you believe Disney would make this acquisition.

b. Assuming that the assets and liabilities of Marvel approximate their individual fair values at the date of acquisition, compute goodwill.

c. This is a 100 percent acquisition. What role does the 29 percent premium play in the computation of goodwill? If this were a less than 100 percent acquisition, how would the 29 percent premium affect the computation of the noncontrolling interest?

d. Disney will record a decrease in its cash and an increase in its shareholders' equity totaling $4 billion at the date of acquisition. Contrast the rest of the financial statement effects on Disney's own records and on its consolidated balance sheet between two scenarios: Marvel is dissolved (a merger) and Marvel continues to exist as a separate legal entity (an acquisition).

e. It is unlikely that the assets and liabilities of Marvel as shown in the condensed quarterly balance sheet approximate their individual fair values at the date of acquisition. Indeed, some of Marvel's most valuable resources might not be recognized on their balance sheet. As a result, the entire excess acquisition price is not likely to be assigned to goodwill. Identify items that are likely to receive a portion of the allocation based on the differences between their book values and fair values.

Chapter 9

Accounting Quality

Learning Objectives

1 Describe the concept of quality of accounting information, including the attributes of economic content and earnings sustainability.

2 Adjust assessments of profitability and risk and predictions of future earnings for various items that occur infrequently yet can have a large impact on reported financial statements, including gains and losses from discontinued operations, extraordinary gains and losses, changes in accounting principles, other comprehensive income items, impairment losses, restructuring charges, changes in estimates, and gains and losses from peripheral activities.

3 Analyze restated financial statements and account classification differences.

4 Define earnings management and be aware of the conditions under which managers might be likely to engage in earnings management.

Chapters 4 and 5 provide a framework and tools for analyzing the profitability and risk of a firm using financial statement data. The presumption in using reported financial statement data is that they accurately portray the economic effects of a firm's decisions and actions during the current period, appropriately characterize the firm's financial position at the end of the period, and are informative about the firm's likely future profitability and risk. The last part of Chapter 5 introduced the Beneish model of financial reporting manipulation risk, indicating that the overall ability of the financial statements to be useful in identifying other risks is contingent on the financial statements being representationally faithful. Thus, to make insightful decisions about profitability and risk based on relations among accounting data (such as ratios and time-series trends), we must assess whether the unadjusted, reported data are the appropriate inputs in the profitability and risk measures used. Chapters 6–8 provide the in-depth understanding of accounting methods and principles that is necessary for assessing accounting quality.

This chapter continues discussion of the concept of accounting quality as it relates to analyzing a firm's profitability and risk and forecasting its future financial statements by illustrating financial reporting for a wide array of items (primarily income statement-related) that typically occur infrequently yet can have a large impact on the financial statements. After providing a general discussion of accounting quality, we discuss reporting for

discontinued operations, extraordinary gains and losses, changes in accounting principles, other comprehensive income items, impairment losses, restructuring charges, changes in estimates, and gains and losses from peripheral activities. The important objectives in analyzing these items are to assess (1) their economic effect on the current period's performance and (2) the likelihood that they will persist in the future. Thus, this chapter serves as a bridge between the accounting focus in Chapters 6–8 and the forecasting and valuation focus in Chapters 10–14. This chapter also discusses additional accounting and reporting items and events that may require adjustment, including retroactively restated financial statements and account classification differences.

The chapter concludes with a discussion of the definition of earnings management and the conditions that might provide incentives for managers to manipulate financial statements. Chapter 5 defines earnings manipulation and fraud as the reporting of accounting data outside the limits of U.S. GAAP or IFRS. This chapter discusses earnings management within the limits of U.S. GAAP or IFRS. The goal is to be aware of managers' incentives and disincentives for earnings management so that you can assess the likelihood of earnings management and adjust your due diligence accordingly.

ACCOUNTING QUALITY

Numerous financial reporting abuses by companies such as HealthSouth, AIG, Adelphia, Enron, WorldCom, Parmalat, Ahold, Satyam, and Global Crossing have raised questions about the quality of accounting information. Terms such as *earnings quality* and, less frequently, *balance sheet quality* appear in the financial press. However, these terms often are not defined and are used loosely to capture a myriad of reporting and accountability concerns. Although accounting quality has many dimensions, the commonality in the aforementioned (and many other) financial abuses is that accounting was used to misrepresent a firm's underlying economics and earnings potential. Further, even correctly applied accounting rules may, on occasion, fail to indicate future earnings potential. Accordingly, we focus on the following two accounting quality issues that are central to analysis and valuation:

- Accounting information should be a fair and complete representation of the firm's economic performance, financial position, and risk.
- Accounting information should provide relevant information to forecast the firm's expected future earnings and cash flows.

We intend that our notion of *accounting quality* encompass the economic information content of the income statement, the balance sheet, the statement of cash flows, notes to the financial statements, and MD&A (management's discussion and analysis). We define accounting quality broadly because each of these elements of the financial statements integrates and articulates with the others; thus, a firm's accounting quality depends on the quality of all of these elements. We intend to analyze broadly the firm's accounting quality so that our analysis can fully inform our assessment of the firm's reported financial position, performance, and risk.

Our view of accounting quality is broader than, and should not be confused with, accounting conservatism, which is sometimes construed as an attribute of reporting quality. Conservative accounting numbers in their own right are not high quality for purposes of financial statement analysis and valuation, but conservatism is a prudent response by accountants and managers when faced with uncertainty in measuring the economic effects of transactions, events, and commercial arrangements.

In the two sections that follow, we explore these two elements more fully.

High Quality Reflects Economic Information Content

Conceptually, accounting numbers contain three elements:

- A reflection of economics
- Measurement error (or noise)
- Bias

High quality accounting information portrays fairly and completely the economic effects of a firm's decisions and actions. High quality accounting information paints an accurate economic portrait of the firm's financial position, performance, and risk. That is, quality accounting information minimizes measurement error and bias. Measurement errors occur when managers, in good faith, make estimates that turn out not to be true. Good faith, well-informed estimates yield small errors in directions that are not predictable. The errors will cancel out over time and across the many estimates that managers must make in a given year, yielding high-quality accounting numbers. Bias occurs when managers apply biased accounting standards (for example, standards that require asset write-downs and do not permit asset write-ups) and when managers take advantage of the discretion and flexibility in the estimation process to (most commonly) inject optimism into accounting numbers. The discussion in the last part of this chapter identifies the incentives and disincentives to inject optimistic or pessimistic bias in accounting numbers to manage earnings. Neutral application of accounting standards to reduce bias yields high-quality accounting numbers.[1]

A high-quality balance sheet portrays the economic resources that can be reasonably expected to generate future economic benefits (and the claims on those resources) at a point in time. The assets on the balance sheet should reflect resources that the firm controls—cash and investment securities, collectible receivables, sellable inventory, productive plant and equipment, intangible rights—and that the firm expects to use to generate future economic benefits. If measurement of the expected future economic benefits is highly uncertain [as in the case of the benefits from certain R&D (research and development), advertising, or brand management expenditures] or is outside the firm's control (for example, human capital) or if the expected future economic benefits have expired, a high-quality balance sheet should exclude these items.

A high-quality balance sheet also provides a complete and fair portrayal of all of the firm's obligations at a point in time, including the present value of long-term liabilities for future payments (for example, for pensions, leases, and other commitments). High quality also requires proper classification of short and long term so that users know when assets will be realized and obligations will be met. Shareholders' equity on a high-quality balance sheet represents the net asset position of the firm at that point in time—the residual value of the assets of the firm after the obligations of the firm have been deducted. High-quality shareholders' equity informs users of the sources of contributed equity capital, the earnings reinvested in the firm, and the dividends paid to investors.

A high-quality income statement completely and fairly summarizes the firm's income or loss from operations as well as any other gains or losses from other transactions or events during a period. A high-quality income statement includes all revenues the firm earned during the period and can reasonably expect to collect. A high-quality income statement includes the costs of all resources consumed, including resources consumed in the production process to generate revenues (that is, costs directly related to revenues, such as cost of sales), as well as resources consumed during the period as a function of time that indirectly relate to revenues (such as fixed administrative costs and interest expenses). A high-quality

[1] Some level of bias (for example, conservative accounting standards) may be preferred by creditors.

income statement also includes the effects of any gains or losses from other transactions and events of that period. Accounting quality is low if net income includes revenues the firm did not earn during the period or may not be able to collect, if it fails to include expenses or losses of the period, if it includes expenses or losses that are attributable to other periods, or if it misclassifies or disguises key income items.

A high-quality statement of cash flows summarizes the cash flow implications of the firm's performance and changes in the firm's financial position over a period of time. All non-cash exchanges appear in the notes and are not reported in the statement of cash flows. A high-quality statement of cash flows appropriately classifies cash flows into operating, investing, and financing activities in sufficient detail for the analyst to understand why cash flows change each period.

Notes to the financial statements provide additional information that enhances the users' understanding of the accounting methods used and the judgments and estimates the firm's managers made in measuring and reporting accounting amounts and changes in those amounts. In the MD&A section of the annual report and in Form 10-K, managers enhance these disclosures with qualitative discussions of operations and risks. (See Appendix B for PepsiCo's MD&A discussions of key assumptions; critical accounting policies, risks, liquidity, and capital resources; and estimates made by the firm.) High-quality notes should provide a useful quantitative disaggregation and explanation of financial statement amounts, and high-quality MD&A discussions should provide an in-depth qualitative and unbiased context to the quantitative data reported in the financial statements.

Accounting standard setters establish principles to provide firms with guidance and rules for measuring the economic effects of firms' activities, performance, and financial position. Standard setters also establish principles to provide auditors with a common basis for auditing the fairness of firms' reporting and to provide users of financial statements with a comparable and understandable set of principles for firms' accounting. Standard setters recognize, however, that measuring the economic effects of firms' activities, performance, and financial position often requires judgment, estimation, and subjectivity. Managers must estimate, for example, the rate at which a long-lived asset such as a building or machine loses service potential, the point when a particular customer's account becomes uncollectible, and the point when a firm has earned revenues. While the degree of subjectivity in measuring economic effects increases, also increasing is the potential for firms to report accounting information that includes unintentional measurement error or intentional bias to portray the firm in a light most favorable to the firm or its managers. Standard setters often react to this potential for intentional bias or unintentional estimation error when establishing principles by making trade-offs between accurately reflecting economic reality and obtaining reliable accounting information. Thus, quality accounting information maximizes relevance and economic faithfulness, which are subject to the constraints of the reliability of the measurements.

Standard setters recognize that a single accounting method may not portray the economic effects of a particular transaction for all firms. Firms' choices and estimates within U.S. GAAP or IFRS should be determined by firms' underlying economic circumstances, including conditions in their industry, competitive strategy, and technology.

For example, firms use up the services of buildings and equipment at different rates over time, so accounting standards allow firms to estimate useful lives and select either straight-line or accelerated depreciation methods. Similarly, some firms structure leasing arrangements so that the lessor bears most of the economic risk in some cases (such as very short-term leases), whereas the lessee bears most of the economic risk in other cases (such as leases that extend for most of an asset's useful life). As discussed in Chapter 6, U.S. GAAP and IFRS allow two methods of accounting for leases—the operating lease method and the capital lease method—to reflect differences in the economics of these leasing arrangements.

Thus, to obtain quality accounting information, firms should select the accounting principles that best portray the economics of their activities from the set permitted.

Even when firms select the accounting principles or methods that best portray the economics of their activities, firms still must make estimates in applying those accounting principles. Virtually all accounting amounts require some degree of estimation. For example, firms must estimate the period of time during which buildings and equipment will provide benefits. Firms must estimate the amount of cash they will ultimately receive from customers for credit sales. Similarly, firms must estimate the expected future cost of warranty plans on products sold during the period. Firms also must estimate fair values of financial instruments and derivatives for financial statement reporting or note disclosures. Firms also must estimate and project expected returns, employee longevity, and future salary levels to estimate pension assets and liabilities. Thus, obtaining quality accounting information requires firms' judgments and estimates in applying U.S. GAAP or IFRS.

Given that firms have discretion in choosing their accounting principles in some cases and must make estimates in applying those accounting principles in most cases, firms should disclose sufficient information in the financial statements and notes to permit users to assess the economic appropriateness of those choices. Thus, informative disclosures are an essential element of quality accounting information.

Finally, in some cases, standard setters have removed accounting method choice and have created a situation where certain accounting principles do not faithfully portray underlying circumstances for all firms all of the time. For example, PepsiCo cannot recognize its valuable brand name as an asset because GAAP views internally-developed intangible assets as very difficult to value reliably in the absence of a market-based, arms-length transaction. Microsoft and Eli Lilly rely heavily on investments made in R&D and have proven technologies, patents, and intellectual property that can be traced to R&D expenditures. Yet because GAAP is concerned about the lack of reliable measurements for such assets, these companies cannot capitalize these resources that are critical to their economic position and performance.

In summary, users of financial statements should consider the following when evaluating the quality of accounting information:

- Economic faithfulness of accounting measurements and classifications
- Reliability of the measurements
- When accounting choices exist in U.S. GAAP or IFRS, how the firm's choices fit its activities
- Reasonableness of the estimates made in applying GAAP or IFRS
- Adequacy of disclosures and credibility of qualitative discussions
- When accounting choices do not exist in U.S. GAAP or IFRS, how the rules fit the firm's underlying economic conditions

The analyst may conclude that the reported financial statements for a particular firm fall short on accounting quality. In these cases, the analyst might adjust reported amounts to enhance the accounting quality before using them to assess operating performance, financial position, or risk. For example, the analyst might judge that an accelerated depreciation method more accurately reflects the economic decline in service potential of a building or machine. Converting the reported amounts from straight-line to accelerated depreciation enhances accounting quality. Alternatively, the analyst might judge that a bad debt provision of 3 percent of sales (instead of a 2 percent rate used by the firm) more accurately reflects the likely uncollectible accounts. Chapters 6–8 discuss accounting choices and estimates firms must make in applying them; those chapters also discuss the types of adjustments the analyst might make to reported amounts to enhance the quality of accounting information.

The analyst can then use the adjusted financial statement amounts for the current period to evaluate the firm's managers, to measure profitability, to assess risk, and to test for earnings

management or fraud. The analyst also can use the adjusted financial statement amounts to evaluate a second element of quality accounting information: persistence of earnings over time.

High Quality Leads to Earnings Persistence over Time

As Chapters 10–14 illustrate, firm value depends on predictions of future payoffs to investors: dividends, free cash flows, or earnings. Therefore, a key quality of financial accounting information is the extent to which it currently captures conditions that will persist into the future versus conditions that are transitory. When using financial statements to value a firm, the analyst should ask this question: What do the reported or restated amounts for the current period suggest about the long-run persistence of income and therefore the economic value of a firm? This question points out the importance of judging the economic content of current period earnings in order to assess historical earnings persistence and to project future earnings persistence.

Quality accounting information should be informative about the economic value implications of the current period's earnings and about the long-run sustainability of profits. For accounting to be deemed of high quality, both components—fair and complete representation of current economic performance and information about expected future earnings and cash flows—are necessary. Consider the following four possibilities:

1. *Earnings could be very informative about current performance and tell you that current performance is sustainable.* This constitutes high quality on both dimensions (for example, a big jump in sales and earnings this period because of new products that will continue to be successful for a long time).

2. *Earnings could be very informative about current performance and tell you that the current level of earnings performance is not sustainable.* Again, this constitutes high quality on both dimensions. For example, the firm realizes an unexpected gain (or loss) this year but clearly classifies and reports it as nonrecurring; there is no ambiguity because the gain is informative in that it will not likely affect future earnings.

3. *Earnings could be informative about current performance but not informative (that is, does not reduce uncertainty) about the future.* In this case, we have high current period information quality but low information quality for the future. For example, a firm experiences a sudden drop in cost of goods sold due to an unexpected reduction in the cost of raw materials inventory. The cost of goods sold measure is relevant and reliable for the current period performance, but this year's greater income does not help the analyst forecast whether the raw material price decrease is relatively permanent and thus whether earnings are sustainable.

4. *Earnings are not informative about current period performance but are informative about sustainability of future earnings.* Here we have low current period information quality but high information quality for the long run. For example, earnings this period include expenses for pre-opening costs for new stores; the new stores are operational and are expected to be profitable in the future.

Chapters 1, 4, 5, and 11 describe the value of an equity security as a function of the returns expected from investing in the equity security relative to the level of risk. Chapters 10–14 discuss and illustrate how the analyst forecasts future financial statement amounts and uses them to derive appropriate equity values. Our concern in this section is with understanding the different signals that quality accounting information might provide about equity values. To link our discussion about current period earnings and expected future earnings to the value implications of earnings, consider the following four scenarios. In each case, we assume that the analyst has adjusted or restated reported earnings amounts to achieve the desired level of economic information content about current period and future period performance as discussed in the previous section.

Scenario 1: Earnings for the current period are high-quality, are in line with previous expectations, and do not suggest any changes in expected future earnings. The analyst should not expect to observe a change in the market price of the equity securities. Market prices likely already reflect the expected earnings levels. Earnings are informative in the sense that they signal the market that its prior expectations have been met and there are no surprises that trigger a change in expectations for the future.

Scenario 2: Earnings for the current period differ from expectations, and the new earnings level is expected to persist. A firm may have introduced a successful new product during the period, and the market had not fully anticipated the success of the new product in pricing the equity security. The new product should enhance earnings for a number of years in the future. The market price of the security should increase for the realized additional earnings of the current period and for the present value of the expected additional earnings in the future. Earnings are informative if they signal the portion of the current period's earnings due to the new product and the additional earnings in the future as a result of the persistence of this new earnings stream.

Consider a second example. A firm unexpectedly loses a patent infringement lawsuit. As a consequence, the firm is enjoined from selling a key line of products that generate substantial profits for the firm and is required to pay immediate damages. The market value of the firm's equity securities should decline as a result of the damages paid. In addition, the level of expected earnings for the future will decline relative to those previously anticipated, which means that the market value of the firm's equity securities also should decline to reflect the present value of the lower expected future profits. Earnings are informative if they signal the amount of the immediate economic loss and the persistent negative effect on future earnings.

Scenario 3: Earnings for the current period differ from expectations, but expected future earnings do not change. Because a local government corrects a processing error, a firm receives an unexpected rebate on property taxes previously paid. The market value of the firm's equity securities should increase as a result of the rebate. Because expected future earnings do not change, there should be no further market price reaction for the equity securities. Earnings are informative if they disclose the amount of the rebate and signal its one-time nature.

Scenario 4: Earnings for the current period do not differ from expectations, but expected future earnings do change. At the end of the current period, a manufacturing firm replaces a piece of equipment with a new piece of equipment that has an identical cost but is more efficient. The new piece of equipment adds to the firm's productive capacity and will reduce manufacturing costs, increasing expected earnings for future periods. The acquisition of the equipment should not materially affect the market value of the firm's equity securities; however, the market value should increase for the present value of the higher expected future earnings. Earnings are informative if they disclose sufficient information for the analyst to forecast the increase in expected future earnings.

SPECIFIC EVENTS AND CONDITIONS THAT AFFECT EARNINGS QUALITY

The remainder of this chapter addresses specific events and conditions that, although infrequent, affect earnings quality, especially as it relates to earnings persistence. The topics discussed are as follows:

- Discontinued operations
- Extraordinary gains and losses

- Changes in accounting principles
- Other comprehensive income items
- Impairment losses on long-lived assets
- Restructuring and other charges
- Changes in estimates
- Gains and losses from peripheral activities

Exhibit 9.1 presents a hypothetical income statement that shows the reporting of the special items if they receive separate line-item treatment in the income statement. (Changes in accounting principles receive separate line-item treatment prior to 2006; changes in accounting estimates do not receive separate line-item treatment.)

Discontinued Operations

When a firm decides to exit a particular component of its business, it classifies that business as a discontinued operation. This classification provides analysts and other financial statements users with information to distinguish the effects of continuing versus discontinuing operations on current period performance and provides a basis for forecasting future income from the continuing operations of the firm. U.S. GAAP stipulates that a discontinued business is either a separable business or a component of the firm with clearly

EXHIBIT 9.1

Statement of Comprehensive Income for a Hypothetical Company

Sales revenue	X
Cost of goods sold	(X)
Selling and administrative expenses	(X)
Operating Income	X
Gains (losses) from peripheral activities	(X)
Restructuring charges	(X)
Impairment losses	(X)
Interest income	X
Interest expense	(X)
Income before Income Taxes	X
Income tax expense	(X)
Income from Continuing Operations	X
Income from discontinued operations, net of taxes	X
Extraordinary gains (losses), net of taxes	(X)
Changes in accounting principles, net of taxes (pre-2006)	X
Net Income	X
Other comprehensive income items, net of taxes	X
Comprehensive Income	X

distinguishable operations and cash flows.[2] The degree to which a particular divested component operationally integrates with ongoing businesses is likely to vary across firms depending on their organizational structures and operating policies. Thus, the gain or loss from the sale of a business might appear in income from continuing operations for one firm (that is, the divested business is operationally integrated) and in discontinued operations for another firm (that is, the divested business is not operationally integrated).

IFRS rules are more restrictive as to what constitutes a discontinued operation.[3] Only disposals of a major line of business or geographic area qualify. For example, if a restaurant chain with a total of 20 restaurants sold three underperforming restaurants with independent cash flows and the chain had no continuing involvement in the operations of the sold restaurants (for example, through franchising agreements), the sale would qualify as a discontinued operation under U.S. GAAP but not under IFRS.[4]

A firm reports the net income or loss from operating the discontinued business between the beginning of the reporting period and the disposal date as a separate item in the discontinued operations section of the income statement (net of tax effects). Firms also report the gain or loss on disposal (net of tax effects) in this same section of the income statement, often labeled "Income, Gains, and Losses from Discontinued Operations." Most U.S. firms include three years of income statement information in their income statements. A firm that decides to divest a business during the current year includes the net income or loss of this business in discontinued operations for the current year and in comparative income statements for the preceding two years even though the firm had previously reported the latter income in continuing operations in the income statements originally prepared for those two years. If final sale has not occurred as of the end of the period, the remaining assets held for sale are assessed for impairment and an impairment loss (net of tax) is included as part of the discontinued operations disclosure. The assets and liabilities of the discontinued operations are isolated and receive separate disclosure on the balance sheet or in notes that support the balance sheet.

Example 1

On August 14, 1997, PepsiCo announced that it would spin off its restaurant businesses (which included Pizza Hut, Taco Bell, and KFC), forming a new restaurant company named TRICON Global Restaurants, Inc. (now known as Yum! Brands, Inc.). For 1997, PepsiCo reported income from continuing operations separately from discontinued operations. In that year, PepsiCo reported a total of $1,491 million of income (net of tax) from continuing operations and $651 million of income (net of tax) associated with the discontinued restaurants segment.

Example 2

Bowne & Co. is one of the largest printers of financial documents in the United States, specializing in the creation and distribution of regulatory and compliance documents. Bowne prints and distributes Form 10-K filings and proxy reports to shareholders, as well as a wide range of other compliance filings required of U.S. firms. During 2004, Bowne decided to sell its document-related outsourcing business to Williams Lea, Inc., to focus on its core

[2] The most recent U.S. GAAP ruling on discontinued operations, Financial Accounting Standards Board, *Statement of Financial Accounting Standards No. 144*, "Accounting for the Impairment or Disposal of Long-Lived Assets" (2001), maintained the basic provisions of Accounting Principles Board, *Opinion No. 30*, "Reporting the Results of Operations" (1973) for presenting discontinued operations, but broadened the presentation to include more disposal transactions. *FASB Codification Topic 360*.

[3] International Accounting Standards Board, *International Financial Reporting Standard 5*, "Noncurrent Assets Held for Sale and Discontinued Operations" (2004).

[4] The FASB and IASB are in the process of converging discontinued operations treatment, probably closer to current IFRS standards, as of the writing of this text.

competency of creation and distribution of regulatory documents. Exhibit 9.2 presents selected data from the financial statements related to discontinued operations.

Note that Bowne presents the income from operating the discontinued businesses separately from the gain on disposal, each net of tax effects. The magnitude of discontinued operations in 2004, net of tax, transforms a small loss from continuing operations into a modest positive net income. Bowne reports the amount of assets and liabilities related to discontinued operations on its balance sheet each year.

When assessing Bowne's sustainable profitability, one should exclude income from discontinued operations from the numerator of the return on assets ratio and exclude the related assets from the denominator as well.

Exhibit 9.2 indicates that Bowne eliminated the effect of discontinued operations from the calculation of cash flow from operations and classified all of the cash flows related to discontinued operations in a separate section of the statement of cash flows after financing activities. Because cash flow from operations contains no amounts related to discontinued operations, the analyst can use it when computing cash flow ratios (for example, cash flow from operations to average current liabilities) without making additional adjustments. If the firm had not excluded the cash flow effects of discontinued operations from cash flow from operations, the analyst should do so.

For some firms that regularly pursue a strategy to acquire firms and subsequently sell them, income from discontinued operations is an ongoing source of profitability, and the analyst might decide to include this income in forecasts of future earnings. For most firms, however, income from discontinued operations represents a source of earnings that does not persist.

Thus, in most cases, the analyst should exclude income from discontinued operations from forecasts of future earnings, focusing instead on income from continuing operations. Exclusion of discontinued operations when predicting Bowne's future profitability (2005 and beyond) makes sense because Bowne reports only one discontinued operation in the 2002–2004 income statements. However, if one examines Bowne income statements after the fact (2005–2008), evidence of persistent discontinued operations exists. Bowne reports net losses from further discontinued operations in 2005, 2006, and 2007 and a gain from discontinued operations in 2008. These losses are $754,000 in 2005 (more than 500 percent of a small income from continuing operations, which causes a net loss to be reported); $14,004,000 in 2006 (114 percent of a modest income from continuing operations, which causes a small net loss to be reported); $223,000 in 2007 (less than 1 percent of a large positive income from continuing operations); and $5,719 in 2008 (almost 20 percent of a loss from continuing operations). Given Bowne's recent history of discontinued operations, the analyst should reassess Bowne's strategy of acquisitions and divestitures to predict future net income.[5]

Extraordinary Gains and Losses

The income statement can include extraordinary gains and losses. To be classified as extraordinary, an income item must meet all three of the following criteria:[6]

- Unusual in nature
- Infrequent in occurrence
- Material in amount

[5] PepsiCo does not report discontinued items in any of the last seven years.

[6] Financial Accounting Standards Board, *Statement of Financial Accounting Standards No. 144*, "Accounting for the Impairment or Disposal of Long-Lived Assets" (2001); Accounting Principles Board, *Opinion No. 30*, "Reporting the Results of Operations" (1973). *FASB Codification Topic 225*.

EXHIBIT 9.2

Bowne & Co. Selected Information Related to Discontinued Operations
(amounts in thousands)

Year Ended December 31:	2004	2003
INCOME STATEMENT		
Revenue	$899,011	$847,636
Expenses:		
Cost of revenue	(574,264)	(536,166)
Selling and administrative	(266,034)	(247,977)
Depreciation	(32,121)	(35,466)
Amortization	(2,713)	(2,478)
Gain on sale of building	896	—
Restructuring, integration, and asset impairment charges	(14,644)	(23,076)
Operating (Loss) Income	$ 10,131	$ 2,473
Interest expense	(10,709)	(11,389)
Loss on extinguishment of debt	(8,815)	—
Other expense, net	(118)	(1,367)
Loss from Continuing Operations before Income Taxes	$ (9,511)	$(10,283)
Income tax benefit (expense)	1,313	729
Loss from Continuing Operations	$ (8,198)	$ (9,554)
Discontinued Operations:		
Income from discontinued operations, net of tax	$ 4,150	$ 1,805
Gain on sale of discontinued operations, net of tax	31,552	—
Net Income from Discontinued Operations	$ 35,702	$ 1,805
Net Income (Loss)	$ 27,504	$ (7,749)
CONDENSED CONSOLIDATED BALANCE SHEETS		
Assets held for sale, noncurrent	—	$106,898
Other assets (details not provided)	—	620,927
Total Assets	$648,811	$727,825
Liabilities held for sale, noncurrent	—	$ 3,882
Other liabilities and shareholders' equity	—	723,943
Total Liabilities and Shareholders' Equity	$648,811	$727,825
CONDENSED CONSOLIDATED STATEMENTS OF CASH FLOWS		
Cash Flows from Operating Activities:		
Loss from continuing operations	$ (8,198)	$ (9,554)
Depreciation and amortization	34,834	37,944
Asset impairment charges	518	2,198
Gain on sale of building	(896)	—
Loss on extinguishment of debt	8,815	—
Changes in other assets and liabilities, net of non-cash transactions	(2,404)	(10,339)
Net Cash Provided by Operating Activities	$ 32,669	$ 20,249
Cash Flows from Investing Activities (details omitted)	148,200	(21,117)
Cash Used in Financing Activities (details omitted)	(97,784)	(10,872)
Net Cash Used in Discontinued Operations	(20,123)	(4,131)
Net increase (decrease) in cash and cash equivalents	$ 62,962	$(15,871)
Cash and cash equivalents—Beginning of period	17,010	32,881
Cash and cash equivalents—End of period	$ 79,972	$ 17,010

A firm applies these criteria in the context of its own operations and to similar firms in the same industry, taking into consideration the environment in which the entities operate. Thus, an item might be extraordinary for some firms but not for others. Income items that meet all three of these criteria are rarely found in corporate annual reports in the United States.

Example 3

DIMON Inc. was an international dealer of leaf tobacco, with operations in more than 30 countries. Headquartered in Virginia, its major customers included the U.S. cigarette manufacturers. In 2003, DIMON recognized an extraordinary gain of $1.7 million resulting from a claim resolution with the United Nations Compensation Commission. The claim was based on an uncollected trade receivable due from the Iraqi Tobacco Monopoly, generated from transactions that took place with the organization prior to the Iraqi/Kuwait war of 1991.

The income statement for the company reveals the following (amounts in thousands):

	2003
Earnings from Continuing Operations before Extraordinary Items	$26,280
Gain on Settlement of Lawsuit (net of $957 in income taxes)	1,777
Net Earnings	$28,057
Basic Earnings per Share:	
Continuing Operations	$ 0.59
Gain from Lawsuit	0.04
Basic Earnings per Share	$ 0.63

The question for the analyst is whether to include or exclude extraordinary gains and losses in current period earnings when using current earnings to forecast expected future earnings.[7] The response depends on the persistence of these gains and losses for a particular firm. By definition, the analyst can assume that they are infrequent in occurrence and in most cases will exclude them from forecasts of future profitability, focusing instead on income from continuing operations. As with discontinued operations, the income statement reports the amounts net of any tax effects.

In the case of DIMON, the analyst probably should not consider the extraordinary gain on the UN settlement as an ongoing source of earnings because 2003 is the only year in the last three years that DIMON reported such a gain or loss. Furthermore, the claim settlement relates to an event that occurred more than ten years earlier than the period in which the gain is reported.

DIMON includes the cash provided by the settlement in cash flow from operations in the statement of cash flows (not reported here). Consistent with excluding this extraordinary gain from earnings when using it to assess future profitability, the analyst should exclude the cash provided by the settlement when forecasting future cash flow from ongoing operations. However, eliminating the amount from the statement of cash flows entirely results in the change in cash on the cash flow statement not reconciling with the change in cash on the balance sheet. This would be inappropriate. If the company has not done so, as is the case with DIMON, the analyst might create a separate section of operating cash flows for unusual or extraordinary items and reclassify the cash provided by the settlement there. This was the approach that Bowne followed with respect to its discontinued operations in

[7] Note that for DIMON, regardless of the decision to adjust for the extraordinary gain for assessing persistent earnings, the gain has real economic content for 2003. That is, the gain positively affects current period performance, regardless of whether it recurs.

Example 2 (Exhibit 9.2). When calculating financial ratios that use cash flow from operations, the analyst should use cash flow from ongoing operations only.

In 2005, DIMON, Inc., merged with another world leader in tobacco processing, Standard Commercial Corporation, to form Alliance One International. Examination of the consolidated financial statements of Alliance One through its 2009 fiscal year-end indicates no additional extraordinary item disclosures, lending support to the idea that such items are nonrecurring.

Extraordinary item treatment is indeed rare. Losses from the events of September 11 and Hurricane Katrina were not considered extraordinary. In the case of the September 11 events, standard setters believe that a reliable separation of event-related losses and non-event losses was not possible and thus prohibited extraordinary item treatment. Katrina was not considered to be unusual in nature and infrequent in occurrence given that hurricanes occur regularly in the Gulf Coast region. However, extraordinary items are still reported occasionally. The Mount St. Helens eruption (first eruption in 130 years) was considered extraordinary. Verizon Communications Inc. reported a 2007 extraordinary item for Venezuela's nationalization of one of its unconsolidated affiliates.

Firms reporting under IFRS isolate and describe material, unusual items. However, IFRS does not allow the term *extraordinary* to appear on the face of or in the notes to the financial statements.[8]

Changes in Accounting Principles

For various reasons, firms occasionally change the accounting principles used to generate the financial statements. Sometimes standard setters mandate the changes, while in other cases, firms voluntarily change from one acceptable principle to another. Until recently, U.S. GAAP required firms to recognize the cumulative effect of changing to an alternative accounting principle on net income of the period of the change. The firm reported this cumulative difference (net of taxes) in a separate section of the income statement.[9] Reporting the effects of the change in accounting method in the income statement raised the visibility of the change and increased the likelihood that statement users would not overlook it. However, this reporting resulted in amounts for net income that did not provide sufficient information for forecasting future earnings. Under this cumulative reporting approach, net income of periods prior to the current period was not formally restated to reflect the new method (although pro forma disclosures of the effect on earnings were required when practicable). Also, net income of the current period included the cumulative effect of the change even though it applied to prior periods.

Beginning in 2006, firms following U.S. GAAP must generally report amounts for the current and prior years as if the new accounting principle had been applied all along (termed *retrospective treatment*). The rationale for this reporting is that it results in net income amounts for the current and prior periods measured using the same accounting principles the firm intends to use in future periods, thereby enhancing the information content of reported earnings in forecasting future earnings. This new standard brought U.S. GAAP in line with IFRS.[10]

[8] International Accounting Standards Board, *International Accounting Standard 1*, "Presentation of Financial Statements" (revised 2003).

[9] Accounting Principles Board, *Opinion No. 20*, "Accounting Changes" (1971).

[10] Financial Accounting Standards Board, *Statement of Financial Accounting Standards No. 154*, "Accounting Changes and Error Corrections—A Replacement of APB Opinion No. 20 and FASB Statement No. 3" (2005); *FASB Codification Topic 250*; International Accounting Standards Board, *International Accounting Standard 8*, "Accounting Policies, Change in Accounting Estimates, and Errors" (revised 2003).

Firms need not restate prior-year earnings retrospectively if it is impracticable to determine the period-specific effects of the change or the cumulative effect of the change. In this case, firms must apply the new accounting policy to the balances of assets and liabilities as of the earliest period for which retrospective application is practicable and to make a corresponding adjustment to retained earnings for that period. When it is impracticable for an entity to determine the cumulative effect of applying a change in accounting principle to *all* prior periods to which it relates, firms must apply the new accounting principle as if it were made prospectively from the start of the year of the change.

For example, if a firm switches from the FIFO cost-flow assumption to the LIFO cost-flow assumption for inventories and cost of goods sold, typically it is impracticable to reconstruct the effects of the accounting change on prior years. In this case, the change to the LIFO cost-flow assumption will be applied prospectively (that is, in current and future years) at the start of the year in which the accounting change takes place.

Note that firms following U.S. GAAP will continue to report on their income statements any cumulative effect of accounting changes that occurred before 2006. In other words, some firms will report on their income statements the cumulative effect of changes in accounting principles because the changes were made in years prior to the effective date of Statement No. 154. The following example illustrates both the old and new reporting of accounting changes.

Example 4

Occidental Petroleum Corporation operates in two industry segments. The oil and gas segment explores for, produces, and markets crude oil and natural gas. The chemical segment manufactures and markets basic chemicals, vinyls, and performance chemicals. Both segments require large capital expenditures on property, plant, and equipment to support their operations. Related to these expenditures, Occidental recognizes a liability for any costs it might have to occur to retire the assets, such as costs to dismantle assets or remediate properties at the end of their useful lives.[11]

In its Form 10-K filing for 2003, Occidental states: "The initial adoption of SFAS No. 143 on January 1, 2003 resulted in an after-tax charge of $50 million, which was recorded as a cumulative effect of a change in accounting principles." Occidental discloses the pro forma effects of the accounting change on previously reported income, indicating that net income for 2002 would have been reduced by approximately $21 million, net of tax, and net income for 2001 would have been reduced by approximately $29 million, net of tax.

The top portion of Exhibit 9.3 illustrates how the change to the new accounting principle required by Statement No. 143 was reported by Occidental Petroleum following the cumulative-effect technique prescribed by Opinion No. 20. The bottom portion of the exhibit illustrates how the firm would have reported the accounting change if the retrospective technique had been applied as required currently under Statement No. 154. Note that Statement No. 154 would require an adjustment to income from continuing operations and retained earnings for each year the effect of the change is known. In addition, Occidental would apply the accounting change to the balances of assets and liabilities of each year the effect of the change is known (not reported in Exhibit 9.3). Retained earnings as of the end of 2003 is the same under both approaches because at that point, the total effect of the change has been captured in income.

The FASB continues to issue new reporting standards, and in most cases, the accounting change will be reported retrospectively, which enhances comparability across reporting

[11] Financial Accounting Standards Board, *Statement of Financial Accounting Standards No. 143*, "Accounting for Asset Retirement Obligations" (2001); *FASB Codification Topic 410*. See Chapter 7 for a discussion of these asset retirement obligations.

EXHIBIT 9.3

Occidental Petroleum Company
Reporting Approaches: Opinion No. 20 and Statement No. 154
(amounts in millions)

	2003	2002	2001
Opinion No. 20 Approach			
Income from Continuing Operations	$1,595.0	$1,163.0	$1,179.0
Cumulative Effect of Change			
in Accounting Principle:			
Adoption of Statement No. 143	(50.0)		
Income from Continuing Operations after			
Accounting Change	$1,545.0	$1,163.0	$1,179.0
Retained Earnings, beginning of year	$2,303.0	$1,788.0	$1,007.0
Retained Earnings, end of year	$3,530.0	$2,303.0	$1,788.0
Statement No. 154 Approach			
Pro Forma Restatement of:			
Income from Continuing Operations	$1,595.0	$1,142.0	$1,150.0
Retained Earnings, beginning of year	$2,253.0	$1,759.0	$1,007.0
Retained Earnings, end of year	$3,530.0	$2,253.0	$1,759.0

periods. In its 2008 10-K, Occidental lists all of the new FASB standards issued since 2005 (there are many), describes the basic accounting issue addressed in each new standard, and states that the standards have no material impact on its financial statements. A review of financial statement disclosures for Occidental confirms the absence of material adjustments.

Example 5

In its Note 7, "Pension, Retiree Medical and Savings Plans," to its 2008 Consolidated Financial Statements (see Appendix A), PepsiCo reports a retrospective adjustment to its owners' equity of $39 million, representing the amount by which application of the measurement date provisions of SFAS 158 reduced its shareholders' equity, net of tax. Under SFAS 158, PepsiCo had to change the date when its actuaries determined their assumptions used to measure pension and other postemployment obligations and assets to coincide with the balance sheet date. The financial statement effects of a sudden remeasurement of assets and liabilities might have appeared as a cumulative adjustment in the income statement of the current year under old accounting standards, but under the preferred retrospective treatment of new accounting standards, the cumulative net asset adjustment (net of tax) of the remeasurement is reflected in beginning balances of the equity accounts. Note 7 shows that the $39 million is reflected in the beginning equity balances by reducing retained earnings by $83 million and increasing accumulated other comprehensive income by $44 million. This split adjustment occurs because, as discussed in Chapter 8, some changes in pension and other postemployment benefits-related assets and liabilities are reflected in net income while others are reflected in other comprehensive income. Thus, remeasurement of prior period changes in these assets and liabilities are properly classified in retained earnings and accumulated other comprehensive income. Beginning with the

point in time when the accounting change was made and going forward, PepsiCo uses the new pension assumption determination date in its calculations of pension and other postemployment assets and liabilities.[12]

Firms periodically change reporting principles on a voluntary basis as well. Analysts should examine carefully any voluntary changes in accounting principles made by firms. Such changes may have some bearing on assessing management's attempts to manage earnings upward or downward. We discuss earnings management at the conclusion of the chapter. We also discuss the use of restated data in profitability and risk analysis later in the chapter.

Example 6

Exhibit 9.4 presents Apple Inc.'s filing of Form 10-K/A to amend its Annual Report on Form 10-K for the year ended September 26, 2009, which was filed with the SEC (Securities and Exchange Commission) on October 27, 2009. In the amendment, Apple explains the financial statement effects when it applied new required accounting methods to account for iPhone and Apple TV. Prior accounting methods were conservative in that they required Apple to defer at the time of sale all revenues and expenses related to sales of iPhone and Apple TV and to recognize these revenues and expenses on a straight-line basis over the expected product life because Apple had promised the possibility of free

EXHIBIT 9.4

Apple Inc.'s Explanation of Change in Revenue Recognition Method
Form 10-K/A filed January 25, 2010

As amended by this Form 10-K/A, the Form 10-K reflects the Company's retrospective adoption of the Financial Accounting Standards Board's ("FASB") amended accounting standards related to revenue recognition for arrangements with multiple deliverables and arrangements that include software elements ("new accounting principles"). The new accounting principles permit prospective or retrospective adoption, and the Company elected retrospective adoption. The Company adopted the new accounting principles during the first quarter of 2010, as reflected in the Company's financial statements included in its Quarterly Report on Form 10-Q for the quarter ended December 26, 2009, which was filed with the SEC on January 25, 2010. The new accounting principles significantly change how the Company accounts for certain revenue arrangements that include both hardware and software elements as described further below.

Under the historical accounting principles, the Company was required to account for sales of both iPhone and Apple TV using subscription accounting because the Company indicated it might from time-to-time provide future unspecified software upgrades and features for those products free of charge. Under subscription accounting, revenue and associated product cost of sales for iPhone and Apple TV were deferred at the time of sale and recognized on a straight-line basis over each product's estimated economic life. This resulted in the deferral of significant amounts of revenue and cost of sales related to iPhone and Apple TV. Costs incurred by the Company for engineering, sales, marketing and warranty were expensed as incurred. As of September 26, 2009, based on the historical accounting principles, total accumulated deferred revenue and deferred costs associated with past iPhone and Apple TV sales were $12.1 billion and $5.2 billion, respectively.

[12] Most, but not all, new standards are expected to incorporate retrospective application.

EXHIBIT 9.4 (Continued)

The new accounting principles generally require the Company to account for the sale of both iPhone and Apple TV as two deliverables. The first deliverable is the hardware and software delivered at the time of sale, and the second deliverable is the right included with the purchase of iPhone and Apple TV to receive on a when-and-if-available basis future unspecified software upgrades and features relating to the product's software. The new accounting principles result in the recognition of substantially all of the revenue and product costs from sales of iPhone and Apple TV at the time of sale. Additionally, the Company is required to estimate a standalone selling price for the unspecified software upgrade right included with the sale of iPhone and Apple TV and recognizes that amount ratably over the 24-month estimated life of the related hardware device. For all periods presented, the Company's estimated selling price for the software upgrade right included with each iPhone and Apple TV sold is $25 and $10, respectively. The adoption of the new accounting principles increased the Company's net sales by $6.4 billion, $5.0 billion and $572 million for 2009, 2008 and 2007, respectively. As of September 26, 2009, the revised total accumulated deferred revenue associated with iPhone and Apple TV sales to date was $483 million; revised accumulated deferred costs for such sales were zero.

The Company had the option of adopting the new accounting principles on a prospective or retrospective basis. Prospective adoption would have required the Company to apply the new accounting principles to sales beginning in fiscal year 2010 without reflecting the impact of the new accounting principles on iPhone and Apple TV sales made prior to September 2009. Accordingly, the Company's financial results for the two years following adoption would have included the impact of amortizing the significant amounts of deferred revenue and cost of sales related to historical iPhone and Apple TV sales. The Company believes prospective adoption would have resulted in financial information that was not comparable between financial periods because of the significant amount of past iPhone sales; therefore, the Company elected retrospective adoption. Retrospective adoption required the Company to revise its previously issued financial statements as if the new accounting principles had always been applied. The Company believes retrospective adoption provides the most comparable and useful financial information for financial statement users, is more consistent with the information the Company's management uses to evaluate its business, and better reflects the underlying economic performance of the Company. Accordingly, the Company has revised its financial statements for 2009, 2008 and 2007 in this Form 10-K/A to reflect the retrospective adoption of the new accounting principles. There was no impact from the retrospective adoption of the new accounting principles for 2006 and 2005. Those years predated the Company's introduction of iPhone and Apple TV.

future upgrades and features. The justification for deferral is typically that revenue has not been earned. New standards require Apple to recognize revenue and expenses relating to existing delivered hardware and software at the time of sale and to defer the estimated fair value of the right to receive free future upgrades and features. Apple had a choice of applying the new standards prospectively (in current and future periods) or retrospectively (adjust prior years' results and then use the new standard in current and future periods). Apple chose retrospective application to enhance comparability.

Note the huge amounts involved. Adoption of the new standards increased Apple's revenue by $6.4 billion in 2009, $5.0 billion in 2008, and $483 million in 2007.

Other Comprehensive Income Items

U.S. GAAP and IFRS often require firms to restate certain assets and liabilities to fair value each period even though firms have not yet realized the value change in a market transaction.

As discussed in Chapter 2, the recognition and valuation of these assets and liabilities do not immediately affect net income and retained earnings, but may affect them in future periods. For this reason, standard setters do not require the change in value to be reported as part of net income. These unrealized gains and losses are reported as other comprehensive income for the period and are closed into accumulated other comprehensive income or loss in the shareholders' equity section of the balance sheet.

Under current U.S. GAAP, four balance sheet items receive this accounting treatment: investment securities deemed available for sale, derivatives held as cash flow hedges, pensions and other postemployment benefits, and investments in certain foreign operations. IFRS also permits upward revaluations of tangible fixed assets used in operations. Chapters 6–8 discussed the accounting for each of these items in great detail.

The analyst must decide whether to include the unrealized gains and losses when assessing earnings persistence and predicting future profitability. These gains and losses should be considered part of sustainable earnings when the following conditions hold: (1) such gains and losses closely relate to ongoing operating activities and will likely recur, and (2) measuring the amount of the gain or loss on certain assets is relatively objective when active markets exist to indicate the amount of the value changes. The case against including the unrealized losses in assessments of persistent profitability arises under the following conditions: (1) such gains and losses are not directly related to the firm's ongoing operating activities, (2) the amount of gain or loss that firms ultimately realize when they sell the assets or settle the liabilities will likely differ from the amount reported each period and might reverse in future years prior to disposal or settlement, and (3) measuring the amount of the gain or loss on certain types of assets can be subjective if they are not traded in active markets.

Making accurate predictions of the future period earnings implications of other comprehensive income items is a complex task. The implications ultimately depend on industry characteristics and company strategy and thus make the case for the industry and strategy analysis (see Chapter 1) that form the initial steps in financial statement analysis and valuation.

Consider, for example, the foreign exchange translation gains and losses discussed in Chapter 7. For a U.S. parent, a foreign exchange translation gain reported in other comprehensive income indicates that the foreign currency used for the foreign subsidiaries operations rose in value relative to the U.S. dollar. When the higher translation rate is multiplied by the positive net asset position of the foreign subsidiary, net assets measured in U.S. dollars increases, reflecting an unrealized gain. Is this change in exchange rate temporary? Will it reverse, yielding a loss in the near term (or does it reverse a loss that occurred in a recent period)? What is the company's strategy with respect to the subsidiary? Will large portions of the foreign subsidiary's expected cash flows from assets be realized from use or by sale and the amount remitted to the U.S. parent in cash, thus locking in the exchange rate gain? Alternatively, will the subsidiary move operations to countries with more favorable exchange rates or continue operations in its current location and possibly face higher operating costs? Will it be able to pass the higher operating costs to customers because of its market power? Again, for a given firm, knowledge of industry economics and company strategy is critical in assessing the future earnings implications of movements in foreign exchange rates.

Using large samples to predict future income, academics and practitioners in accounting and finance are currently assessing the general usefulness of fair value changes in assets and liabilities reported as unrealized gains and losses in comprehensive income. Financial statement analysis of individual firms requires the analyst to understand how a given firm's past unrealized gains and losses link to current earnings as a basis for predicting how current unrealized gains and losses link to future earnings. Chapter 10 further illustrates prediction of comprehensive income.

Impairment Losses on Long-Lived Assets

When a firm acquires assets such as property, plant, equipment, and intangible assets, it assumes that it will generate future benefits through their use. This does not always turn out to be the case, however. The development of new technologies by competitors, changes in government regulations, changes in demographic trends, and other factors external to a firm may reduce the future benefits originally anticipated from the assets. As discussed in Chapter 7, firms must assess whether the carrying amounts of long-lived assets are recoverable, and if they are not, the firms must write down the assets to their fair values and recognize an impairment loss in income from continuing operations.

The FASB cites the following events or circumstances as examples that may signal recoverability problems for a long-lived asset or group of assets:

- A significant decrease in the market price of a long-lived asset
- A significant adverse change in the extent or manner in which a long-lived asset is being used or in its physical condition
- A significant adverse change in legal factors or in the business climate that could affect the value of a long-lived asset, including an adverse action or assessment by a regulator
- An accumulation of costs significantly in excess of the amount originally expected for the acquisition or construction of a long-lived asset
- A current-period operating or cash flow loss combined with a history of operating or cash flow losses or a projection or forecast that demonstrates continuing losses associated with the use of a long-lived asset
- A current expectation that, more likely than not, a long-lived asset will be sold or otherwise disposed of significantly before the end of its previously estimated useful life. The term *more likely than not* refers to a level of likelihood that is more than 50 percent.[13]

What is particularly noteworthy about this list is that a firm, in effect, must accrue an impairment when it anticipates that assets previously acquired will no longer provide the future benefits initially anticipated. This is a valuable disclosure for the analyst attempting to assess a firm's past strategic decisions.

Firms must include impairment losses in income before taxes from continuing operations. Although asset impairments do not warrant presentation in a separate section of the income statement, such as that given for discontinued operations or extraordinary gains or losses discussed earlier, alternative methods for reporting the losses include a separate line item on the income statement or a detailed note that describes what line item on the income statement includes the impairment losses. Because impairment charges are often reported with restructuring charges, both phenomena are discussed further in the next section.

Restructuring and Other Charges

Firms may decide to remain in a segment of their business but elect to make major changes in the strategic direction or level of operations of that business.[14] In many of these cases,

[13] *FASB Codification Topic 360 (-10-35-21);* Also, see Hugo Nurnberg and Nelson Dittmar, "Reporting Impairments of Long-Lived Assets: New Rules and Disclosures," *Journal of Financial Statement Analysis* (Winter 1997), pp. 37–50. The article includes examples of how these impairment indicators are applied by firms in the oil and gas, restaurant, retail food, and service-related industries.

[14] If the firm decides to abandon a business segment or component altogether, the reporting policies discussed earlier for discontinued operations apply. In many cases, however, firms are not abandoning current areas of business, but are "restructuring" them to improve profitability.

firms record a restructuring charge against earnings for the cost of implementing the decision. Employee-related costs from downsizing or employee retraining and reassignment typically make up a substantial portion of restructuring costs. Restructuring plans also tend to trigger asset impairments.

The treatment of restructuring charges in analyzing profitability and assessing earnings persistence is important because recessionary conditions often induce firms to include restructuring charges in their reported earnings for the current period. Whether the recessionary conditions are expected to persist will have a bearing on forecasting earnings in the future. Further, restructurings are expected to yield operating efficiencies or strategic benefits, and thus, may be associated with lower future expenses and higher future revenues. Consistent with this value-added characteristic of restructurings, announcements of restructurings are typically associated with stock price increases.

Interpreting a particular firm's restructuring charge is difficult because firms vary in their treatment of these items, as follows:

- Some firms apply their accounting principles conservatively (for example, use relatively short lives for depreciable assets, immediately expense expenditures for repairs of equipment, or use shorter amortization lives for intangible assets). Such firms have smaller amounts to write off as restructuring charges than if they had applied their accounting principles less conservatively.
- Some firms spread out restructuring charges in an attempt to minimize the impact of the restructuring charge on annual earnings. Such firms often must take restructuring charges for several years to provide adequately for restructuring costs.
- Some firms attempt to maximize the amount of the restructuring charge in a particular year. This approach communicates the "bad news" all at once (referred to as the "big bath" approach) and reduces or eliminates the need for additional restructuring charges in the future. If the restructuring charge later turns out to have been too large, income from continuing operations in a later period includes a restructuring credit that increases reported earnings. Another related concern is that if firms overstate restructuring charges in early years, they create a "cookie jar" reserve that can be accessed in future years (by revising the restructuring liability downward) to offset future negative financial statement items.

The prevalence of restructuring charges in recent years has prompted standard setters to address the measurement and reporting of restructuring charges. Also, U.S. GAAP and IFRS rules differ on the timing of the charges.[15] Under U.S. GAAP, firms record a *restructuring liability* on the balance sheet and the associated *restructuring charge* (an expense) on the income statement when two conditions are present: management has committed to the restructuring plan, and restructuring costs meet the definition of a liability. Recall that a liability is a present obligation (not a planned obligation) that the firm has little or no discretion to avoid. Under IFRS, firms record a *restructuring provision* (a liability) on the balance sheet and the associated *restructuring charge* (an expense) on the income statement when management has committed to the restructuring plan over which it exercises control, has estimated the timing and costs of the restructuring actions, and has notified employees to be terminated under the plan. Because IFRS does not require restructuring costs to meet the definition of a liability, the costs may not be present costs or costs that might be avoided. Therefore, under IFRS rules, firms can recognize restructuring costs and associated liabilities sooner than they can under U.S. GAAP.

[15] Financial Accounting Standards Board, *Statement of Financial Accounting Standards No. 146*, "Accounting for Costs Associated with Exit or Disposal Activities," 2002; *FASB Codification Topic 420*; International Accounting Standards Board, *International Accounting Standard 37*, "Provisions, Contingent Assets and Contingent Liabilities" (1998).

Firms also report "other charges" on the income statement using a variety of different account titles. These other charges have characteristics similar to restructuring charges, but often are not directly related to any strategic decision by the firm or to the level or direction of its operations. The following examples provide illustrations of restructuring and other similar charges.

Example 7

Iomega Corporation (a wholly owned subsidiary of EMC Corporation as of the second quarter of 2008) sells data storage products to consumer and corporate customers. Iomega is a leading manufacturer of portable data storage solutions, including drives and disks, which are used for sharing, transporting, sorting, and backing up critical information.

Employee compensation and associated costs represent one of the largest expenses for Iomega. Other significant expenses include the cost of leased space and depreciation of furniture and fixtures. In its 2004 annual filing, Iomega provided an extensive note on the composition of its restructuring charges for 2003 and 2004, including amounts for employee severance packages, lease termination fees, and furniture write-offs. An excerpt from Note 5, "Restructuring Charges/Reversals," states the following:

> *2004 Restructuring Actions.* During 2004, the Company recorded $3.7 million of restructuring charges for the 2004 restructuring actions, including $2.6 million of cash charges for severance and benefits for 108 regular and temporary personnel worldwide (approximately 19% of the Company's worldwide workforce) who were notified by September 26, 2004 that their positions were being eliminated, $0.7 million of cash charges for lease termination costs and $0.4 million of non-cash charges related to excess furniture. All of the $3.7 million of restructuring charges recorded during 2004 are being shown as restructuring expenses as a component of operating expenses. None of these restructuring charges were allocated to any of the business segments.

> *2003 Restructuring Actions.* The $14.5 million of charges for the 2003 restructuring actions included $6.5 million for severance and benefits for 198 regular and temporary personnel worldwide, or approximately 25% of the Company's worldwide workforce, $3.0 million to exit contractual obligations, $2.6 million to reimburse a strategic supplier for its restructuring expenses, $1.8 million for lease termination costs and $0.6 million related to excess furniture.

Note that Iomega does not disclose the tax savings resulting from the charges for either year. These tax savings are deferred tax assets until the related restructuring liabilities are paid and a deduction is taken on the corporate tax return. Also note that the firm discloses the cash component of the charges for 2004 but not for 2003. The restructuring charges for Iomega also appear to be recurring in nature. Although not reported here, Iomega had a restructuring charge in 2002 as well. Thus, when forecasting future profitability, the analyst appears justified in including them (and related estimated tax effects) in income from continuing operations. Iomega continued to show restructuring charges in future years. It reported $5.7 million in 2005 and $3.0 million in 2006. Iomega did not report a restructuring charge in 2007, the year prior to EMC Corporation acquiring it.

Example 8

Refer to Note 3, "Restructuring and Impairment," of PepsiCo's annual report (Appendix A). During 2008, PepsiCo reported a $543 million charge ($408 million after tax) associated with its Productivity for Growth Program. PepsiCo links the charge with specific income statement accounts, a disclosure that benefits analyses such as the common-size income

statements illustrated in Chapter 4. PepsiCo reports that the pretax charge is split between selling, general, and administrative expense ($455 million) and cost of sales (the remaining $88 million). A substantial portion of the restructuring charge comes from asset impairments ($149 million). In 2007, PepsiCo reported an additional $102 million restructuring charge ($70 million after tax), of which $57 million came from asset impairments. In 2006, PepsiCo reported a $63 million restructuring charge ($43 million after tax), of which $43 million relates to asset impairments. Finally, PepsiCo reports another $83 million ($55 million after tax) as a 2005 restructuring charge. It appears reasonable to expect that PepsiCo will continue its restructuring activities in the future, although it is likely that the activities will eventually cease. Therefore, it is difficult to reach a definitive conclusion about whether to view PepsiCo's restructuring charges as a part of sustainable earnings. As mentioned earlier, restructuring activities are now common for many firms.

Changes in Estimates

As discussed earlier in this chapter, application of accounting standards requires firms to make many estimates. Examples include the amount of uncollectible accounts receivable; the depreciable lives for fixed assets; the percentage of completion rate for a long-term project; the return rate for warranties; and interest, compensation, and inflation rates for pensions, health care, and other retirement benefits.

Firms periodically change these estimates. The amounts reported in prior years for various revenues and expenses will differ from the amount suggested by the new estimates. Standard setters view making and revising estimates as an integral and ongoing part of applying accounting principles. They are concerned about the credibility of financial statements if firms restate their prior financial statements each time they change an accounting estimate. Therefore, current accounting standards require firms to account for changes in estimates by using the new estimates in the current year and in future years.

Because new estimates alone can change current period income, analysts should attempt to determine whether estimate changes are significant. However, often analysts must infer the impact of changes in estimates. For example, Chapter 7 provided a formula for computing average useful lives of depreciable assets. If an analyst detects an increase in average useful lives in a year in which reported earnings barely exceeded expectations, the analyst could recompute depreciation expense using the prior year's average useful life to detect whether the depreciation difference drove the increase in current period earnings. Likewise, analysts can monitor changes in estimated bad debts expense by reviewing the ratio of bad debts expense to sales. Whenever possible, analysts should compare estimated to realized amounts through time to assess the extent of management's changes in estimates through time and to determine whether trends will continue. For example, the notes to Harley Davidson, Inc.'s financial statements disclose the estimated warranty liability and actual warranty costs for consecutive years.

When engaging in this analysis, the analyst must remember that estimates change over time for legitimate reasons. One of the main determinants of the value of accrual-based financial statements is that the amounts of reported assets and liabilities can reflect management's beliefs. Again, knowledge of a company's industry economics and strategy allows for a more informed judgment of whether an estimate change is warranted.

Gains and Losses from Peripheral Activities

Firms often enter into transactions that are peripheral to their core operations but generate gains and losses that must be reported on the income statement. For example, to create,

manufacture, and market products, firms generally need to invest in assets such as buildings and equipment. When a firm decides to sell and replace such assets, the sale usually results in a gain or loss. Similar to restructuring charges, gains and losses from activities peripheral to the primary activities of a firm are included in income from continuing operations. The analyst should search for such items and decide whether to exclude them when assessing current profitability and forecasting future earnings.

Example 9

Bowne & Co., first discussed in Example 2, is one of the largest financial printers in the United States. Note that Bowne's income statement, reported in Exhibit 9.2, includes a "gain on sale of building" for $896,000 in 2004. Bowne provides the following information on the sale in Note 9 of its annual report:

> In May 2004, the Company sold its financial printing facility in Dominguez Hills, California for net proceeds of $6,731,000 recognizing a gain on the sale of $896,000 during the quarter ended June 30, 2004. The Company moved to a new leased facility in Southern California in September of 2004.

Exhibit 9.2 includes excerpts from Bowne's consolidated statement of cash flows as well. The $896,000 gain is eliminated from cash flows from operations (reported as a subtraction from operating cash flows in the exhibit), with the $6,731,000 proceeds reported as part of cash flows from investing activities (included in the total cash flows provided by investing activity of $148,200,000 reported in Exhibit 9.2).

While such gains and losses affect the firm's current period earnings, the analyst must assess whether the gains and losses are sustainable, although peripheral to the firm's operations, and thus whether to include them in income from continuing operations. In many cases, even though the gains and losses do not relate to the sale of the firm's principal products and services, such gains and losses recur and should enter into estimates of future earnings. Of course, firms that rely heavily on such gains and losses for their earnings will not likely survive for long. Thus, a large percentage of reported earnings comprising gains and losses from peripheral activities might signal the need to revise downward the estimates of sustainable earnings.

Similar to impairment and restructuring charges, firms report peripheral gains and losses on a *pretax* basis. Income tax expense includes any tax effects of the gain or loss. If the analyst decides to eliminate the gain or loss from income from continuing operations, he or she also must eliminate the related tax effect from income tax expense using specific information disclosed about the tax effects or using the statutory rate if the firm does not disclose specific information about the tax effects.

Example 10

Gains and losses can be recurring, material, and a part of corporate strategy. Singapore Airlines, for example, reports the following surplus (gains) on disposal of aircraft, spare parts, and spare engines over the 2003–2008 period (dollar amounts in millions):

Fiscal Year	Surplus on Disposal	Pretax Income	Percentage of Pretax Income
2003–2004	$102.7	$ 820.9	12.5%
2004–2005	$215.2	$1,829.4	11.7%
2005–2006	$115.7	$1,662.1	6.9%
2006–2007	$237.9	$2,284.6	10.4%
2007–2008	$ 60.6	$1,198.6	5.0%

Singapore Airlines maintains a reputation for flying newer, technologically advanced aircraft, which results in the use of aircraft for fewer years than other airlines. Thus, the sale of aircraft and spare parts is a significant portion of Singapore Airline's profitability and should be treated as recurring when forecasting future earnings.

Summary of Accounting Data Adjustments

This section discussed the reporting of various types of special events and conditions related to earnings. A large set of factors were identified that may affect the quality of the accounting information as a predictor of future sustainable earnings. The nature and extent of adjustments made to current earnings in order to use it as a predictor requires knowledge of the industry, the firm and its strategy, and the required financial reporting. The process is more art than science and requires considerable judgment on the part of the analyst. The ability to make good judgment is enhanced by understanding the industry economic characteristics and firm strategy.

RESTATED FINANCIAL STATEMENT DATA

High-quality financial statement data enables the analyst to compare financial statement data across years for any firm. Comparability of data is crucial for effective time-series analysis, a technique used by analysts to judge trends over time and forecast future earnings and cash flows. Standard setters also recognize the importance of comparability, and on implementation of Statement No. 154 as discussed earlier in the chapter, firms retroactively apply new accounting principles unless it is impracticable to determine the cumulative effect or the period-specific effects of the change.

A firm also restates the financial statements of prior years when it decides to discontinue a particular line of business, even though the firm had included this income in continuing operations in income statements originally prepared for these years. The firm also may reclassify the net assets of the discontinued business as of the end of the preceding year to a single line, Net Assets of Discontinued Business, even though these net assets appeared among individual assets and liabilities in the balance sheet originally prepared for the preceding year.

The analyst must decide whether to use the financial statement data as originally reported for each year or as restated to reflect the new conditions. Because the objective of most financial statement analysis is to evaluate the past as a guide for projecting the future, the logical response is to use the restated data.

However, the analyst encounters difficulties when using restated data. In their annual reports, most companies include balance sheets for two years and income statements and statements of cash flows for three years. Analysts can calculate ratios and perform other analyses based on balance sheet data (such as current assets/current liabilities or long-term debt to shareholders' equity) on a consistent basis for only two years. Analysts can calculate ratios based on data from the income statement (for example, cost of goods sold/sales) or from the statement of cash flows (for example, cash flow from operations/capital expenditures) for three years at most on a consistent basis. However, many important ratios and other analyses rely on data from the balance sheet and either the income statement or the statement of cash flows. For example, the rate of return on common shareholders' equity equals net income to common shareholders divided by average common shareholders' equity. The denominator of this ratio requires two years of balance sheet data. Thus, it is possible to calculate comparable ratios based on average restated data from the balance sheet and one of the other two financial statements for only one year under the new conditions.

The analysts could obtain balance sheet amounts for prior years from earlier annual reports, but reliance on the earlier reports results in comparing restated income statement or statement of cash flow data with non-restated balance sheet data for those earlier years. The analyst should evaluate the likely magnitude of the effect of the restatement on ratios using prior years' data. In Example 6, Apple Inc.'s 10-K/A restated revenues and net income for the years 2009, 2008, and 2007. Also, Apple disclosed that the restatement effects on earlier years were immaterial due to limited revenues from iPhone sales prior to 2007.

When a firm provides sufficient information so that the analyst can restate prior years' financial statements using reasonable assumptions, the analyst should use retroactively restated financial statement data. When the firm does not provide sufficient information to do the restatements, the analyst should use the amounts as originally reported for each year. To interpret the resulting ratios, the analyst attempts to assess how much of the change in the ratios results from the new reporting condition and how much relates to other factors. Clearly, restatements can create significant interpretation issues when analyzing historical financial data.

ACCOUNTING CLASSIFICATION DIFFERENCES

Accounting classification differences across firms also affect comparability analysis. Firms frequently classify items in their financial statements in different ways. When the analyst is comparing two or more companies, it is important that he or she obtain comparable data sets. If that is not possible, the analyst must understand the significant differences in accounting classifications across firms. A scan of the financial statements should permit the analyst to identify significant differences that might affect the analysis and interpretations.

Example 11

Exhibit 9.5 presents the Consolidated Income Statement from the 2009 Annual Financial Report of the Finnish company Stora Enso, prepared in accordance with IFRS. Stora Enso is a global paper, packaging, and wood products company that produces newsprint and book paper, magazine paper, fine paper, consumer board, industrial packaging, and wood products. Stora Enso's sales totaled EUR 8.9 billion in 2009. The company has approximately 27,000 employees in more than 35 countries worldwide.

Typical of the financial statements for a non-U.S. company, Stora Enso classifies expenses by source instead of function. For example, a U.S. paper company includes as operating expenses cost of goods sold, SG&A (selling, general, and administrative) expenses, possibly some other gains and losses, restructuring charges, and impairments. Wages and salary costs and depreciation costs are allocated to cost of goods sold and SG&A expenses. Cost of goods sold includes the costs allocated to inventory sold that period, such as wages and depreciation (that is, manufacturing overhead) costs, as well as materials costs. Wages, salaries, and depreciation not related to production appear in SG&A. In contrast, Stora Enso does not make those allocations. For example, "Personnel expenses" are listed, but one does not know the portion of those expenses that would be included in inventory and therefore included in cost of goods sold in the U.S. company. Likewise, Stora Enso reports "Depreciation, amortization, and impairment charge," which is different from what is done in the U.S. reporting approach. Instead of cost of goods sold, Stora Enso reports "Materials and services" and "Changes in inventories of finished goods and work in progress." An analyst estimating cost of goods sold would have to include these two accounts, an estimated portion of personnel expenses to be included in inventory, and an estimated portion of depreciation to be included in inventory.

EXHIBIT 9.5

Stora Enso 2009 Annual Report
Consolidated Income Statement

EUR million	Year Ended 31 December		
	2009	2008	2007
Continuing Operations			
Sales	**8 945.1**	**11 028.8**	**11 848.5**
Other operating income	172.8	120.2	88.4
Change in inventories of finished goods and work in progress	(200.5)	(76.1)	81.0
Change in net value of biological assets	(3.3)	(18.2)	7.5
Materials and services	(5 464.3)	(6 815.7)	(7 051.5)
Freight and sales commissions	(833.6)	(1 127.1)	(1 133.9)
Personnel expenses	(1 349.6)	(1 669.1)	(1 712.9)
Other operating expenses	(833.1)	(752.6)	(761.9)
Share of results in equity accounted investments	111.8	7.6	341.3
Depreciations, amortisation and impairment changes	(1 152.9)	(1 422.4)	(1 529.6)
Operating (Loss)/Profit	**(607.6)**	**(726.6)**	**176.9**
Financial income	209.3	356.7	161.9
Financial expense	(488.5)	(523.9)	(318.6)
(Loss)/Profit before Tax	**(886.8)**	**(893.8)**	**20.2**
Income tax	8.6	214.8	(7.4)
Net (Loss)/Profit for the Year from Continuing Operations	**(878.2)**	**(679.0)**	**12.8**
Discontinued Operations Profit/(Loss) after Tax for the Year	—	4.3	(225.2)
Net (Loss) for the Year from Total Operations	**(878.2)**	**(674.7)**	**(212.4)**
Attributable to:			
Equity holders of the Parent Company	(879.7)	(673.4)	(214.7)
Non-controlling interests	1.5	(1.3)	2.3
Net (Loss) for the Year	**(878.2)**	**(674.7)**	**(212.4)**
Earnings per Share			
Basic & diluted (loss) per share, Total Operations, EUR	(1.12)	(0.85)	(0.27)
Basic & diluted (loss)/earning per share, Continuing Operations, EUR	(1.12)	(0.86)	(0.01)

When the analyst can easily and unambiguously reclassify accounts, the reclassified data should serve as the basis for analysis. If the reclassifications require numerous assumptions, the analyst should make them as precisely as possible or avoid making them and note the differences in account classification for further reference when interpreting the financial statement analysis.

FINANCIAL REPORTING WORLDWIDE

Thus far, we have identified many accounting quality and comparability issues. The concerns discussed in the chapter to this point apply equally to firms that follow reporting systems employed outside the United States, such as IFRS. However, important additional concerns also exist in comparing financial data for firms that operate in different countries.

Cross-national analysis of firms entails a two-step approach:

1. Achieve comparability of the reporting methods and accounting principles employed by the firms under scrutiny.
2. Understand corporate strategies, institutional structures, and cultural practices unique to the countries in which the firms operate.

Beginning in 2005, the financial statements of firms in the European Community were required to conform to IFRS pronouncements. In addition, the convergence of IFRS and U.S. GAAP will be central to achieving worldwide conformity of financial reporting. The IASB and FASB pledged to use their best efforts to make existing U.S. and IASB standards fully compatible as soon as practicable and to coordinate their future work programs to ensure that once achieved, compatibility is maintained. Statement No. 154, for example, is the result of close collaboration between the IASB and FASB.

In past years, firms headquartered outside the United States that have debt or equity securities traded in U.S. capital markets were required to file a Form 10-K using U.S. GAAP or a Form 20-F report with the SEC each year. The Form 20-F report included a reconciliation of shareholders' equity and net income as reported under IFRS or GAAP of the firm's local country with GAAP in the United States. With this information, the analyst could convert the financial statements of a non-U.S. firm to achieve comparable accounting principles with U.S. firms.

Preparation of the reconciliation—essentially requiring a foreign filer in the United States to maintain two sets of financial records—is a costly endeavor and a potential deterrent to companies interested in listing on U.S. exchanges. Thus, on November 15, 2007, the SEC relaxed the reporting requirements of non-U.S. filers and began to accept financial reports prepared in accordance with IFRS as legislated by the IASB without reconciliation to U.S. GAAP. In effect on March 4, 2008, the new rule (SEC Final Rule No. 33-8879) provides U.S. investors with two sets of accounting principles—IFRS and U.S. GAAP. The elimination of the reconciliation is a controversial issue because research suggests that material differences between IFRS and U.S. GAAP remain, and eliminating the reconciliation could diminish the relevant information set available to investors in the U.S. and around the world.[16]

Example 12

What did a Form 20-F reconciliation look like? Exhibit 9.6 presents the reconciliations for 2001 through 2003 for Ericsson, a Swedish manufacturer of cell phones. Ericsson provides extensive discussion of each reconciling item in its Form 20-F filing in Note 32, "Reconciliation to Accounting Principles Generally Accepted in the United States." In fact, the note is more than five pages long.

Achieving comparability in reporting is important to the analysis of multinational firms, but the data must be carefully interpreted. Analysis of multinational firms is complicated by the fact that the environments in which the firms operate may vary extensively

[16] Not all firms domiciled in non-U.S. locations use IFRS. Many are required to file legal-based financial statements using home-country standards or IFRS modified for local laws or preferences, and thus would be required to reconcile to U.S. GAAP if listed on U.S. exchanges.

EXHIBIT 9.6

Form 20-F Reconciliations for Ericsson
(amounts in millions)

	2003	2002	2001
Adjustments to Shareholders' Equity			
Reported Shareholders' Equity	SEK 60,481	SEK 73,607	SEK 68,587
Capitalization of Software	6,409	11,652	16,502
Capitalization of Interest Expense	133	172	211
Pensions	(299)	440	99
Goodwill	2,700	1,064	—
Hedging	3,509	2,744	(2,196)
Restructuring Costs	1,442	217	1,458
Sale-Leaseback	(1,381)	(2,063)	(2,176)
Deferred Taxes	(3,347)	(4,021)	(4,487)
Other	316	(609)	(197)
Stockholders' Equity According to U.S. GAAP	SEK 69,963	SEK 83,203	SEK 77,801
Adjustments to Net Income			
Reported Net Loss	SEK (10,844)	SEK (19,013)	SEK (21,264)
Restructuring Costs	1,225	(1,240)	(1,642)
Capitalization of Software Development Costs	(5,153)	(4,940)	(2,135)
Goodwill Amortization	1,636	1,064	—
Pensions	(840)	459	1,006
Hedging	1,603	2,884	(2,233)
Sale-Leaseback	682	113	(815)
Deferred Income Taxes	533	966	2,042
Other	561	(211)	638
Net Income According to U.S. GAAP	SEK (10,597)	SEK (19,918)	SEK (24,403)

across countries. A firm may implement operational strategies in its home country that it cannot implement in other countries. Institutional arrangements, such as significant alliances with banks and extensive intercorporate holdings, may be common in one country but not in another. Cultural characteristics may exist in one country that affect how firms do business in that country—with those same characteristics foreign to other business settings.

For example, in a study addressing comparability of Japanese and U.S. financial reporting, Herrmann, Inoue, and Thomas identify the following environmental characteristics that may influence interpretation of the data:

- Profitability ratios often are more conservative in Japan, attributable in part to the close link between tax and financial reporting systems.
- Japanese companies often have higher debt ratios. High debt ratios are sometimes considered a sign of financial strength because debt is the primary source of capital.

- The corporate group is different in Japan in that Japanese grouping is often based on bank dependence, intercompany loans, mutual shareholding, preferred business transactions, and multiple personal ties.[17]

Herrmann, Inoue, and Thomas stress that environmental factors unique to Japan may influence the financial data reported by Japanese firms in such a way that the data, although comparable to data reported by U.S. firms once the necessary adjustments are made, can be effectively interpreted only when taking these unique factors into consideration.

Other countries have their own unique environmental and business practices. When analyzing multinational firms, the analyst needs to incorporate these factors into his or her interpretation of the data and understand that although the data may be comparable from a measurement perspective, they may not be comparable on other dimensions.

EARNINGS MANAGEMENT

The chapter concludes with a discussion of earnings management because the concepts of accounting quality and earnings management often are linked in a discussion of the need to adjust financial data to better reflect the economic information content of financial data.

As with other concepts discussed in this chapter, earnings management connotes different things to different users of the term.[18] Healy and Wahlen (1999) provide the following definition of earnings management:

> Earnings management occurs when managers use judgment in financial reporting and in structuring transactions to alter financial reports to either mislead some stakeholders about the underlying economic performance of the company or to influence contractual outcomes that depend on reporting accounting numbers.[19]

Chapters 6–9 establish that choices, judgments, and estimates are a necessary part of the reporting process. Healy and Wahlen recognize this and define earnings management as the use of these inherent aspects of the reporting model to mask the underlying economic performance of a firm. Any judgments employed by management that result in lower economic information content of the financial reports (and provide a skewed basis for making decisions) are probably the result of a firm practicing earnings management.

Detecting earnings management is difficult because managers can exercise judgment in financial reporting in so many ways. Moreover, earnings management often creates the same financial statement outcome as fundamental economic growth (for example, increasing sales and receivables). One of the objectives in Chapters 6–8 is to illustrate the judgments that firms must make to apply accounting principles so that the analyst can better discern whether a firm is engaging in earnings management.

Incentives to Practice Earnings Management

Incentives to engage in earnings management exist if use of the choices and estimates allowed in U.S. GAAP or IFRS creates degrees of freedom for optimal contracting and

[17] Don Herrmann, Tatsuo Inoue, and Wayne Thomas, "Are There Benefits to Restating Japanese Financial Statements According to U.S. GAAP?" *Journal of Financial Statement Analysis* (Fall 1996), pp. 61–73.

[18] As Chapter 5 notes, earnings management also is linked at times with earnings manipulation, a topic discussed in that chapter and defined as "preparing financial reports based on reporting techniques outside the limits of GAAP."

[19] Paul M. Healy and James M. Wahlen, "A Review of the Earnings Management Literature and Its Implications for Standard Setting," *Accounting Horizons* (December 1999), pp. 365–383.

resource allocation for the benefit of the firm and its stakeholders. Examples of such reason for earnings management include the following:

- To create optimal manager compensation payments under compensation contracts
- To create optimal job security for senior management
- To create optimal lending environments and to mitigate potential violation of debt covenants
- To influence short-term stock price performance and wealth resource allocation over time
- To minimize/manage reported earnings to thwart industry-specific actions and antitrust actions against the firm

Disincentives to Practice Earnings Management

Managers may be deterred from engaging in earnings management for the following reasons:

- Earnings and cash flows over the life of the firm agree, so firms cannot manage earnings forever. Eventually, earnings aggressively reported in early years must be offset by lower earnings or even losses in later years to compensate.
- Capital markets and regulators such as the SEC penalize firms identified as flagrant earnings managers.
- Firms and managers who are perceived as practicing aggressive earnings management will lose their reputation for being honest and trustworthy among capital market participants and stakeholders.
- Legal consequences can result from aggressive earnings management as well as from earnings management that reverts to earnings manipulation and fraud.[20]
- Firms and managers can use aggressive earnings management to manipulate contracts and stakeholders' claims that depend on reported earnings numbers, thereby creating inefficient or opportunistic capital allocation. For example, managers can use earnings management to manipulate their compensation.

A review of these conditions indicates that the analyst is best served by increasing his or her effort of accounting quality analysis when these conditions are present.

Boundaries of Earnings Management

It is important to note that earnings management has boundaries. Securities regulations and stock exchanges require annual audits by independent accountants. Auditors can monitor particularly aggressive actions taken by management to influence earnings, although an auditor's power to thwart actions taken within the bounds of GAAP is limited. In addition, the ongoing scrutiny of financial analysts and investors serves as a check on earnings management. Security analysts typically follow several firms in an industry and have a sense of the corporate reporting "personalities" and strategies of various firms. The frequency, timeliness, and quality of management's communications with shareholders and analysts signal the forthrightness of management and the likelihood of earnings being highly managed.[21]

[20] Messod D. Beneish, "Detecting GAAP Violation: Implications for Assessing Earnings Management among Firms with Extreme Financial Performance," *Journal of Accounting and Public Policy* (1997), pp. 271–309; "The Detection of Earnings Management," *Financial Analyst Journal* (September/October 1999), pp. 24–36.

[21] Mark H. Lang and Russell J. Lundholm, "Corporate Disclosure Policy and Analyst Behavior," *Accounting Review* (October 1996), pp. 467–492.

The analyst's task is to identify situations in which earnings management is possible and the avenues management might pursue in those situations to carry out earnings management. Understanding when GAAP provides flexibility to manage earnings should permit the analyst to distinguish high economic information content from what some call "cosmetic" (that is, earnings-managed) content of the reported data.

SUMMARY

The financial analysis framework discussed in Chapters 1–5 and the discussion of forecasting and valuation presented in Chapters 10–14 assume that a firm's reported financial statement data accurately reflect the economic effects of a firm's decisions. Another assumption is that the financial data are informative about the firm's likely future profitability and risk. This chapter develops the concept of accounting quality as the basis for assessing the information content of reported financial statement data and for adjusting that data before assessing a firm's profitability and risk or forecasting or valuing the firm.

The illustrations in this chapter identify items that are part of the current period's performance but may not recur in future years. The chapter indicates adjustments the analyst might make to eliminate the effect of such items from forecasts of future earnings.

The chapter concludes with a discussion of earnings management and the conditions that can trigger earnings management. The concepts of accounting quality and earnings management often are linked in discussions of the need to adjust financial data to better reflect the economic information content of financial data.

QUESTIONS, EXERCISES, PROBLEMS, AND CASES

Questions and Exercises

9.1 CONCEPT OF EARNINGS QUALITY. The concept of earnings quality has several dimensions, but two characteristics often dominate: the accounting information should be a fair representation of performance for the reporting period, and it should provide relevant information to forecast expected future earnings. Provide a specific example of poor earnings quality that would hinder the forecasting of expected future earnings.

9.2 RESTATING EARNINGS FOR LITIGATION LOSS. Rock of Ages, Inc., is the largest integrated granite quarrier, manufacturer, and retailer of finished granite memorials and granite blocks for memorial use in North America. The firm reported a net loss for 2004 of $3.2 million. In 2004, the firm reported a pretax litigation settlement loss of $6.5 million, and management stated that, in its opinion, the litigation settlement loss did not reflect the current year's operations because it was the first year in five years that the firm reported such a loss. Calculate pro forma earnings for 2004 excluding the settlement costs and speculate on management's reasoning as to why it believes that pro forma earnings is a better measure of performance for Rock of Ages. State any assumptions you make in your calculations.

9.3 CONCEPT OF EARNINGS MANAGEMENT. The concept of earnings management connotes different things to different users of the term. Define earnings management. Discuss why it is difficult to discern whether a firm does in fact practice earnings management.

9.4 CRITERIA TO IDENTIFY NONRECURRING ITEMS. The chapter discusses eight accounting and disclosure topics that typically occur infrequently but can have a large

impact on financial statements. What criteria should an analyst employ to assess whether to include or eliminate items from the financial statements related to these eight topics?

9.5 EFFECT OF ALTERNATIVE GAAP ON FINANCIAL STATEMENT ANALYSIS. Nestlé Group, a multinational food products firm based in Switzerland, recently issued its financial statements. The auditor's opinion attached to the financial statements stated the following: "In our opinion, the Consolidated Accounts give a true and fair view of the financial position, the net profit and cash flows in accordance with International Financial Reporting Standards (IFRS) and comply with Swiss law." Note that Nestlé's financial reports are prepared using IFRS standards. One of Nestlé's competitors is PepsiCo, which prepares financial reports following U.S. GAAP. Describe the necessary steps an analyst should consider to develop comparable accounting data when conducting a profitability and risk analysis of these two firms.

9.6 REPORTING IMPAIRMENT AND RESTRUCTURING CHARGES. Checkpoint Systems is a global leader in shrink management, merchandising visibility, and apparel labeling solutions. The firm is a leading provider of source tagging, handheld labeling systems, retail merchandising systems, and bar-code labeling systems. In a press release, Checkpoint stated the following:

> GAAP reported net loss for the fourth quarter of 2004 was $29.3 million, or $0.78 per diluted share, compared to net earnings of $4.5 million, or $0.13 per diluted share, for the fourth quarter 2003. Excluding impairment and restructuring charges, net of tax, the Company's net income for the fourth quarter 2004 was $0.30 per diluted share, compared to $0.27 per diluted share in the fourth quarter 2003.

Calculate the amount of the impairment and restructuring charges reported by Checkpoint in 2004 and 2003. Discuss why the firm reported earnings both including and excluding impairment and restructuring charges.

9.7 CONCEPT OF A PERIPHERAL ACTIVITY. Firms often enter into transactions that are peripheral to their core operations but generate gains and losses that must be reported on the income statement. A gain labeled "peripheral" by one firm may not be labeled as such for another firm. Provide an example in which a gain generated from the sale of an equity security may be labeled a peripheral activity by one firm but is considered a core activity by another firm.

9.8 REPORTING IMPAIRMENT CHARGES. Statement No. 144 requires firms to assess whether they will recover carrying amounts of long-lived assets and, if not, to write down the assets to their fair value and recognize an impairment loss in income from continuing operations. Impairment charges often appear as a separate line item on the income statement of companies that experience reductions in the future benefits originally anticipated from the long-lived assets. Conduct a search to identify a firm (other than the examples given in this chapter) that has recently reported an impairment charge. Discuss how the firm (a) reported the charge on the income statement, (b) determined the amount of the charge, and (c) used cash related to the charge.

Problems and Cases

9.9 ADJUSTING FOR UNUSUAL INCOME STATEMENT AND CLASSIFICATION ITEMS. H. J. Heinz is one of the world's leading marketers of branded foods to retail and foodservice channels. According to the firm, Heinz holds the number

one or two branded products in more than 50 world product markets. Among the company's well-known brands are Heinz®, StarKist®, Kibbles 'n Bits®, and 9Lives®. Exhibit 9.7 presents an income statement for Heinz for Year 10, Year 11, and Year 12. Notes to the financial statements reveal the following information:

1. **Gain on sale of Weight Watchers.** In Year 10, Heinz completed the sale of the Weight Watchers classroom business for $735 million. The transaction resulted in a pretax gain of $464.5 million. The sale did not include Weight Watchers® frozen meals, desserts, and breakfast items. Heinz did not disclose the tax effect of the gain reported in Exhibit 9.7.

2. **Accounting change for revenue recognition.** In Year 11, Heinz changed its method of accounting for revenue recognition to recognizing revenue upon the passage of title, ownership, and risk of loss to the customer. The change was driven by a new SEC ruling on revenue recognition. The cumulative effect of the change on prior years resulted in a charge to income of $17 million, net of income taxes of $10 million. Heinz indicated that the effect on Year 11 and prior years was not material.

3. **Sale and promotion costs.** In Year 11, Heinz changed the classification of certain sale and promotion incentives provided to customers and consumers. In the past, Heinz classified these incentives as selling and administrative expenses (see Exhibit 9.7), with the gross amount of the revenue associated with the incentives reported in sales. Beginning in Year 11, Heinz changed to reporting the incentives as a reduction of revenues. As a result of this change, the firm reduced reported revenues by $693 million in Year 12, $610 million in Year 11, and $469 million in Year 10. The firm stated that selling and administrative expenses were "correspondingly reduced such

EXHIBIT 9.7

H. J. Heinz Company
Income Statement
(amounts in millions)
(Problem 9-9)

	Year 12	Year 11	Year 10
Sales	$ 9,431	$ 8,821	$ 8,939
Gain on sale of weight watchers	—	—	465
Cost of goods sold	(6,094)	(5,884)	(5,789)
Selling and administrative expenses	(1,746)	(1,955)	(1,882)
Interest income	27	23	25
Interest expense	(294)	(333)	(270)
Other income (expense)	(45)	1	(25)
Income before Income Taxes and Cumulative Effect of Accounting Changes	$ 1,279	$ 673	$ 1,463
Income tax expense	(445)	(178)	(573)
Income before Cumulative Effect of Accounting Change	$ 834	$ 495	$ 890
Cumulative effect of accounting change	—	(17)	—
Net Income	$ 834	$ 478	$ 890

that net earnings were not affected." Exhibit 9.7 already reflects the adjustments to sales revenues and selling and administrative expenses for Years 10 through 12.

4. **Tax rate.** The U.S. federal statutory income tax rate was 35 percent for each of the years presented in Exhibit 9.7.

Required

a. Discuss whether you would adjust for each of the following items when using earnings to forecast the future profitability of Heinz:
 (1) Gain on sale of Weight Watchers classroom business
 (2) Accounting change for revenue recognition
b. Indicate the adjustment you would make to Heinz's net income for each item in Part a.
c. Discuss whether you believe the reclassification adjustments made by Heinz for the sale and promotion incentive costs (Item 3) are appropriate.
d. Prepare a common-size income statement for Year 10, Year 11, and Year 12 using the amounts in Exhibit 9.7. Set sales equal to 100 percent.
e. Repeat Part d after making the income statement adjustments in Part b.
f. Assess the changes in the profitability of Heinz during the three-year period.

9.10 UNUSUAL INCOME STATEMENT ITEMS. Vulcan Materials Company, a member of the S&P 500 Index, is the nation's largest producer of construction aggregates, a major producer of asphalt mix and concrete, and a leading producer of cement in Florida. Following is a summarized income statement prepared from Vulcan's Consolidated Statement of Earnings for the years ended December 31, 2008, 2007, and 2006.

In thousands	2008	2007	2006
Total revenues	$3,651,438	$3,327,787	$3,342,475
Cost of revenues	2,901,726	2,376,884	2,410,571
SG&A	342,584	289,604	264,276
Goodwill impairment	252,664	—	—
Loss (gain) on sale of property, plant & equipment and businesses, net	(94,227)	(58,659)	(5,557)
Other operating (income) expense, net	(411)	5,541	(21,904)
Total operating expenses, net	3,402,336	2,613,370	2,647,386
Operating earnings	249,102	714,417	695,089
Other income (expense), net	(4,357)	(5,322)	28,541
Interest income	3,126	6,625	6,171
Interest expense	(172,813)	(48,218)	(26,310)
Earnings from continuing operations before income taxes	75,058	667,502	703,491
Provision for income taxes	(76,724)	(204,416)	(223,313)
Earnings from continuing operations	(1,666)	463,086	480,178
Discontinued operations (Note 2)			
Loss from results of discontinued operations	(4,059)	(19,327)	(16,624)
Income tax benefit	1,610	7,151	6,660
Loss on discontinued operations, net of income taxes	(2,449)	(12,176)	(9,964)
Net earnings (loss)	$ (4,115)	$ 450,910	$ 470,214

In Note 2 to the Consolidated Financial Statements, "Discontinued Operations," Vulcan describes a June 2005 sale of substantially all assets of its Chemicals business, known as Vulcan Chemicals, to Basic Chemicals, a subsidiary of Occidental Chemical Corporation. Basic Chemicals assumed certain liabilities relating to the chemicals business, including the obligation to monitor and remediate all releases of hazardous materials at or from the Wichita, Geismar, and Port Edwards plant facilities. The decision to sell the chemicals business was based on Vulcan's desire to focus its resources on the construction materials business. The amounts reported as discontinued operations are not revenues and expenses from Vulcan operating the discontinued segment. Instead, the amounts represent a continual updating of the amount payable by the segment buyer. The receivable held by Vulcan from the sale is dependent on the levels of gas and chemical prices through the end of 2012. Vulcan classifies this financial instrument as a derivative contract that must be marked to market. The derivative does not hedge an existing transaction; therefore, its value changes are reflected in income as part of discontinued operations. As of 2008, Vulcan reported that final gains on disposal (if any) would occur after December 31, 2008.

Goodwill impairment relates to Vulcan's cement segment. Vulcan explains the need for the impairment as arising from the need to increase discount rates due to disruptions in credit markets as well as weak levels of construction activity.

Required

 a. Discuss the appropriate treatment of the following when forecasting future earnings of Vulcan Materials: (1) goodwill impairment; (2) discontinued operations; and (3) loss (gain) on sale of property, plant, and equipment and businesses (net).

 b. Prepare common-size income statements for Vulcan Materials. Interpret changes in profit margin over the three-year period in light of the special items.

9.11 IMPLICATIONS OF A GOODWILL IMPAIRMENT CHARGE FOR FUTURE CASH FLOW AND PROFITABILITY.

Northrop Grumman Corporation is a leading global security company that provides innovative systems products and solutions in aerospace, electronics, information systems, shipbuilding, and technical services to government and commercial customers worldwide. In an early 2009 press release, Northrop reported that it would record a non-cash, after-tax charge of between $3.0 billion and $3.4 billion for impairment of goodwill in its 2008 fourth-quarter income statement. As a result of the charge, Northrop reported net losses for the fourth quarter and all of 2008.

Northrop explained how it determined the impairment as follows: "The company performed its required annual testing of goodwill as of Nov. 30, 2008 using a discounted cash flow analysis supported by comparative market multiples to determine the fair value of its businesses versus their book values. Testing as of Nov. 30, 2008 indicated that book values for Shipbuilding and Space Technology exceeded the fair values of these businesses.... This non-cash charge does not impact the company's normal business operations."

Required

 a. Explain how a company computes a goodwill impairment. Describe the usefulness of discounted cash flow and comparative market multiples in the computation of an impairment.

 b. Explain the consequences of a goodwill impairment for the assessment of (1) current period profitability as measured by ROA, (2) future earnings projections, and (3) future period profitability as measured by ROA.

9.12 RESTRUCTURING CHARGES AT INTEL. Intel Corporation's Consolidated Income Statement from its 2008 Annual Report appears below.

Three Years Ended December 27, 2008 (In Millions, Except Per Share Amounts)	2008	2007	2006
Net revenue	$37,586	$38,334	$35,382
Cost of sales	16,742	18,430	17,164
Gross margin	20,844	19,904	18,218
Research and development	5,722	5,755	5,873
Marketing, general and administrative	5,458	5,417	6,138
Restructuring and asset impairment charges	710	516	555
Operating expenses	11,890	11,688	12,566
Operating income	8,954	8,216	5,652
Gains (losses) on equity method investments, net	(1,380)	3	2
Gains (losses) on other equity investments, net	(376)	154	212
Interest and other, net	488	793	1,202
Income before taxes	7,686	9,166	7,068
Provision for taxes	2,394	2,190	2,024
Net income	$ 5,292	$ 6,976	$ 5,044
Basic earnings per common share	$ 0.93	$ 1.20	$ 0.87

Note 15, which follows, explains the source of the restructuring charges, the breakdown of the charges into employee-related costs and asset impairments, and the balance of the accrued restructuring liability account.

Note 15: Restructuring and Asset Impairment Charges

The following table summarizes restructuring and asset impairment charges by plan for the three years ended December 27, 2008:

(In Millions)	2008	2007	2006
2008 NAND plan	$215	$ —	$ —
2006 efficiency program	495	516	555
Total restructuring and asset impairment charges	$710	$516	$555

We may incur additional restructuring charges in the future for employee severance and benefit arrangements, and facility-related or other exit activities. Subsequent to the end of 2008, management approved plans to restructure some of our manufacturing and assembly and test operations, and align our manufacturing and assembly and test capacity to current market conditions. These actions, which are expected to take place beginning in 2009, include closing two assembly and test facilities in Malaysia, one facility in the Philippines, and one facility in China; stopping production at a 200mm wafer fabrication facility in Oregon; and ending production at our 200mm wafer fabrication facility in California.

2008 NAND Plan

In the fourth quarter of 2008, management approved a plan with Micron to discontinue the supply of NAND flash memory from the 200mm facility within the IMFT manufacturing network. The agreement resulted in a $215 million restructuring charge, primarily related

to the IMFT 200mm supply agreement. The restructuring charge resulted in a reduction of our investment in IMFT of $184 million, a cash payment to Micron of $24 million, and other cash payments of $7 million.

2006 Efficiency Program

The following table summarizes charges for the 2006 efficiency program for the three years ended December 27, 2008:

(In Millions)	2008	2007	2006
Employee severance and benefit arrangements	$151	$289	$238
Asset impairments	344	227	317
Total	$495	$516	$555

The following table summarizes the restructuring and asset impairment activity for the 2006 efficiency program during 2007 and 2008:

(In Millions)	Employee Severance and Benefits	Asset Impairments	Total
Accrued restructuring balance as of December 30, 2006	$ 48	$ —	$ 48
Additional accruals	299	227	526
Adjustments	(10)	—	(10)
Cash payments	(210)	—	(210)
Non-cash settlements	—	(227)	(227)
Accrued restructuring balance as of December 29, 2007	$127	$ —	$127
Additional accruals	167	344	511
Adjustments	(16)	—	(16)
Cash payments	(221)	—	(221)
Non-cash settlements	—	(344)	(344)
Accrued restructuring balance as of December 27, 2008	$ 57	$ —	$ 57

We recorded the additional accruals, net of adjustments, as restructuring and asset impairment charges. The remaining accrual as of December 27, 2008 was related to severance benefits that we recorded within accrued compensation and benefits.

From the third quarter of 2006 through the fourth quarter of 2008, we incurred a total of $1.6 billion in restructuring and asset impairment charges related to this program. These charges included a total of $678 million related to employee severance and benefit arrangements for approximately 11,900 employees, and $888 million in asset impairment charges.

Required

 a. Based on your reading of the note, how would you treat Intel's restructuring charges in the assessment of current profitability and the prediction of future earnings?
 b. Why is the balance of the "accrued restructuring" limited to employee-related costs?

c. Describe the effect on net income of each entry in the "accrued restructuring balance" account reconciliation. (For example, what is the effect of "Additional accruals" on net income?)

d. How do U.S. GAAP and IFRS differ on the rules used to compute the restructuring charge?

EXHIBIT 9.8

General Dynamics Corporation
Balance Sheet
(amounts in millions)
(Problem 9.13)

	Year 9 as Reported	Year 8 as Restated in Year 9 Annual Report	Year 8 as Originally Reported
ASSETS			
Cash and cash equivalents	$ 513	$ 507	$ 513
Marketable securities	432	307	307
Accounts receivable	64	99	444
Contracts in process	1,550	1,474	2,606
Net assets of discontinued businesses	767	1,468	—
Other current assets	329	145	449
Total Current Assets	$3,655	$4,000	$4,319
Property, plant, and equipment, net	322	372	1,029
Other assets	245	300	859
Total Assets	$4,222	$4,672	$6,207
LIABILITIES AND SHAREHOLDERS' EQUITY			
Accounts payable and accruals	$ 553	$ 642	$2,593
Current portion of long-term debt	145	450	516
Other current liabilities	1,250	1,174	—
Total Current Liabilities	$1,948	$2,266	$3,109
Long-term debt	38	163	365
Other noncurrent liabilities	362	263	753
Total Liabilities	$2,348	$2,692	$4,227
Common stock	$ 42	$ 55	$ 55
Additional paid-in capital	—	25	25
Retained earnings	2,474	2,651	2,651
Treasury stock	(642)	(751)	(751)
Total Shareholders' Equity	$1,874	$1,980	$1,980
Total Liabilities and Shareholders' Equity	$4,222	$4,672	$6,207

9.13 USING ORIGINALLY REPORTED VERSUS RESTATED DATA. Prior to Year 8, General Dynamics Corporation engaged in a wide variety of industries, including weapons manufacturing under government contracts, information technologies, commercial aircraft manufacturing, missile systems, coal mining, material service, ship management, and ship financing. During Year 8, General Dynamics sold its information technologies business. During Year 9, General Dynamics sold its commercial aircraft manufacturing business. During Year 9, it also announced its intention to sell its missile systems, coal mining, material service, ship management, and ship financing businesses. These strategic moves left General Dynamics with only its weapons manufacturing business. Financial statements for General Dynamics for Year 9 as reported, Year 8 as restated in the Year 9 annual report for discontinued operations, and Year 8 as originally reported appear in Exhibit 9.8 (balance sheet), Exhibit 9.9 (income statement), and Exhibit 9.10 (statement of cash flows).

Required

a. Refer to the balance sheets of General Dynamics in Exhibit 9.8. Why does the restated amount for total assets for Year 8 of $4,672 million differ from the originally reported amount of $6,207 million?

b. Refer to the income statement for General Dynamics in Exhibit 9.9. Why are the originally reported and restated net income amounts for Year 8 the same (that is, $505 million) when each of the individual revenues and expenses decreased on restatement?

EXHIBIT 9.9

General Dynamics Corporation
Income Statement
(amounts in millions)
(Problem 9.13)

	Year 9 as Reported	Year 8 as Restated in Year 9 Annual Report	Year 8 as Originally Reported
Continuing Operations			
Sales	$ 3,472	$ 3,322	$ 8,751
Operating costs and expenses	(3,297)	(3,207)	(8,359)
Interest income (expense), net	25	4	(34)
Other expense, net	27	(27)	(27)
Earnings before Income Taxes	$ 227	$ 92	$ 331
Income tax credit	21	114	43
Income from Continuing Operations	$ 248	$ 206	$ 374
Discontinued Operations			
Earnings from operations	$ 193	$ 299	$ 131
Gain on disposal	374	—	—
Net Income	$ 815	$ 505	$ 505

EXHIBIT 9.10

General Dynamics Corporation
Statement of Cash Flows
(amounts in millions)
(Problem 9.13)

	Year 9 as Reported	Year 8 as Restated in Year 9 Annual Report	Year 8 as Originally Reported
OPERATIONS			
Income from continuing operations	$ 248	$ 206	$ 374
Depreciation and amortization	56	140	303
(Increase) Decrease in accounts receivable	35	4	(91)
(Increase) Decrease in contracts in process	(76)	(83)	237
(Increase) Decrease in other current assets	(6)	8	13
Increase (Decrease) in accounts payable and accruals	(66)	51	262
Increase (Decrease) in other current liabilities	11	(41)	(469)
Cash flow from continuing operations	$ 202	$ 285	$ 629
Cash flow from discontinued operations	288	324	44
Cash Flow from Operations	$ 490	$ 609	$ 673
INVESTING			
Proceeds from sale of discontinued operations	$ 1,039	$ 184	$ 184
Capital expenditures	(18)	(29)	(82)
Purchase of marketable securities	(125)	(307)	(307)
Other	32	3	56
Cash Flow from Investing	$ 928	$(149)	$(149)
FINANCING			
Issue of common stock	$ 57	$ —	$ —
Repayment of debt	(454)	(11)	(61)
Purchase of common stock	(960)	—	—
Dividends	(55)	(42)	(42)
Other	—	—	(17)
Cash Flow from Financing	$(1,412)	$ (53)	$(120)
Change in Cash	$ 6	$ 407	$ 404
Cash—Beginning of Year	507	100	109
Cash—End of Year	$ 513	$ 507	$ 513

c. Refer to the statement of cash flows for General Dynamics in Exhibit 9.10. Why is the restated amount of cash flow from operations for Year 8 of $609 million less than the originally reported amount of $673 million?

d. If the analyst wanted to analyze changes in the structure of assets and equities between Year 8 and Year 9, which columns and amounts in Exhibit 9.8 would he or she use? Explain.

e. If the analyst wanted to analyze changes in the operating profitability between Year 8 and Year 9, which columns and amounts in Exhibit 9.9 would he or she use? Explain.

f. If the analyst wanted to use cash flow ratios to assess short-term liquidity and long-term solvency risk, which columns and amounts in Exhibit 9.10 would he or she use? Explain.

INTEGRATIVE CASE 9.1

STARBUCKS

Exhibits 1.26–1.28 of Integrative Case 1.1 (Chapter 1) present the financial statements for Starbucks for 2005–2008. Starbucks explains several components of its income during those years in the following notes to the financial statements:

Note 1: Summary of Significant Accounting Policies (selected excerpts)
Long-lived Assets

When facts and circumstances indicate that the carrying values of long-lived assets may be impaired, an evaluation of recoverability is performed by comparing the carrying values of the assets to projected undiscounted future cash flows in addition to other quantitative and qualitative analyses. Upon indication that the carrying values of such assets may not be recoverable, the Company recognizes an impairment loss by a charge to net earnings. The fair value of the assets is estimated using the discounted future cash flows of the assets. Property, plant and equipment assets are grouped at the lowest level for which there are identifiable cash flows when assessing impairment. Cash flows for retail assets are identified at the individual store level. Long-lived assets to be disposed of are reported at the lower of their carrying amount, or fair value less estimated costs to sell. The Company recognized net impairment and disposition losses of $325.0 million, $26.0 million and $19.6 million in fiscal 2008, 2007 and 2006, respectively, due to underperforming Company-operated retail stores, as well as renovation and remodeling activity in the normal course of business. The net losses in fiscal 2008 include $201.6 million of asset impairments related to the US and Australia store closures and charges incurred for office facilities no longer occupied by the Company due to the reduction in positions within Starbucks leadership structure and non-store organization. See Note 3 for further details. Depending on the underlying asset that is impaired, these losses may be recorded in any one of the operating expense lines on the consolidated statements of earnings: for retail operations, these losses are recorded in "Restructuring charges" and "Store operating expenses"; for specialty operations, these losses are recorded in "Other operating expenses"; and for all other operations, these losses are recorded in "Cost of sales including occupancy costs," "General and administrative expenses," or "Restructuring charges."

Asset Retirement Obligations

Starbucks accounts for asset retirement obligations under FASB Interpretation No. 47 ("FIN 47"), "Accounting for Conditional Asset Retirement Obligations—an interpretation of FASB Statement No. 143," which it adopted at the end of fiscal 2006. FIN 47 requires recognition of a liability for the fair value of a required asset retirement obligation ("ARO") when such obligation is incurred. The Company's AROs are primarily associated with leasehold improvements which, at the end of a lease, the Company is contractually obligated to remove in order to comply with the lease agreement. At the inception of a lease with such conditions, the Company records an ARO liability and a corresponding capital asset in an amount equal to the estimated fair value of the obligation. The liability is estimated based on a number of assumptions requiring management's judgment, including store closing costs, cost inflation

rates and discount rates, and is accreted to its projected future value over time. The capitalized asset is depreciated using the convention for depreciation of leasehold improvement assets. Upon satisfaction of the ARO conditions, any difference between the recorded ARO liability and the actual retirement costs incurred is recognized as an operating gain or loss in the consolidated statements of earnings. ARO expense was $6.5 million and $4.2 million, in fiscal 2008 and 2007, respectively, with components included in "Costs of sales including occupancy costs," and "Depreciation and amortization expenses". The initial impact of adopting FIN 47 at the end of fiscal year 2006 was a charge of $27.1 million, with a related tax benefit of $9.9 million, for a net expense of $17.2 million, with the net amount recorded as a cumulative effect of a change in accounting principle on the consolidated statement of earnings for fiscal year 2006. As of September 28, 2008 and September 30, 2007, the Company's net ARO asset included in "Property, plant and equipment, net" was $18.5 million and $20.2 million, respectively, while the Company's net ARO liability included in "Other long-term liabilities" was $44.6 million and $43.7 million, as of the same respective dates.

Insurance Reserves

The Company uses a combination of insurance and self-insurance mechanisms, including a wholly owned captive insurance entity and participation in a reinsurance pool, to provide for the potential liabilities for workers' compensation, healthcare benefits, general liability, property insurance, director and officers' liability insurance and vehicle liability. Liabilities associated with the risks that are retained by the Company are not discounted and are estimated, in part, by considering historical claims experience, demographic factors, severity factors and other actuarial assumptions.

Recent Accounting Pronouncements

In September 2006, the FASB issued SFAS No. 157, "Fair Value Measurements" ("SFAS 157"), which defines fair value, establishes a framework for measuring fair value and expands disclosures about fair value measurements. For financial assets and liabilities, SFAS 157 will be effective for Starbucks first fiscal quarter of 2009. As permitted by FSP-FAS 157-2, SFAS 157 is effective for nonfinancial assets and liabilities for Starbucks first fiscal quarter of 2010. Starbucks believes the adoption of SFAS 157 for its financial assets and liabilities will not have a material impact on the Company's consolidated financial statements and continues to evaluate the potential impact of the adoption of SFAS 157 related to its nonfinancial assets and liabilities.

In February 2007, the FASB issued SFAS No. 159, "The Fair Value Option for Financial Assets and Financial Liabilities" ("SFAS 159"). SFAS 159 permits companies to choose to measure many financial instruments and certain other items at fair value. SFAS 159 will be effective for Starbucks first fiscal quarter of 2009. Starbucks believes the adoption of SFAS 159 will not have a material impact on the Company's consolidated financial statements.

In December 2007, the FASB issued SFAS No. 141 (revised 2007), "Business Combinations" ("SFAS 141R"), which replaces SFAS 141. SFAS 141R establishes principles and requirements for how an acquirer recognizes and measures in its financial statements the identifiable assets acquired, the liabilities assumed, any resulting goodwill, and any non-controlling interest in the acquiree. SFAS 141R also provides for disclosures to enable users of the financial statements to evaluate the nature and financial effects of the business combination. SFAS 141R will be effective for Starbucks first fiscal quarter of 2010 and must be applied prospectively to business combinations completed on or after that date.

In December 2007, the FASB issued SFAS No. 160, "Noncontrolling Interests in Consolidated Financial Statements—an amendment of Accounting Research Bulletin No. 51"

("SFAS 160"), which establishes accounting and reporting standards for noncontrolling interests ("minority interests") in subsidiaries. SFAS 160 clarifies that a noncontrolling interest in a subsidiary should be accounted for as a component of equity separate from the parent's equity. SFAS 160 will be effective for Starbucks first fiscal quarter of 2010 and must be applied prospectively, except for the presentation and disclosure requirements, which will apply retrospectively. The Company is currently evaluating the potential impact that adoption of SFAS 160 may have on its consolidated financial statements.

In March 2008, the FASB issued SFAS No. 161, "Disclosures about Derivative Instruments and Hedging Activities—an amendment of FASB Statement No. 133" ("SFAS 161"), which requires enhanced disclosures about an entity's derivative and hedging activities. SFAS 161 will be effective for Starbucks second fiscal quarter of 2009.

Note 3: Restructuring Charges (selected excerpts)

In January of fiscal 2008, Starbucks began a transformation plan designed to address the deterioration of its US retail business, reduce its global infrastructure costs and position the Company's business for long-term profitable growth. Since the announcement, a number of actions have been initiated, resulting in the recognition of certain exit, impairment and severance costs. The total amount of these restructuring costs recognized in fiscal 2008 was $266.9 million. Certain additional costs from these actions are expected to be recognized in fiscal 2009, nearly all related to US store closures.

US Store Closures—The most significant action was the commitment to close approximately 600 underperforming Company-operated stores in the US market and reduce the number of future store openings. The decision was a result of a rigorous evaluation of the Company-operated store portfolio, and the Company closed the first 205 of these stores during the fourth quarter of fiscal 2008. As a result of the announced store closures and actions taken to date, the Company recognized $206.3 million of restructuring charges in fiscal 2008, comprised of $169.6 million of store asset impairments, lease exit costs of $33.6 million, and severance totaling $3.1 million. The Company expects to complete the remainder of the closures by the end of fiscal 2009, and recognize the total remaining lease exit costs and related severance during that time.

Australia Store Closures—To address the difficulties specific to its Australia market, Starbucks closed 61 Company-operated stores in the fourth quarter of fiscal 2008. As a result of these store closures, the Company recognized $16.9 million of restructuring charges in fiscal 2008, comprised of $1.5 million of store asset impairments, lease exit costs of $11.6 million, and severance totaling $3.8 million. Starbucks continues to have wholly owned operations in Australia but with a more focused presence with 23 Company-operated stores as of September 28, 2008.

Reduction in Force within the Non-store Organization—To address its global cost structure, on July 29, 2008, Starbucks announced the reduction of approximately 1,000 open and filled positions within its leadership structure and its non-store organization. As a result, the Company recognized, in fiscal 2008, $10.7 million in employee termination benefits expense as well as $33.0 million related to consolidation of support facilities, primarily at the corporate headquarters in Seattle.

Note 13: Shareholders' Equity (selected excerpts)
Comprehensive Income

Comprehensive income includes all changes in equity during the period, except those resulting from transactions with shareholders and subsidiaries of the Company. It has two

components: net earnings and other comprehensive income. Accumulated other comprehensive income reported on the Company's consolidated balance sheets consists of foreign currency translation adjustments and the unrealized gains and losses, net of applicable taxes, on available-for-sale securities and on derivative instruments designated and qualifying as cash flow and net investment hedges.

Comprehensive income, net of related tax effects, was as follows (in millions):

Fiscal Year Ended	Sep 28, 2008	Sep 30, 2007	Oct 1, 2006
Net earnings	$315.5	$672.6	$564.3
Unrealized holding gains/(losses) on available-for-sale securities, net of tax (provision)/benefit of $2.4, ($0.2) and ($1.3) in 2008, 2007 and 2006, respectively	(4.0)	0.3	2.2
Unrealized holding gains/(losses) on cash flow hedging instruments, net of tax (provision)/benefit of ($0.4), $7.5 and $1.6 in 2008, 2007 and 2006, respectively	0.7	(12.8)	(2.8)
Unrealized holding losses on net investment hedging instruments, net of tax benefit of $0.6 and $5.2 in 2008 and 2007, respectively	(0.9)	(8.8)	—
Reclassification adjustment for net (gains)/losses realized in net earnings for available-for-sale securities, net of tax provision of $1.1 in 2006	—	—	(1.8)
Reclassification adjustment for net losses realized in net earnings for cash flow hedges, net of tax benefit of $3.0, $0.5 and $2.4 in 2008, 2007 and 2006, respectively	5.0	0.9	4.2
Net unrealized gain/(loss)	0.8	(20.4)	1.8
Translation adjustment, net of tax benefit/(provision) of $0.3, $—, and ($1.8) in 2008, 2007, and 2006, respectively	(7.0)	37.7	14.6
Total comprehensive income	$309.3	$689.9	$580.7

The unfavorable translation adjustment change during fiscal 2008 of $7.0 million was primarily due to the strengthening of the US dollar against several currencies including the Australian dollar, Korean won and Canadian dollar. The favorable translation adjustment change during fiscal 2007 of $37.7 million was primarily due to the weakening of the US dollar against several currencies including the euro, Canadian dollar and British pound sterling. The favorable translation adjustment change during fiscal 2006 of $14.6 million was primarily due to the weakening of the US dollar against several currencies including British pound sterling, the euro and Canadian dollar.

The components of accumulated other comprehensive income, net of tax, were as follows (in millions):

Fiscal Year Ended	Sep 28, 2008	Sep 30, 2007
Net unrealized losses on available-for-sale securities	$(4.1)	$ —
Net unrealized losses on hedging instruments	(22.2)	(27.1)
Translation adjustment	74.7	81.7
Accumulated other comprehensive income	$48.4	$54.6

As of September 28, 2008, the translation adjustment of $74.7 million was net of tax provisionsof $7.0 million. As of September 30, 2007, the translation adjustment of $81.7 million was net of tax provisionsof $7.3 million.

Required

a. Starbucks reports "Restructuring Charges" in its 2008 Income Statement. Assuming a tax rate of 35 percent, discuss whether you would eliminate the charge when forecasting the future earnings of Starbucks. If so, what adjustments would you make to the income statement, balance sheet, and statement of cash flows?

b. Starbucks reports a "Cumulative Effect of an Accounting Change" in its 2006 Income Statement, the last year in which such changes were reported as a separate line item on the income statement. What is the reason for the change? Assuming a tax rate of 35 percent, discuss whether you would eliminate the cumulative effect when assessing Starbucks' current profitability. If so, what adjustments would you make to the income statement, balance sheet, and statement of cash flows. How would you treat the cumulative effect when forecasting the future earnings of Starbucks?

c. Starbucks reports a new line item on its balance sheet beginning in 2007 entitled "Insurance Reserves." Do the changes in this account affect the income statement? If so, describe the likely effect of this account on the income statement and discuss whether you would eliminate the charge when forecasting the future earnings of Starbucks.

d. Examine Starbucks' Note 13 description of comprehensive income. How would you treat the comprehensive income items when forecasting Starbucks' future financial statements?

e. Starbucks lists all of the new pronouncements that may or may not affect its current and future financial statements. Read each pronouncement and discuss how each change might affect the analyst's task of forecasting Starbucks' future earnings.

CASE 9.2

CITI: A VERY BAD YEAR

Citigroup Inc. (Citi) is a leading global financial services company with over 200 million customer accounts and operations in more than 140 countries. Its operating units Citicorp and Citi Holdings provide a broad range of financial products and services to consumers, governments, institutions, and corporations. Services include investment banking, consumer and corporate banking and credit, securities brokerage, and wealth management.

For the year ended December 31, 2008, Citi reported a net loss of $27,684 million, or $5.59 per share. Exhibit 9.11 presents the Consolidated Statements of Income for Citigroup Inc. and Subsidiaries for the year ended December 31, 2008, 2007, and 2006. Various selections from the notes to the consolidated financial statements follow the exhibit.

CONSOLIDATED STATEMENT OF INCOME	*Citigroup Inc. and Subsidiaries*		
	Year ended December 31		
in millions of dollars, except per share amounts	**2008**	**2007**	**2006**
Revenues			
Interest revenue	**$106,655**	$121,429	$93,611
Interest expense	**52,963**	76,051	55,683
Net interest revenue	**$ 53,692**	$ 45,378	$37,928
Commissions and fees	**$ 11,227**	$ 20,706	$18,850
Principal transactions	**(22,188)**	(12,086)	7,990
Administration and other fiduciary fees	**8,560**	9,132	6,903
Realised gains (losses) from sales of investments	**(2,061)**	1,168	1,791
Insurance premiums	**3,221**	3,062	2,769
Other revenue	**342**	11,135	10,096
Total non-interest revenues	**$ (899)**	$ 33,117	$48,399
Total revenues, net of interest expense	**$ 52,793**	$ 78,495	$86,327
Provisions, for credit losses and for benefits and claims			
Provision for loan losses	**$ 33,674**	$ 16,832	$ 6,320
Policyholder benefits and claims	**1,403**	935	967
Provision for unfunded lending commitments	**(363)**	150	250
Total provisions for credit losses and for benefits and claims	**$ 34,714**	$ 17,917	$ 7,537
Operating expenses			
Compensation and benefits	**$ 32,440**	$ 33,892	$29,752
Net occupancy	**7,125**	6,648	5,794
Technology/communication	**4,897**	4,511	3,741
Advertising and marketing	**2,292**	2,803	2,471
Restructuring	**1,766**	1,528	—
Other operating	**22,614**	10,420	8,543
Total operating expenses	**$ 71,134**	$ 59,802	$50,301
Income (loss) from continuing operations before income taxes and minority interest	**$(53,055)**	$ 776	$28,489
Provision (benefit) for income taxes	**(20,612)**	(2,498)	7,749
Minority interest, net of taxes	**(349)**	285	289
Income (loss) from continuing operations	**$(32,094)**	$ 2,989	$20,451
Discontinued operations			
Income from discontinued operations	**$ 1,478**	$ 925	$ 1,177
Gain on sale	**3,139**	—	219
Provision (benefit) for income taxes and minority interest, net of taxes	**207**	297	309
Income from discontinued operations, net of taxes	**$ 4,410**	$ 628	$ 1,087

(Continued)

CONSOLIDATED STATEMENT OF INCOME *Citigroup Inc. and Subsidiaries*

Year ended December 31

in millions of dollars, except per share amounts	**2008**	**2007**	**2006**
Net income (loss)	**$(27,684)**	$ 3,617	$21,518
Basic earning per share [1]			
Income (loss) from continuing operations	**$ (6.42)**	$ 0.60	$ 4.17
Income from discontinued operations, net of taxes	**0.83**	0.13	0.22
Net income (loss)	**$ (5.59)**	$ 0.73	$ 4.39
Weighted average common shares outstanding	**5,265.4**	4,905.8	4,887.3
Diluted earnings per share [1]			
Income (loss) from continuing opetations	**$ (6.42)**	$ 0.59	$ 4.09
Income from discontinued operations, net of taxes	**0.83**	0.13	0.22
Net income (loss)	**$ (5.59)**	$ 0.72	$ 4.31
Adjusted weighted average common shares outstanding	**5,795.1**	4,995.3	4,986.1

(1) Diluted shares used in the diluted EPS calculation represent basic shares for 2009 due to the net loss. Using actual diluted shares would result in anti-dilution.

Excerpts from Financial Statement Notes:
The following excerpts were disclosed in the notes to Citigroup's 2008 financial statements:

3. Discontinued Operations

Sale of Citigroup's German Retail Banking Operations

On December 5, 2008, Citigroup sold its German retail banking operations to Credit Mutuel for Euro 5.2 billion, in cash plus the German retail bank's operating net earnings accrued in 2008 through the closing. The sale resulted in an after-tax gain of approximately $3.9 billion including the after-tax gain on the foreign currency hedge of $383 million recognised during the fourth quarter of 2008.

The sale does not include the corporate and investment banking business or the Germany-based European data center.

The German retail banking operations had total assets and total liabilities as of November 30, 2008, of $15.6 billion and $11.8 billion, respectively.

Results for all of the German retail banking businesses sold, as well as the net gain recognized in 2008 from this sale, are reported as *Discontinued Operations* for all periods presented.

Summarized financial information for *Discontinued Operations*, including cash flows, related to the sale of the German retail banking operations is as follows:

in millions of dollars	**2008**	**2007**	**2006**
Total revenues, net of interest expense	**$6,592**	$2,212	$2,126
Income from discontinued operations	**$1,438**	$ 652	$ 837
Gain on sale	**3,695**	—	—
Provision for income taxes and minority interest, net of taxes	**426**	214	266
Income from discontinued operations, net of taxes	**$4,707**	$ 438	$ 571

in millions of dollars	2008	2007	2006
Cash flows from operating activities	$ (4,719)	$2,227	$2,246
Cash flows from investing activities	18,547	(1,906)	(3,316)
Cash flows from financing activities	(14,226)	(213)	1,147
Net cash provided by (used in) **discontinued operations**	$ (398)	$ 108	$ 77

CitiCapital

On July 31, 2008, Citigroup sold substantially all of CitiCapital, the equipment finance unit in *North America.* The total proceeds from the transaction were approximately $12.5 billion and resulted in an after-tax loss to Citigroup of $305 million. This loss is included in *Income from discontinued operations* on the Company's Consolidated Statement of Income for the second quarter of 2008. The assets and liabilities for CitiCapital totaled approximately $12.9 billion and $0.5 billion, respectively, at June 30, 2008.

This transaction encompassed seven CitiCapital equipment finance business lines, including Healthcare Finance, Private Label Equipment Finance, Material Handling Finance, Franchise Finance, Construction Equipment Finance, Bankers Leasing, and CitiCapital Canada. CitiCapital's Tax Exempt Finance business was not part of the transaction and was retained by Citigroup.

CitiCapital had approximately 1,400 employees and 160,000 customers throughout North America.

Results for all of the CitiCapital businesses sold, as well as the net loss recognized in 2008 from this sale, are reported as *Discontinued operations* for all periods presented.

Summarized financial information for *Discontinued operations,* including cash flows, related to the sale of CitiCapital is as follows:

in millions of dollars	2008	2007	2006
Total revenues, net of interest expense	$ 24	$ 991	$ 1,162
Income (loss) from discontinued operations	$ 40	$ 273	$ 313
Loss on sale	(506)	—	—
Provision (benefit) for income taxes and minority interest, net of taxes	(202)	83	86
Income (loss) from discontinued operations, **net of taxes**	$ (264)	$ 190	$ 227

in millions of dollars	2008	2007	2006
Cash flows from operating activities	$ (287)	$(1,148)	$ 2,596
Cash flows from investing activities	349	1,190	(2,664)
Cash flows from financing activities	(61)	(43)	3
Net cash provided by (used in) **discontinued operations**	$ 1	$ (1)	$ (65)

Sale of the Asset Management Business

On December 1, 2005, the Company completed the sale of substantially all of its Asset Management business to Legg Mason, Inc. (Legg Mason).

On January 31, 2006, the Company completed the sale of its Asset Management business within Bank Handlowy (an indirect banking subsidiary of Citigroup located in Poland) to Legg Mason. This transaction, which was originally part of the overall Asset Management business sold to Legg Mason on December 1, 2005, was postponed due to delays in obtaining local regulatory approval. A gain from this sale of $18 million after-tax and minority interest ($31 million pretax and minority interest) was recognized in the first quarter of 2006 in *Discontinued operations.*

During March 2006, the Company sold 10.3 million shares of Legg Mason stock through an underwritten public offering. The net sale proceeds of $ 1.258 billion resulted in a pre-tax gain of $24 million in *ICG*.

In September 2006, the Company received from Legg Mason the final closing adjustment payment related to this sale. This payment resulted in an additional after-tax gain of $51 million ($83 million pretax), recorded in *Discontinued operations.*

Sale of the Life Insurance and Annuities Business

On July 1, 2005, the Company completed the sale of Citigroup's Travelers Life & Annuity and substantially all of Citigroup's international insurance businesses to MetLife, Inc. (MetLife).

During the first quarter of 2006, $15 million of the total $657 million federal tax contingency reserve release was reported in *Discontinued operations* as it related to the Life Insurance and Annuities business sold to MetLife.

In July 2006, Citigroup recognized an $85 million after-tax gain from the sale of MetLife shares. This gain was reported in income from continuing opetations in *ICG*.

In July 2006, the Company received the final closing adjustment payment related to this sale, resulting in an after-tax gain of $75 million ($ 115 million pretax), which was recorded in *Discontinued operations.*

In addition, during the third quarter of 2006, a release of $42 million of deferred tax liabilities was reported in *Discontinued operations* as it related to the Life Insurance & Annuities business sold to MetLife.

In December 2008, the Company fulfilled its previously agreed upon obligations with regard to its remaining 10% economic interest in the long-term care business that it had sold to the predecessor of Genworth Financial in 2000. Under the terms of the 2005 sales agreement of Citi's Life Insurance and Annuities business to MetLife, Citi agreed to reimburse MetLife for certain liabilities related to the sale of the long-term-care business to Genworth's predecessor. The assumption of the final 10% block Genworth at December 31, 2008, resulted in a pretax loss of $50 million ($33 million after-tax), which has been reported in *Discontinued operations.*

Combined Results for Discontinued Operations

The following is summarized financial information for the German retail banking operations, CitiCapital, Life Insurance and Annuities business, Asset Management business, and TPC:

in millions of dollars	2008	2007	2006
Total revenues, net of interest expense	$6,616	$3,203	$3,507
Income from discontinued operations	$1,478	$ 925	$1,177
Gain on sale	3,139	—	219
Provision (benefit) for income taxes, and minority interest, net of taxes	207	297	309
Income from discontinued operations, net of taxes	$4,410	$ 628	$1,087

Cash Flows from Discontinued Operations

in millions of dollars	2008	2007	2006
Cash flows from operating activities	$ (5,006)	$1,079	$ 4,842
Cash flows from investing activities	18,896	(716)	(5,871)
Cash flows from financing activities	(14,287)	(256)	1,150
Net cash provided by (used in) discontinued operations	$ (397)	$ 107	$ 121

5. Interest Revenue and Expense

For the years ended December 31, 2008, 2007 and 2006, respectively, interest revenue and expense consisted of the following:

in millions of dollars	2008	2007	2006
Interest revenue			
Loan interest, including fees	$ 62,336	$ 63,201	$52,086
Deposits with banks	3,119	3,113	2,240
Federal funds sold and securities purchased under agreements to resell	9,175	18,354	14,199
Investments, including dividends	10,718	13,423	10,340
Trading account assets[1]	17,489	18,507	11,865
Other interest	3,818	4,831	2,881
Total interest revenue	$106,655	$121,429	$93,611
Interest expense			
Deposits	$ 20,271	$ 28,402	$21,336
Federal funds purchased and securities loaned or sold under agreements to repurchase	11,330	23,028	17,448
Trading account liabilities[1]	1,277	1,440	1,119
Short-term borrowings	4,039	7,071	4,632
Long-term debt	16,046	16,110	11,148
Total interest expense	$ 52,963	$ 76,051	$55,683
Net interest revenue	$ 53,692	$ 45,378	$37,928
Provision for loan losses	33,674	$ 16,832	$ 6,320
Net interest revenue after provision for loan losses	$ 20,018	$ 28,546	$31,608

(1) Interest expense on *Trading account facilities* of ICG is reported as a reduction of interest revenue from *Trading account assets.*

6. Commissions and Fees

Commissions and fees revenue includes charges to customers for credit and bank cards, including transaction-processing fees and annual fees; advisory and equity and debt underwriting services; lending and deposit-related transactions, such as loan commitments, standby letters of credit and other deposit and loan servicing activities; investment management-related fees, including brokerage services and custody and trust services; and insurance fees and commissions.

The following table presents commissions and fees revenue for the years ended December 31:

in millions of dollars	2008	2007	2006
Investment banking	$ 2,284	$ 5,228	$ 4,093
Credit cards and bank cards	4,517	5,036	5,191
Smith Barney	2,836	3,265	2,958
ICG trading-related	2,322	2,706	2,464
Checking-related	1,134	1,108	911
Transaction Services	1,423	1,166	859
Other Consumer	1,211	649	279
Nikko Cordial-related[1]	1,086	834	—
Loan servicing[2]	(1,731)	560	660
Primerica	415	455	399
Other ICG	747	295	243
Other	(141)	71	58
Corporate finance[3]	(4,876)	(667)	735
Total commissions and fees	**$11,227**	**$20,706**	**$18,850**

(1) Commissions and fees for Nikko Cordial have not been detailed due to unavailability of the information.

(2) Includes fair value adjustments on mortgage servicing assets. The mark-to-market on the underlying economic hedges of the MSRs is included in *Other revenue*.

(3) Includes write-downs of approximately $4.9 billion in 2008 and $1.5 billion in 2007, net of underwriting fees, on funded and unfunded highly leveraged finance commitments, recorded at fair value and reported as loans held for sale in *Other assets*. Write-downs were recorded on all highly leveraged finance commitments where there was value impairment, regardless of funding date.

7. Principal Transactions

Principal transactions revenue consists of realized and unrealized gains and losses from trading activities. Not included in the table below is the impact of net interest revenue related to trading activities, which is an integral part of trading activities' profitability. The following table presents principal transactions revenue for the years ended December 31:

in millions of dollars	2008	2007	2006[1]
Institutional Clients Group			
Fixed income[2]	$ (6,455)	$ 4,053	$5,593
Credit products[3]	(21,614)	(21,805)	(744)
Equities[4]	(394)	682	866
Foreign exchange[5]	2,316	1,222	693
Commodities[6]	667	686	487
Total ICG	$(25,480)	$(15,162)	$6,895
Consumer Banking/Global Cards[7]	1,616	1,364	504
Global Wealth Management[7]	836	1,315	680
Corporate/Other	840	397	(89)
Total principal transactions revenue	**$(22,188)**	**$(12,086)**	**$7,990**

(1) Reclassified to conform to the current period's presentation.

(2) Includes revenues from government securities and corporate debt, municipal securities, preferred stock, mortgage securities, and other debt instruments. Also includes spot and forward trading of currencies and exchange-traded and over-the-counter (OTC) currency options, options on fixed income securities, interest rate swaps, currency swaps, swap options, caps and floors, financial futures, OTC options, and forward contracts on fixed income securities. Losses in 2008 reflect the volatility and dislocation in the credit and trading markets.

(Continued)

(3) Includes revenues from structured credit products such as North America and Europe collateralized debt obligations, In 2007 and 2008, losses recorded were related to subprime-related exposures in *ICG's* lending and structuring business and exposures to super senior CDOs.

(4) Includes revenues from common, preferred and convertible preferred stock, convertible corporate debt, equity-linked notes, and exchange-traded and OTC equity options and warrants.

(5) Includes revenues from foreign exchange spot, forward, option and swap contracts, as well as translation gains and losses.

(6) Primarily includes the results of Phibro LLC, which trades crude oil, refined oil products, natural gas, and other commodities.

(7) Includes revenues from various fixed income, equities and foreign exchange transactions.

10. Restructuring

In the fourth quarter of 2008, Citigroup recorded a pretax restructuring expense of $1.797 billion pre-tax related to the implementation of a Company-wide re-engineering plan. This initiative will generate headcount reductions of approximately 20,600. The charges related to the 2008 Re-engineering Projects Restructuring Initiative are reported in the Restructuring line on the Company's Consolidated Statement of Income and are recorded in each segment.

In 2007, the Company completed a review of its structural expense base in a Company-wide effort to create a more streamlined organization, reduce expense growth, and provide investment funds for future growth initiatives. As a result of this review, a pretax restructuring charge of $1.4 billion was recorded in *Corporate/Other* during the first quarter of 2007. Additional net charges of $151 million were recognized in subsequent quarters throughout 2007 and a net release of $31 million in 2008 due to a change in estimates. The charges related to the 2007 Structural Expense Review Restructuring Initiative are reported in the Restructuring line on the Company's Consolidated Statement of Income.

The primary goals of the 2007 Structural Expense Review and Restructuring, and the 2008 Re-engineering Projects and Restructuring Initiatives were:

- eliminate layers of management/improve workforce management;
- consolidate certain back-office, middle-office and corporate functions;
- increase the use of shared services;
- expand centralized procurement; and
- continue to rationalize operational spending on technology.

The implementation cf these restructuring initiatives also caused certain related premises and equipment assets to become redundant. The remaining depreciable lives of these assets were shortened, aid accelerated depreciation charges began in the second quarter of 2007 and fourth quarter of 2008 for the 2007 and 2008 initiatives, respectively, in addition to normal scheduled depreciation.

19. Goodwill and Intangible Assets

Goodwill

The changes in goodwill during 2007 and 2008 were as follows:

in millions of dollars	**Goodwill**
Balance at December 31, 2006	$33,264
Acquisition of GFU	865
Acquisition of Quilter	268
Acquisition of Nikko Cordial[1]	892
Acquisition of Grupo Cuscatlán	921
Acquisition of Egg	1,471
Acquisition of Old Lane	516

(*Continued*)

in millions of dollars	Goodwill
Acquisition of BISYS	872
Acquisition of BOOC	712
Acquisition of ATD	569
Sale of Avantel	(118)
Foreign exchange translation, smaller acquisitions and other	821
Balance at December 31, 2007	**$41,053**
Sale of German retail bank	$(1,047)
Sale of CitiCapital	(221)
Sale of Citigroup Global Services Limited	(85)
Purchase accounting adjustments—BISYS	(184)
Purchase of the remaining shares of Nikko Cordial—net of purchase accounting adjustments	287
Acquisition of Legg Mason Private Portfolio Group	98
Foreign exchange translation	(3,116)
Impairment of goodwill	(9,568)
Smaller acquisitions, purchase accounting adjustments and other	(85)
Balance at December 31, 2008	**$27,132**

In the following press release, Citi further describes the source of the goodwill impairment:

Citi Announces Fourth Quarter Goodwill Impairment of $9.6 Billion[22]

Results in Additional Net Loss of $9.0 Billion for 2008

New York – Citi announced today that it recorded a pre-tax goodwill impairment charge of approximately $9.6 billion ($8.7 billion after-tax) in the fourth quarter of 2008. Citi had previously announced in its fourth quarter earnings press release (January 16, 2009) that it was continuing to review its goodwill to determine whether a goodwill impairment had occurred as of December 31, 2008, and this charge is the result of that review and testing. The goodwill impairment charge was recorded in North America Consumer Banking, Latin America Consumer Banking, and EMEA Consumer Banking, and resulted in a write-off of the entire amount of goodwill allocated to those reporting units. The charge does not result in a cash outflow or negatively affect the Tier 1 or Total Regulatory Capital ratios, Tangible Common Equity or Citi's liquidity position as of December 31, 2008.

In addition, Citi recorded a $374 million pre-tax charge ($242 million after-tax) to reflect further impairment evident in the intangible asset related to Nikko Asset Management at December 31, 2008.

The primary cause for both the goodwill and the intangible asset impairments mentioned above was the rapid deterioration in the financial markets, as well as in the global economic outlook generally, particularly during the period beginning mid-November through year-end 2008. This deterioration further weakened the near term prospects for the financial services industry.

Giving effect to these charges, Net Income (Loss) from Continuing Operations for 2008 was $(32.1) billion and Net Income (Loss) was $(27.7) billion, resulting in Diluted Earnings per Share of $(6.42) and $(5.59) respectively.

[22] Press release found at: http://www.citigroup.com/citi/press/2009/090227b.htm. Reprinted by permission.

A complete description of Citi's goodwill impairment testing as of December 31, 2008 and the related charges will be included in Citi's Form 10-K to be filed with the Securities and Exchange Commission on or before March 2, 2009.

Required

Consider the following items reported in Citi's Consolidated Statement of Income:

- Principal transactions
- Realized (gain) losses from sales of investments
- Provision for loan losses
- Restructuring
- Other operating expenses (which presumably includes the goodwill impairment)
- Discontinued operations

Discuss whether you would eliminate all or part of each item when assessing current profitability and forecasting the future earnings of Citi. If so, what adjustments would you make to the financial statements (assuming a tax rate of 35 percent)?

Forecasting Financial Statements

1. Develop the skills to build forecasts of future balance sheets, income statements, and statements of cash flows.

2. Identify and incorporate important business and strategic factors into expectations of future business activities, which we measure with forecasts of future accounting numbers and financial statements.

3. Apply a seven-step forecasting framework for building financial statement forecasts. These seven steps focus on projecting (a) revenue growth; (b) operating expenses; (c) operating assets and liabilities; (d) financial leverage and capital structure; (e) interest, taxes, and dividends; (f) a balance sheet that balances; and (g) cash flows.

4. Understand how and when to use shortcut forecasting techniques.

5. Develop forecast models that are flexible and comprehensive, allowing the analyst to respond efficiently and appropriately to important new information.

6. Test the sensitivity of the forecasts to variations in critical assumptions and parameters.

T hus far, this text has discussed the first four steps of the six-step analysis and valuation framework. Drawing on the disciplines of accounting, finance, economics, and strategy, the preceding nine chapters of this text have demonstrated the first four steps of this framework, describing how to analyze (1) the economics of a firm's industry, (2) the competitive advantages and risks of the firm's strategy, (3) the information content and quality of the firm's accounting, and (4) the firm's financial performance and risk. The next five chapters cover the two culminating steps of the framework: (5) forecasting the future operating, investing, and financing activities of the firm and then (6) valuing the firm.

In this chapter, we shift our focus to the future. Economics teaches that the value of an economic resource is a function of its expected future payoffs and the risks inherent in those payoffs. Therefore, this chapter demonstrates how to use your knowledge about a firm's industry, strategy, accounting quality, and past and current performance to forecast the firm's future business activities (that is, operating, investing, and financing activities). The chapter will demonstrate how to capture those expectations in forecasts of future financial statements—income statements, balance sheets, and statements of cash flows. The

objective in building financial statement forecasts is to develop unbiased expectations for a firm's future earnings, cash flows, and dividends that the analyst can use to estimate the firm's share value. The analyst also can use financial statement forecasts in a wide array of decision contexts, such as strategic planning, credit analysis, corporate management, and mergers and acquisitions.

In subsequent chapters, we will use these financial statement forecasts to derive the future payoffs to the firm's common equity shareholders, including future earnings, cash flows, and dividends, which we will use to estimate firm value, considering its risk. Chapter 11 demonstrates the classical dividends-based valuation model, which is the theoretical foundation for other approaches to firm valuation. Chapter 11 also describes and applies models to incorporate risk into estimates of expected returns on investments and costs of capital. Chapter 12 demonstrates valuation models based on expected future free cash flows. Chapter 13 discusses and implements valuation models that rely on earnings. Chapter 14 demonstrates valuation approaches that rely on comparable companies and market-based multiples, such as price-earnings ratios and market-to-book ratios. Chapter 14 also illustrates some advanced valuation techniques, including computing price differentials and reverse engineering share prices.

INTRODUCTION TO FORECASTING

Analysts must develop realistic expectations for the outcomes of future business activities. To develop these expectations, analysts build a set of *financial statement forecasts*—expected future income statements, balance sheets, and statements of cash flows. Financial statement forecasts represent an integrated portrayal of a firm's future operating, investing, and financing activities. These activities determine the firm's future profitability, growth, financial position, cash flows, and risk. Financial statement forecasts are important tools because the analyst can derive expectations of future payoffs to equity shareholders—earnings, cash flows, and dividends—which are the fundamental bases for share value.

Financial statement forecasts also are important tools in many other decision contexts. Credit decisions require expectations for future cash flows available to make required interest and principal payments. Managers' decisions about firm strategy, potential customer or supplier relationships, potential mergers or acquisitions, and potential carve-outs of divisions or subsidiaries, and even whether a firm presents a good employment opportunity, all depend on their expectations for future payoffs from such decisions and the risks of those payoffs.

Developing forecasts of future payoffs is in many ways the most difficult step of the six-step framework of this text because it requires the analyst to estimate the effects of future activities, which involves a high degree of uncertainty. Forecast errors can prove very costly. Optimistic forecasts can lead the analyst to overestimate future earnings and cash flows or underestimate risk and therefore make poor investment decisions based on an overstated value of the firm. Pessimistic or conservative forecasts can lead the analyst to understate future earnings and cash flows or overstate risk and consequently miss valuable investment opportunities. Analysts need to develop *realistic* (unbiased and objective, not optimistic or conservative) expectations of future earnings and cash flows that will lead to well-informed investment decisions.

Superior forecasting has the potential to help investors pick stocks and earn superior returns. As Chapter 1 discussed, empirical research results from Nichols and Wahlen (2004) suggest the potential to earn abnormal returns by correctly forecasting the *sign* of the

change in annual earnings numbers.[1] Their findings indicate that if a person had accurately predicted the sign of the change in earnings one year ahead for each firm in their sample during their 14-year study period (1988–2001), he or she would have earned returns that beat the market by roughly 19 percent per year by investing in those firms that experienced earnings increases and by roughly 16 percent per year by selling short those firms that experienced earnings decreases.

The evidence in Nichols and Wahlen (2004) also suggests that investors have the potential to earn even greater abnormal returns by correctly forecasting the *sign* and *magnitude* of the change in one-year-ahead earnings.[2] Their findings imply that stock returns for the firms that experience the largest percentage increases in earnings (that is, firms among the top 10 percent of all sample firms each year) generate very large positive returns, beating the market by an average of nearly 50 percent per year. Their findings also indicate that stock returns for firms that experience the largest percentage decreases in earnings (firms among the bottom 10 percent of all sample firms each year) tend to earn stock returns that are on average 22 percentage points per year lower than the market as a whole.

Certainly, analysts do not have perfect foresight to predict one year ahead the direction or amount of earnings increases and decreases for all firms. Nonetheless, analysts should consider the Nichols and Wahlen (2004) results encouraging because those results suggest that by increasing one's accuracy in forecasting future changes in earnings, the analyst should have greater potential to distinguish stocks that are future winners versus losers and earn superior returns. It also is important to keep in mind that firms vary in the quality and detail of the information they disclose to help analysts develop forecasts. Some firms provide rich detail that analysts can use to produce more accurate forecasts, but other firms provide only limited disclosures, perhaps due to concerns about revealing too much information to their competitors.

Accounting researchers also have investigated whether financial statement ratios like those described throughout this text can be used to build models that accurately predict future changes in earnings. For example, Ou and Penman (1989) built prediction models based on regressions of future earnings changes on a set of financial statement ratios.[3] Their earnings-change-prediction models estimate the probability of an earnings increase one year ahead. They conduct out-of-sample tests and find that their probability estimates correctly predict whether one-year-ahead earnings will increase or decrease for roughly 67 percent of their firm-year observations. They also show that taking long positions in shares of firms with a high probability of an earnings increase next year and short positions in shares of firms with a very low probability of an earnings increase next year resulted in average market-adjusted returns of roughly 8 percent per year during their study period. This study and subsequent related studies provide encouraging results suggesting that a fundamental

[1] D. Craig Nichols and James M. Wahlen, "How Do Earnings Numbers Relate to Stock Returns? A Review of Classic Accounting Research with Updated Evidence," *Accounting Horizons* 18 (December 2004), pp. 263–286. This study uses data from 1988–2001 to replicate the seminal findings in Ray Ball and Philip Brown, "An Evaluation of Accounting Income Numbers," *Journal of Accounting Research* (Autumn 1968), pp. 159–178; Roger Kormendi and Robert Lipe, "Earnings Innovations, Earnings Persistence, and Stock Returns," *Journal of Business* 60 (1987), pp. 323–345; and Victor Bernard and Jacob Thomas, "Post-Earnings Announcement Drift: Delayed Price Response or Risk Premium?," *Journal of Accounting Research* (1989 Supplement), pp. 1–48.

[2] See also William Beaver, Roger Clarke, and William Wright, "The Association between Unsystematic Security Returns and the Magnitude of Earnings Forecast Errors," *Journal of Accounting Research* 17 (Autumn 1979), pp. 316–341.

[3] See Jane Ou and Stephen Penman, "Financial Statement Analysis and the Prediction of Stock Returns," *Journal of Accounting and Economics* (November 1989), pp. 295–330. For examples of other studies in this area, see Baruch Lev and Ramu Thiagarajan, "Fundamental Information Analysis," *Journal of Accounting Research* (Autumn 1993), pp. 190–215; and Jeffery Abarbanell and Brian Bushee, "Abnormal Stock Returns to a Fundamental Analysis Strategy," *The Accounting Review* 73 (January 1998), pp. 19–46.

analysis of financial statement ratios can produce more accurate forecasts of future earnings and profitable investment decisions.

To maximize the analyst's potential to develop reliable forecasts of financial statements and to mitigate the potential for costly forecast errors, the analyst should base forecasts on expectations that reflect the economics of the industry, the competitive advantages and risks of the firm's strategy, the quality of the firm's accounting, and the drivers of the firm's profitability and risk. The first four steps of the analytical framework of this text provide the necessary foundation for forecasting. These four steps inform the analyst about the critical risk and success factors of the firm and the key drivers of the firm's profitability and risk. The critical factors that are the focal points of the firm's strategy, accounting quality, profitability, and risk are the most important building blocks for forecasting a firm's future financial statements.

This chapter first outlines general forecasting principles, describes a seven-step process for forecasting financial statements, and offers several practical coaching tips on implementing the seven-step sequence. The chapter then illustrates each of the steps by applying them to PepsiCo, developing forecasts for income statements, balance sheets, and statements of cash flows for the next five years. The chapter then describes a set of techniques to enhance the reliability of forecasts, including sensitivity analysis, iteration, and validity checks. The chapter also describes some simplifying steps for shortcut forecasts and the conditions under which such shortcuts are more likely to be reliable and less likely to result in forecast errors.

PREPARING FINANCIAL STATEMENT FORECASTS

In this section we describe in general how to prepare financial statement forecasts. We first describe general principles of building forecasts, and then a seven-step forecasting procedure, along with some practical forecasting tips. We also briefly describe how to use FSAP to build financial statement forecasts.

General Forecasting Principles

Several key principles of forecasting deserve mention at the outset.

- **As noted earlier, the objective of forecasting is to produce reliable and realistic expectations of future earnings, cash flows, and dividends, which determine the future payoffs to investment.** To maximize reliability and avoid costly forecast errors, financial statement forecasts should provide unbiased and objective predictions of the firm's future operating, investing, and financing activities and should not be conservative or optimistic. Firm managers have a tendency to be optimistic, and accountants tend to be conservative. Ideally, the analyst's forecasts should be neither optimistic nor conservative; instead they should be accurate and realistic.
- **Forecasts should not manifest wishful thinking.** The analyst should incorporate forecast assumptions that reflect business strategies that management intends to execute and can achieve in the future. The analyst should not build forecasts based on wishful thinking. That is, the analyst should not create forecasts based on strategies the analyst *hopes* the firm will pursue or thinks the firm *should* pursue. Instead, the forecasts should capture the strategies the analyst believes the firm *actually will pursue* in the future.
- **Financial statement forecasts should be comprehensive.** The financial statement forecasts should be complete and include *all* expected future operating, investing, and financing activities. For example, suppose an analyst takes a quick-and-dirty approach and simply extrapolates expected future sales growth and then projects expected future earnings assuming a constant profit margin in the future. This approach fails to consider all of the elements that determine profitability from sales and the ways those

elements may change in the future, which can cause the earnings forecasts to be incomplete, erroneous, and misleading. By assuming a constant profit margin on sales, the analyst ignores important considerations, such as whether the cost of goods sold and selling, general, and administrative expenses will increase more quickly or more slowly than sales.

- **Financial statement forecasts must be internally consistent.** Forecasts of financial statements should rely on the *additivity* within financial statements and the *articulation* across financial statements to avoid internal inconsistencies. The analyst can rely on the internal discipline of accounting across the three primary financial statements to reduce the possibility of errors from inconsistent assumptions. For example, future sales growth will trigger future growth in costs of sales; accounts receivable; inventory; and property, plant, and equipment. In turn, future growth in inventory; receivables; and property, plant, and equipment will drive growth in related operating elements including accounts payable, accrued expenses, and depreciation and perhaps trigger additional financing through short-term and long-term borrowing and equity capital issues. Each of these elements will, in turn, have implications for the firm's cash flows. For example, simply projecting increasing future revenues without considering the future increases in inventory, and property, plant, and equipment necessary to achieve the projected revenue growth could result in substantial errors in expected future profitability and cash flow. To capture the many complex relations among operating, investing, and financing activities, financial statement forecasts should add up and articulate with each other. The income statement should measure profit or loss appropriately for each period by including all of the revenues, expenses, gains, and losses each period. The balance sheet should capture all of the elements of financial position, should reflect profitability each period, and should balance. The statement of cash flows should reflect all of the cash inflows and outflows implied by the income statement and all of the changes in the firm's balance sheet. Forecasts of each of the financial statements should articulate, and each will impact and be impacted by each of the other statements.
- **Financial statement forecasts must rely on assumptions that have external validity.** Forecast assumptions should pass the test of common sense. The analyst should impose reality checks on the forecast assumptions. For example, do the sales growth forecast assumptions appropriately reflect the firm's strategy and the competitive conditions in the industry, including market demand and price elasticity for the firm's products, as well as the firm's productive capacity? Analysts also should benchmark the external validity of forecast assumptions by comparing them to industry averages and to the firm's past performance and strategies.

Seven-Step Forecasting Game Plan

To prepare a set of financial statement forecasts, the analyst must forecast the firm's future operating, investing, and financing activities. This business activity-based forecasting approach enables the analyst to identify the necessary sequence of steps to project the three principal financial statements into the future. The particular sequence of steps may vary depending on the reason for forecasting the financial statements. For most forecasts of financial statements, the following seven-step sequence works well:

1. Project revenues from sales and other operating activities.
2. Project operating expenses (for example, cost of goods sold and selling, general, and administrative expenses) and derive projected operating income.
3. Project the operating assets (for example, cash; marketable securities; receivables; inventory; property, plant, and equipment; investments; and intangible assets) that will be necessary to support the level of operations projected in Steps 1 and 2. Also

project the operating liabilities that will be triggered by normal business operations (for example, accounts payable and accrued expenses).

4. Project the financial leverage, financial assets, and common equity capital (for example, short-term and long-term debt, common shareholders' equity except for retained earnings, and any financial assets available to service debt or equity claims) that will be necessary to finance the net operating assets projected in Step 3. In addition, determine the financing costs (such as interest expense) triggered by the financial liabilities and any investment income from financial assets (such as interest income) in the firm's capital structure. From projected operating income from Step 2, subtract interest expense and add interest income.

5. Project nonrecurring gains or losses (if any) and derive projected income before tax. Subtract the projected provision for income taxes to derive projected net income. Subtract expected dividends from net income to obtain the projected change in retained earnings. Also project any other comprehensive income items.

6. Check whether the projected balance sheet is in balance. If it is not in balance, the projected financial structure may need to be adjusted. For example, if projected assets exceed projected liabilities and equities, the firm may be required to raise capital through additional short- or long-term debt or equity issuances. Alternately, if projected liabilities and equities exceed projected total assets, the firm may be able to pay down debt, increase dividends, or repurchase stock. Steps 4 and 5 must be repeated until the balance sheet is in balance.

7. Derive the projected statement of cash flows from the projected income statement and the changes in the projected balance sheet amounts.

Exhibit 10.1 summarizes this procedure.

Throughout this chapter and throughout the book, we demonstrate how the analyst can gain additional insights about a firm by evaluating the operating, investing, and financing activities of the firm. The economic, strategic, and financial analysis techniques in Chapters 1 through 5 emphasize how to analyze operating, investing, and financing activities as integrated drivers of the profitability and risk of the firm. The accounting analysis techniques in Chapters 6 through 9 demonstrate how to assess the accounting quality of the financing, investing, and operating activities of the firm. We carry this perspective into the forecasting and valuation techniques in Chapters 10 through 14. In this chapter, the seven-step forecasting procedure begins with projecting the operating activities that occur in the normal day-to-day operations of producing and selling goods and services. Those activities involve accounts such as cash, receivables, inventory, payables, accrued expenses, and taxes. Projecting the firm's investing activities involves forecasting the acquisition and use of long-lived productive resources such as property, plant, and equipment and intangible assets, as well as financial resources such as short-term and long-term investment securities. The projected financing activities determine the financial capital structure of the firm. They typically involve financial liabilities such as short-term and long-term debt (notes, mortgages, bonds, and capital leases), in addition to preferred and common stock, and stock issues and repurchases and dividend payments. In some circumstances, projecting financing activities can also include projections of financial assets (for example, short-term and long-term investment securities) that will be used to retire debt or pay dividends.

Practical Tips for Implementing the Seven-Step Forecasting Game Plan

The analyst should consider these seven steps as integrated and interdependent tasks that are not necessarily sequential or linear. The order in which an analyst implements

EXHIBIT 10.1

A Schematic Representation of the Seven-Step Process for Preparing Financial Statement Forecasts

Income Statement and the Change in Retained Earnings

Sales Revenues
Other Operating Revenues

Operating Expenses:
- Cost of Goods Sold
- Selling, General, and Administrative Expense
- Other Operating Expenses
Operating Income

- Interest Expense
+ Interest Income

- Income Taxes
Net Income
- Dividends
Change in Retained Earnings

Operating Activities
Net Income
Depreciation Expense
Other Adjustments
Changes in Receivables
Changes in Inventories
Changes in Other Current Assets
Changes in Payables
Changes in Accrued Expenses
Cash Flow from Operations

STEP 1: Projecting Operating Revenues

STEP 2: Projecting Operating Expenses and Deriving Operating Income

STEP 3: Projecting Operating Assets and Liabilities

STEP 4: Projecting Financial Leverage, Financial Assets, Common Equity Capital, and Financial Income Items

STEP 5: Projecting Nonrecurring Items, Provisions for Income Taxes, Net Income, Dividends, Changes in Retained Earnings, and Other Comprehensive Income Items

STEP 6: Balancing the Balance Sheet

STEP 7: Deriving Cash Flows from Operating, Investing, and Financing Activities

Statement of Cash Flows

Balance Sheet

Assets

Cash
Marketable Securities
Accounts Receivable
Inventories
Other Current Assets
Property, Plant, and Equipment
Intangible Assets

Short-Term Investments
Long-Term Investments

Total Assets =

Investing Activities
Net Capital Expenditures on Property, Plant, and Equipment
Purchases or Sales of Investments
Other Investing Transactions
Cash Flow from Investing

Liabilities and Shareholders' Equity

Accounts Payable
Current Accrued Expenses
Income Taxes Payable
Pension and Retirement Benefit Obligations
Deferred Taxes

Short-Term and Long-Term Debt
Contributed Equity Capital

Retained Earnings
Accumulated Other Comprehensive Income

Total Liabilities and Shareholders' Equity

Financing Activities
Changes in Short-Term and Long-Term Debt
Issues or Repurchases of Common Equity
Dividend Payments
Other Financing Transactions
Cash Flow from Financing

these steps and the amount of emphasis placed on each step will depend on the integration of the firm's operating, investing, and financing activities. For example, forecasts of revenues for a retail or restaurant chain may first require forecasts of the number of new stores that will be open. The sales forecasts for a manufacturer may depend on building a new productive plant capacity, which may depend on obtaining long-term financing.

The forecast amounts must articulate between the three forecasted financial statements. Most forecast amounts affect all three financial statements. For example, sales forecasts will affect the income statement, the balance sheet, and the statement of cash flows. As another example, the ending balance in retained earnings on the balance sheet should reflect the beginning balance plus net income from the income statement minus dividends from the statement of cash flows. Property, plant, and equipment on the balance sheet will be affected by capital expenditures from the statement of cash flows and depreciation expense, which affects the income statement and the statement of cash flows. Net cash flow on the statement of cash flows must equal the change in cash on the balance sheet. The financial statement forecasts represent complex, interrelated business activities.

Preparing financial statement forecasts that balance requires at least one flexible financial account and an iterative and circular process. Firms require financial flexibility. They rely on flexible financial accounts—financial assets, financial liabilities, equity capital, and dividends—that can expand or contract with the firm's supply and demand for capital. For example, a firm with growth opportunities that requires capital to acquire assets may need to raise cash through short-term or long-term borrowing or issuing equity shares. A cash-cow firm may generate substantial amounts of excess cash and deploy it by paying down debt, investing in financial assets, paying dividends, or repurchasing its common shares. Therefore, the analyst must identify what financial flexibility the firm can use. Then the analyst must adjust these flexible financial accounts as necessary to appropriately match the firm's future financial capital structure with the firm's future operations and investments. Thus, producing a set of financial statement forecasts will require several iterations and a degree of circularity. For example, the first pass through a set of financial statement forecasts may reveal to the analyst that the firm must increase long-term debt to finance future capital expenditures. Increased long-term debt, however, will increase interest expense and net income will then fall. As a consequence, retained earnings will fall; so the firm may have to increase long-term debt a bit more. The analyst must repeat this process until the balance sheet balances and articulates with the income statement and the statement of cash flows.[4]

Garbage in, garbage out. The quality of the financial statement forecasts—and the quality of the investment decisions based on these forecasts—will depend on the quality of the forecast assumptions. The analyst should thoughtfully evaluate and justify each assumption, especially the most important assumptions that reflect the critical risk and success factors of the firm's strategy. In addition, the analyst can impose reality checks on the assumptions by analyzing the forecasted financial statements using ratios, common-size, and rate-of-change financial statements. These analytical tools (discussed in Chapters 1, 4, and 5) may reveal that certain assumptions are unrealistic or inconsistent.

Sweat the big stuff. Do not sweat the little stuff. The analyst should devote thoughtful time and analysis developing the most important forecasts, those that reflect the critical business activities that will determine the future growth, success, and risk of the business. For example, for most firms, forecasts of revenues, key operating expenses, important assets (property, plant, and equipment), the debt-equity structure, and a few other items usually

[4] Most computer spreadsheet software facilitates iterative and circular processes. For example, in Excel, under the Tools/Options/Calculation menu, you can check the Iteration box to set the spreadsheet to automatically compute iteratively (for example, 1,000 times) until the computations converge to a specified maximum change.

deserve a good amount of thoughtful attention. However, some of the accounts in a set of financial statements are not critical to the risk or success of the business. As such, the analyst should be efficient, making simple reasonable assumptions about these noncritical accounts, and should not get bogged down in "analysis-paralysis."

The analyst should conduct sensitivity analysis on the financial statement forecasts. The analyst should test, for example, variation in earnings and cash flows across different sales growth scenarios, comparing across the most likely, optimistic, and pessimistic growth rate assumptions. Some assumptions will have more significant consequences than others, and sensitivity analyses will help the analyst assess the extent to which forecast results depend on key assumptions.

The subsequent sections of this chapter illustrate the seven-step forecasting procedure using PepsiCo's 2008 financial statements as a base. In this chapter we analyze and use PepsiCo's financial statement data for 2004 through 2008 to carefully develop forecast assumptions and to compute financial statement forecasts for PepsiCo for 2009 through 2013, which we label Year +1 through Year +5 to denote that they are forecasts of activities we expect to occur one year ahead through five years ahead.[5]

Using FSAP to Prepare Forecasted Financial Statements

FSAP, the financial statement analysis package introduced in Chapter 1, contains a Forecast spreadsheet that you can use to prepare financial statement forecasts.[6] If you have not previously designed an Excel spreadsheet to prepare financial statement forecasts, you should do so *before* using the Forecast spreadsheet in FSAP. The proper design of a spreadsheet and the preparation of forecasted financial statements provide excellent learning experiences to enhance and solidify your understanding of the relationships between various financial statement items. Once you become comfortable with using spreadsheets for forecasting financial statements, using the Forecast spreadsheet in FSAP will save you time.

Note that the Forecast spreadsheet in FSAP is a general and adaptable template for forecasting financial statements. In addition, FSAP contains a Forecast Development spreadsheet that provides a scratch pad for the analyst to use in computing various detailed forecast assumptions. To illustrate the use of the Forecast template and the Forecast Development spreadsheet, we incorporate in FSAP the specific forecast assumptions we make for PepsiCo in this chapter. Appendix C presents the output from FSAP for PepsiCo, including printouts of the Forecast spreadsheet for PepsiCo with explicit financial statement forecast assumptions through Year +5, and the Forecast Development spreadsheet with various supporting computations. FSAP also contains useful instructions and user guides for how to use FSAP.

All financial statement amounts throughout this chapter appear in millions. The spreadsheets take all computations to multiple decimal places. Because we express all amounts in this chapter in millions, some minor rounding differences will arise and make it appear as though various subtotals and totals disagree with the sum of the individual items that make up the subtotal or total.

[5] Previous chapters have analyzed data from the most recent three years to evaluate PepsiCo's current profitability, risk, and accounting quality. In forecasting financial statements that extend one to five years or more into the future, it is often helpful for the analyst to draw on a longer time series of historical data to evaluate a firm's long-term trends. This is particularly helpful for stable, mature firms such as PepsiCo. For firms in the introduction or growth phase of the life cycle or for firms that have recently experienced significant mergers or divestitures, a long time series of historical data may not be available or may not permit reliable comparisons with current period data.

[6] The website for this text (www.cengage.com/accounting/wahlen) contains a blank FSAP template and the FSAP PepsiCo file for easy downloading and use.

STEP 1: PROJECTING SALES AND OTHER REVENUES

Projecting Revenues from Sales

The principal business activities of most firms involve generating revenues by selling products or delivering services. Therefore, analysts commonly begin the process of forecasting financial statements by projecting revenues from the principal business activities of the firm. For many types of firms, analysts use the expected future level of revenues as a basis for deriving many other amounts in the financial statement forecasts.

Sales volumes and prices determine sales numbers. In the case of sales *volume*, some firms report specific volume figures (for example, automobile manufacturers report numbers of vehicles sold and beverage makers report gallons or cases sold), enabling the analyst to assess volume and price separately as drivers of historical sales growth and to use them for predicting future sales. Some firms report volume-related measures that the analyst can use to forecast sales, such as new stores for retailers and restaurant chains and passengers and revenue seat miles for airlines. For a stable firm in a mature industry (for example, consumer foods), an analyst may conclude that the firm will not significantly increase its market share, in which case he or she might anticipate that sales volume will grow with population growth in the firm's geographic markets. For a firm that has increased its production capacity in an industry with high anticipated growth (for example, biotechnology or cell phones), the analyst can use the industry growth rate coupled with the expansion in the firm's capacity to project sales volume increases.

When projecting *prices*, the analyst should consider factors specific to the firm and its industry that might affect demand and price elasticity, such as excess or constrained capacity, raw material surpluses or shortages, substitute products, and technological changes in products or production methods. Capital-intensive firms such as manufacturers of paper products or computer chips may require several years to add new capacity. If the firm competes in a capital-intensive industry that the analyst expects will operate near capacity for the next few years, price increases will be more likely. On the other hand, if the firm competes in a capital-intensive industry with excess capacity, price increases will be less likely. Further, a capital-intensive firm with excess capacity in a competitive industry may face high exit barriers and thus may experience future price decreases. A firm in transition from the high-growth to the mature phase of its life cycle or a firm with significant technological improvements in its production processes (for example, some portions of the computer industry or cell phone industry) might expect increases in sales volume but decreases in sales prices per unit. If a firm has established a competitive position for its brand name in its markets or has successfully differentiated unique characteristics for its products, it may have a greater potential to increase prices or to avoid price declines than a competitor firm with generic products.

When projecting revenues, the analyst also should consider economy-wide factors such as the expected rate of general price inflation in the economy and the effects of changes in exchange rates on sales denominated in foreign currencies. As discussed in Chapter 7, a parent company adds the revenues and expenses of controlled subsidiaries to its income statement during the consolidation process. If the financial statements of the subsidiary are denominated in a foreign currency that has appreciated relative to the currency used to prepare the parent company's financial statements, the translation and consolidation process will increase reported sales revenues due the foreign exchange rate increase, thus leading to a higher sales revenue growth unrelated to volume or pricing increases. In addition, the analyst also should factor the effects of corporate transactions such as acquisitions and divestitures into sales revenue forecasts. Acquisitions made during the period increase sales growth from firm expansion, whereas divestitures of subsidiaries reduce sales growth due to firm contraction.

If sales have grown at a reasonably steady rate in prior periods and nothing indicates that economic, industry, or firm-specific factors will change significantly, the analyst can project that the historical sales growth rate will persist in the future. If the firm's historical sales growth rate has been affected by changes in foreign exchange rates or by a major acquisition or divestiture, the analyst should adjust for these effects when making projections. Projecting sales for a firm with a cyclical sales pattern (for example, heavy machinery manufacturers, property-casualty insurers, and investment banks) involves an additional degree of difficulty. For cyclical firms, the historical growth rates for sales often exhibit wide variations in both direction and amount over the business cycle. For such firms, the analyst can project a varying sales growth rate that reflects this cyclical pattern, as long as the analyst can identify the current point in the cycle.

This discussion clearly emphasizes how heavily forecasting depends on the first four steps of the analysis process—understanding the economic and competitive forces of the industry, the competitive strategy of the firm, the quality of the accounting, and the drivers of profitability and risk. Projecting the future business activities such as revenues relies heavily on the information available about the industry, strategy, accounting, profitability, and risk of the firm.

Projecting Sales Revenues for PepsiCo

Earlier chapters indicated that the consumer foods industry in the United States is mature. Industry sales have grown recently at the growth rate for the general population, approximately 2 percent per year. Consumer foods companies that have achieved growth rates higher than 2 percent have generated faster growth through corporate acquisitions, expansions into international sales markets, and entry into related markets such as restaurants. PepsiCo has defied these industry averages, generating a compounded rate of growth in net revenues of 10.9 percent between 2006 and 2008. PepsiCo discloses in the MD&A section titled "Results of Operations—Consolidated Review" (Appendix B) information about net sales over these years. Net revenue amounts (in millions) and growth rates for PepsiCo are as follows:

	2006	2007	2008
Total Net Revenue Amounts	$35,137	$39,474	$43,251
Growth Rates		+12.3%	+9.6%
Compound Growth Rate			+10.9%

In PepsiCo's 2008 Annual Report, the MD&A section titled "Results of Operations—Division Review" (Appendix B) discloses information about sales and operating profits for each of PepsiCo's six operating divisions (also called segments), which it organizes into three business units, grouped by product and geography. The largest business unit in terms of sales is PepsiCo Americas Foods, which consists of three divisions: Frito-Lay North America (snack foods), Quaker Foods North America (cereals and breakfast foods), and Latin America Foods. The second-largest business unit in terms of sales is PepsiCo International (snack foods and beverages), which consists of two divisions: United Kingdom & Europe (renamed and reorganized as "Europe" in 2009) and Middle East, Africa & Asia (renamed and reorganized as Asia, Middle East & Africa in 2009). The smallest business unit in sales is PepsiCo Americas Beverages, which is a single-division segment.

For each division, PepsiCo discloses overall growth rates in sales as well as sales growth rates attributable to volume, effective net pricing, foreign exchange rates, and acquisitions. The data for PepsiCo's sales drivers appear in Exhibit 10.2. These data reveal significant differences in these drivers of sales growth across the six segments. For example, these data show

EXHIBIT 10.2

PepsiCo Sales Growth Analysis by Division

Fiscal Years (dollar amounts in millions)	2006	2007	2008
PepsiCo Total Net Revenues	$35,137	$39,474	$43,251
Annual growth rate		12.3%	9.6%
PepsiCo Americas Foods	$16,585	$18,318	$20,304
Annual growth rate		10.4%	10.8%
Compound growth rate			10.6%
Frito-Lay North America	$10,844	$11,586	$12,507
Annual growth rate		6.8%	7.9%
Compound growth rate			7.4%
Compound growth in volume			1.5%
Compound growth in prices			5.6%
Foreign exchange and acquisitions			0.2%
Quaker Foods North America	$ 1,769	$ 1,860	$ 1,902
Annual growth rate		5.1%	2.3%
Compound growth rate			3.7%
Compound growth in volume			0.2%
Compound growth in prices			2.9%
Foreign exchange and acquisitions			0.5%
Latin America Foods	$ 3,972	$ 4,872	$ 5,895
Annual growth rate		22.7%	21.0%
Compound growth rate			21.8%
Compound growth in volume			2.5%
Compound growth in prices			7.0%
Foreign exchange and acquisitions			11.1%
PepsiCo Americas Beverages	$10,362	$11,090	$10,937
Annual growth rate		7.0%	−1.4%
Compound growth rate			2.7%
Compound growth in volume			−2.8%
Compound growth in prices			4.4%
Foreign exchange and acquisitions			1.2%
PepsiCo International	$ 8,190	$10,066	$12,010
Annual growth rate		22.9%	19.3%
Compound growth rate			21.1%

EXHIBIT 10.2 (Continued)

Fiscal Years (dollar amounts in millions)	2006	2007	2008
United Kingdom & Europe	$ 4,750	$ 5,492	$ 6,435
Annual growth rate		15.6%	17.2%
Compound growth rate			16.4%
Compound growth in volume			4.0%
Compound growth in prices			2.1%
Foreign exchange and acquisitions			9.6%
Middle East, Africa & Asia	$ 3,440	$ 4,574	$ 5,575
Annual growth rate		33.0%	21.9%
Compound growth rate			27.3%
Compound growth in volume			12.5%
Compound growth in prices			3.0%
Foreign exchange and acquisitions			9.8%

that all of the divisions have managed to sustain price increases; however, the PepsiCo Americas Beverages division has been experiencing declining sales volumes. Not surprisingly, sales growth rates in the Latin America Foods division and the two PepsiCo International divisions have been favorably affected by foreign exchange rates. Also, the Latin America Foods division has generated the biggest gains in sales growth through acquisitions. By analyzing the drivers of sales growth at the division level, an analyst can develop more accurate forecasts for PepsiCo's sales growth in each division and, in turn, for PepsiCo's total sales.

Frito-Lay North America Sales Growth

The Frito-Lay North America segment generates PepsiCo's revenues from manufacturing and selling snack foods in the United States and Canada. In PepsiCo's 2008 Annual Report, the MD&A section titled "Results of Operations—Division Review" (Appendix B) discloses that this segment generated 8.0 percent sales growth in 2008 and 7.0 percent sales growth in 2007, implying a compound annual sales growth rate of 7.4 percent between 2006 and 2008 (computed as 7.4% = $[\{(1.08) \times (1.07)\}^\wedge(0.5)] - 1.0$). PepsiCo discloses that Frito-Lay North America experienced no growth in unit sales volume in 2008 and 3 percent growth in unit sales volume, implying a 1.5 percent per year compounded growth in unit sales volume during this period. The disclosure also reveals a 0.2 percent compounded sales growth from foreign exchange and acquisitions. This implies that it experienced a 5.6 percent annual compounded growth in prices ($1.074/(1.015 \times 1.002) = 1.056$).[7] The division experienced solid volume growth in key products (Cheetos®, Ruffles®, and dips) but has been hampered a bit by consecutive year volume declines in trademark brand Lays® products. The increase in prices likely reflects overall brand strength of Frito-Lay despite the relatively price-competitive snack foods markets. Based on the underlying strength of Frito-Lay's core brands and its continuing ability to develop and introduce successful new products, an analyst might expect that sales volume will exhibit 3.0 percent growth per year into the future. An analyst also might expect that future price increases will be limited to

[7] In words, 1 + sales growth rate = (1 + price growth rate) × (1 + volume growth rate) × (1 + foreign exchange and acquisitions growth rate). Rearranging to solve for the implied growth rates in prices, (1 + price growth rate) = (1 + sales growth rate) / [(1 + volume growth rate) × (1 + foreign exchange and acquisitions growth rate)].

3.0 percent per year because of the competitive and mature nature of the snack foods industry in North America. Foreign exchange rates or acquisitions are not likely to have a material persistent effect on this division's future sales. These assumptions produce an annual sales growth rate of 6.1 percent (that is, $1.061 = 1.030 \times 1.030$).

In Year +3, PepsiCo's fiscal year (which ends on the last Saturday of December each year) will contain 53 weeks. To capture this effect in our sales forecasts for Frito-Lay North America in Year +3, we project an overall sales growth rate of 8.1 percent (that is, $1.081 = 1.030 \times 1.030 \times [53/52]$). In Year +4, PepsiCo will revert to a normal 52-week year, so the sales growth rate relative to Year +3 will be only 4.1 percent (that is, $1.041 = 1.030 \times 1.030 \times [52/53]$). PepsiCo will not encounter another 53-week fiscal year for several years in the future, so we ignore the effects on our sales forecasts in Year +5 and beyond.[8]

The sales projections and growth rates for Frito-Lay North America over the first five years of the forecast horizon are as follows (allow for rounding):

2008 actual	$12,507	
Year +1 forecast	$13,269	+6.1%
Year +2 forecast	$14,077	+6.1%
Year +3 forecast	$15,221	+8.1%
Year +4 forecast	$15,843	+4.1%
Year +5 forecast	$16,808	+6.1%

Quaker Foods North America Sales Growth

The Quaker Foods North America division sells cereals and breakfast foods. It is a very stable division in a mature and competitive industry. The Quaker Foods segment experienced a modest compound rate of sales growth over Years 2006 to 2008, 3.7 percent per year. Quaker Foods' sales growth is the result of a 0.2 percent growth in sales volume compounded by an average 2.9 percent increase in prices, further compounded by 0.5 percent sales growth from favorable effects of foreign exchange rates and acquisitions. Looking ahead, an analyst might expect this division to maintain 1.0 percent growth in volume and 3.0 percent price increases. Foreign exchange rates or acquisitions are not likely to have a material affect on this division's future sales. Thus, an analyst might expect the Quaker division to generate 4.0 percent sales growth, on average (that is, $1.040 = 1.010 \times 1.030$). In Year +3, we expect Quaker to generate a 6.0 percent sales growth due to the 53rd week (that is, $1.060 = 1.010 \times 1.030 \times [53/52]$). In Year +4, after reversing the 53rd-week effect, we expect Quaker to experience only a 2.1 percent growth rate in sales (that is, $1.021 = 1.010 \times 1.030 \times [52/53]$). Sales forecast amounts and growth rates for the Quaker Foods North America division over the five-year forecast horizon are as follows:

2008 actual	$1,902	
Year +1 forecast	$1,979	+4.0%
Year +2 forecast	$2,058	+4.0%
Year +3 forecast	$2,183	+6.0%
Year +4 forecast	$2,228	+2.1%
Year +5 forecast	$2,317	+4.0%

[8] Sales forecasts are particularly important because they have crucial impacts on the projected income statements, balance sheets, and cash flows. Analysts should utilize as much relevant information as possible in developing reliable forecast assumptions (recall the "garbage in, garbage out" discussion earlier in this chapter). Analysts can often find useful information for forecasts in company disclosures, competitors' financial statements and disclosures, industry data, and regional- and country-specific economic data. This chapter seeks to illustrate the techniques of using such information in developing forecasts, while also being concise and efficient for you, the reader.

Latin America Foods Sales Growth

The Latin America Foods division sells snacks, cereals, and breakfast foods throughout Latin America. It grew sales at an impressive compound annual rate of 21.8 percent from 2006 to 2008. This growth rate is the result of an average 2.5 percent growth in sales volume compounded by an average 7.0 percent increase in prices and an average of 11.1 percent growth from acquisitions. Changes in foreign exchange rates have had only a minor impact on sales growth.

An analyst might expect this segment to maintain 2.5 percent growth in volume and 5.0 percent price increases due to the strength of its brands in this region. An analyst also might expect PepsiCo to continue to make acquisitions throughout the Latin America region, which could contribute an additional 5.0 percent growth in sales per year, on average. Therefore, an analyst would expect the Latin America Foods division to generate a 13.0 percent sales growth rate (that is, $1.130 = 1.025 \times 1.050 \times 1.050$) each year. In Year +3, this division would be expected to generate a 15.1 percent sales growth due to the effect of the 53rd week (that is, $1.151 = 1.025 \times 1.050 \times 1.050 \times [53/52]$). In Year +4, after reversing the 53rd-week effect, we would expect this division to experience 10.8 percent growth rate in sales (that is, $1.108 = 1.025 \times 1.050 \times 1.050 \times [52/53]$). Sales forecast amounts and growth rates for the Latin America Foods division over the five-year forecast horizon are as follows:

2008 actual	$ 5,895	
Year +1 forecast	$ 6,660	+13.0%
Year +2 forecast	$ 7,524	+13.0%
Year +3 forecast	$ 8,663	+15.1%
Year +4 forecast	$ 9,602	+10.8%
Year +5 forecast	$10,848	+13.0%

PepsiCo Americas Beverages Sales Growth

The PepsiCo Americas Beverages manufactures and sells a wide variety of syrups, concentrates, and finished goods beverages including carbonated and noncarbonated soft drinks, juices, water, tea, and coffee in the United States, Canada, and Latin America. This segment experienced only a modest compound annual sales growth rate of 2.7 percent between 2006 and 2008. The segment's sales growth was driven largely by net pricing increases despite declining or flat sales volumes in North America. These declines were partially offset by modest increases in sales volumes in Latin America. Over 2006 to 2008, the PepsiCo Americas Beverages segment generated an average 2.8 percent decline in sales volume, an average 4.4 percent growth from price increases, and an average 1.2 percent growth from foreign exchange and acquisitions. Overall in North America, the liquid refreshment beverage category declined in 2008.

Going forward, an analyst might expect that PepsiCo's beverage segment will bounce back to sustain 3.0 percent growth in sales volume in the future because it has a deep and broad portfolio of branded products that span the beverages market (for example, carbonated soft drinks, sports drinks, juices, waters, coffees, and teas). One may also expect that the 4.4 percent price growth, which exceeded the rate of inflation in North America during that same period, is unsustainable and that PepsiCo will generate and sustain only 3.0 percent growth in prices in the future, closer to the economy-wide inflation rate. One might also expect minimal impact on future sales from foreign exchange and acquisitions. Together, these assumptions create an annual sales growth rate of 6.1 percent.

After including the 53rd-week effect, the sales growth rate in Year +3 should be 8.1 percent (that is, $1.081 = 1.03 \times 1.03 \times 1.0 \times [53/52]$). After reversing the 53rd-week effect on sales growth in Year +4, the sales growth rate should be 4.1 percent (that is, $1.041 = 1.03 \times 1.03 \times 1.0 \times [52/53]$). In Year +5, the assumption is that sales growth rates will revert to

6.1 percent. Sales forecast amounts and growth rates for the PepsiCo Americas Beverages segment over the five-year forecast horizon are as follows:

2008 actual	$10,937	
Year +1 forecast	$11,603	+6.1%
Year +2 forecast	$12,310	+6.1%
Year +3 forecast	$13,310	+8.1%
Year +4 forecast	$13,855	+4.1%
Year +5 forecast	$14,698	+6.1%

United Kingdom & Europe Sales Growth

The PepsiCo International segment is the fastest-growing segment in the company. In this segment, the United Kingdom & Europe (UKEU) division sells PepsiCo snack food and beverage products throughout the United Kingdom, Europe, Russia, and the former Soviet states. PepsiCo discloses that net revenue growth in the UKEU division was fueled in part by significant growth rates in sales volumes for snack foods and beverages in Russia. The UKEU division experienced an average annual sales growth rate of 16.4 percent for 2006 through 2008, which includes sales volume growth of 4.0 percent, net price growth of 2.1 percent, and growth from acquisitions and foreign exchange of 9.6 percent. Acquisitions contributed 8.0 percent to sales growth in 2008, whereas foreign exchange rate movements contributed nearly 9.0 percent in 2007, particularly because of declines in the value of the British pound and the euro relative to the U.S. dollar. (Therefore, PepsiCo's sales in pounds and euros translate into a greater number of U.S. dollars.)

Based on the track record of PepsiCo's UKEU division, an analyst might expect a 4.0 percent growth in sales volume in the future. An analyst also might expect the division to sustain 2.0 percent growth in prices into the future. The assumption is that favorable foreign currency movements are not likely to persist over the next five years, whereas this division may continue to generate sales growth through acquisitions, perhaps at a rate of 5.0 percent per year. With these assumptions, one would forecast average annual sales growth of 11.4 percent for the UKEU division (that is, $1.114 = 1.040 \times 1.020 \times 1.05$). After including the 53rd-week effect for Year +3, the sales growth rate should be 13.5 percent (that is, $1.135 = 1.040 \times 1.020 \times 1.050 \times [53/52]$). After reversing the 53rd-week effect on projected sales for Year +4, the sales growth rate should be 9.3 percent (that is, $1.093 = 1.04 \times 1.02 \times 1.05 \times [52/53]$). In Year +5, sales growth should be 11.4 percent. Sales amounts and growth rates for PepsiCo's UKEU division over the five-year forecast horizon are as follows:

2008 actual	$ 6,435	
Year +1 forecast	$ 7,168	+11.4%
Year +2 forecast	$ 7,984	+11.4%
Year +3 forecast	$ 9,063	+13.5%
Year +4 forecast	$ 9,905	+9.3%
Year +5 forecast	$11,032	+11.4%

Middle East, Africa & Asia Sales Growth

The single fastest-growing division in PepsiCo is the Middle East, Africa & Asia (MEAA) division, which sells PepsiCo snack food and beverage products throughout these regions. This division experienced a very high average annual sales growth rate of 27.3 percent for 2006 through 2008, which includes sales volume growth of 12.5 percent, net price growth of 3.0 percent, and growth from acquisitions and foreign exchange of 9.8 percent. PepsiCo discloses that net revenue growth in the MEAA division was fueled particularly by significant

growth in sales volumes for snack foods and beverages in the Middle East, China, and India. Acquisitions contributed 2.0 percent and 11.0 percent to sales growth of the division in 2008 and 2007, respectively. Foreign exchange rate movements contributed 1.0 percent and 5.5 percent to sales growth in 2008 and 2007, respectively.

The MEAA division clearly has momentum in generating sales growth, which is likely to persist for at least several years. An analyst might expect PepsiCo's MEAA division to sustain 8.0 percent growth in sales volume in the future. An analyst also might expect the division to sustain 3.0 percent growth in prices into the future. It is difficult to envision persistent favorable foreign currency movements over the next five years, but it is plausible for this division to generate 5.0 percent sales growth per year through acquisitions. With these assumptions, one would project average annual sales growth of 16.8 percent for the MEAA division (that is, $1.168 = 1.080 \times 1.030 \times 1.05$). After including the 53rd-week effect for Year +3, the sales growth rate should be 19.1 percent (that is, $1.191 = 1.080 \times 1.030 \times 1.050 \times [53/52]$). After reversing the 53rd-week effect for Year +4, the sales growth rate should be 14.6 percent (that is, $1.146 = 1.08 \times 1.03 \times 1.05 \times [52/53]$). In Year +5, sales growth should revert to 16.8 percent per year. Sales amounts and growth rates for PepsiCo's MEAA division over the five-year forecast horizon are as follows:

2008 actual	$ 5,575	
Year +1 forecast	$ 6,513	+16.8%
Year +2 forecast	$ 7,610	+16.8%
Year +3 forecast	$ 9,061	+19.1%
Year +4 forecast	$10,387	+14.6%
Year +5 forecast	$12,135	+16.8%

Combined Sales Growth

The following table combines the sales forecasts for each of the six divisions of PepsiCo. The table presents the projected sales amount for each segment, segment sales expressed as a percentage of total net sales (in parentheses), PepsiCo's total net sales, and annual sales growth rates for each year through forecast Year +5.

PepsiCo Sales Forecasts by Division

	Actual:	Forecasts:				
Division:	**2008**	**Year +1**	**Year +2**	**Year +3**	**Year +4**	**Year +5**
Frito-Lay North America	$ 12,507	$ 13,269	$ 14,077	$ 15,221	$ 15,843	$ 16,808
Percentage of total net sales	(28.9%)	(28.1%)	(27.3%)	(26.5%)	(25.6%)	(24.8%)
Quaker Foods North America	$ 1,902	$ 1,979	$ 2,058	$ 2,183	$ 2,228	$ 2,317
Percentage of total net sales	(4.4%)	(4.2%)	(4.0%)	(3.8%)	(3.6%)	(3.4%)
Latin America Foods	$ 5,895	$ 6,660	$ 7,524	$ 8,663	$ 9,602	$ 10,848
Percentage of total net sales	(13.6%)	(14.1%)	(14.6%)	(15.1%)	(15.5%)	(16.0%)
PepsiCo Americas Beverages	$ 10,937	$ 11,603	$ 12,310	$ 13,310	$ 13,855	$ 14,698
Percentage of total net sales	(25.3%)	(24.6%)	(23.9%)	(23.1%)	(22.4%)	(21.7%)
United Kingdom & Europe	$ 6,435	$ 7,168	$ 7,984	$ 9,063	$ 9,905	$ 11,032
Percentage of total net sales	(14.9%)	(15.2%)	(15.5%)	(15.8%)	(16.0%)	(16.3%)
Middle East, Africa & Asia	$ 5,575	$ 6,513	$ 7,610	$ 9,061	$ 10,387	$ 12,135
Percentage of total net sales	(12.9%)	(13.8%)	(14.8%)	(15.8%)	(16.8%)	(17.9%)
PepsiCo Total Net Sales	**$ 43,251**	**$ 47,191**	**$ 51,562**	**$ 57,502**	**$ 61,820**	**$ 67,839**
Annual growth rate		9.1%	9.3%	11.5%	7.5%	9.7%

The Forecast spreadsheet in FSAP gives the analyst the opportunity to input specific forecast parameters (such as sales growth rates) for Year +1 through Year +5, as well as general forecast parameters for Year +6 and beyond. For Years +1 through +5, we will enter the sales growth rates and amounts shown above. The forecast parameters for Year +6 and beyond represent general forecast assumptions over the long-run horizon. We assume PepsiCo will sustain a 3.0 percent sales growth rate in Year +6 and beyond, consistent with long-run growth in the economy and expected long-run inflation that together will average 3.0 percent per year.[9]

The analyst can use the Forecast Development spreadsheet in FSAP to develop detailed revenues forecasts, capturing the key drivers of the firm's sales growth. That has been done here by analyzing and forecasting PepsiCo's sales growth drivers separately for each division and then aggregating those forecasts into total sales forecasts through Year +5. Appendix C illustrates how we used the Forecast Development spreadsheet in FSAP to develop the sales forecasts for PepsiCo.

STEP 2: PROJECTING OPERATING EXPENSES

The procedure for projecting operating expenses depends on the degree to which they have fixed or variable components. If certain operating expenses vary directly with sales and if the analyst anticipates no changes in the relation between these expenses and sales, the analyst can project these future operating expenses using common-size income statement percentages for such expenses relative to sales. Projected sales are simply multiplied by the appropriate percentage to derive the amounts for operating expenses that vary directly with sales. Equivalently, those operating expenses can be projected to grow at the same rate as sales. Unfortunately, firms rarely disclose the fixed versus variable components of their expense structure. Thus, the analyst must estimate the contribution of fixed versus variable expenses to the total amounts reported.

If the analyst determines that operating expenses reflect cost structures that will not change linearly with sales (for example, the firm may experience economies of scale as sales increase or may face expenses that remain relatively fixed even if sales decrease), using the common-size income statement approach can result in operating expense projections that are too high or too low. A possible clue for the existence of fixed costs is the stability of the ratio of the percentage change in an expense relative to the percentage change in sales. Changes in this ratio over time may be due to the existence of fixed costs. In this case, the analyst should attempt to estimate the variable and fixed cost structure of those particular operating expenses.[10] Capital-intensive manufacturing firms often have high proportions of fixed costs in their cost structures, particularly from depreciation on property, plant, and equipment, and fixed labor charges. When sales increase and the percentage increase in costs of goods sold or selling, general, and administrative expenses is significantly less than

[9] Although it is very reasonable and common for analysts to expect that PepsiCo's long-run growth rate will be approximately 3.0 percent, it is unlikely that the revenue growth rate will suddenly and dramatically drop from 9.7 percent in Year +5 to 3.0 percent in Year +6. This somewhat artificial shift in sales growth is a byproduct of using only a five-year forecast horizon for the financial statement projections, which we use to make the exposition of this chapter shorter and more efficient for you. The analyst interested in greater forecast accuracy may want to use longer forecast horizons (for example, ten years), allowing for a more gradual and realistic evolution toward the long-run growth rate.

[10] Many expenses can be viewed as having a fixed portion and a portion that varies with sales. For example, a firm's cost of sales might involve fixed periodic cost such as rent or depreciation on property and equipment and costs for direct labor and materials that vary directly with product sales. Selling, general, and administrative costs often include fixed components for items such as salaries, rent, insurance, and other corporate overhead expenses but variable components that vary directly with sales, such as sales commissions.

the percentage change in sales, it indicates the presence of fixed costs. The analyst can sometimes estimate the variable cost as a percentage of sales for a particular expense (for example, cost of goods sold) by dividing the amount of the change in the expense item between two years by the amount of the change in sales for those two years. The analyst can then multiply the variable-cost percentage times sales to estimate the total variable cost. Subtracting the variable cost from the total cost yields an estimate of the fixed cost for that particular item. Using this approach, one could then project a particular future expense with two components: a fixed component and a component that varies with sales. For a firm that is particularly dependent on property, plant, and equipment, the analyst may need to create a separate schedule to forecast capital expenditures that coincide with or precede projected future sales and depreciation expense amounts that follow property, plant, and equipment (demonstrated later in this chapter).[11]

When projecting operating expenses as a percentage of sales, the analyst should keep in mind that an expense as a percentage of sales can change over time: (1) as expenses change, holding sales constant; (2) as sales change, holding expenses constant; (3) both types of change occurring simultaneously and in the same direction; or (4) both types of change occurring simultaneously but in opposite directions. As an example of case 1, the analyst may expect an expense to become a smaller fraction of sales over time if the firm drives down costs by creating operating efficiencies or new production technologies. As an example of case 2, the analyst may expect that the firm will hold expenses (such as cost of goods sold) relatively steady but will face increased competition for market share and therefore may be forced to lower sales prices, causing the expected expense-to-sales ratio to increase. In case 3, if the analyst expects both sales and operating expenses to increase (or decrease) simultaneously, the net result on the projected expense-to-sales percentage will depend on which of the two effects is proportionally greater. In case 4, if the analyst expects sales to increase while operating expenses decrease (as might occur for a firm in transition from a start-up phase to a growth phase of its life cycle), or vice versa (sales decrease while operating expenses increase, as might occur for a firm in distress), the net result on the projected expense-to-sales percentage will depend on the relative magnitudes of the two effects. In projecting the future relations between revenues and expenses, it is essential to evaluate the firm's strategies with respect to future growth, shifts in product/portfolio mix, changes in the mix of fixed and variable expenses, competitive pressure on pricing, and many other factors that will impact expected future revenues and expenses.

Projecting Cost of Goods Sold

The common-size income statement data discussed in Chapter 1 and 4 (and presented in the Analysis spreadsheet of FSAP presented in Appendix C) indicate that PepsiCo's cost of goods sold as a percent of sales has steadily increased from 43.3 percent in 2004 to 47.1 percent in 2008. In the MD&A section of the annual report (Appendix B), PepsiCo provides very little discussion to explain this negative trend, other than to mention rising raw material commodity costs as a contributing factor. Note 3, "Restructuring and Impairment Charges" (Appendix A), discloses that PepsiCo recognized $543 million of restructuring and impairment charges in 2008 and allocated $88 million of those charges to costs of goods sold.

[11] Sometimes more advanced approaches may be necessary, such as using regression analysis to estimate fixed versus variable components of expenses. For example, an analyst might use time-series data to estimate the relation, $COGS = \alpha + \beta \times Sales + \epsilon$. The estimated level of fixed costs equals the estimated intercept, α, and the variable component would be reflected by the slope coefficient, β.

Without this restructuring charge, the cost of goods sold percentage in 2008 would have been 46.8 percent (computed as ($20,351 million − $88 million)/$43,251 million).

PepsiCo's cost of goods sold as a percent of sales has been increasing despite the prior observation that PepsiCo's recent sales growth in 2007 and 2008 has been driven more by price increases than sales volume increases. With costs held constant, sales price increases should translate into decreasing cost of goods sold percentages. Given this recent performance, an analyst might question whether PepsiCo will be able to improve its performance and reduce the cost of goods sold percentage in the future by cutting costs, given that it has not been able to do so during periods of rising prices.[12]

In recent years, PepsiCo has generated its fastest rates of sales growth in the Latin America Foods division, the UKEU division, and the MEAA division, which generate the lowest operating profit margins of PepsiCo's six divisions (as disclosed in the 2008 Annual Report MD&A section titled "Results of Operations—Division Review" in Appendix B). Therefore, PepsiCo is generating more of its sales from lower profit margin divisions, which also partially explains why the cost of goods sold has been increasing as a percentage of sales. Given that our sales forecasts project that the Latin America Foods division, the UKEU division, and the MEAA division will become increasingly larger proportions of PepsiCo's total sales, an analyst might expect PepsiCo's future cost of goods sold percentage to increase over the five-year forecast horizon. Ideally, PepsiCo would disclose costs of good sold by division and we could vary projected future costs of goods sold across each division. However, PepsiCo only discloses cost of goods sold aggregated across all divisions.

Given all of this analysis, we predict that PepsiCo's cost of goods sold gradually will increase from 47.3 percent of sales in Year +1 to 48.0 percent in Year +5 and beyond. The cost of goods sold forecasts through Year +5 follow:

	Sales	Percentage of Sales	Cost of Goods Sold
Year +1 Projected	$47,191	47.3%	$22,321
Year +2 Projected	$51,562	47.5%	$24,492
Year +3 Projected	$57,502	47.7%	$27,429
Year +4 Projected	$61,820	47.9%	$29,612
Year +5 Projected	$67,839	48.0%	$32,563

Projecting Selling, General, and Administrative Expenses

The common-size income statement data reveal that PepsiCo's selling, general, and administrative (SG&A) expenses as a percentage of sales varied slightly from 36.2 percent in 2006 down to 36.0 percent in 2007 and then up to 36.8 percent in 2008.[13] As disclosed in the 2008 Annual Report MD&A section titled "Our Financial Results" (Appendix B), in 2008, PepsiCo recognized restructuring and impairment charges amounting to $543 million, of which $455 million was included in SG&A expenses. In addition, PepsiCo included mark-to-market losses on commodity derivatives of $346 million in 2008. Absent these charges

[12] PepsiCo's main competitor in the beverage business, Coca-Cola, exhibits much lower (but also rising) cost of goods sold percentages from 33.9 percent to 35.6 percent over 2006 to 2008. Unlike Coca-Cola, which is primarily a beverage company, PepsiCo's sales include a high proportion of snack foods and breakfast foods, which likely have higher costs as a percentage of sales than do beverages.

[13] On this dimension, PepsiCo outperformed its rival Coca-Cola, which experienced SG&A expenses of 39.2 percent of sales in 2006, 37.9 percent in 2007, and 36.9 percent in 2008.

and losses (which are not likely to persist), SG&A expenses would have been only 34.9 percent of sales in 2008. An analyst might reasonably assume that a firm will achieve incremental efficiencies in future SG&A expenses and reduce this percentage over time, particularly a firm with the potential to generate economies of scale or scope or operating synergies. As disclosed in the 2008 Annual Report MD&A section titled "Our Financial Results" (Appendix B), PepsiCo is implementing a program to control costs and generate significant pretax savings, presumably by creating incremental efficiencies in future SG&A expenses. We therefore project that PepsiCo will maintain SG&A expenses equal to roughly 35.0 percent of sales in the future.

The projected amounts for SG&A expenses are as follows:

	Sales	Percentage of Sales	SG&A Expenses
Year +1 Projected	$47,191	35.0%	$16,517
Year +2 Projected	$51,562	35.0%	$18,047
Year +3 Projected	$57,502	35.0%	$20,126
Year +4 Projected	$61,820	35.0%	$21,637
Year +5 Projected	$67,839	35.0%	$23,744

As the title of this expense account implies, SG&A expenses encompass a wide range of operating expenses. In Note 2, "Our Significant Accounting Policies" (Appendix A), PepsiCo discloses that in 2008, SG&A expenses include $2,900 million in advertising and marketing expenses; $5,300 million in shipping and handling expenses; $388 million in R&D expenses; and amounts for compensation and employee benefits, rent, and various other expenses. If the analyst expects these individual expense items to be driven by factors other than sales growth or if the analyst expects the proportionate composition of these expenses to change relative to future sales, then the analyst should project the items individually and then sum them to obtain total SG&A expense projections.

Projecting Other Operating Expenses

In 2006 through 2008, PepsiCo recognized expenses for amortization of intangible assets amounting to $162 million, $58 million, and $64 million, respectively, which are equivalent to 0.5 percent, 0.1 percent, and 0.1 percent of sales, respectively. These expenses represent amortization of intangibles such as brands and trademarks with limited useful lives (ranging from 5 to 40 years). The net book value of PepsiCo's amortizable intangible assets amounts to $732 million on the 2008 balance sheet. In Note 4, "Property, Plant, and Equipment and Intangible Assets" (Appendix A), PepsiCo provides helpful disclosures indicating that it expects amortization expense for these intangible assets to be $64 million in Year +1, $63 million in Year +2, $62 million in Year +3, $60 million in Year +4, and $56 million in Year +5, based on 2008 foreign exchange rates and the assumption of no additional investments in amortizable intangible assets over that period. Therefore, we use these amounts as our forecasts for PepsiCo's amortization expense over this forecast horizon. We also use these amounts to reduce the net book value of the amortizable intangible asset account balance each year.

U.S. GAAP does not require amortization of goodwill or other intangible assets deemed to have indefinite useful lives. Goodwill ($5,124 million) and other nonamortizable intangible assets ($1,128 million) represent roughly 90 percent of PepsiCo's total intangible assets on the 2008 balance sheet. In our forecasts, we include no amortization expenses or impairment losses for these nonamortizable intangibles.

Projecting Nonrecurring Operating Gains and Losses

As described previously, PepsiCo recognized restructuring and impairment charges in cost of goods sold and SG&A expenses in 2008. We will accept PepsiCo's classification of these items as nonrecurring components of operations, and forecast that these amounts will be zero in the future. It is common for analysts to expect nonrecurring amounts to be zero in future years. The analysts should be cautious, however, because some firms demonstrate a tendency for persistent "nonrecurring" charges.

The sales forecasts, together with the projected costs of goods sold, SG&A expenses, and amortization of intangible assets, lead to the following projected amounts of operating income for PepsiCo for Years +1 through +5:

	Year +1	Year +2	Year +3	Year +4	Year +5
Revenues	$ 47,191	$ 51,562	$ 57,502	$ 61,820	$ 67,839
Cost of Goods Sold	−22,321	−24,492	−27,429	−29,612	−32,563
Gross Profit	$ 24,870	$ 27,070	$ 30,074	$ 32,208	$ 35,277
Gross Profit Margin	(52.7%)	(52.5%)	(52.3%)	(52.1%)	(52.0%)
SG&A Expenses	−16,517	−18,047	−20,126	−21,637	−23,744
Amortization of Intangible Assets	−64	−63	−62	−60	−56
Operating Income	$ 8,289	$ 8,960	$ 9,886	$ 10,511	$ 11,477
Operating Profit Margin	(17.6%)	(17.4%)	(17.2%)	(17.0%)	(16.9%)

Exhibit 10.3 presents the complete forecasts of PepsiCo's income statements, as well as comprehensive income and the change in retained earnings, for Years +1 through +5. The format of this exhibit mirrors the format of the Forecast spreadsheet in FSAP (Appendix C). This chapter will discuss the projections of interest income, interest expense, income tax expense, net income, comprehensive income, and the change in retained earnings after projecting PepsiCo's balance sheet, which we discuss in the next sections.

STEP 3: PROJECTING OPERATING ASSETS AND LIABILITIES ON THE BALANCE SHEET

In this section of the chapter, we forecast how the operating activities projected for the income statement will generate future operating assets and liabilities on the balance sheet. We will demonstrate how to develop forecasts using various drivers of growth in different assets and liabilities, allowing the mix of assets and liabilities to change as the business evolves over time. In the next section of this chapter, we will forecast the financing activities that will be necessary to support the firm's operations.

To develop forecasts of individual operating assets and liabilities, the analyst must first determine, if possible, the underlying operating activities that drive them. For some types of assets, such as inventory and property, plant, and equipment, asset growth typically leads future sales growth. Growth for other types of assets, such as accounts receivable, typically lags sales growth. Certain operating liabilities will be determined by operating assets (such

EXHIBIT 10.3

PepsiCo
Actual and Forecast Statements of Net Income and Comprehensive Income

Actual and forecast amounts in bold; historical common-size and rate of change percentages reported below the actual amounts only; forecast assumptions and brief explanations below forecast amounts. Amounts in millions; allow for rounding.

Year	Actuals			Forecasts				
	2006	2007	2008	Year +1	Year +2	Year +3	Year +4	Year +5
INCOME STATEMENT								
Revenues	**35,137**	**39,474**	**43,251**	**47,191**	**51,562**	**57,502**	**61,820**	**67,839**
common size	100.0%	100.0%	100.0%	9.1%	9.3%	11.5%	7.5%	9.7%
rate of change		12.3%	9.6%	(See Forecast Development worksheet for details of revenues forecasts.)				
Cost of Goods Sold	**−15,762**	**−18,038**	**−20,351**	**−22,321**	**−24,492**	**−27,429**	**−29,612**	**−32,563**
common size	−44.9%	−45.7%	−47.1%	−47.3%	−47.5%	−47.7%	−47.9%	−48.0%
rate of change		14.4%	12.8%	(Assume slowly increasing cost of goods sold as a percent of sales.)				
Gross Profit	**19,375**	**21,436**	**22,900**	**24,870**	**27,070**	**30,074**	**32,208**	**35,277**
common size	55.1%	54.3%	52.9%	52.7%	52.5%	52.3%	52.1%	52.0%
rate of change		10.6%	6.8%	8.6%	8.8%	11.1%	7.1%	9.5%
Selling, General, and Administrative Expenses	**−12,711**	**−14,208**	**−15,901**	**−16,517**	**−18,047**	**−20,126**	**−21,637**	**−23,744**
common size	−36.2%	−36.0%	−36.8%	−35.0%	−35.0%	−35.0%	−35.0%	−35.0%
rate of change		11.8%	11.9%	(Assume steady SG&A expense as a percent of sales.)				
Amortization of Intangible Assets	**−162**	**−58**	**−64**	**−64**	**−63**	**−62**	**−60**	**−56**
common size	−0.5%	−0.1%	−0.1%	−64.0	−63.0	−62.0	−60.0	−56.0
rate of change		−64.2%	10.3%	(Amounts based on PepsiCo disclosures in Note 4.)				
Operating Profit	**6,502**	**7,170**	**6,935**	**8,289**	**8,960**	**9,886**	**10,511**	**11,477**
common size	18.5%	18.2%	16.0%	17.6%	17.4%	17.2%	17.0%	16.9%
rate of change		10.3%	−3.3%	19.5%	8.1%	10.3%	6.3%	9.2%

(Continued)

EXHIBIT 10.3 (Continued)

Year	Actuals			Forecasts				
	2006	2007	2008	Year +1	Year +2	Year +3	Year +4	Year +5
Interest Income	173	125	41	73	81	90	98	107
common size	0.5%	0.3%	0.1%	3.0%	3.0%	3.0%	3.0%	3.0%
rate of change		−27.7%	−67.2%	(Interest rate earned on average balance in cash and marketable securities.)				
Interest Expense	−239	−224	−329	−493	−531	−579	−626	−677
common size	−0.7%	−0.6%	−0.8%	−5.8%	−5.8%	−5.8%	−5.8%	−5.8%
rate of change		−6.3%	46.9%	(Interest rate paid on average balance in financial liabilities.)				
Income from Equity Affiliates	553	560	374	480	509	539	572	606
common size	1.6%	1.4%	0.9%	12.0%	12.0%	12.0%	12.0%	12.0%
rate of change		1.3%	−33.2%	(Assume expected return of 12% on investments in noncontrolled affiliates.)				
Income before Tax	6,989	7,631	7,021	8,348	9,019	9,935	10,555	11,513
common size	19.9%	19.3%	16.2%	17.7%	17.5%	17.3%	17.1%	17.0%
rate of change		9.2%	−8.0%	18.9%	8.0%	10.2%	6.2%	9.1%
Income Tax Expense	−1,347	−1,973	−1,879	−2,237	−2,417	−2,663	−2,829	−3,085
common size	−3.8%	−5.0%	−4.3%	−26.8%	−26.8%	−26.8%	−26.8%	−26.8%
rate of change		46.5%	−4.8%	(Effective income tax rate assumptions.)				
Net Income (computed)	5,642	5,658	5,142	6,111	6,602	7,273	7,726	8,427
common size	16.1%	14.3%	11.9%	12.9%	12.8%	12.6%	12.5%	12.4%
rate of change		0.3%	−9.1%	18.8%	8.0%	10.2%	6.2%	9.1%
Other Comprehensive Income Items	456	1,294	−3,793	0	0	0	0	0
common size	1.3%	3.3%	−8.8%	0.0	0.0	0.0	0.0	0.0
rate of change		183.8%	−393.1%	(Assume random walk.)				
Comprehensive Income	6,098	6,952	1,349	6,111	6,602	7,273	7,726	8,427
common size	17.4%	17.6%	3.1%	12.9%	12.8%	12.6%	12.5%	12.4%
rate of change		14.0%	−80.6%	353.0%	8.0%	10.2%	6.2%	9.1%

as inventory purchases driving accounts payable), whereas others will be determined by operating expenses (such as accrued expenses). We project individual operating assets and liabilities for PepsiCo using a combination of forecast drivers, including common-size percentages, growth rates, and assets turnovers. Exhibit 10.4 provides a preview of the projected balance sheets for PepsiCo through Year +5, which we developed using the Forecasts worksheet in FSAP (Appendix C). The following sections discuss the projections of individual operating assets and liabilities.

Projecting Cash

The Analysis worksheet in FSAP (Appendix C) computes the average turnover of sales through the average cash balance each year, so we will use those ratios to project PepsiCo's ending cash balances during the forecast horizon. Like all firms, PepsiCo needs a certain amount of cash on hand for day-to-day liquidity.[14] PepsiCo's cash holdings have varied between 2004 and 2008. During 2004 through 2006, PepsiCo had average cash balances that grew from 13.1 days of sales to 17.5 days, whereas in 2007 and 2008, average cash balances were roughly 12.0 days of sales (computed as 365 days divided by the ratio of sales to the average balance in cash; in 2008, 12.5 days = 365/[$43,251/({$2,064 + $910}/2)]. We assume that PepsiCo will maintain average cash balances equivalent to 12 days of sales in the future.

Applying this approach we use our forecasts of sales and the projected number of days of sales in cash to compute the average balance in cash each year. The Year +1 sales forecast is $47,191 million, or an average of $129.3 million per day. We project PepsiCo will hold an average of 12 days of sales in cash during Year +1, for an average cash balance of $1,551 million. The projected cash balances follow:

| | Cash | | | |
	Annual Sales Forecasts	Average Sales per Day	Days Sales in Cash	Average Cash Balance
Year +1	$47,191	$129.3	12	$1,551
Year +2	$51,562	$141.3	12	$1,695
Year +3	$57,502	$157.5	12	$1,890
Year +4	$61,820	$169.4	12	$2,032
Year +5	$67,839	$185.9	12	$2,230

The forecasts above project the average cash balances that will be included as the end of year balances for Cash and Cash Equivalents in the projected PepsiCo balance sheets. If more precision is preferred, an analyst can adapt the approach to project year-end balances in cash. Given that the beginning cash balance in Year +1 is $2,064 million and the average balance is projected to be $1,551 million, it implies that the ending balance will be $1,039 million (that is, the implied ending balance equals two times the average

[14] The forecasts assume that PepsiCo uses cash for day-to-day operating liquidity purposes, so cash is treated as an element of working capital. Some firms maintain excess cash balances far beyond what is needed for daily liquidity. For such firms, cash may be forecasted in two separate components: cash necessary for liquidity and excess cash. For these firms, the excess cash can serve as the flexible financial account used to balance the balance sheet and should be considered a financial asset.

EXHIBIT 10.4

PepsiCo Actual and Forecast Balance Sheets

Actual and forecast amounts in bold; historical common-size and rate-of-change percentages reported below the actual amounts only; forecast assumptions and brief explanations below forecast amounts. Amounts in millions; allow for rounding.

	Actuals			Forecasts				
	2006	2007	2008	Year +1	Year +2	Year +3	Year +4	Year +5
BALANCE SHEET								
ASSETS:								
Cash and Cash Equivalents	**1,651**	**910**	**2,064**	**1,551**	**1,695**	**1,890**	**2,032**	**2,230**
common size	5.5%	2.6%	5.7%	12.0	12.0	12.0	12.0	12.0
rate of change		−44.9%	126.8%	(Assume ending cash balances equal to 12 days sales.)				
Marketable Securities	**1,171**	**1,571**	**213**	**1,034**	**1,130**	**1,260**	**1,355**	**1,487**
common size	3.9%	4.5%	0.6%	8.0	8.0	8.0	8.0	8.0
rate of change		34.2%	−86.4%	(Assume ending balances equal to 8 days sales.)				
Accounts Receivable—Net	**3,725**	**4,389**	**4,683**	**5,143**	**5,593**	**6,380**	**6,492**	**7,633**
common size	12.4%	12.7%	13.0%	38.0	38.0	38.0	38.0	38.0
rate of change		17.8%	6.7%	(Assume 38 days to collect sales in accounts receivable.)				
Inventories	**1,926**	**2,290**	**2,522**	**2,730**	**3,033**	**3,421**	**3,546**	**4,116**
common size	6.4%	6.6%	7.0%	8.5	8.5	8.5	8.5	8.5
rate of change		18.9%	10.1%	(Assume average inventory turnover of roughly 8.5 times per year.)				
Prepaid Expenses and Other Current Assets	**657**	**991**	**1,324**	**1,445**	**1,578**	**1,760**	**1,892**	**2,077**
common size	2.2%	2.9%	3.7%	9.1%	9.3%	11.5%	7.5%	9.7%
rate of change		50.8%	33.6%	(Assume growth with sales.)				
Current Assets	**9,130**	**10,151**	**10,806**	**11,904**	**13,029**	**14,712**	**15,318**	**17,543**
common size	30.5%	29.3%	30.0%	30.9%	31.3%	32.1%	31.5%	32.8%
rate of change		11.2%	6.5%	10.2%	9.5%	12.9%	4.1%	14.5%
Long-Term Investments	**3,690**	**4,354**	**3,883**	**4,116**	**4,363**	**4,625**	**4,902**	**5,196**
common size	12.3%	12.6%	10.8%	6%	6%	6%	6%	6%
rate of change		18.0%	−10.8%	(Assume steady growth.)				
Property, Plant & Equipment—at cost	**19,058**	**21,896**	**22,552**	**24,723**	**27,662**	**30,939**	**34,463**	**38,330**
common size	63.7%	63.2%	62.7%	(PP&E assumptions—see schedule in Forecast Development worksheet.)				
rate of change		14.9%	3.0%					
Accumulated Depreciation	**−9,371**	**−10,668**	**−10,889**	**−12,471**	**−14,241**	**−16,220**	**−18,426**	**−20,878**
common size	−31.3%	−30.8%	−30.3%	(See depreciation schedule in Forecast Development worksheet.)				
rate of change		13.8%	2.1%					

Amortizable Intangible Assets (net)	637	796	732	668	605	543	483	427
common size	2.1%	2.3%	2.0%	(Assume amortization per PepsiCo disclosures in Note 4; assume no new investments.)				
rate of change		25.0%	−8.0%	−64.0	−63.0	−62.0	−60.0	−56.0
Goodwill and Nonamortizable Intangibles	5,806	6,417	6,252	6,822	7,453	8,312	8,936	9,806
common size	19.4%	18.5%	17.4%	(Assume growth with sales.)				
rate of change		10.5%	−2.6%	9.1%	9.3%	11.5%	7.5%	9.7%
Other Non-Current Assets	980	1,682	2,658	2,738	2,820	2,904	2,992	3,081
common size	3.3%	4.9%	7.4%	(Assume steady growth.)				
rate of change		71.6%	58.0%	3.0%	3.0%	3.0%	3.0%	3.0%
Total Assets	29,930	34,628	35,994	38,499	41,692	45,815	48,669	53,506
common size	100.0%	100.0%	100.0%	100.0%	100.0%	100.0%	100.0%	100.0%
rate of change		15.7%	3.9%	7.0%	8.3%	9.9%	6.2%	9.9%
LIABILITIES:								
Accounts Payable—Trade	2,102	2,562	2,846	3,080	3,442	3,875	3,947	4,768
common size	7.0%	7.4%	7.9%	48.0	48.0	48.0	48.0	48.0
rate of change		21.9%	11.1%	(Assume a steady payment period consistent with recent years.)				
Current Accrued Liabilities	4,394	5,040	5,427	5,921	6,470	7,215	7,757	8,512
common size	14.7%	14.6%	15.1%	(Assume growth with SG&A expenses, which grow with sales.)				
rate of change		14.7%	7.7%	9.1%	9.3%	11.5%	7.5%	9.7%
Notes Payable and Short-Term Debt	274	0	369	385	417	458	487	535
common size	0.9%	0.0%	1.0%	1.0%	1.0%	1.0%	1.0%	1.0%
rate of change		−100.0%	na	(Assume 1.0 percent of total assets.)				
Income Taxes Payable	90	151	145	154	167	183	195	214
common size	0.3%	0.4%	0.4%	0.4%	0.4%	0.4%	0.4%	0.4%
rate of change		67.8%	−4.0%	(Assume steady percent of total assets.)				
Current Liabilities	6,860	7,753	8,787	9,540	10,495	11,731	12,385	14,029
common size	22.9%	22.4%	24.4%	24.8%	25.2%	25.6%	25.4%	26.2%
rate of change		13.0%	13.3%	8.6%	10.0%	11.8%	5.6%	13.3%
Long-Term Debt	2,550	4,203	7,858	8,405	9,102	10,002	10,625	11,681
common size	8.5%	12.1%	21.8%	21.8%	21.8%	21.8%	21.8%	21.8%
rate of change		64.8%	87.0%	(Assume steady percent of total assets.)				
Long-Term Accrued Liabilities	4,624	4,792	7,017	7,656	8,365	9,329	10,030	11,006
common size	15.4%	13.8%	19.5%	(Assume growth with SG&A expenses, which grow with sales.)				
rate of change		3.6%	46.4%	9.1%	9.3%	11.5%	7.5%	9.7%
Deferred Tax Liabilities—Noncurrent	528	646	226	242	262	288	306	336
common size	1.8%	1.9%	0.6%	0.6%	0.6%	0.6%	0.6%	0.6%
rate of change		22.3%	−65.0%	(Assume steady percent of total assets.)				
Total Liabilities	14,562	17,394	23,888	25,843	28,224	31,350	33,345	37,052
common size	48.7%	50.2%	66.4%	67.1%	67.7%	68.4%	68.5%	69.2%
rate of change		19.4%	37.3%	8.2%	9.2%	11.1%	6.4%	11.1%

(Continued)

EXHIBIT 10.4 (Continued)

	Actuals			Forecasts				
	2006	2007	2008	Year +1	Year +2	Year +3	Year +4	Year +5
SHAREHOLDERS' EQUITY								
Preferred Stock	−79	−91	−97	0	0	0	0	0
common size	−0.3%	−0.3%	−0.3%	0.0	0.0	0.0	0.0	0.0
rate of change		15.2%	6.6%	(Preferred stock assumptions.)				
Common Stock + Paid-In Capital	614	480	381	408	441	485	515	566
common size	2.1%	1.4%	1.1%	1.1%	1.1%	1.1%	1.1%	1.1%
rate of change		−21.8%	−20.6%	(Assume steady percent of total assets.)				
Retained Earnings	24,837	28,184	30,638	33,565	36,842	40,296	43,624	47,203
common size	83.0%	81.4%	85.1%					
rate of change		13.5%	8.7%	(Add net income and subtract dividends; see dividends forecast box below.)				
Accum. Other Comprehensive Loss	−2,246	−952	−4,694	−4,694	−4,694	−4,694	−4,694	−4,694
common size	−7.5%	−2.7%	−13.0%	0.0	0.0	0.0	0.0	0.0
rate of change		−57.6%	393.1%	(Add accumulated other comprehensive income items from income statement.)				
Treasury Stock	−7,758	−10,387	−14,122	−16,622	−19,122	−21,622	−24,122	−26,622
common size	−25.9%	−30.0%	−39.2%	−2500	−2500	−2500	−2500	−2500
rate of change		33.9%	36.0%	(Treasury stock repurchases, net of treasury stock reissues.)				
Common Shareholders' Equity	15,447	17,325	12,203	12,656	13,467	14,465	15,323	16,454
common size	51.6%	50.0%	33.9%	32.9%	32.3%	31.6%	31.5%	30.8%
rate of change		12.2%	−29.6%	3.7%	6.4%	7.4%	5.9%	7.4%
Total Liabilities and Equities	29,930	34,628	35,994	38,499	41,692	45,815	48,669	53,506
common size	100.0%	100.0%	100.0%	100.0%	100.0%	100.0%	100.0%	100.0%
rate of change		15.7%	3.9%	7.0%	8.3%	9.9%	6.2%	9.9%

balance minus the beginning balance). Applying this approach, the projected year-end cash balances would be as follows:

			Cash			
	Annual Sales Forecasts	**Average Sales per Day**	**Days Sales in Cash**	**Average Cash Balance**	**Beginning Cash Balance**	**Ending Cash Balance**
Year +1	$47,191	$129.3	12	$1,551	$2,064	$1,039
Year +2	$51,562	$141.3	12	$1,695	$1,039	$2,352
Year +3	$57,502	$157.5	12	$1,890	$2,352	$1,428
Year +4	$61,820	$169.4	12	$2,032	$1,428	$2,638
Year +5	$67,839	$185.9	12	$2,230	$2,638	$1,824

For the three primary financial statement forecasts to articulate with each other, the change in the cash balance on the projected balance sheet each year must agree with the net change in cash on the projected statement of cash flows. We will demonstrate how to compute the implied statement of cash flows later in this chapter.

Operating Asset and Liability Forecasting Techniques

The analyst can use turnover-based techniques to forecast any operating asset and liability accounts that vary reliably with sales, such as accounts receivable; inventories; property, plant, and equipment; and accounts payable. Using turnover rates produces reasonable forecasts of average and year-end account balances if the firm generates sales evenly throughout the year and if the forecasted account varies reliably with sales. However, the analyst should not use a turnover-based forecast technique if the firm will experience substantially different future growth rates in sales and the forecasted account or if the relation between sales and the forecast account varies unpredictably over time.

A less desirable feature of using a sales-turnover forecasting approach is that in some circumstances, it can introduce volatility in ending balances if the firm has exhibited volatility in historical amounts. The preceding illustration using cash is a good example. Notice in the forecasts of PepsiCo's ending cash balances that PepsiCo held a smaller cash balance at the start of 2008 ($910 million) but a larger cash balance at the end ($2,064 million). Because the cash balance at the beginning of Year +1 (the end of 2008; $2,064 million) is larger than the projected average for Year +1 of $1,551 million, the projected ending cash balance for Year +1 ($1,039 million) will be relatively small, partially to compensate for the large beginning balance. The relatively small balance in cash at the end of Year +1 then triggers a relatively large balance at the end of Year +2 ($2,352) to compensate, and so on. Exhibit 10.5 depicts this type of sawtooth pattern of variability.

In certain contexts, this type of variability is a realistic outcome of volatility in the firm's operating environment (such as seasonality or cyclicality). In other contexts, the analyst may prefer smooth forecasts that mitigate the variability in this pattern.[15] Whether one uses

[15] Volatile forecasts that reflect seasonality or cyclicality are often preferable in contexts in which the analyst is concerned about whether a firm will violate certain minimum or maximum requirements, such as debt covenants or regulatory capital requirements. Smooth forecasts are often preferable in contexts where an analyst expects random variable fluctuations around a generally smooth average growth trend over time. Analysts also often prefer smooth growth forecasts because these forecasts tend to be easier to present and explain to an audience.

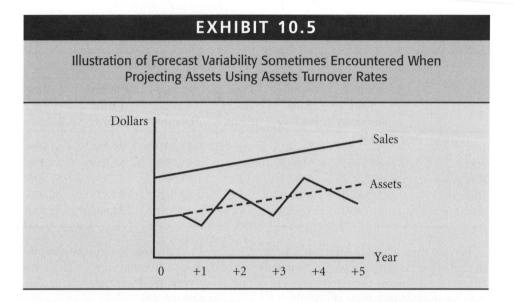

EXHIBIT 10.5

Illustration of Forecast Variability Sometimes Encountered When Projecting Assets Using Assets Turnover Rates

smooth or volatile forecasts for particular accounts such as cash usually has relatively little impact on the valuation of the firm.

A number of techniques exist for the analyst to produce smooth forecasts. One such technique is to project the ending balances to equal the projected average balances. Comparing the average and year-end projections, the averages produce much smoother forecasts, as shown here:

	Average Cash Balance	Ending Cash Balance	Difference: Average Minus Ending Balance	Difference as a Percentage of Ending Cash Balance
Year +1	$1,551	$1,039	+$512	+49.3%
Year +2	$1,695	$2,352	−$656	−27.9%
Year +3	$1,890	$1,428	+$462	+32.4%
Year +4	$2,032	$2,638	−$605	−22.9%
Year +5	$2,230	$1,824	+$407	+22.3%

Smooth forecasts are preferred to simplify the exposition of the chapter, so we will use the average cash balances in our balance sheet projections.

Another technique the analyst can use to produce smooth forecasts involves estimating the average expected rate of growth in cash over a long horizon and then projecting each year-end balance using this growth rate. Alternately, if one expects the ending cash balance to vary directly with sales, then one can simply project growth in cash balances using the expected growth rates in sales. In choosing among forecasting techniques, the analyst must trade off the objectives of achieving forecast precision and minimizing forecast error with avoiding unnecessary computational complexity.

Projecting Marketable Securities

During 2006 through 2008, PepsiCo's marketable securities balances (also commonly referred to as short-term investments) fluctuated inversely with the cash balances,

implying that PepsiCo managed marketable securities and cash as complementary sources of liquidity. In years when the cash balance was relatively low, the marketable securities balance was relatively high, and vice versa. Over this period, combined totals of marketable securities and cash have trended down, from 9.4 percent of assets in 2006 to 6.3 percent in 2008.

During 2006, PepsiCo had average marketable securities balances equal to 22.5 days of sales, whereas during 2007 and 2008, average marketable securities balances dropped steadily to 12.7 and then 7.5 days of sales, respectively (computed as 365 days divided by the ratio of sales to the average balance in marketable securities; in 2008, 7.5 days = 365/[\$43,251/(\{\$213 + \$1,571\}/2)]). Going forward, assume that PepsiCo will maintain average marketable securities balances equivalent to eight days of sales.

Following this approach, we use our forecasts of sales to compute the average balance in marketable securities each year, similar to the approach we used to forecast cash. The Year +1 sales forecast is \$47,191 million (or an average of \$129.3 million per day), and we project that PepsiCo will hold an average of eight days of sales in marketable securities during Year +1, for an average balance of \$1,034 million. The projected balances follow:

	Marketable Securities			
	Annual Sales Forecasts	Average Sales per Day	Days in Marketable Securities	Average Marketable Securities Balance
Year +1	\$47,191	\$129.3	8	\$1,034
Year +2	\$51,562	\$141.3	8	\$1,130
Year +3	\$57,502	\$157.5	8	\$1,260
Year +4	\$61,820	\$169.4	8	\$1,355
Year +5	\$67,839	\$185.9	8	\$1,487

Taken together, the forecasts of cash and marketable securities reflect PepsiCo's strategy to manage these accounts as complementary sources of liquidity. By linking both sets of forecasts to future sales activities, the forecasts assume that PepsiCo will continue to manage these accounts jointly and they will maintain a steady, consistent relation with sales. By using average turnover assumptions that are similar to PepsiCo's 2008 holdings of cash and marketable securities (12 and 8 days of sales, respectively), we expect PepsiCo will continue to hold, on average, lower balances in these accounts than it did in 2004–2006. As described shortly, we will also include on the forecasted income statements the future interest income that we expect the cash and marketable securities will generate.

Projecting Accounts Receivable

Chapter 4's analysis of PepsiCo's accounts receivable turnover ratios revealed that PepsiCo's collection period has grown over the last five years, from an average of 36 days during 2004 through 2006 up to 38 days in 2007 and 2008. (In 2008, for example, 38 days = 365/[\$43,251/(\{\$4,683 + \$4,389\}/2)]). We project accounts receivable by assuming that PepsiCo will maintain an average 38-day collection period in the future, turning over accounts receivable approximately 9.6 times a year (= 365/38). As we demonstrated earlier for our projections of cash, we will use the average turnover rate to project PepsiCo's

average accounts receivable and then compute the implied year-ending balances. The projected amounts follow:

	Accounts Receivable					
	Annual Sales Forecast	Average Sales per Day	Days Sales in Receivables	Average Balance	Beginning Balance	Ending Balance
Year +1	$47,191	$129.3	38	$4,913	$4,683	$5,143
Year +2	$51,562	$141.3	38	$5,369	$5,143	$5,593
Year +3	$57,502	$157.5	38	$5,985	$5,593	$6,380
Year +4	$61,820	$169.4	38	$6,437	$6,380	$6,492
Year +5	$67,839	$185.9	38	$7,064	$6,492	$7,633

Projecting Inventories

Chapter 4's analysis of PepsiCo's inventory turnover ratios revealed that PepsiCo has experienced steady inventory turnover rates of 43 days in 2004, 42 days in 2005 and 2006, and 43 days in 2007 and 2008. Because of the stability in PepsiCo's inventory management, we project PepsiCo will continue to manage turnover inventory every 43 days, or equivalently, an average turnover rate of 8.5 times per year. The projected year-end inventory amounts follow:

	Inventories				
	Cost of Goods Sold	Average Inventory Turnover Ratio	Average Balance	Beginning Balance	Ending Balance
Year +1	$22,321	8.5	$2,626	$2,522	$2,730
Year +2	$24,492	8.5	$2,881	$2,730	$3,033
Year +3	$27,429	8.5	$3,227	$3,033	$3,421
Year +4	$29,612	8.5	$3,484	$3,421	$3,546
Year +5	$32,563	8.5	$3,831	$3,546	$4,116

For some firms, such as retail chains, inventory is a large proportion of total assets. For such firms, the analyst should link inventory forecasts to projections of the number of stores that will be operating in future years (or even more specifically, to the number of square feet of retail space). For retail firms that operate large big-box stores (Walmart, for example), inventory projections may grow stepwise because each new store will require millions of dollars of additional inventory. Retail chains with seasonal sales will strive to have new stores (and thus new inventory) in place before heavy selling seasons (such as the back-to-school season for casual clothing store chains and the Christmas season for toy store chains); so analysts will link inventory forecasts to projections of new stores in advance of these heavy selling seasons.

Projecting Prepaid Expenses and Other Current Assets

Prepaid expenses and other current assets represent items such as prepaid rent, advertising, and insurance. These items often vary in relation to the level of operating activity, such as

sales, advertising, production, new stores or restaurants, and total assets. In the case of PepsiCo, we will simply assume prepaid expenses and other current assets will grow in the future at the same rate as sales. The projected amounts are as follows:

| | **Prepaid Expenses and Other Current Assets** | | | | | |
	2008	Year +1	Year +2	Year +3	Year +4	Year +5
Projected Amounts	$1,324	$1,445	$1,578	$1,760	$1,892	$2,077
Growth Rates		+9.1%	+9.3%	+11.5%	+7.5%	+9.7%

Projecting Investments in Noncontrolled Affiliates

PepsiCo's long-term investments in securities represent its interests in noncontrolled affiliates, primarily bottlers. These investments grew at a compound annual rate of 5.9 percent over the last five years. The assumption is that investments in noncontrolled affiliates will continue to grow 6 percent per year over the five-year forecast horizon. As we will describe shortly, we will also include on the forecasted income statements the future income that we expect PepsiCo will earn from these investments in noncontrolled affiliates.[16] The projected investment amounts are as follows:

| | **Investments in Noncontrolled Affiliates** | | | | | |
	2008	Year +1	Year +2	Year +3	Year +4	Year +5
Ending Balance	$3,883	$4,116	$4,363	$4,625	$4,902	$5,196
Growth Rates		+6.0%	+6.0%	+6.0%	+6.0%	+6.0%

Projecting Property, Plant, and Equipment

PepsiCo's fixed-assets turnover ratio remained steady at 3.8 from 2006–2008 (computed for 2008 as 3.8 = $43,251/[($11,663 + $11,228)/2]). This stable fixed-assets turnover is a result of PepsiCo's sales growth varying with capital spending on PP&E (property, plant, and equipment), which averaged roughly 5.7 percent of sales each year. In the 2008 Annual Report, PepsiCo's MD&A section describing "Our Liquidity and Capital Resources" (Appendix B) discloses that management expects "a high single digit *decrease* in net capital spending in 2009." Given this guidance, we will assume that net capital spending in Year +1 will be 4.6 percent of revenues, which amounts to $2,171 (= $47,292 × 0.046). This represents a decrease of 7.5 percent from 2008, which is consistent with PepsiCo's guidance. Given PepsiCo's stable history of capital spending, the assumption is that capital spending in Year +2 and beyond will revert to the historical average of 5.7 percent of revenues. We include these net capital expenditures in our balance sheet projections by increasing PP&E, and we include them as cash outflows in the investing section of our projections of the statement of cash flows. Also, the assumption is that these amounts

[16] For the analyst who wants greater forecast precision, the projections of future balances in Investments in Noncontrolled Affiliates should follow the accounting methods for equity method investments. As such, the balances should grow with the firm's proportionate share of the net income of the affiliate less dividends received from the affiliate each period, and should increase with additional investments and decrease with dispositions of investments in such affiliates.

reflect net capital expenditures, after proceeds from sales of PP&E (which tend to be very minor amounts for PepsiCo).

The projected amounts for capital expenditures follow:

	Property, Plant, and Equipment		
Year	Annual Sales Forecasts	Capital Spending (% of Sales)	Capital Spending (millions)
+1	$47,191	4.6%	$2,171
+2	$51,562	5.7%	$2,939
+3	$57,502	5.7%	$3,278
+4	$61,820	5.7%	$3,524
+5	$67,839	5.7%	$3,867

PepsiCo's existing PP&E will continue to depreciate as PepsiCo uses these assets in its operations. In addition, PepsiCo's capital expenditures on new PP&E will trigger a new layer of depreciation expense each year. PepsiCo discloses in Note 4, "Property, Plant, and Equipment and Intangible Assets" (Appendix A), that it uses the straight-line depreciation method for financial statement purposes (accelerated depreciation for tax purposes). Note 4 in PepsiCo's financial statements does not disclose information related to salvage values, but an analyst might assume that PepsiCo depreciates PP&E to zero salvage value. Based on this assumption, we can then estimate the average useful life that PepsiCo uses for depreciation by taking the average amount in PP&E at acquisition cost and dividing it by depreciation expense for that year. In 2008, PepsiCo used an average useful life of 15.6 years for depreciation purposes (= [{$22,552 + $21,896}/2]/$1,422). The assumption is that PepsiCo will continue to use a 15.6 year average useful life for depreciation.[17]

In computing depreciation expense for Year +1, we need to forecast two components. The first component is depreciation on the $22,552 million of existing PP&E as of the beginning of Year +1, which will be $1,443 million (= $22,552/15.6 years). The second component is depreciation on the Year +1 capital expenditures of $2,171 million, which will be $139 million (= $2,171/15.6 years). Together, total depreciation expense in Year +1 will be $1,582 million (= $1,443 + $139), and accumulated depreciation will grow to reflect this depreciation. In Year +2, depreciation expense will be $1,770 million, which will consist of those two components plus a third component to reflect depreciation

[17] PepsiCo discloses that 2008 depreciation expense equals $1,422 million in Note 4, "Property, Plant, and Equipment and Intangible Assets." In that note, PepsiCo also discloses that PP&E includes land, which is not depreciable (although land improvements are depreciable), and construction in progress, which is not yet depreciable but will be in the future. The analyst interested in slightly greater precision should exclude these amounts from the useful-life computation and the depreciation expense projections. Also note that on PepsiCo's Statement of Cash Flows for 2008 (Appendix A), PepsiCo adds back $1,543 million in depreciation and amortization expense to net income, which consists of $1,422 million of depreciation expense and $121million of amortization expense. We use the depreciation expense disclosed in Note 4 ($1,422 million) to avoid confounding the estimate of the depreciable useful life with amortization expense. Notice that the total PP&E increased by $656 million, which is less than the $2,348 million in net capital expenditures in 2008. Also notice that the increase in accumulated depreciation during 2008 was only $221 million (from $10,668 million to $10,889 million), an amount significantly less than depreciation expense. These differences arise because PepsiCo sold (or wrote off as impaired) PP&E assets that had accumulated depreciation; so the costs of these assets and their respective accumulated depreciation amounts were removed from the accounts.

expense of $188 million (= $2,939/15.6 years) on Year +2 capital expenditures on PP&E, and so on.

The projected amounts for depreciation expense follow:

	Depreciable Bases	Depreciation Expense				
		Depreciation Amounts per Year (assuming 15.6 year life):				
		Year +1	Year +2	Year +3	Year +4	Year +5
Existing PP&E	$22,552	$1,443	$1,443	$1,443	$1,443	$1,443
Capital Spending +1	$ 2,171	$ 139	$ 139	$ 139	$ 139	$ 139
Capital Spending +2	$ 2,939		$ 188	$ 188	$ 188	$ 188
Capital Spending +3	$ 3,278			$ 210	$ 210	$ 210
Capital Spending +4	$ 3,524				$ 225	$ 225
Capital Spending +5	$ 3,867					$ 247
Total Depreciation Expense		$1,582	$1,770	$1,980	$2,205	$2,453

Like most firms, PepsiCo does not report depreciation expense as a separate line item on the income statement, but it allocates depreciation expense to cost of goods sold and SG&A expense based on whether the underlying assets are being used in production or sales and administration. Therefore, in our projections we do not include these amounts of depreciation expense separately in the income statement and assume these amounts are included in our projections of cost of goods sold and SG&A expense. However, we do add depreciation expense back to net income in our projected statement of cash flows, discussed in a later section of the chapter. The projected amounts for capital expenditures; property, plant, and equipment; depreciation expense; and accumulated depreciation follow:

	Property, Plant, and Equipment				
Year	Capital Spending (millions)	Ending Balance (at Cost)	Depreciation Expense	Accumulated Depreciation	Ending Balance (Net)
2008 actual		$22,552		$(10,889)	$11,663
+1	$2,171	$24,723	$1,582	$(12,471)	$12,252
+2	$2,939	$27,662	$1,770	$(14,241)	$13,421
+3	$3,278	$30,939	$1,980	$(16,220)	$14,719
+4	$3,524	$34,463	$2,205	$(18,426)	$16,038
+5	$3,867	$38,330	$2,453	$(20,878)	$17,452

When forecasting fixed assets for capital-intensive firms (such as manufacturing firms or utility companies) or firms for which fixed-asset growth is a critical driver of future sales growth and earnings (for example, new stores for retail chains or restaurant chains), PP&E is typically a large proportion of total assets and has a material impact on the analysts' forecasts of assets, earnings, cash flows, and firm value. For such firms, analysts often invest considerable time and effort in developing detailed forecasts of capital expenditures, PP&E, and depreciation expense. The FSAP Forecast Development spreadsheet for PepsiCo includes a model for forecasting capital expenditures, PP&E, depreciation expense, and accumulated depreciation. The FSAP output (Appendix C) demonstrates the use of this model to compute the preceding forecasts for PepsiCo.

Projecting Amortizable Intangible Assets

Amortizable intangible assets for PepsiCo include primarily brands, trademarks, and other identifiable intangible assets with limited useful lives that PepsiCo obtained through acquisitions of other companies. As discussed previously, PepsiCo amortizes these assets ratably over their estimated useful lives (ranging from 5–40 years). The net book value of PepsiCo's amortizable intangible assets amounts to $732 million on the 2008 balance sheet (only 2 percent of total assets). Over the last five years, the balance in amortizable intangible assets has decreased each year because of amortization, but the balance also increased slightly in 2006 and 2007 from certain acquisitions. In Note 4, "Property, Plant, and Equipment and Intangible Assets" (Appendix A), PepsiCo discloses the amount of amortization expense it expects on these intangible assets over the next five years, which we include under the heading "Amortization of Intangible Assets" on the projected income statements. The amortizable intangible asset amounts will continue to decrease by the amounts of amortization expense that PepsiCo disclosed. For simplicity, the assumption is that PepsiCo will not make any additional investments in amortizable intangible assets; instead, it will invest in goodwill and nonamortizable intangible assets, which we discuss next.

Projecting Goodwill and Nonamortizable Intangible Assets

The majority of PepsiCo's intangible assets involve goodwill ($5,124 million) and other non-amortizable intangible assets (primarily brands, $1,128 million) with indefinite lives. These intangible assets arise when PepsiCo acquires other companies. These accounts recognize the portion of the acquisition price that PepsiCo allocates to intangible assets such as goodwill and brands. U.S. GAAP and IFRS do not require firms to amortize these assets because they have indefinite useful lives, but GAAP and IFRS do require firms to test their values annually for impairment and to write the carrying values down to fair value if deemed impaired. Thus far, PepsiCo has not deemed it necessary to recognize any impairment losses on its goodwill or brand assets. Had we forecasted sales declines and negative operating income, this might indicate possibly impaired intangible assets, but the strong sales growth and operating income assumptions imply that future impairment losses are unlikely.

Acquiring other companies with valuable goodwill, brand names, and products is a key element of PepsiCo's strategy. Such acquisitions help PepsiCo create new sales growth, expand its product portfolio, and enter new markets around the world. In 2008 and 2007, PepsiCo invested $1,900 million and $1,300 million in acquisitions, respectively. Of these amounts, Note 4, "Property, Plant and Equipment and Intangible Assets" (Appendix A), discloses that PepsiCo allocated $516 million and $382 million to Goodwill and Nonamortizable Assets (brands) in 2008 and 2007, respectively. It seems clear that PepsiCo will continue to pursue the strategy of making acquisitions, but in the absence of inside information, it is very difficult to forecast specific acquisitions. Thus, the assumption is that PepsiCo's goodwill and nonamortizable intangible assets will grow at the same rate as sales. Another assumption is that no future impairment charges will be necessary for these assets. The projected amounts are as follows:

	Goodwill and Nonamortizable Intangible Assets		
	Beginning Balance	Sales Growth Rate	Ending Balance
Year +1	$6,252	9.1%	$6,822
Year +2	$6,822	9.3%	$7,453
Year +3	$7,453	11.5%	$8,312
Year +4	$8,312	7.5%	$8,936
Year +5	$8,936	9.7%	$9,806

Projecting Other Noncurrent Assets

In Note 14, "Supplemental Financial Information" (Appendix A), PepsiCo discloses that other noncurrent assets consist of unallocated purchase prices for recent acquisitions, pension assets, noncurrent receivables, and others. For PepsiCo, these amounts have fluctuated widely over the past five years. For example, in 2008, the unallocated purchase price for recent acquisitions jumped by $1,143 million while pension plan assets fell by $607 million. Over the period 2004–2008, other noncurrent assets grew at a compounded annual rate of 3.2 percent despite wide fluctuation in year-to-year growth. During the same period, sales grew at a compounded rate of 9.9 percent. In the absence of more information to forecast other asset amounts specifically, we assume that other noncurrent assets will grow at a 3.0 percent rate each year. The projected amounts are as follows:

	Other Noncurrent Assets		
	Beginning Balance	Growth Rate	Ending Balance
Year +1	$2,658	3.0%	$2,738
Year +2	$2,738	3.0%	$2,820
Year +3	$2,820	3.0%	$2,904
Year +4	$2,904	3.0%	$2,992
Year +5	$2,992	3.0%	$3,081

Projecting Assets That Vary as a Percentage of Total Assets

In some circumstances, analysts may want to project individual asset amounts that will vary as a percentage of total assets, particularly for firms that maintain a steady proportion of total assets invested in specific types of assets. For example, suppose PepsiCo's strategy is to maintain 4.0 percent of total assets in cash for liquidity purposes. Projected amounts for Year +1 for all of the individual assets other than cash are as follows:

Marketable Securities	$ 1,034
Accounts Receivable	5,143
Inventories	2,730
Prepaid Expenses and Other Current Assets	1,445
Long-Term Investments	4,116
Property, Plant, and Equipment, net	12,252
Amortizable Intangible Assets	668
Goodwill and Nonamortizable Intangible Assets	6,822
Other Noncurrent Assets	2,738
Subtotal of Assets	$36,948

The $36,948 subtotal represents 96.0 percent (= 1.00 − 0.04) of total assets. Therefore, projected total assets should equal $38,488 (= $36,948/0.96). Thus, cash should equal $1,540 (= 0.04 × $38,488. This approach to forecasting introduces some circularity into the projected financial statements: the cash balance is a function of total assets, which is a function of the cash balance. This is not unrealistic, nor does it create a problem for the computations. A later subsection of this chapter discusses how to solve for co-determined elements in financial statement forecasts.

Projecting Accounts Payable

PepsiCo reports accounts payable and other current liabilities on a single line on its balance sheet, amounting to $8,273 million at the end of 2008. Note 14, "Supplemental Financial Information" (Appendix A), discloses that $2,846 million of that total is attributable to accounts payable, and the remainder ($5,427 million) is attributable to accrued liabilities for marketing, compensation, dividends, and other expenses. Different factors may drive the future amounts of accounts payable and accrued expenses. Future credit purchases of inventory and PepsiCo's payment policy to its suppliers will likely drive accounts payable, whereas accrued expenses will likely grow with future selling, general, and administrative expenses. Therefore, we forecast accounts payable and accrued expenses separately.

PepsiCo's days payable was 48 days in 2004, but it dropped to 45 days in 2005 and has gradually increased back to 48 days in 2008. Assume that PepsiCo will continue to maintain an accounts payable period of 48 days in the future. To forecast future accounts payable balances, begin by calculating forecasts of inventory purchases on account, as follows:

	Inventory Purchases				
	Year +1	**Year +2**	**Year +3**	**Year +4**	**Year +5**
Cost of Goods Sold	$22,321	$24,492	$27,429	$29,612	$32,563
Plus Ending Inventory	+2,730	+3,033	+3,421	+3,546	+4,116
Less Beginning Inventory	−2,522	−2,730	−3,033	−3,421	−3,546
Inventory Purchases	$22,529	$24,795	$27,817	$29,737	$33,133

Accounts payable is projected using an average 48 days payable period or, equivalently, an average turnover rate of 7.6 times per year, as follows:

	Accounts Payable				
	Inventory Purchases	**Payables Period**	**Average Balance**	**Beginning Balance**	**Ending Balance**
Year +1	$22,529	48 days	$2,963	$2,846	$3,080
Year +2	$24,795	48 days	$3,261	$3,080	$3,442
Year +3	$27,817	48 days	$3,658	$3,442	$3,875
Year +4	$29,737	48 days	$3,911	$3,875	$3,947
Year +5	$33,133	48 days	$4,357	$3,947	$4,768

In this case, we rely on our prior forecasts of PepsiCo's cost of goods sold and inventory balances to compute inventory purchases, which will flow through accounts payable, and we assume that the payables period will be a constant 48 days. We then compute the average balance in accounts payable and use it to compute the implied ending balance in accounts payable. Because the accounts payable balance at the start of the forecast period was not unusually high or low relative to cost of goods sold, the forecasts project relatively smooth growth in accounts payable over time, avoiding the sawtooth pattern discussed earlier.

Projecting Other Current Accrued Liabilities

As discussed in the prior section, Note 14, "Supplemental Financial Information" (Appendix A), discloses that at the end of 2008, PepsiCo's accrued liabilities for marketing, compensation, dividends, and other general and administrative expenses amount to $5,427 million. Our forecasts

of income for PepsiCo assumed that selling, general, and administrative expenses would remain a steady percentage of sales, and therefore grow proportionately with sales. We therefore forecast that other current accrued liabilities will grow with selling, general, and administrative expenses, which grow with sales.

	Other Current Accrued Liabilities		
	Beginning Balance	SG&A Expense Growth Rate	Ending Balance
Year +1	$5,427	9.1%	$5,921
Year +2	$5,921	9.3%	$6,470
Year +3	$6,470	11.5%	$7,215
Year +4	$7,215	7.5%	$7,757
Year +5	$7,757	9.7%	$8,512

Projecting Current Liabilities: Income Taxes Payable

PepsiCo's current liabilities include a separate line item for income taxes payable. Income taxes payable varies with the income tax provision on the income statement, but income taxes payable also varies with tax payments, settlements of tax disputes, mergers and acquisitions, changes in deferred tax assets and liabilities, and other elements that are difficult to predict with confidence. PepsiCo's income taxes payable has varied within a narrow range between 0.3 percent and 0.4 percent of total assets over 2006–2008. The assumption is that PepsiCo's income taxes payable will average 0.4 percent of total assets in the future. The projected amounts are as follows:

	Income Taxes Payable		
	Total Assets	As a Percentage of Total Assets	Balance
Year +1	$38,499	0.4%	$154
Year +2	$41,692	0.4%	$167
Year +3	$45,815	0.4%	$183
Year +4	$48,669	0.4%	$195
Year +5	$53,506	0.4%	$214

Projecting Other Noncurrent Liabilities

Other noncurrent liabilities are accrued liabilities for expenses that relate to pension obligations, health care obligations, long-term compensation, and other operating and administrative activities. We therefore project other noncurrent liabilities will grow with SG&A expenses, which will grow with sales:

	Other Noncurrent Liabilities		
	Beginning Balance	SG&A Expense Growth Rate	Ending Balance
Year +1	$ 7,017	9.1%	$ 7,656
Year +2	$ 7,656	9.3%	$ 8,365
Year +3	$ 8,365	11.5%	$ 9,329
Year +4	$ 9,329	7.5%	$10,030
Year +5	$10,030	9.7%	$11,006

Projecting Deferred Income Taxes

PepsiCo's Note 5, "Income Taxes" (Appendix A), indicates that deferred taxes relate to a variety of operating items (for example, investments in unconsolidated affiliates; property, plant, and equipment; and pension benefits plans). Over the past three years, deferred income taxes have declined in amount and as a percentage of total assets, from 1.76 percent down to 0.63 percent. We project that deferred tax liabilities will remain at that proportionate level of total assets in future years. The amounts are as follows:

	Deferred Income Taxes		
	Total Assets	As a Percentage of Total Assets	Ending Balance
Year +1	$38,499	0.63%	$242
Year +2	$41,692	0.63%	$262
Year +3	$45,815	0.63%	$288
Year +4	$48,669	0.63%	$306
Year +5	$53,506	0.63%	$336

STEP 4: PROJECTING FINANCIAL ASSETS, FINANCIAL LEVERAGE, COMMON EQUITY CAPITAL, AND FINANCIAL INCOME ITEMS

After completing forecasts of the operating assets and liabilities of the balance sheet, the analyst projects any financial assets the firm will hold, and the financial debt and shareholders' equity capital amounts that will be necessary to finance the firm's operating and investing activities. In addition, the analyst projects the effects of financing on net income, projecting future interest income, interest expense, and other elements of financial income.

For firms that maintain a particular capital structure over time, the analyst can use the common-size balance sheet percentages to project amounts of debt and equity capital. The common-size balance sheet data for PepsiCo (Appendix C) show that the balance sheet percentages for total liabilities climbed fairly dramatically over the last five years, from 51.7 percent of total assets in 2004 to 66.4 percent in 2008. Over the same period, common and preferred shareholders' equity decreased from 48.3 percent of total assets in 2004 to 33.6 percent in 2008. If the analyst predicts that PepsiCo's capital structure will consist of stable proportions of liabilities and equity from this point forward (for instance, the analyst might project that the current structure of 66.4 percent liabilities and 33.6 percent equities will continue into the future), the analyst can use these common-size percentages and the projected amounts of total assets to project future totals of liabilities and equities.

Alternatively, the analyst can project debt capital and shareholders' equity accounts by projecting the financial leverage strategy of the firm. PepsiCo appears to be shifting its financial leverage strategy to recapitalize the firm with greater amounts of short- and long-term debt, while using this debt capital and cash from operations to reduce shareholders' equity through substantial repurchases of common shares and increased dividends. In this section, we forecast debt and equity by projecting the financial leverage strategy of PepsiCo, changing the expected debt and equity amounts over time. Each account is discussed next.

Projecting Financial Assets

In forecasting the firm's future financial capital structure, the analyst must project the future financial assets, such as short-term and long-term investments, that represent financial savings (as opposed to financial liabilities which are borrowings). To do so, the analyst must assess the firm's business and financial strategy to determine whether the firm uses financial assets for operating and liquidity purposes or financial purposes. For example, PepsiCo's 2008 Consolidated Balance Sheet (Appendix A) recognizes short-term investments (marketable securities) and investments in noncontrolled affiliates. As discussed previously, PepsiCo uses short-term investments in conjunction with cash to provide liquidity for operating activities, and the investments in noncontrolled affiliates represent PepsiCo's investments in its affiliated bottlers. As such, we included both of these types of investments in our projections of PepsiCo's operating activities.

By contrast, some firms will hold short-term or long-term investments that are not for operating or liquidity purposes, and are instead intended for future financial purposes, such as corporate acquisitions, debt retirement, repurchasing shares, or paying dividends. Suppose, for example, a firm had issued bonds to finance the purchase of plant and equipment and the bond indenture agreement required the firm to maintain a bond sinking fund (a reserve of cash or securities to be used for future bond retirement). The cash and securities in the sinking fund would represent financial assets for debt retirement, and should be projected with the firm's financial structure rather than as part of the firm's operating activities. As of the 2008 balance sheet, PepsiCo does not have any short-term or long-term investment securities for debt retirement purposes. Because PepsiCo is not likely to need future reserves of investment securities for debt retirement, we will not forecast them.

Projecting Short-Term Debt and Long-Term Debt

PepsiCo's 2008 Consolidated Balance Sheet (Appendix A) recognizes $369 million of short-term obligations. Note 9, "Debt Obligations and Commitments" (Appendix A), reveals that short-term debt obligations actually totaled $1,628 million, which included $273 million of current maturities of long-term debt, $846 million of commercial paper, and $509 million of other short-term borrowings. Of this total, PepsiCo reclassified $1,259 million as long-term debt because of its intent and ability to refinance on a long-term basis. Note 9 also discloses that at the end of 2008, PepsiCo has $7,858 million in long-term debt, including the $1,259 million reclassified as long-term debt, but net of $273 million of long-term debt maturing in 2009.

Note 9 shows that PepsiCo does not rely heavily on short-term debt to meet unexpected cash flow needs. PepsiCo maintains several revolving lines of credit for unexpected cash flow needs; however, PepsiCo draws little on these available lines of credit because it generates substantial amounts of cash from its operations. The Statement of Cash Flows for 2008 for PepsiCo (Appendix A) indicates that the firm generated approximately $7.0 billion of net cash flow from operating activities. PepsiCo used $2.7 billion for investing activities in 2008 and $3.0 billion for financing activities, which primarily involved paying dividends and repurchasing common stock, after raising nearly $3.1 billion (net) from issuing long-term debt. PepsiCo used the remaining $1.2 billion of cash flow from operations to increase the cash account to nearly $2.1 billion. Given that PepsiCo generates so much cash available for financing activities, it is not surprising that short-term borrowings are a minor element of PepsiCo's financial capital structure. The common-size balance sheet data for PepsiCo indicate that short-term debt has ranged from 0.9 percent of total assets in 2006 to 0.0 percent in 2007 to 1.0 percent in 2008. We project that short-term debt will be 1.0 percent of total assets in the future.

With respect to long-term debt, in 2008, PepsiCo shifted its financial leverage strategy to recapitalize using greater amounts of long-term debt instead of common equity. In fact, in the second quarter of 2008, PepsiCo issued $1.75 billion of senior ten-year unsecured notes and in the fourth quarter of 2008 issued another $2.0 billion of senior ten-year unsecured notes for general corporate purposes and for short-term debt retirement. Long-term debt jumped dramatically from $4,203 million at the beginning of 2008 to $7,858 million by the end of 2008. Over the past five years, long-term debt plus current maturities of long-term debt trended down from 9.16 percent of total assets in 2004 to 8.56 percent in 2006, but they have climbed dramatically since then, reaching 21.83 percent of total assets in 2008. We will assume that PepsiCo will maintain long-term debt equal to 21.83 percent of total assets in Year +1 and beyond. The projected amounts for short-term and long-term debt are as follows:

| | | Short-Term and Long-Term Debt | | |
	Total Assets	Short-Term Debt (1.00%)	Long-Term Debt (21.83%)	Total Interest-Bearing Debt
Year +1	$38,499	$385	$ 8,405	$ 8,790
Year +2	$41,692	$417	$ 9,102	$ 9,519
Year +3	$45,815	$458	$10,002	$10,460
Year +4	$48,669	$487	$10,625	$11,112
Year +5	$53,506	$535	$11,681	$12,216

In the next section we will use the preceding projected amounts for interest-bearing debt as a basis to project PepsiCo's future interest expense.

PepsiCo's outstanding long-term debt matures at varying dates extending to 2014 and beyond. Note 9 discloses information to enable the analyst to estimate the amounts that mature in Year +1 through Year +5 and beyond. For analysts developing forecasts for firms that are deleveraging and retiring debt or for firms that are highly leveraged and facing a high probability of bankruptcy, the schedule of future long-term debt maturities is very helpful in projecting when the firm will have to retire or refinance mature debt.

Projecting Interest Expense

We can now project our first-iteration estimate of interest expense, based on our projected balances in interest-bearing short-term and long-term debt. Note 9, "Debt Obligations and Commitments" (Appendix A), indicates that at the end of 2008, the interest rates on various short-term borrowings ranged from 0.7 percent on commercial paper up to 10.0 percent on other short-term borrowings. It also discloses that the average interest rate on long-term notes ($6,382 million; roughly 80 percent of the total long-term debt) was 5.8 percent. In addition, Note 9 indicates that PepsiCo's zero-coupon notes carry an implicit interest rate of 13.3 percent and that other forms of long-term debt carry an average interest rate of 5.3 percent. Dividing the 2008 interest expense by the average amount of interest-bearing debt outstanding during 2008 implies that PepsiCo's weighted average interest rate on debt was roughly 5.3 percent [= $329/({$369 + $0 + $4,203 + $7,858}/2)]. This average is likely to be slightly understated, however, because, as noted earlier, PepsiCo issued two very large senior notes in the second and fourth quarters of 2008; so it did not incur interest expense on them for the full year. The assumption is that interest expense will equal 5.8 percent on average interest-bearing debt in Year +1 through Year + 5 to match the average interest rate on the majority of outstanding long-term debt. Using the projected amounts of debt described previously, the projected interest expense amounts follow:

			Interest Expense on Interest-Bearing Debt			
	Short-Term Debt	Long-Term Debt	Total Interest-Bearing Debt	Average Interest-Bearing Debt	Interest Rate	Interest Expense
2008	$369	$ 7,858	$ 8,227			$329
Year +1	$385	$ 8,405	$ 8,790	$ 8,508.5	5.8%	$493
Year +2	$417	$ 9,102	$ 9,519	$ 9,154.5	5.8%	$531
Year +3	$458	$10,002	$10,460	$ 9,989.5	5.8%	$579
Year +4	$487	$10,625	$11,112	$10,786.0	5.8%	$626
Year +5	$535	$11,681	$12,216	$11,664.0	5.8%	$677

The interest expense projections are appreciably higher than recent past interest expense amounts for PepsiCo, reflecting PepsiCo's shift in financial strategy in 2008 to much greater reliance on long-term debt capital. We can now enter these "first-pass" interest expense amounts in the projected income statements. If the projected balance sheets imply that PepsiCo will need larger or smaller amounts of long-term debt to finance future asset growth, then we will need to recompute the interest expense projections to reflect different amounts of debt.

Projecting Interest Income

We can also project our first-pass estimates of PepsiCo's interest income on financial assets, such as cash and short-term investments in marketable securities. In 2008, PepsiCo recognized $41 million in interest income. The average amount of cash and marketable securities during 2008 was $2,379 million (= [$910 + $2,064 + $1,571 + $213]/2), for an average return of 1.7 percent (= $41/$2,379). This rate of return reflects the very low interest rate environment present during the 2008 economic recession. It is likely that PepsiCo's cash and marketable securities are very low-risk but highly liquid instruments, and therefore yield very low rates of return. The assumption is that PepsiCo will earn a 3.0 percent return, which is the prevailing risk-free rate on medium-term U.S. Treasury bonds at the beginning of Year +1, on the average balances in cash and marketable securities each year. The projected amounts for interest income follow:

		Interest Income			
	Ending Balances:				
Year	Cash	Marketable Securities	Average Balances	Rate of Return	Interest Income
2008	$2,064	$ 213			
+1	$1,551	$1,034	$2,431	3.0%	$ 73
+2	$1,695	$1,130	$2,706	3.0%	$ 81
+3	$1,890	$1,260	$2,988	3.0%	$ 90
+4	$2,032	$1,355	$3,269	3.0%	$ 98
+5	$2,230	$1,487	$3,552	3.0%	$107

If the projected balance sheets imply that PepsiCo will generate larger amounts of cash flow in future years and if we expect that they will retain larger amounts of cash and marketable securities, then we will need to recompute the interest income projections to reflect additional interest-earning assets.

Projecting Bottling Equity Income

PepsiCo generates income from equity investments in noncontrolled affiliates, which are primarily bottlers. To forecast future income from equity investments in bottling affiliates, one can project a normal rate of return and the level of investment in unconsolidated bottling affiliates.[18] During 2008, PepsiCo recognized $374 million in bottling equity income on investments in noncontrolled affiliates with an average book value of $4,119 million [= ($3,883 + 4,354)/2], which implies a rate of return of roughly 9.1 percent.[19] PepsiCo discloses in the MD&A section titled "Results of Operations—Consolidated Review" (Appendix B) that in 2008, one of the bottling affiliates incurred significant restructuring and impairment charges, which reduced PepsiCo's bottling equity income from this affiliate by $138 million. Absent these charges, PepsiCo would have reported bottling equity income of $512 million, which implies a rate of return of 12.2 percent [= ($374 + $138)/{($3,883 +$138 + $4,354)/2}]. In 2007 and 2006, PepsiCo earned considerably higher returns from these affiliates: 13.9 percent and 15.4 percent, respectively. During 2006–2008, PepsiCo earned an average rate of return of 12.8 percent on the book value of these investments. In Note 8, "Noncontrolled Bottling Affiliates" (Appendix A), PepsiCo discloses that its two largest equity investments in unconsolidated bottlers have fair values that exceed their book values by a total of nearly $1 billion. The average rate of return from 2006–2008 relative to the fair value of these investments is roughly 10.1 percent. Bottling companies are relatively low-risk, low-profit-margin businesses, and the income recognized by PepsiCo on these investments has already been adjusted for the income taxes paid by the affiliates. (PepsiCo does not pay taxes on this income until it receives dividends or sells a portion of the investment.) Therefore, it is reasonable to assume that PepsiCo will continue to earn a similar return on these investments. So an analyst can project Bottling Equity Income in future years to be 12.0 percent of the annual average book value of Investments in Noncontrolled Affiliates. We base these forecasts on future book values of the investments (rather than fair values) because the book value amounts are necessary to forecast the balance sheet. We described our projections of book value amounts of Investments in Noncontrolled Affiliates when we projected the assets on the balance sheet. The projected amounts for Bottling Equity Income follow.

| | Bottling Equity Income | | | | |
| | Investments in Noncontrolled Affiliates | | | | |
Year	Beginning Balance	Ending Balance	Average Balance	Rate of Return	Bottling Equity Income
+1	$3,883	$4,116	$3,999	12.0%	$480
+2	$4,116	$4,363	$4,239	12.0%	$509
+3	$4,363	$4,625	$4,494	12.0%	$539
+4	$4,625	$4,902	$4,763	12.0%	$572
+5	$4,902	$5,196	$5,049	12.0%	$606

[18] An alternative approach, which would be more time-consuming but potentially more accurate, would be to prepare a full set of financial statement forecasts for PepsiCo's bottling affiliates and estimate PepsiCo's share of expected future income.

[19] This computation assumes that the bottling equity income account on the income statement can be compared directly to the investments in noncontrolled affiliates account on the balance sheet. This is not likely to be strictly true because PepsiCo likely aggregates other nonbottling affiliates in the balance sheet account. In Note 8, "Noncontrolled Bottling Affiliates" (Appendix A), PepsiCo discloses that the most significant noncontrolled affiliates are bottling companies; so the computation is a reasonable estimate of PepsiCo's return on these investments.

Projecting Preferred Stock and Minority Interest

PepsiCo has a negative amount (−$97 million) in convertible preferred stock at the end of 2008. Note 12, "Preferred Stock" (Appendix A), discloses that Quaker Foods had issued the preferred stock in 2001 as part of an employee stock ownership plan and that the shares can be redeemed by plan participants or repurchased by PepsiCo at a premium. The amount of preferred stock is negative, which is unusual, because PepsiCo raised $41 million in capital by issuing the stock and to date has paid a total of $138 million for the shares that employees have redeemed or that PepsiCo has repurchased. In Note 12, PepsiCo also discloses that the roughly 266,000 outstanding preferred shares have a fair value of $72 million at the end of 2008. We will assume that all of these remaining shares will be repurchased by PepsiCo or redeemed by plan participants in Year +1 at fair value. We assume the payment of $72 million will be a special one-time liquidating dividend to buy back and retire these preferred shares. Because we forecast that all of the preferred shares will be retired by the end of Year +1, we will then forecast the ending balance in preferred stock to be zero at the end of Year +1. We will record the $72 million payment to retire the remaining shares and the $97 million adjustment to zero out the negative balance in the preferred-stock account by reducing retained earnings by $169 million. (See Chapter 6 for a discussion of accounting for share retirements.)

PepsiCo has no equity capital from minority interest shareholders. We assume that this will remain zero in the future.

Projecting Common Stock and Capital in Excess of Par Value

As Chapter 6 explains, these paid-in common equity capital accounts generally increase as the firm raises capital by issuing common shares to investors in the capital markets or by selling shares to individuals exercising stock options the firm has granted or by issuing shares in a merger or acquisition. These paid-in capital accounts decrease as the firm retires shares. PepsiCo's common stock and capital in excess of par value decreased from 2004 through 2008, dropping from roughly 2.32 percent of total assets to roughly 1.06 percent. PepsiCo has shifted its capital strategy to long-term debt, so we do not expect significant future issues of common equity. We will simply project Common Stock and Capital in Excess of Par Value to grow with total assets, remaining at 1.06 percent of total assets. The projected amounts for Common Stock and Capital in Excess of Par Value are as follows:

| | Common Stock and Capital in Excess of Par Value | | |
	Total Assets	As a Percent of Total Assets	Ending Balance
Year +1	$38,499	1.06%	$408
Year +2	$41,692	1.06%	$441
Year +3	$45,815	1.06%	$485
Year +4	$48,669	1.06%	$515
Year +5	$53,506	1.06%	$566

Projecting Treasury Stock

The treasury stock account becomes *more* negative when the firm repurchases some of its outstanding common equity shares. The treasury stock account becomes *less* negative when the firm reissues treasury shares on the open market, uses them to meet stock option exercises,

issues them in merger or acquisition transactions, or retires them. (See Chapter 6 for more discussion of accounting for treasury stock transactions.) For 2006 through 2008, PepsiCo's Statement of Common Shareholders' Equity (Appendix A) reveals that it has repurchased roughly $12 billion in common shares ($3,000 million in 2006, $4,300 million in 2007, and $4,720 million in 2008) to reduce the equity capital base and increase leverage. In addition, over the same period, PepsiCo reissued treasury shares to meet roughly $4.1 billion in stock option exercises ($1,619 million in 2006, $1,582 million in 2007, and $883 million in 2008).[20]

In PepsiCo's 2008 Annual Report, the MD&A section titled "Our Liquidity, Capital Resources and Financial Position" (Appendix B) discloses that during 2008, PepsiCo completed the $8.5 billion share repurchase program that had been approved by the board of directors in 2006 and had begun repurchasing shares under the $8.0 billion share repurchase program approved in 2007 (expiring in 2010). PepsiCo also disclosed that the repurchase program has approximately $6.4 billion remaining for repurchase. PepsiCo will likely continue to make substantial repurchases. PepsiCo's MD&A disclosures also note that the firm historically repurchases significantly more shares than it issues under stock compensation plans, with average net repurchases amounting to 1.8 percent of outstanding shares over the past five years. In fact, in PepsiCo's MD&A, the firm projects that it expects to make treasury stock purchases of up to $2,500 million in Year +1. We will assume that PepsiCo's treasury stock repurchases, net of treasury stock issued for stock compensation plans, will amount to $2,500 during Year +1 and will persist at this level through Year +5. We may need to reduce this assumption if we determine later in our analysis that PepsiCo will not have sufficient cash flow for these repurchases, or if our equity valuation estimates indicate that the capital market has overpriced PepsiCo stock. Alternately, we may increase this assumption if our analysis reveals that PepsiCo will have excess future cash flow or if our valuation estimates indicate PepsiCo's shares are underpriced.

In projecting stock repurchases net of stock reissues, we implicitly assume that employees will continue to exercise stock options and other stock-based compensation awards in future years. We may need to revise this assumption later in the analysis if our equity valuation estimates indicate that PepsiCo's stock options are not likely to be "in the money." Implicitly included in the income statement forecasts is an expense for the fair value of stock-based compensation in the projections of selling, general, and administrative expense.

The projected amounts for treasury stock are as follows:

| | Treasury Stock | | |
	Beginning Balance	Share Repurchases, net of Reissues	Ending Balance
2008 actual	−$10,387	−$3,735	−$14,122
Year +1	−$14,122	−$2,500	−$16,622
Year +2	−$16,622	−$2,500	−$19,122
Year +3	−$19,122	−$2,500	−$21,622
Year +4	−$21,622	−$2,500	−$24,122
Year +5	−$24,122	−$2,500	−$26,622

[20] The stock market often interprets share repurchase announcements as "good news," inferring that management, with its in-depth knowledge of the firm, thinks that the capital market is underpricing the firm's stock (although, ironically, most stock repurchase plans are not completed at the announced levels). The stock market typically reacts to this positive signal by bidding up the price of the firm's shares. Stock repurchases also may be perceived favorably by capital markets participants because they represent a form of implicit dividend to individual shareholders that may be taxed at capital gains rates, which may be lower than the ordinary income tax rates on dividends (depending on the shareholders' holding period and tax status).

Projecting Accumulated Other Comprehensive Loss

According to PepsiCo's Statement of Common Shareholders' Equity at the end of 2008 (Appendix A), Accumulated Other Comprehensive Loss was −$952 million at the beginning of 2008. In 2008, PepsiCo adopted a new accounting standard (SFAS 158) which required PepsiCo to reduce Accumulated Other Comprehensive Loss by $51 million to −$901 million. During 2008, PepsiCo's other comprehensive income items took a huge hit. PepsiCo recognized $3,793 million of losses in comprehensive income for 2008. Consequently, by the end of 2008, Accumulated Other Comprehensive Loss had decreased $3,793 million to an accumulated loss of −$4,694 million. Although PepsiCo reported net income of $5,142 million for 2008, it reported comprehensive income of only $1,349 million. As described in Chapters 7 and 8, these losses were attributable to primarily two phenomena: foreign currency translation adjustments and net losses on pension and retiree benefit plans. In 2008, the U.S. dollar gained against many other currencies in which PepsiCo holds net assets, which triggered the translation losses. Also in 2008, the capital markets suffered a very difficult year, which partly explains the losses on pension and retiree benefit plans, which contain substantial holdings of investment securities. In addition, interest rates fell in 2008; so the present value of future retirement obligations increased, also partly explaining the losses.

In our previous forecasts of revenues from the PepsiCo's various international divisions, we assumed PepsiCo will continue to expand these international operations. However, even for the most experienced macroeconomic experts, it is difficult to forecast whether the U.S. dollar will increase or decrease in value relative to the foreign currencies PepsiCo uses in its international operations over the next five years. Also, PepsiCo might hedge or limit its exposure to adverse foreign currency movements. Thus, we project that PepsiCo will experience neither persistent negative nor positive foreign currency translation adjustments in the future. This is equivalent to assuming that PepsiCo's future foreign currency translation adjustments are equally likely to be positive or negative in any given year and that, on average, they will be zero over time. In addition, it is logical to assume that PepsiCo's pension and retiree benefit plans are equally likely to generate gains or losses in any given year and that, on average, they will be zero over the next five years. Therefore, we project that Accumulated Other Comprehensive Loss will remain at its current level. Accordingly, Other Comprehensive Income Items included in comprehensive income will also be zero in future years.

The gains and losses that impact other comprehensive income items tend to result from asset and liability revaluations for changes in interest rates and foreign exchange rates (such as fair value gains and losses on available-for-sale securities, foreign currency translation adjustments, certain pension and retiree benefit obligation and asset adjustments, and gains and losses on cash flow hedges; see Chapters 7 and 8 for more discussion). Because economy-wide changes in interest rates and foreign exchange rates tend to be transitory and because many firms tend to hedge or mitigate exposure to such risks, it is often very difficult for an analyst to predict with confidence that a particular firm will consistently generate persistent gains or losses from such changes over long periods of time. As such, analysts commonly forecast gains or losses from other comprehensive income items to be zero, on average.

STEP 5: PROJECTING NONRECURRING ITEMS, PROVISIONS FOR INCOME TAX, AND CHANGES IN RETAINED EARNINGS

Thus far we have developed forecasts of PepsiCo's operating activities, including operating income as well as the operating assets and liabilities. In addition, we have projected PepsiCo's future financial liabilities, common equity capital, and financial income items

including interest income, interest expense, and income from noncontrolled affiliates. In Step 5 we complete the forecasting of PepsiCo's net income and dividends, and determine the projection of PepsiCo's retained earnings. This will lead us into Step 6, in which we will determine whether we need to revisit some of our previous forecast assumptions to make our balance sheet forecasts balance.

Projecting Nonrecurring Items

As discussed in prior chapters of this text, it is not uncommon for firms' reported income statements to include other nonrecurring gains or losses that are part of operations, unusual gains or losses that are peripheral to operations, income from discontinued segments, and extraordinary gains or losses. In 2008, for example, PepsiCo included an $88 million impairment charge in cost of goods sold and an impairment charge of $455 million as well as $346 million in mark-to-market losses on commodity derivatives in SG&A expenses. As previous chapters discussed, the analyst must determine whether items such as these are likely to persist in the future and, if so, to include them in the financial statement forecasts. As discussed previously, our projections of future costs of goods sold and SG&A expenses assumed that these charges in 2008 were transitory and will not persist.

Projecting Provisions for Income Taxes

As Chapter 8 discusses, PepsiCo's Note 5, "Income Taxes" (Appendix A), shows the reconciliation between the statutory tax rate and PepsiCo's average, or effective, tax rate. The statutory U.S. federal income tax rate was 35.0 percent during 2006–2008. During 2008, PepsiCo experienced an increase in its average annual tax rate of roughly 0.8 percent from state income taxes and a decrease in its average tax rate of approximately 9.0 percent from lower tax rates in international tax jurisdictions, yielding an average tax rate of approximately 26.8 percent. In 2007 and 2006, PepsiCo experienced even lower effective tax rates of 25.9 percent and 19.3 percent, respectively, from the effects of the favorable settlements of audits of prior years' tax returns.

In PepsiCo's MD&A section titled "Our Critical Accounting Policies," under the heading "Income Tax Expense and Accruals" (Appendix B), PepsiCo discloses that it expects an average tax rate of 26.8 percent in Year +1, equal to the effective rate PepsiCo experienced in 2008. We will rely on that disclosure and assume that the average tax rate for Year +1 will be 26.8 percent. Beyond Year +1, we will assume that PepsiCo's average tax rate will persist at 26.8 percent, which is roughly equivalent to PepsiCo's average combined federal, state, and foreign tax rate of 26.9 percent for 2004 through 2008.

Net Income

All of the elements of the income statement, including first-iteration estimates of interest expense, interest income, and income taxes, are now complete. Recall that Exhibit 10.3 presents these income statement projections. The projected net income amounts, the implied growth rates, and net profit margins are as follows:

Year	Net Income	Implied Percentage Growth	Implied Net Profit Margin
2008 actual	$5,142	−9.1%	11.9%
+1 forecast	$6,111	18.8%	12.9%
+2 forecast	$6,602	8.0%	12.8%
+3 forecast	$7,273	10.2%	12.6%
+4 forecast	$7,726	6.2%	12.5%
+5 forecast	$8,427	9.1%	12.4%

The forecasts of net income for PepsiCo imply more robust growth in net income than PepsiCo has enjoyed in recent years. The forecasts also imply a higher profit margin than in 2008, but lower margins than PepsiCo enjoyed in 2007 and 2006. One contributing factor is the reversion of PepsiCo's earnings growth and profit margins from elimination of the impairment charges and mark-to-market commodity losses that negatively impacted net income in 2008, which should not persist in the future.

Retained Earnings

In general, the retained earnings account typically increases by the amount of net income (or decreases for net loss) and decreases for dividends. During 2004 through 2008, PepsiCo's dividend payout rates varied between 37 percent and 45 percent of prior-year net income. In the 2008 Annual Report, PepsiCo's MD&A section titled "Our Liquidity, Capital Resources and Financial Position" (Appendix B) discloses that PepsiCo's board of directors approved a 13 percent increase in dividend payouts, from $1.50 per share to $1.70 per share.[21] Relying on that disclosure, we project that PepsiCo's dividend payout policy will average 50 percent of prior-year net income from continuing operations in Years +1 through +5. Therefore, forecasts of dividends to common shareholders will vary over time with lagged net income before the effects of discontinued operations. For example, the forecast of dividends to common shareholders in Year +1 is $2,571 million [= 0.50 × ($5,142 − $0)]. This projection is roughly similar to $1.70 per share to each of the 1,553 million outstanding shares as of the beginning of Year +1 ($2,640 million).

Recall that in the discussion of PepsiCo's preferred stock, we projected that PepsiCo would also reduce retained earnings by $169 million to reflect a $72 million payment in Year +1 to retire the remaining outstanding preferred shares and to eliminate the negative $97 million balance in the preferred stock account. The implied changes in retained earnings are as follows (allow for rounding):

[21] The capital markets generally react positively when firms announce plans to increase dividend payouts because market participants infer that this is a signal of managers' favorable private information about expectations for future sustainable earnings and cash flows. Moreover, managers are reluctant to cut or omit dividends because the market usually reacts negatively to such announcements. Thus, managers typically do not increase dividends unless they believe the increase can be sustained.

	Retained Earnings				
	Year +1	Year +2	Year +3	Year +4	Year +5
Beginning of Year	$30,638	$34,009	$37,556	$41,528	$45,618
Plus Net Income	6,111	6,602	7,273	7,726	8,427
Less Dividends to Common Shareholders	(2,571)	(3,055)	(3,301)	(3,636)	(3,863)
Less Retirement of Preferred Stock	(169)	(0)	(0)	(0)	(0)
End of Year	$34,009	$37,556	$41,528	$45,618	$50,182

STEP 6: BALANCING THE BALANCE SHEET

Even though the first-pass forecasts of all amounts on the income statement and balance sheet are complete, the balance sheet does not balance because we have projected individual asset and liability accounts to capture their underlying business activities, which do not vary together perfectly. The difference between the initial projected totals of assets minus the projected total liabilities and shareholders' equity each year represents the total amount by which we must adjust a flexible financial account to balance the balance sheet. If the difference is a positive amount, projected assets exceed projected liability and equity claims; so the firm must raise additional debt or equity capital or reduce projected assets by selling financial assets. If the difference is a negative amount, projected assets are less than projected liability and equity claims, in which case the firm can pay down debt, issue larger dividends, repurchase more shares, or increase investments in financial assets. The change in the difference represents the increment by which we must adjust the flexible financial account each year.

The analyst must evaluate the firm's financial flexibility and adjust the balance sheet accordingly. For some firms (for example, start-ups), financial flexibility may be in cash or marketable securities, which represent financial liquidity "safety valves." These firms often keep relatively large amounts of cash or marketable securities on the balance sheet for financial slack, and they use the funds when necessary to meet periodic cash requirements. For these firms, large inflows of cash (such as from a new stock issue) build up the cash and marketable securities accounts and large outflows (such as for the purchase of an asset or R&D expenditures) deplete the accounts. For these firms, analysts can use cash or marketable securities as the financial flexibility account needed to balance the balance sheet after all other balance sheet amounts have been determined.

For profitable growth firms that do not have large reserves of excess cash or marketable securities, financial flexibility may be exercised through short-term or long-term debt or equity. As the firm grows and invests in increasing productive capacity, it must raise the necessary capital through borrowing or issuing equity. As the firm matures and becomes a cash cow, it will shift how it uses its financial flexibility to pay down debt and perhaps initiate or increase dividends and share repurchases. The analyst should consider carefully what financial flexibility the firm has and will use.

Balancing PepsiCo's Balance Sheets

Currently, our projections of PepsiCo's total assets minus our projections of liabilities, shareholders' equity other than retained earnings (which is a negative amount because of treasury stock), and retained earnings, which follow, indicate the amounts by which our balance sheets do not balance (allow for rounding).

Projections:	Year +1	Year +2	Year +3	Year +4	Year +5
Total Assets (A)	$38,499	$41,692	$45,815	$48,669	$53,506
Total Liabilities	$25,843	$28,224	$31,350	$33,345	$37,052
Shareholders' Equity (other than Retained Earnings)	(20,908)	(23,375)	(25,831)	(28,301)	(30,750)
Retained Earnings	34,009	37,556	41,528	45,618	50,182
Total Liabilities and Shareholders' Equity (L + SE)	$38,945	$42,405	$47,047	$50,662	$56,484
Difference [= A − (L + SE)]	−$444	−$713	−$1,232	−$1,993	−$2,978
Change in the Difference	−$444	−$269	−$517	−$762	−$985
Change in the Difference as a Percentage of Total Assets	−1.2%	−0.6%	−1.1%	−1.6%	−1.8%

For PepsiCo, in Year +1, the first-iteration forecasts project that liabilities and equities exceed assets by $444 million (about 1.2 percent of total assets). We need to adjust a flexible financial account by $444 million (by increasing a financial asset account or decreasing a financial liability or shareholders' equity account) to balance the balance sheet. In Year +2, the first-iteration projections indicate that liabilities and equities will exceed assets by a total of $713 million; so we will need an additional adjustment of −$269 million in Year +2 (about 0.6 percent of total assets), and so on.

A number of PepsiCo's flexible financial accounts could be used for this adjustment each year depending on PepsiCo's strategy for investments and capital structure. Consider the following options:

- Increase marketable securities if PepsiCo will retain excess capital in marketable securities for financial flexibility.
- Reduce short-term or long-term debt if PepsiCo will use its financial flexibility to reduce leverage.
- Reduce retained earnings by increasing projected dividends or treasury stock repurchases if PepsiCo will distribute excess capital to common shareholders.

PepsiCo's MD&A section titled "Our Liquidity and Capital Resources" (Appendix B) states that in 2008, "Management operating cash flow was used primarily to repurchase shares and pay dividends. We expect to continue to return approximately all of our management operating cash flow to our shareholders through dividends and share repurchases."[22] Given this disclosure and the fact that PepsiCo has clearly demonstrated its willingness and ability to pay out increasing amounts of capital to shareholders through dividends and share repurchases, we will adjust dividends as the flexible financial account. Therefore, in Year +1, the dividend forecast must be increased by $444 million, the amount necessary to balance the balance sheet. This simply means that if PepsiCo's financial performance and position during Year +1 exactly match our forecasts, then PepsiCo can increase dividend payments slightly to keep assets in balance with liabilities and equity. In Years +2 through +5, we must also adjust our dividends forecasts upward each year by the incremental amount of the necessary adjustment to balance the balance sheet (that is, $269 million in Year +2, $517 million in Year +3, and so on). We refer to these adjustment

[22] "Management operating cash flow" is PepsiCo's measure of cash flows from operating activities less net capital expenditures for property, plant, and equipment.

amounts as *implied dividends*. The projected total amounts of dividends to common share-holders are as follows:

	Year +1	Year +2	Year +3	Year +4	Year +5
Dividends to Common Shareholders (50% of Lagged Net Income from Continuing Operations)	$2,571	$3,055	$3,301	$3,636	$3,863
Implied Dividends	+444	+269	+517	+762	+985
Total Common Dividends	$3,015	$3,324	$3,818	$4,398	$4,848

Equivalently, we can assume that PepsiCo will distribute the excess capital to sharehold-ers through additional treasury stock repurchases rather than implied dividends. In either case, the assumption that PepsiCo will return the excess capital to shareholders through increased dividends or treasury stock repurchases will have equivalent effects on total assets, total liabilities, total shareholders' equity, and net income. After adjusting our divi-dends projections to include the implied dividends necessary to balance the balance sheet, the changes in retained earnings are as follows (allow for rounding):

	Retained Earnings				
	Year +1	Year +2	Year +3	Year +4	Year +5
Beginning of Year	$30,638	$33,565	$36,842	$40,296	$43,624
Plus Net Income	6,111	6,602	7,273	7,726	8,427
Less Dividends to Common Shareholders	(3,015)	(3,324)	(3,818)	(4,398)	(4,848)
Less Retirement of Preferred Stock	(169)	(0)	(0)	(0)	(0)
End of Year	$33,565	$36,842	$40,296	$43,624	$47,203

The final projections of the balance sheet total amounts, which you should verify by referring back to the projected balance sheets presented in Exhibit 10.4, are as follows (allow for rounding):

Projections:	Year +1	Year +2	Year +3	Year +4	Year +5
Total Assets (A)	$38,499	$41,692	$45,815	$48,669	$53,506
Total Liabilities	$25,843	$28,224	$31,350	$33,345	$37,052
Shareholders' Equity (other than Retained Earnings)	(20,908)	(23,375)	(25,831)	(28,301)	(30,750)
Retained Earnings	33,565	36,842	40,296	43,624	47,203
Total Liabilities and Shareholders' Equity (L + SE)	$38,499	$41,692	$45,815	$48,669	$53,506
Difference (= A − [L + SE])	$ 0	$ 0	$ 0	$ 0	$ 0

Closing the Loop: Solving for Co-determined Variables

If the excess capital had been added to interest-earning asset accounts (for example, marketable securities or cash) or subtracted from interest-bearing liability accounts (for example, short-term or long-term debt), the projected amounts for interest income or interest expense would

need to be adjusted on the income statement. This would create an additional set of co-determined variables in the financial statement forecasts. For example, suppose we use long-term debt as the flexible financial account and adjust it to balance assets with liabilities and shareholders' equity. To determine the necessary plug to long-term debt, all of the other asset, liability, and shareholders' equity amounts, including retained earnings, must be known. To forecast retained earnings, net income, which depends on interest expense on long-term debt, must be known. To determine retained earnings, dividends, which depend on net income, also must be known. Thus, it is necessary to simultaneously solve for at least five variables.

This problem might seem intractable, but it is not because of the computational capabilities of computer spreadsheet programs such as Excel. To solve for multiple variables simultaneously in older versions of Excel, first click the Tools menu, then click the Calculations menu, and then click the Iterations box, so that Excel will solve and resolve circular references up to 1,000 times until all calculations fall within the specified tolerance for precision. In newer versions of Excel, click the Office Button, then click the Excel Options menu at the bottom of the drop-down box, and then click the Formulas tab. At the top of that menu, you will see Calculation options; check the box to "Enable iterative calculation" and allow for up to 1,000 iterations. Then you can program each cell to calculate the variables needed, even if they are simultaneously determined with other variables. With FSAP, the default settings allow for iterative simultaneous computations, but some versions of Excel automatically reset the default settings. So you should follow these steps to double-check that the FSAP spreadsheet will compute co-determined variables simultaneously.

STEP 7: PROJECTING THE STATEMENT OF CASH FLOWS

The final step of the seven-step forecasting process involves projecting the statement of cash flows. This is a relatively straightforward task because the statement of cash flows simply characterizes all of the changes in the balance sheet in terms of the implications for cash. Thus, we derive the statement of cash flows directly from the projected income statements and balance sheets. Chapter 3 described the procedures for preparing this statement. We capture all of the changes in the projected balance sheets each year and express these changes in terms of their implied effects on cash. Increases in assets imply uses of cash; decreases in assets imply sources of cash. Increases in liabilities and shareholders' equity imply sources of cash; decreases in liabilities and shareholders' equity imply uses of cash.

Tips for Forecasting Statements of Cash Flows

The analyst should note that the statement of cash flows will not reconcile with the projected income statement and balance sheets if the balance sheets do not balance and if the income statement does not articulate with the balance sheets. (That is, net income should be included in the change in retained earnings.)

An important point is that you *should not* attempt to project future statements of cash flows from historical statements; instead, you should follow the much simpler procedure we describe here in projecting *the implied statement of cash flows*. Unfortunately, unlike historical balance sheets and income statements, historical statements of cash flows *do not* provide good bases for projecting future cash flows because many of the line items on the statement of cash flows are difficult to reconcile with historical changes in balance sheet amounts. The reason is because in preparing the statement of cash flows, the accountant aggregates numerous cash flows on each line item of the statement and the analyst may not be able to determine what amounts have been aggregated. For example, the accountant must report

separately the net cash flow implications of a business acquisition on one line of the statement, but the business acquisition causes changes in many asset and liability accounts. In addition, the accountant may choose to disclose details of cash flows that the analyst cannot verify. For example, the accountant might disclose separately in the statement of cash flows the amounts of marketable securities purchased and sold, but the analyst cannot verify those amounts because the analyst can only observe the net change in the marketable securities balance from the beginning to the end of the year. Thus, we recommend simply following the steps below to compute the *implied statement of cash flows* from the projected income statements and balance sheets, which the analyst can observe and verify. The Forecasts worksheet in FSAP (Appendix C) is programmed to use this approach to automatically calculate implied statements of cash flows from the projected income statements and balance sheets.

Specific Steps for Forecasting Implied Statements of Cash Flows

Exhibit 10.6 presents the projected implied statement of cash flows for PepsiCo for Years +1 through +5. We describe the derivation of each of the line items next. You should verify how the projected implied statements of cash flows in Exhibit 10.6 capture the cash inflows and outflows described in each of the following line items.

(1) **Net Income:** Use the amounts in the forecasted income statements (Exhibit 10.3).

(2) **Depreciation Expense:** Add back the projected amount of depreciation expense included in net income and used to compute the net change in accumulated depreciation on property, plant, and equipment. The depreciation expense forecast should reconcile with the change in accumulated depreciation on the projected balance sheet (less the decrease in accumulated depreciation from assets that were sold or retired, if any).

(3) **Amortization Expense:** Add back amortization expense on amortizable intangible assets. The amount of amortization expense to add back to net income should reconcile with the change in amortizable intangible assets balance, adjusted for any new investments in those assets (which should be included as cash outflows in the investing section of this statement).[23] For PepsiCo, we add back amortization expense, which we included as an operating expense on PepsiCo's income statement forecasts. For some firms, if the amount of amortization expense is not large, the analyst can ignore adding it back to net income to compute cash flow from operating activities and simply include the net change in amortizable intangible assets in the investing section. This will slightly understate cash inflows from operations and slightly understate cash outflows for investing activities, but the two effects will offset so that net cash is not affected.

(4) **through (9) Working Capital Accounts:** Adjust net income for changes in various operating current asset and current liability accounts other than cash (such as accounts receivable, inventory, accounts payable, accrued expenses, and others) appearing on the projected balance sheets.

(10) **and (11) Deferred Taxes and Long-Term Accrued Expenses:** Adjust net income for changes in deferred taxes, noncurrent liabilities for accrued expenses, and changes in other noncurrent liabilities. These items include changes in long-term accruals for expenses that are part of operations, including deferred taxes, pension

[23] Note that the analyst should not need to add back any amortization expense for nonamortizable intangible assets such as goodwill and brands with indefinite lives because under U.S. GAAP and IFRS, goodwill and other intangibles with indefinite lives are not amortized. Thus, no amortization expense for these assets was included in the projected income statements.

EXHIBIT 10.6

PepsiCo
Actual and Forecast Statements of Cash Flows

Actual and forecast amounts in bold. Amounts in millions; allow for rounding.

IMPLIED STATEMENT OF CASH FLOWS	Actuals		Forecasts				
	2007	2008	Year + 1	Year + 2	Year + 3	Year + 4	Year + 5
(1) Net Income	5,658	5,142	6,111	6,602	7,273	7,726	8,427
(2) Add back Depreciation Expense (net)	1,297	221	1,582	1,770	1,980	2,205	2,453
(3) Add back Amortization Expense (net)	58	64	64	63	62	60	56
(4) (Increase) Decrease in Receivables—Net	(664)	(294)	(460)	(450)	(787)	(112)	(1,141)
(5) (Increase) Decrease in Inventories	(364)	(232)	(208)	(303)	(383)	(125)	(569)
(6) (Increase) Decrease in Prepaid Expenses	(334)	(333)	(121)	(134)	(182)	(132)	(184)
(7) Increase (Decrease) in Accounts Payable—Trade	460	284	234	362	433	72	821
(8) Increase (Decrease) in Current Accrued Liabilities	646	387	494	548	745	542	755
(9) Increase (Decrease) in Income Taxes Payable	61	(6)	9	13	16	11	19
(10) Net Change in Deferred Tax Assets and Liabilities	118	(420)	16	20	26	18	30
(11) Increase (Decrease) in Long-Term Accrued Liabilities	168	2,225	639	709	964	700	977
Net Cash Flows from Operations	7,104	7,038	8,360	9,201	10,142	10,966	11,644
(12) (Increase) Decrease in Prop., Plant, & Equip., at cost	(2,838)	(656)	(2,171)	(2,939)	(3,278)	(3,524)	(3,867)
(13) (Increase) Decrease in Marketable Securities	(400)	1,358	(821)	(96)	(130)	(95)	(132)
(14) (Increase) Decrease in Investment Securities	(664)	471	(233)	(247)	(262)	(277)	(294)
(15) (Increase) Decrease in Amortizable Intangible Assets (net)	(217)	0	0	0	0	0	0
(16) (Increase) Decrease in Goodwill and Nonamort. Intang.	(611)	165	(570)	(632)	(859)	(624)	(870)
(17) (Increase) Decrease in Other Non-current Assets	(702)	(976)	(80)	(82)	(85)	(87)	(90)
Net Cash Flows from Investing Activities	(5,432)	362	(3,874)	(3,996)	(4,613)	(4,607)	(5,253)

(Continued)

EXHIBIT 10.6 (Continued)

	Actuals		Forecasts				
IMPLIED STATEMENT OF CASH FLOWS	2007	2008	Year + 1	Year + 2	Year + 3	Year + 4	Year + 5
(18) Increase (Decrease) in Short-Term Debt	(274)	369	16	32	41	29	48
(19) Increase (Decrease) in Long-Term Debt	1,653	3,655	547	697	900	623	1,056
(20) Increase (Decrease) in Minority Interest and Preferred Stock	(12)	(6)	97	0	0	0	0
(21) Increase (Decrease) in Common Stock + Paid-In Capital	(134)	(99)	27	34	44	30	51
(22) Increase (Decrease) in Accum. OCI and Other Equity Adjs.	1,294	(3,742)	0	0	0	0	0
(23) Increase (Decrease) in Treasury Stock	(2,629)	(3,735)	(2,500)	(2,500)	(2,500)	(2,500)	(2,500)
(24) Dividends	(2,311)	(2,688)	(3,184)	(3,325)	(3,818)	(4,398)	(4,848)
Net Cash Flows from Financing Activities	(2,413)	(6,246)	(4,998)	(5,062)	(5,333)	(6,217)	(6,193)
(25) Net Change in Cash	(741)	1,154	(513)	144	195	142	198
Check: Net Change in Cash − Change in Cash Balance	0	0	0	0	0	0	0

NOTE: We label the statements of cash flows and amounts for 2007 and 2008 as "Actuals" because we derive them from the actual balance sheet and income statement amounts in PepsiCo's financial statements rather than from the financial statement forecasts. Appendix A presents PepsiCo's Statements of Cash Flows for 2007 and 2008 as prepared by PepsiCo according to U.S. GAAP.

and retiree benefit obligations, warranties, and other noncurrent liabilities that appear on the projected balance sheets.

Net Cash Flows from Operations: The sum of lines (1) through (11) is the implied amount of net cash flows from operating activities.

(12) **Property, Plant, and Equipment:** The amount on this line captures cash outflows for the projected capital expenditures included in the change in property, plant, and equipment (at cost) on the projected balance sheet in Exhibit 10.4 less any cash proceeds from sales of property, plant, and equipment. As a check, the analyst should make sure the statement of cash flows captures all of the net cash flow implications of property, plant, and equipment. To verify this, the amount of depreciation expense added back to net income *minus* cash outflows for capital expenditures *plus* cash inflows for any asset sales or retirements should equal the change in net property, plant, and equipment on the projected balance sheet.

(13), (14) **Marketable Securities and Investment Securities (net):** The statement of cash flows classifies net purchases and sales of marketable securities (current asset) and investment securities (noncurrent asset) as investing transactions. The net changes in these accounts on the projected balance sheets determine the cash flow amounts for these items on the statement of cash flows. Some error in the implied cash flow amount from investment securities can occur. This change should be increased (become less negative) for the excess (if any) of equity earnings over dividends received from unconsolidated affiliates (which is a non-cash increase in this asset amount). Similarly, the excess of equity earnings over dividends received also should be subtracted from net income in the operating section of the statement of cash flows. Rather than making assumptions about this relatively immaterial item (the effects of which completely offset each other), we simply treat the change in investments fully as an investing transaction. This choice means that cash flows from operating activities are slightly overstated and cash flows from investing activities are slightly understated by an equivalent amount but that the net change in cash each year is not affected.

(15) **Amortizable Intangible Assets:** Enter the net change in amortizable intangible assets on this line. The change in this asset account on the projected balance sheets is the net of cash outflows to acquire amortizable intangible assets plus any cash inflows from sales or retirements of such assets. As discussed in Item (3), amortization expense is added back to income in the operating section of the statement of cash flows. Thus, the adjustment for cash outflows or inflows for amortizable intangible assets in the investing section of the statement should not include the effects of amortization expense. Given that amortizable intangibles are commonly shown on balance sheets net of accumulated amortization, the change in the net amortizable intangible assets account balance will reflect both effects: cash flows from investing activities and amortization expense. To isolate the cash flows from investing, the analyst should add amortization expense back to the net change in this account balance.

(16) **Goodwill and Nonamortizable Intangible Assets:** Enter the changes in goodwill and nonamortizable intangible assets on this line. Given that these assets are not amortized, the net change in the nonamortizable intangible assets balance on the projected balance sheets should reflect cash outflows to acquire new nonamortizable intangible assets less cash inflows from selling or retiring such assets. If the account balance for goodwill or nonamortizable intangible assets has declined because of an impairment charge, the analyst should add this noncash charge

back to net income in the operating section of the statement of cash flows and adjust accordingly the cash flow implications from net changes in goodwill or nonamortizable intangibles in the investing section (similar to adding back amortization expense).

(17) **Other Noncurrent Assets:** Enter the changes in other noncurrent assets on this line. The changes in the other noncurrent asset accounts on the projected balance sheets measure the cash outflows to acquire such assets net of any cash inflows from sales or retirements of such assets.

 Net Cash Flows from Investing Activities: The sum of lines (12) through (17) on PepsiCo's projected implied statement of cash flows measures the implied amount of net cash flows from investing activities.

(18), (19) **Short-Term and Long-Term Debt:** Changes in interest-bearing debt (short-term notes payable, current maturities of long-term debt, and long-term debt) on the projected balance sheets are financing activities.

(20) **Minority Interest and Preferred Stock:** The changes in minority interest and preferred stock on the projected balance sheets are financing activities. For PepsiCo in Year +1, the adjustment to zero out the negative balance in preferred stock appears as a cash inflow, but that effect is offset by an equivalent adjustment included as a cash outflow with total dividends on line 24.

(21) **Changes in Common Stock and Additional Paid-In Capital:** These amounts represent the financing cash flows from changes in the common stock and paid-in capital accounts on the projected balance sheets.

(22) **Changes in Accumulated Other Comprehensive Income:** These amounts represent the changes in the accumulated other comprehensive income account that is a component of shareholders' equity on the projected balance sheets.

(23) **Treasury Stock:** The amounts represent the net cash flow implications of treasury stock transactions that are captured in the net change in the treasury stock account on the projected balance sheets.

(24) **Dividends:** Enter the projected amounts for common and preferred dividends each year (discussed earlier in the section on Retained Earnings in the projected balance sheets). For PepsiCo in Year +1, this includes the amounts to retire outstanding preferred stock.

 Net Cash Flows from Financing Activities: The sum of lines (18) through (24) measures the implied amount of net cash flows from financing activities.

(25) **Net Change in Cash:** The aggregate of the amounts of cash flows from operations, investing activities, and financing activities. This total should equal the change in cash on the projected balance sheets.

SHORTCUT APPROACHES TO FORECASTING

Thus far, the chapter has emphasized a methodical, detailed approach to forecasting individual accounts on the income statement and balance sheet, allowing the analyst to incorporate drivers of expected future operating, investing, and financing activities related to each account. In some circumstances, however, an analyst may find it necessary to forecast income statement and balance sheet totals directly without carefully considering each account. This shortcut approach has the potential to introduce forecasting error if the shortcut assumptions do not fit each account very well. On the other hand, if the firm is stable and mature in an industry in steady-state equilibrium, shortcut forecasting techniques are efficient approaches to project current steady-state conditions to the future. The

next section illustrates shortcut approaches for forecasting PepsiCo's income statements and balance sheets.

Projected Sales and Income Approach

Shortcut projections for total sales and net income can be developed using PepsiCo's recent sales growth rates and net profit margins. Common-size and rate-of-change income statement data reveal that during 2004 through 2008, PepsiCo generated a compound growth rate in sales of 9.9 percent and an average net profit margin of 13.8 percent. If we simply use these ratios to forecast sales and net income over Years +1 to +5, the projected amounts are as follows:

Year	Sales Growth Rate	Projected Sales	Net Profit Margin	Projected Net Income
2008 actual		$43,251		
+1	9.9%	$47,533	13.8%	$6,560
+2	9.9%	$52,239	13.8%	$7,209
+3	9.9%	$57,411	13.8%	$7,923
+4	9.9%	$63,095	13.8%	$8,707
+5	9.9%	$69,341	13.8%	$9,569

These shortcut projections for sales and net income are much higher than the detailed sales and income projections developed for PepsiCo throughout the chapter (particularly those for Years +3 to +5). By forecasting individual expense amounts, the more detailed projections capture expected changes in expenses relative to sales, whereas the shortcut approach assumes that existing relations between sales and expenses will persist linearly into the future.

Projected Total Assets Approach

Total assets can be projected using the recent historical growth rate in total assets. Between the end of 2003 and the end of 2008, PepsiCo's total assets grew at an annual 7.3 percent compound rate. If this growth rate continues through Year +5, total assets will increase as follows:

Year	Asset Growth Rate	Projected Total Assets
2008 actual		$35,994
+1	7.3%	$38,622
+2	7.3%	$41,441
+3	7.3%	$44,466
+4	7.3%	$47,712
+5	7.3%	$51,195

Using historical growth rates to project total assets can result in erroneous projections if the analyst fails to consider the link between sales growth and asset growth. We assumed a sales growth rate for PepsiCo of 9.9 percent in the shortcut approach to sales projections but a 7.3 percent growth in assets, which implies a significant increase in total assets turnover from 1.22 in 2008 to 1.40 in Year +5. If this increase in total asset efficiency is not realistic, the use of these forecast procedures will lead to erroneous projections.

An alternative shortcut approach to projecting total assets uses the total assets turnover ratio, explicitly linking sales growth and asset growth. Like before, the assumption is that

PepsiCo's sales growth will persist at 9.9 percent per year, but now we will also assume total assets turnover will remain at 1.22 over the next five years. The calculation of projected total assets using the assets turnover ratio shortcut follows:

Year	Projected Sales	Average Assets Turnover Ratio	Projected Average Total Assets	Projected Beginning Total Assets	Projected Ending Total Assets	Implied Percent Change in Total Assets
+1	$47,533	1.22	$38,961	$35,994	$41,929	16.5%
+2	$52,239	1.22	$42,819	$41,929	$43,709	4.2%
+3	$57,411	1.22	$47,058	$43,709	$50,407	15.3%
+4	$63,095	1.22	$51,717	$50,407	$53,027	5.2%
+5	$69,341	1.22	$56,837	$53,027	$60,647	14.4%

This approach ties the projections of total assets to projections of sales. One difficulty sometimes encountered with using total assets turnover to project total assets is that it can result in unusual patterns for projected total assets. The total assets turnover uses average total assets in the denominator. If total assets changed by an unusually large (small) percentage in the most recent year preceding the projections, the next year's assets must change by an unusually small (large) proportion to compensate. This sawtooth pattern, which we described earlier in the chapter and illustrated in Exhibit 10.5, makes little intuitive sense, given a smooth growth in sales. We encounter this problem projecting total assets for PepsiCo using its total assets turnover in the preceding data. Note that the forecasts of PepsiCo's total assets increase 16.5 percent during Year +1, 4.2 percent in Year +2, 15.3 percent in Year +3, and so on, whereas we expect PepsiCo's sales to grow smoothly at 9.9 percent per year.

As shown previously in this chapter, the analyst can deal with the sawtooth problem by basing the assets turnover ratio on the ending balance, instead of the average balance, in total assets. Alternately, the analyst can smooth the rate of increase in assets over the forecast horizon. Assuming that assets turnover is stable at 1.22 and sales growth is smooth at 9.9 percent per year, the preceding data indicate that assets will increase from $35,994 million in 2008 to $60,647 million in Year +5, which reflects a compound average annual growth rate of 11.0 percent. The following table shows the revised projected assets following this smoothed approach. Note that total assets equal $60,647 million at the end of Year +5 in both cases (allow for rounding).

Year	Asset Growth Rate	Projected Total Assets
2008 actual		$35,994
+1	11.0%	$39,953
+2	11.0%	$44,348
+3	11.0%	$49,227
+4	11.0%	$54,641
+5	11.0%	$60,647

Once the analyst projects total assets, common-size balance sheet percentages provide a shortcut approach for allocating total assets to individual assets, liabilities, and shareholders' equity. In using these common-size percentages, the analyst assumes that the firm maintains a constant mix of assets, liabilities, and equities regardless of the level of total

assets. Equivalently, the analyst assumes that each asset, liability, and equity account grows at the same rate as total assets. For example, the common-size balance sheet for 2008 for PepsiCo (Appendix C) indicates that total liabilities represent 66.4 percent of total assets and equities represent 33.6 percent of total assets. If we assume that PepsiCo will maintain exactly the same proportions of debt and equity in its capital structure in future years, and if we use these proportions and the smoothed projections of total assets, we can project total liabilities and shareholders' equity amounts for Years +1 through +5 as follows:

Year	Projected Total Assets	Projected Total Liabilities (66.4%)	Projected Shareholders' Equity (33.6%)
+1	$39,953	$26,529	$13,424
+2	$44,348	$29,447	$14,901
+3	$49,227	$32,687	$16,540
+4	$54,641	$36,282	$18,359
+5	$60,647	$40,270	$20,377

Using common-size balance sheet percentages to project individual assets, liabilities, and shareholders' equity encounters (at least) two potential shortcomings. First, the common-size percentages for individual assets, liabilities, and shareholders' equity are not independent of each other. For example, a firm such as PepsiCo that acquires and disposes of its bottlers on an ongoing basis may experience a changing proportion for investments in securities among its assets. Other asset categories may show decreasing percentages in some years even though their dollar amounts are increasing. The analyst must interpret these decreasing percentages carefully.

Second, using the common-size percentages does not permit the analyst to easily change the assumptions about the future behavior of an individual asset or liability. For example, assume that PepsiCo intended to implement inventory control systems that should accelerate inventory turnover so that inventory will likely comprise a smaller percentage of total assets in the future than it has in the past. The analyst encounters difficulties adjusting the common-size balance sheet percentages to reflect the changes in inventory policies.

In general, shortcut approaches to forecasting have the virtue of greater efficiency but greater potential for error as compared to a thoughtful and more deliberate approach to forecasting each income statement and balance sheet account. Given that forecast errors can be very costly when they lead to bad investment decisions, we strongly advocate the careful, detailed approach to projecting financial statements by forecasting the firm's future operating, investing, and financing activities using individual income statement and balance sheet accounts.

ANALYZING PROJECTED FINANCIAL STATEMENTS

The reasonableness of the forecast assumptions and their internal consistency can be tested by analyzing the projected financial statements using the same ratios and other analytical tools discussed in previous chapters. Exhibit 10.7 presents a ratio analysis for PepsiCo based on the financial statement forecasts for Year +1 to Year +5. The FSAP Forecasts spreadsheet provides these ratio computations (Appendix C).

Forecast growth rates for sales are consistent with PepsiCo's past sales growth performance. The forecasts of net income exhibit growth rates are less volatile than those PepsiCo

EXHIBIT 10.7

PepsiCo
Financial Ratio Analysis Based on Actual and Forecast Financial Statements

	Actuals			Forecasts				
	2006	2007	2008	Year +1	Year +2	Year +3	Year +4	Year +5
FORECAST VALIDITY CHECK DATA:								
GROWTH								
Revenue Growth Rate	7.9%	12.3%	9.6%	9.1%	9.3%	11.5%	7.5%	9.7%
Net Income Growth Rate	38.4%	0.3%	−9.1%	18.8%	8.0%	10.2%	6.2%	9.1%
Total Asset Growth Rate	−5.7%	15.7%	3.9%	7.0%	8.3%	9.9%	6.2%	9.9%
RETURN ON ASSETS								
(based on reported amounts):								
Profit Margin for ROA	16.5%	14.7%	12.4%	13.7%	13.6%	13.4%	13.2%	13.2%
× Assets Turnover	1.1	1.2	1.2	1.3	1.3	1.3	1.3	1.3
= ROA	18.8%	18.0%	15.2%	17.4%	17.4%	17.6%	17.3%	17.5%
RETURN ON ASSETS								
(excluding effects of nonrecurring items):								
Profit Margin for ROA	16.5%	14.7%	12.4%	13.7%	13.6%	13.4%	13.2%	13.2%
× Assets Turnover	1.1	1.2	1.2	1.3	1.3	1.3	1.3	1.3
= ROA	18.8%	18.0%	15.2%	17.4%	17.4%	17.6%	17.3%	17.5%
RETURN ON COMMON EQUITY								
(based on reported amounts):								
Profit Margin for ROCE	16.1%	14.3%	11.9%	12.6%	12.8%	12.6%	12.5%	12.4%
× Assets Turnover	1.1	1.2	1.2	1.3	1.3	1.3	1.3	1.3
× Capital Structure Leverage	2.1	2.0	2.4	3.0	3.1	3.1	3.2	3.2
= ROCE	37.9%	34.5%	34.8%	47.8%	50.5%	52.1%	51.9%	53.0%

RETURN ON COMMON EQUITY

(excluding effects of nonrecurring items):

Profit Margin for ROCE	16.1%	14.3%	11.9%	12.6%	12.8%	12.6%	12.5%	12.4%
× Assets Turnover	1.1	1.2	1.2	1.3	1.3	1.3	1.3	1.3
× Capital Structure Leverage	2.1	2.0	2.4	3.0	3.1	3.1	3.2	3.2
= ROCE	37.9%	34.5%	34.8%	47.8%	50.5%	52.1%	51.9%	53.0%
OPERATING PERFORMANCE:								
Gross Profit/Revenues	55.1%	54.3%	52.9%	52.7%	52.5%	52.3%	52.1%	52.0%
Operating Profit Before Taxes/Revenues	18.5%	18.2%	16.0%	17.6%	17.4%	17.2%	17.0%	16.9%
ASSETS TURNOVER:								
Revenues/Average Accounts Receivable	10.1	9.7	9.5	9.6	9.6	9.6	9.6	9.6
COGS/Average Inventory	8.7	8.6	8.5	8.5	8.5	8.5	8.5	8.5
Revenues/Average Fixed Assets	3.8	3.8	3.8	3.9	4.0	4.1	4.0	4.1
LIQUIDITY:								
Current Ratio	1.3	1.3	1.2	1.2	1.2	1.3	1.2	1.3
Quick Ratio	1.0	0.9	0.8	0.8	0.8	0.8	0.8	0.8
SOLVENCY:								
Total Liabilities/Total Assets	48.7%	50.2%	66.4%	67.1%	67.7%	68.4%	68.5%	69.2%
Total Liabilities/Total Equity	94.3%	100.4%	195.8%	204.2%	209.6%	216.7%	217.6%	225.2%
Interest Coverage Ratio	30.2	35.1	22.3	17.9	18.0	18.1	17.9	18.0

experienced in its recent past. The projected rate of ROA (return on assets) varies slightly between 17.4 percent in Year +1 to 17.5 percent in Year +5, consistent with PepsiCo's recent past levels of ROA. The main driver of the increase in projected ROA is the expected slight increase in assets turnover. Similarly, the projected rate of ROCE (return on common equity) increases dramatically from 34.8 percent in 2008 up to 47.8 percent in Year +1 to 53.0 percent in Year +5. This occurs because of the projected shift in financial leverage to increase long-term debt and decrease shareholders' equity, along with slight increases in profit margin and assets turnover.

The projected increase in capital structure leverage over the forecast horizon is the result of PepsiCo's demonstrated shift to increase outstanding long-term debt, a shift that began in 2008 with the net issuance of $3.1 billion in long-term debt. In addition, PepsiCo has returned and will continue to return all excess cash flows to shareholders through increased dividends and share repurchases. PepsiCo is expected to finance the treasury stock repurchases and dividends with cash flow from operations, which will reduce shareholders' equity relative to debt, thereby increasing the capital structure leverage ratio. The net effect of increasing the ratio of long-term debt to assets, while at the same time reducing equity by repurchasing shares and paying dividends, suggests that PepsiCo's capital structure leverage will increase significantly. Given that PepsiCo also is expected to generate healthy profit margins, the increased capital structure leverage will generate increasingly higher returns to common equity shareholders.

The operating performance ratios, liquidity ratios, assets turnover ratios, and solvency ratios confirm that our forecast assumptions are reasonable given PepsiCo's expected future financial performance and position. Unfortunately, these ratios cannot confirm whether our forecast assumptions will turn out to be correct. These ratios do not tell us whether we have accurately and realistically captured PepsiCo's future sales growth, profitability, cash flows, and financial position. For this confirmation, only time will tell.

SENSITIVITY ANALYSIS AND REACTIONS TO ANNOUNCEMENTS

These financial statement forecasts can serve as the base case from which the analyst assesses the impact of various critical forecast assumptions for the firm and from which the analyst reacts to new announcements from the firm. For example, with these financial statement forecasts, the analyst can assess the sensitivity of projected net income and cash flows to key assumptions about the firm's sales growth rates; gross profit margins; control over selling, general, and administrative expenses; and other assumptions. Using the projected financial statements (Exhibits 10.3, 10.4, and 10.6) as the base case, the analyst can easily assess the impact on PepsiCo's profitability from a one-point increase or decrease in sales growth or from a one-point increase or decrease in the gross profit margin.

The analyst also can use the projected financial statements to assess the sensitivity of the firm's liquidity and leverage to changes in key assumptions. For example, the analyst can assess the impact on PepsiCo's liquidity and solvency ratios by varying the long-term debt to assets assumptions and the interest expense assumptions. Lenders and credit analysts can use the projected financial statements to assess the conditions under which the firm's debt covenants may become binding. For example, suppose PepsiCo's long-term debt and revolving line of credit agreements contain covenants that require PepsiCo to maintain liquidity and interest coverage ratios that exceed certain minimum levels. The financial statement forecasts provide the analyst with a structured approach to assess how far net income and cash flows would need to decrease (and how much long-term debt and interest expense would need to increase) before PepsiCo would violate these debt covenants.

The projected financial statements also enable the analyst to react quickly and efficiently to new announcements by the firm. For example, at the time of this writing, PepsiCo has submitted bids to acquire majority equity interests in its two anchor bottlers. The boards of directors and management teams of the two bottlers have rejected these bids, and it is unclear how PepsiCo will respond. Suppose PepsiCo announces new bids to acquire the shares of the two bottlers, their boards deem the bids to be acceptable, and the acquisitions are completed. The projected financial statements enable the analyst to incorporate the effects of acquisitions relatively efficiently into expectations for PepsiCo's future earnings, balance sheets, and cash flows.

As an alternative example, suppose PepsiCo announces that it is reversing its recapitalization strategy, such that it will discontinue purchases of treasury stock in Year +1 (and will reissue previously acquired treasury shares as needed to meet stock options exercises), and that it intends to use this cash to reduce interest-bearing long-term debt. The original projections included $2,500 million in treasury stock repurchases in Year +1, which should now become zero; instead, PepsiCo will use this capital to reduce (rather than increase) long-term borrowings. The analyst can efficiently incorporate the effects of this announcement into the projected financial statements. PepsiCo's original and revised projected ratios for Year +1 follow:

	Year +1 Original Projections	Year +1 Revised Projections
Net Profit Margin for ROA	13.7%	13.7%
ROA	17.4%	17.4%
ROCE	47.8%	43.8%
Capital Structure Leverage	3.0	2.7
Total Liabilities/Total Assets	67.1%	60.6%
Interest Coverage Ratio	17.9	21.0

Thus, the assumptions about the growth in treasury stock and long-term debt have significant effects on projected financial statements and ratios for PepsiCo. Various other changes in assumptions are possible. By designing a flexible computer spreadsheet for projecting financial statements, the analyst can quickly and efficiently change any one or a combination of assumptions and observe the effect on the financial statements and ratios. FSAP provides a flexible spreadsheet for forecasting.

SUMMARY

This chapter demonstrates a seven-step procedure for developing financial statement forecasts. The preparation of financial statement forecasts requires numerous assumptions about the future operating, investing, and financing activities of the firm, including future growth rates in sales, cost behavior of various expenses, levels of investments in various working capital and fixed assets, the financial capital structure of the firm, and dividend payouts. The analyst should carefully develop realistic expectations for these activities and capture those expectations in financial statement forecasts that provide an objective and realistic portrait of the firm in the future. The analyst should then study the sensitivity of the financial statements to the assumptions made and to the impact of different assumptions. Spreadsheet software can assist in this sensitivity analysis.

After developing careful and realistic expectations for future earnings, cash flows, and dividends using financial statement projections, the analyst can use the information to

make a wide array of decisions about the firm, including evaluating the firm as a potential equity investment. The next four chapters demonstrate how to incorporate expectations for future dividends, cash flows, and earnings into estimates of firm value.

QUESTIONS, EXERCISES, PROBLEMS, AND CASES

Questions and Exercises

10.1 RELYING ON ACCOUNTING TO AVOID FORECAST ERRORS. The chapter states that forecasts of financial statements should rely on the *additivity* within financial statements and the *articulation* across financial statements to avoid internal inconsistencies in forecasts. Explain how the concepts of additivity and articulation apply to financial statement forecasts. Also explain how these concepts can help the analyst avoid potential forecast errors.

10.2 OBJECTIVE AND REALISTIC FORECASTS. The chapter encourages analysts to develop forecasts that are realistic, objective, and unbiased. Some firms' managers tend to be optimistic. Some accounting principles tend to be conservative. Describe the different risks and incentives that managers, accountants, and analysts face. Explain how these different risks and incentives lead managers, accountants, and analysts to different biases when predicting uncertain outcomes.

10.3 PROJECTING REVENUES: THE EFFECTS OF VOLUME VERSUS PRICE. Suppose a firm has generated 10.25 percent revenue growth in the past two years, consisting of 5.0 percent growth in sales volume compounded with 5.0 percent growth in prices. Describe one firm-specific strategic factor, one industry-specific factor, and one economy-wide factor that could help this firm sustain 5.0 percent growth in sales volume next year. Describe one firm-specific strategic factor, one industry-specific factor, and one economy-wide factor that could help this firm sustain 5.0 percent growth in prices next year.

10.4 PROJECTING GROSS PROFIT: THE EFFECTS OF VOLUME VERSUS PRICE. Suppose you are analyzing a firm that is successfully executing a strategy that differentiates its products from those of its competitors. Because of this strategy, you project that next year the firm will generate 6.0 percent revenue growth from price increases and 3.0 percent revenue growth from sales volume increases. Assume that the firm's production cost structure involves strictly variable costs. (That is, the cost to produce each unit of product remains the same.) Should you project that the firm's gross profit will increase next year? If you project that the gross profit will increase, is the increase a result of volume growth, price growth, or both? Should you project that the firm's gross profit margin (gross profit divided by sales) will increase next year? If you project that the gross profit margin will increase, is the increase a result of volume growth, price growth, or both?

10.5 PROJECTING REVENUES, COST OF GOODS SOLD, AND INVENTORY. Walgreens is a leading chain of drugstores in the United States. Use the following data for Walgreens in Years 7 and 8 to project revenues, cost of goods sold, and inventory for Year +1. Assume that Walgreen's Year +1 revenue growth rate, gross profit margin, and inventory turnover will be identical to Year 8. Project the average inventory balance in Year +1 and use it to compute the implied ending inventory balance.

Walgreens (data in millions)	Year 7	Year 8
Sales Revenues	$53,762	$59,034
Cost of Goods Sold	$38,518	$42,391
Ending Inventory	$ 6,791	$ 7,249

10.6 THE FLEXIBLE FINANCIAL ACCOUNT. The chapter describes how firms must use flexible financial accounts to maintain equality between assets and claims on assets from liabilities and equities. Chapter 1 describes how some firms progress through different life-cycle stages—from introduction to growth to maturity to decline—and how firms experience very different cash flows during different stages of the life cycle. For each life-cycle stage, identify the different types of flexible accounts that firms will be more likely to use to balance the balance sheet.

10.7 DIVIDENDS AS A FLEXIBLE FINANCIAL ACCOUNT. The following data for Schwartz Company represent a summary of your first-iteration forecast amounts for Year +1. Schwartz uses dividends as a flexible financial account. Compute the amount of dividends you can assume that Schwartz will pay in order to balance your projected balance sheet. Present the projected balance sheet.

	Year +1
Operating Income	$ 58
Interest Expense	(8)
Income before Tax	$ 50
Tax Provision (20.0 percent effective tax rate)	(10)
Net Income	$ 40
Total Assets	$200
Accrued Liabilities	$ 43
Long-Term Debt	$ 80
Common Stock, at par	$ 20
Retained Earnings (at the beginning of Year +1)	$ 34

10.8 LONG-TERM DEBT AS A FLEXIBLE FINANCIAL ACCOUNT. For this exercise, use the preceding data for Schwartz Company. Now assume that Schwartz pays common shareholders a dividend of $25 in Year +1. Also assume that Schwartz uses long-term debt as a flexible financial account, increasing borrowing when it needs capital and paying down debt when it generates excess capital. For simplicity, assume that Schwartz pays 10.0 percent interest expense on the ending balance in long-term debt for the year and that interest expense is tax deductible at Schwartz's average tax rate of 20.0 percent. Present the projected income statement and balance sheet for Year +1. (Hint: Because of the circularity between interest expense, net income, and debt, several iterations may be needed to balance the projected balance sheet and to have the projected balance sheet articulate with net income. You may find it helpful to program a spreadsheet to work the iterative computations.)

Problems and Cases

10.9 STORE-DRIVEN FORECASTS. The Home Depot is a leading specialty retailer of hardware and home improvement products and is the second-largest retail store chain in the United States. It operates large warehouse-style stores. Despite declining sales

and difficult economic conditions in 2007 and 2008, The Home Depot continued to invest in new stores. The following table provides summary data for The Home Depot.

The Home Depot (amounts in millions except number of stores)	2007	2008
Number of Stores	2,234	2,274
Sales Revenues	$77,349	$71,288
Inventory	$11,731	$10,673
Capital Expenditures, net	$ 3,558	$ 1,847

Required

a. Use the preceding data for The Home Depot to compute average revenues per store, capital spending per new store, and ending inventory per store in 2008.

b. Assume that The Home Depot will add 100 new stores by the end of Year +1. Use the data from 2008 to project Year +1 sales revenues, capital spending, and ending inventory. Assume that each new store will be open for business for an average of one-half year in Year +1. For simplicity, assume that in Year +1, Home Depot's sales revenues will grow, but only because it will open new stores.

10.10 PROJECTING PROPERTY, PLANT, AND EQUIPMENT. Intel is a global leader in manufacturing microprocessors, which is very capital-intensive. The production processes in microprocessor manufacturing require sophisticated technology, and the technology changes rapidly, particularly with each new generation of microprocessor. As a consequence, production and manufacturing assets in the microprocessor industry tend to have relatively short useful lives. The following summary information relates to Intel's property, plant, and equipment for 2007 and 2008:

Intel (amounts in millions)	2007	2008
Property, Plant, and Equipment, at cost	$ 46,052	$ 48,088
Accumulated Depreciation	$(29,134)	$(30,544)
Property, Plant, and Equipment, net	$ 16,918	$ 17,544
Depreciation Expense		$ 4,360
Capital Expenditures, net		$ 5,200

Required

Assume that Intel depreciates all property, plant, and equipment using the straight-line depreciation method and zero salvage value. Assume that Intel spends $6,000 on new depreciable assets in Year +1 and does not sell or retire any property, plant, and equipment during Year +1.

a. Compute the average useful life that Intel used for depreciation in 2008.

b. Project total depreciation expense for Year +1 using the following steps: (i) project depreciation expense for Year +1 on existing property, plant, and equipment at the end of 2008; (ii) project depreciation expense on capital expenditures in Year +1 assuming that Intel takes a full year of depreciation in the first year of service; and (iii) sum the results of (i) and (ii) to obtain total depreciation expense for Year +1.

c. Project the Year +1 ending balance in property, plant, and equipment, both at cost and net of accumulated depreciation.

10.11 IDENTIFYING THE COST STRUCTURE AND PROJECTING GROSS MARGINS FOR CAPITAL-INTENSIVE, CYCLICAL BUSINESSES.

AK Steel is an integrated manufacturer of high-quality steel and steel products in capital-intensive steel mills. AK Steel produces flat-rolled carbon, stainless and electrical steel products, and carbon and stainless tubular steel products for automotive, appliance, construction, and manufacturing markets. Nucor manufactures more commodity-level steel and steel products at the lower end of the market in less capital-intensive mini-mills. The following data describe sales and cost of products sold for both firms for Years 3 and 4.

($ amounts in millions)	Year 3	Year 4
AK Steel		
Sales	$4,042	$ 5,217
Cost of Products Sold	$3,887	$ 4,554
Gross Profit	$ 155	$ 663
Gross Margin	3.8%	12.7%
Nucor		
Sales	$6,266	$11,377
Cost of Products Sold	$5,997	$ 9,129
Gross Profit	$ 269	$ 2,248
Gross Margin	4.3%	19.8%

Industry analysts anticipate the following annual changes in sales for the next five years: Year +1, 5 percent increase; Year +2, 10 percent increase; Year +3, 20 percent increase; Year +4, 10 percent decrease; Year +5, 20 percent decrease.

Required

a. The analyst can sometimes estimate the variable cost as a percentage of sales for a particular cost (for example, cost of products sold) by dividing the amount of the change in the cost item between two years by the amount of the change in sales for those two years. The analyst can then multiply the variable-cost percentage times sales to estimate the total variable cost. Subtracting the variable cost from the total cost yields an estimate of the fixed cost for that particular cost item. Follow this procedure to estimate the manufacturing cost structure (variable cost as a percentage of sales, total variable costs, and total fixed costs) for cost of products sold for both AK Steel and Nucor in Year 4.

b. Discuss the structure of manufacturing cost (that is, fixed versus variable) for each firm in light of the manufacturing process and type of steel produced.

c. Using the analysts' forecasts of sales growth rates, compute the projected sales, cost of products sold, gross profit, and gross margin (gross profit as a percentage of sales) of each firm for Year +1 through Year +5.

d. Why do the levels and variability of the gross margin percentages differ for these two firms for Year +1 through Year +5?

10.12 IDENTIFYING THE COST STRUCTURE. Sony Corporation manufactures and markets consumer electronics products. Selected income statement data for 2007 and 2008 follow (amounts in billions of yen):

	2007	2008
Sales	¥8,296	¥8,871
Cost of Goods Sold	(5,890)	(6,290)
Selling and Administrative Expenses	(1,788)	(1,714)
Operating Income before Income Taxes	¥618	¥867

Required

a. The analyst can sometimes estimate the variable cost as a percentage of sales for a particular cost (for example, cost of goods sold) by dividing the amount of the change in the cost item between two years by the amount of the change in sales for those two years. The analyst can then multiply total sales by the variable-cost percentage to determine the total variable cost. Subtracting the variable cost from the total cost yields the fixed cost component for that particular cost item. Follow this procedure to determine the cost structure (fixed cost plus variable cost as a percentage of sales) for cost of goods sold for Sony.

b. Repeat Part a for selling and administrative expenses.

c. Sony Corporation discloses that it expects sales to grow at the following percentages in future years: Year +1, 12 percent; Year +2, 10 percent; Year +3, 8 percent; Year +4, 6 percent. Project sales, cost of goods sold, selling and administrative expenses, and operating income before income taxes for Sony for Year +1 to Year +4 using the cost structure amounts derived in Parts a and b.

d. Compute the ratio of operating income before income taxes to sales for Year +1 through Year +4.

e. Interpret the changes in the ratio computed in Part d in light of the expected changes in sales.

10.13 SMOOTHING CHANGES IN ACCOUNTS RECEIVABLE.

Hasbro designs, manufactures, and markets toys and games for children and adults in the United States and in international markets. Hasbro's portfolio of brands and products contains some of the most well-known toys and games under famous brands such as Playskool, Tonka Trucks, Milton Bradley, and Parker Brothers and includes such classic games as Scrabble®, Monopoly, and Clue®. Sales during 2008 totaled $4,022 million. Accounts receivable totaled $655 million at the beginning of 2008 and $612 million at the end of 2008.

Required

a. Use the average balance to compute the accounts receivable turnover ratio for Hasbro for 2008.

b. Hasbro generated a compound annual sales growth rate of 13.0 percent over the past two years. Assume that Hasbro's sales will continue to grow at that rate each year for Year +1 through Year +5 and that the accounts receivable turnover ratio each year will equal the ratio computed in Part a for 2008. Project the amount of accounts receivable at year-end through Year +5 based on the accounts receivable turnover computed in Part a. Also compute the percentage change in accounts receivable between each of the year-ends through Year +5.

c. Does the pattern of growth in your projections of Hasbro's accounts receivable seem reasonable considering the assumptions of smooth growth in sales and steady turnover? Explain.

d. The changes in accounts receivable computed in Part b display the sawtooth pattern depicted in Exhibit 10.5. Smooth the changes in accounts receivable by computing

the year-end accounts receivable balances for Year +1 through Year +5 using the compound annual growth rate in accounts receivable between the end of 2008 and the end of Year +1 from Part b.

e. Smooth the changes in accounts receivable using the compound annual growth rate in accounts receivable between the end of 2008 and the end of Year +4 from Part b. Apply this growth rate to compute accounts receivable at the end of Year +1 through Year +5. Why do the amounts for ending accounts receivable using the growth rate from Part d differ from those using the growth rate from this part?

f. Compute the accounts receivable turnover for 2008 by dividing sales by the balance in accounts receivable at the end of 2008 (instead of using average accounts receivable as in Part a). Use this accounts receivable turnover ratio to compute the projected balance in accounts receivable at the end of Year +1 through Year +5. Also compute the percentage change in accounts receivable between the year-ends for Year +1 through Year +5.

10.14 SMOOTHING CHANGES IN INVENTORIES.

Barnes & Noble sells books, magazines, music, and videos through retail stores and on the Web. For a retailer like Barnes & Noble, inventory is a critical element of the business and it is necessary to carry a wide array of titles. In 2008, sales totaled $5,122 million and cost of sales and occupancy totaled $3,541 million. Inventories constitute the largest asset on Barnes & Noble's balance sheet, totaling $1,203 million at the end of 2008 and $1,358 million at the end of 2007.

Required

a. Compute the inventory turnover ratio for Barnes & Noble for 2008.

b. Over the last two years, the number of Barnes & Noble retail stores has remained fairly steady and sales have grown at a compounded annual rate of 11.6 percent. Assume that the number of stores will remain constant and that sales will continue to grow at an annual rate of 11.6 percent each year between Year +1 and Year +5. Also assume that the future cost of goods sold to sales percentage will equal that realized in 2008 (which is very similar to the cost of goods sold percentage over the past three years). Project the amount of inventory at the end of Year +1 through Year +5 using the inventory turnover ratio computed in Part a. Also compute the percentage change in inventories between each of the year-ends between 2008 and Year +5. Does the pattern of growth in your projections of Barnes & Noble inventory seem reasonable to you considering the assumptions of smooth growth in sales and steady cost of goods sold percentages? Explain.

c. The changes in inventories in Part b display the sawtooth pattern depicted in Exhibit 10.5. Smooth the changes in the inventory forecasts between 2008 and Year +5 using the compound annual growth rate in inventories between the end of 2008 and the end of Year +5 implied by the projections in Part b. Does this pattern of growth seem more reasonable? Explain.

d. Now suppose that instead of following the smoothing approach in Part c, you used the rate of growth in inventory during 2008 to project future inventory balances at the end of Year +1 through Year +5. Use these projections to compute the implied inventory turnover rates. Does this pattern of growth and efficiency in inventory for Barnes & Noble seem reasonable? Explain.

10.15 IDENTIFYING FINANCIAL STATEMENT RELATIONS.

Partial forecasts of financial statements for Watson Corporation appear in Exhibit 10.8 (income statement), Exhibit 10.9 (balance sheet), and Exhibit 10.10 (statement of cash flows). Selected amounts have been omitted, as have all totals (indicated by XXXX).

EXHIBIT 10.8

Watson Corporation
Partial Income Statements
(Problem 10.15)

	Year 0 Actual	Year +1 Projected	Year +2 Projected	Year +3 Projected	Year +4 Projected
Sales	$ 46,000	$ 50,600	$ 56,672	$ 64,606	$ 74,943
Cost of goods sold	(29,900)	(32,890)	XXXX	(40,702)	(46,465)
Selling and administrative	(10,580)	(11,638)	(12,468)	(13,567)	(14,989)
Interest expense	(3,907)	(4,298)	d	(3,866)	(5,227)
Income taxes	(565)	(621)	(1,372)	(2,265)	(2,892)
Net Income	$ XXXX	$ XXXX	$ XXXX	$ XXXX	$ XXXX

EXHIBIT 10.9

Watson Corporation
Partial Balance Sheets
(Problem 10.15)

	Year 0 Actual	Year +1 Projected	Year +2 Projected	Year +3 Projected	Year +4 Projected
ASSETS					
Cash	$ 1,200	$ 664	$ 206	$ 416	$ 1,262
Accounts receivable	8,000	8,433	8,855	10,420	12,286
Inventories	7,500	8,223	c	10,711	11,333
Fixed assets:					
Cost	110,400	120,445	126,467	f	169,895
Accumulated depreciation	(33,100)	(36,112)	(37,917)	(45,352)	(50,938)
Total Assets	$ XXXX	$ XXXX	$ XXXX	$ XXXX	$ XXXX
Liabilities and Shareholders' Equity					
Accounts payable	$ 2,500	$ 2,801	$ 3,107	$ 3,376	$ 3,828
Notes payable	6,500	6,852	7,195	8,467	9,982
Other current liabilities	3,300	3,630	e	4,635	5,376
Long-term debt	45,000	49,094	51,549	h	69,251
Total Liabilities	$ XXXX	$ XXXX	$ XXXX	$ XXXX	$ XXXX
Common stock	$15,000	$17,233	$17,539	$22,434	$24,319
Retained earnings	21,700	22,043	23,700	g	31,082
Total Shareholders' Equity	$ XXXX	$ XXXX	$ XXXX	$ XXXX	$ XXXX
Total Liabilities and Shareholders' Equity	$ XXXX	$ XXXX	$ XXXX	$ XXXX	$ XXXX

EXHIBIT 10.10

Watson Corporation
Partial Statements of Cash Flows
(Problem 10.15)

	Year 0 Actual	Year +1 Projected	Year +2 Projected	Year +3 Projected	Year +4 Projected
OPERATIONS					
Net income	$ 1,048	$ 1,153	$XXXX	$ 4,206	$ 5,370
Depreciation	2,378	b	1,805	7,435	5,586
Change in accounts receivable	(394)	(433)	(422)	(1,565)	(1,866)
Change in inventories	(657)	(723)	(1,322)	(1,166)	(622)
Change in accounts payable	274	301	306	269	452
Change in other current liabilities	300	330	436	569	741
Cash Flow from Operations	$XXXX	$ XXXX	$XXXX	$ XXXX	$ XXXX
INVESTING					
Acquisition of fixed assets	$(9,130)	$(10,045)	$(6,022)	$(24,796)	$(18,632)
FINANCING					
Change in notes payable	$ 320	$ 3352	$ 343	$ 1,272	$ 1,515
Change in long-term debt	3,721	4,094	2,455	10,107	7,595
Change in common stock	2,029	2,233	306	4,895	1,885
Dividends	(750)	a	(891)	(1,016)	(1,178)
Cash Flow from Financing	$XXXX	$ XXXX	$XXXX	$ XXXX	$ XXXX
Change in Cash	$XXXX	$ XXXX	$XXXX	$ XXXX	$ XXXX

Required

Determine the amount of each of the following items.

a. Dividends declared and paid during Year 1

b. Depreciation expense for Year 1 assuming that Watson Corporation neither sold nor retired depreciable assets during Year 1

c. Inventories at the end of Year 2

d. Interest expense on borrowing during Year 2, with an interest rate of 7 percent

e. Other current liabilities at the end of Year 2

f. Property, plant, and equipment at the end of Year 3 assuming that Watson Corporation neither sold nor retired depreciable assets during Year 3

g. Retained earnings at the end of Year 3

h. Long-term debt at the end of Year 3

i. The income tax rate for Year 4

j. Purchases of inventories during Year 4

10.16 PREPARING AND INTERPRETING FINANCIAL STATEMENT FORECASTS.

Wal-Mart Stores, Inc. (Walmart) is the largest retailing firm in the world. Building on a base of discount stores, Walmart has expanded into warehouse clubs and Supercenters, which sell traditional discount store items and grocery products.

Exhibits 10.11, 10.12, and 10.13 present the financial statements of Walmart for 2006–2008. Exhibits 4.50–4.52 (Case 4.2 in Chapter 4) also present summary financial statements for Walmart, and Exhibit 4.53 presents selected financial statement ratios for Years 2006–2008. (Note: A few of the amounts presented in Chapter 4 for Walmart differ slightly from the amounts provided here because, for purposes of computing financial analysis ratios, the Chapter 4 data have been adjusted slightly to remove the effects of non-recurring items such as discontinued operations.)

Required (additional requirements follow on page 862)

a. Design a spreadsheet and prepare a set of financial statement forecasts for Walmart for Year +1 to Year +5 using the assumptions that follow. Project the amounts in the order presented (unless indicated otherwise) beginning with the income statement, then the balance sheet, and then the statement of cash flows. For this portion of the problem, assume that Walmart will exercise its financial flexibility with the cash and cash equivalents account to balance the balance sheet.

EXHIBIT 10.11

Balance Sheets for Wal-Mart Stores, Inc.
(Problem 10.16)

	2006	2007	2008
Cash	$ 7,373	$ 5,492	$ 7,275
Receivables	2,840	3,642	3,905
Inventories	33,685	35,159	34,511
Prepaid expenses and other current assets	2,690	2,760	3,063
Current assets of discontinued segments	0	967	195
Current Assets	**$ 46,588**	**$ 48,020**	**$ 48,949**
Property, plant & equipment—At cost	115,190	127,992	131,161
Accumulated depreciation	(26,750)	(31,125)	(35,508)
Goodwill and other non-current assets	16,165	18,627	18,827
Total Assets	**$151,193**	**$163,514**	**$163,429**
Accounts payable—Trade	$ 28,090	$ 30,344	$ 28,849
Accrued liabilities	14,675	15,725	18,112
Accrued income taxes and other current liabilities	706	1,140	760
Notes payable and short term debt	2,570	5,040	1,506
Current maturities of long term debt and leases	5,713	6,229	6,163
Current Liabilities	**$ 51,754**	**$ 58,478**	**$ 55,390**
Long term debt	30,375	33,402	34,549
Deferred taxes and other non-current liabilities	4,971	5,087	6,014
Total Liabilities	**$ 87,460**	**$ 96,967**	**$ 95,953**
Minority interest	2,160	1,939	2,191
Common stock + paid in capital	3,247	3,425	4,313
Retained earnings	55,818	57,319	63,660
Accumulated other comprehensive income	4,971	5,087	(2,688)
Shareholders' Equity	**$ 63,733**	**$ 66,547**	**$ 67,476**
Total Liabilities and Equities	**$151,193**	**$163,514**	**$163,429**

EXHIBIT 10.12

Income Statements for Wal-Mart Stores, Inc.
(Problem 10.16)

	2006	2007	2008
Revenues	$348,368	$378,476	$405,607
Cost of goods sold	(263,979)	(286,350)	(306,158)
Gross Profit	**$ 84,389**	**$ 92,126**	**$ 99,449**
Selling, general, and administrative expense	(63,892)	(70,174)	(76,651)
Operating Profit	**$ 20,497**	**$ 21,952**	**$ 22,798**
Interest income	280	309	284
Interest expense	(1,809)	(2,103)	(2,184)
Income before Tax	**$ 18,968**	**$ 20,158**	**$ 20,898**
Income tax expense	(6,354)	(6,889)	(7,145)
Minority interest in earnings	(425)	(406)	(499)
Income from discontinued operations	(905)	(132)	146
Net Income	**$ 11,284**	**$ 12,731**	**$ 13,400**
Other comprehensive income items	1,575	1,356	(6,552)
Comprehensive Income	**$ 12,859**	**$ 14,087**	**$ 6,848**

EXHIBIT 10.13

Statements of Cash Flows for Wal-Mart Stores, Inc.
(Problem 10.16)

	2006	2007	2008
Net Income	**$ 11,284**	**$ 12,731**	**$ 13,400**
Add back depreciation	5,459	6,317	6,739
Other adjustments to net income	860	132	(146)
Deferred taxes	89	(8)	581
(Increase) Decrease in receivables	(214)	(564)	(101)
(Increase) Decrease in inventories	(1,274)	(775)	(220)
Increase (Decrease) in accounts payable	2,132	865	(410)
Increase (Decrease) in other current liabilities	588	1,034	2,036
Other operating cash flows	1,311	910	1,268
Net Cash Flow From Operations	**$ 20,235**	**$ 20,642**	**$ 23,147**
Proceeds from sales of property, plant, and equipment	394	957	714
Property, plant, and equipment acquired	(15,666)	(14,937)	(11,499)
Investments (acquired) sold	267	(95)	781
Other investment transactions	542	(1,595)	(738)
Net Cash Flow from Investing Activities	**$(14,463)**	**$(15,670)**	**$(10,742)**

(Continued)

	2006	**2007**	**2008**
Increase (Decrease) in short-term borrowing	(1,193)	2,376	(3,745)
Increase (Decrease) in long-term borrowing	1,101	2,101	827
Issue of capital stock	—	—	—
Share repurchases—treasury stock	(1,718)	(7,691)	(3,521)
Dividend payments	(2,802)	(3,586)	(3,746)
Other financing transactions	(510)	(622)	267
Net Cash Flow from Financing Activities	**$ (5,122)**	**$ (7,422)**	**$ (9,918)**
Effects of exchange rate changes on cash	97	252	(781)
Net Change in Cash	**$ 747**	**$ (2,198)**	**$ 1,706**

Note: The net changes in cash reported by Walmart do not reconcile exactly with the changes in cash balances each year because Walmart reclassifies prior year amounts of cash associated with discontinued segments.

Income Statement

Sales

Sales grew by 10.4 percent in 2006, 8.6 percent in 2007, and 7.2 percent in 2008. The compound annual sales growth rate during the last five years was 9.4 percent. Walmart generates sales growth primarily through increasing same-store sales, opening new stores, and acquiring other retailers. In the future, Walmart will continue to grow in international markets by opening stores and acquiring other firms and in domestic U.S. markets by converting discount stores to Supercenters. In addition, despite vigorous competition, Walmart will likely continue to generate steady increases in same-store sales, consistent with its experience through 2008. Assume that sales will grow 7.0 percent each year from Year +1 through Year +5.

Cost of Goods Sold

The percentage of costs of goods sold relative to sales decreased slightly from 75.8 percent of sales in 2006 to 75.7 percent in 2007 to 75.5 percent in 2008. Walmart's everyday low-price strategy, its movement into grocery products, and competition will likely prevent Walmart from achieving significant additional decreases in this expense percentage. Assume that the cost of goods sold to sales percentage will remain steady at 75.5 percent for Year +1 to Year +5.

Selling and Administrative Expenses

The selling and administrative expense percentage has steadily increased from 18.3 percent of sales in 2006 to 18.5 percent in 2007 to 18.9 percent of sales in 2008. Identifying and transacting international corporate acquisitions and opening additional Supercenters, together with the slowdown in the sales growth rate, will put upward pressure on this expense percentage. Assume that the selling and administrative expense to sales percentage will be 19.0 percent of sales for Year +1 to Year +5.

Interest Income

Walmart earns some interest income on its cash and cash equivalents accounts. The average interest rate earned on average cash balances was approximately 4.4 percent during 2008, similar to rates earned in 2006 and 2007. Assume that Walmart will earn interest income

based on a 4.4 percent interest rate on average cash balances (that is, the sum of beginning and end-of-year cash balances divided by 2) for Year +1 through Year +5. (Note: Projecting the amount of interest income must await projection of cash on the balance sheet.)

Interest Expense

Walmart uses long-term mortgages and capital leases to finance new stores and warehouses and short- and long-term borrowing to finance corporate acquisitions. The average interest rate on all interest-bearing debt and capital leases was approximately 5.0 percent during 2007 and 2008. Assume a 5.0 percent interest rate for all outstanding borrowing (short-term and long-term debt, including capital leases, and the current portion of long-term debt) for Walmart for Year +1 through Year +5. Compute interest expense on the average amount of interest-bearing debt outstanding each year. (Note: Projecting the amount of interest expense must await projection of the interest-bearing debt accounts on the balance sheet.)

Income Tax Expense

Walmart's average income tax rate as a percentage of income before taxes has been a steady 34.2 percent during the last two years. Assume that Walmart's effective income tax rate remains a constant 34.2 percent of income before taxes for Year +1 through Year +5. (Note: Projecting the amount of income tax expense must await computation of income before taxes.)

Minority Interest in Earnings

Minority shareholders in Walmart subsidiaries were entitled to a $499 million share in Walmart's 2008 net income. Assume that the minority interest in earnings for Year +1 through Year +5 will remain a constant $499 million.

Balance Sheet

Cash

We will adjust cash as the flexible financial account to equate total assets with total liabilities plus shareholders' equity. Projecting the amount of cash must await projections of all other balance sheet amounts.

Accounts Receivable

As a retailer, a large portion of Walmart's sales are in cash or for third-party credit card charges, which Walmart can convert into cash within a day or two. Walmart has its own credit card that customers can use for purchases at its Sam's Club warehouse stores, but the total amount of receivables outstanding on these credit cards is relatively minor compared to Walmart's total sales. As a consequence, Walmart's receivables turnover is very steady and fast, averaging roughly three days during each of the past three years. Assume that accounts receivable will increase at the growth rate in sales.

Inventories

Walmart has managed to increase the efficiency of inventory turnover ratio in recent years, in part because of the expanding role of grocery products in Walmart's overall inventory. However, that increase in efficiency has been offset slightly by the stocking of new stores and the distribution of merchandise to stores worldwide. Inventory turns have increased from an average of 45 days in 2006 to 44 days in 2007 to 42 days in 2008. Assume that inventory will continue to turn over, on average, every 42 days, or roughly 8.7 times a year, in Years +1 to +5. Use this turnover rate to compute the average inventories each year and then compute the implied ending inventories each year.

Prepaid Expenses

Current assets include prepayments for ongoing operating costs such as rent and insurance. Assume that prepayments will grow at the growth rate in sales.

Current Assets of Discontinued Segments

Walmart's balance sheets in 2007 and 2008 recognize amounts as current assets that are associated with discontinued segments (subsidiaries that Walmart is divesting). Assume that these amounts will be zero in Year +1 through Year +5.

Property, Plant, and Equipment—At Cost

Property, plant, and equipment (including assets held under capital leases) grew 11.6 percent annually during the most recent five years. The construction of new Supercenters and the acquisition of established retail chains abroad will require additional investments in property, plant, and equipment. Assume that property, plant, and equipment will grow 11.6 percent each year from Year +1 through Year +5.

Accumulated Depreciation

In 2007 and 2008, Walmart depreciated property, plant, and equipment using an average useful life of approximately 19.2 years. For Year +1 through Year +5, assume that accumulated depreciation will increase each year by depreciation expense. For simplicity, compute straight-line depreciation expense based on an average 20-year useful life and zero salvage value. In computing depreciation expense each year, make sure you depreciate the beginning balance in property, plant, and equipment—at cost. Also add a new layer of depreciation expense for the new property, plant, and equipment acquired through capital expenditures. Assume that Walmart recognizes a full year of depreciation on new property, plant, and equipment in the first year of service.

Goodwill and Other Assets

Goodwill and other assets include primarily goodwill arising from corporate acquisitions outside the United States. Such acquisitions increase Walmart sales. Assume that goodwill and other assets will grow at the growth rate in sales. Also assume that goodwill and other assets are not amortizable.

Accounts Payable

Walmart has maintained a steady accounts payable turnover, with payment periods averaging ten times per year (an average turnover of roughly 35–37 days) during the last three years. Assume that accounts payable turnover will continue to turn over every 35 days in Years +1 to +5. Use this turnover rate to compute the average accounts payable each year and then compute the implied ending accounts payable each year. To compute accounts payable turnover, remember to add the change in inventory to the cost of goods sold to obtain the total amount of credit purchases of inventory during the year.

Accrued Liabilities

Accrued liabilities relate to accrued expenses for ongoing operating activities and are expected to grow at the growth rate in selling and administrative expenses, which are expected to grow with sales.

Other Current Liabilities

Other current liabilities include primarily income taxes payable. For simplicity, assume that other current liabilities grow with sales.

Other Noncurrent Liabilities

Other noncurrent liabilities include amounts related to deferred taxes, health care benefits, and accruals for long-term expenses. Since 2006, other noncurrent liabilities have grown at an annual compounded rate of 10 percent per year. Assume that other noncurrent liabilities will continue to grow by 10 percent per year for Year +1 through Year +5.

Short-Term Debt, Current Maturities of Long-Term Debt, Capital Leases, and Long-Term Debt

Walmart uses short-term debt, current maturities of long-term debt, capital leases, and long-term debt to augment cash from operations to finance capital expenditures on property, plant, and equipment and acquisitions of existing retail chains outside the United States. Over the past three years, short-term debt and current maturities of long-term debt have fluctuated considerably from year to year, whereas long-term debt has grown fairly steadily at a compound annual rate of 6.0 percent per year. For simplicity, assume that short-term debt and current maturities of long-term debt will remain constant for Year +1 through Year +5 and that any additional borrowing will be in long-term debt (including capital leases). Assume that Walmart's long-term debt will continue to grow at 6.0 percent per year in Year +1 through Year +5.

Minority Interest

Assume that minority interest will not change.

Common Stock and Additional Paid-In Capital

Over the past three years, Walmart has increased common stock and additional paid-in capital by issuing shares to satisfy stock option exercises by managers, employees, and others. Common stock and additional paid-in capital have increased at a net compounded rate of roughly 15.3 percent per year during this period (net of payments to repurchase company shares on the open market, which Walmart then reissues to satisfy stock option exercises). Assume that common stock and additional paid-in capital will grow at a net rate of 10 percent per year for Year +1 through Year +5.

Retained Earnings

The increase in retained earnings equals net income minus dividends. Walmart paid dividends amounting to $3,746 million to common shareholders in 2008, which amounted to roughly 30 percent of prior year net income. Assume that Walmart will maintain a policy to pay 30 percent of lagged net income in dividends each year in Year +1 through Year +5.

Accumulated Other Comprehensive Income

Assume that accumulated other comprehensive income will not change. Equivalently, assume that future other comprehensive income items will be zero, on average, in Year +1 through Year +5.

Cash

At this point, you can project the amount of cash on Walmart's balance sheet at each year-end from Year +1 to Year +5. Assume that Walmart uses cash as the flexible financial account to balance the balance sheet. The resulting cash balance each year should be the total amount of liabilities and shareholders' equity minus the projected ending balances in all non-cash asset accounts.

Statement of Cash Flows

Depreciation Addback

Include depreciation expense, which should equal the change in accumulated depreciation.

Other Addbacks

Assume that changes in other noncurrent liabilities on the balance sheet are operating activities.

Other Investing Transactions

Assume that changes in other noncurrent assets on the balance sheet are investing activities.

Required (continued from page 856)

b. If you have programmed your spreadsheet correctly, the projected amount of cash grows steadily from Year +1 to Year +5 and the projected cash balance at the end of Year +5 is a whopping $33,511 million (allow for rounding), which is more than 12.5 percent of total assets. Identify one problem that so much cash could create for the financial management of Walmart.

c. Assume that Walmart will augment its dividend policy by paying out 30 percent of lagged net income plus the amount of excess cash each year (if any). Assume that during Year +1 to Year +5, Walmart will maintain a constant cash balance of $7,275 million (the ending cash balance in 2008). Revise your forecast model spreadsheets to change the financial flexibility account from cash to dividends. Determine the total amount of dividends that Walmart could pay each year under this scenario. Identify one potential benefit that increased dividends could create for the financial management of Walmart.

d. Calculate and compare the return on common equity for Walmart using the forecast amounts determined in Parts a and c for Year +1 to Year +5. Why are the two sets of returns different? Which results will Walmart's common shareholders prefer? Why?

INTEGRATIVE CASE 10.1

STARBUCKS

The Starbucks integrative case provides you with an opportunity to apply to Starbucks the entire six-step analysis framework of this textbook. Beginning in Chapter 1 and following each chapter of the book, we use the Starbucks Integrative Case to illustrate and apply all of the tools of financial statements analysis and valuation throughout the book. This chapter illustrates the seven-step forecasting procedure by applying it to PepsiCo to develop complete financial statement forecasts through Year +5. This portion of the integrative case relies on the analysis of Starbucks' financial statements through fiscal year 2008 and applies the seven-step forecasting procedure of this chapter to develop complete forecasts of Starbucks' financial statements through Year +5.

Exhibits 10.14 and 10.15 (see pages 866–869) provide Starbucks' income statements and balance sheets for fiscal years 2006 through 2008 in dollar amounts, common-size format, and rate-of-change format. Exhibit 10.16 (see pages 870–871) presents Starbucks' statements of cash flows for fiscal years 2006 through 2008. These financial statements report the financial performance and position of Starbucks and summarize the results of Starbucks' operating, investing, and financing activities. The common-size and rate-of-change balance sheets and income statements for Starbucks highlight relations among accounts and trends over

EXHIBIT 10.14

Starbucks Income Statements in Amounts, Common-Size Percentages, and Percentage Changes (Integrative Case 10.1)

Starbucks: Consolidated Statements of Income: Fiscal Years 2003–2008

(millions except per-share amounts)	2003	2004	2005	2006	2007	2008
Company-operated retail	$3,449.6	$4,457.4	$5,391.9	$6,583.1	$7,998.3	$ 8,771.9
Specialty:						
Licensing	409.6	565.8	673.0	860.7	1,026.3	1,171.6
Foodservice and other	216.3	271.1	304.4	343.2	386.9	439.5
Total Specialty	625.9	836.9	977.4	1,203.8	1,413.2	1,611.1
Net Revenues	**$4,075.5**	**$5,294.2**	**$6,369.3**	**$7,786.9**	**$9,411.5**	**$10,383.0**
Cost of sales (including occupancy costs)	1,681.4	2,191.4	2,605.2	3,178.8	3,999.1	4,645.3
Gross Profit	**2,394.1**	**3,102.8**	**3,764.1**	**4,608.2**	**5,412.4**	**5,737.7**
Store operating expenses	1,379.6	1,790.2	2,165.9	2,687.8	3,215.9	3,745.1
Other operating expenses	141.3	171.6	192.5	253.7	294.1	330.1
Depreciation and amortization	244.7	289.2	340.2	387.2	467.2	549.3
General and administrative expenses	244.6	304.3	361.6	479.4	489.2	456.0
Restructuring charges	—	—	—	—	—	266.9
Income from equity investees	36.7	59.0	76.6	93.9	108.0	113.6
Operating Income	**420.7**	**606.5**	**780.5**	**894.0**	**1,053.9**	**503.9**
Interest and other income	11.9	14.5	17.1	20.7	40.6	9.0
Interest expense	(0.3)	(0.4)	(1.3)	(8.4)	(38.2)	(53.4)
Income Before Income Taxes	**432.3**	**620.6**	**796.3**	**906.2**	**1,056.4**	**459.5**
Provision for income taxes	167.1	231.8	302.0	324.8	383.7	144.0
Cum. effect of an accounting change	—	—	—	(17.2)	—	—
Net Income	**$ 265.2**	**$ 388.9**	**$ 494.4**	**$ 564.3**	**$ 672.6**	**$ 315.5**
Net Income Per Share						
Basic	$ 0.34	$ 0.49	$ 0.63	$ 0.76	$ 0.90	$ 0.43
Diluted	$ 0.33	$ 0.47	$ 0.61	$ 0.73	$ 0.87	$ 0.43

(Continued)

EXHIBIT 10.14 (Continued)

Starbucks: Consolidated Statements of Income: Fiscal Years 2003–2008

	Common-Size						Percentage Change					
	2003	2004	2005	2006	2007	2008	2004	2005	2006	2007	2008	Compound
Company-operated retail	84.6%	84.2%	84.7%	84.5%	85.0%	84.5%	29.2%	21.0%	22.1%	21.5%	9.7%	20.5%
Specialty:												
Licensing	10.0%	10.7%	10.6%	11.1%	10.9%	11.3%	38.2%	18.9%	27.9%	19.2%	14.2%	23.4%
Foodservice and other	5.3%	5.1%	4.8%	4.4%	4.1%	4.2%	25.3%	12.3%	12.8%	12.7%	13.6%	15.2%
Total Specialty	15.4%	15.8%	15.3%	15.5%	15.0%	15.5%	33.7%	16.8%	23.2%	17.4%	14.0%	20.8%
Net Revenues	100.0%	100.0%	100.0%	100.0%	100.0%	100.0%	29.9%	20.3%	22.3%	20.9%	10.3%	20.6%
Cost of sales (including occupancy costs)	41.3%	41.4%	40.9%	40.8%	42.5%	44.7%	30.3%	18.9%	22.0%	25.8%	16.2%	22.5%
Gross Profit	58.7%	58.6%	59.1%	59.2%	57.5%	55.3%	29.6%	21.3%	22.4%	17.5%	6.0%	19.1%
Store operating expenses	33.9%	33.8%	34.0%	34.5%	34.2%	36.1%	29.8%	21.0%	24.1%	19.6%	16.5%	22.1%
Other operating expenses	3.5%	3.2%	3.0%	3.3%	3.1%	3.2%	21.4%	12.2%	31.8%	15.9%	12.2%	18.5%
Depreciation and amortization	6.0%	5.5%	5.3%	5.0%	5.0%	5.3%	18.2%	17.6%	13.8%	20.6%	17.6%	17.6%
General and administrative expenses	6.0%	5.7%	5.7%	6.2%	5.2%	4.4%	24.4%	18.8%	32.6%	2.1%	-6.8%	13.3%
Restructuring charges	0.0%	0.0%	0.0%	0.0%	0.0%	2.6%	na	na	na	na	na	na
Income from equity investees	0.9%	1.1%	1.2%	1.2%	1.1%	1.1%	60.6%	30.0%	22.6%	15.0%	5.2%	25.3%
Operating Income	10.3%	11.5%	12.3%	11.5%	11.2%	4.9%	44.2%	28.7%	14.5%	17.9%	-52.2%	3.7%
Interest and other income	0.3%	0.3%	0.3%	0.3%	0.4%	0.1%	22.0%	17.8%	20.8%	96.3%	-77.8%	-5.5%
Interest expense	0.0%	0.0%	0.0%	-0.1%	-0.4%	-0.5%	33.3%	225.0%	546.2%	354.8%	39.8%	181.9%
Income Before Income Taxes	10.6%	11.7%	12.5%	11.6%	11.2%	4.4%	43.6%	28.3%	13.8%	16.6%	-56.5%	1.2%
Provision for income taxes	4.1%	4.4%	4.7%	4.2%	4.1%	1.4%	38.7%	30.3%	7.5%	18.2%	-62.5%	-2.9%
Cumulative effect of an accounting change	0.0%	0.0%	0.0%	-0.2%	0.0%	0.0%	na	na	na	na	na	na
Net Income	6.5%	7.3%	7.8%	7.2%	7.1%	3.0%	46.6%	27.1%	14.1%	19.2%	-53.1%	3.5%

time. Exhibit 10.17 (see pages 872–873) provides store operating data through fiscal year 2008 for Starbucks, including same-store sales growth rates, new store openings, and total numbers of stores open. Exhibit 10.18 (see page 874) provides a detailed breakdown of Starbucks' revenues and revenue growth by segment and by store. You may want to refer back to Exhibits 1.26–1.30 (Chapter 1) for additional financial statement data. You also may want to refer back to Exhibit 4.44 and 4.45 (Chapter 4) for a ratio analysis of Starbucks' profitability and operating segments. All of the other chapters in the text also have illustrated accounting quality issues and financial statement analysis issues for Starbucks. All of these data and analyses now come into play in this portion of the comprehensive Starbucks case, as you develop forecasts of Starbucks' future financial statements.

Required

Develop complete forecasts of Starbucks' income statements, balance sheets, and statements of cash flows for Years +1 through +5. As illustrated in this chapter, develop objective and unbiased forecast assumptions for all of Starbucks' future operating, investing, and financing activities through Year +5 and capture those expectations using financial statement forecasts.

Specifications

a. Build your own spreadsheets to develop and capture your financial statement forecast assumptions and data for Starbucks. Building your own financial statement forecast spreadsheets is a valuable learning experience. You can use the PepsiCo examples presented throughout this chapter as models to follow in building your spreadsheets. If you have already had the experience of building forecast spreadsheets, you can build your financial statement forecasts using the FSAP template for Starbucks that accompanies this book. If you want to start from scratch, you can download the blank FSAP template from the book's website: www.cengage.com/accounting/wahlen and input the accounting data for Starbucks from Exhibits 10.14–10.16 into the Data Spreadsheet in the blank FSAP template.

b. Starbucks' operating, investing, and financing activities involve primarily opening and operating company-owned retail coffee shops in the United States and around the world. Starbucks' annual reports provide useful data on the number of company-operated stores Starbucks owns, the new stores it opens each year, and the same-store sales growth rates. These data reveal that Starbucks' revenues and revenue growth rates differ significantly across different segments and across U.S. versus international stores. Use these data, summarized in Exhibits 10.17 and 10.18, as a basis to forecast (i) Starbucks' future sales from existing stores, (ii) the number of new company-operated stores Starbucks will open, (iii) future sales from new stores, and (iv) capital expenditures for new stores.

c. Starbucks' business also involves generating revenues from licensing Starbucks stores and selling Starbucks coffee and other products through foodservice accounts, grocery stores, warehouse clubs, and so on. Use the data in Exhibits 10.17 and 10.18 to build forecasts of future revenues from licensing activities and foodservice and other activities.

d. Use your forecasts of capital expenditures for new stores together with Starbucks' data on property, plant, and equipment and depreciation to build a schedule to forecast property, plant, and equipment and depreciation expense as described in the chapter and illustrated in Appendix C for PepsiCo.

e. Starbucks appears to use repurchases of common equity shares as the flexible financial account for balancing the balance sheet. Common equity share repurchases are

EXHIBIT 10.15

Starbucks

Balance Sheets in Dollar Amounts, Common-Size Percentages, and Percentage Changes

(Integrative Case 10.1)

Starbucks: Consolidated Balance Sheets: 2003–2008

(dollars in millions)	2003	2004	2005	2006	2007	2008
ASSETS						
Cash and equivalents	$ 200.9	$ 145.1	$ 173.8	$ 312.6	$ 281.3	$ 269.8
Short-term investments	149.1	508.0	133.2	141.0	157.4	52.5
Receivables	114.4	140.2	190.8	224.3	287.9	329.5
Inventories	342.9	422.7	546.3	636.2	691.7	692.8
Prepaid expenses and other assets	55.2	71.3	94.4	126.9	148.8	169.2
Deferred income taxes, net	47.4	63.7	70.8	88.8	129.5	234.2
Total Current Assets	**910.0**	**1,350.9**	**1,209.3**	**1,529.8**	**1,696.5**	**1,748.0**
Long-term investments	136.2	135.2	60.5	5.8	21.0	71.4
Equity and other investments	144.3	167.7	201.1	219.1	258.8	302.6
Property and equipment, gross	2,516.3	2,877.7	3,467.6	4,257.7	5,306.6	5,717.3
Accumulated depreciation	(1,068.6)	(1,326.3)	(1,625.6)	(1,969.8)	(2,416.1)	(2,760.9)
Property and equipment, net	1,447.7	1,551.4	1,842.0	2,287.9	2,890.4	2,956.4
Other assets	52.1	85.6	72.9	186.9	219.4	261.1
Other intangible assets	24.9	26.8	35.4	38.0	42.0	66.6
Goodwill	63.3	69.0	92.5	161.5	215.6	266.5
Total Assets	**$2,778.5**	**$3,386.5**	**$3,513.7**	**$4,428.9**	**$5,343.9**	**$5,672.6**

LIABILITIES AND STOCKHOLDERS' EQUITY

Accounts payable	$ 169.0	$ 199.3	$ 221.0	$ 340.9	$ 390.8	$ 324.9
Short-term borrowings	—	—	277.0	700.0	710.2	713.0
Accrued compensation and related costs	152.6	208.9	232.4	289.0	292.4	253.6
Accrued occupancy costs	21.7	29.2	44.5	54.9	74.6	136.1
Accrued taxes	54.9	63	78.3	94	92.5	76.1
Insurance reserves	—	—	—	—	137.0	152.5
Other accrued expenses	101.8	123.7	198.1	224.2	160.3	164.4
Deferred revenue	73.5	121.4	175.0	231.9	296.9	368.4
Current portion of long-term debt	0.7	0.7	0.7	0.8	0.8	0.7
Total Current Liabilities	**574.2**	**746.3**	**1,227.0**	**1,935.6**	**2,155.6**	**2,189.7**
Deferred income taxes, net	12.5	21.8	—	—	—	—
Long-term debt	4.4	3.6	2.9	2.0	550.1	549.6
Other long-term liabilities	116.3	144.7	193.6	262.9	354.1	442.4
Total Liabilities	**707.4**	**916.3**	**1,423.4**	**2,200.4**	**3,059.8**	**3,181.7**
Common stock	959.1	956.7	91.0	0.8	0.7	0.7
Paid-in capital	39.4	39.4	39.4	39.4	39.4	39.4
Retained earnings	1,058.3	1,444.9	1,939.0	2,151.1	2,189.4	2,402.4
Accumulated other comp. income	14.3	29.2	20.9	37.3	54.6	48.4
Total Shareholders' Equity	**2,071.1**	**2,470.2**	**2,090.3**	**2,228.5**	**2,284.1**	**2,490.9**
Total Liabilities and Shareholders' Equity	**$2,778.5**	**$3,386.5**	**$3,513.7**	**$4,428.9**	**$5,343.9**	**$5,672.6**

(Continued)

EXHIBIT 10.15 (Continued)

Starbucks: Consolidated Balance Sheets: 2003–2008

	Common-Size						Percentage Change					
	2003	2004	2005	2006	2007	2008	2004	2005	2006	2007	2008	Compound
Cash and equivalents	7.2%	4.3%	4.9%	7.1%	5.3%	4.8%	−27.8%	19.8%	79.9%	−10.0%	−4.1%	6.1%
Short-term investments	5.4%	15.0%	3.8%	3.2%	2.9%	0.9%	240.7%	−73.8%	5.9%	11.6%	−66.7%	−18.8%
Receivables	4.1%	4.1%	5.4%	5.1%	5.4%	5.8%	22.5%	36.0%	17.6%	28.4%	14.4%	23.6%
Inventories	12.3%	12.5%	15.5%	14.4%	12.9%	12.2%	23.2%	29.3%	16.5%	8.7%	0.2%	15.1%
Prepaid expenses and other assets	2.0%	2.1%	2.7%	2.9%	2.8%	3.0%	29.3%	32.4%	34.4%	17.2%	13.7%	25.1%
Deferred income taxes, net	1.7%	1.9%	2.0%	2.0%	2.4%	4.1%	34.3%	11.2%	25.4%	45.8%	80.9%	37.6%
Total Current Assets	**32.8%**	**39.9%**	**34.4%**	**34.5%**	**31.7%**	**30.8%**	**48.5%**	**−10.5%**	**26.5%**	**10.9%**	**3.0%**	**13.9%**
Long-term investments	4.9%	4.0%	1.7%	0.1%	0.4%	1.3%	na	na	−90.4%	261.8%	239.6%	na
Equity and other investments	5.2%	5.0%	5.7%	4.9%	4.8%	5.3%	16.3%	19.9%	9.0%	18.1%	16.9%	16.0%
PP&E gross	90.6%	85.0%	98.7%	96.1%	99.3%	100.8%	14.4%	20.5%	22.8%	24.6%	7.7%	17.8%
Accum. deprec.	−38.5%	−39.2%	−46.3%	−44.5%	−45.2%	−48.7%	24.1%	22.6%	21.2%	22.7%	14.3%	20.9%
PP&E net	52.1%	45.8%	52.4%	51.7%	54.1%	52.1%	7.2%	18.7%	24.2%	26.3%	2.3%	15.3%
Other assets	1.9%	2.5%	2.1%	4.2%	4.1%	4.6%	64.2%	−14.8%	156.4%	17.4%	19.0%	38.0%
Other intangible assets	0.9%	0.8%	1.0%	0.9%	0.8%	1.2%	7.4%	32.1%	7.2%	10.8%	58.4%	21.7%
Goodwill	2.3%	2.0%	2.6%	3.6%	4.0%	4.7%	8.9%	34.1%	74.6%	33.5%	23.6%	33.3%
Total Assets	**100.0%**	**100.0%**	**100.0%**	**100.0%**	**100.0%**	**100.0%**	**21.9%**	**3.8%**	**26.0%**	**20.7%**	**6.2%**	**15.3%**

Accounts payable	6.1%	5.9%	6.3%	7.7%	7.3%	5.7%	18.0%	10.8%	54.3%	14.6%	-16.9%	14.0%
Short-term borrowings	0.0%	0.0%	7.9%	15.8%	13.3%	12.6%	na	na	152.7%	1.5%	0.4%	na
Accrued compensation	5.5%	6.2%	6.6%	6.5%	5.5%	4.5%	36.9%	11.2%	24.4%	1.2%	-13.3%	10.7%
Accrued occupancy	0.8%	0.9%	1.3%	1.2%	1.4%	2.4%	34.5%	52.2%	23.3%	35.9%	82.5%	44.3%
Accrued taxes	2.0%	1.9%	2.2%	2.1%	1.7%	1.3%	14.7%	24.4%	20.1%	-1.6%	-17.7%	6.8%
Insurance reserves	0.0%	0.0%	0.0%	0.0%	2.6%	2.7%	na	na	na	na	11.3%	na
Other accrued expenses	3.7%	3.7%	5.6%	5.1%	3.0%	2.9%	21.5%	60.2%	13.2%	-28.5%	2.6%	10.1%
Deferred revenue	2.6%	3.6%	5.0%	5.2%	5.6%	6.5%	65.2%	44.2%	32.5%	28.0%	24.1%	38.0%
Current portion of long-term debt	0.0%	0.0%	0.0%	0.0%	0.0%	0.0%	1.8%	1.8%	1.9%	1.7%	-9.7%	-0.6%
Total Current Liabilities	**20.7%**	**22.0%**	**34.9%**	**43.7%**	**40.3%**	**38.6%**	**30.0%**	**64.4%**	**57.8%**	**11.4%**	**1.6%**	**30.7%**
Deferred income taxes, net	0.5%	0.6%	0.0%	0.0%	0.0%	0.0%	73.6%	-100.0%	na	na	na	-100.0%
Long-term debt	0.2%	0.1%	0.1%	0.0%	10.3%	9.7%	-16.9%	-20.7%	-31.8%	27996.1%	-0.1%	163.2%
Other long-term liabilities	4.2%	4.3%	5.5%	5.9%	6.6%	7.8%	24.4%	33.8%	35.8%	34.7%	24.9%	30.6%
Total Liabilities	**25.5%**	**27.1%**	**40.5%**	**49.7%**	**57.3%**	**56.1%**	**29.5%**	**55.3%**	**54.6%**	**39.1%**	**4.0%**	**35.1%**
Common stock	34.5%	28.2%	2.6%	0.0%	0.0%	0.0%	-0.3%	-90.5%	-99.2%	-2.4%	0.0%	-76.2%
Paid-in capital	1.4%	1.2%	1.1%	0.9%	0.7%	0.7%	0.0%	0.0%	0.0%	0.0%	0.0%	0.0%
Retained earnings	38.1%	42.7%	55.2%	48.6%	41.0%	42.4%	36.5%	34.2%	10.9%	1.8%	9.7%	17.8%
Accum. other comp. income	0.5%	0.9%	0.6%	0.8%	1.0%	0.9%	104.9%	-28.5%	78.2%	46.5%	-11.4%	27.7%
Total Shareholders' Equity	**74.5%**	**72.9%**	**59.5%**	**50.3%**	**42.7%**	**43.9%**	**19.3%**	**-15.4%**	**6.6%**	**2.5%**	**9.1%**	**3.8%**
Total Liabilities and Shareholders' Equity	**100.0%**	**100.0%**	**100.0%**	**100.0%**	**100.0%**	**100.0%**	**21.9%**	**3.8%**	**26.0%**	**20.7%**	**6.2%**	**15.3%**

EXHIBIT 10.16

Starbucks
Consolidated Statements of Cash Flows
(Integrative Case 10.1)

Starbucks: Consolidated Cash Flows: 2003–2008

(dollars in millions)	2003	2004	2005	2006	2007	2008
OPERATING ACTIVITIES						
Net earnings	$265.4	$389.0	$494.5	$ 564.3	$ 672.6	$ 315.5
Depreciation and amortization	266.3	314.0	367.2	412.6	491.2	604.5
Provisions for impairments and disposals	7.8	13.6	20.2	19.6	26.0	325.0
Deferred income taxes, net	(6.8)	(3.8)	(31.3)	(84.3)	(37.3)	(117.1)
Equity in income of investees	(21.3)	(31.8)	(49.6)	(60.6)	(65.7)	(61.3)
Distributions of income from equity investees	29.0	38.3	30.9	49.2	65.9	52.6
Stock-based compensation	36.6	63.4	110.0	105.7	103.9	75.0
Other non-cash items in net earnings	6.0	11.6	10.1	(96.9)	(84.7)	(11.0)
Operating assets and liabilities:						
Inventories	(64.8)	(77.7)	(121.6)	(85.5)	(48.6)	(0.6)
Accounts payable	25.0	27.9	9.7	105.0	36.1	(63.9)
Accrued expenses and taxes	42.1	54.9	22.7	132.7	86.4	7.3
Deferred revenues	30.7	47.6	53.3	56.6	63.2	72.4
Other operating assets and liabilities	0.2	11.4	7.6	13.2	22.2	60.3
Net Cash Provided by Operating Activities	**$616.1**	**$858.5**	**$923.6**	**$1,131.6**	**$1,331.2**	**$1,258.7**

INVESTING ACTIVITIES

Purchases, sales, maturities of investment securities	(121.3)	(264.7)	452.2	61.1	24.1
Acquisitions, net of cash acquired	(69.9)	(7.5)	(21.6)	(91.7)	(74.2)
Net additions to property, plant, and equipment	(378.0)	(412.5)	(644.0)	(771.2)	(984.5)
Other investments	(47.3)	(64.7)	(7.9)	(39.2)	(52.0)
Net Cash Used in Investing Activities	**$(616.4)**	**$(749.5)**	**$(221.3)**	**$(841.0)**	**$(1,086.6)**
FINANCING ACTIVITIES					
Net (payments on) proceeds from commercial paper	—	—	—	—	(297.2)
Net (payments on) proceeds from short-term borrowings	—	—	277.0	423.0	299.4
Net (payments on) proceeds from long-term debt	(0.7)	(0.7)	(0.7)	(0.9)	(0.6)
Net (repurchases of) issues of common equity shares	31.5	(65.8)	(950.1)	(694.8)	(199.1)
Excess tax benefit from exercise of stock options	—	—	—	117.4	14.7
Other	—	—	—	—	(1.7)
Net Cash Used by Financing Activities	**$ 30.8**	**$ (66.5)**	**$(673.8)**	**$(155.3)**	**$ (184.5)**
Effect of exchange rate changes on cash	3.3	3.1	0.3	3.5	0.9
Net Change in Cash and Cash Equivalents	**$ 33.7**	**$ 45.6**	**$ 28.8**	**$ 138.8**	**$ (11.5)**
Beginning Cash	65.7	99.5	145.1	173.8	281.3
Ending Cash	**$ 99.5**	**$ 145.1**	**$ 173.8**	**$ 312.6**	**$ 269.8**

EXHIBIT 10.17

Starbucks
Store Operating Data
(Integrative Case 10.1)

Starbucks: Store Operating Data: 2003–2008

	2003	2004	2005	2006	2007	2008
Percentage change in comparable store sales:						
U.S.	9%	11%	9%	7%	4%	−5%
International	7%	6%	6%	8%	7%	2%
Consolidated	8%	10%	8%	7%	5%	−3%
Stores opened during the year:						
U.S. Company-operated stores	514	521	580	810	1,065	445
Licensed stores	315	417	596	733	723	438
Int'l. Company-operated stores	126	144	166	233	277	236
Licensed stores	246	262	330	423	506	550
Totals Company-operated stores	640	665	746	1,043	1,342	681
Licensed stores	561	679	926	1,156	1,229	988
Grand total stores opened	1,201	1,344	1,672	2,199	2,571	1,669
Stores open at year-end:						
U.S. Company-operated stores	3,817	4,338	4,918	5,728	6,793	7,238
Licensed stores	1,422	1,839	2,435	3,168	3,891	4,329
Int'l. Company-operated stores	834	978	1,202	1,435	1,712	1,979
Licensed stores	1,152	1,414	1,686	2,109	2,615	3,134
Totals Company-operated stores	4,651	5,316	6,120	7,163	8,505	9,217
Licensed stores	2,574	3,253	4,121	5,277	6,506	7,463
Grand total stores open at year-end	7,225	8,569	10,241	12,440	15,011	16,680

Stores open at year-end:	Common-Size						Percentage Change					
	2003	2004	2005	2006	2007	2008	2004	2005	2006	2007	2008	Compound
U.S. Company-operated stores	52.8%	50.6%	48.0%	46.0%	45.3%	43.4%	13.6%	13.4%	16.5%	18.6%	6.6%	13.7%
Licensed stores	19.7%	21.5%	23.8%	25.5%	25.9%	26.0%	29.3%	32.4%	30.1%	22.8%	11.3%	24.9%
Int'l. Company-operated stores	11.5%	11.4%	11.7%	11.5%	11.4%	11.9%	17.3%	22.9%	19.4%	-9.3%	15.6%	18.9%
Licensed stores	15.9%	16.5%	16.5%	17.0%	17.4%	18.8%	22.7%	19.2%	25.1%	24.0%	19.8%	22.2%
Totals Company-operated stores	64.4%	62.0%	59.8%	57.6%	56.7%	55.3%	14.3%	15.1%	17.0%	18.7%	8.4%	14.7%
Licensed stores	35.6%	38.0%	40.2%	42.4%	43.3%	44.7%	26.4%	26.7%	28.1%	23.3%	14.7%	23.7%
Grand total stores open at year-end	100.0%	100.0%	100.0%	100.0%	100.0%	100.0%	18.6%	19.5%	21.5%	20.7%	11.1%	18.2%

EXHIBIT 10.18

Starbucks
Sales Growth Analysis by Segment
(Integrative Case 10.1)
(amounts in millions)

	2005	2006	2007	2008
Retail Sales	$5,391.9	$6,583.1	$7,998.3	$ 8,771.9
Specialty Revenues	977.4	1,203.8	1,413.2	1,611.1
Net Revenues	**$6,369.3**	**$7,786.9**	**$9,411.5**	**$10,383.0**
Growth rates	20.3%	22.3%	20.9%	10.3%

Sales by Segment and Type:	2005	2006	2007	2008
Retail				
U.S.	$4,539.5	$5,495.2	$6,560.9	$6,997.7
International	852.5	1,087.9	1,437.4	1,774.2
Specialty				
U.S. Licensed	278.0	369.2	439.2	504.2
International Licensed	145.7	186.1	220.8	274.8
Foodservice & CPG	553.6	648.6	753.2	832.1
Net Revenues	**$6,369.3**	**$7,786.9**	**$9,411.5**	**$10,383.0**

Sales per Average Store-Year by Segment and Type:	2005	2006	2007	2008
Retail				
U.S.	$0.981	$1.032	$1.048	$0.997
Growth rates		5.2%	1.5%	−4.8%
International	$0.782	$0.825	$0.914	$0.961
Growth rates		5.5%	10.7%	5.2%
Specialty				
U.S. Licensed	—	$0.132	$0.124	$0.123
Growth rates			−5.6%	−1.4%
International licensed	—	$0.098	$0.093	$0.096
Growth rates			−4.6%	2.3%
Foodservice & CPG	$553.6	$648.6	$753.2	$832.1
Growth rates		17.2%	16.1%	10.5%

similar to dividends as a mechanism to distribute excess capital to common equity shareholders. Therefore, build your financial statement forecasts using dividends as the flexible financial account.

f. Save your forecast spreadsheets. In subsequent chapters, you will continue to use Starbucks as a comprehensive integrative case. In those chapters, you will apply the valuation models to your forecasts of Starbucks' future earnings, cash flows, and dividends to assess Starbucks' share value.

CASE 10.2

MASSACHUSETTS STOVE COMPANY: ANALYZING STRATEGIC OPTIONS[24]

The Woodstove Market

Since the early 1990s, woodstove sales have declined from 1,200,000 units per year to approximately 100,000 units per year. The decline has occurred because of (1) stringent new federal EPA regulations, which set maximum limits on stove emissions beginning in 1992; (2) stable energy prices, which reduced the incentive to switch to woodstoves to save on heating costs; and (3) changes in consumers' lifestyles, particularly the growth of two-income families.

During this period of decline in industry sales, the market was flooded with woodstoves at distressed prices as companies closed their doors or liquidated inventories made obsolete by the new EPA regulations. Downward pricing pressure forced surviving companies to cut prices, output, or both. Years of contraction and pricing pressure left many of the surviving manufacturers in a precarious position financially, with excessive inventory, high debt, little cash, uncollectible receivables, and low margins.

The shakeout and consolidation among woodstove manufacturers and, to a lesser extent, woodstove specialty retailers have been dramatic. The number of manufacturers selling more than 2,000 units a year (characterized in the industry as "large manufacturers") has declined from approximately 90 to 35 in the last ten years. The number of manufacturers selling less than 2,000 units per year (characterized as "small manufacturers") has declined from approximately 130 to 6. Because the current woodstove market is not large enough to support all of the surviving producers, manufacturers have attempted to diversify in order to stay in business. Seeking relief, virtually all of the survivors have turned to the manufacture of gas appliances.

The Gas Appliance Market

The gas appliance market includes three segments: (1) gas log sets, (2) gas fireplaces, and (3) gas stoves. Gas log sets are "faux fires" that can be installed in an existing fireplace. They are primarily decorative and have little heating value. Gas fireplaces are fully assembled fireboxes that a builder or contractor can install in new construction or in renovated buildings and houses. They are mainly decorative and are less expensive and easier to maintain than a masonry/brick fireplace. Gas stoves are freestanding appliances with a decorative appearance and efficient heating characteristics.

The first two segments of the gas appliance market (log sets and fireplaces) are large, established, stable markets. Established manufacturers control these markets, and distribution

[24] The authors acknowledge the assistance of Tom P. Morrissey in the preparation of this case.

is primarily through mass merchandisers. The third segment (gas stoves) is less than five years old. Although it is growing steadily, it has an annual volume of only about 100,000 units (almost identical to the annual volume of the woodstove market). This is the market to which woodstove manufacturers have turned for relief.

The gas stove market is not as heavily regulated as the woodstove market, and there are currently no EPA regulations governing the emissions of gas heating appliances. Gas stoves are perceived as being more appropriate for an aging population because they provide heat and ambiance but require no effort. They can be operated with a wall switch or thermostat or by remote control. Because actual fuel cost (or cost savings) is not an issue for many buyers, a big advantage of heating with wood is no longer a consideration for many consumers. Gas stoves are sold and distributed through mass merchandisers and through natural gas or propane dealers. The gas industry has the financial, promotional, organizational, and lobbying clout to support the development of the gas stove market, attributes that the tiny woodstove industry lacks.

Unfortunately, life has not been rosy for all of the woodstove companies entering this new market. Development costs and selling costs for new products using a different fuel and different distribution system have been substantial. Improvements in gas logs and gas burners have required rapid changes in product design. In contrast, woodstove designs are fairly stable and slow to change. Competition for market share has renewed pricing pressure on gas stove producers. Companies trying to maintain their woodstove sales while introducing gas products must carry large inventories to service both product lines. Failure to forecast demand accurately has left many companies with inventory shortages during the selling season or with large inventories of unsold product at the end of the season.

Many surviving manufacturers who looked to gas stoves for salvation are now quietly looking for suitors to acquire them. A combination of excessive debt and inventory levels, together with high development and distribution costs, has made financial success highly uncertain. Continued consolidation will take place in this difficult market during the next five years.

Massachusetts Stove Company

Massachusetts Stove Company (MSC) is one of the six "small manufacturers" to survive the EPA regulation and industry meltdown. The company has just completed its sixth consecutive year of slow but steady growth in revenue and profit since complying with the EPA regulations. Exhibits 10.19–10.21 (see pages 877–879) present the financial statements of MSC for Year 3–Year 7. Exhibit 10.22 (see page 880) presents selected financial statement ratios.

The success of MSC in recent years is a classic case of a company staying small, marketing in a specific niche, and vigorously applying a "stick-to-your-knitting" policy. MSC is the only woodstove producer that has not developed gas products; 100 percent of its sales currently come from woodstove sales. MSC is the only woodstove producer that sells by mail order directly to consumers. The mail-order market has sheltered MSC from some of the pricing pressure that other manufacturers have had to bear. The combination of high entry costs and high risks make it unlikely that another competitor will enter the mail-order niche.

MSC's other competitive advantages are the high efficiency and unique features of its woodstoves. MSC equips its woodstoves with a catalytic combuster, which reburns gases emitted from burning wood. This reburning not only increases the heat generated by the stoves, but also reduces pollutants in the air. MSC offers a woodstove with inlaid soapstone. This soapstone heats up and provides warmth even after the fire in the stove has dwindled. The soapstone also adds to the attractiveness of the stove as a piece of furniture. MSC's customer base includes many middle- and upper-income individuals.

EXHIBIT 10.19

Massachusetts Stove Company Income Statements (Case 10.2)

	Year Ended December 31:				
	Year 3	**Year 4**	**Year 5**	**Year 6**	**Year 7**
Sales	$1,480,499	$1,637,128	$ 2,225,745	$ 2,376,673	$ 2,734,986
Cost of goods sold	(727,259)	(759,156)	(1,063,135)	(1,159,466)	(1,380,820)
Depreciation	(56,557)	(73,416)	(64,320)	(66,829)	(72,321)
Facilities costs	(59,329)	(47,122)	(66,226)	(48,090)	(45,309)
Facilities rental income	25,856	37,727	38,702	42,142	41,004
Selling expenses	(452,032)	(563,661)	(776,940)	(874,000)	(926,175)
Administrative expenses	(36,967)	(39,057)	(46,444)	(48,046)	(111,199)
Operating Income	$ 174,211	$ 192,443	$ 247,382	$ 222,384	$ 240,166
Interest income	712	2,242	9,541	9,209	16,665
Interest expense	(48,437)	(44,551)	(47,535)	(52,633)	(42,108)
Income Before Income Taxes	$ 126,486	$ 150,134	$ 209,388	$ 178,960	$ 214,723
Income taxes	(35,416)	(42,259)	(64,142)	(45,794)	(60,122)
Net Income	$ 91,070	$ 107,875	$ 145,246	$ 133,166	$ 154,601

MSC believes that profitable growth of woodstove sales beyond gross revenues of $3 million a year in the mail-order niche is unlikely. However, no one is selling gas appliances by mail order. Many of MSC's customers and prospects have asked whether MSC plans to produce a gas stove.

Management of MSC is contemplating the development of several gas appliances to sell by mail order. There are compelling reasons for MSC to do this, as well as some good reasons to be cautious.

Availability of Space

MSC owns a 25,000-square-foot building but occupies only 15,000 square feet. MSC leases the remaining 10,000 square feet to two tenants. The tenants pay rent plus their share of insurance, property taxes, and maintenance costs. The addition of gas appliances to its product line would require MSC to use 5,000 square feet of the space currently rented to one of its tenants. MSC would have to give the tenant six months' notice to cancel its lease.

Availability of Capital

MSC has its own internal funds for product development and inventory, as well as an unused line of credit. But it will lose interest income (or incur interest expense) if it invests these funds in development and increased inventory.

Existing Demand

MSC receives approximately 50,000 requests for catalogs each year and has a mailing list of approximately 220,000 active prospects and 15,000 recent owners of woodstoves. There is anecdotal evidence of sufficient demand so that MSC could introduce its gas stoves with little or no additional marketing expense, other than the cost of printing some catalog pages

EXHIBIT 10.20

Massachusetts Stove Company
Balance Sheets
(Case 10.2)

	December 31:					
	Year 2	Year 3	Year 4	Year 5	Year 6	Year 7
ASSETS						
Cash	$ 50,794	$ 19,687	$ 145,930	$ 104,383	$ 258,148	$ 351,588
Accounts receivable	12,571	56,706	30,934	41,748	30,989	5,997
Inventories	251,112	327,627	347,883	375,258	409,673	452,709
Other current assets	1,368	—	—	—	—	—
Total Current Assets	$ 315,845	$ 404,020	$ 524,747	$ 521,389	$ 698,810	$ 810,294
PP&E, at cost	1,056,157	1,148,806	1,164,884	1,184,132	1,234,752	1,257,673
Accumulated depreciation	(296,683)	(353,240)	(426,656)	(490,975)	(557,804)	(630,125)
Other assets	121,483	94,000	61,500	12,200	—	—
Total Assets	$1,196,802	$1,293,586	$1,324,475	$1,226,746	$1,375,758	$1,437,842
Liabilities and Shareholders' Equity						
Accounts payable	$ 137,104	$ 112,815	$ 43,229	$ 60,036	$ 39,170	$ 47,809
Notes payable	25,000	12,000	—	—	—	—
Current portion of long-term debt	27,600	29,000	21,570	113,257	115,076	27,036
Other current liabilities	39,530	100,088	184,194	189,732	244,241	257,252
Total Current Liabilities	$ 229,234	$ 253,903	$ 248,993	$ 363,025	$ 398,487	$ 332,097
Long-term debt	972,446	953,491	881,415	599,408	574,332	547,296
Deferred income taxes	—	—	—	—	5,460	6,369
Total Liabilities	$1,201,680	$1,207,394	$1,130,408	$ 962,433	$ 978,279	$ 885,762
Common stock	2,000	2,000	2,000	2,000	2,000	2,000
Additional paid-in capital	435,630	435,630	435,630	435,630	435,630	435,630
Retained earnings (deficit)	(442,508)	(351,438)	(243,563)	(98,317)	34,849	189,450
Treasury stock	—	—	—	(75,000)	(75,000)	(75,000)
Total Shareholders' Equity	$ (4,878)	$ 86,192	$ 194,067	$ 264,313	$ 397,479	$ 552,080
Total Liabilities and Shareholders' Equity	$1,196,802	$1,293,586	$1,324,475	$1,226,746	$1,375,758	$1,437,842

EXHIBIT 10.21

Massachusetts Stove Company
Statements of Cash Flows
(Case 10.2)

	Year Ended December 31:				
	Year 3	Year 4	Year 5	Year 6	Year 7
OPERATIONS					
Net income	$ 91,070	$107,875	$ 145,246	$133,166	$ 154,601
Depreciation and amortization	56,557	73,416	64,320	66,829	72,321
Other addbacks	27,483	32,500	49,300	17,660	909
(Increase) Decrease in receivables	(44,135)	25,772	(10,814)	10,759	24,992
(Increase) Decrease in inventories	(76,515)	(20,256)	(27,375)	(34,415)	(43,036)
Decrease in other current assets	1,368	—	—	—	—
Increase (Decrease) in payables	(24,289)	(69,586)	16,807	(20,866)	8,639
Increase in other current liabilities	60,558	84,106	5,538	54,509	13,011
Cash Flow from Operations	$ 92,097	$233,827	$ 243,022	$227,642	$ 231,437
INVESTING					
Capital expenditures	$(92,649)	$(16,078)	$ (19,249)	$(50,620)	$ (22,921)
Cash Flow from Investing	$(92,649)	$(16,078)	$ (19,249)	$(50,620)	$ (22,921)
FINANCING					
Increase in long-term debt	$ 10,000	$ —	$ —	$ —	$ —
Decrease in short-term debt	(13,000)	(12,000)	—	—	—
Decrease in long-term debt	(27,555)	(79,506)	(190,320)	(23,257)	(115,076)
Acquisition of common stock	—	—	(75,000)	—	—
Cash Flow from Financing	$(30,555)	$(91,506)	$(265,320)	$(23,257)	$(115,076)
Change in Cash	$(31,107)	$126,243	$ (41,547)	$153,765	$ 93,440
Cash—Beginning of year	50,794	19,687	145,930	104,383	258,148
Cash—End of Year	$ 19,687	$145,930	$ 104,383	$258,148	$ 351,588

each year. MSC's management worries about the risk of the gas stove sales cannibalizing its existing woodstove sales. Also, if the current base of woodstove sales is eroded through mismanagement, inattention, or cannibalization, attempts to grow the business through expansion into gas appliances will be self-defeating.

Vacant Market Niche

No other manufacturer is selling gas stoves by mail order. Because the entry costs are high and the unit volume is small, it is unlikely that another producer will enter the niche. MSC has had the mail-order market for woodstoves to itself for approximately seven years. MSC believes that this lack of existing competition will give it additional time to develop new products. However, management also believes that a timely entry will help solidify its position in this niche.

Suppliers

MSC has existing relationships with many of the suppliers necessary to manufacture new gas products. The foundry that produces MSC's woodstove castings is one of the largest

EXHIBIT 10.22

Massachusetts Stove Company
Financial Statement Ratios
(Case 10.2)

	Year 3	Year 4	Year 5	Year 6	Year 7
Profit Margin for ROA	8.5%	8.5%	8.1%	7.2%	6.8%
Total Assets Turnover	1.2	1.3	1.7	1.8	1.9
ROA	10.1%	10.7%	14.1%	13.1%	13.1%
Profit Margin for ROCE	6.2%	6.6%	6.5%	5.6%	5.7%
Capital Structure Leverage	30.6	9.3	5.6	3.9	3.0
ROCE	224.0%	77.0%	63.4%	40.2%	32.6%
Cost of Goods Sold/Sales	49.1%	46.4%	47.8%	48.8%	50.5%
Depreciation Expense/Sales	3.8%	4.5%	2.9%	2.8%	2.6%
Facilities Costs Net of Rental					
Income/Sales	2.3%	0.6%	1.2%	0.3%	0.2%
Selling Expense/Sales	30.5%	34.4%	34.9%	36.8%	33.9%
Administrative Expenses/Sales	2.5%	2.4%	2.1%	2.0%	4.0%
Interest Income/Sales	—	0.1%	0.4%	0.4%	0.6%
Interest Expense/Sales	3.3%	2.7%	2.1%	2.2%	1.5%
Income Tax Expense/Income					
before Taxes	28.0%	28.1%	30.6%	25.6%	28.0%
Accounts Receivable Turnover	42.7	37.4	61.2	65.3	147.9
Inventory Turnover	2.5	2.2	2.9	3.0	3.2
Fixed Assets Turnover	1.9	2.1	3.1	3.5	4.2
Current Ratio	1.59	2.11	1.44	1.75	2.44
Quick Ratio	0.30	0.71	0.40	0.73	1.08
Days Accounts Receivable	9	10	6	6	3
Days Inventory Held	146	166	126	122	114
Days Accounts Payable	51	33	16	14	11
Cash Flow from Operations/					
Average Current Liabilities	38.1%	93.0%	79.4%	59.8%	63.4%
Long-Term Debt/					
Shareholders' Equity	1,106.2%	454.2%	226.8%	144.5%	99.1%
Cash Flow from Operations/					
Average Total Liabilities	7.6%	20.0%	23.2%	23.5%	24.8%
Interest Coverage Ratio	3.6	4.4	5.4	4.4	6.1

suppliers of gas heating appliances in central Europe. On the other hand, MSC would be a small, new customer for the vendors that provide the ceramic logs and gas burners. This could lead to problems with price, delivery, or service for these parts.

Synergies in Marketing and Manufacturing

MSC would sell gas appliances through its existing direct-mail marketing efforts. It would incur additional marketing expenses for photography, printing, and customer service.

MSC's existing plant is capable of manufacturing the shell of the gas units. It would require additional expertise to assemble fireboxes for the gas units (valves, burners, and log sets). MSC would have to increase its space and the number of employees to process and paint the metal parts of the new gas stoves. The gross margin for the gas products should be similar to that of the woodstoves.

Lack of Management Experience

Managing new product development, larger production levels and inventories, and a more complex business would require MSC to hire more management expertise. MSC also would have to institute a new organization structure for its more complex business and define responsibilities and accountability more carefully. Up to now, MSC has operated with a fairly loose organizational philosophy.

Required (additional requirements follow on page 883)

 a. Identify clues from the financial statements and financial statement ratios for Year 3– Year 7 that might suggest that Massachusetts Stove Company is in a mature business.

 b. Design a spreadsheet for the preparation of projected income statements, balance sheets, and statements of cash flows for MSC for Year 8–Year 12. Also forecast the financial statements for each of these years under three scenarios: (1) best case, (2) most likely, and (3) worst case. The following sections describe the assumptions you can make.

Development Costs

MSC plans to develop two gas stove models, but not concurrently. It will develop the first gas model during Year 8 and begin selling it during Year 9. It will develop the second gas model during Year 9 and begin selling it during Year 10. MSC will capitalize the development costs in the year incurred (Year 8 and Year 9) and amortize them straight line over five years, beginning with the year the particular stove is initially sold (Year 9 and Year 10). Estimated development cost for each stove are as follows:

 Best Case: $100,000
 Most Likely Case: $120,000
 Worst Case: $160,000

Capital Expenditures

Capital expenditures, other than development costs, will be as follows: Year 8, $20,000; Year 9, $30,000; Year 10, $30,000; Year 11, $25,000; Year 12, $25,000. Assume a six-year depreciable life, straight-line depreciation, and a full year of depreciation in the year of acquisition.

Sales Growth

Changes in total sales relative to total sales of the preceding year are as follows:

	Best Case			Most Likely Case			Worst Case		
Year	Wood Stoves	Gas Stoves	Total	Wood Stoves	Gas Stoves	Total	Wood Stoves	Gas Stoves	Total
8	+2%	—	+ 2%	−2%	—	−2%	−4%	—	−4%
9	+2%	+6%	+ 8%	−2%	+4%	+2%	−4%	+2%	−2%
10	+2%	+12%	+14%	−2%	+8%	+6%	−4%	+4%	+0%
11	+2%	+12%	+14%	−2%	+8%	+6%	−4%	+4%	+0%
12	+2%	+12%	+14%	−2%	+8%	+6%	−4%	+4%	+0%

Because sales of gas stoves will start at zero, the projections of sales should *use the preceding growth rates in total sales.* The growth rates shown for woodstove sales and gas stove sales simply indicate the components of the total sales increase.

Cost of Goods Sold

Manufacturing costs of the gas stoves will equal 50 percent of sales, the same as for woodstoves.

Depreciation

Depreciation will increase for the amortization of the product development costs on the gas stoves and depreciation of additional capital expenditures.

Facilities Rental Income and Facilities Costs

Facilities rental income will decrease by 50 percent beginning in Year 9 when MSC takes over 5,000 square feet of its building now rented to another company and will remain at that reduced level for Year 10–Year 12. Facilities costs will increase by $30,000 beginning in Year 9 for facilities costs now paid by a tenant and for additional facilities costs required by gas stove manufacturing. These costs will remain at that increased level for Year 10–Year 12.

Selling Expenses

Selling expenses as a percentage of sales are as follows:

Year	Best Case	Most Likely Case	Worst Case
8	34%	34.0%	34%
9	33%	33.5%	35%
10	32%	33.0%	36%
11	31%	32.5%	37%
12	30%	32.0%	38%

Administrative Expenses

Administrative expenses will increase by $30,000 in Year 8, $30,000 in Year 9, and $20,000 in Year 10 and then remain at the Year 10 level in Years 11 and 12.

Interest Income

MSC will earn 5 percent interest on the average balance in cash each year.

Interest Expense

The interest rate on interest-bearing debt will be 6.8 percent on the average amount of debt outstanding each year.

Income Tax Expense

MSC is subject to an income tax rate of 28 percent.

Accounts Receivable and Inventories

Accounts receivable and inventories will increase at the growth rate in sales.

Property, Plant, and Equipment

Property, plant, and equipment at cost will increase each year by the amounts of capital expenditures and expenditures on development costs. Accumulated depreciation will increase each year by the amount of depreciation and amortization expense.

Accounts Payable and Other Current Liabilities

Accounts payable will increase with the growth rate in inventories. Other current liabilities include primarily advances by customers for stoves manufactured soon after the year-end. Other current liabilities will increase with the growth rate in sales.

Current Portion of Long-Term Debt

Scheduled repayments of long-term debt are as follows: Year 8, $27,036; Year 9, $29,200; Year 10, $31,400; Year 11, $33,900; Year 12, $36,600; Year 13, $39,500.

Deferred Income Taxes

Deferred income taxes relate to the use of accelerated depreciation for tax purposes and the straight-line method for financial reporting. Assume that deferred income taxes will not change.

Shareholders' Equity

Assume that there will be no changes in the contributed capital of MSC. Retained earnings will change each year in the amount of net income.

Required (continued from page 881)

 c. Calculate the financial statements ratios listed in Exhibit 10.22 for MSC under each of the three scenarios for Year 8–Year 12.

 Note: You should create a fourth spreadsheet as part of your preparation of the projected financial statements that will compute the financial ratios.

 d. What advice would you give the management of MSC regarding its decision to enter the gas stove market? Your recommendation should consider the profitability and risks of this action as well as other factors you deem relevant.

Chapter 11

Risk-Adjusted Expected Rates of Return and the Dividends Valuation Approach

Learning Objectives

1 Estimate risk-adjusted expected rates of return on equity capital, as well as weighted average costs of capital, which you will use to discount future payoffs to present value.

2 Understand the dividends valuation approach and its conceptual and practical strengths and weaknesses.

3 Develop practical valuation techniques to deal with the many difficult issues involved in estimating firm value: (a) dividends versus cash flows versus earnings, (b) cash flows to the investor versus cash flows reinvested in the firm, (c) the forecast horizon, and (d) continuing value.

4 Apply the dividends valuation techniques to estimate firm value using the present value of future dividends.

5 Develop techniques to assess the sensitivity of firm value estimates to key valuation parameters, such as discount rates and expected long-term growth rates.

INTRODUCTION AND OVERVIEW

Economic theory teaches that the value of an investment equals the present value of the projected future payoffs from the investment discounted at a rate that reflects the time value of money and the risk inherent in those expected payoffs. A general model for the present value of a security at time $t=0$ (denoted as V_0) with an expected life of n future periods is as follows:[1]

$$V_0 = \sum_{t=1}^{n} \frac{\text{Projected Future Payoffs}_t}{(1 + \text{Discount Rate})^t}$$

In securities markets that are less than perfectly efficient, price does not necessarily equal value for every security at all times. Therefore, it can be very fruitful to search for and analyze securities that may have prices that have deviated temporarily from their fundamental

[1] Throughout this chapter, t refers to accounting periods. The valuation process determines an estimate of firm value, denoted V_0, in present value as of today, when $t=0$. The period $t=1$ refers to the first accounting period being discounted to present value. Period $t=n$ is the period of the expected final, or liquidating, payoff.

values. When buying a security, the investor pays the security's price and receives the security's value. When selling a security, the investor receives the selling price and gives up the security's value. Price is observable, but value is not; value must be estimated. Therefore, estimating the value of a security to make intelligent investment decisions is a common objective of financial statement analysis. Investors, analysts, investment bankers, corporate managers, and others engage in financial statement analysis and valuation to determine a reliable appraisal of the value of shares of common equity or the value of whole firms. The questions they typically address include the following:

- What value do I think a share of common stock in a particular company is worth?
- Comparing my estimate of value to the current price in the market, should I buy, sell, or hold a particular firm's common shares?
- What price should I assign to the initial public offering of a firm's common shares?
- What is a reasonable price to accept (or ask) as a seller or pay (or bid) as a buyer for the shares of a firm in a corporate merger or acquisition?

Equity valuation models based on dividends, cash flows, and earnings have been the topic of many theoretical and empirical research studies in recent years. These studies provide many insights into valuation, but two very compelling general conclusions emerge and motivate the discussion and application of valuation models in this text: (1) share prices in the capital markets *generally* correlate closely with share value, but (2) share prices *do not always* equal share values, and temporary deviations of price from value occur. First, many empirical studies demonstrate that dividends, cash flows, and earnings-based valuation models generally provide significant explanatory power for share prices observed in the capital markets.[2] The results show that share value estimates determined from these valuation models exhibit high positive correlations with the stock prices observed in the capital markets. These correlations hold across different types of firms, during different periods of time, and across different countries. In the same vein, many empirical research studies also have shown that unexpected *changes* in earnings, dividends, and cash flows correlate closely with *changes* in stock prices.

Second, a number of empirical research studies show that valuation models also help identify when share prices in the capital markets temporarily deviate from fundamental share values. Research results show that dividends, cash flows, and earnings-based valuation models help identify when shares are temporarily overpriced or underpriced, representing potentially profitable investment opportunities. For example, Exhibit 11.1 is a graphic depiction of results from a study by Frankel and Lee (1998) in which they sorted their sample of firms each year into five portfolios based on quintiles of their estimate of value (V) to share price (P).[3] Their findings show striking differences in the average 36-month stock returns earned by their portfolios. The highest value-to-price quintile portfolio generated significantly greater average returns than the lowest value-to-price portfolio. These results and similar results from a number of related studies should be very encouraging for those interested in developing fundamental forecasting and valuation skills for investment purposes.

The six-step analysis and valuation framework that forms the structure of this book (Exhibit 1.1 in Chapter 1) is a logical sequence of steps for understanding the fundamentals of a business and for determining intelligent estimates of its value. First, we analyze the

[2] For examples, see Stephen Penman and Theodore Sougiannis, "A Comparison of Dividend, Cash Flow, and Earnings Approaches to Equity Valuation," *Contemporary Accounting Research* 15, no. 3 (Fall 1998), pp. 343–383, and Jennifer Francis, Per Olsson, and Dennis Oswald, "Comparing the Accuracy and Explainability of Dividend, Free Cash Flow, and Abnormal Earnings Equity Value Estimates," *Journal of Accounting Research* 38 (Spring 2000), pp. 45–70.

[3] Richard Frankel and Charles Lee, "Accounting Valuation, Market Expectation, and Cross-Sectional Stock Returns," *Journal of Accounting and Economics* 25, Issue 3 (1998), pp. 283–319.

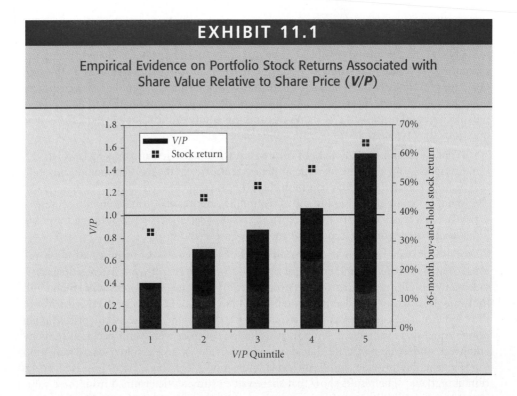

EXHIBIT 11.1

Empirical Evidence on Portfolio Stock Returns Associated with Share Value Relative to Share Price (*V/P*)

economics and competitive conditions of the industry. Second, we analyze the particular firm's strategy in light of the competitive dynamics of the industry. Third, we assess the quality of the firm's accounting and financial reporting. Fourth, we analyze the firm's profitability and risk with a set of financial ratios. Fifth, we use all of this information to project the firm's future financial statements. Finally, we derive from the projected financial statements our forecasts of future earnings, cash flows, and dividends as measures of projected future payoffs for the firm. We use these projected future payoffs as inputs to valuation models to determine the value of the firm. Reliable projections of future payoffs to the firm (the numerator in the general valuation model presented earlier) depend on unbiased and thorough forecasts of future income statements, balance sheets, and statements of cash flows, all of which depend on reliable projections of the firm's future operating, investing, and financing activities. Assessing an appropriate risk-adjusted discount rate (the denominator in the general valuation model) requires an assessment of the inherent risk in the set of expected future payoffs. Therefore, reliable estimates of firm value depend on unbiased estimates of expected future payoffs and an appropriate risk-adjusted discount rate, all of which depend on all six steps of the framework.

This chapter begins the discussion of the sixth and final step of the analytical framework of this text: valuation. The first portion of this chapter describes and demonstrates computing risk-adjusted expected rates of return on equity capital and weighted average costs of capital, which we use as discount rates in the valuation models. The latter portion of this chapter describes and applies the dividends-based valuation model. Throughout the chapter, we demonstrate these techniques using PepsiCo.

Looking further ahead, Chapter 12 presents and applies cash-flow-based valuation approaches. Chapter 13 describes and applies earnings-based valuation approaches. Chapters 11–13 discuss and illustrate the important issues that determine the conceptual and practical strengths and weaknesses of each approach. All three chapters illustrate the

equivalence of these valuation approaches using the theoretical development of the models and applying these approaches to the projected dividends, cash flows, and earnings derived from the financial statements forecasts developed for PepsiCo in Chapter 10. Chapter 14 describes and applies market multiples such as price-earnings ratios and market-to-book ratios that analysts use in some instances to value firms.

EQUIVALENCE AMONG DIVIDENDS, CASH FLOWS, AND EARNINGS VALUATION

As noted earlier, equity valuation models based on dividends, cash flows, and earnings have been the topic of many theoretical and empirical research studies in recent years, which show that, in general, share value estimates determined from these models correlate closely with stock prices observed in the capital markets. However, the valuation models also help identify when stock prices deviate temporarily from share values. Therefore, it is no surprise that analysts, investors, and capital market participants commonly use dividends, cash flows, and earnings to estimate share values. When the analyst derives internally consistent forecasts of future earnings, cash flows, and dividends from a set of financial statement forecasts and uses the same discount rate to compute the present values of those expected future earnings, cash flows, and dividends, the valuation models yield identical estimates of value for a firm. That is, these three valuation models are complementary approaches to valuation that produce equivalent value estimates.

The primary difference between the dividends-, cash-flows-, and earnings-based approaches to valuation are differences in perspective. The dividends-based valuation approach focuses on wealth distribution to shareholders. Essentially, share value is determined by the present value of dividends the shareholder will receive. Cash-flow-based valuation takes an alternative perspective because the analyst forecasts and values the cash flows the firm will generate and use to pay dividends. The cash-flow-based valuation approach measures and values the *free cash flows* that are available for distribution to shareholders after cash is used for necessary investments in operating assets and required payments to debtholders. Free cash flows can be used instead of dividends as the expected future payoffs to the investor in the numerator of the general valuation model. Both approaches, if implemented with consistent assumptions, will lead to identical estimates of value. This equivalence occurs because over the life of the firm, the free cash flows into the firm will be equivalent to the cash flows paid out of the firm in dividends to shareholders.

The earnings-based valuation approach is another alternative valuation perspective, equivalent to both dividends-based and free-cash-flows-based valuation. The earnings-based valuation approach takes the perspective that earnings measures the capital that firms create (or destroy) for common shareholders each period that will ultimately be realized in cash flows and distributed as dividends to shareholders. Thus, the earnings-based valuation approach focuses on the firm's wealth creation for shareholders, the cash-flows-based approach focuses on dividend-paying ability, and the dividends approach focuses on wealth distribution to shareholders. Exhibit 11.2 provides a conceptual illustration of these three approaches to firm valuation.

Analysts who apply these different valuation approaches gain better insights about the value of a firm than analysts who rely on only one approach in all cases. Analysts understand valuation more deeply and thoroughly across a wider array of situations when they can triangulate valuation across the dividends, cash flows, and earnings valuation approaches.

All four valuation chapters (Chapters 11–14) emphasize that the objective of the valuation process is not a single point estimate of value per se; instead, the objective is to determine a reliable distribution of value estimates across the relevant ranges of critical forecast

EXHIBIT 11.2

Conceptual Illustration of Equivalent Approaches to Valuation
Using Dividends, Cash Flows, and Earnings

assumptions and valuation parameters. By estimating share value using cash flows, earnings, and dividends and by assessing the sensitivity of these value estimates across a distribution of relevant forecast assumptions and valuation parameters, the goal is to determine the most likely range of values for a share, which are then compared to the share's price in the capital market for an intelligent investment decision.

RISK-ADJUSTED EXPECTED RATES OF RETURN

We base all of the valuation approaches we describe and demonstrate in Chapters 11–14 on the general valuation model set forth at the beginning of this chapter, in which we determine firm value by discounting projected future payoffs to present value. Therefore, for all of the valuation approaches we need a discount rate to compute the present value of all projected future payoffs. To compensate for the time value of money and risk, the discount rate should equal the required rate of return that capital providers demand from the firm to induce them to commit capital. When the analyst computes the present value of payoffs (dividends, free cash flows, or earnings) to *common equity shareholders,* he or she should

use a discount rate that reflects the risk-adjusted required rate of return on *common equity* capital.

The discount rate should be a forecast of the required rate of return on the investment and, therefore, should be conditional on the expected future riskiness of the firm and expected future interest rates over the period during which the payoffs will be generated. The historical discount rate of the firm may be a good indicator of the appropriate discount rate to apply to the firm in the future, but only if the following three conditions hold:

- The current risk of the firm is the same as the expected future risk of the firm.
- Expected future interest rates arc likely to equal current interest rates.
- The existing capital structure of the firm (that is, the current mix of debt and equity financing) is the same as the expected future capital structure of the firm.

If one or more of these conditions does not hold, the analyst will need to project discount rates that appropriately capture the future risk and capital structure of the firm and future interest rates in the economy over the forecast horizon.

As a starting point to estimate expected rates of return on capital, analysts often compute the prevailing after-tax cost of each type of capital (debt, preferred, and common equity) invested in the firm. Existing costs of capital reflect the required rates of return for the firm's existing capital structure, and they are appropriate discount rates for valuing future payoffs for the firm only if the three preceding conditions hold.

Developing discount rates using costs of capital assumes that the capital markets price capital to reflect the risk-free time value of money plus a premium for risk. The following sections describe and demonstrate techniques to estimate the firm's cost of equity, debt, and preferred stock capital. After these descriptions, the chapter describes and illustrates how to compute a weighted average cost of capital for the firm.

Cost of Common Equity Capital

Analysts commonly estimate the cost of equity capital using the CAPM (capital asset pricing model). The CAPM assumes that the market comprises risk-averse investors holding diversified portfolios of assets. The CAPM assumes that for a given level of expected return, risk-averse investors will seek to bear as little risk as possible and will mitigate risk by diversifying across the types of assets they hold in a portfolio. Therefore, the CAPM hypothesizes that in equilibrium, investors should expect to earn a rate of return on a firm's common equity capital that equals the rate of return the market requires to hold that firm's stock in a diversified portfolio of assets. In theory, the market comprises risk-averse investors who demand a rate of return that (1) compensates them for forgoing the consumption of capital (the time value of money) and (2) compensates them with a risk premium for bearing systematic, marketwide risk that cannot be diversified. Systematic risk arises from economy-wide factors (such as economic growth or recession, unemployment, unexpected inflation, unexpected changes in prices for natural resources such as oil and gas, unexpected changes in exchange rates, and population growth) that affect all firms to varying degrees and therefore cannot be fully diversified. Therefore, the market's required rate of return on equity capital is a function of prevailing risk-free rates of interest in the economy plus a risk premium for bearing risk, all conditional on the level of nondiversifiable risk inherent in the firm's common stock.

Note that the CAPM views nonsystematic risk as factors that are diversifiable by the investor holding a broad portfolio of stocks. Nonsystematic risk factors are industry- and firm-specific, including factors such as the level of competition in an industry, the product portfolio of a particular firm, the sustainability of the firm's strategy, and the firm's ability

to generate revenue growth and control expenses. A competitive equilibrium capital market, according to CAPM, does not expect a return for a firm's nonsystematic risk because such risk can be diversified away in a portfolio of stocks.

Analysts measure nondiversifiable or systematic risk as the degree of covariation between a firm's stock returns and a marketwide index of stock returns. Analysts commonly measure systematic risk using the firm's *market beta*, which is estimated as the slope coefficient from regressing the firm's stock returns on an index of returns reflecting a marketwide portfolio of stocks over a relevant period of time.[4] If a firm's market beta from such a regression is equal to 1, it indicates that, on average, the firm's stock returns covary identically with returns to a marketwide portfolio, indicating that the firm has the same degree of systematic risk as the market as a whole. If a firm's market beta is greater than 1, the firm has a greater degree of systematic risk than the market as a whole, whereas a firm with a market beta less than 1 has less systematic risk than the market as a whole.

Exhibit 11.3 reports industry median market betas for a sample of 42 industries over the years 1999–2007. These data depict wide variation in systematic risk across industries during

EXHIBIT 11.3

Relation between Industry and Systematic Risk over 1999–2007

Industry	Median Beta during 1999–2007
Forestry	0.17
Utilities	0.32
Depository Institutions	0.39
Tobacco	0.39
Real Estate	0.43
Food Processors	0.47
Grocery Stores	0.50
Insurers	0.55
Restaurants	0.61
Metal Products	0.64
Petroleum Refining	0.65
Printing and Publishing	0.66
Wholesalers—Nondurables	0.66
Personal Services	0.68
Textiles	0.69
Rubber and Plastics	0.70
Hotels	0.74
Health Services	0.75
Amusements and Recreation	0.76
Non-Depository Financial Institutions	0.78
Metal Mining	0.80
Paper	0.81

[4] Researchers and analysts have developed a variety of approaches to estimate market betas. For example, one common approach estimates a firm's market beta by regressing the firm's monthly stock returns on a marketwide index of returns (such as the S&P 500 index) over the last 60 months.

EXHIBIT 11.3 (Continued)

Industry	Median Beta during 1999–2007
Miscellaneous Manufacturing	0.85
Oil and Gas Extraction	0.87
Transportation Equipment	0.89
Retailers—General Merchandise	0.92
Engineering Management	0.95
Lumber	0.96
Motion Pictures	0.97
Wholesalers—Durables	0.97
Miscellaneous Retail	1.01
Instruments and Related Products	1.06
Retailing—Apparel	1.08
Chemicals	1.10
Transportation by Air	1.11
Primary Metals	1.18
Retailing—Home Furniture, Furnishings, and Equipment	1.21
Security and Commodity Brokers	1.24
Industrial and Commercial Machinery and Computer Equipment	1.24
Communications	1.30
Business Services	1.51
Electronic and Electrical Equipment	1.64

this nine-year period, with industry median market betas ranging from a low of 0.17 (Forestry) to a high of 1.64 (Electronic and Electrical Equipment). Various financial reference sources and websites regularly publish market betas for common equity in publicly traded firms. It is not uncommon to find considerable variation in market betas among the various sources. This occurs in part because of differences in the period and methodology used to estimate betas.[5]

The CAPM projects the expected return on common equity capital for Firm j as follows:

$$E[R_{Ej}] = E[R_F] + \beta_j \times \left\{ E[R_M] - E[R_F] \right\}$$

where E denotes that the related variable is an expectation; R_{Ej} denotes required return on common equity in firm j; R_F denotes the risk-free rate of return; β_j denotes the market beta

[5] Eugene Fama and Kenneth French developed an empirical model that explains realized stock returns using three factors they found to be correlated with returns during their study period. Their model and results indicate that during their sample period (1963–1990), firms' stock returns were related to firms' market betas, market capitalizations (size), and market-to-book ratios [see Eugene F. Fama and Kenneth R. French, "The Cross Section of Expected Stock Returns," *Journal of Finance* (June 1992), pp. 427–465]. Data to implement their model can be obtained from French's website (http://mba.tuck.dartmouth.edu/pages/faculty/ken.french/data_library.html). Although the model deserves and has received a great deal of attention in academics and practice, more research is necessary to determine the theoretical basis for the model and the risk factors and risk premia that constitute the model. In addition, more research is needed to assess the empirical applicability of the model as a predictor of expected stock returns in periods following their sample period.

for firm j; and R_M denotes the required return on a diversified, marketwide portfolio of stocks (such as the S&P 500). According to the CAPM, a common equity security with no systematic risk (that is, a stock with $\beta_j = 0$) should be expected to earn a return equal to the expected rate of return on risk-free securities. Of course, most equity securities are not risk-free. An equity security with systematic risk equal to the average amount of systematic risk of all equity securities in the market has a market beta equal to 1. The subtraction term in brackets in the preceding equation represents the average market risk premium, which is equal to the amount of return above the risk-free rate that equity investors in the capital markets require for bearing the average amount of systematic risk in the market as a whole. Therefore, the cost of common equity capital for a firm with an average level of systematic risk should be equal to the required return on the market portfolio. A firm with a market beta greater than 1 has higher than average systematic risk and faces a higher cost of equity capital because the capital markets expect the firm to yield a commensurately higher return to compensate investors for bearing greater risk. A firm with a market beta less than 1 faces a lower cost of equity capital because the capital markets expect the firm to yield a commensurately lower return to investors for bearing less risk. Exhibit 11.4 depicts the CAPM graphically.

The analyst should use the market return on securities with zero systematic risk as the risk-free interest rate in the CAPM. Returns on such systematic risk-free securities (for example, U. S. Treasury securities) should exhibit no correlation with returns on a diversified marketwide portfolio of stocks. Given that equity securities have indefinitely long lives, it might seem appropriate to use the yield on long-term U.S. Treasury securities as a proxy for a risk-free rate. However, yields on long-term U.S. government securities tend to exhibit greater sensitivity to changes in inflation and interest rates; therefore, they have a greater degree of systematic risk (although the systematic risk is still quite low) compared to short-term U.S. government securities. Common practice uses the yield on short- or intermediate-term U.S. government securities (for example, yields on three-, five-, or ten-year U.S. Treasury securities) as the risk-free rate. Historically, these yields have averaged around 6 percent over the long run, although in recent years, they have averaged roughly 3–4 percent.

The average realized rate of return on the market portfolio depends on the period studied. Historically, the realized rate of return on the market portfolio has varied between 9 and 13 percent. Thus, the excess return of the market portfolio over the risk-free rate has

EXHIBIT 11.4

Relation between Cost of Equity Capital and Systematic Risk

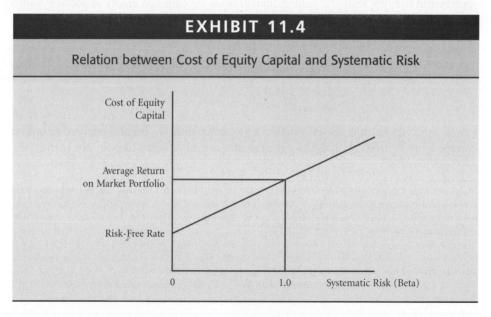

varied between 3 and 7 percent. Some financial economists argue that the market risk premium varies over time with investors' demand for incremental consumption. The economists argue that, on the margin, when the economy is healthy and growing (with low unemployment and high consumer confidence), investors' demand for additional consumption is relatively low; therefore, investors demand relatively low rates of return for postponing incremental consumption and bearing risk. Thus, risk premia tend to be lower (perhaps 3–4 percent) when economic conditions are strong. Conversely, when the economy is weak and investors face a higher degree of uncertainty, investors' demand for additional consumption is relatively high; therefore, they demand relatively high rates of return for postponing consumption and bearing risk. Thus, risk premia tend to be higher (perhaps 6–7 percent) when economic conditions are weak. The theories asserting that risk premia are time-varying (and vary inversely with investors' marginal demand for consumption) seem intuitive and appear to explain risk premia observed in the capital markets quite well, but they require more empirical research.

Example 1: Using the CAPM to Compute Expected Rates of Return

Suppose Firm A has a market beta of 0.60 and Firm B has a market beta of 1.40. Assume that the prevailing yields on three- to five-year U.S. Treasury bonds are roughly 4.0 percent and that the capital markets require a 5.0 percent risk premium for bearing an average amount of systematic risk. Applying the CAPM, we would compute the following expected rates of return for Firm A and Firm B:

$$\text{Firm A: } E[R_A] = 4.0 + (0.60 \times 5.0) = 7.0$$
$$\text{Firm B: } E[R_B] = 4.0 + (1.40 \times 5.0) = 11.0$$

Thus, the CAPM implies that investors require a 7.0 percent rate of return on capital invested in the equity of Firm A and an 11.0 percent rate of return on capital invested in the equity of Firm B. Firm B faces a higher cost of equity capital than Firm A because Firm B has a higher degree of systematic risk. In determining the share values of Firm A and Firm B, investors should discount to present value the expected future payoffs using a 7.0 percent discount rate for Firm A and an 11.0 percent discount rate for Firm B. If investors expect Firm A and Firm B to generate equivalent payoffs (although Firm B's payoffs will be riskier), investors will assign a lower value to (and pay a lower price for) the common shares of Firm B than Firm A. The difference between the value of Firm B's shares and those of Firm A reflects the additional compensation that shareholders demand for holding the riskier Firm B shares relative to shares of Firm A. Shareholders will realize this compensation in the form of the equivalent payoffs, for which shareholders in Firm B paid a lower price than did shareholders in Firm A.

Computing the Required Rate of Return on Equity Capital for PepsiCo

At the end of 2008, different sources provided different estimates of market beta for PepsiCo common stock, ranging from 0.50 to roughly 1.00. Historically, PepsiCo's market beta has varied around 0.75 over time, so we will assume that PepsiCo common stock has a market beta of roughly 0.75 as of the end of 2008. At that time, U.S. Treasury bills with ten years to maturity traded with a yield of just below 4.0 percent, which we use as the risk-free rate. Additionally, economic conditions were in recession, stock market indexes had experienced substantial declines, and investors were more risk-averse than normal; so we will assume investors demanded a 6.0 percent market risk premium. Therefore, the CAPM indicates that PepsiCo has a cost of common equity capital of 8.50 percent [$= 4.0 + (0.75 \times 6.0)$]. At the end of 2008, PepsiCo had 1,553 million shares

outstanding and a share price of $54.77, for a total market capital of common equity of $85,058 million.

Adjusting Market Equity Beta to Reflect a New Capital Structure

Recall from the discussion in Chapter 5 that market beta reflects operating leverage, financial leverage, variability of sales and earnings, and other firm characteristics. In some settings, such as a leveraged buyout, firms plan to make significant changes in the financial capital structure. The market beta computed using historical market price data reflects the firm's existing capital structure. The analyst can project what market beta is likely to be after the firm changes the capital structure. The analyst can "unlever" the current market beta by adjusting it to remove the effects of leverage and then "relever" it by adjusting it to reflect leverage under the new capital structure. The following formula estimates an unlevered market beta (sometimes referred to as an *asset beta*):

$$\text{Current Levered Market Beta} = \text{Unlevered Market Beta} \times$$
$$\left[1 + (1 - \text{Income Tax Rate}) \times \left(\frac{\text{Current Market Value of Debt}}{\text{Current Market Value of Equity}} \right) \right]$$

The intuition behind this formula is that current market beta reflects two components: (1) the systematic risk of the operations and assets of the firm (the unlevered beta), compounded by (2) the financial leverage of the firm (the debt-equity ratio), net of the tax benefit from using leverage (that is, tax savings from interest expense deductions.) Estimating the new levered beta requires two steps. The first step is to solve for the unlevered beta by rearranging the preceding equation to divide the current levered market beta by the term in square brackets on the right-hand side of the equation, as follows:

$$\text{Unlevered Market Beta} = \text{Current Levered Market Beta}/[1 + (1 - \text{Income Tax}$$
$$\text{Rate}) \times (\text{Current Market Value of Debt/Current Market Value of Equity})]$$

The second step is to project the new levered market beta by multiplying the unlevered beta by the term in square brackets on the right-hand side of the equation after substituting the projected new ratio of the market value of debt to the market value of equity in place of the current ratio of the market value of debt to the market value of equity, as follows:[6]

$$\text{New Levered Market Beta} = \text{Unlevered Market Beta} \times [1 + (1 - \text{Income Tax}$$
$$\text{Rate}) \times (\text{New Market Value of Debt/New Market Value of Equity})]$$

Example 2: The Effects of Leverage on Beta and Expected Rates of Return

Suppose a firm has a market beta of 0.9, is subject to an income tax rate of 35 percent, and has a market value of debt to market value of equity ratio of 60 percent. If the risk-free rate is 6 percent and the market risk premium is 7 percent, then according to the CAPM, the

[6] Note that the debt-to-equity ratios used in these computations are based on *market* values of debt and shareholders' equity. These market-value-based ratios will likely differ from the debt to shareholders' equity ratios discussed in Chapter 5 for assessing long-term solvency risk because the ratios in Chapter 5 are based on *book* values of debt and shareholders' equity. As more firms choose the fair value option for recognizing outstanding debt, as discussed in Chapter 6, book and fair values for debt will begin to converge.

market expects this firm to generate equity returns of 12.3 percent $[= 6.0 + (0.9 \times 7.0)]$. The firm intends to adopt a new capital structure that will increase the debt-to-equity ratio to 140 percent. To project the firm's levered beta under the new capital structure, the first step is to solve for the unlevered beta, denoted X, as follows:

$$0.9 = X \times [1 + (1 - 0.35) \times (0.60/1.00)]$$
$$X = 0.9/[1 + (1 - 0.35) \times (0.60/1.00)]$$
$$X = 0.65$$

Because financial leverage is positively related to market beta, removing the effect of financial leverage reduces market beta. The unlevered beta should reflect the effects of the firm's operating risk, sales volatility, and other operating factors, but not risk related to financial leverage. The new market beta is projected to reflect the new debt-to-equity ratio as follows:

$$Y = 0.65 \times [1 + (1 - 0.35) \times (1.40/1.00)] = 1.24$$

The new capital structure will increase the leverage and therefore the systematic risk of the firm. According to the CAPM, this firm will face an equity cost of capital of 14.68 percent $[= 6.0 + (1.24 \times 7.0)]$ under the new capital structure.

Evaluating the Use of the CAPM to Measure the Cost of Equity Capital

The use of the CAPM to calculate the cost of equity capital has been subject to various criticisms, as follows:

- Market betas for a firm should vary over time as the systematic risk of the firm changes; however, market beta estimates are quite sensitive to the time period and methodology used in their computation.
- In theory, the CAPM measures required returns based on the stock's risk relative to a diversified portfolio of assets across the economy, but a return index for a diversified portfolio of assets that spans the entire economy does not exist. Measuring a stock's systematic risk relative to a stock market return index such as the S&P 500 Index fails to consider covariation between the stock's returns and returns on assets outside the stock market, including other financial investments (for example, U.S. government and corporate debt securities and privately held equity), real estate, and human capital.
- The market risk premium is not stable over time and is likewise sensitive to the time period used in its calculation. Considerable uncertainty surrounds the appropriate adjustment for the market risk premium. It is not clear whether the appropriate adjustment should be on the order of 3 percent, 7 percent, or somewhere in between.[7] As noted earlier, some financial economists now argue that the risk premium is lower in periods of economic health and growth and higher in periods of economic weakness and uncertainty, which seems plausible and consistent with observable variation in marketwide stock returns over time. However, this approach requires more research to develop practical models for measuring firm-specific time-varying risk premia.

[7] See, for example, James Claus and Jacob Thomas, "Equity Premia as Low as Three Percent? Empirical Evidence from Analysts' Earnings Forecasts for Domestic and International Stock Markets," *Journal of Finance* 56 (October 2001), pp. 1629–1666. Also see Peter Easton, Gary Taylor, Pervin Shroff, and Theodore Sougiannis, "Using Forecasts of Earnings to Simultaneously Estimate Growth and the Rate of Return on Equity Investment," *Journal of Accounting Research* 40 (June 2000), pp. 657–676.

In light of these criticisms of the CAPM and considering the crucial role of the risk-adjusted discount rate for common equity valuation, it is important to analyze the sensitivity of share value estimates across different discount rates for common equity. For example, the analyst should estimate values for a share of common equity in a particular firm across a relevant range of discount rates for common equity by varying the market risk premium from 3 to 7 percent.

Chapter 14 describes techniques to reverse-engineer the implicit expected rate of return on common equity securities. Chapter 14 also describes an approach to estimate the implicit discount in share price for risk by using risk-free discount rates. These techniques do not require the assumption of an asset pricing model such as the CAPM.

Cost of Debt Capital

The analyst computes the after-tax cost of each component of debt capital, including short-term and long-term notes payable, mortgages, bonds, and capital lease obligations, as the yield to maturity on each type of debt times one minus the statutory tax rate applicable to income tax deductions for interest. The yield to maturity is the rate that discounts the contractual cash flows on the debt to the debt's current fair value. If the fair value of the debt is equal to face value (for example, a $1,000 debenture trades on an exchange for $1,000), the yield to maturity equals the stated interest rate on the debt. If the fair value of the debt exceeds the face value of the debt, yield to maturity is lower than the stated rate. This can occur after interest rates fall; previously issued fixed-rate debt will have a stated rate that exceeds current market yields for debt with comparable credit quality and terms. On the other hand, after interest rates rise, existing fixed-rate debt may have a stated rate that is lower than prevailing market rates for comparable debt, in which case the debt will have a fair value that is less than face value and the yield to maturity will be greater than the stated rate.

Firms disclose in notes to their financial statements the stated interest rates on their existing interest-bearing debt capital. Firms also disclose in notes the estimated fair values of their interest-bearing debt, which should reflect the present value of the debt using prevailing market yields to maturity on the debt. Together, these disclosures allow the analyst to estimate prevailing market yields to maturity on the firm's outstanding debt.

In computing costs of debt capital, analysts typically exclude operating liability accounts (such as accounts payable, accrued expenses, deferred income tax liability, and retirement benefit obligations). Instead, analysts typically treat these items as part of the firm's operating activities rather than as part of the firm's financial capital structure.

A capitalized lease obligation will generally have an implicit after-tax cost of capital equal to the after-tax yield to maturity on collateralized borrowing with equivalent risk and maturity. Firms recognize capital lease obligations on the balance sheet as financial liabilities; however, as described in Chapter 6, firms also may have significant off-balance-sheet commitments to make future payments under operating leases. If the firm has significant commitments under operating leases, the analyst may believe it necessary to include them in the computation of the cost of debt capital. If the analyst elects to adjust the firm's balance sheet to capitalize operating lease commitments as debt (as illustrated in Chapter 6), the analyst should make three sets of adjustments to include the effects of operating leases on the total cost of debt capital. First, the analyst should include the present value of operating lease commitments in calculating the fair value of various components of outstanding debt. Second, the analyst should include the discount rate used to compute the present value of the operating lease commitments as the after-tax interest rate on operating leases in the computation of the cost of debt capital. The lessor bears more risk in an operating lease than in a capital lease, so the cost of capital represented by operating leases is likely to

be higher than for capital leases. Third, if the analyst treats operating leases as part of debt financing, the cash outflow for rent payments under operating leases should be reclassified as interest and principal payments of debt when computing free cash flows. Chapter 6 discusses techniques for the required adjustments to convert operating leases to capital leases, as well as techniques to adjust for other less common forms of off-balance-sheet financing, including contingent liabilities for receivables sold with recourse and product financing arrangements.

The income tax rate used to compute the tax effects of interest should be the firm's tax rate applicable to interest expense deductions. For most firms, the tax rate applicable to interest expense deductions is the statutory federal tax rate, which is 35 percent in the United States in 2009. However, state and foreign taxes or other special tax factors may increase or decrease the combined statutory tax rate depending on where the firm raises its debt capital. Firms generally do not separately disclose statutory state or foreign tax rates, but do summarize the effect of these taxes in the income tax reconciliation found in the income tax note. To achieve greater precision, the analyst could approximate the combined statutory tax rate applicable to interest expense deductions using the effective tax rate disclosed in the income tax footnote.

Cost of Preferred Equity Capital

The cost of preferred stock capital depends on the preference conditions. Preferred stock that has preference over common shares with respect to dividends and priority in liquidation generally sells near its par value. Therefore, its cost of capital is the dividend rate on the preferred stock. Depending on the attributes of the preferred stock, dividends on preferred stock may give rise to a tax deduction, in which case the after-tax cost of capital will be lower than the pretax cost. Preferred stock that is convertible into common stock has both preferred and common equity attributes. Its cost is a blending of the cost of nonconvertible preferred stock and common equity.

Computing the Weighted Average Cost of Capital

In some circumstances, the analyst may want to determine the present value of payoffs to investment in all of the assets of a firm, not just the equity capital of the firm. Such circumstances might arise, for example, if the analyst is considering acquiring all of the assets of a firm or if the analyst is considering acquiring control of a firm by acquiring all of the financial claims (common equity shares, preferred shares, and debt) on the assets of a firm. If the analyst needs to determine the present value of the payoffs from investing in the total assets of the firm, or, equivalently, acquiring all of the debt, preferred, and common equity claims on the firm, the analyst should use a discount rate that reflects the weighted average required rate of return that encompasses the debt, preferred, and common equity capital used to finance the net operating assets of the firm.

A formula for the weighted average cost of capital (denoted as R_A) is given here:

$$R_A = [w_D \times R_D \times (1 - tax\ rate)] + [w_P \times R_P] + [w_E \times R_E]$$

In this formula, w denotes the weight on each type of capital (D denotes debt capital, P denotes preferred stock capital, and E denotes common equity capital), R denotes the cost of each type of capital, and *tax rate* denotes the tax rate applicable to debt capital costs. The weights used to compute the weighted average cost of capital should be the market values of each type of capital in proportion to the total market value of the financial capital structure

of the firm (that is, $w_D + w_P + w_E = 1.0$). On the right-hand side of the equation, the first term in brackets measures the weighted after-tax cost of debt capital, the second term measures the weighted cost of preferred stock capital, and the third term measures the weighted cost of common equity capital.

Example 3: Computing the Weighted Average Cost of Capital

A firm has the following capital structure on its balance sheet:

	Book Value
Long-term bonds, 10 percent annual coupon, issued at par	$20,000,000
Preferred stock, 4 percent dividend, issued at par	5,000,000
Common equity	25,000,000
Total	$50,000,000

The market values of the securities are as follows: bonds, $22,000,000; preferred equity, $5,000,000; common equity, $33,000,000. The market has priced the bonds to yield 8.0 percent. (That is, the interest rate that discounts the annuity of contractual $2,000,000 interest payments and the $20,000,000 maturity value to the bonds' $22,000,000 fair value is 8 percent.) The firm's income tax rate is 35 percent, so the after-tax cost of debt is 5.2 percent $[= (1 - 0.35) \times 8.0$ percent]. Note that this rate is less than the coupon rate of 10 percent and that the market value of the debt is greater than its par value. Use of coupon rates and book values in this case would result in a higher cost of debt capital (6.5 percent $= 0.65 \times$ 10.0 percent) but a smaller weight for debt in the weighted average. Assuming that the dividend on the preferred stock is not tax deductible, its cost is the dividend rate of 4.0 percent because it is selling for par value. The equity capital has a market beta of 0.9. Assuming a risk-free interest rate of 6.0 percent and a market premium of 7.0 percent, the cost of equity capital is 12.3 percent $[= 6.0$ percent $+ (0.9 \times 7.0$ percent$)]$. The calculation of the weighted average cost of capital is as follows:

Security	Market Value	Weight	After-Tax Cost	Weighted Average
Long-Term Debt	$22,000,000	37%	5.2%	1.92%
Preferred Equity	5,000,000	8%	4.0%	0.32%
Common Equity	33,000,000	55%	12.3%	6.77%
Total	$60,000,000	100%		9.01%

Over time, the weights for debt, preferred, and equity capital may change if the analyst expects the firm's capital structure to change over the forecast horizon. In addition, the analyst may expect yields to maturity on debt capital and required rates of return on equity capital to change as interest rates in the economy change, the risk of the firm changes, or the firm's tax status changes. Thus, to capture these changes in the weighted average cost of capital, the analyst may need to project a weighted average cost of capital for each period over the forecast horizon.

To determine the appropriate weights to use in the weighted average cost of capital, the analyst must determine the market values of the debt, preferred, and common equity capital. Market values for debt will be observable only for firms that have issued publicly traded debt; however, U.S. GAAP and IFRS require firms to disclose the fair value of their outstanding debt capital in notes to the financial statements each year. Fair value disclosures may not be

available, however, if the firm is privately owned, the firm is not required to follow U.S. GAAP or IFRS, or the firm is a division and does not publish its own financial statements. If market values are not observable and fair values for the firm's debt are not disclosed, the analyst can (1) estimate the fair value of the firm's debt if sufficient data are available about the firm's credit quality and the maturity and terms of the debt or (2) rely on the book value of debt. The book value of debt can be a reliable estimate of fair value if the debt is recently issued, if the debt bears a variable rate of interest, or if the debt bears a fixed rate of interest but interest rates and the firm's credit quality have been stable since the debt was issued. Because the yield to maturity on debt is inversely related to its market value, analysts sometimes approximate the cost of debt by simply using the coupon rate and the book value of debt when computing the weighted average cost of capital, particularly when interest rates are stable and the market value of debt is likely to be close to book value.

If available, market prices for equity securities provide the amounts for determining the market value of equity. Market prices for equity may not be available, however, if the firm is privately owned or if it is a division of a firm. The analyst can then use the book value of equity as a starting point to compute the weight of equity in the capital structure for purposes of estimating a weighted average cost of capital.

The preceding discussion reveals circular reasoning in computing weighted average costs of capital for valuation purposes. Analysts use the market values of debt and equity to compute the weighted average cost of capital, which is used in turn to compute the value of the debt and equity in the firm. This is circular reasoning because the analyst needs to know the market values to determine the weights but needs to know the weights to determine the weighted average cost of capital to use in estimating firm value. In practice, analysts can use two approaches to avoid this circularity. One approach assumes that the firm will maintain a target debt-to-equity structure in the future based on benchmarks such as the firm's past debt-to-equity ratios, the firm's stated strategy with respect to financial leverage, or industry averages. The other approach computes iteratively the weighted average cost of capital and the value of debt and equity capital until the weights and the values converge. Example 4 illustrates this iterative approach.

Example 4: Computing the Weighted Average Cost of Capital Iteratively

Suppose that someone wants to compute the weighted average cost of capital and the market value of equity for a firm for which no market or fair value data are available. Also suppose that the firm has outstanding debt with a book value of $40 million. The firm recently issued this debt, and it carries a stated rate of 8.0 percent; so the analyst can assume that this is a reliable measure of the cost of debt capital. The firm faces a 35 percent tax rate. The book value of equity is $60 million. Similar firms in the same industry with comparable risks have a market beta of 1.2. Using the same risk-free rate and market risk premium as in Example 3, the cost of equity capital is 14.4 percent [= 6.0 percent + (1.2 × 7.0 percent)]. The first estimate of the weighted average cost of capital is as follows:

Security	Amount	Weight	After-Tax Cost	Weighted Average
Debt	$ 40,000,000	40%	5.2%	2.08%
Common Equity	60,000,000	60%	14.4%	8.64%
Total	$100,000,000	100%		10.72%

After using the 10.72 percent weighted average cost of capital to discount the free cash flows to present value, the analyst determines that the firm's equity value is roughly

$120 million (calculations not shown). Therefore, the values and weights used to compute the weighted average cost of capital are inconsistent with value estimates for equity. The first-iteration estimates placed too much weight on debt and too little weight on equity. The analyst should use the revised estimate of the value of equity to recompute the weighted average cost of capital and then recompute the value of the firm. Using the revised estimates produces a weighted average cost of capital estimate as follows:

Security	Amount	Weight	After-Tax Cost	Weighted Average
Debt	$ 40,000,000	25%	5.2%	1.30%
Common Equity	120,000,000	75%	14.4%	10.80%
Total	$160,000,000	100%		12.10%

The analyst should then use the revised estimate of the weighted average cost of capital of 12.10 percent to recompute the value of equity once again and then iterate this process until the values of debt and equity converge with the weights of debt and equity.

Computing the Weighted Average Cost of Capital for PepsiCo

PepsiCo's balance sheet at the end of 2008 shows interest-bearing debt from short-term obligations and long-term debt obligations totaling $8,227 million (= $369 + $7,858, as reported in Appendix A). Recall that Chapter 10 used information disclosed in Note 9, "Debt Obligations and Commitments" (Appendix A), to assess stated interest rates on PepsiCo's interest-bearing debt. In 2008, PepsiCo's outstanding debt carries a weighted average interest rate of approximately 5.8 percent. In Note 10, "Financial Instruments" (Appendix A), PepsiCo discloses that the fair value of outstanding debt obligations at the end of 2008 is $8,800 million. Thus, PepsiCo has experienced an unrealized (and unrecognized) loss of $573 million (= $8,227 million − $8,800 million) on its debt capital. This unrealized loss is surprising because more than half of PepsiCo's outstanding debt obligations were newly issued in 2008 at prevailing market rates. The unrealized loss implies that the firm's outstanding debt carries stated rates of interest that now exceed prevailing market yields, which at the end of 2008 are at relatively low levels given the recession in the U.S. economy. Based on the fact that most of PepsiCo's outstanding debt obligations were recently issued in 2008 and the expectation that prevailing yields to maturity are temporarily low, Chapter 10 projected that PepsiCo's cost of debt capital will continue to approximate 5.8 percent in Year +1 and beyond. We use the current book value (as a proxy for market value) of PepsiCo's debt for weighting purposes. In Note 5, "Income Taxes" (Appendix A), PepsiCo discloses that the combined average federal, state, and foreign tax rate is approximately 26.8 percent in 2008. Chapter 10 projected that PepsiCo will continue to face average tax rates of roughly 26.8 percent in Year +1 and beyond. Therefore, we will assume the tax rate applicable to PepsiCo's interest expense deductions will be the effective 26.8 percent rate rather than the statutory federal rate of 35 percent. Long-run projections imply that PepsiCo faces an after-tax cost of debt capital of 4.25 percent [4.25 = 5.8 × (1 − 0.268)].

PepsiCo also has a net *negative* balance of $97 million in preferred stock on the 2008 balance sheet. Chapter 10 projected that PepsiCo will retire the remaining outstanding preferred stock during Year +1 and that that PepsiCo will not issue any additional preferred stock capital in future years. Therefore, we include no preferred stock in the computation of PepsiCo's weighted average cost of capital.

Recall that earlier in this chapter we used the CAPM to determine that PepsiCo faces an 8.50 percent cost of equity capital. We also computed that at the end of 2008, PepsiCo had

1,553 million shares outstanding and a share price of $54.77, for a total market capital of common equity of $85,058 million.

Bringing these costs of debt and equity capital together, we compute PepsiCo's weighted average cost of capital to be 8.12 percent as follows:

Capital	Value Basis	Amount	Weight	After-Tax Cost of Capital	Weighted-Average Component
Debt	Book	$ 8,227	8.82%	4.25%	0.37%
Common	Market	85,058	91.18%	8.50%	7.75%
Total		$93,285	100.00%		8.12%

This is just an initial estimate of PepsiCo's weighted average cost of capital. As described earlier, the weighted average cost of capital must be computed iteratively until the weights used are consistent with the present values of debt and equity capital.

RATIONALE FOR DIVIDENDS-BASED VALUATION

In theory, the value of a share of common equity is the present value of the expected future dividends the shareholder will receive.[8] Dividends are the most fundamental value-relevant measure of expected future payoffs to use to value shares because they represent the distribution of wealth from the firm to the shareholders. The equity shareholder invests cash to purchase the share and then receives cash in the form of dividends as the payoffs from holding the share, including the final "liquidating" dividend when the investor sells the share. In dividends-based valuation, we define *dividends* broadly to include *all* cash flows between the firm and the common equity shareholders. Therefore, in valuation, "dividends" encompass all cash flows from the firm to shareholders through periodic dividend payments, stock buybacks, and the liquidating dividend, as well as cash flows from the shareholders to the firm when the firm issues shares (in a sense, *negative* dividends).

The rationale for using expected dividends in valuation is twofold:

1. Cash is the primary medium of exchange for consumption, which is the ultimate source of value. When individuals and firms invest in an economic resource, they forgo current consumption in favor of future consumption. Cash is the medium of exchange that will permit them to consume various goods and services in the future. An investment has value because of its ability to provide future cash flows. Dividends measure the cash that investors ultimately receive from investing in an equity share.

2. Dividends are paid in cash, and cash serves as a measurable common denominator for comparing the future benefits of alternative investment opportunities. One might compare investment opportunities involving the holding of a bond, a stock, or an office building, but comparing these alternatives requires a common measuring unit of their future benefits. The future cash flows derived from their future services serve such a function.

As a practical matter, however, quarterly or annual dividend payment amounts are arbitrary, established by a dividend policy set by the firm's managers and board of directors. Periodic dividend payments do not vary closely with firm performance from one period to the next. Some firms do not pay any regular periodic dividends, particularly young, high-growth firms. For most firms, the final liquidating dividend plays an important role,

[8] John Burr Williams, *The Theory of Investment and Value* (Cambridge, Mass.: Harvard University Press), 1938.

usually representing a large proportion of firm value in a dividends-based valuation. The final liquidating dividend arises when the firm liquidates its assets and returns all of the capital to shareholders, when all of the outstanding shares of the firm are acquired by another firm in a merger or an acquisition transaction, or when shareholders elect to liquidate their investment by selling shares. Therefore, to value a firm's shares using dividends, one must forecast dividends over the life of the firm (or the expected length of time the share will be held), including the final liquidating dividend (that is, the future price at which shares will be retired, acquired, or sold). Thus, the analyst faces the challenge of needing to forecast the value of shares in the future at the time of the liquidating dividend in order to value the shares today.

Dividends-Based Valuation Concepts

This section describes and illustrates key concepts in dividends-based valuation, first presenting simple examples involving a single project and then confronting conceptual measurement issues regarding dividends to the investor versus cash flows to the firm and nominal versus real dividends. Later in the chapter, we illustrate this approach with a more complex and realistic example involving the valuation of PepsiCo using dividends derived from the projected financial statements developed in Chapter 10.

Dividends Valuation for a Single-Asset Firm

For the following examples, make these assumptions:

- The firm consists of a single asset that will generate pretax net cash flows of $2 million per year forever.
- The income tax rate is 40 percent.
- After making debt service payments and paying taxes, the firm pays dividends to distribute any remaining cash flows to the equity shareholders each year.

Example 5: Value of Common Equity in an All-Equity Firm

For this example, make the following additional assumptions:

- Equity shareholders have financed the asset entirely with $10 million of equity capital.
- The cost of equity capital is 10 percent.

The value of the common equity investment to the shareholders can be determined using the present value of dividends for common equity shareholders. The dividends to common equity shareholders each year will be as follows:

Net Pretax Cash Flow for All Debt and Equity Capital	$2,000,000
Interest Paid on Debt	(0)
Income Taxes: 0.40 × $2,000,000	(800,000)
Dividends for Common Equity Shareholders	$1,200,000

The value to the shareholders of the common equity in the firm is $12,000,000 (= $1,200,000/0.10). Dividing by the discount rate is appropriate because the $1,200,000 annual dividend for common equity is a perpetuity. This investment is worth $12,000,000 to those shareholders (a gain of $2,000,000 over their initial $10,000,000 investment) because of the present value of the dividends the investment will pay to the shareholders.

Example 6: Value of Common Equity in a Firm with Debt Financing

Assume the same original facts, but now make the following additional assumptions:

- The equity shareholders finance a portion of the investment in the asset with $4 million of equity capital.
- The firm finances the remainder of the asset using $6 million of debt capital.
- This amount of debt in the firm's capital structure does not alter substantially the risk of the firm to the equity investors, so they continue to require a 10 percent rate of return.
- The debt is issued at par, and it is less risky than equity; so the debtholders demand interest of only 6 percent each year, payable at the end of each year.
- Interest expense is deductible for income tax purposes.

Again the value of the common equity investment can be determined using the present value of dividends for common equity shareholders. The dividend to common equity is as follows:

Net Pretax Cash Flow for All Debt and Equity Capital	$2,000,000
Interest Paid on Debt: 0.06 × $6,000,000	(360,000)
Income Taxes: 0.40 × ($2,000,000 − $360,000)	(656,000)
Dividends for Common Equity Shareholders	$ 984,000

Assuming that the firm will pay this amount of dividend each year in perpetuity, the value of the common equity to the shareholders in the firm is $9,840,000 (= $984,000/0.10). Note that in this example, the present value of the gain to the common equity shareholders in excess of their initial investment is $5,840,000 (= $9,840,000 − $4,000,000). In this example, the gain to the shareholders is $3,840,000 (= $5,840,000 − $2,000,000) larger than in the previous example because (1) the debt capital is less expensive than the equity capital (6 percent rather than 10 percent on $6,000,000 of financing), creating $2,400,000 of value for equity shareholders [= ($6,000,000 × {0.10 − 0.06})/0.10], and (2) the net tax savings from interest expense creates $1,440,000 of value for equity shareholders [= ($800,000 − $656,000)/0.10, or, alternatively, (= $360,000 interest deduction × 0.40 tax rate)/0.10].

Dividends to the Investor versus Cash Flows to the Firm

The beginning of this chapter asserted that the analyst can use dividends expected to be paid to the investor or the free cash flows expected to be generated by the firm (that will ultimately be paid to the investor) as equivalent approaches to measure value-relevant expected payoffs to shareholders. Will using net cash flows into the firm result in the same estimate of value as using dividends paid out of the firm? Cash flows paid to the investor via dividends and free cash flows to the firm that are available for common equity shareholders will differ each period to the extent that the firm reinvests a portion (or all) of the cash flows generated. However, if the firm generates a rate of return on reinvested free cash flow equal to the discount rate used by the investor (that is, the cost of equity capital), either set of payoffs (dividends or free cash flows) will yield the same valuation of a firm's shares at a point in time. To demonstrate this equivalence, consider the following scenarios.

Example 7: Dividend Policy Irrelevance with 100 Percent Payout

A firm expects to generate free cash flows of 15 percent annually on invested equity capital for the rest of its life, which is likely to continue for an indefinitely long period of time into the future (until $t=n$). Equity investors in this firm require a 15 percent return each year, considering the riskiness of the firm. Assume that the firm pays out 100 percent of the free

cash flows each year as dividends to the shareholders. Thus, the free cash flows generated by the firm equal the cash dividends received by the investors each period. Each dollar of capital committed by the investors has a present value of future cash flows equal to one dollar. That is, over an indefinitely long period of time into the future,

$$\$1 = \sum_{t=1}^{n} \frac{\$0.15}{(1.15)^t}$$

Example 8: Dividend Policy Irrelevance with Zero Payout

Assume the same facts as Example 7 except that the firm pays out none of the free cash flows as a dividend. The firm retains the $0.15 free cash flow on each dollar of capital and reinvests it in projects expected to earn 15 percent return per year. In this case, the investor receives no periodic dividends and receives cash only when the investor sells the shares or the firm liquidates at date $t=n$. By the terminal date, n periods in the future, each dollar of capital invested in the firm today will have earned a compound rate of return of 15 percent, equal to the required rate of return. In this case also, each dollar of invested capital has a present value of future cash flows equal to one dollar, exactly the same as in the full payout dividend discount example above. That is,

$$\$1 = \frac{(\$1.15)^n}{(1.15)^n}$$

Example 9: Dividend Policy Irrelevance with Partial Payout

Assume the same facts as Example 8 except that the firm pays out 25 percent of the free cash flow each period as a dividend and reinvests the other 75 percent in projects expected to generate a return of 15 percent. In this case also, each dollar of invested capital has a present value of future cash flows equal to one dollar, the same as in the two preceding examples. That is,

$$V_0 = \sum_{t=1}^{n} \frac{(0.25)(\$0.15)}{(1.15)^t} + \frac{(0.75)(\$1.15)^n}{(1.15)^n}$$

These three examples illustrate the *relevance* of dividends as payoffs that are sufficient for valuation for equity shareholders and the *irrelevance* of the firm's dividend policy in valuation, assuming the firm reinvests cash flows to earn the investors' required rate of return.[9] The same valuation should arise whether the analyst discounts (1) the expected dividends to the investor or (2) the expected free cash flows to the firm that are available to pay future dividends to equity shareholders. Further, the same valuation should arise whether the firm pays all of its cash flows as a dividend, reinvests all cash flows to earn the investors' required rate of return, or pays a portion of cash flows in dividends each period and reinvests the remaining cash flows to earn the investors' required rate of return.

Nominal versus Real Dividends

Changes in general price levels (that is, inflation or deflation) cause the purchasing power of the monetary unit to change over time. Should the valuation use projected nominal dividends,

[9] Merton Miller and Franco Modigliani, "Dividend Policy, Growth and the Valuation of Shares," *Journal of Business* (October 1961), pp. 411–433. Penman and Sougiannis test empirically the replacement property of dividends for future earnings and find support for the irrelevance of dividend policy in valuation. See Stephen H. Penman and Theodore Sougiannis, "The Dividend Displacement Property and the Substitution of Anticipated Earnings for Dividends in Equity Valuation," *The Accounting Review* (January 1997), pp. 1–21.

which include the effects of inflation or deflation, or real dividends, which filter out the effects of changes in general purchasing power?[10] The valuation of an investment in an economic resource should be the same whether nominal or real dividend amounts are used as long as the discount rate used is the nominal or real rate of return that is consistent with the dividend measure. That is, if projected dividends are nominal and include the effects of changes in general purchasing power of the monetary unit, the discount rate should be nominal and include an inflation component. If projected dividends are real amounts that filter out the effects of general price changes, the discount rate should be a real rate of return, excluding the inflation component.

Example 10: Nominal versus Real Dividends

A firm owns an asset that it expects to sell one year from today for $115.5 million. The firm expects the general price level to increase 10 percent during this period. The real interest rate is 5 percent. The nominal discount rate should be 15.5 percent to measure the compound effects of the real rate of interest and inflation $[0.155 = (1.10 \times 1.05) - 1]$. Discounting nominal or real dividends, the value of the asset to the firm today is $100 million, as shown:

Nominal Dividends	×	Discount Rate Including Expected Inflation	=	Value
$115.5 million	×	$1/(1.05 \times 1.10)$	=	$100 million

Real Dividends	×	Discount Rate Excluding Expected Inflation	=	Value
$115.5 million/1.10	×	$1/1.05$	=	$100 million

Both examples derived the value of the equity of the firm by computing the present value of the dividends to common equity shareholders. As a practical matter, costs of capital and expected returns are typically quoted in nominal terms, so analysts usually find it more straightforward to discount nominal dividends using nominal discount rates than to first adjust nominal dividends to real dividends and then discount real dividends using real interest rates.

THE DIVIDENDS VALUATION MODEL

This section presents the dividends valuation model that determines the value of common shareholders' equity in the firm. The sections following the model demonstrate how to implement the model using PepsiCo.

The dividends valuation model determines the value of common shareholders' equity in the firm (denoted as V_0) as the sum of the present value of all future dividends to shareholders over the life of the firm, which is indefinite. The dividends valuation model includes all-inclusive dividends (denoted as D) that encompass all of the net cash flows

[10] Note that the issue here is not with specific price changes of a firm's particular assets, liabilities, revenues, and expenses. These specific price changes affect projections of the firm's dividends, cash flows, and earnings and should enter into the valuation of the firm. The issue is whether some portion, all, or more than all of the specific price changes represent simply an economy-wide change in the purchasing power of the monetary unit, which should not affect the value of a firm.

from the firm to shareholders through periodic dividend payments and stock buybacks and subtracts cash flows from the shareholders to the firm when the firm issues shares. The next section demonstrates how to measure dividends (D). We discount the stream of future dividends to present value using the required return on common equity capital in the firm (denoted as R_E). The following general model expresses the dividends valuation approach:

$$V_0 = \sum_{t=1}^{\infty} \frac{D_t}{(1+R_E)^t} = \frac{D_1}{(1+R_E)^1} + \frac{D_2}{(1+R_E)^2} + \frac{D_3}{(1+R_E)^3} + \ldots$$

Suppose dividend amounts can be reliably forecasted through Year T. At the end of Year T, assume that the continuing value of the common equity of the firm (denoted as V_T) will equal the present value of all expected future continuing dividends in Year T+1 and beyond (a perpetuity of D_{T+1} in every year), which can be expressed as follows:

$$V_T = \sum_{t=1}^{\infty} \frac{D_{T+1}}{(1+R_E)^t}$$

Thus, the value of the firm today can be expressed using periodic dividends over a finite horizon to Year T plus continuing value based on dividends in Year T+1 and beyond as follows:

$$V_0 = \sum_{t=1}^{\infty} \frac{D_t}{(1+R_E)^t} = \frac{D_1}{(1+R_E)^1} + \frac{D_2}{(1+R_E)^2} + \frac{D_3}{(1+R_E)^3} + \ldots + \frac{D_T}{(1+R_E)^T} + \frac{V_T}{(1+R_E)^T}$$

This equation reveals that the estimate of value today (V_0) depends on the estimate of value in the future (V_T).

As described in more detail in an upcoming section, we project the continuing dividends in the continuing value period beyond Year T using the expected, long-run steady state growth of the firm, which we specify as $(1 + g)$. We project the Year T+1 dividend by assuming that each line item on the Year T income statement and balance sheet will grow at rate $(1 + g)$ and then deriving the Year T+1 dividend. As described in an upcoming section, to derive dividends, assume that accounting for the book value of the shareholders' equity (BV) follows the general principle of adding net income (NI) and subtracting dividends to common shareholders each period (that is, $BV_t = BV_{t-1} + NI_t - D_t$). Therefore, the Year T+1 dividend can be derived as follows:

$$D_{T+1} = NI_{T+1} + BV_T - BV_{T+1}$$

The assumption is that growth in net income and book value in Year T+1 equals $(1 + g)$; therefore, $NI_{T+1} = NI_T \times (1 + g)$ and $BV_{T+1} = BV_T \times (1 + g)$. These terms can be substituted, and the D_{T+1} equation can be rewritten as follows:

$$D_{T+1} = [NI_T \times (1 + g)] + BV_T - [BV_T \times (1 + g)]$$

Assuming that D_{T+1} will grow in perpetuity at rate g, the firm can be valued at the end of Year T using the perpetuity-with-growth model as follows:

$$V_T = \sum_{t=1}^{\infty} \frac{D_{T+1}}{(1+R_E)^t} = \frac{D_{T+1}}{(R_E - g)} = \frac{[NI_T \times (1 + g)] + BV_T - [BV_T \times (1 + g)]}{(R_E - g)}$$

Therefore, the present value of common equity today can be expressed using dividends as follows:

$$V_0 = \sum_{t=1}^{\infty} \frac{D_t}{(1 + R_E)^t}$$

$$= \frac{D_1}{(1+R_E)^1} + \frac{D_2}{(1+R_E)^2} + \frac{D_3}{(1+R_E)^3} + \cdots + \frac{D_T}{(1+R_E)^T} + \frac{V_T}{(1+R_E)^T}$$

$$= \frac{D_1}{(1+R_E)^1} + \frac{D_2}{(1+R_E)^2} + \frac{D_3}{(1+R_E)^3} + \cdots + \frac{D_T}{(1+R_E)^T} + \frac{[NI_T \times (1 + g)] + BV_T - [BV_T \times (1 + g)]}{(R_E - g) \times (1 + R_E)^T}$$

IMPLEMENTING THE DIVIDENDS VALUATION MODEL

Implementing the dividends valuation model to determine the value of the common shareholders' equity in a firm involves measuring the following three elements:

1. The discount rate (denoted as R_E in the valuation model) used to compute the present value of the future dividends

2. The expected future dividends over the forecast horizon (denoted as D_t in periods 1 through T in the valuation model)

3. The expected dividend at the final period of the forecast horizon, which we refer to as the *continuing dividend* (denoted as D_{T+1} in the valuation model) and a forecast of the long-run growth rate (denoted as g in the model) in the continuing dividend beyond the forecast horizon

The first part of this chapter discussed the first element, computing the appropriate discount rate. The following sections discuss measuring the second and third of these elements.

Measuring Dividends

Dividends-based valuation values the common equity in a firm by measuring the present value of all net cash flows from the firm to the equity shareholders. Therefore, the objective in dividends valuation is to measure the present value of *total dividends* for common equity shareholders, including *all* of the cash flows the shareholders will receive from holding the share.

Total dividends encompass cash flows from the firm to common equity shareholders through periodic dividend payments such as quarterly or annual dividends paid to shareholders each period based on the firm's dividend payout policy. Total dividends also include cash flows to common equity shareholders through stock buybacks. Further, cash flows from the shareholders to the firm when the firm issues shares are *negative* dividends. Thus, to measure total value-relevant dividends that encompass all of the cash flows from the firm to common equity shareholders each period, the analyst should include the following three components:

+ Quarterly or annual ordinary dividend payments to common equity shareholders
+ Net cash flows to shareholders from common equity share repurchases
− Net cash flows from shareholders through common equity issues
───
= Total dividends to common equity shareholders.

Alternatively, accounting for shareholders' equity is a reliable framework for measuring total dividends for valuation. To begin, assume that the accounting for shareholders' equity

follows *clean surplus accounting*. Under clean surplus accounting, income must include *all* of the elements of income (all revenues and expenses, all gains and losses) generated by the firm for common equity shareholders. Under U.S. GAAP and IFRS, clean surplus income is measured by comprehensive income (that is, net income plus all of the unrealized gains and losses included in other comprehensive income). Also assume that the effects of all of the direct capital transactions between the firm and the common equity shareholders, such as periodic dividend payments, share issues, and share repurchases, are included in the book value of common shareholders' equity.[11]

Under these simple and general principles of clean surplus accounting, the accounting for common equity is represented as follows:

$$BV_t = BV_{t-1} + I_t - D_t$$

where BV_t denotes the book value of equity at the end of year t, I denotes clean surplus income for year t, and D denotes net direct capital transactions between the firm and common shareholders (dividend payments, stock issues, and stock repurchases) during year t. To isolate all of the net cash flows between the firm and the shareholders during year t, simply rearrange the equation as follows:

$$D_t = I_t + BV_{t-1} - BV_t$$

Therefore, total dividends used in dividends valuation should equal clean surplus income each year, adjusted for the change in the book value of common equity as a result of direct capital transactions.

Measuring Dividends for PepsiCo

This section illustrates the dividends measurement approach using PepsiCo. We derive our dividends expectations from our projected financial statements for PepsiCo in Chapter 10.

In development of the financial statement forecasts for PepsiCo for Year +1, for example, we projected that PepsiCo would pay common equity dividends equal to 50 percent of lagged net income from continuing operations, amounting to $2,571.0 million [= 0.50 × ($5,142.0 − $0)]. We also assumed that PepsiCo would use implied dividends as the flexible financial account to balance the balance sheet, so an additional $444.3 million in capital would be distributed to common equity shareholders through additional dividends or share repurchases. Therefore, we projected that net dividends would amount to $3,015.3 million (= $2,571.0 + $444.3) in Year +1.

We also projected that common stock and additional paid-in capital would remain roughly 1.1 percent of total assets. Because the projections expect total assets to grow by 7.0 percent in Year +1, common stock and additional paid-in capital would also grow by 7.0 percent from $381.0 million to $407.5 million by the end of Year +1, implying new stock issues (in effect, negative dividends) of −$26.5 million. Further, we projected that PepsiCo would engage in direct capital transactions with common equity shareholders through the treasury stock account. We projected that PepsiCo would pay $2,500.0 million to repurchase common shares, net of any shares reissued for stock options exercises. Together, these capital transactions would result in a net cash outflow of $2,473.5 million (= $2,500.0 − $26.5) from PepsiCo to common shareholders.

[11] Also assume that direct capital transactions between the firm and common equity shareholders are value-neutral (that is, zero net present value projects) to the existing common shareholders.

Bringing these components together, we projected that total value-relevant dividends to common equity shareholders in Year +1 will be as follows (in millions):

Periodic dividend payments	$3,015.3
Net purchases of treasury stock	2,500.0
Common stock issues	(26.5)
Total dividends to common equity shareholders	$5,488.8

This computation can be reconciled with the clean surplus accounting approach as follows: The Year +1 forecast of comprehensive income is $6,110.9 million. After deducting the forecast of the liquidating dividend to retire the preferred shares, the projected amount of comprehensive income available to common shareholders is as follows (in millions):

$$\$6,110.9 - \$169.0 = \$5,941.9$$

Total book value of common shareholders' equity is $12,203.0 million at the beginning of Year +1 and $12,656.1 million at the end of Year +1. Using the clean surplus accounting approach, dividends in Year +1 are as follows (in millions):

$$D_t = I_t + BV_{t-1} - BV_t = \$5,941.9 + \$12,203.0 - \$12,656.1 = \$5,488.8$$

Exhibit 11.5 demonstrates these computations for Years +1 through +5.

Selecting a Forecast Horizon

For how many future years should the analyst project future payoffs from an investment? The correct answer is the expected life of the investment being valued. This life is a finite number of years for a resource such as a machine, a building, or any resource with limits to its physical existence or a financial instrument with a finite stated maturity (such as a bond, mortgage, or lease). In equity valuation, however, the resource to be valued is an ownership claim on the firm, a resource that has an expected life that is typically indefinite. Therefore, in the case of an equity security, the analyst must project future dividends that, in theory, extend indefinitely.

Of course, as a practical matter, the analyst cannot precisely predict a firm's dividends very many years into the future. Therefore, analysts commonly develop specific projections of all of the elements of the income statements and balance sheets for the firm and use those elements to derive forecasts of dividends over an explicit forecast horizon (for example, five or ten years) depending on the industry, the maturity of the firm, and the expected growth and predictability of the firm's business activities. After the explicit forecast horizon, analysts then typically use general steady-state growth assumptions to project the future income statements and balance sheets and use them to derive the dividends that will persist each period to infinity. Therefore, the analyst will find it desirable to develop specific forecasts of income statements, balance sheets, and cash flows over an explicit forecast horizon that extends until the point at which a firm's growth pattern is expected to settle into steady-state equilibrium, during which time dividends might be expected to grow at a steady, predictable rate.

Selecting a forecast horizon involves trade-offs. Reasonably reliable projections can be developed over longer forecast horizons for stable and mature firms. Projections for such firms, as in the case of PepsiCo demonstrated in Chapter 10, capture relatively steady-state operations. On the other hand, it is more difficult to develop reliable projections over long

EXHIBIT 11.5

Computation of PepsiCo's Total Dividends for the Dividends Valuation Approach

	Computing Total Dividends Using Components				
	Year +1	Year +2	Year +3	Year +4	Year +5
Dividends Paid to Common Shareholders	$ 3,015.3	$ 3,324.5	$ 3,818.5	$ 4,398.5	$ 4,848.3
Less: Common Stock Issues	(26.5)	(33.8)	(43.7)	(30.2)	(51.2)
Plus: Common Stock Repurchases	2,500.0	2,500.0	2,500.0	2,500.0	2,500.0
Total Dividends to Common Equity	$ 5,488.8	$ 5,790.7	$ 6,274.8	$ 6,868.3	$ 7,297.1

	Computing Total Dividends Using Clean Surplus Accounting				
	Year +1	Year +2	Year +3	Year +4	Year +5
Comprehensive Income	$ 6,110.9	$ 6,602.1	$ 7,272.7	$ 7,726.4	$ 8,427.3
Less: Preferred Dividends	(169.0)	(0.0)	(0.0)	(0.0)	(0.0)
Comprehensive Income Available for Common Equity	$ 5,941.9	$ 6,602.1	$ 7,272.7	$ 7,726.4	$ 8,427.3
Plus: Beginning Book Value of Common Equity	12,203.0	12,656.1	13,467.4	14,465.3	15,323.5
Less: Ending Book Value of Common Equity	(12,656.1)	(13,467.4)	(14,465.3)	(15,323.5)	(16,453.6)
Total Dividends to Common Equity	$ 5,488.8	$ 5,790.7	$ 6,274.8	$ 6,868.3	$ 7,297.1

forecast horizons for young high-growth firms because their future operating performance is relatively more uncertain. This difficulty is exacerbated by the fact that a much higher proportion of the value of young growth firms will be achieved in distant future years, after they reach their potential steady-state profitability. Thus, the analyst faces the dilemma of depending most heavily on long-run forecasts for young growth firms for which long-run projections are most uncertain and most difficult to project. The forecasting and valuation process is particularly difficult for growth firms when the near-term dividends are projected to be zero or negative, as is common for rapidly growing firms that finance growth by issuing common stock. In this case, most of the firm's value depends on dividends to be generated in years far into the future.

Unfortunately, there is no way to avoid this dilemma. The predictive accuracy of dividends forecasts many years into the future is likely to be questionable for even the most stable and predictable firms. The analyst must recognize that forecasts and value estimates for all firms,

but especially growth firms, have a high degree of uncertainty and estimation risk. To mitigate this uncertainty and estimation risk, the analyst should adhere to the following points:

- Diligently and comprehensively follow all six steps of the analysis framework. By thoroughly analyzing the firm's industry and strategy, the firm's accounting quality, and the firm's financial performance and risk ratios, the analyst will have more information to use to develop long-term forecasts that are as reliable as possible.
- To the extent possible, confront directly the problem of long-term uncertainty by developing specific projections of dividends derived from projected income statements and balance sheets that extend five or ten years into the future, at which point the firm may be projected to reach steady-state growth.
- Assess the sensitivity of the forecast projections and value estimates across the reasonable range of growth assumptions.

Continuing Value of Future Dividends

The previous section described measuring periodic dividends over an explicit forecast horizon. This section describes techniques to project continuing dividends using a steady-state growth rate continuing beyond the explicit forecast horizon and to measure the present value of continuing dividends. We refer to them as *continuing dividends* because they reflect the cash flows from the firm to the common equity shareholders continuing into the long-run future.

In some circumstances, however, the analyst may not find it necessary to forecast dividends continuing beyond the explicit forecast horizon if he or she can reliably predict that the share will receive a future liquidating dividend. In such circumstances, the liquidating dividend is the final cash flow to the shareholder. The liquidating dividend might arise when the firm liquidates its assets at the end of its business life and distributes the proceeds to shareholders to retire their shares. Alternatively, the liquidating dividend might arise when a firm's shares are acquired by another firm in a merger or an acquisition transaction. The liquidating dividend also can arise when the shareholder elects to sell the share, thereby creating a liquidating dividend from the selling price.

Projecting Continuing Dividends

In most circumstances, the analyst will not be able to reliably predict whether or when the share will receive a liquidating dividend. Therefore, analysts commonly forecast dividends over an explicit forecast horizon until the point at which the analyst expects a firm to mature into a steady-state growth pattern, during which time dividends are assumed to grow at a constant steady-state rate. The long-run sustainable growth rate (denoted as g) in future continuing dividends could be positive, negative, or zero. Sustainable growth in dividends could be driven by long-run expectations for inflation, the industry's sales, the economy in general, or the population. The analyst should select a growth rate that captures realistic long-run expectations for Year $T+1$ and beyond.

Unfortunately, a shortcut analysts sometimes use (and a common error analysts make) in computing the continuing dividends for Year $T+1$ is to multiply the dividends for Year T by $(1 + g)$ instead of deriving the Year $T+1$ dividends from the projected Year $T+1$ income statement and balance sheet. If the analyst wants to compute internally consistent and identical estimates of firm value using dividends, free cash flows, and earnings, he or she should *not* project dividends for Year $T+1$ by simply multiplying dividends for Year T by $(1 + g)$. Doing so ignores the necessary growth in all of the elements of the balance sheet and the income statement, which can introduce inconsistent forecast assumptions for dividends, cash flows, and earnings. Even if the analyst simply projects Year $T+1$ dividends, cash flows,

and earnings to grow at an identical rate $(1 + g)$, doing so may impound inconsistent assumptions and lead to inconsistent value estimates if Year T dividends, cash flows, and earnings are not consistent with their long-run continuing amounts.

Example 11: Projecting Continuing Dividends

Suppose the analyst develops the following forecasts for the firm in Year T−1 and Year T:

	Assets	=	Liabilities	+	Shareholders' Equity
Year T−1 Balances	$100	=	$60	+	$40
+ Net Income	+20				+20
+ New Borrowing	+6		+6		
− Dividends Paid	−10				−10
Year T Balances	$116	=	$66	+	$50

Suppose the analyst projects that the firm will grow at a steady-state rate of 10 percent in Year T+1 and thereafter. If the analyst simply (and erroneously) projects Year T dividends to grow by 10 percent, the Year T+1 projections will be only $11 (= $10 Year T dividends × 1.10), which is not correct because it relies on implicit inconsistent assumptions. This error would force the estimated value of the firm using dividends to be lower than the value estimates using cash flows or earnings.

To project continuing dividends in Year T+1 correctly, the analyst should derive the continuing dividends from the projected Year T+1 income statement and balance sheet. To do so correctly, the analyst should use the expected long-run growth rate (g) to project all of the items of the Year T+1 income statement and balance sheet. That is, the analyst should project each item on the Year T+1 income statement and balance sheet by multiplying each item for Year T times $(1 + g)$. The analyst can then derive Year T+1 dividends using clean surplus accounting as follows:

$$D_{T+1} = NI_{T+1} + BV_T - BV_{T+1} = [NI_T \times (1 + g)] + BV_T - [BV_T \times (1 + g)]$$

The analyst must impose the long-run growth rate assumption $(1 + g)$ uniformly on the Year T+1 income statement and balance sheet projections to derive the dividends for Year T+1 correctly. In the long run, assuming that the firm itself will grow at a steady-state rate, all of the elements of the firm (dividends, revenues, expenses, income, assets, liabilities, shareholders' equity, and cash flows) will grow at the same rate. By applying a uniform growth rate across all of the items of the income statement and balance sheet, the analyst achieves internally consistent steady-state growth across all of the projections of the firm, keeping the balance sheet in balance throughout the continuing forecast horizon and keeping growth in dividends, cash flows, and earnings internally consistent with the long-run growth rate.

Returning to Example 11, to compute continuing dividends in Year T+1 correctly, the analyst should project Year T+1 net income, assets, liabilities, and shareholders' equity to grow by 10 percent each and then compute Year T+1 continuing dividends as follows:

	Assets	=	Liabilities	+	Shareholders' Equity
Year T Balances	$ 116	=	$ 66	+	$50
Growth	×1.10		×1.10		×1.10
Year T+1 Balances	$127.6	=	$72.6	+	$55

The projected net income would be $22 (= $20 × 1.10). The Year T+1 dividends projection would be $17 (= $22 net income + $50 beginning shareholders' equity − $55 ending shareholders' equity). Note that the correct projected Year T+1 dividend amount of $17 is substantially larger than the erroneous $11 dividend projection. Also note that the $17 Year T+1 dividend is substantially larger than the $10 dividend amount for Year T. The reason the firm can begin to pay larger dividends in Year T+1 and beyond is that the firm's long-run growth rate of 10 percent is lower than the Year T growth rate in assets (16 percent) and shareholders' equity (25 percent); thus, this firm will not need to reinvest as much of its earnings to fund growth and will be able to pay larger dividend amounts in Year T+1 and beyond.

In projecting continuing dividends in Year T+1 and beyond, analysts assume that the firm will settle into a long-run sustainable growth rate. Often analysts assume that the firm's long-run sustainable growth rate will be consistent with long-run growth in the economy, on the order of 3–5 percent. For firms that have been growing faster than that in the years leading up to Year T+1, the long-run sustainable growth rate implies that the firm will maintain a lower growth rate in assets and equity and thus will be able to pay out substantially larger dividends. By projecting Year T+1 net income, assets, and equity using the long-run sustainable growth rate, it is possible to solve for the long-run sustainable dividends the firm can pay. The continuing dividend amount derived for Year T+1 may be significantly larger than the amounts the firm actually paid during its higher-growth-rate years. The Year T+1 dividend amount reflects the firm's transition from a high rate of reinvestment to finance high growth in assets to lower reinvestment for lower growth.

Computing Continuing Value

As was demonstrated earlier in the dividends valuation model, once the analyst has computed continuing dividends for Year T+1, he or she can compute continuing value (sometimes called residual value or terminal value) of continuing dividends in Year T+1 and beyond using the perpetuity-with-growth valuation model, as follows:[12]

$$V_T = \sum_{t=1}^{\infty} \frac{D_{T+1}}{(1+R_E)^t} = \frac{D_{T+1}}{(R_E - g)} = \frac{[NI_T \times (1 + g)] + BV_T - [BV_T \times (1 + g)]}{(R_E - g)}$$

Example 12: Valuing Continuing Dividends

An analyst forecasts that the dividends of a firm in Year +5 will be $30 million and that Year +5 earnings and cash flows also will be $30 million. For simplicity in this example, assume the analyst expects that the firm's income statements and balance sheets will grow uniformly over the long run and, therefore, that cash flows, earnings, and dividends will grow uniformly over the long run. But the analyst is uncertain about the steady-state long-run growth rate in Year +6 and beyond. The analyst believes that the growth rate will most likely be zero but could reasonably fall in the range between +6 and −6 percent per year; so the analyst derived the range of Year +6 dividends shown in the following table. Assuming a 15 percent cost of capital, the table shows the range of possible continuing values (in millions) for the firm in present value at the beginning of the continuing value period (that is, the beginning of Year +6) and in present value as of today; that is, the continuing value is discounted to today using a factor of $1/(1.15)^5$:

[12] This formula is simply the algebraic simplification for the present value of a growing perpetuity.

Dividends in Year T	Long-Run Growth Assumption	Dividends in Year T+1	Perpetuity with Growth Factor	Continuing Value in Present Value as of: Beginning of Year T+1	Today
$30.00	0%	$30.00	$1/(0.15 - 0.0)$ = 6.67	$200.00	$ 99.44
$30.00	+6%	$31.80	$1/(0.15 - 0.06)$ = 11.11	$353.30	$175.65
$30.00	−6%	$28.20	$1/(0.15 + 0.06)$ = 4.76	$134.23	$ 66.74

Analysts also can estimate continuing value using a multiple of dividends in the first year of the continuing value period. The following table shows the continuing value multiples using $1/(R - g)$ for various costs of equity capital and growth rates. The multiples increase with growth for a given cost of capital, and they decrease as the cost of capital increases for a given level of growth.

Continuing Value Multiples

Cost of Equity Capital	Long-Run Growth Rates					
	0%	2%	3%	4%	5%	6%
6%	16.67	25.00	33.33	50.00	100.00	na
8%	12.50	16.67	20.00	25.00	33.33	50.00
10%	10.00	12.50	14.29	16.67	20.00	25.00
12%	8.33	10.00	11.11	12.50	14.29	16.67
15%	6.67	7.69	8.33	9.09	10.00	11.11
18%	5.56	6.25	6.67	7.14	7.69	8.33
20%	5.00	5.56	5.88	6.25	6.67	7.14

The continuing value computation using the perpetuity-with-growth valuation model does not work when the growth rate equals or exceeds the discount rate (that is, when $g \geq R$) because the denominator in the computation is zero or negative and the resulting continuing value estimate is meaningless. In this case, the analyst cannot use the perpetuity computation illustrated here. Instead, the analyst must forecast dividend amounts for each year beyond the forecast horizon using the terminal period growth rate and then discount each year's dividends to present value using the discount rate. The analyst also should reconsider whether it is realistic to expect the firm's dividends growth rate to exceed the discount rate (the expected rate of return) in perpetuity. This scenario can exist for some years, but is not likely to be sustainable indefinitely. Competition, technological change, new entrants into an industry, and similar dynamic factors eventually reduce growth rates.

An alternative approach for estimating the continuing value is to use the dividends multiples for comparable firms that currently trade in the market. The analyst identifies comparable companies by studying characteristics such as industry, firm size and age, past growth rates in dividends, profitability, risk, and similar factors. Chapter 14 discusses valuation multiples in more depth.

Because of the uncertainty inherent in long-run growth rate forecasts and because continuing value amounts are commonly large proportions of value estimates, analysts should

conduct sensitivity analysis to assess how sensitive the firm value estimate is to variations in the long-run growth assumption. For example, suppose an analyst is valuing a young high-growth company and can reliably forecast dividends five years into the future. After that horizon, the analyst expects the firm to grow at 6 percent per year, although this is highly uncertain, and long-run growth could range from −3 percent per year to as much as 9 percent per year. The analyst should conduct sensitivity analysis on the projections and valuation, varying long-run growth across the range from −3 to 9 percent per year.

Using the Dividends Valuation Model to Value PepsiCo

At the end of 2008, trading in PepsiCo shares on the New York Stock Exchange closed at $54.77 per share, which is the price at which an investor can buy or sell PepsiCo shares. But what is the value of these shares? The valuation of PepsiCo shares uses the techniques described in this chapter and the forecasts developed in Chapter 10. The forecasts and valuation estimates are developed using the Forecast and Valuation spreadsheets in FSAP.

We estimate the present value of a share of common equity in PepsiCo at the end of 2008 (equivalently, the start of Year +1) using the risk-adjusted rate of return on PepsiCo's equity capital as the appropriate discount rate. A prior section of this chapter computed the PepsiCo equity cost of capital to be 8.5 percent. Exhibit 11.5 summarizes the computations of PepsiCo's dividends in Years +1 to +5. Discounting these future dividends using a discount rate of 8.50 percent yields a present value estimate of $24,699.3 million. Exhibit 11.6 illustrates these computations, and Exhibit 11.7 (see page 917) presents the dividend valuation model from FSAP.

To compute the present value of continuing value of PepsiCo's dividends in Year +6 and beyond, we project that continuing dividends will grow at a 3 percent rate in perpetuity, consistent with long-run average growth in the economy. We forecast Year +6 dividends as follows:

$$D_6 = [NI_5 \times (1 + g)] + BV_5 - [BV_5 \times (1 + g)]$$
$$= [\$8,427.3 \text{ million} \times 1.03] + \$16,453.6 \text{ million} - [\$16,453.6 \text{ million} \times 1.03]$$
$$= \$8,680.1 \text{ million} + \$16,453.6 \text{ million} - \$16,947.2 \text{ million}$$
$$= \$8,186.5 \text{ million}$$

We use the perpetuity-with-growth model to discount dividends in the continuing value period to present value as of the beginning of Year +6 (the beginning of the continuing value period) using PepsiCo's 8.50 percent cost of equity capital, as follows (allowing for rounding):

$$\text{Continuing Value}_0 = [D_6 \times (1/\{R_E - g\})]$$
$$= \$8,186.5 \text{ million} \times [1/(0.085 - 0.030)]$$
$$= \$8,186.5 \text{ million} \times 18.18182$$
$$= \$148,845.45 \text{ million}$$

We then discount the continuing value as of the beginning of Year +6 to present value, as follows (allow for rounding):

$$\text{Present Value of Continuing Value}_0 = \$148,845.45 \text{ million} \times [1/\{1 + R_E\}^5]$$
$$= \$148,845.45 \text{ million} \times [1/\{1 + 0.085\}^5]$$
$$= \$148,845.45 \text{ million} \times 0.665$$
$$= \$98,988.9 \text{ million}$$

EXHIBIT 11.6

Valuation of PepsiCo
Present Value of Dividends to Common Equity
Year +1 through Year +5 and Beyond

	Valuation of Dividends in Year +1 through Year +5				
	Year +1	Year +2	Year +3	Year +4	Year +5
Total Dividends to Common Equity (from Exhibit 11.5)	$ 5,488.8	$5,790.7	$6,274.8	$6,868.3	$7,297.1
Present Value Factors ($R_E = 8.50\%$)	0.922	0.849	0.783	0.722	0.665
Present Value of Dividends	$ 5,058.8	$4,919.0	$4,912.6	$4,956.0	$4,852.9
Sum of Present Value Dividends, Years +1 through +5	$24,699.3				

Continuing Value Based on Dividends in Year + 6 and Beyond

Project Year +6 Dividends:

$D_6 = [NI_5 \times (1 + g)] + BV_5 - [BV_5 \times (1 + g)]$

$= [\$8,427.3 \text{ million} \times 1.03] + \$16,453.6 \text{ million} - [\$16,453.6 \text{ million} \times 1.03]$

$= \$8,680.1 \text{ million} + \$16,453.6 \text{ million} - \$16,947.2 \text{ million}$

$= \$8,186.5 \text{ million}$

Present Value of Continuing Value ($R_E = 8.50\%$ and $g = 3.0\%$):

Present Value of Continuing Value$_0 = D_6 \times [1 / (R_E - g)] \times [1 / (1 + R_E)^5]$

$\qquad = \$8,186.5 \text{ million} \times [1 / (0.085 - 0.030)] \times [1 / (1 + 0.085)^5]$

$\qquad = \$8,186.5 \text{ million} \times 18.18182 \times 0.665$

$\qquad = \$98,988.9 \text{ million}$

Total Value of PepsiCo's Dividends

Present Value of Dividends through Year +5	$ 24,699.3 million
+ Present Value of Continuing Value	+ 98,988.9 million
Present Value of Common Equity	$123,688.2 million
Adjust for Midyear Discounting (multiply by 1 + [R_E/2])	× 1.0425
Total Present Value of Common Equity	$128,945.0 million
Divide by Number of Shares Outstanding	/ 1,553 million
Value per Share of PepsiCo Common Equity	= $ 83.03

The total present value of PepsiCo's free cash flows to common equity shareholders is the sum of these two parts:

Present Value of Dividends through Year +5	$ 24,699.3 million
Present Value of Continuing Value	98,988.9 million
Present Value of Common Equity	$123,688.2 million

EXHIBIT 11.7

Valuation of PepsiCo
Present Value of Dividends to Common Equity Year +1 through Year +5 and Beyond Using the Dividends Valuation Model in FSAP

Dividends-Based Valuation	Year +1	Year +2	Year +3	Year +4	Year +5	Continuing Value Year +6
Dividends Paid to Common Shareholders	$ 3,015.3	$3,324.5	$3,818.5	$4,398.5	$4,848.3	$8,186.50
Less: Common Stock Issues	(26.5)	(33.8)	(43.7)	(30.2)	(51.2)	
Plus: Common Stock Repurchases	2,500.0	2,500.0	2,500.0	2,500.0	2,500.0	
Dividends to Common Equity	$ 5,488.8	$5,790.7	$6,274.8	$6,868.3	$7,297.1	
Present Value Factors	0.922	0.849	0.783	0.722	0.665	
Present Value of Net Dividends	$ 5,058.8	$4,919.0	$4,912.6	$4,956.0	$4,852.9	
Sum of Present Value Net Dividends	$ 24,699.3					
Present Value of Continuing Value	98,988.9					
Total	$123,688.2					
Adjust to midyear discounting	1.0425					
Total Present Value Dividends	$128,945.0					
Shares Outstanding	1,553.0					
Estimated Value per Share	$ 83.03					
Current Share Price	$ 54.77					
Percent difference	52%					

Midyear Discounting

Present value calculations like those illustrated earlier discount amounts for full periods. Thus, the valuation computations include Year $+1$ dividends discounted for a full year, Year $+2$ dividends discounted for two full years, and so on, which is appropriate if the dividends being discounted occur at the end of each year. Dividends often occur throughout the period. If this is the case, present value computations with full-year discounting will overdiscount these flows. To avoid overdiscounting, the analyst can compute the present value discount factors as of the midpoint of each year, thereby effectively discounting the dividends as if they occur, on average, in the middle of each year. Suppose the analyst uses a discount rate of 10 percent ($R = 0.10$). The Year $+1$ dividends would be discounted from the middle of Year $+1$ using a factor of $1/(1 + R)^{0.5} = 1/(1.10)^{0.5} = 0.9535$; the Year $+2$ dividends would be discounted from the middle of Year $+2$ using a factor of $1/(1 + R)^{1.5} = 1/(1.10)^{1.5} = 0.8668$; and so on. The analyst also can use a shortcut approach to this correction by adjusting the total present value to a midyear approximation by adding back one-half year of discounting. To make this midyear adjustment, the analyst multiplies the total present value of the discounted dividends by a factor of $1 + (R/2)$. For example, if $R = 0.10$, the midyear adjustment is 1.05 [$= 1 + (0.10/2)$]. The Valuation spreadsheet computations in FSAP use this shortcut adjustment.[13]

Applying the midyear discounting adjustment to the computation of the present value of PepsiCo dividends results in the following:

Present Value of Common Equity	$123,688.2 million
Midyear Adjustment Factor [$= 1 + (0.085/2)$]	\times 1.0425
Total Present Value of Common Equity	$128,945.0 million

Computing Common Equity Value per Share

Dividing the total present value of common equity of $128,945.0 million by 1,553 million shares outstanding indicates that PepsiCo's common equity shares have a value of $83.03 per share. We will obtain identical value estimates for PepsiCo when we apply the free cash flows to equity valuation model in Chapter 12 and the residual income valuation model in Chapter 13.

Sensitivity Analysis and Investment Decision Making

One should not place too much confidence in the *precision* of firm value estimates using these (or any) forecasts over the remaining life of any firm, even a mature firm such as PepsiCo. Although we have constructed these forecasts and value estimates with care, the forecasting and valuation process has an inherently high degree of uncertainty and estimation error. Therefore, the analyst should not rely too heavily on any one point estimate of the value of a firm's shares and instead should describe a reasonable range of values for a firm's shares.

[13] The valuation models described in this chapter estimate the present value of the firm as of the first day of the first year of the forecast horizon; for example, January 1 of Year $+1$ for a firm with an accounting period that matches the calendar year. However, analysts estimate valuations every day of the year. Suppose the analyst values a firm as of June 17 and compares the value estimate to that day's market price. A present value calculation that determines the value of the firm as of January 1 will ignore the value accumulation between January 1 and June 17 of that year. To refine the calculation, the analyst can adjust the present value as of January 1 to a present value as of June 17 by multiplying V_0 by a future value factor that reflects value accumulation for the appropriate number of days (in this case, 168 days). For example, if the valuation date is June 17 and if $R = 0.10$, the analyst can update the January 1 value estimate by multiplying V_0 by $(1 + R)^{(168/365)} = (1 + 0.10)^{(168/365)} = 1.0448$.

Two critical forecasting and valuation parameters in most valuations are the long-run growth rate assumption and the cost of equity capital assumption. Analysts should conduct sensitivity analysis to test the effects of these and other key valuation parameters and forecast assumptions on the share value estimate. Sensitivity analysis tests should allow the analyst to vary these valuation parameters individually and jointly for additional insights into the correlation between share values, growth rates, and discount rate assumptions.

For PepsiCo, the base case assumptions indicate PepsiCo's share value to be roughly $83. The base case valuation assumes a long-run growth rate of 3.0 percent and a cost of equity capital of 8.50 percent. The sensitivity of the estimates of PepsiCo's share value can be assessed by varying these two parameters (or any other key parameters in the valuation) across reasonable ranges. Exhibit 11.8 contains the results of sensitivity analysis varying the long-run growth rate from 0–10 percent and the cost of equity capital from 5–20 percent. The data in Exhibit 11.8 show that as the discount rate increases, holding growth constant, share value estimates of PepsiCo fall. Likewise, value estimates fall as growth rates decrease, holding discount rates constant. Note that we omit value estimates from this analysis when the assumed growth rate equals or exceeds the assumed discount rate because the continuing value computation is meaningless.

Considering the downside possibilities first, sensitivity analysis should consider how sensitive the share value estimate for PepsiCo is to adverse changes in long-run growth and discount rates. For example, by reducing the long-run growth assumption from 3.0 percent to 2.0 percent while holding the discount rate constant at 8.50 percent, PepsiCo share value falls to $73.36, still well above current market price. In fact, reducing the long-run growth assumption to zero, while holding the discount rate constant at 8.50 percent, PepsiCo's

EXHIBIT 11.8

Valuation of PepsiCo
Sensitivity Analysis of Value to Growth and Equity Cost of Capital

		Long-Run Growth Assumptions							
		0%	2%	3%	4%	5%	6%	8%	10%
Discount	5%	105.16	160.50	229.67	437.20				
Rates:	6%	87.18	120.00	152.81	218.45	415.34			
	7%	74.37	95.73	114.41	145.56	207.85	394.72		
	8.50%	60.84	73.36	83.03	97.00	118.95	158.47	711.69	
	9%	57.34	68.04	76.06	87.30	104.14	132.22	356.87	
	10%	51.41	59.41	65.13	72.75	83.42	99.42	179.45	
	11%	46.57	52.71	56.94	62.37	69.61	79.75	120.30	323.07
	12%	42.55	47.37	50.58	54.59	59.76	66.64	90.73	163.00
	13%	39.16	43.00	45.50	48.55	52.37	57.28	72.98	109.63
	14%	36.26	39.37	41.35	43.73	46.63	50.26	61.15	82.93
	15%	33.76	36.30	37.90	39.78	42.04	44.80	52.70	66.90
	16%	31.57	33.68	34.98	36.50	38.29	40.44	46.35	56.21
	18%	27.95	29.44	30.33	31.35	32.53	33.90	37.47	42.83
	20%	25.08	26.16	26.79	27.51	28.31	29.24	31.55	34.79

share value estimate falls to $60.84, still above current market price. Similarly, increasing the discount rate from 8.5 percent to 9.0 or 10.0 percent while holding constant the long-run growth assumption at 3.0 percent, PepsiCo shares have a value of roughly $76 or $65, respectively, above current market price. If we revise both assumptions at once, and reduce the long-run growth assumption to 2.0 percent and increase the discount rate assumption to 10.0 percent, PepsiCo's share value falls to roughly $59.

On the upside, reducing the discount rate to 7.0 percent while holding growth constant at 3.0 percent or increasing the long-run growth assumption from 3.0 to 4.0 percent while holding the discount rate constant at 8.50 percent, the value estimates jump to roughly $114 per share or $97 per share, respectively. If we reduce the discount rate assumption further, or increase the long-run growth rate further, the share value estimates for PepsiCo jump dramatically higher. For example, increasing the growth rate assumption to 4.0 percent and decreasing the discount rate assumption to 7.0 percent moves the share value estimate to more than $145.

These data suggest that the value estimate is sensitive to slight variations in the baseline assumptions of 3.0 percent long-run growth and an 8.50 percent discount rate, which yield a share value estimate of $83. Adverse variations in valuation parameters could reduce PepsiCo's share value estimates to $55 or lower, whereas favorable variations could increase PepsiCo's share value to over $100.

If the forecast and valuation assumptions are realistic, the baseline value estimate for PepsiCo is $83 per share at the end of 2008. At that time, the market price of $54.77 per share indicates that PepsiCo shares were underpriced by about 52 percent. Under the forecast assumptions, PepsiCo's share value could vary within a range of a low of $51 per share to a high of $114 per share with only minor perturbations in the growth rate and discount rate assumptions. Given PepsiCo's $54.77 share price, these value estimates would have supported a buy recommendation or perhaps a strong buy recommendation at the end of 2008 because the valuation sensitivity analysis reveals limited downside potential but substantial upside potential for the value of PepsiCo shares.

Evaluation of the Dividends Valuation Method

The principal *advantages* of the dividends valuation method include the following:

- This valuation method focuses on dividends. Economists argue that dividends provide the classical approach to valuing shares. Dividends reflect the payoffs that shareholders can consume.
- Projected amounts of dividends result from projecting expected amounts of revenues, expenses, assets, liabilities, and shareholders' equity. Therefore, they reflect the implications of the analyst's expectations for the future operating, investing, and financing decisions of a firm.

The principal *disadvantages* of the dividends valuation method include the following:

- The continuing value (terminal value) tends to dominate the total value in many cases. For firms that do not pay periodic dividends or repurchase shares, the continuing value can comprise the total value of the firm, which requires the analyst to forecast the future value of the firm in order to compute the present value of the firm. Continuing value estimates are sensitive to assumptions made about growth rates after the forecast horizon and discount rates.
- The projection of dividends can be time-consuming for the analyst, making it costly when the analyst follows many companies and must regularly identify under- and overvalued firms.

SUMMARY

This chapter illustrated the computation of risk-adjusted required rates of return on equity and the weighted average cost of capital, which analysts use as discount rates in valuation models. In valuation, analysts use these discount rates to compute the present value of future dividends, cash flows, or earnings. This chapter also described the dividends valuation model and applied it to value PepsiCo at the end of 2008. As with the preparation of projected financial statements in Chapter 10, the reasonableness of the valuations depends on the reasonableness of the forecast assumptions and the valuation parameters. The analyst should assess the sensitivity of the valuation to alternative long-run growth and discount rate parameters and to other key drivers of value. To validate value estimates using the dividends valuation approach, the analyst also should compute the value of the firm using other approaches, such as the free-cash-flows-based approaches discussed in Chapter 12, the earnings-based approaches discussed in Chapter 13, and the valuation multiples approaches described in Chapter 14.

QUESTIONS, EXERCISES, PROBLEMS, AND CASES

Questions and Exercises

11.1 THE RISK-RETURN TRADE-OFF. Explain why analysts and investors use risk-adjusted expected rates of return as discount rates in valuation. Why do risk-adjusted expected rates of return increase with risk?

11.2 THE COMPONENTS OF THE CAPM. The CAPM computes expected rates of return using the following model (described in the chapter):

$$E[R_{Ej}] = E[R_F] + \beta_j \times \{E[R_M] - E[R_F]\}$$

Explain the role of each of the three components of this model.

11.3 NONDIVERSIFIABLE AND DIVERSIFIABLE RISK FACTORS. Identify the types of firm-specific factors that increase a firm's nondiversifiable risk (systematic risk). Identify the types of firm-specific factors that increase a firm's diversifiable risk (idiosyncratic risk or nonsystematic risk). Why do models of risk-adjusted expected returns include no expected return premia for diversifiable risk?

11.4 DEBT AND THE WEIGHTED AVERAGE COST OF CAPITAL. Why do investors typically accept a lower risk-adjusted rate of return on debt capital than equity capital? Suppose a stable, financially healthy, profitable, tax-paying firm that has been financed with all equity and no debt decides to add a reasonable amount of debt to its capital structure. What effect will that change in capital structure likely have on the firm's weighted average cost of capital?

11.5 THE DIVIDENDS VALUATION APPROACH. Explain the theory behind the dividends valuation approach. Why are dividends value-relevant to common equity shareholders?

11.6 MEASURING VALUE-RELEVANT DIVIDENDS. The chapter describes how the dividends valuation approach measures value-relevant dividends to encompass

various transactions between the firm and the common shareholders. What transactions should the analyst include in value-relevant dividends for purposes of implementing the dividends valuation model? Why?

11.7 FIRMS THAT DO NOT PAY PERIODIC DIVIDENDS. Why is the dividends valuation approach applicable to firms that do not pay periodic (quarterly or annual) dividends?

11.8 VALUATION APPROACH EQUIVALENCE. Conceptually, why should an analyst expect the dividends valuation approach to yield equivalent value estimates to the valuation approach that is based on free cash flows available to be distributed to common equity shareholders?

11.9 DIVIDEND POLICY IRRELEVANCE. The chapter asserts that dividends are value-relevant even though the firm's dividend policy is irrelevant. How can that be true? What is the key assumption in the theory of dividend policy irrelevance?

Problems and Cases

11.10 CALCULATING REQUIRED RATES OF RETURN ON EQUITY CAPITAL ACROSS DIFFERENT INDUSTRIES. The data in Exhibit 11.3 on industry median betas suggest that firms in the following three sets of related industries have different degrees of systematic risk.

	Median Beta during 1999–2007
Utilities versus Petroleum Refining	0.32 versus 0.65
Grocery Stores versus Retailing—Apparel	0.50 versus 1.08
Depository Institutions (such as Banks) versus Security and Commodity Brokers	0.39 versus 1.24

Required

a. For each matched pair of industries, describe factors that characterize a typical firm's business model in each industry. Describe how such factors would contribute to differences in systematic risk.

b. For each matched pair of industries, use the CAPM to compute the required rate of return on equity capital for the median firm in each industry. Assume that the risk-free rate of return is 4.0 percent and the market risk premium is 5.0 percent.

c. For each matched pair of industries, compute the present value of a stream of $1 dividends for the median firm in each industry. Use the perpetuity-with-growth model and assume 3.0 percent long-run growth for each industry. What effect does the difference in systematic risk across industries have on the per dollar dividend valuation of the median firm in each industry?

11.11 CALCULATING THE COST OF CAPITAL. Whirlpool manufactures and sells home appliances under various brand names. IBM develops and manufactures computer hardware and offers related technology services. Target Stores operates a chain of general merchandise discount retail stores. Selected data for these companies appear in the following table (dollar amounts in millions). For each firm, assume that the market value of the debt equals its book value.

	Whirlpool	IBM	Target Stores
Total Assets	$13,532	$109,524	$44,106
Interest-Bearing Debt	$ 2,597	$ 33,925	$18,752
Average Pretax Borrowing Cost	6.1%	4.3%	4.9%
Common Equity:			
Book Value	$ 3,006	$ 13,465	$13,712
Market Value	$ 2,959	$110,984	$22,521
Income Tax Rate	35.0%	35.0%	35.0%
Market Equity Beta	2.27	0.78	1.20

Required

a. Assume that the intermediate-term yields on U.S. government Treasury securities are roughly 3.5 percent. Assume that the market risk premium is 5.0 percent. Compute the cost of equity capital for each of the three companies.

b. Compute the weighted average cost of capital for each of the three companies.

c. Compute the unlevered market (asset) beta for each of the three companies.

d. Assume for this part that each company is a candidate for a potential leveraged buy-out. The buyers intend to implement a capital structure that has 75 percent debt (with a pretax borrowing cost of 8.0 percent) and 25 percent common equity. Project the weighted average cost of capital for each company based on the new capital structure. To what extent do these revised weighted average costs of capital differ from those computed in Part b?

11.12 CALCULATION OF DIVIDENDS-BASED VALUE.

Royal Dutch Shell is a petroleum and petrochemicals company. It engages primarily in the exploration, production, and sale of crude oil and natural gas and the manufacture, transportation, and sale of petroleum and petrochemical products. The company operates in approximately 200 countries worldwide—in countries in North America, Europe, Asia-Pacific, Africa, South America, and the Middle East. During 2006–2008, Royal Dutch Shell generated the following total dividends to common equity shareholders (in USD millions):

	2006	2007	2008
Common Dividend Payments	$ 8,142	$ 9,001	$ 9,516
Stock Repurchases	8,047	4,387	3,573
Total Dividends	$16,189	$13,388	$13,089

Analysts project 5 percent growth in earnings over the next five years. Assuming concurrent 5 percent growth in dividends, the following table provides the amounts that analysts project for Royal Dutch Shell's total dividends for each of the next five years. In Year +6, total dividends are projected for Royal Dutch Shell assuming that its income statement and balance sheet will grow at a long-term growth rate of 3 percent.

	Year +1	Year +2	Year +3	Year +4	Year +5	Year +6
Projected Growth	5%	5%	5%	5%	5%	3%
Projected Total Dividends to Common Equity	$13,743	$14,431	$15,152	$15,910	$16,705	$17,206

At the end of 2008, Royal Dutch Shell had a market beta of 0.71. At that time, yields on intermediate-term U.S. Treasuries were roughly 3.5 percent. Assume that the market required a 5.0 percent risk premium. Royal Dutch Shell had 6,241 million shares outstanding at the end of 2008 that traded at a share price of $24.87.

Required

 a. Calculate the required rate of return on equity for Royal Dutch Shell as of the beginning of Year +1.

 b. Calculate the sum of the present value of total dividends for Year +1 through +5.

 c. Calculate the continuing value of Royal Dutch Shell at the start of Year +6 using the perpetuity-with-growth model with Year +6 total dividends. Also compute the present value of continuing value as of the beginning of Year +1.

 d. Compute the total present value of dividends for Royal Dutch Shell as of the beginning of Year +1. Remember to adjust the present value for midyear discounting.

 e. Compute the value per share of Royal Dutch Shell as of the beginning of Year +1.

 f. Given the share price at the start of Year +1, do Royal Dutch Shell shares appear underpriced, overpriced, or correctly priced?

11.13 VALUING THE EQUITY OF A PRIVATELY HELD FIRM. Refer to the financial statement forecasts for Massachusetts Stove Company (MSC) prepared for Case 10.2. The management of MSC wants to know the equity valuation implications of adding gas stoves under the best, most likely, and worst case scenarios. Under the three scenarios from Case 10.2, the actual amounts of net income and common shareholders' equity for Year 7 and the projected amounts for Year 8–Year 12 are as follows:

	Actual	Projected				
	Year 7	Year 8	Year 9	Year 10	Year 11	Year 12
Best-Case Scenario:						
Net Income	$154,601	$148,422	$123,226	$173,336	$ 271,725	$ 390,639
Common Equity	$552,080	$700,502	$823,728	$997,064	$1,268,789	$1,659,429
Most Likely Scenario:						
Net Income	$154,601	$135,343	$ 74,437	$ 72,899	$ 109,357	$ 149,977
Common Equity	$552,080	$687,423	$761,860	$834,759	$ 944,116	$1,094,093
Worst-Case Scenario:						
Net Income	$154,601	$128,263	$ 18,796	$(39,902)	$ (58,316)	$ (77,156)
Common Equity	$552,080	$680,343	$699,139	$659,238	$ 600,921	$ 523,766

MSC is not publicly traded and therefore does not have a market equity beta. Using the market equity beta of the only publicly traded woodstove and gas stove manufacturing firm and adjusting it for differences in the debt-to-equity ratio, income tax rate, and privately owned status of MSC yields a cost of equity capital for MSC of 13.55 percent.

Required

 a. Use the clean surplus accounting approach to derive the projected total amount of MSC's dividends to common equity shareholders in Years 8 through 12.

 b. Given that MSC is a privately held company, assume that ending book value of common equity at the end of Year 12 is a reasonable estimate of the value at which the

common shareholders' equity could be liquidated. Calculate the value of the equity of MSC as of the end of Year 7 under each of the three scenarios. Ignore the midyear discounting adjustment.

c. How do these valuations affect your advice to the management of MSC about adding gas stoves to its woodstove line?

11.14 DIVIDENDS-BASED VALUATION OF COMMON EQUITY.
Problem 10.16 projected financial statements for Walmart for Years +1 through +5. The following data for Walmart include the actual amounts for 2008 and the projected amounts for Year +1 to Year +5 for comprehensive income and common shareholders' equity (assuming Walmart will use implied dividends as the financial flexible account to balance the balance sheet; amounts in millions).

	Actual	Projected				
	2008	**Year +1**	**Year +2**	**Year +3**	**Year +4**	**Year +5**
Comprehensive Income	$ 6,848	$ 13,995	$ 15,024	$ 16,126	$ 17,306	$ 18,569
Common Shareholders' Equity:						
Paid-In Capital	$ 4,313	$ 4,744	$ 5,219	$ 5,741	$ 6,315	$ 6,946
Retained Earnings	63,660	68,692	77,018	80,957	93,955	97,024
Accumulated Other Comprehensive Income	(2,688)	(2,688)	(2,688)	(2,688)	(2,688)	(2,688)
Total Common Equity	$ 65,285	$ 70,749	$ 79,549	$ 84,010	$ 97,582	$101,282

The market equity beta for Walmart at the end of 2008 was 0.80. Assume that the risk-free interest rate was 3.5 percent and the market risk premium was 5.0 percent. Walmart had 3,925 million shares outstanding at the end of 2008, and share price was $46.06.

Required

a. Use the CAPM to compute the required rate of return on common equity capital for Walmart.

b. Compute the weighted average cost of capital for Walmart as of the start of Year +1. At the end of 2008, Walmart had $42,218 million in outstanding interest-bearing debt on the balance sheet and no preferred stock. Assume that the balance sheet value of Walmart's debt is approximately equal to the market value of the debt. Assume that at the start of Year +1, Walmart will incur interest expense of 5.0 percent on debt capital and that Walmart's average tax rate is 34.2 percent.

c. Use the clean surplus accounting approach to derive the projected dividends for Walmart for Years +1 through +5 based on the projected comprehensive income and shareholders' equity amounts.

d. Use the clean surplus accounting approach to project the continuing dividend in Year +6. Assume that the steady-state long-run growth rate will be 3 percent in Year +6 and beyond.

e. Using the required rate of return on common equity from Part a as a discount rate, compute the sum of the present value of dividends for Walmart for Years +1 through +5.

f. Using the required rate of return on common equity from Part a as a discount rate and the long-run growth rate from Part d, compute the continuing value of Walmart as of the beginning of Year +6 based on Walmart's continuing dividends in Years +6

and beyond. After computing continuing value, bring continuing value back to present value at the start of Year +1.

g. Compute the value of a share of Walmart common stock. (i) Compute the sum of the present value of dividends including the present value of continuing value. (ii) Adjust the sum of the present value using the midyear discounting adjustment factor. (iii) Compute the per-share value estimate.

h. Using the same set of forecast assumptions as before, recompute the value of Walmart shares under two alternative scenarios. Scenario 1: Assume that Walmart's long-run growth will be 2 percent, not 3 percent as before, and assume that Walmart's required rate of return on equity is 1 percentage point higher than the rate you computed using the CAPM in Part a. Scenario 2: Assume that Walmart's long-run growth will be 4 percent, not 3 percent as before, and assume that Walmart's required rate of return on equity is 1 percentage point lower than the rate you computed using the CAPM in Part a. To quantify the sensitivity of your share value estimate for Walmart to these variations in growth and discount rates, compare (in percentage terms) your value estimates under these two scenarios with your value estimate from Part g.

i. What reasonable range of share values would you expect for Walmart common stock? Where is the current price for Walmart shares relative to this range? What do you recommend?

INTEGRATIVE CASE 11.1

STARBUCKS

Dividends-Based Valuation of Starbucks' Common Equity

Integrative Case 10.1 projected financial statements for Starbucks for Years +1 through +5. This portion of the Starbucks Integrative Case applies the techniques in Chapter 11 to compute Starbucks' required rate of return on equity and share value based on the dividends valuation model. This case also compares the value estimate to Starbucks' share price at the time of the case development to provide an investment recommendation.

The market equity beta for Starbucks at the end of 2008 was 0.58. Assume that the risk-free interest rate was 4.0 percent and the market risk premium was 6.0 percent. Starbucks had 735.5 million shares outstanding at the end of 2008, and share price was $14.17.

Required

a. Use the CAPM to compute the required rate of return on equity capital for Starbucks.

b. Compute the weighted average cost of capital for Starbucks as of the start of Year +1. At the start of Year +1, Starbucks had $1,263 million in outstanding interest-bearing debt on the balance sheet and no preferred stock. Assume that the balance sheet value of Starbucks' debt is approximately equal to the market value of the debt. Assume that at the start of Year +1, Starbucks will incur interest expense of 6.25 percent on debt capital and that Starbucks' average tax rate is 36.0 percent.

c. From your forecasts of Starbucks' financial statements for Years +1 through +5, derive the projected dividends using the projected amounts for the plug to dividends less the net amounts of common stock issued each year (if any). Then compute projected dividends for Starbucks for Years +1 through +5 using the clean surplus accounting approach based on projected amounts for comprehensive income and

common shareholders' equity. The projected amounts of dividends under the two approaches should be identical.

d. Use the clean surplus accounting approach to project the continuing dividend in Year +6. Assume that the steady-state long-run growth rate will be 3 percent in Year +6 and beyond.

e. Using the required rate of return on common equity capital from Part a as a discount rate, compute the sum of the present value of dividends for Starbucks for Years +1 through +5.

f. Using the required rate of return on common equity capital from Part a as a discount rate and a 3.0 percent long-run growth rate, compute the continuing value of Starbucks as of the beginning of Year +6 based on Starbucks' continuing dividends in Year +6 and beyond. After computing continuing value, bring continuing value back to present value at the start of Year +1.

g. Compute the value of a share of Starbucks' common stock. (i) Compute the sum of the present value of dividends including the present value of continuing value. (ii) Adjust the sum of the present value using the midyear discounting adjustment factor. (iii) Compute the per-share value estimate.

h. Using the same set of forecast assumptions as before, recompute the value of Starbucks shares under two alternative scenarios. Scenario 1: Assume that Starbucks' long-run growth will be 2 percent, not 3 percent as before, and assume that Starbucks' required rate of return on equity is 1 percentage point higher than the rate you computed using the CAPM in Part a. Scenario 2: Assume that Starbucks' long-run growth will be 4 percent, not 3 percent as before, and assume that Starbucks' required rate of return on equity is 1 percentage point lower than the rate you computed using the CAPM in Part a. To quantify the sensitivity of your estimate of share value for Starbucks to variations in long-run growth and discount rates, compare (in percentage terms) your value estimates under these two scenarios with your value estimate from Part f.

i. What reasonable range of share values would you expect for Starbucks' common stock? Where is the current price for Starbucks' shares relative to this range? What do you recommend?

Chapter 12

Valuation: Cash-Flow-Based Approaches

Learning Objectives

1 Understand cash-flow-based valuation models and their conceptual and practical strengths and weaknesses.

2 Apply practical techniques to deal with many of the difficult issues involved in estimating firm value using the present value of expected future free cash flows:

 a. Risk, discount rates, and the cost of capital

 b. Cash flows to the investor versus cash flows to the firm

 c. Nominal versus real cash flows

 d. Pretax versus after-tax cash flows

 e. The forecast horizon

 f. Computation of continuing value

3 Measure free cash flows for all debt and equity capital stakeholders as well as free cash flows for common equity shareholders and understand when each measure is appropriate.

4 Understand the reasons for discounting free cash flows for common equity shareholders using a required rate of return on equity capital and discounting free cash flows for all debt and equity capital stakeholders using a weighted average cost of capital.

5 Apply all of these techniques to estimate firm value using the present value of future free cash flows for common equity shareholders and the present value of future free cash flows for all debt and equity capital stakeholders.

6 Assess the sensitivity of firm value estimates to key valuation parameters such as discount rates and expected long-term growth rates.

INTRODUCTION AND OVERVIEW

This chapter relies heavily on the financial statement forecasts developed for PepsiCo in Chapter 10, as well as the valuation concepts and techniques introduced and applied in Chapter 11. This chapter extends valuation methodology to encompass free-cash-flows-based valuation approaches and applies these valuation approaches to PepsiCo.

As introduced in Chapter 11, economic theory teaches that the value of an investment equals the present value of the expected future payoffs from the investment, discounted at a rate that reflects the risk inherent in those expected payoffs. The general model for estimating the present value of a security (denoted as V_0 with present value denoted at time $t=0$) with an expected life of n future periods is as follows:[1]

$$V_0 = \sum_{t=1}^{n} \frac{\text{Expected Future Payoffs}_t}{(1 + \text{Discount Rate})^t}$$

Valuation methods such as the dividends-based valuation methods demonstrated in the previous chapter, the free-cash-flows-based methods demonstrated in this chapter, and the earnings-based methods demonstrated in the next chapter are all designed to produce reliable estimates of the value of the firm's equity shares. The value estimates that these approaches produce provide the basis for intelligent investment decisions because even in relatively efficient securities markets, price does not necessarily equal value for every security at all times. Price is observable, but value is not; value must be estimated. Therefore, estimating the value of a security is a common objective of financial statement analysis. The financial statement analysis and valuation process enables investors, analysts, portfolio managers, investment bankers, and corporate managers to determine a reliable appraisal of the value of shares of common equity. Comparing value to price then yields a reliable basis to assess whether a firm's equity shares are underpriced, overpriced, or fairly priced in the capital markets.

Whether an analyst will produce reliable estimates of share value as a result of the financial statement analysis and valuation process depends entirely on whether the analyst carefully and thoughtfully applies each step of the process. The six-step analysis framework that forms the structure of this book (Exhibit 1.2 in Chapter 1) is a logical set of steps that enables the analyst to determine reliable estimates of value. Following the first three steps, the analyst should first understand the economics of the industry, then assess the particular firm's strategy, and then carefully evaluate the quality of the firm's accounting, making adjustments if necessary. In the fourth step, the analyst should evaluate the firm's profitability and risk with a set of financial ratios. All of this information should provide the analyst with a solid foundation of information to use in the fifth step, projecting the firm's future financial statements. The analyst can then use those financial statement forecasts to derive expectations of future earnings, cash flows, and dividends, which are the fundamental payoff measures used in valuation. In the sixth and final step, the analyst applies valuation models to these expectations to estimate the value of the firm. Forecasts of expected future payoffs (the numerator in the valuation model) depend on forecasts of future earnings, cash flows, or dividends. Assessing an appropriate risk-adjusted discount rate (the denominator in the valuation model) requires an unbiased assessment of the inherent riskiness in the set of expected future payoffs. Therefore, reliable estimates of firm value depend on unbiased expectations of future payoffs and an appropriate risk-adjusted discount rate, all of which depend on all six steps of the framework.

As explained in the previous chapter, when the analyst derives forecasts of future earnings, cash flows, and dividends from a set of internally consistent financial statement forecasts for a firm and uses the same discount rate in correctly specified models to compute

[1] In this chapter, as in the previous chapter, t refers to accounting periods. The valuation process determines an estimate of firm value, denoted as V_0, in present value as of today, when $t=0$. The period $t=1$ refers to the first accounting period being discounted to present value. Period $t=n$ is the period of the expected final payoff.

present values, the expected earnings, cash flows, and dividends valuation models will yield *identical* estimates of value for a firm. We applied the dividends-based valuation approach to PepsiCo and estimated that, given our forecast assumptions and valuation parameters, PepsiCo's share value should be within a fairly narrow range of around $83 at the time of our analysis. This chapter illustrates the equivalence of the dividends and free cash flows valuation approaches, both in the theoretical development of the models and in their application to the valuation of PepsiCo. The next chapter will describe and apply the earnings-based valuation approach and demonstrate its theoretical and practical equivalence with both the dividends and free cash flows approaches.[2]

It is important that analysts understand the similarities and differences in the dividends, cash flows, and earnings valuation approaches and see their theoretical and practical equivalence. Our experience strongly suggests that applying several different valuation approaches yields better insights about the value of a firm than relying on one approach in all cases. In addition, it is our experience that an analyst is better equipped to work successfully with clients, managers, colleagues, and subordinates in the financial statement analysis and valuation process if the analyst thoroughly understands all three valuation approaches.

All four valuation chapters—Chapters 11–14—emphasize that the objective of the valuation process is not a single point estimate of value per se. Instead, the objective is to determine the distribution of value estimates across the relevant ranges of critical forecast assumptions and valuation parameters. By assessing the sensitivity of value estimates across a distribution of relevant forecast assumptions and valuation parameters, we seek to determine the most likely range of values for a share, which we then compare to the share's current price for an intelligent investment decision.

RATIONALE FOR CASH-FLOW-BASED VALUATION

As we demonstrated in the previous chapter, the value of a share of common equity is the present value of the expected future dividends.[3] Dividends are fundamental expected future payoffs that analysts can use to value shares because they represent the distribution of wealth to shareholders. The equity shareholder invests cash to purchase the share and then receives cash through dividends as the payoffs from holding the share, including the final "liquidating" dividend when the investor sells the share. In dividends-based valuation, we define *dividends* broadly to encompass all cash flows from the firm to the common equity shareholders through periodic dividend payments, stock buybacks, and the liquidating dividend, as well as cash flows from the shareholders to the firm when the firm issues shares (negative dividends).

Cash-flow-based valuation and dividends-based valuation can be considered two sides to the same coin: the analyst can value the firm based on the cash flows into the firm that will be used to pay dividends or, equivalently, value the firm using cash flows the firm pays out in dividends to common shareholders. In the cash flows approach, we focus on the cash that flows *into* the firm; in the dividends approach we focus on the cash that flows *out of* the firm. Instead of focusing on wealth distribution through dividends, the cash-flow-based

[2] For examples of research on the complementarity of these approaches, see Stephen Penman and Theodore Sougiannis, "A Comparison of Dividend, Cash Flow, and Earnings Approaches to Equity Valuation," *Contemporary Accounting Research* 15, no. 3 (Fall 1998), pp. 343–383, and Jennifer Francis, Per Olsson, and Dennis Oswald, "Comparing the Accuracy and Explainability of Dividend, Free Cash Flow, and Abnormal Earnings Equity Value Estimates," *Journal of Accounting Research* 38, no. 1 (Spring 2000), pp. 45–70.

[3] John Burr Williams, *The Theory of Investment and Value* (Cambridge, Mass.: Harvard University Press, 1938).

approach focuses on cash flows generated by the firm that create dividend-paying capacity. In any given period, the amount of cash flow into the firm and the amount of dividends paid out of the firm will likely differ; the equivalence of these two valuation approaches arises because over the lifetime of the firm the cash flows into and out of the firm will be equivalent.

The cash-flow-based valuation approach measures and values the cash flows that are "free" to be distributed to shareholders. That is, *free cash flows* are the cash flows each period that are available for distribution to shareholders, unencumbered by necessary reinvestments in operating assets or required payments to debtholders. Free cash flows can be used instead of dividends as the value-relevant measures of expected future payoffs to the investor in the numerator of the general value model set forth at the outset of this chapter. Both approaches, if implemented with consistent assumptions, will lead to identical estimates of value.

The rationale for using expected free cash flows in valuation is twofold and is essentially the same rationale for using dividends, as follows:

- Cash is the ultimate source of value. When individuals and firms invest in an economic resource, they delay current consumption in favor of future consumption. Cash is the medium of exchange that will permit them to consume various goods and services in the future. A resource has value because of its ability to provide future cash flows. The free cash flows approach measures value based on the cash flows that the firm generates that can be distributed to investors.
- Cash is a measurable common denominator for comparing the future benefits of alternative investment opportunities. One might compare investment opportunities involving the holding of a bond, a stock, or an office building, but comparing these alternatives requires a common measuring unit of their future benefits. The future cash flows derived from their future services serve such a function.

FREE-CASH-FLOWS-BASED VALUATION CONCEPTS

The following sections describe and illustrate these key concepts in free-cash-flows-based valuation methods:

- Risk, discount rates, and the cost of capital
- Cash flows to the investor versus cash flows to the firm
- Nominal versus real cash flows
- Pretax versus after-tax cash flows
- The forecast horizon
- Computation of continuing value

These concepts are the same underlying concepts described in the previous chapter in presenting dividends-based valuation methods. Therefore, we will briefly review those concepts here and describe how they apply to free cash flows valuation. Refer back to the previous chapter for more detailed explanations of these concepts.

We first describe computing discount rates to use in free-cash-flows-based valuation, including required rates of return on equity capital and weighted average costs of capital. We then present simple examples involving a single project. Next, we confront conceptual measurement issues regarding cash flows to the investor versus cash flows to the firm, nominal versus real cash flows, and pretax versus after-tax cash flows. We also address forecast horizons and continuing value. A later section of this chapter describes how to compute free cash flows to equity shareholders versus free cash flows to all debt and equity stakeholders. Later in the chapter, we also illustrate the free cash flow valuation approaches by

valuing PepsiCo using free cash flows derived from the projected financial statements developed in Chapter 10.

Risk, Discount Rates, and the Cost of Capital

The general valuation model described at the beginning of the chapter is a present value model, so the analyst must determine an appropriate discount rate to use to measure future payoffs in present value. This section briefly reviews the computation of the required rate of return on equity capital and the weighted average cost of capital.

Cost of Common Equity Capital

When discounting the free cash flows available to common equity shareholders, the analyst should use a risk-adjusted required rate of return on equity capital. As described in more depth in the previous chapter, analysts commonly estimate the cost of equity capital using an expected return model such as the CAPM (capital asset pricing model). The CAPM assumes that the market is composed of risk-averse investors who demand a rate of return that (1) compensates them for forgoing the consumption of capital and (2) compensates them with a risk premium for bearing systematic (nondiversifiable) risk. Systematic risk arises from economy-wide factors (such as economic growth or recession, unemployment, unexpected inflation, unexpected changes in prices for natural resources such as oil and gas, unexpected changes in exchange rates, and population growth) that affect all firms to varying degrees and therefore cannot be fully diversified. The amount of the risk premium for a particular stock depends on the level of the firm's systematic risk.

Analysts often measure systematic risk using the firm's market beta, which is estimated as the slope coefficient from regressing the firm's stock returns on an index of returns on a marketwide portfolio of stocks over a relevant period of time.[4] Market beta is an estimate of systematic risk based on the degree of covariation between a firm's stock returns and an index of stock returns for all firms in the market. If a firm's market beta from such a regression is equal to 1, it indicates the firm's stock returns covary identically with returns to a marketwide portfolio, indicating that the firm has the same degree of systematic risk as the market as a whole. If a firm's market beta is greater than or less than 1, the firm has a greater or lesser degree of systematic risk than the market portfolio as a whole.

The CAPM computes the expected return on common equity capital for Firm j as follows:

$$E[R_{Ej}] = E[R_F] + \beta_j \times \left\{ E[R_M] - E[R_F] \right\}$$

where E denotes that the related variable is an expectation; R_{Ej} denotes return on common equity in Firm j; R_F denotes the risk-free rate of return; β_j denotes the market beta for Firm j; and R_M denotes the return on a diversified, marketwide portfolio of stocks (such as the S&P 500). According to the CAPM, a common equity security with no systematic risk (that is, a stock with $\beta_j = 0$) should be expected to earn a return equal to the expected rate of return on risk-free securities. The subtraction term in brackets in the preceding equation represents the average market risk premium, equal to the return that equity investors in the capital markets require for bearing the average amount of systematic risk in the market portfolio. An equity security with systematic risk equal to the average amount of systematic

[4] Researchers and analysts have developed a variety of approaches to estimate market betas. For example, one common approach estimates a firm's market beta by regressing the firm's monthly stock returns on a marketwide index of returns (such as the S&P 500) over the last 60 months.

risk of all equity securities in the market has a market beta equal to 1 and should expect to earn the same rate of return as the average stock in the market portfolio.

Note that the CAPM views firm-specific nonsystematic risk as diversifiable by the investor. Nonsystematic risk factors would include, for example, the industry and product portfolio of the firm, the sustainability of the firm's strategy, and the firm's ability to generate revenue growth and control expenses. According to CAPM, a competitive equilibrium capital market does not expect a return for a firm's nonsystematic risk because such risk can be diversified away in a portfolio of stocks.

Computing the Weighted Average Cost of Capital

In some circumstances, the analyst may want to value all of the assets of a firm rather than directly value the common equity of the firm. In such circumstances, the analyst should discount to present value the free cash flows that the assets will generate that will be available to satisfy all of the debt and equity claims that finance the assets of the firm. In these circumstances, analysts commonly use a weighted average cost of capital that reflects the relative proportions of debt, preferred, and common equity capital the firm will use to finance the assets and the respective costs of each type of capital. Such circumstances might arise, for example, if the analyst is considering acquiring all of the assets of a firm or acquiring all of the financial claims (common equity shares, preferred shares, and debt) through a merger with the firm. Therefore, the analyst determines the present value of the future free cash flows available to satisfy all of the firm's financing using a discount rate that reflects the weighted average cost of the debt, preferred, and common equity capital the firm uses to finance the net operating assets.

A formula for the weighted average cost of capital (denoted as R_A to indicate that the discount rate is the required rate of return applicable to the net operating *assets* of the firm) is given here:

$$R_A = [w_D \times R_D \times (1 - \textit{tax rate})] + [w_P \times R_P] + [w_E \times R_E]$$

In this formula, the subscripts D, P, and E refer to different types of capital (debt, preferred stock, and common equity, respectively); w denotes the weight on each type of capital; R denotes the cost of each type of capital; and *tax rate* denotes the tax rate applicable to tax deductions for debt capital costs. The weights used to compute the weighted average cost of capital should be the market values of each type of capital in proportion to the total market value of the capital structure that will be used to finance the firm (that is, $w_D + w_P + w_E = 1.0$). On the right-hand side of this equation, the first term in brackets measures the weighted after-tax cost of debt capital, the second term measures the weighted cost of preferred stock capital, and the third term measures the weighted cost of equity capital. Refer to the previous chapter for more detailed discussions and examples of computing the cost of debt, preferred, and common equity capital.

Free Cash Flows Valuation Examples for a Single-Asset Firm

For the next three examples, make the following assumptions:

- The firm consists of a single asset that will generate net cash flows of $2 million per year forever.
- The income tax rate is 40 percent.

- After making debt service payments and paying taxes, the firm pays dividends to distribute any remaining free cash flows to the equity shareholders each year.
- The cost of equity capital is 10 percent.

Example 1: Value of Common Equity in an All-Equity Firm

Assume that the common equity shareholders have financed the asset entirely with $10 million of equity capital. We can determine the value of the common equity investment to the shareholders using the present value of free cash flows for common equity shareholders. The free cash flow to common equity shareholders each year will be as follows:

Net Cash Flow	$2,000,000
Income Taxes: 0.40 × $2,000,000	(800,000)
Free Cash Flow for Common Equity Shareholders	$1,200,000

The value to the shareholders of the common equity in the firm is $12,000,000 (= $1,200,000/0.10). Dividing by the discount rate is appropriate because the $1.2 million annual free cash flow for common equity is a perpetuity with no growth. This investment is worth $12 million to those shareholders (a gain of $2 million over the original investment of $10 million) because of the present value of the free cash flows the investment will generate and that will in turn be paid out as dividends to the shareholders. Therefore, we would determine the same value for the investment using the dividends-based valuation model as shown in Example 5 in Chapter 11.

Example 2: Value of Common Equity in a Firm with Debt Financing

For this example, we will make the same assumptions as in the preceding example, except we will now make the following additional assumptions to use both debt and equity financing:

- The equity shareholders finance a portion of the investment in the asset with $4 million of equity capital.
- The firm finances the remainder of the asset using $6 million of debt capital.
- This amount of debt in the firm's capital structure does not alter substantially the risk of the firm to the equity investors, so they continue to require a 10 percent rate of return.
- The debt is issued at par, and it is less risky than equity; so the debtholders demand interest of only 6 percent each year, payable at the end of each year.
- Interest expense is deductible for income tax purposes.

We can again determine the value of the common equity investment using the present value of free cash flows for common equity shareholders. Note that this example is essentially the same as Example 6 in Chapter 11, except that the valuation focus changes from dividends to free cash flows. The free cash flow available to common equity shareholders each year is as follows:

Net Cash Flow for All Debt and Equity Capital	$2,000,000
Interest Paid on Debt: 0.06 × $6,000,000	(360,000)
Income Taxes: 0.40 × ($2,000,000 − $360,000)	(656,000)
Free Cash Flow for Common Equity Shareholders	$ 984,000

The value of the common equity to the shareholders in the firm is \$9,840,000 (= \$984,000/0.10). Dividing by the discount rate is appropriate because the \$984,000 annual free cash flow for common equity is a perpetuity with no growth. Note that in this example, the present value of the gain to the common equity shareholders in excess of their initial investment is \$5,840,000 (= \$9,840,000 − \$4,000,000). The gain to the shareholders is \$3,840,000 (= \$5,840,000 − \$2,000,000) larger in this example than in the previous example because (1) the debt capital is less expensive than the equity capital (6 percent rather than 10 percent on \$6,000,000 of financing), creating \$2,400,000 of value for equity shareholders from capital structure leverage [= (\$6,000,000 × {0.10 − 0.06})/0.10], and (2) the net tax savings from interest expense creates \$1,440,000 of value for equity shareholders [= (\$800,000 − \$656,000)/0.10, or, alternatively, = (\$360,000 interest deduction × 0.40 tax rate)/0.10].

Example 3: Value of More Risky Common Equity in a Firm with Debt Financing

Now make the same assumptions as the preceding example except now assume that by changing the capital structure to 60 percent debt and 40 percent equity, the firm becomes more risky to the equity investors and they demand a 15 percent rate of return rather than 10 percent. Under these assumptions, the value of the common equity to the investors in the firm will be \$6,560,000 (= \$984,000/0.15). Note that in this example, the present value of the gain to the common equity investors in excess of their initial investment falls to \$2,560,000 (= \$6,560,000 − \$4,000,000). Because of the increased risk, the investors demand a higher rate of return; so the value for equity investors from the net tax savings from interest expense falls to \$960,000 [= (\$800,000 − \$656,000)/0.15] and the value for equity investors from capital structure leverage falls to \$1,600,000 (= \$2,560,000 − \$960,000).[5]

Cash Flows to the Investor versus Cash Flows to the Firm

The analyst can use expectations of the dividends to be paid to the investor or the free cash flows to be generated by the firm (that will ultimately be paid to the investor) as equivalent approaches to measure the value-relevant expected payoffs to shareholders. Cash flows paid to the investor via dividends and free cash flows that are available for common equity shareholders will differ each period to the extent that the firm reinvests a portion (or all) of the cash flows generated. However, if the firm generates a rate of return on reinvested free cash flow equal to the discount rate used by the investor (that is, the cost of equity capital), either set of payoffs (dividends or free cash flows) will yield the same valuation of a firm's shares. To demonstrate this equivalence, consider the following scenarios.

Example 4: Free Cash Flows with 100 Percent Payout

A firm expects to generate free cash flows of \$0.15 for each dollar of invested equity capital for the foreseeable future (until, for example, $t=n$). Considering the riskiness of the

[5] The lower value to equity investors from capital structure leverage is the net result of two effects. First, the increased risk of the firm causes the equity investors to increase the discount rate from 10 percent to 15 percent, which would (if considered in isolation) cause the value of the project to fall to \$8,000,000 (= \$1,200,000/0.15), which would imply a \$2,000,000 loss on the investors' \$10,000,000 investment. Second, the debt capital is less expensive than the equity capital, creating \$3,600,000 of value for equity investors from capital structure leverage [= (\$6,000,000 × {0.15 − 0.06})/0.15]. The net result is \$1,600,000 of value to equity investors from capital structure leverage, net of the incremental effects of risk.

firm, equity investors in this firm require a 15 percent return each year. We assume that the firm will pay out 100 percent of the free cash flows each year as a dividend. Thus, the free cash flows generated by the firm equal the cash dividends received by the investor each period. Each dollar of capital committed by the investor has a present value of future cash flows equal to one dollar. That is, over an indefinitely long period of time into the future,

$$\$1 = \sum_{t=1}^{n} \frac{\$0.15}{(1.15)^t}$$

Example 5: Free Cash Flows with Zero Payout

Assume the same facts as in Example 4 except that the firm will pay out none of the free cash flows as a dividend. The firm will retain the $0.15 free cash flow on each dollar of capital and reinvest it in projects expected to earn 15 percent return per year. In this case, the investor receives no periodic dividends and receives cash only when the investor sells the shares or the firm liquidates at date $t=n$. By the terminal date, n periods in the future, each dollar of capital invested in the firm today will have earned a compound rate of return of 15 percent, equal to the required rate of return. Therefore, each dollar of invested capital has a present value of future free cash flows equal to one dollar, as in the preceding example with full payout of free cash flows. That is,

$$\$1 = \frac{(\$1.15)^n}{(1.15)^n}$$

Example 6: Free Cash Flows with Partial Payout

Assume the same facts as in Example 5 except that the firm pays out 25 percent of the free cash flow each period as a dividend and reinvests the other 75 percent in projects expected to generate a return of 15 percent. In this case also, each dollar of invested capital has a present value of future cash flows equal to one dollar. That is,

$$\$1 = \sum_{t=1}^{n} \frac{(0.25)(\$0.15)}{(1.15)^t} + \frac{(0.75)(\$1.15)^n}{(1.15)^n}$$

We used these three examples in the previous chapter to illustrate the *relevance* of dividends as payoffs that are sufficient for valuation for equity shareholders and the *irrelevance* of the firm's dividend policy in valuation.[6] We use the same examples here to illustrate that the assumptions we make about dividend policy are the complementary assumptions we make about free cash flows reinvested in the firm. Therefore, *if the firm can be expected to reinvest cash flows to earn the required rate of return,* the same valuation should arise whether the analyst discounts (1) the expected dividends to the investor, or (2) the expected free cash flows to the firm that are available to pay future dividends to equity shareholders. Further, the same valuation should arise whether the firm pays all of its free cash flows as a dividend, reinvests all free cash flows to earn the investors' required rate of return, or pays

[6] Merton Miller and Franco Modigliani, "Dividend Policy, Growth and the Valuation of Shares," *Journal of Business* (October 1961), pp. 411–433. Penman and Sougiannis test empirically the replacement property of dividends for future earnings and find support for the irrelevance of dividend policy in valuation. See Stephen H. Penman and Theodore Sougiannis, "The Dividend Displacement Property and the Substitution of Anticipated Earnings for Dividends in Equity Valuation," *The Accounting Review* (January 1997), pp. 1–21.

a portion of free cash flows in dividends each period and reinvests the remainder to earn the investors' required rate of return. Note that the crucial assumption is that capital retained in the firm will generate a rate of return exactly equal to the investors' required rate of return.

Nominal versus Real Cash Flows

Changes in general price levels (that is, inflation or deflation) cause the purchasing power of the monetary unit to change over time.[7] The valuation of an investment in an economic resource should be the same whether one uses nominal or real free cash flow amounts as long as the valuation uses a consistent discount rate that is the nominal or real rate of return. That is, if projected free cash flows are nominal and include the effects of changes in general purchasing power of the monetary unit, the discount rate should be nominal and include an inflation component. If projected free cash flows are real amounts that filter out the effects of general price changes, the discount rate should be a real rate of return, excluding the inflation component.

Example 7: Nominal versus Real Free Cash Flows

A firm owns an asset that it expects to sell one year from today for $115.5 million. The firm expects the general price level to increase 10 percent during this period. The real interest rate is 5 percent. The nominal discount rate should be 15.5 percent to measure the compound effects of the real rate of interest and inflation $[0.155 = (1.10 \times 1.05) - 1]$. Discounting nominal or real free cash flows, the present value of the asset to the firm is $100 million, as shown:

Nominal Free Cash Flows	×	Discount Rate Including Expected Inflation	=	Value
$115.5 million	×	$1/(1.05 \times 1.10)$	=	$100 million

Real Free Cash Flows	×	Discount Rate Excluding Expected Inflation	=	Value
$115.5 million/1.10	×	$1/1.05$	=	$100 million

In both computations, we derived the value of the equity of the firm by computing the present value of the free cash flows to common equity shareholders. As a practical matter, analysts usually find it more straightforward to discount nominal free cash flows using nominal discount rates than to adjust nominal free cash flows to real free cash flows and then discount real free cash flows using real interest rates. Discount rates derived from the CAPM are nominal because the risk-free rate component incorporates expected inflation. Further, stated and effective interest rates on long-term debt also are nominal because they incorporate expected inflation rates. Thus, readily available or easily estimable discount

[7] Note that the issue here is not with specific price changes of a firm's particular assets, liabilities, revenues, and expenses. These specific price changes affect our projections of the firm's dividends, cash flows, and earnings and should enter into the valuation of the firm. The issue is whether some portion, all, or more than all of the specific price changes simply represent an economy-wide change in the purchasing power of the monetary unit, which should not affect the value of a firm.

rates relating to the cost of equity and debt capital are typically nominal rates, as are weighted average costs of capital.

Pretax versus After-Tax Free Cash Flows

Will the same valuation arise if the analyst discounts pretax-free cash flows at a pretax cost of capital and after-tax free cash flows at an after-tax cost of capital? The answer is no if costs of debt and equity capital receive different tax treatments. For tax purposes, firms can typically deduct the costs of debt capital but cannot deduct the costs of equity capital.

Example 8: Tax Effects on Free Cash Flows

Suppose the firm faces the following costs of capital:

	Proportion in Capital Structure	Pretax Cost	Tax Effect	After-Tax Cost	Weighted Average Cost of Capital Pretax	After-Tax
Debt	0.33	10%	0.40	6%	3.33%	2.00%
Equity	0.67	18%	—	18%	12.00%	12.00%
	1.00				15.33%	14.00%

Assume that this firm expects to generate $90 million of pretax-free cash flows and $54 million of after-tax free cash flows [$= (1 - 0.40) \times \$90$ million] one year from today. This firm would be valued using pretax and after-tax amounts (assuming a one-year horizon) as follows:

Pretax:	$90 million \times 1/1.1533 = $78.04 million
After-tax:	$54 million \times 1/1.14 = $47.37 million

These values are not equivalent because cash inflows from assets are taxed at 40 percent and cash outflows to service debt give rise to a tax savings of 40 percent. However, the cost of equity capital does not provide a tax benefit. The appropriate valuation in this case is $47.37 million. Thus, the analyst should use *after-tax* free cash flows and the *after-tax* cost of capital.

Selecting a Forecast Horizon

The analyst will need to project periodic free cash flows over the remaining expected life of the resource to be valued. This life is a finite number of years for a resource with a finite physical life, such as a machine or a building, or a financial instrument with a finite stated maturity, such as a bond, a mortgage, or a lease. But an equity security is a resource that has an indefinite life; therefore, the analyst must project future periodic free cash flows that, in theory, could extend to infinity. As a practical matter, the analyst cannot precisely predict a firm's free cash flows very many years into the future. Therefore, analysts develop specific projections of income statements and balance sheets for the firm and use them to derive forecasts of free cash flows over an explicit forecast horizon (for example, five or ten years) depending on the industry, the maturity of the firm, and the expected growth and predictability of the firm's cash flows. After the explicit forecast horizon, analysts then use general growth assumptions to project the future income statements and balance sheets and use them to derive the free cash flows that will persist each period to infinity. Therefore, the

analyst will find it desirable to develop specific forecasts of income statements, balance sheets, and free cash flows over an explicit forecast horizon that extends until the point when the firm's growth can be expected to settle into steady-state equilibrium, during which time free cash flows can be expected to grow at a steady, predictable rate.

Selecting a forecast horizon involves trade-offs. For stable and mature firms such as PepsiCo, one can develop reasonably reliable projections over longer forecast horizons, as demonstrated in Chapter 10. For young high-growth firms, it is more difficult to develop reliable projections of free cash flows over long forecast horizons because their future operating performance is relatively more uncertain. This difficulty is magnified by the fact that these firms will achieve a much higher proportion of their value in distant future years, after they reach their potential steady-state profitability. Ironically, the analyst faces the dilemma of depending most heavily on long-run forecasts for young growth firms for which long-run projections are most uncertain. The forecasting and valuation process is particularly difficult for growth firms when the near-term free cash flows are likely to be negative, as is common for rapidly growing firms that finance growth by issuing common stock. Most of the value of these firms depends on free cash flows they will generate in years far into the future.

Unfortunately, this dilemma is inevitable. The analyst must recognize that forecasts and value estimates for all firms have some degree of uncertainty and estimation risk. To mitigate this uncertainty and estimation risk, we suggest the following:

1. Apply all six steps of the analysis framework. By thoroughly analyzing the firm's industry and strategy, the firm's accounting quality, and the firm's financial performance and risk ratios, the analyst will have more information to use to develop long-term forecasts that are as reliable as possible.
2. To the extent possible, confront directly the problem of long-term uncertainty by developing specific projections of free cash flows derived from projected income statements and balance sheets that extend five or ten years into the future, at which point the firm may be projected to reach steady-state growth.
3. Assess the sensitivity of the forecast projections and value estimates across the reasonable range of long-term growth parameter assumptions.

Computing Continuing Value of Future Free Cash Flows

As described in the previous section, the analyst will find it desirable to forecast free cash flows over an explicit forecast horizon, until the point at which the firm's free cash flows growth will settle into a long-run steady-state growth rate. We refer to these free cash flows as *continuing free cash flows* because they reflect the free cash flows continuing into the long-run future of the firm. The long-run steady-state growth rate in future continuing free cash flows could be positive, negative, or zero. Steady-state growth in free cash flows could be driven by long-run expectations for growth attributable to economy-wide inflation, general economic productivity, the population, or demand for the industry's output. The analyst should select a growth rate that captures realistic expectations for the long run.

Once the analyst projects the firm's long-run steady-state growth rate (denoted as g) continuing after the end of the explicit forecast horizon (for example, after Year T), the analyst can derive the continuing free cash flows from the projected income statements and balance sheets. The same principles demonstrated in the previous chapter for projecting continuing dividends apply here in projecting continuing free cash flows. The analyst should use the expected long-run growth rate (g) to project all of the items of the Year T+1 income statement and balance sheet by multiplying each item on the Year T income statement and balance sheet times $(1 + g)$. The analyst can then derive the Year T+1 statement

of cash flows (and thus Year T+1 free cash flows) from the Year T+1 income statement and balance sheet projections. It is necessary to impose the long-run growth rate assumption $(1 + g)$ uniformly on the Year T income statement and balance sheet projections in order to derive the free cash flows for Year T+1 correctly. We assume that in steady state, the firm's assets, liabilities, and shareholders' equity (and therefore the firm's earnings, cash flows, and dividends) will all grow at equivalent rates. By applying a uniform growth rate, the analyst achieves internally consistent steady-state growth across all of the projections of the firm, keeping the balance sheet in balance throughout the continuing forecast horizon and keeping the cash flows, earnings, and dividends internally consistent with the assumed long-run growth rate.

In projecting continuing free cash flows in Year T+1 and beyond, analysts often assume that the firm's long-run sustainable growth rate will be consistent with inflation and long-run growth in the economy, on the order of 3–5 percent. For firms that have been growing more quickly than that (for example, at 10 percent) in the years leading up to Year T+1, the long-run sustainable growth rate implies that the firm will maintain a lower growth rate in assets and equity and thus generate substantially larger amounts of free cash flow. By projecting Year T+1 net income, assets, and equity using the long-run sustainable growth rate, we can solve for the long-run sustainable free cash flows the firm will generate. The continuing free cash flow amount we derive for Year T+1 may be significantly larger than the amounts the firm actually generated during its higher-growth-rate years. The Year T+1 free cash flow amount reflects the firm's transition from a high rate of reinvestment of cash flows for growth in assets to reinvestment for a much lower rate of growth, thereby creating the need to solve for the long-run sustainable free cash flows amount.

If the analyst wants to compute internally consistent and identical estimates of firm value using free cash flows, earnings, and dividends, he or she should *not* simply project free cash flows for Year T+1 by multiplying free cash flows for Year T by $(1 + g)$. Doing so ignores the necessary growth in all of the elements of the balance sheet and the income statement, which can introduce inconsistent forecast assumptions for cash flows, earnings, and dividends. Even if the analyst simply projects that Year T free cash flows, earnings, and dividends will grow at an identical rate $(1 + g)$ in Year T+1, doing so may impound inconsistent assumptions and lead to inconsistent value estimates if Year T cash flows, earnings, and dividends are not consistent with their long-run continuing amounts.

Example 9: Projecting Continuing Value Free Cash Flows

Suppose the analyst develops the following forecasts for the firm in Year T–1 and Year T:

	Assets	=	Liabilities	+	Shareholders' Equity
Year T–1 Balances	$100	=	$60	+	$40
+ Net Income	+20				+20
+ New Borrowing	+ 6		+6		
− Dividends Paid	−10				−10
Year T Balances	$116	=	$66	+	$50

Assume that the entire increase in assets involves growth in assets required for operations, such as inventory and equipment. The analyst would compute Year T free cash flows for common equity shareholders to equal $10 (= $20 net income − $16 increase in assets + $6 increase in liabilities). Now suppose the analyst projects that the firm will grow at a

steady-state rate of 10 percent in Year T+1 and thereafter. The analyst should project Year T+1 net income, assets, liabilities, and shareholders' equity to grow by 10 percent each and then compute Year T+1 free cash flows as follows:

	Assets	=	Liabilities	+	Shareholders' Equity
Year T Balances	$116.0	=	$66.0	+	$50.0
Growth	× 1.10		× 1.10		× 1.10
Year T+1 Balances	$127.6	=	$72.6	+	$55.0

The projected net income would be $22 (= $20 × 1.10). The Year T+1 free cash flow projection would be $17 (= $22 net income − $11.6 increase in assets + $6.6 increase in liabilities). However, if the analyst had simply projected Year T free cash flows to grow by 10 percent, the Year T+1 projections would be only $11 (= $10 Year T free cash flow × 1.10). By making this simple projection of free cash flows, the analyst is implicitly assuming that the $16 increase in assets in Year T will grow by 10 percent in Year T+1 (= $17.6 increase in assets). This is internally inconsistent with our long-run assumption of 10 percent growth in assets, liabilities, equity, and income growth. This will understate free cash flows to equity in Year T+1 by $6 (= $11.6 increase in assets − $17.6 increase in assets). This error will understate the estimated value of the firm using free cash flows, relative to the value estimate using earnings, because of the inconsistent assumptions. Note that the correct projected Year T+1 free cash flow amount of $17 is substantially larger than the $10 free cash flow amount for Year T. The reason the firm will generate larger amounts of free cash flow in Year T+1 and beyond is that the firm's long-run growth rate is 10 percent, which is lower than the Year T growth rate in assets (16 percent) and shareholders' equity (25 percent); thus, this firm will not need to reinvest as much of its cash flows to fund growth and will generate larger free cash flow amounts in Year T+1 and beyond.

As demonstrated for dividends in the previous chapter, once the analyst has computed free cash flows for Year T+1, he or she can compute continuing value (sometimes called terminal value) of future free cash flows for Years T+1 and beyond using the perpetuity-with-growth valuation model:[8]

$$\begin{array}{lll} \text{Continuing Value} & \text{Continuing} & \\ \text{at End of Forecast} & = & \text{Free Cash Flow} & \times & 1/(R - g) \\ \text{Horizon (Year T)} & \text{Projection for T+1} & \end{array}$$

where g denotes the projected steady-state growth rate for Years T+1 and beyond and is applied uniformly to project the income statement and balance sheet in Year T+1, which are then used to project the continuing free cash flows in Year T+1; R denotes the appropriate risk-adjusted discount rate. Once the analyst has computed the continuing value at the end of the forecast horizon (Year T), the analyst must discount continuing value from that point in time to present value today by multiplying by the present value factor of $1/(1 + R)^T$.

Example 10: Computing Continuing Value

An analyst forecasts that the free cash flow of a firm in Year +5 will be $30 million and that Year +5 earnings and dividends also will be $30 million. Assume for the simplicity of this

[8] This formula is simply the algebraic simplification for the present value of a growing perpetuity.

example that the analyst expects that the firm's income statements and balance sheets will grow uniformly over the long run and, therefore, that cash flows, earnings, and dividends will grow uniformly over the long run. But the analyst is uncertain about the steady-state long-run growth rate in Year +6 and beyond. He or she believes that the growth rate will most likely be zero but could reasonably fall between +6 and −6 percent per year. Assuming a 15 percent cost of capital, the following table shows the range of possible continuing values (in millions) for the firm at the beginning of the continuing value period (that is, the beginning of Year +6 or, equivalently, the end of Year +5) and in present value as of today; that is, the continuing value is discounted to today using a factor of $1/(1.15)^5$:

Free Cash Flows in Year T	Long-Run Growth Assumption	Free Cash Flows in Year T+1	Perpetuity with Growth Factor	Continuing Value in Present Value as of:	
				Beginning of Year T+1	Today
$30	0%	$30.00	$\dfrac{1}{(0.15 - 0.00)} = 6.67$	$200.00	$ 99.44
$30	+6%	$31.80	$\dfrac{1}{(0.15 - 0.06)} = 11.11$	$353.30	$175.65
$30	−6%	$28.20	$\dfrac{1}{(0.15 + 0.06)} = 4.76$	$134.23	$ 66.74

Analysts also can estimate a continuing value using a multiple of free cash flow in the first year of the continuing value period to value the common stock of a firm. The following table shows the cash flow multiples using $1/(R - g)$ for various costs of equity capital and growth rates. The multiples increase with growth for a given cost of capital, and they decrease as cost of capital increases for a given level of growth.

Continuing Value Multiples

Cost of Equity Capital	Long-Run Growth Rates					
	0%	2%	3%	4%	5%	6%
6%	16.67	25.00	33.33	50.00	100.00	na
8%	12.50	16.67	20.00	25.00	33.33	50.00
10%	10.00	12.50	14.29	16.67	20.00	25.00
12%	8.33	10.00	11.11	12.50	14.29	16.67
15%	6.67	7.69	8.33	9.09	10.00	11.11
18%	5.56	6.25	6.67	7.14	7.69	8.33
20%	5.00	5.56	5.88	6.25	6.67	7.14

The continuing value computation using the perpetuity-with-growth valuation model does not work when the growth rate equals or exceeds the discount rate (that is, when $g \geq R$) because the denominator in the computation is zero or negative and the resulting continuing value estimate is meaningless. In this case, the analyst cannot use the perpetuity computation illustrated here. Instead, the analyst must forecast free cash flow amounts for each year beyond the forecast horizon using the terminal period growth rate and then discount each year's cash flows to present value using the discount rate. The analyst also should

probably reconsider whether it is realistic to expect the firm's free cash flow growth rate to exceed the discount rate (the expected rate of return) in perpetuity. This scenario can exist for some years, but is not likely to be sustainable indefinitely. Competition, technological change, new entrants into an industry, and similar factors eventually reduce growth rates. Thus, in applying the model, the analyst must attempt to estimate the long-term sustainable growth rate in cash flows. (Refer to the discussion of sustainable earnings in Chapter 9.)

MEASURING PERIODIC FREE CASH FLOWS

This section first presents a conceptual framework for measuring free cash flows. Then it describes specific practical steps to measure free cash flows from two different perspectives—free cash flows to all debt and equity stakeholders and free cash flows to common equity shareholders—and when to use each free cash flow measure.

A Framework for Free Cash Flows

A conceptual framework for free cash flows to the firm emanates from the familiar balance sheet equation in which assets equal liabilities plus shareholders' equity:

$$A = L + SE$$

Recall from Chapter 5 the demonstration of an alternative ROCE decomposition into operating and financial leverage components. Using the same approach, separate all of the assets and liabilities into two categories: operating or financing:

$$OA + FA = OL + FL + SE$$

Operating assets (denoted as OA) and operating liabilities (denoted as OL) relate to the firm's day-to-day operations in the normal course of business. For most firms, operating assets include cash and short-term investment securities necessary for operating liquidity purposes; accounts receivable; inventory; property, plant, and equipment; intangible assets (for example, licenses, patents, trademarks, and goodwill); and investments in affiliated companies. Operating liabilities typically include accounts payable, accrued expenses, accrued taxes, deferred taxes, pension obligations, and other retirement benefits obligations.

Financial liabilities include interest-bearing liabilities that are part of the financial capital structure of the firm. Financial liabilities (denoted as FL) include such interest-bearing items as short-term notes payable; current maturities of long-term debt; and long-term debt in the forms of mortgages, bonds, notes, and capital lease obligations. Insofar as outstanding preferred stock contains features indicating that it is economically similar to debt (features such as limited life, mandatory redemption, and guaranteed dividends), the analyst should include preferred stock with financial liabilities.

In some circumstances, firms may hold financial assets (denoted as FA) such as excess cash and short-term or long-term investment securities to provide the firm with liquidity to repay debt, pay dividends, and repurchase common stock. Distinguishing financial assets that the firm will use to change its financial capital structure from cash and marketable securities the firm will use for liquidity for operating purposes requires a judgment call by the analyst. Analysts consider financial assets to be part of the financial structure of the firm if the firm is likely to use the financial assets to offset or retire debt or if the financial assets could be used to pay dividends or repurchase common equity shares. For example, such financial assets may exist if a firm is accumulating cash or investment securities for purposes of retiring debt, if a firm is required to hold certain amounts of restricted cash or

investment securities under a loan covenant (such as required compensating cash balances), or if a firm is maintaining and accumulating a sinking fund for bond retirement under the terms of a bond debenture. Analysts typically do not consider financial assets to be part of the financial capital structure of a firm when the financial assets are necessary to manage the liquidity needs of the firm's operating activities across different seasons or business cycles and the assets are held in liquid interest-earning accounts such as cash and cash equivalents, marketable securities, and short-term investment securities. Analysts also typically do not consider financial assets to be part of the financial capital structure of the firm when the financial assets include investment securities that are part of the long-term strategy of the firm, such as investments in affiliated subsidiaries with related operating activities or strategic investments in potential acquisition targets.[9] Capital held in these types of accounts for purposes of operating liquidity or strategic investments in securities of affiliated companies or potential takeover targets should be considered operating assets, not financial assets.

Once the analyst has separated the balance sheet into operating and financing components, he or she should rearrange the balance sheet equation to put operating accounts on one side and financing accounts and shareholders' equity on the other side, as follows:

$$OA - OL = FL - FA + SE,$$

which is equivalent to

$$NetOA = NetFL + SE$$

where $NetOA = OA - OL$ and $NetFL = FL - FA$. For most firms, operating assets are likely to exceed operating liabilities and financial liabilities are likely to exceed financial assets. (Financial borrowing usually exceeds financial assets because the firm uses the funds obtained from borrowing to purchase operating assets.)

This rearrangement of the balance sheet provides a useful basis from which to conceptualize free cash flows to the firm. If we substitute for each term the present values of the expected future net cash flows associated with operating activities, financing activities, and shareholders' equity, we can express the balance sheet in the following cash flow terms:

> *Present Value of Net Cash Flows from Operations*
> *= Present Value of Net Cash Flows Available for Debt Financing*
> *+ Present Value of Net Cash Flows Available for Shareholders' Equity*

This expression indicates that the present value of the expected net cash flows from operations of the firm determines the sum of the values of the debt and equity claims on the firm.[10] Therefore, one can estimate the value of the debt and equity capital of the firm by

[9] The calculation of the rate of return on assets, or ROA, in Chapter 4 assumed that all assets were operating assets and that operating income is equal to net income excluding the after-tax cost of financial liabilities. Thus, Chapter 4 made no adjustment to eliminate interest income on financial assets from net income in the numerator of ROA and no adjustment to eliminate financial assets in the denominator. Most manufacturing, retailing, and service firms hold only minor amounts of financial assets, so ignoring adjustments for financial assets does not usually introduce a material amount of bias to the calculation of ROA. A more precise calculation of ROA for firms with a material amount of financial assets in the capital structure adjusts the numerator to eliminate interest income and adjusts the denominator of ROA for the portions of financial assets (cash, marketable securities, and investment securities) that are part of the financial capital structure and are not directly related to operating activities.

[10] The next section explains how our use of Net Cash Flows from Operations in this section differs from Cash Flow from Operations reported in the Statement of Cash Flows.

projecting the net cash flows from operations that are "free" to service debt and equity claims and discounting those free cash flows to present value. We refer to this measure of free cash flows as *the free cash flows for all debt and equity capital stakeholders* because they reflect the cash flows that are available to the debt and equity capital stakeholders in the firm as a whole.

We can rearrange the balance sheet equation slightly further:

$$NetOA - NetFL = SE$$

Using the same present value cash flow terms as before, we can express this form of the balance sheet in terms of present values of expected future cash flows as follows:

> *Present Value of Net Cash Flows from Operations*
> *− Present Value of Net Cash Flows Available for Debt Financing*
> *= Present Value of Net Cash Flows Available for Shareholders' Equity*

With this expression, we can conceptualize free cash flows specifically attributable to the equity shareholders of the firm. The present value of free cash flows produced by the operations of the firm minus the present value of cash flows necessary to service claims of the net debtholders yields *free cash flows available for common equity shareholders*. This measure captures the net free cash flows available to equity shareholders after debt claims are satisfied.

Free Cash Flows Measurement

The following sections describe how to measure free cash flows from the two perspectives described above—*free cash flows for all debt and equity capital stakeholders* and *free cash flows for common equity shareholders*—and when to use each free cash flow measure. In practice, different analysts compute free cash flows from various starting points: the statement of cash flows, net income, EBITDA (earnings before interest, tax, depreciation, and amortization), and NOPAT (net operating profit adjusted for tax). We describe how to measure free cash flows from each starting point.

Measuring Free Cash Flows: The Statement of Cash Flows as the Starting Point

Under U.S. GAAP and IFRS, firms report the statement of cash flows by decomposing the net change in cash into operating, investing, and financing activity components. These three categories do not match the operating and financing classifications we need for computing free cash flows. Thus, the analyst needs to reclassify some of the components of the statement of cash flows to compute free cash flows for valuation purposes. Exhibit 12.1 describes the computation of each of these two measures of free cash flows.

Cash flow from operations from the projected statement of cash flows is the most direct starting point for computing both measures of free cash flows because it requires the fewest adjustments. Recall from Chapter 3 that the statement of cash flows measures cash flow from operations by beginning with net income, adding back any non-cash expenses or losses (such as depreciation and amortization expenses), subtracting any non-cash income or gains (such as income from equity method affiliates), and then adjusting for net cash flows for operating activities (such as changes in receivables, inventory, accounts payable, and accrued expenses).

EXHIBIT 12.1

Measurement of Free Cash Flows

Free Cash Flows for All Debt and Equity Stakeholders:

Operating Activities:

Cash Flow from Operations
 Begin with cash flow from operations on the projected statement of cash flows.

+/– Net Interest after Tax
 Add back interest expense and subtract interest income, net of tax effects.

+/– Changes in Cash Requirements for Liquidity
 Subtract an increase or add a decrease in cash required for purposes of liquidity for operations.

= *Free Cash Flows from Operations for All Debt and Equity*

Investing Activities:

+/– Net Capital Expenditures
 Subtract cash outflows for capital expenditures and add cash inflows from sales of assets that comprise the productive capacity of the operations of the firm (including property, plant, and equipment; affiliated companies; and intangible assets).

= *Free Cash Flows for All Debt and Equity Stakeholders*

Free Cash Flows for Common Equity Shareholders:

Operating Activities:

Cash Flow from Operations
 Begin with cash flow from operations on the projected statement of cash flows.

+/– Changes in Cash Requirements for Liquidity
 Subtract an increase or add a decrease in cash required for purposes of liquidity for operations.

= *Free Cash Flows from Operations for Equity*

Investing Activities:

+/– Net Capital Expenditures
 Subtract cash outflows for capital expenditures and add cash inflows from sales of assets that comprise the productive capacity of the operations of the firm (including property, plant, and equipment; affiliated companies; and intangible assets).

Financing Activities:

+/– Debt Cash Flows

Add cash inflows from new borrowings or subtract cash outflows from repayments of short-term and long-term interest-bearing debt.

+/– Financial Asset Cash Flows

Subtract cash outflows invested in cash, short-term, and long-term investment securities (or add cash inflows from these accounts) if these financial assets are deemed to be part of the financial capital structure of the firm and are not part of the operating activities of the firm.

+/– Preferred Stock Cash Flows

Add cash inflows from new issues of preferred stock or subtract cash outflows from preferred stock retirements and dividend payments.

= *Free Cash Flows for Common Equity Stakeholders*

Free Cash Flows for All Debt and Equity Capital Stakeholders

Free cash flows for all debt and equity capital stakeholders are the cash flows available to make interest and principal payments to debtholders, redeem preferred shares or pay dividends to preferred shareholders, and pay dividends and buy back shares from common equity shareholders. To measure these free cash flows, we begin with cash flow from operations from the projected statement of cash flows, as shown in the left-hand side of Exhibit 12.1. To measure cash flow from operations before the effects of the firm's financial capital structure, the analyst must add back the interest expense on financial liabilities, net of any income tax savings from interest expense. If the analyst makes the judgment call that some or all of the firm's financial assets (such as excess cash holdings or marketable securities) are intended to retire debt and pay dividends and are part of the financial capital structure of the firm (rather than part of the operating liquidity management of the firm), the analyst should subtract the interest income on those financial assets, net of the income taxes paid on that interest income. To adjust interest expense and interest income for tax effects, the analyst typically multiplies interest expense and interest income by one minus the firm's marginal tax rate.[11]

The analyst also should add or subtract any change in the cash balance that the firm will require for operating liquidity. Cash that the firm must maintain for operating liquidity purposes is not available for distribution to debt or equity stakeholders and therefore is not part of free cash flow. For example, suppose an analyst is valuing a retail store chain and the chain must maintain the equivalent of seven days of sales in checking accounts and cash on hand at each store for purposes of conducting retail sales transactions. When the chain opens new stores, it is required to hold additional cash as part of operations (as it would need to hold additional inventory). These additional cash requirements are not available for debt and equity capital providers if the firm intends to maintain its operations. If the firm improves its cash management efficiency and reduces the amount of cash required for operating liquidity, the firm has additional free cash flow that can be distributed to debt or equity stakeholders. Procedurally, the analyst should project the required change in cash for working capital purposes each period and add or subtract that amount to determine free cash flow from operations for debt and equity stakeholders.

Next, the analyst adjusts for cash flows related to capital expenditures on long-lived assets that are a part of the firm's productive capacity (for example, property, plant, and equipment; affiliated companies; intangible assets; and other investing activities). The analyst should subtract cash outflows for purchases and add cash inflows from sales of these types of assets related to the firm's long-term productive activities. The analyst can measure the cash flows for capital expenditures and other investing activities that are part of the long-term productive activities of the firm by using the amounts reported in the investing activities section of the projected statement of cash flows.

As noted earlier, the analyst must make a judgment call about the amounts of the firm's financial assets (for example, in cash and cash equivalents, short-term securities, or long-term investment securities) that are (1) necessary for the liquidity and operating capacity of the firm or (2) part of the financial capital structure of the firm and therefore distributable to debt or equity stakeholders. For example, if the analyst projects that the firm will retain financial assets by saving some portion of its cash flows in a securities account each

[11] Technically, analysts should make these adjustments using the cash amounts of interest paid and interest received rather than the accrual amounts of interest expense and interest income. However, as a practical matter, it is reasonable to assume that forecasted amounts of interest expense will equal interest paid and forecasted amounts of interest income will equal interest received.

period and that this cash can ultimately be used to repay debt, pay dividends, or buy back shares, the analyst should deem these cash flows as free cash flows for debt and equity capital. For instance, the firm may be required by a bond indenture agreement to maintain a sinking fund of cash or liquid securities that will be available to repay the bond when it matures. In this case, the analyst should include the amount of cash added to the bond sinking fund as free cash flows for debt and equity capital.

This adjustment requires a judgment call by the analyst because in some circumstances, firms retain seemingly excess amounts of cash, marketable securities, or investment securities accounts when these assets are in fact not free for potential distribution to capital stakeholders. For example, in some cases, firms with seasonal business need to maintain large balances in cash or securities accounts in order to provide needed liquidity during particular seasons. In other cases, firms may build up large balances in investment securities accounts that represent investments in key affiliates, such as PepsiCo's and Coca-Cola's investments in bottling companies. In scenarios such as these, the analyst should not assess these cash flows as "free" for potential distribution to capital stakeholders, but instead should consider these cash flows necessary investments in the liquidity and productive capacity of the firm.

Together, these computations result in free cash flows for all debt and equity capital stakeholders, which are available to service debt, pay dividends to preferred and common shareholders, and buy back shares or for reinvestment. A later section describes the approach to estimate the present value of the sum of the debt and equity claims on the firm by discounting free cash flows for debt and equity capital using the weighted average cost of capital of the firm.

Free Cash Flows for Common Equity Shareholders

Free cash flows for common equity shareholders are the cash flows specifically available to the common shareholders after all debt service payments have been made to lenders and dividends have been paid to preferred shareholders. Therefore, the free cash flows for common equity shareholders amount to the free cash flows available to all debt and equity capital less any cash flows that are attributable to debt and preferred stock claims.

To measure free cash flows for common equity shareholders, we can again begin with cash flow from operations from the projected statement of cash flows, as presented in the right-hand side of Exhibit 12.1. As in the previous section, the analyst should add or subtract any change in the cash balance that the firm will require for operating liquidity because this cash is not available for distribution to equity shareholders and therefore is not part of free cash flow. Procedurally, the analyst should add or subtract the projected change in cash required for liquidity purposes each period.[12]

Also, as in the previous section, the analyst should adjust for cash flows for capital expenditures on long-lived assets that are a part of the firm's productive capacity (for example, property, plant, and equipment; affiliated companies; intangible assets; and other investing activities). The analyst should subtract cash outflows for purchases and add cash inflows from sales of assets related to the firm's long-term productive activities.

The analyst should incorporate cash flows related to debt claims by adding cash inflows from new borrowing in short- and long-term debt and subtracting cash outflows for repayments of short- and long-term debt. In calculating free cash flows to debt and equity capital, if

[12] Note that unlike the computation of free cash flows for all debt and equity stakeholders, we do not adjust for interest expense or interest income after tax when we compute free cash flows for equity. Our measure of free cash flow for equity already reflects net cash flows for interest payments for interest-bearing debt capital because the statement of cash flows starts with net income to compute cash flow from operations and because net income already reflects interest expense after tax.

the analyst made the judgment call that the firm saves financial capital beyond its immediate liquidity needs in a cash or investment securities account, these cash flows reflect financing activities. Therefore, the analyst must (1) subtract the amount of cash outflow used to purchase the securities because this cash obviously was not paid out to equity shareholders or (2) add the amount of cash inflow received from selling such securities because this cash inflow is available for distribution to equity shareholders. For example, if the firm maintains a bond sinking fund to be used for the eventual retirement of bonds when they mature, the cash invested in the sinking fund is clearly not free cash flows available for common equity shareholders. Finally, the analyst also should add cash inflows from new issues of preferred stock and subtract cash outflows from preferred-stock retirements and dividend payments.[13] These computations measure free cash flows for common equity shareholders. These cash flows are available to common equity shareholders for dividends, stock buybacks, or reinvestment. As described in a later section of this chapter, free cash flows for common equity should be discounted at the cost of equity capital to determine the present value of the common equity of the firm.

Measuring Free Cash Flows: Alternative Starting Points

In practice, different analysts use different starting points to compute free cash flows. The approaches described above used cash flow from operations from the projected statement of cash flows because it is the most direct starting point, requiring the fewest adjustments. However, some analysts compute free cash flows by beginning with projected net income, some start with EBITDA, and yet others start with NOPAT. Exhibit 12.2 describes the steps the analyst must take to adjust each of these starting points to determine free cash flows to all debt and equity stakeholders. Exhibit 12.3 (see page 952) describes the steps the analyst must take to adjust each of these starting points to determine free cash flows to common equity shareholders.

If the analyst starts with net income and wants to determine free cash flows for all debt and equity stakeholders, Exhibit 12.2 indicates that the analyst must add back all non-cash expenses (such as depreciation and amortization expenses), subtract all non-cash income items (such as accrued income from equity method affiliates), and adjust for cash flows related to changes in working capital accounts (such as cash flows related to changes in receivables, inventory, and payables). These adjustments bring the analyst up to our starting point, cash flow from operations. The analyst then incorporates the remaining steps by adjusting for net interest expense after tax, changes in cash requirements for liquidity, and capital expenditures.

Other analysts compute free cash flows for all debt and equity by starting with EBITDA, which already adds back non-cash income items for depreciation and amortization, interest expense (but usually not interest income) and *all* of the provision for income taxes. From this starting point, the analyst must adjust further by adding back any other non-cash expenses (apart from depreciation and amortization), adjust for non-cash income items, and adjust for cash flows related to working capital activities. In addition, because EBITDA adds back all of the provision for income taxes, the analyst must subtract cash taxes paid, net of tax saving on interest expense. These adjustments bring the analyst up

[13] It might seem inappropriate to include changes in debt and preferred stock financing, which appear in the financing section of the statement of cash flows, in the valuation of a firm. Economic theory suggests that the capital structure (that is, the proportion of debt versus equity) should not affect the value. Changes in debt and preferred stock, however, affect the amount of cash available to the common shareholders. The analyst includes cash flows related to debt and preferred stock financing in free cash flows for common equity shareholders but adjusts the cost of equity capital to reflect the amounts of such senior financing in the capital structure.

EXHIBIT 12.2

Measurement of Free Cash Flows for All Debt and Equity Stakeholders from Alternative Starting Points

Starting Point:

Net Income:	EBITDA:[a]	NOPAT:[b]
Operating Activities:	***Operating Activities:***	***Operating Activities:***
Net income	EBITDA	NOPAT
+ Add back all non-cash expenses	+ Add back all non-cash expenses other than depreciation and amortization	+ Add back all non-cash expenses
− Subtract all non-cash income items	− Subtract all non-cash income items	− Subtract all non-cash income items
+/− Working capital cash flows	+/− Working capital cash flows	+/− Working capital cash flows
+/− Net interest after tax	− Subtract cash taxes paid, net of tax savings on interest expense	
+/− Changes in cash requirements for liquidity	+/− Changes in cash requirements for liquidity	+/− Changes in cash requirements for liquidity
= ***Free Cash Flows from Operations for All Debt and Equity Stakeholders***	= ***Free Cash Flows from Operations for All Debt and Equity Stakeholders***	= ***Free Cash Flows from Operations for All Debt and Equity Stakeholders***
Investing Activities:	***Investing Activities:***	***Investing Activities:***
+/− Net capital expenditures	+/− Net capital expenditures	+/− Net capital expenditures
= ***Free Cash Flows for All Debt and Equity Stakeholders***	= ***Free Cash Flows for All Debt and Equity Stakeholders***	= ***Free Cash Flows for All Debt and Equity Stakeholders***

[a] EBITDA denotes earnings before interest, tax, depreciation, and amortization.
[b] NOPAT denotes net operating profit after tax, which equals net income adjusted for net interest expense after tax.

EXHIBIT 12.3

Measurement of Free Cash Flows for Common Equity Shareholders from Alternative Starting Points

Starting Point:

Net Income:

Operating Activities:
Net income
+ Add back all non-cash expenses

− Subtract all non-cash income items
+/− Working capital cash flows

+/− Changes in cash requirements for liquidity

= **Free Cash Flows from Operations for Equity**

Investing Activities:
+/− Net capital expenditures

Financing Activities:
+/− Debt cash flows
+/− Financial asset cash flows
+/− Preferred stock cash flows

= **Free Cash Flows for Common Equity Shareholders**

EBITDA:[a]

Operating Activities:
EBITDA
+ Add back all non-cash expenses other than depreciation and amortization
− Subtract all non-cash income items
+/− Working capital cash flows
− Subtract net interest expense
− Subtract taxes
+/− Changes in cash requirements for liquidity

= **Free Cash Flows from Operations for Equity**

Investing Activities:
+/− Net capital expenditures

Financing Activities:
+/− Debt cash flows
+/− Financial asset cash flows
+/− Preferred stock cash flows

= **Free Cash Flows for Common Equity Shareholders**

NOPAT:[b]

Operating Activities:
NOPAT
+ Add back all non-cash expenses

− Subtract all non-cash income items
+/− Working capital cash flows
− Subtract net interest expense after tax
+/− Changes in cash requirements for liquidity

= **Free Cash Flows from Operations for Equity**

Investing Activities:
+/− Net capital expenditures

Financing Activities:
+/− Debt cash flows
+/− Financial asset cash flows
+/− Preferred stock cash flows

= **Free Cash Flows for Common Equity Shareholders**

[a] EBITDA denotes earnings before interest, tax, depreciation, and amortization.
[b] NOPAT denotes net operating profit after tax, which equals net income adjusted for net interest expense after tax.

to our starting point, cash flow from operations. The analyst then incorporates the remaining steps by adjusting for changes in cash requirements for operating liquidity and capital expenditures.

Still other analysts begin the computation of free cash flows for all debt and equity stakeholders using NOPAT, which is net income with net interest expense (adjusted for tax savings) added back. From this starting point, the analyst should add back all non-cash expense items (such as depreciation and amortization expenses), subtract all non-cash income items (such as accrued income from equity method affiliates), and adjust for cash flows related to working capital activities. The analyst then incorporates the remaining steps by adjusting for changes in cash requirements for liquidity and capital expenditures.

In practice, some analysts also use net income, EBITDA, and NOPAT as starting points to compute free cash flows for equity shareholders. Exhibit 12.3 shows the steps necessary to adjust each of these starting point amounts to complete measures of free cash flows for common equity. Note that many but not all of the additional adjustments are similar to those demonstrated in Exhibit 12.2. Also note that although it occurs in practice, starting with EBITDA or NOPAT to compute free cash flows for equity is inefficient because it is necessary to subtract interest expense after tax from both EBITDA and NOPAT.

The starting point of the computation of free cash flows is less important than the ending point. The analyst can begin the computation of free cash flows with cash from operating activities on the statement of cash flows, net income, EBITDA, or NOPAT, so long as he or she properly makes all of the necessary adjustments to compute a complete measure of free cash flows as described in Exhibits 12.1–12.3.

Which Free Cash Flow Measure Should Be Used?

The appropriate free cash flow measure to use—free cash flows to all debt and equity stakeholders or free cash flows to equity shareholders—depends on the resource to be valued.

- If the objective is to value operating assets net of operating liabilities or, equivalently, the sum of the debt and equity capital of a firm, the free cash flow for all debt and equity capital is the appropriate cash flow measure and the appropriate discount rate is the weighted average cost of capital.
- If the objective is to value the common shareholders' equity of a firm, the free cash flow for common equity shareholders is the appropriate cash flow measure and the appropriate discount rate is the cost of equity capital.

The difference between these two valuations is the value of total debt financing and preferred stock. To reconcile the two valuations, one could value the debt financing instruments by discounting all future debt service cash flows (including repayments of principal) at the after-tax cost of debt capital and all preferred-stock dividends at the cost of preferred equity. Subtracting the present value of debt financing and preferred stock from the present value of the sum of debt and equity capital yields the present value of common equity. The approach to use depends on the valuation setting.

Example 11: Valuing an Asset Acquisition

One firm wants to acquire the net operating assets of a division of another firm. The acquiring firm will replace the financing structure of the division with a financing structure that matches its own. The relevant cash flows for valuing the division's net operating assets are the free operating cash flows the assets will generate minus the expected capital expenditures in operating assets or, equivalently, the free cash flows for all debt and equity capital. The acquiring firm would then discount these projected free cash flows for all debt and equity capital at the expected future weighted average cost of capital of the division to

be acquired, which will match the weighted average cost of capital of the acquiring firm because the acquiring firm will use a similar financing structure for the division.

Example 12: Valuing Equity Shares

An investor wants to value a potential investment in 1,000 shares of common stock in a firm. The relevant cash flows are the free cash flows available for distribution to common equity shareholders. These free cash flows measure the cash flows generated from using the assets of the firm minus the cash required to service the debt. Thus, free cash flows for common equity shareholders should capture the cash generated by operating the assets of the firm plus any beneficial effects of financial leverage on the value of the common equity less the cash flows required to service debt capital. The investor should discount these projected free cash flows at the required return on equity capital.

Example 13: Valuing a Leveraged Buyout

The managers of a firm intend to acquire a target firm through an LBO (leveraged buyout). The managers will offer to purchase the outstanding shares of the target firm by investing their own equity (usually 20–25 percent of the total) and borrowing the remainder from various lenders. The tendered shares serve as collateral for the loan (often called a *bridge loan*) during the transaction. After gaining voting control of the firm, the managers will have the firm engage in sufficient new borrowing to repay the bridge loan. Following an LBO, the firm will likely have a significantly higher debt level in the capital structure from the use of leverage to execute the takeover.

Determining the value of the common shares acquired follows the usual procedure for an equity investment. (See Example 12.) This value should equal the present value of free cash flows for common equity discounted at the cost of common equity capital. The valuation of the equity must reflect the new capital structure and the related increase in debt service costs. Also, the cost of equity capital will likely increase as a result of the higher level of debt in the capital structure; the common shareholders bear more risk as residual claimants on the assets of the firm. Therefore, the valuation must be based on the expected new cost of equity capital.

As an alternative approach that will produce the same value for the common equity, the analyst can treat an LBO as a purchase of assets (similar to Example 11). That is, compute the present value of the free cash flows for all debt and equity capital stakeholders using the expected future weighted average cost of debt and equity capital, using weights that reflect the newly leveraged capital structure of the acquired firm. This amount represents the value of net operating assets. Subtract from the present value of net operating assets the present value of debt raised to execute the LBO.[14] The result is the present value of the common equity.

CASH-FLOW-BASED VALUATION MODELS

Thus far, this chapter has discussed all of the elements of free-cash-flow-based valuation. To bring all of the elements together, we next present equations to describe the free-cash-flow-based valuation models. In each of these equations, all of the variables used to compute firm

[14] It is irrelevant whether any debt on the books of the target firm remains outstanding after the LBO or whether the firm engages in additional borrowing to repay existing debt, as long as the weighted average cost of capital properly includes the costs of each financing arrangement.

value are *expectations* of future free cash flows, future discount rates, and future growth rates. We present the valuation equations with and without explicit terms for continuing values. Recall that Exhibits 12.1–12.3 describe the computations for free cash flows for common equity shareholders and free cash flows for all debt and equity capital stakeholders.

Valuation Models for Free Cash Flows for Common Equity Shareholders

The following equation summarizes the computation of the present value of the common equity of a firm as of time $t=0$ (denoted as V_0) using the present value of free cash flows for common equity shareholders discounted at the required rate of return on equity capital (R_E):

$$V_0 = \sum_{t=1}^{\infty} [\textit{Free Cash Flow Equity}_t/(1 + R_E)^t]$$

This valuation approach expresses the value of the common equity of the firm as a function of the present value of the free cash flows the firm will generate for the common equity shareholders after the firm has met all other cash requirements for working capital, capital expenditures, principal and interest payments on debt financing, preferred stock dividends, and so on. Given that common equity shareholders are the residual risk-bearers of the firm, this valuation approach estimates common equity value using the residual free cash flows available to them. Therefore, it is appropriate to discount these payoffs to present value using a discount rate that reflects the risk-adjusted required rate of return on common equity capital of the firm.

The following equation summarizes the computation of the present value of common equity as of time $t=0$, but in this equation, the analyst computes the present value of the expected future free cash flows for common equity shareholders over a finite forecast horizon through Year T plus the present value of continuing value of free cash flows for equity shareholders continuing in Year T+1 and beyond.[15] The analyst computes continuing value based on the forecast assumption that the firm will grow indefinitely at rate *g* beginning in Year T+1 and continuing thereafter. The analyst derives free cash flows for common equity shareholders in Year T+1 from the projected income statement and balance sheet for Year T+1, in which the analyst projects all of the elements of the Year T income statement and balance sheet to grow at rate *g* beginning in Year T+1. The equation is as follows:

$$V_0 = \sum_{t=1}^{T} [\textit{Free Cash Flow Equity}_t/(1 + R_E)^t]$$
$$+ [\textit{Free Cash Flow Equity}_{T+1}] \times [1/(R_E - g)] \times [1/(1 + R_E)^T]$$

Both of these free-cash-flow-based equations represent the value of the common equity of the firm. The Valuations spreadsheet in FSAP provides a template that calculates V_0 using the present value of free cash flows for common equity shareholders, including the continuing value computation.

Valuation Models for Free Cash Flows for All Debt and Equity Capital Stakeholders

The following equation determines the present value of the net operating assets of a firm as of time $t=0$ (denoted as $VNOA_0$) by computing the present value of all future free cash flows for all debt and equity capital stakeholders (denoted as *Free Cash Flow All*):

$$VNOA_0 = \sum_{t=1}^{\infty} [Free\ Cash\ Flow\ All_t/(1 + R_A)^t]$$

This equation differs from the models in the previous section in three important ways. First, this valuation approach does not compute the value of common shareholders' equity (V_0); instead, it computes the value of the net operating assets of the firm or, equivalently, the value of all of the debt, preferred, and common equity claims on the net assets of the firm. Second, this model differs from the models of the previous section because it includes the analyst's forecasts (as of time $t = 0$) of future free cash flows to all debt and equity stakeholders. The prior equation focused specifically on the value of common equity capital, measured as the present value of all future free cash flows to common equity shareholders. Third, this equation differs from the prior models because it discounts the free cash flows to present value using R_A, which denotes the expected future weighted average cost of capital (which should reflect the weighted average required rate of return on the net operating assets of the firm). The prior equations relied on a discount rate using the required rate of return to equity (R_E).

This valuation approach expresses the value of the financial claims (debt, preferred, and common equity) on the firm as a function of the present value of the free cash flows the firm's net operating assets will generate that can ultimately be distributed to debtholders, preferred stockholders, and common shareholders. Thus, the value-relevant payoff measure in this approach is the excess cash the firm's operations generate that will be available to satisfy all capital claims. Given that these free cash flows will be distributed to debt, preferred, and common equity stakeholders, it is appropriate to discount these payoffs to present value using a discount rate that reflects the weighted average cost of capital across these different capital claims.

The next equation summarizes the same computation but uses the present value of the analyst's forecasts of free cash flows for all debt and equity capital stakeholders over a finite forecast horizon through Year T (for example, T may be five or ten years in the future) plus the present value of continuing value. The analyst computes continuing value based on the forecast assumption that the firm will grow indefinitely at rate g beginning in Year T+1 and continuing thereafter. The analyst derives free cash flows for all debt and equity capital stakeholders in Year T+1 from the projected income statement and balance sheet for Year T+1, in which the analyst projects all elements of the Year T income statement and balance sheet to grow at rate g beginning in Year T+1. The equation is as follows:

$$VNOA_0 = \sum_{t=1}^{T} [Free\ Cash\ Flow\ All_t/(1 + R_A)^t]$$
$$+ [Free\ Cash\ Flow\ All_{T+1}] \times [1/(R_A - g)] \times [1/(1 + R_A)^T]$$

Both of the prior equations represent estimates of the value of the net operating assets of the firm, which is equivalent to the sum of the values of debt, preferred, and common equity capital. To isolate the value of common equity capital, the analyst must subtract the

present value of all interest-bearing debt and preferred stock. The equation to compute the value of equity (denoted as V_0) is as follows:

$$V_0 = VNOA_0 - VDebt_0 - VPreferred_0$$

The Valuations spreadsheet in FSAP provides a template that calculates $VNOA_0$ and V_0 using the present value of free cash flows for all debt and equity capital stakeholders, including the continuing value computation.

In theory, the value of common equity using this valuation approach should be identical to the value of common equity using the free cash flows to equity approach, the dividends valuation approach discussed in the previous chapter, and the earnings-based approaches discussed in the following chapter. As a practical matter, however, it is sometimes difficult to get the equity value estimate from the free cash flows to all debt and equity stakeholders to match the other value estimates. The main reason is the added degrees of circularity in this valuation approach. In this approach, the market-value-based weights for debt, preferred stock, and common equity capital used in computing the weighted average cost of capital must agree with the value estimates for debt, preferred stock, and common equity. Thus, additional degrees of circularity arise because the value estimates depend on the weighted average cost of capital, and the weighted average cost of capital depends on the value estimates. Obtaining an internally consistent set of value estimates for each type of capital and an internally consistent weighted average cost of capital may require a number of iterations until all of the weights and value estimates agree.

FREE CASH FLOWS VALUATION OF PEPSICO

At the end of 2008, trading in PepsiCo shares on the New York Stock Exchange closed at $54.77 per share. Therefore, we know the *price* at which we can buy or sell PepsiCo shares. The free cash flows valuation methods enable us to estimate the *value* of these shares. This section illustrates the valuation of PepsiCo shares using the free cash flows valuation techniques described in this chapter and the forecasts developed in Chapter 10. We develop these forecasts and value estimates using the Forecast and Valuation spreadsheets in FSAP (see Appendix C).

In this section, we estimate the present value of a share of common equity in PepsiCo at the end of 2008 (equivalently, the start of forecast Year +1) two ways by estimating the present value of the following:

1. Free cash flows to common equity shareholders directly, discounted at the required rate of return to common equity
2. Free cash flows to all debt and equity capital stakeholders, discounted using PepsiCo's weighted average cost of capital; then subtract the present value of debt claims.

To proceed with each valuation, we follow four steps:

1. Estimate the appropriate discount rates for PepsiCo.
2. Derive the free cash flows from the projected financial statements for PepsiCo described in Chapter 10 and make assumptions about free cash flows growth in the continuing periods beyond the forecast horizon.
3. Discount the free cash flows to present value, including continuing value.
4. Make the necessary adjustments to convert the present value computation to an estimate of share value for PepsiCo.

Once we have our benchmark estimate of PepsiCo's share value, we conduct sensitivity analysis to determine the reasonable range of values for PepsiCo shares. Finally, we compare

this range of reasonable values to PepsiCo's share price in the market and suggest an appropriate investment decision indicated by our analysis.

Recall in the previous chapter that we used the dividends valuation approach to estimate the value of PepsiCo shares to be in a range around $83 per share. This section shows that we obtain equivalent estimates of value using the free cash flows valuation approaches.

PepsiCo Discount Rates

To discount free cash flows to common equity shareholders, we need to compute PepsiCo's required rate of return on equity capital. To discount free cash flows to all debt and equity capital, we need to compute PepsiCo's weighted average cost of capital. The following sections briefly describe the computations. Recall that we briefly explained these computations at the outset of this chapter, and we explained and described these computations in detail in Chapter 11.

Computing the Required Rate of Return on Equity Capital for PepsiCo

At the end of 2008, different sources provided different estimates of market beta for PepsiCo common stock, ranging from 0.50 to roughly 1.00. Historically, PepsiCo's market beta has varied around 0.75 over time, so we will assume that PepsiCo common stock has a market beta of roughly 0.75 as of the end of 2008. At that time, U.S. Treasury bills with one to five years to maturity traded with a yield of approximately 4.0 percent, which we use as the risk-free rate. Assuming a 6.0 percent market risk premium, the CAPM indicates that PepsiCo has a cost of common equity capital of 8.50 percent [$8.50 = 4.0 + (0.75 \times 6.0)$]. At the end of 2008, PepsiCo had 1,553 million shares outstanding and a share price of $54.77 for a total market capital of common equity of $85,058 million.

Computing the Weighted Average Cost of Capital for PepsiCo

PepsiCo's balance sheet at the end of 2008 shows interest-bearing debt from short-term obligations and long-term debt obligations totaling $8,227 million (= $369 + $7,858, as reported in Appendix A). Recall that in Chapter 10, we used information disclosed in Note 9, "Debt Obligations and Commitments" (Appendix A), to assess stated interest rates on PepsiCo's interest-bearing debt. We determined that in 2008, PepsiCo's outstanding debt carries a weighted average interest rate of approximately 5.8 percent. In Note 10, "Financial Instruments" (Appendix A), PepsiCo discloses that the fair value of outstanding debt obligations at the end of 2008 is $8,800 million. Thus, PepsiCo has experienced an unrealized (and unrecognized) loss of $573 million (= $8,227 million − $8,800 million) on its debt capital. This unrealized loss is surprising because more than half of PepsiCo's outstanding debt obligations were newly issued in 2008 at prevailing market rates. The unrealized loss implies that the firm's outstanding debt carries stated rates of interest that now exceed prevailing market yields, which at the end of 2008 are at relatively low levels given the recession in the U.S. economy. Given that most of PepsiCo's outstanding debt obligations were recently issued in 2008 and that prevailing yields to maturity are expected to be temporarily low, we forecast in Chapter 10 that PepsiCo's cost of debt capital will continue to approximate 5.8 percent in Year +1 and beyond. We use the current book value (as a proxy for market value) of PepsiCo's debt for weighting purposes. In Note 5, "Income Taxes" (Appendix A), PepsiCo discloses that the combined average federal, state, and foreign tax

rate is approximately 26.8 percent in 2008. In Chapter 10, we forecast that PepsiCo will continue to face average tax rates of roughly 26.8 percent in Year +1 and beyond. Therefore, we assume that the tax rate applicable to PepsiCo's interest expense deductions will be the effective 26.8 percent rate rather than the statutory federal rate of 35 percent. Our long-run projections imply that PepsiCo faces an after-tax cost of debt capital of 4.25 percent [4.25 = 5.8 × (1 − 0.268)].

PepsiCo also has a net *negative* balance of $97 million in preferred stock on the 2008 balance sheet. In Chapter 10, we forecast that PepsiCo will retire the remaining outstanding preferred stock during Year +1. We also forecast that PepsiCo will not issue any additional preferred stock capital in future years. Therefore, we do not include any preferred stock in the computation of PepsiCo's weighted average cost of capital.

Bringing the costs of debt and equity capital together, we compute PepsiCo's weighted average cost of capital to be 8.12 percent as follows:

Capital	Value Basis	Amount	Weight	After-Tax Cost of Capital	Weighted-Average Component
Debt	Book	$ 8,227	8.82%	4.25%	0.37%
Common	Market	85,058	91.18%	8.50%	7.75%
Total		$93,285	100.00%		8.12%

Note that this is just our *initial* estimate of PepsiCo's weighted average cost of capital. As described earlier, the weighted average cost of capital must be computed iteratively until the weights used are consistent with the present values of debt and equity capital.

Computing Free Cash Flows for PepsiCo

This section first describes the computations for PepsiCo's free cash flows for all debt and equity stakeholders, then describes the computations for PepsiCo's free cash flows for common equity shareholders. Recall that Exhibits 12.1–12.3 presented the steps to compute free cash flows.

Chapter 10 described detailed projections of PepsiCo's future statements of cash flows by making specific assumptions regarding each item in the income statement and balance sheet and then deriving the related cash flow effects using a five-year forecast horizon. We use these projections of PepsiCo's statements of cash flows (see Exhibit 10.6) to compute projected free cash flows. We present the projections of free cash flows for all debt and equity stakeholders in Exhibit 12.4 and the projections of free cash flows for common equity shareholders in Exhibit 12.5.

PepsiCo's Free Cash Flows to All Debt and Equity Capital Stakeholders

In Exhibit 12.4, we begin our computation of free cash flows with cash flows from operations from the projected statements of cash flows. In Chapter 10, we developed our projections of PepsiCo's statements of cash flows for Year +1 through Year +5. In Year +1, for example, we project that PepsiCo's cash flows from operations will be $8,359.9 million. We then adjust for net interest, adding back interest expense after tax. Specifically, in Year +1, we add back $361.2 million in interest expense after tax [= $493 million × (1 − 0.268)]. We do not make an adjustment to subtract interest income after tax because we assume that

EXHIBIT 12.4

Projected Free Cash Flows to All Debt and Equity Capital Stakeholders for PepsiCo
Year +1 through Year +6 (dollar amounts in millions)

Free Cash Flows for All Debt and Equity	Year +1	Year +2	Year +3	Year +4	Year +5	Year +6
Net Cash Flow from Operations	$ 8,359.9	$ 9,201.1	$10,141.5	$10,965.8	$11,643.5	$ 9,694.4
Add back: Interest Expense after tax	361.2	388.7	424.1	457.9	495.2	510.1
Subtract: Interest Income after tax	(0.0)	(0.0)	(0.0)	(0.0)	(0.0)	(0.0)
Decrease (Increase) in Cash Required for Operations	512.5	(143.7)	(195.3)	(141.9)	(197.9)	(66.9)
Free Cash Flow from Operations for All Debt and Equity Stakeholders	$ 9,233.6	$ 9,446.1	$10,370.3	$11,281.8	$11,940.8	$10,137.6
Net Cash Flow for Investing Activities	(3,874.4)	(3,995.7)	(4,612.9)	(4,607.1)	(5,252.9)	(1,807.5)
Add back: Net Cash Flows into Financial Assets	0.0	0.0	0.0	0.0	0.0	0.0
Free Cash Flows—All Debt and Equity Stakeholders	$ 5,359.3	$ 5,450.4	$ 5,757.4	$ 6,674.7	$ 6,688.0	$ 8,330.1
Present Value Factors (R_A = 8.12%)	0.925	0.855	0.791	0.732	0.677	
Present Value Free Cash Flows	$ 4,956.5	$ 4,662.1	$ 4,554.6	$ 4,883.5	$ 4,525.5	
Sum of Present Value Free Cash Flows for All Debt and Equity Stakeholders, Year +1 through Year +5	$23,582.3					

EXHIBIT 12.5

Projected Free Cash Flows to Common Equity Shareholders for PepsiCo
Year +1 through Year +6 (dollar amounts in millions)

Free Cash Flows for Common Equity Shareholders	Year +1	Year +2	Year +3	Year +4	Year +5	Year +6
Net Cash Flow from Operations	$ 8,359.9	$ 9,201.1	$10,141.5	$ 10,965.8	$ 11,643.5	$ 9,694.4
Decrease (Increase) in Cash Required for Operations	512.5	(143.7)	(195.3)	(141.9)	(197.9)	(66.9)
Free Cash Flow from Operations for Common Equity Shareholders	$ 8,872.4	$ 9,057.4	$ 9,946.2	$ 10,823.9	$ 11,445.6	$ 9,627.5
Net Cash Flows for Investing	(3,874.4)	(3,995.7)	(4,612.9)	(4,607.1)	(5,252.9)	(1,807.5)
Net Cash Flows from Debt Financing	562.8	729.0	941.5	651.5	1,104.4	366.5
Net Cash Flows into Financial Assets	0.0	0.0	0.0	0.0	0.0	0.0
Net Cash Flows—Preferred Stock and Minority Interests	(72.0)	0.0	0.0	0.0	0.0	0.0
Free Cash Flow for Common Equity Shareholders	$ 5,488.8	$ 5,790.7	$ 6,274.8	$ 6,868.3	$ 7,297.1	$ 8,186.5
Present Value Factors ($R_E = 8.50\%$)	0.922	0.849	0.783	0.722	0.665	
Present Value Free Cash Flows	$ 5,058.8	$ 4,919.0	$ 4,912.6	$ 4,956.0	$ 4,852.9	
Sum of Present Value Free Cash Flows For Common Equity Shareholders Year +1 through Year +5	$24,699.3					

all of PepsiCo's interest income relates to financial assets (cash and short-term investments) that are used for liquidity in operating activities and strategic investments in affiliates such as bottlers and are not part of the capital structure. We also adjust cash flow from operations for required investments in operating cash. In Chapter 10, we projected that PepsiCo would need to maintain roughly 12 days of sales in cash for liquidity purposes; therefore, PepsiCo's required cash balance varies with sales. For example, at the end of Year +1, we project that PepsiCo's cash balance will be $1,551 million, equivalent to 12 days of sales in Year +1. Given that this balance is lower than PepsiCo's 2008 year-end cash balance of $2,064 million, it implies that PepsiCo will reduce its cash by $512.5 million. This increment of cash is available to satisfy debt and equity claims, so we add it to free cash flows. [By contrast, in Year +2, we project that the cash balance will grow by $143.7 million to $1,695 million. This additional increment of cash is required for liquidity in Year +2 and therefore is not a free cash flow; so we subtract it.] As a result of these adjustments, we project that PepsiCo's free cash flows for all debt and equity from operations will be $9,233.6 million in Year +1.

Next, we subtract cash flows for capital expenditures using the amount of net cash flow for investing from PepsiCo's projected statements of cash flows. For example, in Year +1, we projected that net cash flows for investing activities will be $3,874.4 million. These investing cash flows include cash outflows for purchases of property, plant, and equipment; acquisitions of goodwill and other intangible assets; and purchases of marketable securities and investment securities. We consider these to be investing activities because we assumed that these securities are for purposes of operating liquidity and are not financial assets that are part of the financing structure of PepsiCo. Also note that PepsiCo's investing cash flows include cash outflows for long-term investments that relate primarily to affiliated bottling companies, which we deem to be part of PepsiCo's operations and therefore not free cash flows. Therefore, we subtract the full amount of net cash flow for investing activities from the free cash flow from operations. We forecast that PepsiCo's free cash flows for all debt and equity capital stakeholders will be $5,359.3 million (= $9,233.6 million − $3,874.4 million) in Year +1. We repeat these steps each year through Year +5.

To project PepsiCo's free cash flows continuing in Year +6 and beyond, we forecast that PepsiCo will sustain a long-run growth rate of 3.0 percent, consistent with 3.0 percent long-term growth in the economy. To compute continuing free cash flows in Year +6, we project each line item on PepsiCo's Year +5 income statement and balance sheet to grow at 3.0 percent per year in Year +6. We use these Year +6 projected income statement and balance sheet amounts to derive the Year +6 free cash flows for all debt and equity capital, which we project will be $8,330.1 million. We assume that this free cash flow amount is the beginning of a perpetuity of continuing free cash flows that PepsiCo will generate beginning in Year +6, growing at 3 percent each year thereafter. The computations are shown in detail in the Forecast and Valuation spreadsheets in FSAP (Appendix C), which permit specific forecast assumptions to extend as far as Year +5 into the future, with continuing value assumptions thereafter.

PepsiCo's Free Cash Flows to Common Equity

Exhibit 12.5 presents estimates of PepsiCo's free cash flows for common equity shareholders through Year +6. The computations begin with the Year +1 projection of $8,359.9 million of cash flows from operations, as described earlier. As in the previous section, we adjust cash flow from operations in Year +1 by adding the increment of $512.5 million of cash no longer required for liquidity. Also as in the previous section, we subtract $3,874.4 million of projected cash outflows for capital expenditures and other investing activities in Year +1. Note that unlike the previous section, we make no adjustment for net interest expense after tax because we need to measure the free cash flows available to equity shareholders net of

all debt-related cash flows. Because our starting point, cash flows from operations, is derived from net income and because we measure net income after interest expense, our cash flows amount is net of interest expense.

To further refine these cash flows to free cash flows available to common equity, we need to adjust them for cash flows related to debt and preferred-stock financing. We first add any cash inflows from new borrowing and subtract any cash outflows for debt repayments. For example, in Year +1, we add $562.8 million in cash flows for our projections of PepsiCo's additional short-term and long-term borrowing. Next, we add inflows and subtract outflows related to transactions with preferred stock and minority equity shareholders (if any). In Year I 1, we subtract $72.0 million for payments to retire the outstanding preferred stock. We also subtract any cash outflows and add any cash inflows related to financial asset accounts that are part of PepsiCo's capital structure (which we have deemed to be zero). The computations project $5,488.8 million in free cash flows for PepsiCo's common equity shareholders in Year +1. We repeat these steps each year through Year +5.

To project PepsiCo's free cash flows for common equity continuing in Year +6 and beyond, we again forecast that PepsiCo can sustain long-run growth of 3.0 percent. We project the Year +5 income statement and balance sheet amounts to grow at a rate of 3.0 percent in Year +6 and derive free cash flows to common equity from the projected Year +6 statements. Our computations indicate that free cash flows to common equity in Year +6 will be $8,186.5 million (shown in detail in the Forecast and Valuation spreadsheets in FSAP in Appendix C). We assume that these free cash flows will continue to grow at 3.0 percent per year thereafter.

Valuation of PepsiCo Using Free Cash Flows to Common Equity Shareholders

We estimate the present value of a share of common equity in PepsiCo at the end of 2008 (equivalently, the start of Year +1) by discounting the free cash flows to equity using PepsiCo's 8.50 percent risk-adjusted required rate of return on equity capital as the appropriate discount rate. Exhibit 12.5 shows that PepsiCo's free cash flows for common equity through Year +5 have a present value of $24,699.3 million. We compute the present value of PepsiCo's continuing value as the present value of a growing perpetuity of free cash flows beginning in Year +6, which we project will be $8,186.5. We project these free cash flows to grow at 3.0 percent and discount them to present value using the 8.50 percent discount rate. The present value of these cash flows is $98,988.9 million. As shown in Exhibit 12.6, the present value of PepsiCo's free cash flows to common equity shareholders is the sum of these two parts:

Present Value Free Cash Flows through Year +5	$ 24,699.3 million
Present Value of Continuing Value in Year +6 and Beyond	98,988.9 million
Present Value of Common Equity	$123,688.2 million

As described in the previous chapter, we need to correct our present value calculations for overdiscounting. To make the correction, we multiply the present value sum by the midyear adjustment factor of 1.0425 [$= 1 + (R_E/2) = 1 + (0.0850/2)$]. The total present value of free cash flows to common equity shareholders should be $128,945.0 million (= $123,688.2 million \times 1.0425).

Dividing the total value of common equity of PepsiCo by 1,553 million shares outstanding indicates that PepsiCo's common equity shares have a value of $83.03 per share. This share value estimate is identical to the share value estimate we computed using dividends

EXHIBIT 12.6

Valuation of PepsiCo Using Free Cash Flows to Common Equity Shareholders

Present Value of Free Cash Flows to Common Equity Shareholders in Year +1 through Year +5:

From Exhibit 12.5:	$ 24,699.3 million

Present Value of Continuing Value of Free Cash Flows to Common Equity in Year +6 and Beyond:

Projected Year +6 Free Cash Flows to
Common Equity (Exhibit 12.5): $8,186.5 million

Continuing Value in Present Value (R_E = 8.50% and g = 3.0%):

Continuing Value	= Free Cash Flow$_{\text{Year}+6}$ × $[1/(R_E - g)]$
	= $8,186.5 million × $[1/(0.0850 - 0.0300)]$
	= $8,186.5 million × 18.18182 = $148,845.4 million

Present Value of		
Continuing Value	= Continuing Value × $[1/(1 + R_E)^5]$	
	= $148,845.4 million × $[1/(1 + 0.0850)^5]$	
	= $148,845.4 million × 0.665	= $98,988.9 million

Total Value of PepsiCo's Free Cash Flows to Common Equity Shareholders:

Present Value of Free Cash Flows through Year +5	$ 24,699.3 million
+ Present Value of Continuing Value	+ 98,988.9 million
Present Value of Common Equity	$123,688.2 million
Adjust for Midyear Discounting (multiply by 1 + $[R_E/2]$)	× 1.0425
Total Present Value of Common Equity	$128,945.0 million
Divide by Number of Shares Outstanding	÷ 1,553 million
Value per Share of PepsiCo Common Equity	= $ 83.03

in the previous chapter. Exhibit 12.7 presents the computations to arrive at PepsiCo's common equity share value using the free cash flows to common equity shareholders approach in the Valuations spreadsheet in FSAP.

Valuation of PepsiCo Using Free Cash Flows to All Debt and Equity Capital Stakeholders

We also estimate the present value of a share of common equity in PepsiCo at the end of 2008 by discounting the free cash flows to all debt and equity stakeholders using PepsiCo's 8.12 percent weighted average cost of capital as the appropriate discount rate. Exhibit 12.4 shows that PepsiCo's free cash flows for all debt and equity stakeholders through Year +5 have a present value of $23,582.3 million. To compute the present value of PepsiCo's continuing value, we compute the continuing value beyond Year +5 using the perpetuity-with-growth

EXHIBIT 12.7

FSAP Valuation of PepsiCo Using Free Cash Flows to Common Equity
Shareholders through Year +5 and Beyond (dollar amounts in millions, except per-share amounts)

Free Cash Flows for Common Equity	Year +1	Year +2	Year +3	Year +4	Year +5	Year +6 Continuing Value
Net Cash Flow from Operations	$ 8,359.9	$ 9,201.1	$10,141.5	$10,965.8	$11,643.5	$ 9,694.4
Decrease (Increase) in Cash Required for Operations	512.5	(143.7)	(195.3)	(141.9)	(197.9)	(66.9)
Free Cash Flow from Operations for Common Equity Shareholders	$ 8,872.4	$ 9,057.4	$ 9,946.2	$10,823.9	$11,445.6	$ 9,627.5
Net Cash Flows for Investing	(3,874.4)	(3,995.7)	(4,612.9)	(4,607.1)	(5,252.9)	(1,807.5)
Net Cash Flows from Debt Financing	562.8	729.0	941.5	651.5	1,104.4	366.5
Net Cash Flows into Financial Assets	0.0	0.0	0.0	0.0	0.0	0.0
Net Cash Flows—Preferred Stock and Minority Interests	(72.0)	0.0	0.0	0.0	0.0	0.0
Free Cash Flow for Common Equity Shareholders	$ 5,488.8	$ 5,790.7	$ 6,274.8	$ 6,868.3	$ 7,297.1	$ 8,186.5
Present Value Factors ($R_E = 8.50\%$)	0.922	0.849	0.783	0.722	0.665	
Present Value Free Cash Flows	$ 5,058.8	$ 4,919.0	$ 4,912.6	$ 4,956.0	$ 4,852.9	
Sum of Present Value Free Cash Flows For Common Equity Shareholders Year +1 through Year +5	$ 24,699.3					
Present Value of Continuing Value	98,988.9					
Total	$123,688.2					
Adjust to midyear discounting	1.0425					
Total Present Value Free Cash Flows to Common Equity Shareholders	$128,945.0					
Shares Outstanding	1,553.0					
Estimated Value per Share	$ 83.03					
Current share price	$ 54.77					
Percent difference	52%					

model. First, as described earlier and shown in Exhibit 12.4, we project that PepsiCo will generate free cash flows of $8,330.1 million in Year +6, and that these free cash flows will grow at a rate of 3.0 percent indefinitely. Exhibit 12.8 demonstrates that in present value, PepsiCo's continuing value has a present value of $109,988.1 million.[16] The present value of PepsiCo's free cash flows to all debt and equity capital stakeholders is the sum of these two parts:

Present Value Free Cash Flows through Year +5	$ 23,582.3 million
Present Value of Continuing Value Year +6 and Beyond	109,988.1 million
Present Value of Free Cash Flows for All Debt and Equity Capital	$133,570.4 million

EXHIBIT 12.8

Valuation of PepsiCo Using Free Cash Flows to All Debt and Equity Stakeholders

Present Value of Free Cash Flows to All Debt and Equity Stakeholders in Year +1 through Year +5:

From Exhibit 12.4:	$ 23,582.3 million

Present Value of Continuing Value of Free Cash Flows to All Debt and Equity Stakeholders in Year + 6 and Beyond:

Projected Year +6 Free Cash Flows to All Debt and Equity Stakeholders
(Exhibit 12.4): $8,330.1 million

Continuing Value in Present Value ($R_A = 8.12\%$ and $g = 3.0\%$):

$$\text{Continuing Value} = \text{Free Cash Flow}_{\text{Year}+6} \times [1/(R_A - g)]$$
$$= \$8,330.1 \text{ million} \times [1/(0.0812 - 0.0300)]$$
$$= \$8,330.1 \text{ million} \times 19.5312$$
$$= \$162,544.5 \text{ million}$$

$$\text{Present Value of Continuing Value} = \text{Continuing Value} \times [1/(1 + R_A)^5]$$
$$= \$162,544.5 \text{ million} \times [1/(1 + 0.0812)^5]$$
$$= \$162,544.5 \text{ million} \times 0.677 \qquad = \$109,988.1 \text{ million}$$

Total Value of PepsiCo's Free Cash Flows to All Debt and Equity Stakeholders:

Present Value of Free Cash Flows through Year +5	$ 23,582.3 million
+ Present Value of Continuing Value	+ 109,988.1 million
Present Value of All Debt and Equity	$133,570.4 million
Subtract Market Value of Debt	− 8,227.0 million
Present Value of Common Equity	$125,343.4 million
Adjust for Midyear Discounting [multiply by $1 + (R_A/2)$]	× 1.0406
Total Present Value of Common Equity	$130,435.3 million
Divide by Number of Shares Outstanding	÷ 1,553 million
Value per Share of PepsiCo Common Equity	= $ 83.99

[16] Because of the effects of rounding, it appears the present value of continuing value computation may be slightly in error. But when computed with greater precision and less rounding the computation is correct, as follows: *Continuing Value = Free Cash Flow*$_{\text{Year}+6} \times [1/(R_A - g)] \times [1/(1 + R_A)^5] = \$8,330.07$ million $\times [1/(0.08125 - 0.0300)] \times [1/(1 + 0.08125)^5] = \$8,330.07$ million $\times 19.51298 \times 0.67666 = \$109,988.1$ million.

Necessary Adjustments to Compute Common Equity Share Value

To narrow this computation to the present value of common equity, we need to subtract the market value of interest-bearing debt and preferred stock and add the present value of interest-earning financial assets that are part of the firm's financial capital structure. Relying on PepsiCo's book values of debt, we subtract $8,227 million for outstanding debt. We assumed that PepsiCo would retire the outstanding preferred stock during Year +1, so our cash outflows already account for the payment to retire that preferred stock. We assumed that PepsiCo's financial assets are not part of the financial capital structure, so we need no adjustments for them. After subtracting the value of debt, the present value of PepsiCo's common equity capital is $125,343.4 million (= $133,570.4 million − $8,227.0 million).

As described earlier, our present value calculations have overdiscounted these cash flows because we have discounted each year's cash flows for a full period when, in fact, PepsiCo generates cash flows throughout each period and we should discount them from the midpoint of the year to the present. Therefore, to make the correction, we multiply the present value sum by the midyear adjustment factor of 1.0406 [= 1 + ($R_A/2$) = 1 + (0.0812/2)]. Therefore, the total present value of free cash flows to common equity capital stakeholders is $130,435.3 million (= $125,343.4 million × 1.0406). Dividing by 1,553 million shares outstanding indicates that PepsiCo's common equity shares have a value of $83.99 per share. Exhibit 12.8 summarizes all of these computations, and Exhibit 12.9 presents the computations to arrive at PepsiCo's common equity share value using the free cash flows to all debt and equity stakeholders approach in the Valuations spreadsheet in FSAP.

Note that our calculation of an $83.99 value for PepsiCo's common equity shares is slightly different from the value of $83.03 per share obtained from the free cash flows to common equity approach described previously and the dividends approach in the previous chapter. This is because we used the current market price per share of PepsiCo common stock ($54.77) in the initial weighted average cost of capital computation. As a consequence, we did not place enough weight on the market value of equity in the initial cost of capital computation. To iterate the valuation approach, we can use the share value estimate of $83.03 to determine that the total value of PepsiCo common equity in the weighted average cost of capital computation. To further iterate the valuation approach, we can recompute the weighted average cost of equity capital each forecast year because our projections indicate that PepsiCo's common equity in the capital structure will gradually fall in proportion to the debt financing in the capital structure in future years. After a number of iterations, the valuation computations and the weights we use to compute the weighted average cost of capital converge. The equity value estimate of $128,945.0 million, or $83.03 per share, is the internally consistent value.

Sensitivity Analysis and Investment Decision Making

As we emphasized in the previous chapter, forecasts of cash flows over the remaining life of any firm, even a mature firm such as PepsiCo, contain a high degree of uncertainty; so one should not place too much confidence in the *precision* of firm value estimates using these forecasts. Although we have constructed these forecasts and value estimates with care, the forecasting and valuation process has an inherently high degree of uncertainty and estimation error. Therefore, the analyst should not rely too heavily on any one point estimate of the value of a firm's shares; instead, the analyst should describe a reasonable range of values for a firm's shares.

EXHIBIT 12.9

FSAP Valuation of PepsiCo Using Free Cash Flows to All Debt and Equity Stakeholders through Year +5 and Beyond (dollar amounts in millions, except per-share amounts)

Free Cash Flows for All Debt and Equity	Year +1	Year +2	Year +3	Year +4	Year +5	Continuing Value Year +6
Net Cash Flow from Operations	$ 8,359.9	$ 9,201.1	$10,141.5	$10,965.8	$11,643.5	$ 9,694.4
Add back: Interest Expense after tax	361.2	388.7	424.1	457.9	495.2	510.1
Subtract: Interest Income after tax	0.0	0.0	0.0	0.0	0.0	0.0
Decrease (Increase) in Cash Required for Operations	512.5	(143.7)	(195.3)	(141.9)	(197.9)	(66.9)
Free Cash Flow from Operations for All Debt and Equity Stakeholders	$ 9,233.6	$ 9,446.1	$10,370.3	$11,281.8	$11,940.8	$10,137.6
Net Cash Flow for Investing Activities	(3,874.4)	(3,995.7)	(4,612.9)	(4,607.1)	(5,252.9)	(1,807.5)
Add back: Net Cash Flows into Financial Assets	0.0	0.0	0.0	0.0	0.0	0.0
Free Cash Flows—All Debt and Equity Stakeholders	$ 5,359.3	5,450.4	$ 5,757.4	$ 6,674.7	$ 6,688.0	$ 8,330.1
Present Value Factors ($R_A = 8.12\%$)	0.925	0.855	0.791	0.732	0.677	
Present Value Free Cash Flows	$ 4,956.5	$ 4,662.1	$ 4,554.6	$ 4,883.5	$ 4,525.5	
Sum of Present Value Free Cash Flows for All Debt and Equity Stakeholders, Year +1 through Year +5	$ 23,582.3					
Present Value of Continuing Value	109,988.1					
Total Present Value Free Cash Flows to Debt and Equity Stakeholders	$133,570.4					
Less: Value of Outstanding Debt	(8,227.0)					
Less: Value of Preferred Stock	(0.0)					
Plus: Value of Financial Assets	0.0					
Present Value of Common Equity	$125,343.4					
Adjust to midyear discounting	1.0406					
Total Present Value of Common Equity	$130,435.3					
Shares Outstanding	1,553.0					
Estimated Value per Share	$ 83.99					
Current share price	$ 54.77					
Percent difference	53%					

Two critical forecasting and valuation parameters in most valuations are the long-run growth rate assumption and the cost of equity capital assumption. Analysts should conduct sensitivity analyses to test the effects of these and other key forecast assumptions and valuation parameters on the share value estimate. Sensitivity analysis tests should allow the analyst to vary these assumptions and parameters individually and jointly for additional insights into the correlation between share value, the growth rate, and the discount rate assumptions.

For PepsiCo, our base case assumptions indicate PepsiCo's share value to be roughly $83. Our base case valuation assumptions include a long-run growth rate of 3 percent and a cost of equity capital of 8.50 percent. We can assess the sensitivity of our estimates of PepsiCo's share value by varying these two parameters (or any other key parameters in the valuation) across reasonable ranges. Exhibit 12.10 contains the results of sensitivity analysis varying the long-run growth rate from 0–10 percent and the cost of equity capital from 5–20 percent. The data in Exhibit 12.10 show that as the discount rate increases, holding growth constant, share value estimates of PepsiCo fall. Likewise, value estimates fall as growth rates decrease, holding discount rates constant.

Considering the downside possibilities first, if we reduce the long-run growth assumption to 2.0 percent while holding the discount rate constant at 8.50 percent, PepsiCo's share value falls to $73.36, still well above current market price. In fact, if we drop the long-run growth assumption to zero while holding the discount rate constant at 8.50 percent, PepsiCo's share value estimate falls to $60.84, still above current market price. Similarly, if we increase the discount rate to 9.0 or 10.0 percent while holding the long-run growth assumption constant at 3.0 percent, PepsiCo shares have a value of roughly $76 or $65, respectively. If we revise both assumptions at once and reduce the long-run growth assumption to 0 percent and increase the discount rate assumption to 10.0 percent, PepsiCo's share value falls to roughly $51, which is slightly below market price of $54.77.

On the upside, if we reduce the discount rate to 7.0 percent while holding long-run growth constant at 3.0 percent or if we increase the long-run growth assumption from 3.0 to 4.0 percent while holding the discount rate constant at 8.50 percent, the value estimates jump to roughly $114 per share or $97 per share, respectively. If we reduce the discount rate assumption further or increase the long-run growth rate further, our share value estimates for PepsiCo jump dramatically higher.

These data suggest that our value estimate is sensitive to slight variations of our baseline assumptions of 3.0 percent long-run growth and an 8.50 percent discount rate, which yield a share value estimate of $83. Adverse variations in valuation parameters could reduce PepsiCo's share value estimates to $55 or lower, whereas favorable variations could increase PepsiCo's share value up to or above $100.

If our forecast and valuation assumptions are realistic, our baseline value estimate for PepsiCo is $83 per share at the end of 2008. At that time, the market price of $54.77 per share indicates that PepsiCo shares were underpriced by about 52 percent. Under our forecast assumptions, PepsiCo's share value could vary within a range of a low of $51 per share to a high of $114 per share with only minor perturbations in our growth rate and discount rate assumptions. Given PepsiCo's $54.77 share price, these value estimates would have supported a buy recommendation or perhaps a strong buy recommendation at the end of 2008 because the valuation sensitivity analysis reveals limited downside potential but substantial upside potential for the value of PepsiCo shares.

EXHIBIT 12.10

Valuation of PepsiCo:
Sensitivity Analysis of Value to Growth and Equity Cost of Capital

Discount Rates:	Long-Run Growth Assumptions							
	0%	2%	3%	4%	5%	6%	8%	10%
5%	105.16	160.50	229.67	437.20				
6%	87.18	120.00	152.81	218.45	415.34			
7%	74.37	95.73	114.41	145.56	207.85	394.72		
8.50%	60.84	73.36	83.03	97.00	118.95	158.47	711.69	
9%	57.34	68.04	76.06	87.30	104.14	132.22	356.87	
10%	51.41	59.41	65.13	72.75	83.42	99.42	179.45	
11%	46.57	52.71	56.94	62.37	69.61	79.75	120.30	323.07
12%	42.55	47.37	50.58	54.59	59.76	66.64	90.73	163.00
13%	39.16	43.00	45.50	48.55	52.37	57.28	72.98	109.63
14%	36.26	39.37	41.35	43.73	46.63	50.26	61.15	82.93
15%	33.76	36.30	37.90	39.78	42.04	44.80	52.70	66.90
16%	31.57	33.68	34.98	36.50	38.29	40.44	46.35	56.21
18%	27.95	29.44	30.33	31.35	32.53	33.90	37.47	42.83
20%	25.08	26.16	26.79	27.51	28.31	29.24	31.55	34.79

EVALUATION OF THE FREE CASH FLOWS VALUATION METHOD

The principal advantages of the present value of future free cash flows valuation method include the following:

- This valuation method focuses on free cash flows, a base that economists would argue has a more basic economic meaning than earnings.
- Projected amounts of free cash flows result from projected amounts of revenues, expenses, assets, liabilities, and shareholders' equities, thereby requiring the analyst to project the future operating, investing, and financing decisions of a firm.
- The free cash flows valuation focuses directly on net cash inflows to the entity that are available to distribute to capital providers, as opposed to focusing on dividends to common equity shareholders. This cash flow perspective is especially pertinent to acquisition decisions.
- The free cash flows valuation approaches are widely used in practice.

The principal disadvantages of the present value of future free cash flows valuation method include the following:

- The projection of free cash flows can be time-consuming for the analyst, making it costly when the analyst follows many companies and must regularly identify under- and overvalued firms.
- The continuing value (terminal value) tends to dominate the total value in many cases. This continuing value is sensitive to assumptions made about growth rates after the forecast horizon and discount rates.
- The analyst must be very careful that free cash flow computations are internally consistent with long-run assumptions regarding growth and payout. Failure to do so can result in unnecessary estimation errors that produce poor valuations that are inconsistent with those derived from expected future dividends and earnings.

SUMMARY

This chapter illustrates valuation using the present value of future free cash flows. As with the preparation of financial statement forecasts in Chapter 10, the reasonableness of the valuations depends on the reasonableness of the assumptions. The analyst should assess the sensitivity of the valuation to alternative assumptions regarding growth and discount rates. To validate value estimates using the free-cash-flows-based approach, the analyst also should compute the value of the common equity of the firm using other approaches, such as the dividends approach described in Chapter 11, the earnings-based approach described in Chapter 13, and the valuation multiples approaches described in Chapter 14.

QUESTIONS, EXERCISES, PROBLEMS, AND CASES

Questions and Exercises

12.1 FREE CASH FLOWS. Explain "free" cash flows. Describe which types of cash flows are *free* and which are not. How do free cash flows available for debt and equity stakeholders differ from free cash flows available for common equity shareholders?

12.2 THE FREE CASH FLOWS VALUATION APPROACH. Explain the theory behind the free cash flows valuation approach. Why are free cash flows value-relevant

to common equity shareholders when they are not cash flows to those shareholders, but rather are cash flows into the firm?

12.3 MEASURING VALUE-RELEVANT FREE CASH FLOWS. The chapter describes free cash flows for common equity shareholders. If the firm borrows cash by issuing debt, how does that transaction affect free cash flows for common equity shareholders in that period? If the firm uses cash to repay debt, how does that transaction affect free cash flows for common equity shareholders in that period?

12.4 MEASURING VALUE-RELEVANT FREE CASH FLOWS. The chapter describes free cash flows for common equity shareholders. Suppose a firm has no debt and uses marketable securities to manage operating liquidity. If the firm uses cash to purchase marketable securities, how does that transaction affect free cash flows for common equity shareholders in that period? If the firm sells marketable securities for cash, how does that transaction affect free cash flows for common equity shareholders in that period?

12.5 VALUATION APPROACH EQUIVALENCE. Conceptually, why should an analyst expect valuation based on dividends and valuation based on the free cash flows for common equity shareholders to yield identical value estimates?

12.6 FREE CASH FLOWS VALUATION WHEN FREE CASH FLOWS ARE NEGATIVE. Suppose you are valuing a healthy, growing, profitable firm and you project that the firm will generate negative free cash flows for equity shareholders in each of the next five years. Can you use the free cash flows valuation approach when cash flows are negative? If so, explain how the free cash flows approach can produce positive valuations of firms when they are expected to generate negative free cash flows over the next five years.

12.7 USING DIFFERENT FREE CASH FLOWS MEASURES. The chapter describes free cash flows for all debt and equity stakeholders and free cash flows for equity shareholders. Give examples of valuation settings in which one approach or the other is appropriate.

12.8 APPROPRIATE DISCOUNT RATES. Describe valuation settings in which the appropriate discount rate to use is the required rate of return on equity capital versus settings in which it is appropriate to use a weighted average cost of capital.

12.9 FREE CASH FLOWS AND DISCOUNT RATES. Describe circumstances and give an example of when free cash flows to equity shareholders and free cash flows to all debt and equity stakeholders will be identical. Under those circumstances, will the required rate of return on equity and the weighted average cost of capital be identical too? Explain.

Problems and Cases

12.10 CALCULATING FREE CASH FLOWS. The 3M Company is a global diversified technology company active in the following product markets: consumer and office; display and graphics; electronics and communications; health care; industrial; safety, security, and protection services; and transportation. At the consumer level, 3M is probably most widely known for products such as Scotch® Brand transparent tape and Post-it® notes. Exhibit 12.11 presents information from the statement of cash flows and income

EXHIBIT 12.11

3M Company
Selected Information from the Statement of Cash Flows
(amounts in millions)
(Problem 12.10)

	2008	2007	2006
Cash Flow from Operating Activities	$ 4,118	$ 4,363	$ 3,896
Investing Activities:			
Fixed Assets Acquired, Net	(1,384)	(1,319)	(1,119)
(Acquisition) Sale of Businesses, Net	(1,306)	358	321
(Purchase) Sale of Investments	291	(406)	(662)
Cash Flow from Investing Activities	$(2,399)	$(1,367)	$(1,460)
Financing Activities:			
Increase (Decrease) in Short-Term Borrowing	361	(1,222)	882
Increase (Decrease) in Long-Term Debt	676	2,444	253
Increase (Decrease) in Common Stock	(1,405)	(2,389)	(1,820)
Dividends Paid	(1,398)	(1,380)	(1,376)
Cash Flow from Financing Activities	$(1,766)	$(2,547)	$(2,061)
Net Increase (Decrease) in Cash & Equivalents	$ (47)	$ 449	$ 375
Cash at Beginning of Year	$ 1,896	$ 1,447	$ 1,072
Cash at End of Year	$ 1,849	$ 1,896	$ 1,447
Interest Income	$ 105	$ 132	$ 51
Interest Expense	$ 215	$ 210	$ 122

statement for the 3M Company for 2006–2008. From 2006 through 2008, 3M increased cash and cash equivalents. Assume that 3M considers these increases in cash and cash equivalents to be necessary to sustain operating liquidity. The interest income reported by 3M pertains to interest earned on cash and marketable securities. 3M holds only small amounts of investments in marketable securities. 3M's income tax rate is 35 percent.

Required
 a. Beginning with cash flows from operating activities, calculate the amount of free cash flows to all debt and equity capital stakeholders for 3M for 2006, 2007, and 2008.
 b. Beginning with cash flows from operating activities, calculate the amount of free cash flows 3M generated for common equity shareholders in 2006, 2007, and 2008.
 c. Reconcile the amounts of free cash flows 3M generated for common equity shareholders in 2006, 2007, and 2008 from Part b with 3M's uses of cash flow for equity shareholders, including share repurchases and dividend payments.

12.11 CALCULATING FREE CASH FLOWS. Dick's Sporting Goods is a chain of full-line sporting goods retail stores offering a broad assortment of brand name sporting goods equipment, apparel, and footwear. Dick's Sporting Goods had its initial public offering of shares in fiscal 2003. Since then, Dick's Sporting Goods has grown its chain of retail

stores rapidly and has acquired several other chains of retail sporting goods stores, including Golf Galaxy and Chick's Sporting Goods in the fiscal year ending in 2008. As of the end of the fiscal year ending in 2009, Dick's Sporting Goods operated 409 stores in 40 states of the United States. Exhibit 12.12 presents information from the statement of cash flows and income statement for Dick's Sporting Goods for the fiscal years ending in 2007 through 2009. Dick's Sporting Goods requires all of its cash and cash equivalents for operating liquidity and reports no interest income on the income statement. The average income tax rate for Dick's Sporting Goods during 2007 through 2009 is 40 percent.

Required

a. Beginning with cash flows from operating activities, calculate free cash flows to all debt and equity capital stakeholders for Dick's Sporting Goods for fiscal years ending in 2009, 2008, and 2007.

b. Beginning with cash flows from operating activities, calculate free cash flows for common equity shareholders for Dick's Sporting Goods for fiscal years ending in 2009, 2008, and 2007.

c. Reconcile the amounts of free cash flows for common equity shareholders for Dick's Sporting Goods for fiscal years ending in 2009, 2008, and 2007 with Dick's Sporting Goods' sources of cash flow from equity shareholders.

d. Why do the free cash flows to all debt and equity capital stakeholders for Dick's Sporting Goods change so much from 2007 through 2009? In each of these three years, why do the free cash flows to all debt and equity capital stakeholders differ so much from the free cash flows to common equity shareholders?

e. In each of these three years, Dick's Sporting Goods produces negative free cash flows for common shareholders. Does that imply that Dick's Sporting Goods is destroying the value of common equity? Explain.

12.12 VALUING A LEVERAGED BUYOUT CANDIDATE.

May Department Stores (May) operates retail department store chains throughout the United States. At the end of Year 12, May reports debt of $4,658 million and common shareholders' equity at book value of $3,923 million. The market value of its common stock is $6,705, and its market equity beta is 0.88.

An equity buyout group is considering an LBO of May as of the beginning of Year 13. The group intends to finance the buyout with 25 percent common equity and 75 percent debt carrying an interest rate of 10 percent. The group projects that the free cash flows to all debt and equity capital stakeholders of May will be as follows: Year 13, $798 million; Year 14, $861 million; Year 15, $904 million; Year 16, $850 million; Year 17, $834 million; Year 18, $884 million; Year 19, $919 million; Year 20, $947 million; Year 21, $985 million; and Year 22, $1,034 million. The group projects free cash flows to grow 3 percent annually after Year 22.

This problem sets forth the steps the analyst might follow in deciding whether to acquire May and the value to place on the firm.

Required

a. Compute the unlevered market equity (asset) beta of May before consideration of the LBO. Assume that the book value of the debt equals its market value. The income tax rate is 35 percent. [See Chapter 11.]

b. Compute the cost of equity capital with the new capital structure that results from the LBO. Assume a risk-free rate of 4.2 percent and a market risk premium of 5.0 percent.

c. Compute the weighted average cost of capital of the new capital structure.

EXHIBIT 12.12

Dick's Sporting Goods
Selected Information from the Statement of Cash Flows
(amounts in thousands)
(Problem 12.11)

	Fiscal year ended:		
	January 31, 2009	February 2, 2008	February 3, 2007
CASH FLOWS FROM OPERATING ACTIVITIES:			
Net (loss) income	$ (35,094)	$ 155,036	$ 112,611
Adjustments to reconcile net (loss) income to net cash provided by operating activities:			
Depreciation and amortization	90,732	75,052	54,929
Impairment of store assets, goodwill and other intangible assets	193,350	—	—
Deferred income taxes	(45,906)	(32,696)	(1,110)
Various addbacks to net income	24,709	2,462	(7,371)
Changes in assets and liabilities, net of acquired assets and liabilities:			
Accounts receivable	3,090	(10,982)	(2,142)
Inventories	29,581	(127,027)	(105,766)
Prepaid expenses and other assets	(10,554)	(4,267)	(29,039)
Accounts payable	(56,709)	12,337	24,444
Accrued expenses	(7,575)	26,222	42,479
Income taxes payable/receivable	(63,089)	114,706	4,750
Deferred construction allowances	19,452	22,256	19,264
Deferred revenue and other liabilities	17,689	29,869	26,560
Net cash provided by operating activities	**$ 159,676**	**$ 262,968**	**$ 139,609**
CASH FLOWS USED IN INVESTING ACTIVITIES:			
Capital expenditures	(191,423)	(172,366)	(162,995)
Purchase of corporate aircraft	(25,107)	—	—
Proceeds from sale of corporate aircraft	27,463	—	—
Proceeds from sale-leaseback transactions	44,873	28,440	32,509
Payment for the purchase of Golf Galaxy, net of $4,859 cash acquired	—	(222,170)	—
Payment for the purchase of Chick's Sporting Goods	—	(69,200)	—
Net cash used in investing activities	**$(144,194)**	**$(435,296)**	**$(130,486)**
CASH FLOWS FROM FINANCING ACTIVITIES:			
Increase (Decrease) Short-term borrowing	(9,927)	4,785	8,829
Long-term borrowing—Construction allowance receipts	11,874	13,282	17,902
Payments on long-term debt and capital leases	(6,793)	(1,058)	(184)
Proceeds from sale of common stock	13,894	69,684	63,708
Net cash provided by financing activities	**$ 9,048**	**$ 86,693**	**$ 90,255**
NET INCREASE (DECREASE) IN CASH	**$ 24,530**	**$ (85,635)**	**$ 99,378**
CASH, BEGINNING OF PERIOD	50,307	135,942	36,564
CASH, END OF PERIOD	**$ 74,837**	**$ 50,307**	**$ 135,942**
Cash paid during the year for interest	$ 8,021	$ 12,314	$ 9,286

d. Compute the present value of the projected free cash flows to all debt and equity capital stakeholders at the weighted average cost of capital. Ignore the midyear adjustment related to the assumption that cash flows occur, on average, over the year. In computing the continuing value, apply the projected growth rate in free cash flows after Year 22 of 3 percent directly to the free cash flows of Year 22.

e. Assume that the buyout group acquires May for the value determined in Part d. Assuming that the realized free cash flows coincide with projections, will May generate sufficient cash flow each year to service the interest on the debt? Explain.

12.13 VALUING A LEVERAGED BUYOUT CANDIDATE. Experian

Information Solutions (Experian) is a wholly owned subsidiary of TRW, a publicly traded company. The subsidiary has (in thousands) total assets of $555,443, long-term debt of $1,839, and common equity at book value of $402,759.

An equity buyout group is planning to acquire Experian from TRW in an LBO as of the beginning of Year 6. The group plans to finance the buyout with 60 percent debt that has an interest cost of 10 percent per year and 40 percent common equity. Analysts for the buyout group project free cash flows to all debt and equity capital stakeholders as follows (in thousands): Year 6, $52,300; Year 7, $54,915; Year 8, $57,112; Year 9, $59,396; and Year 10, $62,366. Because Experian is not a publicly traded firm, it does not have a market equity beta. The company most comparable to Experian is Equifax. Equifax has an equity beta of 0.86. The market value of Equifax's debt is $366.5 thousand, and its common equity is $4,436.8 thousand. Assume an income tax rate of 35 percent throughout this problem.

This problem sets forth the steps the analyst might follow in valuing an LBO candidate.

Required

a. Compute the unlevered market equity (asset) beta of Equifax. [See Chapter 11.]

b. Assuming that the unlevered market equity beta of Equifax is appropriate for Experian, compute the equity beta of Experian after the buyout with its new capital structure.

c. Compute the weighted average cost of capital of Experian after the buyout. Assume a risk-free interest rate of 4.2 percent and a market risk premium of 5.0 percent.

d. The analysts at the buyout firm project that free cash flows for all debt and equity capital stakeholders of Experian will increase 5.0 percent each year after Year 10. Compute the present value of the free cash flows at the weighted average cost of capital. Ignore the midyear adjustment related to the assumption that cash flows occur, on average, over the year. In computing the continuing value, apply the 5.0 percent projected growth rate directly to the free cash flows of Year 10.

e. Assume that the buyout group acquires Experian for the value determined in Part d. Assuming that actual free cash flows to all debt and equity capital stakeholders coincide with projections, will Experian generate sufficient cash flow each year to service the debt? Explain.

12.14 APPLYING VARIOUS PRESENT VALUE APPROACHES TO

VALUATION. An equity buyout group intends to acquire Wedgewood Products (Wedgewood) as of the beginning of Year 8. The buyout group intends to finance 40 percent of the acquisition price with 10 percent annual coupon debt and 60 percent with common equity. The income tax rate is 40 percent. The cost of equity capital is 14 percent. Analysts at the buyout firm project the following free cash flows for all debt and equity capital stakeholders for Wedgewood (in millions): Year 8, $2,100; Year 9, $2,268; Year 10, $2,449; Year 11, $2,645; and Year 12, $2,857. The analysts project that free cash flows for all debt and equity capital stakeholders will increase 8 percent each year after Year 12.

Required

a. Compute the weighted average cost of capital for Wedgewood based on the proposed capital structure.

b. Compute the total purchase price of Wedgewood (debt plus common equity). To do this, discount the free cash flows for all debt and equity capital stakeholders at the weighted average cost of capital. Ignore the midyear adjustment related to the assumption that cash flows occur, on average, over the year. In computing the continuing value, apply the 8 percent projected growth rate in free cash flows after Year 12 directly to the free cash flows of Year 12.

c. Given the purchase price determined in Part b, compute the total amount of debt, the annual interest cost, and the free cash flows to common equity shareholders for Year 8 to Year 12.

d. The present value of the free cash flows for common equity shareholders when discounted at the 14 percent cost of equity capital should equal the common equity portion of the total purchase price computed in Part b. Determine the growth rate in free cash flows for common equity shareholders after Year 12 that will result in a present value of free cash flows for common equity shareholders equal to 60 percent of the purchase price computed in Part b.

e. Why does the implied growth rate in free cash flows to common equity shareholders determined in Part d differ from the 8 percent assumed growth rate in free cash flows for all debt and equity capital stakeholders?

f. The adjusted present value valuation approach separates the total value of the firm into the value of an all-equity firm and the value of the tax savings from interest deductions. Assume that the cost of unlevered equity is 11.33 percent. Compute the present value of the free cash flows to all debt and equity capital stakeholders at this unlevered equity cost. Compute the present value of the tax savings from interest expense deductions using the pretax cost of debt as the discount rate. Compare the total of these two present values to the purchase price determined in Part b.

12.15 VALUING THE EQUITY OF A PRIVATELY HELD FIRM. Refer to the projected financial statements for Massachusetts Stove Company (MSC) prepared for Case 10.2. The management of MSC wants to know the equity valuation implications of not adding gas stoves versus adding gas stoves under the best, most likely, and worst scenarios. Under the three scenarios from Case 10.2 and a fourth scenario involving not adding gas stoves, the projected free cash flows to common equity shareholders for Year 8 to Year 12, and assumed growth rates thereafter, are as follows:

Year	Best	Most Likely	Worst	No Gas
8	$ 73,967	$ 47,034	$ 3,027	$162,455
9	$ 52,143	$ (3,120)	$(84,800)	$132,708
10	$213,895	$135,939	$ 48,353	$106,021
11	$315,633	$178,510	$ 36,605	$ 81,840
12	$432,232	$220,010	$ 10,232	$ 60,007
13–17	20% Growth	10% Growth	Zero Growth	Zero Growth
After Year 17	10% Growth	5% Growth	Zero Growth	Zero Growth

MSC is not publicly traded and therefore does not have a market equity beta. Using the market equity beta of the only publicly traded woodstove and gas stove manufacturing firm

and adjusting it for differences in the debt-to-equity ratio, income tax rate, and privately owned status of MSC yields a cost of equity capital for MSC of 13.55 percent.

Required

a. Calculate the value of the equity of MSC as of the end of Year 7 under each of the four scenarios. Ignore the midyear adjustment related to the assumption that cash flows occur, on average, over the year. Apply the growth rates in free cash flows to common equity shareholders after Year 12 directly to the free cash flow of the preceding year. (That is, Year 13 free cash flow equals the free cash flow for Year 12 times the given growth rate; Year 18 free cash flow equals the free cash flow for Year 17 times the given growth rate.)

b. How do these valuations affect your advice to the management of MSC regarding the addition of gas stoves to its woodstove line?

12.16 FREE-CASH-FLOWS-BASED VALUATION. The Coca-Cola Company is a global soft drink beverage company (ticker symbol = KO) that is a primary and direct competitor with PepsiCo. The data in Exhibits 12.13–12.15 (see pages 980–983) include the actual amounts for 2006, 2007, and 2008 and projected amounts for Year +1 to Year +6 for the income statements, balance sheets, and statements of cash flows for Coca-Cola (in millions).

The market equity beta for Coca-Cola at the end of 2008 is 0.61. Assume that the risk-free interest rate is 4.0 percent and the market risk premium is 6.0 percent. Coca-Cola has 2,312 million shares outstanding at the end of 2008, when Coca-Cola's share price was $44.42.

Required

Part I—Computing Coca-Cola's Share Value Using Free Cash Flows to Common Equity Shareholders

a. Use the CAPM to compute the required rate of return on common equity capital for Coca-Cola.

b. Derive the projected free cash flows for common equity shareholders for Coca-Cola for Years +1 through +6 based on the projected financial statements. Assume that Coca-Cola's changes in cash each year are necessary for operating liquidity purposes. The financial statement forecasts for Year +6 assume that Coca-Cola will experience a steady-state long-run growth rate of 3 percent in Year +6 and beyond.

c. Using the required rate of return on common equity from Part a as a discount rate, compute the sum of the present value of free cash flows for common equity shareholders for Coca-Cola for Years +1 through +5.

d. Using the required rate of return on common equity from Part a as a discount rate and the long-run growth rate from Part b, compute the continuing value of Coca-Cola as of the start of Year +6 based on Coca-Cola's continuing free cash flows for common equity shareholders in Year +6 and beyond. After computing continuing value as of the start of Year +6, discount it to present value at the start of Year +1.

e. Compute the value of a share of Coca-Cola common stock. (1) Compute the total sum of the present value of all future free cash flows for equity shareholders (from Parts c and d). (2) Adjust the total sum of the present value using the midyear discounting adjustment factor. (3) Compute the per-share value estimate.

Part II—Computing Coca-Cola's Share Value Using Free Cash Flows to All Debt and Equity Stakeholders

f. At the end of 2008, Coca-Cola had $9,312 million in outstanding interest-bearing short-term and long-term debt on the balance sheet and no preferred stock. Assume that the balance sheet value of Coca-Cola's debt is approximately equal

to the market value of the debt. The forecasts assume that Coca-Cola will face an interest rate of 4.5 percent on debt capital and that Coca-Cola's average tax rate will be 23.2 percent (based on the past five-year average effective tax rate). Compute the weighted average cost of capital for Coca-Cola as of the start of Year +1.

g. Beginning with projected net cash flows from operations, derive the projected free cash flows for all debt and equity stakeholders for Coca-Cola for Years +1 through +6 based on the projected financial statements. Assume that the change in cash each year is related to operating liquidity needs.

h. Using the weighted average cost of capital from Part f as a discount rate, compute the sum of the present value of free cash flows for all debt and equity stakeholders for Coca-Cola for Years +1 through +5.

i. Using the weighted average cost of capital from Part f as a discount rate and the long-run growth rate from Part b, compute the continuing value of Coca-Cola as of the start of Year +6 based on Coca-Cola's continuing free cash flows for all debt and equity stakeholders in Year +6 and beyond. After computing continuing value as of the start of Year +6, discount it to present value as of the start of Year +1.

j. Compute the value of a share of Coca-Cola common stock. (1) Compute the total value of Coca-Cola's net operating assets using the total sum of the present value of free cash flows for all debt and equity stakeholders (from Parts h and i). (2) Subtract the value of outstanding debt to obtain the value of equity. (3) Adjust the present value of equity using the midyear discounting adjustment factor. (4) Compute the per-share value estimate of Coca-Cola's common equity shares.

Note: Do not be alarmed if your share value estimate from Part e is slightly different from your share value estimate from Part j. The weighted average cost of capital computation in Part f used the weight of equity based on the market price of Coca-Cola's stock at the end of 2008. The share value estimates from Parts e and j likely differ from the market price, so the weights used to compute the weighted average cost of capital are not internally consistent with the estimated share values.

Part III—Sensitivity Analysis and Recommendation

k. Using the free cash flows to common equity shareholders, recompute the value of Coca-Cola shares under two alternative scenarios. Scenario 1: Assume that Coca-Cola's long-run growth will be 2 percent, not 3 percent as before, and assume that Coca-Cola's required rate of return on equity is 1 percent higher than the rate you computed for Part a. Scenario 2: Assume that Coca-Cola's long-run growth will be 4 percent, not 3 percent as before, and assume that Coca-Cola's required rate of return on equity is 1 percent lower than the rate you computed in Part a. To quantify the sensitivity of your share value estimate for Coca-Cola to these variations in growth and discount rates, compare (in percentage terms) your value estimates under these two scenarios with your value estimate from Part e.

l. Using these data at the end of 2008, what reasonable range of share values would you have expected for Coca-Cola common stock? At that time, what was the market price for Coca-Cola shares relative to this range? What investment strategy (buy, hold, or sell) would you have recommended?

12.17 FREE-CASH-FLOWS-BASED VALUATION. In Problem 10.16, we projected financial statements for Wal-Mart Stores, Inc. (Walmart) for Years +1 through +5. The data in Exhibits 12.16–12.18 (see pages 985–987) include the actual amounts for 2008 and the projected amounts for Year +1 to Year +5 for the income statements, balance sheets, and statements of cash flows for Walmart (in millions).

EXHIBIT 12.13

The Coca-Cola Company
Income Statements for 2006 through 2008 (Actual) and Year +1 through +6 (Projected)
(amounts in millions)
(Problem 12.16)

	Actuals			Forecasts					
Year	2006	2007	2008	Year +1	Year +2	Year +3	Year +4	Year +5	Year +6
Revenues	$24,088	$28,857	$31,944	$33,541	$35,218	$36,979	$38,828	$40,770	$41,993
Cost of goods sold	(8,164)	(10,406)	(11,374)	(11,943)	(12,540)	(13,167)	(13,825)	(14,516)	(14,952)
Gross Profit	$15,924	$18,451	$20,570	$21,599	$22,678	$23,812.	$25,003	$26,253	$27,041
Selling, general, and administrative expenses	(9,431)	(10,945)	(11,774)	(12,363)	(12,981)	(13,630)	(14,311)	(15,027)	(15,478)
Other operating expenses	(185)	(254)	(350)	(368)	(386)	(405)	(425)	(447)	(460)
Operating Profit	$ 6,308	$ 7,252	$ 8,446	$ 8,868	$ 9,312	$ 9,777	$10,266	$10,779	$11,103
Interest income	193	236	333	263	264	264	264	265	273
Interest expense	(220)	(456)	(438)	(425)	(442)	(462)	(482)	(503)	(518)
Income (loss) from equity affiliates	102	668	(874)	469	497	527	559	592	610
Income before Tax	$ 6,578	$ 7,873	$ 7,439	$ 9,175	$ 9,631	$10,107	$10,607	$11,134	$11,468
Income tax expense	(1,498)	(1,892)	(1,632)	(2,124)	(2,230)	(2,340)	(2,456)	(2,578)	(2,655)
Net Income	$ 5,080	$ 5,981	$ 5,807	$ 7,051	$ 7,401	$ 7,767	$ 8,151	$ 8,556	$ 8,813
Other comprehensive income items	666	1,917	(3,300)	0	0	0	0	0	0
Comprehensive Income	$ 5,746	$ 7,898	$ 2,507	$ 7,051	$ 7,401	$ 7,767	$ 8,151	$ 8,556	$ 8,813

EXHIBIT 12.14

The Coca-Cola Company

Balance Sheets for 2006 through 2008 (Actual) and Year +1 through +6 (Projected)
(amounts in millions)
(Problem 12.16)

	Actuals			Forecasts					
	2006	2007	2008	Year +1	Year +2	Year +3	Year +4	Year +5	Year +6
ASSETS									
Cash and cash equivalents	$ 2,440	$ 4,093	$ 4,701	$ 4,701	$ 4,701	$ 4,701	$ 4,701	$ 4,701	$ 4,842
Marketable securities	150	215	278	286	295	304	313	322	332
Accounts receivable—Net	2,587	3,317	3,090	3,710	3,430	4,067	3,805	4,461	4,595
Inventories	1,641	2,220	2,187	2,320	2,412	2,556	2,661	2,817	2,902
Prepaid expenses and other current assets	1,623	2,260	1,920	2,016	2,117	2,223	2,334	2,450	2,524
Current Assets	$ 8,441	$12,105	$12,176	$13,033	$12,955	$13,851	$13,813	$14,752	$15,194
Long-term investments in affiliates	6,783	7,777	5,779	6,126	6,493	6,883	7,296	7,734	7,966
Property, plant & equipment—At cost	11,911	14,444	14,400	16,191	18,071	20,045	22,118	24,294	25,023
(Accumulated depreciation)	(5,008)	(5,951)	(6,074)	(7,189)	(8,433)	(9,813)	(11,336)	(13,009)	(13,399)
Amortizable intangible assets (net)	1,687	2,810	2,417	2,417	2,417	2,417	2,417	2,417	2,490
Goodwill and nonamortizable intangibles	3,448	9,409	10,088	10,592	11,122	11,678	12,262	12,875	13,261
Other non-current assets (1)	2,701	2,675	1,733	1,785	1,839	1,894	1,951	2,009	2,069
Total Assets	$29,963	$43,269	$40,519	$42,955	$44,464	$46,954	$48,520	$51,072	$52,604

(Continued)

EXHIBIT 12.14 (Continued)

	Actuals			Forecasts					
	2006	2007	2008	Year +1	Year +2	Year +3	Year +4	Year +5	Year +6
LIABILITIES									
Accounts payable—Trade	$ 929	$ 1,380	$ 1,370	$ 1,277	$ 1,492	$ 1,425	$ 1,628	$ 1,588	$ 1,636
Current accrued liabilities	4,126	5,535	4,835	5,077	5,331	5,597	5,877	6,171	6,356
Notes payable and short-term debt	3,235	5,919	6,066	6,443	6,670	7,043	7,278	7,661	7,891
Current maturities of long-term debt	33	133	465	305	322	333	351	361	372
Income taxes payable	567	258	252	172	178	188	194	204	210
Current Liabilities	$ 8,890	$ 13,225	$ 12,988	$ 13,274	$ 13,992	$ 14,586	$ 15,327	$ 15,985	$ 16,465
Long-term debt	1,314	3,277	2,781	2,948	3,052	3,223	3,330	3,505	3,610
Deferred tax liabilities—Noncurrent	608	1,890	877	930	962	1,016	1,050	1,105	1,139
Other non-current liabilities (1)	2,231	3,133	3,401	3,571	3,750	3,937	4,134	4,341	4,471
Total Liabilities	$ 13,043	$ 21,525	$ 20,047	$ 20,723	$ 21,756	$ 22,762	$ 23,842	$ 24,936	$ 25,685
SHAREHOLDERS' EQUITY:									
Common stock + paid-in capital	$ 6,861	$ 8,258	$ 8,846	$ 9,378	$ 9,707	$ 10,251	$ 10,593	$ 11,150	$ 11,484
Retained earnings	33,468	36,235	38,513	39,742	39,887	40,828	40,973	41,873	43,049
Accum. other comprehensive income (loss)	(1,291)	626	(2,674)	(2,674)	(2,674)	(2,674)	(2,674)	(2,674)	(2,674)
(Treasury stock)	(22,118)	(23,375)	(24,213)	(24,213)	(24,213)	(24,213)	(24,213)	(24,213)	(24,939)
Common Shareholders' Equity	$ 16,920	$ 21,744	$ 20,472	$ 22,232	$ 22,708	$ 24,192	$ 24,679	$ 26,135	$ 26,920
Total Liabilities and Equities	$ 29,963	$ 43,269	$ 40,519	$ 42,955	$ 44,464	$ 46,954	$ 48,520	$ 51,072	$ 52,604

EXHIBIT 12.15

The Coca-Cola Company
Projected Implied Statements of Cash Flows for Year +1 through +6
(amounts in millions)
(Problem 12.16)

			Forecasts			
IMPLIED STATEMENT OF CASH FLOWS	Year +1	Year +2	Year +3	Year +4	Year +5	Year +6
Net Income	$ 7,051	$ 7,401	$ 7,767	$ 8,151	$ 8,556	$ 8,813
Add back depreciation expense (net)	1,115	1,244	1,380	1,523	1,673	390
(Increase) Decrease in receivables—Net	(620)	280	(637)	262	(656)	(134)
(Increase) Decrease in inventories	(133)	(93)	(144)	(104)	(156)	(85)
(Increase) Decrease in prepaid expenses	(96)	(101)	(106)	(111)	(117)	(74)
Increase (Decrease) in accounts payable—Trade	(93)	215	(67)	202	(40)	48
Increase (Decrease) in current accrued liabilities	242	254	267	280	294	185
Increase (Decrease) in income taxes payable	(80)	6	10	6	10	6
Net change in deferred tax assets and liabilities	53	33	54	34	55	33
Increase (Decrease) in other non-current liabilities	170	179	187	197	207	130
Net Cash Flows from Operations	$ 7,608	$ 9,419	$ 8,711	$10,440	$ 9,826	$ 9,313
(Increase) Decrease in prop., plant, & equip. at cost	(1,791)	(1,880)	(1,974)	(2,073)	(2,177)	(729)
(Increase) Decrease in marketable securities	(8)	(9)	(9)	(9)	(9)	(10)
(Increase) Decrease in investment securities	(347)	(368)	(390)	(413)	(438)	(232)
(Increase) Decrease in amortizable intangible assets (net)	0	0	0	0	0	(73)
(Increase) Decrease in goodwill and nonamort. intang.	(504)	(530)	(556)	(584)	(613)	(386)
(Increase) Decrease in other non-current assets	(52)	(54)	(55)	(57)	(59)	(60)
Net Cash Flows from Investing	$(2,702)	$(2,839)	$(2,984)	$(3,136)	$(3,295)	$(1,490)
Increase (Decrease) in short-term debt	217	243	384	252	393	241
Increase (Decrease) in long-term debt	167	104	171	107	175	105
Increase (Decrease) in common stock + paid-in capital	532	329	544	342	557	334
Increase (Decrease) in accum. OCI and other equity adjs.	0	0	0	0	0	0
Increase (Decrease) in treasury stock	0	0	0	0	0	(726)
Dividends	(5,822)	(7,255)	(6,826)	(8,006)	(7,656)	(7,637)
Net Cash Flows from Financing	$(4,906)	$(6,579)	$(5,727)	$(7,305)	$(6,531)	$(7,683)
Net Change in Cash	$ —	$ —	$ —	$ —	$ —	$ 141

The market equity beta for Walmart at the end of Year 4 was 0.80. Assume that the risk-free interest rate was 3.5 percent and the market risk premium was 5.0 percent. Walmart had 3,925 million shares outstanding at the end of 2008. At the end of 2008, Walmart's share price was $46.06.

Required

Part I—Computing Walmart's Share Value Using Free Cash Flows to Common Equity Shareholders

 a. Use the CAPM to compute the required rate of return on common equity capital for Walmart.

 b. Beginning with projected net cash flows from operations, derive the projected free cash flows for common equity shareholders for Walmart for Years +1 through +5 based on the projected financial statements. Assume that Walmart uses any change in cash each year for operating liquidity purposes.

 c. Project the continuing free cash flow for common equity shareholders in Year +6. Assume that the steady-state long-run growth rate will be 3 percent in Year +6 and beyond. Project that the Year +5 income statement and balance sheet amounts will grow by 3 percent in Year +6; then derive the projected statement of cash flows for Year +6. Derive the projected free cash flow for common equity shareholders in Year +6 from the projected statement of cash flows for Year +6.

 d. Using the required rate of return on common equity from Part a as a discount rate, compute the sum of the present value of free cash flows for common equity shareholders for Walmart for Years +1 through +5.

 e. Using the required rate of return on common equity from Part a as a discount rate and the long-run growth rate from Part c, compute the continuing value of Walmart as of the start of Year +6 based on Walmart's continuing free cash flows for common equity shareholders in Year +6 and beyond. After computing continuing value as of the start of Year +6, discount it to present value at the start of Year +1.

 f. Compute the value of a share of Walmart common stock. (1) Compute the total sum of the present value of all future free cash flows for equity shareholders (from Parts d and e). (2) Adjust the total sum of the present value using the midyear discounting adjustment factor. (3) Compute the per-share value estimate.

Note: If you worked Problem 11.14 in Chapter 11 and computed Walmart's share value using the dividends valuation approach, compare your value estimate from that problem with the value estimate you obtain here. They should be the same.

Part II—Computing Walmart's Share Value Using Free Cash Flows to All Debt and Equity Stakeholders

 g. At the end of 2008, Walmart had $42,218 million in outstanding interest-bearing short-term and long-term debt on the balance sheet and no preferred stock. Assume that the balance sheet value of Walmart's debt is approximately equal to the market value of the debt. During 2008, Walmart's income statement included interest expense of $2,184 million. During 2008, Walmart faced an average interest expense of roughly 5.0 percent. Assume that at the start of Year +1, Walmart will continue to incur interest expense of 5.0 percent on debt capital and that Walmart's average tax rate will be 34.2 percent. Compute the weighted average cost of capital for Walmart as of the start of Year +1.

 h. Beginning with projected net cash flows from operations, derive the projected free cash flows for all debt and equity stakeholders for Walmart for Years +1 through +5 based on the projected financial statements.

 i. Project the continuing free cash flows for all debt and equity stakeholders in Year +6. Use the projected financial statements for Year +6 from Part c to derive the projected free cash flow for all debt and equity stakeholders in Year +6.

EXHIBIT 12.16

Wal-Mart Stores, Inc.
Income Statements for 2008 (Actual) and Year +1 through +5 (Projected)
(amounts in millions)
(Problem 12.17)

	Actual			Projected:		
	2008	Year +1	Year +2	Year +3	Year +4	Year +5
Revenues	$ 405,607	$ 433,999	$ 464,379	$ 496,886	$ 531,668	$ 568,885
Cost of goods sold	(306,158)	(327,670)	(350,606)	(375,149)	(401,409)	(429,508)
Gross Profit	$ 99,449	$ 106,330	$ 113,773	$ 121,737	$ 130,259	$ 139,377
Selling, general, and administrative expenses	(76,651)	(82,460)	(88,232)	(94,408)	(101,017)	(108,088)
Interest income	284	320	320	320	320	320
Interest expense	(2,184)	(2,163)	(2,269)	(2,383)	(2,503)	(2,630)
Income before tax	$ 20,898	$ 22,027	$ 23,591	$ 25,266	$ 27,059	$ 28,979
Income tax expense	(7,145)	(7,533)	(8,068)	(8,641)	(9,254)	(9,911)
Minority interest in earnings	(499)	(499)	(499)	(499)	(499)	(499)
Net Income	$ 13,400	$ 13,995	$ 15,024	$16,126	$ 17,306	$ 18,569

EXHIBIT 12.17

Wal-Mart Stores, Inc.
Balance Sheets for 2008 (Actual) and Year +1 through +5 (Projected)
(amounts in millions)
(Problem 12.17)

	Actual			Projected		
	2008	Year +1	Year +2	Year +3	Year +4	Year +5
ASSETS						
Cash and cash equivalents	$ 7,275	$ 7,275	$ 7,275	$ 7,275	$ 7,275	$ 7,275
Accounts receivable—Net	3,905	4,178	4,471	4,784	5,119	5,477
Inventories	34,511	40,815	39,784	46,457	45,821	52,917
Prepaid expenses and other current assets	3,063	3,277	3,507	3,752	4,015	4,296
Current assets of discontinued segments	195	0	0	0	0	0
Current Assets	$ 48,949	$ 55,546	$ 55,037	$ 62,268	$ 62,229	$ 69,965
Property, plant & equipment—At cost	131,161	146,376	163,355	182,304	203,452	227,052
(Accumulated depreciation)	(35,508)	(42,827)	(50,995)	(60,110)	(70,282)	(81,635)
Goodwill and nonamortizable intangibles	18,827	20,145	21,555	23,064	24,678	26,406
Total Assets	$163,429	$179,240	$ 188,952	$ 207,527	$ 220,077	$ 241,788
LIABILITIES						
Accounts payable—Trade	$ 28,849	$ 35,201	$ 31,841	$ 41,385	$ 35,475	$ 48,257
Current accrued liabilities	18,112	19,380	20,736	22,188	23,741	25,403
Notes payable and short-term debt	1,506	1,506	1,506	1,506	1,506	1,506
Current maturities of long-term debt	6,163	6,163	6,163	6,163	6,163	6,163
Income taxes payable	760	813	870	931	996	1,066
Current Liabilities	$ 55,390	$ 63,063	$ 61,117	$ 72,173	$ 67,882	$ 82,395
Long-term debt	34,549	36,622	38,819	41,148	43,617	46,234
Deferred tax liabilities—Noncurrent	6,014	6,615	7,277	8,005	8,805	9,686
Total Liabilities	$ 95,953	$106,300	$ 107,213	$ 121,326	$ 120,304	$ 138,315
SHAREHOLDERS' EQUITY						
Minority interest	2,191	2,191	2,191	2,191	2,191	2,191
Common stock + paid-in capital	4,313	4,744	5,219	5,741	6,315	6,946
Retained earnings	63,660	68,692	77,018	80,957	93,955	97,024
Accum. other comprehensive income (loss)	(2,688)	(2,688)	(2,688)	(2,688)	(2,688)	(2,688)
Common Shareholders' Equity	$ 65,285	$ 70,749	$ 79,549	$ 84,010	$ 97,582	$ 101,282
Total Liabilities and Equities	$163,429	$179,240	$ 188,952	$ 207,527	$ 220,077	$ 241,788

EXHIBIT 12.18

Wal-Mart Stores, Inc.

Projected Implied Statements of Cash Flows for Year +1 through +5

(amounts in millions)

(Problem 12.17)

			Projected		
	Year +1	Year +2	Year +3	Year +4	Year +5
IMPLIED STATEMENT OF CASH FLOWS					
Net Income	$ 13,995	$ 15,024	$ 16,126	$ 17,306	$ 18,569
Add back depreciation expense (net)	7,319	8,168	9,115	10,173	11,353
(Increase) Decrease in receivables—Net	(273)	(292)	(313)	(335)	(358)
(Increase) Decrease in inventories	(6,304)	1,032	(6,673)	637	(7,096)
(Increase) Decrease in prepaid expenses	(214)	(229)	(245)	(263)	(281)
(Increase) Decrease in other current assets	195	0	0	0	0
Increase (Decrease) in accounts payable—Trade	6,352	(3,360)	9,544	(5,910)	12,782
Increase (Decrease) in current accrued liabilities	1,268	1,357	1,452	1,553	1,662
Increase (Decrease) in income taxes payable	53	57	61	65	70
Net change in deferred tax assets and liabilities	601	662	728	800	881
Net Cash Flows from Operations	**$ 22,991**	**$ 22,417**	**$ 29,794**	**$ 24,026**	**$ 37,580**
(Increase) Decrease in prop., plant, & equip. at cost	(15,215)	(16,980)	(18,949)	(21,147)	(23,600)
(Increase) Decrease in goodwill and nonamort. intang.	(1,318)	(1,410)	(1,509)	(1,614)	(1,727)
Net Cash Flows from Investing Activities	**$(16,533)**	**$(18,390)**	**$(20,458)**	**$(22,762)**	**$(25,328)**
Increase (Decrease) in short-term debt	0	0	0	0	0
Increase (Decrease) in long-term debt	2,073	2,197	2,329	2,469	2,617
Increase (Decrease) in minority interest and preferred stock	0	0	0	0	0
Increase (Decrease) in common stock + paid-in capital	431	474	522	574	631
Increase (Decrease) in accumulated OCI	0	0	0	0	0
Dividends	(8,963)	(6,699)	(12,187)	(4,308)	(15,501)
Net Cash Flows from Financing Activities	**$ (6,458)**	**$ (4,027)**	**$ (9,336)**	**$ (1,265)**	**$(12,252)**
Net Change in Cash	**$ 0**	**$ 0**	**$ 0**	**$ 0**	**$ 0**

j. Using the weighted average cost of capital from Part g as a discount rate, compute the sum of the present value of free cash flows for all debt and equity stakeholders for Walmart for Years +1 through +5.

k. Using the weighted average cost of capital from Part g as a discount rate and the long-run growth rate from Part c, compute the continuing value of Walmart as of the start of Year +6 based on Walmart's continuing free cash flows for all debt and equity stakeholders in Year +6 and beyond. After computing continuing value as of the start of Year +6, discount it to present value as of the start of Year +1.

l. Compute the value of a share of Walmart common stock. (1) Compute the total value of Walmart's net operating assets using the total sum of the present value of free cash flows for all debt and equity stakeholders (from Parts j and k). (2) Subtract the value of outstanding debt to obtain the value of equity. (3) Adjust the present value of equity using the midyear discounting adjustment factor. (4) Compute the per-share value estimate of Walmart's common equity shares.

Note: Do not be alarmed if your share value estimate from Part f is slightly different from your share value estimate from Part l. The weighted average cost of capital computation in Part g used the weight of equity based on the market price of Walmart's stock at the end of 2008. The share value estimates from Parts f and l likely differ from the market price, so the weights used to compute the weighted average cost of capital are not internally consistent with the estimated share values.

Part III—Sensitivity Analysis and Recommendation

m. Using the free cash flows to common equity shareholders, recompute the value of Walmart shares under two alternative scenarios. Scenario 1: Assume that Walmart's long-run growth will be 2 percent, not 3 percent as before, and assume that Walmart's required rate of return on equity is 1 percentage point higher than the rate you computed using the CAPM in Part a. Scenario 2: Assume that Walmart's long-run growth will be 4 percent, not 3 percent as before, and assume that Walmart's required rate of return on equity is 1 percentage point lower than the rate you computed using the CAPM in Part a. To quantify the sensitivity of your share value estimate for Walmart to these variations in growth and discount rates, compare (in percentage terms) your value estimates under these two scenarios with your value estimate from Part f.

n. Using these data at the end of Year 4, what reasonable range of share values would you have expected for Walmart common stock? At that time, what was the market price for Walmart shares relative to this range? What would you have recommended?

INTEGRATIVE CASE 12.1

STARBUCKS

Free Cash Flows Valuation of Starbucks' Common Equity

In Integrative Case 10.1, we projected financial statements for Starbucks for Years +1 through +5. In this portion of the Starbucks Integrative Case, we use the projected financial statements from Integrative Case 10.1 and apply the techniques in Chapter 12 to compute Starbucks' required rate of return on equity and share value based on the free cash flows valuation model. We also compare our value estimate to Starbucks' share price at the time of the case development to provide an investment recommendation.

The market equity beta for Starbucks at the end of 2008 is 0.58. Assume that the risk-free interest rate is 4.0 percent and the market risk premium is 6.0 percent. Starbucks has

735.5 million shares outstanding at the end of 2008. At the start of Year +1, Starbucks' share price was $14.17.

Required

Part I—Computing Starbucks' Share Value Using Free Cash Flows to Common Equity Shareholders

 a. Use the CAPM to compute the required rate of return on common equity capital for Starbucks.

 b. Using your projected financial statements from Integrative Case 10.1 for Starbucks, begin with projected net cash flows from operations and derive the projected free cash flows for common equity shareholders for Starbucks for Years +1 through +5. You must determine whether your projected changes in cash are necessary for operating liquidity purposes.

 c. Project the continuing free cash flow for common equity shareholders in Year +6. Assume that the steady-state long-run growth rate will be 3 percent in Year +6 and beyond. Project that the Year +5 income statement and balance sheet amounts will grow by 3 percent in Year +6; then derive the projected statement of cash flows for Year +6. Derive the projected free cash flow for common equity shareholders in Year +6 from the projected statement of cash flows for Year +6.

 d. Using the required rate of return on common equity from Part a as a discount rate, compute the sum of the present value of free cash flows for common equity shareholders for Starbucks for Years +1 through +5.

 e. Using the required rate of return on common equity from Part a as a discount rate and the long-run growth rate from Part c, compute the continuing value of Starbucks as of the start of Year +6 based on Starbucks' continuing free cash flows for common equity shareholders in Year +6 and beyond. After computing continuing value as of the start of Year +6, discount it to present value at the start of Year +1.

 f. Compute the value of a share of Starbucks common stock. (1) Compute the total sum of the present value of free cash flows for equity shareholders (from Parts d and e). (2) Adjust the total sum of the present value using the midyear discounting adjustment factor. (3) Compute the per-share value estimate.

Note: If you worked Integrative Case 11.1 from Chapter 11 and computed Starbucks' share value using the dividends valuation approach, compare your value estimate from that case with the value estimate you obtain here. They should be the same.

Part II—Computing Starbucks' Share Value Using Free Cash Flows to All Debt and Equity Stakeholders

 g. At the end of 2008, Starbucks had $1,263 million in outstanding interest-bearing short-term and long-term debt on the balance sheet and no preferred stock. Assume that the balance sheet value of Starbucks' debt equals the market value of the debt. Starbucks faces an interest rate of roughly 6.25 percent on its outstanding debt. Assume that Starbucks will continue to face the same interest rate on this outstanding debt capital over the remaining life of the debt. Using the amounts on Starbucks' 2008 income statement in Exhibit 1.27 for Integrative Case 1.1 in Chapter 1, compute Starbucks' average tax rate in 2008. Assume that Starbucks will continue to face the same income tax rate over the forecast horizon. Compute the weighted average cost of capital for Starbucks as of the start of Year +1. Compare your computation of Starbucks' weighted average cost of capital with your estimate of Starbucks' required return on equity from Part a. Why do the two amounts differ?

 h. Based on your projections of Starbucks' financial statements, begin with projected net cash flows from operations and derive the projected free cash flows for all debt

and equity stakeholders for Years +1 through +5. Compare your forecasts of Starbucks' free cash flows for all debt and equity stakeholders Years +1 through +5 with your forecast of Starbucks' free cash flows for equity shareholders in Part b. Why are the amounts not identical—what causes the difference each year?

i. Project the continuing free cash flows for all debt and equity stakeholders in Year +6. Use the projected financial statements for Year +6 from Part c to derive the projected free cash flow for all debt and equity stakeholders in Year +6.

j. Using the weighted average cost of capital from Part g as a discount rate, compute the sum of the present value of free cash flows for all debt and equity stakeholders for Starbucks for Years +1 through +5.

k. Using the weighted average cost of capital from Part g as a discount rate and the long-run growth rate from Part c, compute the continuing value of Starbucks as of the start of Year +6 based on Starbucks' continuing free cash flows for all debt and equity stakeholders in Year +6 and beyond. After computing continuing value as of the start of Year +6, discount it to present value at the start of Year +1.

l. Compute the value of a share of Starbucks common stock. (1) Compute the value of Starbucks' net operating assets using the total sum of the present value of free cash flows for all debt and equity stakeholders (from Parts j and k). (2) Subtract the value of outstanding debt to obtain the value of equity. (3) Adjust the present value of equity using the midyear discounting adjustment factor. (4) Compute the per-share value estimate.

m. Compare your share value estimate from Part f with your share value estimate from Part l. These values should be similar.

Part III—Sensitivity Analysis and Recommendation

n. Using the free cash flows to common equity shareholders, recompute the value of Starbucks shares under two alternative scenarios. Scenario 1: Assume that Starbucks' long-run growth will be 2 percent, not 3 percent as before, and assume that Starbucks' required rate of return on equity is 1 percentage point higher than the rate you computed using the CAPM in Part a. Scenario 2: Assume that Starbucks' long-run growth will be 4 percent, not 3 percent as before, and assume that Starbucks' required rate of return on equity is 1 percentage point lower than the rate you computed using the CAPM in Part a. To quantify the sensitivity of your share value estimate for Starbucks to these variations in growth and discount rates, compare (in percentage terms) your value estimates under these two scenarios with your value estimate from Part f.

o. At the end of 2008, what reasonable range of share values would you have expected for Starbucks common stock? At that time, where was the market price for Starbucks shares relative to this range? What would you have recommended?

p. If you computed Starbucks' common equity share value using the dividends-valuation approach in Integrative Case 11.1, compare the value estimate you obtained in that case with the estimate you obtained in this case. They should be identical.

CASE 12.2

HOLMES CORPORATION: LBO VALUATION

Holmes Corporation is a leading designer and manufacturer of material handling and process equipment for heavy industry in the United States and abroad. Its sales have more

than doubled and its earnings have increased more than sixfold in the past five years. In material handling, Holmes is a major producer of electric overhead and gantry cranes, ranging from 5 tons in capacity to 600-ton giants, the latter used primarily in nuclear and conventional power-generating plants. It also builds underhung cranes and monorail systems for general industrial use carrying loads up to 40 tons, railcar movers, railroad and mass transit shop maintenance equipment, and a broad line of advanced package conveyors. Holmes is a world leader in evaporation and crystallization systems and furnishes dryers, heat exchangers, and filters to complete its line of chemical processing equipment sold internationally to the chemical, fertilizer, food, drug, and paper industries. For the metallurgical industry, it designs and manufactures electric arc and induction furnaces, cupolas, ladles, and hot metal distribution equipment.

The information below and on the following pages appears in the Year 15 annual report of Holmes Corporation.

Highlights

	Year 15	Year 14
Net Sales	$102,698,836	$109,372,718
Net Earnings	6,601,908	6,583,360
Net Earnings per Share	3.62*	3.61*
Cash Dividends Paid	2,241,892	1,426,502
Cash Dividends per Share	1.22*	0.78*
Shareholders' Equity	29,333,803	24,659,214
Shareholders' Equity per Share	16.07*	13.51*
Working Capital	23,100,863	19,029,626
Orders Received	95,436,103	80,707,576
Unfilled Orders at End of Period	77,455,900	84,718,633
Average Number of Common Shares Outstanding during Period	1,824,853*	1,824,754*

*Adjusted for June, Year 15, and June, Year 14, 5-for-4 stock distributions.

Net Sales, Net Earnings, and Net Earnings per Share by Quarter

(adjusted for 5-for-4 stock distribution in June, Year 15, and June, Year 14)

	Year 15			Year 14		
	Net Sales	Net Earnings	Per Share	Net Sales	Net Earnings	Per Share
First Quarter	$ 25,931,457	$1,602,837	$0.88	$ 21,768,077	$1,126,470	$0.62
Second Quarter	24,390,079	1,727,112	0.95	28,514,298	1,716,910	0.94
Third Quarter	25,327,226	1,505,118	0.82	28,798,564	1,510,958	0.82
Fourth Quarter	27,050,074	1,766,841	0.97	30,291,779	2,229,022	1.23
	$102,698,836	$6,601,908	$3.62	$109,372,718	$6,583,360	$3.61

Common Stock Prices and Cash Dividends Paid per Common Share by Quarter

(adjusted for 5-for-4 stock distribution in June, Year 15, and June, Year 14)

	Year 15			Year 14		
	Stock Prices		Cash Dividends per Share	Stock Prices		Cash Dividends per Share
	High	Low		High	Low	
First Quarter	22\frac{1}{2}$	18\frac{1}{2}$	$0.26	11\frac{1}{4}$	$ 9$\frac{1}{2}$	$0.16
Second Quarter	25$\frac{1}{4}$	19$\frac{1}{2}$	0.26	12$\frac{3}{8}$	8$\frac{7}{8}$	0.16
Third Quarter	26$\frac{1}{4}$	19$\frac{3}{4}$	0.325	15$\frac{7}{8}$	11$\frac{5}{8}$	0.20
Fourth Quarter	28$\frac{1}{8}$	23$\frac{1}{4}$	0.375	20$\frac{7}{8}$	15$\frac{7}{8}$	0.26
			$1.22			$0.78

Management's Report to Shareholders

Year 15 was a pleasant surprise for all of us at Holmes Corporation. When the year started, it looked as though Year 15 would be a good year but not up to the record performance of Year 14. However, due to the excellent performance of our employees and the benefit of a favorable acquisition, Year 15 produced both record earnings and the largest cash dividend outlay in the company's 93-year history.

There is no doubt that some of the attractive orders received in late Year 12 and early Year 13 contributed to Year 15 profit. But of major significance was our organization's favorable response to several new management policies instituted to emphasize higher corporate profitability. Year 15 showed a net profit on net sales of 6.4 percent, which not only exceeded the 6.0 percent of last year but represents the highest net margin in several decades.

Net sales for the year were $102,698,836, down 6 percent from the $109,372,718 of a year ago but still the second largest volume in our history. Net earnings, however, set a new record at $6,601,908, or $3.62 per common share, which slightly exceeded the $6,583,360, or $3.61 per common share earned last year.

Cash dividends of $2,241,892 paid in Year 15 were 57 percent above the $1,426,502 paid a year ago. The record total resulted from your Board's approval of two increases during the year. When we implemented the 5-for-4 stock distribution in June, Year 15, we maintained the quarterly dividend rate of $0.325 on the increased number of shares for the January payment. Then, in December, Year 15, we increased the quarterly rate to $0.375 per share.

Year 15 certainly was not the most exuberant year in the capital equipment markets. Fortunately, our heavy involvement in ecology improvement, power generation, and international markets continued to serve us well, with the result that new orders of $95,436,103 were 18 percent over the $80,707,576 of Year 14.

Economists have predicted a substantial capital spending upturn for well over a year, but, so far, our customers have displayed stubborn reluctance to place new orders amid the uncertainty concerning the economy. Confidence is the answer. As soon as potential buyers can see clearly the future direction of the economy, we expect the unleashing of a large latent demand for capital goods, producing a much-expanded market for Holmes' products.

Fortunately, the accelerating pace of international markets continues to yield new business. Year 15 was an excellent year on the international front as our foreign customers continue to recognize our technological leadership in several product lines. Net sales of

Holmes products shipped overseas and fees from foreign licensees amounted to $30,495,041, which represents a 31 percent increase over the $23,351,980 of a year ago.

Management fully recognizes and intends to take maximum advantage of our technological leadership in foreign lands. The latest manifestation of this policy was the acquisition of a controlling interest in Societé Francaise Holmes Fermont, our Swenson process equipment licensee located in Paris. Holmes and a partner started this firm 14 years ago as a sales and engineering organization to function in the Common Market. The company currently operates in the same mode. It owns no physical manufacturing assets, subcontracting all production. Its markets have expanded to include Spain and the East European countries.

Holmes Fermont is experiencing strong demand in Europe. For example, in early May, a $5.5 million order for a large potash crystallization system was received from a French engineering company representing a Russian client. Management estimates that Holmes Fermont will contribute approximately $6 to $8 million of net sales in Year 16.

Holmes' other wholly owned subsidiaries—Holmes Equipment Limited in Canada, Ermanco Incorporated in Michigan, and Holmes International, Inc., our FSC (Foreign Sales Corporation)—again contributed substantially to the success of Year 15. Holmes Equipment Limited registered its second best year. However, capital equipment markets in Canada have virtually come to a standstill in the past two quarters. Ermanco achieved the best year in its history, while Holmes International, Inc. had a truly exceptional year because of the very high level of activity in our international markets.

The financial condition of the company showed further improvement and is now unusually strong as a result of very stringent financial controls. Working capital increased to $23,100,863 from $19,029,626, a 21 percent improvement. Inventories decreased 6 percent from $18,559,231 to $17,491,741. The company currently has no long-term or short-term debt, and has considerable cash in short-term instruments. Much of our cash position, however, results from customers' advance payments which we will absorb as we make shipments on the contracts. Shareholders' equity increased 19 percent to $29,393,803 from $24,690,214 a year ago.

Plant equipment expenditures for the year were $1,172,057, down 18 percent from $1,426,347 of Year 14. Several appropriations approved during the year did not require expenditures because of delayed deliveries beyond Year 15. The major emphasis again was on our continuing program of improving capacity and efficiency through the purchase of numerically controlled machine tools. We expanded the Ermanco plant by 50 percent, but since this is a leasehold arrangement, we made only minor direct investment. We also improved the Canadian operation by adding more manufacturing space and installing energy-saving insulation.

Labor relations were excellent throughout the year. The Harvey plant continues to be nonunion. We negotiated a new labor contract at the Canadian plant, which extends to March 1, Year 17. The Pioneer Division in Alabama has a labor contract that does not expire until April, Year 16. While the union contract at Ermanco expired June 1, Year 15, work continues while negotiation proceeds on a new contract. We anticipate no difficulty in reaching a new agreement.

We exerted considerable effort during the year to improve Holmes' image in the investment community. Management held several informative meetings with security analyst groups to enhance the awareness of our activities and corporate performance.

The outlook for Year 16, while generally favorable, depends in part on the course of capital spending over the next several months. If the spending rate accelerates, the quickening pace of new orders, coupled with present backlogs, will provide the conditions for another fine year. On the other hand, if general industry continues the reluctant spending pattern of the last two years, Year 16 could be a year of maintaining market positions while awaiting better market conditions. Management takes an optimistic view and thus looks for a successful Year 16.

The achievement of record earnings and the highest profit margin in decades demonstrates the capability and the dedication of our employees. Management is most grateful for their efforts throughout the excellent year.

T. R. Varnum T. L. Fuller
President Chairman
March 15, Year 16

Review of Operations

Year 15 was a very active year although the pace was not at the hectic tempo of Year 14. It was a year that showed continued strong demand in some product areas but a dampened rate in others. The product areas that had some special economic circumstances enhancing demand fared well. For example, the continuing effort toward ecological improvement fostered excellent activity in Swenson process equipment. Likewise, the energy concern and the need for more electrical power generation capacity boded well for large overhead cranes. On the other hand, Holmes' products that relate to general industry and depend on the overall capital spending rate for new equipment experienced lesser demand, resulting in lower new orders and reduced backlogs. The affected products were small cranes, underhung cranes, railcar movers, and metallurgical equipment.

Year 15 was the first full year of operations under some major policy changes instituted to improve Holmes' profitability. The two primary revisions were the restructuring of our marketing effort along product division lines, and the conversion of the product division incentive plans to a profit-based formula. The corporate organization adapted extremely well to the new policies. The improved profit margin in Year 15, in substantial part, was a result of the changes.

International activity increased markedly during the year. Surging foreign business and the expressed objective to capitalize on Holmes' technological leadership overseas resulted in the elevation of Mr. R. E. Foster to officer status as Vice President-International. The year involved heavy commitments of the product division staffs, engineering groups, and manufacturing organization to such important contracts as the $14 million Swenson order for Poland, the $8 million Swenson project for Mexico, the $2 million crane order for Venezuela, and several millions of dollars of railcar movers for all areas of the world.

The acquisition of control and commencement of operating responsibility of Societé Francaise Holmes Fermont, the Swenson licensee in Paris, was a major milestone in our international strategy. This organization has the potential of becoming a very substantial contributor in the years immediately ahead. Its long-range market opportunities in Europe and Asia are excellent.

Material Handling Products

Material handling equipment activities portrayed conflicting trends. During the year, when total backlog decreased, the crane division backlog increased. This was a result of several multimillion dollar contracts for power plant cranes. The small crane market, on the other hand, experienced depressed conditions during most of the year as general industry withheld appropriations for new plant and equipment. The underhung crane market experienced similar conditions. However, as Congressional attitudes and policies on investment unfold, we expect capital spending to show a substantial upturn.

The Transportation Equipment Division secured the second order for orbital service bridges, a new product for the containment vessels of nuclear power plants. This design is unique and allows considerable cost savings in erecting and maintaining containment shells.

The Ermanco Conveyor Division completed its best year with the growing acceptance of the unique XenoROL design. We expanded the Grand Haven plant by 50 percent to effect further cost reduction and new concepts of marketing.

The railcar moving line continued to produce more business from international markets. We installed the new 11TM unit in six domestic locations, a product showing signs of exceptional performance. We shipped the first foreign 11TM machine to Sweden.

Process Equipment Products

Process equipment again accounted for slightly more than half of the year's business.

Swenson activity reached an all-time high level with much of the division's effort going into international projects. The large foreign orders required considerable additional work to cover the necessary documentation, metrification when required, and general liaison.

We engaged in considerably more subcontracting during the year to accommodate one-piece shipment of the huge vessels pioneered by Swenson to effect greater equipment economies. The division continued to expand the use of computerization for design work and contract administration. We developed more capability during the year to handle the many additional tasks associated with turnkey projects. Swenson research and development efforts accelerated in search of better technology and new products. We conducted pilot plant test work at our facilities and in the field to convert several sales prospects into new contracts.

The metallurgical business proceeded at a slower pace in Year 15. However, with construction activity showing early signs of improvement, and automotive and farm machinery manufacturers increasing their operating rates, we see intensified interest in metallurgical equipment.

Financial Statements

The financial statements of Holmes Corporation and related notes appear in Exhibits 12.19–12.21 (see pages 996–998). Exhibit 12.22 (see page 999) presents five-year summary operating information for Holmes.

Notes to Consolidated Financial Statements Year 15 and Year 14

Note A—Summary of Significant Accounting Policies. Significant accounting policies consistently applied appear below to assist the reader in reviewing the company's consolidated financial statements contained in this report.

Consolidation—The consolidated financial statements include the accounts of the company and its subsidiaries after eliminating all intercompany transactions and balances.

Inventories—Inventories generally appear at the lower of cost or market, with cost determined principally on a first-in, first-out method.

Property, plant, and equipment—Property, plant, and equipment appear at acquisition cost less accumulated depreciation. When the company retires or disposes of properties, it removes the related costs and accumulated depreciation from the respective accounts and credits, or charges any gain or loss to earnings. The company expenses maintenance and repairs as incurred. It capitalizes major betterments and renewals. Depreciation results from applying the straight-line method over the estimated useful lives of the assets as follows:

Buildings	30 to 45 years
Machinery and equipment	4 to 20 years
Furniture and fixtures	10 years

EXHIBIT 12.19

Holmes Corporation
Balance Sheet
(amounts in thousands)
(Case 12.2)

	Year 10	Year 11	Year 12	Year 13	Year 14	Year 15
Cash	$ 955	$ 962	$ 865	$ 1,247	$ 1,540	$ 3,857
Marketable securities	0	0	0	0	0	2,990
Accounts/Notes receivable	6,545	7,295	9,718	13,307	18,759	14,303
Inventories	7,298	8,685	12,797	20,426	18,559	17,492
Current Assets	$14,798	$16,942	$23,380	$34,980	$38,858	$38,642
Investments	0	0	0	0	0	422
Property, plant, and equipment	12,216	12,445	13,126	13,792	14,903	15,876
Less: Accumulated depreciation	(7,846)	(8,236)	(8,558)	(8,988)	(9,258)	(9,703)
Other assets	470	420	400	299	343	276
Total Assets	$19,638	$21,571	$28,348	$40,083	$44,846	$45,513
Accounts payable—Trade	$ 2,894	$ 4,122	$ 6,496	$ 7,889	$ 6,779	$ 4,400
Notes payable—Nontrade	0	0	700	3,500	0	0
Current portion long-term debt	170	170	170	170	170	0
Other current liabilities	550	1,022	3,888	8,624	12,879	11,142
Current Liabilities	$ 3,614	$ 5,314	$11,254	$20,183	$19,828	$15,542
Long-term debt	680	510	340	170	0	0
Deferred tax	0	0	0	216	328	577
Other noncurrent liabilities	0	0	0	0	0	0
Total Liabilities	$ 4,294	$ 5,824	$11,594	$20,569	$20,156	$16,119
Common stock	$ 2,927	$ 2,927	$ 2,927	$ 5,855	$ 7,303	$ 9,214
Additional paid-in capital	5,075	5,075	5,075	5,075	5,061	5,286
Retained earnings	7,342	7,772	8,774	8,599	12,297	14,834
Accumulated other comprehensive income	0	0	5	12	29	60
Treasury stock	0	(27)	(27)	(27)	0	0
Total Shareholders' Equity	$15,344	$15,747	$16,754	$19,514	$24,690	$29,394
Total Liabilities and Shareholders' Equity	$19,638	$21,571	$28,348	$40,083	$44,846	$45,513

EXHIBIT 12.20

Holmes Corporation
Income Statement
(amounts in thousands)
(Case 12.2)

	Year 11	Year 12	Year 13	Year 14	Year 15
Sales	$ 41,428	$ 53,541	$ 76,328	$109,373	$102,699
Other revenues and gains	0	41	0	0	211
Cost of goods sold	(33,269)	(43,142)	(60,000)	(85,364)	(80,260)
Selling and administrative expense	(6,175)	(7,215)	(9,325)	(13,416)	(12,090)
Other expenses and losses	(2)	0	(11)	(31)	(1)
Operating Income	$ 1,982	$ 3,225	$ 6,992	$ 10,562	$ 10,559
Interest expense	(43)	(21)	(284)	(276)	(13)
Income tax expense	(894)	(1,471)	(2,992)	(3,703)	(3,944)
Net Income	$ 1,045	$ 1,733	$ 3,716	$ 6,583	$ 6,602

Intangible assets—The company has amortized the unallocated excess of cost of a subsidiary over net assets acquired (that is, goodwill) over a 17-year period. Beginning in Year 16, GAAP no longer requires amortization of goodwill.

Research and development costs—The company charges research and development costs to operations as incurred ($479,410 in Year 15, and $467,733 in Year 14).

Pension plans—The company and its subsidiaries have noncontributory pension plans covering substantially all of their employees. The company's policy is to fund accrued pension costs as determined by independent actuaries. Pension costs amounted to $471,826 in Year 15, and $366,802 in Year 14.

Revenue recognition—The company generally recognizes income on a percentage-of-completion basis. It records advance payments as received and reports them as a deduction from billings when earned. The company recognizes royalties, included in net sales, as income when received. Royalties total $656,043 in Year 15, and $723,930 in Year 14.

Income taxes—The company provides no income taxes on unremitted earnings of foreign subsidiaries since it anticipates no significant tax liabilities should foreign units remit such earnings. The company makes provision for deferred income taxes applicable to timing differences between financial statement and income tax accounting, principally on the earnings of a foreign sales subsidiary which existing statutes defer in part from current taxation.

Note B—Foreign Operations. The consolidated financial statements in Year 15 include net assets of $2,120,648 ($1,847,534 in Year 14), undistributed earnings of $2,061,441 ($1,808,752 in Year 14), sales of $7,287,566 ($8,603,225 in Year 14), and net income of $454,999 ($641,454 in Year 14) applicable to the Canadian subsidiary.

The company translates balance sheet accounts of the Canadian subsidiary into U.S. dollars at the exchange rates at the end of the year, and operating results at the average of exchange rates for the year.

EXHIBIT 12.21

Holmes Corporation
Statement of Cash Flows
(amounts in thousands)
(Case 12.2)

	Year 11	Year 12	Year 13	Year 14	Year 15
OPERATIONS					
Net income	$ 1,045	$ 1,733	$ 3,716	$ 6,583	$ 6,602
Depreciation and amortization	491	490	513	586	643
Other addbacks	20	25	243	151	299
Other subtractions	0	0	0	0	(97)
(Increase) Decrease in receivables	(750)	(2,424)	(3,589)	(5,452)	4,456
(Increase) Decrease in inventories	(1,387)	(4,111)	(7,629)	1,867	1,068
Increase (Decrease) accounts payable—Trade	1,228	2,374	1,393	1,496	(2,608)
Increase (Decrease) in other current liabilities	473	2,865	4,737	1,649	(1,509)
Cash Flow from Operations	$ 1,120	$ 952	$ (616)	$ 6,880	$ 8,854
INVESTING					
Fixed assets acquired, net	$ (347)	$ (849)	$ (749)	$(1,426)	$(1,172)
Investments acquired	0	0	0	0	(3,306)
Other investing transactions	45	0	81	(64)	39
Cash Flow from Investing	$ (302)	$ (849)	$ (668)	$(1,490)	$(4,439)
FINANCING					
Increase in short-term borrowing	$ 0	$ 700	$ 2,800	$ 0	$ 0
Decrease in short-term borrowing	0	0	0	(3,500)	0
Increase in long-term borrowing	0	0	0	0	0
Decrease in long-term borrowing	(170)	(170)	(170)	(170)	(170)
Issue of capital stock	0	0	0	0	315
Acquisition of capital stock	(27)	0	0	0	0
Dividends	(614)	(730)	(964)	(1,427)	(2,243)
Other financing transactions	0	0	0	0	0
Cash Flow from Financing	$ (811)	$ (200)	$ 1,666	$(5,097)	$(2,098)
Net Change in Cash	$ 7	$ (97)	$ 382	$ 293	$ 2,317
Cash, beginning of year	955	962	865	1,247	1,540
Cash, End of Year	$ 962	$ 865	$ 1,247	$ 1,540	$ 3,857

EXHIBIT 12.22

Holmes Corporation
Five-Year Summary of Operations
(Case 12.2)

	Year 15	Year 14	Year 13	Year 12	Year 11
Orders Received	$ 95,436,103	$ 80,707,576	$121,445,731	$89,466,793	$55,454,188
Net Sales	102,698,836	109,372,718	76,327,664	53,540,699	41,427,702
Backlog of Unfilled Orders	77,455,900	84,718,633	113,383,775	68,265,708	32,339,614
Earnings before Taxes on Income	$ 10,546,213	$ 10,285,943	$ 6,708,072	$ 3,203,835	$ 1,939,414
Taxes on Income	3,944,305	3,702,583	2,991,947	1,470,489	894,257
Net Earnings	6,601,908	6,583,360	3,716,125	1,733,346	1,045,157
Net Property, Plant, and Equipment	$ 6,173,416	$ 5,644,590	$ 4,803,978	$ 4,558,372	$ 4,209,396
Net Additions to Property	1,172,057	1,426,347	748,791	848,685	346,549
Depreciation and Amortization	643,231	585,735	513,402	490,133	491,217
Cash Dividends Paid	$ 2,242,892	$ 1,426,502	$ 963,935	$ 730,254	$ 614,378
Working Capital	23,100,463	19,029,626	14,796,931	12,126,491	11,627,875
Shareholders' Equity	29,393,803	24,690,214	19,514,358	15,754,166	15,747,116
Earnings per Common Share (1)	$ 3.62	$ 3.61	$ 2.03	$ 0.96	$ 0.57
Dividends per Common Share (1)	1.22	0.78	0.53	0.40	0.34
Book Value per Common Share (1)	16.07	13.51	10.68	9.18	8.62
Number of Shareholders, December 31	2,157	2,024	1,834	1,792	1,787
Number of Employees, December 31	1,549	1,550	1,551	1,425	1,303
Shares of Common Outstanding, December 31 (1)	1,824,853	1,824,754	1,824,754	1,824,941	1,827,515
% Net Sales by Product Line					
Material Handling Equipment	46.1%	43.6%	51.3%	54.4%	63.0%
Processing Equipment	53.9%	56.4%	48.7%	45.6%	37.0%

Note: (1) Based on number of shares outstanding on December 31 adjusted for the 5-for-4 stock distributions in June, Year 13, Year 14, and Year 15.

Note C—Inventories. Inventories used in determining cost of sales appear below:

	Year 15	Year 14	Year 13
Raw materials and supplies	$ 8,889,147	$ 9,720,581	$ 8,900,911
Work in process	8,602,594	8,838,650	11,524,805
Total inventories	$17,491,741	$18,559,231	$20,425,716

Note D—Short-Term Borrowing. The company has short-term credit agreements which principally provide for loans of 90-day periods at varying interest rates. There were no borrowings in Year 15. In Year 14, the maximum borrowing at the end of any calendar month was $4,500,000 and the approximate average loan balance and weighted average interest rate, computed by using the days outstanding method, was $3,435,000 and 7.6 percent. There were no restrictions upon the company during the period of the loans and no compensating bank balance arrangements required by the lending institutions.

Note E—Income Taxes. Provision for income taxes consists of:

	Year 15	Year 14
Current		
Federal	$2,931,152	$2,633,663
State	466,113	483,240
Canadian	260,306	472,450
Total current provision	$3,657,571	$3,589,353
Deferred		
Federal	$ 263,797	$ 91,524
Canadian	22,937	21,706
Total deferred	$ 286,734	$ 113,230
Total provision for income taxes	$3,944,305	$3,702,583

Reconciliation of the total provision for income taxes to the current federal statutory rate of 35 percent is as follows:

	Year 15		Year 14	
	Amount	%	Amount	%
Tax at statutory rate	$3,691,000	35.0%	$3,600,100	35.0%
State taxes, net of U.S. tax credit	302,973	2.9	314,106	3.1
All other items	(49,668)	(.5)	(211,623)	(2.1)
Total provision for income taxes	$3,944,305	37.4%	$3,702,583	36.0%

Note F—Pensions. The components of pension expense appear below:

	Year 15	Year 14
Service cost	$476,490	$429,700
Interest cost	567,159	446,605
Expected return on pension investments	(558,373)	(494,083)
Amortization of actuarial gains and losses	(13,450)	(15,420)
Pension expense	$471,826	$366,802

The funded status of the pension plan appears on the next page.

	December 31:	
	Year 15	**Year 14**
Accumulated benefit obligation	$5,763,450	$5,325,291
Effect of salary increases	1,031,970	976,480
Projected benefit obligation	$6,795,420	$6,301,771
Pension fund assets	6,247,940	5,583,730
Excess pension obligation	$ 547,480	$ 718,041

Assumptions used in accounting for pensions appear below:

	Year 15	**Year 14**
Expected return on pension assets	10%	10%
Discount rate for projected benefit obligation	9%	8%
Salary increases	5%	5%

Note G—Common Stock. As of March 20, Year 15, the company increased the authorized number of shares of common stock from 1,800,000 shares to 5,000,000 shares.

On December 29, Year 15, the company increased its equity interest (from 45 percent to 85 percent) in Societé Francaise Holmes Fermont, a French affiliate, in exchange for 18,040 of its common shares in a transaction accounted for as a purchase. The company credited the excess of the fair value ($224,373) of the company's shares issued over their par value ($90,200) to additional contributed capital. The excess of the purchase cost over the under-lying value of the assets acquired was insignificant.

The company made a 25 percent common stock distribution on June 15, Year 14, and on June 19, Year 15, resulting in increases of 291,915 shares in Year 14 and 364,433 shares in Year 15, respectively. We capitalized the par value of these additional shares by a transfer of $1,457,575 in Year 14 and $1,822,165 in Year 15 from retained earnings to the common stock account. In Year 14 and Year 15, we paid cash of $2,611 and $15,340, respectively, in lieu of fractional share interests.

In addition, the company retired 2,570 shares of treasury stock in June, Year 14. The earnings and dividends per share for Year 14 and Year 15 in the accompanying consolidated financial statements reflect the 25 percent stock distributions.

Note H—Contingent Liabilities. The company has certain contingent liabilities with respect to litigation and claims arising in the ordinary course of business. The company cannot determine the ultimate disposition of these contingent liabilities but, in the opinion of management, they will not result in any material effect upon the company's consolidated financial position or results of operations.

Note I—Quarterly Data (unaudited). Quarterly sales, gross profit, net earnings, and earnings per share for Year 15 appear below (first quarter results restated for 25 percent stock distribution):

	Net Sales	**Gross Profit**	**Net Earnings**	**Earnings per Share**
First	$ 25,931,457	$ 5,606,013	$1,602,837	$0.88
Second	24,390,079	6,148,725	1,727,112	0.95
Third	25,327,226	5,706,407	1,505,118	0.82
Fourth	27,050,074	4,977,774	1,766,841	0.97
Year	$102,698,836	$22,438,919	$6,601,908	$3.62

Auditors' Report

Board of Directors and Stockholders

Holmes Corporation

We have examined the consolidated balance sheets of Holmes Corporation and Subsidiaries as of December 31, Year 15 and Year 14, and the related consolidated statements of earnings and cash flows for the years then ended. Our examination was made in accordance with generally accepted auditing standards, and accordingly included such tests of the accounting records and such other auditing procedures as we considered necessary in the circumstances.

In our opinion, the financial statements referred to above present fairly the consolidated financial position of Holmes Corporation and Subsidiaries at December 31, Year 15 and Year 14, and the consolidated results of their operations and changes in cash flows for the years then ended, in conformity with generally accepted accounting principles applied on a consistent basis.

SBW, LLP
Chicago, Illinois
March 15, Year 16

Required

A group of Holmes' top management is interested in acquiring Holmes in an LBO.

 a. Briefly describe the factors that make Holmes an attractive and, conversely, an unattractive LBO candidate.
 b. (This question requires coverage of Chapter 10.) Prepare projected financial statements for Holmes Corporation for Year 16 through Year 20 excluding all financing. That is, project the amount of operating income after taxes, assets, and cash flows from operating and investing activities. State the underlying assumptions made.
 c. Ascertain the value of Holmes' common shareholders' equity using the present value of its future cash flows valuation approach. Assume a risk-free interest rate of 4.2 percent and a market premium of 5.0 percent. Note that information in Part e may be helpful in this valuation. Assume the following financing structure for the LBO:

Type	Proportion	Interest Rate	Term
Term debt	50%	8%	7-year amortization[a]
Subordinated debt	25	12%	10-year amortization[a]
Shareholders' equity	25		
	100%		

[a] Holmes must repay principal and interest in equal annual payments.

 d. (This question requires coverage of Chapter 13.) Ascertain the value of Holmes' common shareholders' equity using the residual income approach.
 e. (This question requires coverage of Chapter 14.) Ascertain the value of Holmes' common shareholders' equity using the residual ROCE model and the price-to-earnings ratio and the market value to book value of comparable companies'

approaches. Selected data for similar companies for Year 15 appear in the following table (amounts in millions):

Industry:	Agee Robotics Conveyor Systems	GI Handling Systems Conveyor Systems	LJG Industries Cranes	Gelas Corp. Industrial Furnaces
Sales	$4,214	$28,998	$123,034	$75,830
Net Income	$ 309	$ 2,020	$ 9,872	$ 5,117
Assets	$2,634	$15,197	$ 72,518	$41,665
Long-Term Debt	$ 736	$ 5,098	$ 23,745	$ 8,869
Common Shareholders' Equity	$1,551	$ 7,473	$ 38,939	$26,884
Market Value of Common Equity	$6,915	$20,000	$102,667	$41,962
Market Beta	1.12	0.88	0.99	0.93

f. Would you attempt to acquire Holmes Corporation after completing the analyses in Parts a–e? If not, how would you change the analyses to make this an attractive LBO?

Appendix **A**

*Financial Statements and
Notes for PepsiCo, Inc. and
Subsidiaries*

Consolidated Statement of Income

PepsiCo, Inc. and Subsidiaries
(in millions except per share amounts)

Fiscal years ended December 27, 2008, December 29, 2007 and December 30, 2006	2008	2007	2006
Net Revenue	$43,251	$39,474	$35,137
Cost of sales	20,351	18,038	15,762
Selling, general and administrative expenses	15,901	14,208	12,711
Amortization of intangible assets	64	58	162
Operating Profit	6,935	7,170	6,502
Bottling equity income	374	560	553
Interest expense	(329)	(224)	(239)
Interest income	41	125	173
Income before Income Taxes	7,021	7,631	6,989
Provision for Income Taxes	1,879	1,973	1,347
Net Income	$ 5,142	$ 5,658	$ 5,642
Net Income per Common Share			
Basic	$　3.26	$　3.48	$　3.42
Diluted	$　3.21	$　3.41	$　3.34

See accompanying notes to consolidated financial statements.

Consolidated Statement of Cash Flows

PepsiCo, Inc. and Subsidiaries
(in millions)

Fiscal years ended December 27, 2008, December 29, 2007 and December 30, 2006	2008	2007	2006
Operating Activities			
Net income	$ 5,142	$ 5,658	$ 5,642
Depreciation and amortization	1,543	1,426	1,406
Stock-based compensation expense	238	260	270
Restructuring and impairment charges	543	102	67
Excess tax benefits from share-based payment arrangements	(107)	(208)	(134)
Cash payments for restructuring charges	(180)	(22)	(56)
Pension and retiree medical plan contributions	(219)	(310)	(131)
Pension and retiree medical plan expenses	459	535	544
Bottling equity income, net of dividends	(202)	(441)	(442)
Deferred income taxes and other tax charges and credits	573	118	(510)
Change in accounts and notes receivable	(549)	(405)	(330)
Change in inventories	(345)	(204)	(186)
Change in prepaid expenses and other current assets	(68)	(16)	(37)
Change in accounts payable and other current liabilities	718	522	279
Change in income taxes payable	(180)	128	(295)
Other, net	(367)	(209)	(3)
Net Cash Provided by Operating Activities	6,999	6,934	6,084
Investing Activities			
Capital spending	(2,446)	(2,430)	(2,068)
Sales of property, plant and equipment	98	47	49
Proceeds from (Investment in) finance assets	–	27	(25)
Acquisitions and investments in noncontrolled affiliates	(1,925)	(1,320)	(522)
Cash restricted for pending acquisitions	(40)	–	–
Cash proceeds from sale of PBG and PAS stock	358	315	318
Divestitures	6	–	37
Short-term investments, by original maturity			
More than three months – purchases	(156)	(83)	(29)
More than three months – maturities	62	113	25
Three months or less, net	1,376	(413)	2,021
Net Cash Used for Investing Activities	(2,667)	(3,744)	(194)
Financing Activities			
Proceeds from issuances of long-term debt	3,719	2,168	51
Payments of long-term debt	(649)	(579)	(157)
Short-term borrowings, by original maturity			
More than three months – proceeds	89	83	185
More than three months – payments	(269)	(133)	(358)
Three months or less, net	625	(345)	(2,168)
Cash dividends paid	(2,541)	(2,204)	(1,854)
Share repurchases – common	(4,720)	(4,300)	(3,000)
Share repurchases – preferred	(6)	(12)	(10)
Proceeds from exercises of stock options	620	1,108	1,194
Excess tax benefits from share-based payment arrangements	107	208	134
Net Cash Used for Financing Activities	(3,025)	(4,006)	(5,983)
Effect of exchange rate changes on cash and cash equivalents	(153)	75	28
Net Increase/(Decrease) in Cash and Cash Equivalents	1,154	(741)	(65)
Cash and Cash Equivalents, Beginning of Year	910	1,651	1,716
Cash and Cash Equivalents, End of Year	$ 2,064	$ 910	$ 1,651

See accompanying notes to consolidated financial statements.

Consolidated Balance Sheet

PepsiCo, Inc. and Subsidiaries
(in millions except per share amounts)

December 27, 2008 and December 29, 2007	2008	2007
ASSETS		
Current Assets		
Cash and cash equivalents	$ 2,064	$ 910
Short-term investments	213	1,571
Accounts and notes receivable, net	4,683	4,389
Inventories	2,522	2,290
Prepaid expenses and other current assets	1,324	991
Total Current Assets	10,806	10,151
Property, Plant and Equipment, net	11,663	11,228
Amortizable Intangible Assets, net	732	796
Goodwill	5,124	5,169
Other nonamortizable intangible assets	1,128	1,248
Nonamortizable Intangible Assets	6,252	6,417
Investments in Noncontrolled Affiliates	3,883	4,354
Other Assets	2,658	1,682
Total Assets	$ 35,994	$ 34,628
LIABILITIES AND SHAREHOLDERS' EQUITY		
Current Liabilities		
Short-term obligations	$ 369	$ —
Accounts payable and other current liabilities	8,273	7,602
Income taxes payable	145	151
Total Current Liabilities	8,787	7,753
Long-Term Debt Obligations	7,858	4,203
Other Liabilities	7,017	4,792
Deferred Income Taxes	226	646
Total Liabilities	23,888	17,394
Commitments and Contingencies		
Preferred Stock, no par value	41	41
Repurchased Preferred Stock	(138)	(132)
Common Shareholders' Equity		
Common stock, par value 1 2/3¢ per share (authorized 3,600 shares, issued 1,782 shares)	30	30
Capital in excess of par value	351	450
Retained earnings	30,638	28,184
Accumulated other comprehensive loss	(4,694)	(952)
Repurchased common stock, at cost (229 and 177 shares, respectively)	(14,122)	(10,387)
Total Common Shareholders' Equity	12,203	17,325
Total Liabilities and Shareholders' Equity	$ 35,994	$ 34,628

See accompanying notes to consolidated financial statements.

Consolidated Statement of Common Shareholders' Equity

PepsiCo, Inc. and Subsidiaries
(in millions)

Fiscal years ended December 27, 2008, December 29, 2007 and December 30, 2006	2008 Shares	2008 Amount	2007 Shares	2007 Amount	2006 Shares	2006 Amount
Common Stock	1,782	$ 30	1,782	$ 30	1,782	$ 30
Capital in Excess of Par Value						
Balance, beginning of year		450		584		614
Stock-based compensation expense		238		260		270
Stock option exercises/RSUs converted (a)		(280)		(347)		(300)
Withholding tax on RSUs converted		(57)		(47)		–
Balance, end of year		351		450		584
Retained Earnings						
Balance, beginning of year		28,184		24,837		21,116
Adoption of FIN 48				7		
SFAS 158 measurement date change		(89)				
Adjusted balance, beginning of year		28,095		24,844		
Net income		5,142		5,658		5,642
Cash dividends declared – common		(2,589)		(2,306)		(1,912)
Cash dividends declared – preferred		(2)		(2)		(1)
Cash dividends declared – RSUs		(8)		(10)		(8)
Balance, end of year		30,638		28,184		24,837
Accumulated Other Comprehensive Loss						
Balance, beginning of year		(952)		(2,246)		(1,053)
SFAS 158 measurement date change		51				
Adjusted balance, beginning of year		(901)				
Currency translation adjustment		(2,484)		719		465
Cash flow hedges, net of tax:						
Net derivative gains/(losses)		16		(60)		(18)
Reclassification of losses/(gains) to net income		5		21		(5)
Adoption of SFAS 158		–		–		(1,782)
Pension and retiree medical, net of tax:						
Net pension and retiree medical (losses)/gains		(1,376)		464		–
Reclassification of net losses to net income		73		135		–
Minimum pension liability adjustment, net of tax		–		–		138
Unrealized (losses)/gains on securities, net of tax		(21)		9		9
Other		(6)		6		–
Balance, end of year		(4,694)		(952)		(2,246)
Repurchased Common Stock						
Balance, beginning of year	(177)	(10,387)	(144)	(7,758)	(126)	(6,387)
Share repurchases	(68)	(4,720)	(64)	(4,300)	(49)	(3,000)
Stock option exercises	15	883	28	1,582	31	1,619
Other, primarily RSUs converted	1	102	3	89	–	10
Balance, end of year	(229)	(14,122)	(177)	(10,387)	(144)	(7,758)
Total Common Shareholders' Equity		$ 12,203		$ 17,325		$15,447

	2008	2007	2006
Comprehensive Income			
Net income	$ 5,142	$ 5,658	$ 5,642
Currency translation adjustment	(2,484)	719	465
Cash flow hedges, net of tax	21	(39)	(23)
Minimum pension liability adjustment, net of tax	–	–	5
Pension and retiree medical, net of tax			
Net prior service cost	55	(105)	–
Net (losses)/gains	(1,358)	704	–
Unrealized (losses)/gains on securities, net of tax	(21)	9	9
Other	(6)	6	–
Total Comprehensive Income	$ 1,349	$ 6,952	$ 6,098

(a) Includes total tax benefits of $95 million in 2008, $216 million in 2007 and $130 million in 2006.

See accompanying notes to consolidated financial statements.

Notes to Consolidated Financial Statements

Note 1 Basis of Presentation and Our Divisions

BASIS OF PRESENTATION

Our financial statements include the consolidated accounts of PepsiCo, Inc. and the affiliates that we control. In addition, we include our share of the results of certain other affiliates based on our economic ownership interest. We do not control these other affiliates, as our ownership in these other affiliates is generally less than 50%. Equity income or loss from our anchor bottlers is recorded as bottling equity income in our income statement. Bottling equity income also includes any changes in our ownership interests of our anchor bottlers. Bottling equity income includes $147 million of pre-tax gains on our sales of PBG and PAS stock in 2008 and $174 million and $186 million of pre-tax gains on our sales of PBG stock in 2007 and 2006, respectively. See Note 8 for additional information on our significant noncontrolled bottling affiliates. Income or loss from other noncontrolled affiliates is recorded as a component of selling, general and administrative expenses. Intercompany balances and transactions are eliminated. Our fiscal year ends on the last Saturday of each December, resulting in an additional week of results every five or six years.

Raw materials, direct labor and plant overhead, as well as purchasing and receiving costs, costs directly related to production planning, inspection costs and raw material handling facilities, are included in cost of sales. The costs of moving, storing and delivering finished product are included in selling, general and administrative expenses.

The preparation of our consolidated financial statements in conformity with generally accepted accounting principles requires us to make estimates and assumptions that affect reported amounts of assets, liabilities, revenues, expenses and disclosure of contingent assets and liabilities. Estimates are used in determining, among other items, sales incentives accruals, tax reserves, stock-based compensation, pension and retiree medical accruals, useful lives for intangible assets, and future cash flows associated with impairment testing for perpetual brands, goodwill and other long-lived assets. We evaluate our estimates on an on-going basis using our historical experience, as well as other factors we believe appropriate under the circumstances, such as current economic conditions, and adjust or revise our estimates as circumstances change. As future events and their effect cannot be determined with precision, actual results could differ significantly from these estimates.

See "Our Divisions" below and for additional unaudited information on items affecting the comparability of our consolidated results, see "Items Affecting Comparability" in Management's Discussion and Analysis.

Tabular dollars are in millions, except per share amounts. All per share amounts reflect common per share amounts, assume dilution unless noted, and are based on unrounded amounts. Certain reclassifications were made to prior years' amounts to conform to the 2008 presentation.

OUR DIVISIONS

We manufacture or use contract manufacturers, market and sell a variety of salty, convenient, sweet and grain-based snacks, carbonated and non-carbonated beverages, and foods in approximately 200 countries with our largest operations in North America (United States and Canada), Mexico and the United Kingdom. Division results are based on how our Chief Executive Officer assesses the performance of and allocates resources to our divisions. For additional unaudited information on our divisions, see "Our Operations" in Management's Discussion and Analysis. The accounting policies for the divisions are the same as those described in Note 2, except for the following allocation methodologies:

- stock-based compensation expense,
- pension and retiree medical expense, and
- derivatives.

Stock-Based Compensation Expense

Our divisions are held accountable for stock-based compensation expense and, therefore, this expense is allocated to our divisions as an incremental employee compensation cost. The allocation of stock-based compensation expense in 2008 was approximately 29% to FLNA, 4% to QFNA, 7% to LAF, 23% to PAB, 13% to UKEU, 13% to MEAA and 11% to corporate unallocated expenses. We had similar allocations of stock-based compensation expense to our divisions in 2007 and 2006. The expense allocated to our divisions excludes any impact of changes in our assumptions during the year which reflect market conditions over which division management has no control. Therefore, any variances between allocated expense and our actual expense are recognized in corporate unallocated expenses.

Pension and Retiree Medical Expense

Pension and retiree medical service costs measured at a fixed discount rate, as well as amortization of gains and losses due to demographics, including salary experience, are reflected in division results for North American employees. Division results also include interest costs, measured at a fixed discount rate,

for retiree medical plans. Interest costs for the pension plans, pension asset returns and the impact of pension funding, and gains and losses other than those due to demographics, are all reflected in corporate unallocated expenses. In addition, corporate unallocated expenses include the difference between the service costs measured at a fixed discount rate (included in division results as noted above) and the total service costs determined using the Plans' discount rates as disclosed in Note 7.

Derivatives

We centrally manage commodity derivatives on behalf of our divisions. These commodity derivatives include energy, fruit and other raw materials. Certain of these commodity derivatives do not qualify for hedge accounting treatment and are marked to market with the resulting gains and losses reflected in corporate unallocated expenses. These derivatives hedge underlying

commodity price risk and were not entered into for speculative purposes. These gains and losses are subsequently reflected in division results when the divisions take delivery of the under- lying commodity. Therefore, division results reflect the contract purchase price of these commodities.

In 2007, we expanded our commodity hedging program to include derivative contracts used to mitigate our exposure to price changes associated with our purchases of fruit. In addition, in 2008, we entered into additional contracts to further reduce our exposure to price fluctuations in our raw material and energy costs. The majority of these contracts do not qualify for hedge accounting treatment and are marked to market with the resulting gains and losses recognized in corporate unallocated expenses within selling, general and administrative expenses. These gains and losses are subsequently reflected in divisional results.

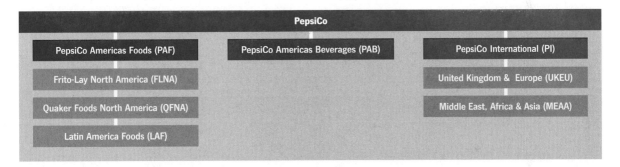

	2008	2007	2006	2008	2007	2006
		Net Revenue			Operating Profit (a)	
FLNA	$12,507	$11,586	$10,844	$2,959	$2,845	$2,615
QFNA	1,902	1,860	1,769	582	568	554
LAF	5,895	4,872	3,972	897	714	655
PAB	10,937	11,090	10,362	2,026	2,487	2,315
UKEU	6,435	5,492	4,750	811	774	700
MEAA	5,575	4,574	3,440	667	535	401
Total division	43,251	39,474	35,137	7,942	7,923	7,240
Corporate – net impact of mark-to-market on commodity hedges	–	–	–	(346)	19	(18)
Corporate – other	–	–	–	(661)	(772)	(720)
	$43,251	$39,474	$35,137	$6,935	$7,170	$6,502

(a) *For information on the impact of restructuring and impairment charges on our divisions, see Note 3.*

Net Revenue

Division Operating Profit

Notes to Consolidated Financial Statements

CORPORATE

Corporate includes costs of our corporate headquarters, centrally managed initiatives, such as our ongoing business transformation initiative and research and development projects, unallocated insurance and benefit programs, foreign exchange transaction gains and losses, certain commodity derivative gains and losses and certain other items.

OTHER DIVISION INFORMATION

	2008	2007	2006	2008	2007	2006
	Total Assets			Capital Spending		
FLNA	$ 6,284	$ 6,270	$ 5,969	$ 553	$ 624	$ 499
QFNA	1,035	1,002	1,003	43	41	31
LAF	3,023	3,084	2,169	351	326	235
PAB	7,673	7,780	7,129	344	450	516
UKEU	8,635	7,102	5,865	377	349	277
MEAA	3,961	3,911	2,975	503	413	299
Total division	30,611	29,149	25,110	2,171	2,203	1,857
Corporate (a)	2,729	2,124	1,739	275	227	211
Investments in bottling affiliates	2,654	3,355	3,081	–	–	–
	$35,994	$34,628	$29,930	$2,446	$2,430	$2,068

(a) Corporate assets consist principally of cash and cash equivalents, short-term investments, derivative instruments and property, plant and equipment.

	2008	2007	2006	2008	2007	2006
	Amortization of Intangible Assets			Depreciation and Other Amortization		
FLNA	$ 9	$ 9	$ 9	$ 441	$ 437	$ 432
QFNA	–	–	–	34	34	33
LAF	6	4	1	194	166	140
PAB	16	16	83	334	321	298
UKEU	22	18	17	199	181	167
MEAA	11	11	52	224	198	155
Total division	64	58	162	1,426	1,337	1,225
Corporate	–	–	–	53	31	19
	$64	$58	$162	$1,479	$1,368	$1,244

	2008	2007	2006	2008	2007	2006
	Net Revenue (a)			Long-Lived Assets (b)		
U.S.	$22,525	$21,978	$20,788	$12,095	$12,498	$11,515
Mexico	3,714	3,498	3,228	904	1,067	996
Canada	2,107	1,961	1,702	556	699	589
United Kingdom	2,099	1,987	1,839	1,509	2,090	1,995
All other countries	12,806	10,050	7,580	7,466	6,441	4,725
	$43,251	$39,474	$35,137	$22,530	$22,795	$19,820

(a) Represents net revenue from businesses operating in these countries.
(b) Long-lived assets represent property, plant and equipment, nonamortizable intangible assets, amortizable intangible assets, and investments in noncontrolled affiliates. These assets are reported in the country where they are primarily used.

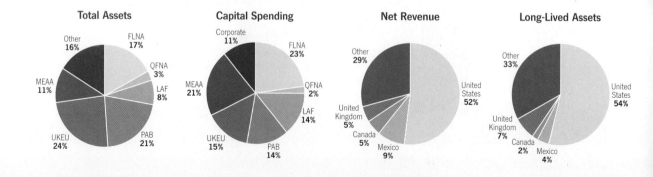

Total Assets — Other 16%, FLNA 17%, QFNA 3%, LAF 8%, PAB 21%, UKEU 24%, MEAA 11%

Capital Spending — Corporate 11%, FLNA 23%, QFNA 2%, LAF 14%, PAB 14%, UKEU 15%, MEAA 21%

Net Revenue — Other 29%, United States 52%, Mexico 9%, Canada 5%, United Kingdom 5%

Long-Lived Assets — Other 33%, United States 54%, Mexico 4%, Canada 2%, United Kingdom 7%

Note 2 Our Significant Accounting Policies

REVENUE RECOGNITION

We recognize revenue upon shipment or delivery to our customers based on written sales terms that do not allow for a right of return. However, our policy for DSD and chilled products is to remove and replace damaged and out-of-date products from store shelves to ensure that our consumers receive the product quality and freshness that they expect. Similarly, our policy for certain warehouse-distributed products is to replace damaged and out-of-date products. Based on our experience with this practice, we have reserved for anticipated damaged and out-of-date products. For additional unaudited information on our revenue recognition and related policies, including our policy on bad debts, see "Our Critical Accounting Policies" in Management's Discussion and Analysis. We are exposed to concentration of credit risk by our customers, Wal-Mart and PBG. In 2008, Wal-Mart (including Sam's) represented approximately 12% of our total net revenue, including concentrate sales to our bottlers which are used in finished goods sold by them to Wal-Mart; and PBG represented approximately 8%. We have not experienced credit issues with these customers.

SALES INCENTIVES AND OTHER MARKETPLACE SPENDING

We offer sales incentives and discounts through various programs to our customers and consumers. Sales incentives and discounts are accounted for as a reduction of revenue and totaled $12.5 billion in 2008, $11.3 billion in 2007 and $10.1 billion in 2006. While most of these incentive arrangements have terms of no more than one year, certain arrangements, such as fountain pouring rights, may extend beyond one year. Costs incurred to obtain these arrangements are recognized over the shorter of the economic or contractual life, as a reduction of revenue, and the remaining balances of $333 million at December 27, 2008 and $314 million at December 29, 2007 are included in current assets and other assets on our balance sheet. For additional unaudited information on our sales incentives, see "Our Critical Accounting Policies" in Management's Discussion and Analysis.

Other marketplace spending, which includes the costs of advertising and other marketing activities, totaled $2.9 billion in 2008, $2.9 billion in 2007 and $2.7 billion in 2006 and is reported as selling, general and administrative expenses. Included in these amounts were advertising expenses of $1.8 billion in both 2008 and 2007 and $1.6 billion in 2006. Deferred advertising costs are not expensed until the year first used and consist of:

- media and personal service prepayments,
- promotional materials in inventory, and
- production costs of future media advertising.

Deferred advertising costs of $172 million and $160 million at year-end 2008 and 2007, respectively, are classified as prepaid expenses on our balance sheet.

DISTRIBUTION COSTS

Distribution costs, including the costs of shipping and handling activities, are reported as selling, general and administrative expenses. Shipping and handling expenses were $5.3 billion in 2008, $5.1 billion in 2007 and $4.6 billion in 2006.

CASH EQUIVALENTS

Cash equivalents are investments with original maturities of three months or less which we do not intend to rollover beyond three months.

SOFTWARE COSTS

We capitalize certain computer software and software development costs incurred in connection with developing or obtaining computer software for internal use when both the preliminary project stage is completed and it is probable that the software will be used as intended. Capitalized software costs include only (i) external direct costs of materials and services utilized in developing or obtaining computer software, (ii) compensation and related benefits for employees who are directly associated with the software project and (iii) interest costs incurred while developing internal-use computer software. Capitalized software costs are included in property, plant and equipment on our balance sheet and amortized on a straight-line basis when placed into service over the estimated useful lives of the software, which approximate five to ten years. Net capitalized software and development costs were $940 million at December 27, 2008 and $761 million at December 29, 2007.

COMMITMENTS AND CONTINGENCIES

We are subject to various claims and contingencies related to lawsuits, certain taxes and environmental matters, as well as commitments under contractual and other commercial obligations. We recognize liabilities for contingencies and commitments when a loss is probable and estimable. For additional information on our commitments, see Note 9.

Notes to Consolidated Financial Statements

RESEARCH AND DEVELOPMENT

We engage in a variety of research and development activities. These activities principally involve the development of new products, improvement in the quality of existing products, improvement and modernization of production processes, and the development and implementation of new technologies to enhance the quality and value of both current and proposed product lines. Consumer research is excluded from research and development costs and included in other marketing costs. Research and development costs were $388 million in 2008, $364 million in 2007 and $282 million in 2006 and are reported within selling, general and administrative expenses.

OTHER SIGNIFICANT ACCOUNTING POLICIES

Our other significant accounting policies are disclosed as follows:
- *Property, Plant and Equipment and Intangible Assets* – Note 4, and for additional unaudited information on brands and good-will, see "Our Critical Accounting Policies" in Management's Discussion and Analysis.
- *Income Taxes* – Note 5, and for additional unaudited information, see "Our Critical Accounting Policies" in Management's Discussion and Analysis.
- *Stock-Based Compensation* – Note 6.
- *Pension, Retiree Medical and Savings Plans* – Note 7, and for additional unaudited information, see "Our Critical Accounting Policies" in Management's Discussion and Analysis.
- *Financial Instruments* – Note 10, and for additional unaudited information, see "Our Business Risks" in Management's Discussion and Analysis.

RECENT ACCOUNTING PRONOUNCEMENTS

In February 2007, the FASB issued SFAS 159 which permits entities to choose to measure many financial instruments and certain other items at fair value. We adopted SFAS 159 as of the beginning of our 2008 fiscal year and our adoption did not impact our financial statements.

In December 2007, the FASB issued SFAS 141R, to improve, simplify and converge internationally the accounting for business combinations. SFAS 141R continues the movement toward the greater use of fair value in financial reporting and increased trans-parency through expanded disclosures. It changes how business acquisitions are accounted for and will impact financial statements both on the acquisition date and in subsequent periods. The provisions of SFAS 141R are effective as of the beginning of our 2009 fiscal year, with the exception of adjustments made to valuation allowances on deferred taxes and acquired tax contin-gencies. Adjustments made to valuation allowances on deferred taxes and acquired tax contingencies associated with acquisitions that closed prior to the beginning of our 2009 fiscal year would apply the provisions of SFAS 141R. Future adjustments made to valuation allowances on deferred taxes and acquired tax contin-gencies associated with acquisitions that closed prior to the beginning of our 2009 fiscal year would apply the provisions of SFAS 141R and will be evaluated based on the outcome of these matters. We do not expect the adoption of SFAS 141R to have a material impact on our financial statements.

In December 2007, the FASB issued SFAS 160. SFAS 160 amends ARB 51 to establish new standards that will govern the accounting for and reporting of (1) noncontrolling interests in par-tially owned consolidated subsidiaries and (2) the loss of control of subsidiaries. The provisions of SFAS 160 are effective as of the beginning of our 2009 fiscal year on a prospective basis. We do not expect our adoption of SFAS 160 to have a significant impact on our financial statements. In the first quarter of 2009, we will include the required disclosures for all periods presented.

In March 2008, the FASB issued SFAS 161 which amends and expands the disclosure requirements of SFAS 133 to provide an enhanced understanding of the use of derivative instruments, how they are accounted for under SFAS 133 and their effect on financial position, financial performance and cash flows. The disclosure provisions of SFAS 161 are effective as of the begin-ning of our 2009 fiscal year.

Note 3 Restructuring and Impairment Charges

2008 RESTRUCTURING AND IMPAIRMENT CHARGE

In 2008, we incurred a charge of $543 million ($408 million after-tax or $0.25 per share) in conjunction with our Productivity for Growth program. The program includes actions in all divisions of the business that we believe will increase cost competitiveness across the supply chain, upgrade and streamline our product portfolio, and simplify the organization for more effective and timely decision-making. Approximately $455 million of the charge was recorded in selling, general and administrative expenses, with the remainder recorded in cost of sales. Substantially all cash payments related to this charge are expected to be paid by the end of 2009.

A summary of the restructuring and impairment charge is as follows:

	Severance and Other Employee Costs	Asset Impairments	Other Costs	Total
FLNA	$ 48	$ 38	$ 22	$108
QFNA	14	3	14	31
LAF	30	8	2	40
PAB	68	92	129	289
UKEU	39	6	5	50
MEAA	11	2	2	15
Corporate	2	–	8	10
	$212	$149	$182	$543

Severance and other employee costs primarily reflect termination costs for approximately 3,500 employees. Asset impairments relate to the closure of 6 plants and changes to our beverage product portfolio. Other costs include contract exit costs and third-party incremental costs associated with upgrading our product portfolio and our supply chain.

A summary of our Productivity for Growth program activity is as follows:

	Severance and Other Employee Costs	Asset Impairments	Other Costs	Total
2008 restructuring and impairment charge	$212	$ 149	$ 182	$ 543
Cash payments	(50)	–	(109)	(159)
Non-cash charge	(27)	(149)	(9)	(185)
Currency translation	(1)	–	–	(1)
Liability at December 27, 2008	$134	$ –	$ 64	$ 198

2007 RESTRUCTURING AND IMPAIRMENT CHARGE

In 2007, we incurred a charge of $102 million ($70 million after-tax or $0.04 per share) in conjunction with restructuring actions primarily to close certain plants and rationalize other production lines across FLNA, LAF, PAB, UKEU and MEAA. The charge was recorded in selling, general and administrative expenses. All cash payments related to this charge were paid by the end of 2008.

A summary of the restructuring and impairment charge is as follows:

	Severance and Other Employee Costs	Asset Impairments	Other Costs	Total
FLNA	$ –	$19	$ 9	$ 28
LAF	14	25	–	39
PAB	12	–	–	12
UKEU	2	4	3	9
MEAA	5	9	–	14
	$33	$57	$12	$102

Severance and other employee costs primarily reflect termination costs for approximately 1,100 employees.

2006 RESTRUCTURING AND IMPAIRMENT CHARGE

In 2006, we incurred a charge of $67 million ($43 million after-tax or $0.03 per share) in conjunction with consolidating the manufacturing network at FLNA by closing two plants in the U.S., and rationalizing other assets, to increase manufacturing productivity and supply chain efficiencies. The charge was comprised of $43 million of asset impairments, $14 million of severance and other employee costs and $10 million of other costs. Severance and other employee costs primarily reflect the termination costs for approximately 380 employees. All cash payments related to this charge were paid by the end of 2007.

Note 4 Property, Plant and Equipment and Intangible Assets

	Average Useful Life	2008	2007	2006
Property, plant and equipment, net				
Land and improvements	10–34 yrs.	$ 868	$ 864	
Buildings and improvements	20–44	4,738	4,577	
Machinery and equipment, including fleet and software	5–14	15,173	14,471	
Construction in progress		1,773	1,984	
		22,552	21,896	
Accumulated depreciation		(10,889)	(10,668)	
		$ 11,663	$ 11,228	
Depreciation expense		$ 1,422	$ 1,304	$1,182
Amortizable intangible assets, net				
Brands	5–40	$ 1,411	$ 1,476	
Other identifiable intangibles	10–24	360	344	
		1,771	1,820	
Accumulated amortization		(1,039)	(1,024)	
		$ 732	$ 796	
Amortization expense		$ 64	$ 58	$ 162

Property, plant and equipment is recorded at historical cost. Depreciation and amortization are recognized on a straight-line basis over an asset's estimated useful life. Land is not depreciated and construction in progress is not depreciated until ready for service. Amortization of intangible assets for each of the next five years, based on average 2008 foreign exchange rates, is expected to be $64 million in 2009, $63 million in 2010, $62 million in 2011, $60 million in 2012 and $56 million in 2013.

Notes to Consolidated Financial Statements

Depreciable and amortizable assets are only evaluated for impairment upon a significant change in the operating or macroeconomic environment. In these circumstances, if an evaluation of the undiscounted cash flows indicates impairment, the asset is written down to its estimated fair value, which is based on discounted future cash flows. Useful lives are periodically evaluated to determine whether events or circumstances have occurred which indicate the need for revision. For additional unaudited information on our amortizable brand policies, see "Our Critical Accounting Policies" in Management's Discussion and Analysis.

NONAMORTIZABLE INTANGIBLE ASSETS

Perpetual brands and goodwill are assessed for impairment at least annually. If the carrying amount of a perpetual brand exceeds its fair value, as determined by its discounted cash flows, an impairment loss is recognized in an amount equal to that excess. No impairment charges resulted from the required impairment evaluations. The change in the book value of nonamortizable intangible assets is as follows:

	Balance, Beginning 2007	Acquisitions	Translation and Other	Balance, End of 2007	Acquisitions	Translation and Other	Balance, End of 2008
FLNA							
Goodwill	$ 284	$ –	$ 27	$ 311	$ –	$ (34)	$ 277
QFNA							
Goodwill	175	–	–	175	–	–	175
LAF							
Goodwill	144	–	3	147	338	(61)	424
Brands	22	–	–	22	118	(13)	127
	166	–	3	169	456	(74)	551
PAB							
Goodwill	2,203	146	20	2,369	–	(14)	2,355
Brands	59	–	–	59	–	–	59
	2,262	146	20	2,428	–	(14)	2,414
UKEU							
Goodwill	1,412	122	92	1,626	45	(215)	1,456
Brands	1,018	–	23	1,041	14	(211)	844
	2,430	122	115	2,667	59	(426)	2,300
MEAA							
Goodwill	376	114	51	541	1	(105)	437
Brands	113	–	13	126	–	(28)	98
	489	114	64	667	1	(133)	535
Total goodwill	4,594	382	193	5,169	384	(429)	5,124
Total brands	1,212	–	36	1,248	132	(252)	1,128
	$5,806	$382	$229	$6,417	$516	$(681)	$6,252

Note 5 Income Taxes

	2008	2007	2006
Income before income taxes			
U.S.	$3,274	$4,085	$3,844
Foreign	3,747	3,546	3,145
	$7,021	$7,631	$6,989
Provision for income taxes			
Current: U.S. Federal	$ 815	$1,422	$ 776
Foreign	732	489	569
State	87	104	56
	1,634	2,015	1,401
Deferred: U.S. Federal	313	22	(31)
Foreign	(69)	(66)	(16)
State	1	2	(7)
	245	(42)	(54)
	$1,879	$1,973	$1,347
Tax rate reconciliation			
U.S. Federal statutory tax rate	35.0%	35.0%	35.0%
State income tax, net of			
U.S. Federal tax benefit	0.8	0.9	0.5
Lower taxes on foreign results	(7.9)	(6.5)	(6.5)
Tax settlements	–	(1.7)	(8.6)
Other, net	(1.1)	(1.8)	(1.1)
Annual tax rate	26.8%	25.9%	19.3%
Deferred tax liabilities			
Investments in noncontrolled affiliates	$1,193	$1,163	
Property, plant and equipment	881	828	
Intangible assets other than			
nondeductible goodwill	295	280	
Pension benefits	–	148	
Other	73	136	
Gross deferred tax liabilities	2,442	2,555	
Deferred tax assets			
Net carryforwards	682	722	
Stock-based compensation	410	425	
Retiree medical benefits	495	528	
Other employee-related benefits	428	447	
Pension benefits	345	–	
Deductible state tax and interest benefits	230	189	
Other	677	618	
Gross deferred tax assets	3,267	2,929	
Valuation allowances	(657)	(695)	
Deferred tax assets, net	2,610	2,234	
Net deferred tax (assets)/liabilities	$ (168)	$ 321	

	2008	2007	2006
Deferred taxes included within:			
Assets:			
Prepaid expenses and other current			
assets	$372	$325	$223
Other assets	$ 22	–	–
Liabilities:			
Deferred income taxes	$226	$646	$528
Analysis of valuation allowances			
Balance, beginning of year	$695	$624	$532
(Benefit)/provision	(5)	39	71
Other (deductions)/additions	(33)	32	21
Balance, end of year	$657	$695	$624

For additional unaudited information on our income tax policies, including our reserves for income taxes, see "Our Critical Accounting Policies" in Management's Discussion and Analysis.

In 2007, we recognized $129 million of non-cash tax benefits related to the favorable resolution of certain foreign tax matters. In 2006, we recognized non-cash tax benefits of $602 million, substantially all of which related to the IRS's examination of our consolidated income tax returns for the years 1998 through 2002.

RESERVES

A number of years may elapse before a particular matter, for which we have established a reserve, is audited and finally resolved. The number of years with open tax audits varies depending on the tax jurisdiction. Our major taxing jurisdictions and the related open tax audits are as follows:

- U.S. – continue to dispute one matter related to tax years 1998 through 2002. Our U.S. tax returns for the years 2003 through 2005 are currently under audit. In 2008, the IRS initiated its audit of our U.S. tax returns for the years 2006 through 2007;
- Mexico – audits have been substantially completed for all taxable years through 2005;
- United Kingdom – audits have been completed for all taxable years prior to 2004; and
- Canada – audits have been completed for all taxable years through 2005. We are in agreement with the conclusions, except for one matter which we continue to dispute. The Canadian tax return for 2006 is currently under audit.

Notes to Consolidated Financial Statements

While it is often difficult to predict the final outcome or the timing of resolution of any particular tax matter, we believe that our reserves reflect the probable outcome of known tax contingencies. We adjust these reserves, as well as the related interest, in light of changing facts and circumstances. Settlement of any particular issue would usually require the use of cash. Favorable resolution would be recognized as a reduction to our annual tax rate in the year of resolution.

For further unaudited information on the impact of the resolution of open tax issues, see "Other Consolidated Results."

In 2006, the FASB issued FASB Interpretation No. 48, *Accounting for Uncertainty in Income Taxes – an interpretation of FASB Statement No. 109,* (FIN 48), which clarifies the accounting for uncertainty in tax positions. FIN 48 requires that we recognize in our financial statements the impact of a tax position, if that position is more likely than not of being sustained on audit, based on the technical merits of the position. We adopted the provisions of FIN 48 as of the beginning of our 2007 fiscal year.

As of December 27, 2008, the total gross amount of reserves for income taxes, reported in other liabilities, was $1.7 billion. Any prospective adjustments to these reserves will be recorded as an increase or decrease to our provision for income taxes and would impact our effective tax rate. In addition, we accrue interest related to reserves for income taxes in our provision for income taxes and any associated penalties are recorded in selling, general and administrative expenses. The gross amount of interest accrued, reported in other liabilities, was $427 million as of December 27, 2008, of which $95 million was recognized in 2008. The gross amount of interest accrued was $338 million as of December 29, 2007, of which $34 million was recognized in 2007.

A rollforward of our reserves for all federal, state and foreign tax jurisdictions, is as follows:

	2008	2007
Balance, beginning of year	$1,461	$1,435
FIN 48 adoption adjustment to retained earnings	–	(7)
Reclassification of deductible state tax and interest benefits to other balance sheet accounts	–	(144)
Adjusted balance, beginning of year	1,461	1,284
Additions for tax positions related to the current year	272	264
Additions for tax positions from prior years	76	151
Reductions for tax positions from prior years	(14)	(73)
Settlement payments	(30)	(174)
Statute of limitations expiration	(20)	(7)
Translation and other	(34)	16
Balance, end of year	$1,711	$1,461

CARRYFORWARDS AND ALLOWANCES

Operating loss carryforwards totaling $7.2 billion at year-end 2008 are being carried forward in a number of foreign and state jurisdictions where we are permitted to use tax operating losses from prior periods to reduce future taxable income. These operating losses will expire as follows: $0.3 billion in 2009, $6.2 billion between 2010 and 2028 and $0.7 billion may be carried forward indefinitely. We establish valuation allowances for our deferred tax assets if, based on the available evidence, it is more likely than not that some portion or all of the deferred tax assets will not be realized.

UNDISTRIBUTED INTERNATIONAL EARNINGS

At December 27, 2008, we had approximately $17.1 billion of undistributed international earnings. We intend to continue to reinvest earnings outside the U.S. for the foreseeable future and, therefore, have not recognized any U.S. tax expense on these earnings.

Note 6 Stock-Based Compensation

Our stock-based compensation program is a broad-based program designed to attract and retain employees while also aligning employees' interests with the interests of our shareholders. A majority of our employees participate in our stock-based compensation program. This program includes both our broad-based SharePower program which was established in 1989 to grant an annual award of stock options to eligible employees, based upon job level or classification and tenure (internationally), as well as our executive long-term awards program. Stock options and restricted stock units (RSU) are granted to employees under the shareholder-approved 2007 Long-Term Incentive Plan (LTIP), our only active stock-based plan. Stock-based compensation expense was $238 million in 2008, $260 million in 2007 and $270 million in 2006. Related income tax benefits recognized in earnings were $71 million in 2008, $77 million in 2007 and $80 million in 2006. Stock-based compensation cost capitalized in connection with our ongoing business transformation initiative was $4 million in 2008, $3 million in 2007 and $3 million in 2006. At year-end 2008, 57 million shares were available for future stock-based compensation grants.

METHOD OF ACCOUNTING AND OUR ASSUMPTIONS

We account for our employee stock options, which include grants under our executive program and our broad-based SharePower program, under the fair value method of accounting using a Black-Scholes valuation model to measure stock option expense at the date of grant. All stock option grants have an exercise price equal to the fair market value of our common stock on the date of grant and generally have a 10-year term. We do not backdate, reprice or grant stock-based compensation awards retroactively. Repricing of awards would require shareholder approval under the LTIP.

The fair value of stock option grants is amortized to expense over the vesting period, generally three years. Executives who are awarded long-term incentives based on their performance are offered the choice of stock options or RSUs. Executives who elect RSUs receive one RSU for every four stock options that would have otherwise been granted. Senior officers do not have a choice and are granted 50% stock options and 50% performance-based RSUs. Vesting of RSU awards for senior officers is contingent upon the achievement of pre-established performance targets approved by the Compensation Committee of the Board of Directors. RSU expense is based on the fair value of PepsiCo stock on the date of grant and is amortized over the vesting period, generally three years. Each RSU is settled in a share of our stock after the vesting period.

Our weighted-average Black-Scholes fair value assumptions are as follows:

	2008	2007	2006
Expected life	6 yrs.	6 yrs.	6 yrs.
Risk free interest rate	3.0%	4.8%	4.5%
Expected volatility	16%	15%	18%
Expected dividend yield	1.9%	1.9%	1.9%

The expected life is the period over which our employee groups are expected to hold their options. It is based on our historical experience with similar grants. The risk free interest rate is based on the expected U.S. Treasury rate over the expected life. Volatility reflects movements in our stock price over the most recent historical period equivalent to the expected life. Dividend yield is estimated over the expected life based on our stated dividend policy and forecasts of net income, share repurchases and stock price.

A summary of our stock-based compensation activity for the year ended December 27, 2008 is presented below:

Our Stock Option Activity

	Options[a]	Average Price[b]	Average Life (years)[c]	Aggregate Intrinsic Value[d]
Outstanding at December 29, 2007	108,808	$47.47		
Granted	12,512	68.74		
Exercised	(14,651)	42.19		
Forfeited/expired	(2,997)	60.13		
Outstanding at December 27, 2008	103,672	$50.42	4.93	$736,438
Exercisable at December 27, 2008	61,085	$43.41	3.16	$683,983

(a) Options are in thousands and include options previously granted under Quaker plans. No additional options or shares may be granted under the Quaker plans.
(b) Weighted-average exercise price.
(c) Weighted-average contractual life remaining.
(d) In thousands.

Our RSU Activity

	RSUs[a]	Average Intrinsic Value[b]	Average Life (years)[c]	Aggregate Intrinsic Value[d]
Outstanding at December 29, 2007	7,370	$58.63		
Granted	2,135	68.73		
Converted	(2,500)	54.59		
Forfeited/expired	(854)	62.90		
Outstanding at December 27, 2008	6,151	$63.18	1.20	$335,583

(a) RSUs are in thousands.
(b) Weighted-average intrinsic value at grant date.
(c) Weighted-average contractual life remaining.
(d) In thousands.

OTHER STOCK-BASED COMPENSATION DATA

	2008	2007	2006
Stock Options			
Weighted-average fair value of options granted	$ 11.24	$ 13.56	$ 12.81
Total intrinsic value of options exercised[a]	$410,152	$826,913	$686,242
RSUs			
Total number of RSUs granted[a]	2,135	2,342	2,992
Weighted-average intrinsic value of RSUs granted	$ 68.73	$ 65.21	$ 58.22
Total intrinsic value of RSUs converted[a]	$180,563	$125,514	$ 10,934

(a) In thousands.

At December 27, 2008, there was $243 million of total unrecognized compensation cost related to nonvested share-based compensation grants. This unrecognized compensation is expected to be recognized over a weighted-average period of 1.7 years.

Notes to Consolidated Financial Statements

Note 7 Pension, Retiree Medical and Savings Plans

Our pension plans cover full-time employees in the U.S. and certain international employees. Benefits are determined based on either years of service or a combination of years of service and earnings. U.S. and Canada retirees are also eligible for medical and life insurance benefits (retiree medical) if they meet age and service requirements. Generally, our share of retiree medical costs is capped at specified dollar amounts, which vary based upon years of service, with retirees contributing the remainder of the costs.

Gains and losses resulting from actual experience differing from our assumptions, including the difference between the actual return on plan assets and the expected return on plan assets, and from changes in our assumptions are also determined at each measurement date. If this net accumulated gain or loss exceeds 10% of the greater of the market-related value of plan assets or plan liabilities, a portion of the net gain or loss is included in expense for the following year. The cost or benefit of plan changes that increase or decrease benefits for prior employee service (prior service cost/(credit)) is included in earnings on a straight-line basis over the average remaining service period of active plan participants, which is approximately 10 years for pension expense and approximately 12 years for retiree medical expense.

On December 30, 2006, we adopted SFAS 158. In connection with our adoption, we recognized the funded status of our Plans on our balance sheet as of December 30, 2006 with subsequent changes in the funded status recognized in comprehensive income in the years in which they occur. In accordance with SFAS 158, amounts prior to the year of adoption have not been adjusted. SFAS 158 also required that, no later than 2008, our assumptions used to measure our annual pension and retiree medical expense be determined as of the balance sheet date, and all plan assets and liabilities be reported as of that date. Accordingly, as of the beginning of our 2008 fiscal year, we changed the measurement date for our annual pension and retiree medical expense and all plan assets and liabilities from September 30 to our year-end balance sheet date. As a result of this change in measurement date, we recorded an after-tax $39 million decrease to 2008 opening shareholders' equity, as follows:

	Pension	Retiree Medical	Total
Retained earnings	$(63)	$(20)	$(83)
Accumulated other comprehensive loss	12	32	44
Total	$(51)	$ 12	$(39)

Selected financial information for our pension and retiree medical plans is as follows:

	Pension				Retiree Medical	
	2008	2007	**2008**	2007	**2008**	2007
	U.S.		**International**			
Change in projected benefit liability						
Liability at beginning of year	**$ 6,048**	$5,947	**$1,595**	$1,511	**$ 1,354**	$ 1,370
SFAS 158 measurement date change	**(199)**	–	**113**	–	**(37)**	–
Service cost	**244**	244	**61**	59	**45**	48
Interest cost	**371**	338	**88**	81	**82**	77
Plan amendments	**(20)**	147	**2**	4	**(47)**	–
Participant contributions	**–**	–	**17**	14	**–**	–
Experience loss/(gain)	**28**	(309)	**(165)**	(155)	**58**	(80)
Benefit payments	**(277)**	(319)	**(51)**	(46)	**(70)**	(77)
Settlement/curtailment loss	**(9)**	–	**(15)**	–	**(2)**	–
Special termination benefits	**31**	–	**2**	–	**3**	–
Foreign currency adjustment	**–**	–	**(376)**	96	**(10)**	9
Other	**–**	–	**(1)**	31	**(6)**	7
Liability at end of year	**$ 6,217**	$6,048	**$1,270**	$1,595	**$ 1,370**	$ 1,354
Change in fair value of plan assets						
Fair value at beginning of year	**$ 5,782**	$5,378	**$1,595**	$1,330	**$ –**	$ –
SFAS 158 measurement date change	**(136)**	–	**97**	–	**–**	–
Actual return on plan assets	**(1,434)**	654	**(241)**	122	**–**	–
Employer contributions/funding	**48**	69	**101**	58	**70**	77
Participant contributions	**–**	–	**17**	14	**–**	–
Benefit payments	**(277)**	(319)	**(51)**	(46)	**(70)**	(77)
Settlement/curtailment loss	**(9)**	–	**(11)**	–	**–**	–
Foreign currency adjustment	**–**	–	**(341)**	91	**–**	–
Other	**–**	–	**(1)**	26	**–**	–
Fair value at end of year	**$ 3,974**	$5,782	**$1,165**	$1,595	**$ –**	$ –
Reconciliation of funded status						
Funded status	**$(2,243)**	$ (266)	**$ (105)**	$ –	**$(1,370)**	$(1,354)
Adjustment for fourth quarter contributions	**–**	15	**–**	107	**–**	19
Adjustment for fourth quarter special termination benefits	**–**	(5)	**–**	–	**–**	–
Net amount recognized	**$(2,243)**	$ (256)	**$ (105)**	$ 107	**$(1,370)**	$(1,335)
Amounts recognized						
Other assets	**$ –**	$ 440	**$ 28**	$ 187	**$ –**	$ –
Other current liabilities	**(60)**	(24)	**(1)**	(3)	**(102)**	(88)
Other liabilities	**(2,183)**	(672)	**(132)**	(77)	**(1,268)**	(1,247)
Net amount recognized	**$(2,243)**	$ (256)	**$ (105)**	$ 107	**$(1,370)**	$(1,335)
Amounts included in accumulated other comprehensive loss/(credit) (pre-tax)						
Net loss	**$ 2,826**	$1,136	**$ 421**	$ 287	**$ 266**	$ 276
Prior service cost/(credit)	**112**	156	**20**	28	**(119)**	(88)
Total	**$ 2,938**	$1,292	**$ 441**	$ 315	**$ 147**	$ 188
Components of the increase/(decrease) in net loss						
SFAS 158 measurement date change	**$ (130)**	$ –	**$ 105**	$ –	**$ (53)**	$ –
Change in discount rate	**247**	(292)	**(219)**	(224)	**36**	(50)
Employee-related assumption changes	**(194)**	–	**52**	61	**6**	(9)
Liability-related experience different from assumptions	**(25)**	(17)	**(4)**	7	**10**	(21)
Actual asset return different from expected return	**1,850**	(255)	**354**	(25)	**–**	–
Amortization of losses	**(58)**	(136)	**(19)**	(30)	**(8)**	(18)
Other, including foreign currency adjustments and 2003 Medicare Act	**–**	–	**(135)**	23	**(1)**	10
Total	**$ 1,690**	$ (700)	**$ 134**	$ (188)	**$ (10)**	$ (88)
Liability at end of year for service to date	**$ 5,413**	$5,026	**$1,013**	$1,324		

Notes to Consolidated Financial Statements

Components of benefit expense are as follows:

	Pension						Retiree Medical		
	2008	2007	2006	2008	2007	2006	2008	2007	2006
		U.S.			International				
Components of benefit expense									
Service cost	$ 244	$ 244	$ 245	$ 61	$ 59	$ 52	$ 45	$ 48	$ 46
Interest cost	371	338	319	88	81	68	82	77	72
Expected return on plan assets	(416)	(399)	(391)	(112)	(97)	(81)	–	–	–
Amortization of prior service cost/(credit)	19	5	3	3	3	2	(13)	(13)	(13)
Amortization of net loss	55	136	164	19	30	29	7	18	21
	273	324	340	59	76	70	121	130	126
Settlement/curtailment loss	3	–	3	3	–	–	–	–	–
Special termination benefits	31	5	4	2	–	–	3	–	1
Total	$ 307	$ 329	$ 347	$ 64	$ 76	$ 70	$124	$130	$127

The estimated amounts to be amortized from accumulated other comprehensive loss into benefit expense in 2009 for our pension and retiree medical plans are as follows:

		Pension	Retiree Medical
	U.S.	International	
Net loss	$ 98	$10	$ 11
Prior service cost/(credit)	11	2	(17)
Total	$109	$12	$ (6)

The following table provides the weighted-average assumptions used to determine projected benefit liability and benefit expense for our pension and retiree medical plans:

	Pension						Retiree Medical		
	2008	2007	2006	2008	2007	2006	2008	2007	2006
		U.S.			International				
Weighted average assumptions									
Liability discount rate	6.2%	6.2%	5.8%	6.3%	5.8%	5.2%	6.2%	6.1%	5.8%
Expense discount rate	6.5%	5.8%	5.7%	5.6%	5.2%	5.1%	6.5%	5.8%	5.7%
Expected return on plan assets	7.8%	7.8%	7.8%	7.2%	7.3%	7.3%			
Rate of salary increases	4.6%	4.7%	4.5%	3.9%	3.9%	3.9%			

The following table provides selected information about plans with liability for service to date and total benefit liability in excess of plan assets:

	Pension				Retiree Medical	
	2008	2007	2008	2007	2008	2007
		U.S.		International		
Selected information for plans with liability for service to date in excess of plan assets						
Liability for service to date	$(5,411)	$(364)	$ (49)	$ (72)		
Fair value of plan assets	$ 3,971	$ –	$ 30	$ 13		
Selected information for plans with benefit liability in excess of plan assets						
Benefit liability	$(6,217)	$(707)	$(1,049)	$(384)	$(1,370)	$(1,354)
Fair value of plan assets	$ 3,974	$ –	$ 916	$ 278		

Of the total projected pension benefit liability at year-end 2008, $587 million relates to plans that we do not fund because the funding of such plans does not receive favorable tax treatment.

FUTURE BENEFIT PAYMENTS AND FUNDING

Our estimated future benefit payments are as follows:

	2009	2010	2011	2012	2013	2014-18
Pension	$350	$335	$370	$400	$425	$2,645
Retiree medical (a)	$110	$115	$120	$125	$130	$ 580

(a) *Expected future benefit payments for our retiree medical plans do not reflect any estimated subsidies expected to be received under the 2003 Medicare Act. Subsidies are expected to be approximately $10 million for each of the years from 2009 through 2013 and approximately $70 million in total for 2014 through 2018.*

These future benefits to beneficiaries include payments from both funded and unfunded pension plans.

In 2009, we will make pension contributions of up to $1.1 billion, with up to $1 billion being discretionary. Our net cash payments for retiree medical are estimated to be approximately $100 million in 2009.

PENSION ASSETS

Our pension plan investment strategy includes the use of actively-managed securities and is reviewed annually based upon plan liabilities, an evaluation of market conditions, tolerance for risk and cash requirements for benefit payments. Our investment objective is to ensure that funds are available to meet the plans' benefit obligations when they become due. Our overall investment strategy is to prudently invest plan assets in high-quality and diversified equity and debt securities to achieve our long-term return expectations. We employ certain equity strategies which, in addition to investments in U.S. and international common and preferred stock, include investments in certain equity- and debt-based securities used collectively to generate returns in excess of certain equity-based indices. Debt-based securities represent approximately 3% and 30% of our equity strategy portfolio as of year-end 2008 and 2007, respectively. Our investment policy also permits the use of derivative instruments which are primarily used to reduce risk. Our expected long-term rate of return on U.S. plan assets is 7.8%, reflecting estimated long-term rates of return of 8.9% from our equity strategies, and 6.3% from our fixed income strategies. Our target investment allocation is 60% for equity strategies and 40% for fixed income strategies. Actual investment allocations may vary from our target investment allocations due to prevailing market conditions. We regularly review our actual investment allocations and periodically rebalance our investments to our target allocations. Our actual pension plan asset allocations are as follows:

	Actual Allocation	
Asset Category	2008	2007
Equity strategies	38%	61%
Fixed income strategies	61%	38%
Other, primarily cash	1%	1%
Total	100%	100%

The expected return on pension plan assets is based on our pension plan investment strategy, our expectations for long-term rates of return and our historical experience. We also review current levels of interest rates and inflation to assess the reasonableness of the long-term rates. To calculate the expected return on pension plan assets, we use a market-related valuation method that recognizes investment gains or losses (the difference between the expected and actual return based on the market-related value of assets) for securities included in our equity strategies over a five-year period. This has the effect of reducing year-to-year volatility. For all other asset categories, the actual fair value is used for the market-related value of assets.

Pension assets include 5.5 million shares of PepsiCo common stock with a market value of $302 million in 2008, and 5.5 million shares with a market value of $401 million in 2007. Our investment policy limits the investment in PepsiCo stock at the time of investment to 10% of the fair value of plan assets.

RETIREE MEDICAL COST TREND RATES

An average increase of 8.0% in the cost of covered retiree medical benefits is assumed for 2009. This average increase is then projected to decline gradually to 5% in 2014 and thereafter. These assumed health care cost trend rates have an impact on the retiree medical plan expense and liability. However, the cap on our share of retiree medical costs limits the impact. A 1-percentage-point change in the assumed health care trend rate would have the following effects:

	1% Increase	1% Decrease
2008 service and interest cost components	$ 6	$ (5)
2008 benefit liability	$33	$(29)

SAVINGS PLAN

Our U.S. employees are eligible to participate in 401(k) savings plans, which are voluntary defined contribution plans. The plans are designed to help employees accumulate additional savings for retirement. We make matching contributions on a portion of eligible pay based on years of service. In 2008 and 2007, our matching contributions were $70 million and $62 million, respectively.

For additional unaudited information on our pension and retiree medical plans and related accounting policies and assumptions, see "Our Critical Accounting Policies" in Management's Discussion and Analysis.

Notes to Consolidated Financial Statements

Note 8 Noncontrolled Bottling Affiliates

Our most significant noncontrolled bottling affiliates are PBG and PAS. Sales to PBG reflected approximately 8%, 9% and 10% of our total net revenue in 2008, 2007 and 2006, respectively.

THE PEPSI BOTTLING GROUP

In addition to approximately 33% and 35% of PBG's outstanding common stock that we owned at year-end 2008 and 2007, respectively, we owned 100% of PBG's class B common stock and approximately 7% of the equity of Bottling Group, LLC, PBG's principal operating subsidiary.

PBG's summarized financial information is as follows:

	2008	2007	2006
Current assets	$ 3,141	$ 3,086	
Noncurrent assets	9,841	10,029	
Total assets	$12,982	$13,115	
Current liabilities	$ 3,083	$ 2,215	
Noncurrent liabilities	7,408	7,312	
Minority interest	1,148	973	
Total liabilities	$11,639	$10,500	
Our investment	$ 1,457	$ 2,022	
Net revenue	$13,796	$13,591	$12,730
Gross profit	$ 6,210	$ 6,221	$ 5,830
Operating profit	$ 649	$ 1,071	$ 1,017
Net income	$ 162	$ 532	$ 522

Our investment in PBG, which includes the related goodwill, was $536 million and $507 million higher than our ownership interest in their net assets at year-end 2008 and 2007, respectively. Based upon the quoted closing price of PBG shares at year-end 2008, the calculated market value of our shares in PBG exceeded our investment balance, excluding our investment in Bottling Group, LLC, by approximately $567 million.

Additionally, in 2007, we formed a joint venture with PBG, comprising our concentrate and PBG's bottling businesses in Russia. PBG holds a 60% majority interest in the joint venture and consolidates the entity. We account for our interest of 40% under the equity method of accounting.

During 2008, together with PBG, we jointly acquired Russia's leading branded juice company, Lebedyansky. Lebedyansky is owned 25% and 75% by PBG and us, respectively. See Note 14 for further information on this acquisition.

PEPSIAMERICAS

At year-end 2008 and 2007, we owned approximately 43% and 44%, respectively, of the outstanding common stock of PAS.

PAS summarized financial information is as follows:

	2008	2007	2006
Current assets	$ 906	$ 922	
Noncurrent assets	4,148	4,386	
Total assets	$5,054	$5,308	
Current liabilities	$1,048	$ 903	
Noncurrent liabilities	2,175	2,274	
Minority interest	307	273	
Total liabilities	$3,530	$3,450	
Our investment	$ 972	$1,118	
Net revenue	$4,937	$4,480	$3,972
Gross profit	$1,982	$1,823	$1,608
Operating profit	$ 473	$ 436	$ 356
Net income	$ 226	$ 212	$ 158

Our investment in PAS, which includes the related goodwill, was $318 million and $303 million higher than our ownership interest in their net assets at year-end 2008 and 2007, respectively. Based upon the quoted closing price of PAS shares at year-end 2008, the calculated market value of our shares in PAS exceeded our investment balance by approximately $143 million.

Additionally, in 2007, we completed the joint purchase of Sandora, LLC, a juice company in the Ukraine, with PAS. PAS holds a 60% majority interest in the joint venture and consolidates the entity. We account for our interest of 40% under the equity method of accounting.

RELATED PARTY TRANSACTIONS

Our significant related party transactions include our noncontrolled bottling affiliates. We sell concentrate to these affiliates, which they use in the production of CSDs and non-carbonated beverages. We also sell certain finished goods to these affiliates, and we receive royalties for the use of our trademarks for certain products. Sales of concentrate and finished goods are reported net of bottler funding. For further unaudited information on these bottlers, see "Our Customers" in Management's Discussion and Analysis. These transactions with our bottling affiliates are reflected in our consolidated financial statements as follows:

	2008	2007	2006
Net revenue	$4,919	$4,874	$4,837
Selling, general and administrative expenses	$ 131	$ 91	$ 87
Accounts and notes receivable	$ 153	$ 163	
Accounts payable and other current liabilities	$ 104	$ 106	

Such amounts are settled on terms consistent with other trade receivables and payables. See Note 9 regarding our guarantee of certain PBG debt.

In addition, we coordinate, on an aggregate basis, the contract negotiations of sweeteners and other raw material requirements for certain of our bottlers. Once we have negotiated the contracts, the bottlers order and take delivery directly from the supplier and pay the suppliers directly. Consequently, these transactions are not reflected in our consolidated financial statements. As the contracting party, we could be liable to these suppliers in the event of any nonpayment by our bottlers, but we consider this exposure to be remote.

Note 9 Debt Obligations and Commitments

	2008	2007
Short-term debt obligations		
Current maturities of long-term debt	$ 273	$ 526
Commercial paper (0.7% and 4.3%)	846	361
Other borrowings (10.0% and 7.2%)	509	489
Amounts reclassified to long-term debt	(1,259)	(1,376)
	$ 369	$ —
Long-term debt obligations		
Short-term borrowings, reclassified	$ 1,259	$ 1,376
Notes due 2009-2026 (5.8% and 5.3%)	6,382	2,673
Zero coupon notes, $300 million due 2009-2012 (13.3%)	242	285
Other, due 2009-2016 (5.3% and 6.1%)	248	395
	8,131	4,729
Less: current maturities of long-term debt obligations	(273)	(526)
	$ 7,858	$ 4,203

The interest rates in the above table reflect weighted-average rates at year-end.

In the second quarter of 2008, we issued $1.75 billion of senior unsecured notes, maturing in 2018. We entered into an interest rate swap, maturing in 2018, to effectively convert the interest rate from a fixed rate of 5% to a variable rate based on LIBOR. The proceeds from the issuance of these notes were used for general corporate purposes, including the repayment of outstanding short-term indebtedness.

In the third quarter of 2008, we updated our U.S. $2.5 billion euro medium term note program following the expiration of the existing program. Under the program, we may issue unsecured notes under mutually agreed upon terms with the purchasers of the notes. Proceeds from any issuance of notes may be used for general corporate purposes, except as otherwise specified in the related prospectus. As of December 27, 2008, we had no outstanding notes under the program.

In the fourth quarter of 2008, we issued $2 billion of senior unsecured notes, bearing interest at 7.90% per year and maturing in 2018. We used the proceeds from the issuance of these notes for general corporate purposes, including the repayment of outstanding short-term indebtedness.

Additionally, in the fourth quarter of 2008, we entered into a new 364-day unsecured revolving credit agreement which enables us to borrow up to $1.8 billion, subject to customary terms and conditions, and expires in December 2009. This agreement replaced a $1 billion 364-day unsecured revolving credit agreement we entered into during the third quarter of 2008. Funds borrowed under this agreement may be used to repay outstanding commercial paper issued by us or our subsidiaries and for other general corporate purposes, including working capital, capital investments and acquisitions. This line of credit remained unused as of December 27, 2008.

This 364-day credit agreement is in addition to our $2 billion unsecured revolving credit agreement. Funds borrowed under this agreement may be used for general corporate purposes, including supporting our outstanding commercial paper issuances. This agreement expires in 2012. This line of credit remains unused as of December 27, 2008.

As of December 27, 2008, we have reclassified $1.3 billion of short-term debt to long-term based on our intent and ability to refinance on a long-term basis.

In addition, as of December 27, 2008, $844 million of our debt related to borrowings from various lines of credit that are maintained for our international divisions. These lines of credit are subject to normal banking terms and conditions and are fully committed to the extent of our borrowings.

INTEREST RATE SWAPS

In connection with the issuance of the $1.75 billion notes in the second quarter of 2008, we entered into an interest rate swap, maturing in 2018, to effectively convert the interest rate from a fixed rate of 5% to a variable rate based on LIBOR. In addition, in connection with the issuance of the $1 billion senior unsecured notes in the second quarter of 2007, we entered into an interest rate swap, maturing in 2012, to effectively convert the interest rate from a fixed rate of 5.15% to a variable rate based on LIBOR. The terms of the swaps match the terms of the debt they modify. The notional amounts of the interest rate swaps outstanding at December 27, 2008 and December 29, 2007 were $2.75 billion and $1 billion, respectively.

Notes to Consolidated Financial Statements

At December 27, 2008, approximately 58% of total debt, after the impact of the related interest rate swaps, was exposed to variable interest rates, compared to 56% at December 29, 2007. In addition to variable rate long-term debt, all debt with maturities of less than one year is categorized as variable for purposes of this measure.

LONG-TERM CONTRACTUAL COMMITMENTS (a)

	Total	2009	2010-2011	2012-2013	2014 and beyond
			Payments Due by Period		
Long-term debt obligations (b)	$ 6,599	$ —	$ 184	$2,198	$4,217
Interest on debt obligations (c)	2,647	388	605	522	1,132
Operating leases	1,088	262	359	199	268
Purchasing commitments	3,273	1,441	1,325	431	76
Marketing commitments	975	252	462	119	142
Other commitments	46	46	—	—	—
	$14,628	$2,389	$2,935	$3,469	$5,835

(a) Reflects non-cancelable commitments as of December 27, 2008 based on year-end foreign exchange rates and excludes any reserves for income taxes under FIN 48 as we are unable to reasonably predict the ultimate amount or timing of settlement of our reserves for income taxes.
(b) Excludes short-term obligations of $369 million and short-term borrowings reclassified as long-term debt of $1,259 million. Includes $197 million of principal and accrued interest related to our zero coupon notes.
(c) Interest payments on floating-rate debt are estimated using interest rates effective as of December 27, 2008.

Most long-term contractual commitments, except for our long-term debt obligations, are not recorded on our balance sheet. Non-cancelable operating leases primarily represent building leases. Non-cancelable purchasing commitments are primarily for oranges and orange juice, cooking oil and packaging materials. Non-cancelable marketing commitments are primarily for sports marketing. Bottler funding is not reflected in our long-term contractual commitments as it is negotiated on an annual basis. See Note 7 regarding our pension and retiree medical obligations and discussion below regarding our commitments to noncontrolled bottling affiliates.

OFF-BALANCE-SHEET ARRANGEMENTS

It is not our business practice to enter into off-balance-sheet arrangements, other than in the normal course of business. However, at the time of the separation of our bottling operations from us various guarantees were necessary to facilitate the transactions. We have guaranteed an aggregate of $2.3 billion of Bottling Group, LLC's long-term debt ($1.0 billion of which matures in 2012 and $1.3 billion of which matures in 2014). In the fourth quarter of 2008, we extended our guarantee of $1.3 billion of Bottling Group, LLC's long-term debt in connection with the refinancing of a corresponding portion of the underlying debt. The terms of our Bottling Group, LLC debt guarantee are intended to preserve the structure of PBG's separation from us and our payment obligation would be triggered if Bottling Group, LLC failed to perform under these debt obligations or the structure significantly changed. At December 27, 2008, we believe it is remote that these guarantees would require any cash payment. See Note 8 regarding contracts related to certain of our bottlers.

See "Our Liquidity and Capital Resources" in Management's Discussion and Analysis for further unaudited information on our borrowings.

Note 10 Financial Instruments

We are exposed to market risks arising from adverse changes in:
• commodity prices, affecting the cost of our raw materials and energy,
• foreign exchange risks, and
• interest rates.

In the normal course of business, we manage these risks through a variety of strategies, including the use of derivatives. Certain derivatives are designated as either cash flow or fair value hedges and qualify for hedge accounting treatment, while others do not qualify and are marked to market through earnings. Cash flows from derivatives used to manage commodity, foreign exchange or interest risks are classified as operating activities. See "Our Business Risks" in Management's Discussion and Analysis for further unaudited information on our business risks.

For cash flow hedges, changes in fair value are deferred in accumulated other comprehensive loss within shareholders' equity until the underlying hedged item is recognized in net income. For fair value hedges, changes in fair value are recognized immediately in earnings, consistent with the underlying hedged item. Hedging transactions are limited to an underlying exposure. As a result, any change in the value of our derivative instruments would be substantially offset by an opposite change in the value of the underlying hedged items. Hedging ineffectiveness and a net earnings impact occur when the change in the value of the hedge does not offset the change in the value of the underlying hedged item. If the derivative instrument is terminated, we continue to defer the related gain or loss and include it as a component of the cost of the underlying hedged item. Upon determination that the underlying hedged item will not be part of an actual transaction, we recognize the related gain or loss in net income in that period.

We also use derivatives that do not qualify for hedge accounting treatment. We account for such derivatives at market value with the resulting gains and losses reflected in our income statement. We do not use derivative instruments for trading or speculative purposes. We perform a quarterly assessment of our counterparty credit risk, including a review of credit ratings, credit default swap rates and potential nonperformance of the counterparty. We consider this risk to be low, because we limit our exposure to individual, strong creditworthy counterparties and generally settle on a net basis.

COMMODITY PRICES

We are subject to commodity price risk because our ability to recover increased costs through higher pricing may be limited in the competitive environment in which we operate. This risk is managed through the use of fixed-price purchase orders, pricing agreements, geographic diversity and derivatives. We use derivatives, with terms of no more than three years, to economically hedge price fluctuations related to a portion of our anticipated commodity purchases, primarily for natural gas and diesel fuel. For those derivatives that qualify for hedge accounting, any ineffectiveness is recorded immediately. However, such commodity cash flow hedges have not had any significant ineffectiveness for all periods presented. We classify both the earnings and cash flow impact from these derivatives consistent with the underlying hedged item. During the next 12 months, we expect to reclassify net losses of $64 million related to cash flow hedges from accumulated other comprehensive loss into net income. Derivatives used to hedge commodity price risks that do not qualify for hedge accounting are marked to market each period and reflected in our income statement.

In 2007, we expanded our commodity hedging program to include derivative contracts used to mitigate our exposure to price changes associated with our purchases of fruit. In addition, in 2008, we entered into additional contracts to further reduce our exposure to price fluctuations in our raw material and energy costs. The majority of these contracts do not qualify for hedge accounting treatment and are marked to market with the resulting gains and losses recognized in corporate unallocated expenses. These gains and losses are then subsequently reflected in divisional results.

Our open commodity derivative contracts that qualify for hedge accounting had a face value of $303 million at December 27, 2008 and $5 million at December 29, 2007. These contracts resulted in net unrealized losses of $117 million at December 27, 2008 and net unrealized gains of less than $1 million at December 29, 2007.

Our open commodity derivative contracts that do not qualify for hedge accounting had a face value of $626 million at December 27, 2008 and $105 million at December 29, 2007. These contracts resulted in net losses of $343 million in 2008 and net gains of $3 million in 2007.

FOREIGN EXCHANGE

Our operations outside of the U.S. generate 48% of our net revenue, with Mexico, Canada and the United Kingdom comprising 19% of our net revenue. As a result, we are exposed to foreign currency risks. On occasion, we enter into hedges, primarily forward contracts with terms of no more than two years, to reduce the effect of foreign exchange rates. Ineffectiveness of these hedges has not been material.

INTEREST RATES

We centrally manage our debt and investment portfolios considering investment opportunities and risks, tax consequences and overall financing strategies. We may use interest rate and cross currency interest rate swaps to manage our overall interest expense and foreign exchange risk. These instruments effectively change the interest rate and currency of specific debt issuances. Our 2008 and 2007 interest rate swaps were entered into concurrently with the issuance of the debt that they modified. The notional amount, interest payment and maturity date of the swaps match the principal, interest payment and maturity date of the related debt.

FAIR VALUE

In September 2006, the FASB issued SFAS 157, *Fair Value Measurements* (SFAS 157), which defines fair value, establishes a framework for measuring fair value, and expands disclosures about fair value measurements. The provisions of SFAS 157 were effective as of the beginning of our 2008 fiscal year. However, the FASB deferred the effective date of SFAS 157, until the beginning of our 2009 fiscal year, as it relates to fair value measurement requirements for nonfinancial assets and liabilities that are not remeasured at fair value on a recurring basis. These include goodwill, other nonamortizable intangible assets and unallocated purchase price for recent acquisitions which are included within other assets. We adopted SFAS 157 at the beginning of our 2008 fiscal year and our adoption did not have a material impact on our financial statements.

The fair value framework requires the categorization of assets and liabilities into three levels based upon the assumptions (inputs) used to price the assets or liabilities. Level 1 provides

Notes to Consolidated Financial Statements

the most reliable measure of fair value, whereas Level 3 generally requires significant management judgment. The three levels are defined as follows:

- *Level 1*: Unadjusted quoted prices in active markets for identical assets and liabilities.
- *Level 2*: Observable inputs other than those included in Level 1. For example, quoted prices for similar assets or liabilities in active markets or quoted prices for identical assets or liabilities in inactive markets.
- *Level 3*: Unobservable inputs reflecting management's own assumptions about the inputs used in pricing the asset or liability.

The fair values of our financial assets and liabilities are categorized as follows:

	2008				2007
	Total	Level 1	Level 2	Level 3	Total
Assets					
Short-term investments – index funds (a)	$ 98	$ 98	$ –	$–	$189
Available-for-sale securities (b)	41	41	–	–	74
Forward exchange contracts (c)	139	–	139	–	32
Commodity contracts – other (d)	–	–	–	–	10
Interest rate swaps (e)	372	–	372	–	36
Prepaid forward contracts (f)	41	–	41	–	74
Total assets at fair value	$691	$139	$552	$–	$415
Liabilities					
Forward exchange contracts (c)	$ 56	$ –	$ 56	$–	$ 61
Commodity contracts – futures (g)	115	115	–	–	–
Commodity contracts – other (d)	345	–	345	–	7
Cross currency interest rate swaps (h)	–	–	–	–	8
Deferred compensation (i)	447	99	348	–	564
Total liabilities at fair value	$963	$214	$749	$–	$640

The above items are included on our balance sheet under the captions noted or as indicated below. In addition, derivatives qualify for hedge accounting unless otherwise noted below.
(a) *Based on price changes in index funds used to manage a portion of market risk arising from our deferred compensation liability.*
(b) *Based on the price of common stock.*
(c) *Based on observable market transactions of spot and forward rates. The 2008 asset includes $27 million related to derivatives that do not qualify for hedge accounting and the 2008 liability includes $55 million related to derivatives that do not qualify for hedge accounting. The 2007 asset includes $20 million related to derivatives that do not qualify for hedge accounting and the 2007 liability includes $5 million related to derivatives that do not qualify for hedge accounting.*
(d) *Based on recently reported transactions in the marketplace, primarily swap arrangements. The 2008 liability includes $292 million related to derivatives that do not qualify for hedge accounting. Our commodity contracts in 2007 did not qualify for hedge accounting.*
(e) *Based on the LIBOR index.*
(f) *Based primarily on the price of our common stock.*
(g) *Based on average prices on futures exchanges. The 2008 liability includes $51 million related to derivatives that do not qualify for hedge accounting.*
(h) *Based on observable local benchmarks for currency and interest rates. Our cross currency interest rate swaps matured in 2008.*
(i) *Based on the fair value of investments corresponding to employees' investment elections.*

Derivative instruments are recognized on our balance sheet in current assets, current liabilities, other assets or other liabilities at fair value. The carrying amounts of our cash and cash equivalents and short-term investments approximate fair value due to the short term maturity. Short-term investments consist principally of short-term time deposits and index funds of $98 million at December 27, 2008 and $189 million at December 29, 2007 used to manage a portion of market risk arising from our deferred compensation liability.

Under SFAS 157, the fair value of our debt obligations as of December 27, 2008 was $8.8 billion, based upon prices of similar instruments in the market place. The fair value of our debt obligations as of December 29, 2007 was $4.4 billion.

The table above excludes guarantees, including our guarantee aggregating $2.3 billion of Bottling Group, LLC's long-term debt. The guarantee had a fair value of $117 million at December 27, 2008 and $35 million at December 29, 2007 based on our estimate of the cost to us of transferring the liability to an independent financial institution. See Note 9 for additional information on our guarantees.

Note 11 Net Income per Common Share

Basic net income per common share is net income available to common shareholders divided by the weighted average of common shares outstanding during the period. Diluted net income per common share is calculated using the weighted average of common shares outstanding adjusted to include the effect that would occur if in-the-money employee stock options were exercised and RSUs and preferred shares were converted into common shares. Options to purchase 9.8 million shares in 2008, 2.7 million shares in 2007 and 0.1 million shares in 2006 were not included in the calculation of diluted earnings per common share because these options were out-of-the-money. Out-of-the-money options had average exercise prices of $67.59 in 2008, $65.18 in 2007 and $65.24 in 2006.

The computations of basic and diluted net income per common share are as follows:

	2008		2007		2006	
	Income	Shares[a]	Income	Shares[a]	Income	Shares[a]
Net income	$5,142		$5,658		$5,642	
Preferred shares:						
Dividends	(2)		(2)		(2)	
Redemption premium	(6)		(10)		(9)	
Net income available for common shareholders	$5,134	1,573	$5,646	1,621	$5,631	1,649
Basic net income per common share	$ 3.26		$ 3.48		$ 3.42	
Net income available for common shareholders	$5,134	1,573	$5,646	1,621	$5,631	1,649
Dilutive securities:						
Stock options and RSUs	–	27	–	35	–	36
ESOP convertible preferred stock	8	2	12	2	11	2
Diluted	$5,142	1,602	$5,658	1,658	$5,642	1,687
Diluted net income per common share	$ 3.21		$ 3.41		$ 3.34	

(a) *Weighted-average common shares outstanding.*

Note 12 Preferred Stock

As of December 27, 2008 and December 29, 2007, there were 3 million shares of convertible preferred stock authorized. The preferred stock was issued only for an ESOP established by Quaker and these shares are redeemable for common stock by the ESOP participants. The preferred stock accrues dividends at an annual rate of $5.46 per share. At year-end 2008 and 2007, there were 803,953 preferred shares issued and 266,253 and 287,553 shares outstanding, respectively. The outstanding preferred shares had a fair value of $72 million as of December 27, 2008 and $108 million as of December 29, 2007. Each share is convertible at the option of the holder into 4.9625 shares of common stock. The preferred shares may be called by us upon written notice at $78 per share plus accrued and unpaid dividends. Quaker made the final award to its ESOP plan in June 2001.

	2008		2007		2006	
	Shares	Amount	Shares	Amount	Shares	Amount
Preferred stock	0.8	$ 41	0.8	$ 41	0.8	$ 41
Repurchased preferred stock						
Balance, beginning of year	0.5	$132	0.5	$120	0.5	$110
Redemptions	–	6	–	12	–	10
Balance, end of year	0.5	$138	0.5	$132	0.5	$120

Notes to Consolidated Financial Statements

Note 13 Accumulated Other Comprehensive Loss

Comprehensive income is a measure of income which includes both net income and other comprehensive income or loss. Other comprehensive income or loss results from items deferred from recognition into our income statement. Accumulated other comprehensive loss is separately presented on our balance sheet as part of common shareholders' equity. Other comprehensive (loss)/income was $(3,793) million in 2008, $1,294 million in 2007 and $456 million in 2006. The accumulated balances for each component of other comprehensive loss were as follows:

	2008	2007	2006
Currency translation adjustment	$(2,271)	$ 213	$ (506)
Cash flow hedges, net of tax (a)	(14)	(35)	4
Unamortized pension and retiree medical, net of tax (b)	(2,435)	(1,183)	(1,782)
Unrealized gain on securities, net of tax	28	49	40
Other	(2)	4	(2)
Accumulated other comprehensive loss	$(4,694)	$ (952)	$(2,246)

(a) Includes $17 million after-tax loss in 2008 and $3 million after-tax gain in 2007 and 2006 for our share of our equity investees' accumulated derivative activity.

(b) Net of taxes of $1,288 million in 2008, $645 million in 2007 and $919 million in 2006. Includes $51 million decrease to the opening balance of accumulated other comprehensive loss in 2008 due to the change in measurement date. See Note 7.

Note 14 Supplemental Financial Information

	2008	2007	2006
Accounts receivable			
Trade receivables	$3,784	$3,670	
Other receivables	969	788	
	4,753	4,458	
Allowance, beginning of year	69	64	$ 75
Net amounts charged to expense	21	5	10
Deductions (a)	(16)	(7)	(27)
Other (b)	(4)	7	6
Allowance, end of year	70	69	$ 64
Net receivables	$4,683	$4,389	
Inventories (c)			
Raw materials	$1,228	$1,056	
Work-in-process	169	157	
Finished goods	1,125	1,077	
	$2,522	$2,290	

(a) Includes accounts written off.

(b) Includes currency translation effects and other adjustments.

(c) Inventories are valued at the lower of cost or market. Cost is determined using the average, first-in, first-out (FIFO) or last-in, first-out (LIFO) methods. Approximately 14% in 2008 and 2007 of the inventory cost was computed using the LIFO method. The differences between LIFO and FIFO methods of valuing these inventories were not material.

	2008	2007
Other assets		
Noncurrent notes and accounts receivable	$ 115	$ 121
Deferred marketplace spending	219	205
Unallocated purchase price for recent acquisitions	1,594	451
Pension plans	28	635
Other	702	270
	$2,658	$1,682
Accounts payable and other current liabilities		
Accounts payable	$2,846	$2,562
Accrued marketplace spending	1,574	1,607
Accrued compensation and benefits	1,269	1,287
Dividends payable	660	602
Other current liabilities	1,924	1,544
	$8,273	$7,602

	2008	2007	2006
Other supplemental information			
Rent expense	$ 357	$ 303	$ 291
Interest paid	$ 359	$ 251	$ 215
Income taxes paid, net of refunds	$ 1,477	$ 1,731	$2,155
Acquisitions (a)			
Fair value of assets acquired	$ 2,907	$ 1,611	$ 678
Cash paid and debt issued	(1,925)	(1,320)	(522)
Liabilities assumed	$ 982	$ 291	$ 156

(a) During 2008, together with PBG, we jointly acquired Lebedyansky, for a total purchase price of $1.8 billion. Lebedyansky is owned 25% and 75% by PBG and us, respectively. The unallocated purchase price is included in other assets on our balance sheet and Lebedyansky's financial results subsequent to the acquisition are reflected in our income statement.

Management's Responsibility for Financial Reporting

To Our Shareholders:

At PepsiCo, our actions – the actions of all our associates – are governed by our Worldwide Code of Conduct. This Code is clearly aligned with our stated values – a commitment to sustained growth, through empowered people, operating with responsibility and building trust. Both the Code and our core values enable us to operate with integrity – both within the letter and the spirit of the law. Our Code of Conduct is reinforced consistently at all levels and in all countries. We have maintained strong governance policies and practices for many years.

The management of PepsiCo is responsible for the objectivity and integrity of our consolidated financial statements. The Audit Committee of the Board of Directors has engaged independent registered public accounting firm, KPMG LLP, to audit our consolidated financial statements and they have expressed an unqualified opinion.

We are committed to providing timely, accurate and understandable information to investors. Our commitment encompasses the following:

Maintaining strong controls over financial reporting. Our system of internal control is based on the control criteria framework of the Committee of Sponsoring Organizations of the Treadway Commission published in their report titled *Internal Control – Integrated Framework*. The system is designed to provide reasonable assurance that transactions are executed as authorized and accurately recorded; that assets are safeguarded; and that accounting records are sufficiently reliable to permit the preparation of financial statements that conform in all material respects with accounting principles generally accepted in the U.S. We maintain disclosure controls and procedures designed to ensure that information required to be disclosed in reports under the Securities Exchange Act of 1934 is recorded, processed, summarized and reported within the specified time periods. We monitor these internal controls through self-assessments and an ongoing program of internal audits. Our internal controls are reinforced through our Worldwide Code of Conduct, which sets forth our commitment to conduct business with integrity, and within both the letter and the spirit of the law.

Exerting rigorous oversight of the business. We continuously review our business results and strategies. This encompasses financial discipline in our strategic and daily business decisions. Our Executive Committee is actively involved – from understanding strategies and alternatives to reviewing key initiatives and

financial performance. The intent is to ensure we remain objective in our assessments, constructively challenge our approach to potential business opportunities and issues, and monitor results and controls.

Engaging strong and effective Corporate Governance from our Board of Directors. We have an active, capable and diligent Board that meets the required standards for independence, and we welcome the Board's oversight as a representative of our shareholders. Our Audit Committee is comprised of independent directors with the financial literacy, knowledge and experience to provide appropriate oversight. We review our critical accounting policies, financial reporting and internal control matters with them and encourage their direct communication with KPMG LLP, with our General Auditor, and with our General Counsel. We also have a compliance team to coordinate our compliance policies and practices.

Providing investors with financial results that are complete, transparent and understandable. The consolidated financial statements and financial information included in this report are the responsibility of management. This includes preparing the financial statements in accordance with accounting principles generally accepted in the U.S., which require estimates based on management's best judgment.

PepsiCo has a strong history of doing what's right. We realize that great companies are built on trust, strong ethical standards and principles. Our financial results are delivered from that culture of accountability, and we take responsibility for the quality and accuracy of our financial reporting.

Peter A. Bridgman
Peter A. Bridgman
Senior Vice President and Controller

Richard Goodman
Richard Goodman
Chief Financial Officer

Indra K. Nooyi
Indra K. Nooyi
Chairman of the Board of Directors and Chief Executive Officer

Management's Report on Internal Control over Financial Reporting

To Our Shareholders:

Our management is responsible for establishing and maintaining adequate internal control over financial reporting, as such term is defined in Rule 13a-15(f) of the Exchange Act. Under the supervision and with the participation of our management, including our Chief Executive Officer and Chief Financial Officer, we conducted an evaluation of the effectiveness of our internal control over financial reporting based upon the framework in *Internal Control – Integrated Framework* issued by the Committee of Sponsoring Organizations of the Treadway Commission. Based on that evaluation, our management concluded that our internal control over financial reporting is effective as of December 27, 2008.

KPMG LLP, an independent registered public accounting firm, has audited the consolidated financial statements included in this Annual Report and, as part of their audit, has issued their report, included herein, on the effectiveness of our internal control over financial reporting.

During our fourth fiscal quarter of 2008, we continued migrating certain of our financial processing systems to SAP software. This software implementation is part of our ongoing global business transformation initiative, and we plan to continue implementing such software throughout other parts of our businesses over the course of the next few years. In connection with the SAP implementation and resulting business process changes,

we continue to enhance the design and documentation of our internal control processes to ensure suitable controls over our financial reporting.

Except as described above, there were no changes in our internal control over financial reporting during our fourth fiscal quarter of 2008 that have materially affected, or are reasonably likely to materially affect, our internal control over financial reporting.

Peter Bridgman

Peter A. Bridgman
Senior Vice President and Controller

Richard Goodman

Richard Goodman
Chief Financial Officer

Indra K. Nooyi

Indra K. Nooyi
Chairman of the Board of Directors and Chief Executive Officer

Report of Independent Registered Public Accounting Firm

The Board of Directors and Shareholders
PepsiCo, Inc.:

We have audited the accompanying Consolidated Balance Sheets of PepsiCo, Inc. and subsidiaries ("PepsiCo, Inc." or "the Company") as of December 27, 2008 and December 29, 2007, and the related Consolidated Statements of Income, Cash Flows, and Common Shareholders' Equity for each of the fiscal years in the three-year period ended December 27, 2008. We also have audited PepsiCo, Inc.'s internal control over financial reporting as of December 27, 2008, based on criteria established in *Internal Control – Integrated Framework* issued by the Committee of Sponsoring Organizations of the Treadway Commission (COSO). PepsiCo, Inc.'s management is responsible for these consolidated financial statements, for maintaining effective internal control over financial reporting, and for its assessment of the effectiveness of internal control over financial reporting, included in the accompanying Management's Report on Internal Control over Financial Reporting. Our responsibility is to express an opinion on these consolidated financial statements and an opinion on the Company's internal control over financial reporting based on our audits.

We conducted our audits in accordance with the standards of the Public Company Accounting Oversight Board (United States). Those standards require that we plan and perform the audits to obtain reasonable assurance about whether the financial statements are free of material misstatement and whether effective internal control over financial reporting was maintained in all material respects. Our audits of the consolidated financial statements included examining, on a test basis, evidence supporting the amounts and disclosures in the financial statements, assessing the accounting principles used and significant estimates made by management, and evaluating the overall financial statement presentation. Our audit of internal control over financial reporting included obtaining an understanding of internal control over financial reporting, assessing the risk that a material weakness exists, and testing and evaluating the design and operating effectiveness of internal control based on the assessed risk. Our audits also included performing such other procedures as we considered necessary in the circumstances. We believe that our audits provide a reasonable basis for our opinions.

A company's internal control over financial reporting is a process designed to provide reasonable assurance regarding the reliability of financial reporting and the preparation of financial statements for external purposes in accordance with generally accepted accounting principles. A company's internal control over financial reporting includes those policies and procedures that (1) pertain to the maintenance of records that, in reasonable detail, accurately and fairly reflect the transactions and dispositions of the assets of the company; (2) provide reasonable assurance that transactions are recorded as necessary to permit preparation of financial statements in accordance with generally accepted accounting principles, and that receipts and expenditures of the company are being made only in accordance with authorizations of management and directors of the company; and (3) provide reasonable assurance regarding prevention or timely detection of unauthorized acquisition, use, or disposition of the company's assets that could have a material effect on the financial statements.

Because of its inherent limitations, internal control over financial reporting may not prevent or detect misstatements. Also, projections of any evaluation of effectiveness to future periods are subject to the risk that controls may become inadequate because of changes in conditions, or that the degree of compliance with the policies or procedures may deteriorate.

In our opinion, the consolidated financial statements referred to above present fairly, in all material respects, the financial position of PepsiCo, Inc. as of December 27, 2008 and December 29, 2007, and the results of its operations and its cash flows for each of the fiscal years in the three-year period ended December 27, 2008, in conformity with U.S. generally accepted accounting principles. Also in our opinion, PepsiCo, Inc. maintained, in all material respects, effective internal control over financial reporting as of December 27, 2008, based on criteria established in *Internal Control – Integrated Framework* issued by COSO.

KPMG LLP

New York, New York
February 19, 2009

Selected Financial Data

(in millions except per share amounts, unaudited)

Quarterly	First Quarter	Second Quarter	Third Quarter	Fourth Quarter
Net revenue				
2008	$8,333	$10,945	$11,244	$12,729
2007	$7,350	$ 9,607	$10,171	$12,346
Gross profit				
2008	$4,499	$ 5,867	$ 5,976	$ 6,558
2007	$4,065	$ 5,265	$ 5,544	$ 6,562
Restructuring and impairment charges (a)				
2008	–	–	–	$ 543
2007	–	–	–	$ 102
Tax benefits (b)				
2007	–	–	$ (115)	$ (14)
Mark-to-market net impact (c)				
2008	$ 4	$ (61)	$ 176	$ 227
2007	$ (17)	$ (13)	$ 29	$ (18)
PepsiCo portion of PBG restructuring and impairment charge (d)				
2008	–	–	–	$ 138
Net income				
2008	$1,148	$ 1,699	$ 1,576	$ 719
2007	$1,096	$ 1,557	$ 1,743	$ 1,262
Net income per common share – basic				
2008	$ 0.72	$ 1.07	$ 1.01	$ 0.46
2007	$ 0.67	$ 0.96	$ 1.08	$ 0.78
Net income per common share – diluted				
2008	$ 0.70	$ 1.05	$ 0.99	$ 0.46
2007	$ 0.65	$ 0.94	$ 1.06	$ 0.77
Cash dividends declared per common share				
2008	$0.375	$ 0.425	$ 0.425	$ 0.425
2007	$ 0.30	$ 0.375	$ 0.375	$ 0.375
2008 stock price per share (e)				
High	$79.79	$ 72.35	$ 70.83	$ 75.25
Low	$66.30	$ 64.69	$ 63.28	$ 49.74
Close	$71.19	$ 67.54	$ 68.92	$ 54.56
2007 stock price per share (e)				
High	$65.54	$ 69.64	$ 70.25	$ 79.00
Low	$61.89	$ 62.57	$ 64.25	$ 68.02
Close	$64.09	$ 66.68	$ 67.98	$ 77.03

2008 results reflect our change in reporting calendars of Spain and Portugal.

(a) The restructuring and impairment charge in 2008 was $543 million ($408 million after-tax or $0.25 per share). The restructuring and impairment charge in 2007 was $102 million ($70 million after-tax or $0.04 per share). See Note 3.

(b) The non-cash tax benefits in 2007 of $129 million ($0.08 per share) relate to the favorable resolution of certain foreign tax matters. See Note 5.

(c) In 2008, we recognized $346 million ($223 million after-tax or $0.14 per share) of mark-to-market net losses on commodity hedges in corporate unallocated expenses. In 2007, we recognized $19 million ($12 million after-tax or $0.01 per share) of mark-to-market net gains on commodity hedges in corporate unallocated expenses.

(d) In 2008, we recognized a non-cash charge of $138 million ($114 million after-tax or $0.07 per share) included in bottling equity income as part of recording our share of PBG's financial results.

(e) Represents the composite high and low sales price and quarterly closing prices for one share of PepsiCo common stock.

Five–Year Summary	2008	2007	2006
Net revenue	$43,251	$39,474	$35,137
Net income	$ 5,142	$ 5,658	$ 5,642
Income per common share – basic	$ 3.26	$ 3.48	$ 3.42
Income per common share – diluted	$ 3.21	$ 3.41	$ 3.34
Cash dividends declared per common share	$ 1.65	$ 1.425	$ 1.16
Total assets	$35,994	$34,628	$29,930
Long-term debt	$ 7,858	$ 4,203	$ 2,550
Return on invested capital (a)	25.5%	28.9%	30.4%

Five–Year Summary (continued)	2005	2004
Net revenue	$32,562	$29,261
Income from continuing operations	$ 4,078	$ 4,174
Net income	$ 4,078	$ 4,212
Income per common share – basic, continuing operations	$ 2.43	$ 2.45
Income per common share – diluted, continuing operations	$ 2.39	$ 2.41
Cash dividends declared per common share	$ 1.01	$ 0.85
Total assets	$31,727	$27,987
Long-term debt	$ 2,313	$ 2,397
Return on invested capital (a)	22.7%	27.4%

(a) *Return on invested capital is defined as adjusted net income divided by the sum of average shareholders' equity and average total debt. Adjusted net income is defined as net income plus net interest expense after-tax. Net interest expense after-tax was $184 million in 2008, $63 million in 2007, $72 million in 2006, $62 million in 2005 and $60 million in 2004.*

• Includes restructuring and impairment charges of:

	2008	2007	2006	2005	2004
Pre-tax	$ 543	$ 102	$ 67	$ 83	$ 150
After-tax	$ 408	$ 70	$ 43	$ 55	$ 96
Per share	$0.25	$0.04	$0.03	$0.03	$0.06

• Includes mark-to-market net expense (income) of:

	2008	2007	2006
Pre-tax	$ 346	$ (19)	$ 18
After-tax	$ 223	$ (12)	$ 12
Per share	$0.14	$(0.01)	$0.01

• In 2008, we recognized $138 million ($114 million after-tax or $0.07 per share) of our share of PBG's restructuring and impairment charges.

• In 2007, we recognized $129 million ($0.08 per share) of non-cash tax benefits related to the favorable resolution of certain foreign tax matters. In 2006, we recognized non-cash tax benefits of $602 million ($0.36 per share) primarily in connection with the IRS's examination of our consolidated income tax returns for the years 1998 through 2002. In 2005, we recorded income tax expense of $460 million ($0.27 per share) related to our repatriation of earnings in connection with the American Job Creation Act of 2004. In 2004, we reached agreement with the IRS for an open issue related to our discontinued restaurant operations which resulted in a tax benefit of $38 million ($0.02 per share).

• On December 30, 2006, we adopted SFAS 158 which reduced total assets by $2,016 million, total common shareholders' equity by $1,643 million and total liabilities by $373 million.

• The 2005 fiscal year consisted of 53 weeks compared to 52 weeks in our normal fiscal year. The 53rd week increased 2005 net revenue by an estimated $418 million and net income by an estimated $57 million ($0.03 per share).

Reconciliation of GAAP and Non-GAAP Information

The financial measures listed below are not measures defined by generally accepted accounting principles. However, we believe investors should consider these measures as they are more indicative of our ongoing performance and with how management evaluates our operational results and trends. Specifically, investors should consider the following:

- Our 2008 and 2007 division operating profit and total operating profit excluding the impact of restructuring and impairment charges (including, for 2008, charges associated with our Productivity for Growth initiatives); 2008 and 2007 total operating profit excluding the mark-to-market net impact on commodity hedges; and our 2008 division operating growth and total operating profit growth excluding the impact of the aforementioned items;

- Our 2008 net income and diluted EPS excluding the impact of restructuring and impairment charges (including, for 2008, charges associated with our Productivity for Growth initiatives), mark-to-market net losses on commodity hedges, and our share of PBG's restructuring and impairment charges; our 2007 net income and diluted EPS excluding the impact of restructuring and impairment charges, mark-to-market net gains on commodity hedges and certain tax benefits; our 2008 net income and diluted EPS growth excluding the impact of the aforementioned items; and our 2006 diluted EPS excluding the impact of restructuring and impairment charges, mark-to-market net losses on commodity hedges and certain tax benefits; and

- Our 2008 return on invested capital (ROIC) excluding the impact of restructuring and impairment charges (including, for 2008, charges associated with our Productivity for Growth initiatives), mark-to-market net impact on commodity hedges, our share of PBG's restructuring and impairment charges and certain tax benefits.

Operating Profit Reconciliation

	2008	2007	Growth
Total PepsiCo Reported Operating Profit	$6,935	$7,170	(3)%
Impact of Mark-to-Market Net Losses/ (Gains) on Commodity Hedges	346	(19)	
Impact of Restructuring and Impairment Charges	543	102	
Total Operating Profit Excluding above Items	7,824	7,253	8%
Impact of Other Corporate Unallocated	651	772	
PepsiCo Total Division Operating Profit Excluding above Items	$8,475	$8,025	6%

Net Income Reconciliation

	2008	2007	Growth
Reported Net Income	$5,142	$5,658	(9)%
Impact of Mark-to-Market Net Losses/ (Gains) on Commodity Hedges	223	(12)	
Impact of Restructuring and Impairment Charges	408	70	
Impact of PBG Restructuring and Impairment Charges	114	—	
Impact of Tax Benefits	—	(129)	
Net Income Excluding above Items	$5,887	$5,587	5%

Diluted EPS Reconciliation

	2008	2007	2008 Growth	2006
Reported Diluted EPS	$3.21	$3.41	(6)%	$3.34
Impact of Mark-to-Market Net Losses/(Gains) on Commodity Hedges	0.14	(0.01)		0.01
Impact of Restructuring and Impairment Charges	0.25	0.04		0.03
Impact of PBG's Restructuring and Impairment Charges	0.07	—		—
Impact of Tax Benefits	—	(0.08)		(0.37)
Diluted EPS Excluding above Items	$3.68*	$3.37*	9%	$3.01

* Does not sum due to rounding

2008 Operating Profit Growth Reconciliation

	PepsiCo Americas Foods	PepsiCo Americas Beverages	PepsiCo International
Reported Operating Profit Growth	8%	(19)%	13%
Impact of Restructuring and Impairment Charges	3	11	3
Operating Profit Growth Excluding above Items	10%*	(7)%*	16%

* Does not sum due to rounding

ROIC Reconciliation

	2008
Reported ROIC	26%
Impact of Mark-to-Market Net Impact on Commodity Hedges	1
Impact of Restructuring and Impairment Charges	2
Impact of PBG's Restructuring and Impairment Charges	1
Impact of Tax Benefits	(0.5)
ROIC Excluding above Items	29%*

* Does not sum due to rounding

Glossary

Acquisitions: reflect all mergers and acquisitions activity, including the impact of acquisitions, divestitures and changes in ownership or control in consolidated subsidiaries. The impact of acquisitions related to our non-consolidated equity investees is reflected in our volume and, excluding our anchor bottlers, in our operating profit.

Anchor bottlers: The Pepsi Bottling Group (PBG), PepsiAmericas (PAS) and Pepsi Bottling Ventures (PBV).

Bottlers: customers to whom we have granted exclusive contracts to sell and manufacture certain beverage products bearing our trademarks within a specific geographical area.

Bottler Case Sales (BCS): measure of physical beverage volume shipped to retailers and independent distributors from both PepsiCo and our bottlers.

Bottler funding: financial incentives we give to our bottlers to assist in the distribution and promotion of our beverage products.

Concentrate Shipments and Equivalents (CSE): measure of our physical beverage volume shipments to bottlers, retailers and independent distributors. This measure is reported on our fiscal year basis.

Consumers: people who eat and drink our products.

CSD: carbonated soft drinks.

Customers: authorized bottlers and independent distributors and retailers.

Derivatives: financial instruments that we use to manage our risk arising from changes in commodity prices, interest rates, foreign exchange rates and stock prices.

Direct-Store-Delivery (DSD): delivery system used by us and our bottlers to deliver snacks and beverages directly to retail stores where our products are merchandised.

Effective net pricing: reflects the year-over-year impact of discrete pricing actions, sales incentive activities and mix resulting from selling varying products in different package sizes and in different countries.

Management operating cash flow: net cash provided by operating activities less capital spending plus sales of property, plant and equipment. It is our primary measure used to monitor cash flow performance.

Mark-to-market net gain or loss or impact: the change in market value for commodity contracts, that we purchase to mitigate the volatility in costs of energy and raw materials that we consume. The market value is determined based on average prices on national exchanges and recently reported transactions in the market place.

Marketplace spending: sales incentives offered through various programs to our customers and consumers (trade spending), as well as advertising and other marketing activities.

Servings: common metric reflecting our consolidated physical unit volume. Our divisions' physical unit measures are converted into servings based on U.S. Food and Drug Administration guidelines for single-serving sizes of our products.

Transaction gains and losses: the impact on our consolidated financial statements of exchange rate changes arising from specific transactions.

Translation adjustment: the impact of converting our foreign affiliates' financial statements into U.S. dollars for the purpose of consolidating our financial statements.

Appendix **B**

Management's Discussion and Analysis for PepsiCo, Inc. and Subsidiaries

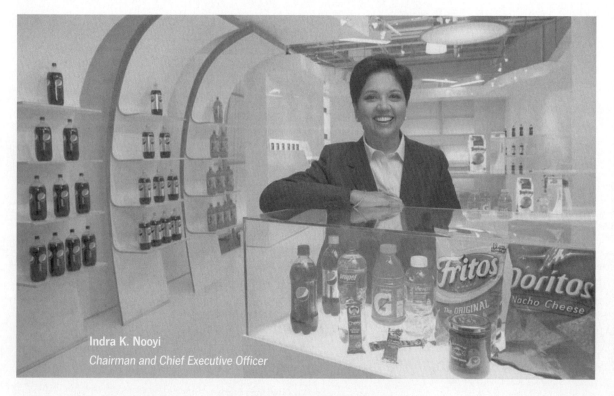

Indra K. Nooyi
Chairman and Chief Executive Officer

Dear Fellow Shareholders,

It is now two years since we introduced a new strategic mission to try to capture the heart and soul of PepsiCo. The simple but powerful idea of Performance with Purpose combines the two things that define what we do—growing the business, and acting as ethical and responsible citizens of the world.

As I look back on 2008, I'm proud to report that Performance with Purpose is woven into the fabric of our company. Wherever we see success, we see both parts of our mission in action.

All over the world, whether it's Cedar Rapids or Calgary, Shanghai or São Paulo, Mexico City, Moscow or Mumbai, our associates draw strength and inspiration from this shared mission. This year's annual report brings some of their stories to life. It shows how performance and purpose combine to great effect in everything we do.

When times are tough it is especially important to be clear about your mission. By any measure, 2008 was a year of extremes, an incredibly volatile year.

Easy credit turned into a credit crunch that left many businesses and consumers strapped for cash. The global economy lurched rapidly into recession. Oil prices approached $150 a barrel before returning back below $40. Corn, sugar, oats and other key commodities saw significant price swings throughout the year. Global business was made harder by foreign exchange rates that fluctuated, at times wildly. The Dow Jones Index began 2008 above 13,000 and ended the year below 9,000. That dragged down even the strongest companies' stock—including PepsiCo shares.

All told, I can't recall a more eventful or trying year. Not that I think pessimism is in order. The ingenuity of our company showed through again. All our teams of extraordinary people applied their can-do spirit and must-do sense of responsibility to meet the economic and market challenges head on.

As a result, PepsiCo performed slightly better for the year than both the Dow Jones Industrial Average and the S&P 500. I believe that's because, while we can't control market volatility, we remained focused on our strategies for growth, and that is why our underlying businesses continued to perform very well in 2008.

We increased our dividend, continued our share repurchase program and positioned ourselves for even stronger performance as economic conditions improve.

- Net revenue grew 10%.
- Core division operating profit grew 6%.*
- Cash flow from operations was $7 billion.
- Core return on invested capital was 29%.
- Core EPS grew 9%.*

In **PepsiCo Americas Foods** we had another year of strong growth to both the top and the bottom lines. That is testament to our strong brands and our efficient go-to-market systems. This year brought unprecedented cost inflation, but we carefully adjusted our pricing and the weights and package formats across our brands to find the right solution for each channel, each market, each customer and each consumer. The year presented some other unexpected problems that we coped with well. Our flagship Quaker plant in Cedar Rapids, Iowa, experienced a major flood but returned to normal production levels by year-end. In Latin America, our Brazil snacks business overcame a fire at one of our major plants to perform really well. We also refreshed the product portfolio. Frito-Lay North America introduced TrueNorth nut snacks and entered a joint venture that offers Sabra refrigerated dips. Some of our established products powered on. The Quaker business and our market-leading Sabritas and Gamesa brands helped us generate tremendous growth. On these strengths, PepsiCo Americas Foods increased revenues by 11 percent and core operating profit by 10 percent.*

PepsiCo Americas Beverages had a difficult year. In North America, our beverage volume was not immune to the overall category weakness triggered by the weak U.S. economy. As a result, PepsiCo Americas Beverages revenues declined by 1 percent and core operating profit fell by 7 percent.* But PepsiCo has proved time and again our skill in anticipating and responding to market changes and consumer preferences. Liquid refreshment beverages in the United States declined in 2008 for the first time in more than 50 years. We acted quickly and decisively to refresh the category. We refreshed the look of our iconic brands Pepsi-Cola, Mtn Dew, Sierra Mist and Gatorade. In Latin America, where we achieved strong results, we introduced SoBe Life, the world's first beverage made with PureVia™, an all-natural, zero-calorie sweetener; and early in 2009, we launched SoBe Lifewater with PureVia in the United States.

*For a reconciliation to the most directly comparable financial measure in accordance with GAAP, see page 1127.

We are investing aggressively to keep our total beverage portfolio relevant to consumers of all ages. In non-carbonated beverages, we are working to deliver the right value for the money, to identify untapped thirst occasions and to deliver even more health benefits. We added vitamins to our Gatorade sublines; and this year we will introduce a new Trop50 orange juice beverage, with half the calories of orange juice, great nutritional benefits and the natural sweetness of PureVia.

We have a great portfolio that gives us all confidence. And we have reexamined how that portfolio connects with today's world. We have brought two things together—the fun and bubbles of our carbonated beverages that people really love, and the symbols and experiences of today's online world.

Our re-branding strategy sets an irresistible tone of joy, optimism and energy. Those are three words that I always want to be associated with PepsiCo.

PepsiCo International's balanced and diverse snack and beverage portfolio had a good year. It delivered strong growth from treats to healthy eats. This thriving business spans Europe, the Middle East, Asia, Africa and Australia, serving 86 percent of the world's population. With per-capita consumption still relatively low in many of these markets, we have a strong opportunity to drive sales ahead of GDP growth.

This year we broadened our beverage portfolio by partnering with The Pepsi Bottling Group to acquire Russia's leading juice company, Lebedyansky, by acquiring V Water in the United Kingdom and by expanding our successful Lipton Tea partnership with Unilever. In the snack business, we acquired Bulgaria's leading nuts and seeds producer, and we introduced a variety of local flavors, including Lay's Shashlyk in Russia and Lay's Cool Blueberry in China. In India, we introduced Kurkure Naughty Tomato and Lay's Balsamic Blast and Spunky Pimento flavors; and our Doritos brand helped drive volume in the Middle East and South Africa. Together, these initiatives helped PepsiCo International revenues grow by 19 percent and core operating profit by 16 percent.*

To sustain our worldwide growth, we announced significant investments in key countries like Brazil, India, Mexico and China. In India and Brazil, we are combining capacity expansion and research and development (R&D) with sustainability efforts as we grow in those regions. Building on a brand history of more than 100 years in Mexico, we are investing over the next five years in R&D, manufacturing and distribution, marketing and advertising. And in China—one of our fastest-growing markets—we are funding capacity expansion, R&D, increased distribution, brand building, agricultural sustainability and resource conservation.

All over the company, we have Performance with Purpose as our mission. And the way we achieve it, all over the world, is always to encourage new ways of working. Innovation is our lifeblood—it drives success in all our businesses.

That is why we implemented a Productivity for Growth initiative across all sections of our business. Over the next three years, our productivity measures are expected to cumulatively free up more than $1.2 billion. That money will allow us to step up investments in long-term product development, innovation and brand building. Our productivity savings will also enhance our operating agility and create some breathing room to respond to the changing economic environment. And, as long as that innovation is driven through the company, we will deliver the demands of Performance with Purpose.

2008 was a year in which our mission could easily have been abandoned. The extraordinary circumstances would have resulted in it being abandoned if it were not already embedded into our culture. So, during 2008 we stayed true to our beliefs, even as the backdrop got tougher.

For example, we never took our eyes off the sustainability agenda that underpins our commercial success. We have now driven sustainability all the way through the business. It is a *part* of what we do, not an *addition* to what we do.

To promote human sustainability, we worked within World Health Organization policies to teach

*For a reconciliation to the most directly comparable financial measure in accordance with GAAP, see page 1127.

children the benefits of nutrition and inspire them to be more active. This work complements and extends our success in transforming our broad portfolio of beverages, snacks and foods, to ensure it delivers everything from treats to healthy eats.

To sustain the environment for future generations, we stepped up our global efforts to conserve water and energy and worked on lightweighting our packages, starting with new packaging for Aquafina that contains 35 percent less plastic.

To sustain our world-class talent, we're developing "PepsiCo University," a new learning management system that brings together functional and leadership training for associates around the world.

Our Performance with Purpose mission is not confined to PepsiCo associates alone. Even retired members of the PepsiCo family have joined our purpose movement, banding together as the PepsiCo Service Corps to further our goals and ideals in the communities we serve.

Such a resolute performance and such a focus on our purpose is why I have such confidence in this company for the future. Nobody can predict exactly how the global economic slowdown will affect specific markets in 2009, or how consumers will respond to the pressures they face. But we've shown we have the competitive strengths, the right strategies and the tenacity to maintain our competitive edge.

We have to remember the deep brand value we have. In good times and bad, people view our products as simple, affordable pleasures that keep them nourished and refreshed. Worldwide, our retail partners consider us a strategic partner whose powerful go-to-market systems deliver strong brands and fast-selling products that help them generate healthy cash flow.

We're led by an experienced management team that has proven it can address hyperinflation, currency devaluation and political turmoil as it keeps us growing. We're sustained by the associates, customers and business partners who help us deliver fun, nourishment and refreshment each day.

And we are always facing the future, looking for new ways of working, new ways of making good on the promise of Performance with Purpose.

What you see in these pages is an account of the immediate past with some sense of how it brought us to the present. But the essential point about our company, the thing that makes us successful year in, year out, is that we are always thinking about the future.

To celebrate the future generation, we asked the children of our associates around the world to draw their favorite PepsiCo products. Some of these drawings are featured on this annual report's cover, demonstrating that we're growing in ways that nurture, sustain and inspire people.

A great company is a place where people come together, with a purpose in common. By defining that purpose, by trying to bottle it, we are bound together. That is the message you see on every page of this report. It is full of stories and portraits that truly demonstrate the deeply personal, emotional connection our associates have made to Performance with Purpose. In any language, our associates will tell you, "We are Performance with Purpose." Please join us on this trip around the globe, and see for yourself why I'm so inspired by the great things we've accomplished together—and so excited about the many opportunities that still lie ahead.

Indra K. Nooyi
Chairman and Chief Executive Officer

Financial Contents

Management's Discussion and Analysis

OUR BUSINESS

Our discussion and analysis is an integral part of understanding our financial results. Definitions of key terms can be found in the glossary on page 1128. Tabular dollars are presented in millions, except per share amounts. All per share amounts reflect common per share amounts, assume dilution unless noted, and are based on unrounded amounts. Percentage changes are based on unrounded amounts.

EXECUTIVE OVERVIEW

We are a leading global beverage, snack and food company. We manufacture or use contract manufacturers, market and sell a variety of salty, convenient, sweet and grain-based snacks, carbonated and non-carbonated beverages and foods in approximately 200 countries, with our largest operations in North America (United States and Canada), Mexico and the United Kingdom. Additional information concerning our divisions and geographic areas is presented in Note 1.

Our commitment to sustainable growth, defined as Performance with Purpose, is focused on generating healthy financial returns while giving back to the communities we serve. This includes meeting consumer needs for a spectrum of convenient foods and beverages, reducing our impact on the environment through water, energy and packaging initiatives, and supporting our employees through a diverse and inclusive culture that recruits and retains world-class talent. In September 2008, we were again included on the Dow Jones Sustainability North America Index and the Dow Jones Sustainability World Index. These indices are compiled annually.

> We were again included on the Dow Jones Sustainability North America Index and the Dow Jones Sustainability World Index.

Our management monitors a variety of key indicators to evaluate our business results and financial conditions. These indicators include market share, volume, net revenue, operating profit, management operating cash flow, earnings per share and return on invested capital.

Key Challenges and Strategies for Growth

To achieve our financial objectives, we consistently focus on initiatives to improve our results and increase returns for our shareholders. For 2009, we have identified the following key challenges and related competitive strategies for growth that we believe will enable us to achieve our financial objectives:

Revitalizing our North American Beverage Business

In 2008, the U.S. liquid refreshment beverage category declined on a year-over-year basis. During 2009, we intend to invest to keep our total beverage portfolio relevant to consumers of all ages. We plan to capitalize on our new "Refresh Everything" campaign, which features new brand identities for trademarks Gatorade, Pepsi, Sierra Mist and Mountain Dew, as well as key product innovations like new SoBe Lifewater, sweetened with PureVia™, an all-natural, zero-calorie sweetener recently approved by the U.S. Food and Drug Administration. In non-carbonated beverages, we will work to identify untapped thirst occasions and to deliver even more functional benefits.

Broadening our Diverse Portfolio of Global Products

Consumer tastes and preferences are constantly changing. The increasingly on-the-go lifestyles of consumers and their desire for healthier choices means that it is more important than ever for us to continue to broaden our diverse portfolio of global products. We remain committed to offering consumers a broad range of choices to satisfy their diverse lifestyles and desires. For example, in 2008, we broadened the beverage portfolio by partnering with The Pepsi Bottling Group (PBG) to acquire JSC Lebedyansky (Lebedyansky), Russia's leading juice company, by acquiring V Water in the United Kingdom and by expanding our successful Lipton Tea partnership with Unilever. We expanded into adjacent snack categories by introducing TrueNorth nut snacks and forming a joint venture that offers Sabra refrigerated dips. During 2009, through a combination of tuck-in acquisitions and innovation, we plan to continue to broaden the range of products we offer in our existing categories and expand into adjacent ones. We are also committed to securing our innovation pipeline, and have coordinated our research and development departments across the Company into one global innovation team.

Successfully Navigating the Global Economic Crisis

We and our customers, suppliers and distributors have all been impacted by the continuing global economic crisis. Global economic conditions have resulted in decreased consumer purchasing power, volatile fluctuations in the prices of key commodities such as oil, corn, sugar and oats and adverse foreign currency exchange rates. To navigate through these conditions we plan to continue to focus on fundamentals, such as ensuring that we offer products with the right price to value proposition and managing cash flow, interest expense and commodity costs. We have also implemented our Productivity for Growth program which is

expected to cumulatively generate more than $1.2 billion in pre-tax savings over the next three years and that will also allow us to increase investments in long-term research and development, innovation, brand building and market-specific growth initiatives.

> We have also implemented our Productivity for Growth program which is expected to cumulatively generate more than $1.2 billion in pre-tax savings over the next three years.

Expanding in International Markets

Our operations outside of the United States contribute significantly to our revenue and profitability. Because per capita consumption of our products is still relatively low in many of these markets, we believe there is a significant opportunity to grow internationally by expanding our existing businesses and through acquisitions, particularly in emerging markets. During 2008, we announced significant capital investments in Brazil, India, Mexico and China. We also strengthened our international presence through acquisitions such as Marbo, a snacks company in Serbia, by expanding our successful Lipton Tea partnership with Unilever, and by partnering with PBG to acquire Russia's largest juice company. We plan to seek opportunities to make similar investments to drive international growth in 2009 and beyond. We also plan to continue developing products that leverage our existing brands but appeal to local tastes.

Maintaining our Commitment to Sustainable Growth

Consumers and government officials are increasingly focused on the impact companies have on the environment. We are committed to maintaining high standards for product quality, safety and integrity and to reducing our impact on the environment through water, energy and packaging initiatives. We plan to continue to invest in programs that help us reduce energy costs, conserve more energy and use clean energy sources, such as our wind turbine project in India which supplies more than two-thirds of the power used by our Mamandur beverage plant each year. We are also actively working on new packaging initiatives to further reduce the amount of plastic used in our beverage containers, and we continue to partner with community organizations to increase recycling efforts.

> We are committed to maintaining high standards for product quality, safety and integrity and to reducing our impact on the environment through water, energy and packaging initiatives.

OUR OPERATIONS

We are organized into three business units, as follows:

(1) PepsiCo Americas Foods (PAF), which includes Frito-Lay North America (FLNA), Quaker Foods North America (QFNA) and all of our Latin American food and snack businesses (LAF), including our Sabritas and Gamesa businesses in Mexico;

(2) PepsiCo Americas Beverages (PAB), which includes PepsiCo Beverages North America and all of our Latin American beverage businesses; and

(3) PepsiCo International (PI), which includes all PepsiCo businesses in the United Kingdom, Europe, Asia, Middle East and Africa.

Our three business units are comprised of six reportable segments (referred to as divisions), as follows:

- FLNA,
- QFNA,
- LAF,
- PAB,
- United Kingdom & Europe (UKEU), and
- Middle East, Africa & Asia (MEAA).

Frito-Lay North America

FLNA manufactures or uses contract manufacturers, markets, sells and distributes branded snacks. These snacks include Lay's potato chips, Doritos tortilla chips, Cheetos cheese flavored snacks, Tostitos tortilla chips, branded dips, Fritos corn chips, Ruffles potato chips, Quaker Chewy granola bars, SunChips multigrain snacks, Rold Gold pretzels, Santitas tortilla chips, Frito-Lay nuts, Grandma's cookies, Gamesa cookies, Munchies snack mix, Funyuns onion flavored rings, Quaker Quakes corn and rice snacks, Miss Vickie's potato chips, Stacy's pita chips, Smartfood popcorn, Chester's fries and branded crackers. FLNA branded products are sold to independent distributors and retailers. In addition, FLNA's joint venture with Strauss Group manufactures, markets, sells and distributes Sabra refrigerated dips.

Quaker Foods North America

QFNA manufactures or uses contract manufacturers, markets and sells cereals, rice, pasta and other branded products. QFNA's products include Quaker oatmeal, Aunt Jemima mixes and syrups, Quaker grits, Cap'n Crunch cereal, Life cereal, Rice-A-Roni, Pasta Roni and Near East side dishes. These branded products are sold to independent distributors and retailers.

Management's Discussion and Analysis

Latin America Foods

LAF manufactures, markets and sells a number of leading salty and sweet snack brands including Gamesa, Doritos, Cheetos, Ruffles, Sabritas and Lay's. Further, LAF manufactures or uses contract manufacturers, markets and sells many Quaker brand cereals and snacks. These branded products are sold to independent distributors and retailers.

PepsiCo Americas Beverages

PAB manufactures or uses contract manufacturers, markets and sells beverage concentrates, fountain syrups and finished goods, under various beverage brands including Pepsi, Mountain Dew, Gatorade, 7UP (outside the U.S.), Tropicana Pure Premium, Sierra Mist, Mirinda, Tropicana juice drinks, Propel, Dole, Amp Energy, SoBe Lifewater, Naked juice and Izze. PAB also manufactures or uses contract manufacturers, markets and sells ready-to-drink tea, coffee and water products through joint ventures with Unilever (under the Lipton brand name) and Starbucks. In addition, PAB licenses the Aquafina water brand to its bottlers and markets this brand. PAB sells concentrate and finished goods for some of these brands to authorized bottlers, and some of these branded finished goods are sold directly by us to independent distributors and retailers. The bottlers sell our brands as finished goods to independent distributors and retailers. PAB's volume reflects sales to its independent distributors and retailers, as well as the sales of beverages bearing our trademarks that bottlers have reported as sold to independent distributors and retailers. Bottler case sales (BCS) and concentrate shipments and equivalents (CSE) are not necessarily equal during any given period due to seasonality, timing of product launches, product mix, bottler inventory practices and other factors. While our revenues are not based on BCS volume, we believe that BCS is a valuable measure as it quantifies the sell-through of our products at the consumer level.

United Kingdom & Europe

UKEU manufactures, markets and sells through consolidated businesses as well as through noncontrolled affiliates, a number of leading salty and sweet snack brands including Lay's, Walkers, Doritos, Cheetos and Ruffles. Further, UKEU manufactures or uses contract manufacturers, markets and sells many Quaker brand cereals and snacks. UKEU also manufactures, markets and sells beverage concentrates, fountain syrups and finished goods, under various beverage brands including Pepsi, 7UP and Tropicana. In addition, through our acquisition of Lebedyansky, we acquired Russia's leading juice brands. These brands are sold to authorized

bottlers, independent distributors and retailers. However, in certain markets, UKEU operates its own bottling plants and distribution facilities. In addition, UKEU licenses the Aquafina water brand to certain of its authorized bottlers. UKEU also manufactures or uses contract manufacturers, markets and sells ready-to-drink tea products through an international joint venture with Unilever (under the Lipton brand name).

UKEU reports two measures of volume. Snack volume is reported on a system-wide basis, which includes our own sales and the sales by our noncontrolled affiliates of snacks bearing Company-owned or licensed trademarks. Beverage volume reflects Company-owned or authorized bottler sales of beverages bearing Company-owned or licensed trademarks to independent distributors and retailers (see PepsiCo Americas Beverages above).

Middle East, Africa & Asia

MEAA manufactures, markets and sells through consolidated businesses as well as through noncontrolled affiliates, a number of leading salty and sweet snack brands including Lay's, Doritos, Cheetos, Smith's and Ruffles. Further, MEAA manufactures or uses contract manufacturers, markets and sells many Quaker brand cereals and snacks. MEAA also manufactures, markets and sells beverage concentrates, fountain syrups and finished goods, under various beverage brands including Pepsi, Mirinda, 7UP and Mountain Dew. These brands are sold to authorized bottlers, independent distributors and retailers. However, in certain markets, MEAA operates its own bottling plants and distribution facilities. In addition, MEAA licenses the Aquafina water brand to certain of its authorized bottlers. MEAA also manufactures or uses contract manufacturers, markets and sells ready-to-drink tea products through an international joint venture with Unilever. MEAA reports two measures of volume (see United Kingdom & Europe above).

New Organizational Structure

Beginning in the first quarter of 2009, we realigned certain countries within PI to be consistent with changes in geographic responsibility. As a result, our businesses in Turkey and certain Central Asia markets will become part of UKEU, which was renamed the Europe division. These countries were formerly part of MEAA, which was renamed the Asia, Middle East & Africa division. The changes did not impact the other existing reportable segments. Our historical segment reporting will be restated in 2009 to reflect the new structure. The division amounts and discussions reflected in this Annual Report reflect the management reporting that existed through 2008.

OUR CUSTOMERS

Our customers include authorized bottlers and independent distributors, including foodservice distributors and retailers. We normally grant our bottlers exclusive contracts to sell and manufacture certain beverage products bearing our trademarks within a specific geographic area. These arrangements provide us with the right to charge our bottlers for concentrate, finished goods and Aquafina royalties and specify the manufacturing process required for product quality.

Since we do not sell directly to the consumer, we rely on and provide financial incentives to our customers to assist in the distribution and promotion of our products. For our independent distributors and retailers, these incentives include volume-based rebates, product placement fees, promotions and displays. For our bottlers, these incentives are referred to as bottler funding and are negotiated annually with each bottler to support a variety of trade and consumer programs, such as consumer incentives, advertising support, new product support, and vending and cooler equipment placement. Consumer incentives include coupons, pricing discounts and promotions, and other promotional offers. Advertising support is directed at advertising programs and supporting bottler media. New product support includes targeted consumer and retailer incentives and direct marketplace support, such as point-of-purchase materials, product placement fees, media and advertising. Vending and cooler equipment placement programs support the acquisition and placement of vending machines and cooler equipment. The nature and type of programs vary annually.

Retail consolidation and the current economic environment continue to increase the importance of major customers. In 2008, sales to Wal-Mart Stores, Inc. (Wal-Mart), including Sam's Club (Sam's), represented approximately 12% of our total net revenue. Our top five retail customers represented approximately 32% of our 2008 North American net revenue, with Wal-Mart (including Sam's) representing approximately 18%. These percentages include concentrate sales to our bottlers which are used in finished goods sold by them to these retailers. In addition, sales to PBG represented approximately 8% of our total net revenue in 2008. See "Our Related Party Bottlers" and Note 8 for more information on our anchor bottlers.

> Retail consolidation and the current economic environment continue to increase the importance of major customers.

Our Related Party Bottlers

We have ownership interests in certain of our bottlers. Our ownership is less than 50%, and since we do not control these bottlers, we do not consolidate their results. We have designated three related party bottlers, PBG, PepsiAmericas, Inc. (PAS) and Pepsi Bottling Ventures LLC (PBV), as our anchor bottlers. We include our share of their net income based on our percentage of economic ownership in our income statement as bottling equity income. Our anchor bottlers distribute approximately 60% of our North American beverage volume and approximately 17% of our beverage volume outside of North America. Our anchor bottlers participate in the bottler funding programs described above. Approximately 6% of our total 2008 sales incentives were related to these bottlers. See Note 8 for additional information on these related parties and related party commitments and guarantees. Our share of net income from other noncontrolled affiliates is recorded as a component of selling, general and administrative expenses.

OUR DISTRIBUTION NETWORK

Our products are brought to market through direct-store-delivery (DSD), customer warehouse and foodservice and vending distribution networks. The distribution system used depends on customer needs, product characteristics and local trade practices.

Direct-Store-Delivery

We, our bottlers and our distributors operate DSD systems that deliver snacks and beverages directly to retail stores where the products are merchandised by our employees or our bottlers. DSD enables us to merchandise with maximum visibility and appeal. DSD is especially well-suited to products that are restocked often and respond to in-store promotion and merchandising.

Customer Warehouse

Some of our products are delivered from our manufacturing plants and warehouses to customer warehouses and retail stores. These less costly systems generally work best for products that are less fragile and perishable, have lower turnover, and are less likely to be impulse purchases.

Foodservice and Vending

Our foodservice and vending sales force distributes snacks, foods and beverages to third-party foodservice and vending distributors and operators. Our foodservice and vending sales force also distributes certain beverages through our bottlers. This distribution system supplies our products to schools, businesses, stadiums, restaurants and similar locations.

Management's Discussion and Analysis

OUR COMPETITION

Our businesses operate in highly competitive markets. We compete against global, regional, local and private label manufacturers on the basis of price, quality, product variety and distribution. In U.S. measured channels, our chief beverage competitor, The Coca-Cola Company, has a larger share of carbonated soft drinks (CSD) consumption, while we have a larger share of liquid refreshment beverages consumption. In addition, The Coca-Cola Company has a significant CSD share advantage in many markets outside the United States. Further, our snack brands hold significant leadership positions in the snack industry worldwide. Our snack brands face local and regional competitors, as well as national and global snack competitors, and compete on the basis of price, quality, product variety and distribution. Success in this competitive environment is dependent on effective promotion of existing products and the introduction of new products. We believe that the strength of our brands, innovation and marketing, coupled with the quality of our products and flexibility of our distribution network, allow us to compete effectively.

OTHER RELATIONSHIPS

Certain members of our Board of Directors also serve on the boards of certain vendors and customers. Those Board members do not participate in our vendor selection and negotiations nor in our customer negotiations. Our transactions with these vendors and customers are in the normal course of business and are consistent with terms negotiated with other vendors and customers. In addition, certain of our employees serve on the boards of our anchor bottlers and other affiliated companies and do not receive incremental compensation for their Board services.

OUR BUSINESS RISKS

Demand for our products may be adversely affected by changes in consumer preferences and tastes or if we are unable to innovate or market our products effectively.

We are a consumer products company operating in highly competitive markets and rely on continued demand for our products. To generate revenues and profits, we must sell products that appeal to our customers and to consumers. Any significant changes in consumer preferences or any inability on our part to anticipate or react to such changes could result in reduced demand for our products and erosion of our competitive and financial position. Our success depends on our ability to respond to consumer trends, including concerns of consumers regarding obesity, product attributes and ingredients. In addition, changes

in product category consumption or consumer demographics could result in reduced demand for our products. Consumer preferences may shift due to a variety of factors, including the aging of the general population, changes in social trends, changes in travel, vacation or leisure activity patterns, weather, negative publicity resulting from regulatory action or litigation against companies in our industry, a downturn in economic conditions or taxes specifically targeting the consumption of our products. Any of these changes may reduce consumers' willingness to purchase our products. See also the discussions under "The global economic crisis has resulted in unfavorable economic conditions and increased volatility in foreign exchange rates and may have an adverse impact on our business results or financial condition." and "Changes in the legal and regulatory environment could limit our business activities, increase our operating costs, reduce demand for our products or result in litigation."

Our continued success is also dependent on our product innovation, including maintaining a robust pipeline of new products, and the effectiveness of our advertising campaigns and marketing programs. Although we devote significant resources to meet this goal, there can be no assurance as to our continued ability either to develop and launch successful new products or variants of existing products, or to effectively execute advertising campaigns and marketing programs. In addition, both the launch and ongoing success of new products and advertising campaigns are inherently uncertain, especially as to their appeal to consumers. Our failure to successfully launch new products could decrease demand for our existing products by negatively affecting consumer perception of existing brands, as well as result in inventory write-offs and other costs.

> Our continued success is also dependent on our product innovation, including maintaining a robust pipeline of new products, and the effectiveness of our advertising campaigns and marketing programs.

Our operating results may be adversely affected by increased costs, disruption of supply or shortages of raw materials and other supplies.

We and our business partners use various raw materials and other supplies in our business, including aspartame, cocoa, corn, corn sweeteners, flavorings, flour, grapefruits and other fruits, juice and juice concentrates, oats, oranges, potatoes, rice, seasonings, sucralose, sugar, vegetable and essential oils, and wheat. Our key packaging materials include polyethylene terephthalate (PET) resin used for plastic bottles, film packaging used for snack

foods, aluminum used for cans, glass bottles and cardboard. Fuel and natural gas are also important commodities due to their use in our plants and in the trucks delivering our products. Some of these raw materials and supplies are available from a limited number of suppliers. We are exposed to the market risks arising from adverse changes in commodity prices, affecting the cost of our raw materials and energy. The raw materials and energy which we use for the production of our products are largely commodities that are subject to price volatility and fluctuations in availability caused by changes in global supply and demand, weather conditions, agricultural uncertainty or governmental controls. We purchase these materials and energy mainly in the open market. If commodity price changes result in unexpected increases in raw materials and energy costs, we may not be able to increase our prices to offset these increased costs without suffering reduced volume, revenue and operating income. See also the discussion under "The global economic crisis has resulted in unfavorable economic conditions and increased volatility in foreign exchange rates and may have an adverse impact on our business results or financial condition."

The global economic crisis has resulted in unfavorable economic conditions and increased volatility in foreign exchange rates and may have an adverse impact on our business results or financial condition.
The global economic crisis has resulted in unfavorable economic conditions in many of the countries in which we operate. Our business or financial results may be adversely impacted by these unfavorable economic conditions, including: adverse changes in interest rates or tax rates; volatile commodity markets; contraction in the availability of credit in the marketplace potentially impairing our ability to access the capital markets on terms commercially acceptable to us, or at all; the effects of government initiatives to manage economic conditions; reduced demand for our products resulting from a slow-down in the general global economy or a shift in consumer preferences to private label products for economic reasons; or a further decrease in the fair value of pension assets that could increase future employee benefit costs and/or funding requirements of our pension plans. The global economic crisis has also resulted in increased foreign exchange rate volatility. We hold assets and incur liabilities, earn revenues and pay expenses in a variety of currencies other than the U.S. dollar. The financial statements of our foreign subsidiaries are translated into U.S. dollars. As a result, our profitability may be adversely impacted by an adverse change in foreign currency

exchange rates. In addition, we cannot predict how current or worsening economic conditions will affect our critical customers, suppliers and distributors and any negative impact on our critical customers, suppliers or distributors may also have an adverse impact on our business results or financial condition.

If we are not able to build and sustain proper information technology infrastructure, successfully implement our ongoing business transformation initiative or outsource certain functions effectively our business could suffer.
We depend on information technology as an enabler to improve the effectiveness of our operations and to interface with our customers, as well as to maintain financial accuracy and efficiency. If we do not allocate and effectively manage the resources necessary to build and sustain the proper technology infrastructure, we could be subject to transaction errors, processing inefficiencies, the loss of customers, business disruptions, or the loss of or damage to intellectual property through security breach.

We have embarked on a multi-year business transformation initiative that includes the delivery of an SAP enterprise resource planning application, as well as the migration to common business processes across our operations. There can be no certainty that these programs will deliver the expected benefits. The failure to deliver our goals may impact our ability to (1) process transactions accurately and efficiently and (2) remain in step with the changing needs of the trade, which could result in the loss of customers. In addition, the failure to either deliver the application on time, or anticipate the necessary readiness and training needs, could lead to business disruption and loss of customers and revenue.

In addition, we have outsourced certain information technology support services and administrative functions, such as payroll processing and benefit plan administration, to third-party service providers and may outsource other functions in the future to achieve cost savings and efficiencies. If the service providers that we outsource these functions to do not perform effectively, we may not be able to achieve the expected cost savings and may have to incur additional costs to correct errors made by such service providers. Depending on the function involved, such errors may also lead to business disruption, processing inefficiencies or the loss of or damage to intellectual property through security breach, or harm employee morale.

Our information systems could also be penetrated by outside parties intent on extracting information, corrupting information or disrupting business processes. Such unauthorized access could disrupt our business and could result in the loss of assets.

Management's Discussion and Analysis

Any damage to our reputation could have an adverse effect on our business, financial condition and results of operations.

Maintaining a good reputation globally is critical to selling our branded products. If we fail to maintain high standards for product quality, safety and integrity, our reputation could be jeopardized. Adverse publicity about these types of concerns or the incidence of product contamination or tampering, whether or not valid, may reduce demand for our products or cause production and delivery disruptions. If any of our products becomes unfit for consumption, misbranded or causes injury, we may have to engage in a product recall and/or be subject to liability. A widespread product recall or a significant product liability judgment could cause our products to be unavailable for a period of time, which could further reduce consumer demand and brand equity. Failure to maintain high ethical, social and environmental standards for all of our operations and activities or adverse publicity regarding our responses to health concerns, our environmental impacts, including agricultural materials, packaging, energy use and waste management, or other sustainability issues, could jeopardize our reputation. In addition, water is a limited resource in many parts of the world. Our reputation could be damaged if we do not act responsibly with respect to water use. Failure to comply with local laws and regulations, to maintain an effective system of internal controls or to provide accurate and timely financial statement information could also hurt our reputation. Damage to our reputation or loss of consumer confidence in our products for any of these reasons could result in decreased demand for our products and could have a material adverse effect on our business, financial condition and results of operations, as well as require additional resources to rebuild our reputation.

Trade consolidation, the loss of any key customer, or failure to maintain good relationships with our bottling partners could adversely affect our financial performance.

We must maintain mutually beneficial relationships with our key customers, including our retailers and bottling partners, to effectively compete. There is a greater concentration of our customer base around the world generally due to the continued consolidation of retail trade. As retail ownership becomes more concentrated, retailers demand lower pricing and increased promotional programs. Further, as larger retailers increase utilization of their own distribution networks and private label brands, the competitive advantages we derive from our go-to-market systems

and brand equity may be eroded. Failure to appropriately respond to these trends or to offer effective sales incentives and marketing programs to our customers could reduce our ability to secure adequate shelf space at our retailers and adversely affect our financial performance.

Retail consolidation and the current economic environment continue to increase the importance of major customers. Loss of any of our key customers could have an adverse effect on our business, financial condition and results of operations.

Furthermore, if we are unable to provide an appropriate mix of incentives to our bottlers through a combination of advertising and marketing support, they may take actions that, while maximizing their own short-term profit, may be detrimental to us or our brands. Such actions could have an adverse effect on our profitability. In addition, any deterioration of our relationships with our bottlers could adversely affect our business or financial performance. See "Our Customers," "Our Related Party Bottlers" and Note 8 to our consolidated financial statements for more information on our customers, including our anchor bottlers.

If we are unable to hire or retain key employees or a highly skilled and diverse workforce, it could have a negative impact on our business.

Our continued growth requires us to hire, retain and develop our leadership bench and a highly skilled and diverse workforce. We compete to hire new employees and then must train them and develop their skills and competencies. Any unplanned turnover or our failure to develop an adequate succession plan to backfill current leadership positions or to hire and retain a diverse workforce could deplete our institutional knowledge base and erode our competitive advantage. In addition, our operating results could be adversely affected by increased costs due to increased competition for employees, higher employee turnover or increased employee benefit costs.

> Our continued growth requires us to hire, retain and develop our leadership bench and a highly skilled and diverse workforce.

Changes in the legal and regulatory environment could limit our business activities, increase our operating costs, reduce demand for our products or result in litigation.

The conduct of our businesses, and the production, distribution, sale, advertising, labeling, safety, transportation and use of many of our products, are subject to various laws and regulations administered by federal, state and local governmental agencies

in the United States, as well as to foreign laws and regulations administered by government entities and agencies in markets in which we operate. These laws and regulations may change, sometimes dramatically, as a result of political, economic or social events. Such regulatory environment changes may include changes in: food and drug laws; laws related to advertising and deceptive marketing practices; accounting standards; taxation requirements, including taxes specifically targeting the consumption of our products; competition laws; and environmental laws, including laws relating to the regulation of water rights and treatment. Changes in laws, regulations or governmental policy and the related interpretations may alter the environment in which we do business and, therefore, may impact our results or increase our costs or liabilities.

In particular, governmental entities or agencies in jurisdictions where we operate may impose new labeling, product or production requirements, or other restrictions. For example, studies are underway by various regulatory authorities and others to assess the effect on humans due to acrylamide in the diet. Acrylamide is a chemical compound naturally formed in a wide variety of foods when they are cooked (whether commercially or at home), including french fries, potato chips, cereal, bread and coffee. It is believed that acrylamide may cause cancer in laboratory animals when consumed in significant amounts. If consumer concerns about acrylamide increase as a result of these studies, other new scientific evidence, or for any other reason, whether or not valid, demand for our products could decline and we could be subject to lawsuits or new regulations that could affect sales of our products, any of which could have an adverse effect on our business, financial condition or results of operations.

We are also subject to Proposition 65 in California, a law which requires that a specific warning appear on any product sold in California that contains a substance listed by that State as having been found to cause cancer or birth defects. If we were required to add warning labels to any of our products or place warnings in certain locations where our products are sold, sales of those products could suffer not only in those locations but elsewhere.

In many jurisdictions, compliance with competition laws is of special importance to us due to our competitive position in those jurisdictions. Regulatory authorities under whose laws we operate may also have enforcement powers that can subject us to actions such as product recall, seizure of products or other sanctions, which could have an adverse effect on our sales or damage our reputation. See also "Regulatory Environment and Environmental Compliance."

Disruption of our supply chain could have an adverse impact on our business, financial condition and results of operations.

Our ability and that of our suppliers, business partners, including bottlers, contract manufacturers, independent distributors and retailers, to make, move and sell products is critical to our success. Damage or disruption to our or their manufacturing or distribution capabilities due to adverse weather conditions, natural disaster, fire, terrorism, the outbreak or escalation of armed hostilities, pandemic, strikes and other labor disputes or other reasons beyond our or their control, could impair our ability to manufacture or sell our products. Failure to take adequate steps to mitigate the likelihood or potential impact of such events, or to effectively manage such events if they occur, could adversely affect our business, financial condition and results of operations, as well as require additional resources to restore our supply chain.

Unstable political conditions, civil unrest or other developments and risks in the countries where we operate may adversely impact our business.

Our operations outside of the United States contribute significantly to our revenue and profitability. Unstable political conditions, civil unrest or other developments and risks in the countries where we operate could have an adverse impact on our business results or financial condition. Factors that could adversely affect our business results in these countries include: import and export restrictions; foreign ownership restrictions; nationalization of our assets; regulations on the repatriation of funds; and currency hyperinflation or devaluation. In addition, disruption in these markets due to political instability or civil unrest could result in a decline in consumer purchasing power, thereby reducing demand for our products.

Risk Management Framework

The achievement of our strategic and operating objectives will necessarily involve taking risks. Our risk management process is intended to ensure that risks are taken knowingly and purposefully. As such, we leverage an integrated risk management framework to identify, assess, prioritize, manage, monitor and communicate risks across the Company. This framework includes:

- The PepsiCo Executive Committee (PEC), comprised of a cross-functional, geographically diverse, senior management group which meets regularly to identify, assess, prioritize and address strategic and reputational risks;

Management's Discussion and Analysis

- Division Risk Committees (DRCs), comprised of cross-functional senior management teams which meet regularly each year to identify, assess, prioritize and address division-specific operating risks;
- PepsiCo's Risk Management Office, which manages the overall risk management process, provides ongoing guidance, tools and analytical support to the PEC and the DRCs, identifies and assesses potential risks, and facilitates ongoing communication between the parties, as well as to PepsiCo's Audit Committee and Board of Directors;
- PepsiCo Corporate Audit, which evaluates the ongoing effectiveness of our key internal controls through periodic audit and review procedures; and
- PepsiCo's Compliance Office, which leads and coordinates our compliance policies and practices.

Market Risks

We are exposed to market risks arising from adverse changes in:
- commodity prices, affecting the cost of our raw materials and energy,
- foreign exchange rates, and
- interest rates.

> In the normal course of business, we manage these risks through a variety of strategies, including productivity initiatives, global purchasing programs and hedging strategies.

In the normal course of business, we manage these risks through a variety of strategies, including productivity initiatives, global purchasing programs and hedging strategies. Ongoing productivity initiatives involve the identification and effective implementation of meaningful cost saving opportunities or efficiencies. Our global purchasing programs include fixed-price purchase orders and pricing agreements. See Note 9 for further information on our noncancelable purchasing commitments. Our hedging strategies include the use of derivatives. Certain derivatives are designated as either cash flow or fair value hedges and qualify for hedge accounting treatment, while others do not qualify and are marked to market through earnings. We do not use derivative instruments for trading or speculative purposes. We perform a quarterly assessment of our counterparty credit risk, including a review of credit ratings, credit default swap rates and potential nonperformance of the counterparty. We consider

this risk to be low, because we limit our exposure to individual, strong creditworthy counterparties and generally settle on a net basis.

The fair value of our derivatives fluctuates based on market rates and prices. The sensitivity of our derivatives to these market fluctuations is discussed below. See Note 10 for further discussion of these derivatives and our hedging policies. See "Our Critical Accounting Policies" for a discussion of the exposure of our pension plan assets and pension and retiree medical liabilities to risks related to stock prices and discount rates.

Inflationary, deflationary and recessionary conditions impacting these market risks also impact the demand for and pricing of our products.

Commodity Prices

We expect to be able to reduce the impact of volatility in our raw material and energy costs through our hedging strategies and ongoing sourcing initiatives.

Our open commodity derivative contracts that qualify for hedge accounting had a face value of $303 million at December 27, 2008 and $5 million at December 29, 2007. These contracts resulted in net unrealized losses of $117 million at December 27, 2008 and net unrealized gains of less than $1 million at December 29, 2007. At the end of 2008, the potential change in fair value of commodity derivative instruments, assuming a 10% decrease in the underlying commodity price, would have increased our net unrealized losses in 2008 by $19 million.

Our open commodity derivative contracts that do not qualify for hedge accounting had a face value of $626 million at December 27, 2008 and $105 million at December 29, 2007. These contracts resulted in net losses of $343 million in 2008 and net gains of $3 million in 2007. At the end of 2008, the potential change in fair value of commodity derivative instruments, assuming a 10% decrease in the underlying commodity price, would have increased our net losses in 2008 by $34 million.

Foreign Exchange

Financial statements of foreign subsidiaries are translated into U.S. dollars using period-end exchange rates for assets and liabilities and weighted-average exchange rates for revenues and expenses. Adjustments resulting from translating net assets are reported as a separate component of accumulated other comprehensive loss within shareholders' equity under the caption currency translation adjustment.

Our operations outside of the U.S. generate 48% of our net revenue, with Mexico, Canada and the United Kingdom comprising 19% of our net revenue. As a result, we are exposed to foreign currency risks. During 2008, net favorable foreign currency, primarily due to appreciation in the euro and Chinese yuan, partially offset by depreciation in the British pound, contributed 1 percentage point to net revenue growth. Currency declines against the U.S. dollar which are not offset could adversely impact our future results.

Exchange rate gains or losses related to foreign currency transactions are recognized as transaction gains or losses in our income statement as incurred. We may enter into derivatives to manage our exposure to foreign currency transaction risk. Our foreign currency derivatives had a total face value of $1.4 billion at December 27, 2008 and $1.6 billion at December 29, 2007. The contracts that qualify for hedge accounting resulted in net unrealized gains of $111 million at December 27, 2008 and net unrealized losses of $44 million at December 29, 2007. At the end of 2008, we estimate that an unfavorable 10% change in the exchange rates would have decreased our net unrealized gains by $70 million. The contracts that do not qualify for hedge accounting resulted in a net loss of $28 million in 2008 and a net gain of $15 million in 2007. All losses and gains were offset by changes in the underlying hedged items, resulting in no net material impact on earnings.

Interest Rates

We centrally manage our debt and investment portfolios considering investment opportunities and risks, tax consequences and overall financing strategies. We may use interest rate and cross currency interest rate swaps to manage our overall interest expense and foreign exchange risk. These instruments effectively change the interest rate and currency of specific debt issuances. Our 2008 and 2007 interest rate swaps were entered into concurrently with the issuance of the debt that they modified. The notional amount, interest payment and maturity date of the swaps match the principal, interest payment and maturity date of the related debt.

Assuming year-end 2008 variable rate debt and investment levels, a 1-percentage-point increase in interest rates would have increased net interest expense by $21 million in 2008.

OUR CRITICAL ACCOUNTING POLICIES

An appreciation of our critical accounting policies is necessary to understand our financial results. These policies may require management to make difficult and subjective judgments regarding uncertainties, and as a result, such estimates may significantly impact our financial results. The precision of these estimates and the likelihood of future changes depend on a number of underlying variables and a range of possible outcomes. Other than our accounting for pension plans, our critical accounting policies do not involve the choice between alternative methods of accounting. We applied our critical accounting policies and estimation methods consistently in all material respects, and for all periods presented, and have discussed these policies with our Audit Committee.

> Our critical accounting policies arise in conjunction with the following:
> * revenue recognition,
> * brand and goodwill valuations,
> * income tax expense and accruals, and
> * pension and retiree medical plans.

REVENUE RECOGNITION

Our products are sold for cash or on credit terms. Our credit terms, which are established in accordance with local and industry practices, typically require payment within 30 days of delivery in the U.S., and generally within 30 to 90 days internationally, and may allow discounts for early payment. We recognize revenue upon shipment or delivery to our customers based on written sales terms that do not allow for a right of return. However, our policy for DSD and chilled products is to remove and replace damaged and out-of-date products from store shelves to ensure that consumers receive the product quality and freshness they expect. Similarly, our policy for certain warehouse-distributed products is to replace damaged and out-of-date products. Based on our experience with this practice, we have reserved for anticipated damaged and out-of-date products. Our bottlers have a similar replacement policy and are responsible for the products they distribute.

Management's Discussion and Analysis

Our policy is to provide customers with product when needed. In fact, our commitment to freshness and product dating serves to regulate the quantity of product shipped or delivered. In addition, DSD products are placed on the shelf by our employees with customer shelf space limiting the quantity of product. For product delivered through our other distribution networks, we monitor customer inventory levels.

As discussed in "Our Customers," we offer sales incentives and discounts through various programs to customers and consumers. Sales incentives and discounts are accounted for as a reduction of revenue and totaled $12.5 billion in 2008, $11.3 billion in 2007 and $10.1 billion in 2006. Sales incentives include payments to customers for performing merchandising activities on our behalf, such as payments for in-store displays, payments to gain distribution of new products, payments for shelf space and discounts to promote lower retail prices. A number of our sales incentives, such as bottler funding and customer volume rebates, are based on annual targets, and accruals are established during the year for the expected payout. These accruals are based on contract terms and our historical experience with similar programs and require management judgment with respect to estimating customer participation and performance levels. Differences between estimated expense and actual incentive costs are normally insignificant and are recognized in earnings in the period such differences are determined. The terms of most of our incentive arrangements do not exceed a year, and therefore do not require highly uncertain long-term estimates. For interim reporting, we estimate total annual sales incentives for most of our programs and record a pro rata share in proportion to revenue. Certain arrangements, such as fountain pouring rights, may extend beyond one year. The costs incurred to obtain these incentive arrangements are recognized over the shorter of the economic or contractual life, as a reduction of revenue, and the remaining balances of $333 million at year-end 2008 and $314 million at year-end 2007 are included in current assets and other assets on our balance sheet.

We estimate and reserve for our bad debt exposure based on our experience with past due accounts and collectibility, the aging of accounts receivable and our analysis of customer data. Bad debt expense is classified within selling, general and administrative expenses in our income statement.

BRAND AND GOODWILL VALUATIONS

We sell products under a number of brand names, many of which were developed by us. The brand development costs are expensed as incurred. We also purchase brands in acquisitions. Upon acquisition, the purchase price is first allocated to identifiable assets and liabilities, including brands, based on estimated fair value, with any remaining purchase price recorded as goodwill. Determining fair value requires significant estimates and assumptions based on an evaluation of a number of factors, such as marketplace participants, product life cycles, market share, consumer awareness, brand history and future expansion expectations, amount and timing of future cash flows and the discount rate applied to the cash flows.

We believe that a brand has an indefinite life if it has a history of strong revenue and cash flow performance, and we have the intent and ability to support the brand with marketplace spending for the foreseeable future. If these perpetual brand criteria are not met, brands are amortized over their expected useful lives, which generally range from five to 40 years. Determining the expected life of a brand requires management judgment and is based on an evaluation of a number of factors, including market share, consumer awareness, brand history and future expansion expectations, as well as the macroeconomic environment of the countries in which the brand is sold.

Perpetual brands and goodwill, including the goodwill that is part of our noncontrolled bottling investment balances, are not amortized. Perpetual brands and goodwill are assessed for impairment at least annually. If the carrying amount of a perpetual brand exceeds its fair value, as determined by its discounted cash flows, an impairment loss is recognized in an amount equal to that excess. Goodwill is evaluated using a two-step impairment test at the reporting unit level. A reporting unit can be a division or business within a division. The first step compares the book value of a reporting unit, including goodwill, with its fair value, as determined by its discounted cash flows. If the book value of a reporting unit exceeds its fair value, we complete the second step to determine the amount of goodwill impairment loss that we should record. In the second step, we determine an implied fair value of the reporting unit's goodwill by allocating the fair value of the reporting unit to all of the assets and liabilities other than goodwill (including any unrecognized intangible assets). The amount of impairment loss is equal to the excess of the book value of the goodwill over the implied fair value of that goodwill.

Amortizable brands are only evaluated for impairment upon a significant change in the operating or macroeconomic environment. If an evaluation of the undiscounted future cash flows indicates impairment, the asset is written down to its estimated fair value, which is based on its discounted future cash flows.

Management judgment is necessary to evaluate the impact of operating and macroeconomic changes and to estimate future cash flows. Assumptions used in our impairment evaluations, such as forecasted growth rates and our cost of capital, are based on the best available market information and are consistent with our internal forecasts and operating plans. These assumptions could be adversely impacted by certain of the risks discussed in "Our Business Risks."

> We did not recognize any impairment charges for perpetual brands or goodwill in the years presented.

We did not recognize any impairment charges for perpetual brands or goodwill in the years presented. As of December 27, 2008, we had $6.3 billion of perpetual brands and goodwill, of which approximately 55% related to Tropicana and Walkers.

INCOME TAX EXPENSE AND ACCRUALS

Our annual tax rate is based on our income, statutory tax rates and tax planning opportunities available to us in the various jurisdictions in which we operate. Significant judgment is required in determining our annual tax rate and in evaluating our tax positions. We establish reserves when, despite our belief that our tax return positions are fully supportable, we believe that certain positions are subject to challenge and that we may not succeed. We adjust these reserves, as well as the related interest, in light of changing facts and circumstances, such as the progress of a tax audit.

An estimated effective tax rate for a year is applied to our quarterly operating results. In the event there is a significant or unusual item recognized in our quarterly operating results, the tax attributable to that item is separately calculated and recorded at the same time as that item. We consider the tax adjustments from the resolution of prior year tax matters to be such items.

Tax law requires items to be included in our tax returns at different times than the items are reflected in our financial statements. As a result, our annual tax rate reflected in our financial statements is different than that reported in our tax returns (our cash tax rate). Some of these differences are permanent, such

as expenses that are not deductible in our tax return, and some differences reverse over time, such as depreciation expense. These temporary differences create deferred tax assets and liabilities. Deferred tax assets generally represent items that can be used as a tax deduction or credit in our tax returns in future years for which we have already recorded the tax benefit in our income statement. We establish valuation allowances for our deferred tax assets if, based on the available evidence, it is more likely than not that some portion or all of the deferred tax assets will not be realized. Deferred tax liabilities generally represent tax expense recognized in our financial statements for which payment has been deferred, or expense for which we have already taken a deduction in our tax return but have not yet recognized as expense in our financial statements.

In 2008, our annual tax rate was 26.8% compared to 25.9% in 2007 as discussed in "Other Consolidated Results." The tax rate in 2008 increased 0.9 percentage points primarily due to the absence of the tax benefits recognized in the prior year related to the favorable resolution of certain foreign tax matters, partially offset by lower taxes on foreign results in the current year. In 2009, our annual tax rate is expected to be approximately the same as 2008.

PENSION AND RETIREE MEDICAL PLANS

Our pension plans cover full-time employees in the U.S. and certain international employees. Benefits are determined based on either years of service or a combination of years of service and earnings. U.S. and Canada retirees are also eligible for medical and life insurance benefits (retiree medical) if they meet age and service requirements. Generally, our share of retiree medical costs is capped at specified dollar amounts which vary based upon years of service, with retirees contributing the remainder of the cost.

Our Assumptions

The determination of pension and retiree medical plan obligations and related expenses requires the use of assumptions to estimate the amount of the benefits that employees earn while working, as well as the present value of those benefits. Annual pension and retiree medical expense amounts are principally based on four components: (1) the value of benefits earned by employees for working during the year (service cost), (2) increase in the liability due to the passage of time (interest cost), and (3) other gains and losses as discussed below, reduced by (4) expected return on plan assets for our funded plans.

Management's Discussion and Analysis

Significant assumptions used to measure our annual pension and retiree medical expense include:

- the interest rate used to determine the present value of liabilities (discount rate);
- certain employee-related factors, such as turnover, retirement age and mortality;
- for pension expense, the expected return on assets in our funded plans and the rate of salary increases for plans where benefits are based on earnings; and
- for retiree medical expense, health care cost trend rates.

Our assumptions reflect our experience and management's best judgment regarding future expectations. Due to the significant management judgment involved, our assumptions could have a material impact on the measurement of our pension and retiree medical benefit expenses and obligations.

At each measurement date, the discount rate is based on interest rates for high-quality, long-term corporate debt securities with maturities comparable to those of our liabilities. Prior to 2008, we used the Moody's Aa Corporate Bond Index yield (Moody's Aa Index) in the U.S. and adjusted for differences between the average duration of the bonds in this Index and the average duration of our benefit liabilities, based upon a published index. As of the beginning of our 2008 fiscal year, our U.S. discount rate is determined using the Mercer Pension Discount Yield Curve (Mercer Yield Curve). The Mercer Yield Curve uses a portfolio of high-quality bonds rated Aa or higher by Moody's. We believe the Mercer Yield Curve includes bonds that provide a better match to the timing and amount of our expected benefit payments than the Moody's Aa Index.

The expected return on pension plan assets is based on our pension plan investment strategy, our expectations for long-term rates of return and our historical experience. We also review current levels of interest rates and inflation to assess the reasonableness of the long-term rates. Our pension plan investment strategy includes the use of actively-managed securities and is reviewed annually based upon plan liabilities, an evaluation of market conditions, tolerance for risk and cash requirements for benefit payments. Our investment objective is to ensure that funds are available to meet the plans' benefit obligations when they become due. Our overall investment strategy is to prudently invest plan assets in high-quality and diversified equity and debt securities to achieve our long-term return expectations. We employ certain equity strategies which, in addition to investments in U.S. and international common and preferred stock, include investments in certain equity- and debt-based securities used collectively to generate returns in excess of certain equity-based indices. Debt-based securities represent approximately 3% and 30% of our equity strategy portfolio as of year-end 2008 and 2007, respectively. Our investment policy also permits the use of derivative instruments which are primarily used to reduce risk. Our expected long-term rate of return on U.S. plan assets is 7.8%, reflecting estimated long-term rates of return of 8.9% from our equity strategies, and 6.3% from our fixed income strategies. Our target investment allocation is 60% for equity strategies and 40% for fixed income strategies. Actual investment allocations may vary from our target investment allocations due to prevailing market conditions. We regularly review our actual investment allocations and periodically rebalance our investments to our target allocations. To calculate the expected return on pension plan assets, we use a market-related valuation method that recognizes investment gains or losses (the difference between the expected and actual return based on the market-related value of assets) for securities included in our equity strategies over a five-year period. This has the effect of reducing year-to-year volatility. For all other asset categories, the actual fair value is used for the market-related value of assets.

The difference between the actual return on plan assets and the expected return on plan assets is added to, or subtracted from, other gains and losses resulting from actual experience differing from our assumptions and from changes in our assumptions determined at each measurement date. If this net accumulated gain or loss exceeds 10% of the greater of the market-related value of plan assets or plan liabilities, a portion of the net gain or loss is included in expense for the following year. The cost or benefit of plan changes that increase or decrease benefits for prior employee service (prior service cost/(credit)) is included in earnings on a straight-line basis over the average remaining service period of active plan participants, which is approximately 10 years for pension expense and approximately 12 years for retiree medical expense.

Effective as of the beginning of our 2008 fiscal year, we amended our U.S. hourly pension plan to increase the amount of participant earnings recognized in determining pension benefits. Additional pension plan amendments were also made as of the beginning of our 2008 fiscal year to comply with legislative and regulatory changes.

The health care trend rate used to determine our retiree medical plan's liability and expense is reviewed annually. Our review is based on our claim experience, information provided by our health plans and actuaries, and our knowledge of the health care industry. Our review of the trend rate considers factors such as demographics, plan design, new medical technologies and changes in medical carriers.

Weighted-average assumptions for pension and retiree medical expense are as follows:

	2009	2008	2007
Pension			
Expense discount rate	6.2%	6.3%	5.7%
Expected rate of return on plan assets	7.6%	7.6%	7.7%
Expected rate of salary increases	4.4%	4.4%	4.5%
Retiree medical			
Expense discount rate	6.2%	6.4%	5.8%
Current health care cost trend rate	8.0%	8.5%	9.0%

Based on our assumptions, we expect our pension expense to decrease in 2009, as expected asset returns on 2009 contributions and costs associated with our Productivity for Growth program recognized in 2008 are partially offset by an increase in experience loss amortization. The increase in experience loss amortization is due primarily to pension plan asset losses in 2008 and a slight decline in discount rates.

Sensitivity of Assumptions

A decrease in the discount rate or in the expected rate of return assumptions would increase pension expense. The estimated impact of a 25-basis-point decrease in the discount rate on 2009 pension expense is an increase of approximately $31 million. The estimated impact on 2009 pension expense of a 25-basis-point decrease in the expected rate of return is an increase of approximately $18 million.

See Note 7 regarding the sensitivity of our retiree medical cost assumptions.

Future Funding

We make contributions to pension trusts maintained to provide plan benefits for certain pension plans. These contributions are made in accordance with applicable tax regulations that provide for current tax deductions for our contributions, and taxation to the employee only upon receipt of plan benefits. Generally, we do not fund our pension plans when our contributions would not be currently tax deductible.

Our pension contributions for 2008 were $149 million, of which $23 million was discretionary. In 2009, we will make contributions of $1.1 billion with up to $1 billion being discretionary. Our cash payments for retiree medical benefits are estimated to be approximately $100 million in 2009. As our retiree medical plans are not subject to regulatory funding requirements, we fund these plans on a pay-as-you-go basis. Our pension and retiree medical contributions are subject to change as a result of many factors, such as changes in interest rates, deviations between actual and expected asset returns, and changes in tax or other benefit laws. For estimated future benefit payments, including our pay-as-you-go payments as well as those from trusts, see Note 7.

> In 2009, we will make pension contributions of $1.1 billion with up to $1 billion being discretionary.

RECENT ACCOUNTING PRONOUNCEMENTS

In February 2007, the Financial Accounting Standards Board (FASB) issued Statement of Financial Accounting Standards (SFAS) 159, *The Fair Value Option for Financial Assets and Financial Liabilities including an amendment of FASB Statement No. 115* (SFAS 159), which permits entities to choose to measure many financial instruments and certain other items at fair value. We adopted SFAS 159 as of the beginning of our 2008 fiscal year and our adoption did not impact our financial statements.

In December 2007, the FASB issued SFAS 141 (revised 2007), *Business Combinations* (SFAS 141R), to improve, simplify and converge internationally the accounting for business combinations. SFAS 141R continues the movement toward the greater use of fair value in financial reporting and increased transparency through expanded disclosures. It changes how business acquisitions are accounted for and will impact financial statements both

Management's Discussion and Analysis

on the acquisition date and in subsequent periods. The provisions of SFAS 141R are effective as of the beginning of our 2009 fiscal year, with the exception of adjustments made to valuation allowances on deferred taxes and acquired tax contingencies. Future adjustments made to valuation allowances on deferred taxes and acquired tax contingencies associated with acquisitions that closed prior to the beginning of our 2009 fiscal year would apply the provisions of SFAS 141R and will be evaluated based on the outcome of these matters. We do not expect the adoption of SFAS 141R to have a material impact on our financial statements.

In December 2007, the FASB issued SFAS 160, *Noncontrolling Interests in Consolidated Financial Statements, an Amendment of ARB 51* (SFAS 160). SFAS 160 amends Accounting Research Bulletin (ARB) 51 to establish new standards that will govern the accounting for and reporting of (1) noncontrolling interests in partially owned consolidated subsidiaries and (2) the loss of control of subsidiaries. The provisions of SFAS 160 are effective as of the beginning of our 2009 fiscal year on a prospective basis. We do not expect our adoption of SFAS 160 to have a significant impact on our financial statements. In the first quarter of 2009, we will include the required disclosures for all periods presented.

In March 2008, the FASB issued SFAS 161, *Disclosures about Derivative Instruments and Hedging Activities* (SFAS 161), which amends and expands the disclosure requirements of SFAS 133, *Accounting for Derivative Instruments and Hedging Activities* (SFAS 133), to provide an enhanced understanding of the use of derivative instruments, how they are accounted for under SFAS 133 and their effect on financial position, financial performance and cash flows. The disclosure provisions of SFAS 161 are effective as of the beginning of our 2009 fiscal year.

OUR FINANCIAL RESULTS

ITEMS AFFECTING COMPARABILITY

The year-over-year comparisons of our financial results are affected by the following items:

	2008	2007	2006
Operating profit			
Mark-to-market net impact	$(346)	$ 19	$ (18)
Restructuring and impairment charges	$(543)	$ (102)	$ (67)
Net income			
Mark-to-market net impact	$(223)	$ 12	$ (12)
Restructuring and impairment charges	$(408)	$ (70)	$ (43)
Tax benefits	–	$ 129	$ 602
PepsiCo share of PBG restructuring and impairment charges	$(114)	–	–
PepsiCo share of PBG tax settlement	–	–	$ 18
Net income per common share – diluted			
Mark-to-market net impact	$(0.14)	$ 0.01	$(0.01)
Restructuring and impairment charges	$(0.25)	$(0.04)	$(0.03)
Tax benefits	–	$ 0.08	$ 0.36
PepsiCo share of PBG restructuring and impairment charges	$(0.07)	–	–
PepsiCo share of PBG tax settlement	–	–	$ 0.01

Mark-to-Market Net Impact

We centrally manage commodity derivatives on behalf of our divisions. These commodity derivatives include energy, fruit and other raw materials. Certain of these commodity derivatives do not qualify for hedge accounting treatment and are marked to market with the resulting gains and losses recognized in corporate unallocated expenses. These gains and losses are subsequently reflected in division results when the divisions take delivery of the underlying commodity.

In 2008, we recognized $346 million ($223 million after-tax or $0.14 per share) of mark-to-market net losses on commodity hedges in corporate unallocated expenses.

In 2007, we recognized $19 million ($12 million after-tax or $0.01 per share) of mark-to-market net gains on commodity hedges in corporate unallocated expenses.

In 2006, we recognized $18 million ($12 million after-tax or $0.01 per share) of mark-to-market net losses on commodity hedges in corporate unallocated expenses.

Restructuring and Impairment Charges

In 2008, we incurred a charge of $543 million ($408 million after-tax or $0.25 per share) in conjunction with our Productivity for Growth program. The program includes actions in all divisions of the business, including the closure of six plants that we believe

will increase cost competitiveness across the supply chain, upgrade and streamline our product portfolio, and simplify the organization for more effective and timely decision-making. In connection with this program, we expect to incur an additional pre-tax charge of approximately $30 million to $60 million in 2009.

In 2007, we incurred a charge of $102 million ($70 million after-tax or $0.04 per share) in conjunction with restructuring actions primarily to close certain plants and rationalize other production lines.

In 2006, we incurred a charge of $67 million ($43 million after-tax or $0.03 per share) in conjunction with consolidating the manufacturing network at FLNA by closing two plants in the U.S., and rationalizing other assets, to increase manufacturing productivity and supply chain efficiencies.

Tax Benefits

In 2007, we recognized $129 million ($0.08 per share) of non-cash tax benefits related to the favorable resolution of certain foreign tax matters.

In 2006, we recognized non-cash tax benefits of $602 million ($0.36 per share), substantially all of which related to the Internal Revenue Service's (IRS) examination of our consolidated tax returns for the years 1998 through 2002.

PepsiCo Share of PBG's Restructuring and Impairment Charges

In 2008, PBG implemented a restructuring initiative across all of its geographic segments. In addition, PBG recognized an asset impairment charge related to its business in Mexico. Consequently, a non-cash charge of $138 million was included in bottling equity income ($114 million after-tax or $0.07 per share) as part of recording our share of PBG's financial results.

PepsiCo Share of PBG Tax Settlement

In 2006, the IRS concluded its examination of PBG's consolidated income tax returns for the years 1999 through 2000. Consequently, a non-cash benefit of $21 million was included in bottling equity income ($18 million after-tax or $0.01 per share) as part of recording our share of PBG's financial results.

RESULTS OF OPERATIONS – CONSOLIDATED REVIEW

In the discussions of net revenue and operating profit below, *effective net pricing* reflects the year-over-year impact of discrete pricing actions, sales incentive activities and mix resulting from selling varying products in different package sizes and in different countries. Additionally, *acquisitions* reflect all mergers and acquisitions activity, including the impact of acquisitions, divestitures and changes in ownership or control in consolidated subsidiaries. The impact of acquisitions related to our non-consolidated equity investees is reflected in our volume and, excluding our anchor bottlers, in our operating profit.

Servings

Since our divisions each use different measures of physical unit volume (i.e., kilos, gallons, pounds and case sales), a common servings metric is necessary to reflect our consolidated physical unit volume. Our divisions' physical volume measures are converted into servings based on U.S. Food and Drug Administration guidelines for single-serving sizes of our products.

In 2008, total servings increased 3% compared to 2007, as servings for both beverages and snacks worldwide grew 3%. In 2007, total servings increased over 4% compared to 2006, as servings for beverages worldwide grew 4% and servings for snacks worldwide grew 6%.

Net Revenue and Operating Profit

				Change	
	2008	2007	2006	**2008**	2007
Total net revenue	**$43,251**	$39,474	$35,137	**10%**	12%
Operating profit					
FLNA	**$ 2,959**	$ 2,845	$ 2,615	**4%**	9%
QFNA	**582**	568	554	**2.5%**	2.5%
LAF	**897**	714	655	**26%**	9%
PAB	**2,026**	2,487	2,315	**(19)%**	7%
UKEU	**811**	774	700	**5%**	11%
MEAA	**667**	535	401	**25%**	34%
Corporate – net impact of mark-to-market on commodity hedges	**(346)**	19	(18)	**n/m**	n/m
Corporate – other	**(661)**	(772)	(720)	**(14)%**	7%
Total operating profit	**$ 6,935**	$ 7,170	$ 6,502	**(3)%**	10%
Total operating profit margin	**16.0%**	18.2%	18.5%	**(2.2)**	(0.3)

n/m represents year-over-year changes that are not meaningful.

2008

Total operating profit decreased 3% and margin decreased 2.2 percentage points. The unfavorable net mark-to-market impact of our commodity hedges and increased restructuring and impairment charges contributed 11 percentage points to the operating profit decline and 1.9 percentage points to the margin decline. Leverage from the revenue growth was offset by the impact of higher commodity costs. Acquisitions and foreign currency each positively contributed 1 percentage point to operating profit performance.

Management's Discussion and Analysis

Other corporate unallocated expenses decreased 14%. The favorable impact of certain employee-related items, including lower deferred compensation and pension costs were partially offset by higher costs associated with our global SAP implementation and increased research and development costs. The decrease in deferred compensation costs are offset by a decrease in interest income from losses on investments used to economically hedge these costs.

2007

Total operating profit increased 10% and margin decreased 0.3 percentage points. The operating profit growth reflects leverage from the revenue growth, offset by increased cost of sales, largely due to higher raw material costs. The impact of foreign currency contributed 2 percentage points to operating profit growth. There was no net impact of acquisitions on operating profit growth.

Other corporate unallocated expenses increased 7%, primarily reflecting increased research and development costs and the absence of certain other favorable corporate items in 2006, partially offset by lower pension costs.

Other Consolidated Results

	2008	2007	2006	Change 2008	2007
Bottling equity income	$ 374	$ 560	$ 553	(33)%	1%
Interest expense, net	$ (288)	$ (99)	$ (66)	$(189)	$(33)
Annual tax rate	26.8%	25.9%	19.3%		
Net income	$5,142	$5,658	$5,642	(9)%	–
Net income per common share – diluted	$ 3.21	$ 3.41	$ 3.34	(6)%	2%

Bottling equity income includes our share of the net income or loss of our anchor bottlers as described in "Our Customers." Our interest in these bottling investments may change from time to time. Any gains or losses from these changes, as well as other transactions related to our bottling investments, are also included on a pre-tax basis. In November 2007, our Board of Directors approved the sale of additional PBG stock to an economic ownership level of 35%, as well as the sale of PAS stock to the ownership level at the time of the merger with Whitman Corporation in 2000 of about 37%. We sold 8.8 million and 9.5 million shares of PBG stock in 2008 and 2007, respectively. In addition, in 2008, we sold 3.3 million shares of PAS stock. The resulting lower ownership percentages reduce the equity income from PBG and PAS that we recognize. See "Our Liquidity and Capital Resources – Investing Activities" for further information with respect to planned sales of PBG and PAS stock in 2009.

2008

Bottling equity income decreased 33%, primarily reflecting a non-cash charge of $138 million related to our share of PBG's restructuring and impairment charges. Additionally, lower pre-tax gains on our sales of PBG stock contributed to the decline.

Net interest expense increased $189 million, primarily reflecting higher average debt balances and losses on investments used to economically hedge our deferred compensation costs, partially offset by lower average rates on our borrowings.

The tax rate increased 0.9 percentage points compared to the prior year, primarily due to $129 million of tax benefits recognized in the prior year related to the favorable resolution of certain foreign tax matters, partially offset by lower taxes on foreign results in the current year.

Net income decreased 9% and the related net income per share decreased 6%. The unfavorable net mark-to-market impact of our commodity hedges, the absence of the tax benefits recognized in the prior year, our increased restructuring and impairment charges and our share of PBG's restructuring and impairment charges collectively contributed 15 percentage points to both the decline in net income and net income per share. Additionally, net income per share was favorably impacted by our share repurchases.

2007

Bottling equity income increased 1%, reflecting higher earnings from our anchor bottlers, partially offset by the impact of our reduced ownership level in 2007 and lower pre-tax gains on our sale of PBG stock.

Net interest expense increased $33 million, primarily reflecting the impact of lower investment balances and higher average rates on our debt, partially offset by higher average interest rates on our investments and lower average debt balances.

The tax rate increased 6.6 percentage points compared to the prior year, primarily reflecting an unfavorable comparison to the prior year's non-cash tax benefits.

Net income remained flat and the related net income per share increased 2%. Our solid operating profit growth and favorable net mark-to-market impact were offset by unfavorable comparisons to the non-cash tax benefits and restructuring and impairment charges in the prior year. These items affecting comparability reduced both net income performance and related net income per share growth by 10 percentage points. Additionally, net income per share was favorably impacted by our share repurchases.

RESULTS OF OPERATIONS – DIVISION REVIEW

The results and discussions below are based on how our Chief Executive Officer monitors the performance of our divisions. In addition, our operating profit and growth, excluding the impact of restructuring and impairment charges, are not measures defined by accounting principles generally accepted in the U.S. However, we believe investors should consider these measures as they are more indicative of our ongoing performance and with how management evaluates our operating results and trends. For additional information on our divisions, see Note 1 and for additional information on our restructuring and impairment charges, see Note 3.

	FLNA	QFNA	LAF	PAB	UKEU	MEAA	Total
Net Revenue, 2008	**$12,507**	**$1,902**	**$5,895**	**$10,937**	**$6,435**	**$5,575**	**$43,251**
Net Revenue, 2007	$11,586	$1,860	$4,872	$11,090	$5,492	$4,574	$39,474
% Impact of:							
Volume (a)	–%	(1.5)%	–%	(4.5)%	4%	13%	1%
Effective net pricing (b)	7	4	11	3	4	6	6
Foreign exchange	–	–	–	–	2	1	1
Acquisitions	–	–	9	–	8	2	2
% Change (c)	8%	2%	21%	(1)%	17%	22%	10%
Net Revenue, 2007	$11,586	$1,860	$4,872	$11,090	$5,492	$4,574	$39,474
Net Revenue, 2006	$10,844	$1,769	$3,972	$10,362	$4,750	$3,440	$35,137
% Impact of:							
Volume (a)	3%	2%	5%	(1)%	4%	12%	3%
Effective net pricing (b)	4	3	5	5	3	5	4
Foreign exchange	0.5	1	2	0.5	9	5.5	2
Acquisitions	–	–	11	2	–	11	3
% Change (c)	7%	5%	23%	7%	16%	33%	12%

(a) *Excludes the impact of acquisitions. In certain instances, volume growth varies from the amounts disclosed in the following divisional discussions due to non-consolidated joint venture volume, and, for our beverage businesses, temporary timing differences between BCS and CSE. Our net revenue excludes non-consolidated joint venture volume, and, for our beverage businesses, is based on CSE.*
(b) *Includes the year-over-year impact of discrete pricing actions, sales incentive activities and mix resulting from selling varying products in different package sizes and in different countries.*
(c) *Amounts may not sum due to rounding.*

Frito-Lay North America

	2008	2007	2006	% Change 2008	% Change 2007
Net revenue	$12,507	$11,586	$10,844	8	7
Operating profit	$ 2,959	$ 2,845	$ 2,615	4	9
Impact of restructuring and impairment charges	108	28	67		
Operating profit, excluding restructuring and impairment charges	$ 3,067	$ 2,873	$ 2,682	7	7

2008

Net revenue grew 8% and pound volume grew 1%. The volume growth reflects our 2008 Sabra joint venture and mid-single-digit growth in trademark Cheetos, Ruffles and dips. These volume gains were largely offset by mid-single-digit declines in trademark Lay's and Doritos. Net revenue growth benefited from pricing actions. Foreign currency had a nominal impact on net revenue growth.

> FLNA's net revenue grew 8% and 7% in 2008 and 2007, respectively.

Operating profit grew 4%, reflecting the net revenue growth. This growth was partially offset by higher commodity costs, primarily cooking oil and fuel. Operating profit growth was negatively impacted by 3 percentage points, resulting from higher fourth quarter restructuring and impairment charges in 2008 related to the Productivity for Growth program. Foreign currency and acquisitions each had a nominal impact on operating profit growth. Operating profit, excluding restructuring and impairment charges, grew 7%.

2007

Net revenue grew 7%, reflecting volume growth of 3% and positive effective net pricing due to pricing actions and favorable mix. Pound volume grew primarily due to high-single-digit growth in trademark Doritos and double-digit growth in dips, SunChips and multipack. These volume gains were partially offset by a mid-single-digit decline in trademark Lay's.

Management's Discussion and Analysis

Operating profit grew 9%, primarily reflecting the net revenue growth, as well as a favorable casualty insurance actuarial adjustment reflecting improved safety performance. This growth was partially offset by higher commodity costs, as well as increased advertising and marketing expenses. Operating profit benefited almost 2 percentage points from the impact of lower restructuring and impairment charges in 2007 related to the continued consolidation of the manufacturing network. Operating profit, excluding restructuring and impairment charges, grew 7%.

Quaker Foods North America

	2008	2007	2006	% Change 2008	% Change 2007
Net revenue	$1,902	$1,860	$1,769	2	5
Operating profit	$ 582	$ 568	$ 554	2.5	2.5
Impact of restructuring and impairment charges	31	–	–		
Operating profit, excluding restructuring and impairment charges	$ 613	$ 568	$ 554	8	2.5

2008

Net revenue increased 2% and volume declined 1.5%, partially reflecting the negative impact of the Cedar Rapids flood that occurred at the end of the second quarter. The volume decrease reflects a low-single-digit decline in Quaker Oatmeal and ready-to-eat cereals. The net revenue growth reflects favorable effective net pricing, due primarily to price increases, partially offset by the volume decline. Foreign currency had a nominal impact on net revenue growth.

> In 2008, QFNA's net revenue grew 2% and volume declined 1.5%, partially reflecting the impact of the Cedar Rapids flood.

Operating profit increased 2.5%, reflecting the net revenue growth and lower advertising and marketing costs, partially offset by increased commodity costs. The negative impact of the flood was mitigated by related business disruption insurance recoveries, which contributed 5 percentage points to operating profit. The fourth quarter restructuring and impairment charges related to the Productivity for Growth program reduced operating profit growth by 5 percentage points. Foreign currency had a nominal impact on operating profit growth. Operating profit, excluding restructuring and impairment charges, grew 8%.

2007

Net revenue increased 5% and volume increased 2%. The volume increase reflects mid-single-digit growth in Oatmeal and Life cereal, as well as low-single-digit growth in Cap'n Crunch cereal. These increases were partially offset by a double-digit decline in Rice-A-Roni. The increase in net revenue primarily reflects price increases taken earlier in 2007, as well as the volume growth. Favorable Canadian exchange rates contributed nearly 1 percentage point to net revenue growth.

Operating profit increased 2.5%, primarily reflecting the net revenue growth partially offset by increased raw material costs.

Latin America Foods

	2008	2007	2006	% Change 2008	% Change 2007
Net revenue	$5,895	$4,872	$3,972	21	23
Operating profit	$ 897	$ 714	$ 655	26	9
Impact of restructuring and impairment charges	40	39	–		
Operating profit, excluding restructuring and impairment charges	$ 937	$ 753	$ 655	24	15

2008

Snacks volume grew 3%, primarily reflecting the acquisition in Brazil, which contributed nearly 3 percentage points to the volume growth. A mid-single-digit decline at Sabritas in Mexico, largely resulting from weight-outs, was offset by mid-single digit growth at Gamesa in Mexico and double-digit growth in certain other markets.

> In 2008, LAF's net revenue and operating profit grew 21% and 26%, respectively.

Net revenue grew 21%, primarily reflecting favorable effective net pricing. Gamesa experienced double-digit growth due to favorable pricing actions. Acquisitions contributed 9 percentage points to the net revenue growth, while foreign currency had a nominal impact on net revenue growth.

Operating profit grew 26%, driven by the net revenue growth, partially offset by increased commodity costs. An insurance recovery contributed 3 percentage points to the operating profit growth. The impact of the fourth quarter restructuring and impairment charges in 2008 related to the Productivity for Growth program was offset by the prior year restructuring charges. Acquisitions contributed 4 percentage points and foreign currency contributed 1 percentage point to the operating profit growth. Operating profit, excluding restructuring and impairment charges, grew 24%.

2007

Snacks volume grew 6%, reflecting double-digit growth at Gamesa and in Argentina and high-single-digit growth in Brazil, partially offset by a low-single-digit decline at Sabritas. An acquisition in Brazil in the third quarter of 2007 contributed 0.5 percentage points to the reported volume growth rate.

Net revenue grew 23%, reflecting favorable effective net pricing and volume growth. Acquisitions contributed 11 percentage points to the net revenue growth. Foreign currency contributed 2 percentage points of growth, primarily reflecting the favorable Brazilian real.

Operating profit grew 9%, driven by the favorable effective net pricing and volume growth, partially offset by increased raw material costs. Acquisitions contributed 3 percentage points to the operating profit growth. Foreign currency contributed 2 percentage points of growth, primarily reflecting the favorable Brazilian real. The impact of restructuring actions taken in the fourth quarter to reduce costs in our operations, rationalize capacity and realign our organizational structure reduced operating profit growth by 6 percentage points. Operating profit, excluding restructuring and impairment charges, grew 15%.

PepsiCo Americas Beverages

	2008	2007	2006	% Change 2008	2007
Net revenue	$10,937	$11,090	$10,362	(1)	7
Operating profit	$ 2,026	$ 2,487	$ 2,315	(19)	7
Impact of restructuring and impairment charges	289	12	–		
Operating profit, excluding restructuring and impairment charges	$ 2,315	$ 2,499	$ 2,315	(7)	8

2008

BCS volume declined 3%, reflecting a 5% decline in North America, partially offset by a 4% increase in Latin America.

Our North American business navigated a challenging year in the U.S., where the liquid refreshment beverage category declined on a year-over-year basis. In North America, CSD volume declined 4%, driven by a mid-single-digit decline in trademark Pepsi and a low-single-digit decline in trademark Sierra Mist, offset in part by a slight increase in trademark Mountain Dew. Non-carbonated beverage volume declined 6%.

> Our North American business navigated a challenging year in the U.S., where the liquid refreshment beverage category declined on a year-over-year basis.

Net revenue declined 1 percent, reflecting the volume declines in North America, partially offset by favorable effective net pricing. The effective net pricing reflects positive mix and price increases taken primarily on concentrate and fountain products this year. Foreign currency had a nominal impact on the net revenue decline.

Operating profit declined 19%, primarily reflecting higher fourth quarter restructuring and impairment charges in 2008 related to the Productivity for Growth program, which contributed 11 percentage points to the operating profit decline. In addition, higher product costs and higher selling and delivery costs, primarily due to higher fuel costs, contributed to the decline. Foreign currency had a nominal impact on the operating profit decline. Operating profit, excluding restructuring and impairment charges, declined 7%.

2007

BCS volume grew 1%, driven by a 4% increase in our Latin America businesses. BCS volume was flat in North America.

In North America, BCS volume was flat due to a 3% decline in CSDs, entirely offset by a 5% increase in non-carbonated beverages. The decline in the CSD portfolio reflects a mid-single-digit decline in trademark Pepsi offset slightly by a low-single-digit increase in trademark Sierra Mist. Trademark Mountain Dew volume was flat. Across the brands, regular CSDs experienced a mid-single-digit decline and diet CSDs experienced a low-single-digit decline. The non-carbonated portfolio performance was driven by double-digit growth in Lipton ready-to-drink teas, double-digit growth in waters and enhanced waters under the Aquafina, Propel and SoBe Lifewater trademarks and low-single-digit growth in Gatorade, partially offset by a mid-single-digit decline in our juice and juice drinks portfolio as a result of previous price increases.

In our Latin America businesses, volume growth reflected double-digit increases in Brazil, Argentina and Venezuela, partially offset by a low-single-digit decline in Mexico. Both CSDs and non-carbonated beverages grew at mid-single-digit rates.

Net revenue grew 7%, driven by effective net pricing, primarily reflecting price increases on Tropicana Pure Premium and CSD concentrate and growth in finished goods beverages. Acquisitions contributed 2 percentage points to net revenue growth.

Management's Discussion and Analysis

Operating profit increased 7%, reflecting the net revenue growth, partially offset by higher cost of sales, mainly due to increased fruit costs, as well as higher general and administrative costs. The impact of restructuring actions taken in the fourth quarter was fully offset by the favorable impact of foreign exchange rates during the year. Operating profit was also positively impacted by the absence of amortization expense related to a prior acquisition, partially offset by the absence of a $29 million favorable insurance settlement, both recorded in 2006. The impact of acquisitions reduced operating profit by less than 1 percentage point. Operating profit, excluding restructuring and impairment charges, increased 8%.

United Kingdom & Europe

	2008	2007	2006	% Change 2008	% Change 2007
Net revenue	**$6,435**	$5,492	$4,750	**17**	16
Operating profit	**$ 811**	$ 774	$ 700	**5**	11
Impact of restructuring and impairment charges	**50**	9	–		
Operating profit, excluding restructuring and impairment charges	**$ 861**	$ 783	$ 700	**10**	12

2008

Snacks volume grew 6%, reflecting broad-based increases led by double-digit growth in Russia. Additionally, Walkers in the United Kingdom, as well as the Netherlands, grew at low-single-digit rates and Spain increased slightly. Acquisitions contributed 2 percentage points to the volume growth.

Beverage volume grew 17%, primarily reflecting the expansion of the Pepsi Lipton Joint Venture and the Sandora and Lebedyansky acquisitions, which contributed 16 percentage points to the growth. CSDs increased at a low-single-digit rate and non-carbonated beverages grew at a double-digit rate.

> In 2008, UKEU net revenue grew 17%, reflecting favorable effective net pricing and volume growth.

Net revenue grew 17%, reflecting favorable effective net pricing and volume growth. Acquisitions contributed 8 percentage points and foreign currency contributed 2 percentage points to the net revenue growth.

Operating profit grew 5%, driven by the net revenue growth, partially offset by increased commodity costs. Acquisitions contributed 5.5 percentage points and foreign currency contributed 3.5 percentage points to the operating profit growth. Operating profit growth was negatively impacted by 5 percentage points, resulting from higher fourth quarter restructuring and impairment charges in 2008 related to the Productivity for Growth program. Operating profit, excluding restructuring and impairment charges, grew 10%.

2007

Snacks volume grew 6%, reflecting broad-based increases led by double-digit growth in Russia and Romania, partially offset by low-single-digit declines at Walkers in the United Kingdom and in France. The acquisition of a business in Europe in the third quarter of 2006 contributed nearly 2 percentage points to the reported volume growth rate.

Beverage volume grew 8%, reflecting broad-based increases led by double-digit growth in Russia and Poland, partially offset by a high-single-digit decline in Spain. The acquisition of a non-controlling interest in a business in the Ukraine in the fourth quarter of 2007 contributed 3 percentage points to the reported volume growth rate. CSDs grew at a low-single-digit rate while non-carbonated beverages grew at a double-digit rate.

Net revenue grew 16%, primarily reflecting volume growth and favorable effective net pricing. Foreign currency contributed 9 percentage points to net revenue growth, primarily reflecting the favorable euro and British pound. The net impact of acquisitions reduced net revenue growth slightly.

Operating profit grew 11%, driven by the net revenue growth, partially offset by increased raw material costs and less-favorable settlements of promotional spending accruals in 2007. Foreign currency contributed 10 percentage points of growth, primarily reflecting the favorable British pound and euro. The net impact of acquisitions reduced operating profit growth by 4 percentage points. Operating profit, excluding restructuring and impairment charges, grew 12%.

Middle East, Africa & Asia

	2008	2007	2006	% Change 2008	% Change 2007
Net revenue	$5,575	$4,574	$3,440	22	33
Operating profit	$ 667	$ 535	$ 401	25	34
Impact of restructuring and impairment charges	15	14	–		
Operating profit, excluding restructuring and impairment charges	$ 682	$ 549	$ 401	24	37

2008

Snacks volume grew 10%, reflecting broad-based increases led by double-digit growth in China, the Middle East and South Africa. Additionally, Australia experienced low-single-digit growth and India grew at mid-single-digit rates.

Beverage volume grew 11%, reflecting broad-based increases driven by double-digit growth in China, the Middle East and India, partially offset by low-single-digit declines in Thailand and the Philippines. Acquisitions had a nominal impact on beverage volume growth. CSDs grew at a high-single-digit rate and non-carbonated beverages grew at a double-digit rate.

> MEAA experienced double-digit volume growth in both 2008 and 2007.

Net revenue grew 22%, reflecting volume growth and favorable effective net pricing. Acquisitions contributed 2 percentage points and foreign currency contributed 1 percentage point to the net revenue growth.

Operating profit grew 25%, driven by the net revenue growth, partially offset by increased commodity costs. Foreign currency contributed 2 percentage points and acquisitions contributed 1 percentage point to the operating profit growth. The impact of the fourth quarter restructuring and impairment charges in 2008 related to the Productivity for Growth program was offset by the prior year restructuring charges. Operating profit, excluding restructuring and impairment charges, grew 24%.

2007

Snacks volume grew 19%, reflecting broad-based growth. The Middle East, Turkey, India, South Africa and China all grew at double-digit rates, and Australia grew at a high-single-digit rate. Acquisitions contributed 4 percentage points to volume growth.

Beverage volume grew 11%, reflecting broad-based growth led by double-digit growth in the Middle East, Pakistan and China, partially offset by a high-single-digit decline in Thailand and a low-single-digit-decline in Turkey. Acquisitions had no impact on the growth rates. Both CSDs and non-carbonated beverages grew at double-digit rates.

Net revenue grew 33%, reflecting volume growth and favorable effective net pricing. Foreign currency contributed 5.5 percentage points to net revenue growth. Acquisitions contributed 11 percentage points to net revenue growth.

Operating profit grew 34%, driven by volume growth and favorable effective net pricing, partially offset by increased raw material costs. Foreign currency contributed 7 percentage points to operating profit growth. Acquisitions contributed 1 percentage point to the operating profit growth rate. The absence of amortization expense recorded in 2006 related to prior acquisitions contributed 11 percentage points to operating profit growth. The impact of restructuring actions taken in the fourth quarter of 2007 to reduce costs in our operations, rationalize capacity and realign our organizational structure reduced operating profit growth by 3.5 percentage points. Operating profit, excluding restructuring and impairment charges, grew 37%.

OUR LIQUIDITY AND CAPITAL RESOURCES

Global capital and credit markets, including the commercial paper markets, experienced in 2008 and continue to experience considerable volatility. Despite this volatility, we continue to have access to the capital and credit markets. In addition, we have revolving credit facilities that are discussed in Note 9. We believe that our cash generating capability and financial condition, together with our revolving credit facilities and other available methods of debt financing (including long-term debt financing which, depending upon market conditions, we intend to use to replace a portion of our commercial paper borrowings), will be adequate to meet our operating, investing and financing needs. However, there can be no assurance that continued or increased volatility in the global capital and credit markets will not impair our ability to access these markets on terms commercially acceptable to us or at all.

In addition, our cash provided from operating activities is somewhat impacted by seasonality. Working capital needs are impacted by weekly sales, which are generally highest in the third quarter due to seasonal and holiday-related sales patterns, and generally lowest in the first quarter.

Management's Discussion and Analysis

Operating Activities

In 2008, our operations provided $7.0 billion of cash, compared to $6.9 billion in the prior year, primarily reflecting our solid business results. Our operating cash flow in 2008 reflects restructuring payments of $180 million, including $159 million related to our Productivity for Growth program, and pension and retiree medical contributions of $219 million, of which $23 million were discretionary.

In 2007, our operations provided $6.9 billion of cash, compared to $6.1 billion in 2006, primarily reflecting solid business results.

Substantially all cash payments related to the Productivity for Growth program are expected to be paid by the end of 2009. In addition, in 2009, we will make a $640 million after-tax discretionary contribution to our U.S. pension plans.

Investing Activities

In 2008, we used $2.7 billion for our investing activities, primarily reflecting $2.4 billion for capital spending and $1.9 billion for acquisitions. Significant acquisitions included our joint acquisition with PBG of Lebedyansky in Russia and the acquisition of a snacks company in Serbia. The use of cash was partially offset by net proceeds from sales of short-term investments of $1.3 billion and proceeds from sales of PBG and PAS stock of $358 million.

In 2007, we used $3.7 billion for our investing activities, reflecting capital spending of $2.4 billion and acquisitions of $1.3 billion. Acquisitions included the remaining interest in a snacks joint venture in Latin America, Naked Juice Company and Bluebird Foods, and the acquisition of a minority interest in a juice company in the Ukraine through a joint venture with PAS. Proceeds from our sale of PBG stock of $315 million were offset by net purchases of short-term investments of $383 million.

We expect a high-single-digit decrease in net capital spending in 2009. In addition, we do not anticipate cash proceeds in 2009 from sales of PBG and PAS stock due to the current capital market conditions.

Financing Activities

In 2008, we used $3.0 billion for our financing activities, primarily reflecting the return of operating cash flow to our shareholders through common share repurchases of $4.7 billion and dividend payments of $2.5 billion. The use of cash was partially offset by proceeds from issuances of long-term debt, net of payments, of $3.1 billion, stock option proceeds of $620 million and net proceeds from short-term borrowings of $445 million.

2008 Cash Utilization

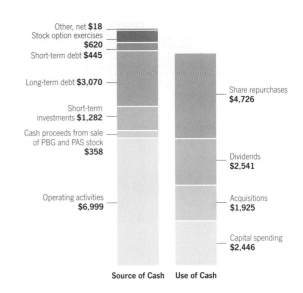

Other, net **$18**
Stock option exercises **$620**
Short-term debt **$445**
Long-term debt **$3,070**
Short-term investments **$1,282**
Cash proceeds from sale of PBG and PAS stock **$358**
Operating activities **$6,999**

Share repurchases **$4,726**
Dividends **$2,541**
Acquisitions **$1,925**
Capital spending **$2,446**

Source of Cash Use of Cash

In 2007, we used $4.0 billion for our financing activities, primarily reflecting the return of operating cash flow to our shareholders through common share repurchases of $4.3 billion and dividend payments of $2.2 billion, as well as net repayments of short-term borrowings of $395 million. The use of cash was partially offset by stock option proceeds of $1.1 billion and net proceeds from issuances of long-term debt of $1.6 billion.

We annually review our capital structure with our Board, including our dividend policy and share repurchase activity. In the second quarter of 2008, our Board of Directors approved a 13% dividend increase from $1.50 to $1.70 per share. During the third quarter of 2008, we completed our $8.5 billion repurchase program publicly announced on May 3, 2006 and expiring on June 30, 2009 and began repurchasing shares under our $8.0 billion repurchase program authorized by the Board of Directors in the second quarter of 2007 and expiring on June 30, 2010. The current $8.0 billion authorization has approximately $6.4 billion remaining for repurchase. We have historically repurchased significantly more shares each year than we have issued under our stock-based compensation plans, with average net annual repurchases of 1.8% of outstanding shares for the last five years. In 2009, we intend, subject to market conditions, to spend up to $2.5 billion repurchasing shares.

2007 Cash Utilization

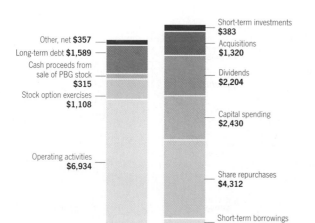

Other, net **$357**
Long-term debt **$1,589**
Cash proceeds from sale of PBG stock **$315**
Stock option exercises **$1,108**
Operating activities **$6,934**

Short-term investments **$383**
Acquisitions **$1,320**
Dividends **$2,204**
Capital spending **$2,430**
Share repurchases **$4,312**
Short-term borrowings **$395**

Source of Cash Use of Cash

2006 Cash Utilization

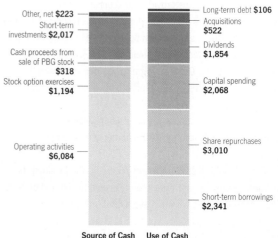

Other, net **$223**
Short-term investments **$2,017**
Cash proceeds from sale of PBG stock **$318**
Stock option exercises **$1,194**
Operating activities **$6,084**

Long-term debt **$106**
Acquisitions **$522**
Dividends **$1,854**
Capital spending **$2,068**
Share repurchases **$3,010**
Short-term borrowings **$2,341**

Source of Cash Use of Cash

Management Operating Cash Flow

We focus on management operating cash flow as a key element in achieving maximum shareholder value, and it is the primary measure we use to monitor cash flow performance. However, it is not a measure provided by accounting principles generally accepted in the U.S. Since net capital spending is essential to our product innovation initiatives and maintaining our operational capabilities, we believe that it is a recurring and necessary use of cash. As such, we believe investors should also consider net capital spending when evaluating our cash from operating activities. The table below reconciles the net cash provided by operating activities, as reflected in our cash flow statement, to our management operating cash flow.

	2008	2007	2006
Net cash provided by operating activities (a)	$ 6,999	$ 6,934	$ 6,084
Capital spending	(2,446)	(2,430)	(2,068)
Sales of property, plant and equipment	98	47	49
Management operating cash flow	$ 4,651	$ 4,551	$ 4,065

(a) *Includes restructuring payments of $180 million in 2008, $22 million in 2007 and $56 million in 2006.*

Management operating cash flow was used primarily to repurchase shares and pay dividends. We expect to continue to return approximately all of our management operating cash flow to our shareholders through dividends and share repurchases. However, see "Our Business Risks" for certain factors that may impact our operating cash flows.

Credit Ratings

Our debt ratings of Aa2 from Moody's and A+ from Standard & Poor's contribute to our ability to access global capital and credit markets. We have maintained strong investment grade ratings for over a decade. Each rating is considered strong investment grade and is in the first quartile of its respective ranking system. These ratings also reflect the impact of our anchor bottlers' cash flows and debt.

Credit Facilities and Long-Term Contractual Commitments

See Note 9 for a description of our credit facilities and long-term contractual commitments.

Off-Balance-Sheet Arrangements

It is not our business practice to enter into off-balance-sheet arrangements, other than in the normal course of business. However, at the time of the separation of our bottling operations from us various guarantees were necessary to facilitate the transactions. In 2008, we extended our guarantee of a portion of Bottling Group LLC's long-term debt in connection with the refinancing of a corresponding portion of the underlying debt. At December 27, 2008, we believe it is remote that these guarantees would require any cash payment. We do not enter into off-balance-sheet transactions specifically structured to provide income or tax benefits or to avoid recognizing or disclosing assets or liabilities. See Note 9 for a description of our off-balance-sheet arrangements.

Appendix C

Financial Statement Analysis Package (FSAP)

Output from FSAP for PepsiCo Inc. and Subsidiaries

The Financial Statement Analysis Package (**FSAP**) that accompanies this text is a user-friendly, adaptable series of Excel®-based spreadsheet templates. FSAP enables the user to manually input financial statement data for a firm and then perform financial statement analysis, forecasting, and valuation. FSAP contains five spreadsheets: Data, Analysis, Forecasts, Forecast Development, and Valuation.

Appendix C presents the output of these spreadsheets using the data for PepsiCo. The output includes the financial statement data for the years 2003–2008, the profitability and risk ratios for the years 2004–2008, financial statement forecasts, and a variety of valuation models applied to the forecasted data for PepsiCo.

FSAP contains a series of User Guides that provide line-by-line instructions on how to use FSAP. You can download a blank FSAP template as well as the FSAP output for PepsiCo from the website for this book: www.cengage.com/accounting/wahlen. FSAP data files also are available for various problems and cases in the book. The FSAP icon has been used throughout the book to denote potential applications for FSAP.

Data Spreadsheet

Analyst Name:	Wahlen, Baginski, and Bradshaw					
Company Name:	PepsiCo					
Year (Most recent in far right column.)	**2003**	**2004**	**2005**	**2006**	**2007**	**2008**
BALANCE SHEET DATA						
Assets:						
Cash and cash equivalents	820	1,280	1,716	1,651	910	2,064
Marketable securities	1,181	2,165	3,166	1,171	1,571	213
Accounts receivable—Net	2,830	2,999	3,261	3,725	4,389	4,683
Inventories	1,412	1,541	1,693	1,926	2,290	2,522
Prepaid expenses and other current assets	687	654	618	657	991	1,324
Deferred tax assets—Current						
Other current assets (1)						
Other current assets (2)						
Current Assets	**6,930**	**8,639**	**10,454**	**9,130**	**10,151**	**10,806**
Long-term investments	2,920	3,284	3,485	3,690	4,354	3,883
Property, plant, and equipment—At cost	14,755	15,930	17,145	19,058	21,896	22,552
<Accumulated depreciation>	−6,927	−7,781	−8,464	−9,371	−10,668	−10,889
Amortizable intangible assets (net)	718	598	530	637	796	732
Goodwill and nonamortizable intangibles	4,665	4,842	5,174	5,806	6,417	6,252
Deferred tax assets—Noncurrent						
Other noncurrent assets (1)	2,266	2,475	3,403	980	1,682	2,658
Other noncurrent assets (2)						
Total Assets	**25,327**	**27,987**	**31,727**	**29,930**	**34,628**	**35,994**
Liabilities and Equities:						
Accounts payable—Trade	1,638	1,731	1,799	2,102	2,562	2,846
Current accrued liabilities	3,575	3,868	4,172	4,394	5,040	5,427
Notes payable and short-term debt	145	894	2,746	274	0	369
Current maturities of long-term debt	446	160	143	0	0	0
Deferred tax liabilities—Current						
Income taxes payable	611	99	546	90	151	145
Other current liabilities (1)						
Other current liabilities (2)						
Current Liabilities	**6,415**	**6,752**	**9,406**	**6,860**	**7,753**	**8,787**
Long-term debt	1,702	2,397	2,313	2,550	4,203	7,858
Long-term accrued liabilities	4,075	4,099	4,323	4,624	4,792	7,017
Deferred tax liabilities—Noncurrent	1,261	1,216	1,434	528	646	226
Other noncurrent liabilities (1)						
Other noncurrent liabilities (2)						
Total Liabilities	**13,453**	**14,464**	**17,476**	**14,562**	**17,394**	**23,888**

Data Spreadsheet (Continued)

Year (Most recent in far right column.)	2003	2004	2005	2006	2007	2008
Minority interest						
Preferred stock	−22	−49	−69	−79	−91	−97
Common stock + Additional paid-in capital	578	648	644	614	480	381
Retained earnings <deficit>	15,961	18,730	21,116	24,837	28,184	30,638
Accum. other comprehensive income <loss>	−1,267	−886	−1,053	−2,246	−952	−4,694
Other equity adjustments						
<Treasury stock>	−3,376	−4,920	−6,387	−7,758	−10,387	−14,122
Common Shareholders' Equity	**11,896**	**13,572**	**14,320**	**15,447**	**17,325**	**12,203**
Total Liabilities and Equities	**25,327**	**27,987**	**31,727**	**29,930**	**34,628**	**35,994**

INCOME STATEMENT DATA	2003	2004	2005	2006	2007	2008
Revenues	26,971	29,261	32,562	35,137	39,474	43,251
<Cost of goods sold>	−11,691	−12,674	−14,176	−15,762	−18,038	−20,351
Gross Profit	**15,280**	**16,587**	**18,386**	**19,375**	**21,436**	**22,900**
<Selling, general, and administrative expenses>	−10,148	−11,031	−12,252	−12,711	−14,208	−15,901
<Research and development expenses>						
<Amortization of intangible assets>	−145	−147	−150	−162	−58	−64
<Other operating expenses (1)>						
<Other operating expenses (2)>						
Other operating income (1)						
Other operating income (2)						
Nonrecurring operating gains						
<Nonrecurring operating losses>	−206	−150				
Operating Profit	**4,781**	**5,259**	**5,984**	**6,502**	**7,170**	**6,935**
Interest income	51	74	159	173	125	41
<Interest expense>	−163	−167	−256	−239	−224	−329
Income <Loss> from equity affiliates	323	380	495	553	560	374
Other income or gains						
<Other expenses or losses>						
Income before Tax	**4,992**	**5,546**	**6,382**	**6,989**	**7,631**	**7,021**
<Income tax expense>	−1,424	−1,372	−2,304	−1,347	−1,973	−1,879
<Minority interest in earnings>						
Income <Loss> from discontinued operations		38				
Extraordinary gains <losses>						
Changes in accounting principles						
Net Income (computed)	**3,568**	**4,212**	**4,078**	**5,642**	**5,658**	**5,142**
Net Income (enter reported amount as a check)	3,568	4,212	4,078	5,642	5,658	5,142
Other comprehensive income items	405	381	−167	456	1,294	−3,793
Comprehensive Income	**3,973**	**4,593**	**3,911**	**6,098**	**6,952**	**1,349**

(Continued)

Data Spreadsheet (Continued)

Year (Most recent in far right column.)	2003	2004	2005	2006	2007	2008
STATEMENT OF CASH FLOWS DATA						
Net Income	3,568	4,212	4,078	5,642	5,658	5,142
Add back depreciation and amortization expenses	1,221	1,264	1,308	1,406	1,426	1,543
Add back stock-based compensation expense	407	368	311	270	260	238
Deferred income taxes	−323	17	440	−510	118	573
<Income from equity affiliates, net of dividends>	−276	−297	−414	−442	−441	−202
<Increase> Decrease in accounts receivable	−220	−130	−272	−330	−405	−549
<Increase> Decrease in inventories	−49	−100	−132	−186	−204	−345
<Increase> Decrease in prepaid expenses	23	−31	−56	−37	−16	−68
<Increase> Decrease in other current assets (1)						
<Increase> Decrease in other current assets (2)						
Increase <Decrease> in accounts payable	−11	216	188	223	500	718
Increase <Decrease> in other current liabilities (1)						
Increase <Decrease> in other current liabilities (2)						
Increase <Decrease> in other noncurrent liabilities (1)	182	−268	609	−295	128	−180
Increase <Decrease> in other noncurrent liabilities (2)	−171	−100	227	64	−107	−367
Other add backs to net income	621	491	464	544	535	1,002
<Other subtractions from net income>	−644	−588	−899	−265	−518	−506
Other operating cash flows						
Net Cash Flow from Operations	4,328	5,054	5,852	6,084	6,934	6,999
Proceeds from sales of property, plant, and equipment	49	38	88	49	47	98
<Property, plant, and equipment acquired>	−1,345	−1,387	−1,736	−2,068	−2,430	−2,446
<Increase> Decrease in marketable securities	−950	−969	−991	2,017	−383	1,282
Investments sold	46	52	3	37	27	364
<Investments acquired>	−71	−64	−1,095	−547	−1,320	−1,925
Other investment transactions (1)			214	318	315	−40
Other investment transactions (2)						
Net Cash Flow from Investing Activities	−2,271	−2,330	−3,517	−194	−3,744	−2,667
Increase in short-term borrowing	128	1,272	1,933	185	83	714
<Decrease in short-term borrowing>	−115	−160	−85	−2,526	−478	−269
Increase in long-term borrowing	52	504	25	51	2,168	3,719
<Decrease in long-term borrowing>	−641	−512	−177	−157	−579	−649
Issue of capital stock						
Proceeds from stock option exercises	689	965	1,099	1,194	1,108	620
<Share repurchases—Treasury stock>	−1,945	−3,055	−3,031	−3,010	−4,312	−4,726
<Dividend payments>	−1,070	−1,329	−1,642	−1,854	−2,204	−2,541
Other financing transactions (1)				134	208	107
Other financing transactions (2)						
Net Cash Flow from Financing Activities	−2,902	−2,315	−1,878	−5,983	−4,006	−3,025

Data Spreadsheet (Continued)

Year (Most recent in far right column.)	2003	2004	2005	2006	2007	2008
Effects of exchange rate changes on cash	27	51	−21	28	75	−153
Net Change in Cash	**−818**	**460**	**436**	**−65**	**−741**	**1,154**
Cash and cash equivalents, beginning of year		820	1,280	1,716	1,651	910
Cash and cash equivalents, end of year		1,280	1,716	1,651	910	2,064

SUPPLEMENTAL DATA	2003	2004	2005	2006	2007	2008
Statutory tax rate	35.0%	35.0%	35.0%	35.0%	35.0%	35.0%
Average tax rate implied from income statement data	28.5%	24.7%	36.1%	19.3%	25.9%	26.8%
After-tax effects of nonrecurring and unusual items on net income	−206	−112	0	0	0	0
Total deferred tax assets (from above)	0	0	0	0	0	0
Deferred tax asset valuation allowance	438	564	532	624	695	657
Allowance for uncollectible accounts receivable	105	97	75	64	69	70
Depreciation expense	1,020	1,062	1,103	1,182	1,304	1,422
Preferred stock dividends (total, if any)	3	3	3	1	2	1
Common shares outstanding	1,705	1,679	1,656	1,638	1,605	1,553
Earnings per share (basic)	2.07	2.45	2.43	3.42	3.48	3.26
Common dividends per share	0.63	0.79	0.99	1.13	1.37	1.64
Market price per share at fiscal year-end	46.47	51.94	55.80	60.18	75.67	54.77

FINANCIAL DATA CHECKS						
Assets – Liabilities – Equities	0	0	0	0	0	0
Net Income (computed) – Net Income (reported)	0	0	0	0	0	0
Cash Changes	0	0	0	0	0	0

Analysis Spreadsheet

Analyst Name:	Wahlen, Baginski, and Bradshaw				
Company Name:	PepsiCo				

PROFITABILITY FACTORS:

Year	2004	2005	2006	2007	2008
RETURN ON ASSETS (based on reported amounts):					
Profit Margin for ROA	14.8%	13.0%	16.5%	14.7%	12.4%
× Asset Turnover	1.1	1.1	1.1	1.2	1.2
= Return on Assets	16.2%	14.2%	18.8%	18.0%	15.2%
RETURN ON ASSETS (excluding the effects of nonrecurring items):					
Profit Margin for ROA	15.1%	13.0%	16.5%	14.7%	12.4%
× Asset Turnover	1.1	1.1	1.1	1.2	1.2
= Return on Assets	16.6%	14.2%	18.8%	18.0%	15.2%
RETURN ON COMMON EQUITY (based on reported amounts):					
Profit Margin for ROCE	14.4%	12.5%	16.1%	14.3%	11.9%
× Asset Turnover	1.1	1.1	1.1	1.2	1.2
× Capital Structure Leverage	2.1	2.1	2.1	2.0	2.4
= Return on Common Equity	33.1%	29.2%	37.9%	34.5%	34.8%
RETURN ON COMMON EQUITY (excluding the effects of nonrecurring items):					
Profit Margin for ROCE	14.8%	12.5%	16.1%	14.3%	11.9%
× Asset Turnover	1.1	1.1	1.1	1.2	1.2
× Capital Structure Leverage	2.1	2.1	2.1	2.0	2.4
= Return on Common Equity	33.9%	29.2%	37.9%	34.5%	34.8%
OPERATING PERFORMANCE:					
Gross Profit/Revenues	56.7%	56.5%	55.1%	54.3%	52.9%
Operating Profit/Revenues	18.0%	18.4%	18.5%	18.2%	16.0%
Net Income/Revenues	14.4%	12.5%	16.1%	14.3%	11.9%
Comprehensive Income/Revenues	15.7%	12.0%	17.4%	17.6%	3.1%
PERSISTENT OPERATING PERFORMANCE (excluding the effects of nonrecurring items):					
Persistent Operating Profit/Revenues	18.5%	18.4%	18.5%	18.2%	16.0%
Persistent Net Income/Revenues	14.8%	12.5%	16.1%	14.3%	11.9%
GROWTH:					
Revenue Growth	8.5%	11.3%	7.9%	12.3%	9.6%
Net Income Growth	18.0%	−3.2%	38.4%	0.3%	−9.1%
Persistent Net Income Growth	14.6%	−5.7%	38.4%	0.3%	−9.1%
OPERATING CONTROL:					
Gross Profit Control Index	100.1%	99.6%	97.7%	98.5%	97.5%
Operating Profit Control Index	101.4%	102.3%	100.7%	98.2%	88.3%
Profit Margin Decomposition:					
Gross Profit Margin	56.7%	56.5%	55.1%	54.3%	52.9%
Operating Profit Index	31.7%	32.5%	33.6%	33.4%	30.3%
Leverage Index	105.5%	106.7%	107.5%	106.4%	101.2%
Tax Index	75.9%	63.9%	80.7%	74.1%	73.2%
Net Profit Margin	14.4%	12.5%	16.1%	14.3%	11.9%
Comprehensive Income Performance:					
Comprehensive Income Index	109.0%	95.9%	108.1%	122.9%	26.2%
Comprehensive Income Margin	15.7%	12.0%	17.4%	17.6%	3.1%

Analysis Spreadsheet (Continued)

RISK FACTORS:

Year	2004	2005	2006	2007	2008
LIQUIDITY:					
Current Ratio	1.28	1.11	1.33	1.31	1.23
Quick Ratio	0.95	0.87	0.95	0.89	0.79
Operating Cash Flow to Current Liabilities	76.8%	72.4%	74.8%	94.9%	84.6%
ASSET TURNOVER:					
Accounts Receivable Turnover	10.0	10.4	10.1	9.7	9.5
Days Receivables Held	36	35	36	38	38
Inventory Turnover	8.6	8.8	8.7	8.6	8.5
Days Inventory Held	43	42	42	43	43
Accounts Payable Turnover	7.6	8.1	8.2	7.9	7.6
Days Payables Held	48	45	45	46	48
Net Working Capital Days	31	32	34	34	33
Revenues/Average Net Fixed Assets	3.7	3.9	3.8	3.8	3.8
Cash Turnover	27.9	21.7	20.9	30.8	29.1
Days Sales Held in Cash	13.1	16.8	17.5	11.8	12.5
SOLVENCY:					
Total Liabilities/Total Assets	51.7%	55.1%	48.7%	50.2%	66.4%
Total Liabilities/Shareholders' Equity	106.6%	122.0%	94.3%	100.4%	195.8%
LT Debt/LT Capital	15.0%	13.9%	14.2%	19.5%	39.2%
LT Debt/Shareholders' Equity	17.7%	16.2%	16.5%	24.3%	64.4%
Operating Cash Flow to Total Liabilities	36.2%	36.6%	38.0%	43.4%	33.9%
Interest Coverage Ratio (reported amounts)	34.4	25.9	30.2	35.1	22.3
Interest Coverage Ratio (recurring amounts)	35.1	25.9	30.2	35.1	22.3
RISK FACTORS:					
Bankruptcy Predictors:					
Altman Z-Score	6.35	5.86	7.29	7.30	5.27
Bankruptcy Probability	0.00%	0.00%	0.00%	0.00%	0.00%
Earnings Manipulation Predictors:					
Beneish Earnings Manipulation Score	−2.60	−2.69	−2.41	−2.49	−2.75
Earnings Manipulation Probability	0.46%	0.35%	0.80%	0.64%	0.30%
STOCK MARKET-BASED RATIOS:					
Stock Returns	13.5%	9.3%	9.9%	28.0%	−25.5%
Price-Earnings Ratio (reported amounts)	21.2	23.0	17.6	21.7	16.8
Price-Earnings Ratio (recurring amounts)	20.6	23.0	17.6	21.7	16.8
Market Value to Book Value Ratio	6.4	6.5	6.4	7.0	7.0

(Continued)

Analysis Spreadsheet (Continued)

INCOME STATEMENT ITEMS AS A PERCENT OF REVENUES:

Year	2004	2005	2006	2007	2008
Revenues	100.0%	100.0%	100.0%	100.0%	100.0%
<Cost of goods sold>	−43.3%	−43.5%	−44.9%	−45.7%	−47.1%
Gross Profit	**56.7%**	**56.5%**	**55.1%**	**54.3%**	**52.9%**
<Selling, general, and administrative expenses>	−37.7%	−37.6%	−36.2%	−36.0%	−36.8%
<Research and development expenses>					
<Amortization of intangible assets>	−0.5%	−0.5%	−0.5%	−0.1%	−0.1%
<Other operating expenses (1)>					
<Other operating expenses (2)>					
Other operating income (1)					
Other operating income (2)					
Nonrecurring operating gains					
<Nonrecurring operating losses>	−0.5%				
Operating Profit	**18.0%**	**18.4%**	**18.5%**	**18.2%**	**16.0%**
Interest income	0.3%	0.5%	0.5%	0.3%	0.1%
<Interest expense>	−0.6%	−0.8%	−0.7%	−0.6%	−0.8%
Income <Loss> from equity affiliates	1.3%	1.5%	1.6%	1.4%	0.9%
Other income or gains					
<Other expenses or losses>					
Income before Tax	**19.0%**	**19.6%**	**19.9%**	**19.3%**	**16.2%**
<Income tax expense>	−4.7%	−7.1%	−3.8%	−5.0%	−4.3%
<Minority interest in earnings>					
Income <Loss> from discontinued operations	0.1%				
Extraordinary gains <losses>					
Changes in accounting principles					
Net Income (computed)	**14.4%**	**12.5%**	**16.1%**	**14.3%**	**11.9%**
Other comprehensive income items	1.3%	−0.5%	1.3%	3.3%	−8.8%
Comprehensive Income	**15.7%**	**12.0%**	**17.4%**	**17.6%**	**3.1%**

Analysis Spreadsheet (Continued)

INCOME STATEMENT ITEMS: GROWTH RATES

Year	2004	2005	2006	2007	2008	Compound Growth Rates
			Year–to–Year Growth Rates			
Revenues	**8.5%**	**11.3%**	**7.9%**	**12.3%**	**9.6%**	**9.9%**
<Cost of goods sold>	8.4%	11.9%	11.2%	14.4%	12.8%	11.7%
Gross Profit	**8.6%**	**10.8%**	**5.4%**	**10.6%**	**6.8%**	**8.4%**
<Selling, general and administrative expenses>	8.7%	11.1%	3.7%	11.8%	11.9%	9.4%
<Research and development expenses>						
<Amortization of intangible assets>	1.4%	2.0%	8.0%	−64.2%	10.3%	−15.1%
<Other operating expenses (1)>						
<Other operating expenses (2)>						
Other operating income (1)						
Other operating income (2)						
Nonrecurring operating gains						
<Nonrecurring operating losses>	−27.2%	−100.0%				
Operating Profit	**10.0%**	**13.8%**	**8.7%**	**10.3%**	**−3.3%**	**7.7%**
Interest income	45.1%	114.9%	8.8%	−27.7%	−67.2%	−4.3%
<Interest expense>	2.5%	53.3%	−6.6%	−6.3%	46.9%	15.1%
Income <Loss> from equity affiliates	17.6%	30.3%	11.7%	1.3%	−33.2%	3.0%
Other income or gains						
<Other expenses or losses>						
Income before Tax	**11.1%**	**15.1%**	**9.5%**	**9.2%**	**−8.0%**	**7.1%**
<Income tax expense>	−3.7%	67.9%	−41.5%	46.5%	−4.8%	5.7%
<Minority interest in earnings>						
Income <Loss> from discontinued operations						
Extraordinary gains <losses>						
Changes in accounting principles						
Net Income (computed)	**18.0%**	**−3.2%**	**38.4%**	**0.3%**	**−9.1%**	**7.6%**
Other comprehensive income items	−5.9%	−143.8%	−373.1%	183.8%	−393.1%	−256.4%
Comprehensive Income	**15.6%**	**−14.8%**	**55.9%**	**14.0%**	**−80.6%**	**−19.4%**

(Continued)

Analysis Spreadsheet (Continued)

COMMON SIZE BALANCE SHEET—AS A PERCENT OF TOTAL ASSETS

Year	2004	2005	2006	2007	2008
Assets:					
Cash and cash equivalents	4.6%	5.4%	5.5%	2.6%	5.7%
Marketable securities	7.7%	10.0%	3.9%	4.5%	0.6%
Accounts receivable—Net	10.7%	10.3%	12.4%	12.7%	13.0%
Inventories	5.5%	5.3%	6.4%	6.6%	7.0%
Prepaid expenses and other current assets	2.3%	1.9%	2.2%	2.9%	3.7%
Deferred tax assets—Current					
Other current assets (1)					
Other current assets (2)					
Current Assets	**30.9%**	**32.9%**	**30.5%**	**29.3%**	**30.0%**
Long-term investments	11.7%	11.0%	12.3%	12.6%	10.8%
Property, plant, and equipment—At cost	56.9%	54.0%	63.7%	63.2%	62.7%
<Accumulated depreciation>	−27.8%	−26.7%	−31.3%	−30.8%	−30.3%
Amortizable intangible assets (net)	2.1%	1.7%	2.1%	2.3%	2.0%
Goodwill and nonamortizable intangibles	17.3%	16.3%	19.4%	18.5%	17.4%
Deferred tax assets—Noncurrent					
Other noncurrent assets (1)	8.8%	10.7%	3.3%	4.9%	7.4%
Other noncurrent assets (2)					
Total Assets	**100.0%**	**100.0%**	**100.0%**	**100.0%**	**100.0%**
Liabilities and Equities:					
Accounts payable—Trade	6.2%	5.7%	7.0%	7.4%	7.9%
Current accrued liabilities	13.8%	13.1%	14.7%	14.6%	15.1%
Notes payable and short-term debt	3.2%	8.7%	0.9%	0.0%	1.0%
Current maturities of long-term debt	0.6%	0.5%	0.0%	0.0%	0.0%
Deferred tax liabilities—Current					
Income taxes payable	0.4%	1.7%	0.3%	0.4%	0.4%
Other current liabilities (1)					
Other current liabilities (2)					
Current Liabilities	**24.1%**	**29.6%**	**22.9%**	**22.4%**	**24.4%**
Long-term debt	8.6%	7.3%	8.5%	12.1%	21.8%
Long-term accrued liabilities	14.6%	13.6%	15.4%	13.8%	19.5%
Deferred tax liabilities—Noncurrent	4.3%	4.5%	1.8%	1.9%	0.6%
Other noncurrent liabilities (1)					
Other noncurrent liabilities (2)					
Total Liabilities	**51.7%**	**55.1%**	**48.7%**	**50.2%**	**66.4%**

Analysis Spreadsheet (Continued)

COMMON SIZE BALANCE SHEET—AS A PERCENT OF TOTAL ASSETS

Year	2004	2005	2006	2007	2008
Minority interest					
Preferred stock	–0.2%	–0.2%	–0.3%	–0.3%	–0.3%
Common stock + Additional paid-in capital	2.3%	2.0%	2.1%	1.4%	1.1%
Retained earnings <deficit>	66.9%	66.6%	83.0%	81.4%	85.1%
Accum. other comprehensive income <loss>	–3.2%	–3.3%	–7.5%	–2.7%	–13.0%
Other equity adjustments					
<Treasury stock>	–17.6%	–20.1%	–25.9%	–30.0%	–39.2%
Common Shareholders' Equity	**48.5%**	**45.1%**	**51.6%**	**50.0%**	**33.9%**
Total Liabilities and Equities	**100.0%**	**100.0%**	**100.0%**	**100.0%**	**100.0%**

BALANCE SHEET ITEMS: GROWTH RATES

Year	2004	2005	2006	2007	2008	Compound Growth Rates
			Year–to–Year Growth Rates			
Assets:						
Cash and cash equivalents	56.1%	34.1%	–3.8%	–44.9%	126.8%	20.3%
Marketable securities	83.3%	46.2%	–63.0%	34.2%	–86.4%	–29.0%
Accounts receivable—Net	6.0%	8.7%	14.2%	17.8%	6.7%	10.6%
Inventories	9.1%	9.9%	13.8%	18.9%	10.1%	12.3%
Prepaid expenses and other current assets	–4.8%	–5.5%	6.3%	50.8%	33.6%	14.0%
Deferred tax assets—Current						
Other current assets (1)						
Other current assets (2)						
Current Assets	**24.7%**	**21.0%**	**–12.7%**	**11.2%**	**6.5%**	**9.3%**
Long–term investments	12.5%	6.1%	5.9%	18.0%	–10.8%	5.9%
Property, plant, and equipment—At cost	8.0%	7.6%	11.2%	14.9%	3.0%	8.9%
<Accumulated depreciation>	12.3%	8.8%	10.7%	13.8%	2.1%	9.5%
Amortizable intangible assets (net)	–16.7%	–11.4%	20.2%	25.0%	–8.0%	0.4%
Goodwill and nonamortizable intangibles	3.8%	6.9%	12.2%	10.5%	–2.6%	6.0%
Deferred tax assets—Noncurrent						
Other noncurrent assets (1)	9.2%	37.5%	–71.2%	71.6%	58.0%	3.2%
Other noncurrent assets (2)						
Total Assets	**10.5%**	**13.4%**	**–5.7%**	**15.7%**	**3.9%**	**7.3%**

(Continued)

Analysis Spreadsheet (Continued)

BALANCE SHEET ITEMS: GROWTH RATES

Year	2004	2005	2006	2007	2008	
						Compound Growth Rates
			Year–to–Year Growth Rates			
Liabilities and Equities:						
Accounts payable—Trade	5.7%	3.9%	16.8%	21.9%	11.1%	11.7%
Current accrued liabilities	8.2%	7.9%	5.3%	14.7%	7.7%	8.7%
Notes payable and short-term debt	516.6%	207.2%	−90.0%	−100.0%		20.5%
Current maturities of long-term debt	−64.1%	−10.6%	−100.0%			−100.0%
Deferred tax liabilities—Current						
Income taxes payable	−83.8%	451.5%	−83.5%	67.8%	−4.0%	−25.0%
Other current liabilities (1)						
Other current liabilities (2)						
Current Liabilities	**5.3%**	**39.3%**	**−27.1%**	**13.0%**	**13.3%**	**6.5%**
Long-term debt	40.8%	−3.5%	10.2%	64.8%	87.0%	35.8%
Long-term accrued liabilities	0.6%	5.5%	7.0%	3.6%	46.4%	11.5%
Deferred tax liabilities—Noncurrent	−3.6%	17.9%	−63.2%	22.3%	−65.0%	−29.1%
Other noncurrent liabilities (1)						
Other noncurrent liabilities (2)						
Total Liabilities	**7.5%**	**20.8%**	**−16.7%**	**19.4%**	**37.3%**	**12.2%**
Minority interest						
Preferred stock	122.7%	40.8%	14.5%	15.2%	6.6%	34.5%
Common stock + Additional paid-in capital	12.1%	−0.6%	−4.7%	−21.8%	−20.6%	−8.0%
Retained earnings <deficit>	17.3%	12.7%	17.6%	13.5%	8.7%	13.9%
Accum. other comprehensive income <loss>	−30.1%	18.8%	113.3%	−57.6%	393.1%	29.9%
Other equity adjustments						
<Treasury stock>	45.7%	29.8%	21.5%	33.9%	36.0%	33.1%
Common Shareholders' Equity	**14.1%**	**5.5%**	**7.9%**	**12.2%**	**−29.6%**	**0.5%**
Total Liabilities and Equities	**10.5%**	**13.4%**	**−5.7%**	**15.7%**	**3.9%**	**7.3%**

Analysis Spreadsheet (Continued)

RETURN ON ASSETS ANALYSIS (excluding the effects of nonrecurring items)

Level 1			RETURN ON ASSETS					

	2006	**2007**	**2008**					
	18.8%	18.0%	15.2%					

Level 2			PROFIT MARGIN FOR ROA			ASSET TURNOVER		
	2006	**2007**	**2008**	**2006**	**2007**	**2008**		
	16.5%	14.7%	12.4%	1.1	1.2	1.2		

Level 3	**2006**	**2007**	**2008**	**2006**	**2007**	**2008**	**Turnovers:**
Revenues	100.0%	100.0%	100.0%	10.1	9.7	9.5	**Receivables**
\<Cost of goods sold\>	−44.9%	−45.7%	−47.1%	8.7	8.6	8.5	**Inventory**
Gross Profit	55.1%	54.3%	52.9%	3.8	3.8	3.8	**Fixed Assets**
\<Selling, general, and administrative expenses\>	−36.2%	−36.0%	−36.8%				
Operating Profit	18.5%	18.2%	16.0%				
Income before Tax	19.9%	19.3%	16.2%				
\<Income tax expense\>	−3.8%	−5.0%	−4.3%				
Profit Margin for ROA*	16.5%	14.7%	12.4%				

*Amounts do not sum.

RETURN ON COMMON EQUITY ANALYSIS
(excluding the effects of nonrecurring items)

	2006	**2007**	**2008**
Return on Common Equity	37.9%	34.5%	34.8%
	2006	**2007**	**2008**
Profit Margin for ROCE	16.1%	14.3%	11.9%
Asset Turnover	1.1	1.2	1.2
Capital Structure Leverage	2.1	2.0	2.4

(Continued)

Analysis Spreadsheet (Continued)

STATEMENT OF CASH FLOWS: SUMMARY

Year	2004	2005	2006	2007	2008
Operating Activities:					
Net Income	4,212	4,078	5,642	5,658	5,142
Add back depreciation and amortization expenses	1,264	1,308	1,406	1,426	1,543
Net cash flows for working capital	−413	564	−561	−104	−791
Other net add backs/subtractions	−9	−98	−403	−46	1,105
Net Cash Flow from Operations	**5,054**	**5,852**	**6,084**	**6,934**	**6,999**
Investing Activities:					
Capital expenditures (net)	−1,349	−1,648	−2,019	−2,383	−2,348
Investments	−981	−2,083	1,507	−1,676	−279
Other investing transactions	0	214	318	315	−40
Net Cash Flow from Investing Activities	**−2,330**	**−3,517**	**−194**	**−3,744**	**−2,667**
Financing Activities:					
Net proceeds from short-term borrowing	1,112	1,848	−2,341	−395	445
Net proceeds from long-term borrowing	−8	−152	−106	1,589	3,070
Net proceeds from share issues and repurchases	−2,090	−1,932	−1,816	−3,204	−4,106
Dividends	−1,329	−1,642	−1,854	−2,204	−2,541
Other financing transactions	0	0	134	208	107
Net Cash Flow from Financing Activities	**−2,315**	**−1,878**	**−5,983**	**−4,006**	**−3,025**
Effects of exchange rate changes on cash	51	−21	28	75	−153
Net Change in Cash	**460**	**436**	**−65**	**−741**	**1,154**

Forecasts Spreadsheet

FSAP OUTPUT: FINANCIAL STATEMENT FORECASTS

Analyst Name: Wahlen, Baginski, and Bradshaw
Company Name: PepsiCo

Row Format:
Actual Amounts
Common-Size Percentage
Rate of Change Percentage

Row Format:
Forecast Amounts
Forecast assumption
Forecast assumption explanation

Year +6 and beyond:
Long-Run Growth Rate: 3.0%
Long-Run Growth Factor: 103.0%

Year	Actuals 2006	2007	2008	Forecasts Year +1	Year +2	Year +3	Year +4	Year +5	Year +6
INCOME STATEMENT									
Revenues	35,137	39,474	43,251	47,191	51,562	57,502	61,820	67,839	69,875
common size	100.0%	100.0%	100.0%	9.1%	9.3%	11.5%	7.5%	9.7%	
rate of change		12.3%	9.6%	See Forecast Development worksheet for details of revenues forecasts.					
<Cost of goods sold>	–15,762	–18,038	–20,351	–22,321	–24,492	–27,429	–29,612	–32,563	–33,540
common size	–44.9%	–45.7%	–47.1%	–47.3%	–47.5%	–47.7%	–47.9%	–48.0%	
rate of change		14.4%	12.8%	Assume slowly increasing cost of goods sold as a percent of sales.					
Gross Profit	19,375	21,436	22,900	24,870	27,070	30,074	32,208	35,277	36,335
common size	55.1%	54.3%	52.9%	52.7%	52.5%	52.3%	52.1%	52.0%	52.0%
rate of change		10.6%	6.8%	8.6%	8.8%	11.1%	7.1%	9.5%	3.0%
<Selling, general, and administrative expenses>	–12,711	–14,208	–15,901	–16,517	–18,047	–20,126	–21,637	–23,744	–24,456
common size	–36.2%	–36.0%	–36.8%	–35.0%	–35.0%	–35.0%	–35.0%	–35.0%	
rate of change		11.8%	11.9%	Assume steady SG&A expense as a percent of sales.					
<Research and development expenses>	0	0	0	0	0	0	0	0	0
common size	0.0%	0.0%	0.0%	0.0%	0.0%	0.0%	0.0%	0.0%	0.0%
rate of change		0.0%	0.0%	Explain assumptions.					
<Amortization of intangible assets>	–162	–58	–64	–64	–63	–62	–60	–56	–58
common size	–0.5%	–0.1%	–0.1%	–64.0	–63.0	–62.0	–60.0	–56.0	
rate of change		–64.2%	10.3%	Amounts based on PepsiCo disclosures in Note 4.					

(Continued)

Forecasts Spreadsheet (Continued)

Year	Actuals			Forecasts					
	2006	2007	2008	Year +1	Year +2	Year +3	Year +4	Year +5	Year +6
<Other operating expenses (1)>	0	0	0	0	0	0	0	0	0
common size	0.0%	0.0%	0.0%	0.0%	0.0%	0.0%	0.0%	0.0%	0.0%
rate of change			0.0%	Explain assumptions.					
<Other operating expenses (2)>	0	0	0	0	0	0	0	0	0
common size	0.0%	0.0%	0.0%	0.0%	0.0%	0.0%	0.0%	0.0%	0.0%
rate of change			0.0%	Explain assumptions.					
Other operating income (1)	0	0	0	0	0	0	0	0	0
common size	0.0%	0.0%	0.0%	0.0%	0.0%	0.0%	0.0%	0.0%	0.0%
rate of change			0.0%	Explain assumptions.					
Other operating income (2)	0	0	0	0	0	0	0	0	0
common size	0.0%	0.0%	0.0%	0.0%	0.0%	0.0%	0.0%	0.0%	0.0%
rate of change			0.0%	Explain assumptions.					
Nonrecurring operating gains	0	0	0	0	0	0	0	0	0
common size	0.0%	0.0%	0.0%	0.0%	0.0%	0.0%	0.0%	0.0%	0.0%
rate of change			0.0	Explain assumptions.					
<Nonrecurring operating losses>	0	0	0	0	0	0	0	0	0
common size	0.0%	0.0%	0.0%	0.0%	0.0%	0.0%	0.0%	0.0%	0.0%
rate of change			0.0	Explain assumptions.					
Operating Profit	6,502	7,170	6,935	8,289	8,960	9,886	10,511	11,477	11,821
common size	18.5%	18.2%	16.0%	17.6%	17.4%	17.2%	17.0%	16.9%	16.9%
rate of change		10.3%	-3.3%	19.5%	8.1%	10.3%	6.3%	9.2%	3.0%
Interest income	173	125	41	73	81	90	98	107	110
common size	0.5%	0.3%	0.1%	3.0%	3.0%	3.0%	3.0%	3.0%	3.0%
rate of change		-27.7%	-67.2%	Interest rate earned on average balance in cash and marketable securities					
<Interest expense>	-239	-224	-329	-493	-531	-579	-626	-677	-697
common size	-0.7%	-0.6%	-0.8%	-5.8%	-5.8%	-5.8%	-5.8%	-5.8%	-5.8%
rate of change		-6.3%	46.9%	Interest rate paid on average balance in financial liabilities					
Income <Loss> from equity affiliates	553	560	374	480	509	539	572	606	624
common size	1.6%	1.4%	0.9%	12.0%	12.0%	12.0%	12.0%	12.0%	12.0%
rate of change		1.3%	-33.2%	Assume expected return of 12% on investments in noncontrolled affiliates.					

Other income or gains	0	0	0	0	0	0	0	0	0
common size	0.0%	0.0%	0.0%	0.0%	0.0%	0.0%	0.0%	0.0%	0.0%
rate of change		0.0%	0.0%	Explain assumptions.	0.0%	0.0%	0.0%	0.0%	0.0%
<Other expenses or losses>	0	0	0	0	0	0	0	0	0
common size	0.0%	0.0%	0.0%	0.0%	0.0%	0.0%	0.0%	0.0%	0.0%
rate of change		0.0%	0.0%	Explain assumptions.	0.0%	0.0%	0.0%	0.0%	0.0%
Income before Tax	6,989	7,631	7,021	8,348	9,019	9,935	10,555	11,513	11,858
common size	19.9%	19.3%	16.2%	17.7%	17.5%	17.3%	17.1%	17.0%	17.0%
rate of change		9.2%	-8.0%	18.9%	8.0%	10.2%	6.2%	9.1%	3.0%
<Income tax expense>	-1,347	-1,973	-1,879	-2,237	-2,417	-2,663	-2,829	-3,085	-3,178
common size	-3.8%	-5.0%	-4.3%	-26.8%	-26.8%	-26.8%	-26.8%	-26.8%	-26.8%
rate of change		46.5%	-4.8%	Effective income tax rate assumptions					
<Minority interest in earnings>	0	0	0	0	0	0	0	0	0
common size	0.0%	0.0%	0.0%	0.0%	0.0%	0.0%	0.0%	0.0%	0.0%
rate of change		0.0%	0.0%	Explain assumptions.	0.0%	0.0%	0.0%	0.0%	0.0%
Income <Loss> from discontinued operations	0	0	0	0	0	0	0	0	0
common size	0.0%	0.0%	0.0%	0.0%	0.0%	0.0%	0.0%	0.0%	0.0%
rate of change		0.0%	0.0%	Explain assumptions.	0.0%	0.0%	0.0%	0.0%	0.0%
Extraordinary gains <losses>	0	0	0	0	0	0	0	0	0
common size	0.0%	0.0%	0.0%	0.0%	0.0%	0.0%	0.0%	0.0%	0.0%
rate of change		0.0%	0.0%	Explain assumptions.	0.0%	0.0%	0.0%	0.0%	0.0%
Changes in accounting principles	0	0	0	0	0	0	0	0	0
common size	0.0%	0.0%	0.0%	0.0%	0.0%	0.0%	0.0%	0.0%	0.0%
rate of change		0.0%	0.0%	Explain assumptions.	0.0%	0.0%	0.0%	0.0%	0.0%
Net Income (computed)	5,642	5,658	5,142	6,111	6,602	7,273	7,726	8,427	8,680
common size	16.1%	14.3%	11.9%	12.9%	12.8%	12.6%	12.5%	12.4%	12.4%
rate of change		0.3%	-9.1%	18.8%	8.0%	10.2%	6.2%	9.1%	3.0%
Other comprehensive income items	456	1,294	-3,793	0	0	0	0	0	0
common size	1.3%	3.3%	-8.8%	0.0%	0.0%	0.0%	0.0%	0.0%	0.0%
rate of change		183.8%	-393.1%	Assume random walk.	0.0%	0.0%	0.0%	0.0%	0.0%
Comprehensive Income	6,098	6,952	1,349	6,111	6,602	7,273	7,726	8,427	8,680
common size	17.4%	17.6%	3.1%	12.9%	12.8%	12.6%	12.5%	12.4%	12.4%
rate of change		14.0%	-80.6%	353.0%	8.0%	10.2%	6.2%	9.1%	3.0%

(Continued)

Forecasts Spreadsheet (Continued)

FSAP OUTPUT: FINANCIAL STATEMENT FORECASTS

Analyst Name: Wahlen, Baginski, and Bradshaw
Company Name: PepsiCo

Row Format:
Actual Amounts
Common-Size Percentage
Rate of Change Percentage

Row Format:
Forecast Amounts
Forecast assumption
Forecast assumption explanation

Year +6 and beyond:
Long-Run Growth Rate: 3.0%
Long-Run Growth Factor: 103.0%

Year	Actuals 2006	2007	2008	Forecasts Year +1	Year +2	Year +3	Year +4	Year +5	Year +6
BALANCE SHEET									
ASSETS:									
Cash and cash equivalents	1,651	910	2,064	1,551	1,695	1,890	2,032	2,230	2,297
common size	5.5%	2.6%	5.7%	12.0	12.0	12.0	12.0	12.0	
rate of change		−44.9%	126.8%	Assume ending cash balances equal to 12 days sales.					
Marketable securities	1,171	1,571	213	1,034	1,130	1,260	1,355	1,487	1,531
common size	3.9%	4.5%	0.6%	8.0	8.0	8.0	8.0	8.0	
rate of change		34.2%	−86.4%	Assume ending balances equal to 8 days sales.					
Accounts receivable—Net	3,725	4,389	4,683	5,143	5,593	6,380	6,492	7,633	7,862
common size	12.4%	12.7%	13.0%	38.0	38.0	38.0	38.0	38.0	
rate of change		17.8%	6.7%	Assume 38 days to collect sales in accounts receivable.					
Inventories	1,926	2,290	2,522	2,730	3,033	3,421	3,546	4,116	4,239
common size	6.4%	6.6%	7.0%	8.5	8.5	8.5	8.5	8.5	
rate of change		18.9%	10.1%	Assume average inventory turnover of roughly 8.5 times per year.					
Prepaid expenses and other current assets	657	991	1,324	1,445	1,578	1,760	1,892	2,077	2,139
common size	2.2%	2.9%	3.7%	9.1%	9.3%	11.5%	7.5%	9.7%	
rate of change		50.8%	33.6%	Assume growth with sales.					
Deferred tax assets—Current	0	0	0	0	0	0	0	0	0
common size	0.0%	0.0%	0.0%	0%	0%	0%	0%	0%	
rate of change		0.0%	0.0%	Assume steady growth.					
Other current assets (1)	0	0	0	0	0	0	0	0	0
common size	0.0%	0.0%	0.0%	0%	0%	0%	0%	0%	
rate of change		0.0%	0.0%	Assume steady growth.					

Other current assets (2)	0	0	0	0	0	0	0	0	0
common size	0.0%	0.0%	0.0%	0%	0%	0%	0%	0%	0%
rate of change *(Assume steady growth.)*	0.0%	0.0%	0.0%	0%	0%	0%	0%	0%	0%
Current Assets	9,130	10,151	10,806	11,904	13,029	14,712	15,318	17,543	18,069
common size	30.5%	29.3%	30.0%	30.9%	31.3%	32.1%	31.5%	32.8%	32.8%
rate of change		11.2%	6.5%	10.2%	9.5%	12.9%	4.1%	14.5%	3.0%
Long-term investments	3,690	4,354	3,883	4,116	4,363	4,625	4,902	5,196	5,352
common size	12.3%	12.6%	10.8%						
rate of change *(Assume steady growth.)*		18.0%	−10.8%	6%	6%	6%	6%	6%	
Property, plant, and equipment—At cost	19,058	21,896	22,552	24,723	27,662	30,939	34,463	38,330	39,480
common size	63.7%	63.2%	62.7%						
rate of change *(PP&E assumptions—see schedule in forecast development.)*		14.9%	3.0%						
<Accumulated depreciation>	−9,371	−10,668	−10,889	−12,471	−14,241	−16,220	−18,426	−20,878	−21,504
common size	−31.3%	−30.8%	−30.3%						
rate of change *(See depreciation schedule in forecast development worksheet.)*		13.8%	2.1%						
Amortizable intangible assets (net)	637	796	732	668	605	543	483	427	440
common size	2.1%	2.3%	2.0%						
rate of change *(Assume amortization per PepsiCo disclosures in Note 4; assume no new investments.)*		25.0%	−8.0%	−64.0	−63.0	−62.0	−60.0	−56.0	
Goodwill and nonamortizable intangibles	5,806	6,417	6,252	6,822	7,453	8,312	8,936	9,806	10,100
common size	19.4%	18.5%	17.4%						
rate of change *(Assume growth with sales.)*		10.5%	−2.6%	9.1%	9.3%	11.5%	7.5%	9.7%	
Deferred tax assets—Noncurrent	0	0	0	0	0	0	0	0	0
common size	0.0%	0.0%	0.0%	0%	0%	0%	0%	0%	0%
rate of change	0.0%	0.0%	0.0%	0%	0%	0%	0%	0%	0%
Other noncurrent assets (1)	980	1,682	2,658	2,738	2,820	2,904	2,992	3,081	3,174
common size	3.3%	4.9%	7.4%						
rate of change *(Assume steady state growth.)*		71.6%	58.0%	3.0%	3.0%	3.0%	3.0%	3.0%	3.0%
Other noncurrent assets (2)	0	0	0	0	0	0	0	0	0
common size	0.0%	0.0%	0.0%	0%	0%	0%	0%	0%	0%
rate of change *(Assume steady state growth.)*	0.0%	0.0%	0.0%	0%	0%	0%	0%	0%	0%
Total Assets	29,930	34,628	35,994	38,499	41,692	45,815	48,669	53,506	55,111
common size	100.0%	100.0%	100.0%	100.0%	100.0%	100.0%	100.0%	100.0%	100.0%
rate of change	15.7%	3.9%	7.0%	8.3%	9.9%	6.2%	9.9%	3.0%	3.0%

(Continued)

Forecasts Spreadsheet (Continued)

	Actuals			Forecasts					
Year	**2006**	**2007**	**2008**	**Year +1**	**Year +2**	**Year +3**	**Year +4**	**Year +5**	**Year +6**
LIABILITIES:									
Accounts payable—Trade	**2,102**	**2,562**	**2,846**	**3,080**	**3,442**	**3,875**	**3,947**	**4,768**	**4,911**
common size	7.0%	7.4%	7.9%	48.0	48.0	48.0	48.0	48.0	
rate of change		21.9%	11.1%	Assume a steady payment period consistent with recent years.					
Current accrued liabilities	**4,394**	**5,040**	**5,427**	**5,921**	**6,470**	**7,215**	**7,757**	**8,512**	**8,768**
common size	14.7%	14.6%	15.1%	9.1%	9.3%	11.5%	7.5%	9.7%	
rate of change		14.7%	7.7%	Assume growth with SG&A expenses, which grow with sales.					
Notes payable and short-term debt	**274**	**0**	**369**	**385**	**417**	**458**	**487**	**535**	**551**
common size	0.9%	0.0%	1.0%	1.0%	1.0%	1.0%	1.0%	1.0%	
rate of change		−100.0%		Assume 1.0 percent of total assets.					
Current maturities of long-term debt	**0**	**0**	**0**	**0**	**0**	**0**	**0**	**0**	**0**
common size	0.0%	0.0%	0.0%	0.0	0.0	0.0	0.0	0.0	
rate of change		0.0%	0.0%	Current maturities of long-term debt per long-term debt note					
Deferred tax liabilities—Current	**0**	**0**	**0**	**0**	**0**	**0**	**0**	**0**	**0**
common size	0.0%	0.0%	0.0%	0.0%	0.0%	0.0%	0.0%	0.0%	
rate of change		0.0%	0.0%	Assume steady state growth.					
Income taxes payable	**90**	**151**	**145**	**154**	**167**	**183**	**195**	**214**	**220**
common size	0.3%	0.4%	0.4%	0.4%	0.4%	0.4%	0.4%	0.4%	
rate of change		67.8%	−4.0%	Assume a steady percentage of total assets.					
Other current liabilities (1)	**0**	**0**	**0**	**0**	**0**	**0**	**0**	**0**	**0**
common size	0.0%	0.0%	0.0%	0.0%	0.0%	0.0%	0.0%	0.0%	
rate of change		0.0%	0.0%	Assume steady state growth.					
Other current liabilities (2)	**0**	**0**	**0**	**0**	**0**	**0**	**0**	**0**	**0**
common size	0.0%	0.0%	0.0%	0.0%	0.0%	0.0%	0.0%	0.0%	
rate of change		0.0%	0.0%	Assume steady state growth.					
Current Liabilities	**6,860**	**7,753**	**8,787**	**9,540**	**10,495**	**11,731**	**12,385**	**14,029**	**14,450**
common size	22.9%	22.4%	24.4%	24.8%	25.2%	25.6%	25.4%	26.2%	26.2%
rate of change		13.0%	13.3%	8.6%	10.0%	11.8%	5.6%	13.3%	3.0%

Long-term debt	2,550	4,203	7,858	8,405	9,102	10,002	10,625	11,681	12,031
common size	8.5%	12.1%	21.8%	21.8%	21.8%	21.8%	21.8%	21.8%	
rate of change		64.8%	87.0%	Assume steady percent of total assets.					
Long-term accrued liabilities	4,624	4,792	7,017	7,656	8,365	9,329	10,030	11,006	11,336
common size	15.4%	13.8%	19.5%	9.1%	9.3%	11.5%	7.5%	9.7%	
rate of change		3.6%	46.4%	Assume growth with SG&A expenses, which grow with sales.					
Deferred tax liabilities—Noncurrent	528	646	226	242	262	288	306	336	346
common size	1.8%	1.9%	0.6%	0.6%	0.6%	0.6%	0.6%	0.6%	
rate of change		22.3%	−65.0%	Assume steady percent of total assets.					
Other noncurrent liabilities (1)	0	0	0	0	0	0	0	0	0
common size	0.0%	0.0%	0.0%	0.0%	0.0%	0.0%	0.0%	0.0%	
rate of change		0.0%	0.0%	Assume steady state growth.					
Other noncurrent liabilities (2)	0	0	0	0	0	0	0	0	0
common size	0.0%	0.0%	0.0%	0.0%	0.0%	0.0%	0.0%	0.0%	
rate of change		0.0%	0.0%	Assume steady state growth.					
Total Liabilities	14,562	17,394	23,888	25,843	28,224	31,350	33,345	37,052	38,164
common size	48.7%	50.2%	66.4%	67.1%	67.7%	68.4%	68.5%	69.2%	69.2%
rate of change		19.4%	37.3%	8.2%	9.2%	11.1%	6.4%	11.1%	3.0%
SHAREHOLDERS' EQUITY:									
Minority interest	0	0	0	0	0	0	0	0	0
common size	0.0%	0.0%	0.0%	0.0	0.0	0.0	0.0	0.0	
rate of change		0.0%	0.0%	Minority interest assumptions					
Preferred stock	−79	−91	−97	0	0	0	0	0	0
common size	−0.3%	−0.3%	−0.3%	0.0	0.0	0.0	0.0	0.0	
rate of change		15.2%	6.6%	0.0	Preferred stock assumptions				
Common stock + Additional paid-in capital	614	480	381	408	441	485	515	566	583
common size	2.1%	1.4%	1.1%	1.1%	1.1%	1.1%	1.1%	1.1%	
rate of change		−21.8%	−20.6%	Assume steady percent of total assets.					
Retained earnings <deficit>	24,837	28,184	30,638	33,565	36,842	40,296	43,624	47,203	48,479
common size	83.0%	81.4%	85.1%						
rate of change		13.5%	8.7%	Add net income and subtract dividends; see dividends forecast box below.					
Accum. other comprehensive income <loss>	−2,246	−952	−4,694	−4,694	−4,694	−4,694	−4,694	−4,694	−4,694
common size	−7.5%	−2.7%	−13.0%	0.0	0.0	0.0	0.0	0.0	
rate of change		−57.6%	393.1%	Add accumulated other comprehensive income items from income statement.					

(Continued)

Forecasts Spreadsheet (Continued)

	Actuals			Forecasts					
Year	2006	2007	2008	Year +1	Year +2	Year +3	Year +4	Year +5	Year +6
Other equity adjustments	0	0	0	0	0	0	0	0	0
common size	0.0%	0.0%	0.0%	0.0	0.0	0.0	0.0	0.0	0
rate of change									
				Other equity adjustments assumptions					
<Treasury stock>	−7,758	−10,387	−14,122	−16,622	−19,122	−21,622	−24,122	−26,622	−27,421
common size	−25.9%	−30.0%	−39.2%	−2,500	−2,500	−2,500	−2,500	−2,500	−2,500
rate of change		33.9%	36.0%	Treasury stock repurchases, net of treasury stock reissues					
Common Shareholders' Equity	15,447	17,325	12,203.0	12,656.1	13,467.4	14,465.3	15,323.5	16,453.6	16,947
common size	51.6%	50.0%	33.9%	32.9%	32.3%	31.6%	31.5%	30.8%	30.8%
rate of change		12.2%	−29.6%	3.7%	6.4%	7.4%	5.9%	7.4%	3.0%
Total Liabilities and Equities	29,930	34,628	35,994	38,499	41,692	45,815	48,669	53,506	55,111
common size	100.0%	100.0%	100.0%	100.0%	100.0%	100.0%	100.0%	100.0%	100.0%
rate of change		15.7%	3.9%	7.0%	8.3%	9.9%	6.2%	9.9%	3.0%
Check figures:									
Balance Sheet A = L + OE?	0	0	0	0	0	0	0	0	0

Account adjusted: **Dividends**
Dividends forecasts:

	Year +1	Year +2	Year +3	Year +4	Year +5	Year +6
Common dividends:	2,571	3,055	3,301	3,636	3,863	3,979
	50.0%	50.0%	50.0%	50.0%	50.0%	50.0%

Assume dividend payout of lagged net income from continuing operations.

	Year +1	Year +2	Year +3	Year +4	Year +5	Year +6
Preferred dividends:	169	0	0	0	0	0
	169.0	0.0	0.0	0.0	0.0	0.0

Enter preferred stock dividend payments, if any.

	Year +1	Year +2	Year +3	Year +4	Year +5	Year +6
Implied dividends:	444	269	517	762	985	3,426

Implied dividend amount to balance the balance sheet

	Year +1	Year +2	Year +3	Year +4	Year +5	Year +6
Total dividends:	3,184	3,325	3,818	4,398	4,848	7,405

Total dividend forecast amounts

Forecasts Spreadsheet (Continued)

FSAP OUTPUT: FINANCIAL STATEMENT FORECASTS

| Analyst Name: | Wahlen, Baginski, and Bradshaw |
| Company Name: | PepsiCo |

	Actuals		Forecasts					
IMPLIED STATEMENT OF CASH FLOWS	2007	2008	Year +1	Year +2	Year +3	Year +4	Year +5	Year +6
Net Income	5,658	5,142	6,111	6,602	7,273	7,726	8,427	8,680
Add back depreciation expense (net)	1,297	221	1,582	1,770	1,980	2,205	2,453	626
Add back amortization expense (net)	58	64	64	63	62	60	56	58
<Increase> Decrease in receivables—Net	−664	−294	−460	−450	−787	−112	−1,141	−229
<Increase> Decrease in inventories	−364	−232	−208	−303	−388	−125	−569	−123
<Increase> Decrease in prepaid expenses	−334	−333	−121	−134	−182	−132	−184	−62
<Increase> Decrease in other current assets (1)	0	0	0	0	0	0	0	0
<Increase> Decrease in other current assets (2)	0	0	0	0	0	0	0	0
Increase <Decrease> in accounts payable—Trade	460	284	234	362	433	72	821	143
Increase <Decrease> in current accrued liabilities	646	387	494	548	745	542	755	255
Increase <Decrease> in income taxes payable	61	−6	9	13	16	11	19	6
Increase <Decrease> in other current liabilities (1)	0	0	0	0	0	0	0	0
Increase <Decrease> in other current liabilities (2)	0	0	0	0	0	0	0	0
Net change in deferred tax assets and liabilities	118	−420	16	20	26	18	30	10
Increase <Decrease> in long-term accrued liabilities	168	2,225	639	709	964	700	977	330
Increase <Decrease> in other noncurrent liabilities (1)	0	0	0	0	0	0	0	0
Increase <Decrease> in other noncurrent liabilities (2)	0	0	0	0	0	0	0	0
Net Cash Flows from Operations	7,104	7,038	8,360	9,201	10,142	10,966	11,644	9,694

(Continued)

Forecasts Spreadsheet (Continued)

FSAP OUTPUT: **FINANCIAL STATEMENT FORECASTS**

Analyst Name: Wahlen, Baginski, and Bradshaw
Company Name: PepsiCo

Year	Actuals		Forecasts					
	2007	2008	Year +1	Year +2	Year +3	Year +4	Year +5	Year +6
IMPLIED STATEMENT OF CASH FLOWS *(Continued)*								
<Increase> Decrease in property, plant, & equip. at cost	−2,838	−656	−2,171	−2,939	−3,278	−3,524	−3,867	−1,150
<Increase> Decrease in marketable securities	−400	1,358	−821	−96	−130	−95	−132	−45
<Increase> Decrease in investment securities	−664	471	−233	−247	−262	−277	−294	−156
<Increase> Decrease in amortizable intangible assets (net)	−217	0	0	0	0	0	0	−70
<Increase> Decrease in goodwill and nonamort. intangibles	−611	165	−570	−632	−859	−624	−870	−294
<Increase> Decrease in other noncurrent assets (1)	−702	−976	−80	−82	−85	−87	−90	−92
<Increase> Decrease in other noncurrent assets (2)	0	0	0	0	0	0	0	0
Net Cash Flows from Investing Activities	**−5,432**	**362**	**−3,874**	**−3,996**	**−4,613**	**−4,607**	**−5,253**	**−1,808**
Increase <Decrease> in short-term debt	−274	369	16	32	41	29	48	16
Increase <Decrease> in long-term debt	1,653	3,655	547	697	900	623	1,056	350
Increase <Decrease> in minority interest and preferred stock	−12	−6	97	0	0	0	0	0
Increase <Decrease> in common stock + paid-in capital	−134	−99	27	34	44	30	51	17
Increase <Decrease> in accum. OCI and other equity adjs.	1,294	−3,742	0	0	0	0	0	0
Increase <Decrease> in treasury stock	−2,629	−3,735	−2,500	−2,500	−2,500	−2,500	−2,500	−799
Dividends	−2,311	−2,688	−3,184	−3,325	−3,818	−4,398	−4,848	−7,405
Net Cash Flows from Financing Activities	**−2,413**	**−6,246**	**−4,998**	**−5,062**	**−5,333**	**−6,217**	**−6,193**	**−7,820**
Net Change in Cash	**−741**	**1,154**	**−513**	**144**	**195**	**142**	**198**	**67**

Check Figure:
Net change in cash − Change in cash balance = 0 | 0 | 0 | 0 | 0 | 0 | 0 | 0

FSAP OUTPUT: FINANCIAL STATEMENT FORECASTS

Analyst Name: Wahlen, Baginski, and Bradshaw
Company Name: PepsiCo

	Actuals			Forecasts						
Year	2006	2007	2008	Year +1	Year +2	Year +3	Year +4	Year +5	Year +6	
FORECAST VALIDITY CHECK DATA:										
GROWTH:										
Revenue Growth Rates	7.9%	12.3%	9.6%	9.1%	9.3%	11.5%	7.5%	9.7%	3.0%	
Net Income Growth Rates	38.4%	0.3%	−9.1%	18.8%	8.0%	10.2%	6.2%	9.1%	3.0%	
Total Asset Growth Rates	−5.7%	15.7%	3.9%	7.0%	8.3%	9.9%	6.2%	9.9%	3.0%	
RETURN ON ASSETS (based on reported amounts):										
Profit Margin for ROA	16.5%	14.7%	12.4%	13.7%	13.6%	13.4%	13.2%	13.2%	13.2%	
× Asset Turnover	1.1	1.2	1.2	1.3	1.3	1.3	1.3	1.3	1.3	
= Return on Assets	18.8%	18.0%	15.2%	17.4%	17.4%	17.6%	17.3%	17.5%	16.9%	
RETURN ON ASSETS (excluding the effects of nonrecurring items):										
Profit Margin for ROA	16.5%	14.7%	12.4%	13.7%	13.6%	13.4%	13.2%	13.2%	13.2%	
× Asset Turnover	1.1	1.2	1.2	1.3	1.3	1.3	1.3	1.3	1.3	
= Return on Assets	18.8%	18.0%	15.2%	17.4%	17.4%	17.6%	17.3%	17.5%	16.9%	
RETURN ON COMMON EQUITY (based on reported amounts):										
Profit Margin for ROCE	16.1%	14.3%	11.9%	12.6%	12.8%	12.6%	12.5%	12.4%	12.4%	
× Asset Turnover	1.1	1.2	1.2	1.3	1.3	1.3	1.3	1.3	1.3	
× Capital Structure Leverage	2.1	2.0	2.4	3.0	3.1	3.1	3.2	3.2	3.3	
= Return on Common Equity	37.9%	34.5%	34.8%	47.8%	50.5%	52.1%	51.9%	53.0%	52.0%	
RETURN ON COMMON EQUITY (excluding the effects of nonrecurring items):										
Profit Margin for ROCE	16.1%	14.3%	11.9%	12.6%	12.8%	12.6%	12.5%	12.4%	12.4%	
× Asset Turnover	1.1	1.2	1.2	1.3	1.3	1.3	1.3	1.3	1.3	
× Capital Structure Leverage	2.1	2.0	2.4	3.0	3.1	3.1	3.2	3.2	3.3	
= Return on Common Equity	37.9%	34.5%	34.8%	47.8%	50.5%	52.1%	51.9%	53.0%	52.0%	

(Continued)

Forecasts Spreadsheet (Continued)

FSAP OUTPUT: FINANCIAL STATEMENT FORECASTS

Analyst Name: Wahlen, Baginski, and Bradshaw
Company Name: PepsiCo

	Actuals			Forecasts						
Year	2006	2007	2008	Year +1	Year +2	Year +3	Year +4	Year +5	Year +6	
OPERATING PERFORMANCE:										
Gross Profit/Revenues	55.1%	54.3%	52.9%	52.7%	52.5%	52.3%	52.1%	52.0%	52.0%	
Operating Profit before Taxes/Revenues	18.5%	18.2%	16.0%	17.6%	17.4%	17.2%	17.0%	16.9%	16.9%	
ASSETS TURNOVER:										
Revenues/Average Accounts Receivable	10.1	9.7	9.5	9.6	9.6	9.6	9.6	9.6	9.0	
COGS/Average Inventory	8.7	8.6	8.5	8.5	8.5	8.5	8.5	8.5	8.0	
Revenues/Average Fixed Assets	3.8	3.8	3.8	3.9	4.0	4.1	4.0	4.1	3.9	
LIQUIDITY:										
Current Ratio	1.3	1.3	1.2	1.2	1.2	1.3	1.2	1.3	1.3	
Quick Ratio	1.0	0.9	0.8	0.8	0.8	0.8	0.8	0.8	0.8	
SOLVENCY:										
Total Liabilities/Total Assets	48.7%	50.2%	66.4%	67.1%	67.7%	68.4%	68.5%	69.2%	69.2%	
Total Liabilities/Total Equity	94.3%	100.4%	195.8%	204.2%	209.6%	216.7%	217.6%	225.2%	225.2%	
Interest Coverage Ratio	30.2	35.1	22.3	17.9	18.0	18.1	17.9	18.0	18.0	

Forecasts Development Spreadsheet

This Forecast Development spreadsheet provides work space in which the analyst can:

- **build detailed sales revenue forecasts**
- **build forecasts of capital expenditures; property, plant, and equipment; depreciation expense; and accumulated depreciation**
- **build detailed forecasts of other financial statement amounts**

It is not necessary to use this spreadsheet to build financial statement forecasts in the FSAP Forecasts spreadsheet. If you use this spreadsheet to build more detailed forecasts, you must link these forecast amounts to the appropriate cells in the financial statements in the FSAP Forecasts spreadsheet.

Analyst Name: Wahlen, Baginski, and Bradshaw
Company Name: PepsiCo

Sales Revenue Forecast Development

Year	Actuals			Forecasts				
	2006	2007	2008	Year +1	Year +2	Year +3	Year +4	Year +5
Revenues	**35,137**	**39,474**	**43,251**	**47,191**	**51,562**	**57,502**	**61,820**	**67,839**
growth rates		12.3%	9.6%	9.1%	9.3%	11.5%	7.5%	9.7%
				Sales growth rate assumptions				
Sales Forecasts Combined by Segments:								
Frito-Lay North America	10,844	11,586	12,507	13,269	14,077	15,221	15,843	16,808
Quaker Foods North America	1,769	1,860	1,902	1,979	2,058	2,183	2,228	2,317
Latin America Foods	3,972	4,872	5,895	6,660	7,524	8,663	9,602	10,848
PepsiCo Americas Foods	**16,585**	**18,318**	**20,304**	**21,907**	**23,659**	**26,067**	**27,673**	**29,974**
PepsiCo Americas Beverages	**10,362**	**11,090**	**10,937**	**11,603**	**12,310**	**13,310**	**13,855**	**14,698**
United Kingdom & Europe	4,750	5,492	6,435	7,168	7,984	9,063	9,905	11,032
Middle East, Africa & Asia	3,440	4,574	5,575	6,513	7,610	9,061	10,387	12,135
PepsiCo International	**8,190**	**10,066**	**12,010**	**13,681**	**15,593**	**18,125**	**20,291**	**23,167**
PepsiCo Total Net Revenues	**35,137**	**39,474**	**43,251**	**47,191**	**51,562**	**57,502**	**61,820**	**67,839**
growth rates		12.3%	9.6%	9.1%	9.3%	11.5%	7.5%	9.7%

(Continued)

Forecasts Development Spreadsheet (Continued)

Sales Forecasts for PepsiCo:

Year	2006	2007	2008	Year +1	Year +2	Year +3	Year +4	Year +5
PepsiCo Americas Foods	16,585	18,318	20,304	21,907	23,659	26,067	27,673	29,974
growth rates		10.4%	10.8%	7.9%	8.0%	10.2%	6.2%	8.3%
compound growth rate			10.6%					
Frito-Lay North America	10,844	11,586	12,507	13,269	14,077	15,221	15,843	16,808
growth rates		6.8%	7.9%	6.1%	6.1%	8.1%	4.1%	6.1%
compound growth rate			7.4%					
compound growth in volume			1.5%	3.0%	3.0%	3.0%	3.0%	3.0%
compound growth in prices			5.6%	3.0%	3.0%	3.0%	3.0%	3.0%
foreign exchange and acquisitions			0.2%	0.0%	0.0%	0.0%	0.0%	0.0%
53rd-week effect				0.0%	0.0%	1.9%	-1.9%	0.0%
Quaker Foods North America	1,769	1,860	1,902	1,979	2,058	2,183	2,228	2,317
growth rates		5.1%	2.3%	4.0%	4.0%	6.0%	2.1%	4.0%
compound growth rate			3.7%					
compound growth in volume			0.2%	1.0%	1.0%	1.0%	1.0%	1.0%
compound growth in prices			2.9%	3.0%	3.0%	3.0%	3.0%	3.0%
foreign exchange and acquisitions			0.5%	0.0%	0.0%	0.0%	0.0%	0.0%
53rd-week effect				0.0%	0.0%	1.9%	-1.9%	0.0%
Latin America Foods	3,972	4,872	5,895	6,660	7,524	8,663	9,602	10,848
growth rates		22.7%	21.0%	13.0%	13.0%	15.1%	10.8%	13.0%
compound growth rate			21.8%					
compound growth in volume			2.5%	2.5%	2.5%	2.5%	2.5%	2.5%
compound growth in prices			7.0%	5.0%	5.0%	5.0%	5.0%	5.0%
foreign exchange and acquisitions			11.1%	5.0%	5.0%	5.0%	5.0%	5.0%
53rd-week effect				0.0%	0.0%	1.9%	-1.9%	0.0%
PepsiCo Americas Beverages	10,362	11,090	10,937	11,603	12,310	13,310	13,855	14,698
growth rates		7.0%	-1.4%	6.1%	6.1%	8.1%	4.1%	6.1%
compound growth rate			2.7%					
compound growth in volume			-2.8%	3.0%	3.0%	3.0%	3.0%	3.0%
compound growth in prices			4.4%	3.0%	3.0%	3.0%	3.0%	3.0%
foreign exchange and acquisitions			1.2%	0.0%	0.0%	0.0%	0.0%	0.0%
53rd-week effect				0.0%	0.0%	1.9%	-1.9%	0.0%

	2006	2007	2008	Year +1	Year +2	Year +3	Year +4	Year +5
PepsiCo International	8,190	10,066	12,010	13,681	15,593	18,125	20,291	**23,167**
growth rates		22.9%	19.3%	13.9%	14.0%	16.2%	12.0%	14.2%
compound growth rate			21.1%					
United Kingdom & Europe	4,750	5,492	6,435	7,168	7,984	9,063	9,905	**11,032**
growth rates		15.6%	17.2%	11.4%	11.4%	13.5%	9.3%	11.4%
compound growth rate			16.4%					
compound growth in volume			4.0%	4.0%	4.0%	4.0%	4.0%	4.0%
compound growth in prices			2.1%	2.0%	2.0%	2.0%	2.0%	2.0%
foreign exchange and acquisitions			9.6%	5.0%	5.0%	5.0%	5.0%	5.0%
53rd-week effect				0.0%	0.0%	1.9%	-1.9%	0.0%
Middle East, Africa & Asia	3,440	4,574	5,575	6,513	7,610	9,061	10,387	**12,135**
growth rates		33.0%	21.9%	16.8%	16.8%	19.1%	14.6%	16.8%
compound growth rate			27.3%					
compound growth in volume			12.5%	8.0%	8.0%	8.0%	8.0%	8.0%
compound growth in prices			3.0%	3.0%	3.0%	3.0%	3.0%	3.0%
foreign exchange and acquisitions			9.8%	5.0%	5.0%	5.0%	5.0%	5.0%
53rd-week effect				0.0%	0.0%	1.9%	-1.9%	0.0%

Forecast Development: Capital Expenditures; Property, Plant, and Equipment; and Depreciation

				CAPEX Forecasts				
Capital Expenditures	2006	2007	2008	Year +1	Year +2	Year +3	Year +4	Year +5
CAPEX:								
PP&E Acquired	2,068	2,430	2,446					
PP&E Sold	-49	-47	-98					
Net CAPEX	2,019	2,383	2,348	2,171	2,939	3,278	3,524	3,867
Net CAPEX as a percent of:								
Gross PP&E	10.6%	10.9%	10.4%					
Revenues	5.7%	6.0%	5.4%	4.6%	5.7%	5.7%	5.7%	5.7%

(Continued)

Forecasts Development Spreadsheet (Continued)

Property, Plant, and Equipment and Depreciation

				Property, Plant, and Equipment and Depreciation Forecasts				
PP&E at cost:	**2006**	**2007**	**2008**	**Year +1**	**Year +2**	**Year +3**	**Year +4**	**Year +5**
Beginning balance at cost:				22,552	24,723	27,662	30,939	34,463
Add: CAPEX forecasts from above:				2,171	2,939	3,278	3,524	3,867
Ending balance at cost:	19,058	21,896	22,552	24,723	27,662	30,939	34,463	38,330
Accumulated Depreciation:								
Beginning Balance:				−10,889	−12,471	−14,241	−16,220	−18,426
Subtract: Depreciation expense forecasts from below:				−1,582	−1,770	−1,980	−2,205	−2,453
Ending Balance:	−9,371	−10,668	−10,889	−12,471	−14,241	−16,220	−18,426	−20,878
PP&E—Net:	9,687	11,228	11,663	12,252	13,421	14,719	16,038	17,452

Depreciation Expense Forecast Development:

				Depreciation expense forecast on existing PP&E:				
Existing PP&E at cost:			22,552	1,443	1,443	1,443	1,443	1,443
PP&E Purchases:				Depreciation expense forecasts on new PP&E:				
CAPEX Year +1			2,171	139	139	139	139	139
CAPEX Year +2			2,939		188	188	188	188
CAPEX Year +3			3,278			210	210	210
CAPEX Year +4			3,524				225	225
CAPEX Year +5			3,867					247
Total Depreciation Expense				1,582	1,770	1,980	2,205	2,453

Depreciation methods:

	2006	**2007**	**2008**
PP&E at Cost	19,058	21,896	22,552
Average Depreciable PP&E		20,477	22,224
Depreciation Expense	1,182	1,304	1,422
Implied Average Useful Life in Years		15.7	15.6
Useful Life Forecast Assumption:			15.6 (years)

Valuation Spreadsheet

DATA CHECKS – Estimated Value per Share

Dividend-Based Valuation	$83.03
Free Cash Flow Valuation	$83.03
Residual Income Valuation	$83.03
Residual Income Market-to-Book Valuation	$83.03
Free Cash Flow for All Debt and Equity Valuation	$83.99

Check: All Estimated Value per Share amounts should be the same, with the possible exception of the share value from the Free Cash Flow for All Debt and Equity model.

FSAP OUTPUT:	VALUATION MODELS

Analyst Name:	**Wahlen, Baginski, and Bradshaw**
Company Name:	**PepsiCo**

VALUATION PARAMETER ASSUMPTIONS

Current share price	$ 54.77	**COST OF DEBT CAPITAL**	
Number of shares outstanding	1,553.0	Debt capital	$ 8,227
Current market value	$85,058	Cost of debt capital, before tax	5.8%
Long-run growth assumption used		Effective tax rate	−26.8%
in forecasts	3.0%	After-tax cost of debt capital	4.25%
Long-run growth assumption used			
in valuation	3.0%	**COST OF PREFERRED STOCK**	
(Both long-run growth assumptions		Preferred stock capital	$ —
should be the same.)		Preferred dividends	$ —
		Implied yield	0.00%
COST OF EQUITY CAPITAL		**WEIGHTED AVERAGE COST OF CAPITAL**	
Equity risk factor (market beta)	0.75	Weight of equity in capital structure	0.912
Risk-free rate	4.0%	Weight of debt in capital structure	0.088
Market risk premium	6.0%	Weight of preferred in capital structure	0.00
Required rate of return on common equity	8.50%	Weighted average cost of capital	8.12%

(Continued)

Valuation Spreadsheet (Continued)

FSAP OUTPUT:	VALUATION MODELS

Analyst Name:	Wahlen, Baginski, and Bradshaw
Company Name:	PepsiCo

	1	2	3	4	5	Continuing Value
DIVIDENDS-BASED VALUATION	Year +1	Year +2	Year +3	Year +4	Year +5	Year +6
Dividends Paid to						
Common Shareholders	3,015.3	3,324.5	3,818.5	4,398.5	4,848.3	
Less: Common Stock Issues	−26.5	−33.8	−43.7	−30.2	−51.2	
Plus: Common Stock Repurchases	2,500.0	2,500.0	2,500.0	2,500.0	2,500.0	
Dividends to Common Equity	**5,488.8**	**5,790.7**	**6,274.8**	**6,868.3**	**7,297.1**	**8,186.5**
Present Value Factors	0.922	0.849	0.783	0.722	0.665	
Present Value Net Dividends	5,058.8	4,919.0	4,912.6	4,956.0	4,852.9	
Sum of Present Value Net Dividends	24,699.3					
Present Value of Continuing Value	98,988.9					
Total	123,688.2					
Adjust to Midyear Discounting	1.0425					
Total Present Value Dividends	128,945.0					
Shares Outstanding	1,553.0					
Estimated Value per Share	$83.03					
Current share price	$54.77					
Percent difference	52%					

Valuation Spreadsheet (Continued)

FSAP OUTPUT: **VALUATION MODELS**

Analyst Name:	**Wahlen, Baginski, and Bradshaw**
Company Name:	**PepsiCo**

	1	2	3	4	5	Continuing Value
FREE CASH FLOWS FOR COMMON EQUITY	Year +1	Year +2	Year +3	Year +4	Year +5	Year +6
Net Cash Flow from Operations	8,359.9	9,201.1	10,141.5	10,965.8	11,643.5	9,694.4
Decrease (Increase) in Cash Required for Operations	512.5	−143.7	−195.3	−141.9	−197.9	−66.9
Net Cash Flow from Investing	−3,874.4	−3,995.7	−4,612.9	−4,607.1	−5,252.9	−1,807.5
Net CFs from Debt Financing	562.8	729.0	941.5	651.5	1,104.4	366.5
Net CFs into Financial Assets	0.0	0.0	0.0	0.0	0.0	0.0
Net CFs—Pref. Stock and Minority Int.	−72.0	0.0	0.0	0.0	0.0	0.0
Free Cash Flow for Common Equity	**5,488.8**	**5,790.7**	**6,274.8**	**6,868.3**	**7,297.1**	**8,186.5**
Present Value Factors	0.922	0.849	0.783	0.722	0.665	
Present Value Free Cash Flows	5,058.8	4,919.0	4,912.6	4,956.0	4,852.9	
Sum of Present Value Free Cash Flows	24,699.3					
Present Value of Continuing Value	98,988.9					
Total	123,688.2					
Adjust to Midyear Discounting	1.0425					
Total Present Value Free Cash Flows to Equity	128,945.0					
Shares Outstanding	1,553.0					
Estimated Value per Share	$83.03					
Current share price	$54.77					
Percent difference	52%					

(Continued)

Valuation Spreadsheet (Continued)

FSAP OUTPUT: VALUATION MODELS

| Analyst Name: | Wahlen, Baginski, and Bradshaw |
| Company Name: | PepsiCo |

FREE CASH FLOW VALUATION SENSITIVITY ANALYSIS:

		Long-Run Growth Assumptions							
		0%	2%	3%	4%	5%	6%	8%	10%
Discount	5%	105.16	160.50	229.67	437.20				
Rates:	6%	87.18	120.00	152.81	218.45	415.34			
	7%	74.37	95.73	114.41	145.56	207.85	394.72		
	8.50%	60.84	73.36	83.03	97.00	118.95	158.47	711.69	
	9%	57.34	68.04	76.06	87.30	104.14	132.22	356.87	
	10%	51.41	59.41	65.13	72.75	83.42	99.42	179.45	
	11%	46.57	52.71	56.94	62.37	69.61	79.75	120.30	323.07
	12%	42.55	47.37	50.58	54.59	59.76	66.64	90.73	163.00
	13%	39.16	43.00	45.50	48.55	52.37	57.28	72.98	109.63
	14%	36.26	39.37	41.35	43.73	46.63	50.26	61.15	82.93
	15%	33.76	36.30	37.90	39.78	42.04	44.80	52.70	66.90
	16%	31.57	33.68	34.98	36.50	38.29	40.44	46.35	56.21
	18%	27.95	29.44	30.33	31.35	32.53	33.90	37.47	42.83
	20%	25.08	26.16	26.79	27.51	28.31	29.24	31.55	34.79

Valuation Spreadsheet (Continued)

FSAP OUTPUT: **VALUATION MODELS**

Analyst Name:	**Wahlen, Baginski, and Bradshaw**	
Company Name:	**PepsiCo**	

	1	2	3	4	5	Continuing Value
RESIDUAL INCOME VALUATION	**Year +1**	**Year +2**	**Year +3**	**Year +4**	**Year +5**	**Year +6**
Comprehensive Income Available for Common Shareholders	5,941.9	6,602.1	7,272.7	7,726.4	8,427.3	8,680.1
Lagged Book Value of Common Shareholders' Equity (at t-1)	12,203.0	12,656.1	13,467.4	14,465.3	15,323.5	16,453.6
Required Earnings	1,037.3	1,075.8	1,144.7	1,229.5	1,302.5	1,398.6
Residual Income	**4,904.6**	**5,526.3**	**6,128.0**	**6,496.9**	**7,124.8**	**7,281.5**
Present Value Factors	0.922	0.849	0.783	0.722	0.665	
Present Value Residual Income	4,520.4	4,694.4	4,797.6	4,688.0	4,738.3	
Sum of Present Value Residual Income	23,438.7					
Present Value of Continuing Value	88,046.5					
Total	111,485.2					
Add: Beginning Book Value of Equity	12,203.0					
Present Value of Equity	123,688.2					
Adjust to Midyear Discounting	1.0425					
Total Present Value of Equity	128,945.0					
Shares Outstanding	1,553.0					
Estimated Value per Share	$83.03					
Current share price	$54.77					
Percent difference	52%					

(Continued)

Valuation Spreadsheet (Continued)

FSAP OUTPUT: **VALUATION MODELS**

| Analyst Name: | **Wahlen, Baginski, and Bradshaw** |
| Company Name: | **PepsiCo** |

RESIDUAL INCOME VALUATION SENSITIVITY ANALYSIS:

| | | *Long-Run Growth Assumptions* | | | | | | | |
		0%	2%	3%	4%	5%	6%	8%	10%
Discount	5%	105.16	160.50	229.67	437.20				
Rates:	6%	87.18	120.00	152.81	218.45	415.34			
	7%	74.37	95.73	114.41	145.56	207.85	394.72		
	8.50%	60.84	73.36	83.03	97.00	118.95	158.47	711.69	
	9%	57.34	68.04	76.06	87.30	104.14	132.22	356.87	
	10%	51.41	59.41	65.13	72.75	83.42	99.42	179.45	
	11%	46.57	52.71	56.94	62.37	69.61	79.75	120.30	323.07
	12%	42.55	47.37	50.58	54.59	59.76	66.64	90.73	163.00
	13%	39.16	43.00	45.50	48.55	52.37	57.28	72.98	109.63
	14%	36.26	39.37	41.35	43.73	46.63	50.26	61.15	82.93
	15%	33.76	36.30	37.90	39.78	42.04	44.80	52.70	66.90
	16%	31.57	33.68	34.98	36.50	38.29	40.44	46.35	56.21
	18%	27.95	29.44	30.33	31.35	32.53	33.90	37.47	42.83
	20%	25.08	26.16	26.79	27.51	28.31	29.24	31.55	34.79

Valuation Spreadsheet (Continued)

FSAP OUTPUT: **VALUATION MODELS**

Analyst Name: **Wahlen, Baginski, and Bradshaw**
Company Name: **PepsiCo**

	1	2	3	4	5	Continuing Value
Market-to-Book Approach	Year +1	Year +2	Year +3	Year +4	Year +5	Year +6
Comprehensive Income Available for Common Shareholders	5,941.9	6,602.1	7,272.7	7,726.4	8,427.3	8,680.1
Book Value of Common Shareholders' Equity (at t-1)	12,203.0	12,656.1	13,467.4	14,465.3	15,323.5	16,453.6
Implied ROCE	48.7%	52.2%	54.0%	53.4%	55.0%	52.8%
Residual ROCE	40.2%	43.7%	45.5%	44.9%	46.5%	44.3%
Cumulative growth factor in common equity as of t-1	100.0%	103.7%	110.4%	118.5%	125.6%	134.8%
Residual ROCE times cumulative growth	**40.2%**	**45.3%**	**50.2%**	**53.2%**	**58.4%**	**59.7%**
Present Value Factors	0.922	0.849	0.783	0.722	0.665	
Present Value Residual ROCE times growth	0.370	0.385	0.393	0.384	0.388	
Sum of Present Value Residual ROCE times growth	1.92					
Present Value of Continuing Value	7.22					
Total Present Value Residual ROCE	9.14					
Add one for book value of equity at t-1	1.00					
Sum	10.14					
Adjust to Midyear Discounting	1.0425					
Implied Market-to-Book Ratio	10.567					
Times Beginning Book Value of Equity	12,203.0					
Total Present Value of Equity	128,945.0					
Shares Outstanding	1,553.0					
Estimated Value per Share	$83.03					
Current share price	$54.77					
Percent difference	52%					

Sensitivity analysis for the market-to-book approach should be identical to that of the residual income approach.

(Continued)

Valuation Spreadsheet (Continued)

FSAP OUTPUT: VALUATION MODELS

| Analyst Name: | Wahlen, Baginski, and Bradshaw |
| Company Name: | PepsiCo |

	1	2	3	4	5	Continuing Value
FREE CASH FLOWS FOR ALL DEBT AND EQUITY	Year +1	Year +2	Year +3	Year +4	Year +5	Year +6
Net Cash Flow from Operations	8,359.9	9,201.1	10,141.5	10,965.8	11,643.5	9,694.4
Add back: Interest Expense after tax	361.2	388.7	424.1	457.9	495.2	510.1
Subtract: Interest Income after tax	0.0	0.0	0.0	0.0	0.0	0.0
Decrease (Increase) in Cash Required for Operations	512.5	−143.7	−195.3	−141.9	−197.9	−66.9
Free Cash Flow from Operations	9,233.6	9,446.1	10,370.3	11,281.8	11,940.8	10,137.6
Net Cash Flow from Investing	−3,874.4	−3,995.7	−4,612.9	−4,607.1	−5,252.9	−1,807.5
Add back: Net Cash Flows into Financial Assets	0.0	0.0	0.0	0.0	0.0	0.0
Free Cash Flows—All Debt and Equity	**5,359.3**	**5,450.4**	**5,757.4**	**6,674.7**	**6,688.0**	**8,330.1**
Present Value Factors	0.925	0.855	0.791	0.732	0.677	
Present Value Free Cash Flows	4,956.5	4,662.1	4,554.6	4,883.5	4,525.5	

Sum of Present Value Free Cash Flows	23,582.3
Present Value of Continuing Value	109,988.1
Total Present Value Free Cash Flows to Equity and Debt	133,570.4
Less: Value of Outstanding Debt	−8,227.0
Less: Value of Preferred Stock	0.0
Plus: Value of Financial Assets	0.0
Present Value of Equity	125,343.4
Adjust to Midyear Discounting	1.0406
Total Present Value of Equity	130,435.3
Shares Outstanding	1,553.0
Estimated Value per Share	$83.99
Current share price	$54.77
Percent difference	53%

Appendix D

Financial Statement Ratios: Descriptive Statistics by Industry and by Year

This appendix contains descriptive statistics on 24 financial statement ratios, which are defined and explained in Chapters 4 and 5 and used throughout this book. The formulae to compute the ratios also are presented on the inside back cover of the book. The descriptive statistics include the 25th percentile, median, and 75th percentile for each industry over the period 1998–2008. In addition, the statistics report the industry median for each ratio in 2008, 2007, and 2006. The appendix contains descriptive statistics for 48 individual industries (listed alphabetically) and aggregated across all industries. These data are helpful for benchmarking financial statement ratios of companies you are analyzing, as well as for developing forecast assumptions and projections.

The website for this book (www.cengage.com/accounting/wahlen) contains an Excel file with these descriptive statistics data, the formulae used to compute the ratios (specified with variable names from the Compustat database), and the specific Standard Industrial Classification (SIC) codes included in each of the 48 industries.

| | | 1998–2008 | | | 2008 | 2007 | 2006 |
		25th Percentile	Median	75th Percentile	Median	Median	Median
All Industries	Stock Return	−0.333	0.018	0.428	−0.455	−0.046	0.130
	Market-to-Book	1.065	1.798	3.302	1.103	1.931	2.212
	Price-Earnings	11.152	16.667	26.784	12.963	17.498	18.470
	Profit Margin for ROA	−0.127	0.035	0.111	0.028	0.048	0.054
	Total Asset Turnover	0.256	0.705	1.296	0.664	0.659	0.687
	ROA	−0.140	0.029	0.077	0.012	0.034	0.041
	Profit Margin for ROCE	−0.132	0.026	0.097	0.016	0.039	0.045
	Capital Structure						
	Leverage	1.458	2.169	3.989	2.104	2.059	2.105
	ROCE	−0.134	0.073	0.171	0.039	0.078	0.095
	Gross Profit Margin	0.198	0.364	0.564	0.352	0.375	0.382
	SG&A Percentage	0.149	0.271	0.475	0.262	0.261	0.264
	Operating Income						
	Margin	−0.061	0.064	0.175	0.066	0.081	0.083
	Days Receivable	33.392	52.871	76.473	49.130	51.840	51.012
	Days Inventory	20.671	58.191	113.093	54.511	54.443	54.420
	Days Payables	29.828	51.414	115.666	48.977	51.717	50.970
	Days Revenues in Cash	9.799	37.625	120.649	42.829	44.162	42.692
	Revenue Growth	−0.042	0.085	0.270	0.054	0.097	0.126
	Earnings Growth	−0.599	0.067	0.602	−0.166	0.020	0.097
	Assets Growth	−0.064	0.056	0.232	0.006	0.078	0.094
	Current Ratio	1.001	1.701	3.070	1.709	1.816	1.776
	Long-Term Debt to						
	Common Equity	0.139	0.484	1.145	0.544	0.469	0.447
	Interest Coverage Ratio	−4.073	1.763	6.962	1.377	2.178	2.618
	Liabilities to Equity	0.414	1.100	2.802	1.103	1.016	1.014
	Operating Cash Flow						
	to Current Liabilities	−0.099	0.074	0.236	0.075	0.075	0.076

		1998–2008			2008	2007	2006
		25th Percentile	Median	75th Percentile	Median	Median	Median
Agriculture	Stock Return	−0.327	0.011	0.347	−0.312	0.221	0.139
	Market-to-Book	0.517	1.062	2.365	1.095	2.187	2.168
	Price-Earnings	8.292	16.827	29.923	10.833	25.381	29.659
	Profit Margin for ROA	−0.092	0.039	0.105	0.028	0.034	0.041
	Total Asset Turnover	0.400	0.760	1.261	1.050	0.803	0.793
	ROA	−0.054	0.032	0.076	0.042	0.060	0.036
	Profit Margin for ROCE	−0.082	0.024	0.077	0.021	0.024	0.023
	Capital Structure Leverage	1.685	2.283	3.286	2.155	2.091	2.425
	ROCE	−0.103	0.060	0.153	0.110	0.060	0.045
	Gross Profit Margin	0.173	0.298	0.394	0.255	0.269	0.286
	SG&A Percentage	0.101	0.206	0.315	0.124	0.141	0.206
	Operating Income Margin	−0.032	0.049	0.118	0.034	0.052	0.040
	Days Receivable	23.803	34.641	69.335	30.235	33.707	34.483
	Days Inventory	37.532	74.519	260.355	45.801	49.878	57.530
	Days Payables	21.025	32.690	49.661	28.402	26.677	33.525
	Days Revenues in Cash	4.459	13.164	42.724	15.211	14.818	16.137
	Revenue Growth	−0.026	0.086	0.208	0.158	0.148	0.124
	Earnings Growth	−0.836	0.053	1.126	0.099	0.354	−0.052
	Assets Growth	−0.057	0.039	0.145	0.062	0.050	0.066
	Current Ratio	1.286	1.643	2.448	1.439	1.653	1.702
	Long-Term Debt to Common Equity	0.171	0.574	1.118	0.387	0.349	0.457
	Interest Coverage Ratio	−1.351	1.909	5.185	1.429	4.354	3.990
	Liabilities to Equity	0.582	1.152	2.152	1.056	1.037	1.152
	Operating Cash Flow to Current Liabilities	−0.009	0.113	0.232	0.089	0.061	0.088

(Continued)

		1998–2008			2008	2007	2006
		25th Percentile	Median	75th Percentile	Median	Median	Median
Aircraft	Stock Return	−0.264	0.066	0.415	−0.444	0.220	0.287
	Market-to-Book	1.104	1.754	3.170	1.327	2.904	2.890
	Price-Earnings	10.458	16.317	21.749	9.285	18.731	19.798
	Profit Margin for ROA	0.012	0.069	0.105	0.072	0.081	0.073
	Total Asset Turnover	0.760	0.907	1.147	1.040	0.988	0.965
	ROA	0.007	0.061	0.094	0.068	0.074	0.064
	Profit Margin for ROCE	0.003	0.050	0.077	0.063	0.069	0.055
	Capital Structure						
	Leverage	1.783	2.505	3.992	2.672	2.354	2.578
	ROCE	0.012	0.118	0.218	0.134	0.164	0.137
	Gross Profit Margin	0.183	0.266	0.350	0.248	0.272	0.275
	SG&A Percentage	0.104	0.135	0.180	0.131	0.131	0.133
	Operating Income						
	Margin	0.045	0.101	0.138	0.107	0.111	0.095
	Days Receivable	42.502	55.337	66.582	52.792	52.652	54.151
	Days Inventory	73.560	110.106	149.471	110.015	106.594	108.293
	Days Payables	30.420	40.362	53.546	43.066	42.824	41.202
	Days Revenues in Cash	5.749	16.652	37.030	19.584	21.347	16.154
	Revenue Growth	−0.006	0.103	0.213	0.127	0.151	0.134
	Earnings Growth	−0.412	0.133	0.645	0.110	0.254	0.398
	Assets Growth	−0.016	0.063	0.183	0.072	0.151	0.066
	Current Ratio	1.372	1.894	2.721	1.992	2.113	1.951
	Long-Term Debt to						
	Common Equity	0.238	0.481	1.189	0.448	0.457	0.444
	Interest Coverage Ratio	0.826	3.575	10.586	7.062	6.630	3.613
	Liabilities to Equity	0.769	1.501	2.770	1.449	1.335	1.601
	Operating Cash Flow						
	to Current Liabilities	0.026	0.098	0.182	0.119	0.086	0.067

| | | 1998–2008 | | | 2008 | 2007 | 2006 |
		25th Percentile	Median	75th Percentile	Median	Median	Median
Apparel	Stock Return	−0.335	−0.005	0.414	−0.448	−0.212	0.158
	Market-to-Book	0.824	1.441	2.668	1.013	1.627	2.577
	Price-Earnings	10.319	15.006	20.620	12.124	16.440	19.105
	Profit Margin for ROA	0.009	0.046	0.074	0.045	0.054	0.057
	Total Asset Turnover	1.252	1.532	1.973	1.476	1.461	1.526
	ROA	0.011	0.066	0.117	0.053	0.069	0.085
	Profit Margin for ROCE	−0.008	0.033	0.067	0.041	0.039	0.050
	Capital Structure Leverage	1.379	1.712	2.326	1.600	1.696	1.662
	ROCE	0.000	0.101	0.182	0.085	0.108	0.123
	Gross Profit Margin	0.283	0.386	0.453	0.424	0.418	0.418
	SG&A Percentage	0.230	0.293	0.353	0.325	0.309	0.295
	Operating Income Margin	0.024	0.071	0.111	0.072	0.078	0.087
	Days Receivable	33.430	47.173	60.139	43.381	48.574	47.174
	Days Inventory	76.383	99.367	133.000	98.562	96.093	95.354
	Days Payables	24.539	34.548	47.059	39.804	40.341	38.954
	Days Revenues in Cash	4.188	14.817	40.468	26.449	16.909	13.630
	Revenue Growth	−0.038	0.051	0.161	0.014	0.051	0.087
	Earnings Growth	−0.537	0.079	0.656	−0.325	0.111	0.115
	Assets Growth	−0.052	0.048	0.177	−0.011	0.067	0.062
	Current Ratio	1.844	2.617	3.828	2.662	2.467	2.665
	Long-Term Debt to Common Equity	0.052	0.222	0.512	0.153	0.145	0.176
	Interest Coverage Ratio	0.792	5.296	21.589	5.678	6.476	6.848
	Liabilities to Equity	0.356	0.685	1.305	0.582	0.680	0.647
	Operating Cash Flow to Current Liabilities	0.040	0.187	0.441	0.207	0.231	0.175

(Continued)

| | | 1998–2008 | | | 2008 | 2007 | 2006 |
		25th Percentile	Median	75th Percentile	Median	Median	Median
Automobiles and Trucks	Stock Return	−0.347	−0.035	0.327	−0.605	−0.048	0.133
	Market-to-Book	0.957	1.518	2.615	0.892	1.656	1.902
	Price-Earnings	9.398	13.197	18.808	10.251	14.997	15.433
	Profit Margin for ROA	−0.041	0.027	0.056	−0.003	0.030	0.029
	Total Asset Turnover	0.883	1.223	1.650	1.235	1.234	1.209
	ROA	−0.054	0.033	0.079	−0.009	0.042	0.037
	Profit Margin for ROCE	−0.049	0.013	0.047	−0.012	0.014	0.018
	Capital Structure Leverage	1.728	2.735	4.427	2.618	2.640	2.646
	ROCE	−0.082	0.097	0.211	−0.013	0.126	0.120
	Gross Profit Margin	0.145	0.214	0.287	0.202	0.210	0.201
	SG&A Percentage	0.084	0.132	0.202	0.135	0.132	0.132
	Operating Income Margin	0.001	0.046	0.082	0.030	0.046	0.038
	Days Receivable	35.044	51.292	65.578	52.991	53.263	52.271
	Days Inventory	36.593	54.276	80.452	58.774	54.900	53.899
	Days Payables	33.155	45.704	61.345	49.220	49.276	50.007
	Days Revenues in Cash	5.748	17.201	34.151	24.768	21.945	17.037
	Revenue Growth	−0.058	0.048	0.167	−0.048	0.047	0.068
	Earnings Growth	−0.764	−0.006	0.512	−0.559	0.051	0.038
	Assets Growth	−0.071	0.031	0.149	−0.089	0.038	0.041
	Current Ratio	1.113	1.478	2.326	1.724	1.675	1.518
	Long-Term Debt to Common Equity	0.208	0.585	1.501	0.749	0.559	0.445
	Interest Coverage Ratio	−1.309	1.886	8.027	−0.265	3.007	2.898
	Liabilities to Equity	0.678	1.647	3.604	1.506	1.588	1.366
	Operating Cash Flow to Current Liabilities	−0.007	0.092	0.196	0.081	0.111	0.093

		1998–2008			2008	2007	2006
		25th Percentile	Median	75th Percentile	Median	Median	Median
Banking	Stock Return	−0.144	0.065	0.304	−0.356	−0.186	0.110
	Market-to-Book	1.030	1.458	2.013	0.782	1.204	1.687
	Price-Earnings	11.635	14.836	19.224	14.958	14.611	16.429
	Profit Margin for ROA	0.040	0.216	0.391	0.066	0.229	0.275
	Total Asset Turnover	0.063	0.073	0.085	0.064	0.074	0.073
	ROA	0.007	0.032	0.056	0.009	0.032	0.042
	Profit Margin for ROCE	0.075	0.124	0.169	0.047	0.104	0.132
	Capital Structure Leverage	8.647	11.038	13.519	10.951	10.513	10.795
	ROCE	0.056	0.106	0.149	0.030	0.081	0.110
	Gross Profit Margin	0.475	0.578	0.679	0.502	0.535	0.584
	SG&A Percentage	0.214	0.270	0.324	0.301	0.267	0.273
	Operating Income Margin	0.213	0.286	0.361	0.198	0.253	0.292
	Days Receivable	72.404	1,096.444	2,722.238	944.495	1,099.943	1,073.813
	Days Inventory	10.261	41.329	152.451	44.592	31.777	33.893
	Days Payables	5,260.518	7,958.902	11,797.255	7,157.698	7,482.045	8,651.434
	Days Revenues in Cash	74.230	123.271	177.434	103.709	102.030	114.833
	Revenue Growth	−0.015	0.082	0.203	−0.043	0.103	0.200
	Earnings Growth	−0.133	0.087	0.300	−0.435	−0.064	0.064
	Assets Growth	0.025	0.090	0.186	0.053	0.066	0.094
	Current Ratio	0.848	1.434	2.838	1.444	1.668	1.704
	Long-Term Debt to Common Equity	0.407	0.917	1.775	1.095	0.834	0.772
	Interest Coverage Ratio	0.871	1.664	3.633	0.831	1.521	2.174
	Liabilities to Equity	7.560	10.002	12.445	9.633	9.428	9.505
	Operating Cash Flow to Current Liabilities	0.008	0.015	0.024	0.013	0.013	0.014

(Continued)

| | | 1998–2008 | | | 2008 | 2007 | 2006 |
		25th Percentile	Median	75th Percentile	Median	Median	Median
Beer & Liquor	Stock Return	−0.150	0.047	0.288	−0.240	0.058	0.154
	Market-to-Book	1.113	1.878	3.811	1.572	2.621	2.890
	Price-Earnings	14.216	18.462	24.040	16.063	18.721	19.610
	Profit Margin for ROA	0.031	0.085	0.132	0.098	0.101	0.094
	Total Asset Turnover	0.532	0.736	0.993	0.693	0.742	0.651
	ROA	0.016	0.060	0.092	0.050	0.061	0.060
	Profit Margin for ROCE	0.024	0.065	0.120	0.082	0.116	0.087
	Capital Structure Leverage	1.631	2.058	2.510	1.924	1.946	1.969
	ROCE	0.044	0.119	0.227	0.079	0.155	0.175
	Gross Profit Margin	0.354	0.470	0.591	0.522	0.504	0.493
	SG&A Percentage	0.233	0.296	0.382	0.302	0.303	0.296
	Operating Income Margin	0.074	0.126	0.191	0.152	0.161	0.152
	Days Receivable	27.138	42.729	62.793	40.361	37.339	38.883
	Days Inventory	47.950	120.629	223.673	122.028	85.129	109.577
	Days Payables	37.589	52.151	81.319	51.582	52.338	54.774
	Days Revenues in Cash	5.228	16.986	42.578	16.529	22.229	25.847
	Revenue Growth	−0.004	0.064	0.178	0.045	0.118	0.078
	Earnings Growth	−0.182	0.092	0.396	−0.134	0.168	0.117
	Assets Growth	−0.026	0.047	0.147	0.034	0.087	0.042
	Current Ratio	1.028	1.602	2.431	1.325	1.394	1.450
	Long-Term Debt to Common Equity	0.177	0.360	0.749	0.306	0.316	0.337
	Interest Coverage Ratio	1.354	3.931	6.701	5.819	5.064	5.295
	Liabilities to Equity	0.601	0.989	1.510	0.937	0.968	0.919
	Operating Cash Flow to Current Liabilities	0.080	0.146	0.296	0.128	0.147	0.186

		1998–2008			2008	2007	2006
		25th Percentile	Median	75th Percentile	Median	Median	Median
Broker Dealers	Stock Return	−0.187	0.109	0.429	−0.408	−0.040	0.309
	Market-to-Book	0.937	1.514	2.799	0.996	1.616	2.015
	Price-Earnings	10.608	17.143	29.462	16.927	20.640	21.725
	Profit Margin for ROA	0.073	0.292	0.526	0.182	0.281	0.320
	Total Asset Turnover	0.118	0.176	0.498	0.156	0.161	0.170
	ROA	0.014	0.052	0.085	0.032	0.050	0.057
	Profit Margin for ROCE	−0.011	0.129	0.308	0.060	0.107	0.146
	Capital Structure Leverage	1.442	2.373	4.139	2.390	2.308	2.383
	ROCE	−0.009	0.085	0.183	0.034	0.075	0.107
	Gross Profit Margin	0.220	0.425	0.670	0.347	0.381	0.416
	SG&A Percentage	0.086	0.236	0.568	0.190	0.185	0.223
	Operating Income Margin	0.117	0.347	0.572	0.287	0.325	0.338
	Days Receivable	25.480	58.290	207.120	62.111	62.604	62.004
	Days Inventory	17.260	69.441	324.476	56.731	90.388	118.043
	Days Payables	35.684	72.779	153.876	68.234	71.453	74.842
	Days Revenues in Cash	14.143	51.200	141.918	65.799	59.401	67.844
	Revenue Growth	−0.053	0.094	0.310	0.015	0.132	0.181
	Earnings Growth	−0.429	0.096	0.630	−0.281	0.044	0.226
	Assets Growth	−0.063	0.052	0.245	−0.027	0.082	0.125
	Current Ratio	0.979	1.851	4.566	1.898	2.020	1.842
	Long-Term Debt to Common Equity	0.413	1.110	2.146	1.180	1.269	1.217
	Interest Coverage Ratio	0.941	1.937	3.669	1.286	1.851	2.028
	Liabilities to Equity	0.365	1.161	2.657	1.235	1.158	1.196
	Operating Cash Flow to Current Liabilities	0.005	0.087	0.195	0.072	0.076	0.083

(Continued)

		1998–2008			2008	2007	2006
		25th Percentile	Median	75th Percentile	Median	Median	Median
Business Services	Stock Return	−0.491	−0.078	0.473	−0.497	−0.005	0.104
	Market-to-Book	1.239	2.355	4.856	1.415	2.556	2.741
	Price-Earnings	13.429	22.950	39.972	14.479	22.950	25.709
	Profit Margin for ROA	−0.523	−0.020	0.069	0.007	0.029	0.035
	Total Asset Turnover	0.476	0.862	1.384	0.872	0.849	0.874
	ROA	−0.388	−0.027	0.066	0.002	0.025	0.036
	Profit Margin for ROCE	−0.580	−0.043	0.056	−0.004	0.020	0.016
	Capital Structure Leverage	1.334	1.691	2.552	1.790	1.745	1.726
	ROCE	−0.405	0.022	0.181	0.061	0.073	0.079
	Gross Profit Margin	0.249	0.471	0.705	0.490	0.524	0.503
	SG&A Percentage	0.269	0.534	0.855	0.444	0.458	0.478
	Operating Income Margin	−0.432	−0.006	0.090	0.043	0.040	0.037
	Days Receivable	45.198	64.117	87.279	62.021	62.665	61.986
	Days Inventory	7.308	22.901	55.543	17.962	19.243	18.828
	Days Payables	24.584	49.309	105.819	40.537	42.295	45.913
	Days Revenues in Cash	21.134	68.492	178.292	59.089	67.994	68.074
	Revenue Growth	−0.062	0.112	0.410	0.084	0.143	0.136
	Earnings Growth	−0.992	0.047	0.692	−0.084	0.098	0.074
	Assets Growth	−0.142	0.053	0.364	−0.009	0.098	0.097
	Current Ratio	1.003	1.699	3.004	1.535	1.671	1.624
	Long-Term Debt to Common Equity	0.014	0.152	0.635	0.228	0.220	0.204
	Interest Coverage Ratio	−22.833	−0.632	7.216	0.325	1.561	2.094
	Liabilities to Equity	0.304	0.654	1.499	0.815	0.692	0.725
	Operating Cash Flow to Current Liabilities	−0.363	0.056	0.284	0.148	0.139	0.130

		1998–2008			2008	2007	2006
		25th Percentile	Median	75th Percentile	Median	Median	Median
Business Supplies	Stock Return	−0.288	−0.044	0.236	−0.529	−0.138	0.154
	Market-to-Book	0.774	1.351	1.993	0.729	1.263	1.495
	Price-Earnings	10.483	15.299	23.132	11.624	14.793	19.207
	Profit Margin for ROA	0.003	0.040	0.075	0.008	0.042	0.039
	Total Asset Turnover	0.726	1.047	1.468	1.096	1.029	1.027
	ROA	0.002	0.043	0.078	0.010	0.055	0.041
	Profit Margin for ROCE	−0.022	0.023	0.056	−0.013	0.022	0.019
	Capital Structure Leverage	1.917	2.612	3.548	2.624	2.551	2.637
	ROCE	−0.062	0.067	0.157	−0.025	0.084	0.049
	Gross Profit Margin	0.184	0.263	0.350	0.205	0.211	0.203
	SG&A Percentage	0.079	0.141	0.234	0.106	0.108	0.123
	Operating Income Margin	0.023	0.060	0.105	0.042	0.057	0.047
	Days Receivable	37.739	46.093	57.996	41.319	43.690	46.209
	Days Inventory	42.805	58.228	75.202	57.331	56.303	57.006
	Days Payables	29.928	39.232	55.922	37.185	41.405	39.327
	Days Revenues in Cash	3.340	9.256	24.913	9.477	11.683	7.980
	Revenue Growth	−0.044	0.040	0.133	0.022	0.044	0.041
	Earnings Growth	−0.683	0.037	0.738	−0.739	0.218	0.425
	Assets Growth	−0.066	0.001	0.100	−0.038	0.050	0.000
	Current Ratio	1.238	1.622	2.231	1.696	1.735	1.850
	Long-Term Debt to Common Equity	0.312	0.664	1.349	0.778	0.622	0.589
	Interest Coverage Ratio	0.265	2.252	5.771	0.696	2.439	2.773
	Liabilities to Equity	0.876	1.528	2.530	1.597	1.436	1.577
	Operating Cash Flow to Current Liabilities	0.046	0.116	0.224	0.083	0.121	0.116

(Continued)

| | | 1998–2008 | | | 2008 | 2007 | 2006 |
		25th Percentile	Median	75th Percentile	Median	Median	Median
Candy & Soda	Stock Return	−0.288	0.018	0.400	−0.375	0.113	0.191
	Market-to-Book	1.627	2.290	4.163	1.690	2.429	3.713
	Price-Earnings	15.276	19.716	28.615	18.157	17.190	23.481
	Profit Margin for ROA	−0.069	0.040	0.076	0.028	0.050	0.041
	Total Asset Turnover	0.815	1.035	1.583	1.094	1.081	1.086
	ROA	−0.201	0.044	0.086	0.029	0.056	0.025
	Profit Margin for ROCE	−0.076	0.026	0.054	−0.010	0.033	0.028
	Capital Structure Leverage	1.856	2.392	3.996	2.155	2.403	2.381
	ROCE	−0.034	0.122	0.217	0.082	0.121	0.129
	Gross Profit Margin	0.305	0.455	0.508	0.449	0.459	0.450
	SG&A Percentage	0.296	0.327	0.425	0.360	0.362	0.322
	Operating Income Margin	−0.035	0.067	0.101	0.066	0.069	0.073
	Days Receivable	21.724	30.734	37.155	32.887	32.618	29.923
	Days Inventory	29.231	36.583	60.710	42.348	38.758	38.834
	Days Payables	31.597	43.086	63.387	42.463	36.520	46.617
	Days Revenues in Cash	4.697	11.226	27.322	18.855	16.123	18.035
	Revenue Growth	−0.001	0.066	0.183	0.030	0.098	0.066
	Earnings Growth	−0.536	0.042	0.586	−0.335	0.099	0.048
	Assets Growth	−0.073	0.030	0.165	−0.098	0.113	0.038
	Current Ratio	0.850	1.143	1.805	1.187	1.269	1.255
	Long-Term Debt to Common Equity	0.360	0.632	1.956	0.666	0.558	0.563
	Interest Coverage Ratio	−1.740	2.046	4.665	1.502	2.044	1.684
	Liabilities to Equity	0.816	1.288	3.041	1.289	1.097	1.312
	Operating Cash Flow to Current Liabilities	−0.032	0.120	0.217	0.101	0.131	0.131

		1998–2008			2008	2007	2006
		25th Percentile	Median	75th Percentile	Median	Median	Median
Chemicals	Stock Return	−0.303	0.020	0.373	−0.501	0.091	0.213
	Market-to-Book	1.194	2.056	3.539	1.438	2.637	2.536
	Price-Earnings	11.460	17.076	25.311	10.213	18.539	20.494
	Profit Margin for ROA	−0.079	0.037	0.082	0.041	0.059	0.048
	Total Asset Turnover	0.637	0.903	1.277	0.960	0.914	0.939
	ROA	−0.094	0.037	0.078	0.030	0.054	0.051
	Profit Margin for ROCE	−0.116	0.017	0.063	0.024	0.036	0.030
	Capital Structure Leverage	1.622	2.393	3.418	2.296	2.145	2.318
	ROCE	−0.118	0.088	0.211	0.089	0.122	0.116
	Gross Profit Margin	0.176	0.293	0.404	0.298	0.292	0.282
	SG&A Percentage	0.095	0.189	0.334	0.155	0.158	0.172
	Operating Income Margin	−0.028	0.063	0.114	0.067	0.075	0.072
	Days Receivable	38.595	52.411	64.391	46.145	51.433	48.844
	Days Inventory	45.387	66.675	107.683	61.250	62.964	65.079
	Days Payables	33.632	46.147	66.050	38.777	44.960	42.945
	Days Revenues in Cash	5.756	17.184	51.354	22.868	21.487	19.876
	Revenue Growth	−0.032	0.075	0.209	0.073	0.091	0.091
	Earnings Growth	−0.660	0.024	0.657	−0.097	0.160	0.130
	Assets Growth	−0.072	0.024	0.144	−0.016	0.075	0.080
	Current Ratio	1.166	1.697	2.552	1.855	1.859	1.866
	Long-Term Debt to Common Equity	0.239	0.560	1.118	0.544	0.534	0.507
	Interest Coverage Ratio	−2.076	1.937	6.216	3.082	2.784	2.880
	Liabilities to Equity	0.588	1.316	2.339	1.282	1.131	1.313
	Operating Cash Flow to Current Liabilities	−0.058	0.085	0.191	0.079	0.093	0.084

(Continued)

		1998–2008			2008	2007	2006
		25th Percentile	Median	75th Percentile	Median	Median	Median
Coal	Stock Return	−0.264	0.237	0.749	−0.568	0.525	−0.241
	Market-to-Book	1.442	2.777	5.612	1.137	4.009	2.701
	Price-Earnings	8.319	13.813	32.518	6.383	21.569	13.120
	Profit Margin for ROA	−0.026	0.056	0.128	0.069	0.054	0.046
	Total Asset Turnover	0.482	0.662	0.978	0.832	0.727	0.738
	ROA	−0.061	0.034	0.094	0.047	0.035	0.034
	Profit Margin for ROCE	−0.105	0.017	0.088	0.065	0.022	0.020
	Capital Structure Leverage	1.551	2.796	5.498	2.327	2.387	2.888
	ROCE	−0.147	0.063	0.294	0.227	0.106	0.062
	Gross Profit Margin	0.130	0.199	0.287	0.249	0.201	0.207
	SG&A Percentage	0.032	0.060	0.152	0.058	0.052	0.042
	Operating Income Margin	−0.078	0.043	0.119	0.103	0.052	0.058
	Days Receivable	23.372	29.658	42.508	25.119	32.039	29.688
	Days Inventory	14.726	29.586	59.141	19.525	20.526	25.350
	Days Payables	28.103	35.959	61.871	32.590	33.418	36.796
	Days Revenues in Cash	5.224	18.456	82.268	47.511	10.903	15.884
	Revenue Growth	−0.015	0.131	0.326	0.329	0.064	0.124
	Earnings Growth	−1.183	−0.111	1.114	0.452	−0.498	−0.296
	Assets Growth	−0.027	0.083	0.382	0.304	0.031	0.163
	Current Ratio	0.881	1.319	2.723	1.252	1.386	1.279
	Long-Term Debt to Common Equity	0.230	0.821	1.783	0.652	0.709	0.691
	Interest Coverage Ratio	−1.229	1.463	6.618	4.235	1.862	1.049
	Liabilities to Equity	0.423	1.552	3.929	1.369	1.347	1.492
	Operating Cash Flow to Current Liabilities	−0.043	0.084	0.262	0.118	0.121	0.081

| | | 1998–2008 | | | 2008 | 2007 | 2006 |
		25th Percentile	Median	75th Percentile	Median	Median	Median
Communications	Stock Return	−0.413	−0.027	0.480	−0.422	0.001	0.196
	Market-to-Book	1.174	2.058	3.941	1.371	2.079	2.219
	Price-Earnings	12.325	19.215	34.978	13.115	19.248	19.423
	Profit Margin for ROA	−0.256	0.047	0.150	0.047	0.090	0.088
	Total Asset Turnover	0.289	0.478	0.715	0.563	0.587	0.580
	ROA	−0.133	0.021	0.075	0.030	0.048	0.046
	Profit Margin for ROCE	−0.384	−0.009	0.100	0.010	0.038	0.033
	Capital Structure Leverage	1.833	2.601	4.021	2.567	2.432	2.469
	ROCE	−0.245	0.058	0.245	0.062	0.109	0.094
	Gross Profit Margin	0.304	0.450	0.602	0.525	0.513	0.487
	SG&A Percentage	0.208	0.306	0.485	0.271	0.271	0.287
	Operating Income Margin	−0.171	0.080	0.195	0.147	0.134	0.127
	Days Receivable	33.724	50.543	69.254	43.641	44.047	42.574
	Days Inventory	7.590	14.908	28.180	16.529	14.025	13.040
	Days Payables	40.766	69.230	118.743	54.270	59.163	55.461
	Days Revenues in Cash	11.722	34.522	95.453	35.244	35.470	35.409
	Revenue Growth	−0.015	0.106	0.326	0.059	0.114	0.118
	Earnings Growth	−0.914	−0.032	0.658	−0.134	0.162	0.084
	Assets Growth	−0.082	0.033	0.251	−0.030	0.043	0.043
	Current Ratio	0.672	1.119	1.822	1.124	1.160	1.240
	Long-Term Debt to Common Equity	0.320	0.755	1.726	0.953	0.727	0.750
	Interest Coverage Ratio	−2.036	1.029	4.328	1.536	2.408	1.916
	Liabilities to Equity	0.726	1.419	2.697	1.713	1.374	1.302
	Operating Cash Flow to Current Liabilities	−0.033	0.096	0.244	0.148	0.136	0.133

(Continued)

		1998–2008			2008	2007	2006
		25th Percentile	Median	75th Percentile	Median	Median	Median
Computers	Stock Return	−0.472	−0.080	0.518	−0.471	−0.147	0.081
	Market-to-Book	1.369	2.386	4.575	1.469	2.461	2.515
	Price-Earnings	15.128	23.938	40.600	17.433	22.911	22.812
	Profit Margin for ROA	−0.374	−0.034	0.057	−0.005	0.003	0.004
	Total Asset Turnover	0.604	0.972	1.462	0.914	0.906	1.000
	ROA	−0.349	−0.037	0.065	−0.010	0.000	−0.003
	Profit Margin for ROCE	−0.380	−0.037	0.053	−0.005	−0.007	0.002
	Capital Structure Leverage	1.314	1.647	2.309	1.693	1.719	1.697
	ROCE	−0.365	0.012	0.165	0.026	0.057	0.059
	Gross Profit Margin	0.273	0.427	0.589	0.475	0.457	0.449
	SG&A Percentage	0.271	0.444	0.716	0.434	0.453	0.456
	Operating Income Margin	−0.298	−0.016	0.072	0.016	0.010	0.003
	Days Receivable	48.445	64.594	86.599	63.586	65.706	64.309
	Days Inventory	27.096	64.044	108.331	51.522	54.841	58.682
	Days Payables	37.709	57.041	90.021	55.662	58.466	56.167
	Days Revenues in Cash	23.616	60.521	141.117	71.730	67.021	57.830
	Revenue Growth	−0.109	0.081	0.310	0.085	0.111	0.146
	Earnings Growth	−0.934	0.077	0.770	0.000	0.094	0.028
	Assets Growth	−0.147	0.041	0.294	−0.013	0.093	0.103
	Current Ratio	1.220	2.029	3.512	1.913	1.976	1.842
	Long-Term Debt to Common Equity	0.019	0.137	0.489	0.215	0.201	0.155
	Interest Coverage Ratio	−20.947	−1.888	7.927	−0.286	−0.448	−0.318
	Liabilities to Equity	0.298	0.621	1.347	0.668	0.678	0.686
	Operating Cash Flow to Current Liabilities	−0.327	0.040	0.302	0.116	0.106	0.072

		1998–2008			2008	2007	2006
		25th Percentile	Median	75th Percentile	Median	Median	Median
Construction	Stock Return	−0.314	0.076	0.552	−0.447	−0.244	0.054
	Market-to-Book	0.778	1.306	2.117	1.198	1.577	1.873
	Price-Earnings	6.194	9.675	19.555	10.000	26.778	15.960
	Profit Margin for ROA	−0.019	0.034	0.069	0.026	0.021	0.035
	Total Asset Turnover	0.854	1.327	1.908	1.083	1.054	1.308
	ROA	−0.033	0.051	0.094	0.029	0.013	0.050
	Profit Margin for ROCE	−0.042	0.024	0.055	0.009	−0.005	0.027
	Capital Structure Leverage	1.982	2.533	3.539	2.458	2.534	2.497
	ROCE	−0.068	0.116	0.232	0.052	−0.008	0.106
	Gross Profit Margin	0.105	0.167	0.231	0.140	0.119	0.173
	SG&A Percentage	0.074	0.104	0.147	0.120	0.117	0.093
	Operating Income Margin	0.001	0.046	0.093	0.040	0.027	0.051
	Days Receivable	37.705	63.414	84.683	63.038	67.795	62.450
	Days Inventory	17.592	61.853	262.784	41.332	44.513	42.165
	Days Payables	21.828	34.113	53.496	32.682	33.547	30.773
	Days Revenues in Cash	6.526	18.255	43.290	37.249	26.809	25.238
	Revenue Growth	−0.050	0.132	0.314	0.067	0.050	0.120
	Earnings Growth	−0.658	0.187	0.657	0.098	−0.479	0.016
	Assets Growth	−0.043	0.100	0.284	−0.014	−0.013	0.150
	Current Ratio	1.174	1.516	2.046	1.666	1.600	1.558
	Long-Term Debt to Common Equity	0.190	0.578	1.053	0.492	0.409	0.447
	Interest Coverage Ratio	−0.657	3.256	8.260	2.643	1.811	5.692
	Liabilities to Equity	0.950	1.501	2.504	1.489	1.374	1.471
	Operating Cash Flow to Current Liabilities	−0.059	0.055	0.180	0.154	0.155	0.075

(Continued)

| | | 1998–2008 | | | 2008 | 2007 | 2006 |
		25th Percentile	Median	75th Percentile	Median	Median	Median
Construction	Stock Return	–0.280	–0.004	0.314	–0.493	–0.153	0.077
Materials	Market-to-Book	0.845	1.331	2.254	0.839	1.581	1.917
	Price-Earnings	8.718	14.395	21.593	11.561	18.672	14.505
	Profit Margin for ROA	0.001	0.044	0.084	0.023	0.039	0.062
	Total Asset Turnover	0.795	1.103	1.531	1.046	1.043	1.165
	ROA	–0.002	0.054	0.093	0.015	0.038	0.079
	Profit Margin for ROCE	–0.016	0.032	0.071	0.012	0.030	0.052
	Capital Structure Leverage	1.511	1.981	2.665	1.890	1.856	1.868
	ROCE	–0.019	0.088	0.175	0.013	0.062	0.130
	Gross Profit Margin	0.192	0.275	0.359	0.265	0.262	0.271
	SG&A Percentage	0.100	0.164	0.237	0.159	0.159	0.142
	Operating Income Margin	0.012	0.068	0.119	0.050	0.065	0.082
	Days Receivable	28.325	43.590	58.147	40.240	40.728	41.275
	Days Inventory	44.099	65.916	96.248	66.818	62.800	59.739
	Days Payables	22.884	34.118	51.549	33.045	34.182	32.472
	Days Revenues in Cash	5.035	14.678	33.401	24.767	16.061	13.716
	Revenue Growth	–0.067	0.048	0.167	–0.057	–0.012	0.090
	Earnings Growth	–0.672	0.038	0.636	–0.510	–0.241	0.219
	Assets Growth	–0.054	0.030	0.131	–0.020	0.018	0.091
	Current Ratio	1.406	1.990	2.873	2.265	2.204	2.060
	Long-Term Debt to Common Equity	0.177	0.424	0.827	0.400	0.393	0.352
	Interest Coverage Ratio	0.113	3.238	7.998	1.543	3.346	4.866
	Liabilities to Equity	0.482	0.954	1.633	0.798	0.816	0.872
	Operating Cash Flow to Current Liabilities	0.034	0.148	0.281	0.120	0.150	0.157

		1998–2008			2008	2007	2006
		25th Percentile	Median	75th Percentile	Median	Median	Median
Consumer Goods	Stock Return	−0.351	−0.041	0.278	−0.489	−0.095	0.087
	Market-to-Book	0.867	1.535	2.872	0.827	1.552	1.823
	Price-Earnings	10.427	15.574	23.293	15.786	15.565	18.404
	Profit Margin for ROA	−0.044	0.034	0.072	0.013	0.037	0.033
	Total Asset Turnover	0.929	1.228	1.667	1.127	1.176	1.204
	ROA	−0.055	0.043	0.092	0.017	0.053	0.038
	Profit Margin for ROCE	−0.066	0.022	0.061	0.007	0.024	0.022
	Capital Structure Leverage	1.518	2.039	3.227	2.006	1.975	1.997
	ROCE	−0.056	0.089	0.189	0.032	0.079	0.092
	Gross Profit Margin	0.265	0.394	0.516	0.427	0.423	0.399
	SG&A Percentage	0.197	0.311	0.435	0.330	0.326	0.324
	Operating Income Margin	−0.002	0.059	0.104	0.043	0.062	0.047
	Days Receivable	41.220	53.733	68.537	51.091	54.269	54.106
	Days Inventory	59.113	89.660	139.540	90.977	92.227	93.286
	Days Payables	32.121	46.314	67.675	58.235	55.466	49.927
	Days Revenues in Cash	4.968	14.813	39.690	21.472	19.515	19.226
	Revenue Growth	−0.062	0.045	0.149	−0.025	0.067	0.061
	Earnings Growth	−0.648	0.061	0.520	−0.301	0.191	0.021
	Assets Growth	−0.072	0.019	0.124	−0.051	0.022	0.045
	Current Ratio	1.255	1.866	2.884	1.898	1.972	1.939
	Long-Term Debt to Common Equity	0.135	0.396	0.949	0.453	0.382	0.404
	Interest Coverage Ratio	−0.863	2.507	10.175	1.813	3.383	2.550
	Liabilities to Equity	0.484	1.028	2.302	1.069	0.934	0.993
	Operating Cash Flow to Current Liabilities	−0.016	0.126	0.261	0.076	0.129	0.127

(Continued)

| | | 1998–2008 | | | 2008 | 2007 | 2006 |
		25th Percentile	Median	75th Percentile	Median	Median	Median
Defense	Stock Return	−0.330	0.017	0.377	−0.343	−0.056	0.093
	Market-to-Book	1.291	2.290	4.533	2.558	3.620	4.585
	Price-Earnings	10.732	17.404	27.459	14.007	18.000	20.920
	Profit Margin for ROA	−0.057	0.056	0.085	0.035	0.053	−0.010
	Total Asset Turnover	0.669	0.960	1.241	1.160	1.169	0.934
	ROA	−0.048	0.054	0.090	0.039	0.066	−0.013
	Profit Margin for ROCE	−0.069	0.039	0.075	0.037	0.053	−0.048
	Capital Structure Leverage	1.291	1.966	4.264	2.577	1.648	2.169
	ROCE	−0.080	0.090	0.235	0.130	0.137	0.102
	Gross Profit Margin	0.168	0.250	0.333	0.215	0.221	0.216
	SG&A Percentage	0.113	0.184	0.239	0.149	0.184	0.218
	Operating Income Margin	0.001	0.073	0.117	0.086	0.080	0.000
	Days Receivable	41.780	55.993	75.915	60.376	62.137	59.918
	Days Inventory	26.851	65.353	110.626	38.766	37.445	46.285
	Days Payables	21.478	36.879	58.228	26.133	23.366	28.213
	Days Revenues in Cash	11.648	30.851	86.483	40.559	45.197	35.965
	Revenue Growth	−0.027	0.065	0.298	0.043	0.200	0.108
	Earnings Growth	−0.658	0.045	0.634	−0.050	0.381	0.197
	Assets Growth	−0.085	0.012	0.121	−0.006	0.059	0.073
	Current Ratio	1.143	1.947	3.963	1.862	1.978	1.582
	Long-Term Debt to Common Equity	0.076	0.515	1.249	0.315	0.333	0.106
	Interest Coverage Ratio	−2.160	3.012	6.766	1.087	1.609	−2.160
	Liabilities to Equity	0.279	0.883	3.114	0.808	0.689	1.462
	Operating Cash Flow to Current Liabilities	−0.029	0.105	0.285	0.231	0.187	0.047

		1998–2008			2008	2007	2006
		25th Percentile	Median	75th Percentile	Median	Median	Median
Electrical	Stock Return	−0.364	−0.003	0.466	−0.485	0.140	0.062
Equipment	Market-to-Book	1.135	1.928	3.432	1.528	2.610	2.309
	Price-Earnings	10.900	16.971	25.000	11.048	19.456	17.877
	Profit Margin						
	for ROA	−0.261	0.019	0.070	0.003	0.012	0.027
	Total Asset Turnover	0.673	1.030	1.385	1.084	1.013	1.094
	ROA	−0.218	0.020	0.083	−0.003	0.006	0.040
	Profit Margin						
	for ROCE	−0.279	0.010	0.059	0.013	0.008	0.023
	Capital Structure						
	Leverage	1.365	1.772	2.555	1.678	1.700	1.755
	ROCE	−0.247	0.053	0.165	0.063	0.065	0.081
	Gross Profit Margin	0.221	0.306	0.385	0.314	0.300	0.295
	SG&A Percentage	0.180	0.255	0.430	0.253	0.251	0.259
	Operating Income						
	Margin	−0.188	0.042	0.100	0.034	0.034	0.046
	Days Receivable	50.101	62.694	79.587	56.542	62.769	60.078
	Days Inventory	67.152	91.661	132.100	80.659	82.190	87.386
	Days Payables	30.893	47.492	72.659	44.158	47.611	48.538
	Days Revenues						
	in Cash	8.582	26.213	75.385	36.619	33.866	35.760
	Revenue Growth	−0.084	0.066	0.238	0.141	0.174	0.112
	Earnings Growth	−0.636	0.058	0.588	0.059	0.130	0.152
	Assets Growth	−0.117	0.031	0.194	−0.019	0.126	0.084
	Current Ratio	1.465	2.075	3.423	2.149	2.240	1.986
	Long-Term Debt to						
	Common Equity	0.056	0.249	0.581	0.192	0.182	0.287
	Interest Coverage						
	Ratio	−7.678	1.595	8.695	1.945	1.051	3.134
	Liabilities to Equity	0.331	0.760	1.520	0.661	0.597	0.815
	Operating Cash						
	Flow to Current						
	Liabilities	−0.315	0.055	0.219	0.039	0.023	0.062

(Continued)

		1998–2008			2008	2007	2006
		25th Percentile	Median	75th Percentile	Median	Median	Median
Electronic	Stock Return	−0.437	−0.073	0.504	−0.522	−0.068	0.001
Equipment	Market-to-Book	1.146	1.971	3.629	0.987	1.911	2.105
	Price-Earnings	14.572	23.202	43.210	13.713	20.545	23.077
	Profit Margin						
	for ROA	−0.277	−0.003	0.075	−0.022	0.019	0.023
	Total Asset Turnover	0.553	0.861	1.261	0.852	0.857	0.887
	ROA	−0.204	−0.004	0.074	−0.032	0.017	0.023
	Profit Margin						
	for ROCE	−0.292	−0.012	0.068	−0.029	0.010	0.016
	Capital Structure						
	Leverage	1.245	1.529	2.129	1.515	1.538	1.516
	ROCE	−0.232	0.024	0.152	0.000	0.054	0.055
	Gross Profit Margin	0.259	0.386	0.534	0.391	0.405	0.403
	SG&A Percentage	0.209	0.346	0.554	0.342	0.324	0.346
	Operating Income						
	Margin	−0.193	0.012	0.092	0.013	0.024	0.025
	Days Receivable	44.601	56.053	72.728	54.630	54.417	53.889
	Days Inventory	55.646	86.902	128.963	86.062	86.204	82.807
	Days Payables	37.144	54.963	83.869	52.846	54.756	53.214
	Days Revenues						
	in Cash	24.765	68.139	147.096	71.837	72.060	70.515
	Revenue Growth	−0.079	0.098	0.341	0.049	0.083	0.145
	Earnings Growth	−0.845	0.118	0.823	−0.174	0.067	0.221
	Assets Growth	−0.115	0.044	0.287	−0.038	0.065	0.082
	Current Ratio	1.629	2.674	4.629	2.735	2.695	2.697
	Long-Term Debt to						
	Common Equity	0.024	0.174	0.497	0.248	0.204	0.183
	Interest Coverage						
	Ratio	−13.308	−0.141	11.208	−1.193	1.107	2.008
	Liabilities to Equity	0.221	0.490	1.074	0.481	0.492	0.495
	Operating Cash						
	Flow to Current						
	Liabilities	−0.212	0.089	0.394	0.138	0.131	0.114

		1998–2008			2008	2007	2006
		25th Percentile	Median	75th Percentile	Median	Median	Median
Entertainment	Stock Return	−0.414	−0.008	0.478	−0.606	−0.100	0.148
	Market-to-Book	0.964	1.937	3.669	1.070	2.327	2.546
	Price-Earnings	11.822	19.518	32.292	17.871	26.620	27.684
	Profit Margin for ROA	−0.134	0.040	0.106	0.003	0.046	0.060
	Total Asset Turnover	0.427	0.655	1.053	0.580	0.627	0.600
	ROA	−0.129	0.023	0.070	−0.004	0.018	0.037
	Profit Margin for ROCE	−0.211	−0.005	0.064	−0.028	0.013	0.019
	Capital Structure Leverage	1.656	2.445	4.308	2.476	2.352	2.657
	ROCE	−0.153	0.064	0.230	0.029	0.059	0.085
	Gross Profit Margin	0.220	0.369	0.490	0.368	0.365	0.375
	SG&A Percentage	0.135	0.208	0.347	0.218	0.214	0.212
	Operating Income Margin	−0.071	0.063	0.146	0.062	0.064	0.073
	Days Receivable	6.055	14.819	42.755	12.485	15.735	14.245
	Days Inventory	3.200	7.664	23.086	5.421	5.129	5.446
	Days Payables	18.177	33.970	77.630	29.183	30.890	31.784
	Days Revenues in Cash	14.353	31.591	72.071	35.266	44.323	42.370
	Revenue Growth	−0.044	0.059	0.237	0.018	0.072	0.106
	Earnings Growth	−0.976	0.055	0.736	−0.208	−0.161	0.158
	Assets Growth	−0.101	0.019	0.186	−0.042	0.029	0.058
	Current Ratio	0.476	0.945	1.516	0.874	1.024	1.106
	Long-Term Debt to Common Equity	0.299	0.945	2.277	0.905	0.869	0.972
	Interest Coverage Ratio	−1.917	0.904	2.734	0.383	0.875	1.167
	Liabilities to Equity	0.627	1.398	3.119	1.523	1.334	1.389
	Operating Cash Flow to Current Liabilities	−0.051	0.081	0.198	0.075	0.081	0.089

(Continued)

| | | 1998–2008 | | | 2008 | 2007 | 2006 |
		25th Percentile	Median	75th Percentile	Median	Median	Median
Fabricated	Stock Return	−0.441	−0.041	0.391	−0.499	0.108	0.195
Products	Market-to-Book	0.671	1.040	1.741	0.714	1.271	1.438
	Price-Earnings	8.373	14.145	22.943	8.562	13.283	19.925
	Profit Margin for ROA	−0.017	0.027	0.056	0.032	0.035	0.024
	Total Asset Turnover	0.884	1.162	1.452	1.311	1.434	1.356
	ROA	−0.027	0.032	0.066	0.042	0.063	0.036
	Profit Margin for ROCE	−0.034	0.011	0.044	0.029	0.030	0.023
	Capital Structure Leverage	1.693	2.186	3.033	1.962	2.017	2.014
	ROCE	−0.108	0.046	0.123	0.071	0.098	0.074
	Gross Profit Margin	0.165	0.219	0.289	0.267	0.194	0.194
	SG&A Percentage	0.097	0.141	0.187	0.135	0.139	0.109
	Operating Income Margin	0.006	0.049	0.085	0.114	0.051	0.050
	Days Receivable	45.241	53.514	66.776	52.595	56.645	54.974
	Days Inventory	42.090	61.945	84.794	67.997	62.220	59.659
	Days Payables	33.591	42.805	57.957	44.160	52.498	45.056
	Days Revenues in Cash	2.598	8.910	26.335	19.701	10.583	12.985
	Revenue Growth	−0.074	0.050	0.174	0.005	0.090	0.179
	Earnings Growth	−1.036	0.023	1.000	−0.286	0.444	0.259
	Assets Growth	−0.091	0.009	0.132	−0.037	0.060	0.101
	Current Ratio	1.215	1.746	2.482	2.126	1.851	1.687
	Long-Term Debt to Common Equity	0.084	0.428	1.158	0.304	0.114	0.281
	Interest Coverage Ratio	−0.571	2.148	5.501	5.787	3.914	3.491
	Liabilities to Equity	0.649	1.207	2.178	1.103	0.948	0.926
	Operating Cash Flow to Current Liabilities	0.036	0.116	0.193	0.195	0.165	0.156

| | | 1998–2008 | | | 2008 | 2007 | 2006 |
		25th Percentile	Median	75th Percentile	Median	Median	Median
Food	Stock Return	−0.214	0.051	0.318	−0.253	0.060	0.127
Products	Market-to-Book	1.031	1.708	3.002	1.444	1.970	1.957
	Price-Earnings	12.151	17.614	26.370	14.261	20.539	21.429
	Profit Margin for ROA	0.007	0.037	0.066	0.030	0.048	0.042
	Total Asset Turnover	1.025	1.489	1.971	1.608	1.488	1.402
	ROA	0.009	0.054	0.092	0.046	0.065	0.056
	Profit Margin for ROCE	−0.006	0.025	0.057	0.021	0.044	0.031
	Capital Structure Leverage	1.483	2.194	3.316	2.059	1.933	1.985
	ROCE	0.010	0.095	0.186	0.081	0.117	0.098
	Gross Profit Margin	0.154	0.281	0.398	0.259	0.274	0.266
	SG&A Percentage	0.106	0.201	0.292	0.175	0.181	0.192
	Operating Income Margin	0.018	0.056	0.101	0.056	0.071	0.061
	Days Receivable	23.174	29.778	38.769	26.875	27.406	30.116
	Days Inventory	34.846	56.171	82.242	56.279	58.516	59.802
	Days Payables	21.189	31.449	47.283	30.033	30.588	33.447
	Days Revenues in Cash	2.423	8.411	24.610	7.387	9.548	11.099
	Revenue Growth	−0.018	0.059	0.172	0.091	0.112	0.075
	Earnings Growth	−0.417	0.093	0.657	−0.131	0.144	0.131
	Assets Growth	−0.037	0.038	0.141	0.034	0.090	0.045
	Current Ratio	1.130	1.700	2.495	1.637	1.777	1.825
	Long-Term Debt to Common Equity	0.180	0.502	1.050	0.477	0.458	0.419
	Interest Coverage Ratio	0.662	3.144	9.346	3.815	4.306	3.534
	Liabilities to Equity	0.470	1.134	2.189	1.178	0.892	0.937
	Operating Cash Flow to Current Liabilities	0.036	0.150	0.304	0.149	0.153	0.153

(Continued)

| | | 1998–2008 | | | 2008 | 2007 | 2006 |
		25th Percentile	Median	75th Percentile	Median	Median	Median
Healthcare	Stock Return	−0.371	0.014	0.550	−0.363	0.006	0.122
	Market-to-Book	1.144	2.063	3.696	1.754	2.775	2.645
	Price-Earnings	12.493	18.263	27.756	13.532	19.917	20.325
	Profit Margin for ROA	−0.042	0.041	0.083	0.056	0.044	0.046
	Total Asset Turnover	0.814	1.196	1.827	1.083	1.237	1.182
	ROA	−0.055	0.053	0.098	0.061	0.059	0.057
	Profit Margin for ROCE	−0.063	0.021	0.058	0.029	0.024	0.026
	Capital Structure Leverage	1.526	2.121	3.031	2.269	2.050	1.895
	ROCE	−0.092	0.085	0.189	0.086	0.097	0.092
	Gross Profit Margin	0.154	0.304	0.446	0.333	0.315	0.321
	SG&A Percentage	0.115	0.236	0.373	0.224	0.249	0.224
	Operating Income Margin	0.002	0.063	0.120	0.073	0.067	0.062
	Days Receivable	41.803	53.764	68.254	49.024	51.385	52.166
	Days Inventory	6.452	10.721	20.217	11.081	10.690	10.147
	Days Payables	13.698	23.032	38.123	21.170	21.809	23.544
	Days Revenues in Cash	6.368	17.449	43.924	19.297	17.499	18.957
	Revenue Growth	0.007	0.112	0.263	0.107	0.131	0.114
	Earnings Growth	−0.594	0.142	0.758	0.145	0.083	0.038
	Assets Growth	−0.038	0.066	0.229	0.049	0.135	0.118
	Current Ratio	1.068	1.662	2.565	1.720	1.617	1.697
	Long-Term Debt to Common Equity	0.137	0.505	1.180	0.583	0.503	0.476
	Interest Coverage Ratio	−1.165	2.311	8.285	3.598	2.707	3.551
	Liabilities to Equity	0.482	1.048	1.922	1.236	1.051	0.925
	Operating Cash Flow to Current Liabilities	0.016	0.139	0.309	0.148	0.161	0.136

		1998–2008			2008	2007	2006
		25th Percentile	Median	75th Percentile	Median	Median	Median
Insurance	Stock Return	−0.197	0.042	0.305	−0.324	−0.044	0.126
	Market-to-Book	0.886	1.286	1.880	0.973	1.244	1.431
	Price-Earnings	9.513	13.119	19.459	14.359	10.986	11.797
	Profit Margin for ROA	0.022	0.073	0.130	0.031	0.115	0.116
	Total Asset Turnover	0.177	0.287	0.566	0.255	0.286	0.284
	ROA	0.004	0.021	0.050	0.009	0.035	0.039
	Profit Margin for ROCE	0.012	0.059	0.114	0.022	0.095	0.102
	Capital Structure Leverage	2.716	4.349	7.808	4.184	3.939	4.197
	ROCE	0.029	0.104	0.164	0.034	0.135	0.148
	Gross Profit Margin	0.079	0.153	0.249	0.106	0.199	0.201
	SG&A Percentage	0.103	0.167	0.299	0.143	0.126	0.146
	Operating Income Margin	0.032	0.101	0.171	0.059	0.147	0.151
	Days Receivable	55.429	159.102	358.112	166.879	150.407	157.844
	Days Inventory	1.696	6.780	24.040	8.588	3.934	3.555
	Days Payables	23.337	53.609	111.231	46.636	45.924	51.433
	Days Revenues in Cash	12.464	33.209	80.609	46.983	35.867	39.425
	Revenue Growth	−0.022	0.075	0.214	−0.070	0.048	0.073
	Earnings Growth	−0.416	0.100	0.580	−0.645	0.061	0.260
	Assets Growth	−0.006	0.072	0.183	−0.031	0.051	0.084
	Current Ratio	0.895	1.227	1.776	1.040	1.274	1.254
	Long-Term Debt to Common Equity	0.160	0.268	0.475	0.337	0.253	0.248
	Interest Coverage Ratio	1.622	7.700	16.885	3.176	9.902	13.070
	Liabilities to Equity	1.686	3.266	6.738	3.258	2.849	2.958
	Operating Cash Flow to Current Liabilities	0.013	0.050	0.134	0.042	0.057	0.064

(Continued)

| | | 1998–2008 | | | 2008 | 2007 | 2006 |
		25th Percentile	Median	75th Percentile	Median	Median	Median
Machinery	Stock Return	−0.310	0.012	0.411	−0.501	0.071	0.138
	Market-to-Book	1.150	1.889	3.171	1.228	2.546	2.354
	Price-Earnings	11.506	17.163	25.946	10.423	17.478	17.161
	Profit Margin for ROA	−0.072	0.036	0.075	0.045	0.062	0.055
	Total Asset Turnover	0.729	1.026	1.337	1.008	1.041	1.077
	ROA	−0.101	0.035	0.084	0.043	0.059	0.065
	Profit Margin for ROCE	−0.078	0.024	0.066	0.041	0.054	0.045
	Capital Structure Leverage	1.488	1.982	2.801	1.836	1.819	1.887
	ROCE	−0.064	0.086	0.189	0.111	0.145	0.141
	Gross Profit Margin	0.244	0.320	0.408	0.314	0.322	0.325
	SG&A Percentage	0.160	0.231	0.351	0.215	0.215	0.226
	Operating Income Margin	−0.024	0.058	0.110	0.082	0.081	0.076
	Days Receivable	51.550	64.592	81.122	61.211	62.725	60.980
	Days Inventory	67.767	96.801	143.782	93.304	95.031	88.883
	Days Payables	34.353	46.202	67.969	45.217	46.199	43.207
	Days Revenues in Cash	7.495	23.404	72.467	24.227	31.575	24.713
	Revenue Growth	−0.068	0.071	0.238	0.081	0.109	0.153
	Earnings Growth	−0.613	0.095	0.738	−0.034	0.125	0.295
	Assets Growth	−0.070	0.044	0.198	0.019	0.093	0.106
	Current Ratio	1.419	2.018	2.991	2.083	2.032	2.077
	Long-Term Debt to Common Equity	0.094	0.323	0.690	0.319	0.230	0.282
	Interest Coverage Ratio	−3.428	2.243	9.649	3.312	5.777	5.834
	Liabilities to Equity	0.468	0.937	1.747	0.853	0.787	0.860
	Operating Cash Flow to Current Liabilities	−0.067	0.097	0.238	0.121	0.126	0.130

| | | 1998–2008 | | | 2008 | 2007 | 2006 |
		25th Percentile	Median	75th Percentile	Median	Median	Median
Measuring and Control Equipment	Stock Return	−0.361	−0.034	0.448	−0.432	0.052	0.101
	Market-to-Book	1.277	2.038	3.565	1.234	2.076	2.227
	Price-Earnings	14.310	22.236	37.973	15.639	23.057	22.671
	Profit Margin for ROA	−0.264	0.021	0.089	0.028	0.035	0.058
	Total Asset Turnover	0.572	0.844	1.181	0.832	0.810	0.862
	ROA	−0.204	0.020	0.085	0.027	0.026	0.056
	Profit Margin for ROCE	−0.268	0.013	0.079	0.018	0.032	0.053
	Capital Structure Leverage	1.212	1.402	1.876	1.432	1.392	1.391
	ROCE	−0.161	0.048	0.158	0.043	0.067	0.092
	Gross Profit Margin	0.379	0.479	0.577	0.463	0.467	0.498
	SG&A Percentage	0.330	0.425	0.592	0.429	0.413	0.393
	Operating Income Margin	−0.173	0.032	0.111	0.042	0.054	0.077
	Days Receivable	55.329	67.300	84.843	65.568	67.300	61.532
	Days Inventory	88.123	129.822	179.752	128.684	112.713	114.002
	Days Payables	33.052	45.849	71.860	45.090	44.722	40.322
	Days Revenues in Cash	23.925	58.354	131.792	62.516	66.643	48.972
	Revenue Growth	−0.081	0.079	0.279	0.065	0.101	0.169
	Earnings Growth	−0.654	0.078	0.744	−0.043	0.076	0.225
	Assets Growth	−0.102	0.045	0.200	−0.012	0.060	0.108
	Current Ratio	1.786	3.002	4.879	2.966	2.950	2.834
	Long-Term Debt to Common Equity	0.015	0.100	0.416	0.166	0.055	0.088
	Interest Coverage Ratio	−16.144	1.398	15.242	3.454	3.209	7.578
	Liabilities to Equity	0.200	0.381	0.861	0.459	0.365	0.376
	Operating Cash Flow to Current Liabilities	−0.251	0.109	0.367	0.159	0.185	0.189

(Continued)

		1998–2008			2008	2007	2006
		25th Percentile	Median	75th Percentile	Median	Median	Median
Medical	Stock Return	−0.369	0.008	0.526	−0.479	0.022	0.010
Equipment	Market-to-Book	1.602	2.839	5.229	1.699	3.027	3.256
	Price-Earnings	15.471	23.842	39.603	17.146	28.768	26.974
	Profit Margin for ROA	−0.726	−0.017	0.085	−0.079	−0.017	−0.019
	Total Asset Turnover	0.491	0.823	1.123	0.718	0.773	0.815
	ROA	−0.473	−0.044	0.081	−0.106	−0.050	−0.059
	Profit Margin for ROCE	−0.768	−0.032	0.076	−0.080	−0.020	−0.025
	Capital Structure Leverage	1.222	1.464	2.001	1.523	1.455	1.394
	ROCE	−0.494	0.021	0.165	0.003	0.026	0.042
	Gross Profit Margin	0.345	0.532	0.678	0.582	0.580	0.549
	SG&A Percentage	0.376	0.542	1.050	0.601	0.590	0.575
	Operating Income Margin	−0.717	−0.019	0.119	−0.025	−0.010	−0.047
	Days Receivable	46.847	60.144	78.924	57.756	57.681	58.122
	Days Inventory	91.522	141.533	205.313	146.249	142.970	129.169
	Days Payables	34.409	54.142	97.259	55.131	55.520	58.458
	Days Revenues in Cash	19.087	62.929	169.272	69.477	75.803	64.341
	Revenue Growth	−0.012	0.123	0.341	0.101	0.144	0.127
	Earnings Growth	−0.538	0.056	0.535	−0.007	−0.047	−0.044
	Assets Growth	−0.105	0.065	0.293	−0.044	0.106	0.158
	Current Ratio	1.729	2.881	4.953	2.701	3.063	3.086
	Long-Term Debt to Common Equity	0.025	0.137	0.409	0.254	0.156	0.130
	Interest Coverage Ratio	−23.852	−0.624	11.100	−2.359	−0.844	−1.496
	Liabilities to Equity	0.202	0.420	0.937	0.568	0.418	0.369
	Operating Cash Flow to Current Liabilities	−0.914	−0.037	0.294	−0.042	−0.029	−0.053

| | | 1998–2008 | | | 2008 | 2007 | 2006 |
		25th Percentile	Median	75th Percentile	Median	Median	Median
Non-Metallic	Stock Return	−0.424	0.084	0.821	−0.712	0.149	0.524
and	Market-to-Book	1.046	2.206	4.071	0.770	2.436	3.178
Industrial	Price-Earnings	9.309	16.242	26.706	6.337	16.818	13.497
Metal	Profit Margin for ROA	−1.532	−0.006	0.163	−0.229	−0.016	0.041
Mining	Total Asset Turnover	0.093	0.422	0.700	0.322	0.350	0.444
	ROA	−0.381	−0.120	−0.010	−0.134	−0.091	−0.120
	Profit Margin for ROCE	−1.862	−0.038	0.130	−0.334	−0.029	0.005
	Capital Structure Leverage	1.050	1.187	1.711	1.177	1.133	1.142
	ROCE	−0.384	−0.111	0.042	−0.143	−0.101	−0.115
	Gross Profit Margin	−0.361	0.239	0.393	0.178	0.329	0.236
	SG&A Percentage	0.070	0.168	0.702	0.201	0.264	0.226
	Operating Income Margin	−2.490	−0.033	0.164	−0.342	−0.032	−0.113
	Days Receivable	30.551	50.755	88.257	38.526	45.286	46.092
	Days Inventory	37.723	63.817	108.923	48.268	74.124	68.667
	Days Payables	40.717	83.332	233.739	93.179	128.918	115.118
	Days Revenues in Cash	17.705	74.153	362.242	62.668	124.198	234.143
	Revenue Growth	−0.157	0.105	0.431	0.062	0.181	0.208
	Earnings Growth	−1.429	−0.171	0.476	−0.497	−0.283	−0.145
	Assets Growth	−0.078	0.133	0.804	0.021	0.449	0.689
	Current Ratio	1.059	2.940	10.344	2.709	4.910	5.053
	Long-Term Debt to Common Equity	0.038	0.214	0.516	0.195	0.175	0.130
	Interest Coverage Ratio	−125.988	−8.347	1.797	−12.272	−10.276	−17.285
	Liabilities to Equity	0.044	0.164	0.625	0.165	0.151	0.113
	Operating Cash Flow to Current Liabilities	−2.559	−0.427	0.017	−0.350	−0.508	−0.702

(Continued)

		1998–2008			2008	2007	2006
		25th Percentile	Median	75th Percentile	Median	Median	Median
Others	Stock Return	−0.328	0.077	0.541	−0.422	0.100	0.212
	Market-to-Book	0.982	1.645	2.980	1.099	2.590	2.426
	Price-Earnings	10.714	17.290	28.661	12.959	21.944	24.441
	Profit Margin for ROA	−0.199	0.045	0.139	0.015	0.005	0.067
	Total Asset Turnover	0.258	0.571	0.951	0.387	0.466	0.488
	ROA	−0.123	0.026	0.065	−0.012	0.006	0.032
	Profit Margin for ROCE	−0.282	0.006	0.081	−0.062	−0.017	0.013
	Capital Structure Leverage	1.705	2.648	4.739	2.635	2.674	2.597
	ROCE	−0.204	0.039	0.172	0.018	−0.038	0.063
	Gross Profit Margin	0.198	0.333	0.436	0.338	0.337	0.349
	SG&A Percentage	0.096	0.160	0.371	0.178	0.158	0.165
	Operating Income Margin	−0.156	0.070	0.173	0.068	0.036	0.073
	Days Receivable	43.090	61.632	89.176	48.129	54.439	55.492
	Days Inventory	5.131	16.413	37.694	21.821	17.462	14.241
	Days Payables	34.320	53.127	107.426	61.488	67.048	50.714
	Days Revenues in Cash	6.154	27.704	85.200	51.223	40.861	50.826
	Revenue Growth	−0.058	0.088	0.310	0.130	0.130	0.139
	Earnings Growth	−0.714	0.028	0.664	−0.065	−0.061	0.017
	Assets Growth	−0.072	0.030	0.294	0.022	0.080	0.064
	Current Ratio	0.824	1.239	1.931	1.262	1.404	1.379
	Long-Term Debt to Common Equity	0.245	0.866	1.965	1.192	1.167	0.915
	Interest Coverage Ratio	−2.967	1.211	3.092	0.615	0.862	1.281
	Liabilities to Equity	0.649	1.528	3.139	1.736	1.709	1.365
	Operating Cash Flow to Current Liabilities	−0.076	0.064	0.170	0.011	0.061	0.080

		1998–2008			2008	2007	2006
		25th Percentile	Median	75th Percentile	Median	Median	Median
Personal Services	Stock Return	−0.390	−0.061	0.409	−0.386	0.112	0.003
	Market-to-Book	0.943	1.798	3.956	1.565	2.541	2.286
	Price-Earnings	14.323	20.552	30.672	17.582	24.257	22.095
	Profit Margin for ROA	−0.040	0.038	0.082	0.057	0.052	0.057
	Total Asset Turnover	0.614	1.121	1.673	1.051	1.099	1.145
	ROA	−0.052	0.038	0.079	0.057	0.055	0.057
	Profit Margin for ROCE	−0.071	0.020	0.064	0.038	0.039	0.033
	Capital Structure Leverage	1.639	2.196	3.597	2.056	1.929	2.150
	ROCE	−0.103	0.069	0.193	0.070	0.095	0.072
	Gross Profit Margin	0.224	0.368	0.560	0.460	0.443	0.427
	SG&A Percentage	0.116	0.272	0.477	0.322	0.306	0.267
	Operating Income Margin	−0.008	0.064	0.122	0.091	0.085	0.082
	Days Receivable	11.154	26.377	47.415	22.644	24.180	23.468
	Days Inventory	8.776	21.174	47.926	16.160	22.567	20.659
	Days Payables	15.488	24.692	50.120	27.212	24.596	23.246
	Days Revenues in Cash	8.685	25.251	59.654	50.146	35.168	30.552
	Revenue Growth	−0.006	0.101	0.254	0.120	0.087	0.077
	Earnings Growth	−0.731	0.140	0.701	0.027	0.241	0.102
	Assets Growth	−0.060	0.043	0.227	0.047	0.075	0.034
	Current Ratio	0.796	1.219	1.837	1.351	1.339	1.193
	Long-Term Debt to Common Equity	0.144	0.545	1.250	0.536	0.563	0.357
	Interest Coverage Ratio	−1.680	1.713	7.415	4.608	4.290	4.596
	Liabilities to Equity	0.580	1.095	2.362	0.887	0.948	0.960
	Operating Cash Flow to Current Liabilities	0.012	0.121	0.313	0.208	0.199	0.153

(Continued)

		1998–2008			2008	2007	2006
		25th Percentile	Median	75th Percentile	Median	Median	Median
Petroleum and	Stock Return	−0.263	0.175	0.728	−0.521	0.048	0.046
Natural Gas	Market-to-Book	1.181	1.946	3.056	0.890	1.993	2.284
	Price-Earnings	9.099	14.435	25.830	7.056	16.090	14.269
	Profit Margin for ROA	−0.070	0.101	0.233	0.044	0.076	0.115
	Total Asset Turnover	0.237	0.385	0.689	0.400	0.317	0.367
	ROA	−0.054	0.047	0.107	0.013	0.029	0.060
	Profit Margin for ROCE	−0.142	0.069	0.197	0.021	0.051	0.091
	Capital Structure Leverage	1.435	1.880	2.510	1.812	1.736	1.737
	ROCE	−0.073	0.083	0.217	0.035	0.043	0.103
	Gross Profit Margin	0.248	0.522	0.730	0.428	0.524	0.521
	SG&A Percentage	0.055	0.104	0.235	0.092	0.113	0.101
	Operating Income Margin	−0.098	0.125	0.296	0.095	0.101	0.137
	Days Receivable	42.512	61.259	85.164	50.982	65.556	64.689
	Days Inventory	9.735	20.896	38.242	16.619	19.637	19.748
	Days Payables	48.930	119.059	376.679	87.201	135.564	123.941
	Days Revenues in Cash	8.019	28.144	104.300	23.734	28.394	24.236
	Revenue Growth	0.020	0.267	0.653	0.355	0.162	0.244
	Earnings Growth	−0.590	0.251	1.123	0.057	−0.117	0.120
	Assets Growth	0.000	0.172	0.514	0.099	0.183	0.286
	Current Ratio	0.652	1.086	1.943	1.230	1.067	1.173
	Long-Term Debt to Common Equity	0.210	0.470	0.873	0.449	0.459	0.411
	Interest Coverage Ratio	−1.239	3.403	10.897	1.992	2.029	4.535
	Liabilities to Equity	0.403	0.846	1.445	0.800	0.746	0.720
	Operating Cash Flow to Current Liabilities	0.029	0.256	0.474	0.272	0.248	0.318

		1998–2008			2008	2007	2006
		25th Percentile	Median	75th Percentile	Median	Median	Median
Pharmaceutical Products	Stock Return	−0.422	−0.022	0.568	−0.469	−0.126	0.104
	Market-to-Book	2.110	3.769	7.000	2.369	3.615	3.971
	Price-Earnings	15.612	23.567	39.897	13.705	20.686	22.786
	Profit Margin for ROA	−5.593	−0.870	0.034	−0.627	−0.766	−1.122
	Total Asset Turnover	0.090	0.340	0.744	0.400	0.327	0.302
	ROA	−0.686	−0.310	−0.006	−0.390	−0.361	−0.365
	Profit Margin for ROCE	−6.264	−0.976	0.020	−0.771	−0.927	−1.262
	Capital Structure Leverage	1.197	1.451	2.069	1.565	1.510	1.522
	ROCE	−0.823	−0.262	0.161	−0.263	−0.365	−0.281
	Gross Profit Margin	−3.316	0.270	0.632	0.389	0.350	0.314
	SG&A Percentage	0.380	0.592	1.434	0.645	0.651	0.681
	Operating Income Margin	−6.098	−0.906	0.046	−0.729	−0.930	−1.310
	Days Receivable	35.352	55.603	80.567	50.809	53.385	53.940
	Days Inventory	43.181	114.955	194.906	121.466	124.238	129.420
	Days Payables	22.795	49.258	104.549	45.590	47.583	47.621
	Days Revenues in Cash	57.148	242.690	1,215.684	220.266	314.843	315.518
	Revenue Growth	−0.167	0.120	0.501	0.095	0.134	0.115
	Earnings Growth	−0.618	−0.054	0.370	0.025	−0.075	−0.113
	Assets Growth	−0.207	0.038	0.420	−0.126	0.070	0.095
	Current Ratio	1.720	3.472	6.948	2.659	3.572	3.533
	Long-Term Debt to Common Equity	0.027	0.133	0.498	0.192	0.136	0.144
	Interest Coverage Ratio	−71.629	−10.808	1.317	−8.689	−9.224	−8.697
	Liabilities to Equity	0.173	0.401	0.976	0.598	0.474	0.458
	Operating Cash Flow to Current Liabilities	−2.014	−0.559	0.087	−0.435	−0.566	−0.554

(Continued)

| | | 1998–2008 | | | 2008 | 2007 | 2006 |
		25th Percentile	Median	75th Percentile	Median	Median	Median
Precious Metals	Stock Return	−0.362	0.098	0.906	−0.568	0.171	0.682
	Market-to-Book	1.080	2.171	4.058	1.024	2.612	3.330
	Price-Earnings	12.837	24.915	51.447	21.678	30.667	23.739
	Profit Margin for ROA	−0.742	−0.102	0.143	−0.034	−0.243	−0.061
	Total Asset Turnover	0.167	0.338	0.512	0.343	0.265	0.308
	ROA	−0.293	−0.088	−0.005	−0.093	−0.091	−0.095
	Profit Margin for ROCE	−0.873	−0.149	0.114	−0.045	−0.248	−0.138
	Capital Structure Leverage	1.060	1.258	1.633	1.213	1.243	1.219
	ROCE	−0.330	−0.099	0.006	−0.108	−0.115	−0.120
	Gross Profit Margin	−0.092	0.239	0.413	0.274	0.282	0.347
	SG&A Percentage	0.084	0.145	0.384	0.190	0.171	0.170
	Operating Income Margin	−0.938	−0.097	0.116	−0.071	−0.170	−0.055
	Days Receivable	11.794	24.271	52.075	18.991	23.672	20.965
	Days Inventory	39.323	71.950	108.608	64.323	81.797	77.772
	Days Payables	42.327	83.706	245.545	79.708	95.809	100.857
	Days Revenues in Cash	36.590	104.065	280.200	53.258	148.047	179.061
	Revenue Growth	−0.179	0.071	0.425	0.298	0.149	0.391
	Earnings Growth	−1.393	−0.091	0.591	−0.190	−0.316	−0.016
	Assets Growth	−0.106	0.074	0.464	0.045	0.266	0.473
	Current Ratio	0.915	2.496	7.955	2.337	3.812	3.959
	Long-Term Debt to Common Equity	0.047	0.156	0.412	0.120	0.157	0.112
	Interest Coverage Ratio	−51.813	−5.454	1.396	−4.571	−9.333	−6.462
	Liabilities to Equity	0.050	0.226	0.566	0.223	0.208	0.194
	Operating Cash Flow to Current Liabilities	−1.572	−0.277	0.089	−0.295	−0.441	−0.459

| | | 1998–2008 | | | 2008 | 2007 | 2006 |
		25th Percentile	Median	75th Percentile	Median	Median	Median
Printing & Publishing	Stock Return	−0.290	−0.014	0.228	−0.522	−0.155	0.002
	Market-to-Book	1.257	2.265	3.999	1.140	1.779	1.827
	Price-Earnings	12.343	17.868	25.002	9.166	14.555	17.446
	Profit Margin for ROA	−0.040	0.066	0.124	0.002	0.070	0.070
	Total Asset Turnover	0.503	0.779	1.100	0.675	0.672	0.696
	ROA	−0.030	0.046	0.087	0.013	0.048	0.051
	Profit Margin for ROCE	−0.073	0.046	0.096	−0.005	0.052	0.045
	Capital Structure Leverage	1.692	2.274	3.817	2.275	2.287	2.206
	ROCE	−0.067	0.103	0.214	−0.002	0.020	0.091
	Gross Profit Margin	0.379	0.509	0.603	0.510	0.519	0.503
	SG&A Percentage	0.270	0.369	0.474	0.382	0.378	0.358
	Operating Income Margin	0.036	0.116	0.167	0.098	0.128	0.123
	Days Receivable	39.271	50.226	68.112	52.119	52.477	48.380
	Days Inventory	9.013	20.522	76.070	25.829	17.736	15.473
	Days Payables	29.694	49.156	79.630	49.512	51.105	43.330
	Days Revenues in Cash	4.170	10.506	35.441	11.011	11.657	8.976
	Revenue Growth	−0.050	0.024	0.121	−0.049	0.012	0.034
	Earnings Growth	−0.691	−0.019	0.442	−0.667	0.078	−0.079
	Assets Growth	−0.081	0.008	0.118	−0.087	0.017	0.024
	Current Ratio	0.826	1.167	1.816	1.235	1.302	1.169
	Long-Term Debt to Common Equity	0.310	0.607	1.469	0.964	0.837	0.735
	Interest Coverage Ratio	−0.241	2.594	6.895	1.100	2.286	1.838
	Liabilities to Equity	0.667	1.317	3.124	1.636	1.508	1.274
	Operating Cash Flow to Current Liabilities	0.030	0.123	0.238	0.142	0.127	0.119

(Continued)

| | | 1998–2008 | | | 2008 | 2007 | 2006 |
		25th Percentile	Median	75th Percentile	Median	Median	Median
Real Estate	Stock Return	−0.224	0.045	0.391	−0.473	−0.044	0.151
	Market-to-Book	0.789	1.277	2.435	0.892	1.887	2.200
	Price-Earnings	8.180	14.544	26.547	12.463	22.587	19.993
	Profit Margin for ROA	0.025	0.163	0.332	0.101	0.187	0.196
	Total Asset Turnover	0.143	0.237	0.505	0.214	0.211	0.236
	ROA	0.002	0.044	0.075	0.022	0.045	0.054
	Profit Margin for ROCE	−0.068	0.059	0.177	0.025	0.084	0.089
	Capital Structure						
	Leverage	1.690	2.720	4.503	2.596	2.574	2.665
	ROCE	−0.019	0.072	0.169	0.041	0.058	0.094
	Gross Profit Margin	0.199	0.413	0.598	0.394	0.419	0.416
	SG&A Percentage	0.082	0.185	0.465	0.224	0.188	0.156
	Operating Income						
	Margin	−0.002	0.148	0.328	0.099	0.156	0.168
	Days Receivable	11.810	37.481	89.480	44.794	46.327	30.955
	Days Inventory	33.723	178.956	503.248	166.287	164.274	169.537
	Days Payables	27.416	65.936	143.407	67.433	64.286	59.168
	Days Revenues in Cash	16.357	44.188	162.060	62.843	60.796	56.154
	Revenue Growth	−0.102	0.066	0.312	0.017	0.050	0.113
	Earnings Growth	−0.670	0.018	0.845	−0.457	−0.038	−0.035
	Assets Growth	−0.058	0.041	0.195	−0.022	0.108	0.110
	Current Ratio	0.701	1.311	2.648	1.630	1.784	1.621
	Long-Term Debt to						
	Common Equity	0.388	1.083	2.531	0.809	0.893	0.916
	Interest Coverage Ratio	0.634	1.672	4.305	1.033	1.911	3.164
	Liabilities to Equity	0.581	1.545	3.195	1.537	1.513	1.540
	Operating Cash Flow to						
	Current Liabilities	−0.050	0.043	0.131	0.009	0.034	0.041

		1998–2008			2008	2007	2006
		25th Percentile	Median	75th Percentile	Median	Median	Median
Recreation	Stock Return	−0.449	−0.098	0.333	−0.579	−0.212	0.102
	Market-to-Book	0.858	1.593	2.851	1.025	1.437	2.050
	Price-Earnings	9.516	15.244	24.469	13.237	13.414	21.053
	Profit Margin for ROA	−0.092	0.024	0.071	−0.042	0.012	0.042
	Total Asset Turnover	0.844	1.175	1.598	1.140	1.088	0.996
	ROA	−0.196	0.024	0.089	−0.059	0.010	0.044
	Profit Margin for ROCE	−0.111	0.013	0.064	−0.037	0.019	0.027
	Capital Structure Leverage	1.344	1.850	3.068	1.807	1.618	1.677
	ROCE	−0.137	0.076	0.207	−0.061	0.081	0.088
	Gross Profit Margin	0.272	0.372	0.466	0.357	0.360	0.378
	SG&A Percentage	0.213	0.302	0.436	0.346	0.299	0.295
	Operating Income Margin	−0.063	0.040	0.098	0.005	0.048	0.056
	Days Receivable	37.572	58.356	75.283	57.139	58.671	55.525
	Days Inventory	59.949	91.227	133.425	99.000	94.782	95.589
	Days Payables	29.661	44.674	68.009	45.394	44.022	45.259
	Days Revenues in Cash	6.721	26.388	65.844	29.003	33.183	39.084
	Revenue Growth	−0.105	0.032	0.218	−0.012	0.051	0.091
	Earnings Growth	−0.848	−0.058	0.642	−0.469	−0.145	0.007
	Assets Growth	−0.131	0.021	0.196	−0.047	0.045	0.111
	Current Ratio	1.231	2.014	3.384	1.946	2.042	2.133
	Long-Term Debt to Common Equity	0.087	0.322	0.920	0.360	0.297	0.309
	Interest Coverage Ratio	−6.288	1.003	6.532	−10.652	0.574	1.634
	Liabilities to Equity	0.323	0.841	1.931	0.957	0.634	0.607
	Operating Cash Flow to Current Liabilities	−0.124	0.084	0.285	0.043	0.103	0.072

(Continued)

		1998–2008			2008	2007	2006
		25th Percentile	Median	75th Percentile	Median	Median	Median
Restaurants,	Stock Return	−0.304	−0.003	0.338	−0.463	−0.189	0.095
Hotels,	Market-to-Book	0.905	1.616	2.979	1.271	2.031	2.738
Motels	Price-Earnings	11.690	17.012	25.926	13.571	20.800	21.423
	Profit Margin for ROA	−0.006	0.036	0.065	0.012	0.037	0.042
	Total Asset Turnover	0.792	1.421	1.887	1.425	1.472	1.518
	ROA	−0.009	0.046	0.086	0.012	0.044	0.064
	Profit Margin for ROCE	−0.032	0.019	0.054	0.003	0.024	0.031
	Capital Structure						
	Leverage	1.639	2.130	3.492	2.489	2.149	2.105
	ROCE	−0.063	0.075	0.169	0.014	0.067	0.087
	Gross Profit Margin	0.154	0.201	0.289	0.202	0.202	0.204
	SG&A Percentage	0.072	0.100	0.167	0.105	0.104	0.103
	Operating Income						
	Margin	0.016	0.055	0.094	0.049	0.060	0.065
	Days Receivable	2.566	5.888	15.353	7.189	7.019	6.518
	Days Inventory	3.902	6.611	11.884	6.146	6.673	6.621
	Days Payables	13.380	18.555	29.912	17.985	17.654	18.763
	Days Revenues in Cash	4.746	11.065	25.887	11.178	12.164	14.288
	Revenue Growth	−0.024	0.060	0.154	0.037	0.067	0.066
	Earnings Growth	−0.606	0.068	0.593	−0.414	−0.066	0.026
	Assets Growth	−0.052	0.032	0.140	0.008	0.062	0.057
	Current Ratio	0.479	0.765	1.150	0.791	0.788	0.846
	Long-Term Debt to						
	Common Equity	0.270	0.583	1.471	0.774	0.675	0.480
	Interest Coverage Ratio	0.045	1.716	5.790	0.600	1.787	2.726
	Liabilities to Equity	0.618	1.114	2.544	1.642	1.332	1.028
	Operating Cash Flow to						
	Current Liabilities	0.051	0.156	0.349	0.126	0.163	0.203

		1998–2008					
		25th Percentile	Median	75th Percentile	2008 Median	2007 Median	2006 Median
Retail	Stock Return	−0.343	−0.001	0.385	−0.446	−0.221	0.092
	Market-to-Book	0.927	1.696	3.093	1.073	1.831	2.309
	Price-Earnings	11.334	16.513	24.552	12.110	15.424	18.775
	Profit Margin for ROA	0.001	0.024	0.046	0.017	0.029	0.029
	Total Asset Turnover	1.515	2.056	2.727	1.888	1.906	2.084
	ROA	0.003	0.053	0.091	0.041	0.055	0.060
	Profit Margin for ROCE	−0.010	0.017	0.040	0.013	0.021	0.022
	Capital Structure Leverage	1.630	2.121	3.055	2.179	2.155	2.028
	ROCE	−0.031	0.097	0.182	0.071	0.103	0.111
	Gross Profit Margin	0.239	0.321	0.403	0.318	0.324	0.330
	SG&A Percentage	0.208	0.266	0.353	0.270	0.270	0.263
	Operating Income Margin	0.010	0.039	0.070	0.035	0.041	0.044
	Days Receivable	3.620	8.307	23.314	7.314	8.238	7.703
	Days Inventory	41.391	73.299	118.215	68.606	70.461	69.759
	Days Payables	24.224	35.219	51.892	34.365	36.110	34.715
	Days Revenues in Cash	3.514	8.791	23.763	10.597	8.925	9.307
	Revenue Growth	0.007	0.082	0.185	0.019	0.062	0.105
	Earnings Growth	−0.500	0.106	0.543	−0.208	0.031	0.092
	Assets Growth	−0.027	0.062	0.182	−0.001	0.049	0.067
	Current Ratio	1.189	1.651	2.449	1.665	1.634	1.616
	Long-Term Debt to Common Equity	0.123	0.395	0.928	0.454	0.420	0.359
	Interest Coverage Ratio	0.312	3.106	11.562	2.269	3.477	4.510
	Liabilities to Equity	0.622	1.111	2.066	1.223	1.197	1.072
	Operating Cash Flow to Current Liabilities	0.045	0.147	0.294	0.158	0.162	0.162

(Continued)

| | | 1998–2008 | | | 2008 | 2007 | 2006 |
		25th Percentile	Median	75th Percentile	Median	Median	Median
Rubber and Plastic Products	Stock Return	−0.385	−0.056	0.338	−0.430	−0.066	0.150
	Market-to-Book	0.888	1.563	2.637	1.087	1.793	2.013
	Price-Earnings	9.959	14.961	21.619	12.500	17.260	17.228
	Profit Margin for ROA	−0.015	0.031	0.069	0.024	0.034	0.036
	Total Asset Turnover	0.916	1.169	1.493	1.217	1.161	1.161
	ROA	−0.035	0.038	0.078	0.022	0.046	0.050
	Profit Margin for ROCE	−0.050	0.010	0.051	0.012	0.022	0.015
	Capital Structure Leverage	1.689	2.441	4.032	2.221	2.206	2.293
	ROCE	−0.066	0.082	0.192	0.104	0.137	0.123
	Gross Profit Margin	0.186	0.265	0.332	0.263	0.273	0.276
	SG&A Percentage	0.105	0.176	0.248	0.171	0.171	0.171
	Operating Income Margin	0.015	0.056	0.095	0.056	0.064	0.065
	Days Receivable	40.741	51.020	64.032	44.420	49.571	50.117
	Days Inventory	42.207	61.112	84.221	61.712	56.333	61.856
	Days Payables	31.046	39.399	53.031	35.734	37.274	38.689
	Days Revenues in Cash	2.755	9.796	31.020	15.535	15.834	13.370
	Revenue Growth	−0.045	0.041	0.167	0.064	0.032	0.046
	Earnings Growth	−0.837	0.074	0.723	−0.104	0.053	0.422
	Assets Growth	−0.081	0.006	0.119	0.000	0.030	0.021
	Current Ratio	1.130	1.651	2.348	1.733	1.692	1.868
	Long-Term Debt to Common Equity	0.245	0.646	1.364	0.448	0.369	0.460
	Interest Coverage Ratio	−0.085	1.393	4.406	1.236	2.418	2.188
	Liabilities to Equity	0.618	1.399	2.818	1.275	1.075	1.043
	Operating Cash Flow to Current Liabilities	0.010	0.094	0.205	0.086	0.105	0.115

		1998–2008			2008	2007	2006
		25th Percentile	Median	75th Percentile	Median	Median	Median
Shipbuilding,	Stock Return	−0.288	0.037	0.338	−0.400	−0.190	0.070
Railroad	Market-to-Book	1.195	1.958	3.056	1.249	2.019	2.886
Equipment	Price-Earnings	11.017	16.845	21.653	11.934	16.055	16.907
	Profit Margin for ROA	0.004	0.036	0.070	0.062	0.048	0.055
	Total Asset Turnover	1.006	1.202	1.506	1.197	1.287	1.232
	ROA	0.003	0.052	0.085	0.074	0.068	0.087
	Profit Margin for ROCE	0.007	0.039	0.068	0.043	0.053	0.054
	Capital Structure Leverage	1.873	2.371	3.897	2.341	2.228	2.210
	ROCE	0.035	0.116	0.197	0.093	0.132	0.200
	Gross Profit Margin	0.127	0.187	0.267	0.183	0.185	0.191
	SG&A Percentage	0.071	0.110	0.158	0.083	0.103	0.094
	Operating Income Margin	0.029	0.075	0.103	0.065	0.088	0.089
	Days Receivable	20.868	34.939	50.656	38.725	26.521	32.689
	Days Inventory	43.891	61.952	81.941	71.657	61.121	61.952
	Days Payables	27.310	36.180	50.789	34.647	36.928	34.869
	Days Revenues in Cash	8.493	20.600	38.762	17.983	27.579	24.330
	Revenue Growth	−0.062	0.104	0.228	0.004	0.108	0.093
	Earnings Growth	−0.411	0.116	0.727	−0.135	0.059	0.328
	Assets Growth	−0.019	0.063	0.176	0.068	0.025	0.146
	Current Ratio	1.177	1.674	2.380	1.953	2.154	1.996
	Long-Term Debt to Common Equity	0.180	0.470	1.012	0.713	0.243	0.282
	Interest Coverage Ratio	0.647	3.146	6.907	4.350	5.622	6.574
	Liabilities to Equity	0.882	1.342	2.496	1.510	1.218	1.277
	Operating Cash Flow to Current Liabilities	0.041	0.136	0.221	0.138	0.215	0.121

(Continued)

		1998–2008			2008	2007	2006
		25th Percentile	Median	75th Percentile	Median	Median	Median
Shipping	Stock Return	−0.208	0.074	0.333	−0.347	0.208	0.325
Containers	Market-to-Book	1.021	1.762	3.282	2.001	2.724	3.139
	Price-Earnings	11.995	15.343	21.340	13.650	15.933	15.799
	Profit Margin for ROA	0.018	0.045	0.070	0.050	0.050	0.042
	Total Asset Turnover	0.849	1.037	1.224	1.171	1.134	1.093
	ROA	0.004	0.040	0.069	0.048	0.047	0.036
	Profit Margin for ROCE	−0.006	0.021	0.044	0.029	0.038	0.017
	Capital Structure Leverage	2.729	3.823	5.593	4.200	4.070	4.124
	ROCE	−0.022	0.083	0.239	0.130	0.159	0.059
	Gross Profit Margin	0.166	0.223	0.272	0.212	0.212	0.212
	SG&A Percentage	0.050	0.098	0.132	0.090	0.095	0.097
	Operating Income Margin	0.056	0.080	0.096	0.085	0.085	0.073
	Days Receivable	32.350	39.482	46.797	35.780	39.007	39.749
	Days Inventory	43.547	53.392	77.320	53.392	45.798	45.384
	Days Payables	33.285	44.027	53.909	47.793	45.507	43.809
	Days Revenues in Cash	2.665	6.767	16.390	17.568	16.337	13.528
	Revenue Growth	−0.004	0.046	0.108	0.042	0.096	0.097
	Earnings Growth	−0.550	0.054	0.716	0.027	0.140	0.260
	Assets Growth	−0.040	0.016	0.096	0.011	0.048	0.080
	Current Ratio	1.119	1.369	1.664	1.220	1.303	1.429
	Long-Term Debt to Common Equity	0.836	1.430	2.535	1.363	1.681	1.679
	Interest Coverage Ratio	0.531	1.592	2.938	2.350	1.370	1.329
	Liabilities to Equity	1.661	2.741	4.196	3.401	3.109	2.666
	Operating Cash Flow to Current Liabilities	0.052	0.104	0.162	0.095	0.084	0.090

		1998–2008			2008	2007	2006
		25th Percentile	Median	75th Percentile	Median	Median	Median
Steel	Stock Return	−0.382	0.036	0.581	−0.577	0.284	0.511
Works	Market-to-Book	0.728	1.294	2.136	1.034	2.143	1.986
	Price-Earnings	7.220	11.145	18.886	7.100	12.538	10.516
	Profit Margin for ROA	−0.028	0.038	0.082	0.044	0.061	0.070
	Total Asset Turnover	0.786	1.078	1.442	1.179	1.139	1.318
	ROA	−0.033	0.042	0.096	0.074	0.094	0.100
	Profit Margin for ROCE	−0.050	0.021	0.066	0.036	0.056	0.060
	Capital Structure Leverage	1.796	2.328	3.180	1.993	2.089	2.124
	ROCE	−0.078	0.087	0.220	0.115	0.180	0.206
	Gross Profit Margin	0.117	0.179	0.269	0.195	0.204	0.214
	SG&A Percentage	0.052	0.079	0.134	0.065	0.071	0.066
	Operating Income Margin	−0.001	0.054	0.108	0.088	0.091	0.103
	Days Receivable	37.211	46.716	57.551	38.805	44.096	41.238
	Days Inventory	54.214	76.134	102.631	66.102	71.154	67.981
	Days Payables	28.035	37.960	53.565	32.198	35.560	33.263
	Days Revenues in Cash	3.535	10.566	28.178	21.129	19.987	12.964
	Revenue Growth	−0.063	0.077	0.267	0.143	0.109	0.220
	Earnings Growth	−0.825	0.033	0.763	−0.088	0.019	0.472
	Assets Growth	−0.076	0.034	0.193	0.029	0.177	0.178
	Current Ratio	1.293	1.882	2.700	2.068	2.224	2.162
	Long-Term Debt to Common Equity	0.212	0.491	0.994	0.287	0.364	0.305
	Interest Coverage Ratio	−0.608	2.426	8.008	4.983	7.583	7.628
	Liabilities to Equity	0.718	1.263	2.099	1.037	0.929	0.893
	Operating Cash Flow to Current Liabilities	0.000	0.091	0.217	0.175	0.151	0.128

(Continued)

| | | 1998–2008 | | | 2008 | 2007 | 2006 |
		25th Percentile	Median	75th Percentile	Median	Median	Median
Textiles	Stock Return	−0.495	−0.142	0.235	−0.588	−0.214	0.019
	Market-to-Book	0.438	0.840	1.298	0.924	1.031	1.294
	Price-Earnings	7.175	12.860	19.556	20.370	17.000	18.632
	Profit Margin for ROA	−0.029	0.022	0.058	−0.097	0.021	0.005
	Total Asset Turnover	0.985	1.194	1.481	1.282	1.242	1.217
	ROA	−0.032	0.025	0.062	−0.101	0.021	0.007
	Profit Margin for ROCE	−0.061	0.001	0.037	−0.090	0.008	0.002
	Capital Structure Leverage	1.749	2.242	3.518	2.092	2.021	2.063
	ROCE	−0.167	0.019	0.113	−0.155	0.014	−0.017
	Gross Profit Margin	0.146	0.221	0.309	0.245	0.233	0.209
	SG&A Percentage	0.094	0.137	0.221	0.165	0.153	0.152
	Operating Income Margin	0.006	0.052	0.086	0.060	0.056	0.039
	Days Receivable	40.463	50.826	61.968	43.570	44.804	44.400
	Days Inventory	59.508	76.863	104.998	70.197	70.764	68.329
	Days Payables	24.183	29.067	37.779	32.705	32.158	26.784
	Days Revenues in Cash	2.021	8.851	23.021	14.050	17.106	14.815
	Revenue Growth	−0.113	−0.017	0.073	−0.011	0.010	0.039
	Earnings Growth	−1.404	−0.177	0.545	−2.922	−0.514	−0.192
	Assets Growth	−0.144	−0.043	0.045	−0.182	0.008	0.016
	Current Ratio	1.718	2.354	3.061	2.673	2.539	2.770
	Long-Term Debt to Common Equity	0.247	0.638	1.235	0.790	0.562	0.521
	Interest Coverage Ratio	−0.861	1.373	3.393	−2.449	2.054	0.273
	Liabilities to Equity	0.740	1.222	2.384	1.435	0.951	0.968
	Operating Cash Flow to Current Liabilities	0.042	0.115	0.204	0.102	0.114	0.108

		1998–2008			2008	2007	2006
		25th Percentile	Median	75th Percentile	Median	Median	Median
Tobacco Products	Stock Return	−0.039	0.210	0.409	−0.170	0.174	0.251
	Market-to-Book	3.072	5.748	13.540	10.977	10.836	10.420
	Price-Earnings	11.067	14.271	17.245	13.066	17.022	15.297
	Profit Margin for ROA	0.082	0.186	0.270	0.209	0.274	0.254
	Total Asset Turnover	0.491	0.699	1.204	0.496	0.546	0.553
	ROA	0.065	0.116	0.258	0.098	0.143	0.134
	Profit Margin for ROCE	0.042	0.147	0.224	0.177	0.234	0.171
	Capital Structure Leverage	2.526	3.381	4.475	3.817	2.776	3.293
	ROCE	−0.295	0.297	0.563	0.531	0.371	0.324
	Gross Profit Margin	0.423	0.494	0.603	0.481	0.549	0.493
	SG&A Percentage	0.213	0.266	0.336	0.222	0.233	0.246
	Operating Income Margin	0.160	0.261	0.388	0.308	0.381	0.305
	Days Receivable	11.554	22.723	56.117	40.866	27.844	15.502
	Days Inventory	96.535	173.412	238.855	128.747	223.261	169.047
	Days Payables	26.991	37.954	58.444	33.816	57.588	31.432
	Days Revenues in Cash	22.693	39.155	88.091	115.437	59.941	48.020
	Revenue Growth	−0.019	0.046	0.105	0.014	0.067	0.026
	Earnings Growth	−0.151	0.076	0.289	−0.064	0.103	0.157
	Assets Growth	−0.056	0.055	0.177	−0.056	0.050	0.060
	Current Ratio	1.140	1.558	2.178	1.279	1.938	1.664
	Long-Term Debt to Common Equity	0.609	1.023	2.008	1.518	0.737	0.960
	Interest Coverage Ratio	3.772	7.011	13.753	8.312	8.097	7.858
	Liabilities to Equity	1.653	2.509	5.676	3.396	2.168	2.107
	Operating Cash Flow to Current Liabilities	0.081	0.144	0.263	0.142	0.219	0.199

(Continued)

		1998–2008			2008	2007	2006
		25th Percentile	Median	75th Percentile	Median	Median	Median
Transportation	Stock Return	−0.256	0.058	0.421	−0.455	0.070	0.153
	Market-to-Book	0.985	1.530	2.565	1.016	1.770	1.943
	Price-Earnings	9.225	15.000	23.631	9.368	16.107	14.122
	Profit Margin for ROA	0.012	0.052	0.134	0.051	0.081	0.078
	Total Asset Turnover	0.416	0.860	1.615	0.724	0.722	0.770
	ROA	0.013	0.053	0.088	0.050	0.062	0.067
	Profit Margin for ROCE	−0.001	0.036	0.103	0.032	0.047	0.057
	Capital Structure Leverage	1.838	2.522	3.609	2.571	2.415	2.335
	ROCE	0.011	0.105	0.190	0.091	0.128	0.131
	Gross Profit Margin	0.127	0.236	0.390	0.260	0.269	0.271
	SG&A Percentage	0.067	0.106	0.165	0.096	0.102	0.095
	Operating Income Margin	0.024	0.075	0.171	0.085	0.100	0.097
	Days Receivable	18.860	36.367	49.885	28.220	30.785	33.759
	Days Inventory	4.516	10.061	18.089	9.636	10.673	9.572
	Days Payables	16.188	28.941	48.712	25.649	28.436	29.356
	Days Revenues in Cash	5.454	18.891	50.961	22.139	21.843	20.475
	Revenue Growth	0.013	0.100	0.231	0.119	0.117	0.127
	Earnings Growth	−0.500	0.097	0.678	−0.225	0.103	0.182
	Assets Growth	−0.019	0.068	0.229	0.037	0.120	0.113
	Current Ratio	0.838	1.206	1.818	1.192	1.269	1.306
	Long-Term Debt to Common Equity	0.341	0.779	1.542	0.973	0.805	0.643
	Interest Coverage Ratio	0.894	2.922	7.433	2.485	3.564	3.693
	Liabilities to Equity	0.812	1.523	2.600	1.622	1.531	1.331
	Operating Cash Flow to Current Liabilities	0.057	0.142	0.272	0.151	0.144	0.174

		1998–2008			2008	2007	2006
		25th Percentile	Median	75th Percentile	Median	Median	Median
Utilities	Stock Return	−0.059	0.114	0.319	−0.185	0.103	0.204
	Market-to-Book	1.293	1.643	2.153	1.356	1.890	1.941
	Price-Earnings	12.826	15.818	20.299	12.900	17.710	17.579
	Profit Margin for ROA	0.070	0.108	0.159	0.100	0.107	0.104
	Total Asset Turnover	0.324	0.434	0.572	0.433	0.435	0.434
	ROA	0.038	0.049	0.061	0.045	0.047	0.047
	Profit Margin for ROCE	0.039	0.070	0.106	0.071	0.070	0.070
	Capital Structure Leverage	2.866	3.358	4.132	3.319	3.246	3.330
	ROCE	0.076	0.110	0.142	0.101	0.109	0.106
	Gross Profit Margin	0.173	0.246	0.342	0.224	0.233	0.234
	SG&A Percentage	0.045	0.101	0.181	0.086	0.090	0.085
	Operating Income Margin	0.103	0.154	0.224	0.140	0.148	0.142
	Days Receivable	31.745	42.836	56.016	41.349	42.352	43.870
	Days Inventory	12.297	22.904	36.118	23.664	25.142	24.581
	Days Payables	31.085	42.596	61.584	41.346	42.088	44.294
	Days Revenues in Cash	1.834	5.438	17.989	5.633	4.701	5.010
	Revenue Growth	−0.008	0.063	0.167	0.080	0.058	0.051
	Earnings Growth	−0.145	0.055	0.331	0.034	0.081	0.078
	Assets Growth	−0.002	0.051	0.121	0.088	0.056	0.047
	Current Ratio	0.665	0.887	1.151	0.957	0.901	0.952
	Long-Term Debt to Common Equity	0.743	1.015	1.388	0.992	0.958	0.959
	Interest Coverage Ratio	2.215	3.132	4.169	3.274	3.336	3.188
	Liabilities to Equity	1.750	2.287	2.990	2.321	2.175	2.259
	Operating Cash Flow to Current Liabilities	0.069	0.101	0.139	0.095	0.103	0.104

(Continued)

		1998–2008			2008	2007	2006
		25th Percentile	Median	75th Percentile	Median	Median	Median
Wholesale	Stock Return	−0.338	0.009	0.434	−0.482	0.030	0.105
	Market-to-Book	0.810	1.392	2.488	0.992	1.774	1.896
	Price-Earnings	9.000	14.175	21.446	10.118	14.967	16.811
	Profit Margin for ROA	−0.004	0.020	0.046	0.020	0.029	0.031
	Total Asset Turnover	1.320	2.041	3.019	2.155	2.094	2.110
	ROA	−0.017	0.046	0.083	0.051	0.059	0.061
	Profit Margin for ROCE	−0.013	0.012	0.035	0.014	0.022	0.024
	Capital Structure Leverage	1.819	2.489	3.570	2.260	2.291	2.296
	ROCE	−0.038	0.096	0.180	0.106	0.125	0.133
	Gross Profit Margin	0.117	0.203	0.305	0.193	0.187	0.192
	SG&A Percentage	0.089	0.161	0.250	0.142	0.140	0.144
	Operating Income Margin	0.005	0.029	0.065	0.032	0.041	0.040
	Days Receivable	29.745	43.500	56.904	41.527	41.224	41.543
	Days Inventory	26.816	52.592	88.476	43.058	48.238	49.354
	Days Payables	26.470	39.168	57.219	36.733	41.556	40.153
	Days Revenues in Cash	2.139	5.842	20.494	7.380	6.134	6.714
	Revenue Growth	−0.044	0.075	0.211	0.064	0.079	0.095
	Earnings Growth	−0.596	0.106	0.656	−0.126	0.123	0.232
	Assets Growth	−0.061	0.055	0.192	0.011	0.072	0.089
	Current Ratio	1.236	1.687	2.481	1.763	1.824	1.764
	Long-Term Debt to Common Equity	0.159	0.450	1.056	0.438	0.345	0.333
	Interest Coverage Ratio	−0.028	2.782	8.564	3.208	4.675	4.757
	Liabilities to Equity	0.753	1.426	2.565	1.245	1.241	1.228
	Operating Cash Flow to Current Liabilities	−0.028	0.082	0.196	0.113	0.100	0.094

Index

Ray J Fall
 ↓
 Ecroth

 unt

565

Spring

495 - 3 Sections
(2)

 unter
 492 495
 (2)

10 560 D

 36
18 / 22
 .61